**SIXTH EDITION
VOLUME II**

ART HISTORY

**MARILYN
STOKSTAD** **MICHAEL W.
COTHREN**

This sixth edition of **ART HISTORY** *is dedicated
to the memory of Marilyn Stokstad (1929–2016) who
conceived and created the first edition, published in 1995.*

Editor-in-Chief: Sarah Touborg
Sponsoring Editor: Helen Ronan
Product Marketing Manager: Jeremy Intal
Product Marketing Assistant: Frank Alarcon
Executive Field Marketer: Wendy Albert
Project Management Team Lead: Melissa Feimer
Content Producer: Barbara Cappuccio
Senior Producer, REVEL: Rich Barnes
Digital Imaging Technician: Corin Skidds

This book was designed and produced by
Laurence King Publishing Ltd., London
www.laurenceking.com

Editorial Manager: Kara Hattersley-Smith
Senior Editor: Sophie Wise
Production Manager: Simon Walsh
Designer: Ian Hunt
Picture Researchers: Katharina Gruber and Julia Ruxton

Cover image: Julia Jumbo, *Two Grey Hills Tapestry Weaving*.
Navajo, 2003. Handspun wool, 36 × 24½″ (91.2 × 62.1 cm).

Acknowledgments of third party content appear on page 1174, which constitutes an extension of this copyright page.

Library of Congress Cataloging-in-Publication Data
Names: Stokstad, Marilyn, 1929-2016, author. | Cothren, Michael Watt, author.
Title: Art History / Marilyn Stokstad, Michael W. Cothren.
Description: Sixth edition. | Upper Saddle River : Pearson, [2018] |
Includes
 bibliographical references and index.
Identifiers: LCCN 2016034108| ISBN 9780134475882 (combined volume) | ISBN 0134475887 (combined volume) |
 ISBN 9780134479279 (student edition volume 1) | ISBN 0134479270 (student edition volume 1) |
 ISBN 9780134479262 (student edition volume 2) | ISBN 0134479262 (student edition volume 2)
Subjects: LCSH: Art--History--Textbooks.
Classification: LCC N5300 .S923 2018 | DDC 709--dc23
LC record available at https://lccn.loc.gov/2016034108

4 17

Student Edition Volume 2
ISBN-10: 0-13-447926-2
ISBN-13: 978-0-13447926-2

Books a la Carte Volume 2
ISBN-10: 0-13-448466-5
ISBN-13: 978-0-13-448466-2

Brief Contents

Contents iv
Letter from the Author xii
What's New xiii
Acknowledgments and Gratitude xiv
Use Notes xvi
Starter Kit xvii
Introduction xxii

18 Fourteenth-Century Art in Europe 542

19 Fifteenth-Century Art in Northern Europe 574

20 Renaissance Art in Fifteenth-Century Italy 606

21 Sixteenth-Century Art in Italy 644

22 Sixteenth-Century Art in Northern Europe and the Iberian Peninsula 690

23 Seventeenth-Century Art in Europe 724

24 Art of South and Southeast Asia after 1200 782

25 Chinese and Korean Art after 1279 806

26 Japanese Art after 1333 828

27 Art of the Americas after 1300 850

28 Art of Pacific Cultures 874

29 Arts of Africa from the Sixteenth Century to the Present 894

30 European and American Art, 1715–1840 920

31 Mid- to Late Nineteenth-Century Art in Europe and the United States 978

32 Modern Art in Europe and the Americas, 1900–1950 1030

33 The International Scene since the 1950s 1096

Glossary 1152
Bibliography 1163
Text Credits 1174
Index 1175

Contents

Contents iv
Letter from the Author x
What's New xi
Acknowledgments and Gratitude xii
Use Notes xiv
Starter Kit xv
Introduction xx

18 Fourteenth-Century Art in Europe 542

FOURTEENTH-CENTURY EUROPE 544

ITALY 545
Florentine Architecture and Metalwork 545
Florentine Painting 548
Sienese Painting 554

FRANCE 562
Manuscript Illumination 562
Metalwork and Ivory 564

ENGLAND 566
Embroidery: *Opus Anglicanum* 566
Architecture 567

THE HOLY ROMAN EMPIRE 568
Mysticism and Suffering 568
The Supremacy of Prague 570

19 Fifteenth-Century Art in Northern Europe 574

THE NORTHERN RENAISSANCE 576

ART FOR THE FRENCH DUCAL COURTS 577
Painting and Sculpture
 for the Chartreuse de Champmol 577
Manuscript Illumination 580
Textiles 582

PAINTING IN FLANDERS 584
The Master of Flémalle 585
Jan van Eyck 587
Rogier van der Weyden 590
Painting at Mid Century: The Second Generation 593
Hugo van der Goes and Hans Memling 593

FRANCE 596
Jean Fouquet and Jean Hey 597
Flamboyant Architecture 598

THE GERMANIC LANDS 599
Painting and Sculpture 599
The Graphic Arts 602
Printed Books 604

20 Renaissance Art in Fifteenth-Century Italy 606

HUMANISM AND THE ITALIAN RENAISSANCE 607

THE EARLY RENAISSANCE IN FLORENCE 609
The Competition Reliefs 609
Filippo Brunelleschi, Architect 610
Sculpture 615
Masaccio 622
Painting in Florence after Masaccio 626

**FLORENTINE ART IN THE SECOND HALF
OF THE FIFTEENTH CENTURY 629**
Verrocchio 629
Pollaiuolo 629
The Morelli-Nerli Wedding Chests 630
Ghirlandaio 632
Botticelli 635

URBINO, MANTUA, ROME, AND VENICE 636
Urbino 636
Mantua 639
Rome 640
Venice 640

21 Sixteenth-Century Art in Italy 644

EUROPE IN THE SIXTEENTH CENTURY 646

THE ROMAN HIGH RENAISSANCE 647
Leonardo da Vinci 648
Raphael 652
Michelangelo 658
Architecture in Rome and the Vatican 665

NORTHERN ITALY 665
Venice and the Veneto 668
The Architecture of Palladio 675

MANNERISM 678
Pontormo, Parmigianino, and Bronzino 678
Anguissola and Fontana 682
Sculpture 683

ART AND THE COUNTER-REFORMATION 684
Rome and the Vatican 684

22 Sixteenth-Century Art in Northern Europe and the Iberian Peninsula 690

THE REFORMATION AND THE ARTS 692

GERMANY 694
Sculpture 694
Painting 695

FRANCE 703
A French Renaissance under Francis I 704
Royal Residences 704

SPAIN AND PORTUGAL 707
Architecture 707
Sculpture 708
Painting 709

THE NETHERLANDS 711
Painting for Aristocratic and Noble Patrons 711
Antwerp 714

ENGLAND 720
Painting at the Tudor Court 720
Architecture 721

23 Seventeenth-Century Art in Europe 724

"BAROQUE" 726

ITALY 727
Maderno and Bernini at St. Peter's 727
Bernini as Sculptor 729
Borromini 731
Painting 732

SPAIN 742
Painting in Spain's Golden Age 742
Architecture 748

FLANDERS 749
Rubens 749
Van Dyck and Peeters: Portraits and Still Lifes 752

THE DUTCH REPUBLIC 754
Painting 755

FRANCE 769
Versailles 771
Painting 774

ENGLAND 778
Architecture 779

24 Art of South and Southeast Asia after 1200 782

FOUNDATIONS OF INDIAN CULTURE 784

SOUTH ASIA 1200–1800 784
Changes in Religion and Art 784
Hindu Architectural Developments 787
Mughal Period 790

SOUTHEAST ASIA 1200–1800 798
Buddhist Art and Kingship 798
Islamic Art in Southeast Asia 801

THE COLONIAL PERIOD AND THE MODERN ERA 802
British Imperialism in South Asia 802
The Modern Period 804

25 Chinese and Korean Art after 1279 806

FOUNDATIONS OF CHINESE CULTURE 808

THE MONGOL INVASIONS AND THE YUAN DYNASTY 808
Painting 810

THE MING DYNASTY 812
Court and Professional Painting 814
Architecture and City Planning 816
The Literati Aesthetic 816

FROM THE QING DYNASTY TO THE MODERN ERA 820
Orthodox and Individualist Painting 820
The Modern Period 822

ARTS OF KOREA FROM THE JOSEON DYNASTY TO THE MODERN ERA 823
Joseon Ceramics 823
Joseon Painting 824
Modernist Painting 826

26 Japanese Art after 1333 828

FOUNDATIONS OF JAPANESE CULTURE 829

MUROMACHI PERIOD 831
Zen Ink Painting 831
Zen Dry Gardens 832

MOMOYAMA PERIOD 833
Architecture 834
Shoin Rooms 834
The Tea Ceremony 836

EDO PERIOD 838
Rinpa School Painting 838
Naturalistic and Literati Painting 840
Ukiyo-e: Pictures of the Floating World 842
Zen Painting: Buddhist Art for Rural Commoners 844
Cloth and Ceramics 844

THE MODERN PERIOD 846
Meiji-Period Nationalist Painting 846
Japan after World War II 847

27 Art of the Americas after 1300 850

THE AZTEC EMPIRE 852
Tenochtitlan 853
Sculpture 855
Featherwork and Manuscripts 856

THE INCA EMPIRE 856
Cusco 857
Machu Picchu 858
Textiles and Metalwork 859
The Aftermath of the Spanish Conquest 860

NORTH AMERICA 860
 The Eastern Woodlands 861
 The Great Plains 864
 The Northwest Coast 866
 The Southwest 868

A NEW BEGINNING 871

28 Art of Pacific Cultures 874

THE PEOPLING OF THE PACIFIC 875

AUSTRALIA 877

MELANESIA AND MICRONESIA 878
 New Guinea 879
 New Ireland and New Britain 881

POLYNESIA 884
 Te-Hau-Ki Turanga 885
 Marquesas Islands 887
 Hawaii, Rapa Nui, Samoa 888

RECENT ART IN OCEANIA 890
 Festival of Pacific Arts 890
 Central Desert Painting 890
 Shigeyuki Kihara 892

29 Arts of Africa from the Sixteenth Century to the Present 894

THE SIXTEENTH THROUGH TWENTIETH CENTURIES:
ROYAL ARTS AND ARCHITECTURE 895
 Key Concepts 896
 Ghana 897
 Cameroon 898
 Democratic Republic of the Congo 899
 Nigeria 901

THE NINETEENTH CENTURY: COLONIALISM
AND MODERNITY 903
 The Colonial Conquest 903
 Modern Objects 905

THE TWENTIETH CENTURY:
INDEPENDENCE-ERA ART 911
 Ghana 911
 Burkina Faso 912
 Postcolonial/Postmodern: Photography, *Récupération,*
 Painting 913

LATE TWENTIETH AND EARLY TWENTY-FIRST CENTURY:
NEW DIRECTIONS 916
 Mpane: The Burden of History 916
 Wangechi Mutu: The International
 Artist Experience 917
 Yinka Shonibare MBE: The Global Flows of History 918
 Muholi: Changing the Political and Cultural
 Discourse 918

30 European and American Art, 1715–1840 920

INDUSTRIAL, INTELLECTUAL, AND POLITICAL
REVOLUTIONS 922

ROCOCO 922
 Rococo Salons 923
 Painting 924
 Sculpture and Architecture 928

THE GRAND TOUR AND NEOCLASSICISM
IN ITALY 929
 Grand Tour Portraits and Views 930
 Neoclassicism in Rome 931

NEOCLASSICISM AND EARLY ROMANTICISM
IN BRITAIN 933
 The Classical Revival in Architecture and Design 934
 The Gothic Revival in Architecture and Design 937
 Iron as a Building Material 938
 Trends in British Painting 939

LATER EIGHTEENTH-CENTURY ART IN FRANCE 948
 Architecture 948
 Painting 949
 Sculpture 955

SPAIN AND SPANISH AMERICA 956
 Goya 956
 The Art of the Americas under Spain 959

**THE DEVELOPMENT OF NEOCLASSICISM
AND ROMANTICISM INTO THE NINETEENTH
CENTURY** 961
 Developments in France 962
 Romantic Landscape Painting 971
 British and American Architecture 974

31 Mid- to Late Nineteenth-
Century Art in Europe
and the United States 978

**EUROPE AND THE UNITED STATES
IN THE MID TO LATE NINETEENTH CENTURY** 980

FRENCH ACADEMIC ARCHITECTURE AND ART 981
 Architecture 981
 Painting and Sculpture 984

**EARLY PHOTOGRAPHY IN EUROPE AND
THE UNITED STATES** 985
 Alexander Gardner and Julia Margaret Cameron 988

REALISM AND THE AVANT-GARDE 989
 Realism and Revolution 989
 Manet: "The Painter of Modern Life" 993
 Responses to Realism beyond France 996

IMPRESSIONISM 1003
 Landscape and Leisure 1003
 Modern Life 1007
 Japonisme 1010

THE LATE NINETEENTH CENTURY 1011
 Post-Impressionism 1011
 Symbolism 1015
 French Sculpture 1017
 Art Nouveau 1018

THE BEGINNINGS OF MODERNISM 1022
 European Architecture: Technology and Structure 1022
 The Chicago School 1023
 The City Park 1026
 Cézanne 1027

32 Modern Art in Europe and
the Americas, 1900–1950 1030

**EUROPE AND AMERICA
IN THE EARLY TWENTIETH CENTURY** 1032

**EARLY MODERN ART AND ARCHITECTURE
IN EUROPE** 1033
 The Fauves: Wild Beasts of Color 1033
 Picasso, "Primitivism," and the Coming
 of Cubism 1036
 Die Brücke and Primitivism 1040
 Independent Expressionists 1042
 Spiritualism of Der Blaue Reiter 1045

**EXTENDING CUBISM AND QUESTIONING ART
ITSELF** 1045
 Toward Abstraction in Sculpture 1049
 Dada: Questioning Art Itself 1050
 Modernist Tendencies in America 1054
 Early Modern Architecture 1059

ART BETWEEN THE WARS IN EUROPE 1064
 Utilitarian Art Forms in Russia 1064
 De Stijl in the Netherlands 1067
 The Bauhaus in Germany 1069
 Surrealism and the Mind 1072
 Unit One in England 1075
 Picasso's *Guernica* 1077

ART BETWEEN THE WARS IN THE AMERICAS 1078

THE HARLEM RENAISSANCE 1078
Rural America 1080
Canada 1082
Mexico, Brazil, and Cuba 1084

POSTWAR ART IN EUROPE AND THE AMERICAS 1086
Figural Responses and Art Informel in Europe 1086
Experiments in Latin America 1087
Abstract Expressionism in New York 1088

33 The International Scene since the 1950s 1096

THE WORLD SINCE THE 1950s 1097
The History of Art since the 1950s 1098

THE EXPANDING ART WORLD 1099
Finding New Forms 1099
New Forms Abroad 1101
Happenings and Fluxus 1102
Pop Art 1106
Minimalism 1109

THE DEMATERIALIZATION OF ART 1110
Conceptual Art and Language 1110
New Media 1111
Process and Materials 1113
Earthworks 1115

FEMINIST ART 1116
Chicago and Schapiro 1117

ARCHITECTURE: MID-CENTURY MODERNISM TO POSTMODERNISM 1120
Mid-Century Modernist Architecture 1120
Postmodern Architecture 1122

POSTMODERNISM 1124
Neo-Expressionism 1124
Appropriation, Identity, and Critique 1125
Identity Politics and the Culture Wars 1128
Controversies over Funding in the Arts 1130
Public Art 1132

HIGH TECH AND DECONSTRUCTIVIST ARCHITECTURE 1134
High Tech Architecture 1134
Deconstructivist Architecture 1135

CONTEMPORARY ART IN AN EXPANDING WORLD 1136
Globalization and the Art World 1136
The Body in Contemporary Art 1138
New Approaches to Painting and Photography 1142
The New Formalism 1145
Activist Strategies and Participatory Art 1148
The Future of New Media 1150

Glossary 1152
Bibliography 1163
Text Credits 1174
Index 1175

Letter from the Author

Dear Colleagues,

When Marilyn Stokstad wrote the first edition of *Art History* in the early 1990s, it represented an historical advance in the conception and teaching of the history of art. The discipline had recently gone through a period of crisis and creativity that challenged the assumptions behind the survey course and questioned the canon of works that had long been its foundation. We all rethought what we were doing, and this soul searching made us better teachers—more honest and relevant, more passionate and inclusive. With characteristic energy and intelligence, Marilyn stepped up to the task of conceiving and creating a new survey book for a new generation of students ready to reap the benefits of this refined notion of art history. From the beginning, she made it global in scope, inclusive in coverage, warm and welcoming in tone. Marilyn highlighted the role of women in the history of art both by increasing the number of women artists and by expanding the range of art to focus on media and genres that had traditionally engaged female artists and patrons.

It was an honor to become part of her project almost a decade ago, and it is my sad responsibility to acknowledge her passing, just as this sixth edition went to press. To me, she was more than a brilliant art historian; she was a loyal and compassionate colleague, a great friend. The warmth and trust with which she welcomed me into the writing of *Art History* was one of the great experiences of my professional life. I will truly miss her, and I will work faithfully to continue her legacy as this book moves into the future. I promised her I would.

After all, reconsidering and refining what we do never ceases. Like art, learning and teaching change as we and our culture change, responsive to new objectives and new understandings. Opportunities for growth sometimes emerge in unexpected situations. One day, while I was inching through sluggish suburban traffic with my daughter Emma—a gifted teacher—I confessed my disappointment about my survey students' struggle with mastering basic information. "Why," I asked rhetorically, "is it so difficult for them to learn these facts?" Emma's unexpected answer shifted the question and reframed the discussion. "Dad," she said, "you are focusing on the wrong aspect of your teaching. What are you trying to accomplish by asking your students to learn those facts? Clarify your objectives first, then question whether your assessment is actually the best way to encourage its accomplishment."

Emma's question inspired me to pause and reflect on what it is we seek to accomplish in art history survey courses. One of my primary goals has been encouraging

my students to slow down and spend extended time studying the illustrations of the works of art, what I call "slow looking." I thought memorizing the IDs would accomplish this. But I have grown to realize that there are more effective ways to make this happen, especially in the new online REVEL format that is transforming this textbook into an interactive learning experience. REVEL is more like a classroom than a book. It is based on the premise that students will focus more effectively on a series of changing formats tailored to the content being presented. When I piloted REVEL in my survey classroom last Fall, I discovered that my students were "slow looking" while taking advantage of interactive REVEL features such as the pan/zoom figures (which allow them to zoom in on details) and the architectural panoramas (which allow them to explore the interacting spaces of architectural interiors from multiple viewpoints). I doubted my students would take advantage of these opportunities while doing "assigned reading," but I was wrong. The first week of class a student's hand shot up to ask if I could explain a detail she had seen when using the pan/zoom. Within the same week, another student shared his surprise at the small size of a work of art discovered when clicking on the pan/zoom's scale feature. In three decades of teaching art history survey, never had a student brought to class an observation or question about scale, even though measurements were included in captions. I love books, I really do, but in my experience REVEL is a more effective teaching resource.

I urge you to continue thinking with me about how the study of art history can be meaningful and nourishing for students. Our discipline originated in dialogue and is founded on the desire to talk with each other about why works of art matter and why they affect us so deeply. I would love to hear from you—mcothre1@swarthmore.edu.

Warm regards,

Michael

What's New

WHY USE THIS NEW EDITION?

Art history—what a fascinating and fluid discipline, which evolves as the latest research becomes available for debate and consideration. The sixth edition of *Art History* has been revised to reflect such new discoveries, recent research, and fresh interpretive perspectives, and also to address the changing needs of the audience—both students and educators. With these goals in mind and by incorporating feedback from our many users and reviewers, we have sought to make this edition an improvement in sensitivity, readability, and accessibility without losing anything in comprehensiveness, in scholarly precision, or in its ability to engage readers.

To facilitate student learning and understanding of art history, the sixth edition is centered on six key Learning Objectives. These overarching goals helped steer and shape this revision with their emphasis on the fundamental reasons we teach art history to undergraduates, and they have been repeated at the beginning of each chapter, tailored to the subject matter in that section of the book so that the student will be continually reminded of the goals and objectives of the study of art history.

LEARNING OBJECTIVES FOR *ART HISTORY*

1. Identify the visual hallmarks of regional and period styles for formal, technical, and expressive qualities.

2. Interpret the meaning of works of art from diverse cultures, periods, and locations based on their themes, subjects, and symbols.

3. Relate artists and works of art to their cultural, economic, and political contexts.

4. Apply the vocabulary and concepts used to discuss works of art, artists, and art history.

5. Interpret art using appropriate art historical methods, such as observation and inductive reasoning.

6. Select visual and textual evidence to support an argument or interpretation.

DESIGNING *ART HISTORY* IN REVEL

One of the principal objectives of the current edition has been to advance the transformation of the traditional narrative into an interactive learning experience in REVEL. REVEL is conceived to promote learning in a digital platform that is engaging and meaningful to today's student. Along with traditional narrative text passages, features such as pan/zoom images, videos, architectural panoramas, and audio text are integrated to better explain and present concepts key to understanding the history of art.

- **Pan/zooms** appear with a simple click for most of the figures, allowing students to zoom in and examine details with stunning clarity and resolution, and then return to the overall view of the work of art, so they can relate these details to the whole.

- The pan/zooms' **scale feature** opens a window where works of art appear next to a scaled human figure (or for small works a scaled human hand), giving students an instant sense of the size of what they are studying. Since all works of art are scaled in a fundamental sense to the size of human creators and viewers (rather than to an arbitrary measuring system), this intuitive communication of size is more instructive for students than the specific measurements found in the captions.

- There are three **writing prompts** in each chapter. All are keyed to specific works of art and appear in conjunction with figures that illustrate the works. **Journaling** prompts focus on building skills of visual analysis; **Shared Writing** responses relate the material in the chapter to today's world; and **Writing Space** prompts encourage students to engage in cross-cultural thinking, often across chapters.

NEW TO THIS EDITION OF REVEL

- **3D animations of architectural and art historical techniques** depict and explain processes and methods that are difficult for students to grasp simply through narrative text.

- **New panoramas from global sites** sourced from 360Cities have been integrated, bringing students into the setting of major buildings and monuments such as the Taj Mahal and Great Zimbabwe.

- **Each and every Closer Look** has been transformed into a REVEL video presentation, where students are guided through a detailed examination of the work, coordinated with the interpretive material about style, subject matter, and cultural context as it unfolds.

SOME ADDITIONAL CONTENT HIGHLIGHTS OF THE NEW EDITION

- **Global coverage has been deepened** with the addition of new works of art and revised discussions that incorporate new scholarship. This is especially true in the cases of South and Southeast Asia, as well as Africa—the chapters addressing these areas have been significantly reworked and expanded.

- **Chapter 33 on contemporary art** has been rethought, reorganized, and reworked for greater clarity and timeliness. Numerous new works have been incorporated.

- Throughout, **images have been updated** whenever new and improved images were available or works of art have been cleaned or restored.

- The **language used to characterize works of art**—especially those that attempt to capture the lifelike appearance of the natural world—has been **refined and clarified** to bring greater precision and nuance.

- In response to readers' requests, **discussion of many major monuments** has been revised and expanded.

- **New works have been added** to the discussion in many chapters to enhance and enrich what is said in the text. These include the Standard of Ur, the Great Mosque of Damascus, a painting from the tomb of Nebamun, the Ardabil Carpet, the burial mask of Pakal the Great, Mesa Verde, Kim Hongdo's scene of roof tiling, Imogen Cunningham's *Two Callas*, and the works of many additional contemporary artists. In addition, the following artists are now discussed through new, and more representative, works: Zhao Mengfu, Rosalba Carriera, Antonio Canova, Georgia O'Keeffe, Vladimir Tatlin, Paula Modersohn-Becker, Suzuki Harunobu, and Mary Cassatt.

Acknowledgments and Gratitude

Art History, originally written by Marilyn Stokstad and first published by Harry N. Abrams, Inc. and Prentice Hall, Inc. in 1995, has relied, each time it has been revised, on the contributions of colleagues . Their work is reflected here, and they deserve enduring gratitude since this sixth edition represents the cumulative efforts of the distinguished group of scholars and educators who contributed to the previous five editions. The work of Stephen Addiss, Chutsing Li, Marylin M. Rhie, and Christopher D. Roy for the original book has been updated by David Binkley and Patricia Darish (Africa); Claudia Brown and Robert Mowry (China and Korea); Patricia Graham (Japan); Rick Asher (South and Southeast Asia); D. Fairchild Ruggles (Islamic); Claudia Brittenham (Americas); Sara Orel and Carol Ivory (Pacific cultures); and Bradford R. Collins, David Cateforis, Patrick Frank, and Joy Sperling (Modern). For this sixth edition, Robert DeCaroli reworked the chapters on South and Southeast Asia; Susan Kart extensively rethought and revised the chapters on African art; and Virginia Spivey did the same for the final chapter, "The International Scene since the 1950s".

Words can hardly express the depth of my own gratitude to Marilyn Stokstad, who welcomed me in 2008 with enthusiasm and trust into the collaborative adventure of revising this historic textbook, conceived for students in the 21st century. We worked together on *Art History* since the fourth edition, and with her passing in 2016 as this sixth edition was going to press, I have lost a treasured colleague.

Marilyn would want me to thank her University of Kansas colleagues Sally Cornelison, Susan Craig, Susan Earle, Charles Eldredge, Kris Ercums, Sherry Fowler, Stephen Goddard, Saralyn Reece Hardy, Marsha Haufler, Marni Kessler, Amy McNair, John Pulz, Linda Stone Ferrier, and John Younger for their help and advice; and also her friends Katherine Giele and Katherine Stannard, William Crowe, David Bergeron, and Geraldo de Sousa for their sympathy and encouragement. Very special thanks go to Marilyn's sister, Karen Leider, and her niece, Anna Leider, without whose enduring support, this book would not have seen the light of day.

At Pearson, I have collaborated closely with two gifted and dedicated editors, Sarah Touborg and Helen Ronan, whose almost daily support in so many ways was at the center of Marilyn's and my work for years. I cannot imagine working on this project without them. Also working with me at Pearson were Barbara Cappuccio, Joe Scordato, Melissa Feimer, Cory Skidds, Victoria Engros, and Claire Ptaschinski. At Laurence King Publishing, Sophie Wise, Kara Hattersley-Smith, Julia Ruxton, Katharina Gruber, and Simon Walsh oversaw the production of this new edition. Much appreciation also goes to Wendy Albert, Marketing Manager extraordinaire, as well as the entire Social Sciences and Arts team at Pearson.My work has been greatly facilitated by the research assistance and creative ideas of Fletcher Coleman, Andrew Finegold, Moses Hanson-Harding, and Zoe Wray, who helped with previous editions. I also have been supported by a host of colleagues at Swarthmore College. Generations of students challenged me to hone my pedagogical skills and steady my focus on what is at stake in telling the history of art. My colleagues in the Art Department—especially Stacy Bomento, Syd Carpenter, June Cianfrana, Randall Exon, Logan Grider, Laura Holzman, Constance Hungerford, Brian Meunier, Thomas Morton, Derek Burdette, Patricia Reilly, and Tomoko Sakomura—have answered questions, shared insights on works in their areas of expertise, and offered unending encouragement and support. I am so lucky to work with them.

Many art historians have provided assistance, often at a moment's notice, and I am especially grateful to Betina Bergman, Claudia Brown, Elizabeth Brown, Brigitte Buettner, David Cateforis, Madeline Caviness, Sarah Costello, Cynthia Kristan-Graham, Joyce de Vries, Cheri Falkenstien-Doyle, Sharon Gerstel, Kevin Glowaki, Ed Gyllenhaal, Julie Hochstrasser, Vida J. Hull, Penny Jolly, Padma Kaimal, Barbara Kellum, Alison Kettering, Benton Kidd, Ann Kuttner, Anne Leader, Steven LeBlanc, Cary Liu, Elizabeth Marlowe, Samuel Morse, Thomas Morton, Kathleen Nolan, David Shapiro, Mary Shepard, Larry Silver, David Simon, Donna Sadler, Jeffrey Smith, Mark Tucker, and Tarynn Witten.

I am fortunate to have the support of many friends especially John Brendler, David Eldridge, Fiona Harrison, Stephen Lehmann, Mary Marissen, Denis Ott, Bruce and Carolyn Stephens, and Rick and Karen Taylor.

My preparation for this work runs deep. My parents, Mildred and Wat Cothren, showered me with unconditional love and made significant sacrifices to support my education, from pre-school through graduate school. Sara Shymanski, elementary school librarian at St. Martin's Episcopal School in Metairie, Louisiana, gave me courage through her example and loving encouragement to pursue unexpected passions for history, art, and the search to make them meaningful in both past and present. Françoise Celly, my painting professor during a semester abroad in Aix-en-Provence, sent me to study the Romanesque sculpture of Autun, initiating my journey toward a career in art history. At Vanderbilt University, Ljubica Popovich fostered this new interest by unlocking the mysteries of Byzantine art. My extraordinary daughters Emma and Nora remain a constant inspiration. I am so grateful for their delight in my passion for art's history, and for their dedication to keeping me from taking myself too seriously. But deepest gratitude is reserved for Susan Lowry, my wife and soul-mate, who brings joy to my life on a daily basis. She is not only patient and supportive during the long distractions of my work on this book; she provides help in countless ways. The greatest accomplishment of my life in art history occurred on the day I met her in graduate school at Columbia University in 1973.

It seems fitting in this sixth edition of *Art History*, dedicated to the memory of the scholar who created it, to conclude with the statement that ended Marilyn's "Preface" for the first edition in 1995, since it captures in her inimitable style my own thoughts as well. "As each of us develops a genuine appreciation of the arts, we come to see them as the ultimate expression of human faith and integrity as well as creativity. I have tried here to capture that creativity, courage, and vision in such a way as to engage and enrich even those encountering art history for the very first time. If I have done that, I will feel richly rewarded."

Michael W. Cothren
Sedona, AZ, and Philadelphia, PA

IN GRATITUDE: As its predecessors did, this sixth edition of *Art History* benefited from the reflections and assessments of a distinguished team of scholars and educators. The authors and Pearson are grateful to the following academic reviewers for their numerous insights and suggestions for improvement: Victor Coonin, Rhodes College; Sarah Blick, Kenyon College; Elizabeth Adan, California Polytechnic State University, San Luis Obispo; Sara Orel, Truman State University; Carolyn E. Tate, Texas Tech University; April Morris, University of Alabama; Catherine Pagani, University of Alabama; Jennie Klein, Ohio University; Rebecca Stone, Emory University; Tanja Jones, University of Alabama; Keri Watson, University of Central Florida; Stephany Rimland, Harper College; Elizabeth Sutton, University of Northern Iowa; Elizabeth Carlson, Lawrence University; Laura Crary, Presbyterian College; Camille Serchuk, Southern Connecticut State University; Lydia Host, Bishop State Community College; K.C. Williams, Northwest Florida State College; Elissa Graff, Lincoln Memorial University; Ute Wachsmann-Linnan, Columbia College; Amy Johnson, Otterbein University; Lisa Alembik, Georgia Perimeter College; Virginia Dacosta, West Chester University; Megan Levacy, Georgia Perimeter College; Victor Martinez, Monmouth College; Julia Sienkewicz, Duquesne University; Jamie Ratliff, University of Minnesota Duluth; Maureen McGuire, Full Sail University; Heather Vinson, University of West Georgia.

This edition has continued to benefit from the assistance and advice of scores of other teachers and scholars who generously answered questions, gave recommendations on organization and priorities, and provided specialized critiques during the course of work on previous editions.

We are grateful for the detailed critiques from the following readers across the country who were of invaluable assistance during work on the third, fourth, and fifth editions:

Craig Adcock, University of Iowa; Charles M. Adelman, University of Northern Iowa; Fred C. Albertson, University of Memphis; Kimberly Allen-Kattus, Northern Kentucky University; Frances Altvater, College of William and Mary; Kirk Ambrose, University of Colorado, Boulder; Michael Amy, Rochester Institute of Technology; Lisa Aronson, Skidmore College; Susan Jane Baker, University of Houston; Jennifer L. Ball, Brooklyn College, CUNY; Samantha Baskind, Cleveland State University; Tracey Boswell, Johnson County Community College; Mary Brantl, St. Edward's University; Jane H. Brown, University of Arkansas at Little Rock; Denise Budd, Bergen Community College; Stephen Caffey, Texas A&M University; Anne Chapin, Brevard College; Michelle Moseley Christian, Virginia Tech; Charlotte Lowry Collins, Southeastern Louisiana University; Sarah Kielt Costello, University of Houston; Roger J. Crum, University of Dayton; Brian A. Curran, Penn State University; Cindy B. Damschroder, University of Cincinnati; Michael T. Davis, Mount Holyoke College; Juilee Decker, Georgetown College; Laurinda Dixon, Syracuse University; Rachael Z. DeLue, Princeton University; Anne Derbes, Hood College; Sheila Dillon, Duke University; Caroline Downing, State University of New York at Potsdam; Laura Dufresne, Winthrop University; Suzanne Eberle, Kendall College of Art & Design of Ferris State University; April Eisman, Iowa State University; Dan Ewing, Barry University; Allen Farber, State University of New York at Oneonta; Arne Flaten, Coastal Carolina University; William Ganis, Wells College; John Garton, Cleveland Institute of Art; Richard Gay, University of North Carolina, Pembroke; Regina Gee, Montana State University; Sharon Gerstel, University of California, Los Angeles; Rosi Gilday, University of Wisconsin, Oshkosh; Kevin Glowacki, Texas A&M University; Amy Golahny, Lycoming College; Steve Goldberg, Hamilton College; Bertha Gutman, Delaware County Community College; Deborah Haynes, University of Colorado, Boulder; Mimi Hellman, Skidmore College; Julie Hochstrasser, University of Iowa; Eva Hoffman, Tufts University; Eunice D. Howe, University of Southern California; Phillip Jacks, George Washington University; Kimberly Jones, University of Texas, Austin; Evelyn Kain, Ripon College; Nancy Kelker, Middle Tennessee State University; Barbara Kellum, Smith College; Patricia Kennedy, Ocean County College; Jennie Klein, Ohio University; Katie Kresser, Seattle Pacific University; Cynthia Kristan-Graham, Auburn University; Barbara Platten Lash, Northern Virginia Community College; Paul Lavy, University of Hawaii at Manoa; William R. Levin, Centre College; Susan Libby, Rollins College; Henry Luttikhuizen, Calvin College; Lynn Mackenzie, College of DuPage; Elisa C. Mandell, California State University, Fullerton; Elizabeth Mansfield, New York University; Pamela Margerm, Kean University; Elizabeth Marlowe, Colgate University; Marguerite Mayhall, Kean University; Katherine A. McIver, University of Alabama at Birmingham; Dennis McNamara, Triton College; Gustav Medicus, Kent State University; Lynn Metcalf, St. Cloud State University; Janine Mileaf, Swarthmore College; Jo-Ann Morgan, Coastal Carolina University; Eleanor Moseman, Colorado State University; Johanna D. Movassat, San Jose State University; Sheila Muller, University of Utah; Beth A. Mulvaney, Meredith College; Dorothy Munger, Delaware Community College; Jacqueline Marie Musacchio, Wellesley College; Bonnie Noble, University of North Carolina at Charlotte; Elizabeth Olton, University of Texas at San Antonio; Leisha O'Quinn, Oklahoma State University; Lynn Ostling, Santa Rosa Junior College; David Parrish, Purdue University; Willow Partington,

Hudson Valley Community College; Martin Patrick, Illinois State University; Ariel Plotek, Clemson University; Patricia V. Podzorski, University of Memphis; Albert Reischuck, Kent State University; Margaret Richardson, George Mason University; James Rubin, Stony Brook University; Jeffrey Ruda, University of California, Davis; Tomoko Sakomura, Swarthmore College; Donna Sandrock, Santa Ana College; Erika Schneider, Framingham State University; Michael Schwartz, Augusta State University; Diane Scillia, Kent State University; Joshua A. Shannon, University of Maryland; David Shapiro; Karen Shelby, Baruch College; Susan Sidlauskas, Rutgers University; Jeffrey Chipps Smith, University of Texas, Austin; Royce W. Smith, Wichita State University; Stephanie Smith, Youngstown State University; Stephen Smithers, Indiana State University; Janet Snyder, West Virginia University; Richard Sundt, University of Oregon; Laurie Sylwester, Columbia College (Sonora); Carolyn Tate, Texas Tech University; Rita Tekippe, University of West Georgia; James Terry, Stephens College; Tilottama Tharoor, New York University; Sarah Thompson, Rochester Institute of Technology; Michael Tinkler, Hobart and William Smith Colleges; Amelia Trevelyan, University of North Carolina at Pembroke; Rebecca Turner, Savannah College of Art and Design; Julie Tysver, Greenville Technical College; Mary Jo Watson, University of Oklahoma; Reid Wood, Lorain County Community College; Jeryln Woodard, University of Houston; Linda Woodward, LSC Montgomery.

Our thanks also to additional expert readers including: Susan Cahan, Yale University; David Craven, University of New Mexico; Marian Feldman, University of California, Berkeley; Dorothy Johnson, University of Iowa; Genevra Kornbluth, University of Maryland; Patricia Mainardi, City University of New York; Clemente Marconi, Columbia University; Tod Marder, Rutgers University; Mary Miller, Yale University; Elizabeth Penton, Durham Technical Community College; Catherine B. Scallen, Case Western University; Kim Shelton, University of California, Berkeley.

Many people reviewed the original edition of *Art History* and have continued to assist with its revision. Every chapter was read by one or more specialists. For work on the original book and assistance with subsequent editions thanks go to: Barbara Abou-el-Haj, SUNY Binghamton; Roger Aiken, Creighton University; Molly Aitken, Anthony Alofsin, University of Texas, Austin; Christiane Andersson, Bucknell University; Kathryn Arnold; Julie Aronson, Cincinnati Art Museum; Michael Auerbach, Vanderbilt University; Larry Beck; Evelyn Bell, San Jose State University; Janetta Rebold Benton, Pace University; Janet Berlo, University of Rochester; Sarah Blick, Kenyon College; Jonathan Bloom, Boston College; Suzaan Boettger; Judith Bookbinder, Boston College; Marta Braun, Ryerson University; Elizabeth Broun, Smithsonian American Art Museum; Glen R. Brown, Kansas State University; Maria Elena Buszek, Kansas City Art Institute; Robert G. Calkins; Annmarie Weyl Carr; April Clagget, Keene State College; William W. Clark, Queens College, CUNY; John Clarke, University of Texas, Austin; Jaqueline Clipsham; Ralph T. Coe; Robert Cohon, The Nelson-Atkins Museum of Art; Alessandra Comini; James D'Emilio, University of South Florida; Walter Denny, University of Massachusetts, Amherst; Jerrilyn Dodds, City College, CUNY; Lois Drewer, Index of Christian Art; Joseph Dye, Virginia Museum of Art; James Farmer, Virginia Commonwealth University; Grace Flam, Salt Lake City Community College; Mary D. Garrard; Paula Gerson, Florida State University; Walter S. Gibson; Dorothy Glass; Oleg Grabar; Randall Griffey, Amherst College; Cynthia Hahn, Florida State University; Sharon Hill, Virginia Commonwealth University; John Hoopes, University of Kansas; Reinhild Janzen, Washburn University; Wendy Kindred, University of Maine at Fort Kent; Alan T. Kohl, Minneapolis College of Art; Ruth Kolarik, Colorado College; Carol H. Krinsky, New York University; Aileen Laing, Sweet Briar College; Janet LeBlanc, Clemson University; Charles Little, The Metropolitan Museum of Art; Laureen Reu Liu, McHenry County College; Loretta Lorance; Brian Madigan, Wayne State University; Janice Mann, Bucknell University; Judith Mann, St. Louis Art Museum; Richard Mann, San Francisco State University; James Martin; Elizabeth Parker McLachlan; Tamara Mikailova, St. Petersburg, Russia, and Macalester College; Anta Montet-White; Anne E. Morganstern, Ohio State University; Winslow Myers, Bancroft School; Lawrence Nees, University of Delaware; Amy Ogata, Cleveland Institute of Art; Judith Oliver, Colgate University; Edward Olszewski, Case Western Reserve University; Sara Jane Pearman; John G. Pedley, University of Michigan; Michael Plante, Tulane University; Eloise Quiñones-Keber, Baruch College and the Graduate Center, CUNY; Virginia Raguin, College of the Holy Cross; Nancy H. Ramage, Ithaca College; Ann M. Roberts, Lake Forest College; Lisa Robertson, The Cleveland Museum of Art; Barry Rubin; Charles Sack, Parsons, Kansas; Jan Schall, The Nelson-Atkins Museum of Art; Tom Shaw, Kean College; Pamela Sheingorn, Baruch College, CUNY; Raechell Smith, Kansas City Art Institute; Lauren Soth; Anne R. Stanton, University of Missouri, Columbia; Michael Stoughton; Thomas Sullivan, OSB, Benedictine College (Conception Abbey); Pamela Trimpe, University of Iowa; Richard Turnbull, Fashion Institute of Technology; Elizabeth Valdez del Alamo, Montclair State College; Lisa Vergara; Monica Visoná, University of Kentucky; Roger Ward, Norton Museum of Art; Mark Weil, St. Louis; David Wilkins; Marcilene Wittmer, University of Miami.

Use Notes

The various features of this book reinforce each other, helping you to become comfortable with terminology and concepts that are specific to art history.

Starter Kit and Introduction The Starter Kit is a very concise primer of basic concepts and tools. The Introduction explores the way they are used to come to an understanding of the history of art.

Captions There are two kinds of captions in this book: short and long. Short captions include information specific to the work of art or architecture illustrated:

 artist (when known)

 title or descriptive name of work

 date

 original location (if moved to a museum or other site)

 material or materials a work is made of

 size (height before width) in feet and inches, with meters and centimeters in parentheses

 present location

The order of these elements varies, depending on the type of work illustrated. Dimensions are not given for architecture, for most wall paintings, or for most architectural sculpture. Some captions have one or more lines of small print below the identification section of the caption that gives museum or collection information. This is rarely required reading; its inclusion is often a requirement for gaining permission to reproduce the work.

Some longer captions also include information that complements the discussion of a work in the main text.

Definitions of Terms You will encounter the basic terms of art history in three places:

 In the text, where words appearing in boldface type are defined, or glossed, at their first use.

 In features on technique and other subjects, where labeled drawings and diagrams visually reinforce the use of terms.

 The glossary contains all the words in boldface type in the text and features.

Maps At the beginning of most chapters you will find a map with all the places mentioned in the chapter.

Other In-Chapter Features Throughout the chapters is special material set off from the main text that complements, explains, or extends the chapter narrative.

"Art and its Contexts" features tell you more about selected works or issues from the chapter. "Closer Look" features help you learn more about specific aspects of important works. "Elements of Architecture" features clarify specific architectural features, often explaining engineering principles or building technology. "Technique" features outline how certain types of art are created.

Bibliography The bibliography lists books in English, organized by general works and by chapter, that are basic to the study of art history today, as well as books cited in the text.

Learning Objectives At the beginning of each chapter is a list of its key learning objectives: what the authors hope you will learn by studying the chapter.

Think About It These critical thinking questions appear at the end of each chapter and help you assess your mastery of the learning objectives by thinking through and applying what you have learned.

Dates, Abbreviations, and Other Conventions This book uses the designations BCE and CE, abbreviations for "Before the Common Era" and "Common Era," instead of BC ("Before Christ") and AD ("Anno Domini," "the year of our Lord"). The first century BCE is the period from 99 BCE to 1 BCE; the first century CE is from the year 1 CE to 99 CE. Similarly, the second century BCE is the period from 199 BCE to 100 BCE; the second century CE extends from 100 CE to 199 CE.

100's	99–1	1–99	100's
second century BCE	first century BCE	first century CE	second century CE

Circa ("about") is used with approximate dates, abbreviated to "c." This indicates that an exact date (or date range) is not yet verified.

An illustration is called a "figure," abbreviated as "fig." Thus, figure 6–7 is the seventh numbered illustration in Chapter 6, and figure Intro–3 is the third figure in the Introduction. There are two types of figures: photographs of artworks or models, and line drawings. Drawings are used when a work cannot be photographed or when a diagram or simple drawing is the clearest way to illustrate aspects of an object or a place.

When introducing artists, we use the words *active* and *documented* with dates, in addition to "b." (for "born") and "d." (for "died"). "Active" means that an artist worked during the years given. "Documented" means that documents link the person to that date.

Accents are used for words in French, German, Italian, and Spanish only. With few exceptions, names of cultural institutions in Western European countries are given in the form used in that country.

Titles of Works of Art It was only over the last 500 years that paintings and works of sculpture created in Europe and North America were given formal titles, either by the artist or by critics and art historians. Such formal titles are printed in italics. At other times, and in other traditions and cultures in which single titles are not important or even recognized, the descriptive titles used here are not italicized. Most often formal titles are given in English, but if a non-English title is commonly used for the work (as in FIG. 31–17, Manet's *Luncheon on the Grass*), that title (*Le déjeuner sur l'herbe*) will appear in parentheses after the English title. In all cases, titles of works that are particularly important in a chapter are shown in all capital letters and bold type.

Starter Kit

Art history focuses on the visual arts—painting, drawing, sculpture, prints, photography, ceramics, metalwork, architecture, and more. This Starter Kit addresses the basic, underlying information and concepts of art history; you can use it as a quick reference guide to the vocabulary used to classify and describe art objects. Understanding these terms is indispensable because you will encounter them again and again in reading, talking, and writing about art.

Let us begin with the basic properties of art. A work of art is a material object having both *form* and *content*. It is often described and categorized according to its *style* and *medium*.

FORM

Referring to purely visual aspects of art and architecture, the term *form* encompasses qualities of *line*, *shape*, *color*, *light*, *texture*, *space*, *mass*, *volume*, and *composition*. These qualities are known as *formal elements*. When art historians use the term *formal*, they mean "relating to form."

Line and **shape** are attributes of form. Line is an element—usually drawn or painted—the length of which is so much greater than the width that we perceive it as having only length. Line can be actual (when the line is visible), or it can be implied (when the movement of the viewer's eyes over the surface of a work follows a path encouraged by the artist). Shape, on the other hand, is the two-dimensional, or flat, area defined by the borders of an enclosing *outline* or *contour*. Shape can be *geometric*, *biomorphic* (suggesting living things; sometimes called *organic*), *closed*, or *open*. The *outline* or *contour* of a three-dimensional object can also be perceived as line.

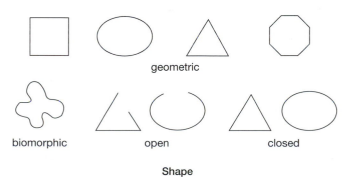

geometric

biomorphic · open · closed

Shape

Color has several attributes. These include *hue*, *value*, and *saturation*.

Hue is what we think of when we hear the word *color*; the terms are interchangeable. We perceive hues as a result of differing wavelengths of electromagnetic energy. The visible spectrum, which can be seen in a rainbow, runs from red through violet. When the ends of the spectrum are connected through the hue red-violet, the result may be diagrammed as a color wheel. The primary hues (numbered 1 in the diagram) are red, yellow, and blue. They are known as primaries because all other colors are made by combining these hues. Orange, green, and violet result from the mixture of two primaries and are known as secondary hues (numbered 2). Intermediate hues, or tertiaries (numbered 3), result from the mixture of a primary and a secondary. Complementary colors are the two colors directly opposite one another on the color wheel, such as red and green. Red, orange, and yellow are regarded as warm colors and appear to advance toward us. Blue, green, and violet, which seem to recede, are called cool colors. Black and white are considered neutrals, not colors but, in terms of light, black is understood as the absence of color and white as the mixture of all colors.

Value is the relative degree of lightness or darkness of a given color and is created by the amount of light reflected from an object's surface. A dark green has a deeper value than a light green, for example. In black-and-white reproductions of colored objects, you see only value, and some artworks—for example, a drawing made with black ink—possess only value, not hue or saturation.

Value scale from white to black.

+ WHITE PURE HUE + BLACK

Value variation in red.

Saturation, also sometimes referred to as *intensity*, is a color's quality of brightness or dullness. A color described as highly saturated looks vivid and pure; a hue of low saturation looks muddy or grayed.

PURE HUE DULLED PURE HUE

Intensity scale from bright to dull.

Texture, another attribute of form, is the tactile (or touch-perceived) quality of a surface. It is described by words such as *smooth*, *polished*, *rough*, *prickly*, *grainy*, or *oily*. Texture takes two forms: the texture of the actual surface of the work of art and the implied (illusionistically described) surface of objects represented in the work of art.

Technique

PICTORIAL DEVICES FOR DEPICTING RECESSION IN SPACE

overlapping

In overlapping, partially covered elements are meant to be seen as located behind those covering them.

diminution

In diminution of scale, successively smaller elements are perceived as being progressively farther away than the largest ones.

vertical perspective

Vertical perspective stacks elements, with the higher ones intended to be perceived as deeper in space.

atmospheric perspective

Through atmospheric perspective, objects in the far distance (often in bluish-gray hues) have less clarity than nearer objects. The sky becomes paler as it approaches the horizon.

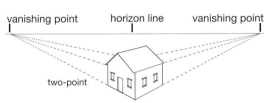

divergent perspective

In divergent or reverse perspective, forms widen slightly and imaginary lines called orthogonals diverge as they recede in space.

intuitive perspective

Intuitive perspective takes the opposite approach from divergent perspective. Forms become narrower and orthogonals converge the farther they are from the viewer, approximating the optical experience of spatial recession.

linear perspective

Linear perspective (also called scientific, mathematical, one-point and Renaissance perspective) is a rationalization or standardization of intuitive perspective that was developed in fifteenth-century Italy. It uses mathematical formulas to construct images in which all elements are shaped by, or arranged along, orthogonals that converge in one or more vanishing points on a horizon line.

Space is what contains forms. It may be actual and three-dimensional, as it is with sculpture and architecture, or it may be fictional, represented illusionistically in two dimensions, as when artists represent recession into the distance on a flat surface—such as a wall or a canvas—by using various systems of *perspective*.

Mass and **volume** are properties of three-dimensional things. Mass is solid matter—whether sculpture or architecture—that takes up space. Volume is enclosed or defined space and may be either solid or hollow. Like space, mass and volume may be illusionistically represented on a two-dimensional surface, such as in a painting or a photograph.

Composition is the organization, or arrangement, of forms in a work of art. Shapes and colors may be repeated or varied, balanced symmetrically or asymmetrically; they may be stable or dynamic. The possibilities are nearly endless, and the artist's choices depend both on the time and place where the work was created and the objectives of individual artists. Pictorial depth (spatial recession) is a specialized aspect of composition in which the three-dimensional world is represented on a flat surface, or *picture plane*. The area "behind" the picture plane is called the *picture space* and conventionally contains three "zones": *foreground*, *middle ground*, and *background*.

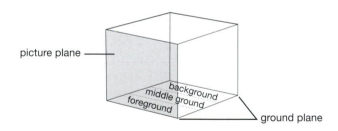

Various techniques for conveying a sense of pictorial depth have been devised by artists in different cultures and at different times (see "Pictorial Devices for Depicting Recession in Space" opposite). In some European art, the use of various systems of perspective has sought to create highly convincing illusions of recession into space. At other times and in other cultures, indications of recession have been suppressed or avoided in order to emphasize surface rather than space.

CONTENT

Content includes *subject matter*, but not all works of art have subject matter. Many buildings, paintings, sculptures, and other art objects include no recognizable references to things in nature nor to any story or historical situation, focusing instead on lines, colors, masses, volumes, and other formal elements. However, all works of art—even those without recognizable subject matter—have content, or meaning, insofar as they seek to communicate ideas, convey feelings, or affirm the beliefs and values of their makers, their patrons, and usually the people who originally viewed or used them.

Content may derive from the social, political, religious, and economic *contexts* in which a work was created, the *intention* of the artist, and the *reception* of the work by beholders (the audience). Art historians, applying different methods of *interpretation*, often arrive at different conclusions regarding the content of a work of art, and single works of art can contain more than one meaning because they are occasionally directed at more than one audience.

The study of subject matter is called *iconography* (literally, "the writing of images") and includes the identification of *symbols*—images that take on meaning through association, resemblance, or convention.

STYLE

Expressed very broadly, *style* is the combination of form and composition that makes a work distinctive. *Stylistic analysis* is one of art history's most developed practices, because it is how art historians recognize the work of an individual artist or the characteristic manner of groups of artists working in a particular time or place. Some of the most commonly used terms to discuss *artistic styles* include *period style, regional style, personal style, representational style, abstract style, linear style,* and *painterly style*.

Period style refers to the common traits of works of art and architecture from a particular historical era. It is good practice not to use the words "style" and "period" interchangeably. Style is the sum of many influences and characteristics, including the period of its creation. An example of proper usage is "an American house from the Colonial period built in the Georgian style."

Regional style refers to stylistic traits that persist in a geographic region. An art historian whose specialty is medieval art can recognize Spanish style through many successive medieval periods and can distinguish individual objects created in medieval Spain from other medieval objects that were created in, for example, Italy.

Personal style refers to stylistic traits associated with an individual artist.

Representational styles are those that describe the appearance of recognizable subject matter in ways that make it seem lifelike.

> **Realism** and **naturalism** are terms that some people use interchangeably to characterize artists' attempts to represent the observable world in a manner that appears to describe its visual appearance accurately. When capitalized, Realism refers to a specific period style (see Chapter 31).

Idealization strives to create images of physical perfection according to the prevailing values or tastes of a culture. An artist may work in a representational style and idealize it to capture an underlying value or expressive effect.

Illusionism refers to a highly detailed style that seeks to create a convincing illusion of physical reality by describing its visual appearance meticulously.

Abstract styles depart from mimicking lifelike appearance to capture the essence of a form. An abstract artist may work from nature or from a memory image of nature's forms and colors, which are simplified, stylized, perfected, distorted, elaborated, or otherwise transformed to achieve a desired expressive effect.

Nonrepresentational (or nonobjective) is a term used for works of art that do not aim to mimic lifelike appearances.

Expressionism refers to styles in which the artist exaggerates aspects of form to draw out the beholder's subjective response or to project the artist's own subjective feelings.

Linear describes both styles and techniques. In linear styles artists use line as the primary means of definition. But linear paintings can also incorporate *modeling*—creating an illusion of three-dimensional substance through shading, usually executed so that brushstrokes nearly disappear.

Painterly describes a style of representation in which vigorous, evident brushstrokes dominate, and outlines, shadows, and highlights are brushed in freely.

MEDIUM AND TECHNIQUE

Medium (plural, *media*) refers to the material or materials from which a work of art is made. Literally anything can be used to make a work of art, including not only traditional materials like paint, ink, and stone, but also rubbish, food, and the earth itself.

Technique is the process that transforms media into a work of art. Various techniques are explained throughout this book in "Technique" features. Two-dimensional media and techniques include painting, drawing, printmaking, and photography. Three-dimensional media and techniques are sculpture (using, for example, stone, wood, clay, or metal), architecture, and small-scale arts (such as jewelry, containers, or vessels) in media such as ceramics, metal, or wood.

Painting includes wall painting and fresco, illumination (the decoration of books with paintings), panel painting (painting on wood panels), painting on canvas, and handscroll and hanging scroll painting. The paint in these examples is pigment mixed with a liquid vehicle, or binder. Some art historians also consider pictorial media such as mosaic and stained glass—where the pigment is arranged in solid form—as a type of painting.

Graphic arts are those that involve the application of lines and strokes to a two-dimensional surface or support, most often paper. Drawing is a graphic art, as are the various forms of printmaking. Drawings may be sketches (quick visual notes, often made in preparation for larger drawings or paintings); studies (more carefully drawn analyses of details or entire compositions); cartoons (full-scale drawings made in preparation for work in another medium, such as fresco, stained glass, or tapestry); or complete artworks in themselves. Drawings can be made with ink, charcoal, crayon, or pencil. Prints, unlike drawings, are made in multiple copies. The various forms of printmaking include woodcut, the intaglio processes (engraving, etching, drypoint), and lithography.

Photography (literally, "light writing") is a medium that involves the rendering of optical images through a recording of light effects. Photographic images are typically recorded by a camera.

Sculpture is three-dimensional art that is carved, modeled, cast, or assembled. Carved sculpture is subtractive in the sense that the image is created by taking away material. Wood, stone, and ivory are common materials used to create carved sculptures. Modeled sculpture is considered additive, meaning that the object is built up from a material, such as clay, that is soft enough to be molded and shaped. Metal sculpture is usually cast or is assembled by welding or a similar means of permanent joining.

Sculpture is either free-standing (that is, surrounded by space) or pictorial relief. Relief sculpture projects from the background surface of the same piece of material. High-relief sculpture projects far from its background; low-relief sculpture is only slightly raised; and sunken relief, found mainly in ancient Egyptian art, is carved into the surface, with the highest part of the relief being the flat surface.

Ephemeral arts include processions, ceremonies, and ritual dances (often with décor, costumes, or masks); performance art; earthworks; cinema and video art; and some forms of digital or computer art. All impose a temporal limitation—the artwork is viewable for a finite period of time and then disappears forever, is in a constant state of change, or must be replayed to be experienced again.

Architecture creates enclosures for human activity or habitation. It is three-dimensional, highly spatial, functional, and closely bound with developments in technology and materials. Since it is difficult to capture in a photograph, several types of schematic drawings are commonly used to enable the visualization of a building:

Plans depict a structure's masses and voids, presenting a view from above of the building's footprint as if it had been sliced horizontally at about waist height.

Plan: Philadelphia, Vanna Venturi House

Sections reveal the interior of a building as if it had been cut vertically from top to bottom.

Section: Rome, Sta. Costanza

Isometric drawings show buildings from oblique angles either seen from above ("bird's-eye view") to reveal their basic three-dimensional forms (often cut away so we can peek inside) or from below ("worm's-eye view") to represent the arrangement of interior spaces and the upward projection of structural elements.

Isometric cutaway from above: Ravenna, San Vitale

Isometric projection from below: Istanbul, Hagia Sophia

Introduction

I.a Explain the cultural foundations of the diverse ways art has been defined and characterized.

I.b Distinguish four ways art historians investigate works of art.

I.c Identify the components of the four-part method of art historical investigation that leads to the historical interpretation of a work of art.

The title of this book seems clear. It defines a field of academic study and scholarly research that has achieved a secure place in college and university curricula across North America. But *Art History* couples two words—even two worlds—that are less well focused when separated. What is art? In what sense does it have a history? Students of art and its history should pause and engage, even if briefly, with these large questions before beginning the journey surveyed in the following chapters.

What is Art?

What are the cultural foundations of the diverse ways art has been defined and characterized?

Artists, critics, art historians, and the general public all grapple with this thorny question. The *Random House Dictionary* defines "art" as "the quality, production, expression, or realm of what is beautiful, or of more than ordinary significance." Others have characterized "art" as something human-made that combines creative imagination and technical skill and satisfies an innate desire for order and harmony—perhaps a human hunger for the beautiful. This seems relatively straightforward until we start to look at modern and contemporary art, where there has been a heated and extended debate concerning "What is art?" The focus is often far from questions of transcendent beauty, ordered design, or technical skill; it centers instead on the conceptual meaning of a work for an elite target audience or the attempt to pose challenging questions or unsettle deep-seated cultural ideas.

The works of art discussed in this book represent a privileged subset of artifacts produced by past and present cultures. They were usually meant to be preserved, and they are currently considered worthy of conservation and display. The determination of which artifacts are exceptional—which are works of art—evolves through the actions, opinions, and selections of artists, patrons, governments, collectors, archaeologists, museums, art historians, and others. Labeling objects as art is usually meant to signal that they transcended or now transcend in some profound way their practical function, often embodying cherished cultural ideas or asserting foundational values. Sometimes it can also mean they are considered beautiful, well designed, and made with loving care, but this is not always the case. We will discover that at various times and places, the complex notion of what art is has little to do with standards of skill or beauty. Some critics and historians argue broadly that works of art are tendentious embodiments of power and privilege, hardly sublime expressions of beauty or truth. After all, art can be unsettling as well as soothing, challenging as well as reassuring, whether made in the present or surviving from the past.

Increasingly, we are realizing that our judgments about what constitutes art—as well as what constitutes beauty—are conditioned by our own education and experience. Whether acquired at home, in classrooms, in museums, at the movies, or on the Internet, our responses to art are learned behaviors influenced by class, gender, race, geography, and economic status as well as education. Even art historians find that their definitions of what constitutes art—and what constitutes artistic quality—evolve with additional research and understanding. Exploring works by twentieth-century painter Mark Rothko and nineteenth-century quilt-makers Martha Knowles and Henrietta Thomas demonstrates how definitions of art and artistic value are subject to change over time.

INTRO–1 Mark Rothko **MAGENTA, BLACK, GREEN ON ORANGE (NO. 3/NO. 13)**
1949. Oil on canvas, 7'1⅜" × 5'5" (2.165 × 1.648 m). Museum of Modern Art, New York.

Credit: © 2016. Digital Image, The Museum of Modern Art, New York/Scala, Florence. © 1998 Kate Rothko Prizel & Christopher Rothko/Artists Rights Society (ARS), New York

vision." In part because they are carefully crafted by an established artist who provided these kinds of intellectual justifications for their character and appearance, Rothko's abstract paintings are broadly considered works of art and are treasured possessions of major museums across the globe.

Works of art, however, do not always have to be created by individuals who perceive themselves as artists. Nor are all works produced for an art market surrounded by critics and collectors ready to explain, exhibit, and disperse them, ideally to prestigious museums. Such is the case with this quilt (**FIG. Intro–2**) made by Martha Knowles and Henrietta Thomas a century before Rothko's painting. Their work is similarly composed of blocks of color, and, like Rothko, they produced their visual effect by arranging these flat chromatic shapes carefully and regularly on a rectangular field. But this quilt was not meant to hang on the wall of an art museum. It is the social product of a friendship, intended as an intimate

Rothko's painting **NO. 3/NO. 13 (MAGENTA, BLACK, GREEN ON ORANGE)** (**FIG. Intro–1**), is a well-known example of the sort of abstract painting that was considered the epitome of artistic sophistication by the mid-twentieth-century New York art establishment. It was created by an artist who meant it to be a work of art. It was acquired by the Museum of Modern Art in New York, and its position on the walls of that museum is a sure sign of its acceptance as art by a powerful cultural institution. However, outside the context of the American artists, dealers, critics, and collectors who made up Rothko's art world, such paintings were often received with skepticism. They were seen by many as incomprehensible—lacking both technical skill and recognizable subject matter, two criteria that were part of the general public's definition of art at the time. Abstract paintings inspired a popular retort: "That's not art; my child could do it!" Interestingly enough, Rothko saw in the childlike character of his own paintings one of the qualities that made them works of art. Children, he said, "put forms, figures, and views into pictorial arrangements, employing out of necessity most of the rules of optical **perspective** and geometry but without the knowledge that they are employing them." He characterized his own art as childlike, as "an attempt to recapture the freshness and naiveté of childish

INTRO–2 Martha Knowles and Henrietta Thomas **MY SWEET SISTER EMMA**
1843. Cotton quilt, 8'11" × 9'1" (2.72 × 2.77 m). International Quilt Studies Center and Museum, University of Nebraska, Lincoln.

gift presented to a loved one for use in her home. An inscription on the quilt itself makes this clear: "From M.A. Knowles to her Sweet Sister Emma, 1843." Thousands of such friendship quilts were made by women during the middle years of the nineteenth century for use on beds, either to provide warmth or as a covering spread. Whereas quilts were sometimes displayed to a broad and enthusiastic audience of producers and admirers at competitions held at state and county fairs, they were not collected by art museums or revered by artists until relatively recently.

In 1971 at the Whitney Museum in New York—an establishment bastion of the art world of which Rothko had been a part—art historians Jonathan Holstein and Gail van der Hoof mounted an exhibition entitled "Abstract Design in American Quilts," demonstrating the artistic affinity we have already noted in comparing the way Knowles and Thomas, like Rothko, create abstract patterns with fields of color. Quilts were later accepted—or perhaps **appropriated**—as works of art and hung on the walls of a New York art museum because of their visual similarities with the avant-garde, abstract works of art created by elite New York artists.

Art historian Patricia Mainardi took the case for quilts one significant step further in a pioneering article of 1973 published in *The Feminist Art Journal*. Entitled "Quilts: The Great American Art," her argument was rooted not only in the aesthetic affinity of quilts with the esteemed work of contemporary abstract painters, but also in a political conviction that the definition of art had to be broadened. What was at stake here was historical veracity. Mainardi began, "Women have always made art. But for most women, the arts highest valued by male society have been closed to them for just that reason. They have put their creativity instead into the needlework arts, which exist in fantastic variety wherever there are women, and which in fact are a universal female art, transcending race, class, and national borders." She argued for the inclusion of quilts within the history of art to give deserved attention to the work of women artists who had been excluded from discussion because they created textiles and because they worked outside the male-dominated professional structures of the art world—because they were women. Quilts now hang as works of art on the walls of museums and appear with regularity in books that survey the history of art.

As these two examples demonstrate, definitions of art are rooted in cultural systems of value that are subject to change. And as they change, the list of works considered by art historians is periodically revised. Determining what to study is a persistent part of the art historian's task.

Architecture

This book contains much more than paintings and textiles. Within these pages you will also encounter sculpture, vessels, books, churches, jewelry, tombs, chairs, temples, photographs, houses, and more. But as with Rothko's *No. 3/No. 13 (Magenta, Black, Green on Orange)* (SEE FIG. Intro-1) and Knowles and Thomas's *My Sweet Sister Emma* (SEE FIG. Intro-2), criteria have been used to determine which works are selected for inclusion in a book titled *Art History*. Architecture—which includes churches, tombs, temples, and houses, as well as many other kinds of buildings—presents an interesting case.

Buildings meet functional human needs by enclosing human habitation or activity. Many works of architecture, however, are considered "exceptional" because they transcend functional demands by manifesting distinguished architectural design or because they embody in important ways the values and goals of the culture that built them. Such buildings are usually produced by architects influenced, like painters, by great works and traditions from the past. In some cases they harmonize with, or react to, their natural or urban surroundings. For such reasons, they are discussed in books on the history of art.

INTRO-3 Le Corbusier
NÔTRE-DAME-DU-HAUT

Ronchamp, France. 1950–1955.

Typical of such buildings is the church of Nôtre-Dame-du-Haut in Ronchamp, France, designed and constructed between 1950 and 1955 by Swiss architect Charles-Edouard Jeanneret, better known by his pseudonym, Le Corbusier (**FIG. Intro-3**). This building is the product of a significant historical moment, rich in international cultural meaning. A pilgrimage church on this site had been destroyed during World War II, and the creation here of a new church symbolized the end of a devastating war, embodying hopes for a brighter global future. Le Corbusier's design—drawing on sources that ranged from Algerian mosques to imperial Roman villas, from crab shells to airplane wings—is sculptural as well as architectural. Built at the crest of a hill, it soars toward the sky but at the same time seems solidly anchored in the earth. And its coordination with the curves of the natural landscape creates an outdoor setting for religious ceremonies (to the right in the figure) to supplement the spaces of the church interior. In fact, this building is so renowned today as a monument of modern architecture that the bus-loads of pilgrims who arrive at the site are mainly architects and devotees of architectural history.

What is Art History?

What are four ways art historians investigate works of art?

There are many ways to study or appreciate works of art. Art history represents one specific approach, with its own goals and its own methods of assessment and interpretation. Simply put, art historians seek to understand the meaning of art from the past within its original cultural contexts, both from the point of view of its producers—artists, architects, and patrons—as well as from the point of view of its consumers—those who formed its original audience. Coming to an understanding of the cultural meaning of a work of art requires detailed and patient investigation on many levels, especially with art that was produced long ago and in societies distinct from our own. This is a scholarly rather than an intuitive exercise. In art history, the work of art is seen as an embodiment of the values, goals, and aspirations of its time and place of origin. It is a part of culture.

Art historians use a variety of theoretical perspectives and interpretive strategies to do their work. But as a place to begin, the work of art historians can be divided into four types of investigation:

1. assessment of physical properties,
2. analysis of visual or formal structure,
3. identification of subject matter or conventional symbolism, and
4. integration within cultural context.

Assessing Physical Properties

Of the methods used by art historians to study works of art, this is the most objective, but it requires close access to the work itself. Physical properties include shape, size, materials, and technique. For instance, many pictures are rectangular (SEE FIG. Intro-1), but some are round (see **FIG. C** in "Closer Look" on page xxvii). Paintings as large as Rothko's require us to stand back if we want to take in the whole image, whereas some paintings (see **FIG. A** in "Closer Look" on page xxvi) are so small that we are drawn up close to examine their detail. Rothko's painting and Knowles and Thomas's quilt are both rectangles of similar size, but they are distinguished by the materials from which they are made—oil paint on canvas versus cotton fabric joined by stitching. In art history books, most physical properties can only be understood from descriptions in captions, but when we are in the presence of the work of art itself, size and shape may be the first thing we notice. To fully understand **medium** and technique, however, it may be necessary to employ methods of scientific analysis or documentary research to figure out the details of the practices of artists at the time when and place where the work was created.

Analyzing Formal Structure

Art historians explore the visual character that artists give their works—using the materials and the techniques chosen to create them—in a process called **formal analysis**. On the most basic level, it is divided into two parts:

- assessing the individual visual elements or formal vocabulary that make up pictorial or sculptural communication, and

- discovering the overall arrangement, organization, or structure of an image, a design system that art historians often refer to as **composition**.

THE ELEMENTS OF VISUAL EXPRESSION Artists control and vary the visual character of works of art to give their subjects and ideas meaning and expression, vibrancy and persuasion, challenge or delight (see "Closer Look" on pages xxvi–xxvii). For example, the motifs, objects, figures, and environments in paintings can be sharply defined by line (SEE FIGS. Intro-2, Intro-4), or they can be suggested by a sketchier definition (SEE FIGS. Intro-1, Intro-5). Painters can simulate the appearance of three-dimensional form through **modeling** or shading (SEE FIG. Intro-4 and **FIG. C** in "Closer Look" on page xxvii), that is, by imitating the way light from a single source will highlight one side of a solid while leaving the other side in shadow. Alternatively, artists can avoid any strong sense of three-dimensionality by emphasizing patterns on a surface rather than forms in space (SEE FIG. Intro-1 and **FIG. A** in "Closer Look" on page xxvi).

A Closer Look

VISUAL ELEMENTS OF PICTORIAL EXPRESSION: LINE, LIGHT, FORM, AND COLOR

LINE

A. CARPET PAGE FROM THE LINDISFARNE GOSPELS

From Lindisfarne, England. c. 715–720. Ink and tempera on vellum, 13⅜ × 9⁷/₁₆″ (34 × 24 cm). The British Library, London.

Credit: © The British Library Board (Cotton Nero D. IV, f.26v)

Every element in this complicated painting is sharply outlined by abrupt changes between light and dark or between one color and another; there are no gradual or shaded transitions. Since the picture was created in part with pen and ink, the linearity is a logical extension of medium and technique. And although line itself is a "flattening" or two-dimensionalizing element in pictures, a complex and consistent system of overlapping gives the linear animal forms a sense of shallow but carefully worked-out three-dimensional relationships to one another.

LIGHT

B. Georges de la Tour **THE EDUCATION OF THE VIRGIN**

c. 1650. Oil on canvas, 33″ × 39½″ (83.8 × 100.4 cm). The Frick Collection, New York. Purchased by the Frick Collection 1948. (1948.1.155).

The source of illumination is a candle depicted within the painting. The young girl's raised right hand shields its flame, allowing the artist to demonstrate his virtuosity in painting the translucency of human flesh.

Since the candle's flame is partially concealed, its luminous intensity is not allowed to distract from those aspects of the painting most brilliantly illuminated by it—the face of the girl and the book she is reading.

FORM

C. Michelangelo
THE HOLY FAMILY
(DONI TONDO)

c. 1503. Oil and tempera
on panel, diameter 3'11¼"
(1.2 m). Galleria degli
Uffizi, Florence.

Credit: © Studio Fotografico
Quattrone, Florence

The complex
overlapping of
their highly three-
dimensionalized bodies
conveys the somewhat
contorted positions
and spatial relationship
of these three figures.

Through the use
of modeling or
shading—a gradual
transition from lights to
darks—Michelangelo
imitates the way solid
forms are illuminated
from a single light
source—the side
closest to the light
source is bright while
the other side is cast
in shadow—and gives
a sense of three-
dimensional form to
his figures.

In a technique called
foreshortening, the
carefully calculated
angle of the Virgin's
elbow makes it seem
to project out toward
the viewer.

The actual three-
dimensional projection
of the sculpted heads
in medallions around
the frame—designed
for this painting by
Michelangelo himself—
heightens the illusion of
three-dimensionality in
the figures painted on
its flat surface.

Junayd chose to flood every aspect of his painting
with light, as if everything in it were illuminated
from all sides at once. As a result, the emphasis
here is on jewel-like color. The vibrant tonalities and
dazzling detail of the dreamy landscape are not
only more important than the simulation of three-
dimensional forms within a space, they actually
upstage the human drama taking place against a
patterned, tipped-up ground in the lower third
of the picture.

COLOR

D. Junayd HUMAY
AND HUMAYUN

From a manuscript
of the Divan of Kwaju
Kirmani. Made in
Baghdad, Iraq. 1396.
Color, ink, and gold
on paper, 12⅝ × 9⁷⁄₁₆"
(32 × 24 cm). The British
Library, London.

Credit: © The British Library
Board (Add. 18113, f.23)

INTRO–4 Raphael **MADONNA OF THE GOLDFINCH (MADONNA DEL CARDELLINO)**
1506. Oil on panel, 42 × 29½" (106.7 × 74.9 cm).
Galleria degli Uffizi, Florence.

The vibrant colors of this important work were revealed in the course of a careful, ten-year restoration, completed in 2008.

Credit: © Studio Fotografico Quattrone, Florence. Courtesy of the Ministero Beni e Att. Culturali

In addition to revealing the solid substance of forms through modeling, dramatic lighting can also guide viewers' attention to specific areas of a picture see **FIG. B** in "Closer Look" on page xxvi), or it can be lavished on every aspect of a picture to reveal all its detail and highlight the vibrancy of its color (see **FIG. D** in "Closer Look" on page xxvii). Color itself can be muted or intensified, depending on the mood artists want to create or the tastes and expectations of their audiences.

Thus, artists communicate with their viewers by making choices in the way they use and emphasize the elements of visual expression, and art historical analysis seeks to reveal how these choices bring meaning to a work of art. For example, in two paintings of women with children (SEE FIGS. Intro–4, Intro–5), Raphael and Renoir work with the same visual elements of line, form, light, and color in the creation of their images, but they employ these shared elements to different expressive ends. Raphael concentrates on line to clearly differentiate each element of his picture as a separate form. Careful modeling describes these outlined forms as substantial solids surrounded by space. This gives his subjects a sense of clarity, stability, and grandeur. Renoir, on the other hand, focuses on the flickering of light and the play of color as he minimizes the sense of three-dimensionality in individual forms. This gives his image a more ephemeral, casual sense. Art historians pay close attention to such variations in the use of visual elements—the building blocks of artistic expression—and use visual analysis to characterize the expressive effect of a particular work, a particular artist, or a general period defined by place and date.

COMPOSITION When art historians analyze composition, they focus not on the individual elements of visual expression but on the overall arrangement and organizing design or structure of a work of art. In Raphael's **MADONNA OF THE GOLDFINCH** (FIG. Intro–4), for example, the group of figures has been arranged in a triangular shape and placed at the center of the picture. Raphael emphasized this central focus by opening the clouds to reveal a patch of blue in the middle of the sky and by flanking the figural group with lacelike trees. Since the Madonna is at the center and the two boys are divided between the two sides of the triangle, roughly—though not precisely—equidistant from the center of the painting, this is a bilaterally symmetrical composition: on either side of an implied vertical line at the center of the picture, there are equivalent forms on left and right, matched and balanced in a mirrored correspondence. Art historians refer to such an implied line—around which the elements of a picture are organized—as an **axis**. Raphael's painting has not only a vertical, but also a horizontal axis, indicated by a line of demarcation between light and dark—as well as between degrees of color saturation—in the landscape. The belt of the Madonna's dress is aligned with this horizontal axis, and this correspondence, taken with the coordination of her head with the blue patch in the sky, relates her harmoniously to the natural world in which she sits, lending a sense of stability, order, and balance to the picture as a whole.

The main axis in Renoir's painting of **MME. CHARPEN-TIER AND HER CHILDREN** (FIG. Intro–5) is neither vertical nor horizontal, but diagonal, running from the upper right to the lower left corner of the painting. All major elements of the composition are aligned along this axis—dog, children, mother, and the table and chair that represent the most complex and detailed aspect of the setting. The upper left and lower right corners of the painting balance each other on either side of the diagonal axis as relatively simple fields of neutral tone, setting off and framing the main subjects between them. The resulting arrangement is not bilaterally symmetrical, but blatantly asymmetrical, with the large figural mass pushed into the left side of the picture. And unlike Raphael's composition, where the spatial relationship of the figures and their environment is mapped by the measured placement of elements that become increasingly smaller in scale and fuzzier in definition as they recede into the background, the relationship of Renoir's figures to their spatial environment is less clearly defined as they recede into the background along the dramatic diagonal axis. Nothing distracts us from the bold informality of this family gathering.

Both Raphael and Renoir arrange their figures carefully and purposefully, but they use distinctive compositional systems that communicate different notions of the way these figures interact with each other and the world around them. Art historians pay special attention to how pictures are arranged, because composition is one of the principal ways artists give their paintings expressive meaning.

Identifying Subject Matter

Art historians have traditionally sought subject matter and meaning in works of art with a system of analysis that was outlined by Erwin Panofsky (1892–1968), an influential German scholar who was expelled from his academic position by the Nazis in 1933 and spent the rest of his career of research and teaching in the United States. Panofsky proposed that when we seek to understand the subject of a work of art, we derive meaning initially in two ways:

- First we perceive what he called "natural subject matter" by recognizing forms and situations that we know from our own experience.

- Then we use what he called "**iconography**" to identify the conventional meanings associated with forms and figures as bearers of narrative or symbolic content, often specific to a particular time and place.

Some artworks, like Rothko's abstractions and Knowles and Thomas's quilt, do not contain subjects drawn from the world around us, from stories, or from conventional symbolism, but Panofsky's scheme remains a standard method of investigating meaning in works of art that present narrative subjects, portray specific people or places, or embody cultural values with iconic imagery or allegory.

NATURAL SUBJECT MATTER We recognize some things in works of visual art simply by virtue of living in a world similar to that represented by the artist. For example, in the two paintings by Raphael and Renoir just examined (SEE FIGS. Intro–4, Intro–5), we immediately recognize the principal human figures in both as a woman and two children—boys in the case of Raphael's painting, girls in Renoir's. We can also make a general identification of the animals: a bird in the hand of Raphael's boys, and a pet dog under one of Renoir's girls. And natural

INTRO–5 Auguste Renoir
MME. CHARPENTIER AND HER CHILDREN
1878. Oil on canvas, 60½ × 74⅞″ (153.7 × 190.2 cm). Metropolitan Museum of Art, New York.

subject matter can extend from an identification of figures to an understanding of the expressive significance of their postures and facial features. We might see in the boy who snuggles between the knees of the woman in Raphael's painting, placing his own foot on top of hers, an anxious child seeking the security of physical contact with a trusted caretaker—perhaps his mother—in response to fear of the bird he reaches out to touch. Many of us have seen insecure children take this very pose in response to potentially unsettling encounters.

The closer the work of art is in both time and place to our own situation temporally and geographically, the easier it sometimes is to identify what is represented. However, it's not always that simple. Although Renoir painted his picture almost 140 years ago in France, the furniture in the background still looks familiar, as does the book in the hand of Raphael's Madonna, painted five centuries before our time. But the object hanging from the belt of the scantily clad boy at the left in Raphael's painting will require identification for most of us. Iconographic investigation is necessary to understand the function of this form.

ICONOGRAPHY Some subjects are associated with conventional meanings established at a specific time or place, some of the human figures portrayed in works of art have specific identities, and some of the objects or forms have symbolic or allegorical meanings in addition to their natural subject matter. Discovering these conventional meanings of art's subject matter is called iconography (see "Closer Look" opposite).

For example, the woman accompanied in the outdoors by two boys in Raphael's *Madonna of the Goldfinch* (SEE FIG. INTRO-4) would have been immediately recognized by members of its intended early sixteenth-century Florentine audience as the Virgin Mary. Viewers would have identified the naked boy standing between her knees as her son Jesus and the boy holding the bird as Jesus's cousin John the Baptist, sheathed in the animal skin garment that he would wear in the wilderness and equipped with a shallow cup attached to his belt, ready to be used in baptisms. Such attributes of clothing and equipment are often critical in making iconographic identifications. The goldfinch in the Baptist's hand was at this time and place a symbol of Christ's death on the cross, an allegorical implication that makes the Christ Child's retreat into secure contact with his mother—already noted on the level of natural subject matter—understandable in relation to a specific story. The comprehension of conventional meanings in this painting would have been almost automatic among those for whom it was painted, but for us, separated by time and place, some research is necessary to recover associations that are no longer part of our everyday world.

Although it may not initially seem as unfamiliar, the subject matter of Renoir's 1878 portrait of *Mme. Charpentier and her Children* (SEE FIG. INTRO-5) is in fact even more obscure. There are those in twenty-first-century American culture for whom the figures and symbols in Raphael's painting are still recognizable and meaningful, but Marguérite-Louise Charpentier died in 1904, and no one living today would be able to identify her based on the likeness Renoir presumably gave to her face in this family portrait commissioned by her husband, the wealthy and influential publisher Georges Charpentier. We need the painting's title to make that identification. And Mme. Charpentier is outfitted here in a gown created by English designer Charles Frederick Worth, the dominant figure in late nineteenth-century Parisian high fashion. Her clothing was a clear attribute of her wealth for those who recognized its source; most of us need to investigate to uncover its meaning. But a greater surprise awaits the student who pursues further research on her children. Although they clearly seem to our eyes to represent two daughters, the child closest to Mme. Charpentier is actually her son Paul, who at age 3, following standard Parisian bourgeois practice, has not yet had his first haircut and still wears clothing comparable to that of his older sister Georgette, perched on the family dog. It is not unusual in art history to encounter situations where our initial conclusions on the level of natural subject matter will need to be revised after some iconographic research.

Integration within Cultural Context

Natural subject matter and iconography were only two of three steps proposed by Panofsky for coming to an understanding of the meaning of works of art. The third step he labeled "**iconology**." Its aim is to interpret the work of art as an embodiment of its cultural situation, to place it within broad social, political, religious, and intellectual contexts. Such integration into history requires more than identifying subject matter or conventional symbols; it requires a deep understanding of the beliefs and principles or goals and values that underlie a work of art's cultural situation as well as the position of an artist and patron within it.

In the "Closer Look" on iconography, the subject matter of two **still life** paintings (pictures of inanimate objects and fruits or flowers taken out of their natural contexts) is identified and elucidated, but to truly understand these two works as bearers of cultural meaning, more knowledge of the broader context and specific goals of artists and audiences is required. For example, the fact that Zhu Da (1626–1705) became a painter was rooted more in the political than the artistic history of China at the middle of the seventeenth century. As a member of the imperial family of the Ming dynasty, his life of privilege was disrupted when the Ming were overthrown during the Manchu conquest of China in 1644. Fleeing for his life, he sought refuge in a Buddhist monastery, where he wrote poetry and painted.

A Closer Look

ICONOGRAPHY

These grapes sit on an imported, Italian silver *tazza*, a luxury object that may commemorate northern European prosperity and trade. This particular object recurs in several of Peeters's other still lifes.

An image of the artist herself appears on the reflective surface of this pewter tankard, one of the ways that she signed her paintings and promoted her career.

Luscious fruits and flowers celebrate the abundance of nature, but because these fruits of the earth will eventually fade, even rot, they could be moralizing references to the transience of earthly existence.

These coins, including one minted in 1608–1609, help focus the dating of this painting. The highlighting of money within a still life could reference the wealth of the owner—or it could subtly allude to the value the artist has crafted here in paint.

Detailed renderings of insects showcased Peeters's virtuosity as a painter, but they also may have symbolized the vulnerability of the worldly beauty of flowers and fruit to destruction and decay.

This knife—which appears in several of Peeters's still lifes—is of a type that is associated with wedding gifts.

A. Clara Peeters **STILL LIFE WITH FRUIT AND FLOWERS**
c. 1612. Oil on copper, 25⅕ × 35″ (64 × 89 cm). Ashmolean Museum, Oxford.

Credit: Bridgeman Images

Quince is an unusual subject in Chinese painting, but the fruit seems to have carried personal significance for Zhu Da. One of his friends was known as the Daoist of Quince Mountain, a site in Hunan Province that was also the subject of a work by one of his favorite authors, Tang poet Li Bai.

The artist's signature reads "Bada Shanren painted this," using a familiar pseudonym in a formula and calligraphic style that the artist ceased using in 1695.

This red block is a seal with an inscription drawn from a Confucian text: "Teaching is half of learning." This was imprinted on the work by the artist as an aspect of his signature, a symbol of his identity within the picture, just as the reflection and inscribed knife identify Clara Peeters as the painter of her still life.

B. Zhu Da (Bada Shanren) **QUINCE (MUGUA)**
1690. Album leaf mounted as a hanging scroll; ink and colors on paper, 7⅞ × 5¾″ (20 × 14.6 cm). Princeton University Art Museum.

Credit: © 2016. University Art Museum/Art Resource/Scala, Florence. Photo: Bruce M. White.

Almost 40 years later, in the aftermath of a nervous breakdown (that could have been staged to avoid retribution for his family background), Zhu Da abandoned his monastic life and developed a career as a professional painter, adopting a series of descriptive pseudonyms—most notably Bada Shanren ("mountain man of eight greatnesses") by which he is most often known today. His paintings are at times saturated with veiled political commentary; at times they seek to accommodate the expectations of collectors to assure their marketability; and in paintings like FIGURE B, the artist seems to hark back to the contemplative, abstract, and spontaneous paintings associated with great Zen masters such as Muqi (c. 1201–after 1269), whose calligraphic pictures of isolated fruits seem almost like acts of devotion or detached contemplations on natural forms, rather than the works of a professional painter.

Clara Peeters's still life (see FIG. A in "Closer Look" on page xxxi), on the other hand, fits into a developing Northern European painting tradition within which she was an established and successful professional, specializing in portrayals of food, flowers, fruit, and reflective objects. Still-life paintings in this tradition could be jubilant celebrations of the abundance of the natural world and the wealth of luxury objects available in the prosperous mercantile society of the Netherlands. Or they could be moralizing **vanitas** paintings, warning of the ephemeral meaning of those worldly possessions or even of life itself. But this painting has also been interpreted in a more personal way. Because the type of knife that sits in the foreground near the edge of the table was a popular wedding gift and is inscribed with the artist's own name, some have suggested that this still life could have celebrated Peeters's marriage. Or this could simply be a witty way to sign her picture. It certainly could be personal and at the same time participate in the broader cultural meaning of still-life paintings.

INTRO-6 Rogier van der Weyden **CRUCIFIXION WITH THE VIRGIN AND ST. JOHN THE EVANGELIST**
c. 1460. Oil on oak panels, 71 × 73" (1.8 × 1.85 m). John G. Johnson Collection, Philadelphia Museum of Art.

Mixtures of private and public meanings have been proposed for Zhu Da's paintings as well. Some have seen his picture of quince as part of a series of allegorical self-portraits that extend across his career as a painter. Art historians frequently discover multiple meanings when interpreting single works. Art often represents complex cultural and personal situations.

A Case Study: Rogier van der Weyden's Philadelphia *Crucifixion*

How does the four-part art historical method lead to an art historical interpretation of a specific work of art?

The basic, four-part method of art historical investigation and interpretation just outlined and explored may become clearer when its extended use is traced in relation to one specific work of art. A particularly revealing subject for such a case study is a seminal and somewhat perplexing painting now in the Philadelphia Museum of Art—the **CRUCIFIXION WITH THE VIRGIN AND ST. JOHN THE EVAN-GELIST** (**FIG. Intro–6**) by the Flemish artist Rogier van der Weyden (c. 1400–1464) (see Chapter 19). Each of the four levels of art historical inquiry reveals important information about this painting—information that has been used by art historians to reconstruct its relationship to its artist, its audience, and its broader cultural setting. The resulting interpretation is rich, but also complex. An investigation this extensive will not be possible for all the works of art in the following chapters, where the text will focus only on one or two facets of more expansive research. Because of the amount and complexity of information involved in a thorough art historical interpretation, it is sometimes only in a second reading that we can follow the subtleties of its argument, after a first reading has provided a basic familiarity with the work of art, its conventional subjects, and its general context.

Physical Properties

Perhaps the most striking aspect of this painting's physical appearance is its division into two separate tall rectangular panels, joined by a frame to form a coherent, almost square composition. These are oak panels, prepared with chalk to form a smooth surface on which to paint with mineral pigments suspended in oil. A technical investigation of the painting in 1981 used infrared reflectography to reveal a very sketchy underdrawing beneath the surface of the paint, indicating that this painting is almost entirely the work of Rogier van der Weyden himself. Famous and prosperous artists of this time and place employed many assistants to work in large production workshops, and they would make detailed underdrawings to ensure that assistants replicated the **style** of the master. But in cases where the masters themselves intended to execute the work, only sketchy compositional outlines were needed. In addition, modern technical investigation of Rogier's painting used **dendrochronology** (the dating of wood based on the patterns of the growth rings) to date the oak panels and consequently the painting itself, now securely situated near the end of the artist's career, c. 1460.

The most recent restoration of the painting—during the early 1990s by Mark Tucker, senior conservator at the Philadelphia Museum of Art—returned it, as close as possible, to what experts currently believe was its original fifteenth-century appearance (see "De-restoring and Restoring Rogier van der Weyden's *Crucifixion*" on page xxxiv). This project included extensive technical analysis of almost every aspect of the picture, during which a critical clue emerged, one that may lead to a sharper understanding of its original use. X-rays revealed dowel holes and plugs running in a horizontal line about one-fourth of the way up from the bottom across the entire expanse of the two-panel painting. Tucker's convincing research suggested that the dowels would have attached these two panels to the backs of wooden boxes or to carved tracery to form a complex work of art that combined sculpture and painting and was hung over the altar in a fifteenth-century church. Recently, Tucker worked collaboratively with art historian Griet Steyaert to identify two paintings that were originally on the reverse of these two panels, demonstrating that the Philadelphia **diptych** (two-panel painting) formed part of the exterior of the wings of the original **polyptych** (multiple-panel painting), visible only when it was closed (SEE FIGS. 19–13, 19–14 for views of another polyptych altarpiece with wings open and closed).

Formal Structure

The visual organization of this two-part painting emphasizes both connection and separation. It is at the same time one painting and two. Continuing across both panels are the strip of midnight blue sky and the stone wall that constricts space within the picture to a shallow corridor, pushing the figures into the foreground and close to the viewer. The shallow strip of mossy ground under the two-figure group in the left panel continues its sloping descent into the right panel, as does the hem of the Virgin's ice-blue garment. We look into this scene as if through a window with a mullion down the middle and assume that the world on the left continues behind this central strip of frame into the right side.

On the other hand, strong visual forces isolate the figures within their respective panels, setting up a system of "compare and contrast" that seems to be at the heart of

RECOVERING THE PAST

DE-RESTORING AND RESTORING ROGIER VAN DER WEYDEN'S *CRUCIFIXION*

Ever since Rogier van der Weyden's strikingly asymmetrical, two-panel rendering of the *Crucifixion* (SEE FIG. Intro–6) was purchased by Philadelphia lawyer John G. Johnson in 1906 for his spectacular collection of European paintings, it has been recognized not only as one of the greatest works by this master of fifteenth-century Flemish painting, but also as one of the most important European paintings in North America. Soon after the Johnson Collection became part of the Philadelphia Museum of Art in 1933, however, this painting's visual character was significantly transformed. In 1941, the museum employed freelance restorer David Rosen to work on the painting. Deciding that Rogier's work had been seriously marred by later overpainting and disfigured by the discoloration of old varnish, Rosen subjected the painting to a thorough cleaning. He also removed the strip of dark blue paint forming the sky above the wall at the top—identifying it as an eighteenth-century restoration—and replaced it with gold leaf to conform with remnants of gold in this area that he thought were surviving fragments of the original background. Rosen's restoration of Rogier's painting was uncritically accepted for almost half a century, and the gold background became a major factor in the interpretations of art historians as distinguished as Erwin Panofsky and Meyer Schapiro.

In 1990, in preparation for a new installation of the work, Rogier's painting received a thorough technical analysis by Mark Tucker, the museum's senior conservator. There were two startling discoveries:

- The dark blue strip that had run across the top of the picture before Rosen's intervention was actually original to the painting. Remnants of paint left behind in 1941 proved to be the same azurite blue that also appears in the clothing of the Virgin, and in no instance did the traces of gold discovered in 1941 run under aspects of the original paint surface. Rosen had removed Rogier's original midnight blue sky.

- What Rosen had interpreted as disfiguring varnish streaking the wall and darkening the brilliant cloths of honor hanging over it were actually Rogier's careful painting of lichens and water stains on the stone and his overpainting on the fabric that had originally transformed a vermillion undercoat into deep crimson cloth.

In meticulous work during 1992–1993, Tucker cautiously restored the painting based on the evidence he had uncovered. Neither the lost lichens and water stains nor the toning crimson overpainting of the hangings were replaced, but a coat of blue-black paint was laid over Rosen's gold leaf at the top of the panels, taking care to apply the new layer in such a way that should a later generation decide to return to the gold leaf sky, the midnight tonalities could be easily removed. That seems an unlikely prospect. The painting as exhibited today comes as close as possible to the original appearance of Rogier's *Crucifixion*. At least we think so for now.

the painting's design. The striking red cloths that hang over the wall are centered directly behind the figures on each side, forming internal frames that highlight them as separate groups and focus our attention back and forth between them rather than on the pictorial elements that unite their environments. As we begin to compare the two sides, it becomes increasingly clear that the relationship between figures and environment is quite distinct on each side of the divide.

The dead figure of Christ on the cross, elevated to the very top of the picture, is strictly centered within his panel, as well as against the cloth that hangs directly behind him. The grid of masonry blocks and creases in the cloth emphasizes his rectilinear integration into a system of balanced, rigid regularity. His head is aligned with the cap of the wall, his flesh largely contained within the area defined by the cloth. His elbows mark the juncture of the wall with the edge of the hanging, and his feet extend just to the end of the cloth, where his toes substitute for the border of fringe they overlap. The environment is almost as balanced. The strip of dark sky at the top is equivalent in size to the strip of mossy earth at the bottom

of the picture, and both are visually bisected by centered horizontals—the cross bar at the top and the alignment of bone and skull at the bottom. A few disruptions to this stable, rectilinear, symmetrical order draw the viewer's attention to the panel at the left: the downward fall of the head of Christ, the visual weight of the skull, the downturn of the fluttering loin cloth, and the tip of the Virgin's gown that transgresses over the barrier to move in from the other side.

John and Mary merge on the left into a single figural mass that could be inscribed into a half-circle. Although set against a rectilinear grid background comparable to that behind Jesus, they contrast with, rather than conform to, the regular sense of order. Their curving outlines offer unsettling unsteadiness, as if they are toppling to the ground, jutting into the other side of the frame. This instability is reinforced by their postures. The projection of Mary's knee in relation to the angle of her torso reveals that she is collapsing into a curve, and the crumpled mass of drapery circling underneath her only underlines her lack of support. John reaches out to catch her, but he has not yet made contact with her body. He strikes a stance

of strident instability without even touching the ground, and he looks blankly out into space with an unfocused expression, distracted from, rather than concentrating on, the task at hand. Perhaps he will come to his senses and grab her. But will he be able to catch her in time, and even then support her, given his unstable posture? The moment is tense; the outcome is unclear. But we are moving into the realm of natural subject matter. The poignancy of this concentrated portrayal seems to demand it.

Iconography

The subject of this painting is among the most familiar themes in the history of European art. The dead Jesus has been crucified on the cross, and two of his closest associates—his mother and John, one of his disciples—mourn his loss. Although easily recognizable, the austere and asymmetrical presentation is unexpected.

More usual is an earlier painting of this subject by the same artist, **CRUCIFIXION TRIPTYCH WITH DONORS AND SAINTS** (FIG. Intro-7), where Rogier situates the crucified Christ at the center of a symmetrical arrangement, the undisputed axial focus of the composition. The scene unfolds here in an expansive landscape with a wider cast of participants, each of whom takes a place with symmetrical decorum on either side of the cross. Most crucifixions follow some variation on this pattern, so Rogier's two-panel portrayal (SEE FIG. Intro-6)—in which the cross is asymmetrically placed and the two figures near it are relegated to a separately framed and severely restricted space—requires some explanation, as does the mysterious,

dark world beyond the wall and the artificial backdrop of the textile hangings.

This scene is not only austere and subdued, it is also sharply focused, and the focus relates it to a specific moment in the story that Rogier decided to represent. The Christian Bible contains four accounts of Jesus's crucifixion, one in each of the four Gospels. Rogier took two verses in John's account as his painting's text (John 19:26–27), cited here in the Douai-Reims literal English translation (1582, 1609) of the Latin Vulgate Bible that was used by Western European Christians during the fifteenth century:

> When Jesus therefore had seen his mother and the disciple standing whom he loved, he saith to his mother: Woman, behold thy son. After that, he saith to the disciple: Behold thy mother. And from that hour, the disciple took her to his own.

Even the textual source uses conventions that need explanation, specifically the way the disciple John is consistently referred to in this Gospel as "the disciple whom Jesus loved." Rogier's painting, therefore, seems to focus on Jesus's call for a newly expanded relationship between his mother and a beloved follower. More specifically, he has projected us slightly forward in time to the moment when John needs to respond to that call—Jesus has died; John is now in charge.

There are, however, other conventional iconographic associations with the crucifixion that Rogier has folded into this spare portrayal. Fifteenth-century viewers would have understood the skull and femur that lie at the base of the cross as the bones of Adam—the first man in the

INTRO-7 Rogier van der Weyden **CRUCIFIXION TRIPTYCH WITH DONORS AND SAINTS**

c. 1440. Oil on wooden panels, 39¾ × 55" (101 × 140 cm). Kunsthistorisches Museum, Vienna.

Credit: © KHM-Museumsverband

Hebrew Bible account of creation—on whose grave Jesus's crucifixion was believed to have taken place. This juxtaposition embodied the Christian belief that Christ's sacrifice on the cross redeemed believers from the death that Adam's original sin had brought to human existence.

Mary's swoon would have evoked another theological idea, the *co-passio*, in which Mary's anguish while witnessing Jesus's suffering and death was seen as a parallel passion of mother with son, both critical for human salvation. Their connection in this painting is underlined visually by the similar bending of their knees, inclination of their heads, and closing of their eyes. They even seem to resemble each other in facial likeness, especially when compared to John.

Cultural Context

In 1981 art historian Penny Howell Jolly published an interpretation of Rogier's Philadelphia *Crucifixion* as the product of a broad personal and cultural context. In addition to building on the work of earlier art historians, she pursued two productive lines of investigation to explain the rationale for this unusually austere presentation:

- the prospect that Rogier was influenced by the work of another artist, and

- the possibility that the painting was produced in a context that called for a special mode of visual presentation and a particular iconographic focus.

INTRO–8 VIEW OF A MONK'S CELL IN THE MONASTERY OF SAN MARCO, FLORENCE

Including Fra Angelico's fresco of the *Annunciation*. c. 1438–1445.

Credit: © Studio Fotografico Quattrone, Florence

INTRO–9 Fra Angelico **MOCKING OF CHRIST WITH THE VIRGIN MARY AND ST. DOMINIC**

Monastery of San Marco, Florence. c. 1441–1445.

Credit: © 2016 Photo Scala, Florence - courtesy of the Ministero Beni e Att. Culturali

FRA ANGELICO AT SAN MARCO We know very little about the life of Rogier van der Weyden, but we do know that in 1450, when he was already established as one of the principal painters in northern Europe, he made a pilgrimage to Rome. Either on his way to Rome or during his return journey home, he stopped in Florence and saw the **altarpiece**, and presumably also the frescos, that Fra Angelico (c. 1400–1455) and his workshop had painted during the 1440s at the monastery of San Marco. The evidence of Rogier's contact with Fra Angelico's work is found in a work Rogier painted after he returned home based on a panel of the San Marco altarpiece. For the Philadelphia *Crucifixion*, however, it was Fra Angelico's devotional frescos on the walls of the monks' individual rooms (or cells) that seem to have had the greatest impact (**FIG. Intro-8**). Jolly compared the Philadelphia *Crucifixion* with a scene of the Mocking of Christ at San Marco to demonstrate the connection (**FIG. Intro-9**). Fra Angelico presented the sacred figures with a quiet austerity that recalls Rogier's unusual composition. More specific parallels are the use of an expansive stone wall to restrict narrative space to a shallow foreground corridor, the description of the world beyond that wall as a dark sky that contrasts with the brilliantly illuminated foreground, and the use of a draped cloth of honor to draw attention to a narrative vignette from the life of Jesus, to separate it out as an object of devotion.

THE CARTHUSIANS Having established a possible connection between Rogier's painting and frescos by Fra Angelico that he likely saw during his pilgrimage to Rome in 1450, Jolly reconstructed a specific context of patronage and meaning within Rogier's own world in Flanders that could explain why the paintings of Fra Angelico would have had such an impact on him at this particular moment in his career.

During the years around 1450, Rogier developed a personal and professional relationship with the monastic order of the Carthusians, and especially with the Belgian Charterhouse (or Carthusian monastery) of Hérrines, where his oldest son was invested as a monk in 1450. Rogier gave money to Hérrines, and texts document his donation of a painting to its chapel of St. Catherine. Jolly suggested that the Philadelphia *Crucifixion* could be that painting. Its subdued colors and narrative austerity are consistent with Carthusian aesthetic attitudes, and the walled setting of the scene recalls the enclosed gardens that were attached to the individual dormitory rooms of Carthusian monks. The reference in this painting to the *co-passio* of the Virgin provides supporting evidence, since this theological idea was central to Carthusian thought and devotion. The *co-passio* was even reflected in the monks' own initiation rites, during which they re-enacted and sought identification with both Christ's sacrifice on the cross and the Virgin's parallel suffering.

In Jolly's interpretation, the religious framework of a Carthusian setting for the painting emerges as a personal framework for the artist himself, since this *Crucifixion* seems to be associated with important moments in his own life—his religious pilgrimage to Rome in 1450 and the initiation of his oldest son as a Carthusian monk at about the same time. The sense of loss and separation that Rogier evoked in his portrayal of a poignant moment in the life of St. John (**FIG. Intro–10**) could have been especially meaningful to the artist himself at the time this work was painted.

ART HISTORY: A CONTINUING PROJECT The final word has not been spoken in the interpretation of Rogier's Philadelphia *Crucifixion*. Mark Tucker's recent work on the physical evidence points toward it having been part of a large sculptured altarpiece. Even if this rules out the prospect that it is the **panel painting** Rogier donated to

INTRO–10 DETAIL OF FIG. INTRO–6 SHOWING PART OF THE LEFT WING

Credit: © 2004. Photo The Phildelphia Museum of Art/Scala, Florence

Hérrines, it does not negate the relationship Jolly drew with Fra Angelico, nor the Carthusian context she outlined. It simply reminds us that our understanding of works such as this will evolve when new evidence about them emerges.

As the history of art unfolds in this book, it will be important to keep two things in mind as you read about individual works of art and their broader cultural contexts. Art historical interpretations are built on extended research comparable to what we have just surveyed for Rogier van der Weyden's Philadelphia *Crucifixion*. But the work of interpretation is never complete. Art history is a continuing project, a work perpetually in progress.

Think About It

1 Analyze the composition of one painting illustrated in this Introduction.

2 Characterize the difference between natural subject matter and iconography, focusing your discussion on a specific work of art.

3 What are the four separate steps proposed here for art historians to interpret works of art? Characterize

the cultural analysis in step four by showing how it expands our understanding of one of the still lifes in the second "Closer Look."

4 What aspect of the case study of Rogier van der Weyden's Philadelphia *Crucifixion* was most interesting to you? Why? How did it affect your understanding of what you will learn in this course?

18–1 Ambrogio Lorenzetti **FRESCOS OF THE SALA DEI NOVE (OR SALA DELLA PACE)**

Palazzo Pubblico, Siena, Italy. 1338–1339. Length of long wall approx. 46′ (14 m).

Chapter 18
Fourteenth-Century Art in Europe

 ## Learning Objectives

18.a Identify the visual hallmarks of fourteenth-century European art for formal, technical, and expressive qualities.

18.b Interpret the meaning of works of fourteenth-century European art based on its themes, subjects, and symbols.

18.c Relate fourteenth-century European art and artists to their cultural, economic, and political contexts.

18.d Apply the vocabulary and concepts relevant to fourteenth-century European art, artists, and art history.

18.e Interpret a work of fourteenth-century European art using the art historical methods of observation, comparison, and inductive reasoning.

18.f Select visual and textual evidence in various media to support an argument or an interpretation of a work of fourteenth-century European art.

In 1338, the Nine—a council of merchants and bankers that governed Siena as an oligarchy—commissioned frescos from the renowned Sienese painter Ambrogio Lorenzetti (c. 1295–c. 1348) for three walls in the chamber of the Palazzo Pubblico where they met to conduct city business. This commission came at the moment of Siena's greatest prosperity and security since the establishment of their government in 1287.

Lorenzetti's frescos combine allegory with panoramic landscapes and cityscapes to visualize and justify the beneficial effects of the Sienese form of government. The moral foundation of the rule of the Nine is outlined in a complicated allegory in which seated personifications (far left in **FIG. 18–1**) of Concord, Justice, Peace, Strength, Prudence, Temperance, and Magnanimity, not only diagram good governance but actually reference the Last Judgment in a bold assertion of the relationship between secular rule and divine authority. This tableau contrasts with a similar presentation of bad government, where Tyranny is flanked by the personified forces that keep tyrants in power—Cruelty, Treason, Fraud, Fury, Division, and War. A group of scholars would have devised this complex program of symbols and meanings; it is unlikely that Lorenzetti would have known the philosophical works that underlie them. Lorenzetti's fame, however, and the wall paintings' secure

position among the most remarkable surviving mural programs of the period, rests on the other part of this ensemble—the effects of good and bad government in city and country life (SEE FIG. 18–16).

Unlike the tableau showing the perils of life under tyrannical rule, the panoramic view of life under good government—which in this work of propaganda means life under the rule of the Nine—is well preserved. A vista of fourteenth-century Siena—identifiable by the cathedral dome and tower peeking over the rooftops in the background—showcases carefree life within shops, schools, taverns, and worksites, as the city streets bustle with human activity. Outside, an expansive landscape highlights agricultural productivity.

Unfortunately, within a decade of the frescos' completion, life in Siena was no longer so stable and carefree. The devastating bubonic plague came in 1348—Ambrogio Lorenzetti himself was probably one of the victims—and the rule of the Nine collapsed in 1355. But this glorious vision of joyful prosperity preserves the dreams and aspirations of a stable government using some of the most progressive and creative ideas in fourteenth-century Italian art, ideas we will see developed at the very beginning of the century, and whose history we will trace over the next two centuries through the Renaissance.

Fourteenth-Century Europe

What are the cultural and historical backgrounds for the transformation of European art during the fourteenth century?

Literary luminaries Dante, Petrarch, Boccaccio, Chaucer, and Christine de Pizan (see "A New Spirit in Fourteenth-Century Literature" below) and the visionary painters Giotto, Duccio, Jean Pucelle, and Master Theodoric participated in a cultural explosion that swept through fourteenth-century Europe, and especially Italy. The poet Petrarch (1304–1374) was a towering figure in this change, writing his love lyrics in Italian, the language of everyday life, rather than Latin, the language of ceremony and high art. Similarly, the deeply moving murals of Florentine painter Giotto di Bondone (c. 1277–1337) were rooted in his observation of the people around him, giving the characters in sacred narratives both great dignity and a striking new humanity. Even in Paris—still the artistic center of Europe as far as refined taste and technical sophistication were concerned—the painter Jean Pucelle began to show an interest in experimenting with established conventions.

Changes in the way that society was organized were also underway, and an expanding class of wealthy merchants supported the arts as patrons. Artisan guilds—organized by occupation—exerted quality control among members and supervised education through an apprenticeship system. Admission to a guild came after examination and the creation of a "masterpiece"—literally, a piece fine enough to achieve master status. The major guilds included cloth finishers, wool merchants, and silk manufacturers, as well as pharmacists and doctors. Painters belonged to the pharmacy guild, perhaps because they used mortars and pestles to grind their colors. Their patron saint, Luke, who was believed to have painted the first image of the Virgin Mary, was also a physician—or so they thought. Sculptors who worked in wood and stone had their own guild, while those who worked in metals belonged to another. Guilds provided social services for their members, including care of the sick and funerals for the deceased. Each guild had its patron saint, maintained a chapel, and participated in religious and civic festivals.

Despite the cultural flourishing and economic growth of the early decades, by the middle of the fourteenth century much of Europe was in crisis. Prosperity had fostered population growth, which began to exceed food production. A series of bad harvests compounded this problem with famine. To make matters worse, a prolonged conflict known as the Hundred Years' War (1337–1453) erupted between France and England. Then, in mid century, a lethal plague known as the Black Death swept across Europe (**MAP 18–1**), wiping out as much as 40 percent of the population. In spite of these catastrophic events, however, the strong current of cultural change still managed to persist through to the end of the century and beyond.

Art and its Contexts

A NEW SPIRIT IN FOURTEENTH-CENTURY LITERATURE

For Petrarch and his contemporaries, the essential qualifications for a writer were an appreciation of Greek and Roman authors and an ability to observe the people living around themselves. Although fluent in Latin, each chose to write in the language of their own time and place—whether Italian, English, or French. Leading the way was Dante Alighieri (1265–1321), who wrote *The Divine Comedy*, his great summation of human virtue and vice, in Italian, establishing his daily language as worthy to express great literary themes.

Francesco Petrarca, called simply Petrarch (1304–1374), raised the status of secular literature with his sonnets to his unattainable beloved, Laura, his histories and biographies, and his writings on the joys of country life in the Roman manner. Petrarch's imaginative updating of Classical themes in a work called *The Triumphs*—which examines the themes of Chastity triumphant over Love, Death over Chastity, Fame over Death, Time over Fame, and Eternity over Time—provided later Renaissance poets and painters with a wealth of allegorical subject matter.

The earthier Giovanni Boccaccio (1313–1375) perfected the art of the short story in *The Decameron*, a collection of amusing and moralizing tales told by a group of young Florentines who move to the countryside to escape the Black Death. With wit and sympathy, Boccaccio presents the full spectrum of daily life in Italy. Such secular literature, written in Italian as it was then spoken in Tuscany, provided a foundation for fifteenth-century Renaissance writers.

In England, Geoffrey Chaucer (c. 1342–1400) was inspired by Boccaccio to write his own series of stories, *The Canterbury Tales*, as if told by pilgrims traveling to the shrine of St. Thomas à Becket (1118?–1170) in Canterbury. Observant and witty, Chaucer depicted the pretensions and foibles, as well as the virtues, of humanity.

Christine de Pizan (1364–c. 1431), born in Venice but living and writing at the French court, became an author out of necessity when she was left a widow with three young children and an aged mother to support. Among her many works are a poem in praise of Joan of Arc and a history of famous women—including artists—from antiquity to her own time. In *The Book of the City of Ladies*, she defended women's abilities and argued for women's rights and status.

These writers, as surely as the visual artists Giotto, Duccio, Peter Parler, and Master Theodoric, led the way into a new era.

MAP 18–1 EUROPE IN THE FOURTEENTH CENTURY

Following its outbreak in the Mediterranean in 1347, the Black Death swept across the European mainland over the next four years.

Italy

How do political, religious, and cultural changes transform the artistic traditions of Florence and Siena during the first half of the fourteenth century?

As great wealth promoted patronage of art in fourteenth-century Italy, artists began to emerge as individuals in the modern sense, both in their own eyes and in the eyes of patrons. Although their methods and working conditions remained largely unchanged from the Middle Ages, artists in Italy contracted freely with wealthy towns-people and nobles as well as with civic and religious bodies. Perhaps it was their economic and social freedom

that encouraged their self-confidence, individuality, and innovation.

Florentine Architecture and Metalwork

The typical medieval Italian city was a walled citadel on a hilltop. Houses clustered around a church and an open city square. Powerful families added towers to their houses, both for defense and as expressions of family pride. In Florence, by contrast, the ancient Roman city—with its axial rectangular plan and open city squares—formed the basis for the civic layout. The cathedral stood northeast of the ancient

forum, and a street following the Roman plan connected it with the Piazza della Signoria, the seat of the government.

THE PALAZZO DELLA SIGNORIA The Signoria (ruling body, from *signore*, meaning "Lord") that governed Florence met in the **PALAZZO DELLA SIGNORIA**, a massive, fortified building with a bell tower 300 feet tall (**FIG. 18–2**). The building faces a large square, or piazza, which became the true center of Florence. The town houses around the piazza often had benches along their walls to provide convenient public seating. Between 1376 and 1382, master builders Benci di Cione and Simone Talenti constructed a huge **loggia**, or covered open-air corridor, at one side—now known as the Loggia dei Lanzi (Loggia of the Lancers)—to provide a sheltered place for ceremonies and speeches.

THE BAPTISTERY DOORS In 1330, Andrea Pisano (c. 1290–1348) was awarded the prestigious commission for a pair of gilded bronze doors for Florence's Baptistery of San Giovanni, situated directly in front of the cathedral. (Andrea's last name means "from Pisa," and he was not related to Nicola and Giovanni Pisano.) The doors were completed within six years and display 20 scenes from the **LIFE OF ST. JOHN THE BAPTIST** (the San Giovanni to whom the baptistery is dedicated), set above eight personifications of the Virtues (**FIG. 18–3**). The overall effect is two-dimensional and decorative: a grid of 28 rectangles with repeated quatrefoils filled with the graceful, patterned poses of delicate human figures. Within the quatrefoil frames, however, the figural compositions create the illusion of three-dimensional forms moving within natural and architectural spaces.

18–2 PIAZZA DELLA SIGNORIA WITH PALAZZO DELLA SIGNORIA (TOWN HALL) AND LOGGIA DEI LANZI (LOGGIA OF THE LANCERS)

Florence. Palazzo della Signoria, 1299–1310; Loggia dei Lanzi, 1376–1382.

Credit: © Achim Bednorz, Cologne

18–3 Andrea Pisano **LIFE OF ST. JOHN THE BAPTIST**
South doors, Baptistery of San Giovanni, Florence. 1330–1336. Gilded bronze, each panel 19¼ × 17″ (48 × 43 cm). Frame, Ghiberti workshop, mid 15th century.

The bronze vine scrolls filled with flowers, fruits, and birds on the lintel and jambs framing the door were added in the mid fifteenth century.

18–4 Andrea Pisano **THE BAPTISM OF THE MULTITUDE**
Detail of the south doors, Baptistery of San Giovanni, Florence. 1330–1336. Gilded bronze, 19¼ × 17" (48 × 43 cm).

Credit: Photo: David G. Wilkins

The scene of John baptizing a multitude (**FIG. 18–4**) takes place on a shelflike stage created by a forward extension of the rocky natural setting, which also expands back behind the figures into a corner of the quatrefoil frame. Composed as a rectangular group, the gilded figures present an independent mass of modeled forms. The illusion of three-dimensionality is enhanced by the way the curving folds of their clothing wrap around their bodies. At the same time, their graceful gestures and the elegant fall of their drapery reflect the soft curves and courtly postures of French Gothic art.

Florentine Painting

Florence and Siena, rivals in so many ways, each supported a flourishing school of painting in the fourteenth century. Both grew out of local thirteenth-century painting traditions and engendered individual artists who became famous in their own time. The Byzantine influence—the *maniera greca* ("Greek style")—continued to provide models of dramatic

pathos and narrative iconography, as well as stylized features including the use of gold for drapery folds and striking contrasts of highlights and shadows in the modeling of individual forms. By the end of the fourteenth century, the painter and commentator Cennino Cennini (see "Cennino Cennini on Panel Painting" on page 556) would be struck by the accessibility and modernity of Giotto's art, which, though it retained traces of the *maniera greca*, was moving toward the depiction of a lifelike, contemporary world anchored in solid, three-dimensional forms.

CIMABUE In Florence, this stylistic transformation began a little earlier than in Siena. About 1280, a painter named Cenni di Pepi (active c. 1272–1302), better known by his nickname "Cimabue," painted a panel portraying the **VIRGIN AND CHILD ENTHRONED** (**FIG. 18–5**), perhaps for the main altar of the church of Santa Trinità in Florence. At over 12 feet tall, this enormous egg-tempera panel painting set a new precedent for monumental altarpieces. Cimabue surrounds the Virgin and Child with angels and

places a row of Hebrew Bible prophets beneath them. The hierarchically scaled figure of Mary holds the infant Jesus in her lap. Looking out at the viewer while gesturing toward her son as the path to salvation, she adopts a formula popular in Byzantine iconography since at least the sixth century (SEE FIG. 8–14).

Mary's huge throne, painted to resemble gilded bronze with inset enamels and gems, provides an architectural framework for the figures. Cimabue creates highlights on the drapery of Mary, Jesus, and the angels with thin lines of gold, as if to capture their divine radiance. The viewer seems suspended in space in front of the image, simultaneously looking down on the projecting elements of the throne and Mary's lap and looking straight ahead at the prophets at the base of the throne and the angels at each side. These spatial ambiguities, the subtle asymmetries within the centralized composition, the Virgin's engaging gaze, and the individually conceived faces of the old men give the picture a sense of life and the figures a sense of presence. Cimabue's ambitious attention to spatial volumes, his use of delicate light-to-dark modeling to simulate three-dimensional form, and his efforts to give naturalistic warmth to human figures had an impact on future Florentine painting.

18–5 Cimabue
VIRGIN AND CHILD ENTHRONED
Most likely painted for the high altar of the church of Santa Trinità, Florence. c. 1280. Tempera and gold on wood panel, 12′7″ × 7′4″ (3.53 × 2.2 m). Galleria degli Uffizi, Florence.

Credit: © Studio Fotografico Quattrone, Florence

GIOTTO DI BONDONE According to the sixteenth-century chronicler Giorgio Vasari, Cimabue discovered a talented shepherd boy, Giotto di Bondone (active c. 1300–1337) and taught him to paint; "not only did the young boy equal the style of his master, but he became such an excellent imitator of nature that he completely banished that crude Greek [Byzantine] style and revived the modern and excellent art of painting, introducing good drawing from live natural models, something which had not been done for more than two hundred years" (Vasari, translated by Bondanella and Bondanella, p. 16). After his training, Giotto may have collaborated on murals at the prestigious

church of St. Francis in Assisi. We know he worked for the Franciscans in Florence and absorbed facets of their teaching. St. Francis's message of humility, simple devotion, direct experience of God, and love for all creatures was gaining followers throughout western Europe, and it had a powerful impact on thirteenth- and fourteenth-century Italian literature and art.

Compared to Cimabue's *Virgin and Child Enthroned*, Giotto's altarpiece of the same subject (**FIG. 18–6**), painted about 30 years later for the church of the Ognissanti (All Saints) in Florence, exhibits greater spatial consistency and sculptural solidity while retaining some of Cimabue's

18–6 Giotto di Bondone **VIRGIN AND CHILD ENTHRONED**

Most likely painted for the high altar of the church of the Ognissanti (All Saints), Florence. 1305–1310. Tempera and gold on wood panel, 10′8″ × 6′8¼″ (3.53 × 2.05 m). Galleria degli Uffizi, Florence.

Credit: © Studio Fotografico Quattrone, Florence

Technique
BUON FRESCO

The two techniques used in mural painting are *buon* ("true") *fresco* ("fresh"), in which water-based paint is applied on wet plaster, and *fresco secco* ("dry"), in which paint is applied to a dry plastered wall. Both methods can be used on the same wall painting.

The advantage of *buon fresco* is its durability. A chemical reaction occurs as the painted plaster dries, which bonds the pigments into the wall surface. In *fresco secco*, by contrast, the color does not become part of the wall and tends to flake off over time. The chief disadvantage of *buon fresco* is that it must be done quickly without mistakes. The painter plasters and paints only as much as can be completed in a day, which explains the Italian term for each of these sections: **giornata**, or a day's work. The size of a *giornata* varies according to the complexity of the painting within it. A face, for instance, might take an entire day, whereas large areas of sky can be painted quite rapidly. In Giotto's Scrovegni Chapel, scholars have identified 852 separate *giornate*, some worked on concurrently within a single day by assistants in Giotto's workshop.

In medieval and Renaissance Italy, a wall to be frescoed was first prepared with a rough, thick undercoat of plaster known as the *arriccio*. When this was dry, assistants copied the master painter's composition onto it with reddish-brown pigment or charcoal. The artist made any necessary adjustments. These underdrawings, known as **sinopia**, have an immediacy and freshness that are lost in the finished painting. Work proceeded in irregularly shaped *giornate* conforming to the contours of major figures and objects. Assistants covered one section at a time with a fresh, thin coat of very fine plaster—the *intonaco*—over the *sinopia*, and when this was "set" but not dry, the artist worked with pigments mixed with water, painting from the top down so that drips fell on unfinished portions. Gilding and pigments such as ultramarine blue (which was unstable in *buon fresco*) would be added after the wall was dry using the *fresco secco* technique.

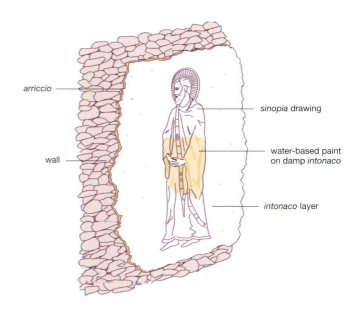

arriccio

wall

sinopia drawing

water-based paint on damp *intonaco*

intonaco layer

conventions. The position of the figures within a symmetrical composition reflects Cimabue's influence. Gone, however, are Mary's modestly inclined head and the delicate gold folds in her drapery. Instead, light and shadow play gently across her stocky form, and her action—holding her child's leg instead of pointing him out to us—seems less contrived. This colossal Mary overwhelms her slender Gothic tabernacle of a throne, where figures peer through openings and haloes overlap faces. In spite of the hierarchic scale, the formal, enthroned image, and the flat, gold background, Giotto has created the sense that these are fully three-dimensional beings, whose plainly draped, bulky bodies inhabit real space. The Virgin's torso is revealed by her thin tunic, and the angels are substantial solids whose foreshortened postures project from the foreground toward us, unlike those of Cimabue, who stay on the surface along lateral strips composed of overlapping screens of color.

Although Giotto was trained in the Florentine tradition, many of his principal works were produced elsewhere. After a sojourn in Rome during the last years of the thirteenth century, he was called to Padua in northern Italy soon after 1300 to paint frescos (see *"Buon Fresco"* above) for a new chapel being constructed at the site of an ancient Roman arena—explaining why it is often referred to as the Arena Chapel. The chapel was commissioned by Enrico Scrovegni, whose family fortune was made through the practice of usury, or charging interest when loaning money, a sin considered so grave at the time that it resulted in exclusion from the Christian sacraments. Enrico's father, Regibaldo, was an egregious case (he appears in Dante's *Inferno* as the prototypical usurer), but evidence suggests that Enrico followed in his father's footsteps, and the building of the Arena Chapel next to his new palatial residence seems to have been conceived at least in part as an attempt to atone not only for his father's sins, but also for his own. He was pardoned by Pope Benedict XI (pontificate 1303–1304).

That Scrovegni called two of the most famous artists of the time—Giotto and Giovanni Pisano (SEE FIG. 17–37)—to decorate his chapel indicates that his goals were to express his power, sophistication, and prestige, as well as to atone for his sins. The building itself has little architectural distinction. It is a simple, barrel-vaulted room with broad

walls to showcase Giotto's paintings (**FIG. 18–7**). Giotto covered the entrance wall with the *Last Judgment* (not visible here) and the sanctuary wall with three highlighted scenes from the life of Christ. The Annunciation spreads over the two painted architectural frameworks on either side of the tall, arched opening into the sanctuary itself. Below this are, to the left, the scene of Judas receiving payment for betraying Jesus and, to the right, the scene of the Visitation, where the Virgin, pregnant with God incarnate, embraces her cousin Elizabeth, pregnant with St. John the Baptist. The compositions and color arrangement of these two scenes create a symmetrical pairing that encourages viewers to relate them, comparing the ill-gotten financial gains of Judas (a rather clear reference to Scrovegni usury) to the miraculous pregnancy that brought the promise of salvation.

Giotto subdivided the side walls of the chapel into framed pictures. A dado of faux-marble and allegorical **grisaille** paintings (monochrome paintings in shades of gray) of the Virtues and Vices support vertical bands painted to resemble marble inlay into which are inserted painted imitations of carved medallions. The central band of medallions spans the vault, crossing a brilliant, lapis-blue, star-spangled sky in which large portrait disks float like glowing moons. Set into this framework are three horizontal bands of rectangular narrative scenes from the life of the Virgin and her parents at the top and Jesus along the middle and lower registers, which make up the primary religious program of the chapel.

Both the individual scenes and the overall program display Giotto's genius for distilling complex stories into a series of compelling moments. He concentrates on the human dimensions of the unfolding drama—from touches of anecdotal humor to expressions of profound anguish—rather than on its symbolic or theological weight. His prodigious narrative skills are apparent in a set of scenes from Christ's life on the north wall (**FIG. 18–8**). At top left Jesus performs his first miracle, changing water into wine at the wedding feast at Cana. The wine steward—looking very much like the jars of new wine himself—sips the results.

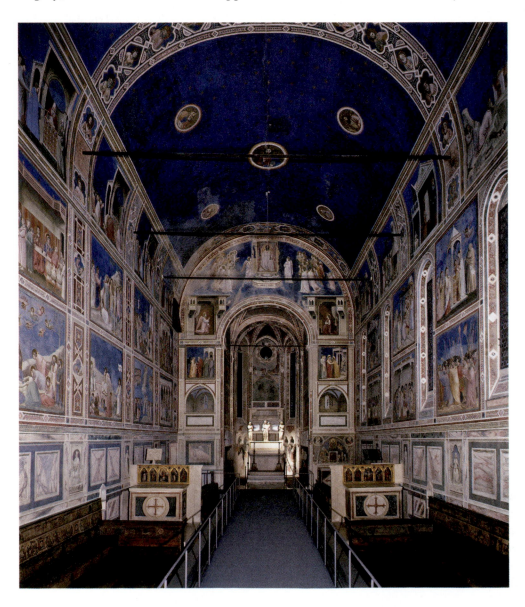

18–7 Giotto di Bondone **SCROVEGNI (ARENA) CHAPEL, VIEW TOWARD EAST WALL**
Padua. 1305–1306. Frescos.

Credit: © Studio Fotografico Quattrone, Florence

18–8 Giotto di Bondone **MARRIAGE AT CANA, RAISING OF LAZARUS, LAMENTATION, AND RESURRECTION/ NOLI ME TANGERE**

North wall of Scrovegni (Arena) Chapel, Padua. 1305–1306. Fresco, each scene approx. 6'5" × 6' (2 × 1.85 m).

Credit: © Studio Fotografico Quattrone, Florence

To the right is the Raising of Lazarus, where boldly modeled and individualized figures twist in space. Through their postures and gestures they react to the human drama by pleading for Jesus's help or by expressing either astonishment at the miracle or revulsion at the smell of death. Jesus is separated from the crowd. His transforming gesture is highlighted against the dark blue of the background, his profile face locked in communication with the similarly isolated Lazarus, whose eyes—still fixed in death—let us know that the miracle has not yet happened.

On the lower register, where Jesus's followers lament over his dead body, Giotto portrays palpable human suffering, drawing viewers into a circle of personal grief. The stricken Virgin pulls her dead son close, while John the Evangelist flings his arms back in convulsive despair and others hunch over the corpse. Much as Giotto linked the scene of Judas's pact and the Visitation across the

sanctuary arch, he links this scene to the mourning of Lazarus on the register above using the continuous diagonal implied by the sharply angled hillside behind both scenes, and the rhyming repetition of mourners in each scene—facing in opposite directions—who throw back their arms to express their emotional state. Viewers would know that the mourning in both scenes is resolved by resurrection, portrayed in the last picture in this set.

Following traditional medieval practice, the fresco program is full of scenes and symbols that are intended to be seen as coordinated or contrasting juxtapositions. What is new here is the way Giotto draws us into the experience of these events. This direct emotional appeal not only allows viewers to imagine the scenes in relation to their own life experiences, it also embodies the new Franciscan emphasis on personal devotion rooted in empathetic responses to sacred stories.

18–9 Giotto di Bondone
KISS OF JUDAS
South wall of Scrovegni (Arena) Chapel, Padua. 1305–1306. Fresco, 6'6¾" × 6'⅞" (2 × 1.85 m).

Credit: © Studio Fotografico Quattrone, Florence

One of the most gripping paintings in the chapel is Giotto's portrayal of the **KISS OF JUDAS**, the moment of betrayal that represents the first step on Jesus's road to the Crucifixion (**FIG. 18-9**). Savior and traitor are slightly off-center in the near foreground. The expansive sweep of Judas's strident yellow cloak—the same outfit he wore at the scene of his payment for the betrayal on the strip of wall to the left of the sanctuary arch—almost completely swallows Christ's body. Surrounding them, faces glare from all directions. A bristling array of weapons radiating from the confrontation draws attention to the encounter between Christ and Judas and documents the militarism of the arresting soldiers. Jesus stands solid, a model of calm resolve that recalls his visual characterization in the *Raising of Lazarus*, and forms a striking foil to the noisy and chaotic aggression that engulfs him. Judas, in simian profile, purses his lips for the kiss that will betray Jesus to his captors, setting up a mythic confrontation of good and evil. In a subplot to the left, Peter lunges forward to sever the ear of the high priest's assistant. They are behind another broad sweep of fabric, this one extended by a figure completely concealed except for the hand that pulls at Peter's cloak. Indeed, a broad expanse of cloth and lateral gestures creates a barrier along the picture plane—as if to protect viewers from the compressed chaos of the scene itself. Rarely has this poignant event been visualized with such riveting power.

Sienese Painting

Like their Florentine rivals, Sienese painters were rooted in thirteenth-century pictorial traditions, especially those of Byzantine art. Sienese painting emphasized the decorative potential of narrative painting with brilliant, jewel-like colors and elegantly posed figures. For this reason, some art historians consider Sienese art more conservative than Florentine art, but we will see that it has its own charm and its own narrative strategies.

DUCCIO DI BUONINSEGNA Siena's foremost painter was Duccio di Buoninsegna (active 1278–1318), whose creative synthesis of Byzantine and French Gothic sources transformed the tradition in which he worked. Between 1308 and 1311, Duccio and his workshop painted a huge altarpiece commissioned for Siena Cathedral and known as the **MAESTÀ** ("Majesty") (**FIG. 18-10**). Creating this altarpiece—assembled from many wood panels bonded together before painting—was an arduous undertaking. The work was not only large—the central panel alone was 7 by 13 feet—but it had to be painted on both sides since it could be seen from all directions when installed on the main altar at the center of the sanctuary.

Because the *Maestà* was dismantled in 1771, its power and beauty can only be imagined from scattered parts, some still in Siena but others elsewhere. FIGURE 18-10A is a

18–10 Duccio di Buoninsegna **CONJECTURAL RECONSTRUCTION OF THE FRONT (A) AND BACK (B) OF THE MAESTÀ ALTARPIECE**

Made for Siena Cathedral. 1308–1311. Tempera and gold on wood, main front panel 7 × 13′ (2.13 × 4.12 m).

Credit: © Lew Minter

Technique

CENNINO CENNINI ON PANEL PAINTING

Il Libro dell' Arte (*The Book of Art*) of Cennino Cennini (c. 1370–1440) is a compendium of Florentine painting techniques from about 1400 that includes step-by-step instructions for making panel paintings, a process also used in Sienese paintings of the same period.

The wood for the panels, he explains, should be fine-grained, free of blemishes, and thoroughly seasoned by slow drying. The first step in preparing such a panel for painting was to cover its surface with clean white linen strips soaked in a **gesso** (primer) made from gypsum, a task, he tells us, best done on a dry, windy day. Gesso provided a ground, or surface, on which to paint, and Cennini specified that at least nine layers should be applied. The gessoed surface should then be burnished until it resembles ivory. Only then could the artist sketch the composition of the work with charcoal made from burned willow twigs. At this point, advised Cennini, "When you have finished drawing your figure, especially if it is in a very valuable [altarpiece], so that you are counting on profit and reputation from it, leave it alone for a few days, going back to it now and then to look it over and improve it wherever it still needs something. When it seems to you about right (and bear in mind that you may copy and examine things done by other good masters; that it is no shame to you), when the figure is satisfactory, take the feather and rub it over the drawing very lightly, until the drawing is practically effaced" (Cennini, trans. Thompson, p. 75). At this point, the final design would be inked in with a fine squirrel-hair brush. Gold leaf, he advises, should be affixed on a humid day, the tissue-thin sheets carefully glued down with a mixture of fine powdered clay and egg white on the reddish clay ground called bole. Then the gold is burnished with a gemstone or the tooth of a carnivorous animal. Punched and incised patterning should be added to the gold leaf later.

Fourteenth- and fifteenth-century Italian painters worked principally in tempera paint: powdered pigments mixed with egg yolk, a little water, and an occasional touch of glue. Apprentices were kept busy grinding pigments and mixing paints, setting them out for more senior painters in wooden bowls or shell dishes.

Cennini outlined a detailed and highly formulaic painting process. Faces, for example, were always to be done last, with flesh tones applied over two coats of a light greenish pigment and highlighted with touches of red and white. The finished painting was to be given a layer of varnish to protect it and intensify its colors.

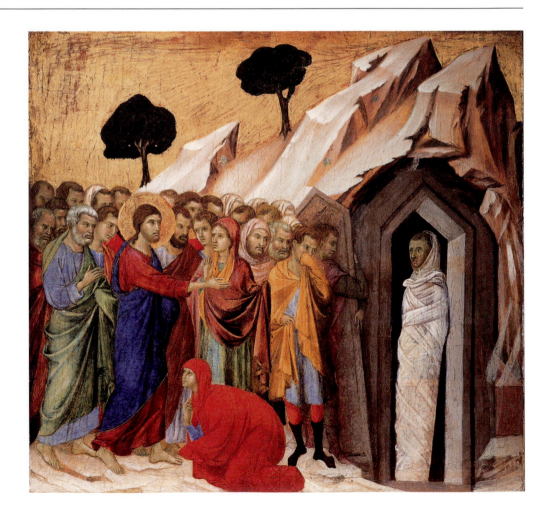

18–11 Duccio di Buoninsegna **RAISING OF LAZARUS**

From the predella of the back of the *Maestà* altarpiece (lower right corner of FIG. 18–10B), made for Siena Cathedral. 1308–1311. Tempera and gold on wood, 17⅛ × 18¼″ (43.5 × 46.4 cm). Kimbell Art Museum, Fort Worth, Texas.

Credit: © 2016. Photo Scala, Florence

18–12 Duccio di Buoninsegna **BETRAYAL OF JESUS**
From the back of the *Maestà* altarpiece (lower center of FIG. 18–10B), made for Siena Cathedral. 1308–1311.
Tempera and gold on wood, 22½ × 40″ (57.2 × 101.6 cm). Museo dell'Opera del Duomo, Siena.

Credit: © 2016. Photo Opera Metropolitana Siena/Scala, Florence

reconstruction of how the front of the original altarpiece might have looked. It is dominated by a large representation of the Virgin and Child in Majesty (thus its title of *Maestà*), flanked by 20 angels and 10 saints, including the 4 patron saints of Siena kneeling in the foreground. Above and below this lateral tableau were small narrative scenes from the last days of the life of the Virgin (above) and the infancy of Christ (spread across the **predella**, the lower zone of the altarpiece). An inscription running around the base of Mary's majestic throne places the artist's signature within an optimistic framework: "Holy Mother of God, be thou the cause of peace for Siena and life to Duccio because he painted thee thus." This was not Duccio's first work for the cathedral. In 1288, he had designed a stunning stained-glass window portraying the Death, Assumption, and Coronation of the Virgin for the huge circular opening in the east wall of the sanctuary. It would have hovered over the installed *Maestà* when it was placed on the altar in 1311.

The enthusiasm with which citizens greeted a great painting or altarpiece like the *Maestà* demonstrates the power of images as well as the association of such magnificent works with the glory of a city itself. According to a contemporary account, on December 20, 1311, the day that Duccio's altarpiece was carried from his workshop to the cathedral, all the shops were shut, and everyone in the city participated in the procession, with "bells ringing joyously, out of reverence for so noble a picture as is this" (Holt, p. 69).

On the back of the *Maestà* (SEE FIG. 18–10B) were episodes from the life of Christ focusing on his Passion. Sacred narrative unfolds in elegant episodes enacted by graceful figures who seem to dance their way through these stories while still conveying emotional content. Characteristic of Duccio's narrative style is the scene of the **RAISING OF LAZARUS** (FIG. 18–11). Lyrical figures enact the event with graceful decorum, but their highly charged glances and expressive gestures—especially the bold reach of Christ—convey a strong sense of dramatic urgency that contrasts with the tense stillness that we saw in Giotto's rendering of this same moment of confrontation (SEE FIG. 18–8). Duccio's shading of drapery, like his modeling of faces, faithfully describes the figures' three-dimensionality, but the crisp outlines of the jewel-colored shapes created by their clothing, as well as the sinuous continuity of folds and gestures, generate rhythmic patterns crisscrossing the surface. Duccio's experimentation with the portrayal of space extends from the receding rocks of the mountainous landscape to the carefully studied interiors, including the tomb of Lazarus, the door of which was removed by a bystander to reveal Jesus's resurrected friend.

Duccio's rendering of the **BETRAYAL OF JESUS** (FIG. 18–12) is more expansive, both pictorially and temporally, occupying one of the broadest panels in the altarpiece (SEE FIG. 18–10B, lower center) and encompassing within one composition several moments in the sequential

narrative of its subject matter. The tableau is centered and stabilized by the frontal figure of Jesus, whose dark mantle with its sinuous gold trim stands out from the densely packed, colorful crowd of figures surrounding him. Judas approaches from the left to identify Jesus. Although the heads of betrayer and betrayed touch in this moment, Duccio avoids the psychological power of Giotto's face-to-face confrontation in the Scrovegni Chapel (SEE FIG. 18–9). Flanking Duccio's stable, packed central scene of betrayal are two subsequent moments in the story, each pulling our attention to the sides. To the left, the apostle Peter lunges with a dynamic gesture to sever the ear of a member of the arresting party, while on the other side of the composition a group of apostles rushes to escape the central scene, abandoning Jesus to his fate. Through the postures and facial expressions of the many figures in this broad, continuous narrative, Duccio expresses the emotional charge of these pivotal moments in the narrative of Christ's Passion. At the same time, he creates a dazzling picture, as rich in color and linear elegance as it is faithful to the human dimensions of the situations it portrays.

SIMONE MARTINI The generation of painters who followed Duccio continued to paint in the elegant style he established, combining the evocation of three-dimensional form with a graceful continuity of linear pattern. One of Duccio's most successful and innovative followers was Simone Martini (c. 1284–1344), whose paintings were in high demand throughout Italy, including in Assisi where he covered the walls of the St. Martin Chapel with frescos between 1312 and 1319. His most famous work, however, was commissioned in 1333 for the cathedral of his native Siena, an altarpiece of the **ANNUNCIATION** flanked by two saints (**FIG. 18–13**) that he painted in collaboration with his brother-in-law, Lippo Memmi.

18–13 Simone Martini and Lippo Memmi **ANNUNCIATION**
Made for Siena Cathedral. 1333. Tempera and gold on wood, 10′ × 8′9″ (3 × 2.67 m). Galleria degli Uffizi, Florence.

Credit: © Studio Fotografico Quattrone, Florence

Art and its Contexts

THE BLACK DEATH

A deadly outbreak of the bubonic plague, known as the Black Death after the dark sores that developed on the bodies of its victims, spread to Europe from Asia by both land and sea in the middle of the fourteenth century. At least half the urban population of Florence and Siena—some estimate 80 percent—died during the summer of 1348, probably including the artists Andrea Pisano and Ambrogio Lorenzetti. Death was so quick and widespread that basic social structures crumbled in the resulting chaos; people did not know where the disease came from, what caused it, or how long the pandemic would last.

Mid-twentieth-century art historian Millard Meiss proposed that the Black Death had a significant impact on the development of Italian art in the middle of the fourteenth century. Pointing to what he saw as a reactionary return to hieratic linearity in religious art, Meiss theorized that artists had retreated from the rounded forms that had characterized the work of Giotto to old-fashioned styles, and that this artistic change reflected a growing reliance on traditional religious values in the wake of a disaster that some interpreted as God's punishment of a world in moral decline.

An altarpiece painted in 1354–1357 by Andrea di Cione, nicknamed "Orcagna" ("Archangel"), under the patronage of Tommaso Strozzi—the so-called **STROZZI ALTARPIECE** (**FIG. 18–14**)—is the sort of painting that led Meiss to his interpretation. It is dominated by a central figure of Christ,

presumably enthroned, but without any hint of an actual seat, evoking the image of the judge at the Last Judgment, outside time and space. The silhouetted outlines of the standing and kneeling saints emphasize surface over depth; the gold floor beneath them does not offer any reassuring sense of spatial recession to contain them and their activity. Throughout, line and color are more prominent than form.

Recent art historians have stepped back from Meiss's contextual explanation of stylistic change. Some have pointed out logical relationships between style and subject in the works Meiss cites; others have seen in them a mannered outgrowth of current style rather than a reversion to an earlier style; still others have discounted the underlying notion that stylistic change is connected with social situations. But there is a clear relationship of works such as the Strozzi Altarpiece with death and judgment, sanctity, and the promise of salvation—themes also suggested in the narrative scenes on the predella: Thomas Aquinas's ecstasy during Mass, Christ's miraculous walk on water to rescue Peter, and the salvation of Emperor Henry II because of a pious donation. While these are not uncommon scenes in sacred art, it is easy to see a relationship between their choice as subject matter here and the specter cast by the Black Death over a world that had recently imagined its prosperity in art firmly rooted in references to everyday life (SEE FIG. 18–16).

18–14 Andrea di Cione (nicknamed "Orcagna") ENTHRONED CHRIST WITH SAINTS, FROM THE STROZZI ALTARPIECE
Strozzi Chapel, Santa Maria Novella, Florence. 1354–1357. Tempera and gold on wood, 9′ × 9′8″ (2.74 × 2.95 m).

Credit: © Studio Fotografico Quattrone, Florence

The smartly dressed figure of Gabriel—the extended flourish of his drapery behind him suggesting he has just arrived, and with some speed—raises his hand to address the Virgin. The words of his message are actually incised into the gold-leafed gesso of the background, running from his opened mouth toward the Virgin's ear: *Ave gratia plena dominus tecum* (Luke 1:28: "Hail, full of grace, the Lord is with thee"). Seemingly frightened—at the very least

18–15 AERIAL VIEW OF THE CAMPO IN SIENA WITH THE PALAZZO PUBBLICO (CITY HALL INCLUDING ITS TOWER) FACING ITS STRAIGHT SIDE
Siena. Palazzo Pubblico 1297–c. 1315; tower 1320s–1340s.

Credit: © Archivi Alinari, Firenze

startled—by this unexpected celestial messenger, Mary recoils into her lavish throne, her thumb inserted into the book she had been reading to safeguard her place, while her other hand pulls at her clothing in an elegant gesture of nobility that relates back to the courtly art of thirteenth-century Paris (see Solomon, second lancet from the right in FIG. 17-11).

AMBROGIO LORENZETTI The most important civic structure in Siena was the **PALAZZO PUBBLICO** (FIG. 18-15), the town hall which served as the seat of government, just as the Palazzo della Signoria did in rival Florence (SEE FIG. 18-2). There are similarities between these two buildings. Both are designed as strong, fortified structures sitting on the edge of a public piazza, and both have a tall tower, making them visible signs of the city from a considerable distance. The Palazzo Pubblico was constructed from 1297 to c. 1315, but the tower was not completed until 1348, when the bronze bell used to signal meetings of the ruling council was installed.

The interior of the Palazzo Pubblico was the site of important commissions by some of Siena's most famous artists. In c. 1315, Simone Martini painted a large mural of the Virgin in Majesty surrounded by saints—clearly based on Duccio's recently installed *Maestà*. Then, in 1338, the Siena city council commissioned Ambrogio Lorenzetti to paint frescos for the council room of the Palazzo known as the Sala dei Nove (Chamber of the Nine), or Sala della Pace (Chamber of Peace), on the theme of the contrast between good and bad government (SEE FIG. 18-1).

Lorenzetti painted the results of both good and bad government on the two long walls. For the expansive scene of **THE EFFECTS OF GOOD GOVERNMENT IN THE CITY AND IN THE COUNTRY**, and in tribute to his patrons, he created an idealized but recognizable portrait of the city of Siena and its immediate environs (FIG. 18-16). The cathedral dome and the distinctive striped campanile are visible in the upper left-hand corner; the streets are filled with the bustling activity of productive citizens who also have time for leisurely diversions. Lorenzetti shows the city from shifting viewpoints so we can see as much as possible, and renders its inhabitants larger in scale than the buildings around them to highlight their activity. Featured in the foreground is a circle of dancers—probably a professional troupe of male entertainers masquerading as women as part of a spring festival—and above them, at the top of the painting, a band of masons on exterior scaffolding is constructing the wall of a new building.

The Porta Romana, Siena's gateway leading to Rome, divides the thriving city from its surrounding countryside. In this panoramic landscape painting, Lorenzetti describes a natural world marked by agricultural productivity, showing activities of all seasons simultaneously—sowing, hoeing, and harvesting. Hovering above the gate that separates city life and country life is a woman clad in a wisp of transparent drapery, a scroll in one hand and a miniature gallows complete with a hanged man in the other. She represents Security, and her scroll bids those coming to the city to enter without fear because she has taken away the power of the guilty who would harm them.

18-16 Ambrogio Lorenzetti **THE EFFECTS OF GOOD GOVERNMENT IN THE CITY AND IN THE COUNTRY**
Sala dei Nove (also known as Sala della Pace), Palazzo Pubblico, Siena, Italy. 1338–1339. Fresco, total length approx. 46′ (14 m).

Credit: © Studio Fotografico Quattrone, Florence

The world of the Italian city-states—which had seemed so full of promise in Ambrogio Lorenzetti's *Good Government* fresco—was transformed into uncertainty and desolation by a series of natural and societal disasters as the middle of the century approached. In 1333, a flood devastated Florence, followed by banking failures in the 1340s, famine in 1346–1347, and epidemics of the bubonic plague, especially virulent in the summer of 1348. Some art historians have traced the influence of these calamities on the visual arts at the middle of the fourteenth century (see "The Black Death" on page 559). Yet as dark as those days must have seemed to the men and women living through them, the cultural and artistic changes initiated earlier in the century would persist. In a relatively short span of time, the European Middle Ages gave way in Florence to a new movement that would blossom in the Italian Renaissance.

France

What features characterize the small-scale works of art produced in Parisian workshops during the fourteenth century?

At the beginning of the fourteenth century, the royal court in Paris was still the arbiter of taste in western Europe, as it had been in the days of King Louis IX (St. Louis). During the Hundred Years' War, however, the French countryside was ravaged by armed struggles and civil strife. The power of the nobility, weakened significantly by warfare, was challenged by townsmen, who took advantage of new economic opportunities that opened up in the wake of the conflict. As centers of art and architecture, the duchy of Burgundy, England, and, for a brief moment, the court of Prague began to rival Paris.

French sculptors found lucrative new outlets for their work—not only in stone, but in wood, ivory, and precious metals, often decorated with enamel and gemstones—in the growing demand among wealthy patrons for religious art intended for homes as well as churches. Manuscript painters likewise created lavishly illustrated books for the personal devotions of the wealthy and powerful. And architectural commissions focused on exquisitely detailed chapels or small churches, often under private patronage, rather than on the building of grand cathedrals funded by Church institutions.

Manuscript Illumination

By the late thirteenth century, private prayer books became popular among wealthy patrons. Because they contained special prayers to be recited at the eight canonical devotional "hours" between morning and night, an individual copy of one of these books came to be called a **Book of Hours**.

Such a book included everything the layperson needed for pious practice—psalms, prayers and offices of the Virgin and other saints (such as the owner's patron or the patron of their home church), a calendar of feast days, and sometimes prayers for the dead. During the fourteenth century, a richly decorated Book of Hours was worn or carried like jewelry, counting among a noble person's most important portable possessions.

THE BOOK OF HOURS OF JEANNE D'ÉVREUX King Charles IV gave his 14-year-old queen, Jeanne d'Évreux, a tiny Book of Hours illuminated by the Parisian painter Jean Pucelle, perhaps on the occasion of their marriage in 1324. When opened, it fits easily within one hand (see "Closer Look" opposite). This book was so precious to the queen that she mentioned it and its illuminator specifically in her will, leaving this royal treasure to King Charles V. Pucelle painted the book's pictures in *grisaille*. His style clearly derives from the courtly mode established in Paris at the time of Louis IX—softly modeled, voluminous draperies gathered loosely and falling in projecting diagonal folds around tall, elegantly posed figures with carefully coiffed, curly hair, broad foreheads, and delicate features. But his conception of space, with figures placed within coherent, discrete architectural settings, suggests a firsthand knowledge of contemporary Sienese art.

Jeanne appears in the initial *D* below the Annunciation, kneeling in prayer before a lectern, perhaps using this Book of Hours to guide her meditations, beginning with the words written on this page: *Domine labia mea aperies* (Psalm 51:15: "O Lord, open thou my lips"). The juxtaposition of the praying Jeanne with a scene from the life of the Virgin Mary suggests that the sacred scene is actually a vision inspired by Jeanne's meditations. The young queen might have identified with and sought to feel within herself Mary's joy at Gabriel's message. Given what we know of Jeanne's life and her royal husband's predicament, it might also have directed the queen's prayers toward the fulfillment of his wish for a male heir.

In the Annunciation, Mary is shown receiving the archangel Gabriel in a Gothic building that seems to project outward from the page toward the viewer, while rejoicing angels look on from windows under the eaves. The group of children at the bottom of the page at first glance seems to echo the angelic jubilation. Folklorists have suggested, however, that the children are playing "froggy in the middle" or "hot cockles," games in which one child was tagged by the others. To the medieval viewer, if the game symbolized the mocking of Christ or the betrayal of Judas, who "tags" his friend, it would have evoked a darker mood—referring to the picture on the other page of this opening and foreshadowing Jesus's imminent death even as his life is beginning.

A Closer Look

THE HOURS OF JEANNE D'ÉVREUX

In this opening Pucelle juxtaposes complementary scenes drawn from the Infancy and Passion of Christ, placed on opposing pages in a scheme known as the Joys and Sorrows of the Virgin. The "joy" of the Annunciation on the right is paired with the "sorrow" of the betrayal and arrest of Christ on the left.

Christ sways back as Judas betrays him with a kiss. The S-curve of his body mirrors the Virgin's pose on the opposite page, as both accept their fate with courtly decorum.

The prominent lamp held aloft by a member of the arresting battalion informs the viewer that this scene takes place at night, in the dark.

The angel who holds up the boxlike enclosure where the Annunciation takes place is an allusion to the legend of the miraculous transportation of this building from Nazareth to Loreto in 1294.

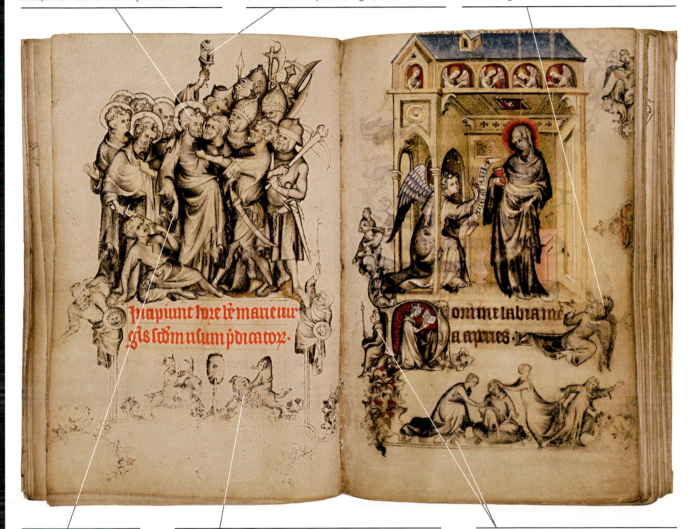

Christ reaches casually down to heal Malchus, the assistant of the high priest, whose ear Peter had just cut off in angry retaliation for his participation in the arrest of Jesus.

Visual puns, off-color jokes, and scenes of secular amusements from everyday life appear at the bottom of many pages of this book. Sometimes they relate to the themes of the sacred scenes above them. These comic knights riding goats may be a commentary on the lack of valor shown by the soldiers assaulting Jesus, especially if this wine barrel conjured up for Jeanne an association with the Eucharist.

The candle held by the cleric who guards the "door" to Jeanne's devotional retreat, as well as the rabbit emerging from its burrow in the marginal scene, are sexually charged symbols of fertility that seem directly related to the prayers of a child bride required to produce a male heir.

18–17 Jean Pucelle **THE KISS OF JUDAS AND THE ANNUNCIATION**

Two-page opening from the Hours of Jeanne d'Évreux. Paris. c. 1324–1328. *Grisaille* and color on vellum, each page 3⅝ × 2⁷⁄₁₆″ (9.2 × 6.2 cm). Metropolitan Museum of Art, New York. The Cloisters Collection (54.1.2), fols. 15v–16r.

Metalwork and Ivory

Fourteenth-century French sculpture is intimate in character. Religious subjects became more emotionally expressive; objects became smaller and demanded closer scrutiny from the viewer. In the secular realm, tales of love and valor were carved on luxury items to delight the rich. Precious materials—gold, silver, and ivory—were preferred.

18–18 VIRGIN AND CHILD

c. 1324–1339. Silver gilt and enamel, height 27⅛" (69 cm). Musée du Louvre, Paris.

Credit: © Jacqueline Guillot/akg-images

A VIRGIN AND CHILD FROM SAINT-DENIS A silver-gilt image of a standing **VIRGIN AND CHILD** (FIG. 18–18) is a rare survivor that verifies the acclaim that was accorded fourteenth-century Parisian goldsmiths. An inscription on the base documents the statue's donation to the abbey church of Saint-Denis in 1339 and the donor's name, the same Queen Jeanne d'Évreux whose Book of Hours we have just examined. In a style that recalls the work of artist Jean Pucelle in that Book of Hours, the Virgin holds Jesus in her left arm with her weight on her left leg, standing in a graceful, characteristically Gothic S-curve pose. Mary originally wore a crown, and she still holds a large enameled and jeweled *fleur-de-lis*—the heraldic symbol of royal France—which served as a reliquary container for strands of Mary's hair. The Christ Child, reaching out tenderly to caress his mother's face, is babylike in both form and posture. On the base, minuscule statues of prophets stand on projecting piers to separate 14 enameled scenes from Christ's Infancy and Passion, reminding us of the suffering to come. The apple in the baby's hand carries the theme further with its reference to Christ's role as the new Adam, whose sacrifice on the cross redeemed humanity from the first couple's fall into sin when Eve bit into the forbidden fruit.

AN IVORY CHEST WITH SCENES OF ROMANCE Fourteenth-century Paris was renowned for more than its goldsmiths (SEE FIG. 18–18). Among the most sumptuous and sought-after Parisian luxury products were small chests assembled from carved ivory plaques that were used by wealthy women to store jewelry or other personal treasures. The entirely secular subject matter of these chests explored romantic love. Indeed, they seem to have been courtship gifts from smitten men to desired women or wedding presents offered by grooms to their brides.

A chest from around 1330 to 1350, now in the Walters Museum (FIG. 18–19), is one of seven that have survived intact; there are fragments of a dozen more. It is a delightful and typical example. Figural relief covers five exterior sides of the box: around the perimeter and on the hinged top. The assembled panels were joined by hardware originally wrought in silver. Although some chests tell a single romantic story in sequential episodes, most, like this one, anthologize scenes drawn from a group of stories, combining courtly romance, secular allegory, and ancient fables.

On the lid of the Walters casket (FIG. 18–20), jousting is the theme. Spread over the central two panels, a single scene catches two charging knights in the heat of a tournament, while trumpeting heralds call the attention of spectators, lined up above in a gallery to observe this public display of virility. The panel at right mocks the very ritual showcased in the middle panels by pitting a woman against a knight, battling not with lances but with

18–19 SMALL IVORY CHEST WITH SCENES FROM COURTLY ROMANCES

Made in Paris. c. 1330–1350. Elephant ivory with modern iron mounts, height 4½ × 9¹¹⁄₁₆ × 4⁷⁄₈″ (11.5 × 24.6 × 12.4 cm). The Walters Art Museum, Baltimore. 71.264

Credit: Photo © The Walters Art Museum, Baltimore

18–20 ATTACK ON THE CASTLE OF LOVE

Top of the chest in FIG. 18–19.

Credit: Photo © The Walters Art Museum, Baltimore

18–21 TRISTAN AND ISEULT AT THE FOUNTAIN; CAPTURE OF THE UNICORN

Left short side of the chest in FIG. 18–19.

Credit: Photo © The Walters Art Museum, Baltimore

a long-stemmed rose (symbolizing sexual surrender) and an oak bough (symbolizing fertility). Instead of observing these goings-on, however, the spectators tucked into the upper architecture pursue their own flirtations. Finally, in the scene on the left, knights use crossbows and a catapult to hurl roses at the Castle of Love, while Cupid returns fire.

On the front of the chest (SEE FIG. 18–19), generalized romantic allegory gives way to vignettes from a specific story. At left, the long-bearded Aristotle teaches the young Alexander the Great, using exaggerated gestures and an authoritative text to emphasize his point. Today's lesson is a warning not to allow women to distract the young prince from his studies. The subsequent scene, however, pokes fun at the eminent teacher, who has become so smitten by a young beauty named Phyllis that he lets her ride

him around like a horse while his student observes from the castle in the background. The two scenes at right relate to an Eastern legend of the fountain of youth, popular in medieval Europe. A line of bearded elders approaches the fountain from the left, steadied by their canes; on the right, two newly rejuvenated couples, now nude, bathe and flirt within the fountain's basin. The man first in line for treatment looks suspiciously like the figure of Aristotle, forming a link between the two stories on the casket front.

Two other well-known medieval themes are juxtaposed on the left short side of the ivory chest (FIG. 18–21). At left, Tristan and Iseult have met secretly for an illicit romantic tryst, while Iseult's husband, King Mark, tipped off by an informant, observes them from a tree. But when they see his reflection in a fountain between them, they

alter their behavior accordingly, and the king believes them innocent of the adultery he had (rightly) suspected. The medieval bestiary ("book of beasts") claimed that only a virgin could capture the mythical unicorn, which at right lays his head, with its aggressively phallic horn, into the lap of just such a pure maiden so that the hunter can take advantage of her alluring powers over the animal to kill it with his phallic counterpart of its horn, a large spear.

Unlike royal marriages of the time, which were essentially business contracts based on political or financial exigencies, the romantic love of the aristocratic wealthy involved passionate devotion. Images of gallant knights and their coy paramours captured the popular Gothic imagination and formed the principal subject matter on personal luxury objects—not only chests like this, but mirror backs, combs, writing tablets, even ceremonial saddles. These stories evoke themes that still captivate us: desire and betrayal, cruel rejection and blissful folly. In this way they allow us some access to the lives of the people who owned these precious objects, even if we ourselves are unable to afford them.

England

What is distinctive about English textiles and architecture during the fourteenth century?

Fourteenth-century England prospered in spite of the ravages of the Black Death and the Hundred Years' War with France. English life at this time is described in the brilliant social commentary of Geoffrey Chaucer in the *Canterbury Tales* (see "A New Spirit in Fourteenth-Century Literature" on page 544). The royal family— especially Edward I (ruled 1272–1307), the castle builder—and many nobles and bishops were generous patrons of the arts.

Embroidery: *Opus Anglicanum*

Since the thirteenth century, the English had been renowned for pictorial needlework, using colored silk and gold threads to create images as detailed as contemporary painters produced in manuscripts. Popular throughout Europe, the art came to be called *opus anglicanum* ("English work"). The popes had more than 100 pieces in the Vatican treasury. The names of several prominent embroiderers are known, but in the thirteenth century no one surpassed Mabel of Bury St. Edmunds, who created both religious and secular articles for King Henry III (ruled 1216–1272).

THE CHICHESTER-CONSTABLE CHASUBLE This *opus anglicanum* liturgical vestment, worn by a priest during Mass (**FIG. 18–22**), was embroidered c. 1330–1350 with

18–22 LIFE OF THE VIRGIN, BACK OF THE CHICHESTER-CONSTABLE CHASUBLE

From a set of vestments embroidered in *opus anglicanum* from southern England. c. 1330–1350. Red velvet with silk and metallic thread and seed pearls; length 4′3″ (129.5 cm), width 30″ (76 cm). Metropolitan Museum of Art, New York. Fletcher Fund, 1927 (27 162.1).

images formed by subtle gradations of colored silk. Where gold threads were laid and couched (tacked down with colored silk), the effect resembles the burnished gold-leaf backgrounds of manuscript illuminations. The Annunciation, the Adoration of the Magi, and the Coronation of the Virgin are set in cusped, crocketed ogee (S-shape) arches, supported on animal-head corbels and twisting branches of oak leaves with seed-pearl acorns. Because the star and crescent moon in the Coronation of the Virgin scene are heraldic emblems of Edward III (ruled 1327–1377), perhaps he or a family member commissioned this luxurious vestment.

During the celebration of the Mass, especially as the priest moved, *opus anglicanum* would have glinted in the candlelight. Court dress was just as rich and colorful as the treasures on the altar, and at court such embroidered garments proclaimed the rank and status of the wearer. Such gold and bejeweled garments became so heavy that their wearers often needed help to move.

Architecture

In the later years of the thirteenth century and early years of the fourteenth, a distinctive and influential Gothic architectural style popularly known as the "Decorated style" developed in England. This change in taste has been credited to Henry III's ambition to surpass Louis IX, who was his brother-in-law, as a royal patron of the arts.

THE DECORATED STYLE AT EXETER One of the most complete Decorated-style buildings is **EXETER CATHEDRAL**. Thomas

of Witney began construction in 1313 and remained master mason from 1316 to 1342, supervising construction of the nave and redesigning upper parts of the choir. He left the towers of the original Norman cathedral, but turned the interior into a dazzling stone forest of colonnettes, moldings, and vault ribs (**FIG. 18–23**). From piers formed by a cluster of colonnettes rise multiple moldings that make the arcade seem to ripple. Bundled colonnettes spring from sculptured foliate corbels (brackets that project from a wall) between the arches and rise up the wall to support conical clusters of 13 ribs that meet at the summit of the vault, a modest 69 feet above the floor. The basic structure

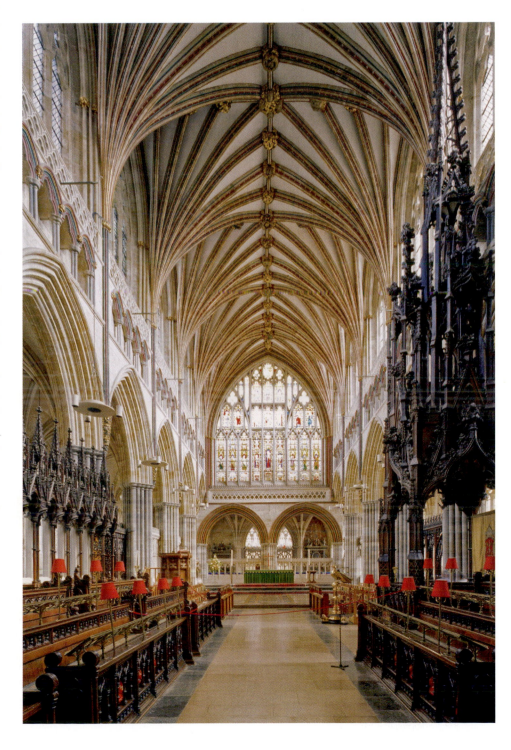

18–23 INTERIOR, EXETER CATHEDRAL

Devon, England. Thomas of Witney, choir, 14th century and bishop's throne, 1313–1317; Robert Lesyngham, east window, 1389–1390.

Credit: © akg/Bildarchiv Monheim

here is the four-part vault with intersecting cross-ribs, but the designer added additional ribs, called tiercerons, to create a richer linear pattern. Elaborately carved bosses (decorative knoblike elements) signal the point where ribs meet along the ridge of the vault. Large bar-tracery clerestory windows illuminate the 300-foot-long nave. Unpolished gray marble shafts, yellow sandstone arches, and a white French stone, shipped from Caen, add subtle gradations of color to the upper wall.

Detailed records survive for the building of Exeter Cathedral, documenting work over the period from 1279 to 1514, with only two short breaks. They record where masons and carpenters were housed (in a hostel near the cathedral) and how they were paid (some by the day with extra for drinks, some by the week, some for each finished piece); how materials were acquired and transported (including horseshoes and fodder for the horses); and, of course, payments for the building materials (not only stone and wood, but rope for measuring and parchment on which to draw forms for the masons). The bishops contributed generously to the building funds. This was not a labor only of love.

Thomas of Witney also designed the intricate, 57-foot-high bishop's throne (at right in FIG. 18–23), constructed by Richard de Galmeton and Walter of Memburg, who led a team of a dozen carpenters. The canopy resembles embroidery translated into wood, with its maze of pinnacles bursting with leafy crockets and tiny carved animals and heads. To finish the throne in splendor, Master Nicolas painted and gilded the wood. When the bishop was seated on his throne wearing embroidered vestments like the Chichester-Constable Chasuble (SEE FIG. 18–22), he must have resembled a golden image in a shrine—more a symbol of the power and authority of the Church than a specific human being.

THE PERPENDICULAR STYLE AT EXETER During the years following the Black Death, work at Exeter Cathedral came to a standstill. The nave had been roofed but not vaulted, and the windows had no glass. When work could be resumed, tastes had changed. The exuberance of the Decorated style gave way to an austere style in which rectilinear patterns and sharp, angular shapes replaced intricate curves, and luxuriant foliage gave way to simple, stripped-down patterns. This phase is known as the Perpendicular style.

In 1389–1390, well-paid master mason Robert Lesyngham rebuilt the great east window (SEE FIG. 18–23, far wall), designing its tracery in the new Perpendicular style. The window fills the east wall of the choir like a luminous altarpiece. A single figure in each light stands under a tall, painted canopy that flows into and blends with the stone tracery. The Virgin with the Christ Child stands in the center over the high altar with four female saints at the left and four male saints on the right, including St. Peter, to whom the church is dedicated. At a distance, the colorful figures silhouetted against the silver *grisaille* glass become a band of color, reinforcing the rectangular pattern of the mullions and transoms. The combination of *grisaille*, silver-oxide stain (staining clear glass with shades of yellow or gold), and colored glass produces a glowing wall and casts a cool, silvery light over the nearby stonework.

Perpendicular architecture heralds the Renaissance style in its regularity, its balanced horizontal and vertical lines, and its plain wall or window surfaces. When Tudor monarchs introduced Renaissance art into the British Isles, builders were not forced to rethink the form and structure of their buildings; they simply changed the ornament from the pointed cusps and crocketed arches of the Gothic style to the round arches and columns and capitals of Roman Classicism. The Perpendicular style itself became an English architectural vernacular. It has even been popular in the United States, especially for churches and college buildings.

The Holy Roman Empire

How do the expressive qualities of the figural arts and the architectural supremacy of Prague lead to a distinctive form of Gothic in the Holy Roman Empire?

By the fourteenth century, the Holy Roman Empire existed more as idealized fiction than fact. The Italian territories had established their independence, and in contrast to England and France, Germany had become further divided into multiple states with powerful regional associations and princes. The Holy Roman emperors, now elected by Germans, concentrated on securing the fortunes of their families. They continued to be patrons of the arts, promoting local styles.

Mysticism and Suffering

The by-now-familiar ordeals of the fourteenth century—famines, wars, and plagues—helped inspire a mystical religiosity in Germany that emphasized both ecstatic joy and extreme suffering. Devotional images, known as *Andachtsbilder* in German, inspired worshipers to contemplate Jesus's first and last hours, especially during evening prayers, or vespers, giving rise to the term *Vesperbild* for the image of Mary mourning her son. Through such religious exercises, worshipers hoped to achieve understanding of the divine and union with God.

VESPERBILD In this well-known example (FIG. 18–24), blood gushes from the hideous rosettes that form the wounds of an emaciated and lifeless Jesus who teeters improbably on the lap of his hunched-over mother.

The Virgin's face conveys the intensity of her ordeal. Such images took on greater poignancy since they would have been compared, in the worshiper's mind, to the familiar, almost ubiquitous images of the young Virgin mother holding her innocent and loving baby Jesus.

THE HEDWIG CODEX The extreme physicality and emotionalism of the *Vesperbild* finds parallels in the actual lives of some medieval saints in northern Europe. St. Hedwig (1174–1243), married at age 12 to Duke Henry I of Silesia and mother of his seven children, entered the Cistercian convent of Trebniz (in present-day Poland) on her husband's death in 1238. She devoted the rest of her life to caring for the poor and seeking to emulate the suffering of Christ by walking barefoot in the snow. As described in her *vita* (biography), she had a particular affection for a small ivory statue of the Virgin and Child, which she carried with her at all times; "she often took it up in her hands to envelop it in love, so that out of passion she could see it more often and through the seeing could prove herself more devout, inciting her to even greater love of the glorious Virgin. When she once blessed the sick with this image they were cured immediately" (translation from Schleif, p. 22). Hedwig was buried clutching the statue, and when her tomb was opened after her canonization in 1267, it was said that although most of her body had deteriorated, the fingers that still gripped the beloved object had miraculously not decayed.

18–24 VESPERBILD (PIETÀ)

From the Middle Rhine region, Germany. c. 1330. Wood and polychromy, height 34½" (88.4 cm). Landesmuseum, Bonn.

Credit: © akg-images/Erich Lessing

18–25 ST. HEDWIG OF SILESIA WITH DUKE LUDWIG I OF LIEGNITZ-BRIEG AND DUCHESS AGNES

Dedication page of the Hedwig Codex. 1353. Ink and paint on parchment, 13$\frac{7}{16}$ × 9$\frac{3}{4}$" (34 × 25 cm). The J. Paul Getty Museum, Los Angeles. MS. Ludwig XI 7, fol. 12v.

A picture of Hedwig serves as the frontispiece (**FIG. 18–25**) of a manuscript of her *vita* known as the Hedwig Codex, commissioned in 1353 by one her descendants, Ludwig I of Liegnitz-Brieg. Duke Ludwig and his wife, Agnes, are shown here kneeling on either side of St. Hedwig, dwarfed by the saint's architectural throne and her own imposing scale. With her prominent, spidery hands, she clutches the famous ivory statue, as well as a rosary and a prayer book, inserting her fingers within it to maintain her place as if our arrival had interrupted her devotions. She has draped her leather boots over her right wrist in a reference to her practice of removing them to walk in the snow. Hedwig's highly volumetric figure stands in a swaying pose of courtly elegance derived from French Gothic, but the intensity of her gaze and posture are far removed from the mannered graciousness of the smiling angel of Reims (see statue at far left in FIG. 17–14), whose similar gesture and extended finger are employed simply to grasp his drapery and assure its elegant display.

The Supremacy of Prague

Charles IV of Bohemia (ruled 1346–1378) was raised in France, and his admiration for the French king Charles IV was such that he changed his own name from Wenceslas to Charles. He was officially crowned King of Bohemia in 1347 and Holy Roman Emperor in 1355. He established his capital in Prague, which, in the view of his contemporaries, replaced Constantinople as the "New Rome." Prague had a great university, a castle, and a cathedral overlooking a

town that spread on both sides of a river joined by a stone bridge, a remarkable structure itself.

When Pope Clement VI made Prague an archbishopric in 1344, construction began on a new cathedral in the Gothic style to be named for St. Vitus. It would also serve as the coronation church and royal pantheon. But the choir was not finished for Charles's first coronation, so he brought Peter Parler from Swabia to complete it.

THE PARLER FAMILY In 1317, Heinrich Parler, a former master of works on Cologne Cathedral, designed and began building the church of the Holy Cross in Schwäbisch Gmünd, in southwest Germany. In 1351, his son Peter

(c. 1330–1399), the most brilliant architect of this talented family, joined the workshop. Peter designed the choir (**FIG. 18–26**) in the manner of a hall church whose triple-aisled form was enlarged by a ring of deep chapels between the buttresses. The contrast between Heinrich's nave and Peter's choir (seen clearly in **FIG. 18–26B**) illustrates the increasing complexity of rib patterns covering the vaults, which emphasizes the unity of interior space rather than its division into bays.

Called by Charles IV to Prague in 1353, Peter turned the unfinished St. Vitus Cathedral into a "glass house," adding a vast clerestory and glazed triforium supported by double flying buttresses, all covered by net vaults that

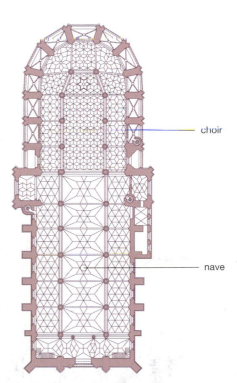

18–26A Heinrich and Peter Parler **PLAN OF THE CHURCH OF THE HOLY CROSS, SCHWÄBISCH GMÜND**

Germany. Begun in 1317 by Heinrich Parler; choir by Peter Parler begun in 1351; vaulting completed 16th century.

Credit: © Achim Bednorz, Cologne

choir

nave

18–26B Heinrich and Peter Parler **INTERIOR OF THE CHURCH OF THE HOLY CROSS, SCHWÄBISCH GMÜND**

Germany. Begun in 1317 by Heinrich Parler; choir by Peter Parler begun in 1351; vaulting completed 16th century.

18–27 Master Theodoric **ST. LUKE**
Holy Cross Chapel, Karlstejn Castle, near Prague. 1360–1364. Paint and gold on panel, 45¼ × 37″ (115 × 94 cm).

Credit: Photo: Radovan Boček

created a continuous canopy over the space. Because of the success of projects such as this, Peter and his family became the most successful architects in the Holy Roman Empire. Their concept of space, luxurious decoration, and intricate vaulting dominated central European architecture for three generations.

MASTER THEODORIC At Karlstejn Castle, a day's ride from Prague, Charles IV built another chapel, covering the walls with gold and precious stones as well as with paintings. There were 130 paintings of the saints serving as reliquaries, with relics inserted into their frames. Master Theodoric, the court painter, provided drawings on the wood panels, and he painted about 30 images himself. Figures are crowded into—even extend over—their frames, emphasizing their size and power. Master Theodoric was head of the Brotherhood of St. Luke, and the way that his painting of **ST. LUKE** (**FIG. 18–27**), patron saint of painters, looks out at the viewer has suggested

to scholars that this may be a self-portrait. His personal style combined a preference for substantial bodies, oversized heads and hands, dour and haunted faces, and soft, deeply modeled drapery, with a touch of grace derived from the French Gothic style. The chapel, consecrated in 1365, so pleased the emperor that in 1367 he gave the artist a farm.

Prague and the Holy Roman Empire under Charles IV had become a multicultural empire where people of different religions (Christians and Jews) and ethnic heritages (German and Slav) lived side by side. But Charles died in 1378, and without his strong central government, political and religious dissent overtook the empire. Jan Hus, dean of the philosophy faculty at Prague University and a powerful reforming preacher, denounced the immorality he saw in the Church. He was burned at the stake, becoming a martyr and Czech national hero. The Hussite Revolution in the fifteenth century ended Prague's—and Bohemia's—leadership in the arts.

Think About It

1 Compare and contrast Giotto's and Duccio's renderings of the biblical story of Christ's Raising of Lazarus (**FIGS. 18–8, 18–11**).

2 Discuss Ambrogio Lorenzetti's engagement with secular subject matter in his frescos for Siena's Palazzo Pubblico (**FIG. 18–16**). How did these paintings relate to their sociopolitical context?

3 Discuss the circumstances surrounding the construction and decoration of the Scrovegni (Arena) Chapel, paying special attention to its relationship to the life and aspirations of its patron.

4 Choose one small work of art in this chapter that was crafted from precious materials with exceptional technical skill. Explain how it was made and how it was used. How does the work of art relate to its cultural and social contexts?

Crosscurrents

Depictions of the Virgin Mary holding the infant Jesus represent a theme that developed early in the history of European Christian art and continues to this day. Describe the relationship between the mother and child in these two examples. Characterize the difference in artistic style. How does the choice of medium contribute to the differences between them? How were they used?

FIG. 16–27

FIG. 18–18

19–1 Jan van Eyck **DOUBLE PORTRAIT OF GIOVANNI ARNOLFINI AND HIS WIFE**
1434. Oil on wood panel, 33 × 22½″ (83.8 × 57.2 cm). National Gallery, London.

Chapter 19
Fifteenth-Century Art in Northern Europe

⌄ Learning Objectives

19.a Identify the visual hallmarks of fifteenth-century Northern European art for formal, technical, and expressive qualities.

19.b Interpret the meaning of works of fifteenth-century Northern European art based on their themes, subjects, and symbols.

19.c Relate fifteenth-century Northern European art and artists to their cultural, economic, and political contexts.

19.d Apply the vocabulary and concepts relevant to fifteenth-century Northern European art, artists, and art history.

19.e Interpret a work of fifteenth-century Northern European art using the art historical methods of observation, comparison, and inductive reasoning.

19.f Select visual and textual evidence in various media to support an argument or an interpretation of a work of fifteenth-century Northern European art.

Fifteenth-century Europe saw the emergence of wealthy merchants whose rise to power was fueled by individual accomplishment, rather than hereditary succession within noble families. Certainly Giovanni Arnolfini—the pasty gentleman with the extravagant hat in this double portrait (**FIG. 19-1**)—earned, rather than inherited, the right to have himself and his wife recorded by renowned artist Jan van Eyck. It was the wealth and connections he made as an Italian cloth merchant providing luxury fabrics to the Burgundian court that put him in the position to commission such a precious picture, in which both patron and painter are identified with conspicuous clarity. Giovanni's face looks more like a personal likeness than anything we have seen since ancient Rome, and not only did Jan van Eyck inscribe his name above the convex mirror ("Jan van Eyck was here 1434"), but his personal painting style also carries the stamp of authorship. The doll-like face of the woman standing next to Giovanni is less individualized. She may be lifting her skirt over her belly so she can follow Giovanni, who has taken her by the hand—or, as most modern observers assume, she may be pregnant. This painting is full of mysteries.

The identity of the couple is still open to scholarly debate, as is the nature of the subject. Is it a wedding, a betrothal, security for a shady financial deal, or a memorial to a beloved wife lost to death, perhaps in childbirth? Only the wealth of the couple is beyond dispute. They are surrounded by luxury objects: lavish bed hangings, a sumptuous chandelier, precious oriental carpet, and rare oranges, not to mention their extravagant clothing. The man wears a fur-lined, silk velvet *heuque* (sleeveless overgarment). The woman's gown not only employs more costly wool fabric than necessary to cover her slight body; the elaborate cutwork decoration and white fur lining of her sleeves is an ostentatious indicator of cost. In fact, the painting itself—probably hung in the couple's home—was an object of considerable value.

Even within its secular setting, however, the picture resonated with sacred meaning. The Church still provided spiritual grounding for men and women of the Renaissance. The crystal prayer beads hanging next to the convex mirror imply the couple's piety, and the mirror itself—a symbol of the all-seeing eye of God—is framed with a circular cycle of scenes from Christ's Passion. A figure of St. Margaret—protector of women in childbirth—is carved at the top of a post in the high-backed chair beside the bed, and the perky *affenpinscher* in the foreground may be more than a pet. In art, dogs served as symbols of fidelity and also had funerary associations, but choosing a rare, ornamental breed for inclusion here may have been yet another opportunity to express wealth.

The Northern Renaissance

What are the cultural and historical backgrounds for the Northern Renaissance?

Revitalized civic life and economic growth in the late fourteenth century gave rise to a prosperous middle class that supported scholarship, literature, and the arts. Their patronage resulted in the explosion of learning and creativity that we refer to as the Renaissance (French for "rebirth")—a term that was assigned to this period by later historians.

A major trait of the Renaissance in northern Europe was a growing, newly intense interest in the natural world. Artists observed birds, plants, and animals closely and depicted their appearance with breathtaking accuracy. They applied the same scrutiny to people and objects, modeling forms with light and shadow to give them

MAP 19-1 FIFTEENTH-CENTURY NORTHERN EUROPE

The dukes of Burgundy—whose territory included much of present-day Belgium and Luxembourg, the Netherlands, and eastern France—became the cultural and political leaders of western Europe. Their major cities of Bruges (Belgium) and Dijon (France) were centers of art and industry as well as politics.

the semblance of three-dimensionality. These carefully described subjects were situated in spatial settings, applying an intuitive perspective system by diminishing their scale as they receded into the distance. In the portrayal of landscapes—which became a northern specialty—artists used atmospheric perspective in which distant elements appear increasingly indistinct and less colorful as they approach the background. The sky, for instance, becomes paler near the horizon, and the distant landscape turns bluish-gray.

One aspect of the desire for accurate visual depictions of the natural world was a new interest in individual personalities. Fifteenth-century portraits have an astonishingly lifelike quality, combining careful—sometimes seemingly unflattering—surface description with an uncanny sense of vitality. Indeed, the individual becomes important in every sphere. More names of artists survive from the fifteenth century, for example, than in the entire span from the beginning of the Common Era to the year 1400, and some artists begin regularly to sign their work.

The new power of cities in Flanders and the greater Netherlands (present-day Belgium, Luxembourg, and the Netherlands) (**MAP 19-1**) provided a critical tension and balance with the traditional powers of royalty and the Church. Increasingly, the urban lay public sought to express personal and civic pride by sponsoring secular architecture, monuments, or paintings directed toward the community. The commonsense values of merchants formed a solid underpinning for the Northern Renaissance, but their influence remained intertwined with the continuing power of the Church and the royal and noble courts. Giovanni Arnolfini's success at commerce and negotiation provided the funding for his extraordinary double portrait (SEE FIG. 19-1), but he was able to secure the services of Jan van Eyck only with the cooperation of the duke of Burgundy.

Art for the French Ducal Courts

What characterizes the works of art in diverse media created for the ducal courts of Burgundy and France during the fifteenth century?

The dukes of Burgundy (controlling present-day east-central France, Belgium, Luxembourg, and the Netherlands) were the most powerful rulers in northern Europe for most of the fifteenth century. Their domain encompassed not only Burgundy itself but also the Flemish and Netherlandish centers of finance and trade, including the thriving cities of Ghent, Bruges, Tournai, and Brussels. The major seaport, Bruges, was the commercial center of northern Europe, rivaling the Italian city-states of Florence, Milan,

and Venice as an economic hub. In the late fourteenth century, Burgundian duke Philip the Bold (ruled 1363–1404) had acquired territory in the Netherlands—including the politically desirable region of Flanders—by marrying the daughter of the Flemish count. But although he and the dukes Jean of Berry and Louis of Anjou were brothers of King Charles V of France, their interests rarely coincided. Even the threat of a common enemy, England, during the Hundred Years' War was not a strong unifying factor, since Burgundy and England were often allied because of common financial interests in Flanders.

While the French king held court in Paris, the dukes held even more splendid courts in their own cities. The dukes of Burgundy and Berry (central France), not the king in Paris, were the real arbiters of taste. Especially influential was Jean, duke of Berry, who commissioned many works from Flemish and Netherlandish painters in the fashionable International Gothic style.

This new, composite style emerged in the late fourteenth century from the multicultural papal court in Avignon in southern France, where artists from Italy, France, and Flanders worked side by side. The International Gothic style became the prevailing manner of late fourteenth-century Europe. It is characterized by slender, gracefully posed figures whose delicate features are framed by masses of curling hair and extraordinarily complex headdresses. Noble men and women wear rich brocaded and embroidered fabrics and elaborate jewelry. Landscape and architectural settings are miniaturized; however, details of nature—leaves, flowers, insects, birds—are rendered in breathtaking detail. Spatial recession is represented by rising tiled floors in rooms that are like stage sets; fanciful mountains and meadows with high horizon lines; progressive diminution in the size of receding objects; and atmospheric perspective. Artists and patrons preferred light, bright colors and a liberal use of gold in manuscript and panel paintings, tapestries, and polychromed sculpture. International Gothic was so appealing that it endured well into the fifteenth century.

Painting and Sculpture for the Chartreuse de Champmol

One of Philip the Bold's most lavish projects was the Carthusian monastery, or *chartreuse* ("charterhouse"), at Champmol, outside Dijon, his Burgundian capital city. Land was acquired in 1377 and 1383, and construction began in 1385. The monastic church was intended to house the family's tombs, and the monks were expected to pray continuously for the souls of Philip and his family. Carthusian monasteries were particularly expensive to maintain because Carthusian monks did not provide for themselves by farming or other physical work, but instead were dedicated exclusively to prayer and solitary meditation.

MELCHIOR BROEDERLAM The duke ordered a magnificent carved and painted altarpiece (see "Altars and Altarpieces" opposite) for the Chartreuse de Champmol. The interior of the altarpiece, carved and gilded by Jacques de Baerze, depicts scenes of the Crucifixion flanked by the Adoration of the Magi and the Entombment. The exteriors of the protective shutters of this triptych were covered not by carvings but by two paintings by Melchior Broederlam (active 1381–1410) showing scenes from the life of the Virgin and the infancy of Christ (**FIG. 19–2**). Broederlam situates his closely observed, International-Style figures within fanciful, miniature architectural and landscape settings. His lavish use of brilliantly seductive colors demonstrates one of the features that made International Gothic so popular.

The archangel Gabriel greets Mary while she is at prayer. She sits in a Gothic room with a back door leading into the dark interior of a Romanesque rotunda that symbolizes the Temple of Jerusalem as a repository of the Old Law. According to legend, Mary was an attendant in the temple prior to her marriage to Joseph. The tiny enclosed garden and conspicuous pot of lilies are symbols of Mary's virginity. In International Gothic fashion, both the interior and exterior of the building are shown, and the floors are tilted up at the back to give clear views of the action. Next, in the Visitation, just outside the temple walls, the now-pregnant Mary greets her older cousin Elizabeth, who will soon give birth to John the Baptist.

On the right shutter is the Presentation in the Temple. Mary and Joseph have brought the newborn Jesus to the temple for his redemption as a first-born son and for Mary's purification, where Simeon takes the baby in his arms to bless him (Luke 2:25–32). At the far right, the Holy Family flees to Egypt to escape King Herod's order that all Jewish male infants be killed. The family travels along treacherous terrain similar to that in the Visitation scene, where a path leads viewers' eyes into the distance along a rising ground plane. Broederlam has created a sense of light and air around solid figures. Details drawn from the real world are scattered throughout the pictures—a hawk flies through the golden sky, the presented baby looks anxiously back at his mother, and Joseph drinks from a flask and carries the family belongings in a satchel over his shoulder on the journey to Egypt. The statue of a pagan god, visible at the upper right, breaks and tumbles from its pedestal as the Christ Child approaches. A new era dawns and a new religion replaces the old, among both Jews and gentiles.

19–2 Melchior Broederlam **ANNUNCIATION, VISITATION, PRESENTATION IN THE TEMPLE, AND FLIGHT INTO EGYPT**
Exterior of the wings of the altarpiece of the Chartreuse de Champmol. 1393–1399. Oil on wood panel, 5′5¾″ × 4′1¼″ (1.67 × 1.25 m). Musée des Beaux-Arts, Dijon.

Art and its Contexts

ALTARS AND ALTARPIECES

The altar in a Christian church symbolizes both the table of Jesus's Last Supper and the tombs of Christ and the saints. As a table, the altar is the site where priests celebrate Mass. And as a tomb, before the Reformation it traditionally contained a relic—placed in a reliquary on the altar, beneath the floor on which the altar rests, or even enclosed within the altar itself.

Altarpieces are painted or carved constructions placed at the back of or behind the altar so that altar and altarpiece appear visually to be joined. By the fifteenth century, important altarpieces had evolved into large and elaborate architectural structures filled with images and protected by movable wings that function like shutters. An altarpiece can sit on a base, called a predella. A winged altarpiece can be a **diptych**, in which two panels are hinged together; a **triptych**, in which two wings fold over a center section, forming a diptych when closed; or a **polyptych**, consisting of more than three panels.

altar and polyptych altarpiece

diptych **triptych**

Credit: Kathy Mrozek

CLAUS SLUTER Flemish sculptor Jean de Marville (active 1366–1389) initially directed the decoration of the Chartreuse, and when he died in 1389, he was succeeded by his talented assistant Claus Sluter (c. 1360–1406), from Haarlem, in Holland. Sluter's distinctive work survives in a monumental **WELL OF MOSES** carved for the main cloister (**FIG. 19-3**), begun in 1395 and left unfinished at Sluter's death.

The design of this work was complex. A pier rose from the water to support a large free-standing figure of Christ on the cross, mourned by the Virgin Mary, Mary Magdalen, and John the Evangelist. Forming a pedestal for this Crucifixion group at the viewer's eye level are life-size stone figures from the Hebrew Bible who Christians believe foretold the coming of

19-3 Claus Sluter **WELL OF MOSES, DETAIL OF MOSES AND DAVID**

The Chartreuse de Champmol, Dijon, France. 1395–1406. Limestone with traces of paint, height of figures about 5′8″ (1.69 m).

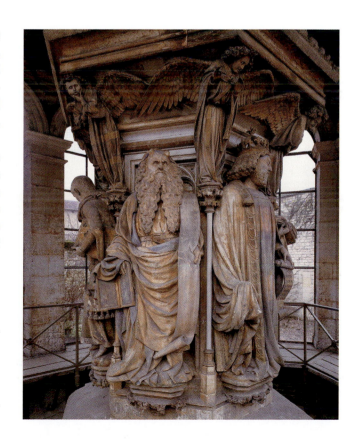

The sculpture's original details included metal used for buckles and even eyeglasses. It was also painted: Moses wore a gold mantle with a blue lining over a red tunic; David's gold mantle had a painted lining of ermine, and his blue tunic was covered with gold stars and wide bands of ornament.

Credit: © Paul M.R. Maeyaert

Christ: Moses, David, and the prophets Jeremiah, Zachariah, Daniel, and Isaiah. This concept may have been inspired by contemporary mystery plays, in which prophets foretell and explain events of Christ's Passion. Sluter's patriarchs and prophets are distinct individuals, physically and psychologically. Moses's eyes blaze out from a memorable face entirely covered with a fine web of wrinkles. Even his horns are wrinkled. (These horns are traditional attributes based on a mistranslation of Exodus 34:29–35 in the Latin Vulgate Bible, where the rays of light radiating from Moses's face become horns.) A mane of curling hair and beard cascades over his heavy shoulders and chest, and an enormous cloak envelops his body. Beside him stands David in the voluminous robes of a medieval king, the personification of nobility.

Sluter looked at the human figure in a new way—as a weighty mass defined by voluminous drapery that lies in deep folds, falls in horizontal arcs and cascading lines, and both conceals and reveals the body, creating strong highlights and shadows. With the vigorous, imposing, and highly individualized figures of the *Well of Moses*, Sluter abandoned the idealized faces, elongated figures, and vertical drapery of International Gothic. He retained, however, the detailed naturalism and rich colors (almost lost, but revealed in recent cleaning) and surfaces still preferred by his patrons.

Manuscript Illumination

Besides religious texts, wealthy patrons treasured richly illuminated secular writings such as herbals (encyclopedias of plants), health manuals, and works of history and literature. A typical manuscript page (**FIG. 19-4**) might have leafy tendrils framing the text, decorated opening initials, and perhaps a small inset picture. Only the most lavish books would have full-page miniature paintings set off with frames. The pictures in these books are conceived as windows looking into rooms or out onto landscapes with distant horizons.

THE LIMBOURG BROTHERS Among the finest Netherlandish painters at the beginning of the century were three brothers—Paul, Herman, and Jean Limbourg—their "last" name referring to their home region. At this time people generally did not have family names in the modern sense, but were known instead by their first names, often followed by a reference to their place of origin, parentage, or occupation.

About 1404, the Limbourg brothers entered the service of avid book-lover Duke Jean of Berry (1340–1416), for whom they produced their most impressive surviving work, the so-called **TRÈS RICHES HEURES** ("Very Sumptuous Book of Hours"), between 1411 and 1416. A Book of Hours, in addition to containing prayers and readings used in daily devotion, also included a calendar of holy days. The Limbourgs created full-page illustrations for the calendar in the *Très Riches Heures*. For each month, subjects including both peasant labors and aristocratic pleasures appeared in a framed lower field, while elaborate calendar devices, with the chariot of the sun and the zodiac symbols, filled a

19-4 PAGE WITH A MINIATURE PAINTING OF THAMYRIS

From Giovanni Boccaccio's *De Claris Mulieribus* (*Concerning Famous Women*). 1402. Ink and tempera on vellum, 14 × 9½" (35.5 × 24 cm). Bibliothèque Nationale, Paris.

This page from a French edition of a work by the Italian author Boccaccio entitled *Concerning Famous Women* includes a picture of Thamyris, an artist of antiquity, at work in her studio. She appears in fifteenth-century dress, painting an image of the Virgin and Child. At the right, an assistant grinds and mixes her colors. In the foreground, her brushes and paints are laid out neatly and conveniently on a table.

Credit: Bibliothèque nationale de France

semicircular area on the upper part of the page. Like most European artists of the time, the Limbourgs showed the working class in a light acceptable to aristocrats—that is, either happily working for the nobles' benefit or displaying an uncouth lifestyle for aristocratic amusement. At times, however, the peasants seem to be enjoying the pleasures of their leisure moments.

In the February page (**FIG. 19–5**), farm folks relax before a fire. Although many country people at this time lived in hovels, this farm looks comfortable and well maintained, with timber-framed buildings, a row of beehives, a sheepfold, and tidy woven-wattle fences. In the distance are a village and church. Within this scene, although all are much lower in social standing than the duke, there is still a hierarchy of class. Largest in scale and most elegantly dressed is the woman closest to us, perhaps the owner of the farm, who carefully lifts her overgarment with both hands as she warms herself. She shares her fire with a couple, smaller because they are farther away, who wear more modest clothing and are considerably less well behaved, especially the man, who exposes himself as he lifts his clothing to take advantage of the fire's warmth.

One of the most remarkable aspects of this painting is the way it conveys the feeling of cold winter weather: the heavy sky and bare trees, the soft snow and huddled sheep, the steamy breath of the worker blowing on his hands, and the comforting smoke curling from the farmhouse chimney. The artists employ several International Gothic conventions: the high placement of the **horizon line**, the small size of trees and buildings in relation to people, and the cutaway view of the house showing both interior and exterior. The muted palette is sparked with touches of yellowish-orange, blue, and bright red, including the man's turban at the lower left. Scale relationships seem consistent with our experience in the natural world since as the landscape recedes, the size of figures and buildings diminishes progressively from foreground to background.

In contrast, the illustration for the other winter month—January—depicts an aristocratic household (**FIG. 19–6**). The duke of Berry himself sits behind a table laden with food and expensive tableware, presiding over his New Year's feast and surrounded by servants and allies. His chamberlain invites smartly dressed courtiers to greet the duke (the words written overhead say "approach"),

19–5 Paul, Herman, and Jean Limbourg **FEBRUARY: LIFE IN THE COUNTRY, TRÈS RICHES HEURES**
1411–1416. Colors and ink on parchment, 11⅜ × 8¼" (29 × 21 cm). Musée Condé, Chantilly, France.
Credit: Photo © RMN-Grand Palais (domaine de Chantilly)/René-Gabriel Ojéda

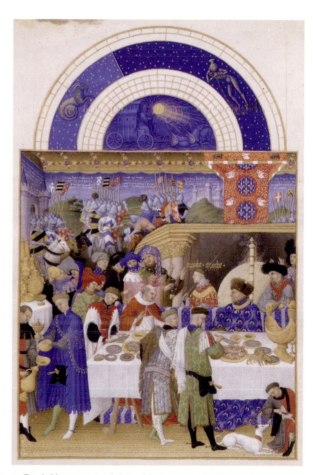

19–6 Paul, Herman, and Jean Limbourg **JANUARY: THE DUKE OF BERRY AT TABLE, TRÈS RICHES HEURES**
1411–1416. Colors and ink on parchment, 11⅜ × 8¼" (29 × 21 cm). Musée Condé, Chantilly, France.
Credit: Photo © RMN-Grand Palais (domaine de Chantilly)/René-Gabriel Ojéda

who is singled out visually by the red cloth of honor with his heraldic arms—swans and the lilies of France—hanging over him and by a large fire screen that circles his head like a secular halo. Tapestries with battle scenes cover the walls. Such luxury objects attest to the wealth of this great patron of the arts, a striking contrast to the farm life depicted in February, encountered when turning to the next page of the book.

THE MARY OF BURGUNDY PAINTER One of the finest painters of Books of Hours later in the century was an artist known as the Mary of Burgundy Painter—so called because he painted a Book of Hours for Mary of Burgundy (1457–1482), the only child of Charles the Bold. Within a full-page miniature in a book only 7½ by 5¼ inches, earthly reality and a religious vision have been rendered equally tangible (**FIG. 19–7**). The painter conjures up a complex pictorial space. We look not only through the "window" of the illustration's frame, but also through an actual window in the wall of the room depicted in the foreground of the painting. The artist shows considerable virtuosity in representing these worlds. Spatial recession leads the

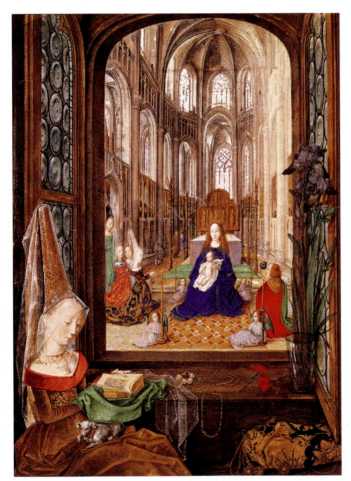

19–7 Mary of Burgundy Painter **MARY AT HER DEVOTIONS, HOURS OF MARY OF BURGUNDY**
Before 1482. Colors and ink on parchment, size of image 7½ × 5¼" (19.1 × 13.3 cm). Österreichische Nationalbibliothek, Vienna.

Credit: © 2016. DeAgostini Picture Libary/Scala, Florence

viewer into the far reaches of the church interior, past the Virgin and the gilded altarpiece in the sanctuary to two people conversing in the far distance. The filmy veil covering Mary of Burgundy's steeple headdress is exquisitely described, as is the transparency of the glass vase, and the distinctive bull's-eye glass (circular panes whose center "lump" was formed by the glassblower's pontil) filling the foreshortened, open window.

Mary of Burgundy appears twice. She is seated in the foreground by a window reading from, or contemplating a picture within, her Book of Hours, held carefully and protected by a lush green cloth, perhaps from the small dog cuddled into her lap. She appears again in the background, within the representation of the personal vision inspired by her private meditations. A glorious Gothic church may form the setting for her vision, but it does not result from attendance at Mass or the direction of a priest. She experiences it in private, a reward for her personal faith. Christians were encouraged in this period to imagine themselves participating in biblical stories and sacred events so they could personally feel the experiences of the protagonists. Secluded in her private space and surrounded by devotional aids on the window ledge—book, rosary, and symbolic flowers (carnations symbolized the nails of the Crucifixion, the irises Mary's sorrow)—it seems that Mary of Burgundy is doing just that. In her vision, she kneels with attendants and angels in front of a gracefully human Virgin and Child.

Textiles

In the fifteenth and sixteenth centuries, the best European tapestries came from Flanders. Major weaving centers at Brussels, Tournai, and Arras produced intricately woven wall hangings for royal and aristocratic patrons across Europe, important church officials including the pope, and even town councils. Among the most common subjects were foliage and flower patterns, scenes from the lives of the saints, and themes from Classical mythology and history, such as the Battle of Troy seen hanging on the walls of Duke Jean of Berry's reception room (SEE FIG. 19–6). Tapestries provided both insulation and decoration for the stone walls of castle halls, churches, and municipal buildings, and because they were much more expensive than wall or panel paintings, they also showed off the owners' wealth. They were also portable, a valuable quality as courts moved from residence to residence.

The price of a tapestry depended on the artists involved, the work required, and the materials used. Rarely was a fine, commissioned series woven only with wool; instead, tapestry producers enhanced the weaving with silk, and with silver and gold threads that must have glittered on the walls, especially at night, illuminated by flickering lamps or candles. Because silver and

gold threads were made of silk wrapped with real silver and gold, people later burned many tapestries to retrieve the precious materials. As a result, few royal tapestries in France survived the French Revolution. If a greater percentage had survived, these luxurious and monumental textile wall paintings would surely figure more prominently in the history of art.

THE UNICORN TAPESTRY Tapestries were often produced in series. One of the best known is the 1495–1505 "Hunt of the Unicorn" series. Four of the seven surviving hangings present scenes of people and animals set against a dense field of trees and flowers, with a distant view of a castle, as in the **UNICORN IS FOUND AT THE FOUNTAIN** (**FIG. 19–8**). The unusually fine condition of the tapestry allows us to appreciate its rich colors, the subtlety in

modeling the faces, the tonal variations in the animals' fur, and even the depiction of reflections in the water. The technical skill of its weavers is astonishing.

In tapestry, designs are woven directly into the fabric. The Unicorn tapestries seem to have been woven on huge, horizontal looms, where weavers interwove fine weft yarn of wool and silk—dyed a multitude of colors from the creative combination of three vegetal dyes—onto the parallel strands of the coarser wool warp. Weavers worked from behind what would be the front surface of the finished tapestry, following the design on a full-scale cartoon laid on the floor under the loom. They could only see the actual effect of their work by checking the front with mirrors. Making a tapestry panel this large was a collaborative effort that required the organizational skills of a talented production manager and five or six weavers working side

19–8 UNICORN IS FOUND AT THE FOUNTAIN
From the "Hunt of the Unicorn" tapestry series. c. 1495–1505. Wool, silk, and silver- and gilt-wrapped thread (13–21 warp threads per inch), 12′1″ × 12′5″ (3.68 × 3.78 m). Metropolitan Museum of Art, New York. Gift of John D. Rockefeller Jr., The Cloisters Collection, 1937 (37.80.2).

19–9 COPE OF THE ORDER OF THE GOLDEN FLEECE
Flemish. Mid 15th century. Cloth with gold and colored silk embroidery, 5'4⁹⁄₁₆" × 10'9⁵⁄₁₆" (1.64 × 3.3 m). Imperial Treasury, Vienna.

Credit: © KHM-Museumsverband

by side on a single loom. What is so extraordinary about their work is the skillful way they created curving lines— since the tapestry process is based on a rectilinear network of threads, curves have to be simulated—and the lighting effects of shading and reflections, which require using yarn in the same hue with a multitude of values.

The subject of this series is the unicorn, a mythical, horselike animal with a single long, twisted horn and supernatural speed; it could only be captured by a virgin, to whom it came willingly. Thus, the unicorn became both a symbol of the Incarnation (Christ is the unicorn captured by the Virgin Mary) and also a metaphor for romantic love (SEE FIG. 18–21). The capture and killing of the unicorn was also equated with Christ's death on the cross to save humanity.

The natural world represented so splendidly in this tapestry also has potential symbolic meaning. For instance, lions represented faith, courage, mercy, and even—because they were thought to breathe life into their cubs—the Resurrection of Christ. The stag is another Resurrection symbol (it sheds and grows its antlers) and a protector against poisonous serpents and evil in general. Even today we see rabbits as symbols of fertility, and dogs of fidelity. Many of the easily identifiable flowers and trees also carry both religious and secular meanings. There is a strong theme of marriage: the strawberry is a common symbol of sexual love; the pansy means remembrance; and the periwinkle, a cure for spiteful feelings and jealousy. The trees include oak for fidelity, beech for nobility, holly for protection against evil, hawthorn for the power of love, and pomegranate and orange for fertility.

COPE OF THE ORDER OF THE GOLDEN FLEECE Surviving vestments of the Order of the Golden Fleece are remarkable examples of Flemish textiles. The Order of the Golden Fleece was an honorary fraternity founded by Duke Philip the Good of Burgundy in 1430 with 23 knights chosen for their moral character and bravery. Religious services were an integral part of the order's meetings, and opulent liturgical and clerical objects were created for the purpose.

The surface of the sumptuous cope (cloak) in **FIGURE 19–9** is divided into compartments filled with the standing figures of saints. At the top of the neck edge, as if presiding over the company, is an enthroned figure of Christ, flanked along the front edge by scholar-saints in their studies. The embroiderers worked with great precision to match the illusionistic effects of contemporary Flemish painting; gold threads are sewn to the surface using unevenly spaced colored silk threads, creating images and an iridescent effect.

Painting in Flanders

What innovative features characterize the Northern Renaissance oil painting tradition established by the Master of Flémalle, Jan van Eyck, Rogier van der Weyden, and their followers?

A strong economy based on the textile industry and international trade provided stability and money for a rapid Flemish flowering in the arts. Civic groups, town councils, and wealthy merchants were important patrons in the Netherlands, where cities were self-governing and largely independent of landed nobility. Guilds oversaw nearly every aspect

of their members' lives, and high-ranking guild members served on town councils and helped run city governments. Even experienced artists who moved from one city to another usually had to work as assistants in a local workshop until they met the requirements for guild membership.

Throughout most of the fifteenth century, Flemish art and artists were greatly admired across Europe. Artists from abroad studied Flemish works, and their influence spread even to Italy. Only at the end of the fifteenth century did the broad preference for Netherlandish painting give way to a taste for the new styles of art and architecture developing in Italy.

Flemish panel painters preferred using an oil medium rather than the tempera paint that was standard in the works of Italian artists. Since it was slow to dry, **oil paint** provided flexibility, and it had a luminous quality. Like manuscript illuminations, Flemish panel paintings provided a window onto a scene rendered with keen attention to describing individual features—people, objects, or aspects of the natural world—with consummate skill.

The Master of Flémalle

Some of the earliest and most outstanding artists using the new Flemish style were painters in the workshop of an artist known as the Master of Flémalle, identified by some art historians as Robert Campin (active 1406–1444). From about 1425 to 1430, these artists painted the triptych now called the **MÉRODE ALTARPIECE**, after its later owners (**FIG. 19-10**). Its relatively small size—slightly over 2 feet tall and about 4 feet wide with the wings open—suggests that it was probably made for a small private chapel.

The Annunciation of the central panel is set in a Flemish home and incorporates common household objects, many invested with symbolic religious meaning. The lilies in the **majolica** (glazed earthenware) pitcher on the table, for example, often appear in Annunciations to symbolize Mary's virginity. The hanging water pot in the background niche refers to Mary's purity and her role as the vessel for the Incarnation of God (God assuming human form). What seems at first to be a towel hung over the prominent, hinged rack next to the niche may be a tallis (Jewish prayer shawl). Some art historians have referred to these as "hidden" or "disguised" symbols because they are treated as a normal part of the setting, but their routine religious meanings would have been obvious to the intended audience.

Some have interpreted the narrative in the central panel as the moment immediately following Mary's acceptance of her destiny. A rush of wind riffles the pages of the book and snuffs the candle (the flame, symbolic of God's divinity, extinguished at the moment he takes human form) as a tiny figure of Christ carrying a cross descends on a ray of light. Having accepted the miracle of the Incarnation, Mary reads her Bible while sitting humbly on the footrest of the long bench. Her position becomes a symbol of her submission to God's will. Other art historians have proposed that the scene represents the moment just prior to the Annunciation. In this view, Mary is not yet aware of Gabriel's presence, and the rushing wind is the result of the angel's rapid entry into the room, where he appears before her, half kneeling and raising his hand in salutation.

In the left wing of the triptych, the donors—presumably a married couple—kneel in an enclosed garden, another symbol of Mary's virginity, before the open door of

Technique
OIL PAINTING

Whereas Italian artists favored tempera, using it almost exclusively for panel painting until the end of the fifteenth century, Flemish artists preferred oil paints, in which powdered pigments are suspended in linseed—and occasionally walnut—oil. They exploited the potential of this medium during the fifteenth century with a virtuosity that has never been surpassed.

Tempera has to be applied in a very precise manner because it dries almost as quickly as it is applied. Shading is restricted to careful, overlapping strokes in graded tones ranging from white and gray to dark brown and black. Because tempera is opaque—light striking its surface does not penetrate to lower layers of color and reflect back—the resulting surface is **matte**, or dull, taking on a sheen only if burnished or overlaid with varnish.

On the other hand, oil paint is a viscous medium which takes hours or even days to dry, and while it is still wet changes can be made easily. Once applied, the paint has time to smooth out as it dries, erasing traces of individual brushstrokes on the surface of the finished panel. Perhaps even more importantly, oil paint is translucent when applied in very thin layers, called glazes. Light striking a surface built up of glazes penetrates to the lower layers and is reflected back, creating the appearance of an interior glow. These luminous effects enabled artists to capture jewel-like colors and the varying effects of light on changing textures, enhancing the illusion that viewers are looking at real objects rather than their painted imitation.

So brilliant was Jan van Eyck's use of oil paint that he was credited by Giorgio Vasari with inventing the medium. Actually, it had been in use since at least the twelfth century, when it was described in Theophilus Presbyter's *De Diversis Artibus* (see "Stained-Glass Windows" in Chapter 17 on page 512).

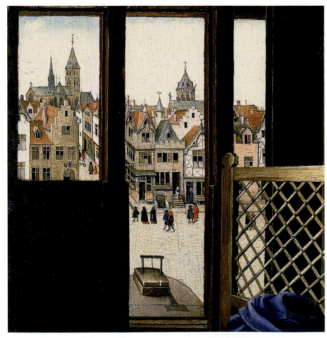

19–11 Workshop of the Master of Flémalle **A FLEMISH CITY**
Detail of the right wing of the Mérode Altarpiece (FIG. 19–10).

the house where the Annunciation is taking place, imply-
ing that the scene is a vision engendered by their faith-
ful meditations, comparable to the vision in the Hours of
Mary of Burgundy (SEE FIG. 19-7). Such presentations, very
popular with Flemish patrons, allowed those who com-
missioned a religious work to appear in the same space
and time, and often on the same scale, as religious figures.
The donors' eyes, which seem unfocused, are directed not
outward but inward, intent on the spiritual exercise of
imagining their own presence within this sacred narrative.

On the right wing, Joseph is working in his carpen-
try workshop. A prosperous Flemish city is exquisitely
detailed in the view through the shop window, with peo-
ple going about their daily business (**FIG. 19-11**). Even here
there is religious symbolism. On the windowsill of Joseph's
shop and on the workbench beside him are mousetraps,
which fifteenth-century viewers would understand as ref-
erences to Christ as the bait in a trap set by God to catch
Satan. Joseph is drilling holes in a small board used as a
drainboard for making wine, calling to mind the Eucharist
and Christ's Passion.

The complex and consistent treatment of light in the
altarpiece represents a major preoccupation of Flemish

19–10 Workshop of the Master of Flémalle **MÉRODE ALTARPIECE (OPEN), (TRIPTYCH OF THE ANNUNCIATION)**

c. 1425–1430s. Oil on wood panel, center 25¼ × 24⅞" (64.1 × 63.2 cm); each wing approx. 25⅜ × 10¾" (64.5 × 27.6 cm). Metropolitan Museum of Art, New York. The Cloisters Collection, 1956 (56.70).

In the late nineteenth century, this triptych was associated with a group of stylistically related works and assigned to an artist called the Master of Flémalle, who was subsequently identified by some art historians as a documented artist named Robert Campin. Recently, however, experts have questioned this association and proposed that the triptych we now see was the work of several artists working within the workshop that created the stylistic cluster. Current opinion holds that the *Annunciation* was initially created as an independent panel, and shortly afterward expanded into a triptych with the addition of the side panels under the patronage of the donor in the foreground at left. Finally, sometime later in the 1430s, the figure of his wife was added behind him, presumably on the occasion of his marriage.

painters. The strongest light comes from an unseen source at upper left in front of the **picture plane** (the picture's front surface), as if sunlight were entering through the open front of the room. More light comes from the rear windows, and painted, linear rays come from the round window at left, a symbolic vehicle for Jesus's descent. Jesus seems to slide down the rays of light linking God with Mary, carrying the cross of human salvation over his shoulder. The light falling on the Virgin's lap emphasizes this connection, and the transmission of the symbolic light through a transparent panel of glass (which remains intact) recalls the virginal nature of Jesus's conception.

Jan van Eyck

In 1425, Jan van Eyck (active 1420s–1441) became court painter to Duke Philip the Good of Burgundy (ruled 1419–1467), who was the uncle of the king of France and one of the most sophisticated men in Europe. Philip made Jan one of his confidential employees and even sent him on a diplomatic mission to Portugal, charged with painting a portrait of a prospective bride for the duke. Philip alluded to Jan's remarkable technical skills in a letter of 1434–1435, saying that he could find no other painter equal to his taste and abilities in art and science. So brilliant was Jan's use of oil glazes that he was mistakenly credited with the invention of oil painting (see "Oil Painting" on page 585).

Jan's 1433 portrait of a **MAN IN A RED TURBAN** (**FIG. 19–12**) projects a particularly strong sense of personality, and the signed and dated frame also bears Jan's personal

motto—"As I can, [but not as I would]"—in Greek letters at the top. Since these letters also form an anagram of his own name, most scholars see this painting as a self-portrait in which physical appearance seems recorded in a magnifying mirror. We see the stubble of a day's growth of beard on his chin and cheeks, and every carefully described wrinkle around the artist's eyes, reddened from the strain of his work and reflecting light that seems to emanate from our own space. That same light source gives the inscriptions the **trompe l'oeil** ("trick of the eye") sense of having been

19–12 Jan van Eyck **MAN IN A RED TURBAN**

1433. Oil on wood panel, 13⅛ × 10¼" (33.3 × 25.8 cm). National Gallery, London.

engraved into the frame, heightening the illusionistic wizardry of Jan's painting.

THE GHENT ALTARPIECE In Jan van Eyck's lifetime, one of his most famous works was a huge polyptych with a very complicated and learned theological program that he painted (perhaps in collaboration with his brother Hubert) for a chapel in what is now the Cathedral of St. Bavo in Ghent; the piece is now known as the **GHENT ALTARPIECE** (**FIG. 19–13**). Jan's artistic wizardry is magnificently demonstrated in the three-dimensional mass of the figures, the volume and remarkable surface realism of the draperies, and the scrupulous attention to luminous details of textures as variable as jewels and human flesh. He has carefully controlled the lighting within this multi-panel ensemble to make it appear that the objects represented are illuminated by sunlight coming through the window of the chapel where it was meant to be installed. Jan's painting is firmly grounded in the terrestrial world, even when he is rendering a visionary subject.

An inscription on the frame of the Ghent Altarpiece seems to identify both Jan and Hubert van Eyck as its artists: "The painter Hubert van Eyck, greater than whom no one was found, began [this work]; and Jan, his brother, second in art, having carried through the task at the expense of Jodocus Vyd, invites you by this verse, on the sixth of May [1432], to look at what has been done."

Many art historians believe Hubert began this altarpiece, and after Hubert's death in 1426 Jan completed it, when free of ducal responsibilities in 1430–1432. Others believe the entire painting was produced by Jan and his workshop, Hubert perhaps being responsible for the frame. At least the commission and situation are clear. Jodocus Vijd, who appears with his wife Isabella Borluut on the outside of the polyptych's two shutters (**FIG. 19–14**), commanded the work. One of a wealthy family of financiers, Jodocus was a city official in Ghent comparable to mayor in 1433–1434; the altarpiece was part of a renovation he funded for the family chapel at the parish church of St. John (now the Cathedral of St. Bavo). He also endowed

19–13 Jan and Hubert (?) van Eyck **GHENT ALTARPIECE (OPEN), ADORATION OF THE MYSTIC LAMB**
Completed 1432. Oil on panel, 11'5¾" × 15'1½" (3.5 × 4.6 m). Cathedral of St. Bavo, Ghent.

daily Masses in the chapel for the salvation of himself, his wife, and their ancestors.

When the altarpiece was closed (SEE FIG. 19–14), the exterior of the shutters displayed the striking likenesses of the donor couple kneeling to face painted statues of John the Baptist (patron of Ghent) and John the Evangelist (patron of this church) that recall those on Sluter's *Well of Moses* (SEE FIG. 19–3). Above this row is an expansive rendering of the Annunciation—whose somber color scheme coordinates with the *grisaille* statues below—situated in an upstairs room that looks out over a panoramic cityscape. As in Simone Martini's *Annunciation* altarpiece (SEE FIG. 18–13), the words that issue from Gabriel's mouth ("Hail, full of grace, the Lord is with thee") appear on the painting's surface, and here there is Mary's response as well ("Behold the handmaid of the Lord"), only it is painted upside down since it is directed to God, who hovers above her head as the dove of the Holy Spirit. Prophets and sibyls perch in the irregular compartments at the top, unfurling scrolls recording their predictions of Christ's coming.

When the shutters were opened (SEE FIG. 19–13) on Sundays and feast days, the mood changed. The effect is no longer muted, but rich in both color and implied sound. Dominating the altarpiece by size, central location, and brilliant color is the enthroned, red-robed figure of God, wearing the triple papal crown, with an earthly crown at his feet, and flanked by the Virgin Mary and John the Baptist holding open books. To either side are first angel musicians and then Adam and Eve, represented as lifelike nudes. Adam seems to have been painted from a model, from whom Jan reproduced even the "farmer's tan" of his hands and face. Eve displays clear features of the female anatomy; the pigmented line running downward from her navel appears frequently during pregnancy. Each of the three themes of the upper register—God with Mary and John, musical angels, and Adam and Eve—is set in a distinct space: the holy trio in a golden shrine, angels against a blue sky, Adam and Eve in shallow stone niches.

The five lower panels present a unified field. A vast landscape with meadows, woods, and distant cities is set against a continuous horizon. A diverse array of saints—apostles, martyrs, confessors, virgins, hermits, pilgrims, warriors, judges—assembles to adore the Lamb of God as described in the book of Revelation. The Lamb stands on an altar, blood flowing into a chalice, ultimately leading to the fountain of life.

The Ghent Altarpiece became a famous work of art almost as soon as it was completed. To celebrate Duke Philip the Good's visit to the city in 1458, citizens of Ghent welcomed him with *tableaux vivants* (living pictures) of its scenes. German artist Albrecht Dürer traveled to Ghent to see the altarpiece in 1521. During the French occupation of Flanders in 1794 it was transferred to Paris (returned in 1815), and during World War II it was confiscated by the Nazis. It is now displayed within a secure glass case in the baptismal chapel of the church for which it was made.

THE ARNOLFINI DOUBLE PORTRAIT The Ghent altarpiece may have been Jan's most famous painting during his lifetime, but his best-known painting today is the distinctive double portrait of Giovanni Arnolfini and his wife encountered earlier (SEE FIG. 19–1). Early interpreters saw this fascinating work as depicting a wedding or betrothal. Above the mirror on the back wall, the artist inscribed the words *Johannes de eyck fuit hic 1434* ("Jan van Eyck was here 1434"). More normal as a signature would have been, "Jan van Eyck made this," so the words "was here" might suggest that Jan served as a witness to a matrimonial episode portrayed in the painting. Jan is not the only witness recorded in the painting. The convex mirror between the figures reflects not only the back of the couple but a front view of two visitors standing in the doorway, entering the room. Perhaps one of them is the artist himself.

19–14 Jan and Hubert (?) van Eyck **GHENT ALTARPIECE (CLOSED), ANNUNCIATION WITH DONORS**
Completed 1432. Oil on panel, height 11'5" (3.48 m). Cathedral of St. Bavo, Ghent.

Credit: © akg-images/Erich Lessing

New research has complicated the developing interpretation of this painting by revealing that the Giovanni Arnolfini traditionally identified as the man in this painting married his wife Giovanna Cenami only in 1447, long after the date on the wall and Jan van Eyck's own death. One scholar has proposed that the picture is actually a prospective portrait of Giovanni and Giovanna's marriage in the future, painted in 1434 to secure the early transfer of the dowry from her father to her future husband. Others have more recently suggested that the man portrayed here is a different Giovanni Arnolfini, accompanied either by his first wife, Costanza Trenta, who died the year before this picture was painted—which would make the painting a memorial portrait—or by a hypothetical second wife whose name is unknown. The true meaning of this masterpiece may remain a mystery, but it is doubtful that scholars will stop trying to solve it.

Rogier van der Weyden

Little as we know about Jan van Eyck, we know even less about the life of Rogier van der Weyden (c. 1400–1464). Not a single existing work of art bears his name. He may have studied under the Master of Flémalle, but the relationship is not completely clear. Rogier established himself in 1432 as an independent master in Tournai; at the peak of his career he maintained a large workshop in Brussels, where he was the official city painter, attracting apprentices and shop assistants from as far away as Italy. To establish the stylistic characteristics of Rogier's art, scholars have turned to a painting of the **DEPOSITION** (FIG. 19–15), an altarpiece commissioned by the Louvain crossbowmen's guild (crossbows can be seen in the tracery painted in the upper corners) sometime before 1443, the date of the earliest known copy of it by another artist.

19–15 Rogier van der Weyden DEPOSITION
From an altarpiece commissioned by the crossbowmen's guild, Louvain, Belgium. Before 1443, possibly c. 1435–1438. Oil on wood panel, 7′2⅝″ × 8′7⅛″ (2.2 × 2.62 m). Museo del Prado, Madrid.

19–16 Rogier van der Weyden
ST. LUKE DRAWING THE VIRGIN AND CHILD

c. 1435–1440. Oil and tempera on wood panel, 54¼ × 43⅝″ (137.7 × 110.8 cm). Museum of Fine Arts, Boston.

Credit: Photograph © 2017 Museum of Fine Arts, Boston

The Deposition was a popular theme in the fifteenth century because of its potential for dramatic, personally engaging portrayal. Rogier sets the act of removing Jesus's body from the cross on the shallow stage of a gilt wooden box, just like the case of a carved and painted altarpiece. The ten solid, three-dimensional figures, however, are not simulations of polychromed wood carving, but near-life-size renderings of human figures who seem to press forward into the viewer's space, allowing no escape from the forceful expressions of grief. Jesus's friends seem real, with their portraitlike faces and scrupulously described contemporary dress, as they remove his body from the cross for burial. Jesus's corpse dominates the center of the composition, drooping in a languid curve framed by jarringly thin, angular arms. His pose is echoed by the rhyming form of the swooning Virgin. It is as if mother and son share in the redemptive passion of his death on the cross, encouraging viewers to identify with them or to join their assembled companions. Although united by sorrow, the mourning figures react in different ways, from the intensity of Mary Magdalen at far right, wringing her hands, to John the Evangelist's blank stare at left as he reaches to support the collapsing Virgin, to the anguish of the woman behind him, mopping her eyes with the edge of her veil.

Rogier's choice of color and pattern balances and enhances his composition. The complexity of the gold brocade worn by Joseph of Arimathea, who offered his new tomb for the burial, and the contorted pose and vivid dress of Mary Magdalen increase the visual impact of the right side of the panel to counter the pictorial weight of the larger number of figures at the left. The palette contrasts subtle, slightly muted colors with brilliant expanses of blue and red, while white accents focus the viewer's attention on the main subjects. The whites of the winding cloth and the tunic of the youth on the ladder set off Jesus's pale body, as the white turban and shawl emphasize the ashen face of Mary.

Another work by Rogier, painted at about the same time as the *Deposition*, is both quieter and more personal. It represents the evangelist St. Luke executing a preparatory drawing for a painting of the Virgin and Child, who seem to have materialized to pose for him (**FIG. 19–16**). The painting is based on a legend with origins in sixth-century Byzantium of a miraculous appearance of the Virgin and Child to Luke so he could record their appearance and pass on his authentic witness to his Christian followers. Rogier's version takes place in a carefully defined interior space that opens onto a garden, and from there into a distant vista of urban life, before dissolving into the countryside through which a winding river guides our exploration all the way to the horizon. The Virgin is preoccupied with nursing her baby, who has pulled away from her breast, smiling and flexing his hand—familiar gestures of actual nursing babies. Luke, half-kneeling, captures the scene in a **silverpoint** sketch, a common preliminary step used by

A Closer Look

A GOLDSMITH IN HIS SHOP

The coat of arms of the dukes of Guelders hangs from a chain around this man's neck, leading some to speculate that the woman, who is the more active of the pair, is Mary of Guelders, niece of Duke Philip the Good, who married King James II of the Scots the same year this picture was painted.

Goldsmiths were expected to perform all their transactions, including the weighing of gold, in public view to safeguard against dishonesty. Here the scales tip toward the couple, perhaps an allusion to the scales of the Last Judgment, which always tip to the side of the righteous.

Three types of coin rest on the shop counter: "florins" from Mainz, "angels" from English king Henry VI's French territories, and "riders" minted under Philip the Good. Such diversity of currency could show the goldsmith's cosmopolitanism, or they could indicate his participation in money changing, since members of that profession belonged to the same guild as goldsmiths.

This coconut cup was supposed to neutralize poison. The slabs of porphyry and rock crystal were "touchstones," used to test gold and precious stones.

The red coral and serpents' tongues (actually fossilized sharks' teeth) were intended to ward off the evil eye.

Two men, one with a falcon on his arm, are reflected in the obliquely placed mirror as they stand in front of the shop. The edges of the reflection catch the red sleeve of the goldsmith and the door frame, uniting the interior and exterior spaces and drawing the viewer into the painting.

The artist signed and dated his work in a bold inscription that appears just under the tabletop at the bottom of the painting: "Master Petrus Christus made me in the year 1449."

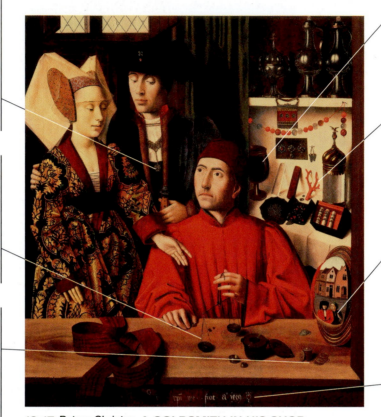

19–17 Petrus Christus **A GOLDSMITH IN HIS SHOP**
1449. Oil on oak panel, 38⅝ × 33½″ (98 × 85 cm). Metropolitan Museum of Art, New York. Robert Lehman Collection, 1975. 1975.1.110.

Credit: © 2016. Image copyright The Metropolitan Museum of Art/Art Resource/Scala, Florence

fifteenth-century Flemish painters in the planning of their paintings, especially portraits. The portraitlike quality of Luke's face here has led scholars to propose that this image of the saint is a self-portrait of the artist himself.

Art historians have traditionally interpreted this painting in two ways. Some see it—especially if Luke is a self-portrait—as a document of Rogier's sense of his own profession. They see him distancing himself and his fifteenth-century Flemish colleagues from identification with the laboring artisans of the Middle Ages and staking a claim for his special role as an inspired creator who recorded sacred visions in valuable, individualistic works of art. The notion of Rogier's own identification with Luke in this painting is supported by the fact that later artists emulated his composition in creating their own self-portraits as the century progressed. But other art historians, proposing that this painting was created for the chapel

of the guildhall of the painters in Brussels (the evidence is suggestive but unclear), have interpreted it as a claim for the importance of the painters' profession because it is rooted in saintly legend. Perhaps this extraordinary picture was both self-fashioning and professional propaganda. But it was also a devotional image. Luke's tenuous, half-kneeling posture, and his dreamy, introspective gaze certainly remind us that one of the tasks of painters in this period was to create inspiring pictures of religious visions that are made to feel real by meticulous references to the earthly world.

For another painting by Rogier van der Weyden that seems to have had a close connection with his life story and is characterized by a similar blending of the real and the visionary, see the discussion of one of his last—and perhaps one of his greatest—works in the "Introduction" and FIG. Intro–6.

Painting at Mid Century: The Second Generation

The extraordinary accomplishments of the Master of Flémalle, Jan van Eyck, and Rogier van der Weyden attracted many followers in Flanders. The work of this second generation of Flemish painters may be simpler, more direct, and often easier to understand than that of their predecessors, but they still produced extraordinary works of great emotional power. They were in large part responsible for the rapid spread of the Flemish style throughout Europe.

PETRUS CHRISTUS Among the most interesting of these painters was Petrus Christus (active 1444–c. 1475/1476), who became a citizen of Bruges in 1444 and signed and dated six paintings in a career that extended over three decades.

In 1449, Christus painted a portrait of a goldsmith serving two well-dressed customers in his shop (see "Closer Look" opposite). A halo around the head of the seated figure—not originally a part of the painting—was removed by restorers in 1993. This coincided with a reevaluation of the subject matter of the work, now seen as a vocational portrait of an actual goldsmith, rather than an image of St. Eloi, patron saint of goldsmiths, set in the present. Finished products and raw materials of the jeweler's trade sit on the shelves behind the goldsmith: containers, rings, brooches, a belt buckle, a string of beads, pearls, gemstones, coral, and crystal cylinders. A betrothal belt curls across the counter. Such a combination of objects suggests that the painting expresses a hope for health and well-being for the couple, who may be in the process of procuring rings for their upcoming marriage.

As in Jan van Eyck's double portrait, a convex mirror extends the viewer's field of vision, in this instance to the street outside, where two men appear. One is stylishly dressed in red and black, and the other holds a falcon, another indication of high status. Whether or not the reflected image has symbolic meaning, the mirror would have had practical value in a goldsmith's shop, allowing him to observe the approach of potential customers to the counter outside his window.

DIERIC BOUTS Dieric Bouts (active c. 1444–1475) is best known among Flemish painters as a storyteller, and he exercised those skills in a series of large altarpieces with narrative scenes drawn from the life of Christ and the lives of the saints. But he also created more intimate pictures, such as this tender rendering of the **VIRGIN AND CHILD**, just 8½ inches tall (**FIG. 19-18**). Even it evokes a story. Mary holds her baby securely, using both of her plain, strong hands to surround completely the lower part of his body. The baby reaches across his mother's chest and around her neck, pulling himself closer to press his face next to hers,

19-18 Dieric Bouts **VIRGIN AND CHILD**
c. 1455–1460. Oil on wood panel, 8½ × 6½" (21.6 × 16.5 cm). Metropolitan Museum of Art, New York.

cheek to cheek, nose to nose, mouth to mouth, eyes locked together, forming a symmetrical system that links them in pattern and almost melds them into a single mirrored form. It is as if a fifteenth-century St. Luke had captured a private moment between the Virgin and Child—a dimpled mother and baby looking very much like the actual people in the artist's world—during their miraculous appearance to sit as his models (compare FIG. 19-16). The concept is actually not so far-fetched. Bouts's painting is modeled after a fourteenth-century Italian image in the cathedral of Cambrai that in the fifteenth century was believed to have been painted by St. Luke himself.

Hugo van der Goes and Hans Memling

Hugo van der Goes (c. 1440–1482), dean of the painters' guild in Ghent (1468–1475), united the intellectual prowess of Jan van Eyck with the emotional sensitivity of Rogier van der Weyden to create an entirely new personal style. Hugo's major work was an exceptionally large altarpiece,

more than 8 feet tall, of the Nativity (**FIG. 19–19**), commissioned by Tommaso Portinari, head of the Medici bank in Bruges. Probably painted between 1474 and 1476, the triptych was sent to Florence and installed in 1483 in the Portinari family chapel, where it had a noticeable impact on Florentine painters.

Tommaso, his wife Maria Baroncelli, and their three oldest children are portrayed kneeling in prayer on the side panels of the wing interiors. On the left wing, looming larger than life behind Tommaso and his son Antonio, are their name saints—SS. Thomas and Anthony of Egypt. Since the younger son, Pigello, born in 1474, was apparently added after the original composition was set, his saintly counterpart is lacking. On the right wing, Maria and her daughter Margherita are presented by SS. Mary Magdalen and Margaret.

The theme of the altarpiece is the Nativity as told by Luke (2:10–19). The central panel represents the Adoration of the newborn Christ Child by Mary and Joseph, a host of angels, and the shepherds who have rushed in from the fields. In the middle ground of the wings are additional scenes. Winding their way through the winter landscape are two groups headed for Bethlehem. On the left wing, Mary and Joseph travel there to take part in a census. Near the end of her pregnancy, Mary has dismounted from her donkey and staggers, supported by Joseph. On the right wing, a servant of the three Magi, who are coming to honor the awaited Savior, asks directions from a peasant.

Hugo paints meadows and woods meticulously, and he uses atmospheric perspective to approximate distance in the landscape. He shifts figure size hierarchically for emphasis: The huge figures of Joseph, Mary, and the shepherds are the same size as the patron saints on the wings, in contrast to the much smaller Portinari family and still smaller angels. Hugo also uses light, as well as the gestures and gazes of the figures, to focus our eyes on the center panel where the mystery of the Incarnation takes place. Instead of lying swaddled in a manger or in his mother's arms, Jesus rests naked and vulnerable on the barren ground. Rays of light emanate from his body. This image was based on the visionary writing of the medieval Swedish mystic St. Bridget (who composed her work c. 1360–1370), which describes Mary kneeling to adore the Christ Child immediately after giving birth.

As in the work of Jan van Eyck, aspects of the setting of this painting are infused with symbolic meaning. In the foreground, the wheatsheaf refers both to the location of the event at Bethlehem, which in Hebrew means "house of bread," and to the Eucharistic Host, which represents the body of Christ. The majolica vessel is decorated with vines and grapes, alluding to the Eucharistic wine, which represents the blood of Christ. It holds a red lily for Christ's blood and three irises—white for purity and purple for Christ's royal ancestry. The seven blue columbines in the glass vessel remind the viewer of the Virgin's future sorrows, and scattered on the ground are violets, symbolizing humility. But Hugo's artistic vision transcends such formal religious symbolism. For example, the shepherds, who stand in awe before the miraculous event, are among the most sympathetically rendered images of common people to be found in the art of any period, and the portraits of the

19–20 Hans Memling **DIPTYCH OF MAARTEN VAN NIEUWENHOVE**

1487. Oil on wood panel, each panel (including frames) 20½ × 16¼" (52 × 41.5 cm). Hans Memling Museum, Musea Brugge, Sint-Jans Hospital, Bruges.

Credit: © akg-images/ Erich Lessing

Portinari children are unusually sensitive renderings of the delicate features of youthful faces.

HANS MEMLING The artist who seems to summarize and epitomize painting in Flanders during the second half of the fifteenth century is German-born Hans Memling (c. 1435–1494). Memling combines the intellectual depth and virtuoso rendering of his predecessors with a delicacy of feeling and exquisite grace, a "prettiness" that made his work exceptionally popular. He may have worked in

Rogier van der Weyden's Brussels workshop in the 1460s, but soon after Rogier's death in 1464, Memling moved to Bruges, where he developed an international clientele that supported a thriving workshop. He also worked for local patrons.

In 1487, the 24-year-old Maarten van Nieuwenhove (1463–1500), member of a powerful political family in Bruges (he became mayor of Bruges in 1497), commissioned from Memling a diptych that combined a meticulously detailed portrait of Maarten with a visionary apparition of the Virgin and Child, presented as a powerful fiction of their physical encounter in Maarten's own home (**FIG. 19–20**). This type of devotional diptych was a specialty of Rogier van der Weyden, but Memling transforms the type into something more intimate by placing it in a domestic setting. An expensively outfitted figure of Maarten appears in the right wing of the diptych, seen from an oblique angle, hands folded in prayer. He seems caught in a moment of introspection inspired by personal devotions—his Book of Hours lies still open on the table in front of him. The window just over his shoulder holds a stained-glass rendering of his name saint, Martin, in the top pane, while a recognizable landmark in Bruges can be seen through the opening below. The Virgin and Child on the adjacent panel are presented frontally, and the strong sense of specific likeness characterizing Maarten's portrait has given way to an idealized delicacy and grace in the visage of the Virgin that complements the extravagance of her clothing. Although she does not seem to be focusing on her baby, a completely nude Jesus stretches out on the pillow in front of her; she stabilizes him with one hand and offers him an apple with the other. This seems a clear reference to their roles as the new Adam and Eve, ready to redeem the

19–19 Hugo van der Goes **PORTINARI ALTARPIECE (OPEN)**

c. 1474–1476. Tempera and oil on wood panel; center 8′3½″ × 10′ (2.53 × 3.01 m), wings each 8′3½″ × 4′7½″ (2.53 × 1.41 m). Galleria degli Uffizi, Florence.

Credit: © Studio Fotografico Quattrone, Florence

sin brought into the world by the first couple. The stained glass behind them is filled with heraldry, devices, and a motto associated with Maarten's family.

Memling's construction of a coherent interior space for these figures is both impressive and meaningful. We are looking through two windows into a rectangular room containing this devotional group. The pillow under the Christ Child casts a shadow, painted on the lower frame of the left panel, to intensify the illusion, and the Virgin's scarlet mantle extends under the division between the two wings of the diptych to reappear on Maarten's side of the painting underneath his Book of Hours. This mantle not only connects the two sides of the painting spatially but also relates Maarten's devotional exercise to the apparition of the Virgin and Child. This relationship is also documented with a device already familiar to us in paintings by Jan van Eyck (SEE FIG. 19–1) and Petrus Christus (SEE FIG. 19–17). On the shadowy back wall, over the Virgin's right shoulder and set against the closed shutters of a window, is a convex mirror that reflects the backs of both Maarten and Mary, bearing visual witness to their presence together within his domestic space and undoing the division between them that is endemic to the diptych format. Maarten's introspective gaze signals that for him the encounter is internal and spiritual, but Memling transforms Maarten's private devotion into a concrete public statement that promotes an image of his piety and freezes him in perpetual prayer. We bear witness to his vision as an actual event.

France

How are painting and architecture transformed in fifteenth-century France?

Flemish art—with its complex symbolism, visionary subjects, atmospheric space, luminous colors, and sensuous surface textures—delighted wealthy patrons and well-educated courtiers both inside and outside Flanders. At first, Flemish artists worked in foreign courts, or their works were commissioned and exported abroad. Flemish manuscripts, tapestries, altarpieces, and portraits appeared in palaces and chapels throughout Europe. But soon regional artists traveled to Flanders to learn oil-painting techniques and practice the Flemish style. By the end of the fifteenth century, distinctive regional variations of Flemish art could be found throughout Europe, from the Atlantic Ocean to the Danube.

The centuries-long struggle for power and territory between France and England continued well into the fifteenth century. When King Charles VI of France died in 1422, England claimed the throne for the king's 9-month-old grandson, Henry VI of England. The plight of Charles VII, the late French king's son, inspired Joan of Arc to raise an army to return him to the throne. Thanks to Joan's efforts, Charles was crowned at Reims in 1429. Although Joan was burned at the stake in 1431, the revitalized French forces drove the English from French lands. In 1461, Louis XI succeeded his father, Charles VII, as king of

19–21 Jean Fouquet **ÉTIENNE CHEVALIER AND ST. STEPHEN, VIRGIN AND CHILD**
The Melun Diptych. c. 1452–1455. Oil on oak panel. Left wing: 36½ × 33½″ (92.7 × 85.5 cm), Staatliche Museen zu Berlin, Preussischer Kulturbesitz, Gemäldegalerie; right wing: 37¼ × 33½″ (94.5 × 85.5 cm), Koninklijk Museum voor Schone Kunsten, Antwerp, Belgium.

Credit: L © 2016. Photo Scala, Florence/bpk, Bildagentur für Kunst, Kultur und Geschichte, Berlin. R © 2016. Album/Scala, Florence

France. Under his rule the French royal court again became a major source of patronage for the arts.

Jean Fouquet and Jean Hey

The leading court artist of fifteenth-century France, Jean Fouquet (c. 1425–1481), was born in Tours and may have trained in Paris as an illuminator and in Bourges in the workshop of Jacob de Littemont, Flemish court painter to Charles VII. He was part of a French delegation to Rome in 1446–1448, but by mid century he had established a workshop in Tours and was a renowned painter. Fouquet drew from contemporary Italian Classicism, especially in rendering architecture, and he was also strongly influenced by Flemish illusionism. He painted pictures of Charles VII, the royal family, and courtiers; he also illustrated manuscripts and designed tombs.

Among the court officials who commissioned paintings from Fouquet was Étienne Chevalier, treasurer of France under Charles VII. Fouquet painted a diptych for him that was installed over the tomb of Chevalier's wife Catherine Budé (d. 1452) in the church of Notre-Dame in Melun (**FIG. 19-21**). Chevalier appears in the left panel, kneeling in prayer with clasped hands and a meditative gaze within an Italianate palace, accompanied by his name saint Stephen (Étienne in French). Fouquet describes the courtier's ruddy features with a mirrorlike precision that is reminiscent of Flemish art. He is expensively dressed in a heavy red wool garment lined with fur, and his "bowl cut" hairstyle represents the latest Parisian fashion. St. Stephen's features convey a comparable sense of likeness and sophistication. A deacon in the Early Christian church in Jerusalem, Stephen was the first Christian martyr, stoned to death for defending his beliefs. Here he wears the fifteenth-century liturgical vestments of a deacon and carries a large stone on a closed Gospel book as evidence of his martyrdom. A trickle of blood can be seen on his tonsured head (male members of religious orders shaved the tops of their heads as a sign of humility). Placing his arm around Étienne Chevalier's back, the saint seems to be introducing the treasurer to the Virgin and Child in the adjacent panel.

The Virgin and Child, however, exist in another world. A supernatural vision unfolds as the queen of heaven is enthroned surrounded by red and blue seraphim and cherubim, who form a tapestrylike background. The Virgin seems a celestial being, conceived by Fouquet as a hybrid of careful description and powerful abstraction. Her fashionable, tightly waisted bodice has been unlaced so she can present her spherical breast to a substantial, seated baby who points across the juncture between the two wings of the diptych to acknowledge Chevalier. According to tradition, Fouquet gave this image of the Virgin the features of the king's much loved and respected mistress, Agnès Sorel, who died in 1450. The original frame that united these

19-22 Jean Hey (The Master of Moulins) **PORTRAIT OF MARGARET OF AUSTRIA**

c. 1490. Oil on wood panel, 12⅞ × 9⅛" (32.7 × 23 cm). Metropolitan Museum of Art, New York. Robert Lehman Collection.

Credit: © 2016. Image copyright The Metropolitan Museum of Art/Art Resource/Scala, Florence

two panels into a diptych—now divided between two museums—is lost, but among the fragments that remain is a stunning medallion self-portrait that served as the artist's signature.

JEAN HEY, THE MASTER OF MOULINS Perhaps the greatest French follower of Jean Fouquet is an artist who for many years was known as the Master of Moulins after a large triptych he painted at the end of the fifteenth century under the patronage of Duke Jean II of Bourbon, for the Burgundian cathedral of Moulins. This triptych combines Flemish attention to color and surface texture with a characteristically French air of reserved detachment. Recently the work of this artist has been associated with the name Jean Hey, a painter of Flemish origin who seems to have been trained in the workshop of Hugo van der Goes, but who pursued his career at the French court.

This charming portrait (**FIG. 19-22**)—which may have been one half of a devotional diptych

comparable to that painted by Memling for Maarten van Nieuwenhove (SEE FIG. 19–20)—portrays Margaret of Austria (1480–1530), daughter of Emperor Maximilian I, who had been betrothed to the future French king Charles VIII (ruled 1483–1498) at age 2 or 3 and was being brought up at the French court. She would return home to her father in 1493 after Charles decided to pursue another, more politically expedient marriage (after two political marriages of her own, the widowed Margaret would eventually become governor of the Habsburg Netherlands), but Hey captures her at a tender moment a few years before those troubled times. She kneels in front of a strip of wall between two windows that open onto a lush country landscape, fingering the pearl beads of her rosary. Details of her lavish velvet and ermine outfit not only proclaim her wealth but provide the clues to her identity—the *C*s and *M*s embroidered on her collar signal her betrothal to Charles and the ostentatious *fleur-de-lis* pendant set with large rubies and pearls proclaims her affiliation with the French court. But it is the delicacy and sweet vulnerability of this 10-year-old girl that are most arresting. They recall Hugo van der Goes's sensitivity to the childlike qualities of the young members of donor families (SEE FIG. 19-19) and provide strong evidence for ascribing Hey's training to the workshop of this Flemish master.

Flamboyant Architecture

The great age of cathedral building that had begun in the second half of the twelfth century was essentially over by the end of the fourteenth century—but growing urban populations needed houses, city halls, guildhalls, and more parish churches. It was in buildings such as these that late Gothic architecture took form in a style we call "Flamboyant" because of its repeated, twisted, flamelike tracery patterns. Late Gothic masons covered their buildings with increasingly elaborate and at times playful architectural decoration. Like painters, sculptors also turned to describing the specific nature of the world around them, and they covered capitals and moldings with ivy, hawthorn leaves, and other vegetation, not just the conventional acanthus motifs inherited from the Classical world.

The **CHURCH OF SAINT-MACLOU** in Rouen, which was begun after a fund-raising campaign in 1432 and dedicated in 1521, is an outstanding and well-preserved example of Flamboyant Gothic (**FIG. 19-23**) probably designed by the Paris architect Pierre Robin. A projecting porch bends to enfold the façade of the church in a screen of tracery. Sunlight on the flame-shape openings casts ever-changing shadows across the intentionally complex surface. **Crockets**—small, knobby, leaflike ornaments that line the steep gables and slender buttresses—break every defining line. In the Flamboyant style, decoration

sometimes disguises structural elements with an overlay of tracery and ornament in geometric and natural shapes, all to dizzying effect.

The house of Jacques Coeur, a wealthy merchant in Bourges, reflects the popularity of the Flamboyant style for secular architecture (**FIG. 19-24**). Built at great expense between 1443 and 1451, it survives almost intact, although it has been stripped of its rich furnishings. The rambling, palatial house is built around an irregular open courtyard, with spiral stairs in octagonal towers giving access to the upper-floor rooms. Tympana over doors indicate the function of the rooms within; for example, over the door to the kitchen a cook stirs the contents of a large bowl. Among the carved decorations are puns on the patron's surname, Coeur (meaning "heart" in French). The house was also Jacques Coeur's place of business, so it had large storerooms for goods and a strongroom for treasure.

19-23 Pierre Robin (?) **CHURCH OF SAINT-MACLOU, ROUEN**

Normandy, France. West façade, 1432–1521; façade c. 1500–1514.

Credit: © Achim Bednorz, Cologne

19-24A PLAN OF JACQUES COEUR HOUSE
Bourges, France. 1443–1451.

courtyard

The Germanic Lands

How is the Northern Renaissance style expressed in painting and the graphic arts in Germany and Switzerland?

Present-day Germany and Switzerland were situated within the Holy Roman Empire, a loose confederation of primarily German-speaking states. Artisan guilds grew powerful and trade flourished under the auspices of the Hanseatic League, an association of cities and trading outposts, stimulating a strengthening of the merchant class. The Fugger family, for example, began their spectacular rise from simple textile workers and linen merchants to bankers for the Habsburgs and the popes.

Painting and Sculpture

Germanic fifteenth-century painters worked in two very different styles. Some, clustered around Cologne, continued the International Gothic style with increased prettiness, softness, and sweetness of expression. Other artists began an intense investigation and detailed description of

19-24B INTERIOR COURTYARD OF JACQUES COEUR HOUSE
Bourges, France. 1443–1451.

Credit: © Hervé Champollion/akg-images

the physical world. The major exponent of the latter style was Konrad Witz (active 1434–1446). A native of Swabia in southern Germany, Witz moved to Basel (in present-day Switzerland), where he found a rich source of patronage in the Church.

Witz's last large commission before his early death in 1446 was an altarpiece dedicated to St. Peter for the cathedral of Geneva, signed and dated to 1444. In one of its scenes—the **MIRACULOUS DRAFT OF FISHES** (**FIG. 19–25**)—Jesus appears posthumously to his disciples as they fish on the Sea of Galilee, and Peter leaps from the boat to greet him. But Witz sets the scene on the Lake of Geneva, with the distinctive dark mountain (the Mole) rising on the north shore and the snow-covered Alps shining in the distance. Witz records every nuance of light and water—the rippling surface, the reflections of boats, figures, and

buildings, and even the lake bottom. Peter's body and legs, visible through the water, are distorted by the refraction. It is one of the earliest times in European art that an artist captures both the appearance and the spirit of nature.

Some patrons in Germanic lands preferred altarpieces that featured polychromed wood carvings rather than the ensembles of panel paintings that we saw in Flanders—for example, the Ghent Altarpiece (**SEE FIGS. 18–13, 18–14**). One of the greatest artists working in this tradition was painter and sculptor Michael Pacher (1435–1498), based in Bruneck, now in the Italian Alps. In 1471, Benedict Eck, abbot of Mondsee, commissioned from Pacher for the pilgrimage church of St. Wolfgang a grand high altarpiece that is still installed in its original church setting (**FIG. 19–26**). The surviving contract specifies materials and subject matter and even documents the cost—1,200 Hungarian florins—but

19–25 Konrad Witz MIRACULOUS DRAFT OF FISHES
From an altarpiece for the Cathedral of St. Peter, Geneva, Switzerland. 1444. Oil on wood panel, 4'3" × 5'1" (1.29 × 1.55 m). Musée d'Art et d'Histoire, Geneva.

Credit: © Musée d'art et d'histoire, Ville de Genève. Photo: Flora Bevilacqua

19–26 Michael Pacher **ST. WOLFGANG ALTARPIECE**
Church of St. Wolfgang, Austria. 1471–1481. Carved, painted, and gilt wood; wings are oil on wood panel.

sets no time limit for its completion. Pacher and his shop worked on it for ten years.

When it is open (as in FIG. 19–26), a dizzyingly complicated sculptural ensemble aligns up the middle, flanked by four large panel paintings portraying scenes from the life of the Virgin on the opened shutters. Both the design and execution were supervised by Pacher, but many other artists collaborated with him on the actual carving and painting. In the main scene, the wood carvings create a vision of Paradise where Christ crowns his mother as the queen of heaven, flanked by imposing images of local saints. The use of soft wood facilitated deep undercutting and amazing detail in the rendering of these figures, and the elaborate polychromy and gold leaf give them a finish that glitters in the changing patterns of natural light or the flickering glow of candles.

The Graphic Arts

Printmaking emerged in Europe at the end of the fourteenth century with the development of printing presses and the increased local manufacture and wider availability of paper. The techniques used by printmakers during the fifteenth century were woodcut and engraving on metal (see "Woodcuts and Engravings on Metal" below). **Woodblocks** cut in relief had long been used to print designs on cloth, but only in the fifteenth century did the printing of images and texts on paper and the production of books in multiple copies of a single edition, or version, begin to replace the copying of each book by hand. Both hand-written and printed books were often illustrated, and printed images were sometimes hand-colored.

Large quantities of single-sheet prints were also made using woodcut and engraving techniques in the early

Technique
WOODCUTS AND ENGRAVINGS ON METAL

Woodcuts are made by drawing on the surface of a block of fine-grained wood, then cutting away all the areas around the lines with a sharp tool called a gouge, leaving the lines in high relief. When the block's surface is inked and a piece of paper pressed down hard on it, the ink on the relief areas transfers to the paper to create a reverse image. The effects can be varied by making thicker and thinner lines, and shading can be achieved by placing the lines closer or farther apart. Sometimes color was painted onto the resulting black-and-white images by hand.

Engraving on metal requires a technique called **intaglio**, in which the lines are cut into the plate with tools called gravers or **burins**. The engraver then carefully polishes the plate to ensure a clean, sharp image. Ink is applied over the whole plate and forced down into the lines, then the plate's surface is carefully wiped clean of the excess ink. When paper and plate are held tightly together by a press, the ink in the recessed lines transfers to the paper.

Woodblocks and metal plates could be used repeatedly to make nearly identical images. If the lines of the block or plate wore down, the artists could repair them. Printing large numbers of identical prints of a single version, called an edition, was usually a team effort in a busy workshop. One artist would make the drawing. Sometimes it was drawn directly on the block or plate with ink, in reverse of its printed direction, sometimes on paper to be transferred in reverse onto the plate or block by another person, who then cut the lines. Others would ink and print the images.

In the illustration of books, the plates or blocks would be reused to print later editions and even adapted for use in other books. A set of blocks or plates for illustrations was a valuable commodity and might be sold by one workshop to another. Early in publishing, there were no copyright laws, and many entrepreneurs simply had their workers copy book illustrations onto woodblocks and cut them for their own publications.

relief printing

intaglio printing

19-27 THE BUXHEIM ST. CHRISTOPHER
Mid 15th century. Hand-colored woodcut, 11⅜ × 8⅛" (28.85 × 20.7 cm). Private collection.

The Latin text reads, "Whenever you look at the face of St. Christopher, you will not die a terrible death that day."

Credit: © Fine Art Images/Archivi Alinari, Firenze

decades of the fifteenth century. Often artists drew the images and then professional woodworkers would cut them from the block.

THE BUXHEIM ST. CHRISTOPHER Devotional images were sold as souvenirs to pilgrims at holy sites. **THE BUX-HEIM ST. CHRISTOPHER** was found in the Carthusian monastery of Buxheim, in southern Germany, glued to the inside of the back cover of a manuscript (**FIG. 19-27**). St.Christopher, patron saint of travelers and protector from the plague, carries the Christ Child across the river. His efforts are witnessed by a monk holding out a light to guide him to the monastery door, but ignored by the hardworking millers on the opposite bank. Both the cutting of the block and the quality of the printing are very high. Lines vary in width to strengthen major forms. Delicate lines are used for inner modeling (facial features) and short, parallel lines indicate shadows (the inner side of draperies). The date 1423, which is cut into the block, was once thought to

identify this print as among the earliest to survive. Recent studies have determined that the date refers to some event, and the print is now dated at mid century.

MARTIN SCHONGAUER Engraving may have originated with goldsmiths and armorers, who recorded their work by rubbing lampblack into the engraved lines of their products and pressing paper over the metal. German artist Martin Schongauer (c. 1435–1491), who learned engraving from his goldsmith father, was an immensely skillful printmaker who excelled both in drawing and in the difficult technique of shading from deep blacks to faintest grays using only line. In **THE TEMPTATIONS OF ST. ANTHONY**, probably engraved during the 1470s (**FIG. 19-28**), Schongauer illustrated the original biblical meaning of temptation as a physical assault rather than a subtle inducement. Wildly acrobatic, slithery, spiky demons lift Anthony up off the ground to torment him in midair. The engraver intensified the horror of the moment by condensing the action into a swirling vortex of

19-28 Martin Schongauer THE TEMPTATIONS OF ST. ANTHONY
c. 1470–1480. Engraving, 12¼ × 9" (31.1 × 22.9 cm). Metropolitan Museum of Art, New York. Rogers Fund, 1920 (20.5.2).

Credit: © 2016. Image copyright The Metropolitan Museum of Art/Art Resource/Scala, Florence

figures beating, scratching, poking, tugging, and no doubt shrieking at the stoical saint, who remains impervious to all, perhaps because of his power to focus inwardly on his private meditations.

Printed Books

The explosion of learning in Europe in the fifteenth century encouraged experiments in faster and cheaper ways of producing books than by hand-copying them. The earliest printed books were block books, for which each page of text, with or without illustrations, was cut in relief on a single block of wood. Movable-type printing, in which individual letters could be arranged and locked together, inked, and then printed onto paper, was first achieved in Europe in the workshop of Johann Gutenberg in Mainz, Germany. More than 40 copies of Gutenberg's Bible, printed around 1455, still exist. As early as 1465, two German printers were working in Italy, and by the 1470s there were presses in France, Flanders, Holland, and Spain. With the invention of this fast way to make a number of identical books, the intellectual and spiritual life of Europe—and with it the arts—changed forever.

THE NUREMBERG CHRONICLE The publication of the *Nuremberg Chronicle* by prosperous Nuremberg printer Anton Koburger was the culmination of his complicated collaboration with scholars, artists, and investors in an early capitalist enterprise that is a landmark in the history of printed books. The text of this history of the world was compiled by physician and scholar Hartmann Schedel, drawing from the work of colleagues and the extensive holdings of his private library. When Koburger set out to publish Schedel's compilation, he sought financial support from Sebald Schregel and his brother-in-law Sebastian Kammermaister, who had a proven record of patronage in book publishing. He also contracted in the 1480s with artists Michael Wolgemut and

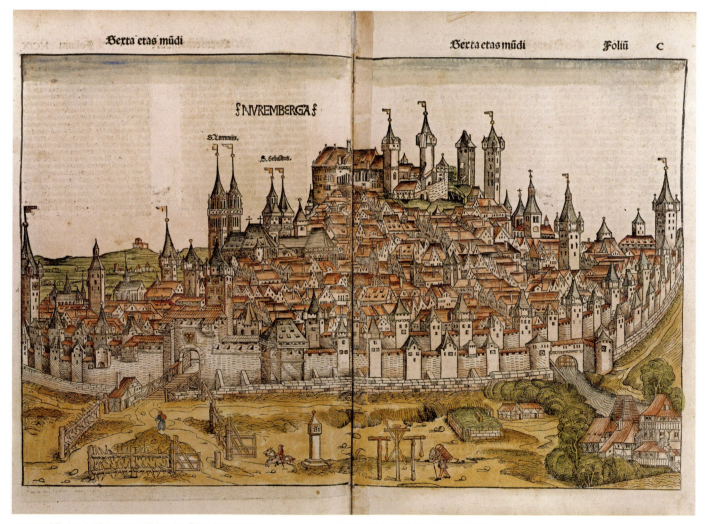

19–29 Michael Wolgemut, Wilhelm Pleydenwurff, and workshop **THE CITY OF NUREMBERG**
Nuremberg Chronicle, published by Anton Koburger in 1493. Woodcut within a printed book, hand-colored after printing, each page 18½ × 12¾" (47 × 32.4 cm). Staatliche Museen zu Berlin.

Wilhelm Pleydenwurff to produce the woodcut illustrations and in 1491 to work on the layout.

The *Nuremberg Chronicle* was published in 1493 in an edition of 2,500. Woodcut illustrations—1,809 in total—were dispersed throughout the book, spreading across the width of whole pages or tucked into the text along either margin. Those interested in purchasing the book could obtain it in Latin or German, on parchment or on paper, bound or unbound, as it came from the press or tinted with color. It seems fitting that the only instance of a double-page picture—filling the entire expanse of an opening with text restricted to headings and labels—is a panoramic view of the city of Nuremberg where this collaborative enterprise was centered (**FIG. 19-29**). Illustrated here is a view of this expansive cityscape in a copy of the book that was originally owned by a bibliophile who could afford to have the woodcuts hand-painted with color to enhance the appearance of this proud Renaissance city's portrait. As we will see, Nuremberg was the site of significant artistic developments in the sixteenth century as well.

Think About It

1 Explain how oil-painting technique allowed fifteenth-century Flemish painters to achieve unprecedented descriptive effects in their work. Support your answer by discussing one specific work in this chapter.

2 Discuss the symbolic meanings that fifteenth-century viewers would have comprehended in the objects in the domestic environment of either the Mérode Altarpiece (**FIG. 19-10**) or the Arnolfini double portrait (**FIG. 19-1**).

3 How have fifteenth-century northern paintings been characterized as devotional visions of the patrons who are portrayed in them? Use a specific work discussed in this chapter as the focus of your answer.

4 Why did printmaking become a major pictorial medium in northern Europe during the fifteenth century? Choose a work discussed in this chapter and explain how it supports your answer.

Crosscurrents

These two paintings portray one of the most popular subjects in Christian art: the Annunciation. They were painted by artists working in different places and trained in different traditions, and they are very different in medium and size. Characterize the differences in style and narrative presentation. How are these features related to the cultural context of each?

FIG. 18-13

FIG. 19-10

20–1 Paolo Uccello **NICCOLÒ DA TOLENTINO LEADING THE CHARGE**

Detail from *The Battle of San Romano* (FIG. 20–24), 1438–1440. Tempera on wood panel. National Gallery, London.

Chapter 20
Renaissance Art in Fifteenth-Century Italy

 ## Learning Objectives

20.a Identify the visual hallmarks of fifteenth-century Italian art for formal, technical, and expressive qualities.

20.b Interpret the meaning of works of fifteenth-century Italian art based on their themes, subjects, and symbols.

20.c Relate fifteenth-century Italian art and artists to their cultural, economic, and political contexts.

20.d Apply the vocabulary and concepts relevant to fifteenth-century Italian art, artists, and art history.

20.e Interpret a work of fifteenth-century Italian art using the art historical methods of observation, comparison, and inductive reasoning.

20.f Select visual and textual evidence in various media to support an argument or an interpretation of a work of fifteenth-century Italian art.

This ferocious but bloodless battle seems to take place in a dream, but it depicts a historical event (**FIG. 20–1**). Under an elegantly fluttering banner, the Florentine general Niccolò da Tolentino leads his men against the Sienese at the Battle of San Romano, which took place on June 1, 1432. The battle rages across a shallow stage defined by the debris of warfare arranged in a neat pattern on a pink ground and backed by blooming hedges. In the center foreground, Niccolò holds up a baton of command, the sign of his authority. His bold gesture—together with his white horse and crimson-and-gold damask hat—ensures that he dominates the scene. His knights charge into the fray, and when they fall, like the soldier at the lower left, they join the many broken lances on the ground—all in conformity with the new mathematical depiction of receding space called **linear perspective**, posed to align with implied lines that converge at a single point on the horizon.

An eccentric Florentine painter nicknamed Paolo Uccello ("Paul Bird") created the panel painting (SEE FIG. 20–24) from which the detail in FIGURE 20–1 is taken. It is one of three related panels—now separated, hanging in major museums in Florence, London, and Paris—commissioned by Lionardo Bartolini Salimbeni (1404–1479), who led the Florentine governing Council of Ten during the war against Lucca and Siena. Uccello's remarkable accuracy when depicting armor from the 1430s, heraldic banners, and even fashionable fabrics and crests surely would have appealed

to Lionardo's civic pride. The hedges of oranges, roses, and pomegranates—all ancient fertility symbols—suggest that Lionardo might have commissioned the paintings at the time of his wedding in 1438. Lionardo and his wife, Maddalena, had six sons, two of whom inherited the paintings.

According to a later complaint brought by Damiano, one of the heirs, Lorenzo de' Medici, the powerful *de facto* ruler of Florence, "forcibly removed" the paintings from Damiano's house. They were never returned, and Uccello's masterpieces are recorded in a 1492 inventory as hanging in the Medici palace. Perhaps Lorenzo, who was called "the Magnificent," saw Uccello's heroic pageant as a trophy more worthy of a Medici merchant prince. Princely patronage was certainly a major factor in the genesis of the Italian Renaissance as it developed in Florence during the early years of the fifteenth century.

Humanism and the Italian Renaissance

What are the cultural and historical backgrounds of Italian Renaissance art and architecture?

By the end of the Middle Ages, the most important Italian cultural centers lay north of Rome in the cities of Florence, Milan, and Venice, and in the smaller court cities of

MAP 20–1 FIFTEENTH-CENTURY ITALY

Powerful families divided the Italian peninsula into city-states: the Medici in Florence, the Visconti and Sforza in Milan, the Montefeltro in Urbino, the Gonzaga in Mantua, and the Este in Ferrara. After 1420, the popes ruled Rome, while in the south Naples and Sicily were French and then Spanish (Aragonese) territories. Venice maintained its independence as a republic.

Mantua, Ferrara, and Urbino. Political power and artistic patronage were both dominated by wealthy families: the Medici in Florence, the Montefeltro in Urbino, the Gonzaga in Mantua, the Visconti and Sforza in Milan, and the Este in Ferrara (**MAP 20–1**). Cities grew in wealth and independence as people migrated from the countryside in unprecedented numbers. Like in northern Europe, commerce became increasingly important. Money conferred status, and a shrewd business or political leader could become very powerful. The period saw the rise of mercenary armies led by entrepreneurial (and sometimes brilliant) military commanders called *condottieri*, who owed allegiance only to those who paid them well; their employer

might be a city-state, a lord, or even the pope. Some *condottieri*, like Niccolò da Tolentino (SEE FIG. 20–1), became rich and famous. Others, like Federico da Montefeltro (SEE FIG. 20–39), were lords or dukes themselves, with territories of their own in need of protection. Patronage of the arts was an important public activity with political overtones. As one Florentine merchant, Giovanni Rucellai, succinctly noted, he supported the arts "because they serve the glory of God, the honour of the city, and the commemoration of myself" (cited in Baxandall, p. 2).

The term Renaissance (French for "rebirth") was only applied to this period by later historians. However, its origins lie in the thought of Petrarch and other

fourteenth-century Italian writers, who emphasized the power and potential of human beings for great individual accomplishment. These Italian humanists also looked back at the thousand years extending from the disintegration of the Western Roman Empire to their own day and determined that the achievements of the Classical world were followed by what they perceived as a period of decline—a "middle" or "dark" age. They proudly saw their own era as a third age characterized by a revival or rebirth ("renaissance"), when humanity began to emerge from what they erroneously saw as intellectual and cultural stagnation to appreciate once more the achievement of the ancients and the value of rational, scientific investigation. They looked to the accomplishments of the Classical past for inspiration and instruction, and in Italy this centered on the heritage of ancient Rome. They sought the physical and literary records of the ancient world—assembling libraries, collecting sculpture and fragments of architecture, and beginning archaeological investigations. Their aim was to live a rich, noble, and productive life—usually within the framework of Christianity, but always adhering to a school of philosophy as a moral basis.

Artists, like the humanists, turned to Classical antiquity for inspiration, emulating ancient Roman sculpture and architecture even as they continued to fulfill commissions for predominantly Christian subjects and buildings. But a number of home furnishings from the secular world, such as birth trays and marriage chests, have survived, richly painted with allegorical and mythological themes. Patrons began to collect art for their personal enjoyment.

Like Flemish artists, Italian painters and sculptors increasingly focused their attention on rendering the illusion of physical reality. They did so in a more analytical way than the northerners. Rather than seeking to describe the visual appearance of nature through luminosity and detailed textural differentiation, Italian artists aimed at achieving lifelike but idealized weighty figures set in a space organized through strict adherence to linear perspective, a mathematical system that gave the illusion of a measured and continuously receding space (see "Renaissance Perspective" on page 623).

The Early Renaissance in Florence

What characterizes the early development of Italian Renaissance architecture, sculpture, and painting in Florence?

In taking Uccello's battle painting (SEE FIG. 20-1), Lorenzo de' Medici was asserting the role his family had come to expect to play in Florence. The fifteenth century witnessed the rise of the Medici from among the most successful of a newly rich middle class (primarily merchants and bankers) to the city's virtual rulers. Unlike the hereditary aristocracy, the Medici emerged from obscure roots to make their fortune in banking; from their money came their power.

The competitive Florentine atmosphere that had fostered mercantile success and civic pride also cultivated competition in the arts and encouraged an interest in ancient literary texts. This has led many to consider Florence the cradle of the Italian Renaissance. Under Cosimo the Elder (1389–1464), the Medici became leaders in intellectual and artistic patronage. They sponsored philosophers and other scholars who wanted to study the Classics, especially the works of Plato and his followers, the Neoplatonists. Neoplatonism distinguished between the spiritual (the ideal or Idea) and the physical (Matter) and encouraged artists to represent ideal figures. But it was writers, philosophers, and musicians—and not artists—who dominated the Medici Neoplatonic circle. Architects, sculptors, and painters learned their craft in apprenticeships and were therefore considered manual laborers. Nevertheless, interest in the ancient world rapidly spread from the Medici circle to visual artists, who gradually began to see themselves as more than laborers. Florentine society soon recognized their best works as achievements of a very high order.

Although the Medici were the *de facto* rulers, Florence was considered a republic. The Council of Ten (headed for a time by Salimbeni, who commissioned Uccello's *Battle of San Romano*) was a kind of constitutional oligarchy where wealthy men formed the government. At the same time, the various guilds wielded tremendous power; guild membership was a prerequisite for holding government office. Consequently, artists could look to the Church and the state—the state including both the city government and the guilds—as well as private individuals for patronage. All these patrons expected the artists to reaffirm and glorify their achievements with works that were not only beautiful but intellectually powerful.

The Competition Reliefs

In 1401, the building supervisors of the baptistery of Florence Cathedral decided to commission a new pair of bronze doors, funded by the powerful wool merchants' guild. Instead of choosing a well-established sculptor with a strong reputation, a competition was announced for the commission. This prestigious project would be awarded to the artist who demonstrated the greatest talent in executing a trial piece: a bronze relief representing Abraham's sacrifice of Isaac (Genesis 22:1–13) composed within the same Gothic quatrefoil framework used in Andrea Pisano's first set of bronze doors for the baptistery, made in the 1330s (SEE FIG. 18-3).

Two competition panels have survived, those submitted by the presumed finalists—Filippo Brunelleschi and

20–2 Filippo Brunelleschi **SACRIFICE OF ISAAC**
1401–1402. Bronze with gilding, 21 × 17½" (53 × 44 cm) inside molding. Museo Nazionale del Bargello, Florence.

Credit: © Studio Fotografico Quattrone, Florence

20–3 Lorenzo Ghiberti **SACRIFICE OF ISAAC**
1401–1402. Bronze with gilding, 21 × 17½" (53 × 44 cm) inside molding. Museo Nazionale del Bargello, Florence.

Credit: © Studio Fotografico Quattrone, Florence

Lorenzo Ghiberti, both young artists in their early twenties (**FIGS. 20-2, 20-3**). Brunelleschi's composition is rugged and explosive, marked by raw dramatic intensity. At the right, Abraham lunges forward, grabbing his son by the neck, while the angel swoops to stop him just as the knife is about to strike. Isaac's awkward pose embodies his fear and struggle. Ghiberti's version is quite different, suave and graceful rather than powerful and dramatic. Poses are controlled and choreographed; the harmonious pairing of son and father contrasts sharply with the wrenching struggle in Brunelleschi's rendering. And Ghiberti's Isaac is not a stretched, scrawny youth, but a fully idealized Classical figure exuding calm composure.

Brunelleschi's biographer, Antonio di Tuccio Manetti, claimed that the competition ended in a tie, and that when the committee decided to split the commission between the two young artists, Brunelleschi withdrew. It is possible, however, that the cloth merchants actually chose Ghiberti to make the doors. They might have preferred the elegance of his figural composition. Perhaps they liked the prominence of gracefully arranged swags of cloth, reminders of the source of their patronage and prosperity. But they also could have been swayed by the technical superiority of Ghiberti's relief. Unlike Brunelleschi, Ghiberti cast background and figures mostly as a single piece, making his bronze stronger, lighter, and less expensive to produce. The finished doors—installed in the baptistery in 1424—were

so successful that Ghiberti was commissioned to create another set (SEE FIG. 20-16), his most famous work, hailed by Michelangelo as the "Gates of Paradise." Brunelleschi would refocus his career on buildings rather than bronzes, becoming one of the most important architects of the Italian Renaissance (SEE FIGS. 20-4, 20-6).

Filippo Brunelleschi, Architect

The defining civic project of the early years of the fifteenth century was the completion of Florence Cathedral with a magnificent dome over the high altar. The construction of the cathedral had begun in the late thirteenth century and had continued intermittently during the fourteenth. As early as 1367, builders had envisioned a very tall dome to span the huge interior space of the crossing, but they lacked the engineering know-how to construct it. When interest in completing the cathedral revived around 1407, the technical solution was proposed by the young sculptor-turned-architect Filippo Brunelleschi.

FLORENCE CATHEDRAL Filippo Brunelleschi (1377–1446) achieved what many had considered impossible: He solved the problem of the dome of Florence Cathedral. Brunelleschi had originally trained as a goldsmith. To further his education, he traveled to Rome to study ancient Roman sculpture and architecture, and it was on his return to Florence that he tackled the dome. After the completion

20–4 Filippo Brunelleschi **DOME OF FLORENCE CATHEDRAL (SANTA MARIA DEL FIORE)**
1420–1436; lantern completed 1471.

Credit: © Javier Martin/123RF

of a tall octagonal drum in 1412, Brunelleschi designed the dome itself in 1417, and it was built between 1420 and 1436 (**FIGS. 20-4, 20-5**). A revolutionary feat of engineering, the dome is a double shell of masonry 138 feet across. The octagonal outer shell is supported on 8 large and 16 lighter ribs. Instead of using a costly and even dangerous scaffold and centering, Brunelleschi devised a system in which temporary wooden supports were cantilevered out from the drum. He moved these supports up as building progressed. As the dome was built up course by course, each portion of the structure reinforced the next one. Vertical

20–5 SCHEMATIC DRAWING OF FLORENCE CATHEDRAL

The separate, central-plan building in front of the façade is the baptistery. Adjacent to the façade is a tall tower designed by Giotto in 1334.

Credit: © Dorling Kindersley

marble ribs interlocked with horizontal sandstone rings, connected and reinforced with iron rods and oak beams. The inner and outer shells were linked internally by a system of arches. When completed, this self-buttressed unit required no external support to keep it standing.

An oculus (round opening) in the center of the dome was topped with a lantern designed in 1436. After Brunelleschi's death, this crowning structure, made up of Roman architectural forms, was completed by another Florentine architect, Michelozzo di Bartolomeo (1396–1472). The final touch—a gilt-bronze ball by Andrea del Verrocchio—was added in 1468–1471 (but replaced in 1602 with a smaller one).

Other commissions came quickly after the cathedral dome project established Brunelleschi's fame. From about 1418 until his death in 1446, Brunelleschi was involved in a series of influential projects. Between 1419 and 1423, he built the elegant Capponi Chapel in the church of Santa Felicità (SEE FIG. 21-37). In 1419, he also designed a foundling hospital for the city.

THE FOUNDLING HOSPITAL In 1419, the guild of silk manufacturers and goldsmiths (Arte della Seta) in Florence undertook a significant public service: It established a large public orphanage and commissioned Filippo Brunelleschi to build it near the church of the Santissima Annunziata (Most Holy Annunciation), which housed a miracle-working painting of the Annunciation, making it a popular pilgrimage site. Completed in 1444, the Foundling Hospital—**OSPEDALE DEGLI INNOCENTI**—was unprecedented in terms of scale and design (FIG. 20-6).

Brunelleschi created a building that paid homage to traditional forms while introducing features that we associate with the Italian Renaissance style. Traditionally, a charitable foundation's building had a portico open to the street to provide shelter, and Brunelleschi built an arcade of striking lightness and elegance, using smooth round columns and richly carved capitals—his own interpretation of the Classical Corinthian order. Although we might initially assume that the sources for this arcade lay in the Roman architecture of Classical antiquity, columns were not actually used in antiquity to support free-standing arcades, only to support straight architraves. In fact, it was local Romanesque architecture that was the source for Brunelleschi's design. It is the details of capitals and moldings that bring an air of the antique to this influential building.

The underlying mathematical basis for Brunelleschi's design—traced to the same Pythagorean proportional systems that were believed to create musical harmony—creates a distinct sense of harmony in this graceful arcade. Each bay encloses a cube of space defined by the 10-*braccia* (20–foot) height of the columns and the diameter of the arches. Domical vaults, half as high again as the columns, cover the cubes. The bays at the end of the arcade are slightly larger than the rest, creating a subtle frame for the composition. Brunelleschi defined the perfect squares

20-6 Filippo Brunelleschi **OSPEDALE DEGLI INNOCENTI (FOUNDLING HOSPITAL), FLORENCE**
Designed 1419; begun under Brunelleschi's direct supervision 1421–1427; construction continued into the 1440s.

Credit: Deposit Photos/Glow Images

20–7 Andrea della Robbia **INFANT IN SWADDLING CLOTHES (ONE OF THE HOLY INNOCENTS MASSACRED BY HEROD)**
Ospedale degli Innocenti (Foundling Hospital), Florence. c. 1487. Glazed terra cotta.

Credit: pio3/Fotolia

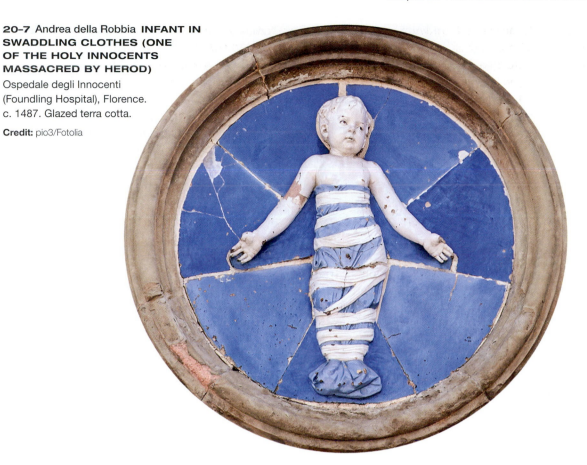

and semicircles of his building with **pietra serena**, a gray Tuscan sandstone, against plain white walls. His training as a goldsmith and sculptor served him well as he led his artisans to carve crisp, elegantly detailed capitals and moldings for the covered gallery.

A later addition to the building seems especially suitable: About 1487, Andrea della Robbia, who had inherited the family ceramics firm and its secret **glazing** formulas from his uncle Luca, created for the spandrels between the arches glazed terra-cotta medallions (**FIG. 20-7**) that signified the building's function. Molds were used in the ceramic workshop to facilitate the production of the series of similar babies in swaddling clothes, one of which was placed at the center of each medallion. The terra-cotta forms were covered with a tin glaze to make the sculptures both weatherproof and decorative, and the baby-blue ceramic backgrounds—a signature color for the della Robbia family workshop—makes the babies seem to float as celestial apparitions. This is not altogether inappropriate. Although they clearly refer to the foundlings (*innocenti*) cared for in the hospital, they are also meant to evoke the innocent baby boys martyred by King Herod in his attempt to rid his realm of the potential rival the Magi had journeyed to venerate (Matthew 2:16).

Andrea della Robbia's ceramic babies—which remain among the most beloved images of the city of Florence—seem to lay claim to the human side of Renaissance humanism, reminding viewers that the city's wealthiest guild cared for the most helpless members of society. Perhaps the Foundling Hospital spoke to fifteenth-century Florentines' increased sense of social responsibility. Or perhaps, by so publicly demonstrating social concerns, the wealthy guild that sponsored the hospital solicited the support of the lower classes in the cut-throat power politics of the day.

SAN LORENZO For the Medicis' parish church of San Lorenzo, Brunelleschi designed and built a centrally planned sacristy (a room where ritual attire and vessels are kept) from 1421 to 1428 and also conceived plans for a new church. The church has a basilican plan with a long nave flanked by side aisles that open into shallow lateral chapels (**FIG. 20-8**). A short transept and square crossing lead to a square sanctuary flanked by additional chapels opening off the transept. Brunelleschi based his mathematically regular plan on a square module—a basic unit of measure that could be multiplied or divided and applied to every element of the design, creating a series of clear, harmonious spaces. Architectural details, all in a Classical style, were carved in the dark gray *pietra serena*, that became synonymous with Brunelleschi's interiors. Below the plain clerestory with its unobtrusive openings, the arches of the nave arcade are carried on tall, slender Corinthian columns made even taller by the insertion of an impost block between the column capital and the springing of the round arches—one of Brunelleschi's

20–8A Filippo Brunelleschi (continued by Michelozzo di Bartolomeo) **INTERIOR OF CHURCH OF SAN LORENZO, FLORENCE**

c. 1421–1428; nave (designed 1434?) 1442–1470.

Credit: © Studio Fotografico Quattrone, Florence

20–8B Filippo Brunelleschi (continued by Michelozzo di Bartolomeo) **PLAN OF CHURCH OF SAN LORENZO, FLORENCE**

c. 1421–1428; nave (designed 1434?) 1442–1470.

favorite details. Flattened architectural moldings in *pietra serena* repeat the arcade in the outer walls of the side aisles, and each bay is covered by its own shallow domical vault. Brunelleschi's rational approach, clear sense of order, and innovative incorporation of Classical motifs inspired later Renaissance architects, many of whom learned from his work firsthand by completing his unfinished projects.

THE MEDICI PALACE Brunelleschi may have been involved in designing the nearby Medici Palace (now known as the **PALAZZO MEDICI-RICCARDI**) in 1446. According to Giorgio Vasari, the sixteenth-century artist and theorist who wrote the first modern history of art, Cosimo de' Medici the Elder rejected Brunelleschi's model for the **palazzo** as too grand (any large house was called a *palazzo*—"palace"). Many now attribute the design of the building to Michelozzo. The austere exterior (**FIG. 20–9**) was in keeping with the Florentine political climate and religious attitudes, both imbued with the Franciscan ideals of poverty and charity. Like many other European cities, Florence had sumptuary laws that forbade ostentatious displays of wealth—but they were often ignored. For example, private homes were supposed to be limited to a dozen rooms, but Cosimo acquired and demolished 20 small houses to provide the site for his new residence. His house was more than a dwelling place; it was his place of business, his company headquarters. The palazzo symbolized the family and established its place in the Florentine social hierarchy.

Huge in scale—each story is more than 20 feet high—the building is marked by harmonious proportions and elegant, Classically inspired details. On one side, the ground floor originally opened through large, round arches onto the street, creating in effect a loggia that provided space for the family business. These arches were walled up in the sixteenth century and given windows designed by Michelangelo. The large, **rusticated** stone blocks—that is, blocks

with their outer faces left rough—facing the lower story clearly set it off from the upper two levels. In fact, all three stories are distinguished by stone surfaces that vary from sculptural at the ground level to almost smooth dressed stone on the third floor.

The builders followed the time-honored tradition of placing rooms around a central courtyard. Unlike the plan of the house of Jacques Coeur (SEE FIG. 19–24A), however, the Palazzo Medici-Riccardi courtyard is square in plan with rooms arranged symmetrically (FIG. 20–10). Round arches on slender columns form a continuous arcade under an enclosed second story. Disks bearing the Medici arms top each arch in a frieze decorated with swags in **sgraffito** work (decoration produced by scratching through a darker layer of plaster or glaze). Such classicizing elements, inspired by the study of Roman ruins, gave the great house an aura of dignity and stability that enhanced the status of its owners. The Medici Palace inaugurated a new fashion for monumentality and regularity in residential Florentine architecture.

Sculpture

The new architectural language inspired by ancient Classical forms was accompanied by a similar impulse in sculpture. By 1400, Florence had enjoyed internal stability and economic prosperity for over two decades. However, until 1428, the city and its independence were challenged by two great anti-republican powers: the duchy of Milan and the kingdom of Naples. In an atmosphere of wealth and civic patriotism, Florentines turned to commissions that would express their self-esteem and magnify the importance of their city. A new attitude toward realism, space, and the Classical past set the stage for more than a century of creativity. Sculptors led the way.

20–9 Attributed to Michelozzo di Bartolomeo **FAÇADE, PALAZZO MEDICI-RICCARDI, FLORENCE**

Begun 1446 (the view shown here includes a two-bay extension constructed during the 19th century).

For the palace site, Cosimo de' Medici the Elder chose the Via de' Gori at the corner of the Via Larga, the widest city street at that time. Despite his practical reasons for constructing a large residence and the fact that he chose simplicity and austerity over grandeur in the exterior design, his detractors commented and gossiped. As one exaggerated, "[Cosimo] has begun a palace which throws even the Colosseum at Rome into the shade."

Credit: © Achim Bednorz, Cologne

20–10 COURTYARD WITH SGRAFFITO DECORATION, PALAZZO MEDICI-RICCARDI, FLORENCE

Begun 1446.

Credit: © Studio Fotografico Quattrone, Florence

20–11 EXTERIOR VIEW OF ORSANMICHELE SHOWING SCULPTURE IN NICHES
Florence. Begun 1337.

At street level, Orsanmichele was constructed originally as an open loggia (similar to the Loggia dei Lanzi in FIG. 18–2); in 1380 the spaces under the arches were filled in. In this view of the southeast corner, appearing on the receding wall to the left is first (in the foreground on the corner pier) Donatello's *St. George*, then, Nanni di Banco's *Four Crowned Martyrs*. However, the sculptures seen in this photograph are modern replicas; the originals have been removed to museums for safekeeping.

Credit: © Studio Fotografico Quattrone, Florence

ORSANMICHELE In 1339, 14 of Florence's most powerful guilds had been commissioned to fill the ground-floor niches that decorated the exterior of **ORSANMICHELE**—a newly completed loggia that served as a grain market—with sculpted images of their patron saints (**FIG. 20-11**). By 1400, only three had fulfilled this assignment. In the new climate of republicanism and civic pride, the government pressured the guilds to fill their niches. This directive resulted in a dazzling display of sculpture produced by the most impressive local practitioners, including Nanni di Banco, Lorenzo Ghiberti, and Donatello, each of whom took responsibility for filling three niches.

In about 1409, Nanni di Banco (c. 1385–1421), son of a sculptor in the Florence Cathedral workshop, was commissioned by the stonecarver and woodworkers' guild (to which he himself belonged) to produce **THE FOUR CROWNED MARTYRS** (**FIG. 20-12**). According to tradition, these third- or fourth-century Christian martyrs were sculptors executed for refusing to make an image of a pagan Roman god for Emperor Diocletian. Although the architectural setting is Gothic in style, Nanni's

figures—with their solid bodies, heavy yet form-revealing togas, noble hair and beards, and portraitlike features—reveal his interest in ancient Roman sculpture, particularly portraiture (SEE FIG. 6–15). They testify to this sculptor's role in the Florentine revival of interest in antiquity.

The saints convey a new spatial relationship to the building and to the viewer. They stand in a semicircle, with feet and drapery protruding beyond the floor of the niche and into the viewer's space. The saints appear to be four individuals interacting within their own world, but a world that opens to engage with passing pedestrians (SEE FIG. 20–11). The relief panel below the niche shows the four sculptors at work, embodied with a similar solid vigor. Nanni deeply undercut both figures and objects to cast shadows that enhance the illusion of three-dimensionality.

DONATELLO Donatello (Donato di Niccolò di Betto Bardi, c. 1386/1387–1466) also received three commissions for the niches at Orsanmichele during the first quarter of the century. Like Nanni a member of the guild of stonecarvers and woodworkers, he worked in both

media, as well as in bronze. During a long and productive career, he developed into one of the most influential and distinguished figures in the history of Italian sculpture, approaching each commission as if it were the opportunity for a new experiment. One of Florence's lesser guilds—the armorers and sword-makers—called on Donatello to carve a majestic and self-assured **ST. GEORGE** for their niche (**FIG. 20–13**). As originally conceived, the saint would have been a standing advertisement for their trade, carrying a metal sword in his right hand and probably wearing a metal

20–12 Nanni di Banco **THE FOUR CROWNED MARTYRS**
c. 1409–1417. Marble, height of figures 6′ (1.83 m). Photographed *in situ* before removal of the figures to the Museo di Orsanmichele, Florence.

Credit: © Studio Fotografico Quattrone, Florence

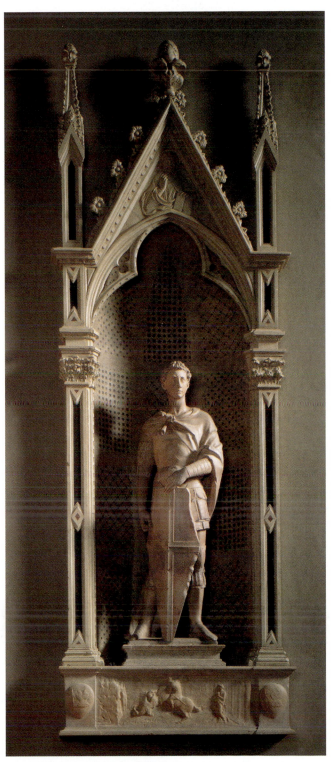

20–13 Donatello **ST. GEORGE**
Formerly in Orsanmichele, Florence. 1417–1420. Marble, height 6′5″ (1.95 m). Museo Nazionale del Bargello, Florence.

Credit: © Studio Fotografico Quattrone, Florence

20–14 Donatello DAVID
c. 1446–1460 (?). Bronze, height 5'2¼" (1.58 m). Museo Nazionale del Bargello, Florence.

This sculpture is first recorded as being in the courtyard of the Medici Palace in 1469, where it stood on a base inscribed with these lines:

The victor is whoever defends the fatherland.
All-powerful God crushes the angry enemy.
Behold, a boy overcomes the great tyrant.
Conquer, O citizens!

Credit: © Studio Fotografico Quattrone, Florence

helmet and sporting a scabbard, all now lost. The figure has remarkable presence, even without his accessories. St. George stands in solid defiance, legs braced to support his armor-heavy torso. He seems to stare out into our world, perhaps sizing up his most famous adversary—a dragon that was holding a princess captive—lurking in the space behind us. With his wrinkled brow and determined expression, he is alert and focused, if perhaps also slightly worried. This complex psychological characterization of the warrior-saint particularly impressed Donatello's contemporaries, not least among them his potential patrons.

For the base of the niche, Donatello carved a remarkable shallow relief showing St. George slaying the dragon and saving the princess, a well-known part of his story. The contours of the foreground figures are slightly undercut to emphasize their mass, while the landscape and architecture are in progressively lower relief until they are barely incised rather than carved, an ingenious emulation of the painter's technique of atmospheric perspective. This is also a pioneering example of linear perspective (see "Renaissance Perspective" on page 623), in which the orthogonals converge on the figure of the saint himself. Donatello used this timely representational system not only to simulate spatial recession, but also to provide narrative focus.

Donatello's long career as a sculptor in a broad variety of media established him as one of the most successful and admired sculptors of the Italian Renaissance. He excelled in part because of his attentive exploration of human emotions and expression, as well as his ability to solve the technical problems posed by various media—from lost-wax casting in bronze and carved marble to polychromed wood.

Donatello's bronze **DAVID** was the first life-size, free-standing nude since antiquity (**FIG. 20–14**), Since nothing is known about the circumstances of its creation, this statue has been the subject of continuing inquiry and speculation. Although the representation of David clearly draws on the Classical tradition of heroic nudity, the meaning of this sensuous, pre-pubescent boy in a jaunty, laurel-trimmed shepherd's hat and boots has long piqued interest. Some art historians have stressed an overt homoeroticism, especially in the openly effeminate conception of David and the way a wing from the helmet on Goliath's severed head brushes the young hero's inner thigh. Others have seen in David's angular pose and boyish torso a sense that he is poised between childish interests and adult responsibility, an image of improbable heroism. David was a potent political image in Florence, a symbol of the citizens' resolve to oppose tyrants regardless of their superior power, since virtue brings divine support and preternatural strength, and we will see other Florentine Renaissance renderings of this biblical hero. Indeed, an inscription engraved into the base where the sculpture once stood suggests that it could have celebrated the Florentine triumph over the Milanese in 1425, a victory that brought resolution to a

20–15 Donatello
**EQUESTRIAN STATUE
OF ERASMO DA NARNI
(GATTAMELATA)**
Piazza del Santo, Padua.
1443–1453. Bronze, height
approx. 12′2″ (3.71 m).

Credit: © akg-images/Cameraphoto

quarter-century struggle with despots and helped give Florence a vision of itself as a strong, virtuous republic.

Probably in 1443, Donatello traveled to Padua to execute one of the first life-size bronze equestrian portraits of the Renaissance—an **EQUESTRIAN STATUE** (FIG. **20–15**) commemorating the Paduan general of the Venetian army, Erasmo da Narni, nicknamed "Gattamelata" (meaning "Honeyed Cat"—a reference to his mother, Melania Gattelli). If any image could be said to characterize the self-made men of the Italian Renaissance, surely it would be those of the *condottieri*—the brilliant generals such as Gattamelata and Niccolò da Tolentino (SEE FIG. 20–1) who organized the armies and fought for any city-state willing to pay for their services. As guardians for hire, they were tough, opportunistic mercenaries. But they also subscribed to an ideal of military and civic virtue. Horsemanship was more than a necessary skill for the *condottieri*. The horse, a

beast of enormous strength, symbolized animal passions, and skilled horsemanship demonstrated physical and intellectual control—self-control, as well as control of the animal—the triumph of "mind over matter."

Donatello's sources for this statue were surviving Roman bronze equestrian portraits, notably the famous image of Marcus Aurelius (SEE FIG. 6–56), which the sculptor certainly knew from his stay in Rome, and the famous set of Roman bronze horses installed on the façade of St. Mark's Cathedral in Venice. Viewed from a distance, Donatello's man–animal juggernaut, installed on a high marble base in front of the church of Sant'Antonio in Padua, seems capable of thrusting forward at the first threat. Seen up close, however, the man's sunken cheeks, sagging jaw, ropy neck, and stern but sad expression suggest a warrior grown old and tired from the constant need for military vigilance and rapid response.

20–16 Lorenzo Ghiberti "GATES OF PARADISE" (EAST BAPTISTERY DOORS)

Formerly on the Baptistery of San Giovanni, Florence. 1425–1452. Gilt bronze, height 15′ (4.57 m). Museo dell'Opera del Duomo, Florence.

The door panels, commissioned by the wool manufacturers' guild, depict ten scenes from the Hebrew Bible beginning with the Creation in the upper left panel. The murder of Abel by his brother, Cain, follows in the upper right panel, succeeded in the same left–right paired order by the Flood and the drunkenness of Noah, Abraham sacrificing Isaac; the story of Jacob and Esau, Joseph sold into slavery by his brothers; Moses receiving the Tablets of the Law, Joshua and the fall of Jericho; and finally David and Goliath, Solomon and the queen of Sheba. Ghiberti placed his own portrait as a signature in the frame at the lower right corner of the Jacob and Esau panel. He wrote in his *Commentaries* (c. 1450–1455): "I strove to imitate nature as clearly as I could, and with all the perspective I could produce, to have excellent compositions with many figures."

Credit: © 2016 Photo Scala, Florence

GHIBERTI'S GATES OF PARADISE The bronze doors that Lorenzo Ghiberti (1381?–1455) produced for the Florentine Baptistery after winning his famous competition with Brunelleschi in 1401 were such a success that in 1425 he was awarded the commission for yet another set of bronze doors for the east side of the baptistery, facing the doors of the cathedral; his first set of doors was moved to the north side. The new door panels, funded by the wool manufacturers' guild, were a significant conceptual leap from the older schemes of 28 small scenes employed for Ghiberti's earlier doors and those of Andrea Pisano in the fourteenth century (SEE FIG. 18–3). Ghiberti departed entirely from the old arrangement, producing a set of ten scenes from the Hebrew Bible—from the Creation to the reign of Solomon—composed in rectangular fields, like a set of framed paintings. Michelangelo reportedly said that the results, installed in 1452, were worthy of the **"GATES OF PARADISE"**—the name by which they are now commonly known (FIG. 20–16).

Ghiberti organized the space in the ten square reliefs either by a system of linear perspective with obvious orthogonal lines (see "Renaissance Perspective" on page 623) or more intuitively by a series of arches, rocks, or trees charting a path into the distance. Foreground figures are grouped in the

lower third of each panel, while the other figures decrease gradually in size to map their positioning in deep space. The use of a system of perspective, with clearly differentiated background and foreground, also helped Ghiberti combine a series of related events, separated by narrative time, within a single pictorial frame.

The story of **JACOB AND ESAU** (Genesis 25 and 27) fills the center panel of the left door. Ghiberti creates a coherent and measurable space peopled by graceful, idealized figures (FIG. 20–17). He pays careful attention to one-point perspective in laying out the architectural setting. Squares in the pavement establish the receding lines of the orthogonals that converge on a vanishing point under the loggia, while towering arches overlap and gradually diminish in size from foreground to background to define the receding space above the figures. The story unfolds in a series of individual episodes beginning in the background. On the rooftop (upper right) Rebecca stands, listening as God warns of her unborn sons' future conflict; under the left-hand arch she gives birth to the twins. The adult Esau sells his rights as oldest son to his brother Jacob, and when he goes hunting (center right), Rebecca and Jacob plot against him. Finally, in the right foreground, Jacob receives Isaac's blessing, while in the center, Esau faces his father. Ghiberti's portrayal of the scene relates more closely to developments in painting than to contemporary sculpture. Ghiberti not only signed his work, but also included his self-portrait in the medallion beside the lower right corner of this panel.

20–17 Lorenzo Ghiberti JACOB AND ESAU, PANEL OF THE "GATES OF PARADISE" (EAST BAPTISTERY DOORS)

Formerly on the Baptistery of San Giovanni, Florence. c. 1435. Gilded bronze, 31¼″ (79 cm) square. Museo dell'Opera del Duomo, Florence.

Credit: © Studio Fotografico Quattrone, Florence

Masaccio

Even though his career lasted less than a decade, Tommaso di Ser Giovanni di Mone Cassai (1401–1428/1429?), nicknamed "Masaccio" (meaning "Big Tom"), established a new direction in Florentine painting much as Giotto had a century earlier. He did this by integrating monumental and consistently scaled figures into rational architectural and natural settings using linear perspective. The chronology of Massacio's works is uncertain, but his fresco of the **TRINITY** in the church of Santa Maria Novella in Florence must have been painted around 1426, the date on the Lenzi family tombstone that once stood in front of it (**FIGS. 20–18, 20–19**).

Masaccio's fresco was meant to give the illusion of a stone funerary monument and altar table set below a deep **aedicula** (framed niche) in the wall. The effect of looking up into a barrel-vaulted niche was made plausible through precisely rendered linear perspective. The eye level of an adult male viewer standing within the church determined the horizon line on which the vanishing point was centered, just below the kneeling figures above the altar. And the painting demonstrates not only Masaccio's intimate

20–18 Masaccio **TRINITY WITH THE VIRGIN, ST. JOHN THE EVANGELIST, AND DONORS**
Church of Santa Maria Novella, Florence. c. 1425–1427/1428. Fresco, 21′ × 10′5″ (6.4 × 3.2 m).

Credit: © Studio Fotografico Quattrone, Florence

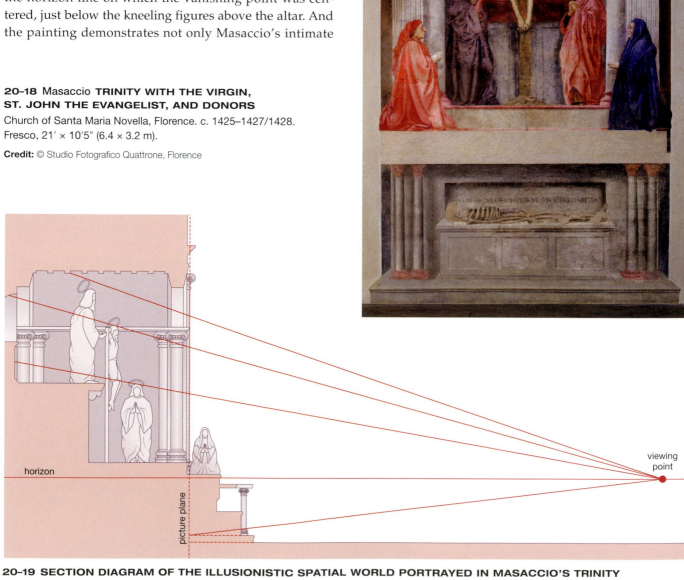

20–19 SECTION DIAGRAM OF THE ILLUSIONISTIC SPATIAL WORLD PORTRAYED IN MASACCIO'S TRINITY

horizon

picture plane

viewing point

Technique

RENAISSANCE PERSPECTIVE

Fifteenth-century Italian artists developed a system known as linear, or mathematical, perspective that enabled them to represent three dimensions on a two-dimensional surface, simulating the recession of space in the visible world pictorially in a way they found convincing. The sculptor and architect Filippo Brunelleschi first demonstrated the system about 1420, and the theorist and architect Leon Battista Alberti codified it in 1436 in his treatise *Della Pittura* (*On Painting*).

For Alberti, in one-point linear perspective a picture's surface was conceived as a flat plane that intersected the viewer's field of vision at right angles. This highly artificial concept presumed a viewer standing dead center at a prescribed distance from a work of art. From this single fixed vantage point, everything would appear to recede into the distance at the same rate, following imaginary lines called orthogonals that met at a single **vanishing point** on the horizon. By using orthogonals in concert with controlled diminution of scale as forms move back toward the vanishing point, artists could replicate the optical illusion that things appear to grow smaller, rise higher, and come closer together as they get farther away from us. Linear perspective makes pictorial spaces seem almost like extensions of the viewer's real space, creating a compelling, even exaggerated sense of depth (**FIG. 20-20**).

Linear perspective is not the only way to simulate spatial recession in two dimensions (see "Pictorial Devices for Depicting Recession in Space" in the Starter Kit on page xviii). In atmospheric perspective, for example, variations in color and clarity convey the feeling of distance: objects and landscape are portrayed less clearly, and colors become grayer, in the background, imitating the natural effects of a loss of clarity and color when viewing things in the distance through an atmospheric haze.

20-20A Perugino **CHRIST GIVING THE KEYS TO ST. PETER**

Fresco on the right wall of the Sistine Chapel (SEE FIG. 20–41), Vatican, Rome. c. 1480–1482. 11′5½″ × 18′8½″ (3.48 × 5.70 m).

Perugino's painting is, among other things, a representation of Alberti's ideal city, described in *De Re Aedificatoria* as having a "temple" (that is, a church) at the very center of a great open space, raised on a dais and separate from any other buildings that might obstruct it.

Credit: Canali Photobank, Milan, Italy

20-20B SCHEMATIC DRAWING SHOWING THE ORTHOGONALS AND VANISHING POINT OF CHRIST GIVING THE KEYS TO ST. PETER

Christ Giving the Keys to St. Peter is a remarkable study in linear perspective. The clear demarcation of the paving stones of the piazza provides a network of orthogonal and horizontal lines for the measured placement of the figures. People and buildings become systematically smaller as the space recedes. Horizontally, the composition is divided between the foreground frieze of figures and the widely spaced background buildings; it is vertically divided by the open space at the center between Christ and Peter and by the symmetrical architectural forms on either side of this central axis.

20–21 Masaccio THE EXPULSION OF ADAM AND EVE FROM PARADISE

Brancacci Chapel, church of Santa Maria del Carmine, Florence. c. 1427. Fresco, 7′ × 2′11″ (214 × 90 cm).

Cleaning and restoration of the Brancacci Chapel paintings revealed the remarkable speed and skill with which Masaccio worked. He painted Adam and Eve in four *giornate* (each *giornata* of fresh plaster representing a day's work). Working from the top down and left to right, he painted the angel on the first day, the portal on the second day, Adam on the third day, and Eve on the fourth.

knowledge of Brunelleschi's perspective experiments (see "Renaissance Perspective" on page 623), but also his architectural style (SEE FIG. 20-8). The painted architecture is an unusual combination of Classical orders. On the wall surface, Corinthian pilasters support a plain architrave below a cornice, while inside the niche Renaissance variations on Ionic columns support framing arches at the front and rear of the barrel vault. The "source" of the consistent illumination of the architecture lies in front of the picture, casting reflections on the coffers, or sunken panels, of the ceiling.

The figures are organized in a measured progression through space. At the near end of the recessed, barrel-vaulted space is the Trinity—Jesus on the cross, the dove of the Holy Spirit poised in downward flight above his tilted halo, and God the Father, who stands behind to support the cross from his perch on a high platform. As in many scenes of the Crucifixion, Jesus is flanked by the Virgin Mary and John the Evangelist, who contemplate the scene on either side of the cross. Mary gazes calmly out at us, her raised hand drawing our attention to the Trinity. Members of the Lenzi family kneel in front of the pilasters—thus closer to us than the Crucifixion; the red robes of the male donor signify that he was a member of the governing council of Florence. Below these donors, in an open sarcophagus, is a skeleton, a grim reminder of the Christian belief that since death awaits us all, our only hope is redemption and the promise of life in the hereafter, rooted in Christ's sacrifice on the cross. The inscription above the skeleton reads: "I was once that which you are, and what I am you also will be."

THE BRANCACCI CHAPEL Masaccio's brief career culminated in the frescos he painted on the walls of the Brancacci Chapel in the church of Santa Maria del Carmine in Florence. Two of the best-known scenes are **THE EXPULSION OF ADAM AND EVE FROM PARADISE** (FIG. 20-21) and **THE TRIBUTE MONEY** (FIG. 20-22). In *The Expulsion*, Masaccio presented Adam and Eve as monumental nude figures, combining his studies of the human figure with an intimate knowledge of ancient Roman sculpture. In contrast to Flemish painters, who sought to record every detail of a figure's surface (compare Adam and Eve from FIG. 19-13), Masaccio focused on the mass of the bodies formed by the underlying bone and muscle structure; a single light source emphasizes their physicality with modeled forms and cast shadows. Departing from earlier interpretations of the event, which emphasized wrongdoing and the fall from grace, Masaccio concerns himself with the psychological impact of shame on these first humans, who have been cast out of paradise and thrown naked into the world.

In *The Tribute Money* (SEE FIG. 20–22), Masaccio portrays an incident from the life of Jesus that highlights St. Peter (Matthew 17:24–27), to whom this chapel was dedicated.

20–22 Masaccio **THE TRIBUTE MONEY**
Brancacci Chapel, church of Santa Maria del Carmine, Florence. c. 1427. Fresco, 8'1" × 19'7" (2.46 × 6 m).

Credit: © Studio Fotografico Quattrone, Florence

In the central scene a tax collector (dressed in a short red tunic and seen from behind) asks Peter (in the left foreground with the short gray beard) if Jesus pays the Jewish temple tax (the "tribute money" of the title). Set against the stable backdrop of a semicircular block of apostolic observers, a masterful series of dynamic diagonals in the postures and gestures of the three main figures interlocks them in a compositional system that gives their interaction a sense of tension calling out for resolution. Jesus instructs Peter to "go to the sea, drop in a hook, and take the first fish that comes up," which Peter does at the far left. In the fish's mouth is a coin, which Peter gives to the tax collector at the far right. The tribute story was especially significant for Florentines because in 1427, to raise money for defense against military aggression, the city enacted a graduated tax, based on the value of people's personal property.

The Tribute Money is particularly remarkable for its early use of both linear and atmospheric perspective to integrate figures, architecture, and landscape into a consistent whole. Jesus and the apostles surrounding him form a clear central focus, from which the landscape seems to recede naturally into the far distance. To create this illusion, Masaccio used linear perspective in the depiction of the house, and then reinforced it by diminishing the sizes of the distant trees and the crouching Peter at far left. The central vanishing point established by the orthogonals of the house corresponds with the head of Jesus.

The cleaning of the painting in the 1980s revealed that it was painted in 32 *giornate* (a *giornata* is a section of fresh

plaster that could be prepared and painted in a single day; see "*Buon Fresco*" in Chapter 18 on page 551). The cleaning also uncovered Masaccio's subtle use of color to create atmospheric perspective in the distant landscape: Mountains fade from grayish-green to grayish-white, and the houses and trees on their slopes are loosely sketched to simulate the lack of clear definition when viewing things in the distance through a haze. Green leaves were painted on the branches *al secco* (meaning "on the dry plastered wall").

As in *The Expulsion*, Masaccio modeled the foreground figures here with bold highlights and long shadows on the ground toward the left, giving a strong sense of volumetric solidity and implying a light source at the far right, as if the scene were lit by the actual window in the rear wall of the Brancacci Chapel. Not only does the lighting give the forms sculptural definition, but the colors also vary in tone according to the strength of the illumination. Masaccio used a wide range of hues—pale pink, mauve, gold, blue-green, seafoam green, apple green, peach— and a sophisticated shading technique using contrasting colors, as in Andrew's green robe, which is shaded with red instead of darker green. The figures of Jesus and the apostles originally had gold-leaf haloes, several of which have flaked off. Rather than silhouette the heads against consistently flat gold circles (for example, see FIG. 18–6), however, Masaccio conceived of haloes as gold disks hovering in space above each head that moved with the heads as they moved, and he foreshortened them depending on the angle from which each head is seen.

Some stylistic innovations take time to be fully accepted, and Masaccio's innovative depictions of volumetric solidity, consistent lighting, and spatial integration—though they clearly had an impact on his immediate successors—were perhaps best appreciated by a later generation of painters. Many important sixteenth-century Italian artists, including Michelangelo, studied and sketched Masaccio's Brancacci Chapel frescos, as they did Giotto's work in the Scrovegni Chapel. In the meantime, painting in Florence after Masaccio's death developed along somewhat different lines.

Painting in Florence After Masaccio

The tradition of covering walls with frescos continued uninterrupted through the fifteenth century. Between 1438 and 1445, Fra Angelico's decoration of the Dominican monastery of San Marco in Florence was one of the most extensive projects.

FRA ANGELICO Guido di Piero da Mugello (c. 1395/1400–1455) earned his nickname "Fra Angelico" ("Angelic Brother") through his piety as well as his painting: In 1982, he was beatified, the first step toward sainthood. Fra Angelico is first documented painting in Florence in 1417–1418, and he remained an active painter after taking vows as a Dominican monk in nearby Fiesole between 1418 and 1421.

Between 1438 and 1445, in the monastery of San Marco, Fra Angelico and his assistants—probably working under the patronage of Cosimo de' Medici—created paintings to inspire meditation in each monk's cell (44 in all; see FIGS. Intro-8, Intro-9), in the chapter house (meeting room), and even in the hallways. At the top of the stairs in the north corridor, where the monks passed frequently on their way to their individual cells, Fra Angelico painted a serene picture of the **ANNUNCIATION** (FIG. 20-23). To describe the quiet, measured space where the demure archangel greets the unassuming, youthful Mary, Fra Angelico used linear perspective with striking sensitivity, extending the monks' stairway and corridor outward into an imagined portico and garden beside the Virgin's home. The slender, graceful figures wear quietly flowing draperies and assume modest poses. Natural light falling from the left models their forms gently, casting an almost supernatural radiance over their faces and hands. This is a sacred vision rendered in a contemporary setting, welcoming the monks to the most intimate areas of the monastery and preparing them for their private meditations. The line of Latin text running along the bottom of the picture directs the monks, "As you revere this figure of the intact Virgin while passing before it, beware lest you omit to say a Hail Mary."

20-23 Fra Angelico ANNUNCIATION
North dormitory corridor, monastery of San Marco, Florence. c. 1438–1445. Fresco, 7'1" × 10'6" (2.2 × 3.2 m).

The shadowed vault of the portico is supported by a wall on one side and by slender Ionic and Corinthian columns on the other, a new building technique used by Brunelleschi (SEE FIG. 20-6).

20–24 Paolo Uccello **THE BATTLE OF SAN ROMANO**

1438–1440. Tempera on wood panel, approx. 6′ × 10′6″ (1.82 × 3.2 m). National Gallery, London.

Credit: © 2016. Copyright The National Gallery, London/Scala, Florence

UCCELLO At mid century, when Fra Angelico was still painting his radiant visions of Mary and Jesus in the monastery of San Marco, other artists explored different directions. Thoroughly familiar with the theories of Brunelleschi and Alberti, they had mastered the techniques of depicting figures in a constructed architectural space. Paolo Uccello devoted himself with special fervor to the study of linear perspective (**FIG. 20-24**; see also FIG. 20-1). In his biographies of Italian artists, Vasari described Uccello as a man so obsessed with the science of perspective that he neglected his painting, his family, and even his pet birds (his *uccelli*). According to Vasari, Uccello's wife complained that he sat up drawing all night, and when she called to him to come to bed he would say, "Oh, what a sweet thing this perspective is!" (Vasari, trans. Bondanella and Bondanella, p. 83).

CASTAGNO Andrea del Castagno (c. 1417/1419–1457) is best known for a fresco of **THE LAST SUPPER** painted for a convent of Benedictine nuns in 1447 (**FIG. 20-25**). The subject was often painted in monastic refectories (dining halls) to remind the monks or nuns of Christ's Last Supper with his first followers and encourage them to see their daily gatherings for meals almost as a sacramental act rooted in this biblical tradition. Here Castagno has not portrayed the

20–25 Andrea del Castagno **THE LAST SUPPER**

Refectory, convent of Sant'Apollonia, Florence. 1447. Fresco, width approx. 16 × 32′ (4.6 × 9.8 m).

Castagno worked quickly, completing this huge mural in at most 32 days.

Credit: © Studio Fotografico Quattrone, Florence

scene in the biblical setting of an "upper room." Rather, the humble house of the original account has become a great palace with sumptuous marble revetment. The most brilliantly colored and wildly patterned marble panel frames the off-center heads of Christ and Judas to focus viewers on the most important part of the picture. Judas takes his traditional position on the viewer's side of the table, separated from the other apostles. Equally conventional is the seemingly sleeping figure of St. John, head collapsed onto the tabletop (John 13:23). The lines of floor tiles, ceiling rafters, and paneled walls draw viewers into the scene; the

20-26 Fra Filippo Lippi PORTRAIT OF A WOMAN AND MAN (ANGIOLA DI BERNARDO SAPITI AND LORENZO DI RANIERI SCOLARI?)

c. 1435–1445. Tempera on wood panel, 25¼ × 16½″ (64.1 × 41.9 cm). Metropolitan Museum of Art, New York.

Some art historians have seen in the sumptuousness of this woman's costume an indication that she is a newlywed, outfitted in the extravagant clothing and jewelry presented to her by her husband at the time of their marriage, especially since the pearls sewn with gold threads into the embroidery on her sleeve spell out the word *lealtà*, meaning "loyalty." Florentine law prevented a woman from wearing such ostentatious expressions of wealth—particularly the jewelry—more than three years after her marriage.

nuns would have seen the painting as an extension of their own dining hall. At first, the lines of the orthogonals seem perfectly logical, but close examination reveals that only the lines of the ceiling converge to a single point. Two windows light the painting's room from the direction of the actual refectory windows, further unifying the two spaces.

FRA FILIPPO LIPPI During the middle of the fifteenth century, portraiture came into its own as a major artistic form in Italy, and among the most extraordinary—if enigmatic—examples is this **PORTRAIT OF A WOMAN AND MAN** (FIG. 20-26), an early work of Fra Filippo Lippi (c. 1406–1469). This painting is also the earliest surviving double portrait of the Italian Renaissance. Lippi grew up as an orphan in the Carmelite church where Masaccio had painted frescos in the Brancacci Chapel, and art historians have stressed the impact this work had on Lippi's development as an artist. But although he may have absorbed Masaccio's predilection for softly rounded forms situated in carefully mapped spaces, in Lippi's hands these artistic tools became the basis for pictures that often ask more questions than they answer, by stressing outline at the same time as form and creating complex and often confusing spatial systems.

The emphasis in this double portrait is squarely on the woman. She is spotlighted in the foreground, sharply profiled against a window that serves as an unsettling internal frame, not big enough to contain her. This window opens onto a vista, clearly a fragment of a larger world, but one that highlights an orthogonal to emphasize a spatial recession only partially revealed. The woman blocks most of this vista with her shining visage and sumptuous costume—notably its embroidered velvet, fur lining, and luminous pearls. There is no engagement with the viewer and little sense of likeness. And it is not at all clear what she is looking at, especially since the gaze of the man in the background does not meet hers. He is even more of a mystery. We see only a masklike sliver of his profile, capped by the red *berretta* that signals his high status—although the substantiality of his face is reinforced by the strong shadow it casts against the window casement through which he looks. Unlike the woman, who clasps her inert hands in front of her as if to highlight her rings, this man fidgets with his fingers, perhaps to draw our attention to the heraldic device below him that may identify him as a member of the Scolari family. This could be a double portrait of Lorenzo di Ranieri Scolari and Angiola di Bernardo Sapiti, who married in 1436 and welcomed a son in 1444. But what does the painting say about them? Does it commemorate their marriage, celebrate the birth of their child, or memorialize one of their deaths? All have been proposed by art historians as an explanation for this innovative double portrait, but it remains a puzzle to be pondered. Could that pondering be the point of the picture?

Florentine Art in the Second Half of the Fifteenth Century

How do Renaissance sculpture and painting continue to develop in Florence during the second half of the fifteenth century?

Florence remained a thriving artistic center throughout the fifteenth century. Sculptors continued to explore Classical themes and experiment with the representation of the human form. Florentine painting pursued a love of material opulence, an interest in describing the natural world, and a poetic, mystical spirit, motivated by the patronage of citizens who sought to advertise their wealth and social standing, as well as by the religious fervor that arose at the very end of the century.

20–27 Andrea del Verrocchio **DAVID**
Commissioned by Lorenzo de' Medici for the Medici Palace. c. 1470–1475. Bronze with gilded details, height 49⅝″ (1.26 m). Museo Nazionale del Bargello, Florence.

Credit: © Studio Fotografico Quattrone, Florence

Verrocchio

One of the most prestigious and active workshops in Florence was that of Andrea di Michele Cioni (1435–1488), nicknamed "Verrocchio" ("true eye"). Trained as a goldsmith, but best known for his works as a painter and bronze sculptor, Verrocchio was also a gifted teacher, counting among his pupils Perugino and Leonardo da Vinci. Around 1470, Lorenzo de' Medici commissioned a bronze statue of David from Verrocchio for the Palazzo Medici, the location where Donatello's sculpture of the same subject (SEE FIG. 20-14) was then displayed. Verrocchio's work (**FIG. 20-27**) seems to have been conceived as a response to the demure, sleek, but awkwardly boyish nude of his famous predecessor. Verrocchio's triumphant biblical hero is a poised and proud adolescent, modestly clothed and confidently looking out to meet the gaze of the viewer. Although slight, he is equipped with the developing musculature required for the daunting task—whose accomplishment is signaled by the severed head of his foe, displayed like a trophy between his feet. The careful attention to the textural details of hair and clothing reveal Verrocchio's training as a goldsmith.

Pollaiuolo

Florentine sculptors created not only large-scale figures, but also small works. The ambitious and multi-talented Antonio del Pollaiuolo (c. 1431–1498)—a goldsmith, embroidery designer, printmaker, sculptor, and painter who came to work for the Medici family in Florence about 1460—created mostly small bronze sculptures. His **HERCULES AND ANTAEUS** of about 1475 is one of the largest (**FIG. 20-28**). This study of complex, interlocking figures has an explosive energy that can best be appreciated by viewing it from every angle.

Statuettes of religious subjects were still popular, but humanist patrons were beginning to collect bronzes of Classical subjects. Many sculptors, especially those trained as goldsmiths, started to cast small copies of well-known ancient works. Some artists also executed original designs *all'antica* ("in the antique style") to appeal to a cultivated humanist taste. Hercules was always a popular figure; as a patron of Florence, he was on the city seal. Among the many courageous acts by which Hercules gained immortality was the slaying of the evil Antaeus in a wrestling match by lifting him off the Earth, the source of the giant's great physical power.

An engraving by Pollaiuolo, **THE BATTLE OF THE NUDES** (**FIG. 20-29**), reflects two interests of Renaissance scholars—anatomical research and the study of Classical sculpture. Although this is Pollaiuolo's only known print, it was still highly influential. He may have intended it as a compositional study of the human figure in action.

20–28 Antonio del Pollaiuolo **HERCULES AND ANTAEUS**

c. 1475. Bronze, height with base 18″ (45.7 cm). Museo Nazionale del Bargello, Florence.

Credit: © 2016. Photo Scala, Florence - courtesy of the Ministero Beni e Att. Culturali

The naked men fighting each other ferociously against a tapestrylike background of foliage seem to represent the same individual in a variety of poses, many of which were taken from Classical sources. Like the artist's *Hercules and Antaeus*, much of the engraving's fascination lies in its depiction of the muscles of the male body reacting under tension. This depiction is more impressive than realistic; anatomical accuracy was clearly not the point.

The Morelli-Nerli Wedding Chests

The palazzos of wealthy Florentine families were outfitted with massive pieces of elaborate furniture. Constructed of richly carved wood that was gilded and often covered with paintings, these household objects were a central feature of the fifteenth-century Florentine art world. Some of the most impressive surviving examples of Renaissance furniture are great chests—called **cassoni**—that were used to store clothing and other precious personal objects in a couple's bedroom. They were frequently commissioned in pairs on the occasion of a wedding.

Marriages between members of wealthy Florentine families were not the result of romantic connections between two young people. They were political alliances and economic transactions that involved the transfer of capital and gifts as displays of wealth. In preparation for such marriages, husbands refurbished their living quarters in the family palazzo, where they would bring a bride into the household. We have a detailed accounting of the extent of work required, as well as the expenditure, when 30-year-old Lorenzo di Matteo Morelli prepared his apartments for the arrival of his young bride, Vaggia di Tanai

20–29 Antonio del Pollaiuolo **THE BATTLE OF THE NUDES**

c. 1490. Engraving, 15¾ × 22¹³⁄₁₆″ (40 × 58 cm). Yale University Art Gallery, New Haven, Connecticut. Maitland F. Griggs, B.A. 1896, Fund (1951.9.18).

Credit: Image courtesy Yale University Art Gallery

20–30 Jacopo del Sellaio, Biagio d'Antonio (painters), and Zanobi di Domenico (woodworker) **CASSONE MADE FOR THE MARRIAGE OF LORENZO DI MATTEO MORELLI AND VAGGIA DI TANAI NERLI (ONE OF A SET OF TWO)**
1472. Tempera and gold on wood, chest 83½ × 75 × 30″ (212 × 193 × 76.2 cm). The Samuel Courtauld Trust, the Courtauld Gallery, London. (F.1947.LF.4).

Credit: © Samuel Courtauld Trust, The Courtauld Gallery, London, UK/Bridgeman Images

Nerli, after their marriage in 1472. His commissioning of a pair of *cassoni*—one for him and one for Vaggia—represented almost two-thirds of the entire cost of redecoration. Fortunately, the two chests still survive (**FIG. 20–30**). They are among the most important and best-preserved Renaissance *cassoni* that have come down to us, especially since they still maintain the original backboard—called a *spalliera*—that was produced concurrent with and hung on the wall directly behind the chests when they were placed in Lorenzo's bedroom. The lion's feet on which the chests now stand are modern additions, and the *spalliera* was originally hung as one continuous painting above both *cassoni*, not two separate panels mounted behind each lid as in the current configuration. Otherwise these chests give a strong sense of their original appearance.

Like most Renaissance *cassoni*, Lorenzo's chest is painted with pictures drawn from stories that extol moral virtues and reflect some of their values and glories on Lorenzo himself. The long painted scene on the front tells the story of ancient Roman hero Marcus Furius Camillus

defeating the Gauls as he chases them out of Rome. On the *spalliera*, *trompe l'oeil* ("fool-the-eye") curtains part to reveal the scene of another Roman hero defending a bridge against insurmountable odds. Presumably Lorenzo wanted to be seen as the heroic descendant of such illustrious Romans—strong, brave, and triumphant. The scenes portrayed on Vaggia's chest (like Lorenzo's, identified by her coat of arms) challenge her to care for the children she is expected to produce and to practice the virtues of temperance, prudence, and patience that were valued in Florentine patrician brides.

The Morelli–Nerli *cassoni* passed from Lorenzo to his son, and they remained in the Morelli family at least until 1680, maybe into the nineteenth century, when they first appeared together on the art market. Elaborate Renaissance furniture became coveted items in the homes of wealthy art collectors in late nineteenth-century Europe and America, where the new owners doubtless saw themselves as worthy successors to the rich and powerful merchants who had originally commissioned them.

Ghirlandaio

The most prolific later fifteenth-century Florentine painting workshop was that of Domenico di Tommaso Bigordi (1449–1494), known as "Ghirlandaio" ("Garland-Maker"), a nickname first adopted by his father, who was a goldsmith noted for his floral wreaths. A skilled storyteller, the younger Ghirlandaio reinterpreted the art of earlier fifteenth-century painters into a visual language of descriptive immediacy and structural clarity. Among Ghirlandaio's most impressive narrative programs was the fresco cycle of the **LIFE OF ST. FRANCIS**, commissioned by the wealthy manager of the Medici bank, Francesco Sassetti, and painted between 1483 and 1486 on the walls of the Sassetti family burial chapel in the Florentine church of Santa Trinità (**FIG. 20–31**).

In the uppermost tier of the paintings (**FIG. 20–32**), Pope Honorius gives a confirmation of the Franciscan order to the kneeling figure of St. Francis, with the Loggia dei Lanzi and the Palazzo della Signoria (SEE FIG. 18–2) in the background. The foreground figures—arranged in a composition that parallels the sacred scene behind them—are portrait likenesses of well-known Florentines. At far right are (from left to right) poet Antonio Pucci, Lorenzo de' Medici, the patron Francesco Sassetti, and Sassetti's son Federigo, all of whom seem to be receiving the approaching retinue coming up the stairs at the lower center of the fresco—humanist poet Poliziano leading his pupils, the sons of Lorenzo de' Medici. Just below this scene, in the middle register (SEE FIG. 20–31), a small boy who has fallen from an upper window is resurrected by St. Francis. This miracle is likewise witnessed by contemporary Florentines, including other members of the Sassetti family and Ghirlandaio himself, and the scene takes place in the piazza outside the actual church of Santa Trinità. Ghirlandaio has thus transferred both events from thirteenth-century Rome to contemporary Florence, painting recognizable views of the city and portraits of living Florentines, and delighting in local color and anecdotal detail. Perhaps Renaissance painters, like Gothic painters, represented sacred narratives in contemporary settings to emphasize their current relevance, or perhaps they and their patrons simply enjoyed seeing themselves dressed in their finery, witnessing these dramas within the cities of which they were justifiably proud.

The altarpiece Ghirlandaio painted for the Sassetti Chapel portrays the **NATIVITY AND ADORATION OF THE SHEPHERDS** (**FIG. 20–33**). It is still in its original frame in the place for which it was painted (SEE FIG. 20–31). The influence of Hugo van der Goes's Portinari Altarpiece (SEE FIG. 19–19), which had been placed on the high altar of the church of Sant'Egidio in 1483, two years earlier, is strong. Ghirlandaio's Christ Child also lies on the ground, adored by the Virgin while rugged shepherds kneel at the right. Ghirlandaio even copies some of Hugo's flowers—although here the iris, a symbol of the Passion, springs not from a vase, but from the earth in the lower right corner. But Ghirlandaio highlights references to Classical Rome. First to catch the eye are two

20–31 Domenico Ghirlandaio **SCENES FROM THE LIFE OF ST. FRANCIS; ALTARPIECE WITH NATIVITY AND ADORATION OF THE SHEPHERDS**

Sassetti Chapel, church of Santa Trinità, Florence. 1483–1486. Fresco, chapel 12′2″ deep × 17′2″ wide (3.7 × 5.25 m).

Credit: © Archivi Alinari, Firenze

20–32 Domenico Ghirlandaio **CONFIRMATION OF THE FRANCISCAN RULE BY POPE HONORIUS III**
Sassetti Chapel, church of Santa Trinità, Florence. 1483–1486. Fresco, width at base 17′2″ (5.25 m).
Credit: © Studio Fotografico Quattrone, Florence

Classical pilasters with Corinthian capitals, one of which is dated by inscription to 1485. The manger is an ancient sarcophagus with an inscription that promises resurrection (as in the fresco directly above the altarpiece where St. Francis is reviving a child), and in the distance a Classical arch inscribed with a reference to the Roman general Pompey the Great frames the road along which the Magi travel. Weighty, restrained actors replace the psychologically intense figures of Hugo's painting. Ghirlandaio joins a clear foreground, middle ground, and background in part with the road and in part with **aerial perspective**, which creates a seamless transition of color from the sharp details and primary hues of the Adoration to the soft gray mountains in the distance.

20–33 Domenico Ghirlandaio **NATIVITY AND ADORATION OF THE SHEPHERDS**
Altarpiece in the Sassetti Chapel, church of Santa Trinità, Florence. 1485. Panel, 65¾″ (1.67 m) square.

Credit: © Studio Fotografico Quattrone, Florence

A Closer Look

PRIMAVERA

Mercury, the sign for the month of May, disperses the winter clouds with his caduceus. This staff, wound about with serpents, became a symbol for the medical profession. The name Medici means "doctors."

Venus, clothed in contemporary costume and crowned with a marriage wreath, appears in her role as the goddess of wedded love. The presence of both Venus and Mercury may be an astrological reference; prominent Neoplatonist Marsilio Ficino told Lorenzo di Pierfrancesco de' Medici that these planets were aligned in his horoscope.

The setting of the painting is a grove of orange trees. These hold a double meaning—suggestive of Venus's Garden of the Hesperides, with its golden fruit, and also perhaps an allusion to the Medici, whose coat of arms featured golden orbs.

This three-figure grouping tells a story. Zephyrus, the west wind, is accosting the virgin nymph Chloris, identifiable from the roses pouring out of her mouth. Once Zephyrus makes her his bride, Chloris is transformed into the goddess Flora, the elaborately dressed personification of spring at the front of the group.

The gold flames decorating Mercury's garment are also an attribute of St. Lawrence, the namesake of Lorenzo di Pierfrancesco de' Medici, for whom this painting was made. The laurel tree (*laurus* in Latin) behind Zephyrus also alludes to Lorenzo's name.

The Three Graces symbolize ideal female virtues—Chastity, Beauty, Love. Venus's son Cupid—the embodiment of romantic desire—playfully aims his arrow at them.

So accurate is the representation of the flowering plants in the painting that 138 of the 190 total have been identified. Almost all grow in the neighborhood of Florence between the months of March and April, and most carry symbolic associations with love and marriage.

Flora scatters flowers held in a fold of her dress at the level of her womb, equating female procreative fertility with the fecundity brought about by changing seasons.

20–34 Sandro Botticelli **PRIMAVERA**
c. 1482. Tempera on wood panel, 6'8″ × 10'4″ (2.03 × 3.15 m). Galleria degli Uffizi, Florence.

Credit: © Studio Fotografico Quattrone, Florence

Botticelli

Like most artists in the second half of the fifteenth century, Alessandro di Mariano di Vanni Filipepi (1445–1510), called "Botticelli" ("the little barrel," a nickname borrowed from his older brother), painted sculptural figures that were modeled by light from a consistent source and placed in a setting rendered illusionistic by linear perspective. An outstanding portraitist, he, like Ghirlandaio, often included recognizable contemporary figures among the saints and angels in religious paintings. He worked in Florence, frequently for the Medici, before being called to Rome in 1481 by Pope Sixtus IV to help decorate the new Sistine Chapel along with Ghirlandaio, Perugino, and other artists.

Botticelli returned to Florence that same year and entered a new phase of his career. Like other artists working for patrons steeped in Classical scholarship and humanistic thought, he was exposed to philosophical speculations on beauty—as well as to the examples of ancient art in his employers' collections. For the Medici, Botticelli produced secular paintings of mythological subjects inspired by ancient works and by contemporary Neoplatonic thought. Art historian Michael Baxandall has shown that these works were also patterned on the slow movements of fifteenth-century Florentine dance, in which the dancers acted out their relationships to one another in public performances that would have influenced the thinking and viewing habits of both painters and their audience.

The overall appearance of Botticelli's **PRIMAVERA**, or *Spring* (see "Closer Look" opposite), recalls Flemish tapestries (SEE FIG. 19–8), which were very popular in Italy at the time. And its subject—like the subjects of many tapestries—is a highly complex **allegory** (a symbolic illustration of a concept or principle) interweaving Neoplatonic ideas with esoteric references to Classical sources. In simple terms, Neoplatonic philosophers and poets conceived Venus, the goddess of love, as having two natures. The first ruled over earthly, human love and the second over universal, divine love. In this way the philosophers could argue that Venus was a Classical equivalent of the Virgin Mary. *Primavera* was painted at the time of the wedding of Lorenzo di Pierfrancesco de' Medici and Semiramide d'Appiano in 1482. The theme suggests love and fertility in marriage, and the painting can be read as a lyrical wish for a similar fecundity in the union of Lorenzo and Semiramide—a sort of highly refined fertility dance.

Several years later, some of the same mythological figures reappeared in Botticelli's **BIRTH OF VENUS** (**FIG. 20–35**), in which the central image represents the Neoplatonic idea of divine love in the form of a nude Venus based on an antique statue type known as the "modest Venus" ultimately deriving from Praxiteles's *Aphrodite of Knidos* (SEE FIG. 5–54). Botticelli's Classical goddess of love and beauty, born of sea foam, averts her eyes from our gaze as she floats ashore on a scallop shell, carefully arranging her hands and hair to hide—but actually drawing attention

20–35 Sandro Botticelli BIRTH OF VENUS
c. 1484–1486. Tempera and gold on canvas, 5'8⅞" × 9'1⅞" (1.8 × 2.8 m). Galleria degli Uffizi, Florence.

Credit: © Studio Fotografico Quattrone, Florence

to—her sexuality. Indeed, she is an arrestingly alluring figure, set within a graceful composition organized by Botticelli's characteristically decorative use of line. Blown by the wind, Zephyrus (with his love, the nymph Chloris), Venus arrives at her earthly home. She is welcomed by a devotee who offers her a garment embroidered with flowers. The circumstances of this commission are uncertain. It is painted on canvas, which suggests that it may have been a banner or a painted, tapestrylike wall hanging.

Botticelli's later career was apparently affected by a profound spiritual crisis. While the artist was creating his mythologies for the Medici, a Dominican monk, Fra Girolamo Savonarola (active in Florence 1490–1498), was preaching impassioned sermons denouncing the worldliness of Florence. Many Florentines reacted with orgies of self-recrimination, and processions of weeping penitents wound through the streets. Botticelli, too, may have fallen into a state of religious fervor. In a gesture of repentance, he burned many of his earlier paintings and began to produce highly emotional pictures dominated by an intense religiosity.

Urbino, Mantua, Rome, and Venice

How does the Renaissance style spread from Florence to other Italian cities?

In the second half of the fifteenth century, the ideas and ideals of artists like Brunelleschi, Donatello, and Masaccio began to spread from Florence to the rest of Italy, as artists who had trained or worked in Florence traveled to other cities to work. Northern Italy embraced the new Classical ideas swiftly, especially in the court cities of Urbino and Mantua. Venice and Rome also emerged as innovative art centers in the last quarter of the century.

Urbino

Under Federico da Montefeltro, Urbino developed into a thriving artistic center. A new palace was under construction, and prominent architects and artists were brought into the court to make the new princely residence a showcase of ducal splendor.

THE PALACE AT URBINO Construction of the palace had been underway for about 20 years in 1468 when Federico hired Luciano Laurana (c. 1420/1425–1479) to direct the work. Among Laurana's major contributions to the palace were closing the courtyard with a fourth wing and redesigning the courtyard façades (**FIG. 20-36**). The result is a superbly rational solution to the problems created in courtyard design by the awkward juncture of the arcades at the four corners. The ground-level portico on each side has arches supported by columns, but piers embellished with pilasters bridge the corner angles. This arrangement avoided the awkward visual effect of two arches springing from a single column (SEE FIG. 20-10) and gave the corner a greater sense of stability. A variation of the composite capital (a Corinthian capital with added Ionic volutes) was used, perhaps for the first time, on the ground level. Corinthian pilasters flank the windows in the story above, forming divisions that repeat the bays of the portico. (The two low upper stories were added later.) The plain architrave was engraved with inscriptions praising Federico, added when the count became duke of Urbino in 1476.

The interior of the Urbino palace likewise reflected its patron's embrace of new Renaissance ideas and interest in Classical antiquity, seen in carved marble fireplaces and window and door surrounds. In creating luxurious home furnishings and interior decorations for sophisticated clients such as Federico, Italian artists found freedom to experiment with new subjects, treatments, and techniques. Among these was the creation of remarkable *trompe l'oeil* effects using exacting linear perspective and foreshortening in **intarsia** (wood inlay) decoration. An extraordinary example is on the walls of Federico da Montefeltro's **STUDIOLO**, or study, a room for private conversation and the owner's collection of fine books and art objects (**FIG. 20-37**). The work,

20-36 Luciano Laurana **COURTYARD, DUCAL PALACE, URBINO**
Courtyard c. 1468–1472; palace begun c. 1450.

Credit: © akg-images/De Agostini Picture Lib./L. Romano

20–37 Giuliano da Maiano (?) **STUDIOLO OF FEDERICO DA MONTEFELTRO**
Ducal palace, Urbino. 1476. Intarsia, height 7′3″ (2.21 m).

Credit: © 2016. Photo Scala, Florence – courtesy of the Ministero Beni e Att. Culturali

practice—including Brunelleschi's system of spatial illusion and linear perspective, Masaccio's powerful modeling of forms and atmospheric perspective, and Alberti's theoretical treatises. Piero was one of the few practicing artists who also wrote his own books of theory. Not surprisingly, in his treatise on perspective he emphasized the geometry and the volumetric construction of forms and spaces that were so apparent in his own work.

These characteristic features are clearly apparent in a serene image of the **BAPTISM OF CHRIST** that has become one of Piero's signature works (**FIG. 20–38**). It was commissioned by the Graziani family, probably

probably done by the architect and woodworker Giuliano da Maiano (1432–1490), carries the date 1476.

The elaborate scenes in the small room are created entirely of wood inlaid on flat surfaces. Each detail is rendered with convincing illusionism: pilasters, carved cupboards with latticed doors, niches with statues, paintings, and built-in tables. Prominent in the decorative scheme is the prudent and industrious squirrel, a Renaissance symbol of the ideal ruler—in other words, of Federico da Montefeltro. A large "window" looks out onto an elegant marble loggia with a distant view of the countryside through its arches, and the shelves, cupboards, and tables are filled with all manner of fascinating things: scientific instruments, books, even the duke's armor hanging like a suit in a closet.

PIERO DELLA FRANCESCA Federico also brought the artist Piero della Francesca (c. 1415–1492) to Urbino. Piero had worked in Florence in the 1430s before settling in his native Borgo San Sepolcro, a Tuscan hill town under papal control. He knew current art theory and art

20–38 Piero della Francesca **BAPTISM OF CHRIST**
c. 1450. Tempera on wood panel, 66 × 45¾″
(1.67 × 1.16 m). National Gallery, London.

The three angels standing in a cluster at left, partially overlapped by the foreground tree, have been interpreted as an emblem of concord—representing the rapprochement reached between the Roman and Byzantine Christian churches in 1439 at the Council of Florence. Another reference to this council has been seen in the exotic costumes of the figures in the far background. Since the accord reached at the council was very short-lived, this interpretation would move the date of the painting into the early 1440s rather than the 1450s.

Credit: © 2016. Copyright The National Gallery, London/Scala, Florence

during the 1450s, for the priory of San Giovanni Battista in Borgo San Sepolchro. The central figure of Christ dominates the painting, standing in a shallow stream of glassy water under a tree of manicured regularity. Christ's legs and the sleek tree trunk set up a series of emphatically upright forms, one of many formal relationships that reverberate both across the picture's surface and into its carefully measured space. Feet and ankles rotate across the lower quarter of the painting, providing a clear and well-distributed sense of grounding for the figural composition, while the radically foreshortened dove (Holy Spirit), John's baptismal dish, and the clouds create a rhythmic line of horizontals that adds stability above and creates a staccato rhythm that merges foreground and background on the painting's surface. The mirrored profiles and gestures of the outside angel and the baptizing John provide an internal frame for the central action. Such carefully crafted formal correspondences infuse this picture with an air of quiet calm and peaceful stasis—a stillness suggesting that nothing will ever change, no one will ever move in this frozen moment within a story that, for Christian believers, actually changed everything.

Piero traveled widely—to Rome, to the Este court in Ferrara, and especially to Urbino. In about 1474, he painted the portraits of **FEDERICO DA MONTEFELTRO** and his recently deceased wife, **BATTISTA SFORZA** (FIG. 20-39). The small panels resemble Flemish painting in their detail and luminosity, their record of surfaces and textures, and their vast landscapes. But in traditional Italian fashion, figures are portrayed in strict profile, disengaged psychologically from the viewer. The profile format also allowed for an accurate recording of Federico's likeness without emphasizing two disfiguring scars—the loss of his right eye from a lance blow and his broken nose. His good left eye is shown, and the angular profile of his nose might easily be merely a distinctive family trait. Typically, Piero emphasized the underlying geometry of the forms. Dressed in the most elegant fashion (Federico wears his red ducal robe and Battista's jewels are meticulously recorded), they are silhouetted against a panoramic landscape. These are the hills around Urbino, seemingly dissolving into infinity through an atmospheric perspective as subtle and luminous as in any Flemish panel painting. Piero used another Northern European device: In the harbor view just in front of Federico,

20-39 Piero della Francesca **BATTISTA SFORZA AND FEDERICO DA MONTEFELTRO**
c. 1474. Oil on wood panel, each 18½ × 13″ (47 × 33 cm). Galleria degli Uffizi, Florence.

Battista Sforza died in 1472 at age 26, shortly after the birth of her ninth child, a son who would one day be duke. We are told that Federico was disconsolate. Some arranged aristocratic marriage alliances blossomed into loving partnerships, and it seems that one of them was memorialized in this double portrait.

20–40 Andrea Mantegna **TWO VIEWS OF THE CAMERA PICTA, DUCAL PALACE, MANTUA**

1465–1474. Fresco, diameter of false oculus 8'9" (2.7 m); room 26'6" (8 m) square.

Credit: (left) © 2016. Photo Scala, Florence - courtesy of the Ministero Beni e Att. Culturali., (below) © Studio Fotografico Quattrone, Florence

the water narrows into a river that leads us into the distant landscape (SEE FIG. 19–16). He would have had contact in Urbino with the Flemish artists who were also working there.

Mantua

Ludovico Gonzaga, the marquis of Mantua, ruled a territory that lies on the north Italian plain between Venice and Milan. Like Federico, he made his fortune as a *condottiere*. Ludovico was schooled by humanist teachers and created a court where humanist ideas flourished in art as well as in literature.

MANTEGNA Working at Ludovico's court was Andrea Mantegna (1431–1506), a painter trained in Padua and profoundly influenced by the sculptor Donatello, who arrived in Padua in 1443 and worked there for a decade. Mantegna learned the Florentine system of linear perspective and pushed it to its limits with radically foreshortened forms and dramatic spatial recessions. He went to work for Ludovico Gonzaga in 1460 and continued to work for the Gonzaga family for the rest of his life.

Perhaps his finest works are the frescos of the **CAMERA PICTA** ("Painted Room"), a tower chamber in Ludovico's palace, which Mantegna decorated between 1465 and 1474 (**FIG. 20–40**). Around the walls the family—each member seemingly identified by a portrait likeness—learns of the return of and ultimately welcomes Ludovico's son, Cardinal Francesco Gonzaga. On the domed ceiling, the artist painted a *tour-de-force* of radical perspective in a technique called *di sotto in sù* ("from below upwards"). The room appears to be open to a cloud-filled sky through a large oculus in a simulated marble- and mosaic-covered vault. On each side of a precariously balanced planter, four young women—one an African, outfitted in an exotic turban—peer over a marble balustrade into the room below, while a fourth looks dreamily upward. Joined by a large peacock, several *putti* play around the balustrade, seemingly oblivious to the danger of their perch. Three stand on the interior ledge of a cornice unprotected by the balustrade, toes projecting into space. This ceiling began a long tradition of illusionistic ceiling painting that culminated in the extravagant and explosive ceilings of Baroque churches (see Chapter 23).

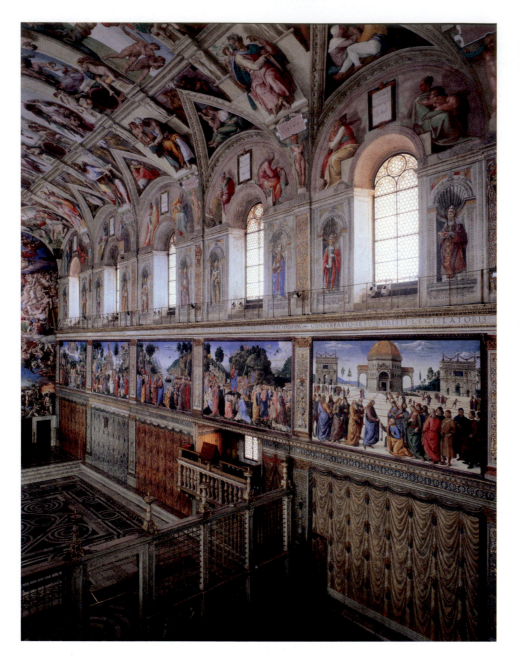

20–41 VIEW OF THE SISTINE CHAPEL SHOWING PAINTINGS COMMISSIONED FOR THE SIDE WALLS BY POPE SIXTUS IV
Vatican, Rome. At lower right, Perugino's *Christ Giving the Keys to St. Peter*, c. 1480–1482. 11′5½″ × 18′8½″ (3.48 × 5.7 m).

Credit: Photo © Musei Vaticani/IKONA

his contributions, *Christ Giving the Keys to St. Peter* (foreground painting at lower right in FIG. 20–41; also FIG. 20–20A), portrayed the event that provided biblical support for the supremacy of papal authority (Matthew 16:19). In a light-filled piazza in which banded paving stones provide a geometric grid for perspectival recession, the figures stand like chess pieces on the squares, scaled to size according to their distance from the picture plane and modeled by a consistent light source from the upper left. Triumphal arches inspired by ancient Rome frame the church and focus attention on the center of the composition, where the vital key is being transferred. The carefully calibrated scene is softened by the subdued colors, the distant idealized landscape and cloudy skies, and the variety of the figures' positions.

Rome

Rome's development into a Renaissance center of the arts was greatly enhanced in the early 1480s when Pope Sixtus IV called to the city a group of young Florentine and Umbrian artists to decorate the walls of his newly built chapel (1479–1481), now named the **SISTINE CHAPEL** after him (FIG. **20–41**). Botticelli and Ghirlandaio were among the most famous artists summoned to the chapel to paint, but many art historians believe that Perugino was the supervising artist in charge of the project.

PERUGINO Pietro Vannucci, called "Perugino" (c. 1445–1523), was originally from near the town of Perugia in Umbria (thus the nickname), and he worked for a while in Florence, but by 1479 he was in Rome. Two years later, he was working on the Sistine murals. One of

Venice

In the last quarter of the fifteenth century, Venice emerged as a major Renaissance art center. Ruled as an oligarchy (government by a select few) with an elected duke (*doge* in the Venetian dialect), the city government was founded at the end of the Roman Empire and survived until the Napoleonic era. In building their city, the Venetians had turned marshes into a commercial seaport, and they saw the sea as a resource, not a threat. They depended on naval power and on the natural defense of their lagoons rather than city walls. Venice turned toward the east, especially after the crusaders' conquest of Constantinople in 1204, designing the church of St. Mark as a great Byzantine building sheathed in mosaics (SEE FIG. 8–24A). In addition to its long history of painting and sculpture, Venice excelled in the arts of textiles and jewelry, gold and enamel, glass and mosaic, fine printing and bookbinding.

VENETIAN PALACES Venice was a city of waterways with few large public spaces. Even palaces had only small interior courtyards and tiny gardens and were separated by narrow alleys. Their façades overlooked the canals, permitting owners to display on these major thoroughfares the large portals, windows, and loggias that proclaimed their importance through the lavishness of their residences—a sharp contrast to the fortresslike character of most Florentine town houses (SEE FIG. 20-9). Similar to the Florentine great houses, however, Venetian structures combined a place of business with a dwelling.

The **CA D'ORO** (House of Gold), home of the wealthy nobleman Marino Contarini, has a splendid front with three superimposed loggias facing the Grand Canal (FIG. 20-42). The house was constructed between 1421 and 1437, and its asymmetrical elevation is based on a traditional Byzantine plan. A wide central hall ran from front to back all the way through the building to a small inner courtyard with a well and garden. The entrance on the canal permitted goods to be delivered directly into the warehouse that constituted the ground floor. An outside stair led to the main floor on the second level, which had a salon and reception room opening on the richly decorated loggia. It was filled with light from large windows, and more light reflected off the polished terrazzo floor. Private family rooms filled the upper stories. Contarini specified that the façade was to be painted with white enamel and ultramarine blue and that the red stones in the patterned wall should be oiled to make them even brighter. Details of carving, such as coats of arms and balls on the crest at the roofline, were to be gilded. Beautiful as the palace is today, in the fifteenth and sixteenth centuries it must have been truly spectacular.

THE BELLINI BROTHERS The domes of the church of St. Mark dominated the city center, and the rich colors of its glowing mosaics captured painters' imaginations. Perhaps it was their love of color that encouraged the Venetian painters to embrace the oil medium for both panel and canvas painting.

The most important Venetian artists of this period were two brothers: Gentile (c. 1429–1507) and Giovanni (c. 1430–1516) Bellini, whose father, Jacopo (c. 1400–1470), had also been a central figure in Venetian art. Andrea Mantegna became part of this circle when he married Jacopo's daughter in 1453.

Gentile Bellini celebrated the daily life of the city in large, lively narratives, such as the **PROCESSION OF THE RELIC OF THE TRUE CROSS BEFORE THE CHURCH OF ST. MARK** (FIG. 20-43). Every year on the feast of St. Mark (April 25), the Confraternity of St. John the Evangelist carried the miracle-working relic of the True Cross in a procession through the square in front of the church. Bellini's painting of 1496 depicts an event that had occurred in 1444: the miraculous recovery of a sick child whose father (the man in red kneeling to the right of the relic) prayed for help as the relic passed by. Gentile has rendered the cityscape with great attention to detail. The mosaic-encrusted Byzantine Cathedral of St. Mark (SEE FIG. 8-24A) forms a backdrop for the procession, and the doge's palace and base of the bell tower can be seen at the right. The gold reliquary is carried under a canopy, surrounded by marchers with giant candles led by a choir and followed at the far right by the doge and other officials. Gentile's procession serves as a reminder that fifteenth-century piazzas and buildings were sites of ceremony, and it was in moments such as this that they were brought to life.

Gentile's brother Giovanni amazed and attracted patrons with his artistic virtuosity for almost 60 years. The **VIRGIN AND CHILD ENTHRONED WITH SS. FRANCIS, JOHN THE BAPTIST, JOB, DOMINIC, SEBASTIAN, AND LOUIS OF TOULOUSE** (FIG. 20-44), painted in about 1478 for the chapel of the Hospital of San Giobbe (St. Job), exhibits a dramatic perspectival view

20-42 CA D'ORO (CONTARINI PALACE), VENICE

1421–1437.

Credit: © Cameraphoto Arte, Venice

20–43
Gentile Bellini
PROCESSION OF THE RELIC OF THE TRUE CROSS BEFORE THE CHURCH OF ST. MARK
1496. Oil on canvas, 12′ × 24′5″ (3.67 × 7.45 m). Galleria dell'Accademia, Venice.

Credit: © Cameraphoto Arte, Venice

up into a tunnel vault that leads to an apse. Giovanni may have known his brother-in-law Mantegna's early experiments in radical foreshortening and the use of a low vanishing point. Here Giovanni positions the vanishing point for the rapidly converging lines of the architecture at bottom center, just above the floor. His figures stand in a Classical architectural interior with a coffered barrel vault reminiscent of Masaccio's *Trinity* (SEE FIG. 20–18). The gold mosaic, with its identifying inscription and stylized seraphim (angels of the highest rank), recalls Byzantine art and the long tradition of Byzantine-inspired painting and mosaics in Venice.

Giovanni Bellini's painting of **ST. FRANCIS IN ECSTASY** (**FIG. 20–45**), also from the 1470s, recalls Flemish painting in the fine detail with which the natural world is rendered. The saint stands bathed in early morning sunlight, his outspread hands displaying his stigmata. Francis had moved to a cave in the barren wilderness in his search for communion with God, but in the world Giovanni creates for him, the fields blossom and flocks of animals graze. The grape arbor over his desk adds to the atmosphere of sylvan delight. Like

20–44 Giovanni Bellini VIRGIN AND CHILD ENTHRONED WITH SS. FRANCIS, JOHN THE BAPTIST, JOB, DOMINIC, SEBASTIAN, AND LOUIS OF TOULOUSE
Originally commissioned for the chapel of the Hospital of San Giobbe, Venice. c. 1478. Oil on wood panel, 15′4″ × 8′4″ (4.67 × 2.54 m). Galleria dell'Accademia, Venice.

Art historians have given the name **sacra conversazione** ("holy conversation") to this type of composition that shows saints, angels, and sometimes even the painting's donors in the same pictorial space with the enthroned Virgin and Child. Despite the name, no "conversation" or spoken interaction takes place in a literal sense. Instead, the individuals portrayed are joined in a mystical and eternal communion that occurs outside human time and space.

Credit: © Cameraphoto Arte, Venice

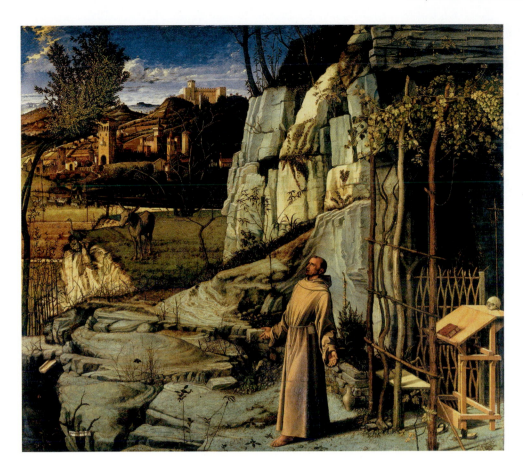

most of the fifteenth-century religious art we have seen, however, Giovanni presents viewers with a natural world saturated in symbolism. Here a relationship between St. Francis and Moses is outlined. The tree symbolizes the burning bush; the stream, the miraculous spring brought forth by Moses. The crane and donkey represent the monastic virtue of patience. The detailed description, luminous palette, and symbolic surroundings suggest Flemish art, but the golden light suffusing the painting is unmistakably Venetian.

20–45 Giovanni Bellini
ST. FRANCIS IN ECSTASY
c. 1470s. Oil on wood panel,
49¹⁄₁₆ × 55⁷⁄₈″ (124.6 × 142 cm).
The Frick Collection, New York.

Think About It

1 Explain how one of the Florentine sculptors discussed in this chapter helped establish the increasing naturalism and emulation of Classical models that would be central to the early Italian Renaissance.

2 Discuss Masaccio's use of linear perspective in either *The Tribute Money* or *Trinity with the Virgin, St. John the Evangelist, and Donors*. How does he use this technique? Illustrate your points with a comparative reference to a work discussed earlier in this chapter or in a previous chapter.

3 Choose a wealthy merchant or *condottiere* and discuss how his patronage fostered the emergence of the Renaissance in fifteenth-century Italy. Make reference to specific works in forming your answer.

4 Discuss the 1401 competition to choose an artist to create the bronze doors of the Florence Baptistery. How did the competition affect the careers of the two finalists, Ghiberti and Brunelleschi?

Crosscurrents

Compare the representation of the human nude in these two examples of Renaissance art, one from Flanders and one from Florence. How do these works relate to the character of art in these two parts of Europe in the early fifteenth century? How do they embody the cultural expectations of their time and place?

FIG. 19–13

FIG. 20–21

21–1 Leonardo da Vinci **MONA LISA**

c. 1503–1506. Oil on wood panel, 30¼ × 21″ (77 × 53 cm). Musée du Louvre, Paris. (INV. 779).

Chapter 21
Sixteenth-Century Art in Italy

 ## Learning Objectives

21.a Identify the visual hallmarks of sixteenth-century Italian Renaissance art and architecture for formal, technical, and expressive qualities.

21.b Interpret the meaning of sixteenth-century Italian Renaissance works of art based on their themes, subjects, and symbols.

21.c Relate sixteenth-century Italian Renaissance artists and art to their cultural, economic, and political contexts.

21.d Apply the vocabulary and concepts relevant to sixteenth-century Italian Renaissance art, artists, and art history.

21.e Interpret a work of sixteenth-century Italian Renaissance art using the art historical methods of observation, comparison, and inductive reasoning.

21.f Select visual and textual evidence in various media to support an argument or an interpretation of a work of sixteenth-century Italian Renaissance art.

Is it Mona Lisa's "smile" that grabs us? Or the sense of mystery created by the smoky haze that envelops both her and the weird landscape behind her—or the way she turns to confront us directly with such self-confidence? Compelling to centuries of art lovers, this may be the world's most famous European painting.

Actually the **MONA LISA** (FIG. 21-1) is not especially mysterious. No secret code needs to be cracked. Leonardo da Vinci, one of the most famous painters and most fertile minds of the Italian Renaissance, painted this portrait between 1503 and 1506, while he was living in Florence. Although there is lingering uncertainty, most art historians agree with the sixteenth-century Italian biographer Giorgio Vasari, who claimed that the *Mona Lisa* portrays Lisa di Antonio Maria Gherardini, the wife of Florentine merchant Francesco del Giocondo. ("Mona" is a term of respect, a contraction of "Madonna," meaning "my lady"). Lisa married Francesco in 1495, when she was 16, so Leonardo painted her during her mid-twenties. But he never delivered the painting. He kept it with him for the rest of his life, continuing to tinker with it, probably working on it while he was in Rome after 1513 and taking it with him in 1516 when he moved to France at the invitation of Francis I. After Leonardo's death in 1519, the king purchased the *Mona Lisa* for Fontainebleau. Louis XIV moved it to Versailles, and Napoleon hung it in his bedroom in the Tuileries Palace. It now hangs at the Louvre. It is one of the most popular destinations for tourists visiting Paris.

This was an unusual portrait for its time. Leonardo abandoned the long-standing Italian tradition of painting wealthy wives in profile view, wearing the sumptuous clothing and jewelry that signified their status and their husbands' wealth (SEE FIGS. 20–26, 20–39). Mona Lisa seems to be the likeness of a specific woman who turns with calm assurance to engage viewers, hands relaxed in her lap. Her expression has been called enigmatic. It hides rather than reveals her thoughts and personality, and it lacks the warmth one expects to see in her eyes, which have shifted to the side to look straight out at us. The psychological complexity Leonardo has given to this face may explain the spell it has cast over viewers.

One thing is clear. This portrait embodies many of the hallmarks of the High Renaissance style that will solidify in Rome during the first two decades of the sixteenth century—the blend of naturalistic description and classicizing idealism, and the clarity and balanced structure of the pyramidal composition that gives utter stability to the monumentally sculptural human form.

Europe in the Sixteenth Century

What are the cultural and historical backgrounds for the development of Italian Renaissance art and architecture during the sixteenth century?

The sixteenth century was an age of social, intellectual, and religious ferment that transformed European culture. It was marked by continual armed conflict triggered by the expansionist ambitions of warring rulers. The humanism of the fourteenth and fifteenth centuries, with its medieval roots and its often uncritical acceptance of the authority of Classical texts, slowly developed into a critical exploration of new ideas, the natural world, and distant lands. Cartographers began to acknowledge the Earth's curvature and the degrees of distance, giving Europeans a more accurate understanding of their place within the world. The printing press sparked an explosion in book production, spreading new ideas through the translation and publication of ancient and contemporary texts, broadening the horizons of educated Europeans, and encouraging the development of literacy. Since travel was growing more common, artists and their work became mobile, and the world of art was transformed into a more international community.

At the start of the sixteenth century, England, France, and Portugal were nation-states under strong monarchs. German-speaking central Europe was divided into dozens of principalities, counties, free cities, and small territories. But even states as powerful as Saxony and Bavaria acknowledged the supremacy of the Habsburg Holy Roman Empire—in theory the greatest power in Europe. Charles V, elected emperor in 1519, also inherited Spain, the Netherlands, and vast territories in the Americas. Italy, which was divided into numerous small states, was a diplomatic and military battlefield where for much of the century the Italian city-states, Habsburg Spain, France, and the papacy fought each other in shifting alliances. Popes behaved like secular princes, using diplomacy and military force to regain control over central Italy and in some cases to establish family members as hereditary rulers.

The popes' incessant demands for money, to finance the rebuilding of St. Peter's as well as their self-aggrandizing art projects and luxurious lifestyles, aggravated the religious dissent that had long been developing, especially north of the Alps. Early in the century, religious reformers within the established Church challenged its beliefs and practices, especially Julius II's sale of indulgences promising forgiveness of sins and assurance of salvation in exchange for a financial contribution to the Church. Because they protested, these northern European reformers came to be called Protestants; their demand for reform gave rise to a movement called the Reformation.

The political maneuvering of Pope Clement VII (pontificate 1523–1534) led to a direct clash with Holy Roman Emperor Charles V. In May 1527, Charles's troops attacked Rome, beginning a six-month orgy of killing, looting, and burning. The Sack of Rome, as it is called, shook the sense of stability and humanistic confidence that until then had characterized the Renaissance, and it sent many artists fleeing from the ruined city. Nevertheless, Charles saw himself as the leader of the Catholic forces—and he was the sole Catholic ally Clement had at the time. In 1530, Clement VII crowned Charles emperor in Bologna.

Sixteenth-century patrons valued artists highly and rewarded them well, not only with generous commissions but sometimes even with high social status. Charles V, for example, knighted the painter Titian. Some painters and sculptors became entrepreneurs and celebrities, selling prints of their works on the side and creating international reputations for themselves. Many artists recorded their activities—professional and private—in diaries, notebooks, and letters that have come down to us. In addition, contemporary writers began to report on the lives of artists, documenting their physical appearance and assessing their individual reputations. In 1550, Giorgio Vasari wrote the first survey of Italian art history (revised and expanded in 1568)—*Lives of the Most Excellent Architects, Painters, and Sculptors*. It was organized as a series of critical biographies, but at its core was a work of critical judgment. Vasari also commented on the role of patrons and argued that art had become more realistic and more beautiful over time, reaching its apex of perfection in his own age. From his characterization developed our notion of this period as the High Renaissance—that is, as a high point in art after the early experiments of Cimabue and Giotto, marked by a balanced synthesis of Classical ideals and a lifelike rendering of the natural world.

During this period, the fifteenth-century humanists' notion of painting, sculpture, and architecture not as manual arts but as liberal (intellectual) arts, requiring education in the Classics and mathematics as well as in the techniques of the craft, became a topic of intense interest. And from these discussions arose the Renaissance formulation—still with us today—of artists as divinely inspired creative geniuses, a step above most of us in their gifts of hand and mind. This idea weaves its way through Vasari's work like an organizing principle. And this newly elevated status favored men. Although few artists of either sex had access to the humanist education required by the often esoteric subject matter used in paintings (usually devised by someone other than the artist), women were also denied the studio practice necessary to study and draw from nude models. Furthermore, it was almost impossible for an artist to achieve international status without traveling extensively and frequently relocating to follow commissions—something most women could not do. Still, some European women managed to establish careers as artists during this period despite these obstacles.

The Roman High Renaissance

What characterizes the art of the High Renaissance in Rome as embodied by the works of Leonardo, Raphael, Michelangelo, and Bramante?

Italian art between the mid-1480s and the 1520s has been called the High Renaissance. As we have already seen with the High Classical period in ancient Athens, the term "High Renaissance" encapsulates an art historical judgment, claiming that what happened in Italy at this time represents a pinnacle of achievement within a longer artistic movement, and that it set standards for the future (**MAP 21–1**). High Renaissance art is characterized by a sense of gravity and decorum, a complex but ordered relationship of individual parts to the whole, and an emulation of the principles artists saw in ancient Classical art. Art historian Sydney Freedberg has stressed the way High Renaissance art fuses the real and the ideal, characterizing Leonardo's *Mona Lisa*, for example, as "a rare perfection between art and reality; an image in which a breathing instant and a composure for all time are held in suspension" (Freedberg, p. 28).

Two important practical developments at the turn of the sixteenth century affected the arts in Italy. Technically, the use of tempera had almost completely given way to the more flexible oil painting medium; and economically, with increasing commissions from private sources, artists no longer depended so heavily on the patronage of the Church, the court, or civic associations.

Florence's renowned artistic tradition had attracted a stream of young artists to that city throughout the fifteenth century. They traveled there to study its many

MAP 21-1 RENAISSANCE AND EARLIER MONUMENTS IN ROME

In addition to situating the principal works of the Roman Renaissance that emerged from Julius II's campaign to revitalize the papal city, this map also locates the surviving works of Roman antiquity that would have been available to the Renaissance artists and architects who masterminded the Classical revival.

artistic treasures, not least of which were Masaccio's solid, monumental figures in the Brancacci Chapel paintings (SEE FIGS. 20–21, 20–22), with their eloquent facial features, poses, and gestures. The young Michelangelo's sketches of the chapel frescos document the importance of Masaccio to his developing style. In fact, Leonardo, Michelangelo, and Raphael—the three leading artists of the High Renaissance—all worked in Florence early in their careers, although they soon moved to other centers of patronage and their influence spread well beyond that city, even beyond Italy.

Leonardo da Vinci

Leonardo da Vinci (1452–1519) was 12 or 13 when his family moved to Florence from the Tuscan village of Vinci. After an apprenticeship in the shop of the Florentine painter and sculptor Andrea del Verrocchio and a few years on his own, Leonardo traveled to Milan in 1481 or 1482 to work for the ruling Sforza family.

Leonardo spent much of his time in Milan on military and civil engineering projects, including both urban-renewal and fortification plans for the city, but he also created a few key monuments of Renaissance painting. In April 1483, Leonardo contracted with the Confraternity of the Immaculate Conception to paint an altarpiece for their chapel in the church of San Francesco Grande in Milan, a painting now known as **THE VIRGIN OF THE ROCKS** (FIG. 21-2). The contract stipulated a painting of the Virgin and Child with angels, but Leonardo added a figure of the young John the Baptist, who balances the composition at the left, pulled into dialogue with his younger cousin Jesus by the long, protective arm of the Virgin. She draws attention to her child by extending her other hand over his head, while the enigmatic figure of the angel—who looks out without actually making eye contact with the viewer—points to the center of interaction. The stable, balanced, pyramidal figural group—a compositional formula that will become a standard feature of High Renaissance Classicism—is set against an exquisitely detailed landscape that dissolves mysteriously into the misty distance.

To assure their dominance in the picture, Leonardo picks out the four figures with spotlights, creating a

21-2 Leonardo da Vinci **THE VIRGIN OF THE ROCKS**

c. 1485. Oil on wood panel (now transferred to canvas), 6′6″ × 4′ (1.9 × 1.2 m). Musée du Louvre, Paris.

Credit: Photo © Réunion des Musées Nationaux/ Musée du Louvre, Paris

Art and its Contexts

THE VITRUVIAN MAN

Artists throughout history have turned to geometric shapes and mathematical proportions to seek the ideal representation of the human form. Leonardo, following the first-century ᴄᴇ Roman architect and engineer Vitruvius, equated the ideal man with both circle and square. Ancient Egyptian artists had laid out square grids as aids to design (see "Conventions and Technique of Egyptian Pictorial Relief" in Chapter 3 on page 52). Medieval artists adapted a variety of figures, from triangles to pentagrams (SEE FIG. 17–17).

Vitruvius, in his ten-volume *De architectura* (*On Architecture*), wrote: "For if a man be placed flat on his back, with his hands and feet extended, and a pair of compasses centered at his navel, the fingers and toes of his two hands and feet will touch the circumference of a circle described therefrom. And just as the human body yields a circular outline, so too a square figure may be found from it. For if we measure the distance from the soles of the feet to the top of the head, and then apply that measure to the outstretched arms, the breadth will be found to be the same as the height" (Book III, Chapter 1, Section 3). Vitruvius determined that the ideal body should be eight heads high. Leonardo added his own observations in the reversed writing he always used in his notebooks when he created his well-known diagram for the ideal male figure, called the **VITRUVIAN MAN** (**FIG. 21–3**).

21–3 Leonardo da Vinci **VITRUVIAN MAN**
c. 1490. Ink, 13½ × 9⅝″ (34.3 × 24.5 cm). Galleria dell'Accademia, Venice.

Credit: © Cameraphoto Arte, Venice

strong **chiaroscuro** (from the Italian words *chiaro*, meaning "light," and *oscuro*, meaning "dark") that enhances their modeling as three-dimensional forms. This painting is an excellent early example of a specific variant of this technique, called **sfumato** ("smoky"), in which there are subtle, almost imperceptible, transitions between light and dark in shading. *Sfumato* became a hallmark of Leonardo's style, although the effect is artificially enhanced in this painting by the yellowing of its thick varnish, which masks the original vibrancy of its color.

At Duke Ludovico Sforza's request, Leonardo painted **THE LAST SUPPER** (FIGS. 21–4, 21–5) in the refectory, or dining hall, of the monastery of Santa Maria delle Grazie in Milan between 1495 and 1498. In fictive space defined by a coffered ceiling and four pairs of tapestries that seem to extend the refectory into another room, Jesus and his disciples are seated at a long table placed parallel to the picture plane and to the monastic diners who would have been seated in the hall below. In a sense, Jesus's meal with his disciples prefigures the daily gathering of this local monastic community at mealtimes. The stagelike space recedes from the table to three windows on the back wall, where the vanishing point of the one-point linear perspective lies behind Jesus's head. A stable, pyramidal Jesus at the center is flanked by his 12 disciples, grouped in four interlocking sets of three.

On one level, Leonardo has painted a scene from a story—one that captures the individual reactions of the apostles to Jesus's announcement that one of them will betray him. Leonardo was an acute observer of human behavior, and his art captures human emotions with compelling immediacy. On another level, *The Last Supper* is a symbolic evocation of Jesus's coming sacrifice for the salvation of humankind, the foundation of the institution of the Mass. Breaking with traditional representations of the subject (SEE FIG. 20–25) to create compositional clarity, balance, and cohesion, Leonardo placed the traitor Judas—clutching his money bags in the shadows—within the first triad to Jesus's right, along with the young John the Evangelist and the elderly Peter, rather than isolating Judas on the opposite side of the table. Judas, Peter, and John were each to play an essential role in Jesus's mission: Judas set in motion the events leading to Jesus's sacrifice; Peter led the Church after Jesus's death; and John, the visionary, foretold the Second Coming and the Last Judgment in the book of Revelation.

The painting's careful geometry, the convergence of its perspective lines, the stability of its pyramidal forms, and Jesus's calm demeanor at the mathematical center of all the commotion, work together to reinforce the sense of gravity, balance, and order. The clarity and stability of this painting epitomize High Renaissance style.

The French, who had invaded Italy in 1494, next claimed Milan by defeating Leonardo's Milanese patron,

Ludovico Sforza, and Leonardo returned to Florence in 1500. Perhaps the most famous of his Florentine works is the portrait he painted between about 1503 and 1506 known as the **MONA LISA** (SEE FIG. 21–1). In a departure from tradition, the young woman is portrayed without jewelry, not even a ring. The solid pyramidal form of her halflength figure—another departure from traditional portraiture, which was limited to the upper torso—is silhouetted against distant hazy mountains, giving the painting a sense of mystery reminiscent of *The Virgin of the Rocks* (SEE FIG. 21–2). The expressive complexity of Mona Lisa's smile and the sense of psychological presence it gives the human face—especially in the context of the masklike detachment that was more characteristic of Renaissance portraiture (compare FIG. 20–39 or even FIG. 21–8)—is what makes this innovative painting so arresting and haunting, even today.

A fiercely debated topic in Renaissance Italy was the relative merits of painting and sculpture. Leonardo insisted on the supremacy of painting as the best and most complete means of creating an illusion of the natural world, while Michelangelo argued for sculpture. Yet in creating a painted illusion, Leonardo considered color to be secondary to the depiction of sculptural volume, which he achieved through his virtuosity in *sfumato*. He also unified his compositions by covering them with a thin, lightly tinted varnish, which enhanced the overall smoky haze. Because early evening light tends to produce a similar effect naturally, Leonardo considered dusk the finest time of day and recommended that painters set up their studios in a courtyard with black walls and a linen sheet stretched overhead to reproduce twilight.

Leonardo's fame as an artist is based on only a few works, for many other interests took him away from painting. Unlike his humanist contemporaries, he was not particularly interested in Classical literature or archaeology. Instead, his passions were mathematics, engineering, and the natural world. He compiled volumes of detailed drawings and notes on anatomy, botany, geology, meteorology, architectural design, and mechanics. In his drawings of human figures, he sought not only the precise details of anatomy but also the geometric basis of perfect proportions (see "The Vitruvian Man" on page 649). Leonardo's searching mind is evident in his drawings not only of natural objects and human beings, but also of machines, so clearly and completely worked out that modern engineers have used them to construct working models. He designed flying machines, a kind of automobile, a parachute, and all sorts of military equipment, including a mobile fortress. His imagination outran his means to bring his creations into being. For one thing, he lacked a source of power other than men and horses. For another, he may have lacked focus and follow-through. His contemporaries complained that he never finished anything and that his inventions distracted him from his painting.

21–4 Leonardo da Vinci **THE LAST SUPPER**

Refectory of the monastery of Santa Maria delle Grazie, Milan. 1495–1498. Tempera and oil on plaster, 15′2″ × 28′10″ (4.6 × 8.8 m).

Credit: © Studio Fotografico Quattrone, Florence

21–5 REFECTORY OF THE MONASTERY OF SANTA MARIA DELLE GRAZIE, SHOWING LEONARDO'S LAST SUPPER

Milan.

Instead of painting in fresco, Leonardo devised an experimental technique for this mural. Hoping to achieve the freedom and flexibility of painting on wood panel, he worked directly on dry *intonaco*—a thin layer of smooth plaster—with an oil-and-tempera paint for which the formula is unknown. The result was disastrous. Within a short time, the painting began to deteriorate, and by the middle of the sixteenth century its figures could be seen only with difficulty. In the seventeenth century, the monks saw no harm in cutting a doorway through the lower center of the composition. The work has barely survived the intervening period, despite many attempts to halt its deterioration and restore its original appearance. It narrowly escaped complete destruction in World War II, when the refectory was bombed to rubble. The coats of arms at the top are those of patron Ludovico Sforza, duke of Milan (ruled 1494–1499), and his wife, Beatrice.

Credit: © Studio Fotografico Quattrone, Florence

Leonardo returned to Milan in 1508 and lived there until 1513. He also lived for a time in the Vatican at the invitation of Pope Leo X, but there is no evidence that he produced any works of art during his stay. In 1516, he accepted the French king Francis I's invitation to relocate to France as an advisor on architecture, taking the *Mona Lisa*, as well as other important works, with him. He remained at Francis's court until his death in 1519.

Raphael

In about 1505—while Leonardo was working on the *Mona Lisa*—Raphael (Raffaello Santi or Sanzio, 1483–1520) arrived in Florence from his native Urbino after studying in Perugia with the city's leading artist, Perugino (SEE FIG. 20–20A). Raphael quickly became successful in Florence, especially with small, polished paintings of the Virgin and Child, such as **THE SMALL COWPER MADONNA** (named for a modern owner) of about 1505 (**FIG. 21–6**). Already a superb painter technically, the youthful Raphael shows his indebtedness to his teacher in the delicate tilt of the figures' heads, the brilliant tonalities, and the pervasive sense of serenity. But Leonardo's impact is also evident here in the simple grandeur of the monumental shapes, the pyramidal composition activated by the spiraling movement of the child, and the draperies that cling to the Virgin's substantial form. In other Madonnas from this period, Raphael included the young John the Baptist (**FIG. 21–7**) and experimented with the multiple-figure interactions pioneered by Leonardo in *The Virgin of the Rocks* (SEE FIG. 21–2).

At the same time as he was producing engaging images of elegant Madonnas, Raphael was also painting flawlessly executed portraits of prosperous Florentine patrons like the 30-year-old cloth merchant Agnelo Doni, who commissioned **pendant** portraits (**FIG. 21–8**) to commemorate his marriage in 1504 to Maddalena Strozzi, the 15-year-old daughter of a powerful banking family. As Piero della Francesca had done in his portraits of Battista Sforza and Federico da Montefeltro (SEE FIG. 20–39), Raphael silhouettes Maddalena and Agnelo against a meticulously described panoramic landscape. But unlike his predecessors, Raphael turned his subjects to address the viewer. Agnelo is commanding but casual, leaning his arm on a balustrade to add three-dimensionality to his posture. Maddalena's pose imitates Leonardo's innovative presentation of his subject in the *Mona Lisa* (SEE FIG. 21–1), which Raphael had obviously seen in progress. But with Maddalena there is no sense of mystery, indeed little psychological presence, and Raphael follows tradition in emphasizing the sumptuousness of her clothing and making ostentatious display of her jewelry. The wisps of hair that escape from her sculpted coiffure are the only hint of human vulnerability.

Raphael left Florence about 1508 for Rome, where Pope Julius II put him to work almost immediately decorating rooms (*stanze*, singular *stanza*) in the papal apartments. In the Stanza della Segnatura (**FIG. 21–9**)—the pope's private library and study—Raphael painted the four branches of knowledge as conceived in the sixteenth century: Religion (the *Disputà*, depicting discussions concerning the true presence of Christ in the Eucharistic Host), Philosophy (*The School of Athens*, to the right in FIG. 21–9), Poetry (*Parnassus*, home of the Muses, to the left in FIG. 21–9), and Law (the *Cardinal Virtues* under a figure of *Justice*).

Raphael's most influential achievement in the papal rooms was *The School of Athens*, painted about 1510–1511 (see "Closer Look" on page 655). Here, the painter summarizes the ideals of the Renaissance papacy in a grand conception of harmoniously arranged forms in a rational space, as well as in the calm dignity of the figures that

21–6 Raphael **THE SMALL COWPER MADONNA**
c. 1505. Oil on wood panel, 23⅜ × 17⅜" (59.5 × 44.1 cm). National Gallery of Art, Washington, DC. Widener Collection (1942.9.57).

In the distance on a hilltop, Raphael has painted a scene he knew well from his childhood, the domed church of San Bernardino, 2 miles outside Urbino. The church contains the tombs of dukes of Urbino, Federico and Guidobaldo da Montefeltro, along with their wives (SEE FIG. 20–39). Donato Bramante, whose architecture was key in establishing the High Renaissance style, may have designed the church.

Credit: Image courtesy the National Gallery of Art, Washington

21–7 Raphael **MADONNA OF THE GOLDFINCH (MADONNA DEL CARDELLINO)**
1506. Oil on panel, 42 × 29½″ (106.7 × 74.9 cm). Galleria degli Uffizi, Florence.

The vibrant colors of this important work were revealed in the course of a careful, ten-year restoration completed in 2008.

Credit: © Studio Fotografico Quattrone, Florence

occupy it. If the learned Julius II did not actually devise the subjects, he certainly must have approved them. Greek philosophers Plato and Aristotle take center stage—placed to the right and left of the vanishing point—silhouetted against the sky and framed under three successive barrel vaults. Surrounding Plato and Aristotle are mathematicians, naturalists, astronomers, geographers, and other philosophers debating and demonstrating their theories with and to onlookers and each other. The scene takes place in an immense interior flooded with a clear, even light from a single source, seemingly inspired by the new design for St. Peter's, under construction at the time. The grandeur of the building is matched by the monumental dignity of the philosophers themselves, each of whom has a distinct physical and intellectual presence. The sweeping arcs of the composition are activated by the variety and energy of their poses and gestures, creating a dynamic unity that is a prime characteristic of High Renaissance art.

21–8 Raphael **AGNELO DONI AND MADDALENA STROZZI**
c. 1506. Oil on wood panel, each 24½ × 17¼″ (63 × 45 cm). Palazzo Pitti, Florence.

These portraits were not the only paintings commissioned by Agnelo Doni to commemorate his upwardly mobile marriage alliance with Maddalena Strozzi. He ordered a tondo portraying the Holy Family from rival artist Michelangelo (see "Closer Look" in the Introduction on page xxviii). Vasari reports that although the original price for that painting was set at 70 ducats, Doni only sent Michelangelo 40. In order to obtain his painting, the patron eventually had to pay the artist double the original price—140 ducats.

Credit: © Studio Fotografico Quattrone, Florence

21–9 Raphael **STANZA DELLA SEGNATURA**

Vatican, Rome. Fresco in the left lunette, *Parnassus*; in the right lunette, *The School of Athens*. 1510–1511.

Credit: Photo © Musei Vaticani/IKONA

A Closer Look

THE SCHOOL OF ATHENS

Looking down from niches in the walls are sculptures of Apollo (the god of sunlight, rationality, poetry, music, and the fine arts) and Minerva (the goddess of wisdom and the mechanical arts).

Plato points upward to the realm of ideas and pure forms that were at the center of his philosophy. His pupil Aristotle gestures toward his surroundings, signifying the empirical world that for him served as the basis for understanding.

The figure bent over a slate with a compass is Euclid, the father of geometry. Vasari claimed that Raphael gave this mathematician the portrait likeness of Bramante, the architect whose redesigned St. Peter's was under construction not far from this room and who was also a distant relative of Raphael.

Raphael placed his own portrait in a group that includes the geographer Ptolemy, who holds a terrestrial globe, and the astronomer Zoroaster, who holds a celestial globe.

The brooding figure of Heraclitus, a late addition to the composition, is a portrait of Michelangelo, who was working next door on the ceiling of the Sistine Chapel and whose monumental figural style is here taken (or mimicked) by Raphael. The stonecutter's boots on his feet refer to Michelangelo's self-identification—or Raphael's insistence that he be seen—as a sculptor rather than a painter.

Vasari's account of the painting identifies this figure as Diogenes the Cynic. It is more likely that he is Socrates, however. The cup next to him could refer to his deadly draught of hemlock, and his reclining position recalls his teaching from his prison bed.

The group of figures gathered around Euclid illustrate the various stages of understanding: literal learning, dawning comprehension, anticipation of the outcome, and assisting the teacher. Raphael was praised for his ability to communicate so clearly through the poses and expressions of his figures.

21–10 Raphael **THE SCHOOL OF ATHENS**
Fresco in the Stanza della Segnatura, Vatican, Rome. c. 1510–1511. 19 × 27′ (5.79 × 8.24 m).

Credit: Photo © Musei Vaticani/IKONA

TAPESTRIES FOR THE SISTINE CHAPEL In 1515, Raphael was commissioned by Pope Leo X (pontificate 1513–1521) to provide designs on themes from the Acts of the Apostles to be woven into a lavish set of tapestries for the strip of blank wall below the fifteenth-century wall paintings of the Sistine Chapel (this surface is now decorated with painted simulations of hanging drapery: see FIG. 21-16). Raphael produced full-scale cartoons for the weavers in Brussels to match. Pictorial weaving was the most prestigious and costly kind of wall decoration. With murals by the leading painters of the fifteenth century above his work and Michelangelo's work circling over all, Raphael must have felt both honored and challenged: The pope had chosen him for the chapel's most valuable works of art. They cost Leo X more than five times what Julius II had paid Michelangelo to paint the ceiling. Raphael only received a sixteenth of the total cost of the tapestries, however, for designing the program and producing the cartoons; the expense here involved production more than design.

The cartoons were created in Raphael's workshop between 1515 and 1516. Raphael was clearly the intellect behind the compositions, and he participated in the actual preparation and execution. This was a prestigious commission that would reflect directly on the reputation of the master. But he could not have accomplished this imposing task in a little over a year without the collaboration of numerous assistants. The cartoons were first drawn with charcoal on paper (160–170 separate sheets were glued together to form the expanse of a single tapestry), then overpainted with color, and finally sent to Brussels, where they were woven into tapestries in the workshop of Pieter van Aelst. The first was complete in 1517, seven were hanging in the chapel for Christmas 1519, and the entire cycle was installed by Leo X's death in 1521.

The process of creation, from design through production, can be charted by examining the tapestry portraying **CHRIST'S CHARGE TO PETER** (John 21:15–17; Matthew 16:17–19) at three stages in its development. We have Raphael's preliminary drawing (**FIG. 21-11**), where models—it is tempting to see these as Raphael's assistants, stripped to their underwear to help the master work out his composition—are posed to enact the moment when Jesus addresses his apostles. This is a preliminary idea for the pose of Christ. In the final cartoon (**FIG. 21-12**), Raphael changes Christ's gesture so that he addresses the kneeling Peter specifically rather than the whole apostolic group; for the patron, this would be an important detail since papal power rested in the belief that Christ had transferred authority to Peter, who was considered the first pope, with subsequent popes inheriting this authority in unbroken succession. Comparison of drawing and cartoon also reveals an important aspect of the design process. The cartoon reverses the figural arrangement of the drawing because in the production process the tapestry would be woven from the back—so the weavers would need to follow a reversed version of the original drawing in order to come out with the intended orientation for the resulting tapestry (**FIG. 21-13**). Comparison of cartoon and tapestry also indicates that the weavers were not required to follow their models slavishly. They embellished the costume of Christ, perhaps in an attempt to ensure that the viewer's attention would be immediately drawn to this most important figure in the scene.

After they had been used to create the tapestries hung in the Sistine Chapel, Raphael's cartoons remained in Brussels, where several additional sets of tapestries were made from them—one for Henry VIII of England, another for Francis I of France—before seven surviving cartoons were acquired in 1623 by the future Charles I of England. They remain in the British Royal Collection. The tapestries themselves, although still in the Vatican, are displayed in the museum rather than on the walls of the chapel for which they were originally conceived, as one of the most prestigious artistic projects from the peak of the Roman High Renaissance.

21-11 Raphael STUDY FOR CHRIST'S CHARGE TO PETER

c. 1515. Red chalk. Royal Library, Windsor Castle, England.

21–12 Raphael and assistants **CARTOON FOR TAPESTRY PORTRAYING CHRIST'S CHARGE TO PETER**
c. 1515–1516. Distemper on paper (now transferred to canvas), 11′1″ × 17′4″ (3.4 × 5.3 m). Lent by Her Majesty the Queen
to the Victoria & Albert Museum, London.

Credit: V&A Images/Victoria and Albert Museum

21–13 Shop of Pieter van Aelst, Brussels, after cartoons by Raphael and assistants **CHRIST'S CHARGE TO PETER**
Woven 1517, installed 1519 in the Sistine Chapel. Wool and silk with silver-gilt-wrapped threads. Musei Vaticani, Pinacoteca,
Rome.

Credit: Photo © Musei Vaticani/IKONA

Michelangelo

Michelangelo Buonarroti (1475–1564) was born in the Tuscan town of Caprese into an impoverished Florentine family that laid a claim to nobility—a claim the artist carefully advanced throughout his life. He grew up in Florence, where at age 13 he was apprenticed to Ghirlandaio (SEE FIG. 20-31), in whose workshop he learned the technique of fresco painting and studied drawings of Classical monuments. Soon the talented youth joined the household of Lorenzo the Magnificent, head of the ruling Medici family, where he came into contact with Neoplatonic philosophy and the family's distinguished sculpture collection. After Lorenzo died in 1492, Michelangelo traveled to Venice and Bologna, then returned to Florence.

Michelangelo's major early work at the turn of the century was a marble sculpture of the **PIETÀ** commissioned by a French cardinal and installed as a tomb monument in Old St. Peter's (**FIG. 21-14**). The theme of the *pietà* (in which the Virgin supports and mourns the dead Jesus in her lap), long popular in northern Europe (SEE FIG. 18-24), was an unusual theme in Italy at the time. Michelangelo traveled to the marble quarries at Carrara in central Italy to select the block from which to make this large work, a practice he was to continue for nearly all his sculpture. The choice of stone was important to him because he envisioned his sculpture as already existing within the marble, needing only his tools to set it free. Michelangelo was a poet as well as an artist and later wrote in his Sonnet 15: "The greatest artist has no conception which a single block of marble

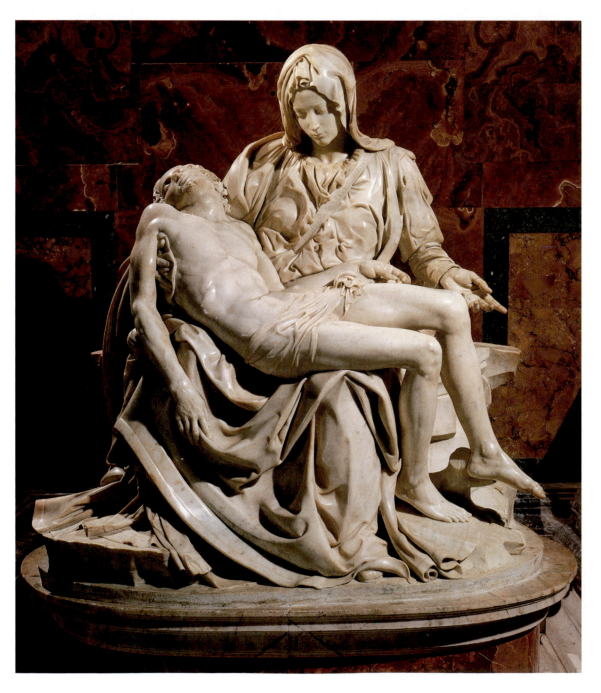

21-14 Michelangelo
PIETÀ
c. 1500. Marble, height 5'8½" (1.74 m). St. Peter's, Vatican, Rome.

Credit: Canali Photobank, Milan, Italy

21–15 Michelangelo DAVID
1501–1504. Marble, height 17′ (5.18 m) without pedestal. Galleria dell'Accademia, Florence.

Michelangelo's most famous sculpture was cut from an 18-foot-tall marble block. The sculptor began with a small model in wax, then sketched the contours of the figure as they would appear from the front on one face of the marble. According to his friend and biographer Vasari, Michelangelo then chiseled in from the drawn-on surface, as if making a figure in very high relief. The completed statue took four days to move on tree-trunk rollers down the narrow streets of Florence from the cathedral workshop to its location outside the Palazzo della Signoria (SEE FIG. 18–2). In 1504, the Florentines gilded the tree stump and added a gilded wreath to the head and a belt of 28 gilt-bronze leaves, since removed. In 1873, the statue was replaced by a copy, and the original was moved into the museum of the Florence Academy.

does not potentially contain within its mass, but only a hand obedient to the mind can penetrate to this image."

Michelangelo's Virgin is a young woman of heroic stature holding the unnaturally smaller, lifeless body of her grown son. Inconsistencies of scale and age are forgotten, however, when contemplating the sweetness of expression, technical virtuosity of the carving, and smooth interplay of the forms. Michelangelo's compelling vision of beauty was meant to be seen up close so that the viewer can look directly into Jesus's face. The 25-year-old artist is said to have slipped into the church at night to sign the statue on a strap across the Virgin's breast after it was finished, answering directly questions that had come up about the identity of its creator.

In 1501, Michelangelo accepted a Florentine commission for a statue of the biblical hero **DAVID** (FIG. 21–15) to be placed high atop a buttress of the cathedral. But when it was finished in 1504, the *David* was so admired that the city council instead placed it in the principal city square, next to the Palazzo della Signoria (SEE FIG. 18–2), the seat of Florence's government. There it stood as a reminder of Florence's republican status, which was briefly reinstated after the expulsion of the powerful Medici oligarchy in 1494. Although in its muscular nudity Michelangelo's *David* embodies the antique ideal of the athletic male nude, the emotional power of its expression and its concentrated gaze are entirely new. Unlike Donatello's bronze *David* (SEE FIG. 20–14), this is not a triumphant hero with the trophy head of the giant Goliath already under his feet. Slingshot over his shoulder and a rock in his right hand, Michelangelo's *David* knits his brow and stares into space, seemingly preparing himself psychologically for the danger ahead, a mere youth confronting a gigantic experienced warrior. This *David* stands for the supremacy of right over might—a perfect emblem for the Florentines, who had recently fought the forces of Milan, Siena, and Pisa and still faced political and military pressure.

THE CEILING OF THE SISTINE CHAPEL Despite Michelangelo's contractual commitment to Florence Cathedral for additional statues, Pope Julius II, who saw Michelangelo as an ideal collaborator in the artistic aggrandizement of the papacy, arranged in 1505 for him to come to Rome to work on the spectacular tomb Julius planned for himself. Michelangelo began the tomb project, but two years later the pope ordered him to begin painting the ceiling of the **SISTINE CHAPEL** instead (**FIG. 21–16**).

Michelangelo considered himself a sculptor, but the strong-minded pope wanted paintings; work began in 1508. Michelangelo complained bitterly in a sonnet to a friend: "This miserable job has given me a goiter…. The force of it has jammed my belly up beneath my chin. Beard to the sky….Brush splatterings make a pavement of my face…. I'm not a painter." Despite his physical misery as he stood on a scaffold, painting the ceiling just above him, the results were extraordinary, and Michelangelo

21–16 INTERIOR, SISTINE CHAPEL

Vatican, Rome. Built 1475–1481; ceiling painted 1508–1512; end wall, 1536–1541. The ceiling measures 45 × 128′ (13.75 × 39 m).

Credit: Musei Vaticani/Zigrossi, Brachetti/IKONA

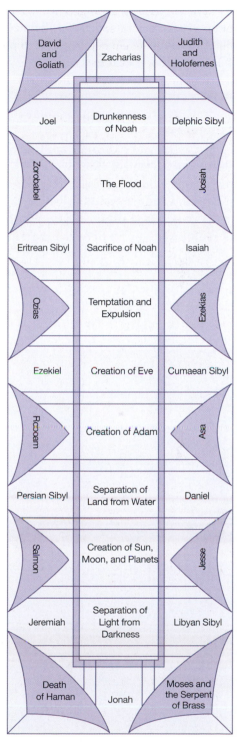

David and Goliath	Zacharias	Judith and Holofernes
Joel	Drunkenness of Noah	Delphic Sibyl
Zorobabel	The Flood	Josiah
Eritrean Sibyl	Sacrifice of Noah	Isaiah
Ozias	Temptation and Expulsion	Ezekias
Ezekiel	Creation of Eve	Cumaean Sibyl
Roboam	Creation of Adam	Asa
Persian Sibyl	Separation of Land from Water	Daniel
Salmon	Creation of Sun, Moon, and Planets	Jesse
Jeremiah	Separation of Light from Darkness	Libyan Sibyl
Death of Haman	Jonah	Moses and the Serpent of Brass

ALTAR

21–17 Michelangelo SISTINE CHAPEL CEILING WITH DIAGRAM IDENTIFYING SCENES

1508–1512. Fresco.

Credit: Photo © Musei Vaticani/IKONA

established a new and remarkably powerful style in Renaissance painting.

Julius's initial order for the ceiling was simple: *trompe l'oeil* coffers to replace the original star-spangled blue decoration. Later he wanted the 12 apostles seated on thrones on the triangular spandrels between the lunettes framing the windows. According to Michelangelo, when he objected to the limitations of Julius's plan, the pope told him to paint whatever he liked. This Michelangelo presumably did, although he was certainly guided by a theological advisor and his plan no doubt required the pope's approval.

In Michelangelo's design, an illusionistic marble architecture establishes a framework for the figures and narrative scenes on the vault of the chapel (**FIG. 21–17**). Running completely around the ceiling is a painted cornice with projections supported by pilasters decorated with "sculptured" *putti*. Between the pilasters are figures of prophets and sibyls (female seers from the Classical world) who were believed to have foretold Jesus's birth. Seated on the fictive cornice are heroic figures of nude young men called *ignudi* (singular, *ignudo*), holding sashes attached to large gold medallions. Rising behind the *ignudi*, shallow bands of fictive stone span the center of the ceiling and divide it into nine compartments containing successive scenes from Genesis—recounting the Creation, the Fall, and the Flood—beginning over the altar and ending near the chapel entrance. God's earliest acts of creation are therefore closest to the altar, the Creation of Eve at the center of the ceiling, followed by the imperfect actions of humanity: Temptation, Fall, Expulsion from Paradise, and God's eventual destruction of all people except Noah and his family by the Flood. The eight triangular spandrels over the windows, as well as the lunettes crowning them, contain paintings of the ancestors of Jesus.

Perhaps the most familiar scene on the ceiling is the **CREATION OF ADAM** (**FIG. 21–18**), where Michelangelo captures the moment when God charges the languorous Adam—in a pose adapted from the Roman river-god type—with the spark of life. As if to echo the biblical text, Adam's heroic body, outstretched arm, and profile almost mirror those of God, in whose image he has been created. Emerging under God's other arm and looking across him in the direction of her future mate is the robust and energetic figure of Eve before her creation.

21–18 Michelangelo **CREATION OF ADAM, SISTINE CHAPEL CEILING**
1511–1512. Fresco, 9'2" × 18'8" (2.8 × 5.7 m).

Credit: Photo © Musei Vaticani/IKONA

SAN LORENZO After the Medici regained power in Florence in 1512 and Leo X (Giovanni de' Medici) succeeded Julius in 1513, Michelangelo became chief architect for Medici family projects at the church of San Lorenzo in Florence—including a new chapel for the tombs of Lorenzo the Magnificent, his brother Giuliano, and two younger dukes, also named Lorenzo and Giuliano, ordered in 1519 for the so-called New Sacristy (SEE FIG. 20–8B). The older men's tombs were never built to Michelangelo's designs, but the unfinished tombs for the younger relatives were placed on opposite side walls (**FIG. 21–19**).

Each of the two monuments consists of an idealized portrait of the deceased, who turns to face the family's unfinished ancestral tomb. The men are dressed in a sixteenth-century interpretation of Classical armor and seated in wall niches above pseudo-Classical sarcophagi. Balanced precariously atop the sarcophagi are male and female figures representing the times of day. Their positions would not seem so unsettling had reclining figures of river gods been installed below them, as originally planned, but even so there is a conspicuous tension here between the substantiality of the figures and the limitations imposed on them by their architectural surrounds. In the tomb illustrated here, Michelangelo represents Giuliano as the Active Life, and his sarcophagus figures are allegories of Night and Day. Night at left is accompanied by her symbols: a star and crescent moon on her tiara; poppies, which induce sleep; and an owl under the arch of her leg. The huge mask at her back may allude to Death, since Sleep and Death were said to be the children of Night. Some have seen in this mask that glares out at viewers in the chapel a self-portrait of the artist, serving both as signature and as a way of proclaiming his right to be here because of his long relationship with the family. On the other tomb, Lorenzo, representing the Contemplative Life, is supported by Dawn and Evening.

Concurrent with work on the Medici tombs was the construction of a new library at San Lorenzo. The idea for the library belongs to Cardinal Giulio de' Medici and dates to 1519, but it was only after he was elected Pope Clement VII in 1523 that the money became available to realize it. Michelangelo was commissioned to design and also supervise construction of the new

21–19 Michelangelo **TOMB OF GIULIANO DE' MEDICI WITH ALLEGORICAL FIGURES OF NIGHT AND DAY**

New Sacristy (Medici Chapel), church of San Lorenzo, Florence. 1519–1534. Marble, height of seated figure approx. 5′10″ (1.8 m).

Credit: © Studio Fotografico Quattrone, Florence

VESTIBULE (FIG. 21-20) and reading room and to spare no expense in making them both grand and ambitious. The pope paid keen attention to the library's progress—not, he said, to verify the quality of the design, but because the project had a special interest for him.

Michelangelo coordinated his work within a decorative tradition established at San Lorenzo when Brunelleschi designed the church itself a century earlier (SEE FIG. 20-8A), using stylized architectural elements carved in dark gray *pietra serena*, set against and within a contrasting white wall. However, Michelangelo plays with the Classical architectural etiquette that Brunelleschi had used to create such clarity, harmony, and balance in the nave. In Michelangelo's vestibule, chunky columns are recessed

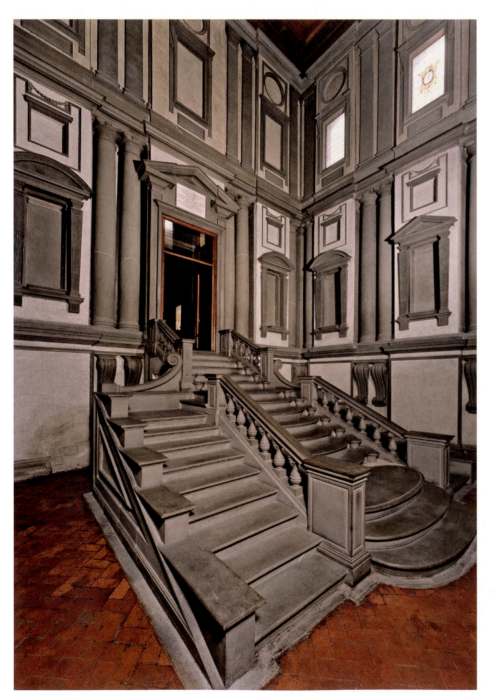

into rectangular wall niches that can barely contain them. They are crowded and overlapped by the aggressive lateral extension of the pediment over the door. The door itself is broken into parts, sides jutting forward as fluted pilasters that are then partially obscured by the frame around the opening. The three flights of stairs leading up to the reading room almost fill the vestibule, and the central stairs cascade forward forcefully toward visitors, who are hardly encouraged to go against the flow and step up. Through their playfulness, these creative combinations of architectural forms draw attention to themselves and their design rather than the function of the building itself or the comfortable accommodation of its users, prime characteristics of the Mannerist architecture then coming into fashion.

Fearing for his life when ongoing political struggles flared up in Florence, Michelango returned to Rome in 1534 and settled permanently. He had left both the Medici Chapel and the library unfinished. In 1557, he sent a plaster model of the library staircase to Florence to ensure that its completion conformed to his design. In 1545, his students had assembled the tomb sculptures, including unfinished figures of the times of day, into the composition we see today.

The figures of the dukes are finely finished, but the times of day are notable for their contrasting areas of rough unfinished and polished marble. These are the only unfinished sculptures Michelangelo apparently permitted to be put in place, and we do not know what his reasons were. Specialists in Renaissance art history characterize these works with the word *nonfinito* ("unfinished"), proposing that Michelangelo had begun to view his artistic creations as symbols of human imperfection. Indeed, Michelangelo's poetry often expressed his belief that humans could achieve perfection only in death.

21-20 Michelangelo
VESTIBULE OF THE LAURENTIAN LIBRARY
Church of San Lorenzo, Florence. Begun 1524; stairway designed 1550s.

Credit: © Studio Fotografico Quattrone, Florence

Architecture in Rome and the Vatican

The election of Julius II as pope in 1503 crystallized a resurgence of papal power, but France, Spain, and the Holy Roman Empire all had designs on Italy. During his ten-year papacy, Julius fought wars and formed alliances to consolidate his power. He also enlisted Bramante, Raphael, and Michelangelo to carry out his vision of a revitalized Rome as the center of a new Christian architecture, inspired by the achievements of their fifteenth-century predecessors as well as the monuments of antiquity. Although most commissions were for churches, opportunities also arose to create urban palaces and country villas.

BRAMANTE Donato Bramante (1444–1514) was born near Urbino and trained as a painter, but turned to architectural design early in his career. About 1481, he became attached to the Sforza court in Milan, where he would have known Leonardo da Vinci. In 1499, Bramante settled in Rome, but work came slowly. The architect was nearing 60 when Julius II asked him to redesign St. Peter's (see "St. Peter's Basilica" on page 687) and the Spanish rulers Queen Isabella and King Ferdinand commissioned a small shrine over the spot in Rome where the apostle Peter was believed to have been crucified (**FIG. 21-21**). In this tiny building, known as Il Tempietto ("Little Temple"), Bramante combined his interpretation of the principles of Vitruvius and Alberti, from the stepped base to the Tuscan columns and Doric frieze (Vitruvius had advised that the Doric order be used for temples to gods of particularly forceful character) to the elegant balustrade. The centralized plan and the tall drum supporting a hemispheric dome recall Early Christian shrines built over martyrs' relics, as well as ancient Roman circular temples. Especially notable is the sculptural effect of the building's exterior, with its deep wall niches and sharp contrasts of light and shadow. Bramante's design called for a circular cloister around the church, but the cloister was never built.

21-21 Donato Bramante IL TEMPIETTO, CHURCH OF SAN PIETRO IN MONTORIO
Rome. 1502–1510; dome and lantern were restored in the 17th century.

Credit: © Vincenzo Pirozzi, Rome

Northern Italy

How are the sixteenth-century Renaissance buildings, paintings, and sculptures in northern Italy distinctive from what was created at the same time in Rome?

While Rome was Italy's preeminent arts center at the beginning of the sixteenth century, wealthy and powerful families elsewhere also patronized the arts and letters, just as the Montefeltros and Gonzagas had in Urbino and Mantua during the fifteenth century. The architects and painters working for these sixteenth-century patrons created fanciful structures and developed a new colorful, illusionistic painting style. The result was witty, elegant, and finely executed art designed to appeal to the jaded taste of the intellectual elite in cities such as Mantua, Parma, Bologna, and Venice.

21–22 Giulio Romano **COURTYARD FAÇADE, PALAZZO DEL TE, MANTUA**
1527–1534.

Credit: © SuperStock

GIULIO ROMANO In Mantua, Federigo II Gonzaga (ruled 1519–1540) continued the family tradition of patronage when, in 1524, he lured a Roman follower of Raphael, Giulio Romano (c. 1499–1546), to build him a pleasure palace. Indeed, the **PALAZZO DEL TE** (**FIG. 21-22**) devoted more space to gardens, pools, and stables than to rooms for residential living. Since Federigo and his well-educated friends would have known Classical orders and proportions, they could appreciate the playfulness with which they are used here. The building is full of visual jokes, such as lintels masquerading as arches and triglyphs that slip sloppily out of place. Like the similar, if more sober, subversions of Classical architectural decorum in Michelangelo's contemporary Laurentian Library (SEE FIG. 21-20), the Palazzo del Te's sophisticated humor and exquisite craft have been seen as a precursor to Mannerism or as a manifestation of Mannerism itself.

Giulio Romano continued his witty play in the decoration of the two principal rooms. One, dedicated to the loves of the

21–23 Giulio Romano **FALL OF THE GIANTS**
Sala dei Giganti, Palazzo del Te. 1530–1532. Fresco.

Credit: © 2016. Photo Scala, Florence

gods, depicted the marriage of Cupid and Psyche. The other room is a remarkable feat of *trompe l'oeil* painting in which the entire building seems to be collapsing around the viewer as the gods defeat the giants (**FIG. 21-23**). Here, Giulio Romano accepted the challenge Andrea Mantegna had laid down in the Camera Picta of the Gonzaga Palace (SEE FIG. 20-40), painted for Federigo's grandfather: to dissolve architectural barriers and fantasize a world of playful delight beyond the walls and ceilings. But the Palazzo del Te was not just fun and games. The unifying themes were love and politics, the former focused on the separate apartments built to house Federigo's mistress, Isabella Boschetti. The palace was constructed in part as a place where they could meet beyond the watchful gaze of her husband, but the decoration also seems to reflect Federigo's dicey alliance

with Charles V, who stayed in the palace in 1530 and again in 1532, when the scaffolding was removed from the Sala dei Giganti so the emperor could see the paintings in progress. He must have been impressed with his host's lavish new residence, and doubtless he saw a connection between these reeling paintings and his own military successes.

CORREGGIO At about the same time that Giulio Romano was building and decorating the Palazzo del Te, in nearby Parma an equally skillful master, Correggio (Antonio Allegri da Correggio, c. 1489–1534), was creating similarly theatrical effects with dramatic foreshortening in Parma Cathedral. Correggio's great work, the **ASSUMPTION OF THE VIRGIN** (**FIG. 21-24**), a fresco painted between about 1526 and 1530 in the cathedral's

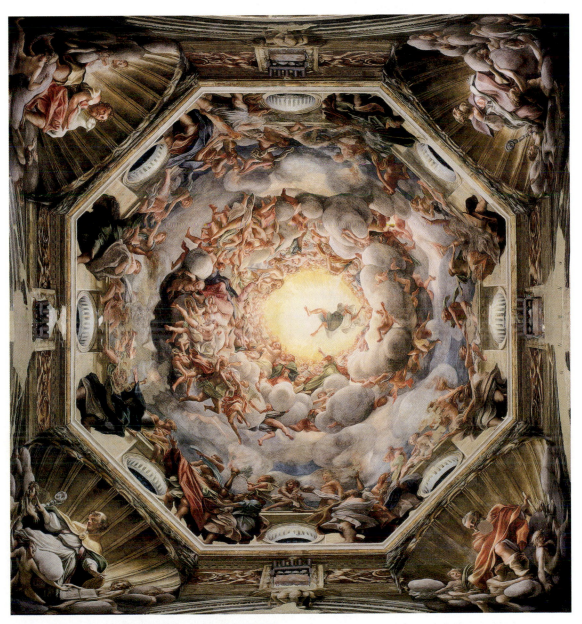

21-24 Correggio ASSUMPTION OF THE VIRGIN
Main dome, interior, Parma Cathedral, Italy. c. 1526–1530. Fresco, diameter of base of dome approx. 36′ (11 m).

Credit: © 2016. Photo Scala, Florence

21–25 Properzia de' Rossi **JOSEPH AND POTIPHAR'S WIFE**
Cathedral of San Petronio, Bologna. 1525–1526. Marble, 1'9" × 1'11" (54 × 58 cm). Museo de San Petronio, Bologna.
Credit: Berardi/IKONA

in the 1550 edition of *Lives of the Artists*; he wrote that a rival male sculptor prevented her from being paid fairly for this piece and from securing additional commissions.

Venice and the Veneto

In the sixteenth century the Venetians did not see themselves as rivals of Florence and Rome, but rather as their superiors. Their city was the greatest commercial sea power in the Mediterranean, they had challenged Byzantium, and now they confronted the Muslim Turks. Favored by their unique geographical situation—protected by water and controlling sea routes in the Adriatic Sea and the eastern Mediterranean—the Venetians became wealthy and secure patrons of the arts. Their Byzantine heritage, preserved by their conservative tendencies, encouraged an art of rich patterned surfaces emphasizing light and color.

The idealized style and oil-painting technique initiated by the Bellini family in the late fifteenth century (see Chapter 20) were developed further by sixteenth-century Venetian painters. Venetians were the first in Italy to use oils for painting on both wood panel and canvas. Possibly because they were a seafaring people accustomed to working with large sheets of canvas, and possibly because humidity made their walls crack and mildew, the Venetians were also the first to cover walls with large canvas paintings instead of frescos. Because oils dried slowly, errors could be corrected and changes made easily during the work. The flexibility of the canvas support, coupled with the radiance and depth of oil-suspended pigments, eventually made oil on canvas the preferred medium, especially since it was particularly well suited to the rich color and lighting effects favored by Giorgione and Titian, two of the city's major painters of the sixteenth century.

dome, distantly recalls the illusionism of Mantegna's ceiling in the Gonzaga Palace, but Correggio has also assimilated Leonardo da Vinci's use of *sfumato* and Raphael's idealism into his own style. Correggio's *Assumption* is a dazzling illusion—the architecture of the dome seems to dissolve and the forms seem to explode through the building, drawing viewers into the swirling vortex of saints and angels who rush upward amid billowing clouds to accompany the Virgin as she soars into heaven. Correggio's sensual rendering of the figures' flesh and clinging draperies contrasts with the spirituality of the theme (the miraculous transporting of the Virgin to heaven at the moment of her death). The viewer's strongest impression is of a powerful, upward-spiraling motion of alternating cool clouds and warm, alluring figures.

PROPERZIA DE' ROSSI Very few women had the opportunity to become sculptors. Properzia de' Rossi (c. 1490–1529/1530), who lived in Bologna, was an exception. She mastered many arts, including engraving, and was famous for her miniature sculptures, including an entire *Last Supper* carved on a peach pit. She carved several pieces in marble—two sibyls, two angels, and this relief of **JOSEPH AND POTIPHAR'S WIFE**—for the Cathedral of San Petronio in Bologna (**FIG. 21–25**). According to Vasari, it was inspired by Properzia's own love for a young man, which she got over by carving this panel. Joseph escapes, running, as the partially clad seductress snatches at his cloak. Properzia is the only woman Vasari included

GIORGIONE The career of Giorgione (Giorgio da Castelfranco, c. 1475–1510) was brief—he died from the plague, and most scholars accept fewer than ten paintings as entirely by his hand. But his importance to Venetian painting is critical. He introduced new, enigmatic pastoral themes, known as **poesie** (or "painted poems"), that were inspired by the contemporary literary revival of ancient pastoral verse but defy specific narrative or symbolic interpretation. He is significant above all for his appreciation of

nature in landscape painting. His early life and training are undocumented, but his work suggests that he studied with Giovanni Bellini. Perhaps Leonardo da Vinci's subtle lighting system and mysterious, intensely observed landscapes also inspired him.

One of Giorgione's most compelling works, called today **THE TEMPEST** (**FIG. 21–26**), was painted shortly before his death, potentially in response to personal, private impulses—as with many modern artists—rather than to fulfill an external commission. Simply trying to

understand what is happening in this enigmatic picture piques our interest. At the right, a woman is seated on the ground, nude except for the end of a long white cloth thrown over her shoulders. Her nudity seems maternal, her sensuality generative rather than erotic, as she nurses the baby protectively and lovingly embraced at her side. Across the dark, rocky edge of her elevated perch stands a mysterious man, variously interpreted as a German mercenary soldier and as an urban dandy wandering in the country. His shadowed head turns in the direction of the

21–26 Giorgione **THE TEMPEST**
c. 1506. Oil on canvas, 32 × 28¾" (82 × 73 cm). Galleria dell'Accademia, Venice.

Credit: © Cameraphoto Arte, Venice

woman, but he only appears to have paused for a moment before turning back toward the viewer or resuming his journey along the path. X-rays of the painting show that Giorgione altered the composition while he was still working on the painting—the man replaced a second nude woman who was bathing. Between the figures, a spring gushes to feed a lake surrounded by substantial houses, and in the far distance a bolt of lightning splits the darkening sky. Indeed, the artist's attention seems focused as much on the landscape and the unruly elements of nature as on the figures posed within it. Some interpreters have seen references to the Classical elements of water, earth, air, and fire in the lake, the verdant ground, the billowing clouds, and the lightning bolt.

For a few years before Giorgione's untimely death in 1510, he was associated with Tiziano Vecellio, a painter better known today as Titian (c. 1488–1576). The painting known as **THE PASTORAL CONCERT** (FIG. 21-27) has been attributed to both of them, although scholarly opinion

today favors Titian. As in Giorgione's *The Tempest*, the idyllic landscape, here bathed in golden, hazy, late-afternoon sunlight, seems to be one of the main subjects of the painting. In this mythic world, two men—an aristocratic musician in rich red silks and a barefoot, singing peasant in homespun cloth—turn toward each other, seemingly unaware of the two naked women in front of them. One woman plays a pipe and the other pours water into a well; the white drapery sliding to the ground enhances rather than hides their nudity. Perhaps they are the musicians' muses. Behind the figures, the sunlight illuminates another shepherd and his animals near lush woodland. The painting evokes a golden age of love and innocence recalled in ancient Roman and Italian Renaissance pastoral poetry. In fact, the painting is now interpreted as an allegory on the invention of poetry. Both artists were renowned for painting sensuous female nudes whose bodies seem to glow with an incandescent light, inspired by flesh and blood as much as any source from poetry or art.

21-27 Giorgione or Titian **THE PASTORAL CONCERT OR ALLEGORY ON THE INVENTION OF PASTORAL POETRY**
c. 1510. Oil on canvas, 41¼ × 54¾" (105 × 136.5 cm). Musée du Louvre, Paris.

TITIAN Titian's early life is obscure. He supposedly began an apprenticeship as a mosaicist, then studied painting under Gentile and Giovanni Bellini, perhaps working later with Giorgione. He certainly absorbed Giorgione's style and completed at least one of Giorgione's unfinished paintings.

In 1519, Jacopo Pesaro, commander of the papal fleet that had defeated the Turks in 1502, commissioned Titian to commemorate the victory in a votive altarpiece for a side-aisle chapel in the Franciscan church of Santa Maria Gloriosa dei Frari in Venice. Titian worked on the painting for seven years and changed the concept three times before he finally came up with a revolutionary composition—one that complemented the viewer's approach from the left.

He created an asymmetrical setting of huge columns on high bases soaring right out of the frame (**FIG. 21-28**). Into this architectural setting, he placed the Virgin and Child on a high throne at one side and arranged saints and the Pesaro family below on a diagonal axis, crossing at the central figure of St. Peter (a reminder of Jacopo's role as head of the papal forces in 1502). The red of Francesco Pesaro's brocade garment and of the banner diagonally across sets up a contrast of primary colors against St. Peter's blue tunic and yellow mantle and the red and blue draperies of the Virgin. St. Maurice (behind the kneeling Jacopo at the left) holds the banner with the papal arms, and a cowering Turkish captive reminds the viewer of the Christian victory. A youth turning to meet our gaze at lower right guarantees our engagement, and light floods in from above, illuminating not only this and other faces, but also the great columns, where *putti* in the clouds carry a cross. Titian was famous for his mastery of light and color, but this altarpiece demonstrates that he also could draw and model as solidly as any Florentine. The perfectly balanced composition, built on color and diagonals instead of a vertical and horizontal grid, looks forward to the art of the seventeenth century.

In 1529, Titian, who was well known outside Venice, began a long professional relationship with Emperor Charles V, who vowed to let no one else paint his portrait and ennobled Titian in 1533. The next year Titian was commissioned to paint a portrait of

21-28 Titian **PESARO MADONNA**
1519–1526. Oil on canvas, 16′ × 8′10″ (4.9 × 2.7 m). Side-aisle altarpiece, Santa Maria Gloriosa dei Frari, Venice.

Credit: © Cameraphoto Arte, Venice

21-29 Titian **ISABELLA D'ESTE**
1534–1536. Oil on canvas, 40⅛ × 25³⁄₁₆″ (102 × 64.1 cm).
Kunsthistorisches Museum, Vienna.

Credit: © KHM-Museumsverband

the marchesa of Mantua, Isabella d'Este (1474–1539; **FIG. 21-29**), a patron of painters, musicians, composers, writers, and literary scholars. Married to Francesco II Gonzaga at age 15, she had great wealth and a brilliant mind that made her a successful diplomat and administrator. A true Renaissance woman, she was an avid collector of manuscripts and books and sponsored the publication of an edition of Virgil while still in her twenties. She also collected ancient art and objects, as well as works by contemporary Italian artists such as Mantegna, Leonardo, Perugino, Correggio, and Titian. Her study in her Mantuan palace was a veritable museum. The walls above the storage and display cabinets were painted with frescos by Mantegna, and the carved wood ceiling was covered with mottoes and visual references to Isabella's literary interests.

Isabella was past 60 when Titian portrayed her in 1534–1536, but she asked to appear as she had in her

21-30 Titian **"VENUS" OF URBINO**
c. 1538. Oil on canvas, 3′11″ × 5′5″ (1.19 × 1.65 m). Galleria degli Uffizi, Florence.

Credit: © Studio Fotografico Quattrone, Florence

21–31 Veronese **FEAST IN THE HOUSE OF LEVI**
From the refectory of the monastery of SS. Giovanni e Paolo, Venice. 1573. Oil on canvas, 18′3″ × 42′ (5.56 × 12.8 m).
Galleria dell'Accademia, Venice.

Credit: © Cameraphoto Arte, Venice

twenties. Titian was able to satisfy her wish by referring to an early portrait by another artist, but he also conveyed the mature Isabella's strength, self-confidence, and energy.

No photograph can convey the vibrancy of Titian's paint surfaces, which he built up in layers of pure colors, chiefly red, white, yellow, and black, on his canvases. A recent scientific study of Titian's paintings revealed that he ground his pigments much finer than had earlier, wood-panel painters. The complicated process by which he produced many of his works began with a charcoal drawing on the prime coat of lead white that was used to seal the pores and smooth the surface of the rather coarse Venetian canvas. The artist then built up the forms with fine glazes of different colors, sometimes in as many as 15 layers. Titian had the advantage of working in Venice, the first place to have professional retail "color sellers." These merchants produced a wide range of specially prepared pigments, even mixing their oil paints with ground glass to increase their glowing transparency. Not until the second half of the sixteenth century did color sellers open their shops in other cities.

Paintings of nude, reclining women became especially popular in court circles, where men could appreciate the "Venuses" under the cloak of respectable Classical mythology. Seemingly typical of such paintings is the **"VENUS"** Titian delivered to Guidobaldo della Rovere, duke of Urbino, in spring 1538 (**FIG. 21–30**). Here, we seem to see a beautiful Venetian courtesan with deliberately provocative gestures, stretching languidly on her couch in a spacious palace, her glowing flesh and golden hair set off by white sheets and pillows. But for its original audience, art

historian Rona Goffen has argued, the painting was more about marriage than mythology or seductiveness. The multiple matrimonial references in this work include the pair of *cassoni* (SEE FIG. 20–30) where servants are removing or storing the woman's clothing in the background, the bridal symbolism of the myrtle and roses she holds in her hand, and even the spaniel snoozing at her feet—a traditional symbol of fidelity and domesticity, especially when sleeping so peacefully. Titian's picture might be associated with Duke Guidobaldo's marriage in 1534 to the 10-year-old Giulia Verano. Four years later, when this painting arrived, she would have been considered an adult rather than a child bride. It seems to represent neither a Roman goddess nor a Venetian courtesan, but a bride welcoming her husband into their lavish bedroom.

VERONESE AND TINTORETTO Later sixteenth-century Venetian oil painters expanded upon the color, light, and expressively loose brushwork initiated by Giorgione and Titian. Paolo Caliari (1528–1588) took his nickname, "Veronese," from his hometown, Verona, but he worked mainly in Venice. His paintings are nearly synonymous today with the popular image of Venice as a splendid city of pleasure and pageantry sustained by a nominally republican government and great mercantile wealth. Veronese's elaborate architectural settings and costumes, still lifes, anecdotal vignettes, and other everyday details—often unconnected with the main subject—proved immensely appealing to Venetian patrons.

One of Veronese's most famous works is a *Last Supper* that he renamed **FEAST IN THE HOUSE OF LEVI** (FIG. 21–31),

21–32 Tintoretto **THE LAST SUPPER**
Church of San Giorgio Maggiore, Venice. 1592–1594. Oil on canvas, 12′ × 18′8″ (3.7 × 5.7 m).

Tintoretto, who had a large workshop, often developed a composition by creating a small-scale model like a miniature stage set, which he populated with wax figures. He then adjusted the positions of the figures and the lighting until he was satisfied with the entire scene. Using a grid of horizontal and vertical threads placed in front of this model, he could easily sketch the composition onto squared paper for his assistants to copy onto a large canvas. His assistants also primed the canvas, blocking in the areas of dark and light, before the artist himself, free to concentrate on the most difficult passages, finished the painting. This efficient working method allowed Tintoretto to produce a large number of paintings in all sizes.

painted in 1573 for the Dominican monastery of SS. Giovanni e Paolo. At first glance, the subject of the painting seems to be primarily its architectural setting and only secondarily Christ seated at the table. Symmetrically disposed, balustraded stairways lead to an enormous loggia framed by colossal arches, beyond which sits an imaginary city of white marble. Within this grand setting, lifelike figures in lavish costumes strike theatrical poses, surrounded by the sort of anecdotal details loved by the Venetians— such as parrots, monkeys, a man picking his teeth, and foreign soldiers—but the painting's monastic patrons were shocked. They saw these as profane distractions, especially in a representation of the Last Supper.

As a result of the furor, Veronese was called before the Inquisition, a papal office that prosecuted heretics, to explain his painting. There he justified himself first by asserting that the picture actually depicted not the Last Supper, but rather the feast in the house of Simon, a small dinner held shortly before Jesus's final entry into

Jerusalem. He also noted that artists customarily invent details in their pictures and that he had received a commission to paint the piece in his own way. His argument fell on unsympathetic ears, and he was ordered to change the painting. Later he sidestepped the issue by changing its title to that of another banquet, one given by the tax collector Levi, whom Jesus had called to follow him (Luke 5:27–32). Perhaps with this change of subject, Veronese took a modest revenge on the Inquisitors: When Jesus himself was criticized for associating with such unsavory people at this meal, he replied, "I have not come to call the righteous to repentance but sinners" (Luke 5:32).

Jacopo Robusti (1518–1594), called Tintoretto ("Little Dyer," because his father was a dyer), carried Venetian painting in another direction. Tintoretto's goal, declared on a sign in his studio, was to combine Titian's coloring with the drawing of Michelangelo. His large painting of **THE LAST SUPPER** (FIG. **21–32**) for the choir of Palladio's church of San Giorgio Maggiore (SEE FIG. 21–33) is quite different

from Leonardo da Vinci's painting of the same subject almost a century earlier (SEE FIG. 21-4). Instead of Leonardo's frontal view of a closed and logical space with massive figures reacting in individual ways to Jesus's statement, Tintoretto views the scene from a corner, with the vanishing point on a high horizon line at far right. The table, coffered ceiling, and inlaid floor all seem to plunge dramatically into the distance. The figures, although still large bodies modeled by flowing draperies, turn and move in a continuous serpentine line that unites apostles, servants, and angels. Tintoretto used two internal light sources: one real, the other supernatural. Over the near end of the table, light streams from the oil lamp flaring exuberantly, with angels swirling out from the flame and smoke. A second light emanates from Jesus himself and is repeated in the glow of the apostles' haloes. The intensely spiritual, otherworldly mood is enhanced by deep colors flashed with dazzling highlights on elongated figures, consistent with Mannerist tendencies. Homey details like the still lifes on the tables and the cat in the foreground connect with viewers' own experiences. And the narrative emphasis has shifted from Leonardo's more worldly study of personal betrayal to Tintoretto's reference to the institution of the Eucharist. Jesus offers bread and wine to a disciple in the same way that a priest would administer the sacrament at the altar next to the painting.

Although the brilliance and immediacy of Tintoretto's work are much admired today—twentieth-century gestural painters particularly appreciated his slashing brushwork—the speed with which he drew and painted was cited as evidence of carelessness in his own time. Rapid production may have been a byproduct of his working methods. Tintoretto

had a large workshop of assistants, and he usually provided only the original conception, the early drawings, and the final brilliant touches on the finished paintings. His workshop also included members of his family: Four of his eight children became artists. His oldest daughter, Marietta Robusti, worked with him as a portrait painter, and two or three of his sons also joined the shop. So skillfully did Marietta capture her father's style and technique that today art historians cannot separate their work.

The Architecture of Palladio

Just as Veronese and Tintoretto built on the rich Venetian tradition of oil painting initiated by Giorgione and Titian, Andrea Palladio dominated architecture during the second half of the century by expanding upon the principles of Alberti and the ancient Romans. His buildings—whether villas, palaces, or churches—were characterized by harmonious symmetry and controlled ornamentation. Born

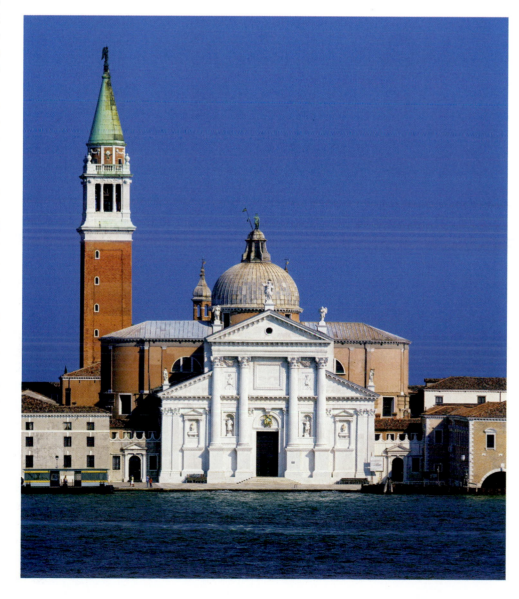

21-33 Palladio **CHURCH OF SAN GIORGIO MAGGIORE, VENICE**

Plan 1565; construction 1565–1580; façade 1597–1610; campanile 1791. Finished by Vincenzo Scamozzi following Palladio's design.

Credit: © Cameraphoto Arte, Venice

21–34 NAVE, CHURCH OF SAN GIORGIO MAGGIORE, VENICE
Begun 1566. Tintoretto's *Last Supper* (not visible) hangs to the left of the altar.

Credit: © Cameraphoto Arte, Venice

Andrea di Pietro della Gondola (1508–1580), probably in Padua, Palladio began his career as a stonecutter. After moving to Vicenza, he was hired by Giangiorgio Trissino, a nobleman, humanist scholar, and amateur architect who gave him the nickname "Palladio" for the Greek goddess of wisdom, Pallas Athena, and the fourth-century Roman writer Palladius. Palladio learned Latin at Trissino's small academy and accompanied his benefactor on three trips to Rome, where he made drawings of Roman monuments.

Over the years, Palladio became involved in several publishing ventures, including a guide to Roman antiquities and an illustrated edition of Vitruvius. He also published his own books on architecture—including ideal plans for country estates using proportions derived from ancient Roman buildings—that would be valued for centuries as resources for architectural design. Despite their theoretical bent, his writings were often more practical than earlier treatises. Perhaps his early experience as a stonemason enabled him to discuss technical problems with the same clarity as theories of ideal proportion and uses of the Classical orders. By the eighteenth century, Palladio's *Four Books of Architecture* were in the libraries of most educated people. Thomas Jefferson had one of the first copies in America.

SAN GIORGIO MAGGIORE By 1559, when he settled in Venice, Palladio was one of the foremost architects in Italy. In 1565, he undertook a major architectural commission: the monastery **CHURCH OF SAN GIORGIO MAGGIORE** (FIG. 21-33). His variation on the traditional Renaissance façade for a basilica—a wide lower level fronting the nave and side aisles, surmounted by a narrower front for the nave clerestory—creates the illusion of two temple fronts of different heights and widths, one set inside the other. At the center, colossal columns on high pedestals support an entablature and pediment; these columns correspond to the width of the nave within. Behind the taller temple front, a second front consists of pilasters

supporting another entablature and pediment; this wider front spans the entire width of the church, aisles as well as nave. Although the façade was not built until after the architect's death, his original design was followed.

The interior of San Giorgio (**FIG. 21–34**) is a fine example of Palladio's harmoniously balanced geometry, expressed here in strong verticals and powerfully opened arches. The tall engaged columns and shorter pilasters of the nave arcade piers echo the two levels of orders on the façade, helping to unify the building's exterior and interior.

THE VILLA ROTONDA Palladio's versatility was already apparent in numerous villas built early in his career. In the 1560s, he started his most famous and influential villa just outside Vicenza (**FIGS. 21–35, 21–36**). Although villas were working farms, Palladio designed this one in part as a retreat—literally a party house. To maximize vistas of the countryside, he placed a porch elevated at the top of a wide staircase on each face of the building. The main living quarters are on this second level, and the lower level is reserved for the kitchen, storage, and other utility rooms. Upon its completion in 1569, the building was dubbed the **VILLA ROTONDA** because it had been inspired by another round building, the Roman Pantheon. The plan shows the geometric clarity of Palladio's

conception: a circle inscribed in a small square inside a larger square, with symmetrical rectangular compartments and identical rectangular projections from each of its faces. The use of a central dome on a domestic building was a daring innovation that effectively secularized the dome and initiated what was to become a long tradition of domed country houses, particularly in England and the United States.

21–35 Palladio **PLAN OF VILLA ROTONDA, VICENZA**
Italy. Begun 1560s.

21–36 Palladio **EXTERIOR VIEW OF VILLA ROTONDA, VICENZA**

After its purchase in 1591 by the Capra family, the Villa Rotonda became known as the Villa Capra.

Credit: © Cameraphoto Arte, Venice

Mannerism

How do art historians define Mannerism, the new style that appears in Florentine painting and sculpture during the 1520s?

A new style developed in Florence and Rome in the 1520s that some art historians have associated with the death of Raphael and labeled "Mannerism," a word deriving from the Italian *maniera* (meaning "style"). Mannerism developed into an anti-Classical movement in which artificiality, grace, and elegance took priority over the ordered balance and lifelike references that were hallmarks of High Renaissance art. Patrons favored esoteric subjects, displays of extraordinary technical virtuosity, and the pursuit of beauty for its own sake. Painters and sculptors quoted from ancient and modern works of art in the same self-conscious manner that contemporary poets and authors were quoting from ancient and modern literary classics.

Architects working in the Mannerist style designed buildings that defied uniformity and balance and used Classical orders in unconventional, even playful, ways.

Painters working in the Mannerist style fearlessly manipulated and distorted accepted formal conventions, creating contrived compositions and irrational spatial environments. Figures take on elongated proportions, enigmatic gestures, dreamy expressions, and complicated, artificial poses. The pictures are full of quoted references to the works of illustrious predecessors.

Pontormo, Parmigianino, and Bronzino

The frescos and altarpiece painted between 1525 and 1528 by Jacopo Carucci da Pontormo (1494–1557) for the 100-year-old **CAPPONI CHAPEL** in the church of Santa Felicità in Florence (**FIG. 21-37**) bear the hallmarks of early Mannerist painting. Open on two sides, Brunelleschi's chapel forms an interior loggia in which frescos on the right-hand wall depict the Annunciation, and tondi (circular paintings) on the pendentives under the cupola represent the four evangelists. In the *Annunciation* the Virgin accepts the angel's message but also seems moved by the adjacent vision of her future sorrow, as she turns to see her son's body lowered from the cross in the altarpiece on the adjoining wall.

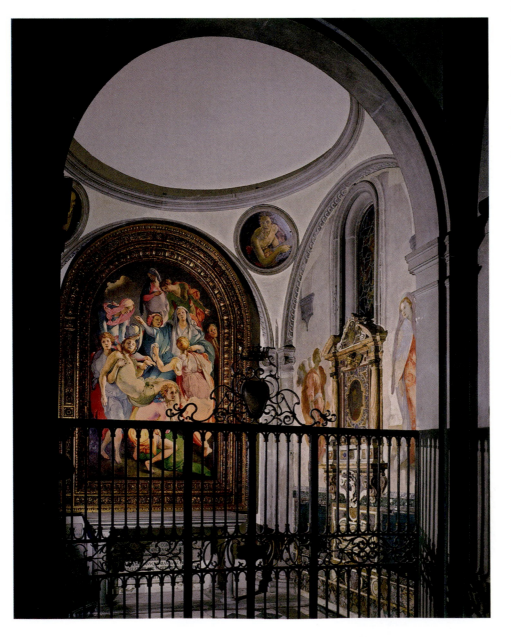

21-37 CAPPONI CHAPEL, CHURCH OF SANTA FELICITÀ, FLORENCE

Chapel by Filippo Brunelleschi for the Barbadori family, 1419–1423; acquired by the Capponi family, who ordered paintings by Pontormo, 1525–1528.

Credit: Index Ricerca Iconografica

Pontormo's ambiguous composition in the **DEPOSITION** (FIG. **21–38**) enhances the visionary quality of the altarpiece. The shadowy ground and cloudy sky give no sense of a specific location and little sense of grounding for the figures. Some press forward into the viewer's space, while others seem to levitate or stand precariously on tiptoe. Pontormo chose a moment just after Jesus's removal from the cross, when the youths who have lowered him pause to regain their hold on the corpse, which recalls Michelangelo's Vatican *Pietà* (SEE FIG. 21–14). Odd poses and drastic shifts in scale charge the scene emotionally, but perhaps most striking is the use of strange colors in unusual combinations—baby blue and pink with accents of olive green, yellow, and scarlet. The overall tone of the picture

21–38 Pontormo
DEPOSITION
Altarpiece in the Capponi Chapel, church of Santa Felicità, Florence. 1525–1528. Oil and tempera on wood panel, 10′3″ × 6′4″ (3.1 × 1.9 m).

The dreamy-eyed male figure in the background shadows at upper right is a self-portrait by the artist.

Credit: © Studio Fotografico Quattrone, Florence

21–39 Parmigianino **MADONNA OF THE LONG NECK**
1534–1540. Oil on wood panel, 7'1" × 4'4" (2.16 × 1.32 m). Galleria degli Uffizi, Florence.

Art historian Elizabeth Cropper has noted the visual relationship between the shape of the swelling, tapering-necked, ovoid vessel held by the figure at far left and the form of the figure of the Virgin herself, and has proposed that this visual analogy references a sixteenth-century literary conceit that related ideal beauty in women to the slender necks and swelling shapes of antique vessels.

Credit: © Studio Fotografico Quattrone, Florence

is set by the unstable youth crouching in the foreground, whose skintight bright pink shirt is shaded in iridescent, pale gray-blue, and whose anxious expression projects out of the painting, directly at the viewer.

When Parmigianino (Francesco Mazzola, 1503–1540) left his native Parma in 1524 for Rome, the strongest influence on his work was Correggio (SEE FIG. 21–24). In Rome, however, Parmigianino met Giulio Romano; he also studied the work of Raphael and Michelangelo. What he assimilated developed into a distinctive Mannerist style, calm but strangely unsettling. After the Sack of Rome in 1527, he moved to Bologna and then back to Parma.

Left unfinished at the time of his early death is a disconcerting painting known as the **MADONNA OF THE LONG NECK** (FIG. 21–39). The unnaturally proportioned figure of Mary, whose massive legs and lower torso contrast with her narrow shoulders and long neck and fingers, is presumably seated on a throne, but there is no seat in sight. The languid expanse of the sleeping child recalls the pose of the ashen Christ in a *pietà*; indeed, there is more than a passing resemblance here to Michelangelo's famous sculpture in the Vatican, even to the inclusion of a diagonal band across the Virgin's chest (SEE FIG. 21–14). The plunge into a deep background to the right reveals a startlingly small St. Jerome, who unrolls a scroll in front of huge, white columns from what was to be a temple in the unfinished background, whereas at the left a crowded mass of blushing boys blocks any view into the background. Like Pontormo, Parmigianino presents a well-known image in a challenging manner calculated to intrigue viewers.

About 1522, Agnolo di Cosimo di Mariano Tori (1503–1572), whose nickname of "Bronzino" means "copper-colored" (just as we might call someone "Red"), became Pontormo's pupil and assistant, probably helping with the tondi on the pendentives of the Capponi Chapel (SEE FIG. 21–37). In 1530, he established his own workshop, though he continued to work with Pontormo on occasional large

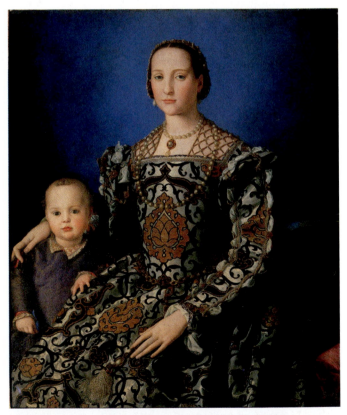

21–40 Bronzino **PORTRAIT OF ELEONORA DE' TOLEDO AND HER SON GIOVANNI DE' MEDICI**
1545. Oil on wood panel, 45¼ × 37¾" (115 × 96 cm). Galleria degli Uffizi, Florence.

Credit: © Studio Fotografico Quattrone, Florence

21–41 Bronzino **ALLEGORY WITH VENUS AND CUPID**

Mid-1540s. Oil on panel, 57½ × 46" (1.46 × 1.16 m). National Gallery, London.

Credit: © 2016. Copyright The National Gallery, London/Scala, Florence

Church. Already archbishop of Pisa as a teenager, he became a cardinal in 1560 at age 17, only two years before both he and his mother died of malaria.

Bronzino's **ALLEGORY WITH VENUS AND CUPID** is one of the strangest paintings of the sixteenth century (**FIG. 21–41**). It contains all the formal, iconographical, and psychological characteristics of Mannerist art and could almost stand alone as a summary of the movement. Seven figures, three masks, and a dove interweave in an intricate, formal composition pressed claustrophobically into the foreground plane. Taken as individual images, the figures display the exaggerated poses, graceful forms, polished surfaces, and delicate colors that characterize Mannerist art. But a closer look into this composition uncovers disturbing erotic attachments and bizarre irregularities. The painting's complex allegory and relentless ambiguity probably delighted mid-sixteenth-century courtiers who enjoyed equally sophisticated wordplay and esoteric Classical references, but for us it defies easy explanation. Nothing is quite what it seems.

Venus and her son Cupid engage in an unsettlingly lascivious dalliance, encouraged by a *putto* striding in from the right—representing Folly, Jest, or Playfulness—who is about to throw pink roses at them while stepping on a thorny branch that draws blood from his foot. Cupid gently kisses his mother and pinches her erect nipple while she snatches an arrow from his quiver, leading some scholars to suggest that the painting's title should be *Venus Disarming Cupid*. Venus holds the golden apple of discord given to her by Paris; her dove conforms to the shape of Cupid's foot without actually touching it, while a pair of masks lying at her feet reiterates the theme of duplicity. An old man, Time or Chronos, assisted by an outraged Truth or Night, pulls back a curtain to expose the couple. Lurking just behind Venus, a monstrous serpent—which has the upper body and head of a beautiful young girl and the legs and claws of a lion—crosses her hands to hold a honeycomb and the stinger at the end of her tail. This strange hybrid has been interpreted both as Fraud and Pleasure.

projects. By 1540, he was court painter to the Medici. Although he produced altarpieces, fresco decorations, and tapestry designs over his long career, he is best known today for his elegant portraits, the focus of his work for Duke Cosimo I de' Medici (ruled 1537–1574). Bronzino's virtuosity in rendering costumes and settings, combined with the self-contained, masklike quality given to the faces, results in cold and formal portraits that admirably convey the haughtiness of his subjects and the absolutism of Cosimo's rule.

Typical is an elegantly restrained state portrait of 1545 portraying Cosimo's wife, **ELEONORA OF TOLEDO** (1522–1562), and their second son, Giovanni de' Medici (**FIG. 21–40**). Bronzino characteristically portrays this mother and son as aloof and self-assured, their class and connection much more prominent than any sense of individual likeness or personality. This double portrait is an iconic embodiment of dynastic power and an assurance of Medici succession. Giovanni, however, did not succeed his father as duke—that path was taken by his elder brother Francesco. Instead he pursued a fast-tracked career in the

In the shadows to the left, a pale and screaming man tearing at his hair has recently been identified as a victim of syphilis, which raged as an epidemic during this period. The painting could, therefore, be a warning of the dangers of this disease, believed in the sixteenth century to be spread principally by coitus, kissing, and breast feeding, all of which are alluded to in the intertwined Cupid and Venus. But the complexity of the painting makes room for multiple meanings, and deciphering them would be typical of the sorts of games enjoyed by sixteenth-century intellectuals. Perhaps the allegory tells of the impossibility of constant love and the folly of lovers, which becomes apparent across time. Or perhaps it is a warning of the dangers of illicit sexual liaisons, including the pain, hair loss, and disfiguration of venereal disease. It could be both, and even more. Duke Cosimo commissioned the painting and presented it as a diplomatic gift to the French king Francis I, who would doubtless have relished its overt eroticism and flawless execution.

Anguissola and Fontana

Northern Italy, more than any other part of the peninsula, produced a number of gifted women artists. In the latter half of the sixteenth century, Bologna, for example, boasted some two dozen women painters and sculptors, as well as a number of learned women who lectured at the university. Sofonisba Anguissola (c. 1532–1625), born into a noble family in Cremona (between Bologna and Milan), was unusual in that she was not the daughter of an artist. Her father gave all his children a humanistic education and encouraged them to pursue careers in literature, music, and especially painting. He consulted Michelangelo about his daughter's artistic talents in 1557, asking for a drawing that she might copy and return to be critiqued. Michelangelo evidently obliged, because her father wrote an enthusiastic letter of thanks.

Anguissola was a gifted portrait painter who also created miniatures, an important aspect of portraiture in the sixteenth century, when people had few means of recording the features of a lover, friend, or family member. Anguissola painted a miniature **SELF-PORTRAIT** holding a medallion, the border of which spells out her name and hometown, Cremona (**FIG. 21–42**). The interlaced letters at the center of the medallion pose a riddle; they seem to form a monogram with the first letters of her sisters' names: Minerva, Europa, Elena. Such names are further evidence of the Anguissola family's enthusiasm for the Classics.

In 1560, Anguissola accepted the invitation of the queen of Spain to become a lady-in-waiting and court painter, a post she held for 20 years. Unfortunately, most of her Spanish works were lost in a seventeenth-century palace fire, but a 1582 Spanish inventory described her as the best portrait painter of the age—extraordinary praise

in a court that patronized Titian. After her years at court, she retired to Spanish-controlled Sicily, where she died in her nineties. Anthony van Dyck met her in Palermo in 1624, where he sketched her and claimed that she was then 96 years old. He wrote that she advised him on positioning the light for her portrait, asking that it not be placed too high because the strong shadows would bring out her wrinkles.

Bolognese artist Lavinia Fontana (1552–1614) learned to paint from her father. By the 1570s her success was so well rewarded that her husband, the painter Gian Paolo Zappi, gave up his own painting career to care for their large family and help his wife with the technical aspects of her work, such as framing. In 1603, Fontana moved to Rome as an official painter to the papal court. She also soon came to the attention of the Habsburgs, who became major patrons.

While still in her twenties, Fontana painted a **NOLI ME TANGERE** (**FIG. 21–43**), where Christ reveals himself for the first time to Mary Magdalen following his Resurrection, warning her not to touch him (John 20:17). Christ's broad-brimmed hat and spade refer to the passage in John's Gospel claiming that Mary Magdalen at first thought Christ

21–42 Sofonisba Anguissola SELF-PORTRAIT
c. 1556. Varnished watercolor on parchment, 3¼ × 2½″ (8.3 × 6.4 cm). Museum of Fine Arts, Boston. Emma F. Munroe Fund 60.155.

Credit: Photograph © 2017 Museum of Fine Arts, Boston

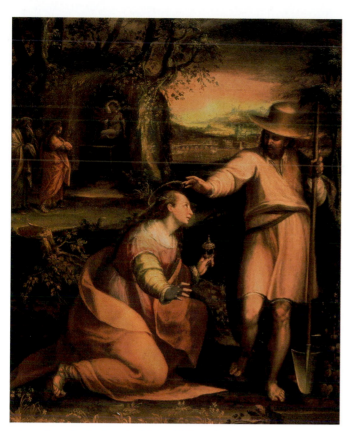

21–43 Lavinia Fontana **NOLI ME TANGERE**

1581. Oil on canvas, 47⅜ × 36⅝″ (120.3 × 93 cm). Galleria degli Uffizi, Florence.

Credit: Canali Photobank, Milan, Italy

was the gardener. In the middle distance Fontana portrays a second version of the Resurrection, where women followers of Christ discover an angel in his empty tomb. This secondary scene's dizzying diagonal plunge into depth is a typical feature of late Mannerist painting in Italy, as are the affected pose of the foreground Christ and the elongated proportions of Mary Magdalen.

Sculpture

Mannerist sculpture—often small in size and made from precious metals—stylizes body forms and emphasizes technical skill in ways that are reminiscent of Mannerist painting.

CELLINI The Florentine goldsmith and sculptor Benvenuto Cellini (1500–1571), who wrote a dramatic—and scandalous—autobiography and a practical handbook for artists, worked in the French court at Fontainebleau. There he made the famous **SALTCELLAR OF KING FRANCIS I** (**FIG. 21-44**), a table accessory transformed into an elegant sculptural ornament by fanciful imagery and superb execution. In gold and enamel, the Roman sea god Neptune, representing the source of salt, sits next to a tiny, boat-shaped container for the seasoning, while a personification of Earth guards the plant-derived pepper contained in the triumphal arch to her right. Representations of the seasons and the times of day on the base refer to both daily meal schedules and festive seasonal celebrations. The two main figures lean away from each other at impossible angles yet are connected and visually balanced by glance, gestures, and coordinated poses—mirroring each other with one bent and one straight leg. Their supple, elongated bodies and small heads reflect the Mannerist conventions of artists like Parmigianino (SEE FIG. 21-39). Cellini wrote, "I represented the Sea and the Land, both seated, with their legs intertwined just as some branches of the sea run into the land and the land juts into the sea…" (Cellini, *Autobiography*, translated by G. Bull, p. 291).

GIAMBOLOGNA In the second half of the sixteenth century, the most influential sculptor in Italy was probably Jean Boulogne, better known by his Italian names, Giovanni Bologna or Giambologna (1529–1608). Born in Flanders, he settled during the 1550s in Florence, where he worked at the court of Duke Cosimo I de' Medici.

21–44 Benvenuto Cellini **SALTCELLAR OF KING FRANCIS I OF FRANCE**

1540–1543. Gold and enamel, 10½ × 13⅛″ (26.67 × 33.34 cm). Kunsthistorisches Museum, Vienna.

Credit: © KHM-Museumsverband

He not only influenced and trained a later generation of Italian sculptors, he also spread the Mannerist style to the north through artists who came to study his work.

Although Giambologna's prodigious artistic output included elaborate fountains and many works in bronze—both imposing public monuments and exquisitely rendered statuettes—his most famous sculpture is a monumental marble carving now known as **THE CAPTURE OF A SABINE WOMAN** (FIG. 21–45), a title given to it by a member of the Florentine Academy of Design after it was finished. Giambologna himself conceived of this composition of three nude figures—rising in an energetic, tightly wound column—not in relation to any particular subject or story, but as a formal exercise in figural representation and technical virtuosity. In spite of the deep undercutting and dramatically projecting gestures, the entire sculpture was carved from a single block of marble. Because of the spiraling composition, viewers must walk around the sculpture to explore it; it cannot be fully grasped from any single viewpoint. Grand Duke Francesco I de' Medici installed Giambologna's masterpiece in a place of honor at the front of the Loggia dei Lanzi, where it remains today (SEE FIG. 18–2).

21-45 Giambologna **THE CAPTURE OF A SABINE WOMAN**
1581–1582. Marble, height 13'6" (4.1 m). Loggia dei Lanzi, Florence.

Credit: © Studio Fotografico Quattrone, Florence

Art and the Counter-Reformation

What is the impact of the Counter Reformation on Roman painting and architecture?

Pope Clement VII, whose miscalculations had spurred Emperor Charles V to attack and destroy Rome in 1527, also misjudged the threat to the Church and to papal authority posed by the Protestant Reformation. His failure to address the issues raised by the reformers enabled the movement to spread. His successor, Paul III (pontificate 1534–1549), the rich and worldly Roman noble Alessandro Farnese, was the first pope to pursue Church reform in response to the rise of Protestantism. In 1536, he appointed a commission to investigate charges of Church corruption and later convened the Council of Trent (1545–1563) to define Catholic dogma, initiate disciplinary reforms, and regulate the training of clerics.

Pope Paul III also addressed Protestantism through repression and censorship. In 1542, he instituted the Inquisition, a papal office that sought out heretics for interrogation, trial, and sentencing. The enforcement of religious unity extended to the arts. Guidelines issued by the Council of Trent limited what could be represented in Christian art and led to the destruction of some works. Traditional images of Christ and the saints were approved, but art was examined closely for traces of heresy and profanity. At the same time, art became a powerful weapon of propaganda, especially in the hands of members of the Society of Jesus, a new religious order founded by the Spanish nobleman Ignatius of Loyola (1491–1556) and confirmed by Paul III in 1540. Dedicated to piety, education, and missionary work, the Jesuits, as they are known, spread worldwide and became important leaders of the Counter-Reformation movement and the revival of the Catholic Church.

Rome and the Vatican

To restore the heart of the city of Rome, Paul III began rebuilding the Capitoline Hill as well as continuing work on St. Peter's. His commissions include some of the finest art and architecture of the late Italian Renaissance. His first major commission brought Michelangelo, after a quarter of a century, back to the Sistine Chapel.

MICHELANGELO'S LATE WORK In his early sixties, Michelangelo complained bitterly of feeling old, but he nonetheless undertook the important and demanding task of painting the **LAST JUDGMENT** on the 48-foot-high end wall above the Sistine Chapel altar between 1536 and 1541 (FIG. 21–46).

Abandoning the clearly organized medieval conception of the Last Judgment, in which the saved are neatly separated from the damned, Michelangelo painted a writhing swarm of resurrected humanity. At left, the dead are dragged from their graves and pushed up into a vortex of figures around Christ, who wields his arm like a sword of justice. The shrinking Virgin under Christ's raised right arm represents a change from Gothic tradition, where she had sat enthroned beside, and equal in size to, her son. To the right of Christ's feet is St. Bartholomew, who was

21–46 Michelangelo **LAST JUDGMENT, SISTINE CHAPEL**
1536–1541. Fresco, 48 × 44′ (14.6 × 13.4 m).

Dark, rectangular patches intentionally left by recent restorers (visible, for example, in the upper left and right corners) contrast with the vibrant colors of the chapel's frescos. These dark areas show just how dirty the walls had become over the centuries before their cleaning.

Credit: Photo: Vatican Museums/IKONA

martyred by being skinned alive. He holds his flayed skin, and Michelangelo seems to have painted his own distorted features on the skin's face. Despite the efforts of several saints to save them, the damned are plunged toward hell on the right, leaving the elect and still-unjudged in a dazed state. On the lowest level of the mural, right above the altar, is the gaping, fiery entrance to hell, toward which Charon, the ferryman of the dead to the underworld, propels his craft. The painting was long interpreted as a grim and constant reminder to celebrants of the Mass—the pope and his cardinals—that ultimately they too would face stern judgment at the end of time. Conservative clergy criticized it for its nudity, and after Michelangelo's death they ordered bits of drapery to be added by artist Daniele da Volterra to conceal the offending areas, earning Daniele the unfortunate nickname "Il Braghettone" ("breeches painter").

Another of Paul III's ambitions was to complete the new St. Peter's, a project that had been underway for 40 years (see "St. Peter's Basilica" opposite). Michelangelo was well aware of the work done by his predecessors— from Bramante to Raphael to Antonio da Sangallo the Younger. When he began his own work on the project, the 71-year-old sculptor, confident of his architectural expertise, demanded the right to deal directly with the pope, rather than through a committee of construction deputies. Michelangelo further shocked the deputies—but not the pope—by undoing parts of Sangallo's design, then simplifying and strengthening Bramante's central plan, long associated with shrines of Christian martyrs.

Although seventeenth-century additions and renovations dramatically changed the original plan of the church and the appearance of its interior, Michelangelo's **ST. PETER'S** (FIG. 21–47) still can be seen in the contrasting forms of the flat and angled exterior walls and the three surviving hemicycles (semicircular structures). Colossal pilasters, blind windows (frames without openings), and niches surround the sanctuary of the church. The current dome, erected by Giacomo della Porta in 1588–1590, retains Michelangelo's basic design: segmented with regularly spaced ribs, seated on a high drum with pedimented windows between paired columns, and topped with a tall lantern.

21–47 Michelangelo **ST. PETER'S BASILICA, VATICAN**

c. 1546–1564; dome completed 1590 by Giacomo della Porta; lantern 1590–1593. View from the west.

Credit: Canali Photobank, Milan, Italy. © James Morris, Ceredigion

Art and its Contexts

ST. PETER'S BASILICA

The history of St. Peter's in Rome is a case study of the effects of individual and institutional demands on the design, construction, and remodeling of a major religious building. The original church—now called Old St. Peter's—was built in the fourth century by Constantine, the first Christian Roman emperor, to mark the grave of the apostle Peter, the first bishop of Rome and therefore considered the first pope. Because the site was so holy, Constantine's architect had to build a structure large enough to hold the crowds of pilgrims who came to visit St. Peter's tomb. To provide a platform for the church, a huge terrace was cut into the side of the Vatican Hill across the Tiber River from the city. Here Constantine's architect erected a basilica with a new feature, a transept, to allow large numbers of visitors to approach the shrine at the front of the apse. The rest of the church was, in effect, a covered cemetery, carpeted with the tombs of believers who wanted to be buried near the apostle's grave. When it was built, Constantine's basilica, as befitted an imperial commission, was one of the largest buildings in the Roman world (interior length 368 feet, width 190 feet). For more than a thousand years it was the most important pilgrimage site in Europe.

In 1506, Pope Julius II made the astonishing decision to demolish the Constantinian basilica, which had fallen into disrepair, and replace it with a new building. That anyone, even a pope, should have had the nerve to pull down such a venerated building is an indication of the extraordinary self-assurance of the Renaissance—and of Julius himself. To design and build the new church, the pope appointed Donato Bramante, who envisioned the new St. Peter's as a central-plan building, in the shape of a cross with four arms of equal length, crowned by an enormous dome. This design was intended to emulate the Early Christian tradition of constructing domed and round buildings over the tombs of martyrs, itself derived from the Roman practice of building centrally planned tombs. In Renaissance thinking, the central plan and dome symbolized the perfection of God.

The deaths of pope and architect in 1513 and 1514 put a temporary halt to the project. Successive plans by Raphael, Antonio da Sangallo, and others extended one arm of the cross to provide the church with an extended nave. However, when Michelangelo was appointed architect in 1546, he returned to the centralized plan and simplified Bramante's design to create a single, unified space covered with a hemispherical dome. The dome was finally completed some years after Michelangelo's death by Giacomo della Porta, who retained Michelangelo's basic design but gave the dome a taller profile (SEE FIG. 21-47).

During the Counter-Reformation, the Catholic Church emphasized congregational worship; as a result, more space was needed to house the congregation and allow for processions. To expand the church—and to make it more closely resemble Old St. Peter's—Pope Paul V in 1606 commissioned the architect Carlo Maderno to change Michelangelo's central plan back once again into a longitudinal plan. Maderno extended the nave to its final length of slightly more than 636 feet and added a new façade, thus completing St. Peter's as we see it today. Later in the seventeenth century, the sculptor and architect Gianlorenzo Bernini created an elaborate approach to the basilica by surrounding the space in front of it with a great colonnade, like a huge set of arms extended to embrace the faithful as they approach the principal church of Western Christendom.

Old St. Peter's
4th century

Bramante, plan for
New St. Peter's
1506

Michelangelo, plan
for New St. Peter's
1546–1564

Maderno, plan of
St. Peter's Basilica
1607–1615

21–48A Vignola and Giacomo della Porta **FAÇADE OF THE CHURCH OF IL GESÙ, ROME**

c. 1568–1584.

Credit: © 2016. Photo Scala, Florence

The aging Michelangelo, often described by his contemporaries as difficult and even arrogant, alternated between periods of depression and frenzied activity. Yet he was devoted to his friends and helpful to young artists. He believed that his art was divinely inspired and became increasingly devoted to religious works—many left unfinished—that subverted Renaissance ideals of human perfectibility and denied the idealism of youth. In the process he pioneered new stylistic directions that would inspire succeeding generations of artists.

VIGNOLA A young artist who worked to meet the need for new Roman churches was Giacomo Barozzi (1507–1573), known as Vignola after his native town. He worked in Rome during the late 1530s, surveying ancient Roman monuments and providing illustrations for an edition of Vitruvius. From 1541 to 1543, he was in France with

21–48B Vignola and Giacomo della Porta
PLAN OF THE CHURCH OF IL GESÙ, ROME
c. 1568–1584.

Francesco Primaticcio at the château of Fontainebleau. After returning to Rome, he secured the patronage of the Farnese family and profited from the Counter-Reformation church-building initiatives.

Catholicism's new emphasis on individual, emotional participation brought a focus on sermons and music, requiring churches with wide naves and unobstructed views of the altar, instead of the complex interiors of medieval and earlier Renaissance churches. Ignatius of Loyola was determined to build **IL GESÙ**, the Jesuit headquarters church in Rome, according to these precepts, although he did not live to see it finished (**FIG. 21-48**). The cornerstone was laid in 1540, but construction did not begin until 1568, after a period of fund-raising. Cardinal Alessandro Farnese (Paul III's namesake and grandson) donated to the project in 1561 and selected Vignola as architect. After Vignola died in 1573, Giacomo della Porta finished the dome and façade to his own designs.

Il Gesù was admirably suited for congregational worship. Vignola designed a wide, barrel-vaulted nave with shallow, connected side chapels. There are no aisles and only truncated transepts contained within the line of the outer walls—enabling all worshipers to gather in the central space. A single, huge apse and dome over the crossing directed attention to the altar. The design also allows the building to fit compactly into a city block—a requirement that now often overrode the desire to orient a church along an east–west axis. The symmetrical façade, in Vignola's original design as well as della Porta's variation on it, emphasized the central portal with Classical pilasters, engaged columns and pediments, and volutes scrolling out laterally to hide the buttresses of the central vault and link the tall central section with the lower sides.

As finally built by Giacomo della Porta, the façade design had significant influence well into the next century. The early Renaissance grid of Classical pilasters and entablatures was abandoned for a two-story design that coordinates paired columns or pilasters, aligned vertically to tie together the two stories of the central block, which corresponds with the nave elevation. The main entrance, with its central portal aligned with a tall upper-story window, became the focus of the composition. Centrally aligned pediments break into the level above, leading the eye upward to the cartouches with coats of arms—here of both Cardinal Farnese, the patron, and the Jesuits (whose arms display the initials IHS, the monogram of Christ).

Think About It

1 Some art historians have claimed that Rome and Florence were oriented toward drawing, but Venice was oriented toward color. Evaluate this claim, discussing specific works from each tradition in your answer.

2 Analyze either the Palazzo del Te (**FIG. 21-22**) or the Villa Rotonda (**FIG. 21-36**). Explain how the design of the building differs from the design of grand churches during this same period, even though architects clearly used Classical motifs in both sacred and secular contexts.

3 Discuss Julius II's efforts to aggrandize the city of Rome and create a new golden age of papal art. Focus your answer on at least two specific works that he commissioned—one in painting and the other architectural.

4 Select either Pontormo's *Deposition* (**FIG. 21-38**) or Parmigianino's *Madonna of the Long Neck* (**FIG. 21-39**) and explain why it characterizes Mannerist style. How does your chosen work depart from the Classical norms of the High Renaissance? How would you characterize its relationship to Michelangelo's *Last Judgment* (**FIG. 21-46**)?

Crosscurrents

These two paintings, each commissioned by a powerful political figure, combine Classical and allegorical themes in unusual ways. Each addresses a select audience. Compare the nature of the message each painting presents and evaluate how the style of presentation relates to the traditions and objectives of Florentine art during the period in which it was painted.

FIG. 20–34

FIG. 21–41

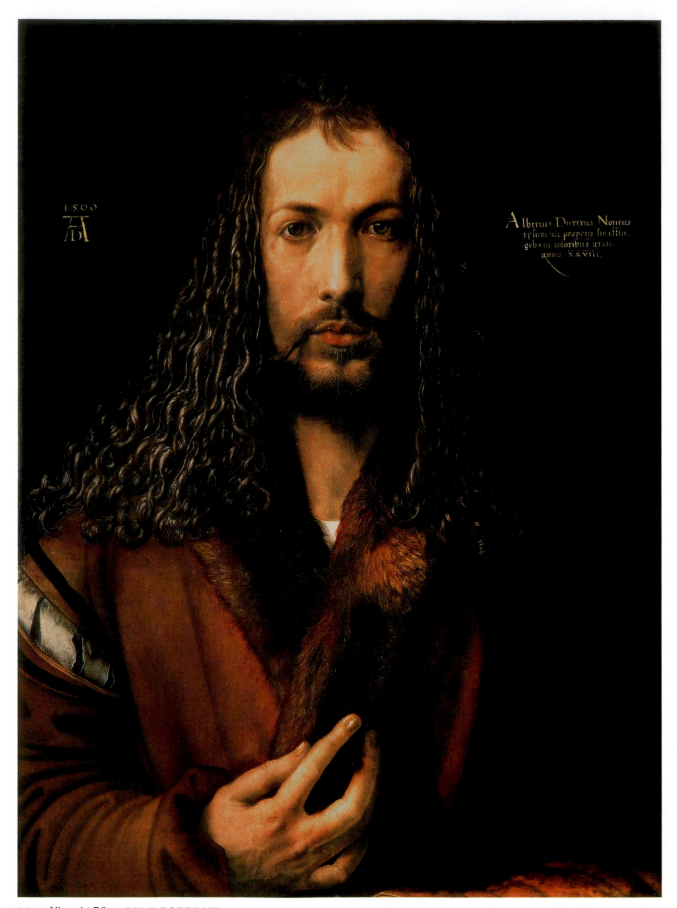

22-1 Albrecht Dürer **SELF-PORTRAIT**

1500. Signed "Albrecht Dürer of Nuremberg … age 28." Oil on wood panel, 26¼ × 19¼″ (66.3 × 49 cm). Alte Pinakothek, Munich.

Chapter 22
Sixteenth-Century Art in Northern Europe and the Iberian Peninsula

 ## Learning Objectives

22.a Identify the visual hallmarks of sixteenth-century Northern European and Iberian Peninsular art and architecture for formal, technical, and expressive qualities.

22.b Interpret the meaning of works of sixteenth-century Northern European and Iberian Peninsular art based on their themes, subjects, and symbols.

22.c Relate sixteenth-century Northern European and Iberian Peninsular artists and art to their cultural, economic, and political contexts.

22.d Apply the vocabulary and concepts relevant to sixteenth-century Northern European and Iberian Peninsular art, artists, and art history.

22.e Interpret a work of sixteenth-century Northern European or Iberian Peninsular art using the art historical methods of observation, comparison, and inductive reasoning.

22.f Select visual and textual evidence in various media to support an argument or an interpretation of a work of sixteenth-century Northern European or Iberian Peninsular art.

This striking image (**FIG. 22-1**), dated 1500, seems to depict a blessing Christ, meant to rivet our attention and focus our devotion. But an inscription to the right of the face identifies this as a **SELF-PORTRAIT** by Albrecht Dürer, painted when he was 28 years old. We are already familiar with the practice of artists painting their own image. Self-portraits appear with some frequency during the Middle Ages (SEE FIGS. 16–35, 17–23); they truly blossom during the Renaissance (SEE FIGS. 19–12, 21–42). But this image still seems peculiar, marked by an artistic hubris that may embarrass us. The picture becomes less puzzling, however, seen in context.

Dürer strikes an odd pose for a self-portrait—frontal and hieratic, intentionally recalling iconic images of Christ as *Salvator Mundi* (Savior of the World) that were very popular in northern Europe. Dürer even alters the natural color of his own hair to align the image more closely with contemporary notions of Christ's physical appearance. But there is no reason to see this as blasphemous. Since a principal component of Christian devotion in Dürer's time was the attempt to imitate Christ in the believer's own life, Dürer could be visualizing a popular spiritual practice. He could also be depicting literally the biblical statement that humans are created in the image of God. But he is also claiming that artists are learned and creative geniuses—perhaps Godlike—not laboring craftspeople. He wrote, "The more we know, the more we resemble the likeness of Christ who truly knows all things" (Snyder, p. 314).

Dürer had traveled to Italy in 1494–1495, where he encountered a new conception of artists as noble intellectuals: participants in humanistic discourse and purveyors of ideas as well as pictures. In 1498, back in Nuremberg, he published a woodcut series on the Apocalypse (SEE FIG. 22-7) that brought him a kind of international notice that was new to the German art world. He certainly had reason to feel pride. This stable, triangular composition—so consistent with High Renaissance norms of harmony and balance—could reflect Dürer's Italian adventure. But at its core, this picture fits into a long-standing Northern European interest in the meticulous description of surface texture—the soft sheen of human flesh, the reflective wetness of eyes, the matte softness of cloth, and the tactile quality of hair, emphasized here by the way Dürer's hand fingers his fur collar, encouraging viewers to feel it as they see it. Ultimately what is showcased here are Dürer's awesome artistic gifts of hand as much as his

intellectual gifts of mind, two aspects perhaps emblemized by the brightly illuminated body parts that align on a vertical axis to dominate this arresting self-portrait.

The Reformation and the Arts

How does the Protestant Reformation affect sixteenth-century Northern European art and artists?

In spite of the dissident movements and heresies that had challenged the Roman Catholic Church through the centuries, its authority and that of the pope always prevailed—until the sixteenth century (**MAP 22–1**). Then, against a backdrop of broad dissatisfaction with financial abuses and decadent lifestyles among the clergy, religious reformers from within the Church itself challenged first its practices and then its beliefs.

Two of the most important reformers in the early sixteenth century were themselves Catholic priests and trained theologians: Desiderius Erasmus (1466?–1536) of Rotterdam in Holland, who worked to reform the Roman Catholic Church from within, and Martin Luther (1483–1546) in Germany, who eventually broke with it. Indeed, many locate the beginning of the Reformation in 1517, when Luther issued his "95 Theses" calling for Church reform. Among Luther's concerns were the practice of selling indulgences (guarantees of relief from the punishment required after death for forgiven sins) and the excessive veneration of saints and their relics, which he considered superstitious. Luther and others emphasized individual faith and regarded the Bible as the ultimate religious authority. As they challenged the pope's supremacy, it became clear that the Protestants had to break away from Rome. The Roman Catholic Church condemned Luther in 1521.

MAP 22–1 WESTERN EUROPE DURING THE REFORMATION, C. 1560

Sixteenth-century Europe remained largely Roman Catholic, except in Switzerland and the far north, where the impact of the Protestant Reformation was strongest.

Increased literacy and the widespread use of the printing press aided the reformers and allowed scholars throughout Europe to enter the religious debate. In Germany, the wide circulation of Luther's writings—especially his German translation of the Bible and his works maintaining that salvation comes through faith alone—eventually led to the establishment of the Protestant (Lutheran) Church there. In Switzerland, John Calvin (1509–1564) led an even more austere Protestant revolt; and in England, King Henry VIII (ruled 1509–1547) broke with Rome in 1534 for reasons of his own. By the end of the sixteenth century, Protestantism in some form prevailed throughout northern Europe.

Leading the Catholic cause was Holy Roman Emperor Charles V. Europe was racked by religious war from 1546 to 1555 as Charles battled Protestant forces in Germany, until a meeting of the provincial legislature of Augsburg in 1555 determined that the emperor must accommodate the Protestant Reformation in his lands. By the terms of the peace, local rulers could select the religion of their subjects—Catholic or Protestant. Tired of the strain of government and prematurely aged, Charles abdicated in 1556 and retired to a monastery in Spain, where he died in 1558. His son Philip II inherited Habsburg Spain and the Spanish colonies, while his brother Ferdinand led the Austrian branch of the dynasty.

The years of political and religious strife had a grave impact on artists and art. Some artists found their careers at an end because of their reformist religious sympathies. Then, as Protestantism gained ascendancy, it was Catholic artists who had to leave their homes to seek patronage abroad. There was also widespread destruction of religious art. In some places, Protestant zealots smashed sculpture and stained-glass windows and destroyed or whitewashed religious paintings to rid churches of what they considered idols—though Luther himself never directly supported iconoclasm (the destruction of religious images). With the sudden loss of patronage for religious art in the newly

Art and its Contexts

GERMAN METALWORK: A COLLABORATIVE VENTURE

In Nuremberg, a city known for its master metalworkers, Hans Krug (d. 1519) and his sons Hans the Younger and Ludwig were among the finest. They created marvelous display pieces for the wealthy, such as this silver-gilt **APPLE CUP** (**FIG. 22-2**). Made in about 1510, a gleaming apple, in which the stem forms the handle of the lid, balances on a leafy branch that serves as its base.

The Krug family was responsible for the highly refined casting and finishing of the final product, but several artists worked together to produce such pieces—one drawing designs, another making the models, and others creating the final piece in metal. A drawing by Dürer may have been the basis for the apple cup. Though we know of no piece of goldwork by the artist himself, Dürer was a major catalyst in the growth of Nuremberg as a key center of German goldsmithing. He accomplished this by producing designs for metalwork throughout his career. Designers played an essential role in the metalwork process. With design in hand, the modelmaker created a wooden form for the goldsmith to follow. The result of this artistic collaboration was a technical *tour-de-force* and an exquisitely clever object.

22-2 Workshop of Hans Krug (?) **APPLE CUP**
c. 1510–1515. Gilt silver, height 8½″ (21.5 cm). Germanisches Nationalmuseum, Nuremberg.

Credit: © 2016. Photo Scala, Florence

Protestant lands, many artists turned to portraiture and other secular subjects, including moralizing depictions of human folly and weaknesses, still lifes, and landscapes. The popularity of these themes stimulated the burgeoning of a free art market centered in Antwerp.

Germany

What are the diverse trends in sixteenth-century German sculpture and painting?

In German-speaking regions, the arts flourished until religious upheavals and iconoclastic purges took their toll at mid century. German cities had strong business and trade interests, and their merchants and bankers accumulated self-made, rather than inherited, wealth. They ordered portraits of themselves and fine furnishings for their large, comfortable houses. Entrepreneurial artists like Albrecht Dürer became major commercial successes. And, as in the Middle Ages, the production of small luxury objects crafted with high finish out of precious materials was an important aspect of artistic production.

Sculpture

Although, like the Italians, German Renaissance sculptors worked in stone and bronze, they produced their most original work in wood, especially fine-grained limewood. Most of these wooden images were gilded and painted, continuing an interest in heightening naturalism, until Tilman Riemenschneider began to favor natural wood finishes.

TILMAN RIEMENSCHNEIDER Tilman Riemenschneider (c. 1460–1531) became a master in 1485 and soon had the largest workshop in Würzburg, including specialists in both wood and stone sculpture. Riemenschneider attracted patrons from other cities, and in 1501 he signed a contract with the church of St. James in Rothenburg, where a relic said to be a drop of Jesus's blood was preserved. The **ALTARPIECE OF THE HOLY BLOOD** (FIG. 22-3) is a spectacular limewood construction standing nearly 30 feet high. Erhart Harschner, a specialist in architectural shrines, had begun work on the elaborate Gothic frame in 1499, and was paid 50 florins for his work. Riemenschneider was commissioned to provide the figures and scenes to be placed within this frame. He was paid 60 florins for the sculpture, giving us a sense of the relative value patrons placed on their contributions.

The main panel of the altarpiece portrays the moment at the Last Supper when Christ revealed that one of his followers would betray him. Unlike Leonardo da Vinci, who chose the same moment (SEE FIG. 21-4), Riemenschneider puts Judas at center stage and Jesus off-center at the left. The disciples sit around the table. As the event is described

in the Gospel of John (13:21–30), Jesus extends a morsel of food to Judas, signifying that he will be the traitor who sets in motion the events leading to the Crucifixion. One apostle points down, a strange gesture until we realize that he is pointing to the crucifix in the predella, to the relic of Christ's blood, and to the altar table, the symbolic representation of the table of the Last Supper and the tomb of Christ.

22-3 Tilman Riemenschneider ALTARPIECE OF THE HOLY BLOOD (OPEN)
Sankt Jakobskirche (church of St. James), Rothenburg ob der Tauber, Germany. Center, *Last Supper*. c. 1499–1505. Limewood, glass, height of tallest figure 39″ (99.1 cm), height of altar 29′6″ (9 m).

Credit: © akg-images/Erich Lessing

Rather than creating individual portraits of the apostles, Riemenschneider repeated an established set of facial types. His figures have large heads, prominent features, sharp cheekbones, sagging jowls, baggy eyes, and elaborate hair with thick wavy locks and deeply drilled curls. The muscles, tendons, and raised veins of hands and feet are also especially lifelike. His assistants and apprentices copied these features either from drawings or from three-dimensional models made by the master. In the altarpiece, deeply hollowed folds create active patterns in the voluminous draperies whose strong highlights and dark shadows harmonize the figural composition with the intricate carving of the framework. The Last Supper is set in a real space containing actual benches for the figures. Windows in the back wall are glazed with bull's-eye glass so that natural light shines in from two directions to illuminate the scene, producing changing effects depending on the time of day and the weather. Although earlier sculpture had been painted and gilded, Riemenschneider introduced the use of a natural wood finish toned with varnish. This meant that details of both figures and environment had to be carved into the wood itself, not added later with paint. Since this required more skillful carvers and more time for them to carve, this new look was a matter of aesthetics, not cost-saving.

In addition to producing an enormous number of religious images for churches, Riemenschneider was politically active in Würzburg, serving as mayor in 1520. His career ended during the Peasants' War (1524–1526), an early manifestation of the Protestant movement. His support for the peasants led to a fine and imprisonment in 1525, and although he survived, Riemenschneider produced no more sculpture and died in 1531.

NIKOLAUS HAGENAUER Prayer was the principal source of solace and relief to the ill before the advent of modern medicine. About 1505, the Strasbourg sculptor Nikolaus Hagenauer (active 1493–1530s) carved an altarpiece for the abbey of St. Anthony in Isenheim near Colmar (**FIG. 22–4**), where a hospital specialized in the care of patients with skin diseases, including the plague, leprosy, and St. Anthony's Fire (caused by eating rye and other grains infected with the ergot fungus). The shrine includes images of SS. Anthony, Jerome, and Augustine. Three tiny men—their size befitting their subordinate status—kneel at the feet of the saints: the donor, Jean d'Orliac, and two men offering a rooster and a piglet.

In the predella, Jesus and the apostles bless the altar, Host, and assembled patients in the hospital. The flesh of the sculpted figures was painted in lifelike colors, but most of the altarpiece was gilded to enhance its resemblance to a metalwork reliquary. A decade later, Matthias Grünewald painted wooden shutters to cover the shrine (SEE FIGS. 22–5, 22–6).

Painting

The work of two very different German artists has come down to us from the first decades of the sixteenth century. Matthias Grünewald continued currents of medieval mysticism and emotional spirituality to create extraordinarily moving paintings. Albrecht Dürer, on the other hand, used intense observation of the world to render lifelike representations of nature, mathematical perspective to create convincing illusions of space, and a reasoned canon of proportions to standardize depictions of the human figure.

MATTHIAS GRÜNEWALD As a court artist to the archbishop of Mainz, Matthias Grünewald (Matthias Gothart Neithart, c. 1470/1475–1528) was a man of many talents who worked as an architect and hydraulic engineer as well as a painter. He is best known today for paintings on the shutters or wings attached to Nikolaus Hagenauer's carved Isenheim Altarpiece (SEE FIG. 22–4). The completed altarpiece is impressive in its size and complexity. Grünewald painted one set of fixed wings and two sets of movable ones, plus one set of panels to cover the predella. The altarpiece could be exhibited in different configurations depending upon the church calendar. The wings and carved wooden shrine complemented one another, the inner sculpture seeming to bring the surrounding paintings to life, and the painted wings in turn protecting the precious carvings.

On weekdays, when the altarpiece was closed, viewers saw a grisly image of the Crucifixion in a darkened landscape, a *Lamentation* below it on the predella, and life-size figures of SS. Sebastian and Anthony Abbot—both associated with the plague—standing on *trompe l'oeil* pedestals on the fixed wings (**FIG. 22–5**). The intensity of feeling here has suggested that Grünewald may have been inspired by the visions of St. Bridget of Sweden, a fourteenth-century mystic whose works—including morbidly detailed descriptions of the Crucifixion—were published in Germany beginning in 1492. Grünewald has scrupulously described the horrific character of the tortured body of Jesus, covered with gashes from his beating and pierced by the thorns used to form a crown for his head. His ashen body, clotted blood, open mouth, and blue lips signal his death. In fact, he appears already to be decaying, an effect enhanced by the palette of putrescent green, yellow, and purplish-red—all described by St. Bridget. She wrote, "The color of death spread through his flesh…." An immaculately garbed Virgin Mary has collapsed in the arms of a ghostlike John the Evangelist, and Mary Magdalen has fallen in anguish to her knees; her clasped hands with outstretched fingers seem to echo Jesus's fingers, cramped in rigor mortis. At the right, John the Baptist points to Jesus and repeats his prophecy, "He shall increase." The Baptist and the lamb, holding a cross and bleeding from its breast into a golden chalice, allude to baptism, the Eucharist, and

22–4 Nikolaus Hagenauer (central panels and predella) and Matthias Grünewald (wings) **ISENHEIM ALTARPIECE (OPEN)**
From the Community of St. Anthony, Isenheim, Alsace, France. Center panels and predella: *St. Anthony Enthroned between SS. Augustine and Jerome; Christ and the Apostles,* c. 1500. Painted and gilt limewood, center panel 9'9½" × 10'9" (2.97 × 3.28 m), predella 2'5½" × 11'2" (0.75 × 3.4 m). Wings: *SS. Anthony and Paul the Hermit* (left); *The Temptation of St. Anthony* (right). 1510–1515. Oil on wood panel, 8'2½" × 3'½" (2.49 × 0.93 m). Musée d'Unterlinden, Colmar, France.

Credit: Bridgeman Images

to Christ as the sacrificial Lamb of God. In the predella, Jesus's bereaved mother and friends prepare his racked body for burial—an activity that must have been a common sight in the abbey's hospital.

In contrast to these grim scenes, the first opening displays events of great joy—the Annunciation, the Nativity, and the Resurrection—appropriate for Sundays and feast days (**FIG. 22-6**). Praying in front of these pictures, the patients must have hoped for miraculous recovery and taken comfort in these visions of divine rapture and orgiastic color. Unlike the darkness of the Crucifixion, the inner scenes are brilliantly illuminated, in part by phosphorescent auras and haloes; stars glitter in the night sky of the Resurrection. The technical virtuosity of Grünewald's painting is enough to inspire euphoria.

The central panels show the heavenly and earthly realms joined in one space. In a variation on the Northern European visionary tradition, the new mother adores her miraculous Christ Child while envisioning her own future as queen of heaven amid angels and cherubim. Grünewald portrayed three distinct types of angels in the foreground—young, mature, and a feathered hybrid

with a birdlike crest on its human head. The range of ethnic types in the heavenly realm may have emphasized the global dominion of the Church, whose missionary efforts were expanding as a result of European exploration. St. Bridget describes the jubilation of the angels as "the glowing flame of love."

The second opening of the altarpiece (SEE FIG. 22-4) reveals Hagenauer's sculpture and was reserved for the special festivals of St. Anthony. The wings in this second opening show to the left the meeting of St. Anthony with the hermit St. Paul, and to the right St. Anthony attacked by horrible demons, perhaps inspired by the horrors of the diseased patients, but also modeled in part on Schongauer's well-known print of the same subject (SEE FIG. 19-28). The meeting of the two hermits in the desert glorifies the monastic life, and in the wilderness Grünewald depicts medicinal plants used in the hospital's therapy. Grünewald painted the face of St. Paul with his own self-portrait, while St. Anthony is a portrait of the donor and administrator of the hospital, the Italian Guido Guersi, whose coat of arms Grünewald painted on the rock next to him.

22–5 Matthias Grünewald **ISENHEIM ALTARPIECE (CLOSED)**

From the Community of St. Anthony, Isenheim, Alsace, France. Center panels: *Crucifixion*; predella: *Lamentation*; side panels: *SS. Sebastian* (left) and *Anthony Abbot* (right). c. 1510–1515. Date 1515 on ointment jar. Oil on wood panel, center panels 9′9½″ × 10′9″ (2.97 × 3.28 m) overall, each wing 8′2½″ × 3′1½″ (2.49 × 0.93 m), predella 2′5½″ × 11′2″ (0.75 × 3.4 m). Musée d'Unterlinden, Colmar, France.

Credit: Bridgeman Images

22–6 Matthias Grünewald **ISENHEIM ALTARPIECE (FIRST OPENING)**

Left to right: *Annunciation, Virgin and Child with Angels, Resurrection*. c. 1510–1515. Oil on wood panel, center panels 9′9½″ × 10′9″ (2.97 × 3.28 m) overall, each wing 8′10″ × 4′8″ (2.69 × 1.42 m). Musée d'Unterlinden, Colmar, France.

Credit: Bridgeman Images

22–7 Albrecht Dürer **THE FOUR HORSEMEN OF THE APOCALYPSE**
From *The Apocalypse*. 1497–1498.
1511 edition. Woodcut, 15½ × 11¹⁄₁₆"
(39.4 × 28.1 cm). Yale University Art Gallery,
New Haven, Connecticut. Library transfer, Gift
of Paul Mellon, B.A. 1929 (1956.16.3e).

Credit: Image courtesy Yale University Art Gallery

Venture" on page 693). Dürer did complete an apprenticeship in gold working, as well as in stained-glass design, painting, and the making of woodcuts—which he learned from Michael Wolgemut, illustrator of the *Nuremberg Chronicle* (SEE FIG. 19–29). It was as a painter and graphic artist, however, that he built his artistic fame.

In 1490, Dürer began traveling to extend his education. He went to Basel, Switzerland, hoping to meet Martin Schongauer, but arrived after the master's death. By 1494, Dürer had moved from Basel to Strasbourg. His first trip to Italy (1494–1495) introduced him to Italian Renaissance ideas and attitudes and, as we considered at the beginning of this chapter, to the concept of the artist as an independent creative genius. In his self-portrait of 1500 (SEE FIG. 22–1), Dürer represents himself as an idealized, Christlike figure in a severely frontal pose, staring self-confidently at the viewer.

As with Riemenschneider, Grünewald's involvement with the Peasants' War may have damaged his artistic career. He left Mainz and spent his last years in Halle, whose ruler was the chief protector of Martin Luther and a long-time patron of Grünewald's contemporary Albrecht Dürer.

ALBRECHT DÜRER Studious, analytical, observant, and meticulous—and as self-confident as Michelangelo—Albrecht Dürer (1471–1528) was the foremost artist of the German Renaissance. He made his home in Nuremberg, where he became a prominent citizen. Nuremberg was a center of culture as well as of business, with an active group of humanists and internationally renowned artists. It was also a leading publishing center. Dürer's father was a goldsmith and must have expected his son to follow in his trade (see "German Metalwork: A Collaborative

On his return to Nuremberg, Dürer began to publish his own prints to bolster his income, and ultimately it was prints, not paintings, that made his fortune. His first major publication, *The Apocalypse*, appeared simultaneously in German and Latin editions in 1497–1498. It consisted of a woodcut title page and 14 full-page illustrations with the text printed on the back of each. Perhaps best known is **THE FOUR HORSEMEN OF THE APOCALYPSE** (FIG. 22–7), based on figures described in Revelation 6:1–8: a crowned rider, armed with a bow, on a white horse (Conquest); a rider with a sword, on a red horse (War); a rider with a set of scales, on a black horse (Plague and Famine); and a rider on a sickly pale horse (Death). Earlier artists had simply lined up the horsemen in the landscape, but Dürer created a compact, overlapping group of wild riders charging across the world and trampling its cowering inhabitants.

Dürer probably did not cut his own woodblocks but employed a skilled carver who followed his drawings faithfully. The dynamic figures show affinities with Schongauer's *Temptations of St. Anthony* (SEE FIG. 19–28). Dürer adapted Schongauer's metal-engraving technique to the woodcut medium, using a complex pattern of lines to model the forms. His early training as a goldsmith is evident in his meticulous attention to detail and in his decorative cloud and drapery patterns. Following the tradition established by his late fifteenth-century predecessors, he fills the foreground with large, active figures.

Perhaps as early as the summer of 1494, Dürer began to experiment with engravings, cutting the metal plates himself with an artistry rivaling Schongauer's. His growing interest in Italian art and his theoretical investigations are reflected in his 1504 engraving **ADAM AND EVE (FIG. 22–8)**, which represents his first documented use of ideal human proportions based on Roman copies of ancient Greek sculpture. He may have seen figures of Apollo and Venus in Italy, and he would have known ancient sculpture from contemporary prints and drawings. But around these idealized human figures he represents plants and animals with typically Northern attention to descriptive detail.

Dürer filled the landscape with symbolic content reflecting the medieval theory that after Adam and Eve disobeyed God, they and their descendants became vulnerable to imbalances in the body fluids that controlled human temperament. An excess of black bile from the liver would produce melancholy, despair, and greed; yellow bile caused anger, pride, and impatience; phlegm in the lungs resulted in lethargy and apathy; and an excess of blood made a person unusually optimistic but also compulsively interested in the pleasures of the flesh. These four human temperaments, or personalities, are symbolized here by the melancholy elk, the choleric cat, the phlegmatic ox, and the sanguine (or sensual) rabbit. The mouse

22–8 Albrecht Dürer ADAM AND EVE
1504. Engraving, 9⅝ × 7⅝" (24.4 × 19.3 cm). Yale University Art Gallery, New Haven, Connecticut. Fritz Achelis Memorial Collection, Gift of Frederic George Achelis, B.A. 1907; reacquired in 1972 with the Henry J. Heinz II, B.A. 1931, Fund; Everett V. Meeks, B.A. 1901, Fund; and Stephen Carlton Clark, B.A. 1903, Fund (1925.29).

Credit: Image courtesy Yale University Art Gallery

is a symbol of Satan (see the mousetrap in FIG. 19–11), whose earthly power, already manifest in the Garden of Eden, was capable of bringing human beings to a life of woe through their own bad choices. Adam seems to be releasing the mouse into the world of his paradise as he thinks about eating the forbidden fruit that Eve receives from the snake. Dürer placed his signature prominently on a placard hung on a tree branch in Adam's grasp on which perches a parrot—possibly symbolizing false wisdom, since it can only repeat mindlessly what it hears.

Dürer's familiarity with Italian art was greatly enhanced by a second, leisurely trip over the Alps in 1505–1506. Thereafter, he seems to have resolved to reform the art of his own country by publishing theoretical writings and manuals that discussed Italian Renaissance problems of perspective, ideal human proportions, and the techniques of painting.

Dürer admired Martin Luther, but they never met. In 1526, the artist openly professed his Lutheranism in a pair of inscribed panels, the **FOUR APOSTLES** (FIG. 22–9).

22–9 Albrecht Dürer FOUR APOSTLES
1526. Oil on wood panel, each panel 7′1½″ × 2′6″ (2.15 × 0.76 m). Alte Pinakothek, Munich.

Dürer presented these panels to the city of Nuremberg, which had already adopted Lutheranism as its official religion. Dürer wrote, "For a Christian would no more be led to superstition by a picture or effigy than an honest man to commit murder because he carries a weapon by his side. He must indeed be an unthinking man who would worship picture, wood, or stone. A picture therefore brings more good than harm, when it is honourably, artistically, and well made" (Snyder, p. 333).

On the left panel, the elderly Peter, who normally has a central position as the first pope, has been displaced with his keys to the background by Luther's favorite evangelist, John, who holds an open Gospel that reads "In the beginning was the Word," reinforcing the Protestant emphasis on the Bible. On the right panel, Mark stands behind Paul, whose epistles were particularly admired by the Protestants. A long inscription on the frame warns the viewer not to be led astray by "false prophets" but to heed the words of the New Testament as recorded by these "four excellent men." Below each figure are excerpts from their letters and from the Gospel of Mark—drawn from Luther's German translation of the New Testament—warning against those who do not understand the true Word of God. These paintings were surely meant to chart the possibility of a Protestant visual art.

CRANACH, BALDUNG, AND ALTDORFER Martin Luther's favorite painter, Lucas Cranach the Elder (1472–1553), moved his workshop to Wittenberg in 1504 after a number of years in Vienna. In addition to the humanist milieu of its university and library, Wittenberg offered the patronage of the Saxon court. Appointed court painter to Elector Frederick the Wise, Cranach created woodcuts, altarpieces, and many portraits.

Just how far German artists' style and conception of the figure could differ from Italian Renaissance idealism is easily seen in Cranach's **NYMPH OF THE SPRING** (FIG. 22-10), especially when compared with Titian's *"Venus" of Urbino* (SEE FIG. 21-30). The sleeping nymph was a Renaissance theme, not an ancient one. Cranach was inspired by a fifteenth-century inscription on a fountain beside the Danube, cited in the upper left corner of the painting: "I am the nymph of the sacred font. Do not interrupt my sleep for I am at peace." Cranach records the Danube landscape with characteristic Northern attention to detail and turns his nymph into a rather provocative young woman, who glances slyly out at the viewer through half-closed eyes. She has cast aside a fashionable red velvet gown, but still wears her jewelry, which together with her transparent veil enhances rather than conceals her nudity—especially those coral beads that fall between her breasts, mapping their contours. Unlike other artists working for Protestant patrons, many of whom looked on earthly beauty as a sinful vanity, Cranach seems delighted by earthly things—the lush foliage that provides the nymph's couch, the pair of partridges (symbols of Venus and married love), and Cupid's bow and quiver of arrows hanging on the tree. This nymph is certainly not an embodiment of an idealized, Classical Venus; perhaps she was a living beauty from the Wittenberg court.

Cranach's slightly younger contemporary, Hans Baldung Grien (1484/1485–1545)—his nickname tag "Grien" ("green," apparently a favorite color) dates from his apprenticeship days and was used to distinguish him from the numerous other apprentices named Hans—is known for very different visualizations of women. Born into an affluent and well-educated family, Baldung was working in Strasbourg by 1500, before moving to Nuremberg in 1503 and eventually joining Dürer's workshop in 1505–1507. Over the course of his long career, he also worked in Halle and Freiburg, but his principal artistic home was Strasbourg, where he lived out a prosperous professional life as a painter, printmaker, and stained-glass designer.

During the first half of his career, Baldung created a series of paintings on the theme of **DEATH AND THE MATRON** that juxtapose sensuality with mortality, voluptuousness with decay, attraction with repulsion. The example in FIG. 22-11 (painted in about 1520–1525 for a private collector in Basel) uses brilliant illumination and open poses to draw our attention first to the nude, who is fleshier and considerably more sensual than Cranach's nymph (SEE FIG. 22-10) or Dürer's Eve (SEE FIG. 22-8). But this focus is soon overtaken by a sense of surprise that mirrors her own, as she turns her head to discover that the figure stroking her hair and clutching at her breast is not her lover but Death himself. The putrid decay of his yellowing flesh contrasts sharply with her soft contours, and his bony, molting head is the antithesis of her full, pink cheeks, flowing tresses, and soft traces of body hair. That the encounter takes place in a cemetery, on top of a tombstone, serves to underline the warning against the transitory pleasures of the flesh, but Baldung also seems to depend on the viewer's own erotic engagement to make the message not only moral but personal.

Landscape, with or without figures, became a popular theme in the sixteenth century. In the fifteenth century, Northern artists had examined and recorded nature with the care and enthusiasm of biologists, but painted landscapes were reserved for the backgrounds of figural compositions, usually sacred subjects. In the 1520s, however, religious art found little favor among Protestants. Landscape painting, on the other hand, had no overt religious content, although it could be seen as a reflection or even glorification of God's works on Earth. The most accomplished German landscape painter of the period was Albrecht Altdorfer (c. 1480–1538).

Altdorfer probably received his early training in Bavaria from his father, but he became a citizen of Regensburg in 1505 and remained there painting the Danube River Valley for the rest of his life. **DANUBE LANDSCAPE** of about 1525 (FIG. 22-12) is an early example of pure landscape painting, without a narrative subject, human figures, or overt religious significance. A small work on vellum laid down on a wood panel, it shows a landscape that seems to be a minutely detailed reproduction of the natural terrain, but the forest seems far more poetic and

22–10 Lucas Cranach the Elder **NYMPH OF THE SPRING**

c. 1537. Oil on panel, 19 × 28½″ (48.5 × 72.9 cm). National Gallery of Art, Washington, DC. (1925.29)

Credit: Image courtesy the National Gallery of Art, Washington

mysterious than Dürer's or Cranach's carefully observed views of nature. The low mountains, gigantic lacy pines, neatly contoured shrubberies, and fairyland castle with red-roofed towers at the end of a winding path announce a new sensibility. The eerily glowing yellow–white horizon below moving gray and blue clouds in a sky that takes up more than half the composition prefigures the Romanticism of German landscape painting in later centuries.

22–11 Hans Baldung Grien **DEATH AND THE MATRON**

c. 1520–1525. Oil on wood panel, 12⅜ × 7⅜″ (31.3 × 18.7 cm). Öffentliche Kunstsammlung, Basel.

Although more erotically charged and certainly more dramatic than Dürer's Eve in FIG. 22–8, Baldung's woman is based in certain ways on that famous image, which was engraved while he was assisting in Dürer's workshop. In many respects, the similarities in pose (especially the feet) and form (wide hips with narrowing waist and torso) only point up the differences in expressive content.

Credit: Photo © Hans Hinz/ARTOTHEK

22–12 Albrecht Altdorfer
DANUBE LANDSCAPE

c. 1525. Oil on vellum on wood panel, 12 × 8½″ (30.5 × 22.2 cm). Alte Pinakothek, Munich.

Credit: © 2016. Photo Scala, Florence/bpk, Bildagentur für Kunst, Kultur und Geschichte, Berlin

France

How does King Francis I's enthusiasm for Italian art transform Renaissance art and architecture in France?

Renaissance France followed a different path from that taken in Germany. In 1519, Pope Leo X came to an agreement with the French king Francis I (ruled 1515–1547) that spared the country the turmoil suffered in Germany. Furthermore, whereas Martin Luther had devoted followers in France, French reformer John Calvin (1509–1564) fled to Switzerland in 1534, where he led a theocratic state in Geneva.

During the second half of the century, however, warring political factions favoring either Catholics or Huguenots (Protestants) competed to exert power over the French crown, with devastating consequences. In 1560, the devoutly Catholic Catherine de' Medici, widow of Henry II (ruled 1547–1559), became regent for her young son, Charles IX, and tried, but failed, to find a balance between the two sides. Her machinations ended in religious polarization and a bloody conflict that began in 1562. When her third son, Henry III (ruled 1574–1589), was murdered by a fanatical Dominican friar, a Protestant cousin, Henry, king of Navarre, inherited the throne

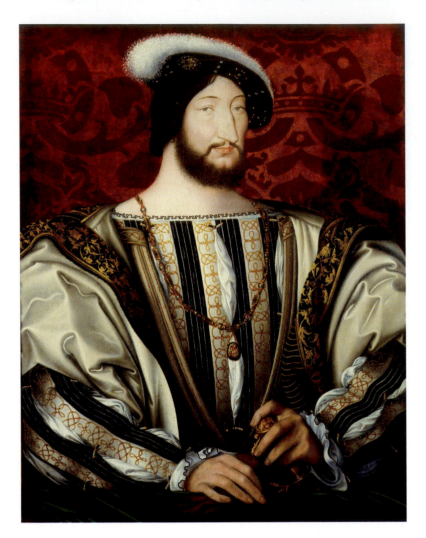

22–13 Jean Clouet **FRANCIS I**
1525–1530. Oil and tempera on wood panel,
37¾ × 29⅛" (95.9 × 74 cm). Musée du Louvre, Paris.

Credit: © 2016. Photo Scala, Florence

created a flattering image of Francis by softening the king's distinctive features with shading and highlighting the nervous activity of his fingers. At the same time he conceived an image of pure power. Elaborate, puffy sleeves broaden the king's shoulders to fill the entire width of the panel, much as Renaissance parade armor turned scrawny men into giants. The detailed rendering of the delicately worked costume of silk, satin, velvet, jewels, and gold embroidery could be painted separately from the portrait itself. Royal clothing was often loaned to the artist or modeled by a servant to spare the "sitter" (the subject of the portrait) the boredom of posing. In creating such official portraits, the artist sketched the subject, then painted a prototype that, upon approval, became the model for numerous replicas made for diplomatic and family purposes.

Royal Residences

With the enthusiasm of Francis for things Italian and the widening distribution of Italian books on architecture, the Italian Renaissance style soon infiltrated French architecture. Builders of elegant rural palaces, called **châteaux**, were quick to introduce Italianate decoration to otherwise Gothic buildings, but French architects soon adapted Classical principles of building design as well.

One of the most beautiful châteaux was not built as a royal residence, although it soon became one. In 1512, Thomas Bohier, a royal tax collector, bought the castle of Chenonceau on the River Cher, a tributary of the Loire (**FIG. 22-14**) (see "The Castle of the Ladies" opposite). He demolished the old castle, leaving only a tower. Using the piers of a water mill on the river bank as part of the foundation, he and his wife erected a new Renaissance home. The plan reflects the Classical principles of geometric regularity and symmetry—a rectangular building with rooms arranged on each side of a wide central hall. Only the library and chapel, which are corbelled out over the water, break the line of the walls. In the upper story, the builders used traditional features of medieval castles—battlements, corner turrets, steep roofs, and dormer windows. The owners died soon after the château was finished in 1521, and their son gave it to Francis I, who turned it into a hunting lodge.

and became the first Bourbon king. Henry converted to Catholicism and ruled as Henry IV. Backed by a country sick of bloodshed, he quickly settled the religious question by proclaiming tolerance of Protestants in the Edict of Nantes in 1598.

A French Renaissance Under Francis I

Immediately after his ascent to the throne, Francis I sought to "modernize" the French court by acquiring the versatile talents of Leonardo da Vinci, who moved to France in 1516. Officially, Leonardo was there to advise the king on royal architectural projects and, the king said, for the pleasure of his conversation. Francis supported an Italian-inspired Renaissance in French art and architecture throughout his long reign.

JEAN CLOUET Not all the artists working at the court of Francis I, however, were Italian. Flemish artist Jean Clouet (c. 1485–c. 1540) found great favor at the royal court, especially as a portrait painter. About the same time that he became principal court painter in 1527, he produced an official portrait of the king (**FIG. 22-13**). Clouet

22-14 CHÂTEAU OF CHENONCEAU
Touraine, France. Original building (at right) 1513–1521; gallery on bridge at left by Philibert de l'Orme, finished c. 1581.

Chenonceau continued to play a role in the twentieth century. During World War I, it was used as a hospital. During the German occupation in World War II (1940–1942), when the River Cher formed the border with Vichy "Free" France, the gallery bridge at Chenonceau became an escape route.

Credit: Wildman/Fotolia

Art and its Contexts

THE CASTLE OF THE LADIES

Women played an important role in the patronage of the arts during the Renaissance. Nowhere is their influence stronger than in the châteaux of the Loire River Valley. At Chenonceau (SEE FIG. 22–14), women built, saved, and restored the château, which now is often referred to as "The Castle of the Ladies." Catherine Briconnet and her husband, Thomas Bohier, originally acquired the property, including a fortified mill, on which they built their country residence. Catherine supervised the construction, which included such modern conveniences as a straight staircase (an Italian and Spanish feature) instead of traditional medieval spiral stairs, and a kitchen inside the château instead of in a distant outbuilding. After Thomas died in 1524 and Catherine in 1526, their son gave Chenonceau to King Francis I.

King Henry II, Francis's son, gave Chenonceau to his mistress Diane de Poitiers in 1547. She managed the estate astutely, increased its revenue, developed the vineyards, added intricately planted gardens in the Italian style, and built a bridge across the Cher. When Henry died in a tournament, his queen, Catherine de' Medici (1519–1589), appropriated the château for herself.

Catherine, like so many in her family a great patron of the arts, added the two-story gallery to the bridge at Chenonceau, as well as outbuildings and additional formal gardens. Her parties were famous: mock naval battles on the river, fireworks, banquets, dances, and on one occasion two choruses of young women dressed as mermaids in the moat and nymphs in the shrubbery—who were then chased about by young men costumed as satyrs.

When Catherine's third son became king as Henry III in 1574, she gave the château to his wife, Louise of Lorraine, who lived in mourning at Chenonceau after Henry III was assassinated in 1589. She wore only white and covered the walls, windows, and furniture in her room with black velvet and damask. She left Chenonceau to her niece when she died.

In the eighteenth and nineteenth centuries, women continued to determine the fate of Chenonceau. During the French Revolution (1789–1793), the owner, Louise Dupin, was so beloved by the villagers that they protected her and saved her home. Then, in 1864, Marguerite Pelouze bought Chenonceau and restored it by removing Catherine de' Medici's Italian "improvements."

Later, Roman-trained French Renaissance architect Philibert de l'Orme (d. 1570) designed for Catherine de' Medici a gallery for an existing bridge across the river. Completed about 1581, it incorporates contemporary Italianate window treatments, wall molding, and cornices that harmonized almost perfectly with the forms of the original turreted building.

FONTAINEBLEAU Having chosen as his primary residence the medieval hunting lodge at Fontainebleau, Francis I began transforming it into a grand country palace. In 1530, he imported a Florentine artist, the Mannerist painter Rosso Fiorentino (1495–1540), to direct the project. After Rosso died, he was succeeded by his Italian colleague Francesco Primaticcio (1504–1570), who had joined Rosso in 1532 after working with Giulio Romano in Mantua (SEE FIG. 21–23). Primaticcio would spend the rest of his career working on the decoration of Fontainebleau. During that time, he also commissioned and imported a large number of copies and casts of original Roman sculpture, from the newly discovered Laocoön (SEE FIG. 5–65) to the relief decoration on the Column of Trajan (SEE FIG. 6–47). These works provided an invaluable visual resource of figures and techniques for the Northern European artists employed on the Fontainebleau project.

Among Primaticcio's first projects at Fontainebleau was the redecoration in the 1540s of the rooms of the king's official mistress, Anne, duchess of Étampes (**FIG. 22–15**). Woodwork, stucco relief, and fresco painting are combined in a complex interior design. The stucco nymphs, with their elongated bodies and small heads,

recall Parmigianino's paintings (SEE FIG. 21–39). Their spiraling postures and bits of clinging drapery are playfully erotic. Garlands, mythological figures, and Roman architectural ornament almost overwhelm the walls with visual enrichment, yet the whole remains graceful, orderly, and lighthearted. The first School of Fontainebleau, as this Italian phase of the palace decoration is called, established an Italianate tradition of Mannerism in painting and interior design that spread to other centers in France and into the Netherlands.

THE LOUVRE Before Francis I's defeat at Pavia by Holy Roman Emperor Charles V and subsequent imprisonment in Spain in 1525, the French court had been a mobile unit, and the locus of French art resided outside Paris in the Loire Valley. After his release in 1526, Francis made Paris his bureaucratic seat, and the Île-de-France—Paris and its region—took the artistic lead. The move to the capital gave birth to a style of French Classicism when Francis I and Henry II decided to modernize the medieval castle of the Louvre. Work began in 1546 with the replacement of the west wing of the square court, or **COUR CARRÉE (FIG. 22–16**), by architect Pierre Lescot (c. 1510–1578) working with sculptor Jean Goujon (1510–1568). They designed a building that incorporated Renaissance ideals of balance and regularity with Classical architectural details and rich sculptural decoration. The irregular rooflines seen in a château such as the one at Chenonceau (SEE FIG. 22–14, right part of the building) gave way to discreetly rounded arches and horizontal balustrades. Classical pilasters and entablatures replaced Gothic buttresses and stringcourses.

22–15 Primaticcio **STUCCO AND WALL PAINTING, CHAMBER OF THE DUCHESS OF ÉTAMPES, CHÂTEAU OF FONTAINEBLEAU**

France. 1540s.

22–16 Pierre Lescot and Jean Goujon **WEST WING OF THE COUR CARRÉE, PALAIS DU LOUVRE, PARIS** Begun 1546.

Credit: © akg-images/Erich Lessing

A round-arched arcade on the ground floor suggests an Italian loggia. On the other hand, the sumptuousness of the decoration recalls the French Flamboyant style (see Chapter 19), only with Classical pilasters and acanthus replacing Gothic colonnettes and cusps.

Spain and Portugal

How do the Escorial, the Convent of Christ in Tomar, and the paintings of El Greco embody the religion and politics of Renaissance Spain and Portugal?

The sixteenth century saw the peak of Spanish political power. The country had been united in the fifteenth century by the marriage of Isabella of Castile and Ferdinand of Aragon. Only Navarre (in the Pyrenees) and Portugal remained outside the union. When Isabella and Ferdinand's grandson Charles V abdicated in 1556, his son Philip II (ruled 1556–1598) became the king of Spain, the Netherlands, and the Americas, as well as ruler of Milan, Burgundy, and Naples, but Spain was Philip's permanent residence. For more than half a century, he supported artists in Spain, Italy, and the Netherlands. His navy, the famous Spanish Armada, halted the advance of Islam in the Mediterranean and secured control of most of the Americas. Despite enormous effort, however, Philip could not suppress the revolt of the northern provinces of the Netherlands, nor could he prevail in his war against the English, who destroyed his

navy in 1588. He was able to gain control of the entire Iberian peninsula, however, by claiming Portugal in 1580, and it remained part of Spain until 1640.

Architecture

Philip built **THE ESCORIAL** (**FIG. 22-17**), the great monastery-palace complex outside Madrid, partly to comply with his father's direction to construct a "pantheon" in which all Spanish kings might be buried, and partly to house his court and government. In 1559, Philip summoned from Italy Juan Bautista de Toledo (d. 1567), who had been Michelangelo's supervisor of work at St. Peter's from 1546 to 1548. Juan Bautista's design for the monastery-palace reflected his indoctrination in Bramante's Classical principles in Rome, but the king himself dictated the severity and size of the structure. The Escorial's grandeur comes from its overwhelming size, fine proportions, and excellent masonry. The complex includes not only the royal residence but also the Royal Monastery of San Lorenzo, a school, a library, and a church, its crypt serving as the royal burial chamber. The plan was said to resemble a gridiron, the instrument of martyrdom of its patron saint, Lawrence, who was roasted alive.

In 1572, Juan Bautista's assistant, Juan de Herrera, was appointed architect, and he immediately changed the design, adding second stories on all wings and breaking the horizontality of the main façade with a central frontispiece

22–17 Juan Bautista de Toledo and Juan de Herrera **THE ESCORIAL**

Madrid. 1563–1584. Detail from an anonymous 17th-century painting. Oil on canvas, 30¼ × 35⅞ (77 × 91cm). Monasterio-Pintura, San Lorenzo Del Escorial, Madrid.

Credit: © akg-images/Album/Oronoz

that resembled the superimposed temple fronts that were fashionable on Italian churches at this time (SEE FIGS. 21–33, 21–48A). Before beginning the church in the center of the complex, Philip solicited the advice of Italian architects including Vignola and Palladio. The final design combined ideas that Philip approved and Herrera carried out, and it embodies Italian Classicism in its geometric clarity, symmetry, and superimposed temple-front façade. In its austerity, it embodies the deep religiosity of Philip II.

Sculpture

One of the most beautiful, if also one of the strangest, sixteenth-century sculptures in Portugal seems to float over the cloisters of the convent of Christ in Tomar. In the heart of the castle-monastery complex, one comes unexpectedly face to face with the Old Man of the Sea. He supports on his powerful shoulders an extraordinary growth—part roots and trunk of a gnarled tree and part tangled mass of seaweed, algae, ropes, and anchor chains. Barnacle- and coral-encrusted piers lead the eye upward, revealing a large, lattice-covered window, the great **WEST WINDOW** of the church of the Knights of Christ (**FIG. 22-18**).

When Pope Clement V disbanded the Templars (a monastic order of knights founded in Jerusalem after the First Crusade) in 1314, King Dinis of Portugal offered them

a renewed existence as the Knights of Christ. As a result, in 1356, they made the former Templar castle and monastery in Tomar their headquarters. When Prince Henry the Navigator (1394–1460) became the grand master of the order, he invested their funds in the exploration of the African coast and the Atlantic Ocean. The Templar insignia, the squared cross, became the emblem used on the sails of Portuguese ships.

King Manuel I of Portugal (ruled 1495–1521) commissioned the present church, with its amazing sculpture by Diogo de Arruda, in 1510. So distinctive is the style developed under King Manuel by artists like the Arruda brothers, Diogo (active 1508–1531) and Francisco (active 1510–1547), that Renaissance art in Portugal is called "Manueline." In the window at Tomar, every surface is carved with architectural and natural detail associated with the sea. Twisted ropes form the corners of the window; the coral pillars support great swathes of seaweed. Chains and cables drop to the place where the head of a man—perhaps a self-portrait of Diogo de Arruda—emerges from the roots of a tree. Above the window, more ropes, cables, and seaweed support the emblems of the patron—armillary spheres at the upper outside corners (topped by pinnacles) and at dead center, the coat of arms of Manuel I with its Portuguese castles framing the five wounds of Christ. Topping the composition is the square

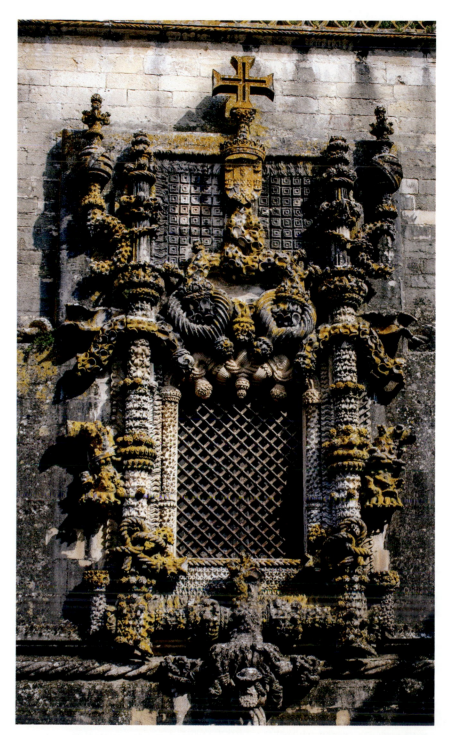

22–18 Diogo de Arruda **WEST WINDOW, CHURCH IN THE CONVENT OF CHRIST, TOMAR**

Portugal. c. 1510. Commissioned by King Manuel I of Portugal.

Credit: Lemtal/Fotolia

Painting

The most famous painter working in Spain during the last quarter of the sixteenth century was Domenikos Theotokopoulos (1541–1614), who arrived in Spain in 1577 after working for ten years in Italy. El Greco ("The Greek"), as he is called, was trained as an icon painter in the Byzantine manner in his native Crete, then under Venetian rule. In about 1566, he entered Titian's studio in Venice, where he also studied the paintings of Tintoretto and Veronese. From about 1570 to 1577, he worked in Rome, living for a time in the Farnese Palace. Probably encouraged by Spanish church officials whom he met in Rome, El Greco eventually settled in Toledo, seat of the Spanish archbishop. He had hoped for a court appointment, but Philip II—a great patron of the Venetian painter Titian and a collector of Netherlandish artists such as Bosch—disliked the painting he had commissioned from El Greco for the Escorial and never again gave him work.

In Toledo, El Greco joined the circle of humanist scholars. He wrote that the artist's goal should be to copy nature, that Raphael relied too heavily on the ancients, and that the Italians' use of mathematics to achieve ideal proportions hindered their painting of nature. At this same time an intense religious revival was underway in Spain, expressed in the impassioned preaching of Ignatius of Loyola, as well as in the poetry of two great Spanish mystics: St. Teresa of Ávila (1515–1582) and her follower, St. John of the Cross (1542–1591). El Greco's style—rooted in Byzantine icon painting and strongly reflecting the rich colors and loose brushwork of Venetian painting—was well equipped to express the intense spirituality of these mystics.

In 1586, Andrés Nuñez, parish priest of the church of Santo Tomé, commissioned a painted altarpiece from El Greco to honor Count Orgaz, a great benefactor of the Church. At Count Orgaz's funeral in 1323, SS. Augustine and Stephen were said to have appeared to lower the body

cross of the Order of Christ, clearly delineated against the wall of the chapel.

The armillary sphere became a symbol of the era. This complex form of a celestial globe, with the sun at the center surrounded by rings marking the paths of the planets, was a teaching device for the new scientific theory that the Sun, not the Earth, was the center of the solar system. (Copernicus published his theories about this in 1531 and 1543.) King Manuel's use of the armillary sphere as his emblem signals his determination to make Portugal the leader in the exploration of the sea. Indeed, in Manuel's reign the Portuguese reached India and Brazil.

into his tomb as his soul was seen ascending to heaven. El Greco's painting the **BURIAL OF COUNT ORGAZ** (FIG. **22–19**) captures these miracles in a Mannerist composition that recalls Pontormo (SEE FIG. 21–38), packing the pictorial field with figures and eliminating specific reference to the spatial setting. An angel lifts Orgaz's soul along the central axis of the painting toward the enthroned Christ at the apex of the canvas. The otherworldly light emanating from

Christ in this heavenly vision is quite unlike the natural light below, where El Greco surrounded the burial scene with portraits of the local aristocracy and religious notables. He placed his own 8-year-old son at the lower left next to St. Stephen and signed the painting on the boy's white kerchief. El Greco may also have put his own features on the man just above the saint's head, the only other figure who, like the child, looks straight out at the viewer.

22–19 El Greco **BURIAL OF COUNT ORGAZ**
Church of Santo Tomé, Toledo, Spain. 1586. Oil on canvas, 16′ × 11′10″ (4.88 × 3.61 m).

Credit: Courtesy of Marilyn Stokstad

The Netherlands

How do the diverse interests of wealthy bourgeois and noble patrons affect painting in the Netherlands during the sixteenth century?

In the Netherlands, the sixteenth century was an age of bitter religious and political conflict. Despite the opposition of the Spanish Habsburg rulers, the Protestant Reformation took hold in the northern provinces. Seeds of unrest were sown still deeper over the course of the century by continued religious persecution, economic hardship, and inept governors. Widespread iconoclasm characterized 1566–1567, and a long battle for independence began with a revolt in 1568 that lasted until Spain relinquished all claims to the region 80 years later. As early as 1579, when the seven northern Protestant provinces declared themselves the United Provinces, the discord split the Netherlands, eventually dividing it along religious lines into the United Provinces (the present-day Netherlands) and Catholic Flanders (present-day Belgium).

Despite such turmoil, Antwerp and other cities developed into thriving art centers. The Reformation led artists to seek patrons outside the Church. While courtiers and burghers alike continued to commission portraits, the demand arose for small paintings with interesting secular subjects appropriate for homes. For example, some artists became specialists known for their landscapes or satires. In addition to painting, textiles, ceramics, printmaking, and sculpture in wood and metal flourished in the Netherlands. Flemish tapestries were sought after and highly prized across Europe, as they had been in the fifteenth century, and leading Italian artists made cartoons to be woven into tapestries in Flemish workshops (see Chapter 21). The **graphic arts** emerged as an important medium, providing many artists with another source of income. Pieter Bruegel the Elder, for instance, began his career drawing amusing moralizing images to be printed and published by At the Four Winds, an Antwerp publishing house.

Like Vasari in Italy, Carel van Mander (1548–1606) recorded the lives of his Netherlandish contemporaries in engaging biographies that mix fact and gossip. He, too, intended his 1604 book *Het Schilder-boeck* (*The Painter's Book*) to be a survey of the history of art, and he included material from the ancient Roman writers Pliny and Vitruvius as well as from Vasari's revised and expanded *Lives*, published in 1568.

Painting for Aristocratic and Noble Patrons

Artistic taste among the wealthy bourgeoisie and noble classes in the early sixteenth-century Netherlands was characterized by a striking diversity, encompassing the imaginative and difficult visions of Hieronymus Bosch as well as the more Italianate compositions of Jan Gossaert. In the later years of his life, Bosch's membership in a local but prestigious confraternity called the Brotherhood of Our Lady seems to have opened doors to noble patrons such as Count Hendrick III of Nassau and Duke Philip the Fair. His younger contemporary Gossaert left the city of Antwerp as a young man to spend the majority of his active years as the court painter for the natural son of Duke Philip the Good. His art also attracted members of the Habsburg family, including Charles V, who were seduced by Gossaert's combination of Northern European and Italian styles.

HIERONYMUS BOSCH Among the most fascinating Netherlandish painters to modern viewers is Hieronymus Bosch (1450–1516), who depicted the sort of imaginative fantasies more often associated with medieval than Renaissance art. A superb colorist and virtuoso technician, Bosch spent his career in the town whose name he adopted, 's-Hertogenbosch. Bosch's religious devotion is certain, and his range of subjects shows that he was well educated. Challenging and unsettling paintings such as his **GARDEN OF EARTHLY DELIGHTS** (FIG. 22-20) have led modern scholars to label Bosch both a mystic and a social critic. The subject of the triptych seems to be founded on Christian belief in the natural state of human sinfulness, but it was not painted for a church.

In the left wing, God introduces doll-like figures of Adam and Eve under the watchful eye of the owl of perverted wisdom. The owl symbolizes both wisdom and folly. Folly had become an important concept to the Northern European humanists, who believed in the power of education. They believed that people would choose to follow the right way once they knew it. Here the owl peers out from an opening in the spherical base of a fantastic pink fountain in a lake from which vicious creatures creep out into the world.

In the central panel, the Earth teems with such monsters, but also with vivacious human revelers and huge fruits, symbolic of fertility and sexual abandon. In hell, at the right, sensual pleasures—eating, drinking, music, and dancing—become instruments of torture in a dark world of fire and ice. The emphasis in the right wing on the torments of hell, with no hint of the rewards of heaven, seems to caution that damnation is the natural outcome of a life lived in ignorant folly and that humans ensure their damnation through their self-centered pursuit of pleasures of the flesh—the sins of gluttony, lust, greed, and sloth—outlined with such fantastic and graphic abandon in the central panel.

One scholar has proposed that the central panel is a parable on human salvation in which the practice of alchemy—the process that sought to turn common metals

22–20 Hieronymus Bosch **GARDEN OF EARTHLY DELIGHTS (OPEN)**

c. 1505–1515. Oil on wood panel; center panel 7′2½″ × 6′4¾″ (2.20 × 1.95 m), each wing 7′2½″ × 3′2″ (2.20 × 0.97 m). Museo del Prado, Madrid.

Despite—or perhaps because of—its bizarre subject matter, this triptych was woven in 1566 into tapestries, and at least one painted copy was made as well. Bosch's original triptych was sold at the onset of the Netherlands Revolt and sent in 1568 to Spain, where it entered the collection of Philip II.

into gold—parallels Christ's power to convert human dross into spiritual gold. In this theory, the bizarre fountain at the center of the lake in the middle distance can be seen as an alchemical "marrying chamber," complete with the glass vessels for collecting the vapors of distillation. Others see the theme as the power of women over men. In this interpretation, the central pool is the setting for a display of seductive women and sex-obsessed men. Women frolic alluringly in the pool while men dance and ride in a mad circle trying to attract them. In this strange garden, men are slaves to their own lust. An early seventeenth-century critic focused on the fruit, writing that the triptych was known as *The Strawberry Plant* because it represented the "vanity and glory and the passing taste of strawberries or the strawberry plant and its pleasant odor that is hardly

remembered once it has passed." Luscious fruits of obvious sexual symbolism—strawberries, cherries, grapes, and pomegranates—appear everywhere in the garden, serving as food, as shelter, and even as a boat. The message may be that human life is as fleeting and insubstantial as the taste of a strawberry. But yet another modern reading sees the central tableau as depicting the course of life in paradise if Adam and Even had not consigned humanity to sin by eating the forbidden fruit.

Conforming to a long tradition of triptych altarpieces made for churches, Bosch painted a more sober *grisaille* picture on the reverse of the side wings. When the triptych is closed, a less enigmatic, but equally fascinating, scene is displayed (**FIG. 22–21**). A transparent, illusionistic rendering of a receding sphere floating within a void encloses the

22–21 Hieronymus Bosch **GARDEN OF EARTHLY DELIGHTS (CLOSED)**

Credit: © 2016. Photo Scala, Florence

flat circular shelf of Earth on its third day of creation. Fragments of the fantastic fruit that will appear fully formed in the interior pictures float here in the primordial sea, while dark clouds promise the rain that will nurture them into their full ripeness. A tiny, crowned figure of God the Creator hovers in a bubble within clouds at the upper left, displaying a book, perhaps a Bible opened to the words from Psalm 33:9 that are inscribed across the top: "For he spoke, and it came to be; he commanded, and it stood firm."

The *Garden of Earthly Delights* was commissioned by an aristocrat (probably Count Hendrick III of Nassau) for his Brussels town house, and the artist's choice of a triptych format, which suggests an altarpiece, may have been an understated irony. In a private home the painting surely inspired lively discussion, even

ribald commentary, much as it does today in the Prado Museum. Perhaps that, rather than a single meaning, is the true intention behind this dazzling display of artistic imagination.

JAN GOSSAERT In contrast to the private visions of Bosch, Jan Gossaert (c. 1478–c. 1533) maintained traditional subject matter and embraced the new Classical art of Italy. Gossaert (who later called himself Mabuse after his native city Maubeuge) entered the service of Philip, the illegitimate son of the duke of Burgundy, accompanying him to Italy in 1508 and remaining in his service after Philip became archbishop of Utrecht in 1517.

Gossaert's "Romanizing" style—inspired by Italian Mannerist paintings and decorative details drawn from

22–22 Jan Gossaert **ST. LUKE DRAWING THE VIRGIN MARY**
1520. Oil on panel, 43⅜ × 32¼″ (110.2 × 81.9 cm). Kunsthistorisches Museum, Vienna.

Credit: © akg-images/Erich Lessing

ancient Roman art—is evident in his painting of **ST. LUKE DRAWING THE VIRGIN MARY** (FIG. 22-22), a traditional subject we already know from a painting by Rogier van der Weyden (SEE FIG. 19-16). In Gossaert's version, the artist's studio is an extraordinary structure of Classical piers and arches, carved with a dense ornament of foliage and medallions. Mary and the Christ Child appear in a blaze of golden light and clouds in front of the saint, who kneels at a desk, his hand guided by an angel as he records the vision in a drawing. Luke's crumpled red robe replicates fifteenth-century drapery conventions in a seeming reference to Rogier's famous picture. Seated above and behind Luke on a columnar structure, Moses holds the Tablets of the Law, referencing his own visions of God on Mount Sinai. Just as Moses had removed his shoes in God's presence, so has Luke in the presence of his vision. Gossaert, like Dürer before him, seems to be staking a claim for the divine inspiration of the artist.

Antwerp

During the sixteenth century, Antwerp was the commercial and artistic center of the southern Netherlands. Its deep port made it an international center of trade (it was one of the European centers for trade in spices), and it was the financial center of Europe. Painting, printmaking, and book production flourished in this environment, attracting artists and craftspeople from all over Europe. The demand

for luxury goods fostered the birth of the art market, in which art was transformed into a commodity for both local and international consumption. In response to this market, many artists became specialists in one area, such as portraiture or landscape, and worked with art dealers, who emerged as middlemen, further shaping the commodification of art, its production, and its producers.

QUENTIN MASSYS Early accounts of the prosperous Antwerp artist Quentin Massys (1466–1530) claim that he began working in his native Louvain as a blacksmith (his father's profession) but changed to painting to compete with a rival for the affections of a young woman; Carel van Mander claims he was a self-trained artist. We know he entered the Antwerp painters' guild in 1491, and at his death in 1530 he was among its most prosperous and renowned members, supervising a large workshop to meet the market in this burgeoning art center.

One of his most fascinating paintings—**MONEY CHANGER AND HIS WIFE** (FIG. 22–23)—recalls, like Gossaert's *St. Luke*, a famous fifteenth-century work, in this case the picture of a goldsmith painted for the Antwerp goldsmiths' guild by Petrus Christus (see "Closer Look" in Chapter 19 on page 592). Here, however, a couple is in charge of the business, and they present us with two different profiles of engagement. The soberly dressed proprietor

22–23 Quentin Massys **MONEY CHANGER AND HIS WIFE**
1514. Oil on panel, 27¾ × 26⅜" (70.5 × 67 cm). Musée du Louvre, Paris.

Credit: Photo © RMN-Grand Palais (Musée du Louvre)/Tony Querrec

focuses intently on weighing coins. His brightly outfitted wife—dressed in an archaic fifteenth-century costume that harks back to a golden age of Flemish painting—looks to the side, her husband's activity distracting her from the meticulously described Book of Hours spread out on the table in front of her. It would be easy to jump to the conclusion that this is a moral fable, warning of the danger of losing sight (literally) of religious obligations because of a preoccupation with affairs of business. But the painting is not that simple. An inscription that ran around the original frame quoted Leviticus 19:36—"You shall have honest balances and honest weights"—claiming just business practices as a form of righteous living. Perhaps the painting's moral juxtaposes not worldliness and spirituality, but attentive and distracted devotional practice. The wife seems to have been idly flipping through her prayer book before turning to observe her husband, whereas a man reflected in the convex mirror next to her Book of Hours is caught in rapt attention to the book in front of him, and the nature of his reading is suggested by the church steeple

through the window behind him. The sermon here concerns the challenge of godly living in a worldly society, but wealth itself is not necessarily the root of the problem.

CATERINA VAN HEMESSEN Antwerp painter Caterina van Hemessen (1528–1587) developed an illustrious reputation as a portraitist. She had learned to paint from her father, the Flemish Mannerist Jan Sanders van Hemessen, who was dean of the Antwerp painters' guild in 1548, but the quiet realism and skilled rendering of her subjects is distinctively her own. To direct viewers' focus to her foreground subjects, Van Hemessen painted them against even, dark-colored backgrounds, on which she identified the sitter by name and age, signing and dating each work. The inscription in her **SELF-PORTRAIT** (FIG. 22-24) reads: "I Caterina van Hemessen painted myself in 1548. Her age 20." In delineating her own features, Van Hemessen presented a serious young person who looks up to acknowledge us, interrupting her work on a portrait of a woman client. Between the date of this self-portrait and 1552, she painted ten signed and dated portraits of women, which seems to have been a specialty. She became a favored court artist to Mary of Hungary, sister of Emperor Charles V and regent of the Netherlands, for whom she painted not only portraits but also religious works, and whom she followed back to Spain when Mary ceased to be regent in 1556.

PIETER BRUEGEL THE ELDER The works of Hieronymus Bosch remained so popular that nearly half a century after Bosch's death, Pieter Bruegel (c. 1525–1569) began his career by imitating them. Like Bosch, he often painted large narrative works crowded with figures, and he chose moralizing or satirical subject matters. He traveled throughout Italy,

22-24 Caterina van Hemessen
SELF-PORTRAIT
1548. Oil on wood panel, 12¼ × 9¼" (31.1 × 23.5 cm). Öffentliche Kunstsammlung, Basel.

Credit: Kunstmuseum Basel. Photo: Martin Buhler/ Kunstmuseum Basel

22–25 Pieter Bruegel the Elder **RETURN OF THE HUNTERS**
1565. Oil on wood panel, 3′10½″ × 5′3¾″ (1.18 × 1.61 m). Kunsthistorisches Museum, Vienna.

Credit: © akg-images/Erich Lessing

but, unlike many Renaissance artists, he did not record the ruins of ancient Rome or the wonders of Italian cities. Instead, he was fascinated by the landscape, particularly the formidable, jagged rocks and sweeping panoramic views of Alpine valleys, which he recorded in detailed drawings. Back home in his studio, he made an impressive leap of the imagination as he painted the flat and rolling lands of Flanders as broad panoramas, even adding imaginary mountains on the horizon. He also visited country fairs to sketch the farmers and townspeople who became the focus of his paintings. Bruegel presented humans not as unique individuals, but as well-observed types whose universality makes them familiar even today.

Cycles, or series, of paintings unified by a developing theme or allegorical subject—for instance, the Times of the Day, the Four Seasons, or the Five Senses—became popular wall decorations in prosperous Flemish homes during the sixteenth century. In 1565, Bruegel was commissioned to paint a series of six large paintings, each over 5 feet wide, surveying the months of the year, two months to a picture. They were made to be hung together in a room—probably

the dining room, since food figures prominently in them—in the suburban villa of wealthy merchant Nicolaes Jonghelinck just outside Antwerp.

RETURN OF THE HUNTERS (FIG. 22–25), representing December and January, captures the bleak atmosphere of early winter nightfall with a freshness that recalls the much earlier paintings of his compatriots the Limbourgs (SEE FIG. 19–5). Hunters are returning home at dusk with meager results: a fox slung over the largest man's shoulder. But the landscape, rather than the figures, seems to be the principal subject. On the left, a receding row of trees, consistently diminishing in scale, draws our attention into the space of the painting along the same orthogonal descent as the hillside of houses. Like the calendar illustrations of medieval Books of Hours, the landscape is filled with behavior emblematic of the time of year: the singeing of the pig outside the farmhouse at left, the rhythmic movement of ice skaters across frozen fields. We see it all from an elevated viewpoint, like one of the birds that perch in the trees or glide across the snow-covered fantasy of an alpine background.

The mood is very different in the painting representing the late summer days of August and September, another slice of everyday life faithfully reproduced within a carefully calculated composition (**FIG. 22-26**). Here the light is warmer, the landscape lush, and the human activity rooted in agricultural labor or a momentary respite from it. Birds still perch and glide, and a silhouetted tree still dominates the foreground—as if Bruegel wanted to set up obvious relationships between the scenes so that viewers would assess them comparatively—but the setting here is more rural. Architecture keeps its distance or is screened by foliage. Farm workers harvest grain and gather stalks into tidy sheaves. The figural focus, however, is in the foreground, on a shift of workers on their lunch break—serving themselves from baskets, gnawing on pieces of bread, spooning milk from bowls, or gulping from an uplifted jug. One man takes the opportunity for a quick nap. Some have seen in this figure an emblem of sloth or a display of uncouth behavior, reminiscent of the embarrassing exposure of the peasant couple before the fire in the February page of Duke

Jean de Berry's *Très Riches Heures* (SEE FIG. 19-5), painted by the Netherlandish Limbourg brothers a century and a half earlier.

Indeed, Bruegel's series invites comparison with this venerable tradition—dating to the early Middle Ages—of showing peasant activity within the calendar cycles of prayer books made for wealthy patrons. Perhaps the rich were amused by peasant behavior, enjoyed representations of the productivity of their land, or even longed for a simpler life, idealized here as a harmony between the natural world and the people who live from it. But the peasants in this sunny scene are only on a lunch break. Another shift is already at work in the fields, and the wealth of the patrons who supported the growth of an art market was dependent on the labor of countless others like them.

As a depiction of Netherlandish life, these landscape-focused peasant scenes represent a relative calm before the storm. Three years after they were painted, the anguished struggle of the northern provinces for independence from Spain began.

22-26 Pieter Bruegel the Elder **THE HARVESTERS**
1565. Oil on wood panel, 46⅞ × 63¾" (1.17 × 1.6 m). Metropolitan Museum of Art, New York. Rogers Fund, 1919. (19.164).

A Closer Look

THE FRENCH AMBASSADORS

Embossing on the sheath of the dagger tells us that de Dinteville is 29, while an inscription on the edge of the book (Bible?) under de Selve's arm records that he is 25.

This globe perched on the shelf above the table has Polisy, the de Dinteville family estate, marked at the center. It was here that this painting was hung when the ambassador returned to France at the end of 1533.

These objects on the top shelf were used to observe natural heavenly phenomena and chart the passage of time. The items displayed on the lower shelf relate more to terrestrial concerns.

Music is a common symbol of harmony in this period, and the broken string on this lute has been understood as an allusion to the discord created by the sweep of Protestant reform across Europe.

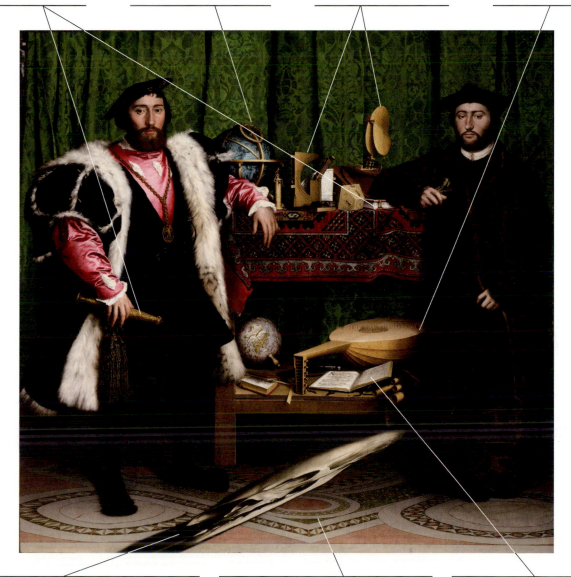

This bizarre, but prominently placed skull—as well as the skull badge that appears on de Dinteville's cap—reminded viewers of their own mortality. The foreground skull is distorted by anamorphosis, in which images are stretched horizontally with the use of a trapezoidal grid so that they must be viewed from the side to appear correctly proportioned.

This pavement—known as "Cosmati work" after the thirteenth-century Italian family that specialized in it—is copied from the floor in Westminster Abbey and may proclaim the ambassadors' involvement in a holy enterprise of reconciliation. The artist signed the painting on the left edge of the floor: "Johannes Holbein pingebat, 1533."

This is a Lutheran hymnal published in 1527, open at one of Luther's best-known compositions: "Come, Holy Ghost, our souls inspire." Neither man was a Protestant, but some of de Selve's contemporaries saw him as sympathetic to the cause of the reformers.

22–27 Hans Holbein the Younger THE FRENCH AMBASSADORS
1533. Oil on wood panel, 81⅛ × 82⅝" (2.07 × 2.1 m). National Gallery, London.

Credit: © 2016. Copyright The National Gallery, London/Scala, Florence

England

How do painting and architecture reflect the interests of the English Tudor court?

Tudor England, in spite of the disruption caused by the Reformation, was economically and politically stable enough to provide sustained support for the arts, as Henry VIII strived to compete with the wealthy, sophisticated court of Francis I. Music, literature, and architecture flourished, but painting was principally left to foreigners.

As a young man, Henry VIII (ruled 1509–1547) was loyal to the Church, defending it against Luther's attacks. He was rewarded by the pope in 1521 by being granted the title "Defender of the Faith." But when the pope refused to annul his marriage to Catherine of Aragon, Henry broke with Rome. By action of Parliament in 1534 he became the "Supreme Head on Earth of the Church and Clergy of England." He mandated an English translation of the Bible in every church, and in 1536 and 1539 he dissolved the monasteries, confiscating their great wealth and rewarding his followers with monastic lands and buildings. Shrines and altars were stripped of their jewels and precious metals to bolster the royal purse, and in 1548, during the reign of Henry's son, Edward VI, religious images were officially prohibited.

During the brief reign of Mary (ruled 1553–1558), England officially returned to Catholicism, but the accession of Elizabeth in 1558 confirmed England as a Protestant country. So effective was Elizabeth, who ruled until 1603, that the last decades of the sixteenth century in England are called the Elizabethan Age.

Painting at the Tudor Court

A remarkable record of the appearance of Tudor notables survives in portraiture. Since the Tudors had long favored Netherlandish and German artists, it is hardly surprising that it was a German-born painter, Hans Holbein the Younger (c. 1497–1543), who shaped the taste of the English court and upper classes.

HANS HOLBEIN Holbein first visited London from 1526 to 1528 and was introduced by the Dutch scholar Erasmus to the humanist circle around the English statesman Thomas More. He returned to England in 1532 and was appointed court painter to Henry VIII about four years later. During the 1530s, he created a spectacular series of portraits of nobles and diplomats associated with the Tudor court. The court's climate of international interaction is captured in a double portrait that Holbein painted in 1533 (see "Closer Look" on page 719)—a German painter's rendering in England of two French diplomats,

one of them representing the court of Francis I in the Vatican. *The French Ambassadors* foregrounds Holbein's virtuosity as a painter and constructs a rich characterization of Jean de Dinteville, French ambassador to England, and his friend Georges de Selve, bishop of Lavaur and ambassador to the Holy See. With detail that recalls the work of Jan van Eyck, the artist describes the textures and luminosity of the many objects placed in the painting to reflect the intellectual gifts and evoke the political accomplishments of these two men. References in these objects to the conflicts between European states and within the Catholic Church itself imply that these confident young ambassadors will apply their diplomatic skills to finding a resolution.

PORTRAITS OF ELIZABETH Queen Elizabeth I carefully controlled the way artists represented her in official portraits and was known to have imprisoned artists whose unofficial images did not meet with her approval. A stark and hieratic regal image by Flemish artist Marcus Gheeraerts typifies the look she was after (**FIG. 22-28**). Called the *Ditchley Portrait* because it seems to have been commissioned for Ditchley, the estate of her courtier Sir Henry Lee, to commemorate the queen's visit in 1592, the full-length figure of Elizabeth—more costume than body—stands supreme on a map of her realm with her feet in Oxfordshire, near Ditchley. The stark whiteness of her elaborate dress and the pale abstraction of her severe face assert the virginal purity that she cultivated as a part of her image. A storm passes out of the picture on the right while the sun breaks through on the left. It is as if the queen is in control not only of England but of nature itself.

NICHOLAS HILLIARD In 1570, Nicholas Hilliard (1547–1619) arrived in London from southwest England to pursue a career as a jeweler, goldsmith, and painter of miniatures. Hilliard never received a court appointment, but he created miniature portraits of the queen and court notables, including **GEORGE CLIFFORD** (1558–1605), third Earl of Cumberland (**FIG. 22-29**). Cumberland was a regular participant in the annual tilts and festivals celebrating the anniversary of Elizabeth's ascent to the throne. In Hilliard's miniature, Cumberland, a man of about 30, wears a richly engraved and gold-inlaid suit of armor forged for his first appearance in 1583 (see "Armor for Royal Games" on page 722). Hilliard gives him a marked air of courtly jauntiness, with a stylish beard, mustache, and curled hair, but Cumberland is also humanized by his direct gaze and receding hairline. His motto—"I bear lightning and water"—is inscribed on a stormy sky with a lightning bolt in the form of a caduceus, one of his emblems. After all, he was that remarkable Elizabethan type—a naval commander and gentleman pirate.

22–28 Marcus Gheeraerts the Younger **QUEEN ELIZABETH I (THE DITCHLEY PORTRAIT)**
c. 1592. Oil on canvas, 95 × 60" (2.4 × 1.5 m). National Portrait Gallery, London.

Credit: Photo © Stefano Baldini/Bridgeman Images

22–29 Nicholas Hilliard **GEORGE CLIFFORD, THIRD EARL OF CUMBERLAND**
c. 1595. Watercolor on vellum on card, oval 2¾ × 2³⁄₁₆" (7.1 × 5.8 cm). The Nelson-Atkins Museum of Art, Kansas City, Missouri. Gift of Mr. and Mrs. John W. Starr through the Starr Foundation. F58-60/188.

Architecture

To increase support for the Tudor dynasty, Henry and his successors granted titles to rich landowners. To display their wealth and status, many of these newly created aristocrats embarked on extensive building projects, constructing lavish country residences that sometimes surpassed the French châteaux in size and grandeur. Rooted in the Perpendicular Gothic style (SEE FIG. 18-23, far wall), Elizabethan architecture's severe walls and broad expanses of glass were modernized by replacing medieval ornament with Classical motifs copied from architectural handbooks and pattern books. The first architectural manual in English, published in 1563, was written by John Shute, one of the few builders who had spent time in Italy. Most influential were the treatises on architectural design by the Italian architect Sebastiano Serlio.

HARDWICK HALL One of the grandest of all the Elizabethan houses was Hardwick Hall, the home of Elizabeth, countess of Shrewsbury, known as "Bess of Hardwick" (**FIG. 22-30**). When she was in her seventies, the countess—who inherited riches from all four of her deceased husbands—employed Robert Smythson (c. 1535–1614), England's first Renaissance architect, to build Hardwick Hall (1591–1597).

The medieval great hall was transformed into a two-story entrance hall with rooms arranged symmetrically around it—a nod to Classical balance. A sequence of rooms leads to a grand stair up to the long gallery and **HIGH**

22–30 Robert Smythson
HARDWICK HALL
Derbyshire, England. 1591–1597.

Credit: © Phil MacD Photography/Shutterstock

GREAT CHAMBER on the second floor that featured an ornately carved fireplace (**FIG. 22-32**). It was here the countess received guests, entertained, and sometimes dined. Illuminated by enormous windows, the room seems designed to showcase a precious set of six Brussels tapestries featuring the story of Ulysses. They serve as yet another reminder of the international character of the lavish decoration of residences created for wealthy Renaissance patrons throughout Europe during the sixteenth century.

Art and its Contexts

ARMOR FOR ROYAL GAMES

The medieval tradition of holding tilting, or jousting, competitions at English festivals and public celebrations continued during Renaissance times. Perhaps most famous were the Accession Day Tilts, held annually to celebrate the anniversary of Elizabeth I's coming to the throne. The gentlemen of the court, dressed in armor made especially for the occasion, held mock battles in the queen's honor. They rode their horses from opposite directions, trying to strike each other with long lances during six passes as judges rated their performances.

The elegant armor worn by George Clifford, third Earl of Cumberland, at the Accession Day Tilts has been preserved in the collection of the Metropolitan Museum of Art in New York (**FIG. 22–31**). Tudor roses and back-to-back capital *E*s in honor of the queen decorate the armor's surface. As the queen's champion, beginning in 1590, Clifford also wore her jeweled glove attached to his helmet as he met all comers in the tiltyard of Whitehall Palace in London.

Made by Jacob Halder in the royal armories at Greenwich, the 60-pound suit of armor is recorded in the sixteenth-century Almain Armourers' Album along with its "exchange pieces." These allowed the owner to vary his appearance by changing mitts, side pieces, or leg protectors, and also provided backup pieces if one were damaged.

22–31 Jacob Halder **ARMOR OF GEORGE CLIFFORD, THIRD EARL OF CUMBERLAND**
Made in the royal workshop at Greenwich, England. c. 1580–1583.
Steel and gold, height 5′9½″ (1.77 m). Metropolitan Museum of Art, New York.
Munsey Fund, 1932 (32.130.6).

Credit: © 2016. Image copyright The Metropolitan Museum of Art/Art Resource/ Scala, Florence

22–32 Robert Smythson **HIGH GREAT CHAMBER, HARDWICK HALL**
Derbyshire, England. 1591–1597. Brussels tapestries 1550s; painted plaster sculpture by Abraham Smith.

Credit: National Trust Photographic Library/Andreas von Einsiedel/Bridgeman Images

Think About It

1 Explore the influence of Italian art and ideas on the work and persona of German artist Albrecht Dürer. Choose one of his works from this chapter and discuss its Italianate features and the ways in which it departs from and draws on earlier Northern European traditions.

2 Discuss the impact of the Protestant Reformation on the visual arts in northern Europe, focusing your discussion on types of subject matter that patrons sought.

3 Choose one European court that employed artists working in a "foreign" tradition from another part of Europe and assess how this internationalism fostered the breaking down of regional and national boundaries in European art. Ground your discussion in the work of specific artists.

4 Choose a work of art from this chapter that displays extraordinary technical skill in more than one medium. How was its virtuosity achieved, and how is that virtuosity highlighted as an important factor in the work's significance?

Crosscurrents

Gossaert's painting of St. Luke drawing the Virgin Mary suggests that he knew Rogier van der Weyden's famous earlier painting of the same subject. Compare these two works, separated in date by almost a century, discussing Gossaert's references to Rogier's painting but also describing the way each of these two artists embodied the style that characterized their particular moment in the history of art. What did these paintings mean for their original audiences?

FIG. 19–16

FIG. 22–22

23–1 Gianlorenzo Bernini **ST. TERESA OF ÁVILA IN ECSTASY**

Cornaro Chapel, church of Santa Maria della Vittoria, Rome. 1645–1652. Marble, height of the group 11′6″ (3.5 m).

Chapter 23

Seventeenth-Century Art in Europe

 ## Learning Objectives

23.a Identify the visual hallmarks of seventeenth-century European art for formal, technical, and expressive qualities.

23.b Interpret the meaning of works of seventeenth-century European art based on their themes, subjects, and symbols.

23.c Relate seventeenth-century European art and artists to their cultural, economic, and political contexts.

23.d Apply the vocabulary and concepts relevant to seventeenth-century European art, artists, and art history.

23.e Interpret a work of seventeenth-century European art using the art historical methods of observation, comparison, and inductive reasoning.

23.f Select visual and textual evidence in various media to support an argument or an interpretation of a work of seventeenth-century European art.

In the church of Santa Maria della Vittoria in Rome, the sixteenth-century Spanish mystic **ST. TERESA OF ÁVILA** (1515–1582, canonized 1622) swoons in ecstasy on a bank of billowing marble clouds (**FIG. 23–1**). A smiling angel tugs at her clothing while balancing an arrow pointed in her direction. Gilded bronze rays of supernatural light descend, even as actual light illuminates the figures from a hidden window above. This dramatic scene, created by Gianlorenzo Bernini (1598–1680) between 1645 and 1652, represents a famous vision described with startling clarity by Teresa, in which an angel pierced her body repeatedly with an arrow, transporting her to a state of ecstatic oneness with God.

The sculpture is an exquisite example of the emotional, theatrical style perfected by Bernini in response to the religious and political climate in Rome during the period of spiritual renewal known as the Counter-Reformation. Many had seen the Protestant Reformation of the previous century as an outgrowth of Renaissance humanism with its emphasis on rationality and independent thinking. In response, the Catholic Church took a reactionary, authoritarian position, supported by the new Society of Jesus founded by Ignatius of Loyola (d. 1556, canonized 1622). In the "spiritual exercises" (1522–1523) initiated by

St. Ignatius, Christians were enjoined to use all their senses to transport themselves emotionally as they imagined the events on which they were meditating. They were to feel the burning fires of hell or the bliss of heaven, the lashing of the whips and the flesh-piercing crown of thorns. Art became an instrument of propaganda and also a means of leading the spectator to a reinvigorated Christian practice and belief.

Of course, the arts had long been used to convince or inspire, but the Catholic Church in the seventeenth century pushed this practice to a new height of effectiveness. To serve the educational and evangelical mission of the revitalized and conservative Church, paintings and sculpture had to depict events and people accurately and clearly, following guidelines established by religious leaders. Throughout Catholic Europe, painters such as Rubens and Caravaggio created brilliant religious art under official Church sponsorship. And although today some viewers find this sculpture of St. Teresa uncomfortably charged with sexuality, the Church approved of the depictions of such sensational and supernatural mystical visions. They helped worshipers achieve the emotional state of religious ecstasy that was a goal of the Counter-Reformation.

"Baroque"

What are the cultural and historical backgrounds for the development of European art during the seventeenth century?

The intellectual and political forces set in motion by the Renaissance and Reformation of the fifteenth and sixteenth centuries intensified during the seventeenth century. Religious wars continued, although gradually the Protestant forces gained control in the north, where Spain recognized the independence of the Dutch Republic in 1648. Catholicism maintained its primacy in southern Europe, the Holy Roman Empire, and France through the efforts of an energized papacy aided by the new Society of Jesus, also known as the Jesuit Order (**MAP 23–1**). At the same time, scientific advances compelled people to question their

worldview. Of great importance was the growing understanding that the Earth was not the center of the universe, but a planet revolving around the Sun. As rulers' economic strength began to slip away, artists found patrons in the Church and the secular state, as well as in the newly confident and prosperous urban middle classes. What evolved was a style that art historians have called "Baroque." The label may be related to the Italian word *barocco*, a jeweler's term for an irregularly shaped pearl—something beautiful, fascinating, and strange.

Baroque art deliberately evokes intense emotional responses from viewers. Dramatically lit, theatrical compositions often combine several media within a single work as artists highlight their technical virtuosity. But the seventeenth century also saw its own version of Classicism, a more moving and dramatic variant of Renaissance principles featuring idealization based on observation of

MAP 23–1 SEVENTEENTH-CENTURY EUROPE

Protestantism still dominated northern Europe, while in the south Roman Catholicism remained strong after the Counter-Reformation. The Habsburg Empire was now divided into two parts, under separate rulers.

the material world; balanced (though often asymmetrical) compositions; diagonal movement in space; rich, harmonious colors; and visual references to ancient Greece and Rome. Many seventeenth-century artists sought lifelike depiction of their world in portraiture, **genre paintings** (scenes from everyday life), still life, and religious scenes enacted by ordinary people in ordinary settings. Intense emotional involvement, lifelike renderings, and Classical references may all exist in the same work.

The role of viewers also changed. Italian Renaissance painters and patrons had been fascinated with the visual possibilities of perspective; they treasured an idealism of form and subject that kept viewers at a distance, reflecting intellectually on what they were seeing. Seventeenth-century artists, on the other hand, sought to engage viewers as participants in the work of art and often reached out to incorporate or activate the surrounding environment into the meaning of the work itself. In Catholic countries, representations of horrifying scenes of martyrdom or the passionate spiritual life of mystics sought to inspire viewers to a reinvigorated faith by making them feel what was going on, not simply contemplate it. In Protestant countries, images of communal parades and city views sought to inspire pride in civic accomplishments. Viewers participated in works of art like audiences in a theater—vicariously but completely—as the work of art drew them visually and emotionally into its orbit. The seventeenth-century French critic Roger de Piles (1635–1709) described this exchange when he wrote: "True painting ... calls to us; and has so powerful an effect, that we cannot help coming near it, as if it had something to tell us" (Puttfarken, p. 55).

Italy

How is the Baroque style established and developed in Rome?

Seventeenth-century Italy remained a divided land in spite of a common history, language, and geography. The Kingdom of Naples and Sicily was Spanish; the Papal States crossed the center; Venice maintained its independence as a republic; and the north remained divided among small principalities. Churchmen and their families remained powerful patrons of the arts, especially as they sought to use art in revitalizing the Roman Catholic Church. The Council of Trent (concluded 1563) had set guidelines for church art that went against the arcane, worldly, and often lascivious trends exploited by Mannerism. The clergy's call for clarity, simplicity, chaste subject matter, and the ability to rouse a very Catholic piety in the face of Protestant revolt found a response in the fresh approaches to subject matter and style offered by a new generation of artists.

A major goal of the Counter-Reformation was the proper embellishment of churches and their settings. Pope Sixtus V (pontificate 1585–1590) had begun the renewal in Rome by cutting long, straight avenues through the city to link the major pilgrimage churches with one another and with the main gates of Rome. Sixtus also ordered open spaces—piazzas—to be cleared in front of major churches, marking each site with an Egyptian obelisk. In a practical vein, he also reopened one of the ancient aqueducts to stabilize the city's water supply. Unchallengeable power and vast financial resources were required to carry out such an extensive plan of urban renewal and to refashion Rome—parts of which had been neglected since the Middle Ages—once more into the center of spiritual and worldly power.

The Counter-Reformation popes had great wealth, although they eventually nearly bankrupted the Church with their building programs. Sixtus began to renovate the Vatican and its library; he completed the dome of St. Peter's and built splendid palaces. The Renaissance ideal of the central-plan church continued to be used for the shrines of saints, but Counter-Reformation thinking called for churches with long, wide naves to accommodate large congregations assembled to hear inspiring sermons as well as to participate in the Mass. In the sixteenth century, the decoration of new churches had been relatively austere, but seventeenth- and eighteenth-century Catholic taste favored opulent and spectacular visual effects to heighten the emotional involvement of worshipers.

Maderno and Bernini at St. Peter's

Half a century after Michelangelo had returned St. Peter's Basilica to Bramante's original vision of a central-plan building, Pope Paul V Borghese (pontificate 1605–21) commissioned Carlo Maderno (1556–1629) to provide the church with a longitudinal nave and a new façade (**FIG. 23-2**). Construction began in 1607, and everything but the façade bell towers was completed by 1615 (see "St. Peter's Basilica" in Chapter 21 on page 687). Rooted in the design of Il Gesù's façade (SEE FIG. 21-48A), Maderno's façade for St. Peter's steps forward in three progressively projecting planes: from the corners to the doorways flanking the central entrance area, then the entrance area, then the central doorway itself. Similarly, the colossal orders connecting the first and second stories are flat pilasters at the corners but fully round columns where they flank the doorways. These columns support a continuous entablature that also steps out—following the columns—as it moves toward the central door.

When Maderno died in 1629, Gianlorenzo Bernini (1598–1680), his collaborator of five years, succeeded him as Vatican architect. Bernini was taught by his father, and part of his training involved sketching the Vatican collection of ancient sculpture, such as *Laocoön and His Sons* (SEE FIG. 5-65), as well as the many examples of Renaissance painting in the papal palace. Throughout his life, Bernini

23-2 Carlo Maderno and Gianlorenzo Bernini **ST. PETER'S BASILICA AND PIAZZA, VATICAN, ROME**
Maderno, façade, 1607–1626; Bernini, piazza design, c. 1656–1657.

Perhaps only a Baroque artist of Bernini's talents could have unified the many artistic periods and styles that come together in St. Peter's Basilica (starting with Bramante's original design for the building in the sixteenth century). The basilica in no way suggests a piecing together of parts made by different builders at different times but rather presents itself as a triumphal unity of all the parts in one coherent whole.

Credit: © Alinari Archives/Corbis

admired antique art and, like other artists of this period, considered himself a Classicist. Today, we not only appreciate his strong debt to the Renaissance tradition but also acknowledge the way he broke through that tradition to develop a new, Baroque style.

When Urban VIII was elected pope in 1623, he unhesitatingly gave the young Bernini the daunting task of designing an enormous bronze *baldacchino*, or canopy, over the high altar of St. Peter's. The church was so large that a dramatic focus on the altar was essential. The resulting **BALDACCHINO** (**FIG. 23-3**), completed in 1633, stands almost 100 feet high and exemplifies the Baroque objective to create multimedia works—combining architecture, sculpture, and sometimes painting as well—that defy simple categorization. The gigantic corner columns symbolize the union of Christianity and its Jewish tradition; the vine of the Eucharist climbs the twisted columns associated with the Temple of Solomon. They support an entablature

with a crowning element topped with an orb (a sphere representing the universe) and a cross (symbolizing the reign of Christ). Figures of angels and *putti* decorate the entablature, which is hung with tasseled panels in imitation of a cloth canopy. This imposing work not only marks the site of the tomb of St. Peter, but also serves as a tribute to Urban VIII and his family, the Barberini, whose emblems are prominently displayed—honeybees and suns on the tasseled panels and laurel leaves on the climbing vines.

Between 1627 and 1641, Bernini and several other sculptors, again in multimedia extravaganzas, rebuilt Bramante's crossing piers as giant reliquaries. Statues of SS. Helena, Veronica, Andrew, and Longinus stand in niches below alcoves containing their relics to the left and right of the *baldacchino*. Visible through the *baldacchino*'s columns in the apse of the church is another reliquary: the Chair of Peter, a gilded-stone, bronze, and stucco shrine made by Bernini between 1657 and 1666 for the ancient

23–3 Gianlorenzo
Bernini **BALDACCHINO**

St. Peter's Basilica, Vatican, Rome.
1624–1633. Gilt bronze, height
approx. 100′ (30.48 m). Chair of
Peter shrine, 1657–1666; gilt bronze,
marble, stucco, and glass. Pier
decorations, 1627–1641; gilt bronze
and marble.

Credit: © akg-images/Bildarchiv Monheim

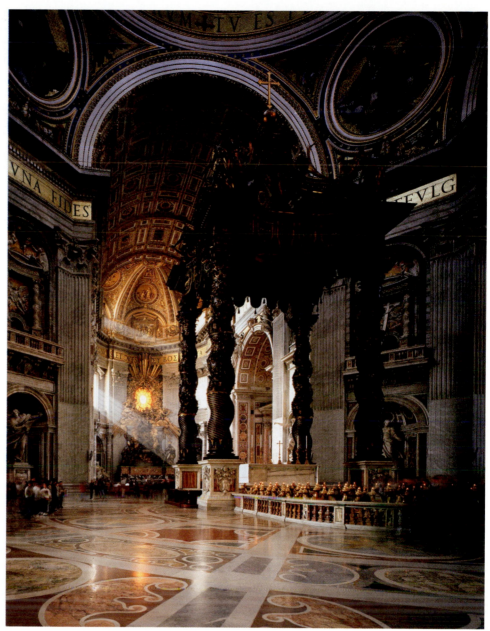

wooden throne thought to have belonged to St. Peter as the first bishop of Rome. It symbolized the direct descent of Christian authority from Peter to the current pope, a belief rejected by Protestants and therefore deliberately emphasized in Counter-Reformation Catholicism. Above the shrine, a brilliant stained-glass window portrays the Holy Spirit as a dove surrounded by an oval of golden rays. Gilded angels and gilt-bronze rays fan out around the window and seem to extend the penetration of the natural light—and the Holy Spirit—into the apse of the church. The gilding also reflects the light back to the window itself, creating a dazzling, ethereal effect that the seventeenth century, with its interest in mystics and visions, would see as the activation of divinity.

At approximately the same time that he was at work on the Chair of Peter, Bernini designed and supervised the building of a colonnade to form a huge double piazza in front of the entrance to St. Peter's (SEE FIG. 23-2). The open space that he had to work with was irregular, and an Egyptian obelisk and a fountain previously installed by Sixtus V had to be incorporated into the overall plan. Bernini's remarkable design frames the oval piazza with two enormous curved porticos, or covered walkways, supported by Tuscan columns. These curved porticos are connected to two straight porticos, which lead up a slight incline to the two ends of the church façade. Bernini characterized his design as the "maternal arms of the church" reaching out to the world. He had intended to build a third section of the colonnade closing the side of the piazza facing the church, so that only after pilgrims had crossed the Tiber River bridge and made their way through narrow streets would they encounter the enormous open space before the imposing church. This element of surprise would have made the basilica and its setting an even more awe-inspiring vision. The approach today—along the grand avenue of the Via della Conciliazione running from the Tiber to the Basilica—was conceived by Mussolini in 1936 as part of his master plan to transform Rome into a grand fascist capital.

Bernini as Sculptor

Even after Bernini's appointment as Vatican architect in 1629, he was still able to accept outside commissions thanks to his large workshop. In fact, he first became famous as a sculptor, and he continued to create sculpture throughout his career for both the papacy and private clients. He was also a painter and even a playwright—an interest that dovetailed with his genius for dramatic presentation.

Bernini's **DAVID** (FIG. 23-4), made for a nephew of Pope Paul V in 1623, introduced a new type of three-dimensional composition that intrudes forcefully into the viewer's space. The young hero bends at the waist and twists far to one side, ready to launch the lethal rock at Goliath. Unlike Donatello's sassy boy (SEE FIG. 20–14) and Verrocchio's poised and proud adolescent (SEE FIG. 20–27)—both already victorious—or Michelangelo's pensive young man contemplating the task ahead (SEE FIG. 21–15), Bernini's more mature David, with his sinewy body, tightly clenched mouth, and straining muscles, is all tension, action, and determination. By creating a twisting figure caught in movement, Bernini incorporates the surrounding space within his composition, implying the presence of an unseen adversary somewhere behind the viewer. Thus, the viewer becomes part of the action, rather than its displaced and dispassionate observer.

23-4 Gianlorenzo Bernini **DAVID**
1623. Marble, height 5′7″ (1.7 m). Galleria Borghese, Rome.

Credit: © Per concessione del Ministero per i Beni e le Attività Culturali/Archivi Alinari, Firenze

23-5 Gianlorenzo Bernini **CORNARO CHAPEL, CHURCH OF SANTA MARIA DELLA VITTORIA, ROME**
1642–1652.

Credit: © Vincenzo Pirozzi, Rome

From 1642 until 1652, Bernini worked on the decoration of the funerary chapel of the Venetian cardinal Federigo Cornaro (FIG. 23-5) in the Roman church of Santa Maria della Vittoria, designed by Carlo Maderno earlier in the century. The Cornaro family chapel was dedicated to the Spanish saint Teresa of Ávila, canonized only 20 years earlier. Bernini designed it as a rich and theatrical setting for the portrayal of a central event in Teresa's life. He covered the walls with multicolored marble panels and crowned them with a projecting cornice supported by marble pilasters.

In the center of the chapel, framed by columns in the huge oval niche above the altar, is Bernini's marble group *St. Teresa of Ávila in Ecstasy* (SEE FIG. 23–1), which represents an eroticized vision described by the Spanish mystic in which an angel pierced her body repeatedly with an arrow, transporting her to a state of indescribable pain, religious ecstasy, and a sense of oneness with God. St. Teresa and the angel, who seem to float upward, are cut from a heavy mass of solid marble supported on a seemingly drifting pedestal that was fastened by hidden metal bars to the chapel wall. Bernini's skill at capturing the movements

and emotions of these figures is matched by his virtuosity in simulating different textures and colors in the pure white marble; the angel's gauzy, clinging draperies seem silken in contrast with Teresa's heavy woolen monastic robe. Bernini effectively used the configuration of the garment's folds to convey the saint's swooning, sensuous body beneath, even though only Teresa's face, hands, and bare feet are actually visible.

Kneeling against what appear to be balconies on both sides of the chapel are marble portrait sculptures of Federigo, his deceased father (a Venetian doge), and six cardinals of the Cornaro family. The figures are informally posed and naturalistically portrayed. Two read from their prayer books, others exclaim at the miracle taking place in the light-infused realm above the altar, and one leans out from his seat, apparently to look at someone entering the chapel—perhaps the viewer, whose space these figures share. Bernini's intent was not to produce a spectacle for its own sake, but to capture a critical, dramatic moment at its emotional and sensual height, and by doing so guide viewers to identify totally with the event—and perhaps be transformed in the process.

Borromini

The intersection of two of the wide, straight avenues created by Pope Sixtus V inspired city planners to add a special emphasis, with fountains marking each of the four corners of the crossing. In 1634, Trinitarian monks decided to build a new church at the site and awarded the commission for San Carlo alle Quattro Fontane (St. Charles at the Four Fountains) to Francesco Borromini (1599–1667). Borromini, a nephew of architect Carlo Maderno, had arrived in Rome in 1619 from northern Italy to enter his uncle's workshop. Later, he worked under Bernini's supervision on the decoration of St. Peter's. Some details of the *baldacchino*, as well as its structural engineering, are now attributed to him, but San Carlo was his first independent commission. Unfinished at Borromini's death, the church was nevertheless completed according to his design.

SAN CARLO ALLE QUATTRO FONTANE stands on a narrow piece of land with one corner cut off to accommodate one of the fountains that give the church its name (**FIG. 23-6**). To fit the irregular site, Borromini created an elongated central-plan interior space with undulating walls. Robust pairs of columns support a massive entablature, over which an oval dome, supported on pendentives,

23-6A Francesco Borromini **FAÇADE OF THE CHURCH OF SAN CARLO ALLE QUATTRO FONTANE**
Rome. 1638–1667.

23-6B Francesco Borromini **PLAN OF THE CHURCH OF SAN CARLO ALLE QUATTRO FONTANE**
Rome. 1638–1667.

23-7 Francesco Borromini **VIEW INTO THE DOME OF THE CHURCH OF SAN CARLO ALLE QUATTRO FONTANE**
Rome. 1638–1667.

Credit: © View Pictures Ltd/Alamy Stock Photo

might, subdividing modular units to obtain more complex, rational shapes. For example, the elongated, octagonal plan of San Carlo is composed of two triangles set base to base along the short axis of the plan (SEE FIG. 23-6B). This diamond shape is then subdivided into secondary triangular units made by calculating the distances between what will become the concave centers of the four major and five minor niches. Yet Borromini's conception of the whole is not medieval. The chapel is dominated horizontally by a Classical entablature that breaks any surge upward toward the dome. Borromini's treatment of the architectural elements as if they were malleable was also unprecedented. His contemporaries understood immediately what an extraordinary innovation the church represented; the Trinitarian monks who had commissioned it received requests for plans from visitors from all over Europe. Although Borromini's innovative work had little impact on the architecture of Classically minded Rome, it was widely imitated in northern Italy and beyond the Alps.

Borromini's design for San Carlo's façade (SEE FIG. 23-6A), executed more than two decades later, was as innovative as his planning of the interior. He turned the building's front into an undulating, sculpture-filled screen punctuated with large columns and deep concave and convex niches that create dramatic effects of light and shadow. He also gave his façade a strong vertical thrust in the center by placing over the tall doorway a statue-filled niche, then a windowed niche covered with a canopy, then a giant, forward-leaning cartouche held up by angels carved in such high relief that they appear to hover in front of the wall. The entire composition is crowned with a balustrade broken by the sharply pointed frame of the cartouche. As with the design of the building itself, Borromini's façade was enthusiastically imitated in northern Italy and especially in northern and eastern Europe.

Painting

Painting in seventeenth-century Italy followed one of two principal paths: the ordered Classicism of the Carracci family or the dramatic naturalism of Caravaggio. Although the leading exponents of these paths were northern Italians—the Carracci were from Bologna, and Caravaggio was born in or near Milan—they were all eventually drawn to Rome, the center of power and patronage. All, too, were schooled in northern Italian Renaissance traditions, with its emphasis on *chiaroscuro*, as well as in Venetian color and *sfumato*. However, the Carracci quite consciously rejected the artifice of the Mannerist style and fused their northern roots with the central Italian High Renaissance insistence on line (*disegno*), compositional structure, and figural solidity. They looked to Raphael, Michelangelo, and antique Classical sculpture for their ideal figural types and their expressive but decorous compositions. Caravaggio, on the other

seems to hover (FIG. 23-7). The coffers (inset panels in geometric shapes) filling the interior of the oval dome form an eccentric honeycomb of crosses, elongated hexagons, and octagons. These coffers decrease sharply in size as they approach the apex, or highest point, where the dove of the Holy Spirit hovers in a climax that brings together the geometry used in the chapel: oval, octagon, circle, and—very important—a triangle, symbol of the Trinity as well as of the church's patrons. The dome appears to be shimmering and inflating—almost floating up and away—thanks to light sources placed in the lower coffers and the lantern.

It is difficult today to appreciate how audacious Borromini's design for this small church was. He abandoned the modular, additive system of planning taken for granted by every architect since Brunelleschi. He worked instead from an overriding geometrical scheme, as a Gothic architect

hand, satisfied the Baroque demand for drama and clarity by developing realism in a powerful new direction. He painted people he saw in the world around him—even the lowlife of Rome—and worked directly from models without elaborate drawings and compositional notes. Unlike the Carracci, he claimed to ignore the influence of the great masters so as to focus steadfastly on a sense of immediacy and invention.

THE CARRACCI The brothers Agostino (1557–1602) and Annibale (1560–1609) Carracci and their cousin Ludovico (1555–1619) shared a studio in Bologna. As their re-evaluation of the High Renaissance masters attracted interest

among their peers, they opened their doors to friends and students and then, in 1582, founded an art academy, where students drew from live models and studied art theory, Renaissance painting, and antique Classical sculpture. The Carracci placed a high value on accurate drawing, complex figure compositions, complicated narratives, and technical expertise in both oil and fresco painting. During its short life, the academy had an impact on the development of the arts and art education through its insistence on both life drawing (to achieve naturalism) and aesthetic theory (to achieve artistic harmony).

In 1595, Annibale was hired by Cardinal Odoardo Farnese to decorate the principal rooms of his family's immense Roman palace. In the long *galleria* (gallery), the artist was requested to paint scenes of love based on Ovid's *Metamorphoses* (**FIG. 23-8**) to celebrate the wedding of Duke Ranuccio Farnese of Parma to the niece of the pope. Undoubtedly, Annibale and Agostino, who assisted him, felt both inspiration and competition from the important collection of antique sculpture exhibited throughout the palace.

The primary image, set in the center of the vault, is *The Triumph of Bacchus and Ariadne*, a joyous procession celebrating the wine god Bacchus's love for Ariadne, whom he rescued after her lover, Theseus, abandoned her on the island of Naxos. Annibale combines the great northern Italian

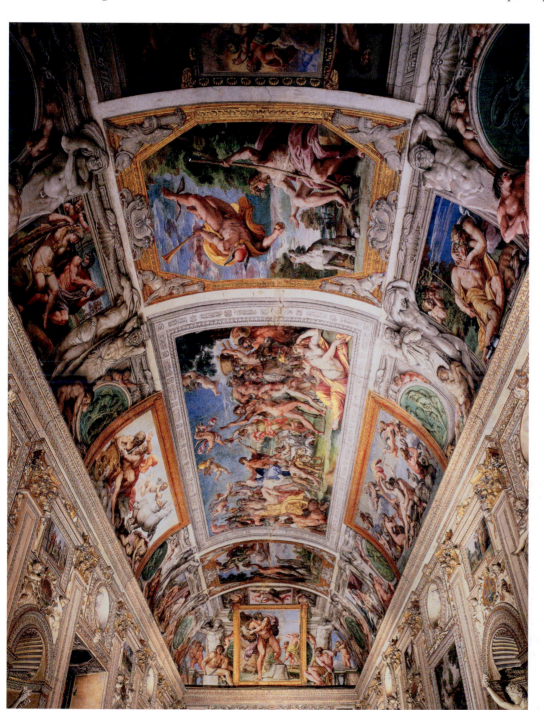

23-8 Annibale Carracci **CEILING OF GALLERY, PALAZZO FARNESE**
Rome. 1597–1601.
Fresco, approx. 68 × 21′ (20.7 × 6.4 m).

Credit: Canali Photobank, Milan, Italy

tradition of ceiling painting—seen in the work of Mantegna and Correggio (SEE FIGS. 20–40, 21–24)—with his study of central Italian Renaissance painters and the Classical heritage of Rome. He organized his complex theme by using illusionistic devices to create multiple levels of reality. Painted imitations of gold-framed easel paintings called *quadri riportati* ("transported paintings") appear to rest on the actual cornice of the vault and overlap painted bronze medallions that are flanked, in turn, by realistically colored *ignudi*, dramatically lit from below. The viewer is invited to compare the warm flesh tones of these youths and their lifelike poses with the more idealized painted bodies in the framed scenes next to them. Above, paintings of stucco-colored sculptures of herms (plain shafts topped by human torsos) twist and turn as they support the painted framework of the vault, exposing a variety of feelings with their expressions and seemingly communicating with one another. Many of Annibale's ideas are inspired by motifs in Michelangelo's Sistine Chapel ceiling (SEE FIG. 21–17). The figure types, true to their source, are heroic, muscular, and drawn with precise anatomical accuracy. But instead of Michelangelo's cool illumination and intellectual detachment, the Carracci ceiling glows with a warm light that recalls the work of the Venetian painters Titian and Veronese and seems buoyant with optimism and lively engagement.

The ceiling was highly admired, famous from the moment it was finished. The proud Farnese family generously allowed young artists to sketch the figures there, so that Carracci's masterpiece influenced Italian art well into the following century.

CARAVAGGIO Michelangelo Merisi (1571–1610), known as "Caravaggio" after his family's home town in Lombardy, introduced a powerfully frank realism and dramatic, theatrical lighting and gesture to Italian Baroque art.

23–9 Caravaggio
BACCHUS
1595–1596. Oil on canvas, 37 × 33½″ (94 × 85.1 cm). Galleria degli Uffizi, Florence.

A restoration of this painting in 2009 revealed in the reflection on the surface of the glass carafe at lower left, a self-portrait of the artist, brush in hand, caught in the process of painting this picture.

Credit: © Quattrone, Florence

The young painter brought an interest, perhaps a specialization, in still-life painting with him when he arrived in Rome from Milan late in 1592 and found studio work as a specialist painter of fruit and vegetables. When he began to work on his own, he continued to paint still lifes, but began to include half-length figures with them. By this time, his reputation had grown to the extent that an agent offered to market his pictures.

Caravaggio painted for a small, sophisticated circle associated with the household of art patron Cardinal del Monte, where the artist was invited to live. His subjects from the 1590s include not only still lifes but also genre scenes featuring fortune-tellers, cardsharps, and glamorous young men dressed as musicians or mythological figures. The **BACCHUS** of 1595–1596 (**FIG. 23–9**) is among the most polished of these early works. Caravaggio seems to have painted exactly what he saw, reproducing the "farmer's tan" of those parts of this partially dressed youth's skin—hand and face—that have been exposed to the sun, as well as the dirt under his fingernails. The figure himself is strikingly androgynous. Made up with painted lips and smoothly arching eyebrows, he seems to offer the viewer the gorgeous goblet of wine held delicately in his left hand, while fingering the black bow that holds his loose clothing together at the waist. This may be a provocative invitation to an erotic encounter or a young actor outfitted for the role of Bacchus, god of wine—and the juxtaposition of the youth's invitation with a still life of rotting fruit may add a message about the transitory nature of sensual pleasure, either admonishing viewers to avoid sins of the flesh or encouraging them to enjoy life's pleasures while they can. The ambiguity makes the painting even more provocative.

One of Caravaggio's first religious commissions, obtained through the efforts of Cardinal del Monte, was oil paintings to be installed in the Contarelli Chapel in the French community's church of St. Louis (San Luigi dei Francesi) (**FIG. 23–10**).

San Luigi dei Francesi served the French community in Rome, and the building itself was constructed between 1518 and 1589, its completion made possible by the patronage of Catherine de' Medici, queen of France. The chapel Caravaggio decorated was founded in 1565 by Mathieu Cointrel—Matteo Contarelli—a French noble at the papal court who would serve as a financial administrator under Gregory XIII (pontificate 1572–1585). Although earlier artists had been called on to provide paintings for the chapel, it was only after Contarelli's death in 1585 that the executors of his will brought the decoration to completion, hiring Giuseppe Cesare in 1591 to paint the ceiling frescos and Caravaggio in 1599 to provide paintings of scenes from the life of the patron's patron saint: **THE CALLING OF ST. MATTHEW** on the left wall (**FIG. 23–11**) and *The Martyrdom of St. Matthew* on the right (not visible in **FIG. 23–10**), both installed in July 1600.

The subject is conversion, a common Counter-Reformation theme. Jesus calls Levi, the tax collector, to join his apostles (Matthew 9:9; Mark 2:14). Levi—who will become St. Matthew—sits at a table, counting or collecting money, surrounded by elegant young men in plumed hats, velvet doublets, and satin shirts. Nearly hidden behind the back of a beckoning apostle—probably St. Peter—at the right, the gaunt-faced Jesus points dramatically at Levi. An intense raking light enters the painting from upper right, as if it were coming from the chapel's actual window above the altar to spotlight the important features of this darkened scene. Viewers encountering the painting obliquely across the empty space of the chapel interior seem to be witnessing the scene as it is occurring, elevated on a recessed stage opening through the wall before them.

The commissioning document was explicit, requiring the artist to show in *The Calling of St. Matthew* the saint rising from his seat to follow Christ in ministry. But Caravaggio was never very good at following rules. Among the group of smartly dressed Romans who form Matthew's circle of friends seated around the table at the left, no one rises to leave. Art historians have not even been able to agree on which figure is Matthew. Many identify him with the bearded man in the center, interpreting his pointing gesture as a self-referential, questioning response to Jesus's call, as if to say, "Who, me?". But some see Matthew in the figure hunched over the scattered coins at far left, seemingly unmoved by Jesus's presence. In this case, the bearded figure's pointing would question whether this bent-over colleague was the one Jesus sought. The painting is marked by mystery, not by the clarity sought by Counter-Reformation guidelines.

In February 1602, Caravaggio received a second commission for the Contarelli Chapel, this time for a painting over the altar showing St. Matthew accompanied by his angelic symbol and writing his Gospel. It was to be completed within three months, but Caravaggio did not receive payment for the picture until September of that year, and the painting he delivered was rejected. The clergy considered Caravaggio's rendering of the saint unacceptably crude and common, his cross-legged pose uncouth and unnecessarily revealing. The fleshiness of the angel, who sidled cozily up to Matthew, was judged inappropriately risqué. In short, the painting was inconsistent with guidelines for saintly decorum set for artists by the Council of Trent. Caravaggio had to paint a second, more decorous altarpiece for the chapel (seen in **FIG. 23–10**), with a nobler Matthew and a more distant angel. The rejected version was snapped up by Roman collector Vincenzo Giustiniani, who actually paid for the replacement in order to acquire the more sensational original. Unfortunately, this first painting was destroyed in the 1945 bombing of Berlin during World War II.

23–10 CONTARELLI CHAPEL, SAN LUIGI DEI FRANCESI

Rome. Paintings by Caravaggio 1599–1600.

Credit: © 2016. Photo Scala, Florence

a heavenly apparition, only Paul's response to it. There is no clear physical setting, only mysterious darkness. And Paul's experience is personal. Whereas he has been flung from his horse and threatens to tumble into the viewer's own space—arms outstretched and legs akimbo, bathed in a strong spotlight—the horse and groom behind him seem oblivious to Paul's experience. The horse takes up more space in the painting than the saint, and the unsettling position of its lifted foreleg, precariously poised over Paul's sprawled body, adds further tension to an already charged presentation.

Most of Caravaggio's commissions after 1600 were religious, and reactions to them were

The emotional power of Caravaggio's theatrical approach to sacred narrative is nowhere more evident than in his **CONVERSION OF ST. PAUL** for the Cerasi Chapel in Santa Maria del Popolo (**FIG. 23–12**). This is one of two paintings commissioned for this chapel in 1600; the other portrayed the Crucifixion of St. Peter. As with Caravaggio's *St. Matthew* for the Contarelli Chapel, the first pair was rejected when Caravaggio delivered them and later acquired by a private collector. This second version of Paul's conversion is direct and simple. Caravaggio focuses on Paul's internal involvement with a pivotal moment, not its external cause. There is no indication of

mixed. Sometimes patrons rejected his powerful, sometimes brutal, naturalism as unsuitable to the subject's dignity. Critics differed as well. An early critic, the Spaniard Vincente Carducho, wrote in his *Dialogue on Painting* (Madrid, 1633) that Caravaggio was an "omen of the ruin and demise of painting" because he painted "with nothing but nature before him, which he simply copied in his amazing way" (Enggass and Brown, pp. 173–174). Others recognized him as a great innovator who reintroduced realism into art and developed new, dramatic lighting effects. Seventeenth-century art historian Giovanni Bellori described Caravaggio's painting as

… reinforced throughout with bold shadows and a great deal of black to give relief to the forms. He went so far in this manner of working that he never brought his figures out into the daylight, but placed them in the dark brown atmosphere of a closed room, using a high light that descended vertically over the principal parts of the bodies while leaving the remainder in shadow in order to give force through a strong contrast of light and dark…. (Bellori, *Lives of the Painters*, Rome, 1672, in Enggass and Brown, p. 79)

Caravaggio's approach has been compared to the preaching of Filippo Neri (1515–1595), the Counter-Reformation priest and mystic who founded a Roman religious group called the Congregation of the Oratory. Neri, called the Apostle of Rome and later canonized, focused his missionary efforts on ordinary people for whom he strove to make Christian history and doctrine understandable and meaningful. Caravaggio, too, interpreted his religious subjects directly and dramatically, combining intensely observed figures, poses, and expressions with strongly contrasting effects of light and color. His knowledge of

23–11 Caravaggio THE CALLING OF ST. MATTHEW
Contarelli Chapel, church of San Luigi dei Francesi, Rome. 1599–1600. Oil on canvas, 10′7½″ × 11′2″ (3.24 × 3.4 m).

Credit: © Quattrone, Florence

23–12 Caravaggio **THE CONVERSION OF ST. PAUL**

Cerasi Chapel, Santa Maria del Popolo, Rome. c. 1601. Oil on canvas, 7'6" × 5'8" (2.3 × 1.75 m).

Credit: © Vincenzo Pirozzi, Rome

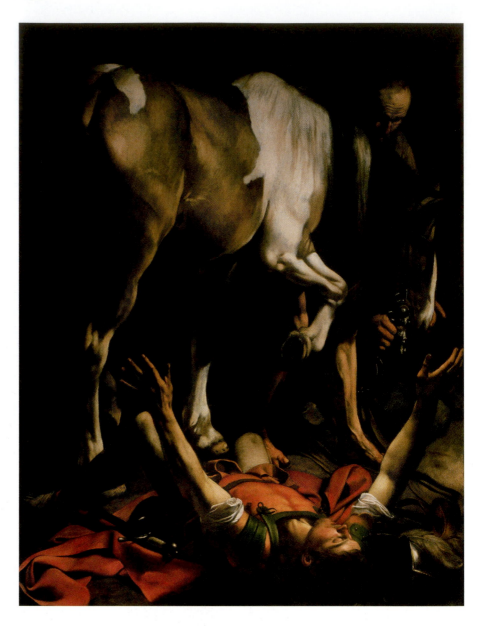

Lombard painting, where the influence of Leonardo was strong, must have facilitated his development of the technique now known as **tenebrism**, in which forms emerge from a dark background into a strong light that often falls from a single source outside the painting. The effect is that of a theatrical spotlight.

Despite the great esteem in which Caravaggio was held by some, especially the younger generation of artists, his violent temper repeatedly got him into trouble. During the last decade of his life, he was frequently arrested, initially for minor offenses such as carrying arms illegally or street brawling. But in May of 1606 he killed a man in a duel fought over a disputed tennis match and had to flee Rome as a fugitive under a death sentence. He supported himself while on the run by painting in Naples, Malta, and Sicily. The Knights of Malta awarded him the cross of their religious and military order in July 1608, but in October he was imprisoned for insulting one of them, and again he escaped and fled. Caravaggio died on July 18, 1610, just short of his 39th birthday, of a fever contracted during a journey back to Rome, where he had expected to be pardoned of his capital offense. Caravaggio's realism and tenebrism influenced nearly every important European artist of the seventeenth century.

ARTEMISIA GENTILESCHI One of Caravaggio's most brilliant Italian followers was Artemisia Gentileschi (1593– c. 1652/1653), whose international reputation helped spread the Caravaggesque style beyond Rome. Gentileschi first studied and worked under her father, Orazio, one of the earliest followers of Caravaggio. In 1616 she moved from Rome to Florence, where she worked for Grand Duke Cosimo II de' Medici and was elected, at the age of 23, to the Florentine Academy of Design.

One of her most famous paintings, a clear example of her debt to Caravaggio's tenebrism and naturalism, is

JUDITH BEHEADING HOLOFERNES (**FIG. 23–13**), which she gave to Cosimo II shortly before she left Florence to return to Rome in 1620. The subject is drawn from the biblical book of Judith, which recounts the story of the destructive invasion of Judah by the Assyrian general Holofernes, when the brave Jewish widow Judith risked her life to save her people. Using her charm to gain Holofernes's trust, Judith enters his tent with her maidservant while he is drunk and beheads him with his own sword. Gentileschi emphasizes the grisly facts of this heroic act, as the women struggle to subdue Holofernes while blood spurts from the severing of his jugular. Dramatic spotlighting and a convergence of compositional diagonals rivet our attention on the most sensational aspects of the scene, which have been pushed toward us in the foreground. Throughout her life, Gentileschi painted many such images of heroic biblical women, which art historians have interpreted in relation to her own struggle to claim her rightful place in an art world dominated by men.

CORTONA AND GAULLI: BAROQUE CEILINGS Theatricality, intricacy, and the opening of space reached an apogee in Baroque ceiling decoration—complex constructions combining architecture, painting, and stucco sculpture. These grand, illusionistic projects were carried out in the domes and vaults of churches, civic buildings, palaces, and villas, and went far beyond even Michelangelo's Sistine Chapel ceiling (SEE FIG. 21-17) or Correggio's dome at Parma (SEE FIG. 21-24). Baroque ceiling painters sought the drama of an immeasurable heaven that extended into vertiginous zones far beyond the limits of High Renaissance taste. To achieve this, they employed the system of *quadratura* (literally, "squaring" or "gridwork"): an architectural setting painted in meticulous perspective and usually requiring viewing from a specific spot to achieve the desired effect of soaring space. The resulting viewpoint is called *di sotto in sù* ("from below upwards"), which we first saw, in a limited fashion, in Mantegna's ceiling in Mantua (SEE FIG. 20-40). Because it required such careful calculation, figure painters usually had specialists in *quadratura* paint the architectural frame for them.

Pietro Berrettini (1596–1669), called "Pietro da Cortona" after his hometown, carried the development of the Baroque ceiling away from Classicism into a more strongly unified and illusionistic direction. Trained in Florence and inspired by Veronese's ceiling in the Doge's Palace, which he saw on a trip to Venice in 1637, the artist was commissioned in the early 1630s by the Barberini family of Pope Urban VIII to decorate the ceiling of the audience hall of their Roman palace.

Pietro da Cortona's great fresco **THE GLORIFICATION OF THE PAPACY OF URBAN VIII** became a model for a

23-13 Artemisia Gentileschi **JUDITH BEHEADING HOLOFERNES**

c. 1619–20. Oil on canvas, 6′6⅜″ × 5′4″ (1.99 × 1.63 m). Galleria degli Uffizi, Florence.

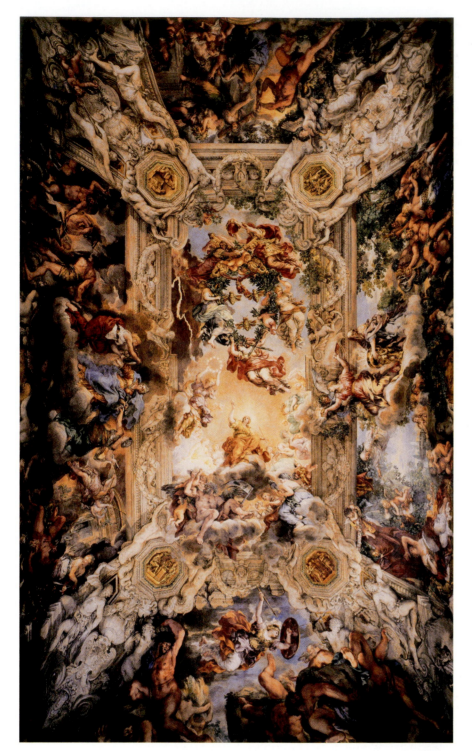

23–14 Pietro da Cortona **THE GLORIFICATION OF THE PAPACY OF URBAN VIII**

Ceiling in the Gran Salone, Palazzo Barberini, Rome. 1632–1639. Fresco.

Credit: Palazzo Barberini, Italy/Canali Photobank, Milan, Italy

with deep shadows, fuses the ceiling into a dense but unified whole.

The subject is an elaborate allegory of the virtues of the pope. Just below the center of the vault, seated at the top of a pyramid of clouds and figures personifying Time and the Fates, Divine Providence (in gold against an open sky) gestures toward three giant bees surrounded by a huge laurel wreath (both Barberini emblems) carried by Faith, Hope, and Charity. Immortality offers a crown of stars, while other figures present the crossed keys and the triple-tiered crown of the papacy. Around these figures are scenes of Roman gods and goddesses, who demonstrate the pope's wisdom and virtue by triumphing over the vices. So complex was the imagery that a guide gave visitors an explanation, and one member of the household published a pamphlet explaining the painting that is still in use today.

The most spectacular of all illusionistic Baroque ceilings is Giovanni Battista Gaulli's **THE TRIUMPH OF THE NAME OF JESUS AND FALL OF THE DAMNED** (FIG. 23–15), which fills the vault of the Jesuit church Il Gesù (SEE FIG. 21–48A). In the 1560s, Giacomo da Vignola had designed an austere interior for Il Gesù, but when the Jesuits renovated their church a century later, they commissioned a religious allegory to cover the nave's plain ceiling. Gaulli (1639–1709) designed and executed the spectacular illusion between 1672 and 1685, fusing sculpture and painting to eliminate any appearance of architectural division. It is difficult to sort carved three-dimensional figures from the painted imitations, and some paintings are on real panels that extend over the actual architectural frame. Gaulli, who arrived in Rome from Genoa in 1657, had worked in his youth for Bernini, from whom he absorbed a taste for drama and multimedia effects. The elderly Bernini, who worshiped daily at Il Gesù, may well have offered his personal advice to his former assistant, and Gaulli was certainly familiar with other

succession of Baroque illusionistic palace ceilings throughout Europe (**FIG. 23–14**). He structured his mythological scenes around a vaultlike skeleton of architecture painted in *quadratura* that appears to be attached to the actual cornice of the room. But in contrast to Annibale Carracci's neat separations and careful *quadro riportato* framing (SEE FIG. 23–8), Pietro's figures weave in and out of their setting in active and complex profusion; some rest on the actual cornice, while others float weightlessly against the sky. Instead of Annibale's warm, nearly even light, Pietro's dramatic illumination, with its bursts of brilliance alternating

illusionistic paintings in Rome as well, including Pietro da Cortona's Barberini ceiling (SEE FIG. 23-14).

Gaulli's astonishing creation went beyond anything that had preceded it in unifying architecture, sculpture, and painting. Every element is dedicated to creating the illusion that clouds and angels have descended through an opening in the top of the church into the upper reaches of the nave. The extremely foreshortened figures are projected as if seen from below, and the whole composition is focused off-center on the golden aura around the letters IHS, the monogram of Jesus and the insignia of the Jesuits. The subject is the Last Judgment, with the elect rising toward the name of God and the damned plummeting through the ceiling toward the nave floor. The sweeping extension of the work into the nave space, the powerful appeal to the viewer's emotions, and the near-total unity of the multimedia visual effect—all hallmarks of Italian Baroque—were never surpassed.

23–15 Giovanni Battista Gaulli **THE TRIUMPH OF THE NAME OF JESUS AND FALL OF THE DAMNED**
Vault of the church of Il Gesù, Rome. 1672–1685. Fresco with stucco figures.

Credit: © Vincenzo Pirozzi, Rome

Spain

What constitutes the "Golden Age" of painting in Spain?

When the Holy Roman Emperor Charles V abdicated in 1556, he left the Holy Roman Empire (Germany and Austria) to his brother Ferdinand, while Spain and its American colonies, as well as the Netherlands, Burgundy, Milan, and the Kingdom of Naples and Sicily, went to his son Philip II. Ferdinand and the Habsburg emperors who succeeded him ruled their territories from Vienna in Austria, but much of German-speaking Europe remained divided into small units in which local rulers decided on the religion of their territory. Catholicism prevailed in southern and western Germany and in Austria, while the north was Lutheran.

The Spanish Habsburg kings Philip III (ruled 1598–1621), Philip IV (ruled 1621–1665), and Charles II (ruled 1665–1700) reigned over a weakening empire. After repeated local rebellions, Portugal re-established its independence in 1640. The Kingdom of Naples remained in a constant state of unrest. After 80 years of war, the Protestant northern Netherlands—which had formed the United Provinces—gained independence in 1648. Amsterdam grew into one of the wealthiest cities in Europe, and the Dutch Republic became an increasingly serious threat to Spanish trade and colonial possessions. The Catholic southern Netherlands (Flanders) remained under Spanish and then Austrian Habsburg rule.

What had seemed an endless flow of gold and silver from the Americas to Spain diminished, as precious-metal production in Bolivia and Mexico lessened. Agriculture, industry, and trade at home also suffered. As the Spanish kings tried to defend the Roman Catholic Church and their empire on all fronts, they squandered their resources and finally went bankrupt in 1692. Nevertheless, despite the decline of the Habsburgs' Spanish empire, seventeenth-century writers and artists produced some of the greatest Spanish literature and art, and the century is often called the Spanish Golden Age.

Painting in Spain's Golden Age

The primary influence on Spanish painting in the fifteenth century had been the art of Flanders; in the sixteenth, it had been the art of Florence and Rome. Seventeenth-century Spanish painting, profoundly influenced by Caravaggio, was characterized by an ecstatic religiosity, as well as realistic surface detail that emerges from the deep shadows of tenebrism.

JUAN SÁNCHEZ COTÁN Late in the sixteenth century, Spanish artists developed a significant interest in paintings of artfully arranged objects rendered with intense attention to detail. Juan Sánchez Cotán (1561–1627) was one of the earliest painters of these pure still lifes in Spain. In **STILL LIFE WITH QUINCE, CABBAGE, MELON, AND CUCUMBER** (FIG. 23-16), of about 1602, he contrasts the irregular, curved shapes of the fruits and vegetables with the angular geometry of their setting. His precisely ordered subjects—two of which are suspended from strings—form a long, sagging arc from the upper left to the lower right. The fruits and vegetables appear within a *cantarero* (primitive pantry), but it is unclear why they have been arranged in this way. Set in a strong light against impenetrable darkness, this highly artificial arrangement of strikingly lifelike forms suggests not only a fascination with spatial ambiguity, but also a contemplative sensibility and interest in the qualities of objects that look forward to the work of Zurbarán and Velázquez.

JUSEPE DE RIBERA Jusepe (or José) de Ribera (c. 1591–1652) was born in Seville but studied in Rome and settled in Spanish-ruled Naples; in Italy, he was known as "Lo Spagnoletto" ("the Little Spaniard"). He combined the Classical and Caravaggesque styles he had learned in Rome to create a new Neapolitan—and eventually

23-16 Juan Sánchez Cotán **STILL LIFE WITH QUINCE, CABBAGE, MELON, AND CUCUMBER**

c. 1602. Oil on canvas, 27⅛ × 33¼" (68.8 × 84.4 cm). San Diego Museum of Art. Gift of Anne R. and Amy Putnam.

Credit: © akg-images/De Agostini Picture Lib.

realistic faces with the dramatic light of tenebrism and describes the aging, wrinkled flesh in great detail. The compression of the figures into the foreground space heightens our sense of being witness to this scene (SEE FIG. 23–12).

FRANCISCO DE ZURBARÁN Francisco de Zurbarán (1598–1664) represents another martyrdom, in this case already accomplished, in his 1628 painting of **ST. SERAPION** (FIG. 23–18). Little is known of Zurbarán's early years before 1625, but he came under the influence of the Caravaggesque taste prevalent in Seville, the

Spanish—style. Ribera became the link extending from Caravaggio in Italy to the Spanish masters Zurbarán and Velázquez.

During this period, the Church—aiming to draw people back to Catholicism—commissioned portrayals of heroic martyrs who had endured shocking torments as witness to their faith. Ribera's painting of the **MARTYRDOM OF ST. BARTHOLOMEW** (the apostle who was martyred by being skinned alive) captures the horror of the violence to come while emphasizing the saint's spirituality and acceptance (FIG. 23–17). The bound Bartholomew looks heavenward as his executioner tests the sharpness of the knife that he will soon use on his victim. Ribera has learned the lessons of Caravaggio well, as he highlights the intensely

major city in southwestern Spain, while his interest in abstract design has been traced to the heritage of Islamic art in Spain.

Zurbarán primarily worked for the monastic orders. In this painting, he portrays the martyrdom of Serapion, a member of the thirteenth-century Mercedarians, a Spanish order founded to rescue the Christian prisoners of the Moors. Following the vows of his order, Serapion sacrificed himself in exchange for Christian captives. The dead man's pallor, his rough hands, and the coarse ropes contrast with the off-white of his creased habit, its folds arranged in a pattern of highlights and varying depths of shadow. The only colors are the red and gold of the insignia. This timelessly immobile composition is like a tragic still life, a study of fabric and flesh become inanimate.

VELÁZQUEZ AND MURILLO Diego Rodríguez de Silva y Velázquez (1599–1660), the greatest painter to emerge from the Caravaggesque school of Seville, shared Zurbarán's fascination with objects. He entered Seville's painters' guild in 1617. Like Ribera, he began his career as a tenebrist and naturalist. During his early years, he painted scenes set in taverns, markets, and kitchens, and emphasized still lifes of various foods and kitchen utensils. His early **WATER CARRIER OF SEVILLE** (**FIG. 23-19**) is a study of the surfaces and textures of the splendid ceramic pots that have characterized folk art through the centuries. Velázquez was devoted to studying and sketching from life: The man in the painting was a well-known Sevillian waterseller. Like Sánchez Cotán, Velázquez arranged the elements of his paintings with almost mathematical rigor. The objects and figures allow the artist to exhibit his virtuosity in rendering volumes and contrasting textures in dramatic natural light. Light reflects in different ways off the glazed waterpot at the left and the coarser clay jug in the foreground; it is absorbed by the rough wool and dense velvet of the costumes; it is refracted as it passes through the clear glass held by the man and the waterdrops on the jug's surface.

In 1623, Velázquez moved to Madrid, where he became court painter to the young King Philip IV, a prestigious position that he held until his death in 1660. The opportunity to study paintings in the royal collection, as well as to travel, enabled the development of his distinctive personal style. The Flemish painter Peter Paul Rubens, during a 1628–1629 diplomatic visit to the Spanish court, convinced the king that Velázquez should visit Italy. Velázquez made two trips, the first in 1629–1631 and the second in 1649–1651. He was profoundly influenced by contemporary Italian painting, and on the first trip seems to have taken a special interest in narrative paintings with complex figure compositions.

23-19 Diego Velázquez **WATER CARRIER OF SEVILLE**

c. 1619. Oil on canvas, 41½ × 31½" (105.3 × 80 cm). Victoria & Albert Museum, London.

Credit: V&A Images/Victoria and Albert Museum

23–20 Diego Velázquez **THE SURRENDER AT BREDA (THE LANCES)**
1634–1635. Oil on canvas, 10′7⅞″ × 12′½″ (3.07 × 3.67 m). Museo del Prado, Madrid.

Credit: © 2016. Image Copyright Museo Nacional del Prado. © Photo MNP/Scala, Florence

Velázquez's Italian studies and his growing skill in composition are apparent in both figure and landscape paintings. In **THE SURRENDER AT BREDA** (FIG. 23–20), painted in 1634–1635, Velázquez treats the theme of triumph and conquest in an entirely new way—far removed from traditional gloating military propaganda. Years earlier, in 1625, Ambrosio Spinola, the duke of Alba and the Spanish governor, had defeated the Dutch at Breda. As Velázquez imagined the scene of surrender, the opposing armies stand on a hilltop overlooking a vast valley where the city of Breda burns and soldiers are still deployed. The Dutch commander, Justin of Nassau, hands over the keys of Breda to the victorious Spanish commander. The entire exchange seems extraordinarily gracious, an emblem of a courtly ideal of gentlemanly conduct. The victors stand at attention, holding their densely packed lances upright in a vertical pattern—giving the painting its popular name, *The Lances*—while the defeated Dutch, a motley group, stand out of order, with pikes and banners drooping.

In fact, according to reports, no keys were involved and the Dutch were more presentable in appearance than the Spaniards. Velázquez has taken liberties with historical fact to create for his Spanish patron a work of art that focuses on the meaning of the surrender, rather than its actual appearance.

Velázquez displays here his compositional virtuosity and his extraordinary gifts as a visual storyteller. A strong diagonal, starting in the sword of the Dutch soldier in the lower left foreground and ending in the checked banner on the upper right, unites the composition and moves the viewer from the defeated to the victorious soldiers in the direction of the surrender itself. Portraitlike faces, meaningful gestures, and controlled color and texture convince us of the reality of the scene. Across the upper half of the huge canvas, the landscape background is startling. Velázquez painted an entirely imaginary Netherlands in greens and blues worked with flowing, liquid brushstrokes. Luminosity is achieved by laying

23–21 Diego Velázquez **LAS MENINAS (THE MAIDS OF HONOR)**
1656. Oil on canvas, 10′5″ × 9′½″ (3.18 × 2.76 m). Museo del Prado, Madrid.

The cleaning of *Las Meninas* in 1984 revealed much about Velázquez's methods. He used a minimum of underdrawing, building up his forms with layers of loosely applied paint and finishing off the surfaces with dashing highlights in white, lemon yellow, and pale orange. Rather than using light to model volumes in the time-honored manner, Velázquez tried to depict the optical properties of light reflecting from surfaces. On close inspection his forms dissolve into a maze of individual strokes of paint.

down a thick layer of lead white and then flowing the layers of color over it. The silvery light forms a background for dramatically silhouetted figures and weapons. Velázquez revealed a breadth and intensity unsurpassed in his century, and became an inspiration to modern artists such as Manet and Picasso.

Velázquez's most enigmatic, and perhaps most striking, work is the enormous multiple portrait known as **LAS MENINAS (THE MAIDS OF HONOR)** (FIG. 23-21), painted in 1656, near the end of his life. Nearly 10½ feet tall and over 9 feet wide, this painting continues to challenge viewers and stimulate debate among art historians. Velázquez draws viewers directly into the scene. In one interpretation, the viewer stands in the very space occupied by King Philip and his queen, whose reflections can be seen in the large mirror on the back wall, perhaps a clever reference to Jan van Eyck's *Double Portrait of Giovanni Arnolfini and his Wife* (SEE FIG. 19-1), which was a part of the Spanish royal collection at this time. Echoing pictorially the claim made in Jan's signature, Velázquez himself is also present, brushes in hand, beside a huge canvas. The central focus, however, is neither the artist nor the royal couple but their brilliantly illuminated 5-year-old daughter, the Infanta (princess) Margarita, who is surrounded by her attendants, most of whom are identifiable portraits.

No consensus exists today on the meaning of this monumental painting. It is a royal portrait; it is also a self portrait of Velázquez standing at his easel. But fundamentally, *Las Meninas* is a personal statement. Throughout his life, Velázquez had sought respect and acclaim for himself and for the art of painting. Here, dressed as a courtier, the Order of Santiago on his chest (added later) and the keys of the palace tucked into his sash, Velázquez proclaims the dignity and importance of painting itself.

The Madrid of Velázquez was the center of Spanish art. Seville declined after an outbreak of plague in 1649, but it remained a center for trade with the Spanish colonies, where the work of Bartolomé Esteban Murillo (1617–1682) had a profound influence on art and religious iconography. Many patrons wanted images of the Virgin Mary and especially of the Immaculate Conception, the controversial

idea that Mary was born free from original sin. Although the Immaculate Conception became Catholic dogma only in 1854, the concept, as well as devotion to Mary, grew during the seventeenth and eighteenth centuries.

Counter-Reformation authorities had provided specific instructions for artists painting the Virgin of the Immaculate Conception: Mary was to be dressed in blue and white, her hands folded in prayer as she is carried upward by angels, sometimes in large flocks. She may be surrounded by an unearthly light ("clothed in the sun") and may stand on a crescent moon in reference to the woman of the Apocalypse (SEE FIG. 15-14). Angels often carry palms and symbols of the Virgin, such as a mirror, a fountain, roses, and lilies, and they may vanquish the serpent, Satan. The Church exported to the New World many paintings faithful to these orthodox guidelines by Murillo, Zurbarán, and others. When the indigenous population began to visualize the Christian story (SEE FIG. 30-47), paintings such as Murillo's **THE IMMACULATE CONCEPTION** (FIG. 23-22) provided prompts for their imaginings.

23-22 Bartolomé Esteban Murillo
THE IMMACULATE CONCEPTION
c. 1660–1665. Oil on canvas, 81⅛ × 56⅝"
(2.06 × 1.44 m). Museo del Prado, Madrid.

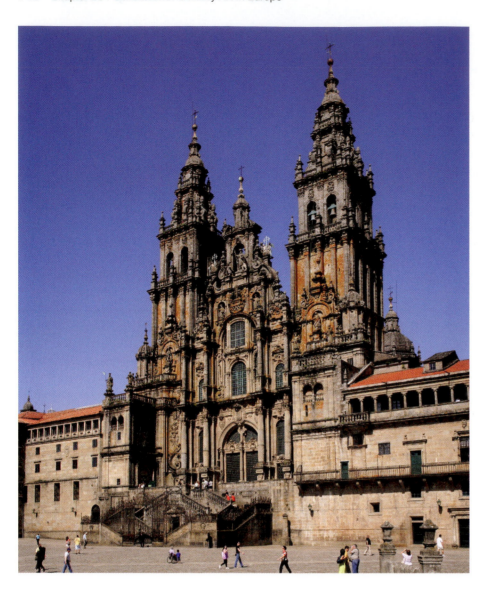

Architecture

Turning away from the severity displayed in the sixteenth-century El Escorial monastery-palace (SEE FIG. 22-17), seventeenth-century Spanish architects again embraced the lavish decoration that had characterized their art since the fourteenth century. Profusions of ornament swept back into fashion, first in huge *retablos* (altarpieces), then in portals (main doors often embellished with sculpture), and finally in entire buildings.

THE CATHEDRAL OF SANTIAGO DE COMPOSTELA

In the seventeenth century, the role of St. James as patron saint of Spain was challenged by the supporters of St. Teresa of Ávila and then by supporters of St. Michael, St. Joseph, and other popular saints. It became important to the archbishop and other leaders in Santiago de Compostela, where the Cathedral of St. James was located, to re-establish their primacy. They reinforced their efforts to revitalize the regular flow of pilgrims to the city, undertaken by Spaniards since the ninth century, and used architecture as part of their campaign.

Renewed interest in pilgrimages to the shrines of saints in the seventeenth century brought an influx of pilgrims, and consequently financial security, to the city and the Church. The cathedral chapter ordered an elaborate façade to be added to the twelfth-century pilgrimage church (**FIG. 23-23**). A south tower was built in 1667–1680 and then later copied as the north tower.

The last man to serve as architect and director of works at the cathedral, Fernando de Casas y Nóvoas (active 1711–1749), tied the disparate elements—towers, portal, stairs—together at the west end in a grand design focused on a veritable wall of glass, popularly called "The Mirror." His design culminates in a free-standing gable soaring above the roof, visually linking the towers and framing a statue of St. James. The extreme simplicity of the cloister walls and the archbishop's palace at each side of the portal heightens the dazzling effect of this enormous expanse of windows, glittering, jewel-like, in their intricately carved granite frame.

Flanders

What new developments in Flemish painting are evident in the workshop of Peter Paul Rubens?

Led by the nobleman Prince William of Orange, the Netherlands' Protestant northern provinces (present-day Holland) began to rebel against Spain in 1568. The seven provinces joined together as the United Provinces in 1579 and began a long struggle for independence, achieved only in the seventeenth century. The king of Spain considered the Dutch heretical rebels, but finally the Dutch prevailed. In 1648, the United Provinces joined emissaries from Spain, the Vatican, the Holy Roman Empire, and France on equal footing in peace negotiations. The resulting Peace of Westphalia officially recognized the independence of the northern Netherlands.

Flanders, the southern—and predominantly Catholic—part of the Netherlands, enjoyed a period of relative autonomy under Habsburg regents starting in 1598, but returned to direct Spanish rule in 1621. Catholic churches were restored and important commissions focused on sacred art. As Antwerp, Flanders' capital city and major arts center, gradually recovered from the turmoil of the religious wars, artists of great talent flourished there. Painters like Peter Paul Rubens and Anthony van Dyck established international reputations that brought them important commissions from foreign as well as local patrons.

Rubens

Peter Paul Rubens (1577–1640), whose painting has become synonymous with Flemish Baroque art, was born in Germany, where his father, a Protestant, had fled from his native Antwerp to escape religious persecution. Rubens's mother returned with her children to Antwerp and to Catholicism in 1587, after her husband's death. Rubens decided in his late teens to become an artist and at age 21 was accepted into the Antwerp painters' guild, a testament to his energy, intelligence, and skill. Shortly thereafter, in 1600, he left for Italy. In Venice, his work came to the attention of the duke of Mantua, who offered him a court post. Rubens's activities on behalf of the duke over the next eight years did much to prepare him for the rest of his long and successful career. The duke had him copy famous paintings in collections all over Italy to add to the ducal collection.

Rubens visited every major Italian city, went to Madrid as the duke's emissary, and spent two extended periods in Rome, where he studied the great works of Roman antiquity and the Italian Renaissance. While in Italy, Rubens studied the paintings of two contemporaries, Caravaggio and Annibale Carracci. By 1607 Rubens had persuaded the duke of Mantua to buy the former's *Death of the Virgin*

23–24 Peter Paul Rubens
SELF-PORTRAIT WITH ISABELLA BRANDT
1609–1610. Oil on canvas, 5′9″ × 4′5″ (1.78 × 1.36 m). Alte Pinakothek, Munich.
Credit: Photo © Blauel Gnamm/ARTOTHEK

(c. 1601–1602), which had been rejected by Caravaggio's patrons because of its shocking realism.

In 1608, Rubens returned to Antwerp, where in 1609 he accepted a position as court painter to the Habsburg regents of Flanders, Archduke Albert and Princess Isabella Clara Eugenia, the daughter of Philip II. Ten days after that appointment, he married the 18-year-old Isabella Brandt (1596–1626), an alliance that was financially beneficial to the artist, then almost twice the age of his bride. He commemorated the marriage with a spectacular double portrait of himself and his bride seated together in front of a honeysuckle bower that evokes a state of marital bliss (**FIG. 23-24**). The self-confident couple looks out to engage viewers directly, and the rich detail of their lavish costumes is described with precision, demonstrating both the artist's virtuosity and the couple's wealth and sophistication. They join right hands in a traditional gesture of marriage,

23–26 Peter Paul Rubens **THE RAISING OF THE CROSS**
Made for the church of St. Walpurga, Antwerp, Belgium. 1610–1611. Oil on panel, center panel 15'1⅞" × 11'1½" (4.62 × 3.39 m),
each wing 15'1⅞" × 4'11" (4.62 × 1.52 m). Now in the Cathedral of Our Lady, Antwerp.

Credit: Onze Lieve Vrouwkerk, Antwerp Cathedral, Belgium/Bridgeman Images

23–27 Peter Paul Rubens **HENRY IV RECEIVING THE PORTRAIT OF MARIE DE' MEDICI**

1621–1625. Oil on canvas, 12'11⅛" × 9'8⅛" (3.94 × 2.95 m). Musée du Louvre, Paris.

Credit: Photo © RMN-Grand Palais (Musée du Louvre)/René-Gabriel Ojéda/Thierry Le Mage

Rubens's first major commission in Antwerp was a large canvas triptych for the main altar of the church of St. Walpurga, **THE RAISING OF THE CROSS** (**FIG. 23–26**), painted in 1610–1611. He extended the central action and the landscape through all three panels. At the center, Herculean figures strain to haul upright the wooden cross with Jesus already stretched upon it. At the left, the followers of Jesus join in mourning, and at the right, soldiers supervise the execution. The drama and intense emotion of Caravaggio is merged here with the virtuoso technique of Annibale Carracci, but transformed and reinterpreted according to Rubens's own unique ideal of thematic and formal unity. The heroic nude figures, dramatic lighting effects, dynamic diagonal composition, and intense emotions show his debt to Italian art, but the rich colors and careful description of surface textures reflect his native Flemish tradition.

Rubens's expressive visual language was considered just as appropriate for representing secular rulers as it was for religious subjects. Moreover, his intelligence, courtly manners, and personal charm made him a valuable and trusted courtier to his royal patrons, who included Philip IV of Spain, Queen Marie de' Medici of France, and Charles I of England. In 1621, Marie de' Medici, who had been regent for her son Louis XIII, asked Rubens to paint the story of her life, to glorify her role in ruling France and commemorate the founding of the new Bourbon royal dynasty. In 24 paintings, Rubens portrayed Marie's life and career as one continuous triumph overseen by the ancient gods of Greece and Rome.

In the painting depicting the royal engagement (**FIG. 23–27**), Henry IV immediately falls in love with Marie as he gazes at her portrait, shown to him—at the exact center of the composition—by Cupid and Hymen, the god of marriage. The supreme Roman god Jupiter and his wife Juno look down approvingly from the clouds. A personification of France encourages Henry, outfitted with steel

and the artist slips his foot into the folds of Isabella's flowing red skirt, suggesting a more intimate connection between them. They would have three children before Isabella's untimely death in 1626.

In 1611, Rubens purchased a residence in Antwerp. The original house was large and typically Flemish, but Rubens added a studio in the Italian manner across a courtyard, joining the two buildings by a second-floor gallery over the entrance portal (**FIG. 23–25**). Beyond the courtyard lay the large formal garden, laid out in symmetrical beds. The living room permitted access to a gallery overlooking Rubens's huge studio, a room designed to accommodate large paintings and to house what became virtually a painting factory. The tall, arched windows provided ample light for the single, two-story room, and a large door permitted the assistants to move finished paintings out to their designated owners. Through the gates at one side of the courtyard, one can see the architectural features of the garden.

breastplate and silhouetted against a landscape in which the smoke of a battle lingers in the distance, to abandon war for love, as *putti* play below with the rest of his armor. The ripe colors, lavish textures, and dramatic diagonals give sustained visual excitement to these enormous canvases, making them not only important works of art but also political propaganda of the highest order.

To satisfy his clients all over Europe, Rubens employed dozens of assistants, many of whom were, or became, important painters in their own right. Using workshop assistants was standard practice for a major artist, but Rubens was particularly methodical, training or hiring specialists in costumes, still lifes, landscapes, portraiture, and animal painting who together could complete works from his detailed sketches. Some of his most spectacular paintings were collaborations. Frans Snyders (1579–1657), a specialist in painting animals and flowers, was brought in by Rubens to paint the enormous eagle who devours the liver of the mythical hero in **PROMETHEUS BOUND** (see

"Closer Look" below), begun in 1611–1612 and perhaps worked on as late as 1618. The dramatic lighting, dynamic composition, and loose, energetic brushwork of this painting—which the artist kept for a while in his own personal collection—was clearly Rubens's own, while Snyders's tight and detailed technique sets up within the painting a telling representational contrast between the massive predator and its writhing victim. Among Rubens's other collaborators were his friend and neighbor Jan Brueghel the Elder (1568–1625, son of Pieter Bruegel the Elder, see Chapter 22) and Anthony van Dyck.

Van Dyck and Peeters: Portraits and Still Lifes

Anthony van Dyck (1599–1641) had an illustrious independent career as a portraitist in addition to collaborating with Rubens. Son of an Antwerp silk merchant, he was listed as a pupil of the dean of Antwerp's Guild of St. Luke at age

A Closer Look
PROMETHEUS BOUND

The eagle in this picture was painted by Frans Snyders, a specialist in painting animals and flowers whom Rubens brought in to render the detailed feathers and powerful posture of this bird of prey.

During the seventeenth century, the struggle between Prometheus and the eagle was interpreted allegorically sometimes as the struggle involved in artistic creativity, other times as the heroism involved in enduring suffering of body or soul. Some saw in Prometheus a prototype of the Christ of the Crucifixion, an association furthered here by the placement of the gash on Prometheus's side.

After the main composition was complete, Rubens added this 17½-inch strip of canvas to the left side of the painting to provide more space for the dramatic action, allowing the inclusion at lower left of the fire that got Prometheus into trouble and, on the horizon, the bright light that some have interpreted as a touch of optimism to counteract the punishment in the foreground.

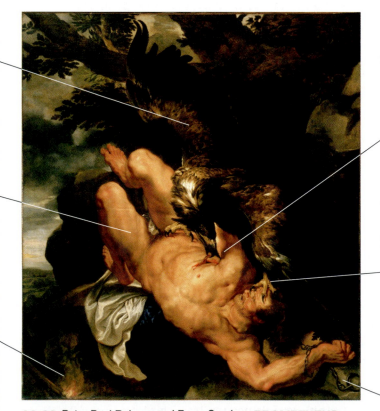

The eagle has pierced Prometheus's side to devour his liver, an action that identifies the subject here. This hero of Greek myth was chained to Mount Caucasus and sentenced to this sensational punishment because, in direct defiance of Zeus's command, he stole fire from Mount Olympus and brought it to earth so humankind would no longer be confined to cold and darkness. Since Prometheus's liver regrew each night, his fate was to have it plucked out again and again, day after day.

The talons of the eagle are poised to dig into the groin and face of the struggling hero to underline for viewers the excruciating nature of his pain.

These small chains that confine Prometheus to the rock seem hardly adequate to confine the powerfully muscular hero, leading some to speculate that the artist wanted his incarceration to seem more psychological than physical.

23-28 Peter Paul Rubens and Frans Snyders **PROMETHEUS BOUND**
c. 1611–1618. Oil on canvas, 95½ × 82½″ (2.43 × 2.1 m). Philadelphia Museum of Art.

Credit: © 2016. Photo The Philadelphia Museum of Art/Art Resource/Scala, Florence

to enhance the stature of Henry IV; see FIG. 23–27), Charles, who was in fact very short, appears here taller than his pages and even than his horse, since its head is down and its heavy body is partly off the canvas. The viewer's gaze is diverted from the king's delicate frame to his pleasant features, framed by his jauntily cocked cavalier's hat and the graceful cascade of his hair. As if in polite homage, the tree branches bow gracefully toward him, echoing the curving lines of the hat.

Our use of the term "still life" for paintings of objects on a table comes from the Dutch *stilleven*, a word coined about 1650. The Antwerp artist Clara Peeters (1594– c. 1657) specialized in still lifes (see "Closer Look" in the Introduction on page xxxi). She was a precocious young woman whose career seems to have begun before she was 14. Of some 50 paintings now attributed to her (of which more than 30 are signed), many are of the type called "breakfast pieces," showing a table set for a meal of bread and fruit. Peeters was one of the first artists to combine flowers and food in a single painting, as in her **STILL LIFE WITH FLOWERS, GOBLET, DRIED FRUIT, AND PRETZELS** (**FIG. 23–30**) of 1611. Peeters arranged rich tableware and food against neutral, almost black backgrounds, the better to emphasize the fall of light over the contrasting surface textures. In a display of precious objects that must have appealed to her clients, the luxurious goblet and bowl contrast with simple stoneware and pewter, as do the delicate flowers with the homey pretzels. The pretzels are a particularly interesting Baroque element, with their complex multiple curves.

10. He had his own studio and roster of pupils at age 16 but was not made a member of the guild until 1618, the year after he began his association with Rubens as a specialist in painting heads. The need to blend his work seamlessly with that of Rubens enhanced Van Dyck's technical skill. After a trip to the English court of James I (ruled 1603–1625) in 1620, Van Dyck traveled to Italy and worked as a portrait painter for seven years before returning to Antwerp. In 1632, he returned to England as the court painter to Charles I (ruled 1625–1649), by whom he was knighted and given a studio, a summer home, and a large salary.

Van Dyck's many portraits of the royal family provide a sympathetic record of their features and demeanor. In **CHARLES I AT THE HUNT** (**FIG. 23–29**), of 1635, Van Dyck was able, by clever manipulation of the setting, to portray the king truthfully and still present him as an imposing figure. Dressed casually for the hunt and standing on a bluff overlooking a distant view (a device used by Rubens

23–30 Clara Peeters **STILL LIFE WITH FLOWERS, GOBLET, DRIED FRUIT, AND PRETZELS**
1611. Oil on panel, 20½ × 28¾″ (52 × 73 cm). Museo del Prado, Madrid.

Like many "breakfast pieces," this painting features a pile of pretzels among the elegant tableware. The salty, twisted bread was called *pretzel* (from the Latin *pretiola*, meaning "small reward") because it was invented by German monks to reward children who had learned their prayers. The twisted shapes represented the crossed arms of a child praying.

Credit: © 2016. Image Copyright Museo Nacional del Prado. © Photo MNP/Scala, Florence

The Dutch Republic

What are the distinctive styles and subjects preferred in paintings from the Protestant Netherlands?

The House of Orange was not notable for its patronage of the arts, but patronage improved significantly under Prince Frederick Henry (ruled 1625–1647), and Dutch artists found many other eager patrons among the prosperous middle class in Amsterdam, Leiden, Haarlem, Delft, and Utrecht. The Hague was the capital city and the preferred residence of the House of Orange, but Amsterdam was the true center of power, because of its sea trade and the enterprise of its merchants, who made the city an international commercial center. The Dutch delighted in depictions of themselves and their country—the landscape, cities, and domestic life—not to mention beautiful and interesting objects in still-life paintings and interior scenes.

A well-educated people, the Dutch were also fascinated by history, mythology, the Bible, new scientific discoveries, commercial expansion abroad, and colonial exploration.

Visitors to the Netherlands in the seventeenth century noted the popularity of art among merchants and working people. This taste for art stimulated a free market for paintings that functioned like other commodity markets. Artists had to compete to capture the interest of the public by painting on speculation—completing paintings before offering them for sale, in contrast to commissions, which were created only after a purchase agreement was made. Specialists in particularly popular types of images were most likely to be financially successful, and what most Dutch patrons wanted were paintings of themselves, their country, their homes, their possessions, and the life around them—characterized by active trade, bustling mercantilism, Protestant religiosity, and jarring class distinctions. The demand for art also gave rise to an active market for

the graphic arts, both for original compositions and for copies of paintings, since one copperplate could produce hundreds of impressions, and worn-out plates could be reworked and used again.

Painting

Hendrick ter Brugghen (1588–1629) spent time in Rome, perhaps between 1608 and 1614, where he must have seen Caravaggio's works and became an enthusiastic follower. On his return home, in 1616, Ter Brugghen entered the Utrecht painters' guild, introducing Caravaggio's style into the Netherlands in paintings such as **ST. SEBASTIAN TENDED BY ST. IRENE** (**FIG. 23-31**), and becoming the best known of the Utrecht "Caravaggisti." The sickly gray-green flesh of the nearly dead St. Sebastian, painted in an almost monochromatic palette, contrasts with the brilliant red-and-gold brocade of what seems to be his

crumpled garment. (Actually this is the cope of the bishop of Utrecht, which had survived destruction by Protestants and become a symbol of Catholicism in Utrecht.) The saint is cast as a heroic figure, his strong, youthful body still bound to the tree. But St. Irene (the patron saint of nurses) delicately removes one of the arrows that pierce him, and her maid reaches to untie his wrists. In a typically Baroque manner, the powerful diagonal created by St. Sebastian's left arm dislodges him from the triangular stability of the group. The immediacy and emotional engagement of the work are enhanced by crowding all the figures into the foreground plane, an effect strengthened by the low horizon line, another aspect of this painting that recalls the work of Caravaggio. The tenebrism and dramatic lighting effects are likewise Caravaggesque, as is the frank realism of the women's faces, with reddened noses and rosy cheeks. Rembrandt, Vermeer, and Rubens all admired Ter Brugghen's painting.

HALS AND LEYSTER Frans Hals (c. 1581/1585–1666), the leading painter of Haarlem, developed a style grounded in the Netherlandish love of description and inspired by the Caravaggesque style introduced by artists such as Ter Brugghen. Like Velázquez, he tried to recreate the optical effects of light on the shapes and textures of objects. He painted boldly, with slashing strokes and angular patches of paint. Only when seen at a distance do the colors merge into solid forms over which a flickering light seems to move. In Hals's hands, this loose and seemingly effortless technique suggests the spontaneity of an infectious joy in life. He was known primarily as a portraitist.

23–31 Hendrick ter Brugghen
ST. SEBASTIAN TENDED BY ST. IRENE
1625. Oil on canvas, 58¹⁵/₁₆ × 47½"
(149.6 × 120 cm). Allen Memorial Art Museum, Oberlin College, Ohio. R.T. Miller Jr. Fund (1953.256).

Credit: Bridgeman Images

23–32 Frans Hals
OFFICERS OF THE HAARLEM MILITIA COMPANY OF ST. ADRIAN
c. 1627. Oil on canvas, 6′ × 8′8″ (1.83 × 2.67 m). Frans Hals Museum, Haarlem.

Credit: Frans Hals Museum, Haarlem. Photo: © Margareta Svensson

Seventeenth-century Dutch portraiture took many forms, ranging from single figures in sparsely furnished settings to allegorical depictions of groups in elaborate costumes surrounded by symbols and attributes. Although the faithful description of facial features and costumes was the most important gauge of a portrait's success, some painters, like Hals, went beyond likeness to convey a sense of mood or emotion in the sitter. Fundamentally, portraits functioned as social statements of the sitters' status coupled with a clear sense of identity rooted in recognizable faces.

Group portraiture documenting the membership of corporate organizations was a Dutch specialty, and Hals painted some of the greatest examples. These large canvases, filled with many individuals who shared the cost of the commission, challenged painters to present a coherent, interesting composition that nevertheless gave equal attention to each individual portrait. Most artists arranged their sitters in neat rows to depict every face clearly, but in **OFFICERS OF THE HAARLEM MILITIA COMPANY OF ST. ADRIAN** (**FIG. 23–32**) of about 1627, Hals transforms the group portrait into a lively social event. The company, made up of several guard units, was charged with the military protection of Haarlem. Officers came from the upper middle class and held their commissions for three years, whereas the ordinary guards were tradespeople and craftspeople. Each company was organized like a guild, traditionally under the patronage of a saint, and functioned mainly as a fraternal order, holding archery competitions and taking part in city processions. Hals's composition is based on a strong underlying geometry of diagonal lines—gestures, banners, and sashes—balanced by the stabilizing

perpendiculars of table, window, and tall glass. The black suits and hats make the white ruffs and sashes of rose, white, and baby blue even more brilliant.

Although Hals focused his career on portraits of wealthy members of Haarlem's merchant class, he also painted images of eccentric local figures that, although they follow the format of portraiture, functioned as genre paintings by commenting on the nature of modern life. Among the most striking of these is a painting of the 1630s, portraying a laughing—presumably drunk—older woman with a large beer tankard in her right hand and a shadowy owl perched on her shoulder, known as **MALLE BABBE** (**FIG. 23–33**). The figure is based on a well-known Haarlem barmaid who was eventually confined to a charitable mental institution; the word "Malle" means loony or mad, and the owl was a popular symbol of folly. Hals's painting technique in this character study is looser and more energetic than in most of his formal portraits, where he often restrained his stylistic exuberance to conform to the expectations of his wealthy sitters. Here he felt freer in a painting that may have had personal significance. The historical Malle Babbe was confined to the same workhouse for the mentally impaired as Hals's own son Pieter, raising the question of whether this lively vignette of pub life was meant as a bracing social commentary.

A painting that was long praised as one of Hals's finest works is actually by Judith Leyster (c. 1609–1660), Hals's contemporary. A cleaning uncovered her distinctive signature, the monogram "JL" with a star, which refers to her surname, meaning "pole star." Leyster's work clearly shows her exposure to the Utrecht painters who had enthusiastically adopted the principal features

23-33 Frans Hals **MALLE BABBE**

c. 1630–1633. Oil on canvas, 30⅞ × 26″ (78.5 × 66.2 cm). Staatliche Museen zu Berlin.

Credit: © 2016. Photo Scala, Florence/bpk, Bildagentur für Kunst, Kultur und Geschichte, Berlin

whose popularity was based on the very type of painting in progress on her easel. One critic has suggested that her subject—a man playing a violin—may be a visual pun on the painter with palette and brush. Leyster's understanding of light and texture is remarkable. The brushwork she used to depict her own flesh and delicate ruff is more controlled than Hals's loose technique and forms an interesting contrast to the broad strokes of thick paint she used to create her full, stiff skirt. She further emphasized the difference between her portrait and her painting by executing the image on her easel in lighter tones and softer, looser brushwork. The narrow range of colors sensitively dispersed in the composition and the warm spotlighting are typical of Leyster's mature style.

REMBRANDT VAN RIJN The most important painter working in Amsterdam in the seventeenth century was Rembrandt van Rijn (1606–1669). One of nine children born in Leiden to a miller and his wife, Rembrandt studied under Pieter Lastman (1583–1633), the principal painter in Amsterdam at the time. From Lastman, a history painter who had worked in Rome, Rembrandt absorbed an interest in the naturalism, drama, and tenebrism championed by Caravaggio. By the 1630s, Rembrandt was established in Amsterdam primarily as a portrait painter, although he also painted a wide range of narrative themes and landscapes.

of Caravaggio's style. Since Leyster signed in 1631 as a witness at the baptism of one of Hals's children, it is assumed they were close; she may also have worked in his shop. She entered Haarlem's Guild of St. Luke in 1633, which allowed her to take pupils into her studio, and her competitive relationship with Frans Hals around that time is made clear by the complaint she lodged against him in 1635 for luring away one of her apprentices.

Leyster is known primarily for informal scenes of daily life, which often carry an underlying moralistic theme. In her lively **SELF-PORTRAIT** of 1635 (**FIG. 23-34**), the artist has interrupted her work to lean back and look at viewers, as if they had just entered the room. Her elegant dress and the fine chair in which she sits are symbols of her success as an artist

23-34 Judith Leyster **SELF-PORTRAIT**

1635. Oil on canvas, 29⅜ × 25⅝″ (74.6 × 65.1 cm). National Gallery of Art, Washington, DC. Gift of Mr. and Mrs. Robert Woods Bliss (1949.6.4).

Credit: Image courtesy the National Gallery of Art, Washington

23–35 Rembrandt van Rijn **THE ANATOMY LESSON OF DR. NICOLAES TULP**
1632. Oil on canvas, 5′3¾″ × 7′1¼″ (1.6 × 2.1 m). Mauritshuis, The Hague.

Credit: © 2016. Photo Scala, Florence

In his first group portrait, **THE ANATOMY LESSON OF DR. NICOLAES TULP** (**FIG. 23–35**) of 1632, Rembrandt combined his scientific and humanistic interests. Frans Hals had activated the group portrait rather than conceiving it as a simple reproduction of posed figures and faces; Rembrandt transformed it into a charged moment from a life story. Dr. Tulp, head of the surgeons' guild from 1628 to 1653, sits right of center, while a group of fellow physicians gathers around to observe the cadaver and learn from the famed anatomist. Rembrandt built his composition on a sharp diagonal that pierces space from right to left, uniting the cadaver on the table, the calculated arrangement of speaker and listeners, and the open book into a dramatic narrative event. Rembrandt makes effective use of Caravaggio's tenebrist technique, as the figures emerge from a dark and undefined ambience, their attentive faces framed by brilliant white ruffs. Light streams down to spotlight the ghostly flesh of the cadaver, drawing our attention to the extended arms of Dr. Tulp, who flexes his own left hand to demonstrate the action of the cadaver's arm

muscles that he lifts up with silver forceps. Unseen by the viewers are the illustrations of the huge book, presumably an edition of Andreas Vesalius's study of human anatomy, published in Basel in 1543, which was the first attempt at accurate anatomical illustrations in print. Rembrandt's painting has been seen as an homage to Vesalius and to science, as well as a portrait of the members of the Amsterdam surgeons' guild.

Prolific and popular with his Amsterdam clientele, Rembrandt ran a busy studio producing works that sold for high prices. The prodigious output of his large workshop and of the many followers who imitated his manner has made it difficult for scholars to define his body of work, and many paintings formerly attributed to Rembrandt have recently been assigned to other artists. Rembrandt's mature work reflected his cosmopolitan city environment, his study of science and nature, and the broadening of his artistic vocabulary by the study of Italian Renaissance art, chiefly from engravings and paintings imported by the busy Amsterdam art market.

In 1642, Rembrandt was one of several artists commissioned by a wealthy civic-guard company to create large group portraits of its members for its new meeting hall. The result, **THE COMPANY OF CAPTAIN FRANS BANNING COCQ** (FIG. 23–36), carries the idea of a group portrait as a dramatic event even further. Because a dense layer of grime had darkened and obscured its colors, this painting was once thought to be a nocturnal scene and was therefore called *The Night Watch*. After cleaning and restoration in 1975–1976, it now exhibits a natural golden light that sets afire the palette of rich colors—browns, blues, olive-green, orange, and red—around a central core of lemon yellow in the costume of a lieutenant. To the dramatic group composition, showing a company forming for a parade in an Amsterdam street, Rembrandt added several colorful but seemingly unnecessary figures. While the officers stride purposefully forward, the rest of the men and several

mischievous children mill about. The radiant young girl in the left middle ground, carrying a chicken with prominent claws (*klauw* in Dutch), may be a pun on the kind of guns (*klower*) that gave the name (the *Kloveniers*) to the company. Chicken legs with claws also are part of its coat of arms. The complex interactions of the figures and the vivid, individualized likenesses of the militiamen make this one of the greatest group portraits in the Dutch tradition.

In his enthusiasm for printmaking as an important art form with its own aesthetic qualities, Rembrandt was remarkably like Albrecht Dürer (SEE FIGS. 22-7, 22-8). Beginning in 1627, he focused on **etching**, which uses acid to inscribe a design on metal plates. About a decade later, he began to experiment with making additions to his compositions in the **drypoint** technique, in which the artist uses a sharp needle to scratch shallow lines in a plate. Because etching and drypoint allow the artist to work directly

23–36 Rembrandt van Rijn **THE COMPANY OF CAPTAIN FRANS BANNING COCQ (THE NIGHT WATCH)**
1642. Oil on canvas, 11'11" × 14'4" (3.63 × 4.37 m) (cut down from the original size). Rijksmuseum, Amsterdam.

Technique

ETCHING AND DRYPOINT

Rembrandt was the first artist to popularize etching as a major form of artistic expression. Etching is an intaglio technique, meaning that the design is carved out of the surface of the printing plate. First the metal plate is coated on both sides with an acid-resistant resin that dries hard without being brittle. Then, instead of laboriously cutting the lines of the desired image directly into the plate as in an engraving (see "Woodcuts and Engravings on Metal" in Chapter 19 on page 603) the artist scratches delicately through the resin with a sharp needle to expose the metal. The plate is then immersed in acid, which eats into the metal exposed by the drawn lines. By controlling the time the acid stays on different parts of the plate, the artist can make shallow, fine lines or deep, heavy ones. After the resin coating is removed from the surface of the plate, an impression is taken. If changes need to be made, lines can be "erased" with

a sharp metal scraper. Not surprisingly, a complex image with a wide range of tones requires many steps.

Another intaglio technique for registering images with incised lines on a metal plate is called drypoint, in which a sharp needle is used to scratch lines directly into the metal. In drypoint, however, the burr (metal pushed up by the drypoint needle) is left in place. Unlike engraving, in which the burr is scraped off, here both the burr and the groove hold the ink. This creates a printed line with a rich black appearance that is impossible to achieve with engraving or etching alone. Unfortunately, drypoint burr is fragile, and no more than a dozen prints can be made before it flattens and loses its character. Rembrandt's earliest prints were entirely etched, but later he added drypoint to develop tonal richness.

on the plate, the style of the finished print can have the relatively free and spontaneous character of a drawing (see "Etching and Drypoint" above). In these works Rembrandt alone took charge of the creative process, from the preparation of the plate to its inking and printing, and he constantly experimented with the technique, with methods of inking, and with papers for printing. Rembrandt's prints were widely collected and attracted high prices even in his lifetime.

Rembrandt's deep speculations on the meaning of the life of Christ evolve in a series of prints of the **THREE**

CROSSES that comes down to us in five states, or stages, of the creative and printing process, in this case created entirely with the drypoint technique. (Only the first and fourth states are reproduced here.) Rembrandt sought to capture the moment described in the Gospels when, during the Crucifixion, darkness covered the Earth and Jesus cried out, "Father, into thy hands I commend my spirit." In the first state (**FIG. 23–37**), the centurion kneels in front of the cross while other people run. The Virgin Mary and St. John share the light flooding down from heaven. By the fourth state (**FIG. 23–38**), Rembrandt has completely

23–37 Rembrandt van Rijn **THREE CROSSES** **(FIRST STATE)**

1653. Drypoint, 15⅛ × 17¾" (38.5 × 45 cm). Rijksmuseum, Amsterdam.

23–38 Rembrandt van Rijn **THREE CROSSES** **(FOURTH STATE)**

1653. Drypoint, 15⅛ × 17¾" (38.5 × 45 cm). Rijksmuseum, Amsterdam.

reworked and reinterpreted the theme. As in the first state, the shattered hill of Golgotha dominates the foreground, but now the scene is considerably darker, and some of the people in the first state, including even Mary and Jesus's friends, have almost disappeared. The horseman holding the lance now faces Jesus. The composition has become more compact, the individual elements are simplified, and the emotions are intensified. An oval of light below the base of the cross draws viewers' attention to the figure of Jesus, and the people around him are trapped in mute confrontation. The first state is a rendering of a narrative moment, bustling with detail; the fourth state reduces the event to its mysterious essence.

As he aged, Rembrandt painted ever more brilliantly, varying textures and paint from the thinnest glazes to thick **impasto** (heavily applied paint), creating a rich, luminous *chiaroscuro* ranging from deepest shadow to brilliant highlights in a dazzling display of gold, red, and chestnut-brown. His sensitivity to the human condition is perhaps nowhere more powerfully expressed than in his late self-portraits, which became more searching as he aged. Distilling a lifetime of study and contemplation, he expressed an internalized spirituality new in the history of art. In his **SELF-PORTRAIT** of 1658 (**FIG. 23–39**), the artist assumes a regal pose, at ease, with arms and legs spread, holding a staff as if it were a baton of command. Yet we know that fortune no longer smiled on him; he had declared bankruptcy in 1656, and over the two-year period between that moment and this self-portrait he had sold his private art collection and even his house to cover his debts. It is possible to relate the stress of this situation to the way he represents himself here. A few well-placed brushstrokes suggest physical tension in the fingers and weariness in the deep-set eyes. Mercilessly analytical, the portrait depicts the furrowed brow, sagging flesh, and aging face of one who has suffered pitfalls but managed to survive, retaining his dignity.

JOHANNES VERMEER One of the most intriguing Dutch artists of this period is Johannes Vermeer (1632–1675), who was also an innkeeper and art dealer. He entered the Delft artists' guild in 1653 and painted only for local patrons. Meticulous in his technique, with a unique and highly structured compositional approach and soft, liquid painting style, Vermeer produced fewer than 40 canvases that can be securely attributed to him. The more these paintings are studied, the more questions arise about the artist's life and his methods. Vermeer's **VIEW OF DELFT** (**FIG. 23–40**), for example, is no simple cityscape. Although the artist convinces the viewer of its authenticity, he does not paint a photographic reproduction of the scene; he moves buildings around to create an ideal composition. Vermeer endows the city with a timeless stability through a stress on horizontal lines, the careful placement of buildings, the quiet atmosphere, and the clear, even light that seems to emerge from beneath low-lying clouds. Vermeer may also have experimented with the mechanical device known as the **camera obscura** (a cameralike box used to record images from the real world; see Chapter 31). This would not have been used by Vermeer as a method of reproducing the image but as another tool in the visual analysis of the composition. The camera obscura would have enhanced optical distortions that led to the "beading" of highlights (seen here on the harbored ships and dark

gray architecture), which creates the illusion of brilliant light but does not dissolve the underlying form.

Most of Vermeer's paintings portray enigmatic scenes of women in their homes, alone or with a servant, occupied with a refined activity such as writing, reading letters, or playing a musical instrument. These are quiet and still interior scenes, gentle in color, asymmetrical but strongly geometric in organization. By creating a contained and consistent architectonic world in which each object adds to the clarity and balance of the composition, Vermeer transports everyday scenes to a level of unearthly perfection. An even, pearly light from a window often gives solidity to the figures and objects in a room. All emotion is subdued, evoking a mood of quiet meditation. Vermeer's brushwork is so controlled that it becomes invisible, except when he paints his characteristic pools of reflected light as tiny, pearl-like droplets of color.

In **WOMAN HOLDING A BALANCE** (**FIG. 23–41**), studied equilibrium creates a monumental composition and a moment of supreme stillness. The woman contemplates the balance in her right hand, drawing our attention to the act of weighing and judging. Her hand and the scale are central, but directly behind her head is a painting of the Last Judgment, highlighting the figure of Christ the Judge in a gold oval above her head. The juxtaposition seems to turn Vermeer's genre scene into a metaphor for eternal

23–40 Johannes Vermeer **VIEW OF DELFT**
c. 1662. Oil on canvas, 38½ × 46¼″ (97.8 × 117.5 cm). Royal Picture Gallery, Mauritshuis, The Hague.

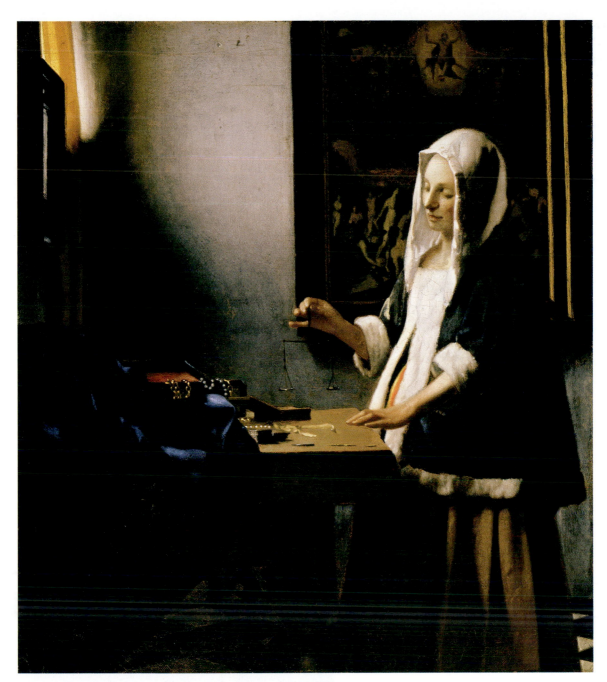

23–41 Johannes Vermeer **WOMAN HOLDING A BALANCE**
c. 1664. Oil on canvas, 15⅝ × 14″ (39.7 × 35.5 cm). National Gallery of Art, Washington, DC. Widener Collection (1942.9.97).

Credit: Image courtesy the National Gallery of Art, Washington

judgment, a sobering religious reference that may reflect the artist's own position as a Catholic living in a Protestant country. The woman's moment of quiet introspection in front of the gold and pearls displayed on the table before her, shimmering with reflected light from the window, also evokes the *vanitas* theme of the transience of earthly life.

GENRE SCENES Continuing a long Netherlandish tradition, seventeenth-century genre paintings—generally made for private patrons and depicting scenes of contemporary daily life—were often laden with symbolic references, although their meaning is not always clear to us

now. A clean house might indicate a virtuous housewife and mother, while a messy household suggested laziness and the sin of sloth. Ladies dressing in front of mirrors certainly could be succumbing to vanity, and drinking parties led to overindulgence and lust.

Gerard ter Borch (1617–1681) was one of the most refined of the genre painters. In his painting traditionally known as **THE SUITOR'S VISIT** (**FIG. 23-42**), from about 1658, a well-dressed man bows gracefully to an elegant woman in white satin, who stands in a sumptuously furnished room in which another woman plays a lute. Another man, in front of a fireplace, turns to observe

23–42 Gerard ter Borch **THE SUITOR'S VISIT**

c. 1658. Oil on canvas, 32½ × 29⅝″ (82.6 × 75.3 cm). National Gallery of Art, Washington, DC. Andrew W. Mellon Collection.

Credit: Image courtesy the National Gallery of Art, Washington

success. Most of his scenes used everyday life to portray moral tales, illustrate proverbs and folk sayings, or make puns to amuse the spectator. Since Steen traveled throughout the Netherlands all his life and was a tavern owner in Leiden during the 1670s, he had many sources of inspiration for the lively human dramas in his paintings.

Steen's paintings of children are especially remarkable, for he captured not only their childish physiques but also their fleeting moods and expressions with rapid, fluid brushstrokes. A characteristic example is **THE FEAST OF ST. NICHOLAS** (**FIG. 23–43**), from the 1660s. Steen's household setting holds neither the intimate order and stillness favored

the newcomer. The painting appears to represent a prosperous gentleman paying a call on a lady of equal social status, possibly a courtship scene. The spaniel and the musician seem to be simply part of the scene, but we are already familiar with the dog as a symbol of fidelity, and stringed instruments were said to symbolize, through their tuning, the harmony of souls and thus, possibly, a loving relationship. On the other hand, music making was also associated with sensory pleasure evoked by touch. Ter Borch's exquisite rendering highlights the lace, velvet, and especially the satin of these opulent outfits, potentially symbols of personal excess. If there is a moral lesson, it is presented discreetly and ambiguously.

Another important genre painter is Jan Steen (1626–1679), whose larger brushstrokes contrast with the meticulous treatment of Ter Borch and reveal an artistic affinity with Frans Hals. Steen painted over 800 works but never achieved financial

23–43 Jan Steen **THE FEAST OF ST. NICHOLAS**

c. 1660–1665. Oil on canvas, 32¼ × 27¾″ (82 × 70.5 cm). Rijksmuseum, Amsterdam.

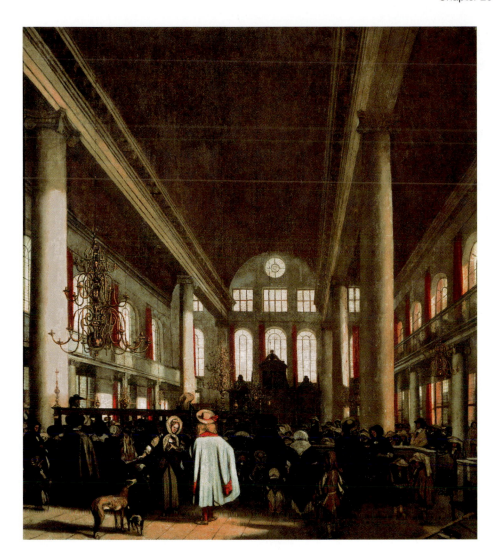

23–44 Emanuel de Witte
**PORTUGUESE SYNAGOGUE,
AMSTERDAM**
1680. Oil on canvas, 43½ × 39"
(110.5 × 99.1 cm). Rijksmuseum,
Amsterdam.

Architects Daniel Stalpaert and
Elias Bouman built the synagogue in
1671–1675.

by Vermeer, nor the elegant decorum and guarded interaction portrayed by Ter Borch. This is a scene of noisy commotion within a joyous family get-together, where children react in various ways—disappointment, delight, possessiveness—to the pre-Christmas gifts St. Nicholas has left for them in their shoes. Steen renders the objects scattered in the disordered foreground with meticulous attention to the details of surface texture, but the focus here is the festive atmosphere of a boisterous holiday morning and the folksy figures who delight in the celebration.

Emanuel de Witte (1617–1692) of Rotterdam specialized in architectural interiors, first in Delft in the 1640s and then in Amsterdam after settling there permanently in 1652. Although many of his interiors were composites of features from several locations combined in one idealized architectural view, De Witte also painted faithful "portraits" of actual buildings. One of these is his **PORTUGUESE SYNAGOGUE, AMSTERDAM** (FIG. 23–44) of 1680. The synagogue shown here, which still stands in Amsterdam, is a rectangular hall divided into one wide central aisle with narrow side aisles, each covered with a wooden barrel vault resting on lintels supported by columns. De Witte's shift of the viewpoint slightly to one side has created an

intriguing spatial composition, and strong contrasts of light and shade add dramatic movement to the simple interior. The elegant couple and the dogs in the foreground provide both a sense of scale for the architecture and some human interest for viewers.

Today, this painting is interesting not only as a work of art, but also as a record of seventeenth-century synagogue architecture, documenting Dutch religious tolerance in an age when European Jews were often persecuted. Expelled from Spain and Portugal from the late fifteenth century on, many Jews had settled in Amsterdam, and their community numbered about 2,300 people, most of whom were well-to-do merchants. Fund-raising for a new synagogue began in 1670, and in 1671 Elias Bouman and Daniel Stalpaert began work on the building. With its classical architecture, Brazilian jacaranda-wood furniture, and 26 brass chandeliers, this synagogue was considered one of the most impressive buildings in Amsterdam.

LANDSCAPE AND STILL LIFE The Dutch loved the landscapes and vast skies of their own country, but landscape painters worked in their studios rather than in nature, and they were never afraid to rearrange, add to, or

subtract from a scene in order to give their compositions formal organization or a desired mood. Starting in the 1620s, landscape painters generally followed a convention in which little color was used beyond browns, grays, and beiges. After 1650, they used more individualistic styles, but nearly all brought a broader range of colors into play. One continuing motif was the emphasis on cloud-filled expanses of sky dominating a relatively narrow horizontal band of earth below.

The Haarlem landscape specialist Jacob van Ruisdael (1628/1629–1682), whose popularity drew many pupils to his workshop, was especially adept at both the invention of dramatic compositions and the projection of moods. His **VIEW OF HAARLEM FROM THE DUNES AT OVERVEEN (FIG.** **23–45)**, painted about 1670, celebrates the flatlands outside Haarlem that had been reclaimed from the sea as part of a massive landfill project that the Dutch compared with God's restoration of the Earth after Noah's Flood. Such a religious interpretation may be referenced here in the prominent Gothic church of St. Bavo looming on the horizon. There may be other messages as well. While almost three-quarters of this painting is devoted to a rendering of the powerfully cloudy sky, tiny humans can be seen laboring below, caught in the process of spreading white linen across the broad fields to bleach in the sun. This glorification of the industriousness of citizens engaged in one of Haarlem's principal industries must have made the painting particularly appealing to the patriotic local market.

23–45 Jacob van Ruisdael **VIEW OF HAARLEM FROM THE DUNES AT OVERVEEN**
c. 1670. Oil on canvas, 22 × 24¼″ (55.8 × 62.8 cm). Royal Picture Gallery, Mauritshuis, The Hague.

23–46 Pieter Claesz **STILL LIFE WITH TAZZA**
1636. Oil on panel, 17⅜ × 24″ (44 × 61 cm). Royal Cabinet of Paintings, Mauritshuis, The Hague.

The heavy round glass is a Roemer, a relatively inexpensive, everyday item, as are the pewter plates. The silver cup (*tazza*) was a typical ornamental piece. Painters owned and shared such valuable props, and this and other showpieces appear in many paintings.

The Dutch were so proud of their still-life painting tradition that they presented a flower painting by Rachel Ruysch to the French queen Marie de' Medici during her state visit to Amsterdam. Like genre paintings, a still-life painting might carry moralizing connotations and commonly had a *vanitas* theme, reminding viewers of the transience of life and material possessions, even art. Yet it could also document and showcase the wealth of its owner.

One of the first Dutch still-life painters was Pieter Claesz (1596/1597–1660) of Haarlem, who, like Antwerp artist Clara Peeters (SEE FIG. 23–30), painted "breakfast pieces," that is, meals of bread, fruits, and nuts. In subtle, nearly monochromatic paintings such as **STILL LIFE WITH TAZZA** (FIG. 23–46), Claesz seems to give life to inanimate objects. He organizes dishes in diagonal positions to give a strong sense of space—here reinforced by the spiraling strip of lemon peel, foreshortened with the plate into the foreground and reaching toward the viewer's own space—and

he renders the maximum contrast of textures within a subtle palette of yellows, browns, greens, and silvery whites. The tilted silver *tazza* contrasts with the half-filled glass, which becomes a monumental presence and permits Claesz to display his skill with transparencies and reflections. Such paintings suggest the prosperity of Claesz's patrons. The food might be simple, but a silver ornamental cup like this would have graced the tables of only the wealthy. The meticulously painted timepiece could suggest deeper meanings—it alludes to human technological achievement, but also to the inexorable passage of time and the fleeting nature of human life, thoughts also prompted by the interrupted breakfast, casually placed knife, and toppled tableware.

Still-life paintings in which cut-flower arrangements predominate were referred to simply as "flower pieces." Significant advances were made in botany during the seventeenth century through the application of orderly scientific methods and objective observation (see "Science

and the Changing Worldview" opposite). Then, as now, the Dutch were major growers and exporters of flowers, especially the tulips that appear in nearly every flower piece in dozens of exquisite variations. The Dutch tradition of flower painting peaked in the long career of Rachel Ruysch (1664–1750) of Amsterdam. Her flower pieces were highly prized for their sensitive, free-form arrangements and their unusual and beautiful color harmonies. During her 70-year career, she became one of the most sought-after and highest-paid still-life painters in Europe—her paintings brought in twice what Rembrandt's did.

In her **FLOWER STILL LIFE** (FIG. **23–47**) painted shortly after the end of the century, Ruysch placed the container at the center of the canvas's width, then created an asymmetrical floral arrangement of pale oranges, pinks, and yellows rising from lower left to top right of the picture, offset by the strong diagonal of the tabletop. To further balance the painting, she placed highlighted blossoms and leaves on the dark left half of the canvas and silhouetted them against the light wall area on the right. Ruysch often emphasized the beauty of curving flower stems and enlivened her compositions with interesting additions, such as casually placed pieces of fruit or insects, in this case a large gray moth (lower left) and two snail shells.

Flower painting was almost never a straightforward depiction of actual fresh flowers. Instead, artists made color sketches of fresh examples of each type of flower and studied scientifically accurate color illustrations in botanical publications. In the studio, using their sketches and notebooks, they would compose bouquets of perfect specimens of a variety of flowers that could never be found blooming at the same time. The short life of flowers was a poignant reminder of the fleeting nature of beauty and of human life.

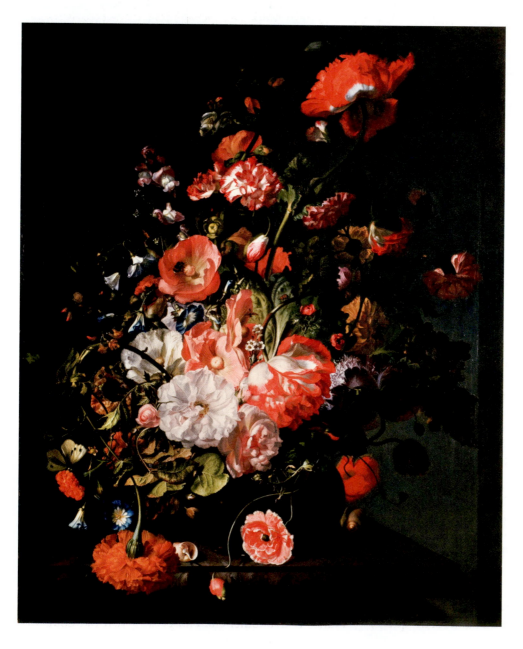

23–47 Rachel Ruysch **FLOWER STILL LIFE**

After 1700. Oil on canvas, 30 × 24" (76.2 × 61 cm). The Toledo Museum of Art, Ohio. Purchased with funds from the Libbey Endowment. Gift of Edward Drummond Libbey (1956.57).

Credit: The Toledo Museum of Art, Toledo, Ohio (1956.57)

Art and its Contexts

SCIENCE AND THE CHANGING WORLDVIEW

From the mid sixteenth through the seventeenth centuries, new discoveries about the natural world brought a sense of both the grand scale and the microscopic detail of the universe. To publish their theories and research, early scientists learned to draw or depended on artists to draw what they discovered in the world around them. This practice would continue until the invention of photography in the nineteenth century.

Artist and scientist were seldom the same person, but Anna Maria Sibylla Merian (1647–1717) contributed to botany and entomology both as a researcher and as an artist. German by birth and Dutch by training, Merian was once described by a Dutch contemporary as a painter of unclean and undesirable subjects such as worms, flies, mosquitoes, and spiders. In 1699, the city of Amsterdam subsidized Merian's research on plants and insects in the Dutch colony of Surinam in South America, where she spent two years exploring the jungle and recording insects. On her return to the Dutch Republic, she published the results of her research as **THE METAMORPHOSIS OF THE INSECTS OF SURINAM**, illustrated with 72 large prints created as copies of her watercolors (**FIG. 23–48**). For all her meticulous scientific accuracy, Merian arranged her depictions of exotic insects and elegant fruits and flowers into skillful and harmonious compositions.

But interest in scientific exploration was not limited to the Netherlands. The writings of philosophers Francis Bacon (1561–1626) in England and René Descartes (1596–1650) in France helped establish a new scientific method of studying the world by insisting on scrupulous objectivity and logical reasoning. Bacon argued that the facts be established from observation and tested by controlled experiments. Descartes, who was also a mathematician, argued for the deductive method of reasoning, in which conclusions were arrived at logically from basic premises.

In 1543, the Polish scholar Nicolaus Copernicus (1473–1543) published *On the Revolutions of the Heavenly Spheres*, which contradicted the long-held view that the Earth was the center of the universe (the Ptolemaic theory) by arguing instead that it and the other planets revolved around the Sun. The Church put Copernicus's work on its *Index of Prohibited Books* in 1616, but Johannes Kepler (1571–1630) continued demonstrating that the planets revolve around the Sun in elliptical orbits. Galileo Galilei (1564–1642), an astronomer, mathematician, and physicist, developed the telescope as a tool for observing the heavens and provided further confirmation of Copernican theory, but since

23-48 Anna Maria Sibylla Merian **PLATE 9 FROM THE METAMORPHOSIS OF THE INSECTS OF SURINAM**
1719. Hand-colored engraving, 18⅞ × 13" (47.9 × 33 cm). Getty Research Institute, Los Angeles (89-B10750).

the Church prohibited its teaching, Galileo was tried for heresy by the Inquisition and forced to deny his views.

The new seventeenth-century science turned to the study of the very small as well as to the vast reaches of space. This included the development of the microscope by the Dutch lens-maker and amateur scientist Anton van Leeuwenhoek (1632–1723). Leeuwenhoek perfected grinding techniques and increased the power of his lenses far beyond what was required for a simple magnifying glass. Ultimately, he was able to study the inner workings of plants and animals and even see micro-organisms.

France

How does the art of France differ from art and architecture produced elsewhere in Europe?

Early seventeenth-century France was marked by almost continuous foreign and civil wars. The assassination of King Henry IV in 1610 left France in the hands of the queen,

Marie de' Medici (regency 1610–1617; SEE FIG. 23–27), as regent for her 9-year-old son, Louis XIII (ruled 1610–1643). When Louis came of age, the brilliant and unscrupulous Cardinal Richelieu became chief minister and set about increasing the power of the crown at the expense of the French nobility. The death of Louis XIII again left France with another child king, the 5-year-old Louis XIV

(ruled 1643–1715). His mother, Anne of Austria, became regent, with the assistance of another powerful minister, Cardinal Mazarin. At Mazarin's death in 1661, Louis XIV began his long personal reign, assisted by yet another able minister, Jean-Baptiste Colbert.

An absolute monarch whose reign was the longest in European history, Louis XIV made the French court the envy of every ruler in Europe. He became known as "le Roi Soleil" ("the Sun King") and was sometimes glorified in art through identification with the Classical sun god, Apollo. In a 1701 portrait by court painter Hyacinthe Rigaud (1659–1743), the richly costumed **LOUIS XIV** is framed by a lavish, billowing curtain (**FIG. 23–49**). Proudly showing off his elegant legs, the 63-year-old monarch poses in a blue robe of state, trimmed with gold *fleurs-de-lis* and lined with white ermine. He wears the high-heeled shoes he devised to compensate for his shortness. Despite his pompous pose and magnificent surroundings, the

23–49 Hyacinthe Rigaud **LOUIS XIV**

1701. Oil on canvas, 9′2″ × 7′10¾″ (2.19 × 2.4 m). Musée du Louvre, Paris.

Louis XIV had ordered this portrait as a gift for his grandson, the future Philip V of Spain (ruled 1700–1746), but when Rigaud finished the painting, Louis liked it too much to give it away and only three years later ordered a copy from Rigaud to give to his grandson. The request for copies of royal portraits was not unusual since the aristocratic families of Europe were linked through marriage. Paintings made appropriate gifts and at the same time memorialized important political alliances by recording them in visual form.

Art and its Contexts

GRADING THE OLD MASTERS

The members of the French Royal Academy of Painting and Sculpture considered ancient Classical art to be the standard by which contemporary art should be judged. By the 1680s, however, younger artists of the academy began to argue that modern art might equal, or might even surpass, the art of the ancients—a radical thought that sparked controversy.

A debate arose over the relative merits of drawing and color in painting. The conservatives argued that drawing was superior to color because drawing appealed to the mind while color appealed to the senses. They saw Nicolas Poussin as embodying perfectly the Classical principles of subject and design. But the young artists who admired the vivid colors of Titian, Veronese, and Rubens claimed that painting should deceive the eye, and since color achieves this deception more convincingly than drawing, application of color should be valued over drawing. Adherents of the two positions were called *poussinistes* (in honor of Poussin) and *rubénistes* (for Rubens).

The portrait painter and critic Roger de Piles (1635–1709) took up the cause of the *rubénistes* in a series of pamphlets. In *The Principles of Painting*, de Piles evaluated the most important painters on a scale of 0 to 20 in four categories. He gave no score higher than 72 (18 in each category), since no mortal artist could achieve perfection. Caravaggio received a 0 in expression and a 6 in drawing, while Michelangelo and Leonardo both got a 4 in color and Rembrandt a 6 in drawing.

Most of the painters examined here do not do very well. Raphael and Rubens get 65 points (A on our grading scale), Van Dyck comes close with 55 (C+). Poussin and Titian earn 53 and 51 (solid Cs), while Rembrandt slips by with 50 (C–). Leonardo da Vinci gets 49 (D), and Michelangelo and Dürer with 37 and Caravaggio with 28 are resounding failures in de Piles's view. Tastes change. Someday our own ideas may seem just as misguided as those of the academicians.

directness of the king's gaze and the frankness of his aging face make him appear surprisingly human.

The arts, like everything else, came under royal control. In 1635, Cardinal Richelieu had founded the French Royal Academy, directing the members to compile a definitive dictionary and grammar of the French language. In 1648, the Royal Academy of Painting and Sculpture was founded, which, as reorganized by Colbert in 1663, maintained strict control over the arts (see "Grading the Old Masters" above). Although it was not the first European arts academy, none before it had exerted such dictatorial authority—an authority that would last in France until the late nineteenth century. Membership of the academy assured an artist of royal and civic commissions and financial success, but many talented artists did well outside it.

Versailles

French architecture developed along Classical lines in the second half of the seventeenth century under the influence of François Mansart (1598–1666) and Louis Le Vau (1612–1670). When the Royal Academy of Architecture was founded in 1671, its members developed guidelines for architectural design based on the belief that mathematics was the true basis of beauty. Their chief sources for ideal models were the books of Vitruvius and Palladio.

In 1668, Louis XIV began to enlarge the small château built by Louis XIII at Versailles, not far from Paris. Louis moved to the palace in 1682 and eventually required his court to live in Versailles; 5,000 aristocrats lived in the palace itself, together with 14,000 servants and military staff

members. The town had another 30,000 residents, most of whom were royal employees. The designers of the palace and park complex at Versailles were Le Vau, Charles Le Brun (1619–1690), who oversaw the interior decoration, and André Le Nôtre (1613–1700), who planned the gardens (see "Garden Design" on page 772). For both political and sentimental reasons, the old château was left standing, and the new building went up around it. This project consisted of two phases: the first additions by Le Vau, begun in 1668; and an enlargement completed after Le Vau's death by his successor, Jules Hardouin-Mansart (1646–1708), from 1670 to 1685.

Hardouin-Mansart was responsible for the addition of the long lateral wings and the renovation of Le Vau's central block on the garden side to match these wings (**FIG. 23–50**). The three-story façade has a lightly rusticated ground floor, a main floor lined with enormous arched windows separated by Ionic columns or pilasters, an attic level whose rectangular windows are also flanked by pilasters, and a flat, terraced roof. The overall design is a sensitive balance of horizontals and verticals relieved by a restrained overlay of regularly spaced projecting blocks with open, colonnaded porches.

In his renovation of Le Vau's center-block façade, Hardouin-Mansart enclosed the previously open gallery on the main level, creating the famed **HALL OF MIRRORS** (**FIG. 23–51**), which is about 240 feet long and 47 feet high. He achieved architectural symmetry and a sense of both splendor and expansiveness by lining the interior wall with glass mirrors, matching in size and shape the arched windows in the opposing wall. Mirrors were small

Elements of Architecture

GARDEN DESIGN

Wealthy and aristocratic French landowners commissioned garden designers to transform their large properties into gardens extending over many acres. The challenge for garden designers was to unify diverse elements—buildings, pools, monuments, plantings, and natural land formations—into a coherent whole. At Versailles, André Le Nôtre imposed order upon the vast expanses of palace gardens and park by using broad, straight avenues radiating from a series of round focal points. He succeeded so thoroughly that his plan inspired generations of urban designers as well as landscape architects.

In Le Nôtre's hands, the palace terrain became an extraordinary work of art and a visual delight for its inhabitants. Neatly contained expanses of lawn and broad, straight vistas seemed to stretch to the horizon, while the formal gardens became an exercise in precise geometry. The gardens at Versailles are classically harmonious in their symmetrical, geometric design but Baroque in their vast size and extension into the surrounding countryside, where the gardens thickened into woods cut by straight avenues.

The most formal gardens lay nearest the palace, and plantings became progressively less elaborate and larger in scale as their distance from the palace increased. Broad, intersecting paths

separated reflecting pools and planting beds, which are called embroidered **parterres** for their colorful patterns of flowers outlined with trimmed hedges. After the formal zone of parterres came lawns, large fountains on terraces, and trees planted in thickets to conceal features such as an open-air ballroom and a colonnade. Statues carved by at least 70 sculptors also adorned the park. A mile-long canal, crossed by a second canal nearly as large, marked the main axis of the garden. Fourteen waterwheels brought the water from the river to supply the canals and the park's 1,400 fountains. Only the fountains near the palace played all day; the others were turned on only when the king approached.

At the north end of the secondary canal, a smaller pavilion-palace, the Trianon, was built in 1669. To satisfy the king's love of flowers year-round, the gardens of the Trianon were bedded out with blooming plants from the south shipped in by the French navy. Even in midwinter, the king and his guests could stroll through a summer garden. The head gardener is said to have had nearly 2 million flowerpots at his disposal. In the eighteenth century, Louis XV added greenhouses and a botanical garden. The facilities of the fruit and vegetable garden that supplied the palace in 1677–1683 today house the National School of Horticulture.

Grand Canal

orangerie

parterre

château

parterre

reflecting pools

Grand Trianon

Petit Trianon

PLAN OF THE GARDENS OF THE PALACE OF VERSAILLES (LOUIS LE VAU AND ANDRÉ LE NÔTRE, c. 1661–1785)

Credit: John Woodcock © Dorling Kindersley

23–50 Louis Le Vau and Jules Hardouin-Mansart **GARDEN FAÇADE OF THE PALACE OF VERSAILLES**
1678–1685. Foreground: Jean-Baptiste Tuby's *Neptune*.

Credit: © Onairda/Shutterstock

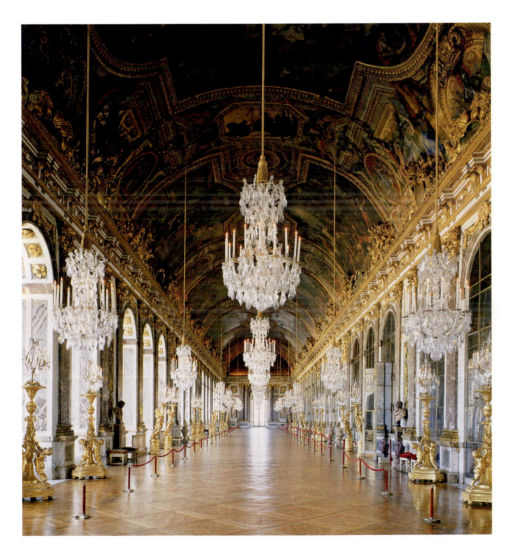

23–51 Jules Hardouin-Mansart and Charles Le Brun **HALL OF MIRRORS, PALACE OF VERSAILLES**

Begun 1678. Length approx. 240′ (73 m).

In the seventeenth century, mirrors and clear window glass were enormously expensive. To furnish the Hall of Mirrors, hundreds of glass panels of manageable size had to be assembled into the proper shape and attached to one another with glazing bars, which became part of the decorative pattern of the vast room.

Credit: © Massimo Listri/Corbis

and extremely expensive in the seventeenth century, and these huge walls of reflective glass were created by fitting 18-inch panels together. They reflect the natural light from the windows and give the impression of an even larger space; at night, the reflections of flickering candles must have turned the mirrored gallery into a shimmering tableau in which the king and courtiers saw themselves as they promenaded.

Inspired by Carracci's Farnese ceiling (SEE FIG. 23–8), Le Brun decorated the vaulted ceiling with paintings on canvas (more stable in the damp northern climate) glorifying the reign and military triumphs of Louis XIV, accompanied by Classical gods. In 1642, Le Brun had studied in Italy, where he came under the influence of the Classical style of his compatriot Nicolas Poussin. As "first painter to the king" and director of the Royal Academy of Painting and Sculpture, Le Brun controlled art education and patronage from 1661/1663 until his death in 1690. He tempered the warmly exuberant Baroque ceilings he had seen in Rome with Poussin's cool Classicism. The underlying theme for his design and decoration of Versailles was the glorification of the king as Apollo the sun god, with whom Louis

identified. Louis XIV thought of the duties of kingship, including its pageantry, as a solemn performance, so it is most appropriate that Rigaud's portrait presents him on a raised, stagelike platform, with a theatrical curtain (SEE FIG. 23–49). Versailles became the splendid stage on which the king played the principal role in the grandiose drama of state.

Painting

Sixteenth-century French Mannerism began to give way in the 1620s to Classicism and the impact of Caravaggio, especially his tenebrism and compression of large-scale figures into the foreground. As the century progressed, the control of the Royal Academy and its encouragement of studies of the Classics and the surviving antiquities in Rome guided French painting toward the Classicism promoted by Le Brun.

CARAVAGGIO'S INFLUENCE: GEORGES DE LA TOUR AND THE LE NAIN BROTHERS One of Caravaggio's most important followers in France, Georges de La Tour (1593–1652) received major royal and ducal commissions and became court painter to Louis XIII in 1639. La Tour may have traveled to Italy in 1614–1616, and in the 1620s he almost certainly visited the Netherlands, where Caravaggio's style was having an impact (SEE FIG. 23–31). Like Caravaggio, La Tour filled the foreground of his compositions with imposing figures, but in place of Caravaggio's focus on descriptive detail, La Tour's work revels in the dramatic effects of lighting, usually from sources within the paintings themselves. Often, it seems, light is his real subject (see "Closer Look" in the Introduction on page xxvi).

23–52 Georges de La Tour **MARY MAGDALEN WITH THE SMOKING FLAME**
c. 1640. Oil on canvas, 46¼ × 36⅛"
(117 × 91.8 cm). Los Angeles County Museum of Art. Gift of the Ahmanson Foundation (M. 77.73).

23-53 Louis or Antoine Le Nain **A PEASANT FAMILY IN AN INTERIOR**

c. 1640. Oil on canvas, 44½ × 62½" (1.13 × 1.59 m). Musée du Louvre, Paris.

Credit: © akg-images/Erich Lessing

La Tour painted many images of Mary Magdalen. In **MARY MAGDALEN WITH THE SMOKING FLAME** (**FIG. 23-52**), as in many of his other paintings, the light emanates from a source shown in the painting, in this case the flame from an oil lamp. Its warm glow gently brushes over hand and skull—symbol of mortality—to establish the foreground. The compression of the figure into the front of the pictorial space conveys a sense of intimacy between the saint and viewers, although she is completely unaware of our presence. Light not only unifies the painting, its controlled character also creates its somber mood. Mary Magdalen has put aside her rich clothing and jewels to meditate on the frailty and vanity of human life. Even the flickering light that rivets our attention on her meditative face and gesture is of limited duration.

The same feeling of timelessness and a comparable interest in effects of light characterize the paintings of the Le Nain brothers, Antoine (c. 1588–1648), Louis (c. 1593–1648), and Mathieu (1607–1677). Although all three were working in Paris by about 1630 and were founding members of the Royal Academy of Painting and Sculpture in 1648, little else is known about their lives and careers. Because they collaborated closely with each other, art historians have only recently begun to sort out their individual styles. They are best known for their painting of genre scenes in which French peasants pause from labor for quiet family diversions. **A PEASANT FAMILY IN AN INTERIOR** (**FIG. 23-53**) of about 1640, probably by Louis Le Nain, is the largest and one of the most lyrical of these noble scenes of peasant life. Three generations of this family are gathered around a table. The adults acknowledge our presence—a spotlighted woman at left even seems to offer us some wine—whereas the children remain lost in dreams or focused on play. The casualness of costume and behavior is underlined by the foreground clutter of pets and kitchen equipment. It is only after we survey the frieze of figures illuminated around the table that the painting reveals one of its most extraordinary passages—a boy in the left background, warming himself in front of a fireplace and represented only as a dark silhouette from behind, edged by the soft golden firelight. Why the brothers chose to paint these peasant families, and who bought their paintings, are questions still unresolved.

23-54
Nicolas Poussin
LANDSCAPE WITH ST. MATTHEW AND THE ANGEL
1639–1640. Oil on canvas, 39 × 53⅛″ (99 × 135 cm). Staatliche Museen zu Berlin.

Credit: © 2016. Photo Scala, Florence/ bpk, Bildagentur für Kunst, Kultur und Geschichte, Berlin. Photo: Joerg P. Anders

THE CLASSICAL LANDSCAPE: POUSSIN AND CLAUDE LORRAIN

French painters Nicolas Poussin (1594–1665) and Claude Gellée (called "Claude Lorrain" or simply "Claude," 1600–1682) pursued their careers in Italy although they usually worked for French patrons. They perfected the French ideal of the "Classical" landscape and profoundly influenced painters for the next two centuries. We refer to Poussin and Claude as Classicists because they organized natural elements and figures into gently illuminated, idealized compositions. Both were influenced by Annibale Carracci and to some extent by Venetian painting, yet each evolved an unmistakably personal style that conveyed an entirely different mood from that of their sources and from each other.

Nicolas Poussin was born in Normandy but settled in Paris, where his initial career as a painter was unremarkable. He arrived in Rome, and the Barberini family became his foremost patrons. Bernini considered Poussin one of the greatest painters in Rome, and others clearly agreed. In 1639, Giovanni Maria Roscioli, secretary to Pope Urban VIII, commissioned from Poussin two large paintings showing the evangelists John and Matthew composing their texts within expansive landscapes dotted with Classical buildings and antique ruins (**FIGS. 23-54, 23-55**). The paintings were completed by October 1640, just before Poussin left for two years in Paris to work for Louis XIII. Perhaps they were the first installment of a set of four

evangelists within landscapes, but only these two had been painted when the patron died in 1644.

These paintings epitomize and are among the earliest examples of a new style of rigorously ordered and highly idealized Classical landscapes with figures—an artistic theme and format created by Poussin that would have a long future in European painting. Although each is individually composed to create an ordered whole on its own, the paintings were designed as a pair. The large clumps of trees at the outside edges form "bookends" that bring lateral closure to the broad panorama that stretches across both canvases. Their unity is emphasized by the evangelists' postures, turned inward toward each other, and solidified at the lower inside corners where huge blocks of Classical masonry converge from both pictures as coordinated remains of the same ruined monument. A consistent perspective progression in both pictures moves from the picture plane back into the distance through a clearly defined foreground, middle ground, and background, illuminated by an even light with gentle shadows and highlights. In the middle distance, behind St. John, are a ruined temple and an obelisk; the round building in the distant city is Hadrian's Tomb, which Poussin knew from Rome. Precisely placed trees, hills, mountains, water, and even clouds take on a solidity of form that seems almost as structural as this architecture. The subject of Poussin's paintings is not the writing evangelists but the balance and order of nature.

When Claude Lorrain went to Rome in 1613, he first studied with Agostino Tassi, an assistant of Guercino and a specialist in architectural painting. Claude, however, preferred landscape. He sketched outdoors for days at a time, then returned to his studio to compose paintings. Claude was fascinated with light, and his works are often studies of the effect of the rising or setting sun on colors and the atmosphere. A favorite and much-imitated device was to place one or two large objects in the foreground—a tree, building, a figural group, or hill—past which the viewer's

eye enters the scene and proceeds, often by diagonal paths, into the distance.

Claude used this compositional device to great effect in paintings such as **A PASTORAL LANDSCAPE** of the late 1640s (**FIG. 23–56**). Instead of balancing symmetrically placed elements in a statement of stable order, Claude leads viewers actively into the painting in a continuing, zigzagging fashion. A conversing couple frames the composition at the right. Their gestures and the ambling of the cows they are tending lead our attention toward the left on a slightly rising diagonal, where a bridge and the traveler moving across it establish a middle ground. Across the bridge into the distance is a city, setting up a contrast between the warm, soft contours of the pastoral right foreground and the misty angularity of the fortified walls and blocks of the distant fortress. More distant still are the hazy outlines of hills that seem to take this space into infinity. The picture evokes a city dweller's nostalgia for the simpler and more sensuous life of the country, and it is easy to imagine the foreground shepherd boasting to his companion the superior virtues of their life in contrast to that in the city, toward which he gestures.

England

What features characterize the Classicism of English architecture?

England and Scotland were joined in 1603 with the ascent to the English throne of James VI of Scotland, who reigned over Great Britain as James I (ruled 1603–1625). James increased royal patronage of British artists, especially in literature and architecture. William Shakespeare wrote *Macbeth*, featuring the king's legendary ancestor Banquo, in tribute to the new royal family, and the play was performed at court in December 1606.

Although James's son Charles I was an important collector and patron of painting, religious and political tensions that erupted into civil war cost Charles his throne and his life in 1649. A succession of republican and monarchical rulers who alternately supported Protestantism or Catholicism followed, until the Catholic king James II was deposed in the Glorious Revolution of 1689 by his Protestant son-in-law and daughter, William and Mary. After Mary's death in 1694, William (the Dutch great-

23–57 Inigo Jones **BANQUETING HOUSE, WHITEHALL PALACE**
London. 1619–1622.

Credit: © akg-images /A.F.Kersting

grandson of William of Orange, who had led the Netherlands' independence movement) ruled on his own until his death in 1702. He was succeeded by Mary's sister, Anne (ruled 1702–1714).

Architecture

In sculpture and painting, the English court favored foreign artists. The field of architecture, however, was dominated in the seventeenth century by the Englishmen Inigo Jones, Christopher Wren, and Nicholas Hawksmoor. They replaced the country's long-lived Gothic style with Classicism.

INIGO JONES In the early seventeenth century, Inigo Jones (1573–1652) introduced to England his version of Renaissance Classicism, based on the style of Italian architect Andrea Palladio. Jones had studied Palladio's work in Venice, and he filled his copy of Palladio's *Four Books of Architecture*—still preserved—with notes. Appointed surveyor-general in 1615, Jones was commissioned to design the Queen's House in Greenwich and the Banqueting House for the royal palace of Whitehall.

The **BANQUETING HOUSE** (**FIG. 23-57**), built in 1619–1622 to replace an earlier hall destroyed by fire, was used for court ceremonies and entertainments such as the popular masques—stylized dramas combining theater, music, and dance in spectacles performed by professional actors, courtiers, and even members of the royal family itself. The west front, shown here, consisting of what appears to be two upper stories

with superimposed Ionic and Composite orders raised over a plain basement level, exemplifies the understated elegance of Jones's interpretation of Palladian design. Pilasters flank the end bays, and engaged columns subtly emphasize the three bays at the center, a disposition repeated in the balustrade along the roofline. A rhythmic effect results from varying window treatments—triangular and segmental (semicircular) pediments on the first level, cornices with volute (scroll-form) brackets on the second. The sculpted garlands just below the roofline add an unexpected decorative touch.

Although the exterior suggests two stories, the interior of the Banqueting House (**FIG. 23-58**) is actually one large hall divided by a balcony, with antechambers at each end. Ionic columns and pilasters suggest a colonnade but do

23–58 INTERIOR, BANQUETING HOUSE, WHITEHALL PALACE

Ceiling paintings of the apotheosis of King James and the glorification of the Stuart monarchy by Peter Paul Rubens. 1630–1635.

Credit: Historic Royal Palaces Enterprises Ltd

not impinge on the ideal, double-cube space, which measures 55 feet in width by 110 feet in length by 55 feet in height. In 1630, Charles I commissioned Peter Paul Rubens—who was in England on a peace mission—to decorate the ceiling. Jones had divided the flat ceiling into nine compartments, for which Rubens painted canvases glorifying the reign of James I. Installed in 1635, the central oval shows the triumph of the Stuart dynasty with the king carried to heaven on clouds of glory. The large rectangular panel beyond it depicts the birth of the new nation, flanked by allegorical paintings of heroic strength and virtue overcoming vice. In the long paintings alongside the oval, *putti* holding the fruits of the earth symbolize the peace and prosperity of England and Scotland under Stuart rule. So proud was Charles of the result that, rather than allow the smoke of candles and torches to harm the ceiling decoration, he moved evening entertainments to an adjacent pavilion.

**23–60 Christopher Wren FAÇADE OF
ST. PAUL'S CATHEDRAL, LONDON**
Designed 1673, built 1675–1710.

CHRISTOPHER WREN After Jones's death, English architecture was dominated by Christopher Wren (1632–1723) who began his professional career in 1659 as a professor of astronomy. For Wren, architecture was a sideline until 1665, when he traveled to France to further his education. While there, he met with French architects and with Bernini, who was in Paris to consult on designs for the Louvre. Wren returned to England with architecture books, engravings, and a greatly increased admiration for French Classical Baroque design. In 1669, he was made surveyor-general, the position once held by Jones, and in 1673, he was knighted.

After the Great Fire of 1666 destroyed large parts of central London, Wren was continuously involved in rebuilding the city, including more than 50 churches. His major project from 1675 to 1710 was the rebuilding of **ST. PAUL'S CATHEDRAL** (**FIG. 23-59**). Attempts to salvage the burned-out Gothic church on the site failed, and a new cathedral was needed. Wren's famous second design for St. Paul's (which survives in the so-called "Great Model" of 1672–1673) was for a centrally planned building with a great dome in the manner of Bramante's original plan for St. Peter's. This was rejected, but Wren ultimately succeeded in reconciling Reformation tastes for a basilica with the unity inherent in the use of a dome. St.

Paul's has a long nave and equally long sanctuary articulated by small, domed bays. Semicircular, colonnaded porticos open into short transepts that compress themselves against the crossing, where the dome rises 366 feet from ground level. Wren's dome has an interior masonry vault with an oculus and an exterior sheathing of lead-covered wood, but also has a brick cone rising from the inner oculus to support a tall lantern. The ingenuity of the design and engineering remind us that Wren had been a mathematician and professor of astronomy at Oxford. The columns surrounding the drum on the exterior recall Bramante's Tempietto in Rome (SEE FIG. 21-21), although Wren never went to Italy and knew Italian architecture only from books.

On the façade of St. Paul's (**FIG. 23-60**), two levels of paired Corinthian columns support a carved pediment. The deep-set porticos and columned pavilions atop the towers create dramatic areas of light and shadow. The huge size of the cathedral combines with its triumphant verticality, complexity of form, and *chiaroscuro* effects to make it a major monument of English architecture. Wren recognized the importance of the building. On the simple marble slab that forms his tomb in the crypt of the cathedral, he had engraved: "If you want to see his memorial, look around you."

Think About It

1 Discuss how Bernini and Caravaggio established the Baroque style in sculpture and painting, respectively. Locate the defining traits of the style in at least one work from this chapter by each artist.

2 Discuss the development of portraiture, still life, and genre painting in the Dutch Republic during the seventeenth century. What accounts for the increased importance of these subjects at this time?

3 Choose two paintings of monarchs in this chapter and explain how the artists who painted them embodied the ruler's prestige and power. Are the strategies of these painters different from those employed by painters of powerful people in the sixteenth century?

4 Determine how Poussin's landscapes depart from other stylistic currents at the time. What is meant by the term "Classicism" in relation to Poussin's style? Comment on its importance for the future of French art.

Crosscurrents

These two works visualize the same religious theme—the Last Judgment. But they are placed in different locations within their buildings, engaging different audiences in distinct ways. How do they represent the cultural goals and stylistic systems of their time and place? Do they have anything other than their subject in common?

FIG. 16–24

FIG. 23–15

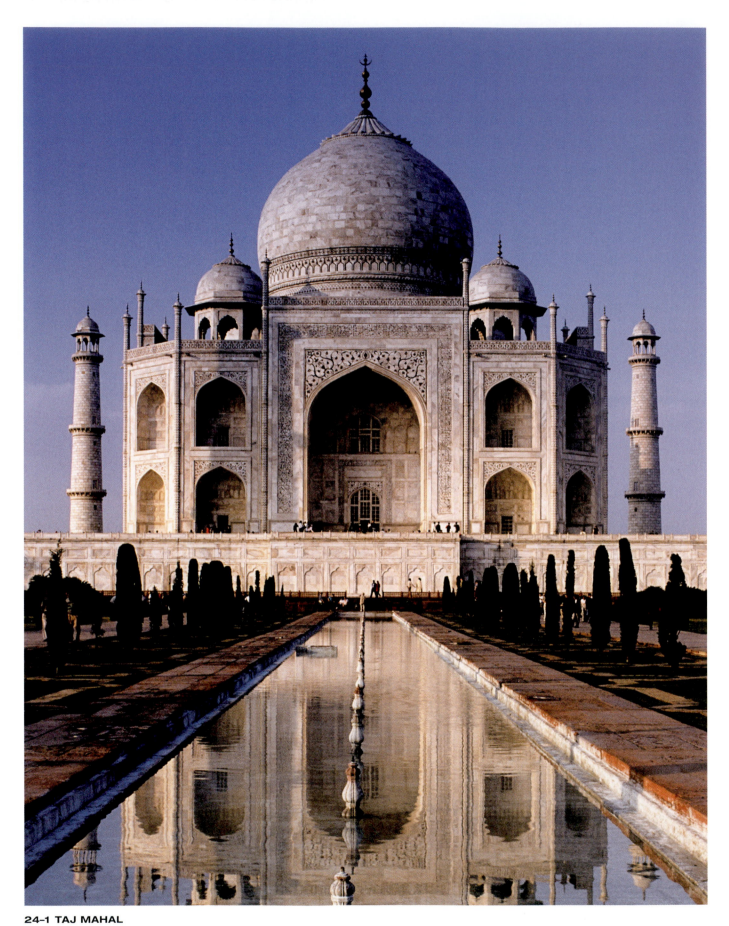

24–1 TAJ MAHAL

Agra, India. Mughal period, reign of Shah Jahan, c. 1631–1648.

Credit: © Peter Adams/Corbis

Chapter 24
Art of South and Southeast Asia after 1200

 ## Learning Objectives

24.a Identify the visual hallmarks of South and Southeast Asian art after 1200 for formal, technical, and expressive qualities.

24.b Interpret the meaning of works of South and Southeast Asian art after 1200 based on their themes, subjects, and symbols.

24.c Relate artists and art of South and Southeast Asia after 1200 to their cultural, economic, and political contexts.

24.d Apply the vocabulary and concepts relevant to the art, artists, and art history of South and Southeast Asia after 1200.

24.e Interpret a work of South or Southeast Asian art after 1200 using the art historical methods of observation, comparison, and inductive reasoning.

24.f Select visual and textual evidence in various media to support an argument or an interpretation of a work of South or Southeast Asian art after 1200.

Upon entering the gateway that today serves as the entrance to the great Taj Mahal complex, the visitor beholds the majestic white marble structure that is one of the world's best-known monuments. Its reflection shimmers in the pools of the garden meant to evoke a vision of paradise as described in the Qur'an. The building's façades are delicately inlaid with inscriptions designed by India's foremost calligrapher of the time, Amanat Khan, and floral arabesques in semiprecious stones: carnelian, agate, coral, turquoise, garnet, lapis, and jasper. Above, its luminous white marble dome reflects each shift in light, flushing rose at dawn, dissolving in its own brilliance in the noonday sun. This extraordinary building—originally and appropriately called the Illuminated Tomb and only since the nineteenth century known as the **TAJ MAHAL** (FIG. 24–1)—was built between 1631 and 1648 by the Mughal ruler Shah Jahan as a mausoleum for his favorite wife, Mumtaz Mahal, who died in childbirth, and likely as a tomb for himself.

Inside, the Taj Mahal invokes the *hasht behisht* ("eight paradises") with the eight small chambers that ring the interior—one at each corner and one behind each *iwan*, a vaulted opening with an arched portal that is a typical feature of eastern Islamic architecture. In two stories (for a total of 16 chambers), the rooms ring the octagonal

central area, which rises the full two stories to a domed ceiling that is lower than the outer dome. In this central chamber, surrounded by a finely carved octagonal openwork marble screen, are the exquisite inlaid **cenotaphs** (funerary monuments to someone whose remains lie elsewhere) of Shah Jahan and his wife, whose actual tombs lie in the crypt below.

The Taj Mahal complex includes much more than the white marble tomb. On one side is a mosque, while opposite and very similar in appearance is a building that may have served as a rest house. The enormous garden, both in front of the building and in its continuation on the opposite side of the Jamuna River, lends a lush setting consistent with Islamic notions of paradise. The side buildings and the two parts of the garden provide a sense of perfect symmetry to the entire complex.

A dynasty of Central Asian origin, the Mughals were the most successful of the many Islamic groups that established themselves in India beginning in the twelfth century. Under their patronage, Persian and Central Asian influences continued, but the Mughals intentionally cultivated connections with older traditions of the South Asian subcontinent, adding yet another dimension to the already ancient and complex artistic heritage of India.

Foundations of Indian Culture

What aspects of the early history, culture, and art of South Asia form a critical background for the development of art and architecture after 1200?

The earliest civilization on the Indian subcontinent flourished toward the end of the third millennium BCE along the Indus River in present-day Pakistan. Remains of its expertly engineered brick cities have been uncovered, together with works of art that intriguingly suggest spiritual practices and reveal artistic traits known in later Indian culture.

The decline of the Indus civilization during the mid second millennium BCE coincides with the arrival from the northwest of a seminomadic people who spoke an Indo-European language and referred to themselves as Aryans. Over the next millennium they were influential in formulating the new civilization that gradually emerged. The most important Aryan contributions to this new civilization included the Sanskrit language and the sacred texts called the Vedas. The evolution of Vedic thought under the influence of indigenous Indian beliefs culminated in the mystical philosophical texts called the Upanishads, which took shape sometime after 800 BCE.

The Upanishads teach that the material world is illusory; only Brahman, the universal soul, is real and eternal. We—that is, our individual souls—are trapped in this illusion in a relentless cycle of birth, death, and rebirth. The ultimate goal of religious life is to liberate ourselves from this cycle and to unite our individual soul with Brahman.

Buddhism and Jainism are two of the many religions that developed in the wake of Upanishadic thought. Buddhism is based on the teachings of Shakyamuni Buddha, who lived in central India about 500 BCE. Jainism was shaped slightly earlier by the followers of the spiritual leader Mahavira. Both religions acknowledged the cyclical nature of existence and taught a means of liberation from it, but they rejected the authority, rituals, and social strictures of Vedic religion. The Vedic religion was in the hands of a hereditary priestly class, but Buddhist and Jain communities welcomed all members of society, which gave them great appeal. The Vedic tradition eventually evolved into the many sects now collectively known as Hinduism.

Through most of its history India was a mosaic of regional dynastic kingdoms, but from time to time empires emerged that unified large parts of the subcontinent. The first was that of the Maurya dynasty (c. 322–185 BCE), whose great king Ashoka patronized Buddhism. From this time Buddhist doctrines spread widely and its artistic traditions were established.

In the first century CE the Kushans, a Central Asian people, created an empire extending from present-day Afghanistan down into central India. Buddhism prospered under Kanishka, the most powerful Kushan king, and spread into Central Asia and East Asia. Under the new Kushan cultural and political climate, the image of the Buddha first appeared.

Later, under the Gupta dynasty (c. 320–550 CE) in northern India, Buddhist art and culture reached a high point. However, Gupta monarchs also patronized Hindu art, and from this time Hinduism grew to become the dominant Indian religious tradition, with its emphasis on the great gods Vishnu, Shiva, and the Goddess—all with multiple forms.

After the tenth century, numerous regional dynasties prevailed, some quite powerful and long-lasting. Hindu temples, in particular, developed monumental and complex forms that were rich in symbolism and ritual function, with each region of India producing its own variation.

South Asia 1200–1800

What are the characteristic features of the Buddhist, Jain, Islamic, and Hindu art and architecture of India from 1200 to 1800?

By 1200, India was already among the world's oldest civilizations. The art that survives from its earlier periods is often inspired by the three principal religions: Buddhism, Hinduism, and Jainism. These three religions remained a primary focus for Indian art, even as dynasties arriving from the northwest began to expand the influential religious culture of Islam.

Changes in Religion and Art

After many centuries of prominence, Buddhism began to decline as a cultural force in India after the eighth century, many of its sacred centers and much of its imagery having been absorbed into Hinduism. As patronage diminished, many Indian Buddhist monks sought out more supportive communities in Southeast Asia, where Buddhism remained an important religion. At the start of the twelfth century, Kyanzittha, the Burmese king of Bagan, who was known to have hosted Indian monks, actually sent crews to Buddhist centers in South Asia to repair the neglected monuments. By 1200, the remaining Buddhist enclaves in South Asia were concentrated in the northeast, in the region that had been ruled by the Pala dynasty (c. 750–1199). There, in great monastic universities that attracted monks from as far away as China, Korea, and Japan, a form of Buddhism known as Tantrism or Vajrayana was cultivated.

Over these same centuries, Hinduism quickly rose to new prominence, inspiring grand temples, sculpture, and poetry across the subcontinent. Jainism continued to prosper as its relatively small community of adherents grew in regional influence. And the new religion of Islam entered from the northwest, eventually to have a profound influence on South Asian culture.

MAP 24–1 SOUTH AND SOUTHEAST ASIA

Throughout its history, the kingdoms comprising the Indian subcontinent engaged—sometimes peacefully, sometimes militarily—with neighboring and more distant people, contributing significantly to the development of its art.

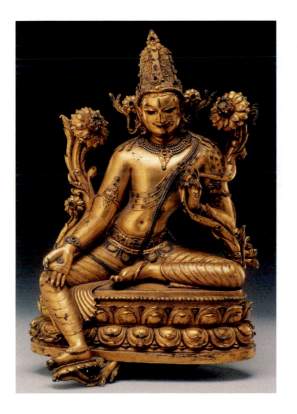

THE BODHISATTVA AVALOKITESHVARA The practices of Tantric Buddhism, which include techniques for visualizing deities, encouraged the development of images with precise iconographic details, such as the twelfth-century gilt-bronze sculpture of **THE BODHISATTVA AVALOKITESHVARA** (**FIG. 24–2**) from the site of Kurkihar in eastern India. Bodhisattvas are compassionate beings who are well advanced on the path to buddhahood (enlightenment) and who have vowed to help others achieve enlightenment. Avalokiteshvara, the bodhisattva of greatest compassion who vowed to forgo buddhahood until all others become buddhas, became the most popular of these saintly beings in India and in East Asia.

Characteristic of bodhisattvas, Avalokiteshvara is distinguished in art by his princely garments, unlike a buddha, who wears monk's robes. Avalokiteshvara is specifically recognized by the lotus flower he holds and by the presence in his crown of his "parent" Buddha, in this case Amitabha, the Buddha of the Western Pure Land (a Buddhist paradise). Other marks of Avalokiteshvara's extraordinary status are

24–2 THE BODHISATTVA AVALOKITESHVARA
From Kurkihar, Bihar. Pala dynasty, 12th century. Gilt-bronze, height 10″ (25.5 cm). Patna Museum, Patna.

Credit: Photo © Dirk Bakker/Bridgeman Images

the third eye (symbolizing his omniscience) and the wheel on his palm (an emblem of the Buddhist *dharma*). Avalok-iteshvara is shown here in the relaxed pose known as the posture of "royal ease." One leg angles down; the other is drawn up onto the lotus seat.

With the fall of the Pala dynasty in the late twelfth century, the last centers of Buddhism in northern India collapsed, and most of the monks dispersed, mainly into Nepal and Tibet (**MAP 24-1**)—which have remained the principal stronghold of Tantric Buddhist practice and its arts since that time. The artistic style perfected under the Palas, however, came to influence international style throughout East and Southeast Asia.

LUNA VASAHI, MOUNT ABU The history of Jainism makes an interesting counterpoint to that of Buddhism. Although both are monastic traditions, the Jains never gained the widespread popularity of Buddhism—but nei-ther did they suffer a precipitous decline. The Jain reli-gion traces its roots to a spiritual leader called Mahavira (c. 599–527 BCE), whom it regards as the last in a series of 24 saviors known as pathfinders (*tirthankaras*). Devotees seek through purification and moral action to become worthy of escaping the cycle of rebirth. Jain monks live a life of austerity, and even laypeople avoid killing any liv-ing creature. The Jain commitment to nonviolence means that there are relatively few Jain kings in South Asian his-tory, but this same commitment led many Jains to gravi-tate toward lucrative professions in banking and trade. It is from these ranks of merchants and ministers that some of the most important donors of Jain art come, as in the case of the Dilwara Temples erected on Mount Abu in Raj-asthan, India. The modest exterior enclosure walls and relatively small size of the five Dilwara Temples do little to prepare the visitor for the lacelike splendor of the interior. Every inch of these spaces is filled with deeply cut relief carvings in white marble whose complicated details had to be produced through abrasion and rubbing rather than with a chisel. One of the most impressive of these temples, the Luna Vasahi, was dedicated to the 22nd Jain *tirthankara*, Neminatha, and was built in 1230 by two brothers, Tejpala and Vastupala, who served as ministers to the local ruler. They are known to have sponsored temples in at least two other locations. The structure has had to be repaired in places, the damage most likely caused by raids, but most of the delicate sculpture is still intact.

The main sanctuary is set in a courtyard surrounded by two columned arcades. These open to reveal the tem-ple's most impressive architectural feature, the ornate dome that crowns the *mandapa* hall. This corbeled dome is made of concentric bands of sculpted stone capped with a meticulously carved pendant which hangs down from the apex. Surrounding this decorative element are images of 16 goddesses of wisdom, attached individually to the

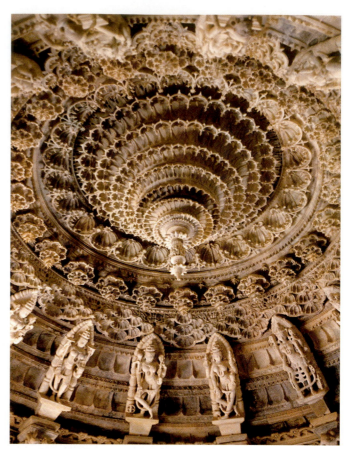

24-3 LUNA VASAHI, MANDAPA CEILING
Mount Abu, India. 1230.

Credit: © Eye Ubiquitous/Alamy Stock Photo

surface of the dome. This, in turn, is held aloft by eight pillars linked by undulating architraves (**FIG. 24-3**). Every surface is adorned with narrative scenes, animals, protec-tive deities, and plant motifs. These riotous forms high-light the calm, unadorned image of the *tirthankara*, which looks out from the quietude of the sanctuary. The dramatic contrast speaks to the difference between the active world of constant rebirth and the steady peace of enlightenment.

QUTB MINAR Traders and merchants were the first to bring Islam to South Asia, but the backing of political rul-ers, which helped to establish it across the region, did not occur until the eighth century when Arab communities established a small territory near the Indus River. Later, beginning around 1000, Turkic factions from Central Asia, relatively recent converts to Islam, began military cam-paigns into north India—at first purely for plunder, then seeking territorial control. From the thirteenth century various Turkic and Afghan dynasties ruled portions of the subcontinent from the northern city of Delhi. These sultan-ates, as they are known, constructed forts, mausoleums, monuments, and mosques.

The first Delhi Sultanate was founded in 1206 by Qutb-ud-din Aibak of the Slave dynasty, so named because Aibak had begun his life as a soldier-slave (*mamluk*) under

the Ghorids. Although he did not reign long, he began construction of a large mosque adorned with a truly massive minaret. The mosque complex, called Quwwat ul-Islam ("strength of Islam"), was built over the citadel of Delhi's previous rulers, and portions of the Jain and Hindu religious structures from this location were reused in the construction of the mosque. By far the most visible element of this complex is the tower known as the **QUTB MINAR** (FIG. **24-4**). This minaret was begun by Aibak and completed under his successor, Iltutmish. It stands over 237 feet high and was among the tallest structures in South Asia at the time. It was constructed of sandstone in five segments, each of which is marked by the presence of a balcony that encircles the tower. The stories get smaller farther up the tower, and the final balcony rests on the top. Minarets are traditionally used to call Muslims to prayer, but this tower is too tall to serve that purpose easily and serves more clearly as an expression of power and political authority than as a functioning religious structure.

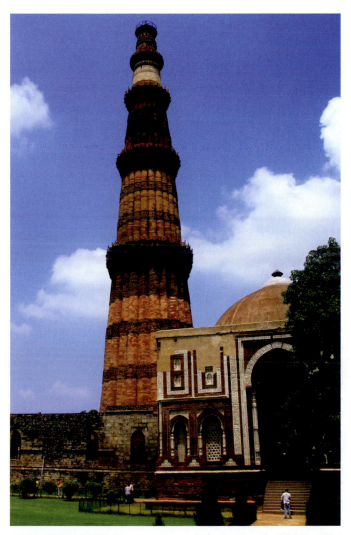

24-4 QUTB MINAR
Quwwat ul-Islam Mosque, Mehrauli Archaeological Park, Delhi. 1211–1236.

Credit: Icon72/Fotolia

Hindu Architectural Developments

With the increasing popularity of Hindu sects came the rapid development of Hindu temples. Spurred by the ambitious building programs of wealthy donors, well-formulated regional styles had evolved by about 900. The most spectacular structures of the era were monumental, with a complexity and grandeur of proportion rarely equaled even in later Indian art.

Emphasis on monumental temples gave way to the building of vast temple complexes and more moderately scaled, yet more richly ornamented, individual temples. These developments took place largely in the south of India, although some of the largest temples are in the north—for example, the Sun Temple at Konarak, built in the thirteenth century, and the Govind Deva Temple in Brindavan, built in the sixteenth century under the patronage of the Mughal emperor Akbar. The mightiest of the southern Indian kingdoms was Vijayanagara (c. 1336–1565), whose rulers successfully countered the potential incursions of neighboring dynasties, both Hindu and Muslim, for more than 200 years. Under the patronage of the Vijayanagara kings and their successors, the Nayaks, some of India's most spectacular Hindu architecture was created.

VIJAYANAGARA ("the City of Victory") was the capital of an empire that flourished in South India between the fourteenth and sixteenth centuries. Scholars estimate that at its peak the city was the second most populous in the world and had fortifications encompassing an area of 250 square miles. As a center of trade, Vijayanagara housed small, itinerant communities from across Asia, Europe, and the Middle East, and within the settled population were devotees of Hinduism, Islam, Jainism, and Christianity. Among the visitors drawn by this city's wealth and fame were those who left travel accounts praising its lush gardens, expansive waterways, abundant markets, grand temples, and stone arcades. At the heart of this sprawling urban center stood the **VIRUPAKSHA TEMPLE** (FIG. **24-5**); its founding pre-dates the birth of the city, but it was expanded in size and splendor along with the empire's capital.

The brothers Bukka and Harihara first enlarged this temple to Shiva in the mid fourteenth century as they prayed for the protection and success of their new empire. Most of the temple as it now stands, however, was built by later donors in the fifteenth and sixteenth centuries. The temple is notable for its grand eastward-facing **gopura** (entrance gateway), whose nine-tiered tower reaches over 160 feet in height. This gateway connects the outer temple courtyard to a long, colonnaded road that was used for ceremonial processions and may also have contained stalls for vendors. A smaller *gopura*, which along with the central pillared hall was donated by the great king Krishnadevaraya in the early 1500s, provides access to the inner courtyard. Krishnadevaraya, like all kings of Vijayanagara,

24–5 VIRUPAKSHA TEMPLE, VIJAYANAGARA

Hampi, India. Founded before the 9th century but expanded in the 14th–16th centuries.

Credit: © Eugil Chandran/Alamy Stock Photo

continued to recognize the Virupaksha form of Shiva as the special defender of the empire and the royal line.

While the temples in Vijayanagara tend to follow conservative South Indian architectural forms, the civic architecture exhibits hybrid forms that reflect the religious and ethnic diversity of the city's population. This appropriation of diverse architectural techniques is apparent in the royal **ELEPHANT STABLES** (FIG. 24-6). The structure utilizes both traditional South Indian architectural forms and elements associated with Islamic (or sultanate) architecture, namely the arch and dome, to span the large spaces needed to comfortably house such massive animals. The court stabled its elephants in grand fashion because these powerful animals had both ceremonial and military functions. They were living emblems of the state's pageantry and power. The structure contains ten chambers divided by a central structure capped with a rooftop pavilion. This pavilion most likely held musicians and served as a viewing platform from which important individuals could observe military maneuvers conducted in the parade grounds that stretch out in front of the stables. The individual chambers are placed in a row and alternate between two types, one

24–6 ELEPHANT STABLES, VIJAYANAGARA

Hampi, India. 15th century.

Credit: © age fotostock/Alamy Stock Photo

crowned by a semicircular dome and the other by a conical vault. As with many structures in Vijayanagara this building is unique, and its style reflects the court's comfort with foreign ideas.

TEMPLE AT MADURAI The enormous temple complex at Madurai, one of the capitals of the Nayaks, is a fervent expression of Hindu faith. Founded around the fourteenth century and greatly expanded in the seventeenth, it is dedicated to the goddess Minakshi (the local name for Parvati, the consort of the god Shiva) and to Sundareshvara (the local name for Shiva himself). The temple complex stands in the center of the city and is the focus of Madurai life. At its heart are the two oldest shrines, one to Minakshi and the other to Sundareshvara. Successive additions over the centuries gradually expanded the complex around these small shrines and came to dominate the visual landscape. The most dramatic features of this and similar southern "temple cities" were the thousand-pillar halls, large ritual-bathing pools, and especially the entrance gateways (*gopuras*) that tower above the temple site and the surrounding city like modern skyscrapers (**FIG. 24-7**).

As a temple city grew, it needed bigger enclosing walls, and thus new gateways. Successive rulers and powerful merchants of the Chettiyar community, often seeking to outdo their predecessors, donated taller and taller *gopuras*. As a result, the tallest structures in temple cities are often at the periphery, rather than at the central temples, which are sometimes totally overwhelmed by the height of the surrounding structures. The temple complex at Madurai has 11 *gopuras*, the largest over 160 feet tall.

Formally, the *gopura* has its roots in the pyramidal tower characteristic of the seventh-century southern temple style. As the *gopura* evolved, it took on the graceful concave silhouette shown here. The exterior is embellished with thousands of sculpted figures, evoking a teeming world of gods and goddesses. Inside, stairs lead to the top for an extraordinary view.

24–7 OUTER GOPURA OF THE MINAKSHI-SUNDARESHVARA TEMPLE
Madurai, Tamil Nadu, India. Nayak dynasty, mostly 13th to mid 17th century, with modern renovations.

Credit: Courtesy of Marilyn Stokstad

Mughal Period

The Mughals, like many of the Delhi sultans, came from Central Asia. Muhammad Zahir-ud-Din, known as Babur ("Lion" or "Panther"), was the first Mughal emperor of India (ruled 1526–1530). He emphasized his Turkic heritage, though he had equally impressive Mongol ancestry. After some initial conquests in Central Asia, he amassed an empire stretching from Afghanistan to Delhi, which he conquered in 1526. Akbar (ruled 1556–1605), the third ruler, extended Mughal control over most of north India, and under his two successors, Jahangir and Shah Jahan, northern India was generally unified by 1658. The Mughal Empire lasted until 1858, when the last Mughal emperor was deposed and exiled to Burma (today's Myanmar) by the British.

Mughal architects were heir to a 300-year-old tradition of Islamic building in India. The Delhi sultans who preceded them had great forts housing government and court buildings. Their architects had introduced two fundamental Islamic structures, the mosque and the tomb, along with construction based on the arch and the dome. (Earlier Indian architecture had been based primarily on post-and-lintel construction.) They had also drawn freely on Indian architecture, borrowing both decorative and structural elements to create a variety of hybrid styles, and had especially benefited from the centuries-old Indian virtuosity in stonecarving and masonry. The Mughals followed in this tradition, synthesizing Indian, Persian, and Central Asian elements for their forts, palaces, mosques, tombs, and cenotaphs.

The third emperor, Akbar, presided over a period of openness and expansion. His inclusive policies and tolerance toward religious difference did much to help solidify and stabilize his massive empire. A dynamic, humane, and just leader, Akbar enjoyed religious discourse and loved the arts, especially painting. He created an imperial **atelier** (workshop) of painters, which he placed under the direction of two artists from the Persian court. Learning from these two masters, the Indian painters of the atelier soon transformed Persian styles into the more vigorous, naturalistic styles that mark Mughal painting (see "Indian Painting on Paper" below).

FATEHPUR SIKRI Despite all this success Akbar was concerned about who would follow him on the throne. In desperation, he sought the advice of the Sufi mystic Shaikh Salim Chishti. This Muslim holy man foretold the birth of a prince, and when his prediction proved accurate, Akbar built a new capital near Chishti's home to commemorate and celebrate the event. Built primarily during Akbar's residence at the site from about 1572 to 1585, there are two major components to Fatehpur Sikri: one section including the Jami Mosque, which houses the tomb of Salim Chishti, and another containing the administrative and residential section. Among the most extraordinary buildings in the administrative and residential section is the private audience hall or **DIWAN-I-KHAS** (FIG. 24–8). In the center of the hall is a tall pillar supporting a circular platform reached by four walkways. On this perch Akbar could have sat majestically as he received his nobles and dispensed

Technique
INDIAN PAINTING ON PAPER

Before the fourteenth century most painting in India had been on walls or palm leaves. With the introduction of paper, about the same time in India as in Europe, Indian artists adopted painting techniques from Persia and over the ensuing centuries produced jewel-toned works on paper.

Painters usually began their training early. As young apprentices, they learned to make brushes and grind pigments. Brushes were made from the curved hairs of a squirrel's tail, arranged to taper from a thick base to a single hair at the tip. Paint came from pigments of vegetables and minerals—lapis lazuli to make blue, malachite for pale green—that were ground to a paste with water, then bound with a solution of gum from the acacia plant. Paper was made by crushing fibers of cotton and jute to a pulp, pouring the mixture onto a woven mat, drying it, and then burnishing with a smooth piece of agate, often achieving a glossy finish.

First, the painter applied a thin wash of a chalk-based white, which sealed the surface of the paper while allowing any underlying sketches to show through. Next, outlines were filled with thick washes of brilliant, opaque, unmodulated color. When the colors were dry, the painting was laid face down on a smooth marble surface and burnished with a rounded agate stone, rubbing first up and down, then side to side. The indirect pressure against the marble polished the pigments to a high luster. Then outlines, details, and modeling—depending on the style—were added with a fine brush.

Sometimes certain details were purposely left until last, such as the eyes, which were said to bring the painting to life. Gold and raised details were applied when the painting was nearly finished. Gold paint, made from pulverized, 24-carat gold leaf bound with acacia gum, was applied with a brush and burnished to a high shine. Raised details such as the pearls of a necklace were made with thick, white, chalk-based paint, with each pearl a single droplet hardened into a tiny raised mound.

My liking for painting and my practice in judging it have arrived at such a point that when any work is brought before me, either of deceased artists or of those of the present day, without their names being told me I say on the spur of the moment that it is the work of such and such a man, and if there be a picture containing many portraits, and each face be the work of a different master, I can discover which face is the work of each of them. And if any other person has put in the eye and eyebrow of a face, I can perceive whose work the original face is and who has painted the eye and eyebrows.

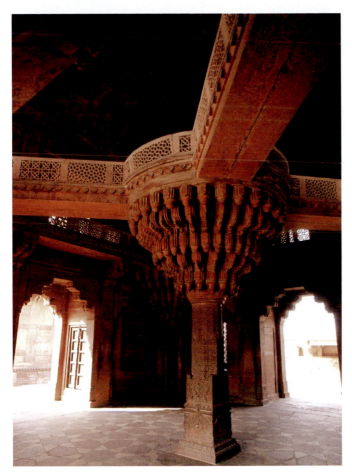

24-8 DIWAN-I-KHAS (PRIVATE AUDIENCE HALL)
Fatehpur Sikri, India. 1570.

Credit: MrPeak/Fotolia

justice. The structure recalls, perhaps consciously, the pillars erected by Ashoka to publicize his law.

Unlike most Mughal emperors, Akbar did not write his own biography; instead he entrusted its creation to his vizier Abul Fazl. This text, the *Akbarnama* (**FIG. 24-9**), details the actions and accomplishments of the emperor, including the events leading to the construction of Fatehpur Sikri.

Paintings commissioned to illustrate this event round out our understanding of Mughal building techniques and reveal Akbar's personal interest in the progress. Among the most fascinating illustrations in this manuscript are those that record Akbar's supervision of the construction of Fatehpur Sikri. One painting (SEE FIG. 24-9) documents his inspection of the stonemasons and other craftspeople. Akbar's love of painting set a royal precedent that his successors enthusiastically continued.

PAINTING IN THE COURT OF JAHANGIR Jahangir (ruled 1605–1627), Akbar's son and successor, was a connoisseur of painting; he had his own workshop, which he established even before he became emperor. His focus on detail was much greater than that of his father. In his memoirs, he claimed:

24-9 AKBAR INSPECTING THE CONSTRUCTION OF FATEHPUR SIKRI
From the *Akbarnama*. c. 1590. Opaque watercolor on paper, 14¾ × 10″ (37.5 × 25 cm). Victoria & Albert Museum, London. (I.S.2-1896 91/117).

Many of the painters in the Mughal imperial workshops are recorded in texts of the period. Based on those records and on signatures that occur on some paintings, the design of this work has been attributed to Tulsi Kalan (Tulsi the Elder), the painting to Bandi, and the portraits to Madhu Kalan (Madhu the Elder) or Madhu Khurd (Madhu the Younger).

Credit: V&A Images/Victoria and Albert Museum

24–10 Nadir al-Zaman (Abu'l Hasan)
JAHANGIR AND SHAH ABBAS
From the St. Petersburg Album. Mughal period,
c. 1618. Opaque watercolor, gold, and ink on
paper; 9⅜ × 6″ (23.8 × 15.4 cm). Freer Gallery
of Art, Smithsonian Institution, Washington, DC.
Purchase, F1945.9.

Credit: Bridgeman Images

together, an ancient symbol of har-
mony, also appears to bolster this inter-
pretation. Indeed, the fact that the men
are framed by the sun and moon while
standing on a map of the world might
imply that these bonds of trust and peace
extend even to their respective states. Yet
nothing could be further from the truth.

This painting was created in a
moment of high tension between Shah
Abbas and the Mughal throne. The trou-
ble centered on Kandahar in Afghani-
stan. The prosperous city had been given
to Shah Abbas's ancestor by the Mughal
emperor Humayun, but later, in the time
of Akbar, the Mughals took back control
of the city. Shah Abbas then waited for a
chance to reclaim it, believing it was his
right to do so. When the Mughals were
distracted by civil conflict in South Asia,
he seized the opportunity and recaptured
Kandahar in a swift assault. He immedi-
ately made conciliatory gestures to Jahan-
gir, who was furious but unable to spare
the military force needed to retake the city.

Another look at the painting reveals
new details. Jahangir is depicted much
larger than Shah Abbas, who appears to
bow deferentially to the Mughal emperor.
Jahangir's head is centered in the halo and
he stands on the predatory lion, whose
body spans a vast territory, including Shah Abbas's own
holdings in Afghanistan and Iran. These details invert the
initial impression conveyed by the subject, revealing a new
meaning. The painting, cloaked in the diplomatic language of
cordiality and reconciliation, is a strong reminder of Mughal
superiority and a potent warning against further expansion

Despite the proliferation of portrait painting, depictions
of court women occur rarely in Mughal art, due in part to
the restricted access male painters had to the women's quar-
ters. An important exception to this was Jahangir's favorite
wife, Empress Nur Jahan, of whom a few images exist. As
Jahangir grew older he succumbed to addiction and illness.
During this period, in which he was largely incapacitated,
Nur Jahan ran the empire on his behalf, carrying his seal

Portraits became a major art under Jahangir. We can only
speculate on the target audience for the portrait Jahangir
commissioned of himself with the Safavid-dynasty Per-
sian ruler, Shah Abbas. The painting of **JAHANGIR AND
SHAH ABBAS** (FIG. 24–10) is of such small size it could not
be publicly displayed and was, therefore, certainly not
intended for Jahangir's subjects. But because we know that
paintings were commonly conveyed by embassies from
one kingdom to another, it may have been intended to be
taken, or even just seen, by one of Shah Abbas's represen-
tatives at court.

At first glance this painting of two rulers embracing
seems to tell of a close bond of friendship between the
men. The presence of a lion and lamb laying peacefully

and issuing decrees in his name. Although she ruled in Jahangir's name, the images of her at court and the imperial coins that bore her name suggest her role was no secret.

The idyllic scene depicted in **FIGURE 24-11** portrays Nur Jahan serving food and drink to Jahangir and his son by another wife, Prince Khurram. Seated on ornate carpets the royal family members sit near a fountain as court women bring food and wave fans. This deceptively harmonious tableau is qualified by the verses in Persian surrounding the painting. These refer to Jahangir's displeasure over Khurram's attempts to take the throne, an outcome that Nur Jahan also wished to prevent. After Jahangir died, however, and Nur Jahan was confined to her palace, Khurram managed to seize the throne, taking the royal name Shah Jahan.

THE TAJ MAHAL Shah Jahan (ruled 1628–58) achieved a number of military and political victories, but he is best known as the patron of what is perhaps the most famous of all Indian Islamic structures, the Taj Mahal. Built between

24-11 JAHANGIR AND PRINCE KHURRAM FEASTED BY NUR JAHAN

Mughal period, 1617. Paint and gold on paper, 9^{15}/$_{16}$ × 5^{5}/$_8$″ (25.2 × 14.3 cm). Freer Gallery of Art, Smithsonian Institution, Washington, DC. Gift of Charles Lang Freer (F1907.258).

Credit: Bridgeman Images

1631 and 1648 on the banks of the Jamuna River, it was commissioned as a mausoleum for Mumtaz Mahal, the wife of Shah Jahan, who is believed to have taken a major part in overseeing its design and construction. Shah Jahan's personal motivations add a poignancy to this structure, but it must also be recalled that this was the first major architectural undertaking of Shah Jahan's reign. That the Taj Mahal effectively evokes both personal loss and imperial authority is perhaps its most remarkable strength.

As visitors enter through a monumental, hall-like gate, the tomb rises before them across a spacious garden set with long reflecting pools (SEE FIG. 24-1). Measuring some 1,000 by 1,900 feet, the enclosure is unobtrusively divided into quadrants planted with trees and flowers, and framed by broad walkways and stone inlaid in geometric patterns. In Shah Jahan's time, fruit trees and cypresses—symbolic of life and death, respectively—lined the walkways, and fountains played in the shallow pools. Collectively these features evoked paradise on earth.

Recent archaeology has revealed that the garden continued on the far bank of the Jamuna River. A garden filled with night-blooming plants and a large octagonal fountain provided a vantage point for viewing the Taj Mahal from across the river. Thus while the structure appears to visitors to be set at the end of a garden, it is in fact in the center of a four-part garden, a traditional Mughal tomb setting used for earlier tombs. The tomb is flanked by two smaller structures not visible in FIGURE 24-1, one a mosque and the other a hall designed to mirror it. Like the entrance hall, they are made mostly of red sandstone, rendering even more startling the full glory of the tomb's white marble, a material previously reserved for the tombs of saints and here implying an elevated religious stature for Shah Jahan and Mumtaz Mahal. The tomb is raised higher than these structures on its own marble platform, emphasizing its importance. This aggrandizement of the tomb is further achieved by having the minarets flank the tomb rather than the mosque. The minarets' three levels correspond to those of the tomb, creating a bond between them. Crowning each minaret is a **chattri** (pavilion). Traditional embellishments of Indian palaces, *chattris* quickly passed into the vocabulary of Indian Islamic architecture, where they appear prominently. A lucid geometric symmetry pervades the tomb. It is basically square, but its **chamfered** (sliced-off)

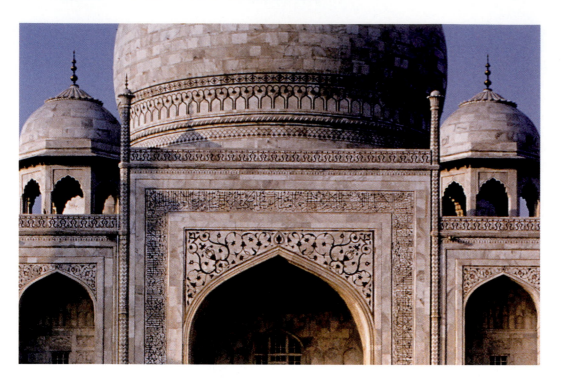

24–12 TAJ MAHAL, DETAIL

Agra, India. Mughal period, reign of Shah Jahan, c. 1631–1648.

Credit: © Peter Adams/Corbis

Rajput painting, more abstract than the Mughal style, included subjects like those treated by Mughal painters: royal portraits and court scenes, as well as indigenous subjects such as Hindu myths, love poetry, and Ragamala illustrations (illustrations of musical modes).

corners create a subtle octagon. Measured to the base of the finial (the spire at the top), the tomb is almost exactly as tall as it is wide. Each façade is identical, with a central *iwan* flanked by two stories of smaller *iwans*. By creating voids in the façades, these *iwans* contribute to the building's sense of weightlessness. On the roof, four octagonal *chattris*, one at each corner, create a visual transition to the lofty, bulbous dome. Framed but not obscured by the *chattris*, the dome rises gracefully and is lifted higher by its drum than in earlier Mughal tombs, allowing the swelling curves and elegant lines of its surprisingly large form to emerge with perfect clarity.

The pristine surfaces of the Taj Mahal are embellished with utmost subtlety (**FIG. 24–12**). Even the sides of the platform on which the Taj Mahal stands are carved in relief with a **blind arcade** (decorative arches set into a wall) motif and carved relief panels of flowers. The portals are framed with verses from the Qur'an and inlaid in black marble, while the spandrels are decorated with floral arabesques inlaid in colored semiprecious stones, a technique known by its Italian name, *pietra dura*. Not strong enough to detract from the overall purity of the white marble, the embellishments enliven the surfaces of this impressive yet delicate masterpiece.

RAJPUT PAINTING Outside the Mughal strongholds at Delhi and Agra, much of northern India was governed regionally by local princes, often descendants of the so-called Hindu Rajput warrior clans, who were allowed to keep their lands in return for allegiance to the Mughals. Like the Mughals, Rajput princes frequently supported painters at their courts, and in these settings a variety of strong, indigenous Indian painting styles were perpetuated.

The Hindu devotional movement known as *bhakti*, which had done much to spread the faith in the south from around the seventh century, now experienced a revival in the north. As it had earlier in the south, *bhakti* inspired an outpouring of poetic literature, this time devoted especially to Krishna, the popular human incarnation of the god Vishnu. Most renowned is the *Gita Govinda*, a cycle of rhapsodic poems about the love between God and humans expressed metaphorically through the love between the young Krishna and the cowherd Radha.

The illustration here (**FIG. 24–13**) is from a manuscript of the *Gita Govinda* probably produced about 1525–1550 in what is present-day Rajasthan. The blue god Krishna sits in dalliance with a group of cowherd women. Standing with her maid and consumed with love for Krishna, Radha peers through the trees, overcome by jealousy. Her feelings are indicated by the cool blue color behind her, while the crimson red behind the Krishna grouping suggests passion. The bold patterns of curving stalks and flowering vines express both the exuberance of springtime, when the story unfolds, and the heightened emotional tensions of the scene. Birds, trees, and flowers are as brilliant against the black, hilly landscape edged in an undulating white line. All the figures are of a single type, with plump faces in profile and oversized eyes. Yet the resilient line of the drawing gives them life, and the variety of textile patterns provides some individuality. The intensity of the color and resolute flatness of the scene engage the viewer in the drama.

Quite a different mood dominates **HOUR OF COW-DUST**, a work from the Kangra School in the Punjab Hills, foothills of the Himalayas north of Delhi (**FIG. 24–14**). Painted around 1790, some 250 years later than the *Gita Govinda* illustration, it shows the influence of Mughal

24–13 KRISHNA AND THE GOPIS

From the *Gita Govinda*, Rajasthan, India. Mughal period, c. 1525–1550. Gouache on paper, 4⅞ × 7½″ (12.3 × 19 cm). Prince of Wales Museum, Mumbai.

The lyrical poem *Gita Govinda*, by the poet-saint Jayadeva, was probably written in eastern India during the latter half of the twelfth century. The poem traces the progress of Krishna and Radha's love through separation, reconciliation, and fulfillment,

naturalism on the later schools of Indian painting. The theme is again Krishna. Wearing his peacock crown, garland of flowers, and yellow garment—all traditional iconography of Krishna-Vishnu—he returns to the village with his fellow cowherds and their cattle. All eyes are upon him as he plays his flute, said to enchant all who hear it. Women with water jugs on their heads turn to look; others lean from windows to watch and call out to him. We are drawn into this village scene by the diagonal movements of the cows as they surge through the gate and into the courtyard beyond. Pastel houses and walls create a sense of space, and in the distance we glimpse other villagers going about their work or peacefully sitting in their houses. A rim of dark trees softens the horizon, and an atmospheric sky completes the aura of enchanted naturalism. Again, all the figures are similar in type, this time with refined proportions and a gentle, lyrical movement that complement the idealism of the setting.

24–14 HOUR OF COWDUST

From the Punjab Hills, India. Mughal period, Kangra School, c. 1790. Gouache on paper, 14¹⁵⁄₁₆ × 12⁹⁄₁₆″ (38 × 31.9 cm). Museum of Fine Arts, Boston. Denman W. Ross Collection (22.683).

24–15 CITY PALACE, UDAIPUR

India, 1559 onward.

Credit: © Ozphotoguy/Getty Images

RAJPUT ARCHITECTURE Just as each Rajput court had a distinctive style of painting, so too was each royal household situated within its own majestic architectural setting. Due to both tradition and political reality, these massive structures often combined regal splendor with imposing fortifications. Royal families typically placed these palaces at strategic hilltop locations and gradually expanded them over the course of generations. As a result, the plans of such structures are often asymmetrical and exceedingly complex, with multiple terraces and courtyards opening into complicated arrangements of chambers and hallways, some of which were intended for public use and others reserved solely for members of the royal family.

Many spectacular examples of Rajput palaces and forts remain; a fine example is the **CITY PALACE** in Udaipur (**FIG. 24–15**). Construction on the palace began in 1559 when Maharana Udai Singh II relocated the capital of the Mewar Kingdom from Chittor after the town had been sacked by Mughal forces under Akbar. The new location proved to be more defensible, and the Mewar rulers expanded both the city and their royal residences almost continuously over the next 300 years. Located on a ridge above a lake, this extensive architectural complex is better understood as a linked series of palaces rather than as a single building.

The structure is built primarily of granite and marble, but architects ornamented the dull stone with bright flourishes of paint, inlaid stone, silverwork, and inset pieces of mirror and colored glass. Despite its vast size, artists lavished attention on the finest points of decoration. This attention to detail reminds us that the palace was far more than just a military center; it functioned equally well as a backdrop for political events and displays of state

24–16 MOR CHOWK OF THE CITY PALACE, UDAIPUR

India. 17th century with 19th-century additions.

Credit: Donyanedomam/Fotolia

power. One such lavishly ornamented space in the Udai-pur City Palace complex is the **MOR CHOWK** (FIG. 24–16) or "Peacock Courtyard." Built in the seventeenth century by Maharana Sajjan Singh, it housed ceremonial gatherings. The public nature of this space and its function as an extension of royal authority are reflected in the decoration. The court gets its name from the three molded, high-relief images of peacocks inset with colored glass that adorn the courtyard's lower level, but the decoration becomes even more elaborate on the upper story. Here images of courtiers and carved stone screens depicting trees flank a projecting balcony with Mewari cusped arches. The entire surface is ornamented with delicately inset foliage patterns of colored tile and stained glass. Although the courtyard was first constructed in the 1600s, much of the current decoration represents the work of later centuries. This longevity attests to the continued importance of display as a component of court politics.

Art and its Contexts

SOUTHEAST ASIAN CERAMICS

Before the fourteenth century, China dominated the international trade in ceramics, but with the rise of the Ming dynasty, China began to look inward, limiting and regulating most forms of international trade. The resulting scarcity of Chinese trade ceramics, sometimes called the "Ming gap," was an opportunity for the merchants and artists of Southeast Asia. Both the Burmese and Thai kingdoms produced ceramics, often inspired by stonewares and porcelains from China. Sukhothai potters, for example, made green-glazed and brown-glazed wares at the renowned kilns of Sawankhalok. But it was the potters of Vietnam who were most successful in meeting the international demand for porcelains. So many ceramics were exported from Vietnam that most of what remained to be found by archaeologists were the broken or discarded leftovers.

This changed with the excavation of a sunken ship laden with ceramics for export, found 22 miles off the coast of Hoi An. This wreck brought to light over 250,000 ceramic works made by Vietnamese potters dating back to the late fifteenth to early sixteenth century (FIG. 24–17). Painted in underglaze cobalt blue and further embellished with overglaze enamels, these wares were shipped throughout Southeast Asia and beyond, as far east as Japan and as far west as England and the Netherlands.

24–17 GROUP OF VIETNAMESE CERAMICS FROM THE HOI AN HOARD
Late 15th to early 16th century. Porcelain with underglaze blue decoration; barbed-rim dishes: (left) diameter 14″ (35.1 cm); (right) diameter 13¼″ (34.7 cm). Phoenix Art Museum, Arizona. (2000.105–109).

Credit: Photo: Craig Smith.

Southeast Asia 1200–1800

What characterizes the Buddhist art and architecture of Southeast Asia from 1200 to 1800?

India's Buddhist and Hindu traditions found acceptance in Southeast Asia and were instrumental in validating newly rising kingdoms. Buddhism, in particular, was quickly and widely adopted. Starting in the twelfth century, Islam, carried by Arab and Chinese traders, began to gain influence in the region as well. Religious ideas, however, were not the only foreign influence at work in Southeast Asia. Throughout this time trade expanded and, as demand for Southeast Asian goods rose abroad, colonial powers saw the region as an attractive target (see "Southeast Asian Ceramics" on page 797). European, East Asian, and American economic and military interests had profound consequences on regional history, culture, and society.

Buddhist Art and Kingship

As Buddhism declined in the land of its origin, it continued to thrive in Southeast Asia, where it was shaped and developed in new ways. As it gained adherents among the population, rulers at times found it vital to align themselves with Buddhist ideas. Yet the individual incentives for espousing Buddhist ideas were as varied as the artistic forms they employed.

SEATED BUDDHA When Khmer king Jayavarman VII took the throne of Angkor in 1181, it marked the end of a long struggle against internal rebellions and foreign invaders. During his reign, he raised up the kingdom of Angkor in a final flowering, building more than any of his royal predecessors. In an unusual move, he elected to associate himself with the Buddha, rather than with a Hindu deity, and in so doing adapted Buddhist ideas to the Khmer concept of the god-king or, in his case, the buddha-king (*buddharaja*). Before starting construction of his massive temple-mountain complex at Angkor Thom, he sought legitimacy for his claims of Buddhist authority by dedicating large temples to each of his parents in the guise of bodhisattvas. This process reached its logical conclusion when he associated himself directly with the Buddha (as well as with the bodhisattva Lokeshvara).

Although Jayavarman VII's artists and architects produced a staggering number of spectacular sculptures and grand temples, few are as sublime as a simple sandstone Buddha image in the collection of the National Museum of Cambodia in Phnom Penh (**FIG. 24–18**). A few similar images exist, and in each example the seated Buddha displays nearly identical facial features. This consistency has led scholars to believe that these works are in fact portraits of Jayavarman VII seated serenely in the guise of the Buddha. Just as his ancestors had linked themselves

24–18 SEATED BUDDHA

From Angkor Thom. Reign of Jayavarman VII, late 12th–early 13th century. Sandstone, 4′6″ (1.4 m). National Museum of Cambodia, Phnom Penh.

Credit: © Luca Tettonni/Getty Images

with Hindu deities, Jayavarman VII represented himself as a Buddha: with downturned, meditative eyes, distended earlobes, hair pulled back into a topknot, and a simple garment. The authority of the king and Buddha are here expressed in a single understated, almost humble, image.

SHWEDAGON STUPA, MYANMAR In northern Burma from the eleventh to the thirteenth century, rulers raised thousands of religious monuments—temples, monasteries, and stupas—in the Bagan Plain, following the scriptures of Theravada Buddhism. To the south arose the port city now called Yangon (founded as Dagon and also formerly known as Rangoon). Established by Mon rulers before the eleventh century, Yangon is the site of the **SHWEDAGON STUPA** (**FIG. 24–19**), which enshrines relics of the four past Buddhas, including hair from Shakyamuni. The modern structures of Shwedagon ("Golden Dagon") rise from an ancient Mon core that was rebuilt and enlarged in the fourteenth century. In subsequent decades it underwent continual restoration and enhancement by pious Burmese kings and queens. The site continues to be a focus for lavish devotion and generosity. The bell-shaped spire is

capped by an umbrella-like ornament (*hti*) adorned with a large diamond, and the sides of the terraces are covered in gold plate. While most of this wealth was donated by royalty, over the centuries people from all walks of life have offered gold for its construction and maintenance. Images of the Buddha, and sometimes his footprints alone, provide focal points for devotion.

TEMPLE OF THE EMERALD BUDDHA, THAILAND

The Dvaravati culture remained regionally dominant until Khmer invasions in the tenth century. During this turmoil a new ethnic group, the Thai, entered the scene from the north, gradually gaining control and adopting Buddhism, as well as some aspects of Hinduism, from the Mon. The first Thai kingdom, Sukhothai, was established in 1238 and

flourished under the guidance of kings like the renowned Ram Khamhaeng before falling to rival Thai states.

The Sukhothai period was a formative time of innovation in Thai art. Among the creations of Sukhothai artists was an elegant new style of Buddha image. Featuring draping, almost boneless, limbs and attenuated heads adorned with spire-like flames, the Buddha images of this period are immediately recognizable. Art historians have explored diverse explanations for the distinctive, otherworldly features of Sukhothai Buddhas. One strong possibility is that they are literally poetry given tangible form (see "Closer Look" on page 800). The artists may have been working from descriptions found in the Indian Buddhist texts, which use evocative similes to describe the Buddha's beautiful appearance.

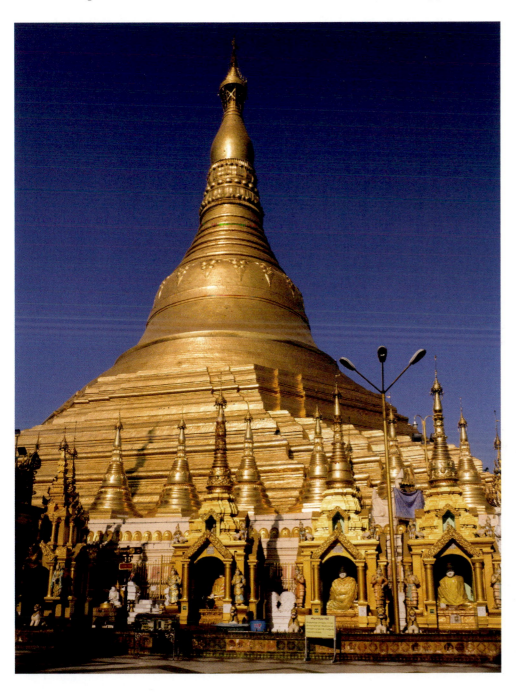

24–19 SHWEDAGON STUPA (PAGODA)

Yangon, Myanmar. 15th century; construction at the site dates from at least the 14th century, with continuous replastering and redecoration to the present.

Credit: Thor Jorgen Udvang/Fotolia

A Closer Look

THE SUKHOTHAI BUDDHA

The graceful Buddhas of the Sukhothai period were at times further enhanced by a second Sukhothai innovation: the walking Buddha pose. Sukhothai Buddhas reveal not just the surface of the Buddha's form, but also aspects of his character and life. Smooth skin is indicative of royal upbringing; long arms and broad shoulders mark someone born into a lineage of warriors; and lack of genitals alludes to his celibacy as an ascetic. Consider the following descriptions taken from Buddhist texts in relation to this example.

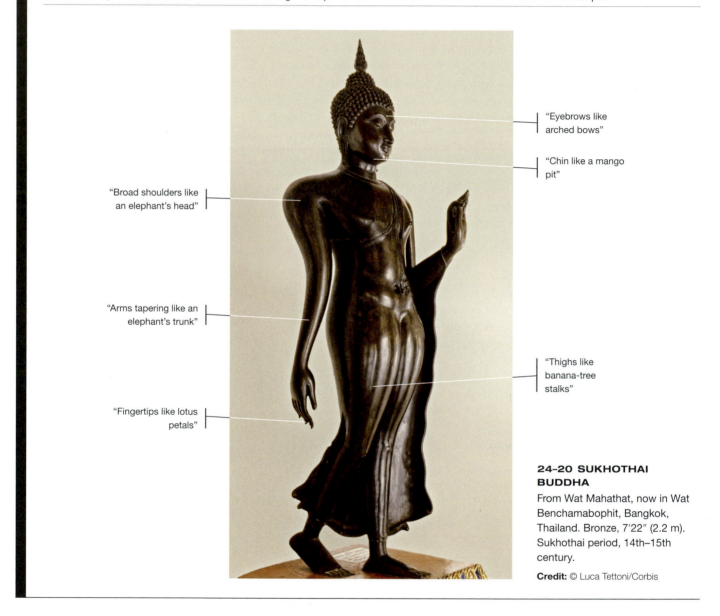

"Eyebrows like arched bows"

"Chin like a mango pit"

"Broad shoulders like an elephant's head"

"Arms tapering like an elephant's trunk"

"Thighs like banana-tree stalks"

"Fingertips like lotus petals"

24–20 SUKHOTHAI BUDDHA

From Wat Mahathat, now in Wat Benchamabophit, Bangkok, Thailand. Bronze, 7′22″ (2.2 m). Sukhothai period, 14th–15th century.

Credit: © Luca Tettoni/Corbis

Despite its cultural importance, the kingdom of Sukhothai did not last long, giving way to a succession of dynasties. The capital was eventually moved south to Bangkok, and under the rule of the Chakri king Rama I, construction began there on a grand new temple to house the Thais' most sacred Buddha image.

The Emerald Buddha ("emerald" refers to its color; it is actually made of jadeite) is featured in legends that place its creation in India under the direction of major Buddhist figures and trace its travels through great Buddhist nations of the past. These stories, although not grounded in historical evidence, suggest that the image has a special link to the world's foremost Buddhist kings, among whose lineage the Thai king is the most recent. The king himself ritually changes the image's golden garments three times a year. In one of these costumes the Emerald Buddha is dressed as a king, further strengthening the association between the Buddha and the state.

The temple complex that houses this sacred image is suitably spectacular (**FIG. 24–21**). The enclosure covers

24-21 TEMPLE OF THE EMERALD BUDDHA (WAT PHRA KAEW)
Grand Palace Complex, Bangkok, Thailand. 1782, and greatly expanded in later centuries.

Credit: psstockfoto/Fotolia

over 200 acres and contains hundreds of buildings, most of which are crowned by high, pointed roofs tiled in vibrant orange and green. These colorful rooftops shade the walls and pillars, whose surfaces are inset with intricate patterns of glass, gold leaf, and tile that shimmer in the intense sunlight. Although the core of this complex dates to 1782, it has been greatly expanded since then and remains an important Thai religious and political center.

Islamic Art in Southeast Asia

Muslim merchants played a major role in overseas trade, and they frequently spent months at port waiting for the trade winds to change. Over time their faith, Islam, was accepted by local populations living in Malaysia and the island of Sumatra (Indonesia) around the Straits of Malacca. From there it spread across island Southeast Asia. Indonesia is today the world's most populous Muslim country.

KUDUS MOSQUE, INDONESIA Islamic monuments in Indonesia, like the earlier Hindu and Buddhist ones, draw from a rich and diverse repertoire of styles and motifs. One of the earliest examples of Islamic architecture in Java is the Kudus mosque, dedicated to one of Java's nine great saints. Although the mosque itself has been renovated, most of the tower-like **MINARET** still survives from the earliest phase of construction in 1549 (**FIG. 24-22**). Its brickwork and decorative niches are reminiscent of earlier Hindu shrine towers, but this structure served to call Muslims to worship five times daily. In a traditional Javanese fashion, this was done with a large drum (*bedug*) along

24-22 MINARET, KUDUS MOSQUE
1549. Kudus, Java, Indonesia.

Credit: © B.O'Kane/Alamy Stock Photo

with the sung prayers typical in other parts of the world. The lower bands of the tower are decorated with inset porcelain plates imported from China, which add color to the exterior. The various indigenous and international influences that helped shape this tower speak to the remarkably cosmopolitan nature of sixteenth-century Java.

The Colonial Period and the Modern Era

How are South and Southeast Asian art and architecture transformed during colonialism and the modern era?

By the late eighteenth century, India's regional rulers, both Hindu and Muslim, had reasserted themselves, and the vast Mughal Empire had shrunk to a small area around Delhi. At the same time, however, a new power, Britain, was making itself felt, inaugurating a markedly different period in Indian history.

British Imperialism in South Asia

First under the commercial interests of the British East India Company in the seventeenth and eighteenth centuries, and then under the direct control of the British government as a part of the British Empire in the nineteenth century, India was brought forcefully into contact with the West and its culture. The political concerns of the British

Empire extended even to the arts. Over the course of the nineteenth century, the small settlements of Calcutta (present-day Kolkata), Madras (Chennai), and Bombay (Mumbai) were transformed into cities to serve trade with the British Empire. In the process, they took on a European aspect as British architects built in the revivalist styles favored in England.

VICTORIA TERMINUS, MUMBAI The British insistence on European styles of architecture was at its most strident in the early years of colonial rule. Even after South Asia transitioned to direct control by the British Crown in 1858, a period known as the Raj, British architects strove to emphasize difference. Nowhere is this more visible than at the **VICTORIA TERMINUS** (now Chhatrapati Shivaji Terminus) in Mumbai (**FIG. 24–23**). This massive train station built in a Gothic Revival style was designed by architect Frederick William Stevens and opened in 1887, the year of Queen Victoria's Golden Jubilee. The building makes a few concessions to its South Asian setting, as with the inclusion of turret-like domes, but it is overwhelmingly a self-conscious statement of British imperial power. This pairing of cathedral architecture and train station celebrates ideas of British technology and authority. In place of the saints that might normally decorate a cathedral, personifications of Progress, Commerce, Agriculture, and Science adorn the exterior. Originally, this structure was crowned by an image of Queen Victoria, which was later removed.

24–23 Frederick Stevens **VICTORIA TERMINUS**
Mumbai, India. 1887.

Credit: © Joe Ravi/Shutterstock

24-24 George Wittet
GATEWAY OF INDIA
Mumbai, India. 1924.

Credit: © Pete Burana/Shutterstock

24-25 Abanindranath
Tagore **BHARAT MATA
(MOTHER INDIA)**
1905. Watercolor on paper,
10½ × 6″ (26.7 × 15.3 cm).
Rabindra Bharati Society,
Kolkata.

Credit: Courtesy of Marilyn Stokstad

GATEWAY OF INDIA, MUMBAI Over time, the British reduced their insistence on promoting difference through their choice of architectural forms and began to appreciate aspects of indigenous style. Completed in 1924, the **GATEWAY OF INDIA** was built to welcome King George V on his visit to India (**FIG. 24-24**). The British constructed the monument in the form of a European triumphal arch, while embellishing it with South Asian architectural features. Stone screens, ornate brackets, pointed arches, and floral decorations were taken directly from earlier Hindu and Muslim architectural practices in the subcontinent. This hybrid style, known as the Indo-Saracenic style, became the preferred architectural style for British governmental buildings and elite private estates in India by the late nineteenth century; a few examples were built in England and in other parts of the empire as well. India won its independence in 1947, and the last British troops in South Asia departed through this gate a year later in 1948.

MOTHER INDIA Well before Britain's consolidation of imperial power in New Delhi, a new spirit of Indian independence and pan-Asiatic solidarity was awakening. For example, working near Calcutta (Kolkata), the painter Abanindranath Tagore (1871–1951)—nephew of the poet Rabindranath Tagore (1861–1941), who won the Nobel Prize for Literature in 1913—deliberately rejected the medium of oil painting and the academic realism of Western art. Like the Nihonga artists of Japan (SEE FIG. 26-18) with whom he was in contact, Tagore strove to create a style that reflected his ethnic origins. In **BHARAT MATA (MOTHER INDIA)** he invents a nationalistic icon by using Hindu symbols while also drawing upon the format and techniques of Mughal and Rajput painting (**FIG. 24-25**).

24–26 Maqbool Fida Husain **VEDIC**
From the "Theorama" series, 1994. Limited-edition color print, 23½ × 36″ (60 × 92 cm).

Credit: Photo: Philip de Bay

The Modern Period

Marked by both inspirational expressions of peaceful resistance and bloody warfare, the modern history of South and Southeast Asia has been a study in extremes. But as the turmoil of earlier decades fades across most of the region, many states have emerged as leaders in international commerce, technology, and finance. In an international age, they are capitalizing on the region's centuries-old tradition of bridging cultures and adapting new ideas. These qualities are seen clearly in the South and Southeast Asian art of the modern period, which blends the traditional with the new.

MODERN SOUTH ASIA In the wake of World War II, the imperial powers of Europe began to shed their colonial domains. The attainment of self-rule had been five long decades in the making, when finally—pressured by the nonviolent example of Mahatma Gandhi (1869–1948)—the British Empire gave up its "Jewel in the Crown," which was partitioned to form the modern nations of India, Pakistan, and (in 1972) Bangladesh. After independence in 1947, the exuberant young nations welcomed a modern, internationalist approach to art and architecture.

One of India's most influential and prolific modern artists was Maqbool Fida Husain (1915–2011). Beginning his career in the 1940s, he embraced Modernism and used its techniques to express South Asian

24–27 César Pelli and Deejay Cerico **PETRONAS TOWERS**
Kuala Lumpur, Malaysia. 1998.

Credit: © Travelpix Ltd/Getty Images

themes. He drew his subjects from diverse sources such as Hindu literature, historical events, and the natural world, as well as from the traditions of his Muslim upbringing. He was highly productive, and his range of subject matter at times drew objections from religious groups, who opposed his use of religious imagery. These complaints led him reluctantly to spend the final years of his life in Qatar, but he consistently returned to South Asian themes for his inspiration.

His simplified and schematic style can be seen in the "Theorama" series, which addresses nine of the world's major religions. Pictured here is **VEDIC** (**FIG. 24-26**), Husain's tribute to Hinduism. Despite its abstraction, the figure of Krishna can be seen dancing on the serpent deity Kaliya, whose body merges with the story of the Churning of the Ocean of Milk (SEE FIG. 10-43). The event pivots on a triangular form with three faces reminiscent of the Shiva from Elephanta (SEE FIG. 10-24), and a goddess on elephant-back dispenses abundance in the form of coins or seeds from her outstretched hand. The composition is framed on the right by a seated ascetic whose head is a spoked wheel. This wheel may reference the spinning wheels whose use Gandhi advocated to break dependence on British textiles, but it also reaches back further into the South Asian past and evokes the wheel of *dharma*.

MODERN SOUTHEAST ASIA The transition from colonial control varied greatly across Southeast Asia, due largely to the range of colonial powers in the region and their varying attitudes toward relinquishing power. Some nations, like Thailand, managed to avoid imperial domination entirely, whereas others fought long wars to establish their independence. In some cases, the power vacuum was filled by local regimes that brought new hardship, like the horrors perpetrated by the Khmer Rouge in Cambodia. The region has gradually achieved stability and growing prosperity, as exemplified by its internationally recognized artwork and contemporary architecture.

Dominating the skyline of Kuala Lumpur, Malaysia, are the **PETRONAS TOWERS** (**FIG. 24-27**), which from 1998 to 2004 were the tallest structures in the world. These paired skyscrapers, linked by a sky bridge at the 41st and 42nd floors, are built primarily of reinforced concrete surrounded by a casing of steel and glass. They were designed collaboratively by Argentine architect César Pelli and Filipino-Malaysian engineer Deejay Cerico, who drew inspiration for their designs from traditional Malaysian Islamic forms. The towers stand 1,242 feet tall and took seven years to build. Today they house many business offices, a shopping mall, and the Malaysian Philharmonic Orchestra. They are characteristic of the growth and development across the region.

Think About It

1 Consider the Qutb Minar (**FIG. 24-4**) and Fatehpur Sikri (**FIG. 24-8**). Do these structures reveal differences in the way each kingdom viewed itself in relation to wider Indian culture? If so, explain how. Can similar differences be seen when comparing the Victoria Terminus and the Gateway of India? Explain.

2 Great wealth is often required to build grand structures, and typically this wealth rests in the hands of rulers. Who were the patrons of the Luna Vasahi (**FIG. 24-3**) and the *gopuras* at the temple in Madurai (**FIG. 24-7**)? What does this tell us about the importance of trade and increased access to public displays of piety?

3 The Emerald Buddha and the Seated Buddha from the reign of Jayavarman VII are both closely associated with royal power. Explain how each Buddhist image lends authority to the king; emphasize both similarities and differences between the two examples.

4 Consider the paintings *Jahangir and Shah Abbas* (**FIG. 24-10**) and *Mother India* (**FIG. 24-25**). What are their political messages and to whom were these messages directed? Who would have seen these works?

Crosscurrents

Consider some of the ways that Islamic art and culture impacted South and Southeast Asia. Explain how the Taj Mahal and the Kudus mosque minaret are similar. In what ways do they differ from one another? What historical and cultural influences help account for those differences?

FIG. 24-1 FIG. 24-22

25-1 Wang Hui **A THOUSAND PEAKS AND MYRIAD RAVINES**

Qing dynasty, 1693. Hanging scroll with ink on paper, 8'2½" × 3'4½" (2.54 × 1.03 m). National Palace Museum, Taibei, Taiwan, Republic of China.

Credit: Photo © National Palace Museum, Taipei, Taïwan, Dist. RMN-Grand Palais/image NPM

Chapter 25
Chinese and Korean Art after 1279

 ## Learning Objectives

25.a Identify the visual hallmarks of Chinese and Korean art after 1279 for formal, technical, and expressive qualities.

25.b Interpret the meaning of works of Chinese and Korean art after 1279 based on their themes, subjects, and symbols.

25.c Relate artists and art of China and Korea after 1279 to their cultural, economic, and political contexts.

25.d Apply the vocabulary and concepts relevant to the art, artists, and art history of China and Korea after 1279.

25.e Interpret a work of Chinese or Korean art after 1279 using the art historical methods of observation, comparison, and inductive reasoning.

25.f Select visual and textual evidence in various media to support an argument or an interpretation of a work of Chinese or Korean art after 1279.

Mountains, rivers, waterfalls, trees, rocks, temples, pavilions, houses, bridges, boats, wandering scholars, fishers—all are included in **A THOUSAND PEAKS AND MYRIAD RAVINES (FIG. 25-1)**, painted by Wang Hui (1632–1717). These are common motifs and subjects in the landscape tradition of Chinese ink painting, already many centuries old when this large work was painted in 1693. At the top of the hanging scroll, the artist himself has written:

> Moss and weeds cover the rocks and mist hovers
> over the water.
> The sound of dripping water is heard in front of the
> temple gate.
> Through a thousand peaks and myriad ravines the
> spring flows,
> And brings the flying flowers into the sacred caves.
> In the fourth month of the year 1693, in an inn in
> the capital, I painted this based on a Tang-dynasty
> poem in the manner of [the painters] Dong [Yuan]
> and Ju[ran].
> (Translation by Chu-tsing Li)

The inscription refers to the artist's inspiration—for the subject, found in the lines of a Tang-dynasty poem, and for the style, found in the work of tenth-century painters Dong Yuan and Juran. Wang Hui's art embodies the ideals of the scholar in imperial China.

China's scholar class was unique, the product of an examination system designed to recruit the finest minds in the country for government service. Instituted during the Tang dynasty (618–907) and based on even earlier traditions, the civil service examinations were excruciatingly difficult, but for the tiny percentage who passed at the highest level, the rewards were great—prestige, position, power, and wealth. Steeped in philosophy, literature, and history, China's scholars—often called *wenren* (literati)—shared an outlook. Following Confucianism, they became officials to fulfill their obligation to the world, but pulled by Daoism, they retreated from society in order to come to terms with nature and the universe—to create a garden, to write poetry, or to paint.

During the Song dynasty (960–1279) the examinations were expanded and regularized. More than half of all government positions came to be filled by scholars. In the subsequent Yuan and Ming periods, the tradition of **literati painting** (a style that reflected the taste of the educated class) developed further. When the Yuan period of foreign rule came to an end, the new Ming ruling house revived the court traditions of the Song. The Ming also became the model for the rulers of Korea's Joseon dynasty, under whose patronage these styles achieved a distinctive and austere beauty.

In the Qing era, China was again ruled by an outside group, this time the Manchus. While maintaining their traditional connections to Tibet and inner Asia through patronage of Tibetan Buddhism, the Manchu rulers also embraced Chinese ideals, especially those of the literati. Practicing painting and calligraphy, composing poetry in Chinese, and collecting esteemed Chinese works of art, these rulers amassed the great palace collections that can now be seen in Beijing and Taibei.

Foundations of Chinese Culture

What aspects of the early history, culture, and art of China form a critical background for the development of art and architecture after 1279?

Chinese culture is distinguished by a long and continuous development that traces to the prehistoric period. Between 6000 and 2000 BCE a variety of Neolithic cultures flourished across China. Through long interaction these cultures became increasingly similar, and they eventually gave rise to the three Bronze Age dynastic states with which Chinese history traditionally begins: the Xia, the Shang (c. 1700–1100 BCE), and the Zhou (1100–221 BCE).

The Shang developed traditions of casting ritual vessels in bronze, working jade in ceremonial shapes, and writing consistently in scripts that directly evolved into the modern Chinese written language. Society was stratified, and the ruling group maintained its authority in part by claiming power as intermediaries between the human and spirit worlds. Under the Zhou a feudal society developed, with nobles related to the king ruling over numerous small states.

During the latter part of the Zhou dynasty, states began to vie with each other for supremacy through intrigue and increasingly ruthless warfare. The collapse of social order profoundly influenced China's first philosophers, who largely concerned themselves with the pragmatic question of how to bring about a stable society.

In 221 BCE, rulers of the state of Qin triumphed over the remaining states, unifying China as an empire for the first time. The Qin created the mechanisms of China's centralized bureaucracy, but their rule was harsh and the dynasty was quickly overthrown. The ensuing Han dynasty (206 BCE–220 CE) brought peace and prosperity to China as Confucianism became the official state ideology, and in the process assumed the form and force of a religion. Developed from the thought of Confucius (551–479 BCE), one of the many philosophers of the Zhou, Confucianism is an ethical system for the management of society based on establishing correct relationships among people. Providing a counterweight was Daoism, which also came into its own during the Han dynasty. Based on the thought of Laozi, a possibly

legendary contemporary of Confucius, and the philosopher Zhuangzi (369–286 BCE), Daoism is a view of life that seeks to harmonize the individual with the Dao, or Way, the process of the universe. Confucianism and Daoism remained central to Chinese thought—one addressing the public realm of duty and conformity, and the other the private world of individualism and creativity.

Following the collapse of the Han dynasty, China experienced a centuries-long period of disunity (220–589 CE). Invaders from the north and west established numerous kingdoms and dynasties, while a series of six precarious Chinese dynasties held sway in the south. Buddhism, which had spread from India into China over trade routes during the Han era, began to flourish.

China was reunited under the Sui dynasty (581–618 CE), which quickly fell to the Tang (618–907), one of the most successful dynasties in Chinese history. Strong and confident, Tang China fascinated and, in turn, was fascinated by the cultures around it. Caravans streamed across central Asia to the capital, Chang'an (present-day Xi'an), then the largest city in the world. Japan and Korea sent thousands of students to study Chinese culture, and Buddhism reached the height of its influence before a period of persecution signaled the start of its decline.

The mood of the Song dynasty (960–1279) was quite different. The martial vigor of the Tang gave way to a culture of increasing refinement and sophistication, and Tang openness to foreign influences was replaced by a conscious cultivation of China's own traditions. In art, landscape painting emerged as the most esteemed genre, capable of expressing both philosophical and personal concerns. With the fall of the north to invaders in 1126, the Song court set up a new capital in the south, which became the cultural and economic center of the country.

The Mongol Invasions and the Yuan Dynasty

How is Chinese art transformed after the Mongol invasions during the Yuan dynasty?

At the beginning of the thirteenth century the Mongols, a nomadic people from the steppes north of China, began to amass an empire. Led first by Genghiz Khan (c. 1162–1227), then by his sons and grandsons, they swept westward into central Europe and overran Islamic lands from Central Asia through present-day Iraq. To the east, they quickly captured northern China, and in 1279, led by Kublai Khan, they conquered southern China as well. Grandson of the mighty Genghiz, Kublai proclaimed himself emperor of China and founded the Yuan dynasty (1279–1368).

The Mongol invasions were traumatic; their effect on China was long-lasting. During the Song dynasty, China

had grown increasingly introspective. Rejecting foreign ideas and influences, intellectuals had focused on defining the qualities that constituted true "Chinese-ness." They drew a clear distinction between their own people, whom they characterized as gentle, erudite, and sophisticated, and the "barbarians" outside China's borders, whom they regarded as wild and uncivilized. Now, faced with the reality of foreign occupation, China's inward gaze intensified in spiritual resistance. For centuries to come, long after the Mongols had gone, leading scholars continued to seek intellectually more challenging, philosophically more profound, and artistically more subtle expressions of all that could be identified as authentically Chinese.

The Mongols established their capital in the northern city now known as Beijing (**MAP 25–1**). The cultural centers of China, however, remained the great cities of the south, where the Song court had been located for the previous 150 years. Combined with the tensions of Yuan rule, this

separation of China's political and cultural centers created a new dynamic in the arts.

Throughout most of Chinese history, the imperial court had set the tone for artistic taste: Artisans attached to the court produced architecture, paintings, gardens, and objects of jade, lacquer, ceramics, and silk especially for imperial use. Over the centuries, painters and calligraphers gradually moved higher up the social scale, for these "arts of the brush" were often practiced by scholars and even emperors, whose high status reflected positively on whatever interested them. With the establishment of an imperial painting academy during the Song dynasty, painters finally achieved a status equal to that of court officials. For the literati, painting came to be grouped with calligraphy and poetry as the trio of accomplishments suited to members of the cultural elite.

But while the literati elevated the status of painting by virtue of practicing it, they also began to develop their own

MAP 25–1 CHINA AND KOREA

The map shows the borders of both contemporary China and Korea. The colored areas indicate the historical extent of the Qing-dynasty empire (1644–1911), including its tributary states.

ideas of what painting should be. Not needing to earn an income from their art, they cultivated an amateur ideal in which personal expression counted for more than professional skill. They created for themselves a status as artists totally separate from and superior to professional painters, whose art they felt was inherently compromised, since it was done to please others and tainted by money.

The conditions of Yuan rule now encouraged a clear distinction between court taste, ministered to by professional artists and artisans, and literati taste. The Yuan dynasty continued to see patronage of the arts as an imperial responsibility, commissioning buildings, murals, gardens, paintings, and decorative arts. Western visitors, such as the Italian Marco Polo (c. 1254–1324), who spent 17 years in the service of Kublai Khan, were mightily impressed by the magnificence of the Yuan court. But scholars, profoundly alienated from the new government, took little notice of these accomplishments. Nor did Yuan rulers have much use for scholars, especially those from the south. The civil service examinations were abolished, and the highest government positions were bestowed, instead, on Mongols and their foreign allies. Scholars now tended to turn inward to search for solutions of their own and try to express themselves in personal and symbolic terms.

Painting

Zhao Mengfu (1254–1322) was a descendant of the imperial line of Song. Unlike many scholars of his time, he eventually chose to serve the Yuan government and was made a high official. A distinguished painter, calligrapher, and poet, Zhao was especially known for his carefully rendered paintings of horses, but he also practiced traditional landscape painting. One of his best-known works is a sensitively composed and beautifully balanced painting of two farm animals, **SHEEP AND GOAT** (**FIG. 25-2**), which he claimed to have drawn from life. This may be too simplistic an assessment, because the two animals are portrayed in clearly different styles. The goat, on the right, is carefully described and lifelike in appearance, but the sheep, on the left, is more abstracted, almost flattened. The markings on its body create a sense of pattern rather than the appearance of natural irregularities. Some have seen pride in the sheep's posture and submission in the pose of the goat—although with head down, the goat could also be prepared to attack. Some have proposed that Zhao was expressing either acceptance of or resistance to the rule of the foreign Yuan dynasty, or since the same Chinese word is used for these two animals, perhaps he implies that the Mongols and the Chinese are not as different as they seem.

Zhao Mengfu became a prime practitioner of literati painting with his unassuming brushwork, sparing use of color (many literati paintings, like **FIG.** 25-2, give up color altogether), and use of traditional painting to convey personal meaning. The literati did not paint for public display but for each other, and Zhao's *Sheep and Goat* was actually created at the request of a friend of the artist. The literati favored small formats such as handscrolls, **hanging scrolls**, or **album** leaves (book pages), which could easily be shown to friends or shared at small gatherings (see "Formats of Chinese Painting" opposite).

25-2 Zhao Mengfu **SHEEP AND GOAT**
Yuan dynasty, c. 1300. Handscroll with ink on paper, 9⅞ × 19″ (25.2 × 48.4 cm). Freer Gallery of Art, Smithsonian Institution, Washington, DC.
Credit: Bridgeman Images

Technique

FORMATS OF CHINESE PAINTING

With the exception of large wall paintings that typically decorated palaces, temples, and tombs, most Chinese paintings were created from ink and water-based colors on silk or paper. Finished works were generally mounted as handscrolls, hanging scrolls, or leaves in an album.

An album is made up of a set of paintings of identical size mounted in a book. (A single painting from an album is called an album leaf.) The paintings in an album are usually related in subject, such as various views of a famous site or a series of scenes glimpsed on one trip.

Album-size paintings might also be mounted as a handscroll, generally a horizontal format about 12 inches high and anywhere from a few feet to dozens of feet long. More typically, however, a handscroll would be a single, continuous painting. Handscrolls were not meant to be displayed all at once, the way they are commonly presented today in museums. Rather, they were unrolled only occasionally, to be savored in much the same spirit as we might view a favorite film. Placing the scroll on a flat surface such as a table, a viewer would unroll it a foot or two at a time, moving gradually through the entire scroll from right to left, lingering over favorite details. The scroll was then rolled up and returned to its box until the next viewing.

Like handscrolls, hanging scrolls were not displayed permanently but were taken out for a limited time: a day, a week, or a season. Unlike a handscroll, however, the painting on a hanging scroll was viewed as a whole—unrolled and hung on a wall, with the roller at the lower end acting as a weight to help the scroll hang flat. Although some hanging scrolls are quite large, they are still fundamentally intimate works, not intended for display in a public place.

Creating a scroll was a time-consuming and exacting process accomplished by a professional mounter. The painting was first backed with paper to strengthen it. Next, strips of paper-backed silk were pasted to the top, bottom, and sides, framing the painting on all four sides. Additional silk pieces were added to extend the scroll horizontally or vertically, depending on the format. The assembled scroll was then backed again with paper and fitted with a half-round dowel, or wooden rod, at the top of a hanging scroll or on the right end of a handscroll, with ribbons for hanging and tying, and with a wooden roller at the other end. Hanging scrolls were often fashioned from several patterns of silk, and a variety of piecing formats were developed and codified. On a handscroll, a painting was generally preceded by a panel giving the work's title and often followed by a long panel bearing colophons—inscriptions related to the work, such as poems in its praise or comments by its owners over the centuries. A scroll would be remounted periodically to better preserve it, and colophons and inscriptions would be preserved in each remounting. Seals added another layer of interest. A treasured scroll often bears not only the seal of its maker but also those of collectors and admirers through the centuries.

colophon panel frontispiece

handscroll rolled for storage
handscroll

handscroll

front back
hanging scroll

label

NI ZAN Of the considerable number of Yuan painters who took up Zhao's ideas, several became models for later generations. One was Ni Zan (1301–1374), whose most famous surviving painting is **THE RONGXI STUDIO** (**FIG. 25-3**). Done entirely in ink, the painting depicts the lake region in Ni's home district. Mountains, rocks, trees, and a pavilion are sketched with a minimum of detail using a dry brush technique—a technique in which the

25-3 Ni Zan **THE RONGXI STUDIO**
Yuan dynasty, 1372. Hanging scroll with ink on paper, height 29⅜"
(74.6 cm). National Palace Museum, Taibei, Taiwan, Republic of China.

The idea that a painting is not an attempt to capture the visual appearance of nature or to satisfy others but is executed freely for the artist's own amusement is at the heart of the literati aesthetic. Ni Zan once wrote this comment on a painting: "What I call painting does not exceed the joy of careless sketching with a brush. I do not seek formal likeness but do it simply for my own amusement. Recently I was rambling about and came to a town. The people asked for my pictures, but wanted them exactly according to their own desires and to represent a specific occasion. [When I could not satisfy them,] they went away insulting, scolding, and cursing in every possible way. What a shame! But how can one scold a eunuch for not growing a beard?" (translated in Bush and Shih, p. 266).

brush is not fully loaded with ink but rather is about to run out, so that white paper "breathes" through the ragged strokes. The result is a painting with a light touch and a sense of simplicity and purity. Literati styles were believed to reflect an individual painter's personality, and Ni's spare, dry style became associated with a noble spirit. Many later painters adopted or paid homage to it.

Ni Zan's eccentric behavior became legendary in the history of Chinese art. In his early years he was one of the richest men in the region, the owner of a large estate. His pride and his aloofness from daily affairs often got him into trouble with the authorities. His cleanliness was notorious. In addition to washing himself several times daily, he ordered his servants to wash the trees in his garden and to clean the furniture after his guests had left. He was said to be so unworldly that late in life he gave away most of his possessions and lived as a hermit in a boat, wandering on rivers and lakes.

Whether these stories are true or not, they were important elements of Ni's legacy to later painters, for Ni's life as well as his art served as a model. Literati painting was associated with a viewpoint concerning what constituted an appropriate life. The ideal, as embodied by Ni Zan and others, was a brilliantly gifted scholar whose spirit was too refined for the dusty world of government service and who thus preferred to live as a recluse or had retired after having become frustrated by a brief stint as an official.

The Ming Dynasty

What characterizes Chinese painting and architecture during the Ming Dynasty?

The founder of the next dynasty, the Ming (1368–1644), came from a family of poor, uneducated peasants. As Zhu Yuanzhang rose through the ranks in the army, he enlisted the help of scholars to gain power and solidify his following. Once he had driven the Mongols from Beijing and firmly established himself as emperor, however, he grew to distrust intellectuals. His rule was despotic, even ruthless. Throughout the nearly 300 years of Ming rule, most emperors shared his attitude, so although the civil service examinations were reinstated, scholars remained alienated from the government they were trained to serve.

MING BLUE-AND-WHITE WARES Ming China became famous the world over for its exquisite ceramics, especially porcelain. The imperial kilns in Jingdezhen, in Jiangxi Province, became the most renowned center for porcelain not only in China, but in all the world. During the reigns of the Yongle (1403–1424) and Xuande (1426–1435) emperors, major trade and diplomatic missions traveled to the Middle East, and Ming porcelain made its way to Turkey and Iran, where its refined decoration and flawless glazing was admired. The shapes of two porcelain flasks

used for decanting wine in the Chinese imperial household (**FIG. 25–4**) were probably inspired by Islamic glass vessels brought back to China with traders returning from these missions. The underglaze cobalt blue decoration shows the variety of ornamental motifs and representational systems that were used by the painters of Ming porcelain: The body of one dragon is rendered with fine descriptive detail against a background of delicate plant motifs, whereas the other dragon is a bold white silhouette reserved from the densely painted waves of its ocean habitat.

25-4 TWO FLASKS
Ming dynasty, 1403–1424 (reign of Yongle emperor). Porcelain with decoration painted in underglaze cobalt blue.
Percival David Foundation Collection, British Museum, London.

Dragons have featured prominently in Chinese folklore from earliest times—Neolithic examples have been found painted on pottery and carved in jade. In Bronze Age China, dragons came to be associated with powerful and sudden manifestations of nature, such as wind, thunder, and lightning. At the same time, they became associated with superior beings such as virtuous rulers and sages. With the emergence of China's first firmly established empire during the Han dynasty, the dragon was appropriated as an imperial symbol, and it remained so throughout Chinese history. Dragon sightings were duly recorded and considered auspicious. Yet even the Son of Heaven could not monopolize the dragon. During the Tang and Song dynasties the practice arose of painting pictures of dragons to pray for rain, and for Chan (Zen) Buddhists, the dragon was a symbol of sudden enlightenment.

Technique
THE SECRET OF PORCELAIN

Marco Polo, it is said, was the one who named a new type of ceramic he found in China. Its translucent purity reminded him of the smooth whiteness of the cowrie shell, *porcellana* in Italian. Porcelain is made from kaolin, an extremely refined white clay, and petuntse, a variety of the mineral feldspar. When properly combined and fired at a high-enough temperature (generally in the range of 1300° to 1400°C), the two materials fuse into a glasslike, translucent ceramic that is far stronger than it looks.

Porcelaneous stoneware, fired at lower temperatures, was known in China by the seventh century, but true porcelain was perfected during the Song dynasty. To create blue-and-white porcelain such as the flasks in FIGURE 25–4, blue pigment was made from cobalt oxide, finely ground and mixed with water. The decoration was painted directly onto the unfired porcelain vessel, then a layer of clear glaze was applied over it. (In this technique, known as **underglaze** painting, the pattern is painted beneath the glaze.) After firing, the piece emerged from the kiln with a clear blue design set sharply against a snowy white background.

Entranced with the exquisite properties of porcelain, European potters tried for centuries to duplicate it. The technique was finally "discovered" in 1709 by Johann Friedrich Böttger in Dresden, Germany, who tried—but failed—to keep it a secret.

Court and Professional Painting

The contrast between the luxurious world of the court and the austere ideals of the literati continued through the Ming dynasty.

A typical example of Ming court taste is **HUNDREDS OF BIRDS ADMIRING THE PEACOCKS** (FIG. 25–5), a large painting on silk by Yin Hong, an artist active during the late fifteenth and early sixteenth centuries. A pupil of well-known courtiers, Yin probably served in the court at Beijing. This painting is an example of the birds-and-flowers genre, which had been popular with artists of the Song academy. Here the subject takes on symbolic meaning, with the homage of the birds to the peacocks representing the homage of court officials to the imperial state. Although the style is faithful to Song academic models, the large format and intense attention to detail are traits of the Ming.

A related, yet bolder and less constrained, landscape style was also popular during this period. It is sometimes called the Zhe style since its roots were in Hangzhou, Zhejiang Province, where the Southern Song court had been located. An example is **RETURNING HOME LATE FROM**

A SPRING OUTING (FIG. 25–6), unsigned but attributed to Dai Jin (1388–1462). Zhe-style works such as this will become sources for Korean and Japanese artists such as An Gyeon (SEE FIG. 25–19) and Sesshu (SEE FIG. 26–3).

QIU YING A preeminent professional painter in the Ming period was Qiu Ying (1494–1552), who lived in Suzhou, a prosperous southern city. He inspired generations of imitators with exceptional works such as a long handscroll known as **SPRING DAWN IN THE HAN PALACE**

25–6 Attributed to Dai Jin **RETURNING HOME LATE FROM A SPRING OUTING**

Ming dynasty. Hanging scroll with ink on silk, 5'6" × 2'8¾" (1.68 × 0.83 m). National Palace Museum, Taibei, Taiwan, Republic of China.

Credit: © Corbis

25–5 Yin Hong **HUNDREDS OF BIRDS ADMIRING THE PEACOCKS**

Ming dynasty, late 15th–early 16th century. Hanging scroll with ink and color on silk, 7'10½" × 6'5" (2.4 × 1.96 m). The Cleveland Museum of Art. Purchase from the J.H. Wade Fund (1974.31).

Credit: Bridgeman Images

25–7A Qiu Ying **SECTION OF SPRING DAWN IN THE HAN PALACE**
Ming dynasty, 1500–1550. Handscroll with ink and color on silk, 1′ × 18′13⁄16″ (0.3 × 5.7 m). National Palace Museum, Taibei, Taiwan,
Republic of China.

Credit: Photo © National Palace Museum, Taipei, Taïwan, Dist. RMN-Grand Palais/image NPM

(FIG. 25–7). The painting is based on Tang-dynasty depictions of women in the court of the Han dynasty (206 BCE– 220 CE). While in the service of a well-known collector, Qiu Ying had the opportunity to study many Tang paintings, whose artists usually concentrated on figures set on blank backgrounds. Qiu's graceful and elegant figures— although modeled after those in Tang works—are situated within a carefully described setting of palace buildings. They engage in courtly pastimes, such as chess, music, calligraphy, and painting. With its antique subject matter, refined technique, brilliant color, and controlled composition, *Spring Dawn in the Han Palace* brought professional painting to another level (see a detail from this scroll in "Closer Look" below).

A Closer Look

SPRING DAWN IN THE HAN PALACE

Two ladies of the court unwrap a *qin*, the zither or lute that was the most respected musical instrument at the time.

A seated woman plays the *pipa*, an instrument introduced from Central Asia during the Tang dynasty.

Antique vessels of bronze, lacquer, and porcelain adorn the room and suggest the women's refined taste.

A tray landscape featuring an eroded rock provides a sculptural counterpart to landscape (mountain-and-water) painting and suggests a place where immortals might dwell.

Two women dance together, letting their sleeves and sashes swirl.

25–7B DETAIL OF FIG. 25–7A

Credit: Photo © National Palace Museum, Taipei, Taïwan, Dist. RMN-Grand Palais/image NPM

Architecture and City Planning

Centuries of warfare and destruction have left very few early Chinese architectural monuments intact. The most important remaining example of traditional architecture is **THE FORBIDDEN CITY**, the imperial palace compound in Beijing, whose principal buildings were constructed during the Ming dynasty (**FIG. 25-8**).

THE FORBIDDEN CITY The basic plan of Beijing was the work of the Mongols, who laid out their capital city according to traditional Chinese principles. City planning had begun early in China—in the seventh century, in the case of Chang'an (present-day Xi'an), the capital of the Sui and Tang emperors. The walled city of Chang'an was organized on a rectangular grid with evenly spaced streets that ran north–south and east–west. At the northern end stood a walled imperial complex.

Beijing, too, was developed as a walled, rectangular city with streets laid out in a grid. The palace enclosure occupied the center of the northern part of the city, which was reserved for the Mongols. Chinese lived in the southern third of the city. Later, Ming and Qing emperors preserved this division, with officials living in the northern or Inner City and commoners living in the southern or Outer City. The third Ming emperor, Yongle (ruled 1403–1424), rebuilt the Forbidden City as we see it today.

The approach was impressive. Visitors entered through the Meridian Gate, a monumental complex with perpendicular side wings (in the center of **FIG. 25-8**). Next they encountered a broad courtyard crossed by a bow-shaped waterway spanned by five arched marble bridges. At the opposite end of this courtyard is the Gate of Supreme Harmony, opening onto an even larger courtyard that houses three ceremonial halls raised on a broad platform. First is the Hall of Supreme Harmony, where on the most important state occasions the emperor sat on his throne, facing south. Beyond is the smaller Hall of Central Harmony, then the Hall of Protecting Harmony. Behind these vast ceremonial spaces, still on the central axis, is the inner court, again with a progression of three buildings, this time more intimate in scale. In its balance and symmetry the plan of the Forbidden City reflects ancient Chinese beliefs about the harmony of the universe, and it emphasizes the emperor's role as the Son of Heaven, maintaining the cosmic order from his throne in the middle of the world.

The Literati Aesthetic

In the south, particularly in the district of Suzhou, literati painting, associated with the educated men who served the court as government officials, remained the dominant artistic trend. One of the major literati painters from the Ming period is Shen Zhou (1427–1509), who had no desire to enter government service and spent most of his life in Suzhou. He studied the Yuan painters avidly and tried to recapture their spirit in such works as *Poet on a Mountaintop* (see "*Poet on a Mountaintop*" opposite). Although the style of the painting recalls the freedom and simplicity of Ni Zan (SEE FIG. 25-3), the motif of a poet surveying the landscape from a mountain plateau is Shen's creation.

25-8 THE FORBIDDEN CITY
Now the Palace Museum, Beijing. Mostly Ming dynasty. View from the southwest.
Credit: © View Stock/Getty

Art and its Contexts

POET ON A MOUNTAINTOP

In earlier landscape paintings, human figures were typically shown dwarfed by the grandeur of nature. Travelers might be seen scuttling along a narrow path by a stream, while overhead towered mountains whose peaks were in the clouds and whose heights were inaccessible. But in **FIGURE 25-9** the poet has climbed the mountain and dominates the landscape. Even the clouds are beneath him. Before his gaze, a poem hangs in the air, as though he were projecting his thoughts.

The poem, composed by Shen Zhou himself, and written in his distinctive hand, reads:

White clouds like a scarf enfold the
mountain's waist;
Stone steps hang in space—a long,
narrow path.
Alone, leaning on my cane, I gaze
intently at the scene,
And feel like answering the murmuring
brook with the music of my flute.

(Translation by Jonathan Chaves,
The Chinese Painter as Poet, p. 46.)

Shen Zhou composed the poem and wrote the inscription at the time he painted the album. The style of the calligraphy, like the style of the painting, is informal, relaxed, and straightforward—qualities that were believed to reflect the artist's character and personality.

The painting visualizes Ming philosophy, which held that the mind, not the physical world, was the basis for reality. With its tight synthesis of poetry, calligraphy, and painting and its harmony of mind and landscape, *Poet on a Mountaintop* represents the essence of Ming literati painting.

25-9 Shen Zhou **POET ON A MOUNTAINTOP**
Leaf from an album of landscapes; painting mounted as part of a handscroll. Ming dynasty, c. 1500. Ink and color on paper, 15¼ × 23¾" (40 × 60.2 cm). The Nelson-Atkins Museum of Art, Kansas City, Missouri. Purchase: William Rockhill Nelson Trust (46-51/2).

LITERATI INFLUENCE ON FURNITURE, ARCHITEC-TURE, AND GARDEN DESIGN The taste of the literati also influenced the design of furniture, architecture, and especially gardens. Characteristic of Chinese furniture during the Ming period, the **ARMCHAIR** in **FIGURE 25-10** is constructed without the use of glue or nails. Instead, pieces fit together based on the principle of the mortise-and-tenon joint, in which a projecting element (tenon) on one piece fits snugly into a cavity (mortise) on another. Each piece of the chair is carved—not bent or twisted—and the joints are crafted with great precision. The patterns of the wood grain provide subtle interest, unconcealed by painting or other embellishment. The style, like that of Chinese architecture, is simple, clear, symmetrical, and balanced. The effect is formal and dignified but natural and simple—virtues central to the traditional Chinese view of proper human conduct as well.

The art of landscape gardening also flourished during the Ming dynasty, as many literati surrounded their homes with gardens. The most famous gardens were created in the southern cities of the Yangzi Delta, especially in Suzhou, including the largest surviving garden of the era—the **GARDEN OF THE CESSATION OF OFFICIAL LIFE**

25-10 ARMCHAIR
Ming dynasty, 16th–17th century. Huanghuali wood (hardwood), 39⅜ × 27¼ × 20″ (100 × 69.2 × 50.8 cm). The Nelson-Atkins Museum of Art, Kansas City, Missouri. Purchase: William Rockhill Nelson Trust (46–78/1).

(**FIG. 25-11**). Although modified and reconstructed many times since the sixteenth century, it still reflects many of the basic ideas of the original Ming owner. About one third of the garden is devoted to water through artificially created brooks and ponds. The landscape is dotted with pavilions, kiosks, libraries, studios, and corridors—many with poetic names, such as Rain Listening Pavilion and Bridge of the Small Flying Rainbow.

DONG QICHANG, LITERATI THEORIST The ideas underlying literati painting found their most influential expression in the writings of Dong Qichang (1555–1636). This high official in the late Ming period embodied the literati tradition as poet, calligrapher, and painter. He developed a view of Chinese art history that divided painters into two opposing schools, northern and southern. The categorization is unrelated to the actual geographic homes of the painters—a painter from the south might well be classed as northern—but reflects parallels Dong perceived with the northern and southern schools of Chan (Zen) Buddhism in China. The southern school of Chan, founded by the eccentric monk Huineng (638–713), was unorthodox, radical, and innovative; the northern Chan school was traditional and conservative. Similarly, Dong's two schools of painters represented progressive and conservative traditions. In Dong's view, the conservative northern school was dominated by professional painters whose academic, often decorative, style emphasized technical skill. In contrast, the progressive southern school preferred ink to color and free brushwork to meticulous detail. Its painters aimed for poetry and personal expression. In promoting this theory, Dong privileged literati painting, which he positioned as the culmination of the southern school, and this viewpoint fundamentally influenced the way the Chinese viewed their own tradition.

Dong Qichang summarized his views on the proper training for literati painters in the famous statement "Read ten thousand books and walk ten thousand miles." By this he meant that one must first study the works of the great masters, then follow "heaven and earth," the world of nature. Such study would prepare the way for greater self-expression through brush and ink, the goal of literati painting. Dong's views rested on an awareness that a painting of scenery and the actual scenery are two very different things. The excellence of a painting does not lie in its degree of resemblance to the natural world—that gap can never be bridged—but in its expressive power. In this view, the expressive language of painting is inherently abstract, rooted in the construction of its brushstrokes. For example, in a painting of a rock, the rock itself is not expressive; rather, the brushstrokes that suggest the rock are expressive.

With such thinking Dong brought painting close to the realm of calligraphy, which had long been considered the

25–11 GARDEN OF THE CESSATION OF OFFICIAL LIFE (ALSO KNOWN AS THE HUMBLE ADMINISTRATOR'S GARDEN)

Suzhou, Jiangsu. Ming dynasty, early 16th century.

Early in the sixteenth century, an official in Beijing, frustrated after serving in the capital for many years without promotion, returned home. Taking an ancient poem, "The Song of Leisurely Living," for his model, he began to build a garden. He called his retreat the Garden of the Cessation of Official Life to indicate that he had exchanged his career as a bureaucrat for a life of leisure. By leisure, he meant that he could now dedicate himself to calligraphy, poetry, and painting, the three arts most valued by scholars in China.

Credit: © Meiqianbao/Shutterstock

highest form of artistic expression in China. More than a thousand years before Dong's time, a body of critical terms and theories had evolved to discuss calligraphy in relation to the formal and expressive properties of brushwork and composition. Dong incorporated some of these terms— categories such as opening and closing, rising and falling, and void and solid—into the criticism of painting.

Dong's theories take visual form in his painting of **THE QINGBIAN MOUNTAINS** (FIG. 25–12). As documented in his own inscription, he based this painting on a work by the tenth-century artist Dong Yuan. Dong Qichang's style, however, is quite different from the styles of the masters he admired. Although there is some indication of foreground, middle ground, and distant mountains, the space is ambiguous, as if all the elements were compressed to the surface of the picture. With this flattening of space, the trees, rocks, and mountains become more readily legible as semiabstract forms made of brushstrokes.

Six trees arranged diagonally at the lower right define the extreme foreground and announce themes that the rest of the painting repeats, varies, and develops. The left-most of these foreground trees, with its outstretched branches and full foliage, is echoed first in the shape of another tree just across the river and again in a tree farther up and to the left. The tallest tree of the foreground grouping anticipates the high peak that towers in the distance almost directly above it, while the forms of the smaller foreground trees, especially the one with the darkest leaves, are repeated in many variations across the painting. At the same time, the ordinary-looking boulder in the foreground is transformed in the conglomeration of rocks, ridges, hills, and mountains above. This double reading— both abstract and representational, on the surface and into space—parallels the work's dual nature as a painting of a landscape and an interpretation of a traditional landscape painting.

25–12 Dong Qichang **THE QINGBIAN MOUNTAINS**
Ming dynasty, 1617. Hanging scroll with ink on paper, 21′8″ × 7′4⅜″
(6.72 × 2.25 m). Cleveland Museum of Art. Leonard C. Hanna, Jr., Fund.

Credit: Bridgeman Images

The influence of Dong Qichang on the development of Chinese painting of later periods cannot be overstated. Indeed, nearly all Chinese painters since the early seventeenth century have engaged with his ideas in one way or another.

From the Qing Dynasty to the Modern Era

What traditions and styles endure and what are the new developments in Chinese art from the Qing Dynasty into the modern era?

In 1644, when the armies of the Manchu people northeast of China marched into Beijing, many Chinese reacted as though their civilization had come to an end. Yet the Manchus had already adopted many Chinese customs and institutions. After gaining control of all of China, a process that took decades, they showed great respect for Chinese tradition. All the major artistic trends of the late Ming dynasty eventually continued into the Manchu, or Qing, dynasty (1644–1911).

Orthodox and Individualist Painting

Literati painting had been established as the dominant tradition; it now became orthodox. Scholars followed Dong Qichang's recommendation, basing their approach on the study of past masters—especially Song and Yuan artists—and imitating antique styles as a way of expressing their own learning, technique, and taste.

The Qing emperors of the late seventeenth and eighteenth centuries were painters themselves. They collected literati painting, and their taste was shaped mainly by artists such as Wang Hui (SEE FIG. 25–1). Thus literati painting, long associated with reclusive scholars, ultimately became an academic style practiced at court. Imbued with values associated with scholarship and virtue, these paintings constituted the highest art form of the Qing court. The emperors also valued a style of bird-and-flower painting developed by Yun Shouping (1633–1690) that, like the orthodox style of landscape painting, was embraced by literati painters, many of them court officials themselves. Most often seen in albums or fans, the style recalled aspects of Song- and Yuan-dynasty bird-and-flower painting, and artists cited their ancient models as a way to enrich both the meaning and the beauty of these small-format works. In a leaf from an album of flowers, bamboo,

25-13 Yun Shouping AMARANTH

Leaf from an album of flowers, bamboo, fruits, and vegetables. Qing dynasty, 1633–1690. Album of 10 leaves; ink and color on paper; each leaf 10 × 13″ (25.3 × 33.5 cm). Collection of Phoenix Art Museum, Arizona. Gift of Marilyn and Roy Papp. (2006.164)

The leaf is inscribed by the artist: "Autumn garden abounds in beauty, playfully painted by Ouxiangguan (Yun Shouping)." (Translation by Momoko Soma Welch)

fruits, and vegetables that employs a variety of brush techniques (**FIG. 25-13**), Yun Shouping painted flowers representing the autumn season.

INDIVIDUALIST PAINTING The first few decades of Qing rule had been both traumatic and dangerous for those who were loyal—or worse, related—to the Ming. Some committed suicide, while others sought refuge in monasteries or wandered the countryside. Among them were several painters—now known as the individualists—who expressed their anger, defiance, frustration, and melancholy in their art. They took Dong Qichang's idea of painting as an expression of the artist's personal feelings very seriously and cultivated highly original styles. Among the most accomplished was Zhu Da, whose painting of quince we have already encountered in the Introduction (**FIG. 25-14**; see the Introduction on pages xxx–xxxiii).

SHITAO Another individualist was Shitao (1642–1707), Zhu Da's distant imperial cousin, who was descended from the first Ming emperor and, like Zhu Da, took refuge in Buddhist temples when the dynasty fell. In his later life he brought his painting to the brink of abstraction in such works as **REMINISCENCES OF QINHUAI RIVER**, the final leaf of a landscape album (**FIG. 25-15**). In this painting, a monk stands in a boat, looking up at the mountains that seem to be reaching downward toward him, lined by inverted trees. The inscription filling the negative space above the mountains explains that the painting was made for one of Shitao's friends who had sent him paper for a requested painting. In these nostalgic paintings the artist refers to a happier time in the 1680s when the two friends had searched for plum blossoms along the Qinhuai River. Throughout his life Shitao identified himself with the fallen Ming, filled with longing for the secure world that had turned to chaos with the Manchu conquest.

25–14 Zhu Da (Bada Shanren) **QUINCE (MUGUA)**
Qing dynasty, 1690. Album leaf mounted as a hanging scroll;
ink and colors on paper, 7⅞ × 5¾″ (20 × 14.6 cm). Princeton
University Art Museum.

Credit: © 2016. Princeton University Art Museum/Art Resource, NY/Scala,
Florence

25–15 Shitao **REMINISCENCES OF QINHUAI RIVER**
One of eight leaves from an album. Qing dynasty, c. 1695–1700.
Ink and color on paper, 10 × 8″ (25.5 × 20.2 cm). Cleveland Museum
of Art.

Credit: Bridgeman Images

The Modern Period

In the mid and late nineteenth century, China was shaken from centuries of complacency by a series of humiliating military defeats at the hands of Western powers and Japan. Only then did the government finally realize that these new rivals were not like the Mongols of the thirteenth century. China was no longer at the center of the world, a civilized country surrounded by "barbarians." Spiritual resistance was no longer sufficient to solve the problems brought on by change. New ideas from Japan and the West began to filter in, and the demand arose for political and cultural reforms. In 1911, the Qing dynasty was overthrown, ending 2,000 years of imperial rule, and China was reconceived as a republic.

During the first decades of the twentieth century Chinese artists traveled to Japan and Europe to study Western art. Returning to China, many sought to introduce the ideas and techniques they had learned, and they explored ways to synthesize Chinese and Western traditions. After the establishment of the present-day Communist government in 1949, individual artistic freedom was curtailed as

the arts were pressed into the service of the state and its vision of a new social order. After 1979, however, cultural attitudes began to relax, and Chinese painters again pursued their own paths.

WU GUANZHONG One artist who emerged during the 1980s as a leader in Chinese painting was Wu Guanzhong (1919–2010). Combining his French artistic training with his Chinese background, Wu Guanzhong developed a semiabstract style to depict scenes from the Chinese landscape. He made preliminary sketches on site. Then, back in his studio, he developed these sketches into free interpretations based on his feeling and vision. An example of his work, **PINE SPIRIT**, depicts a scene in the Huang (Yellow) Mountains (**FIG. 25-16**). The technique, with its sweeping gestures of paint, is clearly linked to Abstract Expressionism, an influential Western movement of the post–World War II years (Chapter 32); yet the painting also claims a place in the long tradition of Chinese landscape as exemplified by such masters as Shitao.

25-16 Wu Guanzhong **PINE SPIRIT**

1984. Ink and color on paper, 2'3⅝" × 5'3½" (0.70 × 1.61 m). Spencer Museum of Art, University of Kansas, Lawrence. Gift of the E. Rhodes and Leonard B. Carpenter Foundation (1991.0003).

Credit: © Wu Guanzhong

Like all aspects of Chinese society, Chinese art has felt the strong impact of Western influence, and the question remains whether Chinese artists will absorb Western ideas without losing their traditional identity. Interestingly, landscape remains an important subject, as it has been for more than a thousand years, and calligraphy continues to play a vital role. Using the techniques and methods of the West, some of China's artists have joined an international avant-garde (see, for example, Wenda Gu in Chapter 33, FIG. 33-54), while other painters still seek communion with nature through their ink brushstrokes as a means to come to terms with human life and the world.

Arts of Korea from the Joseon Dynasty to the Modern Era

How do Korean ceramics and painting develop from the fifteenth to the twentieth century?

In 1392, General Yi Seonggye (1335–1408) overthrew the Goryeo dynasty (918–1392), establishing the Joseon dynasty (1392–1910), sometimes called the Yi dynasty. He first maintained his capital at Gaeseong, the old Goryeo capital, but moved it to Seoul in 1394, where it remained through the end of the dynasty. The Joseon regime rejected Buddhism, espousing Neo-Confucianism as the state philosophy. Taking Ming-dynasty China as its model, the new government patterned its bureaucracy on that of the Ming emperors, even adopting as its own such outward symbols of Ming imperial authority as blue-and-white porcelain. The early Joseon era was a period of cultural refinement and scientific achievement during which Koreans invented Han'geul (the Korean alphabet) and movable type, not to mention the rain gauge, astrolabe, celestial globe, sundial, and water clock.

Joseon Ceramics

Like their Silla and Goryeo forebears, Joseon potters excelled in the manufacture of ceramics, taking their cue from contemporaneous Chinese wares but seldom copying them directly.

BUNCHEONG CERAMICS Descended from Goryeo celadons, Joseon-dynasty stonewares, known as *buncheong* wares, enjoyed widespread usage throughout the peninsula. Their decorative effect relies on the use of white slip that makes the humble stoneware resemble more expensive white porcelain. In fifteenth-century examples, the slip is often seen inlaid into repeating design elements stamped into the clay body.

Sixteenth-century *buncheong* wares are characteristically embellished with wonderfully fluid, calligraphic brushwork painted in iron-brown slip on a white slip ground. Most painted *buncheong* wares have stylized floral

25–17 HORIZONTAL WINE BOTTLE WITH DECORATION OF A BIRD CARRYING A NEWLY CAUGHT FISH
Korea. Joseon dynasty, 16th century. *Buncheong* ware: light gray stoneware with decoration painted in iron-brown slip on a white slip ground; 6¹⁄₁₀ × 9½″ (15.5 × 24.1 cm). Museum of Oriental Ceramics, Osaka, Japan. Gift of the Sumitomo Group (20773).

décor, but rare pieces, such as a charming **WINE BOTTLE** (**FIG. 25–17**), feature pictorial decoration. In fresh, lively brushstrokes, a bird with outstretched wings grasps a fish that it has just caught in its talons; waves roll below, while two giant lotus blossoms frame the scene.

Japanese armies repeatedly invaded the Korean peninsula between 1592 and 1597, destroying many of the *buncheong* kilns and essentially bringing ceramic production to a halt. Tradition holds that the Japanese took many *buncheong* potters home with them to produce *buncheong*-style wares, which were greatly admired by connoisseurs of the tea ceremony. In fact, the spontaneity

25–18 BROAD-SHOULDERED JAR WITH DECORATION OF A FRUITING GRAPEVINE
Korea. Joseon dynasty, 17th century. Porcelain with decoration painted in underglaze iron-brown slip, height 22⅕″ (53.8 cm). Ewha Women's University Museum, Seoul, Republic of Korea.

Credit: *Courtesy of Ewha Woman's University Museum, Seoul*

of Korean *buncheong* pottery has inspired Japanese ceramics to this day.

PAINTED PORCELAIN Korean potters produced porcelains with designs painted in underglaze cobalt blue as early as the fifteenth century, inspired by Chinese porcelains of the early Ming period (SEE FIG. 25–4). The Korean court dispatched artists from the royal painting academy to the porcelain kilns—located some 30 miles southeast of Seoul—to train porcelain painters. As a result, from the fifteenth century onward, the painting on the best Korean porcelains closely approximated that on paper and silk, unlike in China, where ceramic decoration followed a path of its own with little reference to painting traditions.

In another unique development, Korean porcelains from the sixteenth and seventeenth centuries often feature designs painted in underglaze iron-brown rather than the cobalt blue customary in Ming porcelain. Also uniquely Korean are porcelain jars with bulging shoulders, slender bases, and short, vertical necks, which appeared by the seventeenth century and came to be the most characteristic ceramic shapes in the later Joseon period. One example, a seventeenth-century jar painted in underglaze iron-brown (**FIG. 25–18**), depicts a fruiting grape branch around its shoulder. In typical Korean fashion, the painting spreads over a surface unconstrained by borders, resulting in a balanced but asymmetrical design that incorporates the Korean taste for unornamented spaces.

Joseon Painting

Korean secular painting came into its own during the Joseon dynasty. Continuing Goryeo traditions, early Joseon examples employ Chinese styles and formats, their range of subjects expanding from botanical motifs to include landscapes, figures, and a variety of animals.

Painted in 1447 by An Gyeon (b. 1418), **DREAM JOURNEY TO THE PEACH BLOSSOM LAND** (**FIG. 25–19**) is the

25–19 An Gyeon **DREAM JOURNEY TO THE PEACH BLOSSOM LAND**
Korea. Joseon dynasty, 1447. Handscroll with ink and light colors on silk, 15¼ × 41¾″ (38.7 × 106.1 cm). Central Library, Tenri University, Tenri (near Nara), Japan.

Credit: Photo courtesy of Central Library, Tenri University, Tenri, Japan

earliest extant and dated Joseon secular painting. It illustrates a fanciful tale by China's revered nature poet Tao Qian (365–427) about chancing upon a utopia secluded from the world for centuries while meandering among the peach blossoms of spring.

As with their Goryeo forebears, the monumental mountains and vast, panoramic vistas of such fifteenth-century Korean paintings echo Northern Song painting styles. Chinese paintings of the Southern Song (1127–1279) and Ming (1368–1644) periods also influenced Korean painting of the fifteenth, sixteenth, and seventeenth centuries, though these styles never completely supplanted the imprint of the Northern Song masters.

THE SILHAK MOVEMENT In the eighteenth century, a truly Korean style emerged, inspired by the *silhak* ("practical learning") movement, which emphasized the study of things Korean in addition to the Chinese classics. The impact of the movement is exemplified by the painter Jeong Seon (1676–1759), who chose well-known Korean vistas as the subjects of his paintings, rather than the Chinese themes favored by earlier artists. Among Jeong Seon's paintings are numerous representations of the Diamond Mountains (Geumgang-san), a celebrated range of craggy peaks along Korea's east coast. One hanging scroll painted in 1734 (**FIG. 25–20**) aptly captures the Diamond Mountains' needle-like peaks. The subject is Korean, and so is the energetic spirit and the intensely personal style,

25–20 Jeong Seon **PANORAMIC VIEW OF THE DIAMOND MOUNTAINS (GEUMGANG-SAN)**
Korea. Joseon dynasty, 1734. Hanging scroll with ink and colors on paper, 40⅝ × 37″ (130.1 × 94 cm). Lee'um, Samsung Museum, Seoul, Republic of Korea.

Credit: National Treasure # 217

25–21 Kim Hongdo **ROOF TILING**
From *Album of Genre Paintings*. Korea.
Joseon dynasty,18th century. Ink and light colors
on paper, 10⅝ × 8⅞" (27 × 22.7 cm). National
Museum of Korea, Seoul, Republic of Korea.
Treasure No. 527.

Credit: National Museum of Korea, Seoul, Republic
of Korea.

with its crystalline mountains, distant clouds of delicate ink wash, and individualistic brushwork.

Other artists expanded the growing interest in Korean themes to different sorts of subject matter. Kim Hongdo (1745–1806) painted genre scenes that showcased the everyday lives and occupations not of the nobility, but of commoners. His painting of **ROOF TILING** (**FIG. 25–21**)—one of a series of 25 album leaves portraying genre scenes—shows a team of six laborers engaged in various aspects of their roofing job. At lower right a carpenter smooths a propped-up board with his plane, while two colleagues perch on the roof itself, one about to hoist up a bundle of materials and the other catching a tile that has been heaved to him from below. The seventh man, leaning on his staff at upper right to survey the work, is presumably the roofers' supervisor. The circular figural composition animates the compressed foreground tableau and organizes the viewer's examination of the carefully detailed workers, whose depiction is energized by active poses and expressive faces. Kim creates a strong sense of narrative; we seem to have come unexpectedly into the middle of an unfolding story.

Modernist Painting

Long known as "the Hermit Kingdom," the Joseon dynasty pursued a policy of isolationism, closing its borders to most of the world except China, until 1876. Japan's annexation of Korea in 1910 brought the Joseon dynasty to a close, but effectively prolonged the country's seclusion from the outside world. The legacy of self-imposed isolation was compounded by colonial occupation (1910–1945)—not to mention the harsh circumstances imposed by World War II (1939–1945) and the even worse conditions of the Korean War (1950–1953)—and impeded Korea's artistic and cultural development during the first half of the twentieth century.

Despite these privations, some modern influences did reach Korea indirectly via China and Japan, and beginning in the 1920s and 1930s a few Korean artists experimented with contemporary Western styles, typically painting in the manner of Cézanne or Gauguin, but sometimes trying abstract, nonrepresentational styles. Among these, Whanki Kim (1913–1974) was influenced by Constructivism and geometric abstraction and would become one of twentieth-century Korea's influential painters. Like many Korean artists after the Korean War, Kim wanted to examine Western Modernism at its source. He visited Paris in 1956 and then, from 1964 to 1974, lived and worked in New York, where he produced his best-known works. His painting **UNIVERSE 5-IV-71 #200** presents a large pair of circular, radiating patterns composed of small dots and squares in tones of blue, black, and gray (**FIG. 25–22**). While appearing wholly Western in style, medium, concept, and even the adoption of the date of the work's creation as part of its title, this work also seems related to East Asia's venerable tradition of monochrome **ink painting**, while suggesting a transcendence that seems Daoist or Buddhist in feeling. Given that the artist was Korean, that he learned the Chinese classics in his youth, that he studied art in Paris, and that he then worked in New York, it is possible that his painting embodies all of the above. It illustrates the dilemma faced by many modern artists seeking to find a distinctive, personal style: whether to paint in an updated

version of a traditional style, in a wholly international style, in an international style with a distinctive local twist, or in an eclectic, hybrid style that incorporates both native and naturalized elements from diverse artistic traditions.

By addressing these questions, Whanki Kim blazed a trail for subsequent Korean-born artists, such as the renowned video artist Nam June Paik (1932–2006), whose work will be discussed in Chapter 33.

25-22 Whanki Kim **UNIVERSE 5-IV-71 #200**

Korea. 1971, Oil on cotton, 8'4" × 8'4" (254 × 254 cm). Whanki Museum, Seoul, Republic of Korea.

Credit: © Whanki Foundation - Whanki Museum

Think About It

1 Discuss the place of Dong Qichang's *The Qingbian Mountains* (**FIG. 25-12**) within the history of Chinese landscape painting, drawing specific comparisons with works that came before and after it.

2 Examine a work commissioned by the court at Beijing and distinguish which of its features are typical of court art.

3 Characterize the culture of the literati, including their values and their art patronage.

4 Theorize reasons for the emergence of individualist painting in China, using specific works to support your argument.

Crosscurrents

Both of these expansive paintings use landscape, figures, and text in compositions that embody important ideas, values, and themes characteristic of two very different cultures. Discuss the meanings in these two works. How do they represent the aspirations of the artists who created them and the viewers who originally encountered them?

FIG. 18–15

FIG. 25–9

26–1 Suzuki Harunobu THE FLOWERS OF BEAUTY IN THE FLOATING WORLD: MOTOURA AND YAEZAKURA OF THE MINAMI YAMASAKIYA

Edo period, 1769. Polychrome woodblock print on paper, 11⅜ × 8½″ (28.9 × 21.8 cm). Honolulu Museum of Art, Gift of James A. Michener, 1957 (14044)

Chapter 26

Japanese Art after 1333

Learning Objectives

26.a Identify the visual hallmarks of Japanese art after 1333 for formal, technical, and expressive qualities.

26.b Interpret the meaning of works of Japanese art after 1333 based on their themes, subjects, and symbols.

26.c Relate artists and art of Japan after 1333 to their cultural, economic, and political contexts.

26.d Apply the vocabulary and concepts relevant to post-1333 Japanese art, artists, and art history.

26.e Interpret a work of Japanese art after 1333 using the art historical methods of observation, comparison, and inductive reasoning.

26.f Select visual and textual evidence in various media to support an argument or an interpretation of a work of Japanese art after 1333.

Perched on a window seat, a young woman pauses from smoking her pipe while the girl at her side peers intently through a telescope at boats in the bay below (**FIG. 26–1**). The scene takes place in the city of Edo (now Tokyo) in the 1760s, during an era of peace and prosperity that had started some 150 years earlier when the Tokugawa shoguns unified the nation. Edo was then the largest city in the world, with over 1 million inhabitants: samurai-bureaucrats and working-class townspeople. The commoners possessed a vibrant culture centered in urban entertainment districts, where geisha and courtesans, such as the lady and her young trainee portrayed in this woodblock print, worked.

In the 1630s, the Tokugawa shogunate banned Japanese citizens from traveling abroad and restricted foreign access to the country. Nagasaki became Japan's sole international port, which only Koreans, Chinese, and Dutch could enter—and they could not travel freely in the country once there. The government did this to deter Christian missionaries and to assert authority over foreign powers. Not until 1853, when Commodore Matthew Perry of the United States forced Japan to open additional ports, did these policies change. But even prior to 1853, foreign influences and products could not be prevented, as the tobacco pipe and telescope in this print testify.

The Japanese had first encountered Westerners—Portuguese traders—in the mid sixteenth century. The Dutch reached Japan by 1600 and brought tobacco and, soon after that, the telescope and other exotic optical devices—including spectacles and microscopes—as well as other objects, including books, many illustrated. The Japanese eagerly welcomed these foreign goods and imitated foreign customs, which conferred an air of sophistication on the user. Looking through telescopes like the one in this print was a popular amusement of courtesans and their customers. It conveyed the sort of sexual overtones—because of the telescope's phallic shape—that characterized the ribald humor then in vogue. Western optical devices, all readily available by the mid eighteenth century, offered a new way of seeing that affected the appearance of Japanese pictorial art. As in the early history of Japanese art, however, Chinese influence remained strong and now spread throughout the population as never before, due to new efforts to educate the broader populace in Chinese studies. In varying degrees, the intermingling of diverse native and foreign artistic traditions continued to shape the arts of Japan.

Foundations of Japanese Culture

What aspects of the early history, culture, and art of Japan form a critical background for the development of art and architecture after 1333?

With the end of the last Ice Age roughly 15,000 years ago, rising sea levels submerged the lowlands connecting Japan to the Asian landmass, creating the chain of islands we

MAP 26-1 JAPAN

Japan's wholehearted emulation of many aspects of Chinese culture began in the fifth century. It was challenged by new influences from the West only in the mid nineteenth century after Western powers forced Japan to open its treaty ports to international trade.

know today as Japan (**MAP 26-1**). Not long afterward, early Paleolithic cultures gave way to a Neolithic culture known as Jomon (c. 11,000–400 BCE) after its characteristic cord-marked pottery. During the Jomon period, a sophisticated hunter-gatherer culture developed. Agriculture supplemented hunting and gathering by around 5000 BCE, and rice cultivation began some 4,000 years later.

A fully settled agricultural society emerged during the Yayoi period (c. 400 BCE–300 CE), accompanied by hierarchical social organization. As people learned to manufacture bronze and iron, use of those metals became widespread. Yayoi architecture, with its unpainted wood and thatched roofs, already showed the Japanese affinity for natural materials and clean lines; the style of Yayoi granaries in particular persisted in the design of shrines in later centuries. The trend toward social organization continued during the Kofun period (c. 300–552 CE), an era characterized by the construction of large royal tombs following the Korean practice. Veneration of leaders grew into the beginnings of the imperial system that has lasted to the present day.

The Asuka era (552–645 CE) began with a period of profound change as elements of Chinese civilization flooded into Japan, initially through the intermediary of Korea. The three most significant Chinese contributions to the developing Japanese culture were Buddhism (with its attendant art and architecture), a system of writing, and the structures of a centralized bureaucracy. The earliest extant Buddhist temple compound in Japan, Horyuji, which contains the oldest currently existing wooden buildings in the world, dates from this period (SEE FIG. 12–4).

The arrival of Buddhism also prompted some formalization of Shinto, the loose collection of indigenous Japanese beliefs and practices. Shinto is a religion that connects people to nature. Its rites are shamanistic and emphasize ceremonial purification. These include the invocation and appeasement of spirits, including those of the recently dead. Many Shinto deities are thought to inhabit various aspects of nature, such as particularly magnificent trees, rocks, and waterfalls, and living creatures such as deer. Shinto and Buddhism have in common an intense awareness of the transience of life, and as their goals are complementary—purification in the case of Shinto, enlightenment in the case of Buddhism—they have generally existed comfortably alongside each other.

The Nara period (645–794 CE) takes its name from the location of Japan's first permanently established imperial capital. During this time the founding works of Japanese literature were compiled, and Buddhism became the most important force in Japanese culture. Its influence at court grew so great that in 794 the emperor moved the capital from Nara to Heian-kyo (present-day Kyoto), far from powerful monasteries.

During the Heian period (794–1185 CE) an extremely refined court culture thrived, embodied today in an exquisite legacy of poetry, calligraphy, and painting. An efficient method for writing the Japanese language was developed, and with it a woman at the court wrote Japan's most celebrated fictional story, which some describe as the world's first novel: *The Tale of Genji*. Esoteric Buddhism, as hierarchical and intricate as the aristocratic world of the court, became popular.

The end of the Heian period was marked by civil warfare as regional warrior (samurai) clans were drawn into the factional conflicts at court. Pure Land Buddhism, with its simple message of salvation, offered consolation to many in troubled times. In 1185, the Minamoto clan defeated their arch rivals, the Taira, and their leader, Minamoto Yoritomo, assumed the position of shogun (general-in-chief). While paying respect to the emperor, Minamoto Yoritomo took actual military and political power for himself, setting up his own capital in Kamakura. The Kamakura era (1185–1333 CE) began a tradition of rule by shogun that lasted in various forms until 1868. It was also the time in which renewed contacts with China

created the opportunity for Zen Buddhism, which was then flourishing in China (and was known there as Chan), to be introduced to Japan. By the end of the Kamakura period, numerous Zen monasteries had been founded in Kyoto and Kamakura, and Chinese and Japanese Chan/Zen monks were regularly visiting each other's countries.

Muromachi Period

What is the impact of Zen aesthetics on ink painting and garden design during the Muromachi period?

By the year 1333, the history of Japanese art was already long and rich. Very early, a particularly Japanese sensitivity to artistic production had emerged, including a love of natural materials, a fondness for representing elements of the natural world, and a cultivation of fine craft. Aesthetically, Japanese art manifested a taste for asymmetry, abstraction, boldness of expression, and humor—characteristics that will continue to distinguish Japanese art in its evolving history.

Late in the twelfth century, the authority of the emperor had been superseded by powerful and ambitious warriors (samurai) under the leadership of the shogun, the general-in-chief. But in 1333, Emperor Go-Daigo attempted to retake power. He failed and was forced into hiding in the mountains south of Kyoto where he set up a "southern court." Meanwhile, the shogunal family then in power, the Minamoto, was overthrown by warriors of the Ashikaga clan, who placed a rival to the upstart emperor on the throne in Kyoto, in a "northern court," and had him declare their clan head as shogun. They ruled the country from the Muromachi district in Kyoto and finally vanquished the southern court emperors in 1392. The Muromachi period, also known as the Ashikaga era (1392–1573), formally began with this event.

The Muromachi period is marked by the ascendance of Zen Buddhism, introduced into Japan in the late twelfth century, whose austere ideals particularly appealed to the highly disciplined samurai. While Pure Land Buddhism, which had spread widely during the latter part of the Heian period (794–1185), remained popular, Zen (which means meditation) became the dominant cultural force in Japan among the ruling elite.

Zen Ink Painting

During the Muromachi period, the creation of brightly colored narrative handscrolls in traditional Japanese style continued, but monochrome painting in black ink and its diluted grays—which had just been introduced to Japan from the continent at the end of the Kamakura period (1185–1333)—reigned supreme. Muromachi ink painting was heavily influenced by the aesthetics of Zen, but unlike

earlier Zen paintings that had concentrated on portrayals of important individuals associated with the Zen monastic tradition, Chinese-style landscapes in ink also began to be produced. Traditionally, the monk-artist Shubun (active c. 1418–1463) is regarded as Japan's first great master of ink landscape painting. Unfortunately, no undisputed work of his survives. Two landscapes by Shubun's pupil Bunsei (active c. 1450–1460), however, do survive. The one reproduced in **FIGURE 26-2** is closely modeled on Korean

26-2 Bunsei LANDSCAPE
Muromachi period, mid 15th century. Hanging scroll with ink and light colors on paper, 28¾ × 13″ (73.2 × 33 cm). Museum of Fine Arts, Boston. Special Chinese and Japanese Fund (05.203).

Credit: Photograph © 2017 Museum of Fine Arts, Boston

ink landscape paintings, which were themselves copied from Ming-period Chinese models (such as FIG. 25-6). The foreground consists of a spit of rocky land with an overlapping series of motifs—a spiky pine tree, a craggy rock, a poet seated in a hermitage, and a brushwood fence surrounding a small garden of trees and bamboo. In the middle ground is open space—emptiness, the void. We are expected to "read" the unpainted expanse as water. Beyond the blank space, subtle tones of gray ink delineate a distant shore where fishing boats, a small hut, and two people stand. The two parts of the painting seem to echo each other across a deep expanse. The painting illustrates well the pure, lonely, and ultimately serene spirit of the Zen poetic landscape tradition.

SESSHU Another of Shubun's pupils, Sesshu (1420–1506), has come to be regarded as one of the greatest Japanese painters of all time. Although Shubun and his

26-3 Sesshu WINTER LANDSCAPE
Muromachi period, c. 1470s. Hanging scroll with ink on paper, 18¼ × 11½" (46.3 × 29.3 cm). Collection of the Tokyo National Museum. National Treasure.

Credit: © Burstein Collection/Corbis

followers completed training to become Zen monks at the monastery, they specialized in art rather than in religious ritual or teaching. This distinguished them from earlier Zen monk-painters, for whom painting was but one facet of their lives. By Shubun's day, temples had formed their own professional painting ateliers in order to meet the large demand from warrior patrons for paintings. Sesshu trained as a Zen monk at Shokokuji, where Shubun had his studio. He worked in the painting atelier under Shubun for 20 years before leaving Kyoto to head a small provincial Zen temple in western Japan, where he could concentrate on painting unencumbered by monastic duties and entanglements with the political elite. His new temple was under the patronage of a wealthy warrior clan that engaged in trade with China. Funded by them, he had the opportunity to visit China in 1467 on a diplomatic mission. He traveled extensively there for three years, viewing the scenery, stopping at Chan (Zen) monasteries, and studying Chinese paintings by professional artists rather than those by contemporary literati masters.

When Sesshu returned from China, he remained in the provinces to avoid the turmoil in Kyoto, at that time devastated by civil warfare that would last for the next hundred years. Only a few paintings created prior to his sojourn in China have come to light. They are in a style closer to Shubun, and Sesshu signed them with another name. In contrast, the paintings he produced after his return demonstrate a conscious break artistically with the refined landscape style of his teacher. These masterful later paintings exhibit a bold, new spirit, evident in his **WINTER LANDSCAPE** (**FIG. 26-3**). A cliff descending from the mist seems to cut the composition in two parts. Jagged brushstrokes delineate a series of rocky hills, where a lone figure makes his way to a Zen monastery. Instead of a gradual recession into space, flat, overlapping planes fracture the composition into crystalline facets. The white of the paper is left to indicate snow, while the sky is suggested by tones of gray. A few trees cling to the rocky land. The harsh chill of winter is almost palpable.

Zen Dry Gardens

Zen monks led austere lives in their quest for the attainment of enlightenment. In addition to daily meditation, they engaged in manual labor to provide for themselves and maintain their temple properties. Many Zen temples constructed dry landscape courtyard gardens, not for strolling in but for the purpose of contemplative viewing. Cleaning and maintaining these gardens—pulling weeds, tweaking unruly shoots, and raking the gravel—was a kind of active meditation that helped to keep the monks' minds grounded.

The dry landscape gardens of Japan, *karesansui* ("dried-up mountains and water"), exist in perfect

26-4 ROCK GARDEN, RYOANJI, KYOTO
Muromachi period, c. 1480. Photographed spring 1993. UNESCO World Heritage Site, National Treasure.

The American composer John Cage, who composed a piece entitled "Ryoanji" in 1983, loved this garden, believing that every stone was in just the right place but also claiming that if they were rearranged, they would still be in the right place. His remark is thoroughly Zen in spirit. There are many ways to experience Ryoanji. For example, we can imagine the rocks as having different visual "pulls" that relate them to one another. Yet there is also enough space between them to give each a sense of self-sufficiency and permanence.

Credit: © Michael S. Yamashita/Corbis

harmony with Zen Buddhism. The dry garden in front of the abbot's quarters in the Zen temple at Ryoanji is one of the most renowned Zen creations in Japan (**FIG. 26-4**). A flat rectangle of raked gravel, about 29 by 70 feet, surrounds 15 stones of different sizes in islands of moss. The stones are set in asymmetrical groups of two, three, and five. Low, plaster-covered walls establish the garden's boundaries, but beyond the perimeter wall maple, pine, and cherry trees add color and texture to the scene. Called "borrowed scenery," these elements are a considered part of the design even though they grow outside the garden. This garden is celebrated for its severity and its emptiness.

Dry gardens began to be built in the fifteenth and sixteenth centuries in Japan. By the sixteenth century, Chinese landscape painting influenced the gardens' composition, and miniature clipped plants and beautiful stones were arranged to resemble famous paintings. Especially fine and unusual stones were coveted and even carried off as war booty, such was the cultural value of these seemingly mundane objects.

The Ryoanji garden's design, as we see it today, probably dates from the mid seventeenth century, at which point such stone and gravel gardens had become highly intellectualized, abstract reflections of nature. This garden has been interpreted as representing islands in the sea or mountain peaks rising above the clouds, perhaps even a swimming tigress with her cubs, or constellations of stars and planets. All or none of these interpretations may be equally satisfying—or irrelevant—to a monk seeking clarity of mind through contemplation.

Momoyama Period

What are the major contributions of the Momoyama period in architectural design and art?

The civil wars that were sweeping Japan laid bare the basic flaw in the Ashikaga system—samurai were primarily loyal to their own feudal lord (*daimyo*), rather than to the central government. Battles between feudal clans grew more frequent, and it became clear that only a warrior powerful and bold enough to unite the entire country could control Japan. As the Muromachi period drew to a close, three leaders emerged who would change the course of Japanese history.

The first of these leaders was Oda Nobunaga (1534–1582), who marched his army into Kyoto in 1568 and overthrew the reigning Ashikaga shogun in 1573, initiating a new age of Japanese politics. A ruthless warrior, Nobunaga went so far as to destroy a Buddhist monastery because the monks refused to join his forces. Yet he was also a patron of the most rarefied and refined arts.

After he took his own life to avoid succumbing to his enemies in the midst of a military campaign, he was succeeded by one of his generals, Toyotomi Hideyoshi (1537–1598), who soon gained complete power in Japan. He, too, was a patron of the arts when not leading his army, since he considered culture a vital adjunct to his rule. Hideyoshi, however, was overly ambitious. He believed he could conquer both Korea and China, and he wasted much of his resources on two ill-fated invasions. A stable and long-lasting military regime finally emerged soon after 1600 with the triumph of a third leader, Tokugawa Ieyasu (1543–1616), a former ally of Nobunaga who served as a senior retainer to Hideyoshi and only asserted his power after Hideyoshi's death. But despite its turbulence, the era of Nobunaga and Hideyoshi, known as the Momoyama period (1573–1615), was one of the most creative eras in Japanese history.

Today the very word Momoyama conjures up images of bold warriors, luxurious palaces, screens shimmering with gold leaf, and, in contrast, rustic tea-ceremony ceramics. Europeans first made an impact in Japan at this time. After the arrival of a few wayward Portuguese explorers in 1543, traders and missionaries soon followed. It was only with the rise of Nobunaga, however, that Westerners were able to extend their activities beyond the ports of Kyushu, Japan's southernmost island. Nobunaga welcomed foreign traders, who brought him various products, the most influential of which were firearms.

Architecture

European muskets and cannons quickly changed the nature of Japanese warfare and Japanese castle architecture. In the late sixteenth century, castles became heavily fortified garrisons to defend against these new weapons. Some were eventually lost to warfare or torn down by victorious enemies, and others have been extensively altered over the years. One of the most beautiful of the few that have survived intact is **HIMEJI**, not far from the city of Osaka (**FIG. 26–5**). Rising high on a hill above the plains, Himeji has been given the name White Heron. To reach the upper fortress, visitors must follow angular paths beneath steep walls, climbing from one area to the next past stone ramparts and through narrow, fortified gates, all the while feeling lost in a maze with no sense of direction or progress. At the main building, a further climb up a series of narrow ladders leads to the uppermost chamber. There, the footsore visitor is rewarded with a stunning 360-degree view of the surrounding countryside.

Shoin Rooms

Castles such as Himeji were sumptuously decorated, offering artists unprecedented opportunities to work on a grand scale. Interiors were divided into *shoin*-style rooms by paper-covered sliding doors (**fusuma**). Alcoves were created for specialized placement of art and activities.

26–5 HIMEJI CASTLE, HYOGO, NEAR OSAKA
Momoyama period, 1601–1609. UNESCO World Heritage Site, National Treasure.
Credit: © Louis W/Shutterstock

The use of *fusuma* provided expansive surfaces for large-scale murals. Free-standing folding screens (*byobu*) were also popular. Some of these paintings had gold-leaf backgrounds, whose glistening surfaces reflected light back into rooms and demonstrated the wealth of the warrior leaders who commissioned them. They were used in castles, as well as in grand reception rooms in temples where the monks met with visitors, notably the patrons themselves (see "*Shoin* Design" below). Artists working in the famous Kano School were often called on to meet the growing need for paintings to decorate *shoin*-style rooms.

A sumptuous set of *fusuma* in full color on a gold background was commissioned from Kano School artists for the reception room in a subtemple of Ryonji; the patron was a member of the ruling elite from the

Elements of Architecture
SHOIN DESIGN

The Japanese tea ceremony and *shoin*-style interior used in residential architecture were undoubtedly the most significant and enduring expressions of Japanese taste established during the Momoyama period. **Shoin** combine a number of interior features in more or less standard ways, though no two rooms are ever the same. These features include wide verandas, walls divided by wooden posts, floors covered with woven straw **tatami** mats, recessed panels in ceilings, sometimes painted and sometimes covered with reed matting, several shallow alcoves for prescribed purposes, *fusuma* (paper-covered sliding doors), and **shoji** screens—wood frames covered with translucent rice paper. The *shoin* illustrated here was built in 1601 as a guest hall, called Kojoin, at the Buddhist temple of Onjoji near Kyoto.

The *shoin* is a formal room for receiving important upper-class guests. With some variations due to differences in status, these rooms were designed for buildings used by samurai, aristocrats, and even well-to-do commoners. They are found in various types of buildings: private residences; living quarters, guesthouses, and reception rooms at religious complexes (both Shinto shrines and Buddhist temples); and the finest houses of entertainment (such as seen in FIG. 26–1) where geisha and courtesans entertained important guests. The owner of the building or the most important guest would be seated in front of the main alcove (*tokonoma*), which would contain a hanging scroll, an arrangement of flowers, or a large painted screen. Alongside that alcove was another that featured staggered shelves, often for displaying precious objects. The veranda side of the room also contained a writing space fitted with a low writing desk.

The architectural harmony of a *shoin* is derived from standardization of its basic units, or modules. In Japanese carpentry, the common module of design and construction is the bay, reckoned as the distance from the center of one post to the center of another, which is governed in turn by the standard size of *tatami* floor mats. Although varying slightly from region to region, the size of a single *tatami* is about 3 by 6 feet. Room area in Japan is still expressed in terms of the number of *tatami* mats; for example, a room may be described as an eight-mat room.

shoji — veranda — writing alcove — *tokonoma* — *tatami* — staggered shelves — *fusuma*

ARTIST'S RENDERING OF THE KOJOIN GUEST HOUSE AT ONJOJI
Otsu, Shiga prefecture. Momoyama period, 1601. National Treasure.

26–6 Kano School **APPRECIATION OF PAINTING**
Fusuma (sliding screens) from the patron's reception room of the abbot's quarters, Ryoanji, Kyoto. Momoyama period, c. 1606.
Ink, color, and gold leaf on paper; 72″ × 24′ (1.83 × 7.32 m). Metropolitan Museum of Art, New York.

Credit: © 2016. Image copyright The Metropolitan Museum of Art/Art Resource/Scala, Florence

Hosokawa family, either Hosokawa Yusai (1534–1610) or his son Sansai (1564–1645), powerful samurai warriors who were also intellectual and political figures in Momoyama Japan. Portraying secular Chinese themes, the *fusuma* were once installed within the *hojo* (or abbot's quarters) overlooking the famous rock garden at Ryoanji (SEE FIG. 26–4). **FIGURE 26–6** shows one of a set of screens from this room that portrayed the Confucian scholarly arts of music, painting, calligraphy, and chess. To the right a gathering of sages admires an unrolled hanging scroll, while the celebrated Tang poet Li Bo approaches from the left. In his inebriated state, the poet needs the assistance of two boys, one to each side. The drunken Li Bo was a popular Momoyama subject, representing the ideal of an unencumbered life.

The Tea Ceremony

Japanese art is never one-sided. Along with castles and their opulent interior decoration, there was an equal interest during the Momoyama period in the quiet, the restrained, and the natural. This was expressed primarily through the tea ceremony.

The term "tea ceremony," a phrase now in common use, does not convey the full meaning of *chanoyu*, the Japanese ritual drinking of tea. There is no counterpart in Western culture. Tea had been introduced to Japan in the ninth century, when it was molded into cakes and boiled. However, the advent of Zen brought to Japan a different way of preparing tea, with the leaves ground into powder and then whisked in bowls with hot water. Zen monks used such tea as a mild stimulant to aid meditation. Others found it had medicinal properties.

SEN NO RIKYU The most famous tea master in Japanese history was Sen no Rikyu (1522–1591). He conceived of the tea ceremony as an intimate gathering in which a few people, often drawn from a variety of backgrounds—warriors, courtiers, wealthy merchants—would enter a small rustic room, drink tea carefully prepared in front of them by their host, and quietly discuss the tea utensils or a Zen scroll hanging on the wall. He largely established the aesthetic of modesty, refinement, and rusticity that permitted the tearoom to serve as a respite from the busy and sometimes violent world outside. A traditional tearoom combines simple elegance and rusticity. It is made of natural materials such as bamboo and wood, with mud walls, paper windows, and a floor covered with *tatami*. One tearoom that preserves Rikyu's design is named **TAIAN** (FIG. 26–7). Built in 1582, it has a tiny door (guests must crawl to enter) and miniature *tokonoma* (alcove) for displaying a Zen scroll or a simple flower arrangement. At first glance, the room seems symmetrical. But a longer look reveals the disposition of the *tatami* does not match the

26–7 Sen no Rikyu TAIAN TEAROOM

Myokian Temple, Kyoto. Momoyama period, 1582. National Treasure.

spacing of the *tokonoma*, providing a subtle undercurrent of irregularity. The walls seem scratched and worn with age, but the *tatami* are replaced frequently to keep them clean and fresh. The mood is quiet; the light is muted and diffused through three small paper windows. Above all, there is a sense of spatial clarity. Since nonessentials have been eliminated, there is nothing to distract from focused attention. This tearoom aesthetic became an important element in Japanese culture.

THE TEA BOWL Every utensil connected with tea, including the water jar, the kettle, the tea scoop, the whisk, the tea caddy, and, above all, the tea bowl, came to be appreciated for its aesthetic quality, and many works of art were created for use in *chanoyu*.

The age-old Japanese admiration for the natural and the asymmetrical found full expression in tea ceramics. Korean-style rice bowls made for peasants were suddenly considered the epitome of refined taste, and tea masters urged potters to mimic their imperfect shapes. But not every misshapen bowl would be admired. A rarified appreciation of beauty developed that took into consideration such factors as how well a tea bowl fitted into the hands, how subtly the shape and texture of the bowl appealed to the eye, and who had previously used and admired it. For this purpose, the inscribed storage box became almost as important as the ceramic that it held, and if a bowl had been given a name by a leading tea master, it was especially treasured by later generations.

26-8 Chojiro **TEA BOWL, CALLED YUGURE ("TWILIGHT")**
Momoyama period, late 16th century. *Raku* ware, height 3½" (9 cm).
Gotoh Museum, Tokyo.

Connoisseurs developed a subtle vocabulary to discuss the
aesthetics of tea. A favorite term was *sabi* ("loneliness"), which refers
to the tranquility found when feeling alone. Other virtues were *wabi*
("poverty"), which suggests the artlessness of humble simplicity, and
shibui ("bitter" or "astringent"), meaning elegant restraint. Tea bowls
embody these aesthetics.

Credit: Photo courtesy the Gotoh Museum, Tokyo

One of the finest surviving early **TEA BOWLS** (**FIG.
26-8**) is attributed to Chojiro (1516–1592), the founder of
the Raku family of potters. Named *Yugure* ("Twilight") by
tea master Sen no Sotan (1578–1658), a grandson of Rikyu,
this bowl is an excellent example of red **raku** ware—a hand-
built, low-fired ceramic of gritty red clay, developed espe-
cially for use in the tea ceremony. The glaze-shaded red hue
and lively surface texture evoke a gentle landscape, illumi-
nated by the setting sun. With its small foot, straight sides,
irregular shape, and crackled texture, this bowl exemplifies
tea taste at the beginning of its development.

Edo Period

What diverse forms, subjects, and media characterize art from the Edo period?

When Tokugawa Ieyasu gained control of Japan, he forced
the emperor to proclaim him shogun, a title neither Nobu-
naga nor Hideyoshi had held. His reign initiated the Edo
period (1615–1868), named after the city that he founded
(present-day Tokyo) as his capital. This period is alter-
natively known as the Tokugawa era. Under the rule of
the Tokugawa family, peace and prosperity came at the
price of a rigid and repressive bureaucracy. The problem
of a potentially rebellious *daimyo* was solved by ordering
all feudal lords to spend either half of each year, or every
other year, in Edo, where their families were required to
live. Zen Buddhism was supplanted as the prevailing

intellectual force by a form of Neo-Confucianism, a philos-
ophy formulated in Song-dynasty China that emphasized
loyalty to the state, although the popularity of Buddhism
among the commoner population surged at this time.

The shogunate officially divided Edo society into four
classes. Samurai officials constituted the highest class, fol-
lowed by farmers, artisans, and finally merchants. As time
went on, however, merchants began to control the money
supply, and in Japan's increasingly mercantile economy,
their accumulation of wealth soon exceeded that of the
samurai, which helped, unofficially, to elevate their sta-
tus. Reading and writing became widespread at all levels
of society, and with literacy came intellectual curiosity
and interest in the arts. All segments of the population—
including samurai, merchants, townspeople, and rural
peasants—were able to acquire art. A rich cultural atmo-
sphere developed unlike anything Japan had experienced
before, in which artists worked in a wide variety of styles
to appeal to these different groups of consumers.

Rinpa School Painting

During the Edo period, Edo was the shogun's city while life
in Kyoto took its cues from the resident emperor and his
court. Kyoto was also home to wealthy merchants, artists,
and craftspeople who served the needs of the courtiers and
shared their interest in refined pursuits, such as the tea cer-
emony, and also their appreciation of art styles that recalled
those perfected by aristocratic artists in the Heian period.
The most famous and original Kyoto painter who worked
for this group of patrons was Tawaraya Sotatsu (active
c. 1600–1640). Sotatsu is considered the first great painter
of the Rinpa school, the modern name given to a group of
artists whose art reinterpreted ancient courtly styles. These
artists are grouped together because of their shared artistic
interests; they did not constitute a formal school, such as
the Kano. Rinpa masters were not just painters, however:
They sometimes collaborated with craftspeople.

One of Sotatsu's most famous pairs of screens prob-
ably depicts the islands of Matsushima near the northern
city of Sendai (**FIG. 26-9**). On the right screen (shown here
on top), mountainous islands echo the swing and sweep
of the waves, with stylized gold clouds emerging from the
gold ground at upper left. On the left screen (here below)
the gold clouds continue until they become a sand spit
from which twisted pines grow. One branch to the left
seems to stretch down toward a strange island in the lower
left, composed of an organic, amoebalike form in gold sur-
rounded by mottled ink. This mottled effect was a spe-
cialty of Rinpa-school painters.

As one of the "three famous beautiful views of Japan,"
Matsushima was often depicted in art. Most painters chose
a viewpoint above the pine-covered islands that make the
area famous. Sotatsu's genius was to portray the islands in

26–9 Tawaraya Sotatsu **WAVES AT MATSUSHIMA**

Edo period, 17th century. Pair of six-panel folding screens with ink, mineral colors, and gold leaf on paper; each screen 4′9⅞″ × 11′8½″ (1.52 × 3.56 m). Freer Gallery of Art, Smithsonian Institution, Washington, DC. Gift of Charles Lang Freer (F1906.231 & 232).

The six-panel screen format was a triumph of scale and practicality. Each panel consisted of a light wood frame surrounding a latticework interior covered with several layers of paper. Over this foundation was pasted a high-quality paper, silk, or gold-leaf ground, ready to be painted by the finest artists. Held together with ingenious paper hinges, a screen could be folded for storage or transportation, resulting in a mural-size painting, light enough to be carried by a single person and ready to be displayed as needed.

Credit: Bridgeman Images

an abbreviated manner and from a fresh vantage point, as though the viewer were passing them in a boat on the roiling waters. The artist's asymmetrical composition and his use of thick mineral colors in combination with soft, playful brushwork and sparkling gold leaf create the boldly decorative effect that is the hallmark of the Rinpa tradition.

LACQUER BOX Rinpa-school painters also participated in the collaborative production of luxury objects. The painter Ogata Korin (1658–1716) designed the **LACQUER BOX** shown here (**FIG. 26–10**) and oversaw its execution, although he left the actual work to highly trained craftspeople. He also frequently collaborated with his brother Kenzan, a celebrated potter.

The upper tray of the box housed writing implements, and the larger bottom section stored paper (see "Inside a Writing Box" on page 840). Korin's design sets a motif of irises and a plank bridge in a dramatic asymmetrical

26–10 Ogata Korin **EXTERIOR (A) AND VIEWS OF INTERIOR AND LID (B) OF A LACQUER BOX FOR WRITING IMPLEMENTS**

Edo period, late 17th–early 18th century. Lacquer, lead, silver, and mother-of-pearl, 5⅝ × 10¾ × 7¾″ (14.2 × 27.4 × 19.7 cm). Tokyo National Museum, Tokyo. National Treasure.

Credit: TNM Image Archives

composition created from mother-of-pearl, silver, lead, and gold lacquer. The subject was one he frequently represented in painting because it was immensely popular with the educated Japanese of his day, who would have recognized the imagery as an allusion to a famous passage from the tenth-century Japanese literary classic *Tales of Ise*. A nobleman poet, having left his wife in the capital, pauses at a place called Eight Bridges, where a river branches into eight streams, each covered with a plank bridge. Irises are in full bloom, and his traveling companions urge the poet to write a *waka*—a 5-line, 31-syllable poem—beginning each line with a syllable from the word for "iris": *Kakitsubata* (*ka-ki-tsu-ba-ta*; *ba* is the voiced form of *ha*, which here begins the penultimate line). The poet responds:

> *Karagoromo*
> *kitsutsu narenishi*
> *tsuma shi areba*
> *harubaru kinuru*
> *tabi o shi zo omou.*
> When I remember
> my wife, fond and familiar
> as my courtly robe,
> I feel how far and distant
> my travels have taken me.
> (Translated by Stephen Addiss)

The poem in association with the scene became so famous that any image of a group of irises, with or without a plank bridge, immediately called the episode to mind.

Lacquer is derived in Asia from the sap of the lacquer tree, *Rhus verniciflua*, indigenous to China but also grown commercially throughout East Asia very early in history. It is gathered by tapping into a tree and letting the sap flow into a container, and it can be colored with vegetable or mineral dyes. Applied in thin coats to a surface of wood or leather, lacquer hardens into a glasslike protective coating that is waterproof, heat- and acid-resistant, and airtight. Its practical qualities made it ideal for storage containers and vessels for food and drink. The creation of a piece of lacquer can take several years. First, the item is fashioned of wood and sanded smooth. Next, up to 30 layers of lacquer are thinly applied, each dried and polished before the next is brushed on.

Japanese craftspeople exploited the decorative potential of lacquer to create expensive luxury items such as this box, which was created when lacquer arts had been perfected. It features inlays of mother-of-pearl and precious metals in a style known as *makie* ("sprinkled design"), in which flaked or powdered gold or silver was embedded in a still-damp coat of lacquer.

Naturalistic and Literati Painting

NAGASAWA ROSETSU By the middle of the eighteenth century, the taste of wealthy Kyoto merchants had shifted, influencing the styles of artists who competed for their patronage. The public was enthralled with novel imagery captured in magnifying glasses, telescopes, and an optical device that enhanced the three-dimensional effects of

Art and Its Contexts
INSIDE A WRITING BOX

Writing boxes hold tools basic for both writing and painting: ink stick, ink stone, brushes, and paper—all beautiful objects in their own right.

Ink sticks are basically soot from burning wood or oil that is bound into a paste with resin and pressed into small, stick-shaped or cake-shaped molds to harden.

Fresh ink is made for each writing or painting session by grinding the hard, dry ink stick in water against a fine-grained stone. A typical ink stone has a shallow well at one end sloping up to a grinding surface at the other. The artist fills the well with water from a waterpot. The ink stick, held vertically, is dipped into the well to pick up a small amount of water, then is rubbed in a circular motion firmly on the grinding surface. Grinding ink is viewed as a meditative task, time for collecting one's thoughts and concentrating on the painting or calligraphy ahead.

Brushes are made from animal hair set in simple bamboo or hollow-reed handles. Brushes taper to a fine point that responds sensitively to any shift in pressure. Although great painters and

calligraphers do eventually develop their own styles of holding and using the brush, all begin by learning the basic position for writing. The brush is held vertically, grasped firmly between the thumb and first two fingers, with the fourth and fifth fingers often resting against the handle for more subtle control.

writing implements

26–11 Nagasawa Rosetsu
BULL AND PUPPY
Edo period, late 18th century.
Left of a pair of six-panel
screens with ink and gold
wash on paper, 5'7¼" × 12'3"
(1.70 × 3.75 m). Los Angeles
County Museum of Art. Joe and
Etsuko Price Collection (L.83.45.3a).

Credit: © 2016. Digital Image
Museum Associates/LACMA/Art
Resource NY/Scala, Florence

Western-style perspective pictures. Schools of independent artists emerged in Kyoto to satisfy demands for naturalistic-style paintings that reflected this fascination. The most influential was founded by Maruyama Okyo, who had perfected methods to incorporate Western shading and perspective into a more native Japanese decorative style, creating a sense of volume new to East Asian painting, while still retaining a sense of familiarity.

Okyo's most famous pupil was Nagasawa Rosetsu (1754–1799), a painter of great natural talent who added his own boldness and humor to his master's tradition. Rosetsu delighted in surprising his viewers with odd juxtapositions and unusual compositions. One of his finest works is a pair of screens, the left one depicting a **BULL AND PUPPY** (FIG. 26–11). The bull is so immense that his mammoth body exceeds the borders of the screen, an effect undoubtedly influenced by new optical devices. The tiny puppy, white against the dark gray of the bull, helps to emphasize the bull's huge size through its contrasting smallness. The puppy's relaxed and informal pose, looking happily straight out at the viewer, gives this powerful painting a humorous touch that increases its charm. In the hands of a master such as Rosetsu, simple and common subject matter became simultaneously delightful and monumental.

LITERATI PAINTING Because the city of Kyoto was far from the watchful eyes of the government in Edo, and the emperor resided there with his court, it enjoyed a degree of privilege and independence not found in any other Japanese city. These conditions allowed for the creation of art in the new Rinpa and naturalistic styles. They also encouraged the emergence of new schools of philosophy based on interpretations of Chinese Confucianism that disagreed with those taught at schools sponsored by Tokugawa shoguns. These new interpretations incorporated ideas from Chinese Daoism, which promoted the cultivation of a person's uniqueness, thus encouraging artistic creativity. Kyoto's intellectuals, who admired Chinese culture, even created a new, more informal tea ceremony of their own,

featuring steeped tea called *sencha* because this was the tea drunk by Ming-dynasty Chinese literati. They did this as a political protest—by then *chanoyu* had become encumbered by rules and was closely associated with the repressive shogunate.

Influenced by such new ideas, a Chinese manner of painting arose in the mid eighteenth century in emulation of literati painting. Artists who embraced this style—both professionals who painted for paying clients and amateurs who painted for their own enjoyment—quickly grew to number in the hundreds as its popularity spread throughout Japan, along with increased interest in drinking *sencha* and other aspects of Chinese culture. These artists learned about Chinese literati painting not only from the paintings themselves, but also from woodblock-printed painting manuals imported from China, and Chinese emigrant monks and merchants who lived in Japan.

The best and most successful of these artists took Chinese literati painting models as starting points for their own original interpretations of literati themes. One of them was Ike Taiga (1723–1776), admired as much for his magnetic personality as for his art. He was born into a poor farming family near Kyoto and showed innate talent for painting at a young age. Moving to Kyoto in his teens, he became friends with Chinese scholars there, including those who promoted drinking *sencha*. Taiga became a leader in this group, attracting admirers who were enamored of both his quasi-amateurish painting style and his quest for spiritual self-cultivation. His character and personal style are seen in the scintillating, rhythmic layering of strokes used to define the mountains in his **VIEW OF KOJIMA BAY** (FIG. 26–12), which blends Chinese models, Japanese aesthetics, and personal brushwork. The gentle rounded forms of the mountains intentionally recall the work of famous Chinese literati painters, and Taiga utilizes a stock landscape composition that separates foreground and background mountains with a watery expanse (COMPARE FIG. 26–2). However, he did not paint an imaginary Chinese landscape but a personal vision of an actual Japanese place that he had visited—Kojima Bay—as a document accompanying the

26–12 Ike Taiga **VIEW OF KOJIMA BAY**
Edo period, third quarter of 18th century. Hanging scroll with ink and color on silk, 39¼ × 14⅝" (99.7 × 37.6 cm). Hosomi Museum, Kyoto.

painting explains. Still, in deference to his admiration for Chinese literati, Taiga places two figures clad in Chinese robes on the right, midway up the mountain.

Ukiyo-e: Pictures of the Floating World

Edo served as the shogun's capital as well as the center of a flourishing popular culture associated with tradespeople.

Deeply Buddhist, commoners were acutely aware of the transience of life, symbolized, for example, by the cherry tree which blossoms so briefly. Putting a positive spin on this harsh realization, they sought to live by the mantra: Let's enjoy life to the fullest as long as it lasts. This they did to excess in the restaurants, theaters, bathhouses, and brothels of the city's pleasure quarters, named after the Buddhist phrase *ukiyo* ("floating world"). Every major city in Japan had these quarters, and most were licensed by the government. But those of Edo were the largest and most famous. The heroes of the floating world were not famous samurai or aristocratic poets. Instead, swashbuckling kabuki actors and beautiful courtesans were admired. These paragons of pleasure soon became immortalized in paintings and—because paintings were too expensive for common people—in woodblock prints known as **ukiyo-e** ("pictures of the floating world;" see "Japanese Woodblock Prints" opposite). Most prints were inexpensively produced by the hundreds and not considered serious fine art. Yet when first imported to Europe and America, they were immediately acclaimed and strongly influenced late nineteenth- and early twentieth-century Western art (see Chapter 31).

HARUNOBU The first woodblock prints had no color, only black outlines. Soon artists were adding colors by hand, but to produce colored prints more rapidly they gradually devised a system to print them using multiple blocks. The first artist to design prints that took advantage of this new technique, known as *nishiki-e* ("brocade pictures"), was Suzuki Harunobu (1724–1770), famous for his images of courtesans (SEE FIG. 26–1).

SHARAKU Toshusai Sharaku is one of the most mysterious, if today among the most admired, masters of *ukiyo-e*. He seems to have been active less than a year in 1794–1795, during which he produced 146 prints, of which all but ten are pictures of famous actors in a popular form of theater known as kabuki. He was renowned for half-length portraits that captured the dramatic intensity of noted performers outfitted in the costumes and makeup of the characters they played on stage. Much as people today buy posters of their favorite sports, music, or movie stars, in the Edo period people clamored for images of their kabuki idols. The crossed eyes, craning neck, and stylized gestures of Sharaku's portrayal of actor **OTANI ONIJI** (FIG. 26–13) capture a frozen, tension-filled moment in an action-packed drama, precisely the sort of stylized intensity that was valued in kabuki performance.

HOKUSAI During the first half of the nineteenth century, pictures of famous sights of Japan grew immensely popular. The two most famous *ukiyo-e* printmakers,

Technique

JAPANESE WOODBLOCK PRINTS

The production of woodblock prints combined the expertise of three individual specialists: the artist, the carver, and the printer. Coordinating and funding this collaborative endeavor was a publisher, who commissioned the project and distributed the prints to stores or traveling vendors, who would sell them.

The artist designed and supplied the master drawing for the print, executing its outlines with brush and ink on tissue paper. Colors might be indicated, but more often they were understood or determined later. The drawing was passed on to the carver, who pasted it face down on a hardwood block—preferably cherrywood—so that the outlines were visible through the tissue paper in reverse. A light coating of oil might be brushed on to make the paper more transparent, allowing the drawing to stand out even more clearly. The carver then cut around the lines of the drawing with a sharp knife, always working in the same direction as the original brushstrokes. The rest of the block was then chiseled away, leaving only the outlines in relief. This block, which reproduced the master drawing, was called the **key block**. If the print was to be polychrome, involving multiple colors, prints made from the key block were in turn pasted face down as carving guides on blocks that would become the color blocks. Each color generally required a separate block, although both sides of a block might be used for economy.

Once the blocks were completed, the printer took over. Paper for printing was covered lightly with animal glue (gelatin), and before printing, the coated paper was lightly moistened so that it would take ink and color well. Water-based ink or color was brushed over the blocks, and the paper was placed on top and rubbed with a smooth, padded device called a *baren* until the design was completely transferred. The key block was printed first, then the colors, one by one. Each block was carved with two small marks called **registration marks**, in exactly the same place in the margins, outside of the image area—an L in one corner, and a straight line in another. By aligning the paper with these marks before letting it fall over the block, the printer ensured that the colors would be placed correctly within the outlines. One of the most characteristic effects of later Japanese prints is a grading of color from dark to pale. This was achieved by wiping some of the color from the block before printing or by moistening the block and then applying the color gradually with an unevenly loaded brush—a brush loaded on one side with full-strength color and on the other with diluted color.

26-13 Toshusai Sharaku **OTANI ONIJI IN THE ROLE OF YAKKO EDOBE**

Edo period, 1794. Polychrome woodblock print with ink, colors, and white mica on paper, 15 × 9⅞″ (38.1 × 25.1 cm). Metropolitan Museum of Art, New York. Henry L. Phillips Collection, Bequest of Henry L. Phillips, 1939 (JP2822).

Credit: © 2016. Image copyright The Metropolitan Museum of Art/Art Resource/Scala, Florence

Utagawa Hiroshige (1797–1858) and Katsushika Hokusai (1760–1849) (see Chapter 31), specialized in this genre. Hiroshige's *Fifty-Three Stations of the Tokaido* and Hokusai's *Thirty-Six Views of Mount Fuji* became the most successful sets of graphic art the world has known. The woodblocks were printed, and printed again, until they wore out. They were then recarved, and still more copies were printed. This process continued for decades, and thousands of prints from the two series still survive.

THE GREAT WAVE (FIG. 26-14) is the most famous of the scenes from *Thirty-Six Views of Mount Fuji*. The great wave rears up like a dragon with claws of foam, ready to crash down on the figures huddled in the boats below. Exactly at the point of imminent disaster, but far in the distance, rises Japan's most sacred peak, Mount Fuji, whose slopes swing up like waves and whose snowy crown is like foam—comparisons the artist makes clear in the wave nearest us. In the late nineteenth century when Japonisme, a style of French and American nineteenth-century art that was highly influenced by Japanese art, became the vogue in the West, Hokusai's art was greatly appreciated, even more so than it had been in Japan: The first book on the artist was published in France.

26–14 Katsushika Hokusai THE GREAT WAVE

From *Thirty-Six Views of Mount Fuji*. Edo period, c. 1831. Polychrome woodblock print on paper, 9⅞ × 14⅝" (25 × 37.1 cm). Honolulu Academy of Art. Gift of James A. Michener 1995 (HAA 13, 695).

Credit: Image courtesy Yale University Art Gallery

Zen Painting: Buddhist Art for Rural Commoners

Outside Japan's urban centers, art for commoners also flourished, much of it tied to their devotion to Buddhism. Deprived of the support of the samurai officials who now favored Confucianism, Buddhism nevertheless thrived during the Edo period through patronage from private individuals, many of them rural peasants. In the early eighteenth century, one of the great monks who preached in the countryside was the Zen master Hakuin Ekaku (1685–1769), born in a small village near Mount Fuji. After hearing a fire-and-brimstone sermon in his youth he resolved to become a monk, and for years he traveled around Japan seeking out the strictest Zen teachers. He became the most important Zen master in 500 years and composed many *koan* (questions posed to novices by Zen masters to guide their progression toward enlightenment during meditation), including the famous "What is the sound of one hand clapping?" In his later years he taught himself painting and calligraphy and freely gave away his scrolls to admirers—who included not only farmers but also artisans, merchants, and even samurai—as a way of spreading his religious message.

Hakuin's art differed from that of Muromachi period monk-painters like Bunsei and Sesshu (SEE FIGS. 26–2, 26–3). It featured everyday Japanese subjects or Zen themes that conveyed his ideas in ways his humble followers could easily understand. He often painted Daruma (Bodhidharma in Sanskrit) (FIG. 26–15), the semilegendary Indian monk who founded Zen. Hundreds of Zen monks of the Edo period and later created simply brushed Zen ink paintings, largely within the standards that Hakuin had set.

Cloth and Ceramics

The ingenuity and technical proficiency that contributed to the development of *ukiyo-e* came about because of Japan's long and distinguished history of what the Western tradition considers fine crafts. Japanese artists had excelled in the design and production of textiles, ceramics, lacquer, woodwork, and metalwork for centuries, and in pre-modern Japan, unlike the West, no separate words distinguished fine arts (painting and sculpture) from "crafts." (The Japanese word for fine art and corresponding modern Japanese language words for various types of craft were not coined until 1872.) This was largely because professional Japanese artistic studios basically followed the same hereditary, hierarchical structure, regardless of medium. A master artist directed all activity in a workshop of trainees, who gradually gained seniority through innate talent and years of apprenticeship. Sometimes, such as when a pupil was not chosen to succeed the master, he would leave to establish his own studio. Teamwork under masterful supervision was the approach to artistic production.

KOSODE In the West, the robe most often known as a kimono has become as emblematic of Japanese culture as the "tea ceremony." These loose, unstructured garments, wrapping around the body and cinched with a sash, were the principal outer article of clothing for both men and women by the end of the fifteenth century. Robes with short sleeves were known as *kosode* ("small sleeves"). Because they wore out from being worn, few *kosode* prior to the Edo period have survived, but the early examples that remain reveal the opulent tastes of affluent women at this time (see "Closer Look" on page 846). In this early

26–15 Hakuin Ekaku GIANT DARUMA

Edo period, mid 18th century. Hanging scroll with ink on paper, 4′3½″ × 1′9¾″ (130.8 × 55.2 cm). Los Angeles County Museum of Art. Gift of Murray Smith (M.91.220)

As a self-taught amateur painter, Hakuin's painting style is the very antithesis of that of professionals, such as painters of the Kano or Rinpa schools. The appeal of his art lies in its artless charm, humor, and astonishing force. Here Hakuin has portrayed the wide-eyed Daruma during his nine years of meditation in front of a temple wall in China. Intensity, concentration, and spiritual depth are conveyed by a minimal number of broad, forceful brushstrokes. The inscription is the ultimate Zen message, attributed to Daruma himself: "Pointing directly to the human heart, see your own nature and become Buddha."

eighteenth-century *kosode*, the curving branches of a citrus tree (the *tachibana*, native to Japan) emerge above a bamboo fence along the bottom of the robe to grow up its height and across its sleeves, creating an asymmetrical composition with an area of undecorated fabric concentrated at the center toward the left. The textile artists employed many techniques to create the rich interplay of textures and pictures. The extensive use of stencil dyeing and embroidery associate this *kosode* with the tastes of wives of warriors during the early eighteenth century. The individual design elements and the principles of composition resemble those found in paintings and on ceramics during the Edo period, when the pattern books created for garment-makers disseminated motifs among artists working in a variety of media.

JAPANESE PORCELAIN While the history of ceramic production dates to the earliest days of Japanese civilization, production of glazed, high-fired stoneware ceramics proliferated in Japan only from the sixteenth century. The industry thrived in southern Japan, where, in the years following 1600, influxes of more highly skilled Korean potters helped native artisans learn new continental technologies that allowed them to manufacture porcelain for the first time. One town, Arita, became the center for the production of porcelain, created not only for domestic use but for export to the West. While tea ceremony aesthetics still favored rustic wares

such as Chojiro's tea bowl (SEE FIG. 26–8), porcelain was widely adopted for everyday use in response to a growing fashion for Chinese arts. Porcelains made in Arita are known by various names according to their dating and decorative schemes. The plate in FIGURE 26–17 is an example of Nabeshima ware, produced in kilns that had been established in Arita by the Nabeshima samurai clan as early as 1628. Initially, ceramics from these kilns were reserved for family use or as gifts to the Tokugawa shogunate, but eventually Nabeshima ware was also acquired by other powerful noble families. The multicolor decorative motifs often combine an organically irregular natural form (here a branch of flowering wisteria) and a more abstracted, stabilizing design drawn from the built environment (here a trellis on which the wisteria can grow). Contemporary textile designs—well known through the publication of pattern books that documented the latest fashion—frequently served as source material for the decoration of Nabeshima ware.

The Modern Period

How is Japanese art transformed during the period between the forced opening of the country to the West and the aftermath of World War II?

The tensions that resulted from Commodore Matthew Perry's forced opening of trade ports in Japan in 1853 precipitated the downfall of the Tokugawa shogunate. In 1868, the emperor was formally restored to power, an event known as the Meiji Restoration. The court soon moved from Kyoto to Edo, which was renamed Tokyo ("Eastern Capital"). After two decades of intense industrialization, influential private individuals and government officials, sometimes working cooperatively, created new arts institutions including juried exhibitions, artists' associations, arts universities, and cultural heritage laws. These rekindled appreciation for the art of the past, encouraged perpetuation of artistic techniques threatened by adoption of Western ways, and stimulated new artistic production. Many of these arts institutions still exist today.

A Closer Look

WOMAN'S *KOSODE*

Embroidery with vermilion threads gives a vibrant tonality to this citrus fruit and other motifs throughout the design.

The white silk damask fabric of this robe is woven with a key-fret pattern, most visible with reflected light as the wearer moves.

Some of the leaves and citrus fruits are embroidered with radiant gold threads. Some of these threads have become loose, revealing the written inscriptions that told the embroiderer which kind of thread to use.

The decoration flows up the back of the robe in the form of an inverted *C*, leaving an area of unornamented silk at middle left. This design demonstrates an early 18th-century taste for asymmetry.

There is extensive use of the *kata-kanoko* technique, in which stencils were used to create dotted patterns with the application of resist paste and dipping and/or painting with dye. This imitated the elaborate tie-dying that had been popular in earlier robes but was now too time-consuming to meet a growing demand for garments.

26–16 WOMAN'S *KOSODE* WITH DESIGN OF BAMBOO FENCE AND CITRUS TREE (TACHIBANA)
Edo period, early 18th century. White figured satin (*rinzu*), with embroidery (gold and silk thread) and stencil dyeing. Length 62½" (158.8 cm). Philadelphia Museum of Art. Gift of Mr. and Mrs. Rodolphe Meyer de Schauensee, 1951.

Credit: © 2016. Photo The Philadelphia Museum of Art/Art Resource/Scala, Florence

Meiji-Period Nationalist Painting

The Meiji period (1868–1912) marked a major change for Japan. Japanese society adopted various aspects of Western education, governmental systems, clothing, medicine, industrialization, and technology in efforts to modernize the nation. Teachers of sculpture and oil painting came from Italy, while adventurous Japanese artists traveled to Europe and America to study.

A MEIJI PAINTER Ernest Fenollosa (1853–1908), an American who had recently graduated from Harvard, traveled to Japan in 1878 to teach philosophy and political economy at Tokyo University. Within a few years, he and a former student, Okakura Kakuzo (1862–1913), began urging artists to study traditional Japanese arts rather than focusing exclusively on Western art styles and media, but to infuse these traditional practices with a modern sensibility. Yokoyama Taikan (1868–1958) subsequently developed his personal style within the Nihonga (modern Japanese painting) genre promoted by Okakura. Encouraged by Okakura, who had gone there before him, Taikan visited India in 1903. He embraced Okakura's ideals of pan-Asian cultural nationalism, expressed in the first line of Okakura's book *Ideals of the East* (1903) with the words "Asia is one."

26–17 PLATE WITH WISTERIA AND TRELLIS PATTERN
Edo period, 18th century. Nabeshima ware. Porcelain with underglaze
blue decoration and overglaze enamels, diameter 12³⁄₁₆″ (31 cm).
Kyushu National Museum, Japan. Important Cultural Property.

Credit: Photographer: FUJIMORI Takeshi

This outlook later contributed to fueling Japan's imperialist ambitions. Taikan's **FLOATING LIGHTS** (**FIG. 26–18**) was
inspired by a visit to Calcutta (Kolkata), where he observed
women engaged in divination on the banks of the Ganges.
The naturalism of their semitransparent robes and the gently rippling water reveal his indebtedness to Western art. In
contrast, the lightly applied colors and gracefully composed
branches with delicate, mottled brushwork defining the
leaves recall techniques of Rinpa-school artists.

Japan after World War II

In the aftermath of World War II (1941–1945), Japan was
a shambles, her great cities ruined. Nevertheless, under
the U.S.-led Allied Occupation (1946–1952), the Japanese
people immediately began rebuilding, unified by a sense
of national purpose. Within ten years, Japan established
nascent automobile, electronics, and consumer goods
industries. Rail travel, begun in 1872, expanded and
improved significantly after the war, and by the time of the
Tokyo Olympics in 1964, the capital had an extensive commuter rail system. Japan became the world leader in city-to-
city high-speed rail transit with its new Shinkansen (bullet
train). As the rest of the world came to know Japan, foreign
interest in its arts focused especially on the country's still
thriving "crafts" traditions. Not only were these a source of
national pride and identity, the skills and attitudes they fostered also served as the basis for Japan's national revival.

TANGE KENZO The **HIROSHIMA PEACE MEMO
RIAL MUSEUM** and Park (**FIG. 25–19**) was one of the first

monuments constructed after World War II. A memorial to
those who perished on August 6, 1945, and an expression of
prayers for world peace, it attests the spirit of the Japanese
people at this difficult juncture in history. Tange Kenzo (1913–
2005), who would eventually become one of the masters of
Modernist architecture, designed the complex after winning
an open competition as a young, up-and-coming architect.

The building's design befits the solemnity of its context. Concrete piers raise its compact concrete form 20 feet
off the ground. The wood formwork of the concrete recalls

26–18 Yokoyama Taikan FLOATING LIGHTS
Meiji period, 1909. Hanging scroll with ink, colors, and gold on silk,
56½ × 20½″ (143 × 52 cm). Museum of Modern Art, Ibaraki.

Credit: Photographer: Kodaira Tadao

26–19 Tange Kenzo **HIROSHIMA PEACE MEMORIAL MUSEUM**
Showa period, 1955. Main building (center) repaired in Heisei period, 1991. East building (right), the former Peace Memorial Hall, which first opened in 1955, was rebuilt in June 1994 and attached to the main building. Designated UNESCO World Heritage Site in 1996.

Credit: Courtesy Tange Kenzo and Hiroshima Peace Memorial Museum

the wooden forms of traditional Japanese architecture, but the use of concrete as a building material was inspired by Le Corbusier's 1920s Modernist villas (see Chapter 32). Evenly spaced vertical concrete fins lining the façade provide light shade. They suggest both the regular spacing of elements present in modular *shoin* architecture (see "*Shoin Design*" on page 835) and the values of Modernist architects, who demanded a strict correlation between structure and form. In this commission Tange infused Modernist tendencies and materials with a Japanese sense of interval and refinement, characteristics still seen in the work of younger contemporary Japanese architects.

FUKAMI SUEHARU Perhaps because the arts of tea ceremony and flower arrangement both require ceramic vessels, the Japanese have long had a particular affection for pottery. While some ceramicists continue to create *raku* tea bowls and other traditional wares, others experiment with new styles and techniques.

Fukami Sueharu (b. 1947) is among the most innovative clay artists in Japan today. Yet his art has roots in the past—in his case, in Chinese porcelains with pale bluish-green glazes (*seihakuji*). Even so, his forms and fabrication methods, as in his **SKY II**, are ultramodern (**FIG. 26–20**). He created the piece using a slip casting technique in which he injected liquid clay into a mold using a high-pressure compressor. Although Fukami sometimes makes functional pieces, mainly cylinders that could hold flower arrangements, he shows his mastery of pure form in *Sky II*. The title suggests sources of this abstract sculptural shape: a wing or a blade of an aircraft slicing through the sky. The pale sky-blue glaze only enhances this reference. The fusion of traditions, media, techniques, and forms looks back to a distinguished artistic heritage, but the suave mastery of abstraction and subtle evocation of thematic meaning point forward to a global art world, where Japanese artists are clearly taking their place.

CRAFTSPEOPLE AS LIVING NATIONAL TREASURES Throughout the history of Japanese art, there has been a salient sensitivity toward the surface quality of things, for polish, for line, for exquisite facture and stylish articulation. This is certainly the case with an exquisite wooden box (**FIG. 26–21**) by Eri Sayoko (1945–2007). In 2002, the government designated her a Living National Treasure for her accomplishment in the art of cut-gold leaf (*kirikane*), traditionally used to decorate Buddhist sculpture and paintings. The National Treasure designation originated in Japanese laws of 1897 that were intended to safeguard the nation's artistic heritage at a time when art was

26–20 Fukami Sueharu **SKY II**
Heisei period, c. 1990. Celadon-glazed porcelain with wood base, 3 × 44⅛ × 9½" (7.7 × 112.1 × 24.2 cm). Spencer Museum of Art, University of Kansas, Lawrence. Museum purchase: R. Charles and Mary Margaret Clevenger Fund (1992.0072).

Credit: © Fukami Sueharu. Courtesy Erik Thomsen Gallery, New York

being bought by Western collectors but suffering neglect at home. In 1955, the government added provisions to honor living individuals who excel in traditional craft techniques with the title Living National Treasure. This historic preservation system is the most complex of its type in the world.

In its encouragement of traditional arts, the Living National Treasure system has greatly assisted women in gaining much-deserved recognition. In pre-modern Japan (up to the start of the Meiji period in 1868), women mostly operated in the private sphere of the home where they created crafts for their own enjoyment or for devotional purposes. By the eighteenth century, this situation had begun to change, so that women could be poets, calligraphers, and painters; the wives or daughters of famous male artists gained the most recognition. Among the most famous was Gyokuran, wife of the literati painter Ike Taiga (SEE FIG. 26–12). However, the conservative nature of traditional Japanese craft workshops meant women could not hold leadership positions in them, and until the post–World War II period they were seldom recognized for their achievements. Eri Sayoko flourished in the new climate as one of the first women to work in the medium of cut-gold, which she took up via an unorthodox route.

Eri specialized in Japanese painting in high school and in design-dyeing in junior college. After marriage to a traditional Buddhist sculptor she started producing Buddhist paintings and began an apprenticeship with a master *kirikane* craftsman. She was so talented that after only three years she was able to exhibit her work professionally.

Her art is informed by her deep study of the history of the technique, and her special sensitivity for color betrays her training in dyeing. Eri's elegant, functional objects are infused with modern sensibilities, proving that a traditional technique can still result in artistic originality.

26–21 Eri Sayoko ORNAMENTAL BOX: DANCING IN THE COSMOS

Heisei period, 2006. Wood with polychrome and cut gold, $33\frac{7}{8}$ × $6\frac{1}{2}$ × $6\frac{1}{2}$" (86 cm × 16.5 cm × 16.5 cm). Collection of Eri Kokei.

Credit: Courtesy Koukei Eri

Think About It

1 Discuss how the Japanese tea ceremony works and observe the role that art plays within it. Include the unique aesthetics of the tearoom and the artistic practices associated with the ceremony, making reference to at least one work from this chapter.

2 Chose one woodblock print discussed in this chapter and explain how its subject matter represents the culture of the "floating world" in Edo.

3 Reflect on the differences between the styles of artists from Kyoto and artists from Edo. How do they relate to the variations in the social status and cultural and intellectual interests of residents of these two cities? How would you fit the lacquer box by a Rinpa-school artist from Kyoto (FIG. 26–10) and the *kosode* robe made in Edo ("Closer Look" on page 846) into your discussion?

4 Chose one of the three Japanese works in this chapter from the period after World War II and evaluate how it draws from both traditional Japanese and foreign artistic practices. Is the larger debt to tradition or to innovation?

Crosscurrents

Garden design weaves its way throughout the history of art. These two examples were produced for two very different architectural complexes to serve very different populations. Assess how the gardens were used and discuss how their form is related to their function. How are they representative of their cultural contexts?

PAGE 772

FIG. 26–4

27–1 Julia Jumbo **TWO GREY HILLS TAPESTRY WEAVING**
Navajo, 2003. Handspun wool, 36 × 24½″ (91.2 × 62.1 cm).

Credit: Photo: Addison Doty

Chapter 27
Art of the Americas after 1300

 ## Learning Objectives

27.a Identify the visual hallmarks of post-1300 art of the Americas in its distinct cultures for formal, technical, and expressive qualities.

27.b Interpret the meaning of post-1300 works of art of the Americas in its distinct cultures based on their themes, subjects, and symbols.

27.c Relate the art of the Americas after 1300 to its distinct cultural, economic, and political contexts.

27.d Apply the vocabulary and concepts relevant to the art of the Americas after 1300.

27.e Interpret a work of art of the Americas after 1300 using the art historical methods of observation, comparison, and inductive reasoning.

27.f Select visual and textual evidence in various media to support an argument or an interpretation of a work of art of the Americas after 1300.

According to Navajo mythology, the universe itself is a weaving, its fibers spun by Spider Woman out of sacred cosmic materials. Spider Woman taught the art of weaving to Changing Woman (an aspect of Mother Earth), and she in turn taught it to Navajo women, who continue to keep this art vital, seeing its continuation as a sacred responsibility. Early Navajo blankets were composed of simple horizontal stripes, but over time weavers have introduced more intricate patterns, and today Navajo rugs are woven in numerous distinctive styles.

The tapestry weaving in **FIGURE 27-1** is designed in the Two Grey Hills style that developed during the early twentieth century around a trading post of that name in northwest New Mexico. Weavers who work in this style use the natural colors of undyed sheep's wool (only the black wool is sometimes dyed) to create dazzling geometric patterns. Julia Jumbo (1928–2007), who learned to weave as a child, used her weavings to support her family. She raised her own sheep and carded and spun her wool by hand before incorporating it into painstakingly made textiles. Jumbo is renowned for the clarity of her designs and the technical perfection of her fine weave.

When the first Europeans arrived, the Western Hemisphere had been inhabited for 10,000 years by peoples with long histories and rich cultural traditions (**MAP 27-1**).

After 1492, when Christopher Columbus and his companions first sailed to the Western Hemisphere, the arrival of Europeans completely altered the destiny of the Americas. In Mesoamerica and South America the break with the past was sudden and violent: Two great empires—the Aztec in Mexico and the Inca in South America—that had risen to prominence in the fifteenth century were rapidly destroyed. In North America the change took place more gradually, but the outcome was much the same. In both North and South America, indigenous peoples contracted European diseases to which they had no immunity, especially smallpox, leading to massive population loss and social disruption. Over the next 400 years, many Native Americans were displaced from their ancestral homelands, and many present-day Native American ethnic groupings were formed by combinations of various survivor groups.

Despite all the disruption, during the past century the indigenous arts of the Americas have undergone a re-evaluation and revitalization. Native American artists like Julia Jumbo continue to revive and reimagine indigenous traditions, revisit traditional outlooks, and restate their ancient customs and ideas in new ways, while at the same time contemporary painters like Jaune Quick-to-See Smith (SEE FIG. 27-25) engage with European traditions to challenge European assessments.

The Aztec Empire

What characterizes the art and architecture produced during the Aztec Empire in Mesoamerica?

In November 1519, the army of the Spanish soldier Hernán Cortés saw for the first time the great Aztec capital of Tenochtitlan. The shimmering city, which seemed to be floating on the water, was built on an island in the middle of Lake Texcoco in the Valley of Mexico and linked by broad causeways to the mainland. One of Cortés's companions later recalled the wonder the Spanish felt at that moment: "When we saw so many cities and villages built on the water and other great towns on dry land and that straight and level causeway going towards [Tenochtitlan], we were amazed … on account of the great towers and temples and buildings rising from the water, and all built of masonry. And some of our soldiers even asked whether the things that we saw were not a dream." (Bernal Díaz del Castillo, cited in Coe and Koontz, p. 190.)

The Mexica people who lived in the remarkable city that Cortés found were then rulers of much of the land that later took their name, Mexico. Their rise to power had been recent and swift. Only 400 years earlier, according to their own legends, they had been a nomadic people living far north of the Valley of Mexico in a distant place called Aztlan. The term Aztec derives from the word Aztlan and refers to all those living in Central Mexico who came from this mythical homeland, not just to the Mexica of Tenochtitlan.

The Mexica arrived in the Valley of Mexico in the thirteenth century and settled—according to their mythologized account—on an island in Lake Texcoco where they had seen an eagle perching on a prickly pear cactus (*nochtli*) growing out of a stone (*tetl*), a sign that their god Huitzilopochtli told them would mark the end of their wandering. They called the place Tenochtitlan. The city on the island was gradually expanded by reclaiming land from the lake and serviced by a grid of artificial canals.

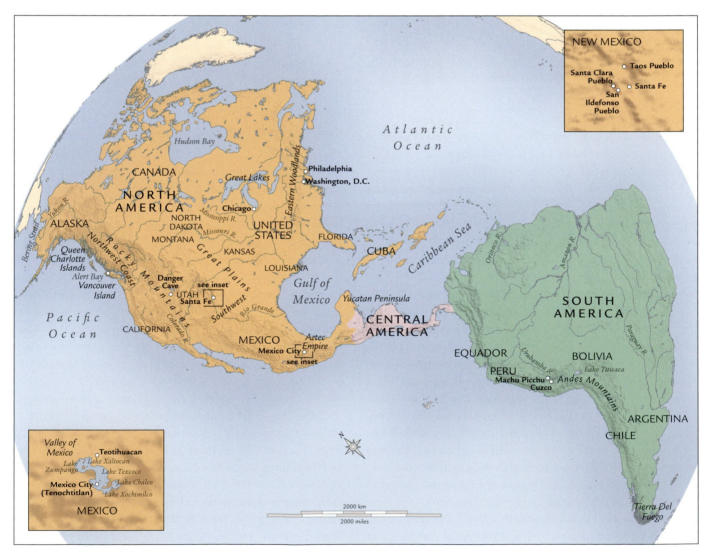

MAP 27-1 THE AMERICAS AFTER 1300

Diverse cultures inhabited the Americas, each shaping a distinct artistic tradition.

A Closer Look

CALENDAR STONE

According to Mexica belief, the gods created the world four times before the present era. These cartouches name the days on which the four previous suns were destroyed: 4 Jaguar, 4 Wind, 4 Rain, and 4 Water.

This central face combines elements of the sun god as the night sun in the underworld, with the clawed hands and flint tongue of earth gods, symbolizing the night sun and the hungry earth.

Two fire serpents encircle the outer part of the disk. Stylized flames rise off their backs. Their heads meet at the bottom, and human faces emerge from the mouths of the serpents.

Together, these four calendrical glyphs and the face and claws of the central god combine to form the glyph for 4 Motion, the day on which the fifth Sun will be destroyed by a giant earthquake.

This band forms the Aztec symbol for the sun, a round disk with triangular projections denoting the sun's rays.

This band contains the 20 day signs of the 260-day ritual calendar.

27–2 CALENDAR STONE
Mexico. Aztec, c. 1500. Diameter 11′6¾″ (3.6 m). Museo Nacional de Antropología, Mexico City.

Credit: © Jejim/Shutterstock

In the fifteenth century, the Mexica joined allies in a triple alliance and began an aggressive campaign of expansion. The tribute they exacted from all over the Aztec Empire transformed Tenochtitlan into a glittering capital.

Aztec religion was based on a complex pantheon that combined Aztec deities with more ancient ones that had long been worshiped in Central Mexico. According to Aztec belief, the gods had created the current era, or sun, at the ancient city of Teotihuacan in the Valley of Mexico. The continued existence of the world depended on human actions, including rituals of bloodletting and human sacrifice, because blood was the life force that was owed the gods to help keep the cosmos going and time running. Many Mesoamerican peoples believed that the world had been created multiple times before the present era. But while most Mesoamericans believed that they were living in the fourth era, or Sun, the Mexica asserted that they lived in the fifth Sun, a new era that coincided with

the Aztec Empire. The Calendar Stone (see "Closer Look" above) boldly makes this claim, using the dates of the destructions of the four previous eras to form the glyph that names the fifth sun, 4 Motion.

Tenochtitlan

The first Spanish viceroy of New Spain from 1535 to 1550, Antonio Mendoza, is believed to have commissioned a book with drawings by indigenous artists for presentation to Holy Roman Emperor Charles V (who was also king of Spain) so that the emperor could learn about his new subjects. The frontispiece of the Codex Mendoza shows a schematized version of Tenochtitlan and its founding, Mexica war victories, and the Spanish invasions (**FIG. 27–3**). An eagle perched on a prickly pear cactus growing out of a stone—the symbol of the city—fills the center of the page. Waterways divide the city into four quarters and indicate

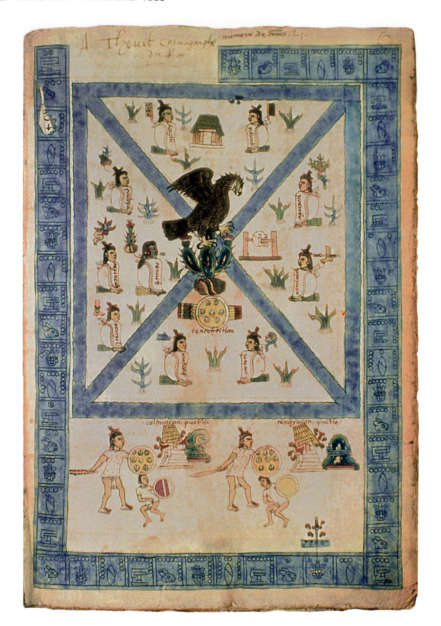

27–3 THE FOUNDING OF TENOCHTITLAN

Page from Codex Mendoza. Mexico. Aztec, 1545. Ink and color on paper, 12⅜ × 8⁷⁄₁₆″ (31.5 × 21.5 cm). Bodleian Library, University of Oxford, England. MS. Arch Selden. A.1, fol. 2r.

Credit: The Bodleian Libraries, The University of Oxford

the lake surrounding the city. Early leaders of Tenochtitlan are shown sitting in the four quadrants. The victorious warriors at the bottom of the page represent Aztec conquests, and a count of years surrounds the entire scene. This image combines historical narration with idealized cartography, showing the city in the middle of the lake at the moment of its founding.

At the center of Tenochtitlan was the sacred precinct, a walled enclosure that contained dozens of temples and other buildings. This area has been the site of intensive archaeological excavations in Mexico City since 1978, work that has greatly increased our understanding of this aspect of the Aztec city. The focal point of the sacred precinct was the Great Pyramid (or Templo Mayor), with paired temples on top: The one on the north was dedicated to Tlaloc, an ancient rain god with a history extending back to Teotihuacan, and the one on the south to Huitzilopochtli, the solar god of the newly arrived Mexica tribe (**FIG. 27-4**). During the winter rainy season the sun rose behind the temple of Tlaloc, and

during the dry season it rose behind the temple of Huitzilopochtli. The double temple thus united two natural forces, sun and rain, or fire and water. During the spring and autumn equinoxes, the sun rose between the two temples.

Two steep staircases led up the west face of the pyramid from the plaza in front. Sacrificial victims climbed these stairs to the temple of Huitzilopochtli, where priests threw them over a stone, quickly cut open their chests, and pulled out their still-throbbing hearts, a sacrifice that ensured the survival of the sun, the gods, and the Aztecs. The bodies were then rolled down the stairs and dismembered. Thousands of severed heads were said to have been kept on a skull rack in the plaza, represented in FIGURE 27-3 by the rack with a single skull to the right of the eagle. In addition to major works of Aztec sculpture, current excavations have uncovered a series of deep shafts containing multiple levels of offerings—precious objects as well as animals—and some believe that eventually human burials will be discovered, perhaps those of Aztec kings.

27-4 RECONSTRUCTION OF THE GREAT PYRAMID (TEMPLO MAYOR) OF TENOCHTITLAN, c. 1500

Credit: Hernan Canellas/National Geographic Creative

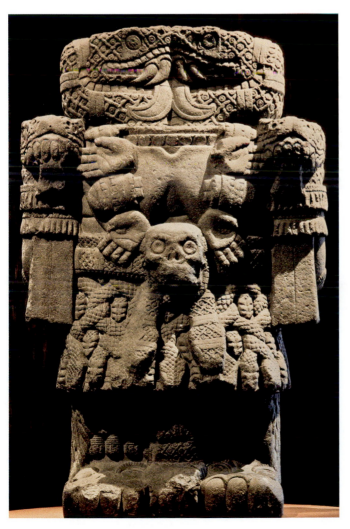

Sculpture

Aztec sculpture was monumental, powerful, and often unsettling. A particularly striking example is an imposing statue of **COATLICUE**, mother of the Mexica god Huitzilopochtli (**FIG. 27-5**). Coatlicue means "she of the serpent skirt," and this broad-shouldered figure with clawed feet has a skirt of twisted snakes. The sculpture may allude to the moment of Huitzilopochtli's birth: When Coatlicue conceived Huitzilopochtli from a ball of down, her other children—the stars and the moon—jealously conspired to kill her. As they attacked, Huitzilopochtli emerged from his mother's body fully grown and armed, drove off his half-brothers, and destroyed his half-sister, the moon goddess Coyolxauhqui. Coatlicue, however, did not survive the encounter. In this sculpture, she has been decapitated and a pair of serpents, symbols of gushing blood, rise from her neck to form her head. Their eyes are her eyes; their fangs, her teeth. Around her stump of a neck hangs a necklace of human hands, hearts, and a dangling skull. Despite the surface intricacy, the statue's massive form creates an impression of solidity, and the entire sculpture leans forward, looming over the viewer. The colors with which it was originally painted—red, white, ocher, black, and blue—would have heightened its dramatic impact.

27-5 THE GODDESS COATLICUE
Mexico. Aztec, c. 1500. Basalt, height 8'6" (2.65 m).
Museo Nacional de Antropología, Mexico City.

Credit: Werner Forman Archive

Featherwork and Manuscripts

Other Aztec art was colorful as well. An idea of its splendor is captured in the **FEATHER HEADDRESS** (FIG. 27-6) said to have been given by the Aztec emperor Moctezuma to Cortés, and thought to be the one listed in the inventory of treasures Cortés shipped to Charles V, the Habsburg emperor in Spain, in 1519. Featherwork was one of the glories of Mesoamerican art, but very few of these extremely fragile artworks survive. The tropical feathers in this headdress exemplify the exotic tribute paid to the Aztecs; the long, iridescent green feathers that make up most of the headdress are the exceedingly rare tail feathers of the quetzal bird—each male quetzal has only two such plumes. The feathers were gathered in small bunches, reinforced with reed tubes, and then sewn to the frame in overlapping layers, the joins concealed by small gold plaques. Feather-workers were esteemed artists. After the Spanish invasion, they turned their exacting skills to "feather paintings" of Christian subjects.

MANUSCRIPTS Aztec scribes also created brilliantly colored books: histories, maps, and divinatory almanacs. Instead of being bound on one side like European books, Mesoamerican books were accordion-pleated so that each page was connected only to the two adjacent pages. This format allowed great flexibility: A book could be opened to show two pages, or unfolded to show six or eight pages simultaneously; different sections of the book could also be opened next to one another at the same time. A rare manuscript that survived the Spanish conquest provides a concise summary of Mesoamerican cosmology (FIG. 27-7). Mesoamerican peoples recognized five key directions: north, south, east, west, and center. At the center of the image is Xiuhtecuhtli, god of fire, time, and the calendar. Radiating from him are the four cardinal directions—each associated with a specific color, a deity, and a tree with a bird in its branches. The 260 dots that trace the eight-lobed path around the central figure refer to the 260-day Mesoamerican divinatory calendar; the 20 day signs of this calendar are also distributed throughout the image. By linking the 260-day calendar to the four directions, this image speaks eloquently of the unity of space and time in the Mesoamerican worldview.

The Inca Empire

What characterizes the architecture, textiles, and metalwork produced during the Inca Empire in the Andes region of South America?

At the beginning of the sixteenth century the Inca Empire was one of the largest states in the world. It extended more than 2,600 miles along western South America, encompassing most of present-day Peru, Ecuador, Bolivia, and northern Chile and reaching into Argentina. Like the Aztec Empire, its rise was rapid and its destruction abrupt.

The Incas called their empire the "Land of the Four Quarters." At its center was their capital, Cusco, "the navel of the world," located high in the Andes Mountains. The Inca state began as one of many small competing

27-6 FEATHER HEADDRESS OF MOCTEZUMA
Mexico. Aztec, before 1519. Quetzal, blue cotinga, and other feathers and gold on a fiber frame; 45⅝ × 68⅞" (116 × 175 cm). Weltmuseum, Vienna.

This extraordinary and fragile work from the late Aztec Empire has been in Europe since the sixteenth century, presumably sent or taken back across the Atlantic by someone connected with the invading Spanish army in 1519. During 2010–2012, the headdress was the subject of a thorough collaborative conservation study sponsored by the Kunsthistorisches Museum of Vienna and the Instituto Nacional de Antropología e Historia of Mexico City.

Credit: Bridgeman Images

27-7 A VIEW OF THE WORLD
Page from the Codex Fejervary-Mayer. Mexico. Aztec or Mixtec, c. 1400–1519. Paint on animal hide, each page 6⅞ × 6⅞" (17.5 × 17.5 cm), total length 13'3" (4.04 m). National Museums, Liverpool, England.

Credit: © akg-images/De Agostini Picture Lib.

kingdoms that emerged in the highlands. In the fifteenth century the Incas began to expand, suddenly and quickly, and had subdued most of their vast domain through conquest, alliance, and intimidation by 1500.

To hold this linguistically and ethnically diverse empire together, the Inca ("Inca" refers to both the ruler and the people) relied on religion, an efficient bureaucracy, and various forms of labor taxation, in which the payment was a set amount of time spent performing tasks for the state. In return the state provided gifts through local leaders and sponsored lavish ritual entertainments. Men might cultivate state lands, serve in the army, or work periodically on public works projects—building roads and terracing hillsides, for example—while women wove cloth as tribute. Inca writing took the form of complex knotted and color-coded cords known as *khipus*; according to the Spanish, these devices recorded and communicated tribute, census, history, poetry, and astronomy.

To move their armies and speed transport and communication within the empire, the Incas built more than 23,000 miles of roads. These varied from 50-foot-wide thoroughfares to 3-foot-wide paths. Two main north–south roads, one along the coast and the other through the highlands, were linked by east–west roads. Travelers journeyed on foot, using llamas as pack animals. Stairways helped them negotiate steep mountain slopes, and rope suspension bridges allowed river gorge crossings. All along the roads, storehouses and lodgings—more than a thousand have been found—were spaced a day's journey apart. A relay system of runners could carry messages between Cusco and the farthest reaches of the empire in about a week.

Cusco

Cusco, a capital of great splendor, was home to the Inca, ruler of the empire. Its urban plan was said to have been designed by the Inca Pachacuti (ruled 1438–1471) in the shape of a puma, its head the fortress of Sacsayhuaman, and its belly the giant plaza at the center of town. The city was divided into upper and lower parts, reflecting the dual organization of Inca society. Cusco was the symbolic as well as the political center of the Inca Empire: Everyone had to carry a burden when entering the city, and gold, silver, or textiles brought into the city could not afterward be removed from it.

Cusco was a showcase of the finest Inca masonry, some of which can still be seen in the city today (see "Inca Masonry" on page 858). Architecture was a major

27-8 INCA MASONRY, DETAIL OF A WALL AT MACHU PICCHU

Peru. Inca, 1450–1530.

Credit: © Galyna Andrushko/Shutterstock

expressive form for the Inca—the very shape of individually worked stones conveyed a sense of power, and the way they come together to make up walls without needing mortar expressed Inca social order (FIG. 27-8). In contrast to the massive walls, Inca buildings had gabled, thatched roofs.

Doors, windows, and niches were trapezoids, narrower at the top than the bottom.

Machu Picchu

MACHU PICCHU was originally a vibrant city and is now one of the most spectacular archaeological sites in the world (FIG. 27-9). At almost 8,000 feet above sea level, it straddles a ridge between two high peaks in the eastern slopes of the Andes and looks down on the Urubamba River. Stone buildings, today lacking only their thatched roofs, occupy terraces around central plazas, and narrow agricultural terraces descend into the valley. The site, near the eastern limits of the empire, was the royal estate of the Inca ruler Pachacuti. The court might have retired to this warmer, lower-altitude palace when the Cusco winter became too harsh. Important diplomatic negotiations and ceremonial feasts may also have taken place at this country retreat. It provides an excellent example of Inca architectural planning: The entire complex is designed with great sensitivity to its surroundings. Walls and plazas frame stupendous vistas of the surrounding landscape, and carefully selected stones echo the shapes of the mountains beyond.

Elements of Architecture

INCA MASONRY

Working with the simplest of tools—mainly heavy stone hammers—and using no mortar, Inca builders created stonework of great refinement and durability: roads and bridges that linked the entire empire, terraces for growing crops, and structures both simple and elaborate. Great effort was expended on stone construction. Fine Inca masonry used in elite contexts consisted of either rectangular blocks or irregular polygonal blocks (SEE FIG. 27-8). In both types, adjoining blocks were painstakingly shaped to fit tightly together without mortar. Their stone faces might be slightly beveled along their edges so that each block presented a "pillowed" shape with recessed joins, or walls might be smoothed into a continuous, flowing surface

in which the individual blocks formed a seamless whole. At a few Inca sites, the stones used in construction were boulder-size: up to 27 feet tall. In Cusco, and elsewhere in the Inca Empire, Inca masonry has survived earthquakes that destroyed later structures.

At Machu Picchu (SEE FIGS. 27-8, 27-9), all buildings and terraces within its 3-square-mile extent were made of granite, the hard stone occurring at the site. Commoners' houses and some walls were constructed of irregular stones that were carefully fitted together, while fine polygonal or smoothed masonry distinguished palaces and temples.

polygonal-stone wall

smooth-surfaced wall

27-9 MACHU PICCHU
Peru. Inca, 1450–1530.

Credit: © Ocphoto/Shutterstock

Textiles and Metalwork

The production of fine textiles was already an important art in the Andes by the third millennium BCE. Among the Incas, textiles of cotton and camelid fibers (from llama, vicuña, and alpaca) were an indication of wealth. One form of labor taxation required the manufacture of fibers and cloth, and textiles as well as agricultural products filled Inca storehouses. Cloth was deemed a fitting gift for the gods, so fine garments were draped around statues and even burned as sacrificial offerings.

The patterns and designs on garments were not simply decorative; they carried symbolic messages, including indications of a person's ethnic identity and social rank. In the elaborate **TUNIC** in **FIGURE 27-10**, some squares represent miniature tunics. For example, tunics with checkerboard patterns were worn as military uniforms.

27-10 TUNIC
Peru. Inca, c. 1500. Camelid fiber and cotton, 35⅞ × 30″ (91 × 76.5 cm). Dumbarton Oaks Research Library and Collections, Pre-Columbian Collection, Washington, DC.

Credit: Justin Kerr/Dumbarton Oaks, Byzantine Photograph and Fieldwork Archives, Washington, DC

Perhaps an exquisite tunic such as this, containing patterns associated with multiple ranks and statuses, was woven as a royal garment.

METALWORK When they arrived in Peru in 1532, the Spanish were far less interested in Inca cloth than in their vast quantities of gold and silver. The Inca valued objects made of gold and silver not for their precious metal, but because they saw in them symbols of the sun and the moon. They are said to have called gold the "sweat of the sun" and silver the "tears of the moon." On the other hand, the Spanish exploration of the New World was propelled by feverish tales of native treasure. Whatever gold and silver objects the Spanish could obtain were melted down to enrich their royal coffers. Only a few small figures buried as offerings, like the little **LLAMA** shown in **FIGURE 27-11**, escaped destruction. The llama was thought to have a special connection with the sun, with rain, and with fertility, and a white llama was sacrificed to the sun every morning in Cusco. In this small silver figurine, the essential character of a llama is rendered with only a few well-chosen details, but in keeping with the value that Andeans placed on textiles the blanket on its back is thoroughly described.

27-11 LLAMA

From Bolivia or Peru, found near Lake Titicaca. Inca, 15th century. Cast silver with gold and cinnabar, 9 × 8½ × 1¾" (22.9 × 21.6 × 4.4 cm). American Museum of Natural History, New York.

Credit: Courtesy Dept. of Library Services, American Museum of Natural History. Photo: John Bigelow Taylor, NY

The Aftermath of the Spanish Conquest

Native American populations declined sharply after the Spanish invasions of the Aztec and Inca empires because of the exploitative policies of the conquerors and the ravages of smallpox and other European diseases. This demographic collapse meant that the population of the Americas declined by as much as 90 percent in the century after contact with Europe. European missionaries suppressed local beliefs and practices and worked to spread Christianity throughout the Americas. Although increasing numbers of Europeans began to settle and dominate the land, the production of art did not end with the Spanish conquest. Traditional media, including fine weaving, continue to flourish to this day, transforming and remaining vital as indigenous peoples adjust to a changing world.

North America

How do the style and functions of art and architecture differ among cultures across North America?

In America north of Mexico, from the upper reaches of Canada and Alaska to the southern tip of Florida, many different peoples with widely varying cultures coexisted. Here, the Europeans came less as military men seeking riches to plunder than as families seeking land to farm. Unlike the Spaniards, they found no large cities with urban populations to resist them. However, although they imagined that the lands they settled were an untended wilderness, in fact nearly all of North America was occupied by indigenous peoples. Over the next 400 years, by means of violence, bribery, and treaties, the English colonies and, in turn, the United States displaced nearly all Native Americans from their ancestral homelands. For example, beginning in the 1830s and continuing through the nineteenth century, thousands of Native Americans (46,000 by 1938) were relocated from their ancestral homelands to newly assigned territory in present-day Oklahoma, a forced migration that became known as the Trail of Tears.

Euro-Americans did not recognize indigenous aesthetic objects as anything more than ethnographic curiosities. Native American works that were small, portable, and usually fragile, were often collected—sometimes forcibly— as souvenirs or anthropological artifacts. Today, Native peoples have begun to reclaim sacred objects and human remains that were forcibly taken from them, and museums are beginning to work with Native communities to present their art in respectful and culturally sensitive ways. Here, we will be able to look at art from only four North American cultural areas: the Eastern Woodlands, the Great Plains, the Northwest Coast, and the Southwest (**MAP 27-2**).

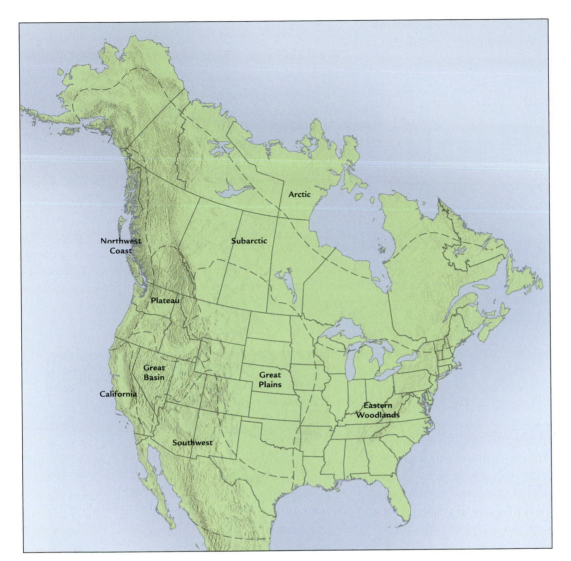

The Eastern Woodlands

In the Eastern Woodlands, after the decline of the great Mississippian centers, most tribes lived in stable villages, and they combined hunting, gathering, and agriculture for their livelihood. In the sixteenth century, the Iroquois formed a powerful confederation of five northeastern Native American nations, which played a prominent military and political role until after the American Revolution. The Huron and Illinois also formed sizable confederacies.

In the seventeenth century, the arrival on the Atlantic coast of a few boatloads of Europeans seeking religious freedom, farmland, and a new life for themselves brought major changes. Trade with these settlers gave the Woodlands peoples access to things they valued, while the colonists learned Native forms of agriculture, hunting, and fishing—skills they needed in order to survive. Native Americans traded furs for such useful items as metal tools, cookware, needles, and cloth, and they especially prized European glass beads and silver. These trade items largely replaced older materials, such as crystal, copper, and shell.

WAMPUM Woodlands peoples made belts and strings of cylindrical purple and white beads—made from whelk and clam shells—called wampum. The Iroquois and Delaware peoples used wampum to keep records (the purple and white patterns served as memory aids) and exchanged belts of wampum to seal treaties (**FIG. 27-12**). Few actual wampum treaty belts have survived, so this one, said to commemorate an unwritten treaty when the land that is now the state of Pennsylvania was ceded by the Delawares in 1682, is especially prized. The belt, with two figures of equal size holding hands, suggests the mutual respect enjoyed by the Delaware and Penn's Society of Friends (Quakers), a respect that later collapsed into land fraud and violence. In general, wampum strings and belts had the authority of legal agreement and also symbolized a moral and political order.

QUILLWORK Woodlands art focused on personal adornment—tattoos, body paint, and elaborate dress—and fragile arts such as **quillwork**. Quillwork involved dyeing porcupine and bird quills with a variety of natural dyes, soaking the quills to soften them, and then working them

27–12 WAMPUM BELT, TRADITIONALLY CALLED WILLIAM PENN'S TREATY WITH THE DELAWARE
1680s. Shell beads, 17⅜ × 6⅛" (44 × 15.5 cm). Royal Ontario Museum, Canada.

Credit: With permission of the Royal Ontario Museum © ROM

into rectilinear, ornamental surface patterns on deerskin clothing and on birch-bark items like baskets and boxes. A Sioux legend recounts how a mythical ancestor, Double-woman ("double" because she was both beautiful and ugly, benign and dangerous), appeared to a woman in a dream and taught her the art of quillwork. As the legend suggests, quillwork was a woman's art form, as was basketry. The Sioux **BABY CARRIER** in **FIGURE 27–13** is richly decorated with symbols of protection and well-being, including bands of antelopes in profile and thunderbirds flying with their heads turned and tails outspread. The thunderbird was an especially helpful symbol, thought to be capable of protecting against both human and supernatural adversaries.

BEADWORK AND BASKETRY Shell beads were used in wampum, but decorative beadwork did not become commonplace until Native American artists began to acquire European colored-glass beads in the late eighteenth century; in the nineteenth century they favored the tiny seed beads from Venice and Bohemia. Early beadwork mimicked the patterns and colors of quillwork. In the nineteenth century it largely replaced quillwork and incorporated European designs. Among other sources of inspiration were Canadian nuns, who introduced the young women in their schools to embroidered European floral motifs, European needlework techniques, and patterns from European garments, all of which Native embroiderers began to adapt into their own work. Functional aspects of garments might be transformed into purely decorative motifs; for example, a pocket would be replaced by an area of beadwork shaped like a pocket. A **BANDO-LIER BAG** from Kansas, made by a Delaware woman (**FIG. 27–14**), is covered with curvilinear plant motifs in contrast to the rectilinear patterns of traditional quillwork. White

27–13 BABY CARRIER
Upper Missouri River area. Eastern Sioux, 19th century. Wooden board, buckskin, porcupine quill length 31" (78.8 cm). Department of Anthropology, Smithsonian Institution Libraries, Washington, DC. Catalog No. 7311.

Credit: Catalogue No. 73311, Department of Anthropoogy, Smithsonian Institution

27–14 BANDOLIER BAG
Kansas. Delaware people, c. 1860. Wool fabric, cotton fabric and thread, silk ribbon, and glass beads, 22 × 17″ (56 × 43 cm); bag without strap, 8⅝ × 7¾″ (22 × 19.7 cm). The Detroit Institute of Arts. Founders Society Purchase (81.216).

Credit: Bridgeman Images

lines outline brilliant pink and blue leaf-shaped forms on both bag and shoulder straps, heightening the intensity of the colors, which alternate within repeated patterns, exemplifying the evolution of beadwork design and its adaptation to a changing world. The shape of bandolier bags is adapted from ammunition pouches carried by European soldiers and trappers.

Basketry is the weaving of reeds, grasses, and other plant materials to form containers. In North America the earliest evidence of basketwork, found in Danger Cave, Utah, dates to as early as 8400 BCE. Over the subsequent centuries, Native American women across North America developed basketry into an art form that combined utility with great beauty. There are three principal basket-making techniques: coiling, twining, and plaiting. **Coiling** involves sewing together a spiraling foundation of rods with some other material. **Twining** twists

Art and Its Contexts

CRAFT OR ART?

In many cultures, the distinction between "fine art" and "craft" does not exist. The traditional Western academic hierarchy of materials (in which marble, bronze, oil paint, and fresco are valued more than ceramic, glass, and watercolor) and the equally artificial hierarchy of subjects (in which history painting, including religious history, stands supreme) are irrelevant to non-Western art and to much art produced in the West before the modern era.

Indigenous peoples of the Americas did not produce objects as works of art to be displayed in museums. In their eyes all pieces were utilitarian objects, adorned in ways necessary for their intended purposes. A work was valued for its effectiveness and for the role it played in society. Some, like a Sioux baby carrier (SEE FIG. 27–13), enrich mundane life with their aesthetic qualities. Others, such as Pomo baskets, commemorate important events. The function of an Inca tunic may have been to identify or confer status on its owner or user through its material value or symbolic associations. And as with art in all cultures, many pieces had great spiritual power. Such works of art cannot be fully comprehended or appreciated when they are seen only on pedestals or encased in glass boxes in museums

or galleries. They must be imagined, or better yet seen, as acting in their societies: Kwakwaka'wakw masks (SEE FIG. 27–20), for example, functioning in religious drama, changing not only the outward appearance, but also the very essence of the individuals wearing them.

At the beginning of the twentieth century, European and American artists broke away from the academic bias that promoted the Classical heritage of Greece and Rome. They found new inspiration in the art—or craft, if you will—of many different non-European cultures. Artists explored a new freedom to use absolutely any material or technique that challenged outmoded assumptions and opened the way for a free and unfettered delight in, and an interest in understanding, Native American art as well as the art of other non-Western cultures. The more recent twentieth- and twenty-first-century conception of art as a multimedia adventure has helped validate works of art once seen only in ethnographic collections. Today, objects once called "primitive" are recognized as works of art and acknowledged to be an essential dimension of a twenty-first-century worldview. The line between "art" and "craft" seems more artificial and less relevant than ever before.

27-15 FEATHERED BASKET
California. Pomo culture, c. 1877. Willow, bulrush, fern, feather,
shells, glass beads; height 5½" (14 cm), diameter 12" (36.5 cm).
Philbrook Museum of Art, Inc., Tulsa, Oklahoma.
Gift of Clark Field (1948.39.37).

and the softly waving feathers create layers and textural
contrasts characteristic of works of art. This blending of
aesthetics and functionality is found throughout Native
North American art.

The Great Plains

Between the Eastern Woodlands region and the Rocky
Mountains to the west lay an area of prairie grasslands
called the Great Plains. On the Great Plains, two differing
ways of life developed, one a relatively recent and short-
lived (1700–1870) nomadic lifestyle—dependent on the
region's great migrating herds of buffalo for food, clothing,
and shelter—and the other a much older sedentary and
agricultural lifestyle. Horses, taken from wild herds that
had descended from feral horses brought to America by
Spanish explorers in the sixteenth and seventeenth centu-
ries, made travel, and thus a nomadic way of life, easier for
the dispossessed eastern groups that moved to the plains.

On the eastern seaboard, both Native Americans and
European backcountry settlers were living in loosely vil-
lage-based, farming societies and thus were competing
for the same resources. Increasingly, European settlers
pressured the Eastern Woodlands peoples, seizing their
farmlands and forcing them westward. The resulting inter-
action of Eastern Woodlands artists with one another and
with Plains artists led in some cases to the emergence of
new hybrid styles, while other artists consciously fought to
maintain their own traditional cultures.

multiple elements around a vertical warp of rods. Plaiting
weaves strips over and under each other.

The coiled basket shown here was made by a Pomo
woman in California (**FIG. 27-15**). According to Pomo leg-
end, the Earth was dark until their ancestral hero stole the
sun and brought it to Earth in a basket. He hung the basket
first just over the horizon, but, dissatisfied with the light it
gave, he kept suspending it in different places across the
dome of the sky. He repeats this process every day, which
is why the sun moves across the sky from east to west.

In the Pomo basket, the structure of coiled willow and
bracken fern root produces a spiral surface into which the
artist worked sparkling pieces of clam shell, trade beads,
and soft tufts of woodpecker and quail feathers. The
underlying patterns in the basket, the glittering shells,

PORTABLE ARCHITECTURE The nomadic Plains peo-
ples hunted buffalo for food and hides from which they
created clothing and a light, portable dwelling known as
a tipi (formerly spelled teepee) (**FIG. 27-16**). The tipi was
well adapted to withstand the strong and
constant wind, the dust, and the violent
storms of the prairies. The framework of a
tipi consisted of a stable pyramidal frame
of three or four long poles, filled out with
about 20 additional poles, in a roughly
oval plan. The framework was covered
with hides specially prepared to make
them flexible and waterproof—later, can-
vas was used—to form a conical structure.
Between 20 and 40 hides were needed for
a tipi, depending on its size. An opening
at the top served as the smoke hole for a
central hearth. The tipi leaned slightly into

**27-16 BLACKFOOT WOMEN
RAISING A TIPI**
Photographed c. 1900. Montana Historical Society
Research Center.

the prevailing west wind while the flap-covered door and smoke hole faced east, away from the wind. An inner lining covered the lower part of the walls and the perimeter of the floor to protect the occupants from drafts.

Tipis were the property and responsibility of women, who set them up at new encampments and lowered them when the group moved on. Blackfoot women could set up their huge tipis in less than an hour. Women quilled, beaded, and embroidered tipi linings, as well as backrests, clothing, and equipment. The patterns with which tipis were decorated, like the tipis' proportions and colors, varied from nation to nation, family to family, and individual to individual. In general, the bottom was covered with traditional motifs and the center section held personal images. When disassembled and packed to be dragged by a horse to another location, the tipi served as a platform for transporting other possessions. The Sioux arranged

their tipis in two half-circles—one for the sky people and one for the earth people—divided along an east–west axis. When the Blackfeet people gathered in the summer for their ceremonial Sun Dance, their encampment contained hundreds of tipis in a circle a mile in circumference.

PLAINS INDIAN PAINTING Plains men recorded their exploits in paintings on tipis and on buffalo-hide robes. The earliest documented painted buffalo-hide robe, presented to Lewis and Clark during their transcontinental expedition, illustrates a battle fought in 1797 by the Mandan (of what is now North Dakota) and their allies against the Sioux (**FIG. 27-17**). The painter, trying to capture the full

27-17 BATTLE SCENE, HIDE PAINTING

North Dakota. Mandan, 1797–1800. Tanned buffalo hide, dyed porcupine quills, and black, red, green, yellow, and brown pigment, 7′10″ × 8′6″ (2.44 × 2.65 m). Peabody Museum of Archaeology and Ethnology, Harvard University.

This robe, "collected" in 1804 by Meriwether Lewis and William Clark on their expedition into western lands acquired by the United States in the Louisiana Purchase, is the earliest documented example of Plains painting. It was one of a number of Native American artworks that Lewis and Clark sent to President Thomas Jefferson, who displayed the robe in the entrance hall of his home at Monticello, Virginia.

extent of a conflict in which five nations took part, shows a party of warriors in 22 separate episodes. The party is led by a man with a pipe and an elaborate eagle-feather headdress, and the warriors are armed with bows and arrows, lances, clubs, and flintlock rifles. Details of equipment and emblems of rank—headdresses, sashes, shields, feathered lances, powder horns for the rifles—are depicted carefully. Horses are shown in profile with stick legs, C-shaped hooves, and either clipped or flowing manes.

The figures stand out clearly against the light-colored background of the buffalo hide. The painter pressed lines into the hide, then filled in the forms with black, red, green, yellow, and brown pigments. A strip of colored porcupine quills runs down the spine of the buffalo hide. The robe would have been worn draped over the shoulders of the powerful warrior whose deeds it commemorates. As the wearer moved, the painted horses and warriors would seem to come alive, transforming him into a living representation of his exploits.

Life on the Great Plains changed abruptly in 1869, when the transcontinental railway linking the east and west coasts of the United States was completed, providing easy access to Native American lands. Between 1871 and 1890, Euro-American hunters killed off most of the buffalo, and soon ranchers and then farmers moved into the Great Plains. The U.S. government forcibly moved the outnumbered and outgunned Native Americans to reservations, land considered worthless until the later discovery of oil and, in the case of the Black Hills, gold.

The Northwest Coast

From southern Alaska to northern California, the Pacific coast of North America is a region of unusually abundant resources. Its many rivers fill each year with salmon returning to spawn. Harvested and dried, the fish could sustain large populations throughout the year. The peoples of the Northwest Coast—among them the Tlingit, the Haida, and the Kwakwaka'wakw (formerly spelled Kwakiutl)—exploited this abundance to develop a complex and distinctive way of life in which the arts played a central role.

ANIMAL IMAGERY Animals feature prominently in Northwest Coast art because each extended family group (clan) claimed descent from a mythic animal or animal-human ancestor, from whom the family took its name and the right to use certain animals and spirits as totemic emblems, or crests. These emblems appear frequently in Northwest Coast art, notably in carved cedar house poles and the tall, free-standing mortuary poles erected to memorialize dead chiefs. Chiefs, who were males in the most direct line of descent from the mythic ancestor, validated their status and garnered prestige for themselves and their families by holding ritual feasts known

as potlatches, during which they gave valuable gifts to the invited guests. Shamans, who were sometimes also chiefs, mediated between the human and spirit worlds. Some shamans were female, giving them unique access to certain aspects of the spiritual world.

Northwest Coast peoples lived in large, elaborately decorated communal houses made of massive timbers and thick planks. Carved and painted partition screens separated the chief's quarters from the rest of the house. The Tlingit screen illustrated in **FIGURE 27–18** came from the house of Chief Shakes of Wrangell (d. 1916), whose family crest was the grizzly bear. The image of a rearing grizzly painted on the screen is itself made up of smaller bears and bear heads that appear in its ears, eyes, nostrils, joints, paws, and body. The oval door opening is a symbolic vagina; passing through it re-enacts the birth of the family from its ancestral spirit.

27–18 GRIZZLY BEAR HOUSE-PARTITION SCREEN
From the house of Chief Shakes of Wrangell, Canada. Tlingit people, c. 1840. Cedar, paint, and human hair, 15 × 8' (4.57 × 2.74 m). Denver Art Museum. Native Arts acquisition funds (1951.315).

27–19 CHILKAT BLANKET
Southeast Alaska. Tlingit people, c. 1850. Mountain-goat wool, yellow cedar bark, linen thread, approx. 55 × 72" (130 × 183 cm). Thaw Collection, Fenimore Art Museum, Cooperstown, New York.

Credit: Photo: John Bigelow Taylor

TEXTILES Blankets and other textiles produced collaboratively by the men and women of the Chilkat Tlingit had great prestige among Northwest Coast peoples (**FIG. 27-19**). Men drew the patterns on boards, and women wove them into the blankets, using shredded cedar bark and mountain-goat wool. The weavers did not use looms; instead, they hung cedar warp threads from a rod and twined colored goat wool back and forth through them to make the pattern, which in this technique can be defined by curving lines. The ends of the warp form the fringe at the bottom of the blanket.

The popular design used here is known as the diving whale—the central panel shows the downward-facing whale(s), while the panels to the sides have been interpreted as this animal's body or seated ravens seen in profile. Characteristic of Northwest painting and weaving, the images are composed of two basic elements: the ovoid (a slightly bent rectangle with rounded corners) and the formline (a continuous, shape-defining line). Here, subtly swelling black formlines define gently curving ovoids and C shapes. When the blanket was worn, its two-dimensional shapes would have become three-dimensional, with the dramatic central figure curving over the wearer's back and the intricate side panels crossing over his shoulders and chest.

MASKS To call upon guardian spirits, many Native American cultures staged ritual dance ceremonies in which dancers wore complex costumes and striking carved and painted wooden masks. Isolated in museums as "art," the masks doubtless lose some of the shocking vivacity they have in performance; nevertheless their bold forms and color schemes retain power and meaning that can be activated by the viewer's imagination.

Some of the most elaborate masks are those used by the Kwakwaka'wakw in the Winter Ceremony that initiates members into the shamanistic Hamatsa society. The dance re-enacts the taming of Hamatsa, a cannibal spirit, and his three attendant bird spirits. Magnificent carved and painted masks transform the dancers into Hamatsa and the attendants, who search for victims to eat. Strings allow the dancers to manipulate the masks so that the beaks open and snap shut with spectacular effect. With snapping beaks and cries of "Hap! Hap! Hap!" ("Eat! Eat! Eat!"), Hamatsa and his three assistants threaten and even attack the Kwakwaka'wakw people who gather for the Winter Ceremony.

In the Winter Ceremony, youths are captured, taught the Hamatsa lore and rituals, and then in a spectacular theater–dance performance are "tamed" and brought back into civilized life. All the members of the community, including singers, gather in the main room of the great house, which is divided by a painted screen (SEE FIG. 27-18). The audience members fully participate in the performance; in early times, they brought containers of blood so that when the bird-dancers attacked them, they could appear to bleed and have flesh torn away.

27–20 Attributed to Willie Seaweed **KWAKWAKA'WAKW BIRD MASK**

Alert Bay, Vancouver Island, Canada. Prior to 1951. Cedar wood, cedar bark, feathers, and fiber, 10 × 72 × 15″ (25.4 × 183 × 38.1 cm). Collection of the Museum of Anthropology, Vancouver, Canada. (A6120).

The name "Seaweed" is an anglicization of the Kwakwaka'wakw name *Siwid*, meaning "Paddling Canoe," "Recipient of Paddling," or "Paddled To"—referring to a great chief to whose potlatches guests paddled from afar. Willie Seaweed was not only the chief of his clan, but a great orator, singer, and tribal historian who kept the tradition of the potlatch alive during years of government repression.

Credit: Courtesy of the UBC Museum of Anthropology, Vancouver, Canada

Whistles from behind the screen announce the arrival of the Hamatsa (danced by an initiate), who enters through the central hole in the screen in a flesh-craving frenzy. Wearing hemlock, a symbol of the spirit world, he crouches and dances wildly with outstretched arms as attendants try to control him. He disappears but returns again, now wearing red cedar and dancing upright. Finally tamed, a full member of society, he even dances with the women.

Then the masked bird-dancers appear—first Raven-of-the-North-End-of-the-World, then Crooked-Beak-of-the-End-of-the-World, and finally the untranslatable Huxshukw, who cracks open skulls with his beak and eats the brains of his victims. Snapping their beaks, these masters of illusion enter the room backward, their masks pointed up as though the birds are looking skyward. They move slowly counterclockwise around the floor. At each change in the music they crouch, snap their beaks, and let out their wild cries of "Hap! Hap! Hap!" Essential to the ritual dances are the huge wooden masks. Among the finest are those by Willie Seaweed (1873–1967), a Kwakwaka'wakw chief, whose brilliant colors and exuberantly decorative carving style determined the direction of twentieth-century Kwakwaka'wakw sculpture (**FIG. 27–20**).

The Canadian government, abetted by missionaries, outlawed the Winter Ceremony and potlatches in 1885, claiming the event was injurious to health, encouraged prostitution, endangered children's education, damaged the economy, and was cannibalistic. But the Kwakwaka'wakw refused to give up their "oldest and best" festival—one that spoke powerfully to them in many ways, establishing social rank and playing an important role in arranging marriages. By 1936, the government and the missionaries, who called the Kwakwaka'wakw "incorrigible," gave up. But not until 1951 could the Kwakwaka'wakw people gather openly for winter ceremonies, including the initiation rites of the Hamatsa society.

The Southwest

The Native American peoples of the southwestern United States include, among others, the modern Puebloans (sedentary village-dwelling groups) and the Navajo. The Puebloans (living, for example, in Hopi, Acoma, Zuni, and a series of pueblos along the Rio Grande in New Mexico) are heirs of the Ancestral Puebloans (former Anasazi), Hohokam, and Mogollan cultures (see Chapter 13). The Ancestral Puebloans built apartmentlike villages and cliff dwellings whose ruins are found throughout the Four Corners region of New Mexico, Colorado, Arizona, and Utah. The Navajo, who arrived in the region sometime between 1100 and 1500 CE, developed a semisedentary way of life based on agriculture and (after the introduction of sheep by the Spaniards) shepherding. Being among the very few Native American tribal groups whose reservations are located on their actual ancestral homelands, both groups have succeeded in maintaining the continuity of their traditions despite Euro-American pressure. Today, their arts reflect the adaptation of traditional forms to new technologies, new media, and the dominant American culture that surrounds them.

THE PUEBLOS Some Pueblos, like those of their ancient ancestors, consist of multi-storied dwellings made of adobe. One of these, **TAOS PUEBLO (FIG. 27–21)**, is located in north-central New Mexico. Continually occupied and modified for over 500 years, the up-to-five-story house blocks of Taos Pueblo provide flexible, communal

27-21 TAOS PUEBLO
Taos, New Mexico. Acetate negative, 1947. © 1979 Amon Carter Museum of American Art, Fort Worth, Texas. Bequest of the artist (P1979.208.698).

Laura Gilpin (1891–1979), an American photographer of the landscape, architecture, and people of the American Southwest, began her series on the Pueblos and Navajos in the 1930s. She published her work in four volumes of photographs between 1941 and 1968.

Credit: © 1979 Amon Carter Museum of American Art, Fort Worth, Texas. P1979.208.698.

dwellings. Ladders provide access to the upper stories and to insulated inner rooms entered through holes in the ceiling. Two large house blocks are arrayed around a central plaza that opens toward the neighboring mountains, rising in a stepped fashion to provide a series of roof terraces that can serve as viewing platforms. The plazas and roof terraces are centers of communal life and ceremony, as can be seen in Pablita Velarde's painting of the winter solstice celebrations (SEE FIG. 27-23).

CERAMICS Traditionally, pottery was women's art among Pueblo peoples. Wares were made by coiling and other hand-building techniques and then fired at low temperature in wood fires. The best-known twentieth-century Pueblo potter was Maria Montoya Martinez (1887–1980) of San Ildefonso Pueblo in New Mexico. Inspired by prehistoric pottery that was unearthed at nearby archaeological excavations and by the then-fashionable Art Deco style, she and her husband, Julian Martinez (1885–1943), developed a distinctive **blackware** ceramic style notable for its elegant forms and subtle textures (**FIG. 27-22**). Maria Martinez made pots covered with a slip that was then burnished. Using additional slip, Julian Martinez painted the pots with designs that interpreted traditional Pueblo and Ancestral Puebloan imagery. After firing, the burnished ground became a lustrous black and the slip painting retained a matte surface. By the 1930s, production of blackware in San Ildefonso had become a communal enterprise. Family members and friends all worked making pots, and Maria Martinez signed all the pieces so that, in typical Pueblo communal solidarity, everyone profited from her fame within the art market.

THE SANTA FE INDIAN SCHOOL In the 1930s, Anglo-American art teachers and dealers worked with Native Americans of the Southwest to create a distinctive, stereotypical "Indian" style in several media—including jewelry, pottery, weaving, and painting—to appeal to tourists and collectors. A leader in this effort was Dorothy Dunn (1903–1991), who opened an art studio known as the Studio School within the Santa Fe Indian School, an off-reservation government boarding school in New Mexico, from 1932 to 1937. Dunn inspired her students to create a painting style that combined the outline drawing and flat colors of folk art, the decorative qualities of Art Deco, and exotic "Indian" subject matter. Restrictive as the Studio School was, Dunn's success made painting a viable occupation for some young Native American artists.

Pablita Velarde (1918–2006), from Santa Clara Pueblo in New Mexico and a 1936 graduate of Dorothy Dunn's Studio School, was only a teenager when one of her paintings was selected for exhibition at the Chicago World's Fair in 1933. Thereafter, Velarde documented Pueblo ways of

27-22 Maria Montoya Martinez and Julian Martinez BLACK-ON-BLACK STORAGE JAR
New Mexico. c. 1942. Ceramic, height 18¾″ (47.6 cm), diameter 22½″ (57.1 cm). Museum of Indian Arts and Culture/Laboratory of Anthropology, Museum of New Mexico, Santa Fe. Gift of Henry Dendahl.

Credit: Museum of Indian Arts and Culture/Laboratory of Anthropology, Santa Fe.

27–23 Pablita Velarde **KOSHARES OF TAOS**
New Mexico. 1940s. Watercolor on paper, 13⁷⁄₈ × 22³⁄₈″ (35.3 × 56.9 cm). Philbrook Museum of Art, Tulsa, Oklahoma.
Museum purchase (1947.37).

Credit: © Helen Tindel. Photograph © 2017. The Philbrook Museum of Art, Inc., Tulsa, Oklahoma

life in a large series of murals for the Bandelier National Monument (a small Ancestral Puebloan site near Los Alamos, New Mexico), launching a long and successful career. In smaller works on paper, such as the one illustrated here, she continued this focus on Pueblo life. **KOSHARES OF TAOS** (**FIG. 27–23**) illustrates a moment during a ceremony celebrating the winter solstice when *koshares*, or clowns, take over the plaza from the Katsinas. Katsinas—the supernatural counterparts of animals, natural phenomena like clouds, and geological features like mountains—are central to traditional Pueblo religion. They manifest themselves in the human dancers who impersonate them during ceremonies throughout the year, as well as in the small figures known as Katsina dolls that are given to children to help them learn to identify the masks. Velarde's painting combines bold, flat colors and a simplified decorative line with European perspective. Her paintings, with their Art Deco abstraction, helped establish the popular idea of the "Indian" style in art.

THE NAVAJOS While some Navajo arts, like sand painting, have deep traditional roots, others have developed over the centuries of European contact. Navajo weaving (SEE FIG. 27–1) depends on the wool of sheep introduced by the Spaniards, and the designs and colors of Navajo blankets continue to evolve today in response to tourism and

changing aesthetics. Similarly, jewelry made of turquoise and silver did not become an important Navajo art form until the mid nineteenth century. Traditionally, Navajo arts had strict gender divisions: women wove cloth, and men worked metal.

Sand painting, a traditional Navajo art, is the exclusive province of men. Sand paintings are made to the accompaniment of chants by shaman-singers in the course of healing and blessing ceremonies, and they have great sacred significance. The Night Chant, sung toward the end of the ceremony, signals the restoration of inner harmony and balance:

> In beauty (happily) I walk.
> With beauty before me I walk.
> With beauty behind me I walk.
> With beauty below me I walk.
> With beauty all around me I walk.
> It is finished (again) in beauty.
> It is finished in beauty.

Navajo sand paintings depict mythic heroes and events; and as ritual art, they follow prescribed rules and patterns that ensure their power. To make them, the singer dribbles pulverized colored stones, pollen, flowers, and other natural colors over a hide or sand ground. The rituals are intended to cure by restoring harmony to

the world. The paintings are not meant to be seen by the public and certainly not to be displayed in museums. They are meant to be destroyed by nightfall of the day on which they are made.

In 1919, a respected shaman-singer named Hosteen Klah (1867–1937) began to incorporate sand-painting images into weaving, breaking with the traditional prohibitions. Many Navajos took offense at Klah both for recording the sacred images and for doing so in what was traditionally a woman's art form. But the Navajo traditionally recognize at least three genders; Hosteen Klah was a *nadle*, or Navajo third-gender, and he had learned to weave from his mother and sister. Hence, he could learn both female and male arts; that is, he was trained both to weave and to heal. Hosteen Klah was not breaking artistic barriers in a conventional sense, but rather exemplifying the complexities of the traditional Navajo gender system. Klah's work was ultimately accepted because of his great skill and prestige.

The **WHIRLING LOG CEREMONY** sand painting, woven into tapestry (**FIG. 27-24**), depicts part of the Navajo creation myth. The Holy People create the earth's surface and divide it into four parts. They create humans, and bring forth corn, beans, squash, and tobacco—the four sacred plants. A male–female pair of humans and one of the sacred plants stand in each of the four quarters, defined by the central cross. The four Holy People (the elongated figures) surround the image, and the guardian figure of Rainbow Maiden frames the scene on three sides. Like all

Navajo artists, Hosteen Klah hoped that the excellence of the work would make it pleasing to the spirits. Recently, shaman-singers have made permanent sand paintings on boards for sale, but they usually introduce slight errors in them to render the paintings ceremonially harmless.

A New Beginning

How are Native American artists and arts institutions responding to the contemporary global art world?

While Native American art has long been displayed in anthropology and natural history museums, today the art of indigenous peoples is finally achieving full recognition by the art establishment (see "Craft or Art?" on page 863). The Institute of American Indian Arts (IAIA), founded in 1962 in Santa Fe and attended by Native American students from all over North America, supports Native American aspirations in the arts today just as Dorothy Dunn's Studio School did in the 1930s. Staffed by Native American artists, the school encourages the incorporation of indigenous ideals in the arts without creating an official "style." As alumni have achieved distinction and the IAIA museum in Santa Fe has established a reputation for excellence, the institute has led Native American art into the mainstream of contemporary art (see Chapter 33).

Contemporary Native American artist Jaune Quick-to-See Smith (b. 1940) borrowed a well-known image by Leonardo da Vinci for **THE RED MEAN (FIG. 27-25)**, a work she describes as a self-portrait. Indeed, the center of the work has a bumper sticker that reads "Made in the U.S.A." above an identification number. The central figure quotes Leonardo's *Vitruvian Man* (see "The Vitruvian Man" in Chapter 21 on page 649), but the message here is autobiographical. Leonardo inscribed the human form within perfect geometric shapes to emphasize the perfection of the human body, while Smith put her silhouette inside the red X that signifies nuclear radiation. This image alludes both to the uranium mines found on some Indian reservations and to the fact that many have become temporary repositories for nuclear waste. The image's background is a collage of Native American tribal newspapers. Her self-portrait thus includes her ethnic identity and life on the reservation as well as allusions to the history of Western art.

Other artists, such as Canadian Haida artist Bill Reid (1920–1998), have sought to sustain and revitalize traditional art in their work. Trained as a woodcarver, painter, and jeweler, Reid revived the art of carving totem poles and dugout canoes in the Haida homeland of Haida Gwaii—"Islands of the People"—known on maps today as the Queen Charlotte Islands. Late in life he began to create large-scale sculptures in bronze. With their black patina, these works recall traditional Haida carvings in shiny black argillite.

27-24 Hosteen Klah WHIRLING LOG CEREMONY
Sand painting; tapestry by Mrs. Sam Manuelito. Navajo, c. 1925. Wool, 5'5" × 5'10" (1.69 × 1.82 m). Heard Museum, Phoenix, Arizona.

27–25 Jaune Quick-to-See Smith **THE RED MEAN: SELF-PORTRAIT**

1992. Acrylic, newspaper collage, and mixed media on canvas, 90 × 60″ (228.6 × 154.4 cm). Smith College Museum of Art, Northampton, Massachusetts. Part gift from Janet Wright Ketcham, class of 1953, and part purchase from the Janet Wright Ketcham, class of 1953, Acquisition Fund. (SC 1993:10a.b.).

Credit: © Jaune Quick-to-See Smith (Salish member of Confederated Salish and Kootenai Nation Mt). Courtesy of the Artist and Catherine Louisa Gallery, MT. Photo: Petegorsky/Gipe

Reid's imposing **THE SPIRIT OF HAIDA GWAII** now stands outside the Canadian Embassy in Washington, DC (**FIG. 27-26**). This sculpture, which Reid viewed as a metaphor for modern Canada's multicultural society, depicts a boatload of figures from the natural and mythic worlds struggling to paddle forward. The dominant figure is a shaman in a spruce-root basket hat and Chilkat blanket holding a speaker's pole. On the prow, the place reserved for the chief in a war canoe, sits the Bear. He faces backward rather than forward, and is bitten by an Eagle, with formline-patterned wings. The Eagle, in turn, is bitten by the Seawolf. The Eagle and the Seawolf, together with the man behind them, nevertheless continue paddling. At the stern, steering the canoe, is the Raven, the trickster in Haida mythology. The Raven is assisted by Mousewoman, the traditional guide and escort of humans in the spirit realms. According to Reid, the work represents a "mythological and environmental lifeboat," where "the entire family of living things … whatever their differences, … are paddling together in one boat, headed in one direction" (Bringhurst 1991).

27–26 Bill Reid **THE SPIRIT OF HAIDA GWAII**

Haida, 1991. Bronze, approx. 13 × 20′ (4 × 6 m). Canadian Embassy, Washington, DC.

Credit: © Chris Cheadle/ Alamy Stock Photo

THE NATIONAL MUSEUM OF THE AMERICAN INDIAN In September 2004, the National Museum of the American Indian finally opened on the Mall in Washington, DC, directly below Capitol Hill and across from the National Gallery of Art. Inspired by the colors, textures, and forms of the American Southwest, the museum building established a new presence for Native Americans on the Mall (**FIG. 27-27**). Symbolizing the Native relationship to the environment, the museum is surrounded by boulders ("Grandfather Rocks"), water, and plantings that recall the varied landscapes of North America, including wetlands, meadows, forest, and traditional cropland with corn, squash, and tomatoes. The entrance to the museum on the east side faces the morning sun and recalls the orientation of prairie tipis. Inside the building a Sun Marker of stained glass in the south wall throws its dagger of light across the vast atrium as the day progresses. The Native peoples of North America have at last taken their rightful place alongside other American ethnicities and many artistic traditions from around the globe.

27-27 NATIONAL MUSEUM OF THE AMERICAN INDIAN

The Smithsonian Institution, Washington, DC. Opened September 2004. Architectural design: GBQC in association with Douglas Cardinal (Blackfoot). Architectural consultants: Johnpaul Jones (Cherokee-Choctaw) and Ramona Sakiestewa (Hopi). Landscape consultant: Donna House (Navajo-Oneida), ethno-botanist.

Credit: J. Scott Applewhite/AP Photos

Think About It

1 Distinguish characteristic styles and techniques developed by two Native American cultures—one in the north, and one in the south—and discuss how they are demonstrated in one specific work from each culture.

2 Explain how symbols and themes are used in **FIGURE 27-7** to articulate the Aztec worldview.

3 Choose a work of art in this chapter that is best understood in connection with its use in religious or political ritual. Discuss its meaning in relation to its ceremonial context. How could such works be displayed in museums in such a way that viewers would be able to understand this critical aspect of their meaning?

4 Evaluate the ways in which two Native North American works from this chapter show influences from European culture.

Crosscurrents

As is frequently the case in the history of art, artist Jaune Quick-to-See Smith has drawn, in *The Red Mean: Self-Portrait*, on a famous work of art from the past—in this case Leonardo da Vinci's *Vitruvian Man*. Discuss how grasping the meaning of Smith's work depends on the viewer's understanding of Leonardo's drawing. Does thinking about the comparison change the way you understand the earlier work?

FIG. 21-3

FIG. 27-25

THE BARUNGA STATEMENT

We the indigenous owners and occupiers of Australia call on the Australian Government and people to recognise our rights

- to self determination and self management including the freedom to pursue our own economic, social religous and cultural development;
- to permanent control and enjoyment of our ancestral lands;
- to compensation for the loss of use of lands, there having been no extinction of original title;
- to protection and control of access to our sacred sites, sacred objects, artifacts, designs, knowledge and works of art;
- to the return of the remains of our ancestors for burial in accordance with our traditions;
- to respect for and promotion of our Aboriginal identity, including the cultural, linguistic, religious and historical aspects, including the right to be educated in our own languages, and in our own culture and history;
- in accordance with the Universal Declaration of Human Rights, the International Covenant on Economic, Social and Cultural Rights, the International Covenant on Civil and Political Rights, and the International Convention on the Elimination of All Forms of Racial Discrimination, including rights to life, liberty, security of person, food, clothing, housing, medical care, education and employment opportunities, necessary social services and other basic human rights.

We call on the Commonwealth Parliament to pass laws providing:

- a national elected Aboriginal and Islander organisation to oversee Aboriginal and Islander affairs;
- a national system of land rights;
- a police and justice system which recognises our customary laws and frees us from discrimination and any activity which may threaten our identity or security, interfere with our freedom of expression or association, or otherwise prevent our full enjoyment and exercise of universally recognised human rights and fundamental freedoms.

We call on the Australian Government to support Aborigines in the development of an International Declaration of Principles for Indigenous Rights, leading to an International Covenant.

And we call on the Commonwealth Parliament to negotiate with us a Treaty or Compact recognising our prior ownership, continued occupation and sovereignty and affirming our human rights and freedoms.

28–1 Galarrwuy Yunupingu Wenten Rubuntja, Lindsay Turner Jampikina, Dennis Williams Japanangka, Bakulangay Marawili, Djambawa Marawili, Marrirra Marawili, Djewiny Ngurruwithun **THE BARUNGA STATEMENT**
1988. Ochers on composition board with collage of printed text on paper, 48 x 47¼" (122 x 120 cm). Parliament House Art Collection, Parliament House, Canberra.

Credit: Courtesy of Parliament House Art Collection, Department of Parliamentary Services, Canberra A.C.T. Reproduced with permission of the Northern and Central Land Councils.

Chapter 28
Art of Pacific Cultures

 ## Learning Objectives

28.a Identify the visual hallmarks of the art of Pacific cultures for formal, technical, and expressive qualities.

28.b Interpret the meaning of works of art of Pacific cultures based on their themes, subjects, and symbols.

28.c Relate artists and art of Pacific cultures to their cultural, economic, and political contexts.

28.d Apply the vocabulary and concepts relevant to the art, artists, and art history of Pacific cultures.

28.e Interpret the art of Pacific cultures using the art historical methods of observation, comparison, and inductive reasoning.

28.f Select visual and textual evidence in various media to support an argument or an interpretation of the art of Pacific cultures.

In 1788, when Captain James Cook arrived in Australia, it was home to at least 300,000 Indigenous Australians, whose ancestors had arrived 50,000 years earlier and who spoke over 250 languages. For 40,000 years Indigenous Australians had been creating rock art; they were the oldest continuous culture in the world. Nevertheless, Cook claimed Australia for Britain as a *terra nullius*, a land that belonged to no one. Within a few decades, European diseases had killed 50 percent of Indigenous Australians. Colonization and the arrival of missionaries changed their lives forever.

Two hundred years later, Indigenous Australians presented what is now known as **THE BARUNGA STATEMENT** (**FIG. 28–1**) to the then prime minister Bob Hawke. It was inspired by the Yirrkala Bark Petitions, which 25 years earlier had gained national attention when indigenous land rights claims were presented to the government on traditional bark paintings from Arnhem Land in the Northern Territory. The Barunga Statement placed its call for broader Aboriginal rights in text on paper collaged onto composition board decorated with two different styles of indigenous painting: one from Arnhem Land (on the left; see also FIG. 28–3) and the other from the Central Desert area (on the right; see also "Closer Look" on page 892). Painted in natural ochers, the cross hatching (*rarrk*) and zigzag patterns from the north contrast with the more fluid curved lines and dots that fill the central desert painting. In both, the artists used a dazzling array of symbols to retell stories about the adventures of ancestral beings.

In 1992, the Australian High Court rejected Cook's *terra nullius* argument and granted land rights to Indigenous Australians. When no treaty between the national government and Indigenous Australians followed, Galarrwuy Yunupingu, an indigenous leader, asked for the Barunga Statement back so that he could bury it. Today, however, it still hangs in Parliament and the struggle for full rights for Indigenous Australians continues.

Throughout the Pacific, contact with the West has had a significant impact on indigenous cultures, though to different degrees. In New Zealand, for example, the Treaty of Waitangi (1840) recognized Maori ownership of land and gave Maori the rights of British subjects, establishing early on a different political dynamic. Nonetheless, although numerous issues remain there, as well as in other parts of the region, Pacific islanders continue to use the arts to express and preserve their own rich and distinctive cultural identities.

The Peopling of the Pacific

What are the geographic and cultural backgrounds for the art of the Pacific islands?

On a map with the Pacific Ocean as its center, only the peripheries of the great landmasses of Asia and the Americas appear. Nearly one third of the earth's surface is taken up by this vast watery expanse. Europeans arriving in

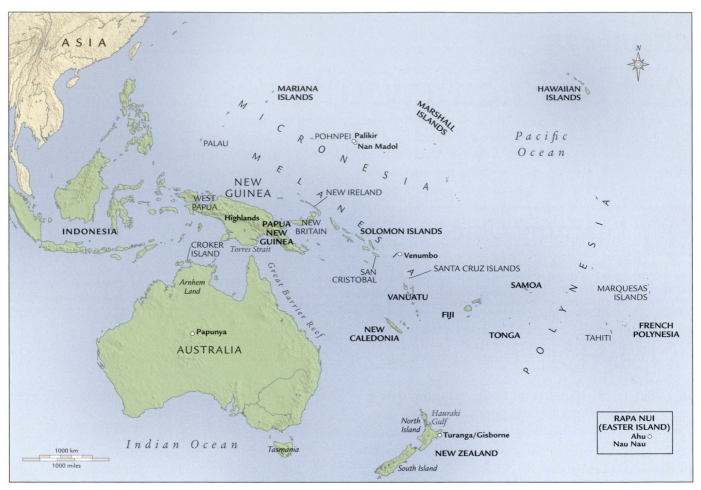

MAP 28–1 PACIFIC CULTURAL-GEOGRAPHIC REGIONS

The Pacific cultures are spread over four vast areas: Australia, Melanesia, Micronesia, and Polynesia.

Oceania in the late eighteenth and early nineteenth centuries noted four distinct but connected cultural-geographic areas: Australia, Melanesia, Micronesia, and Polynesia (**MAP 28-1**). Australia includes the continent, as well as the island of Tasmania to the southeast. Melanesia ("black islands," a reference to the dark skin color of its inhabitants) includes New Guinea and the string of islands that extends eastward from it as far as Fiji and New Caledonia. Micronesia ("small islands"), to the north of Melanesia, is a region of small islands and coral atolls. Polynesia ("many islands") is scattered over a huge, triangular region defined by New Zealand in the south, Rapa Nui (Easter Island) in the east, and the Hawaiian islands to the north. The last region on earth to be inhabited by humans, Polynesia covers some 7.7 million square miles, of which fewer than 130,000 square miles are dry land—and most of that is New Zealand. With the exception of temperate New Zealand, with its marked seasons and snowcapped mountains, Oceania is in the tropics, that is, between the tropic of Cancer in the north and the tropic of Capricorn to the south.

Australia, Tasmania, and New Guinea formed a single continent during the last Ice Age, which began some

2.5 million years ago. About 50,000 years ago, when the sea level was about 330 feet lower than it is today, people moved to this continent from Southeast Asia, making at least part of the journey over open water. Around 27,000 years ago, humans were settled on the large islands north and east of New Guinea as far south as San Cristobal, but they ventured no farther for another 25,000 years. By about 4000 BCE—possibly as early as 7000 BCE—the people of Melanesia were raising pigs and cultivating taro, a plant with edible rootstocks. As the glaciers melted, the sea level rose, flooding low-lying coastal land. By around 4000 BCE a 70-mile-wide waterway, now called the Torres Strait, separated New Guinea from Australia, whose indigenous people continued their hunting and gathering way of life into the twentieth century.

The settling of the rest of the islands of Melanesia and the westernmost islands of Polynesia—Samoa and Tonga—coincided with the spread of the Lapita culture, named for a site in New Caledonia. The Lapita people were Austronesian speakers who probably migrated from Taiwan to Melanesia about 6,000 years ago and spread throughout the islands of Melanesia beginning around

1500 BCE. They were farmers and fisherfolk who cultivated taro and yams and brought dogs, pigs, and chickens with them for food. They also brought the distinctive ceramics whose remnants today enable us to trace the extent of their travels. Lapita potters produced dishes, platters, bowls, and jars. Sometimes they covered their wares with a red slip, and they often decorated them with bands of incised and stamped patterns—dots, lines, and hatching—that may also have been used on bark cloth and in tattoos. Most of the decoration was geometric, but some was figurative. The human face that appears in the example in FIG-URE 28-2 is among the earliest representations of a human being, one of the most important subjects in Oceanic art. The Lapita people were skilled shipbuilders and navigators and engaged in inter-island trade. Over time the Lapita culture lost its widespread cohesion and evolved into various local forms. Its end is generally dated to the early centuries of the Common Era.

Polynesian culture emerged in the eastern Lapita region on the islands forming Tonga and Samoa. Just before the beginning of the first millennium CE, daring Polynesian seafarers, probably in double-hulled sailing canoes, began settling the scattered islands of Far Oceania and eastern Micronesia. Voyaging over open water, sometimes for thousands of miles, they reached Hawaii and Rapa Nui after about 500 CE and settled New Zealand around 800/900–1200 CE.

While this history of migrations across Melanesia to Polynesia and Micronesia allowed for cross-cultural borrowings, there are distinctions between these areas and within the regions as well. The islands that make up Micronesia, Melanesia, and Polynesia include both low-lying coral atolls and the tall tops of volcanic mountains that rise from the ocean floor. Raw materials available to residents of these islands vary greatly, and islander art and architecture use these materials in different ways. The soil of volcanic islands can be very rich, supporting densely populated settlements with a local diversity of plants and animals. On the other hand, the poorer soil of coral atolls cannot support large populations. Similarly, whereas volcanic islands provide good stone for tools and building (as at Nan Madol, see FIG. 28-10), coral is sharp but not particularly hard, and the strongest tools on a coral atoll are often those made from giant clam shells. Generally, the diversity of both plants and animals decreases from west to east among the Pacific islands.

The arts of this vast and diverse region display an enormous variety that is closely linked to each community's ritual and religious life. In this context, the visual arts were often just one strand in a rich weave that also included music, dance, and oral literature.

Australia

How is the concept of the "dreaming" fundamental in Indigenous Australian art?

Until European settlers disrupted their way of life, the hunter-gatherers of Australia were closely attuned to the environments in which they lived. Their only modification of the landscape was regular controlled burning of the underbrush, which encouraged new plant life and attracted animals. Their intimate knowledge of plants, animals, and water sources enabled them to survive and thrive in a wide range of challenging environments.

Indigenous Australian life is intimately connected with the concept of the Dreamtime, or the Dreaming. Not to be confused with our notions of sleep and dreams, the Dreaming refers to the period before humans existed. (The term, a translation from Arrente, one of the more than 250 languages spoken in Australia when Europeans arrived, was first used in the late nineteenth century in an attempt to understand the indigenous worldview.) According to this complex belief system, the world began as a flat, featureless place. Ancestral Spirit Beings emerged from the earth or arrived from the sea, taking many different forms. The Spirit Beings had numerous adventures, and in crossing the continent, they created all of its physical features: mountains, sand hills, creeks, and water holes. They also brought about the existence of animals, plants, and humans and created the ceremonies and sacred objects needed to ensure that they themselves were remembered, a system sometimes referred to as Aboriginal Laws. The Spirit Beings eventually returned to the earth or became

28-2 FRAGMENTS OF A LARGE LAPITA JAR
From Venumbo Reef, Santa Cruz Island, Solomon Islands. c. 1200–1100 BCE. Clay, height of human face motif approx. 1½″ (4 cm).

Credit: Courtesy of the Anthropology Photographic Archive, Department of Anthropology, The University of Auckland

28–3 Jimmy Midjaw Midjaw **THREE DANCERS AND TWO MUSICIANS: CORROBOREE OF MIMI, SPIRITS OF THE ROCKS**

Minjilang (Croker Island), West Arnhem Land, Australia. Mid 20th century. Natural pigments on eucalyptus bark, 23 × 35″ (59 × 89 cm). Musée du Quai Branly, Paris, France. (MNAO 64.9.103).

Credit: Photo © RMN-Grand Palais (musée du quai Branly)/Jean-Gilles Berizzi

literally one of its features. Thus, they are identified with specific places, which are honored as sacred sites. Indigenous Australians who practice this traditional religion believe that they are descended from the Spirit Beings and associate themselves with particular places related to the ancestors' stories and transformations.

Knowledge of the Dreaming stories and of the objects related to them is sacred and secret. Multiple levels of meaning are learned over a lifetime and restricted to those properly trained and initiated to know each level. As a result, an outsider's understanding of the stories and related art (objects and motifs) is strictly limited to what is allowed to be public. Some stories are shared by many tribes across great distances, while others are specific to one area. Men and women have their own stories, women's often associated with food and food gathering.

Since the Dreaming has never ceased, the power of the ancestral Spirit Beings still exists. Indigenous Australians have developed a rich artistic life to relive the stories of the ancestors and transmit knowledge about them to subsequent generations. Ceremonial art forms include paintings on rock and bark, sand drawings, and ground sculptures. Sacred objects, songs, and dances are used to renew the supernatural powers of the ancestors in ceremonial meetings called corroborees. In **FIGURE 28–3**, Western Arnhem Land artist Jimmy Midjaw Midjaw depicts such a meeting held by a group of Mimi, spirits who live

in the narrow spaces between rocks by day and come out at night. Specific to this area, they taught humans how to hunt and cook animals, as well as to dance, sing, and play instruments in ceremonies. Tall, thin, humanlike figures, often in motion, they were painted in ancient rock shelters, and since at least the late nineteenth century, on eucalyptus bark.

Bark paintings are found throughout northern Australia, where numerous regional styles exist. In Western Arnhem Land, the background is usually a monochromatic red ocher wash, with figures in white, black, and red pigments. In the 1950s and 1960s, Midjaw Midjaw was part of a prolific group of artists on Minjilang (Croker Island) that became well known through the anthropologists and collectors working in the area.

Melanesia and Micronesia

What are the diverse forms of art and architecture found on the islands that make up Melanesia and Micronesia?

Since the inhabitants of Melanesia usually rely at least partially on agriculture for survival, they live in permanent settlements, many of which feature spaces set aside for ritual use. Social position and status are not inherited or determined by birth, but are achieved by the accumulation of wealth (often in the form of pigs), by the demonstration

of leadership, and, often, by participation in men's societies. Much ceremony is related to rituals associated with these societies, including initiation into different levels or grades. Other important rituals facilitate relationships with the deceased and with supernatural forces.

Melanesian art is frequently bold, and masking and body decoration—often as part of ceremonial performances—are important, though they can be ephemeral. Men are prominent in the sculptural and masking traditions; women play significant roles as audience and also make bark cloth, woven baskets, pottery, and other aesthetically pleasing objects.

New Guinea

New Guinea, at 1,500 miles long and 1,000 miles wide, is the largest island in the Pacific and the second-largest in the world. It is today divided between two countries. Its eastern half is part of the modern nation of Papua New Guinea; the western half is West Papua, a province of present-day Indonesia. Located near the equator and with mountains that rise to 16,000 feet, the island has a variety of environments, from coastal mangrove marshes to grasslands, dense rainforests to swampy river valleys. The population is equally diverse, with coastal fishermen, riverine hunters, slash-and-burn agriculturalists, and more-stable farmers in the highlands. Among New Guinea and its smaller neighboring islands, more than 700 languages have been identified.

THE KORAMBO (CEREMONIAL HOUSE) OF THE ABELAM OF PAPUA NEW GUINEA The Abelam, who live in the foothills of the mountains on the north side of the Sepik River in Papua New Guinea, raise pigs and cultivate yams, taro, bananas, and sago palms. In traditional Abelam society, people live in extended families or clans in hamlets. Wealth among the Abelam is measured in pigs, but men gain status from participation in a yam cult that has a central place in Abelam society. The yams that are the focus of this cult—some of which reach an extraordinary 12 feet in length—are associated with clan ancestors and the potency of their growers. Village leaders renew their relationship with the forces of nature as represented by yams during the Long Yam Festival, which is held at harvest time and involves processions, masked figures, singing, and the ritual exchange of the finest yams.

An Abelam hamlet includes sleeping houses, cooking houses, storehouses for yams, a central space for rituals, and a ceremonial or spirit house, the **korambo** (*haus tambaran* in Pidgin). In this ceremonial structure reserved for the men of the village, the objects associated with the yam cult and with clan identity are kept hidden from women and uninitiated boys. Men of the clan gather in the *korambo* to organize rituals, especially initiation rites, and to conduct community business. The prestige of a hamlet is linked to the quality of its *korambo* and the size of its yams. Constructed on a frame of poles and rafters and roofed with split cane and thatch, *korambo* are built with a triangular floor plan, the side walls meeting at the back of the building. The elaborately decorated façade consists of three parts, beginning at the bottom: a woven mat, a painted and carved wooden lintel, and painted sago bark panels (**FIG. 28–4**). In this example, built about 1961, red, white, and black faces of spirits (*nggwal*) appear on the façade's bark panels, and the figure at the top is said to represent a female flying witch. This last figure is associated with the feminine power of the house itself. The projecting pole at the top of the *korambo* is the only male element of the architecture, and is said to be the penis of the house. The small door at the lower right is a female element, a womb; entering and exiting the house is the symbolic equivalent to death and rebirth. The Abelam believe the paint itself has magical qualities. Regular, ritual repainting revitalizes the images and ensures their continued potency.

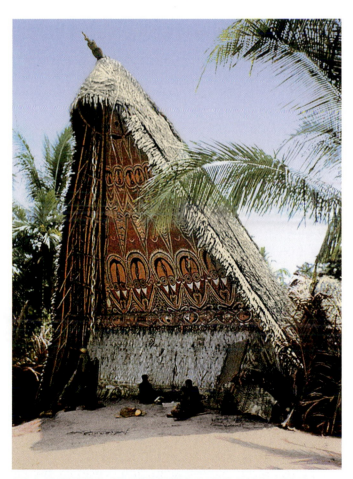

28–4 EXTERIOR OF KORAMBO (HAUS TAMBARAN)
Kinbangwa village, Sepik River, Papua New Guinea. Abelam, 20th century.

Credit: Mandeville Special Collections Library Geisel Library University of California, San Diego. Photo: Anthony Forge, 1962

Every stage in the construction of a *korambo* is accompanied by ceremonies, which are held in the early morning while women and boys are still asleep. The completion of the façade of a house is celebrated with a ceremony called *mindja*, which includes all-night dancing, and which may continue for six months, until the roof is completely thatched. Women participate in these inaugural ceremonies and are allowed to enter the new house, which afterward is ritually cleansed and closed to them.

BILUM—CONTEMPORARY NET BAGS OF HIGHLAND NEW GUINEA

Women's arts in Papua New Guinea tend to be less spectacular than men's, but nonetheless significant. Both functionally and symbolically, they contribute to a balance between male and female roles in society. **Bilum**, for example, are netted bags made mainly by women throughout the central highlands of New Guinea (**FIG. 28-5**). Looped from a single long thread spun on the thigh, *bilum* are very strong and, as loosely woven work bags, are used to carry items from vegetables to beer. The bones of a deceased man may be stored in a special *bilum* in a village's men's house (which is similar in function to the Abelam *korambo* in FIG. 28-4), while his widow wears his personal bag as a sign of mourning. Women wear decorative *bilum*, into which marsupial fur is often incorporated, as adornment, exchange them as gifts, and use them to carry babies.

Bilum are rich metaphorical symbols. Among the women of the Wahgi tribe, who live in the Wahgi Valley of the central highlands, seen in FIGURE 28-5, the term *bilum* may be used as a synonym for womb and bride, and they are also associated with ideas of female attractiveness. Depending on how they are worn, they can indicate whether a girl is eligible for marriage.

In the past, *bilum* were made from natural fibers, most commonly the inner bark of a ficus plant. Today, while the technique for making them remains unchanged, a wide array of colorful contemporary fibers, including nylon and acrylic yarn, are used, and new designs incorporating complicated patterns and words are constantly appearing. *Bilum* are now made by women throughout Papua New Guinea, not just in the highlands. They are sold commercially in markets and towns and have become one of the country's national symbols.

28-5 WOMEN WEARING NET BAGS (BILUM)
Wahgi Valley, Western Highlands Province, Papua New Guinea. 1990.
Credit: Michael O'Hanlon

28–6 ASMAT ANCESTRAL SPIRIT POLES (BISJ)
Buepis village, Fajit River, West Papua Province, Indonesia. c. 1960.
Wood, paint, palm leaves, and fiber, height approx. 18' (5.48 m).

Credit: © 2016. Image copyright The Metropolitan Museum of Art/
Art Resource, NY

SPIRIT POLES OF THE ASMAT OF WEST PAPUA The
Asmat, who live along rivers in the coastal swamp forests
of the southwest coast, were known in the past as warriors
and headhunters. In Asmat culture, trees are identified
with human beings, their fruit with human heads. Fruit-
eating birds were thus the equivalent of headhunters, and
were often represented in war and mortuary arts, along
with the praying mantis, whose female bites off the head
of the male during mating. In the past, the Asmat believed
that death was always caused by an enemy, either by direct
killing or through magic, and that it required revenge, usu-
ally in the form of taking an enemy's head, to appease the
spirit of the person who had died and thus maintain bal-
ance between hostile groups.

Believing that the spirit of the dead person remained in
the village, the Asmat erected elaborately sculpted memo-
rial poles (**FIG. 28-6**) known as *bisj* (pronounced bish),
which embodied the spirits of the ancestors and paid trib-
ute to them. Placed in front of special houses belonging to

the village's men's society, *bisj* poles are generally carved
from mangrove trees, although some have been identified
as wild nutmeg wood. The felling of a tree is a ritual act
in which a group of men attack the tree as if it were an
enemy. The figures on the poles represent the dead indi-
viduals who are to be avenged; small figures represent
dead children. The bent pose of the figures associates them
with the praying mantis. The large, lacy phalluses emerg-
ing from the figures at the top of the poles are carved from
the projecting roots of the tree and symbolize male fertil-
ity, while the surface decoration suggests body ornamenta-
tion. The poles faced the river to ensure that the spirits of
the dead would travel to the realm of the ancestors (*safan*),
which lay beyond the sea. The *bisj* pole also served sym-
bolically as the dugout canoe that would take the spirit of
the deceased down the river to *safan*.

By carving *bisj* poles (usually for several deceased at
the same time) and organizing a *bisj* feast, relatives pub-
licly indicated their responsibility to avenge their dead in a
headhunting raid. As part of the ceremonies, mock battles
were held, the men boasting of their bravery, the women
cheering them on. After the ceremonies, the poles were left
in the swamp to deteriorate and transfer their supernatural
power back to nature. Today, Asmat continue to carve *bisj*
poles and use them in funerary ceremonies, although they
stopped headhunting in the 1970s. Poles are also made to
sell to outsiders.

New Ireland and New Britain

MALAGAN DISPLAY OF NEW IRELAND New Ire-
land is one of the large eastern islands of the nation of
Papua New Guinea. The northern people on the island
still practice a complex set of death and commemora-
tive rites known as *malagan* (pronounced malang-gan),
which can take place as much as two years after a per-
son's death. In the past, clan leaders rose to prominence
primarily through *malagan* ceremonies that honored their
wives' recently deceased family members. The greater
the *malagan* ceremony, the greater prominence the clan
leader had achieved.

Malagan also include rites to initiate young men and
women into adulthood. After several months' train-
ing in seclusion in a ritual enclosure, they are presented
to the public and given carved and painted figures. The
combined funerary and initiation ceremonies include
feasts, masked dances, and the creation of a special
house to display elaborately carved and painted sculp-
tures (**FIG. 28-7**) that honor the dead. The display house
illustrated, which dates to the early 1930s, is more
than 11 feet wide and honors 12 deceased individu-
als. The carvings are large (the first on the left is nearly
6 feet in height) and take the form of horizontal friezes,
standing figures, and poles containing several figures.

28–7 MALAGAN DISPLAY

Medina village, New Ireland, Papua New Guinea. c. 1930. 6′10⅝″ × 11′5¾″ (2.1 m × 3.5 m). Museum für Völkerkunde, Basel, Switzerland.

They are visually complex, with tensions created between solids and voids and between the two-dimensional painted patterns on three-dimensional sculptural forms. Such displays are kept secret until their unveiling at the climax of festivities. After the ceremonies they are no longer considered ritually "active" and are destroyed or, since the late nineteenth century, sold to outsiders. *Malagan* figures are still being carved in association with continuing ceremonies.

TUBUAN MASK OF NEW BRITAIN In the Papua New Guinea province of New Britain—including the Duke of York Islands—Tubuan masks represent the Tolai male secret society, which has different levels of increasing knowledge and power and wields both spiritual and social control, especially during the three months of ceremonies known as the "Time of the Tubuan." Though initiation to the society is the main purpose of the ceremonies, the men of the village, who have achieved power through the accumulation of wealth (in the past through bravery in war), use this period to call up the spirits represented by the masks, who have the authority to settle disputes, stop fights, punish lawbreakers, and force the payment of debts. Political power and authority are underscored and enhanced by their appearance. In the past they had the power of life and death.

The masks represent both female and male spirits, though all the masks are danced by men. Local stories say women originally owned the masks and that men

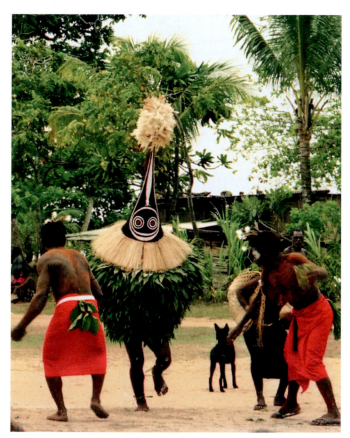

28–8 TUBUAN MASK BEING DANCED

Tolai people, Duke of York Islands, New Britain, Papua New Guinea. c. 1990. Cloth, paint, fiber, and feathers.

stole them. The **TUBUAN MASK** (FIG. 28-8) represents the Mother, who gives birth to her children, the Duk Duk masks, representing the new initiates into the society. With the appearance first of the Mother masks, then of the Duk Duk masks, the initiates return to the village from the bush, where they have undergone intensive preparation to enter the society. The Tubuan mask has a distinctive, tall conical shape and prominent eyes formed by concentric white circles. The green leaf skirt is a very sacred part of the mask, which is itself made from painted bark cloth, various fibers, and feathers. Black feathers on top indicate a more powerful spirit than white feathers.

MICRONESIA The majority of Micronesia's islands are small, low-lying coral atolls, but in the western region several are volcanic in origin. The eastern islands are more closely related culturally to Polynesia, while those in the west show connections to Melanesia, especially in the men's houses found on Palau and Yap. The atolls—circular coral reefs surrounding lagoons where islands once stood—have a limited range of materials for creating objects of any kind. Micronesians are known especially for their navigational skills and their fine canoes. They also create textiles from banana and coconut fibers, bowls from turtle shells, and abstract human figures from wood, which is scarce. As in other parts of the Pacific, tattooing and performative arts remain central to life.

WAPEPE NAVIGATION CHART Sailors from the Marshall Islands relied on celestial navigation—using the sun and moon and stars—as well as a detailed understanding of the ocean currents and trade winds to travel from one island to another. To teach navigation to younger generations, elders traditionally used stick charts (*wapepe* or *mattang*)—maps that showed land, but also the path from one island to the next over the water (FIG. 28-9).

In common use until the 1950s, stick charts were schematic diagrams of the prevailing ocean currents and the characteristic wave patterns encountered between islands. Currents are represented by sticks held together by coconut fibers; attached shells mark islands along the route. The arrangement of sticks around a shell indicates a zone of distinctive waves shaped by an island deflecting the prevailing wind. Such refracted waves enable a navigator to sense the proximity of land without being able to see it and to discern the least difficult course for making landfall. Although *wapepe* are primarily functional, their combination of clarity, simplicity, and abstraction has an aesthetic impact.

NAN MADOL The basalt cliffs of the island of Pohnpei provided the building material for one of the largest and most remarkable stone architectural complexes in Oceania. Nan Madol, on Pohnpei's southeast coast,

28-9 WAPEPE NAVIGATION CHART
Marshall Islands. 19th century. Sticks, coconut fiber, and shells, 29½ × 29½" (75 × 75 cm). Peabody Essex Museum, Salem.
Credit: Courtesy Peabody Essex Museum. Photo: Jeffrey Dykes.

consists of 92 artificial islands set within a network of canals covering about 170 acres (MAP 28-2). Seawalls and breakwaters 15 feet high and 35 feet thick protect the area from the ocean. When it was populated, openings in the breakwaters gave canoes access to the ocean and allowed seawater to flow in and out with the tides, flushing clean the canals. While other similar complexes have been identified in Micronesia, Nan Madol is the largest and most impressive, reflecting the importance of the kings who ruled from the site. The artificial islands and the buildings atop them were constructed between the early thirteenth century and the dynasty's political decline in the seventeenth. The site had already been abandoned by the time Europeans discovered it in the nineteenth century Nan Madol was an administrative and ceremonial center for powerful kings, who commanded a local labor force to construct this monumental city of as many as 1,000 people.

Both the buildings and the underlying islands are built of massive masonry set in alternating layers of log-shaped stones and boulders of prismatic basalt. The largest of the artificial islets is more than 100 yards long, and one basalt cornerstone alone is estimated to weigh about 50 tons. The stone logs were split from the cliffs by alternately heating the stone and dousing it with water. Most of the islands are oriented northeast–southwest, receiving the benefit of the cooling prevailing winds.

MAP 28-2 THE COMPLEX OF NAN MADOL

Pohnpei, Federated States of Micronesia. c. 1200/1300– c. 1500/1600.

28-10 ROYAL MORTUARY COMPOUND, NAN MADOL
Pohnpei, Federated States of Micronesia. Basalt blocks, wall height up to 25′ (7.62 m).

Credit: © Stephen Alvarez/ National Geographic/Getty Images

The walls of the **ROYAL MORTUARY COMPOUND**, which once dominated the northeast side of Nan Madol (**FIG. 28-10**), rise in subtle upward and outward curves to a height of 25 feet. To achieve the sweeping, rising lines, the builders increased the number of stones in the header courses (those with the ends of the stones laid facing out along the wall) relative to the stretcher courses (those with the lengths of the stones laid parallel to the wall) as they came to the corners and entryways. The plan of the structure consists of progressively higher rectangles within rectangles—the outer walls leading by steps up to interior walls that lead up to a central courtyard with a small, cubical tomb.

Polynesia

How are the art and architecture of Polynesia distinct from that of Melanesia and Micronesia?

The settlers of the far-flung islands of Polynesia developed distinctive cultural traditions but also retained linguistic and cultural affinities that reflect their common origin. Traditional Polynesian society was generally far more stratified than Melanesian society: A person's genealogy, tracing his or her descent from an ancestral god, determined his or her place in society. First-born children of the hereditary elite were considered the most sacred because they inherited more spiritual power (*mana*) at their birth. *Mana* could be gained through leadership, courage, or skill, but it could be lost because

of failure in warfare. It was protected by strict laws of conduct called *tapu*, a word that came into the English language as "taboo."

All of the arts in Polynesia were sacred, and their creation was a sacred act. Master artists were also ritual specialists. Objects were crafted from a variety of materials, some of which, like jadeite in New Zealand, were considered spiritually powerful. Some objects were practical, such as canoes, fishhooks, and weapons; others indicated the status and rank of the society's elite. Objects had their own *mana*, which could increase or decrease depending on how successful they were in performing their functions. Quality and beauty were important. Objects were made to endure, and many were handed down as heirlooms from generation to generation. In addition, the human body itself was the canvas for the art of tattoo (*tatau* in several Polynesian languages).

Polynesian religions included many levels of gods, from creator gods and semidivine hero-gods (such as Maui, who appears in the stories of many of the Polynesian cultures) to natural forces, but the most important were ancestors, who became gods at their death. Since they remained influential in daily life, they had to be honored and placated, and their help was sought for important projects and in times of trouble. Throughout much of Polynesia, figures in human form—often generically called *tiki*—were carved in stone, wood, and in some places, including the Marquesas Islands, human bone. These statues represented the ancestors and were often placed on sacred ritual sites attended by ritual specialists (SEE FIG. 28-12) or, as in New Zealand, incorporated into meeting houses.

Te-Hau-Ki Turanga

New Zealand was settled sometime after 800 CE by intrepid seafaring Polynesians now known as the Maori. As part of the process of adapting their Polynesian culture to the temperate New Zealand environment, they began to build wooden-frame homes, the largest of which, the chief's house, evolved after Western contact into the meeting house (*whare nui*). The meeting house stands on an open plaza (*marae*), a sacred place where a Maori tribe (*iwi*) or subtribe (*hapu*) still today greets visitors, discusses important issues, and mourns the dead. In it, tribal history and genealogy are recorded and preserved. Created by the master carver Raharuhi Rukupo and his 18 named assistants in the early 1840s, **TE-HAU-KI-TURANGA** is the oldest existing, fully decorated meeting house in New Zealand (**FIG. 28-11**). Built by Rukupo as a memorial to his elder brother, its name refers to the region of New Zealand where it was made—Turanga, today Gisborne and its region, on the northeast coast of the North Island. It has been translated as "The Breezes of Turanga" or "The Spirit of Turanga."

In this area of New Zealand, the meeting house symbolizes the tribe's founding ancestor, for whom it is often named. The ridgepole is the backbone, the rafters are the ribs, and the slanting bargeboards—the boards attached to the projecting end of the gable—are the outstretched enfolding arms. The face appears in the gable mask. Relief figures of ancestors cover the support poles, wall planks, and the lower ends of the rafters. The ancestors, in effect, support the house. They were thought to take an active interest in community affairs and to participate in the discussions held in the meeting house. Rukupo, who was an

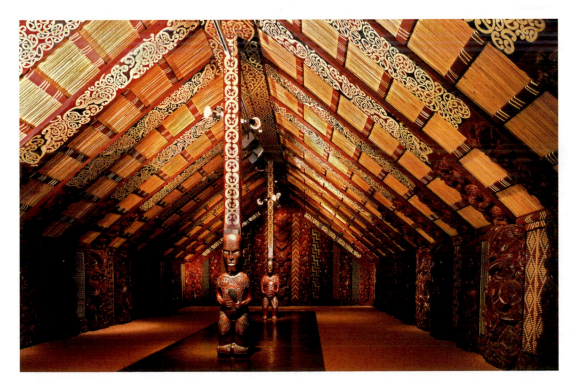

28-11 Raharuhi Rukupo, master carver **TE-HAU-KI-TURANGA (MAORI MEETING HOUSE)**

Gisborne/Turanga, New Zealand; built and owned by the Rongowhakaata people of Turanga. 1842–1843, restored in 1935. Wood, shell, grass, flax, and pigments. Museum of New Zealand/Te Papa Tongarewa, Wellington. (Neg. B18358).

Credit: Museum of New Zealand Te Papa Tongarewa

front

interior side wall

parts of the meeting house

interior rear wall

important political and religious leader as well as a master carver, included an unusual naturalistic portrait of himself among them.

Painted curvilinear patterns (**kowhaiwhai**) decorate the rafters in white on a red-and-black background. The **koru** pattern, a curling stalk with a bulb at the end that resembles the young tree fern, dominates the design system. Lattice panels (**tukutuku**) made by women fill the spaces between the wall planks. Because ritual prohibitions, or taboos, prevented women from entering the meeting house, they worked from the outside and wove the panels from the back. They created the black, white, and orange patterns from grass, flax, and flat slats. Each pattern has a symbolic meaning: chevrons representing the teeth of the sea monster Taniwha, steps the stairs of heaven climbed by the hero-god Tawhaki, and diamonds the flounder.

When Captain Cook arrived in New Zealand in the second half of the eighteenth century, each tribe and geographical region had its own style. A storehouse doorway from the Ngäti Päoa tribe (**FIG. 28–12**), which lived in the Hauraki Gulf area to the west of Turanga, dates to this period of time (or earlier) and shows the soft, shallow surface carving resulting from the use of stone tools. In comparison, a house panel (**poupou**) from Te-Hau-ki-Turanga (**FIG. 28–13**), carved with steel tools, shows the deeply cut, very precisely detailed surface carving characteristic of that time.

As is typical throughout Polynesia (SEE FIG. 28–17), the figures face frontally and have large heads with open eyes. The Hauraki Gulf figure has both hands placed on its stomach and represents a male ancestor, while the Te-Hau-ki-Turanga figure is a female ancestor nursing a child. In both, a small figure, representing their descendants, stands between their legs.

Considered a national treasure by the Maori, this meeting house was restored in 1935 by Maori artists who knew the old, traditional methods; it is now preserved at the Museum of New Zealand/Te Papa Tongarewa in Wellington and considered *taonga* (cultural treasure).

28–12 CARVED FIGURE FROM STOREHOUSE DOORWAY

Ngäti Päoa, Hauraki Gulf, New Zealand. 1500–1800. Wood, height 33⅞″ (86 cm). Museum of New Zealand/Te Papa Tongarewa, Wellington.

Credit: Museum of New Zealand Te Papa Tongarewa/ Michael Hall

28–13 POUPOU (PANEL)

From Te-Hau-ki-Turanga. Wood and red pigment, height 4′7″ (140 cm). Museum of New Zealand/Te Papa Tongarewa, Wellington.

Credit: Museum of New Zealand Te Papa Tongarewa

Marquesas Islands

TATTOO IN THE MARQUESAS ISLANDS The art of tattoo was widespread and ancient in Oceania. Tattoo chisels made of bone have been found in Lapita sites. They are quite similar to the tools used to decorate Lapita pottery, suggesting some symbolic connection between the marking of pottery and human skin. The Polynesians, descendants of the Lapita people, brought tattooing with them as they migrated throughout the Pacific, and as they became isolated from each other over time, distinctive styles evolved. Spirals became a hallmark of the Maori facial tattoo (*moko*), and rows of triangles became prominent in Hawaiian designs.

The people of the Marquesas Islands—an archipelago about 900 miles northeast of Tahiti—were the most extensively tattooed of all Polynesians. The process of tattooing involves shedding blood, the most *tapu* (sacred) substance in Polynesia. In the Marquesas, the process for a young man of high social rank began around age 18; by age 30 he would be fully tattooed (**FIG. 28–14**). Because of the sacredness and prestige of the process, some men continued to be tattooed until their skin was completely covered and the designs

28–14 TATTOOED NATIVE OF NUKAHIVA
Plate 10 in A. J. von Krusenstern's *Voyage Round the World in the Years 1803, 1804, 1805, 1806, ...* 1813. Richard Belgrave Hoppner (trans.). London: J. Murray.

Credit: © The British Library Board (981.i.8 frontispiece)

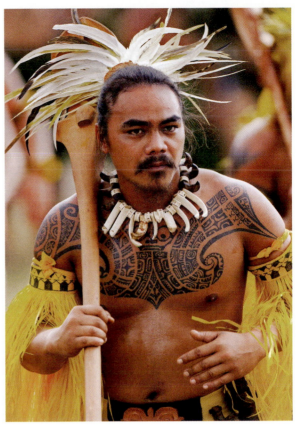

28–15 DANCER FROM THE MARQUESAS ART AND CULTURE FESTIVAL
2015. Ua Huka, Marquesas. Photo: Lionel Gouverneur.

Credit: Photographer Lionel Gouverneur

disappeared. Marquesan women were also tattooed, usually on the hands, ankles, lips, and behind the ears.

Tattooing was painful and expensive. Though women could be tattooed with little ceremony in their own homes, in the case of both men and women of high rank, special houses were built for the occasion. The master tattooer and his assistants had to be fed and paid, and at the end of the session a special feast was held to display the new tattoos. Each design had a name and a meaning. Tattooing marked passages in people's lives and their social positions; it commemorated special events or accomplishments. Some tattoos denoted particular men's societies or eating groups. Especially for men, tattoos demonstrated courage and were essential to their sexual attractiveness.

Tattooing was forbidden in the nineteenth century by French colonial administrators and Catholic missionaries, and it died out in the Marquesas. Beginning in the 1970s, however, there was a resurgence of the art throughout the Pacific, and in 1980 Teve Tupuhia became the first Marquesan in modern times to be fully tattooed. Marquesans quickly reclaimed their tattoo heritage as a mark of identity and pride in their culture (**FIG. 28–15**). Because of the beauty and complexity of contemporary Marquesan-style tattoo designs, they are seen today throughout French Polynesia.

Hawaii, Rapa Nui, Samoa

FEATHER CLOAK FROM HAWAII The Hawaiian islanders had one of the most highly stratified of all Polynesian societies, with valleys and whole islands ruled by high chiefs. Soon after contact with the West, the entire archipelago was unified for the first time under the rule of Kamehameha I (ruled 1810–1819), who assumed the title of king in the European manner.

Among the members of the Hawaiian elite, feathered capes and cloaks were emblems of high social status. A full-length cloak made with thousands of red and yellow feathers (**FIG. 28-16**) was reserved for the highest ranks of the elite men and called an *'ahu 'ula* ("red cloak")—the color red is associated with high status and rank throughout Polynesia. Often given as gifts to important visitors to Hawaii, this particular cloak was presented in 1843 to Commodore Lawrence Kearny, commander of the USS *Constellation*, by King Kamehameha III (ruled 1825–1854).

Draped over the wearer's shoulders, such a cloak creates a sensuously textured and colored abstract design, which in this example joins to create matching patterns of paired crescents on front and back. The cloak's foundation consisted of coconut fiber netting onto which were tied bundles of feathers. The red, and especially the yellow, feathers were highly prized and came from several species of birds including the *i'iwi, apapane, 'o'o,* and *mamo* (which is now extinct). In some cases, each bird yielded only seven or eight feathers, making the collecting of feathers very labor-intensive and increasing the value of the cloaks.

Cloaks were so closely associated with the spiritual power (*mana*) of the elite person that they could be made only by specialists trained in both the complicated technique of manufacture and the rituals attending their fabrication. Surrounded by protective objects, they created the cloak while reciting the chief's genealogy to imbue it with the power of his ancestors. As a result, the cloaks were seen as protective of the wearer, while also proclaiming his elite status and political and economic power.

Feathers were also used for decorating helmets, capes, blankets, and garlands (*leis*), all of which conferred status and prestige. The annual tribute paid to the king by his subjects included feathers, and tall feather pompons (*kahili*) mounted on long slender sticks were symbols of royalty. Even the effigies of gods that Hawaiian warriors carried into battle were made of light, basketlike structures covered with feathers.

MONUMENTAL MOAI ON RAPA NUI Rapa Nui (Easter Island) is the most isolated inhabited locale in Oceania, located 2,300 miles west of the coast of South America and 1,200 miles from Pitcairn Island, the nearest Polynesian outpost. Three volcanoes, one at each corner, make up the small triangular island. Originally known to its native inhabitants as Te Pito o te Henúa ("Navel of the World") and now known as Rapa Nui, it was named Easter Island by Captain Jacob Roggeveen, the Dutch explorer who first landed there on Easter Sunday in 1722. Rapa Nui became part of Chile in 1888.

Rapa Nui is the site of Polynesia's most impressive stone sculpture. Though many imaginative theories have been posited regarding the origins of its statues—from space aliens to Native Americans—they are definitely part of an established Polynesian tradition. Sacred religious sites (*marae*) with stone altar platforms (*ahu*) are common throughout Polynesia. On Rapa Nui the Polynesians who arrived at the island in canoes between 800 and 1200 CE built most of the *ahu* near the coast, parallel

28-16 FEATHER CLOAK (KNOWN AS THE KEARNY CLOAK)

Hawaii. c. 1843. Red, yellow, and black feathers, olona cordage, and netting; length 55¾" (143 cm). Bishop Museum, Honolulu.

King Kamehameha III (ruled 1825–1854) presented this cloak to Commodore Lawrence Kearny, commander of the frigate USS *Constellation*.

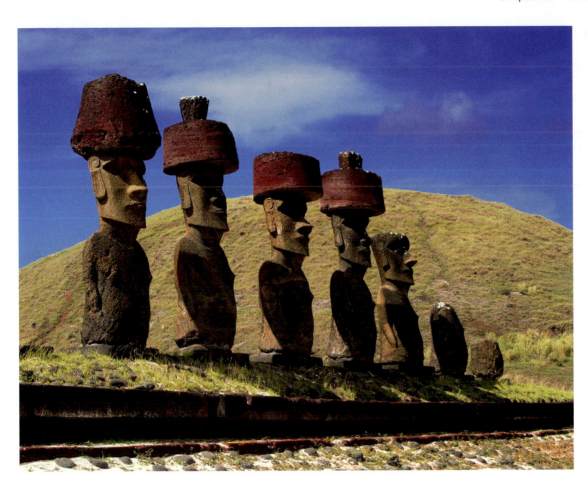

28–17 MOAI ANCESTOR FIGURES

Ahu Nau Nau, Rapa Nui (Easter Island). c. 1000?–1500 CE, restored 1978. Volcanic stone (tufa), average height approx. 36' (11 m).

Credit: © Shin/Shutterstock

to the shore, and began to erect stone figures on them, perhaps as memorials to deceased chiefs or ancestors. Nearly 1,000 of these figures, called **moai**, have been found on the island, including some 400 unfinished ones in the quarry at Rano Raraku where they were being carved. The statues themselves are made from yellowish-brown volcanic tuff. On their heads, *pukao* (topknots of hair) were rendered in red scoria, another volcanic stone. When the statues were in place, the insertion of white coral and stone "opened" the eyes. In 1978, several figures on Ahu Nau Nau (**FIG. 28–17**) were restored to their original condition. These are about 36 feet tall, but *moai* range in size from much smaller to a 65-foot statue that is still in the quarry. A recent theory proposes that the completed *moai* were "walked" up to 11 miles from the quarry to the sites of the *anu* as handlers rocked them from side to side using attached ropes. The fragmentary remains of statues, which line the road away from the quarry, indicate that not all *moai* completed the journey.

Like other Polynesian statues, the *moai* face frontally. Their large heads have deep-set eyes under a prominent brow ridge; a long, concave, pointed nose; a small mouth with pursed lips; and an angular chin. The extremely elongated earlobes have parallel engraved lines that suggest ear ornaments. The figures have schematically indicated breastbones and pectorals, and small arms with hands pressed close to the sides. Since their bodies emerge from the ground at just below waist level, they have no legs.

The island's indigenous population, which has been estimated at 3,000 people when the Dutch arrived in 1722, was nearly eradicated in 1877 when Peruvian slave traders set off an epidemic of smallpox and tuberculosis that left only 110 inhabitants alive. Today, a vibrant population of some 5,000 people is known especially for its energetic and athletic dance performances and thrives primarily on tourism.

TAPA (SIAPO) IN SAMOA As they migrated across the Pacific, Polynesians brought with them the production of bark cloth. Known by various names throughout the Pacific, most commonly as **tapa**, in Samoa bark cloth is called **siapo**. It is usually made by women, although sometimes men help obtain the bark or decorate the completed cloth. In Samoa, *siapo* is made by stripping the inner bark from branches of the paper mulberry tree (banyan and breadfruit are sometimes used in other archipelagos). The bark is beaten with a wooden mallet, then folded over and beaten again, to various degrees of softness. Larger pieces can be made by building up the cloth in a process of felting or by using natural pastes as glue. The heavy wooden mallets used for beating the cloth are often incised with complex patterns, which leave impressions like watermarks in the cloth, viewable when held up to the light.

28–18 TAPA (SIAPO VALA)

Samoa. 20th century. 58⅝ × 57" (149 × 145 cm). Auckland Museum, New Zealand. (AM 46892).

Credit: Photo: Krzysztof Pfeiffer, Auckland Museum

Plain and decorated *tapa* of various thicknesses and qualities was used throughout Polynesia for clothing, sails, mats, and ceremonial purposes, including wrapping the dead. *Tapa* was also used to cover wooden or wicker frames to make human effigies in the Marquesas and Rapa Nui, serving a purpose we still do not completely understand. In western Polynesia (Samoa and Tonga), very large pieces, 7–10 feet across and hundreds of feet long, were traditionally given in ceremonial exchanges of valuables and as gifts. Along with fine mats, *siapo* is still sometimes given on important ceremonial occasions. And *tapa* was widely used for clothing. Samoan men and women wore large pieces of *siapo* as wraparound skirts (*lavalava*) (SEE FIG. 28–19). Special chiefs, called talking chiefs, who spoke on behalf of the highest-ranking chief in the village council, wore special *tapa* skirts called *siapo vala* (FIG. 28–18).

Distinctive design styles for *tapa* evolved across the Pacific, even when the cloth used was essentially the same from one island to the next. It could be dyed bright yellow with turmeric or brown with dyes made from nuts. It could also be exposed to smoke to turn it black or darker brown. Today, contemporary fabric paint is often used. Decorative designs were made through a variety of means from freehand painting to printing with tiny bamboo stamps or using stencils, as is done in Fiji. This Samoan *siapo vala* has designs that were produced by first placing the cloth over a wooden design tablet, an **upeti**, and then rubbing pigment over the cloth to pick up the carved pattern. Subsequently, this lighter rubbed pattern was overpainted by hand. The result is a boldly patterned, symmetrical design.

Recent Art in Oceania

What are some recent developments in the art of Oceania?

In the late 1960s and early 1970s, a cultural resurgence swept across the Pacific. Growing independence and autonomy throughout the region, the model of civil rights and other movements in the United States, and dramatic increases in tourism, among other factors, brought a new awareness of the importance of indigenous cultures. Many of them had been fundamentally changed, if not nearly destroyed, by colonial rule and missionary efforts to eradicate local customs and beliefs.

Festival of Pacific Arts

In the early 1970s, the South Pacific Commission conceived the idea of an arts festival that would promote traditional song and dance. The first Festival of Pacific Arts was held in 1972 in Fiji; subsequent festivals, held every four years, have been hosted by New Zealand, Papua New Guinea, Tahiti, Australia, the Cook Islands, Samoa, New Caledonia, Palau, and American Samoa.

Musicians from the highlands of Papua New Guinea (FIG. 28–19) were among the more than 2,000 participants from 27 countries at the tenth festival at Pago Pago, American Samoa, in 2008. Carrying traditional drums, they wore elaborate headdresses topped with bird of paradise feathers and neck ornaments made from kina shells, a once valuable medium of exchange in New Guinea.

In the decades since their founding, the festivals have had an enormous impact on the arts. Many Pacific cultures now have their own festivals; in the Marquesas Islands one is held every four years. In an age of globalization and the Internet, festivals are one of the main ways in which young people become involved in and learn about their culture and heritage. However, the festivals are not without controversy: Some people are critical of an increasing level of professionalism and commercialism.

Central Desert Painting

In Australia, indigenous artists have adopted canvas and acrylic paint for rendering imagery traditionally associated with more ephemeral media like body and sand drawing. Sand drawing is an ancient ritual art form that involves creating large colored designs on bare earth. Made with red and yellow ochers, seeds, and feathers arranged on the ground in symbolic patterns, they are used to convey tribal knowledge to initiates. In 1971, several indigenous Pintubi men living in government-controlled Papunya Tula in the Central Desert of Australia who were trained and initiated in sacred knowledge were encouraged by a non-indigenous art teacher to transform their ephemeral art into a

28–19 MUSICIANS FROM PAPUA NEW GUINEA AT THE FESTIVAL OF PACIFIC ARTS
Pago Pago, American Samoa, 2008.

Credit: Photo: Caroline Yacoe

painted mural on the school wall. The success of the public mural encouraged community elders to allow others to try their hand at painting. In Utopia, a neighboring community, it was the women who began painting in 1988 after success in tie-dyeing with fabrics. Starting in Alice Springs, art galleries spread the art form, and "dot paintings" were a worldwide phenomenon by the late 1980s. Paintings became an economic mainstay for many Indigenous Australian groups in the central and western Australia desert. Although the artists are creating work for sale, they can paint only stories to which they have earned rights and must be careful to depict only what a non-initiated person is allowed to know.

Clifford Possum Tjapaltjarri (c. 1932–2002), a founder of the Papunya Tula Artists Cooperative in 1972, gained an international reputation after a 1988 exhibition of his paintings. He worked with his canvases on the floor, as in traditional sand painting, using ancient patterns and colors, principally red and yellow, as well as touches of blue. The superimposed layers of concentric circles and undulating lines and dots in a painting like *Man's Love Story* (see "Closer Look" on page 892) create an effect of shifting colors and lights that was highly valued in the global art world.

The painting seems entirely abstract, but it actually conveys a narrative involving two mythical ancestors. One of these ancestors—represented by the white U shape on the left, seated in front of a water hole with an ants' nest indicated by concentric circles—came to Papunya in search of honey ants. His digging stick lies to his right, and white sugary leaves to his left. The straight white "journey line" represents his trek from the west. The second ancestor—represented by the brown-and-white U-shaped

form—came from the east, leaving footprints, and sat down by another water hole nearby. He began to spin a hair string on a spindle (the form leaning toward the upper right of the painting), but was distracted by thoughts of the woman he loved, who belonged to a kinship group into which he could not marry. When she approached, he let his hair string blow away (represented by the brown flecks below him) and lost all his work. Four women (the dotted U shapes) came at night and surrounded the camp to guard the lovers. Symbolism also fills other areas of the painting: the white footprints are those of another ancestral figure following a woman, and the wavy line at the top is the path of yet another ancestor. The black, dotted oval area indicates the site where young men were taught this story. The long horizontal bars are mirages, while the wiggly shapes represent caterpillars, a source of food. Possum Tjapaltjarri painted numerous variations of this Dreaming story.

The painting is effectively a map showing the ancestors' journeys. To begin the work Possum Tjapaltjarri first painted the landscape features and the impressions left on the earth by the figures—their tracks, direction lines, and the U-shaped marks they left when sitting. Then, working carefully, dot by dot, he captured the vast expanse and shimmering light of the arid landscape. The painting's resemblance to modern Western painting styles such as Abstract Expressionism, gestural painting, Pointillism, or color field painting (see Chapters 31 and 32) is coincidental. Possum Tjapaltjarri's work is rooted in the mythic narratives of the Dreaming. It serves as a model for other contemporary indigenous artists, who use both age-old and new media to express the deepest meanings of their culture.

A Closer Look

MAN'S LOVE STORY

Designs may have multiple meanings. A circle can represent a water hole or ant hole, as here, but also a hole where the ancestral Spirit Beings exited and entered the earth, a person viewed from above, or a campfire.

Honey ants are a sweet delicacy. A digging stick is used to open up the nest, exposing the ant colony so that the ants can be removed and eaten.

Hair is spun into string using a spindle that is rotated across the thigh. The string is surprisingly strong and was used for utilitarian and ceremonial purposes, depending on the region.

Acrylic paint replaces the earth-toned ochers used in the sand paintings that provide the model for paintings such as this.

Women are important figures in the Dreaming stories and are represented in several places in this painting. Indigenous women artists paint their own stories, too, which usually center on food and food gathering.

The dots are made using a stick with a round, flat end that is dipped into the paint. Several people can work at the same time to fill in dotted areas.

28–20 Clifford Possum Tjapaltjarri **MAN'S LOVE STORY**
1978. Synthetic polymer paint on canvas, 6'11¾" × 8'4¼" (2.15 × 2.57 m). Art Gallery of South Australia, Adelaide. Visual Arts Board of the Australia Council Contemporary Art Purchase Grant, 1980.

Credit: © Estate of the artist 2016, licensed by Aboriginal Artists Agency Ltd

Shigeyuki Kihara

Many contemporary Pacific artists live in urban settings, were trained at colleges and universities, and create artworks in modern media that deal with a range of political issues, including the colonial legacy, discrimination, misappropriation, cultural identity, and land rights.

Shigeyuki Kihara is a multimedia and performance artist of Samoan and Japanese descent who lives in New Zealand. In **ULUGALI'I SAMOA: SAMOAN COUPLE (FIG. 28–21)**, she explores culture, stereotypes, authenticity, and gender roles through a reappropriation of nineteenth- and early twentieth-century colonial photographs. Made in studio settings, colonial photographs were often turned

into postcards depicting Pacific island men and women, both alone and in couples, the women as bare-breasted and sexualized "dusky maidens" and the men as emasculated "noble savages." Kihara confronts these stereotyped images in carefully staged, sepia-toned photographs that, through ironic twists, also challenge the viewer's understanding of gender and gender roles.

In this photograph of a male and female couple both figures are clothed as they might have been in the nineteenth century, wearing large pieces of Samoan bark cloth (SEE FIG. 28–18), and holding traditional Samoan status objects—a plaited fan and a fly-whisk. Kihara herself poses as the native woman, but has also superimposed her own face, with wig and mustache, onto the body of the male figure. *Ulugali'i Samoa: Samoan Couple* is part of a series of photographs called "Fa'a fafine: In a Manner of a Woman." *Fa'a fafine* is the Samoan term for a biological male who lives as a woman, the "third gender" socially accepted historically throughout much of Polynesia (as in the Americas, see FIG. 27–24). Kihara is herself *fa'a fafine*, a transgender woman who lives and identifies in that gender role. In this photograph and the others in the series, she blurs stereotyped notions of who or what is male or female, original or copy, reality or perception. This work was part of the exhibition "Shigeyuki Kihara: Living Photographs," the first solo exhibition by a Samoan in the Metropolitan Museum of Art in New York. Her work and that of other urban artists draws on the richness of Pacific cultures while addressing global issues of the twenty-first century.

28-21 Shigeyuki Kihara **ULUGALI'I SAMOA: SAMOAN COUPLE**

2004–2005. C-type photograph, edition of 5, 31½ × 23⅗" (80 × 60 cm). Metropolitan Museum of Art, New York. Gift of Shigeyuki Kihara, 2009.

Credit: © 2016. Image copyright The Metropolitan Museum of Art/Art Resource/Scala, Florence

Think About It

1 Explain how differences in environment, including available resources, affect the nature of the visual arts in the Pacific. Include architectural forms and body adornment in your answer.

2 How is the human body adorned and/or depicted in art across the Pacific? How do these adornments and depictions define or enhance status, authority, and gender roles?

3 Assess the importance of ancestors and the different ways in which they are engaged, honored, or invoked through various Pacific art forms. Focus your answer on two works from two different cultural and geographic settings.

4 Discuss the impact of contact with Western society on the arts and cultures of the peoples of the Pacific. How are contemporary indigenous artists throughout the Pacific addressing the issues of their own time and place?

Crosscurrents

The production of fabric was an important aspect of the cultures of both Peru and Samoa. Although there are strong similarities in the designs of these two cloths, their style, media, and context of production are distinct in significant ways. Discuss these differences and how they relate to the cultural values and distinctive environments of the artists who made them and the societies that valued them.

FIG. 27–10

FIG. 28–18

29–1 Amir Nour **GRAZING AT SHENDI**

1969. Steel, 202 pieces. Collection of the artist.

Credit: © Amir Nour

Chapter 29

Arts of Africa from the Sixteenth Century to the Present

 ## Learning Objectives

29.a Identify the visual hallmarks of post-1500 African art in its distinct cultures for formal, technical, and expressive qualities.

29.b Interpret the meaning of works of post-1500 African art in their distinct cultures based on their themes, subjects, and symbols.

29.c Relate African artists and art after 1500 to their distinct cultural, economic, and political contexts.

29.d Apply the vocabulary and concepts relevant to post-1500 African art, artists, and art history.

29.e Interpret a work of African art after 1500 using the art historical methods of observation, comparison, and inductive reasoning.

29.f Select visual and textual evidence in various media to support an argument or an interpretation of a work of African art after 1500.

Sudanese sculptor Amir Nour (b. 1939) works with metal and stone materials that are frequently industrially made to his specifications. His objects sit directly on the ground, often in **site-specific** locations, and as a result, they engage directly with both their setting and the audience—no pedestal, barrier, or other staging device separates them from the viewer. **GRAZING AT SHENDI** (1969), his best-known work (**FIG. 29–1**), is composed of 202 bent stainless steel tubes of varying sizes. When arranged on the ground in a group, they form an abstract image of herd animals grazing in the fields. Shendi, a farming town and trade center in Sudan, is located not far from the famous pyramids at Meroë (see Chapter 14). Nour grew up in Shendi, and this sculpture speaks to both his observations of animals grazing in the town of his birth and to a greater global perspective. Trained as an artist and art historian in London, the United States, and Scotland, Nour's education allows him to see his own work as participating in more than just African art history and art making. In *Grazing at Shendi*, he displays his virtuosity with techniques used by artists of the Minimalist movement in the United States in the 1960s and 70s (see Chapter 33) as well as the international projects of conceptualism and Postmodernism. Nour epitomizes the artistic choices of many artists of African descent working today. Globally educated and historically motivated, they see their work as interrogating the complex histories of the continent and countries of their birth.

Arguably, since the sixteenth century these histories of Africa and the art they produced have dramatically impacted world art history: One cannot tell the story of art without them.

The Sixteenth through Twentieth Centuries: Royal Arts and Architecture

What are the key concepts of African art after 1500, and how do art objects participate in royal activities in early modern African architecture and sculpture?

The continent of Africa is the second largest in the world (**MAP 29–1**). More than 2,000 African languages have been identified, and an even greater number of distinct cultural groups call the continent home. With this kind of linguistic and cultural diversity, it is impossible to easily summarize four centuries of African culture and creativity, as well as their connectivity to one another and to the global world.

This chapter traces some important moments in African art history, from royal arts of the sixteenth century through the colonial period, which dramatically reshaped art making across the continent. Also considered are examples of postcolonial and contemporary art, which frequently involve techniques, technologies, and materials that are both African and global in reach.

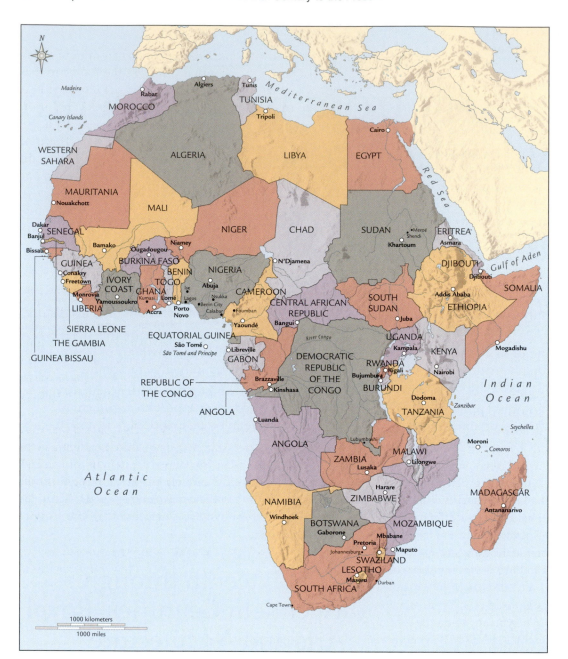

MAP 29-1 POLITICAL MAP OF AFRICA IN 2015

The vast continent of Africa is home to 54 internationally recognized countries, each of which is home to multiple cultural and ethnic groups with their own linguistic and religious practices.

Key Concepts

This chapter focuses on four key concepts that permeate African art from the sixteenth century to the present day.

PARTICIPATION More so than in European art, African art objects are intended to be part of human activities. Seldom is one meant to simply look at or contemplate them from a distance. They are meant to physically participate in human aesthetic events. They are frequently portable and can be changed or altered depending on the circumstances of their use.

CONTEMPORANEITY Art objects not made for museum or gallery display are often made for temporary use, either to be part of a particular ceremony or masquerade or to serve a single town or individual. When the

ceremony is over or the user no longer needs the object, it can be discarded or reworked. Old and worn-out objects are far less desirable than newly made ones. In this way, art objects are always "contemporary" or new. They keep up with the times, and innovation is always prized in the creation of a new variation on a favorite object.

ABSTRACTION From the Renaissance through the nineteenth century, European artists strove to emulate nature or to idealize the world around them in their arts. Artists in Africa during this time took a very different trajectory. Their objects were not made to describe or imitate anything (or anyone) in the real world. Rather, African artists were aiming to convey intangible or non-visual ideas with their objects, such as modesty, justice, or the abuse of political power. Artists were often expected to depict individuals

as part human and part supernatural (as ancestors, deities, or spirits). This chapter explains how African artists have taken these conceptual ideas and given them physical form. Often the resulting work is far removed from what can be observed in the natural world.

CULTURAL FLUENCY African artists who work in African countries or who live and work elsewhere value their ability to function in multiple cultures at once. Given that African countries are some of the most linguistically and culturally diverse in the world, it is no wonder that the most skilled artists are those who can communicate with people from a variety of cultural backgrounds. Along with defining the cultural ideals of a particular group, art objects must also incorporate those ideals into relationships with others.

Art made for royal use in the sixteenth through twentieth centuries exhibits all of these traits. Wealthy kings and queens who ruled the Asante, Bamum, Edo, Kuba, and Yoruba kingdoms, to name but a few, commissioned dynamic works of art ranging from textiles, sculptures, decorated architectural palaces, and houses to personal items. Many of these items survive today because their unique combinations of abstraction and naturalism appealed not only to African rulers, but also to European collectors. They were often exchanged as gifts between African kings and their European counterparts, or else admired and collected by museum curators for the quality and diversity they brought to their art collections and the evolving understanding of global art history. In fact, the royal art objects produced during the eighteenth and nineteenth centuries are some of the best represented in the world's museums.

Ghana

The Republic of Ghana took its name from the ancient Ghana Empire that flourished during the fourth to thirteenth centuries in what is present-day Mali, far to the north of the country of Ghana. One of the shared traits between the ancient empire and the modern country is that both are situated over massive deposits of gold. This gold was used strategically in trade and certainly solidified the power of the Akan Empire, which divided the region into kingdoms during the thirteenth century. The most powerful of these was the Asante (formerly spelled Ashanti), who initially occupied the southern and coastal regions of the area and controlled a majority of the gold trade.

THE ASANTE EMPIRE By the eighteenth century, the Asante Empire stretched nearly the entirety of the contemporary country of Ghana. When the Portuguese first arrived along the coast of present-day Ghana in the 1470s, they were so impressed by the abundance of Asante gold mines they called the territory El Mina ("the Mine"). The contemporary city of Elmina on the coast of Ghana draws its name from the fifteenth-century Portuguese trading castle that was built there.

Until the kings of the Asante (called *Asantehene*) were forced into power sharing with the British beginning in the mid-1800s, they ruled from their capital city of Kumasi. After independence, the nation of Ghana recognized the Asante Empire as a traditional subnation state. Today the lineage of *Asantehene* continues, and the king still presides at the royal palace in Kumasi.

Asante royal households were famous during the eighteenth century for their prized **KENTE CLOTH** (FIG. 29-2)

29-2 KENTE CLOTH
Asante, c. 1980. Rayon, 10′3½″ × 7′1½″ (3.14 × 2.17 m). Fowler Museum of Cultural History, University of California in Los Angeles.

Credit: © Photo courtesy of the Fowler Museum at UCLA

and their wealth of sculptural objects, adornments, and ritual paraphernalia, all covered with or made entirely of gold. Not many early examples of **kente** fabric have survived over the centuries, for new ones were commissioned to replace older worn fabrics or to update the patterns to the newest styles.

Kente is a term derived from the Asante word for "basket," acknowledging the woven nature of the fabric. Asante weavers—traditionally men—work on double-heddle looms, allowing them to produce long, narrow strips of cloth with vertical stripes that alternate with horizontal bands and geometric patterns. The strips are then sewn together to form large rectangles of finished *kente* cloth. The strips are joined in such a way that their patterns do not exactly line up with each other. This is intentional, in order to make the finished fabric more dazzling and less predictable.

Kente was originally produced under royal control. Weaving guilds at Kumasi produced cloth exclusively for royal patrons. *Kente* cloth is still worn by the royal family and the *Asantehene* in Kumasi, although Ghanaians of all descent can now also wear it. It is very expensive and worn only on special occasions.

29–3 Attributed to Kojo Bonsu **FINIAL OF AN OKYEAME POMA (SPEAKER'S STAFF)**
Ghana. Asante, 1960s–70s. Wood and gold, height 11¼" (28.57 cm). Barbier-Muller Collection, Gold of Africa Museum, Cape Town, South Africa.

Along with royal *kente* cloth, the Asante used sculptural objects to identify those who held power and to validate their right to their authority. Expensive gold jewelry, royal staffs, and a ritual throne known as the Golden Stool represented the importance of the *Asantehene* to his community and communicated his authority to members of society. The Asante also greatly admire fine language and poetic speech. Consequently their governing system includes the special post of *okyeame*, or spokesman, for the *Asantehene*.

Whenever the *okyeame* for an Asante king was conferring with that ruler or announcing the ruler's words to an audience, he held a staff called an **OKYEAME POMA** to symbolize his authority to speak on behalf of the *Asantehene* (**FIG. 29–3**). This twentieth-century staff was made following traditions established at the inception of the Asante Empire. It is composed of a long, wooden pole with a sculpture covered in gold leaf on top. The sculpture, of a seated man holding an egg, enters into direct conversation with the *Asantehene* and his *okyeame* and participates in their shared rituals of rulership and speech. "Political power is like an egg," says an Asante proverb. "Grasp it too tightly and it will shatter in your hand; hold it too loosely and it will slip from your fingers." The sculptural imagery reminds the *Asantehene* and his *okyeame* to always speak carefully and refrain from abusing their political and social power.

Cameroon

In Cameroon, hundreds of city-states and small kingdoms existed during the sixteenth to twentieth centuries. The most dominant of these included the Bamileke, the Tikar, and the Bamum. Cameroon is also the ancestral home of the Bantu-speaking peoples who migrated southward and went on to become the dominant cultural group across the entirety of Africa south of the equator.

BAMUM KINGDOM The Bamum kingdom is based at the walled city of Fumban in the elevated grasslands region of what is now Northwestern Cameroon. It was founded by King Nchare in 1394 and, except for the period 1924–1933, has lasted uninterrupted until the present. In 1918, *Fon* (chief) Ibrahim Njoya came to power and led the Bamum in a period of wealth accumulation, advanced learning, and calculated interactions with German, then British, then French colonial powers. Njoya established a written script for the Bamum language in order to prove to colonial powers that his culture was not lacking in literature, history, and the written arts. He alternately practiced Christianity and Islam when it served him in his negotiations with the Germans, French, and North Africans, and was well known for variously adopting European colonial, Islamic, and traditional Bamum clothing as the political occasion warranted (**FIG. 29–4**). When his ancestral wooden palace burned in a fire, he and his son designed a new palace built in stone at Fumban. Njoya was an avid

29-4 KING NJOYA OF BAMUM IN THE UNIFORM OF AN OFFICER WITH HIS FATHER'S THRONE IN FRONT OF THE OLD PALACE AT FUMBAN

1906 photo from Basel Mission Archives, E-30.29.042. Beaded throne of King Nsangu, father of King Njoya. Bamum, Cameroon. Late 1880s.

The king stands next to his father's throne, which he gifted to Kaiser Wilhelm II in 1908.

Credit: Photograph delivered by Friedrich Lutz, May 1906 - African Crossroads: Intersections between History and Anthropology in Cameroon. Basel Mission Archives/Basel Mission Holdings (E-30.29.042)

supporter of all arts, and Bamum sculptures and beadwork became world famous under his rule. He went on to declare himself Sultan, in lieu of the historical title of *Fon*, and his heirs have continued this tradition. Njoya was deposed by the French in 1924 and exiled in 1931 under the pretense that he was a threat to French authority. He passed away in 1933, and today, his grandson Sultan Ibrahim Mbombo Njoya rules the Bamum kingdom from Fumban.

In this 1906 photograph, King Njoya stands next to his father's beaded throne wearing what is clearly a German officer's outfit. The photograph documents a truly significant event in Bamum and German history, one that also exemplifies the impressive level of cultural fluency achieved by Bamum artists. Captain Hans Ramsey, an administrator for a German trading company, had traveled to Fumban for the first time in 1902 in the hopes of expanding German trade farther inland. In all his written records,

we can see he was captivated by Njoya and impressed with the beauty of the palace's architecture and the organization and power of the kingdom. After several trade negotiations were worked out, Ramsey asked Njoya if he would consider giving a gift to the Kaiser of Germany, from one king to another. Ramsey wanted Njoya's beaded throne, a monumental, multipart work that Njoya had inherited from his father, King Nsangu, who had commissioned it in the late 1880s. In this photograph, Njoya shows off the handsome throne, carved in wood and entirely covered in brightly colored seed beads acquired from European trade. On the back of the throne is a standing ancestral couple. When Nsangu (and later Njoya) was seated on this throne, this gave the effect of the ancestors looking over his shoulders as he ruled and passed judgments. The footrest depicts two attendants carrying guns; the king would rest his feet upon the barrels of the guns, showing that military might literally rested under his feet.

Njoya consented to give the royal ancestral throne to the Kaiser, but only after Ramsey offered to pay for a new throne to be carved and beaded for Njoya and gave him a German officer's uniform, complete with pith helmet and saber—which Njoya is wearing in this official photograph. Njoya's new throne, finished in 1912, is still at the palace of Fumban, while Nsangu's throne, along with many other smaller beaded stools and thrones that Njoya gave as gifts to the German Kaiser, eventually made its way to the Ethnographic Museum (now the Staatliche Museen) in Berlin. Njoya remained a key ally for the Germans until their defeat in World War I, when the German colony of Kamerun was ceded to the French and renamed Cameroon.

After the French sent Njoya into exile for challenging their authority in the region, his son Seidou Njimouluh Njoya was able to ascend the throne at Fumban. He continued much of his father's work in support of the arts, literature, and culture. The Bamum kingdom today is recognized as a semi-autonomous political entity within the nation of Cameroon.

Democratic Republic of the Congo

The earliest of the powerful kingdoms along the Congo River and its tributaries (today encompassed by the Republic of the Congo, the Democratic Republic of the Congo [DRC] and Angola) was the Kongo kingdom founded at the turn of the fourteenth century. A century later the powerful Luba and Lunda kingdoms emerged in the DRC, followed by the Kuba kingdom in the early 1600s. All were founded by Bantu speakers from the north and spoke variations of Bantu languages. They shared similar religious and political structures, although they often clashed over control of significant river trade routes.

KUBA KINGDOM The Kuba people—more properly called Bakuba, given the nature of their Bantu language

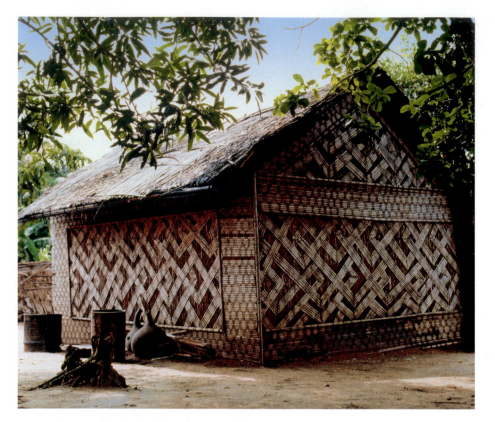

**29-5 SLEEPING HOUSE
OF THE NYIM**

Royal Compound at Nsheng, Democratic
Republic of the Congo. 1980.

Credit: Photo: Angelo Turconi

structure—live near the geographic center of the Democratic Republic of the Congo. In the seventeenth and eighteenth centuries, their kingdom was an artistic powerhouse in the region. Kuba sculptures, textiles, and luxury domestic goods were reserved for royal use locally, but could be sold or traded outside of the kingdom with those willing to pay the very high price required for their manufacture.

The Kuba king, or *nyim*, ruled from his royal compound, which was composed of multiple highly ornamented buildings to house all the functions required of an elite political and religious government system. Of these buildings, the *nyim's* sleeping house was one of the most spectacularly decorated (**FIG. 29–5**). The structure itself is not elaborate: a rectangular building made of wood and palm canes with a thatched gable roof. The exterior, however, is decorated in its entirety. Palm fronds attach reeds to the façade, creating geometric interlocking patterns of diamonds created by right-angled "streets." A border of contrasting natural and dyed palm fronds creates honeycomb patterns along the ridgeline, corners, and tops and sides of the walls. The patterns are similar to the woven diamonds and "streets" seen on the Kongo textile in Chapter 14 (SEE FIG. 14–19) because the two neighboring kingdoms shared many religious and aesthetic values.

The interlocking diamond patterns on the *nyim's* sleeping house are also found on the base of this wooden commemorative portrait (**FIG. 29–6**), called an **ndop**—a Kuba word meaning "portrait statue." The patterns are associated with royalty, so it is very appropriate that they appear on all the *nyim's* possessions. Kuba *nyim* often had their portraits sculpted, not to commemorate how they looked in real life, but rather to show how they conducted themselves in the role of king. This particular portrait depicts the *nyim* Mishe miShyaang maMbul, who reigned during the mid-eighteenth century. The facial features are remarkably similar to those of many other *ndop* produced of Kuba *nyim*, stressing the importance of the office as ongoing, even though its power would pass from man to man. The forehead is high and rounded and the facial expression still, with the body carved smoothly and to a smaller scale than the head. All *ndop* show the king seated cross-legged

**29-6 NDOP PORTRAIT OF KING MISHE
MISHYAANG MAMBUL**

Kuba. c. 1760–80. Wood, camwood powder, 19½ × 7⅝ × 8⅝"
(49.5 × 19.4 × 21.9 cm). Lulua Province (Democratic Republic
of the Congo). Brooklyn Museum, New York.

and holding the regalia of his office (a staff, belt, armbands and bracelets). In fact the only way to identify this sculpture as the *ndop* of Mishe miShyaang maMbul is the symbol of an open hand placed on the side of the drum in front of him. This was his personal attribute, and anyone in his kingdom would have recognized it as his symbol. *Ndop* were used to commemorate kings while they lived, and they participated in his rule, for the sculptures were frequently placed near the king to absorb his power. Upon the king's death, the sculpture, now invested with the life force of its owner, was passed to the next king. Subsequent *nyim* spent time with the *ndop*, including keeping it in their sleeping house, in order to absorb the wisdom and spirit of the deceased king.

Nigeria

Along with the powerful Edo kingdom that ruled from its palace in Benin City, many Yoruba kingdoms are well known to history. Important palaces were constructed at the city-states of Ise, Ikere and Osi-Ilorin, to name but a few. The Yoruba people have been known throughout history as prolific carvers. Monumental sculptures, masquerade headpieces, and architectural sculptures such as columns and doors were masterfully worked in wood. Even today, Yoruba artists keep these traditional arts alive for wealthy kings, political leaders, and private patrons.

YORUBA Among the most important Yoruba artists of the early twentieth century was Olowe of Ise (c. 1873–1938), who carved doors and veranda posts for the rulers of the Ekiti-Yoruba kingdoms in southwestern Nigeria. His unique style of carving means that sculptural programs for several royal palaces can be attributed to him.

Olowe was a royal court carver for the kings of Ise and Ikere, both located to the east of the holy city of Ife and north of Benin City. His competitor was a sculptor named Arowogun, who worked around the same time for the kings at Osi-Ilorin to the north. These two artists are among a huge class of specialized artists who worked for the Yoruba kings in Nigeria in pre-colonial and colonial times. Olowe and Arowogun were more than just artists. Along with their fellow royal carvers, they depicted histories, lineages, important events, and rituals, all in the most unique, up-to-date styles possible so as to demonstrate the kings' prosperity and capacity for innovation.

Olowe worked on a large scale, doing entire design sequences for palaces at Ise and Ikere. One of his most well-known compositions is the figural column sequence for the veranda of the king's palace at Ikere. Olowe carved three massive columns, each from a single tree trunk, to support the roof of the veranda (**FIG. 29–7**). The left column as one faces the porch from the courtyard depicts a royal wife standing with her hands on top of her twin daughters' heads. The threesome faces sideways, in order to look at the central column, which shows the seated

Yoruba *arinjale* (king) of the city of Ikere with his senior wife standing behind him. The column on the right portrays an equestrian soldier who also faces the royal couple.

The columns were fully painted, but that paint is now largely faded. The queen was painted mostly in blue, a color the Yoruba associate with women and their female ancestors, while the king was done in red. Notice that the scale of the two figures on this central column is not proportional: The queen is much larger than her smaller, seated husband. Olowe uses this hierarchy of scale to show that even though the king is the ruler, he rules only with the help and guidance of others, particularly his female ancestors and his senior wife.

Olowe has also balanced this important column of the king and queen geometrically; the angle of the queen's jaw is picked up in the angle of her breasts, and then in the king's own jawline. These diagonals counterbalance the rigid horizontal lines of the seat of the king's throne and his bent legs. Vertical lines of the throne are repeated in

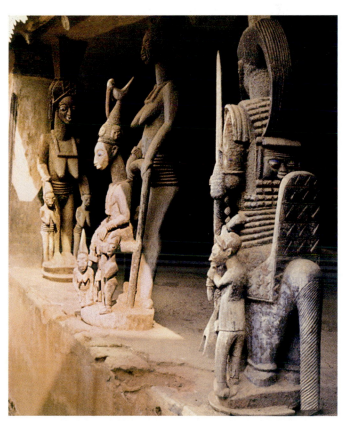

29–7 Olowe of Ise **VERANDA POSTS (LEFT TO RIGHT): ROYAL WIFE WITH TWIN DAUGHTERS, ENTHRONED KING AND SENIOR WIFE (OPO OGOGA), AND ROYAL WARRIOR ON HORSEBACK**

From the palace of the king of Ikere, Ekiti region, Nigeria. Yoruba, 1910/1914. Wood and pigment, 60 × 12½ × 16″ (152.5 × 31.75 × 40.6 cm) each. Photograph 1964. Memorial Art Gallery, Rochester, New York, Marion Stratton Gould Fund (71.13) (royal wife); Art Institute of Chicago, Major Acquisitions Centennial Fund, 1984.550 (king and wife); and New Orleans Museum of Art museum purchase, Ella West Freeman Foundation Matching Fund (70.20) (royal warrior).

Credit: Photo: John Picton

the strict columnar forms of the queen's legs. The geometries give a sense of order, balance, strength, and calm—all desired attributes of a king. Furthermore, the king and queen, along with the soldier and royal wife at their sides, literally hold up the palace roof, symbolic of the way a king supports his community.

At the nearby palace at Ise, Olowe was commissioned to make a set of doors commemorating the *arinjale*'s reception of Major W. R. Reeve-Tucker, the first British traveling commissioner for the province, and his entourage (**FIG. 29-8**). This door panel depicts the Yoruba court as they welcome the British to the palace of Ise; a second door panel (not shown) presents the European entourage. The door is carved very deeply on a massive single plank of wood. Tall figures with bodies in profile turn their heads outward to confront the viewer. Their long necks and elaborate hairstyles make them appear even taller, unlike typical Yoruba sculpture, which until Olowe's time favored shorter figures. The relief is so high that the figures' upper portions are actually carved in the round. The figure of the *arinjale* on horseback, for example, has a body carved in the round, while his legs and the horse upon which he sits are done in relief. Olowe intended his viewers to understand that the more fully carved the figure, the more important he or she was in Yoruba royal society. Combining relief and sculpture-in-the-round in the same figure had not been done before; it is one of the attributes of Olowe's innovative style.

In the second register of this panel, the *arinjale* appears on horseback wearing a conical crown and accompanied by court messengers. Other registers contain other members of the court—royal wives lifting their breasts (a gesture of generosity and affection performed by older women), men carrying kegs of gunpowder, royal guards, and priests. The bottom register portrays a deceased person, perhaps a criminal, with birds (standing in for the ancestors, who mete out justice) pecking at the corpse. The two rows of heads on the left side of the panel may represent either ancestors of the king or enemies taken in battle. The entire surface of the doors was originally painted, but only traces of the original colors remain.

Olowe's sculptures for the *arinjale* of Ise and Ikere, among others, were emulated throughout the Yoruba kingdom. His style marked the art of his generation and he was renowned for his contemporary, cosmopolitan compositions and his ability to capture the abstract workings of political rule (interdependence on others, respect for tradition, and willingness to engage in new relations) in visual form. All of Olowe's surviving carved monuments are now in museum collections and are highly prized sculptural masterpieces.

29-8 Olowe of Ise ONE OF TWO DOORS FROM THE KING'S PALACE AT ISE
Nigeria. Yoruba. c. 1904–1910.
Wood and pigment, 81½ × 34⅝ × 6¼"
(207 × 88 × 15.9 cm). National Museum of African Art, Smithsonian Institution, Washington, DC. Gift of Dr. and Mrs Robert Kuhn (88-13-1).

Credit: Photo: Frank Khoury

The Nineteenth Century: Colonialism and Modernity

How do art and artists respond to the new conditions created by European colonialism?

Modernism and modernity in art history have usually been understood as European and North American, while colonialism was applied to Africa, and yet both concepts ought to be applied equally to both regions. Modernity on the African continent is defined through increasing urbanization, trade, travel, and war, which occurred in tandem with the continent's deepening entanglements with European nations. The synthesis of these dynamic changes created the burgeoning artistic production in African nations during the nineteenth century. Artists gained European patrons who desired "traditional" African objects for their collections, while local patrons needed new types of objects to negotiate the new political and social realities of their lives under colonial rule. The arts of nineteenth-century Africa give visual form to Africans' merging and modern ties with Europe as a result of their colonial power struggles.

The Colonial Conquest

Early in the nineteenth century the trade in human slaves was becoming less profitable to European traders and was also under increasing moral attack from abolitionists in Great Britain. In an attempt to redirect their business to more profitable and less reprehensible activities, European explorers began to investigate the African interior, looking for ways to expand their control over natural and trade resources. They were joined by missionaries and eager anthropologists and adventurers, whose reports created even wider European interest in the continent.

THE BERLIN CONFERENCE OF 1884–1885 Drawn by the potential wealth of Africa's natural resources, European governments began to seek territorial concessions from African rulers. Diplomacy eventually gave way to force, and by the end of the nineteenth century, competition among rival European powers fueled the so-called Scramble for Africa, during which England, France, Germany, Belgium, Italy, Spain, and Portugal raced to lay claim to whatever part of the continent they could. This resulted in a conference called by German Chancellor Otto von Bismarck in 1884 where the European nations effectively divided up African territories among themselves (**MAP 29-2**). In many cases, the boundaries drawn up at this conference are still the active borders between countries today.

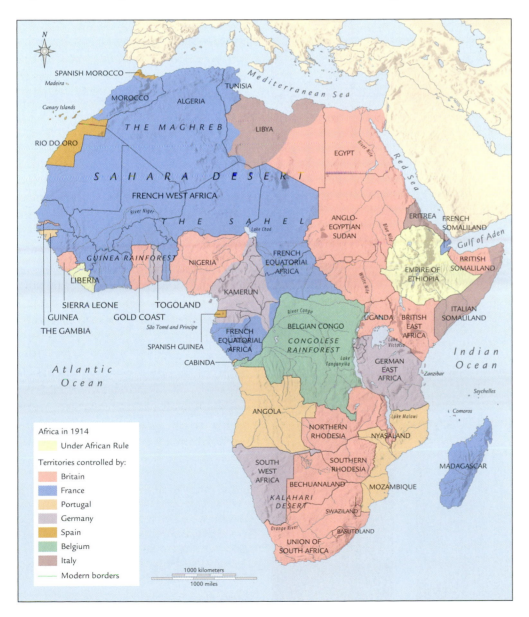

MAP 29-2 THE COLONIAL CONQUEST OF AFRICA

The political boundaries shown are those of 1914, resulting from the divisions created at the Berlin Conference of 1884–1885.

The borders between territories they devised had everything to do with the European desire to control resources and trade routes and nothing to do with cultural or political boundaries as they had been established by Africans themselves. As a result, unified ethnic groups often found themselves split into two or more partitions, unable to rule themselves with any autonomy and often unable to visit each other across the new colonial borders. The treaties signed at the Berlin Conference of 1884–1885 meant that by 1914 virtually all of Africa (except for Ethiopia and Liberia) had fallen under European colonial rule.

THE BRITISH PUNITIVE EXPEDITION OF 1897 As territory was taken under European control, vast quantities of art objects flowed into European city, state, national, and private collections due to expanding interest in cultural trade items. Objects also entered Western collections through conflict. The most infamous of these occurred in 1897 when a British delegation headed by the newly appointed Acting Council-General James Phillips

embarked on a mission to gain more favorable trade agreements with the *oba* (king) of the Edo people in Benin City, then located in the British protectorate of Nigeria. Outside the city walls, Philips was told he could not enter the city or meet with the king without permission granted in advance. Phillips refused to leave, and the *oba*'s warrior chiefs defended their king by attacking the British delegation, killing all but two of them.

To retaliate for the Benin City attack, the British organized an expedition that destroyed much of Benin City; the *oba* was imprisoned and the royal palace stripped of all valuables and then burned to the ground (**FIG. 29-9**). The British Punitive Expedition of 1897 resulted in the seizure of over 2,000 objects, including Edo antiquities, royal shrine sculptures, carved ivory tusks, brass palace plaques, and vast quantities of jewelry and royal body adornment—nearly the entire store of artifacts from the royal palace. The objects taken by the British were brought to England. After the customary third was given to Queen Victoria, the rest were auctioned. These objects are now

29-9 MEMBERS OF THE BRITISH PUNITIVE EXPEDITION TO BENIN CITY

Seen in the Royal Palace with objects from the *oba's* treasury. 1897 photograph.

All of these items were subsequently taken to England. The jugs at the soldiers' feet are filled with palm oil, the subject of the trade agreement desired by the British when they were refused entry to the city by the *oba's* royal guards. The three brass standing figures and the brass leopard in the foreground (along with the ivory leopard sculpture at the left, cut off by the frame of the photo) can now be seen at the British Museum.

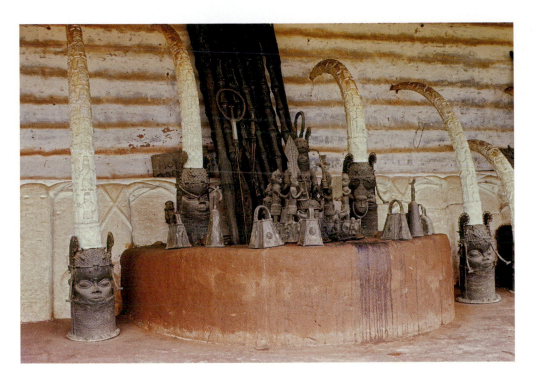

29–10 BENIN CITY PALACE ANCESTRAL ALTAR DEDICATED TO OBA OVONRAMWEN
Benin City, Nigeria c.1959. Image no. EEPA EECL 7584. Eliot Elisofon Photographic Archives, National Museum of African Art, Smithsonian Institution, Washington, DC.

Credit: Photograph by Eliot Elisofon 1959

dispersed in museums and private collections throughout the world. Visible in the foreground of this photograph are three standing figures cast in brass, along with the *oba*'s bronze stool decorated with frogs, a brass leopard, and the back of an ivory leopard with copper disks forming the spots. These sculptures, along with several of the carved ivory tusks, are now in the British Museum in London.

As part of the 1897 Punitive Expedition, the British exiled the city's *oba*, Ovonramwen, to the city of Calabar, and the Edo had no formal state recognition until the restoration of the Benin monarchy in 1914. The newly instated *oba* Enweka II commissioned new ancestral altar shrines, as the previous ones had been dismantled and taken by the British (**FIG. 29–10**). This altar, complete with copies of the traditional brass, ivory, and coral objects that would have been on the original, is dedicated to Enweka II's father, Ovonramwen, who died in exile.

Both the Edo kingdom at Benin City and the nation of Nigeria have pressured the British government to return items taken from Benin City during the 1897 Punitive Expedition, but no decision has been reached as to whether the brass plaques will be returned to the palace walls in Benin City. In the meantime, the kingdom has continued to rebuild and resurrect the art objects that were taken or destroyed by the British.

Modern Objects

The colonial experience spurred the creation of modern objects that responded to the new conditions of life and society on the African continent. In the best of circumstances, artists gained new appreciative patrons in the European residents of their continent, and wealth gained from doing business with Europeans increased for the few willing to cooperate with European law and political control. The Europeans also introduced the idea of the art object as an object simply for aesthetic appreciation, not for actual use. Once artists understood that their European buyers had no interest in using an object in any purposeful ritual or sacred manner, they modified objects for these buyers to be larger and more decorative than the ones they made for local use. This in turn inspired local African buyers to buy these new variations themselves to show off their financial means and their cosmopolitan awareness of the international value of their culture's art objects. One sculpture that may have been created and purchased in this manner is a **LIDDED VESSEL** from South Africa (**FIG. 29–11**).

The vessel is almost 25 inches tall, much larger than earlier wooden containers with lids, and is carved with deep, parallel grooves over the entire surface. Unlike other carved patterns we have seen that have royal or religious meaning, these grooves appear to have been done purely for the visual effect, as well as for the tactile pleasure they would have given to those who handled the vessel. The entire object was carved from a single piece of wood, making the four handles and the ring that joins them particularly remarkable and difficult to produce. Analysis of the inside of the vessel revealed that it had never been used to hold anything (no traces of foods or liquids were found), and therefore was most likely to have been carved as a display item. We do not know if the patron who purchased the sculpture was European or African, but the fact that it was used for visual appreciation certainly demonstrates the European influence on how art objects were understood in the nineteenth century.

29–11 LIDDED VESSEL
South Africa or kingdom of Swaziland, southern Africa. North Nguni, 19th century. Wood, height 24¹³⁄₁₆″ (63 cm). Metropolitan Museum of Art. Purchase, Anonymous Gift, Richard, Ann, John, and James Solomon Families Foundation, Adam Lindemann and Amalia Dayan, and Herbert and Lenore Schorr Gifts, Rogers Fund, and funds from various donors, (2013.165a, b).

Credit: © 2016. Image copyright The Metropolitan Museum of Art/Art Resource/Scala, Florence

NEW OBJECTS: THE NKISI NKONDI In less positive circumstances, artists had to create new forms of objects due to European interference in their daily lives. One example of this is found with the *nkisi nkondi* class of objects made by the Kongo peoples. The *nkisi nkondi* (also *n'kondi*) was a hunter object used by chiefs, elders, and diviners to help administer justice in their local communities (FIG. 29–12).

In the territories now contained by the Democratic Republic of the Congo, Belgian colonial authorities removed local systems of justice and handled all arbitration through their own colonial courts based on Belgian law, which was foreign and inapplicable to the traditions of most local populations. The emerging consensus among scholars is that *minkisi* (plural of *nkisi*) *nkondi* were invented to solve the lack of access to local, recognizable systems of justice.

When a dispute arose between members of the community that they alone could not resolve, they would take their case to the chief, who served as caretaker for the *nkisi*

nkondi. The chief would bring out the sculpture to hear the case, and then, if the clients still could not reach an agreement, even when faced with the threatening figure of the *nkondi,* they would drive a nail, blade, or other pointed object into the figure to capture the *nkisi nkondi*'s attention and prick it into action. The object could then recognize, hunt down, and punish whichever party was in the wrong.

The *nkisi nkondi* seen here was carved from a single block of wood. It is a rare example in that it retains its original bundled raffia skirt, packed earthen neck ruff,

29–12 NKISI NKONDI
Democratic Republic of the Congo. Kongo, 19th century. Wood, nails, raffia, organic materials, and pigment, height 44″ (111.7 cm). The Field Museum, Chicago.

Near the end of the colonial period in the mid-twentieth century, *minkisi nkondi* stopped being made for judicial use; most likely they were no longer needed after independence from Europe and judicial systems returned to African control. The objects are still made now, but for tourist and collector markets.

Credit: © The Field Museum, Image No. A109979_Ac, Cat. No. 91300. Photo: Diane Alexander White

and fur collar. These types of items were frequently lost or removed from *minkisi nkondi* as they disintegrated or become damaged over time. The large number of objects driven into this *nkondi* suggests that its powers were both formidable and efficacious.

The *nkisi nkondi* stands with its hands on its hips, its knees bent, and its mouth and eyes wide open in a pose called *pakalala*, a stance of alertness like a wrestler challenging an opponent. Other *minkisi nkondi* hold a knife or spear in an upraised right hand, ready to attack. This posture was used to convey to petitioners the power that was contained within the body of the *nkisi nkondi*, ready to be unleashed at the first sign of wrongdoing on the part of either party.

Kongo culture is based in oral, not written history. One's word was one's honor, and the spoken word of chiefs or elders was the word of law. Here, the *nkisi nkondi*'s mouth is open, indicating that it is breathing or speaking, therefore capable of speaking justice. Additionally, it has filed teeth. This is not to make it look frightening; rather, it followed the local custom of important members of society filing their teeth. This painful process was a marker of important status and also drew attention to the speaker's mouth, focusing listeners on the power of the words being spoken.

PRIVATE OBJECTS: THE SPIRIT SPOUSE While the *minkisi nkondi* were public objects, used in the service of entire communities, it was not uncommon for objects to be made for very private use. One example comes from the Baule peoples who live in the present-day country of the Ivory Coast (Côte d'Ivoire).

The Baule make a particular type of object known as the spirit spouse (*blolo bla* if female and *blolo bian* if male) (**FIG. 29-13**). It is sculpted to represent an idealized individual. The objects do not, however, imitate actual living people—they are a synthesis of physical, moral, and spiritual ideals of beauty in a carved wooden form.

If an individual is suffering in his or her romantic or married life, Baule spirituality explains it as an otherworldly lover who is making trouble for the living person who is the object of their affection. To remedy the situation, the person imagines what this spirit spouse looks like and commissions an artist to produce a sculpture that will flatter the spirit. By pleasing the spirit with a beautiful object, it is hoped that the spirit will assist his or her earthly lover to have a more productive and healthy life, marriage, and family. The objects therefore, transfer the burden of romantic failure away from the individual and onto an intangible spirit. Psychologically, this has the effect of freeing the person from his or her own guilt or inhibition. The spirit spouse allows the person to realize that he or she *is* loved already, despite the temporary lack of a love relationship on earth.

This spirit wife, or *blolo bla,* stands upright with a slight bend at the knees. The spine and neck are rigid and create a strong vertical line from the head to the feet. The vertical axis is softened by the curving forms of the face, belly, buttocks, and calves, which create a gentle zigzag movement from the front to the back of the figure. This figure holds her hands on her swelling belly, symbolizing maternity and a woman's ability to bear and nurture children. The bent knees indicate preparedness, a readiness to

29-13 BLOLO BLA (FEMALE SPIRIT SPOUSE)
Ivory Coast. Baule, early–mid 20th century. Wood and glass beads, height 19¼" (48.9 cm). National Museum of African Art, Smithsonian Institution, Washington DC. Museum purchase (85.15.2).

The cheeks, torso, and back of this figure are decorated with raised bumps called cicatrizations. On this sculpture the scarifications created a tactile sensation when the figure was touched or rubbed with oil. The scarifications also contribute to creating subtle patterns of light and shadow, adding visual interest to the object.

Credit: Photo: Frank Khoury

move, contrasting with the stillness of the overall figure. This symbolizes not only a woman's physical strength, but also patience and the ability to think or wait before acting.

The eyes occupy the majority of her face. They are proportionally much larger than human eyes and appear to be closed or downcast. The figure's eyes and small mouth signify characteristics of restraint: She is not a gossip and will not pry into the affairs of others. Her breasts are small and constrained, symbolizing female physical beauty without overt eroticism. The full calves indicate health and beauty, and the shiny, well-oiled surface of the sculpture resembles healthy skin.

The head of this figure is proportionally oversized compared to the rest of the body. Also, the torso and neck are elongated. These deviations from human proportion indicate the supernatural aspect of the object. It prevents anyone from understanding the sculpture as a portrait of a living woman and encourages viewers to see the abstractions as markers of what the Baule considered intangible aspects of character and moral beauty.

Ironically, these private objects that were once kept in bedrooms are now some of the most widely displayed in public museums. Certainly the fine workmanship of the sculptures makes them visually stunning to display, but the bright lights and glass vitrines around them make it difficult to remember that these were once very intimate objects, certainly not meant to be seen by strangers.

ALTERED OBJECTS: THE BIERI FIGURE Along with new objects that emerged during the colonial period, existing objects were frequently modified due to changing circumstances. In these cases, the uses of the original objects were still necessary, but often their use had to be concealed to prevent European colonizers' awareness of the objects and their functions, which were often seen as threatening to European social control.

The Fang (pronounced "fong"), who live in Gabon, traditionally preserved the skulls, bones, and relics of their family ancestors in a cylindrical bark container. On top of this container, they placed a carved wooden guardian figure, or **BIERI** (also spelled *byeri*) (**FIG. 29-14**). These sculptures were attached to their boxes with a post that descended from their buttocks and inserted into a hole in the top of the bark container. The sculptures functioned as points of contact for ancestral support and as guardians to protect the relics from malevolent spirit forces.

Bieri were carved in a number of different forms and styles. Some are large heads with long necks that were inserted into the lid of the container, which represents the ancestral body. Other *bieri*, such as this one, were created as full figures with carefully arranged hairstyles, fully rounded torsos, and heavily muscled legs and arms. Here, the figure's firmly set jaw and powerful, muscular body exudes a sense of authority and confidence.

29–14 EYEMA-O-BYERI (RELIQUARY FIGURE)
Gabon. Fang, mid–late 19th century. Wood, metal, and shell; height 21¼" (53.97 cm). Dallas Museum of Art. The Eugene and Margaret McDermott Art Fund, Inc. (2000.3.MCD).

These sculptures were often enhanced by feathers, beads, clothing, and the frequent application of cleansing and purifying palm oil. The entire object served as a reliquary, not unlike the medieval practice in Europe of preserving the bones or clothing of saints in ornamented reliquary altars in cathedrals.

Due to the similarity of Fang reliquary objects to their own Christian relics, the French, who colonized the area in 1885, viewed the Fang *bieri* objects as idols and a threat to the Christian religion. Colonial officials banned many Fang ritual practices and often confiscated and destroyed the *bieri* sculptures. In order to preserve the bones of their ancestors, which were the most important part of the *bieri* reliquary, the Fang willingly turned over their sculptures for destruction or sale to the French. As the bark boxes themselves were not figurative in nature like the sculptures, they were less threatening to the French. During the early colonial period, therefore, the Fang ceased almost entirely to sculpt guardian figures for their *bieri* boxes.

Those *bieri* that were not burned by missionaries or otherwise destroyed ended up in Europe as curiosities. To make them more appealing to collectors, European dealers frequently modified them to look more like "sculpture" and less like functional objects. The posts used to secure them to their boxes were cut off, feathers and beads were removed, and some were even polished black to render them uniform in color. Like the private Baule spirit spouses, Fang *bieri* are most often seen today under glass in museums. They are all missing their bark boxes with the ancestral remains they guarded; many are also missing their support posts, beads, feathers, and other decorations. Fang *bieri* as we see them today in museums are among the objects most heavily altered from their original appearance.

DECONTEXTUALIZED OBJECTS: MOVING INTO MUSEUMS The earliest collections of African art were, for the most part, acquired by European museums of natural history or ethnography, which exhibited the works as curious artifacts of the "less civilized" cultures that had come under European control during the colonial expansion. By the latter half of the twentieth century, however, African objects were better understood and were steadily moved into art museums, where their aesthetic qualities were studied. As with any object in a museum that was originally made for a different venue or use, the original context of the object is missing in museum displays and has to be reconstructed through wall labels, videos, maps, and written essays to help viewers understand how these objects were used in their original societies.

For example, this sculpture from Madagascar of a male and female couple was once the topmost portion of a *hazomanga*, a ritual post placed outside a family's home to honor their ancestors (**FIG. 29-15**). The *hazomanga* serve as markers of lineage, like a family tree. They are therefore the focal points of ceremonies where families come together at marriages or enlarge through births or are reduced in number by death. The post in its entirety would have been almost 6 feet tall. This couple—at some point in history cut off from the bottom of their column—stands only 39 inches tall. In the Sakalava language, *hazo* means tree or wood, while *manga* means blue and beauty simultaneously. The "blue tree" or "beautiful wood" was in some ways a symbolic phallus, representing fertility and continuation of the family line.

29-15 STANDING COUPLE, PINNACLE COMPONENT OF HAZOMANGA POLE

Madagascar. Sakalava/Menabe, 17th–late 18th century. Wood and pigment, height 39″ (99.06 cm). Metropolitan Museum of Art, New York. Purchase, Lila Acheson Wallace, Daniel and Marian Malcolm, and James J. Ross Gifts, 2001 (2001.408).

Credit: © 2016. Image copyright The Metropolitan Museum of Art/Art Resource/Scala, Florence

Given this context, the image of the male and female in this sculpture makes perfect sense; they are the original matriarch and patriarch of the family, the pinnacle of the family that grows underneath them. In a museum, however, this aspect is more difficult to imagine.

RECONTEXTUALIZED OBJECTS: THE BRITISH MUSEUM SOWEI MASK

In 2013, the British Museum in London organized an exhibition called "*Sowei* Mask: The Spirit of Sierra Leone" to display their large collection of polished black masks called *sowei*, made for the Sande women's society in Sierra Leone. Most of the museum's *sowei* masks had been collected during the 1880s by Thomas Joshua Alldridge, who was asked to form a collection of Sierra Leone objects to display at the "Colonial and Indian Exhibition" held in 1886 in London. Now the museum was looking for a more contemporary and accurate way to display these objects and to

29–16 SOWEI MASK FROM THE SHERBRO DISTRICT
Mende, 1880–1886. Wood, pigment, and raffia fiber; height 16.9" (43 cm) (mask), 17.3" (44 cm) (fringe). British Siuseum, London. Purchase from Thomas Joshua Alldridge (Af1886,1126.1).

Credit: © The Trustees of the British Museum. All rights reserved.

break away from their colonial history, which had presented the masks as primitive, exotic, and the opposite of civilized European society. To do this, they invited members of the Sierra Leone diaspora community living in London to assist with the development of the exhibition and its programming. The women of the Sande society in London found one mask in particular to have an especially troubled past, so they worked with the British Museum to create a series of programs to adjudicate its colonial history (**FIG. 29-16**).

With its glossy black surface, high forehead, and refined facial features, the **SOWEI MASK** seen here, as with all *sowei* masks, represents ideal female beauty for the Mende, Temne, Vai, and Kpelle peoples who live in what is today Liberia and Sierra Leone. When in use, the mask would have been worn by a senior member of the Sande women's society at the initiation ceremony of young girls into the society. The Sande society is unique: While men are the musicians at the initiation ceremony and carve the *sowei* masks worn by the dancers, Sande women dance the masquerade. The performance honors the female ancestors of the past and welcomes the newest generation of young women into the society.

The meanings of the mask are complex. Its rounded conical form refers to the chrysalis of a butterfly. Thus, the young woman entering adulthood is like a butterfly emerging from its cocoon. The small eyes and lips indicate modesty, and that the voice will only be used when it is important, never in gossip or slander. The high forehead symbolizes wisdom and generosity of thoughts and actions. This mask also wears a European style top hat. In Europe in the 1880s, the top hat was a symbol of male sophistication, wealth, and elite status in society. By co-opting this symbol into their mask, Sande women used it to articulate the power of Sande to create women of sophistication, wealth, and power, who would of course go on to attract husbands of similar rank and wealth.

By 2013, the mask had lost the raffia fringe around its collar due to decay, and the Sande society women in London asked that a new fringe be made for it. They were also concerned that the mask had lost its name. When Alldridge acquired it, he did not realize that all *sowei* masks are individually named, so did not record that information. Therefore, the Sande women held a naming ceremony (**FIG. 29-17**) during which they sang songs to the mask and asked it to accept a name by suggesting historical ancestors and throwing cowrie shells to see if the mask agreed. Finally, the name Gbavo (meaning "to attract the attention of crowds") emerged, a highly appropriate choice for a mask in a world museum. The Sande women then formally presented the newly named mask with its new fringe collar to the museum, righting the past wrongs of its colonial collection and incomplete display.

The Twentieth Century: Independence-Era Art

What are the predominant conceptual concerns of African artists working in the 1960s to 1980s, and how do they differ from those of colonial-period artists?

In the years following World War I, nationalistic movements resisting European domination arose across Africa. Their leaders were inspired by the Pan-African movement, the Harlem Renaissance, and later the American civil rights movement, as well as Marxism and communism. African political and religious leaders demanded the transformation of colonial divisions into modern nation-states governed by Africans. By the mid-1950s all of North Africa had broken away from European colonial rule, and Ghana was the first sub-Saharan nation to declare independence (from Britain) in 1957. It would take until the late 1970s, however, for all African nations to be free of colonial rule. Portugal finally gave up its claim on Angola in 1975 and Britain and France subsequently let go of the Seychelles (1976) and Djibouti (1977), respectively.

Ghana

Great pride exists among Ghanaians for their status as the first sub-Saharan nation to gain independence from Europe. Indeed, Ghana inspired many other African regions to push for their own independence. Kwame Nkrumah, the first president of independent Ghana, was inspired by the power wielded by the ancient Ghana Empire and their resources of gold. Therefore, he elected to use its name for his new country, which had been dubbed the "Gold Coast" by the British.

Since independence, Ghana has celebrated its long cultural history by maintaining the Asante kingdom at its traditional capital city Kumasi and encouraging the development and sustenance of African history, language learning, and the arts. Ghana is one of many African nations to use the arts as an important component of nation building in the independence era by preserving historical and traditional forms of local art and architecture and celebrating innovative new work by contemporary artists such as El Anatsui, who is discussed later in this section.

One example of keeping traditional arts alive comes from the Nankani people, a community of farmers that lives in an arid region on the northern border of Ghana. This region lies just south of the Sahara desert and is part of the wide swath of agriculturally important land called the Sahel. The rainy season lasts three months; otherwise the area is hot and dry.

Nankani farming communities create distinctive painted adobe homes (**FIG. 29-18**). Adobe is a material used worldwide in arid climates. Sand and clay are mixed with water and fill material (such as straw, grasses, animal bones, or compost). The mixture is then molded into bricks and allowed to bake in the sun. When the bricks are hard, they are stacked with layers of adobe mortar between the courses. These buildings have no windows, which keeps them cool by preventing the hot sun from entering during the day. No windows also mean that blowing dust and sand do not enter the house during the dry season. Once the bricks and mortar are dry, a thick adobe slip is applied by hand over the entire surface of the building (inside and out) and allowed to harden. This seals the structure, making it temporarily waterproof, and during the hardening process, the slip can be sculpted and painted with decorative designs.

29-18 HOUSE COMPOUND IN SIRIGU

Ghana. Nankani, 1972.

Among the Nankani people, creating living areas is a cooperative but gender-specific project. Men build the structures; women decorate the surfaces. The structures are also gendered. The round dwellings shown here are women's houses, located in an interior courtyard; men occupy rectangular flat-roofed houses.

Credit: © Margaret Courtney-Clarke/Corbis

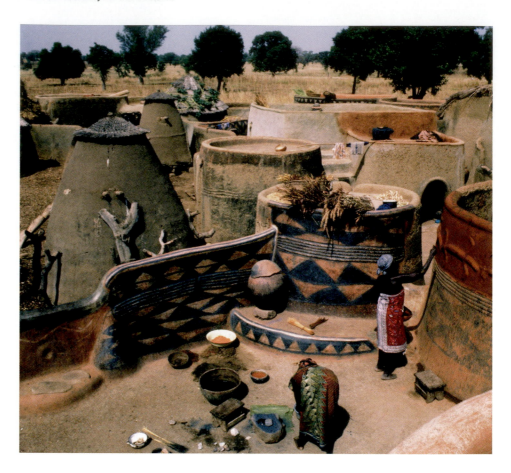

The homes seen in this 1972 photograph were most likely built during the first half of the twentieth century. Women are shown repainting their homes where the exterior decorations have faded. They have decorated one set of the walls with horizontal molded ridges called *yidoor* ("rows in a cultivated field") and then surrounded them with blue diamond-shaped "long life" symbols to express good wishes and agricultural success for the family. The triangular patterns contrast elegantly with the curvature of the walls.

The Nankani use these same geometric motifs on pottery and baskets and for scarification of the skin. The fact that the Nankani were continuing to use historic, and most likely ancient, symbols in the 1970s to enhance their homes, their possessions, and even their bodies sheds light on how important those symbols were in connecting the Nankani to their own past, and not that of British colonial occupation. Certainly the Nankani, like many Ghanaians, were looking for ways to celebrate their own history and traditions after so many centuries of having the traditions, languages, and cultures of others imposed on them.

Burkina Faso

The Bwa people in Burkina Faso are another cultural group that has elected to maintain much of their historic religion and traditions despite French colonialism and the presence of both Islam and Christianity in the region. The Bwa continue to initiate young men and women into adulthood following the onset of puberty. Initiation provides young people with instruction on the social, familial, and religious obligations they need to follow as adults. At the end of their initiation period, the initiates display their new knowledge in a public masquerade ceremony (**FIG.**

29-19). Each young man performs one of the masks, while the young women sing the accompanying songs. At the end of the ceremony all the initiates rejoin their families as adults, ready to marry, start farms, and begin families of their own.

The masks seen in this 1984 masquerade are made of painted wood and represent animal messengers of the important spiritual figure, Do, who mediates between the Bwa people and their creator god. Do's realm is wild, untamed nature and the life force that it generates. Along with initiations, masquerades honoring Do are performed at funerals, as well as at planting and harvest ceremonies. Dancing a masquerade for a funeral, for example, assists the deceased family member in making the journey from the world of the living to the world of the spirits and ancestors.

The masks are commissioned and maintained by family groups who compete with each other to make and dance the most spectacular masks. The imagery consists of human and animal forms combined with painted abstract symbols using only three colors: red, black, and white. The dance costume, traditionally made of leaves, is now frequently made with fibers dyed a brilliant red or black to match the bold colors of the masks.

Bwa masks draw from the natural world to depict people, animals, and insects in a highly abstract manner. The red beaks seen on three of these masks imitate those of the hornbill, a water bird, while the horned figure (second

from left) represents a buffalo, and the incredibly long, slender mask at center represents a serpent. The mask at the far right features three small figures on top of the central plank. This type of mask stresses the commissioning family's own connection to the spirit world.

While the theatrical masquerade performance can only be appreciated by participating in the event, the masks and costumes are often all that is viewed by outsiders, as the Bwa have traded or sold these objects in the past and still produce them on commission for sale to collectors. Collecting and displaying Bwa masks for others to view, however, poses significant problems for museums. Few institutions can exhibit such large objects, and museums often only have the wooden headpieces. The feather, leaf, and fiber costumes have typically either been lost or removed due to damage or deterioration. In museum cases, it is difficult for viewers to imagine how a Do mask would have looked when worn and performed. Only by participating in an actual masquerade do the size and grandeur of the masks, and the incredible talent of the dancers, become fully evident.

Postcolonial/Postmodern: Photography, *Récupération*, Painting

Along with retaining pre-colonial artistic traditions, artists working in the 1950s to 1980s engaged with new materials and theories to give aesthetic voice to the changes occurring with continental independence from Europe. The technology of photography, imported from Europe in the nineteenth century, became a tool by which Africans could reclaim their own image from the colonial gaze and display their bodies on their own terms for the camera. Painting proved equally popular with independence-era artists. Painting, after all, was the backbone of European

art up through the colonial period, and a measure by which artists around the world were being judged. African artists took to disrupting this narrative; they interfered with painting's precious status by using organic materials (such as earth, milk, and clay) as pigments or by painting on canvas taken from flour or potato sacks. They painted with brushes, with palette knives, or with their feet. They also adopted oil on canvas to great success, showing European artists that they could master the art of painting as well as anybody.

Along with co-opting photography and painting, two of Europe's prized contemporary art forms, African artists, particularly in French-speaking countries, began to develop their own contemporary theoretical explorations, this time focusing on the found object. The influence of the European **readymade** (an object from popular or material culture presented without further manipulation as an artwork by the artist; see Chapter 32) was certainly part of this impulse, but African modes of art making that use found objects as their primary materials go back centuries. The French term **récupération** (to re-find, reuse, or re-make) defines the African practices of converting preexisting objects from the man-made and natural world into political, aesthetic, and three-dimensional objects; it became one of the most widely used and influential art practices mastered by African artists during the second half of the twentieth century.

PHOTOGRAPHY One of the best-known photographers of the late colonial and early independence era was Seydou Keïta (c. 1921–2001). Born in the capital city of Bamako, Mali (then French West Africa), Keïta's interest in photography was sparked by his uncle's gift to him of a Kodak Brownie Flash camera in 1935. He acquired a large-format camera in 1948 and opened his own studio in

29–19 THREE PLANK MASKS, BUFFALO MASK, AND SERPENT MASK PERFORMING IN THE TOWN OF DOSSI

Burkina Faso. Bwa, 1984. Wood, pigments, and raffia fiber. Plank masks height 7' (2.13 m); serpent mask height over 14' (4.3 m).

Bigger masks symbolize greater means and influence on the part of the family that commissioned the mask, as well as greater talent on the part of the sculptor. Some Bwa masks, especially serpent masks, reach over 25 feet in height, while most plank masks average between 5 and 7 feet tall. Others, such as those representing birds or butterflies, may only be a couple feet high but possess wingspans of over 6 feet.

Credit: © Charles & Josette Lenars/Corbis

Bamako where he became renowned as a portraitist, taking engaging black-and-white photographs of the cosmopolitan residents of the city. He photographed his sitters as prosperous and urban, often providing props such as jewelry, watches, radios, televisions, and glasses, which his sitters readily adopted to enhance their portraits. Along with depicting people as they were in reality, he captured how they wished to be seen and who they aspired to be. His approach fought back against a century of colonial photography where Malians (and all Africans) were photographed by Europeans as ethnographic subjects, exotic others, or naked "savages," so as to belittle African civilizations as inferior to those of Europe.

Keïta's aesthetic approach was unique in that he used a very shallow depth of field, which had the effect of making his sitters pop out against the patterned fabrics he used as backdrops. He shot most of his "studio" portraits outside to make the most of the sharp black-and-white contrasts afforded by natural light. In the family portrait shown here, the sitters occupy a visually luxurious space (**FIG. 29-20**). The heavy, strong patterns of the wife's clothing contrast with the stark white worn by her husband and child. Keïta's elegant composition monumentalizes

29-20 Seydou Keïta **UNTITLED (FAMILY PORTRAIT)**
Bamako, Mali. Gelatin silver print, 1952–1955.

Credit: *Courtesy The Contemporary African Art Collection, Geneva*

individuals whose power and pride are communicated through their commanding poses, impeccable dress, and relaxed gestures. While Keïta made his photographs for domestic consumption (his studio archive comprised over 10,000 negatives), his work found its way to France in the 1990s, and his photographs have been frequently exhibited in Europe and the United States ever since.

RÉCUPÉRATION The complex, multimedia work of El Anatsui (b. 1944) affirms African artists' extensive history of using unexpected materials, and he is one of many in his generation to work with the powerful technique of *récupération*. Born in Ghana, Anatsui studied art in Kumasi, where he took coursework he describes as predominantly Western in orientation, while Ghana's own rich artistic legacy was ignored. Following his own inclinations, he began to study Ghanaian surface design traditions as produced by Ewe and Asante textile artists. In 1975, Anatsui took a position in the Fine Arts Department of the University of Nigeria at Nsukka. There he found a like-minded spirit in Uche Okeke, who was intensely interested in revitalizing *uli*, an important Igbo surface design system. Anatsui began to create what would become a large body of work inspired by *uli* and other graphic systems using tools such as chainsaws and blowtorches.

Later, while still concerned with the survival and transmission of inherited traditions, Anatsui began to use found objects, including soda- and beer-bottle caps, aluminum can lids from canned goods, and the tops and neck labels from liquor bottles, to create revelatory art forms in a variety of media. These include immense wall sculptures that fold and undulate like textiles but are made from metal bottle caps "sewn" together with copper wire (**FIG. 29-21**).

Anatsui's wall hangings have proven immensely popular around the world, and he gives several reasons for this global appeal. First, they are glittering, massive objects; they look like tapestries made of gold and silver, so they speak to the love of big objects that look expensive. Second, they carry historical meaning; Anatsui creates them in the spirit of *kente* cloth, where small segments are made and then "stitched" together. He names his works, just as *kente* patterns have their own names, and thus brings a long-standing tradition to the awareness of a new generation of African and international audiences alike. Third, they speak to environmental concerns, where humans worldwide are consuming and throwing away more than we need and more than the earth can handle. Anatsui's bottle-cap sculptures and tin-can-lid objects keep thousands of pounds of material out of the trash stream. Finally, his works carry the weight of political critique. In **FLAG FOR A NEW WORLD POWER**, we are all asked to examine how the world's political systems operate, including the importance we attach to nationalism and to flags that announce the nation-state to the world. Anatsui's work asks us to consider if a unified

29–21 El Anatsui **FLAG FOR A NEW WORLD POWER**

2004. Aluminum (bottle caps) and copper wire, 16'4" × 14'9" (5 × 4.5 m). Private collection.

Credit: © El Anatsui. Courtesy October Gallery, London.

shops, movie theaters, and event venues. In 1973, he began working with an eastern European anthropologist who encouraged him to paint scenes of life in Zaire. Tshibumba found great pleasure in this topic and subsequently embarked on a project to document the entirety of the history of the Congo in a painted series of over 100 acrylic paintings on flour-sack canvases. Using vivid colors and willfully violating the traditional rules of European linear perspective in favor of the more African hierarchical perspective, Tshibumba painted early kings and queens, the violence of the regime of King Leopold II and the Belgian colonial powers, the excitement at independence, and the violence that tore his country apart in the post-independence years. In **TOMBEAU SANS CERCUEIL** ("Tomb without

world will be made from our ruins, our trash, or our commitment to overcome humanity's own destructive impulses.

out a Coffin"), Tshibumba paints one of the hero figures of Congolese independence, Patrice Lumumba, who also served briefly as the first democratically elected leader of the independent country of Congo (**FIG. 29-22**). Lumumba was assassinated under suspicious circumstances less than four months after taking office, a victim of the international power struggle for control over the Congo and its natural resources.

PAINTING Politics in fact, are one of the most common subjects explored by independence-era artists. Logically, artists were leaders in giving visual presence to the rapidly changing and complex political and social realities for Africans in the 1960s and 70s. One artist whose work is particularly poignant today is Tshibumba Kanda Matulu, born in 1947 in the city of Lubumbashi (then the Belgian Congo, renamed Zaire in 1971, now the Democratic Republic of the Congo). Tshibumba never trained as a painter, but found local success painting signboards for barber

29–22 Tshibumba Kanda Matulu **TOMBEAU SANS CERCUEIL (TOMB WITHOUT A COFFIN)**

ca. 1974. Canvas (recycled flour sack), paint, wood, and staples, 39.2 × 60.2" (99.5 × 152.9 cm). Fowler Museum at UCLA. Anonymous Gift (2002.30.2).

Credit: © Photo courtesy of the Fowler Museum at UCLA

Tshibumba paints Lumumba as a Christlike figure. Despite his bound arms, ripped T-shirt, and signs of being tortured, he is peaceful, seemingly resigned to his fate. As Lumumba's death by firing squad was not announced to the Congolese until a month after the fact, rumors circulated that he had escaped and survived or that, like Jesus, he had risen from the dead and would come again to liberate his people.

Tragically, Tshibumba disappeared under similar circumstances in the early 1980s. It is not known whether he lived or died during the civil war that raged near his hometown in the late 1970s. His paintings, however, bear substantial witness to the political turmoil witnessed by generations of Congolese during the twentieth century, and they remain invaluable historical and visual documents of the violent end of the colonial era.

Late Twentieth and Early Twenty-First Century: New Directions

How do today's artists make use of past cultural styles even as they push in new artistic and global directions?

In addition to continuing traditional art making, adopting new materials and technologies, and confronting the politics of their time, African artists today have broadened their study of art. Along with training with local masters, many study abroad at renowned art schools worldwide and live between two or more countries. The diversity

of influences on contemporary artists of African descent makes it impossible to render a single view of what makes up African art in the twenty-first century.

However, one significant attribute of many contemporary artists, as mentioned at the beginning of this chapter, is their cultural fluency. Each artwork by the four artists discussed below translates meanings across cultures, and often across time and space, in order to present specific issues and cultural concerns to a broad audience. Asking a global audience to consider the lasting colonial burden on the Congo, for example, requires Aimé Mpane not only to know the colonial history of his country, but also to realize that many others around the world do not know it. Incorporating aesthetics, history, awareness, and insight into art objects is what these four artists, and many of their contemporaries not discussed here, do so brilliantly.

Mpane: The Burden of History

In a manner related to El Anatsui's *récupération* use of bottle caps and tin can lids, Aimé Mpane cut the sulfurous heads off of thousands of wooden matches and glued the sticks together into the life-size hollow framework of a man to produce a signature work: **CONGO: SHADOW OF A SHADOW** (**FIG. 29-23**). Mpane lives between Kinshasa in the Democratic Republic of the Congo, where he was born in 1968, and Brussels, Belgium. He is a painter, sculptor, and installation artist and *Congo: Shadow of a Shadow* brought him instant international recognition. It is a *tour-de-force* in wood, not sculpted from a single block as a traditional carver would do (and as Mpane himself has done in other works), but rather painstakingly assembled from small sticks of wood. The matchstick sculpture of the man stands at the foot of a grave, meant to be his own, where the tombstone is a cross marked with the words "Congo ... 1885." A

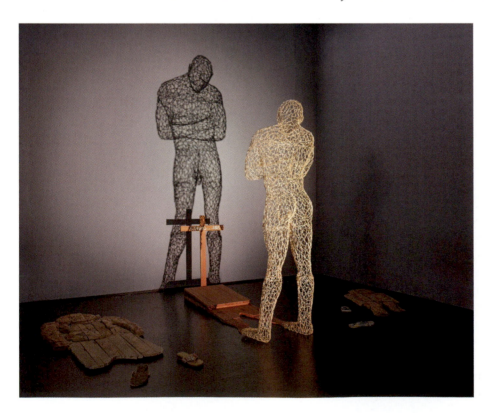

29–23 Aimé Mpane **CONGO: SHADOW OF A SHADOW**

2005. Installed in the exhibition "Shaping Power: Luba Masterworks from the Royal Museum for Central Africa," July 7, 2013–May 4, 2014), Los Angeles County Museum of Art (LACMA). Mixed media (matchsticks, wood, shoes, beads, and metal), dimensions variable. National Museum of African Art, Smithsonian Institution, Washington, D.C. Museum purchase (2009.10.1).

Credit: © 2016. Digital Image Museum Associates/LACMA/Art Resource NY/ Scala, Florence

bright light is positioned out of view behind the man, casting the shadow of his transparent body onto the wall in front of him. He can literally be seen as a shadow of his former self. Around the man lie silhouettes made from assembled planks of wood, shaped to resemble a man, woman, and child. Actual shoes are placed at the feet of each silhouette, and the impression is one of white lines drawn around fallen bodies on the ground to mark the places they died.

By personifying the Congo as a man, Mpane humanizes the brutality that was visited upon the Congolese people during the colonial era and in the civil wars that have wracked the country ever since. By giving a "death date" of 1885, Mpane clearly indicates that the Berlin Conference killed his home country. At that conference, in fact, the territory now comprising the Democratic Republic of the Congo was granted to King Leopold II of Belgium as his personal property. It would eventually pass into the hands of the Belgian government until independence was achieved in 1960. Throughout the period of King Leopold's and Belgian control, Congolese men were forced to work in deplorable conditions on rubber plantations and in diamond and mineral mines. Those who resisted were sent to brutal work camps. Women and children were forced into slavery-like conditions for Belgian investors and residents in the region. The history of the Congo under colonialism is one of the most tragic and brutal accounts of human suffering. Mpane's sculpture mourns the countless dead and the loss of his indigenous country to the greed of the European powers around the conference table in Berlin.

Wangechi Mutu: The International Artist Experience

Wangechi Mutu was born in Nairobi, Kenya, in 1972 and currently works in New York. She trained as both an anthropologist and artist and originally thought to pursue a career in film. She instead discovered a powerful medium in **collage** (pasting separate elements together on a surface) and a way to make it describe the experiences of women across international borders. Mutu cuts out images of women's bodies from fashion magazines, historical books on fashion, medical and botanical textbooks, and gynecological drawings of the female body. She reassembles these images together with her own painted imagery onto diverse grounds of paper, reflective Mylar, and original pages cut from manuscripts. Mutu points out that women carry the marks of culture more than men do, for better or for worse. In making women the subject of her work, she can cross cultural boundaries more explicitly and focus on the demands that various cultures place on women and their bodies.

In **LE NOBLE SAUVAGE**, Mutu spins off of the colonial-period stereotype of non-European women as being somehow exotic or savage due to their skin color, their clothing, and their body shape (**FIG. 29-24**). The collage contains cut-outs of animals stereotypically associated with Africa: parrots, lions, cheetahs, water buffalo, and snakes, while shredded papers create grass, palm fronds, and the woman's skirt. Part woman, part tree, the figure seems wild and untamed, and the lions depicted are all in the act of eating their freshly killed prey, making the image rather gruesome. The woman's skin color is ambiguous; mottled spots and geometric shapes of light and dark skin tones indicate she is a universal female figure, rather than one who can be associated with any particular race. The snakes emerge from her head, reminiscent of Medusa in ancient Greek mythology. By exposing stereotypes associated not only with wild African animals, but also the dangerous Greek goddess, Mutu points out that many

29-24 Wangechi Mutu **LE NOBLE SAUVAGE**
2006. Ink and collage on Mylar, 7'7¾" × 4'6" (233 × 137.2 cm). Collection of Martin and Rebecca Eisenberg, Scarsdale, New York.

Credit: © Wangechi Mutu. Image courtesy the artist.

societies negatively view the bodies of women of color as dangerous, uncivilized, and animalistic. Ironically, this is the exact opposite of how women's bodies appear in the fashion magazines where Mutu gets her images. Her work points out that beauty is always contrived and that women around the world are held to unnatural standards in regard to their looks, behavior, and cultural backgrounds.

Yinka Shonibare MBE: The Global Flows of History

Yinka Shonibare MBE (Member of the British Empire) has made the interconnected histories of Europe and Africa his primary artistic subject. He was born in England to Nigerian parents, and in his artistic career he focuses on the nineteenth century, when colonialism was at its height. His works expose the uneven power exchanges between Europeans and Africans and the damages they created over time. And yet, he does this in a disarmingly beautiful manner. He has made **wax-print fabric** his signature material, largely for the way it conveys the flow of history between Europe and Africa (**FIG. 29–25**).

Cotton wax-print fabrics came to African coastal cities in the nineteenth century. In their journeys to Indonesia for trade, the Dutch had bought expensive, hand-made Indonesian batik (wax-printed) fabrics, thinking to trade them back home in Europe, but discovered that African traders loved them. In order to capitalize on this trade on both the inbound and outbound legs of their travels, the Dutch began industrially manufacturing less expensive, brightly colored wax-print fabrics in the Netherlands in order to sell them to African traders on their way to Indonesia. The fabrics were hugely popular, so much so that in order to meet demand, African people began printing them locally. These fabrics, now ubiquitously associated with "African" fashion, are in fact, Dutch in origin.

In **SCRAMBLE FOR AFRICA** (2003), Shonibare imagines the cast of European heads of state during the Berlin Conference of 1884–1885 assembled around a table arguing over which pieces of the African "pie" they want to claim for themselves. He dresses his mannequins in the traditional style of European nineteenth-century men's dress: straight trousers worn with a tuxedo shirt, vest, and bowtie paired with a long or short waistcoat. He has replaced the traditional plain wool and silk fabrics with the wax print. Initially it looks like he has dressed European men in African fabric, and the effect is rather funny. However, upon recognizing that the "African" fabric is actually European, viewers realize that what is perceived to be authentically European or authentically African cannot be so easily separated after all. Rather, cultures influence each other throughout history, largely inspired by the global flows of trade and art. Shonibare points out that the results can be beautiful and ugly at the same time.

Muholi: Changing the Political and Cultural Discourse

Zanele Muholi was born in Durban, South Africa, in 1972. She lived under the brutal racially based political system known as **apartheid** until it was abolished in 1994. Identifying as a black lesbian, Muholi found herself not only constantly subjected to discrimination against black women under apartheid, but also targeted for her same-sex relationships. Her work in photography, installation, and film has always been part of her political activism, geared toward raising awareness of gender and sexual equality and fighting for equal civil rights.

29–25 Yinka Shonibare **SCRAMBLE FOR AFRICA**
2003. 14 life-size fiberglass mannequins, 14 chairs, table, and Dutch wax-printed cotton. The Pinnell Collection, Dallas.

Credit: Courtesy James Cohan Gallery, NY

29–26 Zanele Muholi **THOBE AND PHILA I**

2012. Silver gelatin print, 19⅞ × 30⅛" (50.5 × 76.5 cm). Edition of 5 + 2 AP.

Credit: © Zanele Muholi. Courtesy of Stevenson, Cape Town/Johannesburg and Yancey Richardson, New York.

One of Muholi's longest-standing art projects is the "Faces and Phases" series begun in 2006, in which the artist takes half-length portrait photographs in black and white of individual people who identify as lesbian, gay, bisexual, transgender, or queer. Her goal with this project is to document people on their own terms, giving visual and aesthetic strength to one of South Africa's most targeted minority communities. In another series, "Being," which she began in 2007, Muholi presents photographs of individuals and couples, honoring their relationships and normalizing them as just "being" people, existing side by side with the rest of their communities (**FIG. 29–26**). In **THOBE AND PHILA I**, Muholi photographs the couple standing one behind the other. Phila gently leans her cheek on her partner's shoulder in a gesture of comfort and ease. Both women gaze directly at the camera, Phila's soft expression balanced by Thobe's stronger, more aggressive stare. The close-up confrontation between the couple and the viewer is not a violent or challenging one; rather, the women demand to be looked at as equals: as South African, as lovers, as people.

As Muholi explains, "Every individual in my photographs has her own or his own story to tell. But sadly we come from spaces in which most black people never had that opportunity. I'm not [here] to speak for the people, but to share and change the portrayal of black bodies.... It's about time that we bring positive imagery of us in space where we are there, but hardly seen."

Think About It

1 How do the royal arts of the sixteenth to twentieth centuries display the attributes of participating in society, cultural fluency of artists, contemporary nature, and abstract subjects?

2 How did African objects made during the colonial period respond to the new contemporary situations of colonial society?

3 How did the arts of the independence period participate in redefining African art in the 1950s to 1980s?

4 Cultural fluency arguably means something different for artists working for royal patrons than it does for artists working for a global art market. How are late twentieth- and early twenty-first-century artists interpreting cultural and global fluency?

Crosscurrents

Njoya's father's throne and Yinka Shonibare's sculpture both present the sustained and complex relationship between Europe and Africa during the colonial period. How does each object display its "Europeanness" and its "Africanness"? How does the combination of elements from both African and European cultures contribute to the power and meaning of each work of art?

FIG. 29–4

FIG. 29–25

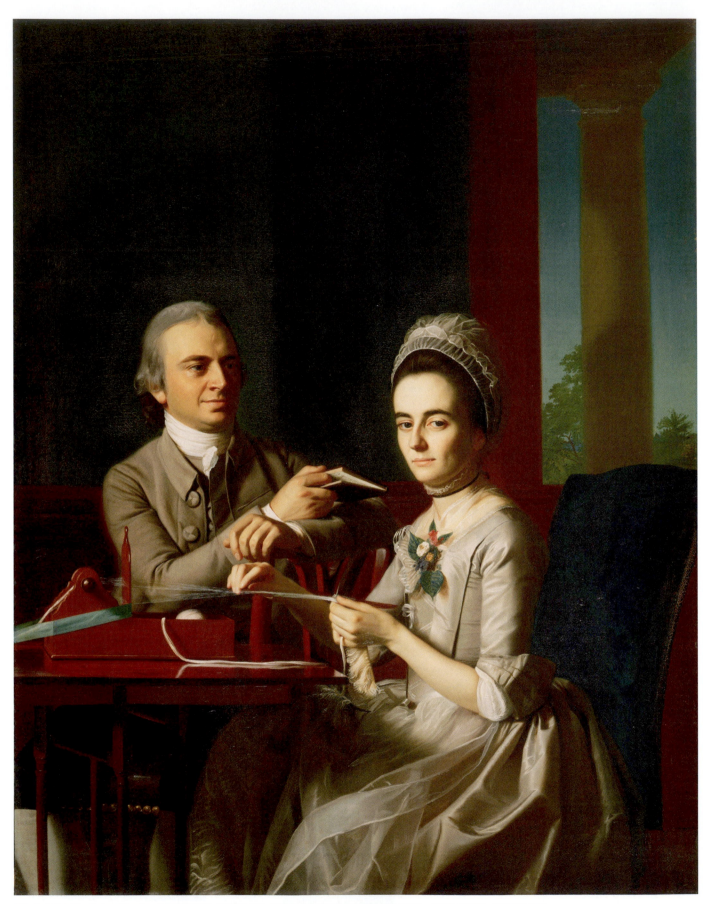

30–1 John Singleton Copley **THOMAS MIFFLIN AND SARAH MORRIS (MR. AND MRS. MIFFLIN)**
1773. Oil on canvas, 61⅝ × 48″ (156.5 × 121.9 cm). Philadelphia Museum of Art.

Chapter 30

European and American Art, 1715–1840

Learning Objectives

30.a Identify the visual hallmarks of eighteenth- and early nineteenth-century European and American art for formal, technical, and expressive qualities.

30.b Interpret the meaning of eighteenth- and early nineteenth-century European and American works of art based on their themes, subjects, and symbols.

30.c Relate eighteenth- and early nineteenth-century European and American art and artists to their cultural, economic, and political contexts.

30.d Apply the vocabulary and concepts relevant to eighteenth- and early nineteenth-century European and American art, artists, and art history.

30.e Interpret a work of eighteenth- or early nineteenth-century European and American art using the art historical methods of observation, comparison, and inductive reasoning.

30.f Select visual and textual evidence in various media to support an argument or an interpretation of a work of eighteenth- or early nineteenth-century European and American art.

John Singleton Copley (1738–1815) painted this double portrait of Thomas Mifflin and his wife, Sarah Morris (**FIG. 30-1**), in 1773 when the Philadelphia couple was visiting Boston for a family funeral. This was the same year when American colonists protested against the British tax on tea by staging the Boston Tea Party—seizing British tea and tossing it into Boston harbor. The painting must have hung in the couple's Philadelphia home when Thomas Mifflin, a prominent merchant and politician, and other leading representatives of the colonies negotiated a strategy for the impending break with Britain at the First Continental Congress. The painting proclaims the couple's identity as American patriots, committed to the cause of independence.

Sarah—not her famous husband—is the center of attention. She sits in the foreground, wearing a stylish silk dress decorated with expensive laces, a finely wrought lace cap atop her smoothly coiffed head. She is certainly rich and elegant, but she wears no jewelry except for a modest choker. In fact, rather uncharacteristically for a woman of her social status, she is shown with her sleeves rolled up, working silk threads on the large wooden frame that sits on her polished table. Her work is domestic and pragmatic, not the kind of activity we expect to see highlighted in a large and expensive formal portrait, but it was included here for important political reasons. Sarah is weaving a

type of decorative silk fringe that in the past would have been imported from England. By portraying her involved in this work, Copley demonstrates her commitment both to her home as a good and industrious wife and to the revolutionary cause as a woman without pretension who can manage well without British imported goods. Meeting the viewer's gaze with confidence and intelligence, she is clearly a full partner with her husband in the important work of resisting British colonial power. He is content to sit in the background of this picture, interrupting his reading to look admiringly at his beloved Sarah.

By 1773, John Singleton Copley was Boston's preeminent portrait painter and a wealthy man. His reputation stood on his remarkable ability to represent the upper level of society in a clear, precise painting style that seemed to reveal not only every detail of a sitter's physical appearance and personality, but also the gorgeous satins, silks, and laces of the women's dresses and the expensive polished furniture that signified his patrons' wealth and status. Although his father-in-law was the Boston representative of the East India Company (whose tea was dumped into the harbor), Copley was sympathetic to the revolutionary cause and, in fact, tried unsuccessfully to mediate the crisis in Boston. This portrait of Sarah Morris and Thomas Mifflin was painted when Copley himself was

ambivalent about the political future of the colonies—he would flee the unsettled climate of the colonies the following year to begin a second career in London—but his sitters reveal only their own sober commitment to the cause.

Industrial, Intellectual, and Political Revolutions

What are the political and social backgrounds for eighteenth- and early nineteenth-century European and American art and architecture?

The American War of Independence was just one of many revolutions to shake the established order during the eighteenth and early nineteenth centuries. This was an age of radical change in society, thought, and politics, and while these transformations were felt especially in England, France, and the United States, they had consequences throughout the West and, eventually, the world.

The transformations of this period were informed by a new way of thinking that had its roots in the scientific revolution of the previous century (see "Science and the Changing Worldview" in Chapter 23 on page 769). In England, John Locke (1632–1704) argued that reasonable and rational thought should supplant superstition, and Isaac Newton (1643–1727) insisted upon empirical observation, rational evaluation, and logical consideration in mathematics and science. In 1702, Bernard de Fontenelle (1657–1757), a French popularizer of scientific innovation, wrote that he anticipated "a century which will become more enlightened day by day, so that all previous centuries will be lost in darkness by comparison." Over the course of the eighteenth century, this emphasis on thought "enlightened" by reason was applied to political and moral philosophy as well as science. Enlightenment thinking is marked by a conviction that humans are not superstitious beings ruled by God or the aristocracy, and that all men (some thinkers also included women) should have equal rights and opportunities for "life, liberty, and the pursuit of happiness." Most Enlightenment philosophers believed that, when freed of past religious and political shackles, men and women could and would act rationally and morally. The role of the state was to protect and facilitate these rights, and when the state failed, the moral solution was to change it. Both the American Revolution of 1776 and the French Revolution of 1789 were justified on this basis.

The eighteenth century was also a period of economic and social transformation set in motion by the Industrial Revolution. In the Europe of 1700, wealth and power belonged to the aristocracy, who owned the land and controlled the lives of poor tenant farmers. The Industrial Revolution eventually replaced the land-based power of the aristocracy with the financial power of capitalists, who were able to use new sources of energy to mechanize

manufacturing and greatly increase the quantity and profitability of saleable goods. Factory work lured the poor away from the countryside to the cities with the promise of wages and greater independence. The conditions that urban workers endured, however, were dreadful, both at their grueling factory jobs and in their overcrowded and unsanitary neighborhoods. These conditions would sow the seeds of dissent and revolution in several European countries in the mid nineteenth century. Industrialization also produced a large middle class that both bought and sold the new goods made in factories.

By the early nineteenth century, the aristocracy was weak and ineffectual in many nations and virtually eliminated in France. Upper-middle-class industrialists and merchants dominated European commerce, industry, and politics, and their beliefs and customs defined social norms. At the same time, the idealism of the Enlightenment had eroded, particularly in France in the wake of the Revolution, when the new republican form of government "by the people" brought chaos and bloodshed rather than order and stability. A new intellectual trend, known as Romanticism, started as a literary movement in the 1790s and served as a counterpoint to Enlightenment rationalism. It critiqued the idea that the world was knowable and ruled by reason alone. The central premise of Romanticism was that an exploration of emotions, the imagination, and intuition—areas of the mind not addressed by Enlightenment philosophy—could lead to a more nuanced understanding of the world. Rather than one replacing the other, Romanticism and Enlightenment thought coexisted as different parts of a complex cultural whole.

Rococo

How does the ornate style of Rococo art and architecture originate in salon life among the aristocracy and develop more broadly?

In the modern age, the shift from art produced for individual or institutional patrons—the monarchy, aristocracy, Church, and wealthy merchants—to art produced as a commodity to be sold to the industrial rich and the emerging middle classes had its roots in the Rococo, when the court culture of Versailles was replaced by the salon culture of Paris. The term Rococo combines the Italian word *barocco* (an irregularly shaped pearl, possibly the source of the word "baroque") and the French *rocaille* (a popular form of garden or interior ornamentation using shells and pebbles) to describe the refined and fanciful style that became fashionable in parts of Europe during the eighteenth century. The Rococo developed in France around 1715, when the duc d'Orléans, regent for the boyking Louis XV (ruled 1715–1774), moved his home and the French court from Versailles to Paris. The movement spread quickly across Europe (**MAP 30-1**).

MAP 30-1 EUROPE AND NORTH AMERICA IN THE EIGHTEENTH CENTURY

During the eighteenth century, three major artistic styles—Rococo, Neoclassicism, and Romanticism—flourished in Europe and North America.

Rococo Salons

The French court was happy to escape its confinement in the rural palace of Versailles and relocate to Paris. There courtiers built elegant town houses (in French, *hôtels*), whose social rooms may have been smaller than at Versailles, but were no less lavishly decorated. These became the center of social life for aristocrats who cultivated witty exchanges, elegant manners, and a playfully luxurious life specifically dedicated to pleasure, leisure, and sensuality that frequently masked social insecurity and ambivalence. **Salons**, as the rooms and the events held in them were known, were intimate, fashionable, and intellectual gatherings, often including splendid entertainments that mimicked in miniature the rituals of the Versailles court. The salons were hosted on a weekly basis by accomplished, educated women of the upper class including Mesdames de Staël, de La Fayette, de Sévigné, and du Châtelet.

30–2 Germain Boffrand **SALON DE LA PRINCESSE, HÔTEL DE SOUBISE**

Paris. Begun 1732.

Credit: © Hervé Champollion/akg-images

The Rococo style cannot be fully appreciated through single objects, but is evident everywhere in the salons, with their profusely decorated walls and ceilings bursting with exquisite three-dimensional embellishments in gold, silver, and brilliant white paint; their intimate, sensual paintings hung among the rich ornament; and their elaborate crystal chandeliers, mirrored walls, and delicate decorated furniture and tabletop sculptures. When these Parisian salons were lit by candles, they must have glittered with light reflected and refracted by the gorgeous surfaces. The rooms were no doubt also enlivened by the energy of aristocrats, fancifully dressed in a profusion of pastel blues, yellows, greens, and pinks to complement the light, bright details of the Rococo architecture, paintings, and sculptures around them.

The **SALON DE LA PRINCESSE** in the Hôtel de Soubise (**FIG. 30–2**), designed by Germain Boffrand (1667–1754), was the setting for such intimate gatherings of the Parisian aristocracy in the years prior to the French Revolution. Its delicacy and lightness are typical of French Rococo salon design of the 1730s, with architectural elements rendered in sculpted stucco including arabesques (characterized by flowing lines and swirling shapes), S shapes, C shapes, reverse C shapes, volutes, and naturalistic plant forms. Intricate polished surfaces included carved wood panels called boiseries and inlaid wood designs on furniture and floors. The glitter of silver and gold against white and pastel shades and the visual confusion of mirror reflections all enhanced this Rococo interior.

Painting

The paintings and sculpture that decorated Rococo salons and other elegant spaces were instrumental in creating their atmosphere of sensuality and luxury. Pictorial themes were often taken from Classical love stories, and both pictures and sculpted ornament were typically filled with playful *putti*, lush foliage, and fluffy clouds. The paintings of Jean-Antoine Watteau, François Boucher, and Jean-Honoré Fragonard and the tabletop sculpture of Claude Michel, known as Clodion, were highly coveted in salon culture.

WATTEAU Jean-Antoine Watteau (1684–1721) has been seen as the originator, and for some the greatest practitioner, of the French Rococo style in painting. Born in the

30–3 Jean-Antoine Watteau THE SIGNBOARD OF GERSAINT
c. 1721. Oil on canvas, 5′4″ × 10′1″ (1.62 × 3.06 m). Stiftung Preussische Schlössen und Gärten Berlin-Brandenburg, Schloss Charlottenburg.

Watteau painted this signboard for the Paris art gallery of Edmé-François Gersaint, a dealer who introduced to France the English idea of selling paintings by catalog. The systematic listing of works for sale gave the name of the artist and the title, the medium, and the dimensions of each work of art. The shop depicted on the signboard, however, is not Gersaint's but a gallery created from Watteau's imagination and visited by typically elegant and cultivated patrons. The sign was so admired that Gersaint sold it only 15 days after it was installed. Later it was cut down the middle, and each half was framed separately, which resulted in the loss of some canvas along the sides of each section. The painting was restored and its two halves reunited only in the twentieth century.

30-4 Jean-Antoine Watteau **PILGRIMAGE TO THE ISLAND OF CYTHERA**
1717. Oil on canvas, 4′3″ × 6′4½″ (1.3 × 1.9 m). Musée du Louvre, Paris.

Credit: Photo © RMN-Grand Palais (musée du Louvre)/Stéphane Maréchalle

provincial town of Valenciennes, Watteau came to Paris around 1702, where he studied Rubens's paintings for Marie de' Medici (SEE FIG. 23-27), then displayed in the Luxembourg Palace, and the paintings and drawings of sixteenth-century Venetians such as Giorgione and Titian (SEE FIGS. 21-26, 21-27), which he saw in a Parisian private collection. Incorporating the fluent brushwork and rich colors of such works from the past, Watteau perfected a graceful personal style that embodied the spirit of his own time.

Watteau painted for the new urban aristocrats who frequently purchased paintings for their homes through art dealers in the city. The signboard he painted for the art dealer Edmé-François Gersaint (FIG. 30-3) shows the interior of one of these shops—an art gallery filled with paintings from the Venetian and Netherlandish schools that Watteau admired. Indeed, the glowing satins and silks of the women's gowns pay homage to artists such as Gerard ter Borch (SEE FIG. 23-42). The visitors to the gallery are elegant ladies and gentlemen, at ease in these surroundings and apparently knowledgeable about painting; they create an atmosphere of aristocratic sophistication. At the left, a woman in shimmering pink satin steps across the threshold, ignoring her companion's outstretched hand, to watch the two porters packing. While one porter holds a mirror, the other carefully lowers into the wooden case a portrait of Louis XIV, which may be a reference to the name of Gersaint's shop,

Au Grand Monarque ("At [the Sign of] the Great Monarch"). It also suggests the passage of time, for Louis had died six years earlier.

Other elements in the work also suggest transience. On the left, the clock directly above the king's portrait, topped with an allegorical figure of Fame and sheltering a pair of lovers, is a **memento mori**, a reminder of mortality, suggesting that both love and fame are subject to the ravages of time. Well-established *vanitas* emblems are the easily destroyed straw (in the foreground) and the young woman gazing into the mirror (set next to a vanity case on the counter)—mirrors and images of young women looking at their reflections had been familiar symbols of the fragility of human life since the Baroque period. Notably, the two gentlemen at the end of the counter also appear to gaze at the mirror, and are thus also implicated in the *vanitas* theme. Watteau, who died from tuberculosis before he was 40, produced this painting during his last illness. Gersaint later wrote that Watteau had completed the painting in eight days, working only in the mornings because of his failing health. When the *Signboard* was installed, it was greeted with almost universal admiration; Gersaint sold it in less than a month.

In **PILGRIMAGE TO THE ISLAND OF CYTHERA** (FIG. 30-4), painted four years earlier, Watteau portrayed an imagined vision of the idyllic and sensual life of Rococo

30–5 François Boucher
GIRL RECLINING: LOUISE O'MURPHY
1751. Oil on canvas, 23¼ × 28¾" (59 × 73 cm). Wallraf-Richartz Museum, Cologne.

Credit: Rheinisches Bildarchiv, Museen der Stadt Köln

aristocrats, but with the same undertone of melancholy that hints at the fleeting quality of human happiness. This is a dream world in which beautifully dressed and elegantly posed couples, accompanied by *putti*, conclude the romantic trysts of their day on Cythera, the island sacred to Venus, the goddess of love, whose garlanded statue appears at the extreme right. The lovers, dressed in exquisite satins, silks, and velvets, gather in the verdant landscape. Such idyllic and wistfully melancholic visions of aristocratic leisure charmed both early eighteenth-century Paris and most of Europe. Watteau painted *Pilgrimage to the Island of Cythera* in 1717 as his official examination canvas for admission to membership of the French Royal Academy of Painting and Sculpture. Although there was no academic category to cover the painting, the academicians were so impressed by the canvas that they created a new category, the **fête galante**, or elegant outdoor entertainment, to describe this genre.

BOUCHER The artist most closely associated with Parisian Rococo painting after Watteau's death is François Boucher (1703–1770). The son of a minor painter, Boucher in 1723 entered the workshop of an engraver where he was hired to reproduce Watteau's paintings for a collector, laying the groundwork for the future direction of his career.

After studying in Rome from 1727 to 1731 at the academy founded there by the French Royal Academy of Painting and Sculpture, Boucher settled in Paris and became an academician. Soon his life and career were intimately bound up with two women. The first was his artistically talented wife, Marie-Jeanne Buseau, who was her husband's frequent model as well as his studio assistant. The other was Louis XV's mistress, Madame de Pompadour, who became his major patron and supporter. Pompadour was an amateur artist herself and took lessons in printmaking from Boucher. After he received his first royal commission in 1735, Boucher worked almost continuously on the decorations for the royal residences at Versailles and Fontainebleau. In 1755, he was made chief inspector at the Gobelins tapestry manufactory; he provided designs for it as well as for the Sèvres porcelain and Beauvais tapestry manufactories. Boucher operated in a much more commercial market than artists in the previous century had done—all these workshops produced both furnishings for the royal household and wares for sale on the open market by merchants such as Edmé-François Gersaint.

In 1765, Boucher became First Painter to the King. In this role he painted portraits of Louis XV, scenes of daily life, mythological pictures, and a series of erotic works for private enjoyment, often depicting the adventures of Venus. The subject of one such painting—**GIRL RECLINING: LOUISE O'MURPHY** (FIG. 30-5)—however, is hardly mythological. The teenage Louise O'Murphy, who would soon be one of the mistresses of Louis XV, appears provocatively pink and completely naked, sprawled across a day bed on her stomach, looking out of the painting and completely unaware of our presence. Her satiny clothing is crushed beneath her, and her spread legs sink into a pillow; braids and a blue ribbon decorate her hair, while a fallen pink rose is highlighted on the floor. Louise's plump buttocks are displayed at the very center of the painting, leaving little doubt about the painting's subject. In contrast to Watteau's *fête galante*, in which imaginary aristocrats and *putti* frolic decorously in idyllic settings, the overtly sensual woman shown here is clearly human, a known contemporary personality, and presented to us in a very real Rococo room.

FRAGONARD Another master of French Rococo painting, Jean-Honoré Fragonard (1732–1806), studied with Boucher, who encouraged him to enter the competition for the Prix de Rome, a three- to five-year scholarship awarded to the top students graduating from the art school of the French Royal Academy of Painting and Sculpture. Fragonard won the prize in 1752 and spent the years 1756 to 1761 in Italy, but it was not until 1765 that he was finally accepted as a member of the Academy. He catered to the tastes of an aristocratic clientele, and, as a decorator of interiors, began to fill the vacuum left by Boucher's death in 1770.

Fragonard's **THE SWING** (**FIG. 30–6**) of 1767 was originally commissioned from another painter, Gabriel-François Doyen, although the identity of the patron is unknown. Doyen described the subject he was asked to paint as sensually explicit, and he refused the commission, giving it to Fragonard, who created a small jewel of a painting. A pretty young woman is suspended on a swing, her movement created by an elderly guardian obscured by the shadow of the bushes on the right who pulls her with a rope. On the left, the girl's blushing lover hides in the bushes, swooning with anticipation. As the swing approaches, he is rewarded with an unobstructed view up her skirt, lifted on his behalf by an

30–6 Jean-Honoré Fragonard **THE SWING**

1767. Oil on canvas, 31⅞ × 25¼" (81 × 64.2 cm). The Wallace Collection, London.

Credit: © Wallace Collection, London, UK/ Bridgeman Images

extended leg. The young man reaches out toward her with his hat as if to make a mockingly useless attempt to conceal the view, while she glances down, seductively slinging one of her shoes toward him. The playful abandon of the lovers, the complicity of the sculpture of Cupid on the left, his shushing gesture assuring that he will not tell, the *putti* and dolphin beneath the swing who seem to urge the young woman on, and the poor, duped guardian to the right all work together to create an image that bursts with anticipation and desire, but also maintains a robust sense of humor.

Sculpture and Architecture

CLODION In the last quarter of the eighteenth century, Rococo largely fell out of favor in France, its style and subject matter attacked for being frivolous at best and immoral at worst. One sculptor who clung to the style almost until the French Revolution, however, was Claude Michel, known as Clodion (1738–1814). Most of his work consisted of playful, erotic tabletop sculpture, mainly in unpainted terra cotta. Typical of his Rococo designs is the terra-cotta model he submitted to win a 1784 royal commission for a large monument to **THE INVENTION OF THE BALLOON** (**FIG. 30-7**). In the eighteenth century, hot-air balloons were elaborately decorated with painted Rococo scenes, gold braid, and tassels. Clodion's balloon, circled with bands of ornament, rises from a columnar launching pad belching billowing clouds of smoke, assisted at the left by a puffing wind god with butterfly wings and heralded at the right by a trumpeting Victory. Some *putti* stoke the fire basket, providing the hot air that allows the balloon to ascend, while others gather reeds for fuel and carry them up to feed the fire.

CHURCH DESIGN AND DECORATION The beginning of the Rococo coincided with the waning importance of the Church as a major patron of art in northern Europe. Although churches continued to be built and decorated, the dominance of both the Church and the hereditary aristocracy as patrons diminished significantly. The Rococo proved, however, to be a powerful vehicle for spiritual experience. Several important churches were built in the style, showing how visual appearance can be tailored to a variety of social meanings. One of the most opulent Rococo churches is dedicated to the Vierzehnheiligen (the "Fourteen Auxiliary Saints" or "Holy Helpers"); it was designed by Johann Balthasar Neumann (1687–1753) and constructed in Bavaria between 1743 and 1772. The plan (**FIG. 30-8**), based on six interpenetrating oval spaces of varying sizes around a vaulted ovoid center, recalls that of Borromini's Baroque church of San Carlo alle Quattro Fontane in Rome (**SEE FIG. 23-6B**). But the effect here is airy lightness. In the nave (**FIG. 30-9**), the Rococo love of undulating surfaces with overlays of decoration creates a

30-7 Clodion **THE INVENTION OF THE BALLOON**
1784. Terra-cotta model for a monument, height 43½" (110.5 cm). Metropolitan Museum of Art, New York. Rogers Fund and Frederick R. Harris Gift, 1944 (44.21a b).

Clodion had a long career as a sculptor in the exuberant Rococo manner seen in this work commemorating the 1783 invention of the hot-air balloon. During the austere revolutionary period of the First Republic (1792–1804), he became one of the few Rococo artists to adopt successfully the more acceptable Neoclassical manner. In 1806, he was commissioned by Napoleon to provide the relief sculpture for two Paris monuments, the Vendôme Column and the Carrousel Arch near the Louvre.

visionary world where surfaces scarcely exist. Instead, the viewer is surrounded by clusters of pilasters and engaged columns interspersed with two levels of arched openings to the side aisles, and large clerestory windows illuminating the gold and white of the interior. The foliage of the fanciful capitals is repeated in arabesques, wreaths, and the ornamented frames of irregular panels lining the vault. An ebullient sense of spiritual uplift is achieved by the complete integration of architecture and decoration.

30–8 Johann Balthasar Neumann **PLAN OF THE CHURCH OF THE VIERZEHNHEILIGEN**

Near Bamberg, Bavaria, Germany. c. 1743.

30–9 Johann Balthasar Neumann **INTERIOR, CHURCH OF THE VIERZEHNHEILIGEN**

Near Bamberg, Bavaria, Germany. 1743–1772.

Credit: © Achim Bednorz, Cologne

The Grand Tour and Neoclassicism in Italy

What is the relationship between the Grand Tour and the development of Neoclassicism in Italy?

From the late 1600s until well into the nineteenth century, the education of a wealthy young northern European or American gentleman—few women were considered worthy of such education—was completed on the **Grand Tour**, an extended visit to the major cultural sites of southern Europe. Accompanied by a tutor and an entourage of servants, the Grand Tourist began in Paris, moved on to southern France to visit a number of well-preserved Roman buildings and monuments there, then headed to Venice, Florence, Naples, and Rome. As the repository of the Classical and Renaissance pasts, Italy was the focus of the Grand Tour.

Italy— Rome in particular—was also the primary destination for artists and scholars interested in the Classical past. In addition to the ancient architecture and sculpture throughout Rome, the nearby sites of Pompeii and Herculaneum offered sensational new material for study and speculation. In the mid eighteenth century, archaeologists began the systematic excavation of these two prosperous Roman towns buried by a sudden volcanic eruption in 79 CE.

The artists and intellectuals who found inspiration in the Classical past were instrumental in the development of Neoclassicism, which was both a way of viewing the world and an influential movement in the visual arts. Neoclassicism (*neo* means "new") sought to present Classical ideals and subject matter in a style derived from Classical Greek and Roman sources. Neoclassical paintings reflect the clear forms, tight compositions, and shallow space of ancient relief sculpture. Because the ancient world was considered the source of British and European democracy, secular government, and civilized thought and action, its art was viewed as the embodiment of timeless civic and moral lessons. Neoclassical paintings and sculptures were frequently painted for and displayed in public places in order to inspire patriotism, nationalism, and courage. Neoclassicism was especially popular in Britain, America, and France as a visual expression of the state and political stability.

Grand Tour Portraits and Views

Artists in Italy benefited not only from their access to authentic works of antiquity, but also from the steady stream of wealthy art collectors on the Grand Tour. Tourists visited the studios of important Italian artists in order to view and purchase works that could be brought home and displayed as evidence of their cultural travels.

CARRIERA Wealthy European visitors to Italy frequently sat for portraits by Italian artists. Rosalba Carriera (1675–1757), the leading portraitist in Venice in the first half of the eighteenth century, worked mainly in pastel, a medium better suited than slow-drying oil to accommodate sitters whose time in the city was limited. **Pastel** is fast and versatile: Pastel crayons, made of pulverized pigment bound to a chalk base by weak gum water, can be used to sketch quickly and spontaneously, or they can be rubbed and blended on the surface of paper to produce a shiny and highly finished surface.

Carriera began her career designing lace patterns and painting miniature portraits on the ivory lids of snuffboxes before she graduated to pastel portraits. Her portraits were so widely admired that she was awarded honorary membership of Rome's Academy of St. Luke in 1705 and was later admitted to the academies in Bologna and Florence. In 1720, she traveled to Paris, where she made a pastel portrait of the young Louis XV and was elected to

30–10 Rosalba Carriera **GUSTAVUS HAMILTON, 2ND VISCOUNT BOYNE**

1730–1731. Pastel on blue paper, 22¼ × 16⅞" (56.5 × 42.9 cm). Metropolitan Museum, New York.

Credit: © 2016. Image copyright The Metropolitan Museum of Art/Art Resource/Scala, Florence

30–11 Canaletto **THE DOGE'S PALACE AND THE RIVA DEGLI SCHIAVONI**

Late 1730s. Oil on canvas, 24⅛ × 39¼" (61.3 × 99.8 cm). National Gallery, London. Wynn Ellis Bequest 1876 (NG 940).

Credit: © 2016. Copyright The National Gallery, London/Scala, Florence

30–12 Giovanni Battista Piranesi **VIEW OF THE PANTHEON, ROME**

From the *Views of Rome* series, first printed in 1756. Etching, 18⁹⁄₁₆ × 27⅛" (47.2 × 69.7 cm). Yale University Art Gallery, The Arthur Ross Collection (2012.159.11.60.)

Credit: Image courtesy Yale University Art Gallery

the French Royal Academy of Painting and Sculpture, despite the 1706 rule forbidding the further admission of women. Returning to Italy in 1721, she established herself in Venice as a portraitist of handsome young men such as the Irish aristocrat **GUSTA-VUS HAMILTON, 2ND VISCOUNT BOYNE** (FIG. 30-10). He visited Venice in both 1730 and 1731, and Carriera portrays him dressed for carnival with a half mask and lace veil under his stylish tricorne hat.

CANALETTO A painted city view was by far the most prized souvenir of a stay in Venice. Two kinds of views were produced in Venice: the **capriccio** ("caprice," plural *capricci*), an imaginary landscape or cityscape in which the artist mixed actual structures, such as famous ruins, with imaginary ones to create attractive compositions; and the **veduta** ("view," plural *vedute*), a more naturalistic rendering of famous views and buildings, well-known tourist attractions, and local color in the form of tiny figures of Venetian people and visiting tourists. *Vedute* often encompassed panoramic views of famous landmarks, as in **THE DOGE'S PALACE AND THE RIVA DEGLI SCHIAVONI** (FIG. 30-11) by the Venetian artist Giovanni Antonio Canal, called Canaletto (1697–1768). It was thought that Canaletto used a camera obscura (see Chapter 31) to render his *vedute* with exact topographical accuracy, but his drawings show that he seems to have worked freehand. In fact, his views are rarely topographically accurate; more often than not, they are composite images, so skillfully composed that we can easily believe that Canaletto's *vedute* are "real." He painted and sold so many to British visitors that his dealer sent him to London from 1746 to 1755 to paint views of the English capital city for his British clients, who included several important aristocrats as well as King George III.

PIRANESI The city of Rome was also captured in *vedute* for tourists and armchair travelers, notably by Giovanni Battista Piranesi (1720–1778). Trained in Venice as an architect, he moved to Rome in 1740 and studied etching,

eventually establishing a publishing house and becoming one of the century's most successful printmakers. Piranesi produced a large series of *vedute* of ancient Roman monuments, whose ruined, deteriorating condition made them even more interesting for his customers. His **VIEW OF THE PANTHEON** (FIG. 30-12) demonstrates his careful study of this great work of ancient Roman architecture, which seems even more monumental in relation to the dramatic clouds that frame it and the small figures who surround it on the ground, admiring its grandeur from all directions.

Neoclassicism in Rome

The intellectuals and artists who came to study and work in Rome often formed communities with a shared interest in Neoclassical ideals. One such British group included Angelica Kauffmann (SEE FIG. 30-28), Benjamin West (SEE FIG. 30-29), and Gavin Hamilton (1723–1798), all of whom contributed to early Neoclassicism, and there were similar gatherings of artists from France and Germany. One of the most influential communities was formed at the Villa Albani on the outskirts of Rome, under the sponsorship of Cardinal Alessandro Albani (1692–1779).

Cardinal Albani built his villa in 1760–1761 specifically to house and display his vast collection of antique sculpture, sarcophagi, intaglios (objects with designs carved into the surface), cameos, and ceramics, and it became one of the most important stops on the Grand Tour. The villa was more than a museum: It was also a place to buy art and artifacts. Albani sold items to artists and tourists alike to help satisfy the growing craze for antiquities; unfortunately, many had been faked or heavily restored by artisans in the cardinal's employ.

In 1758, Albani hired Johann Joachim Winckelmann (1717–1768), the leading theoretician of Neoclassicism, as his secretary and librarian. The Prussian-born Winckelmann had become an expert on Classical art while working in Dresden, where the French Rococo style that he deplored was still fashionable. In 1755, he had published a pamphlet, *Thoughts on the Imitation of Greek Works in Painting and Sculpture*, in which he attacked the Rococo as decadent, arguing that modern artists could only claim their status as legitimate artists by imitating Greek art. After relocating to Rome to work for Albani, Winckelmann published a second influential treatise, *The History of Ancient Art* (1764), often considered the beginning of modern art-historical study. In it Winckelmann was the first to analyze the history of art as a succession of period styles, an approach which later became the norm for art history books (including this one).

MENGS Winckelmann's closest friend and colleague in Rome was a fellow German, the painter Anton Raphael Mengs (1728–1779). In 1761, Cardinal Albani commissioned Mengs to paint the ceiling of the great gallery in his new villa. To our eyes Mengs's **PARNASSUS** ceiling (**FIG. 30–13**) may seem stilted, but it is nevertheless significant as the first full expression of Neoclassicism in painting. The scene is taken from Classical mythology. Mount Parnassus in central Greece was where the ancients believed Apollo (god of poetry, music, and the arts) and

the nine Muses (female personifications of artistic inspiration) resided. Mengs depicted Apollo—practically nude and holding a lyre and olive branch to represent artistic accomplishment—standing at the compositional center, his pose copied from the famous *Apollo Belvedere* in the Vatican collection, one of Winckelmann's favorite Greek statues. Around Apollo are the Muses and their mother, Mnemosyne (Memory, leaning on a Doric column). Mengs arranged his figures in a roughly symmetrical, pyramidal composition parallel to the picture plane, like the relief sculpture he had studied at Herculaneum. Winckelmann praised this work, claiming that it captured the "noble simplicity and calm grandeur" of ancient Greek sculpture. Shortly after its completion, Mengs left for Spain, where he served as court painter until 1777, bringing Neoclassical ideas with him. Other artists from Rome carried the style elsewhere in Europe.

CANOVA The theories of the Albani–Winckelmann circle were applied most vigorously by sculptors in Rome, who remained committed to Neoclassicism for almost 100 years. The leading Neoclassical sculptor of the late eighteenth and early nineteenth centuries was Antonio Canova (1757–1822). Born near Venice into a family of stonemasons, he settled in Rome in 1781, where he adopted the Neoclassical style under the guidance of the Scottish painter Gavin Hamilton and quickly became the most sought-after European sculptor of the period.

30–13 Anton Raphael Mengs **PARNASSUS**
Ceiling fresco in the Villa Albani, Rome. 1761.

30–14 Antonio Canova **CUPID AND PSYCHE**

1787–1793. Marble, 61 × 68″ (1.55 × 1.73 m). Musée du Louvre, Paris.

Credit: Photo © Musée du Louvre, Dist. RMN-Grand Palais/Raphaël Chipault

One of Canova's most admired works depicts the erotically charged mythological subject **CUPID AND PSYCHE** (**FIG. 30-14**) in a way that recalls the ancient Classical sculpture that attracted artists and scholars to Rome. Condemned to a death-like sleep by a jealous Venus, Psyche revives at Cupid's kiss. His projecting wings offset the rounded forms of the two linked bodies and balance the downward diagonal extensions of the figures' legs. The lustrous finish of their marble skin shines against the contrasting textures of drapery and rocks. Although carved fully in the round, the work is meant to be experienced frontally, as a symmetrically stable composition of interlocking triangles and ovals. The effect is ordered, decorous, and calming, if still titillating.

Neoclassicism and Early Romanticism in Britain

What distinguishes Neoclassicism and Romanticism in the eighteenth-century art and architecture of England?

British tourists and artists in Italy became leading supporters of early Neoclassicism, partly because of the early burgeoning taste for revival styles at home, but the Classical revival in Britain had a slightly different focus from what we saw in Rome. It is in British art and literature that we find the beginnings of Romanticism.

While Roman Neoclassicism looked to the past in order to revive a sense of moral and civic virtue, many later eighteenth-century British artists harnessed the concept of civic virtue to patriotism to create more Romantic works of art dedicated specifically to the British nation.

Like Neoclassicism, Romanticism describes not only a style but also an attitude: It celebrates the individual and the subjective, while Neoclassicism celebrates the universal and the rational. Romanticism takes its name and many of its themes from the "romances"—novellas, stories, and poems written in Romance (Latin-derived) languages. The term "Romantic" suggests something fantastic or novelistic, perhaps set in a remote time or place, infused by a poetic melancholy, occasionally inciting terror or horror. One of the best examples of early Romanticism in literature is *The Sorrows of Young Werther* (1774) by Johann Wolfgang von Goethe (1749–1832), in which a sensitive, outcast young man fails at love and kills himself. This is a story about a troubled individual who loses his way; it does not recall ancient virtues or civic responsibility.

Neoclassicism and Romanticism existed side by side in the later eighteenth and early nineteenth centuries—two ways of looking at the world, serving distinct purposes in society. Neoclassicism tended to be a more public art form, and Romanticism more individual and private. Sometimes Neoclassicism even functioned within Romanticism. Distinctions were not always clear.

30–15A Richard Boyle (Lord Burlington) **EXTERIOR VIEW OF CHISWICK HOUSE**
West London, England. 1724–1729. Interior decoration (1726–1729) and new gardens (1730–1740) by William Kent.

Credit: © Achim Bednorz, Cologne

The Classical Revival in Architecture and Design

Ancient Greece and Rome provided a morally elevated inspiration for eighteenth-century British buildings, utensils, poetry, and even clothing. Women started wearing white muslin gowns and men curled their hair forward in imitation of Classical statues. In the 1720s, a group of professional architects and wealthy amateurs in Britain, led by a Scot, Colen Campbell (1676–1729), stood against what they viewed as the immoral extravagance of the Italian Baroque. They advocated a return to the austerity and simplicity of the Classically inspired architecture of Andrea Palladio, and his country houses in particular.

CHISWICK HOUSE Designed in 1724 by its owner, Richard Boyle, the third Earl of Burlington (1695–1753), **CHISWICK HOUSE** (FIG. 30–15) is a fine example of British Neo-Palladianism. In visiting Palladio's country houses in Italy, Burlington was particularly struck by the Villa Rotonda (SEE FIGS. 21–35, 21–36), which inspired his design for Chiswick House. The plan shares the bilateral symmetry of Palladio's villa, although its central core is octagonal rather than round and there are only two entrances. The main entrance, flanked here by matching staircases, is a Roman temple front, an imposing entrance for the earl. Chiswick's elevation is characteristically Palladian, with

30–15B Richard Boyle (Lord Burlington) **PLAN OF CHISWICK HOUSE**
West London, England. 1724.

a main floor resting on a basement, and tall, rectangular windows with triangular pediments. The few, crisp details seem perfectly suited to the refined proportions of the whole. The result is a lucid evocation of Palladio's design.

When in Rome, Burlington persuaded the English expatriate William Kent (1685–1748) to return to London as his collaborator. Kent designed Chiswick's surprisingly ornate interior as well as its grounds, the latter in a style that became known throughout Europe as the English landscape garden. Kent's garden abandoned the regularity and rigid formality of Baroque gardens (see "Garden Design" in Chapter 23 on page 772). It featured winding paths, a lake with a cascade, irregular plantings of shrubs, and other effects that imitated the appearance of a natural, rural landscape. In fact, it was carefully designed and manicured.

STOURHEAD Following Kent's lead at Chiswick, landscape architecture flourished in England in the hands of such designers as Lancelot ("Capability") Brown (1716–1783) and Henry Flitcroft (1697–1769). In the 1740s, the banker Henry Hoare began redesigning the grounds of his estate at Stourhead in Wiltshire (**FIG. 30–16**) with the assistance of Flitcroft, a protégé of Burlington. The resulting gardens at Stourhead carried Kent's ideas for the English garden much further. Stourhead is a perfect example of the English **picturesque** garden: Its conception and views intentionally mimic the compositional devices of "pictures" by French landscape painter Claude Lorrain (SEE FIG. 23–56), whose paintings were popular in England. The picturesque view illustrated here shows a garden designed with "counterfeit neglect," intentionally contrived to look natural and unkempt. The small lake is crossed by a rustic bridge, while in the background we see a "folly," a miniature version of the Pantheon in Rome. The park is punctuated by other Classically inspired temples, copies of antique statues, artificial grottoes, a rural cottage, a Chinese bridge, a Gothic spire, and even a Turkish tent. The result is a delightful mixture of styles and cultures that combines aspects of both the Neoclassical and the Romantic. Inside the house, Hoare commissioned Mengs to paint *The Meeting of Antony and Cleopatra*, a blended work that chooses from Classical history a Romanticized subject.

DECORATIVE ARTS The interiors of country houses like Chiswick and Stourhead were designed partly as settings for the art collections of British aristocrats, which included antiquities as well as a range of Neoclassical paintings, sculpture, and decorative wares (see "Closer Look" on page 936).

The most successful producer of Neoclassical decorative art was Josiah Wedgwood (1730–1795). In 1769, near his native village of Burslem, he opened a pottery factory called Etruria after the ancient Etruscan civilization in central Italy known for its pottery. His production-line shop had several divisions, each with its own kilns and workers trained in diverse specialties. A talented chemist, in the mid-1770s Wedgwood perfected a fine-grained, unglazed, colored pottery which he called **jasperware**. His most popular jasperware featured white figures against a

30–16 Henry Flitcroft and Henry Hoare THE PARK AT STOURHEAD
Wiltshire, England. Laid out 1743, executed 1744–1765, with continuing additions.

Credit: Gail Johnson/Fotolia

A Closer Look

GEORGIAN SILVER

All of the objects shown here bear the marks of silver shops run either wholly or partly by women, who played a significant role in the production of silver during the Georgian period—the years from 1714 to 1830, when Great Britain was ruled by four successive kings named George.

This goblet was used for drinking punch, a potent alcoholic beverage enjoyed by British high society. The gilded interior protected the silver from the acid in punch.

This snuffbox was made to hold snuff, a pulverized tobacco inhaled by both men and women of the upper class. It has curved sides for easy insertion into the pocket of a gentleman's tight-fitting trousers.

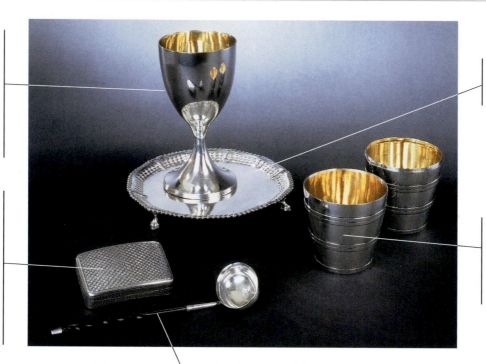

The filled goblets would have been served from a tray called a salver.

These "double beaker" cups were also for drinking punch. The smaller size made them convenient for use when traveling.

This ladle was used to pour punch from a bowl into a goblet. Its twisted whalebone handle floats, making it easy to retrieve from the bowl.

30–17 GEORGIAN SILVER

Elizabeth Morley: George III toddy ladle, 1802; Alice and George Burrows: George III snuffbox, 1802; Elizabeth Cooke: George III salver, 1767; Ann and Peter Bateman: George III goblet, 1797; Hester Bateman: George III double beaker, 1790.

National Museum of Women in the Arts, Washington, DC. Silver collection assembled by Nancy Valentine. Purchased with funds donated by Mr. and Mrs. Oliver Grace and family.

blue ground, as in **THE APOTHEOSIS OF HOMER** jar (**FIG. 30–18**). The low-relief decoration was designed by the sculptor John Flaxman Jr. (1755–1826), who worked for Wedgwood from 1775 to 1787. Flaxman based this scene on a book illustration portraying a particular Greek vessel in the collection of William Hamilton (1730–1803), a leading collector of antiquities and one of Wedgwood's major patrons. Flaxman simplified the original design to accommodate the popular, idealized notion of ancient Greek art and the demands of mass production.

The socially conscious Wedgwood, informed by Enlightenment thinking, established a village for his employees and showed concern for their well-being. He was also active in the international effort to halt the African slave trade and abolish slavery. To publicize the abolitionist cause, he commissioned the sculptor William Hackwood (c. 1757–1839) to design an emblem for the British Committee to Abolish the Slave Trade, formed in 1787. Hackwood created a small medallion of black-and-white jasperware with a cameo likeness of an African man kneeling in chains and the legend **"AM I NOT A MAN AND A BROTHER?"** (**FIG. 30–19**). Wedgwood sent copies of the medallion to Benjamin Franklin, the president of the Philadelphia Abolition Society, and to others in the abolitionist movement. The image was so compelling that the women's suffrage movement in the United States later modified it to represent a woman in chains with the motto "Am I Not a Woman and a Sister?"

30–18 Josiah Wedgwood **THE APOTHEOSIS OF HOMER**
Made at the Wedgwood Etruria factory, Staffordshire, England.
1790–1795. White jasperware body with a mid-blue dip and white
relief, height 18″ (45.7 cm). *Relief of the Apotheosis of Homer*
adapted from a plaque by John Flaxman, Jr., 1778. Trustees of the
Wedgwood Museum, Barlaston, Staffordshire, England.

Credit: Photo © Wedgwood Museum/WWRD

30–19 William Hackwood for Josiah Wedgwood **"AM I NOT
A MAN AND A BROTHER?"**
1787. Black-and-white jasperware, 1⅜ × 1⅜″ (3.5 × 3.5 cm).
Trustees of the Wedgwood Museum, Barlaston, Staffordshire, England.

Credit: Photo © Wedgwood Museum/WWRD

The Gothic Revival in Architecture and Design

The Gothic Revival emerged alongside Neoclassicism in Britain in the mid eighteenth century and spread to several other nations after 1800. An early advocate of the Gothic Revival was the conservative politician and author Horace Walpole (1717–1797), who in 1764 published *The Castle of Otranto*, widely regarded as the first Gothic novel. This tale of mysterious and supernatural happenings set in the Middle Ages almost single-handedly launched a fashion for the Gothic. In 1749, Walpole began to remodel his country house, **STRAWBERRY HILL**, transforming it into the kind of Gothic castle that he described in his fiction (**FIG. 30–20**).

30–20 Horace Walpole and others **STRAWBERRY HILL**
Twickenham, England. 1749–1776.

Credit: Photo: Robert Neuman

30–21 Horace Walpole, John Chute, and Richard Bentley **PICTURE GALLERY SHOWING FAN-VAULTED CEILING, STRAWBERRY HILL**

After 1754.

Credit: © akg-images /A.F.Kersting

Working with several friends and architects, over the next 30 years he added decorative crenellations (higher and lower sections alternating along the top of a wall), tracery windows, and turrets. The interior, too, was redesigned according to Walpole's fanciful Gothic interpretation of the British historical past. His **PICTURE GALLERY** (**FIG. 30–21**) drew on engravings of medieval architecture from antiquarian books in his library. The gallery ceiling is modeled on that of the Chapel of Henry VII at Westminster, but transformed to suit Walpole's taste. For example, the strawberry design on the fan vaults would not have appeared in medieval architecture.

Iron as a Building Material

In 1779, Abraham Darby III built a bridge over the Severn River (**FIG. 30–22**) at Coalbrookdale in Shropshire, England, a town typical of industrial England, with factories and workers' housing filling the valley. Built primarily for function, the bridge demonstrated a need for newer, better transportation routes for moving industrial goods. Its importance lies in the fact that it is probably the first large-scale example of the use of structural metal in bridge building: Iron struts replace the heavy, hand-cut stone voussoirs of earlier bridges.

Five pairs of cast-iron, semicircular arches form a strong, economical 100-foot span. In functional architecture such as this, the form is determined in large part by the available technology, the properties of the material, and the requirements of engineering, often producing an unintended new aesthetic. Here, the use of metal made possible the light, open, skeletal structure sought by builders since the twelfth century. Cast iron was quickly adopted for the construction of engineering wonders like the soaring train stations of the nineteenth century, leading ultimately to such marvels as the Eiffel Tower (SEE FIG. 31–1).

30–22 Abraham Darby III **SEVERN RIVER BRIDGE**
Coalbrookdale, England. 1779.

Credit: © Dorling Kindersley

Trends in British Painting

In the mid eighteenth century, portraits remained popular in British painting among those with the means to commission them. But a taste was also developing for other subjects, such as moralizing satire and caricature, ancient and modern history, scenes from British literature, and the actual British landscape and its people. Whatever their subject matter, many of the paintings and prints created in Britain reflected Romantic sensibilities and Enlightenment values, including an interest in social change, the embracing of natural beauty, and an enthusiasm for science and technology.

THE SATIRIC SPIRIT The industrialization of Britain created a large and affluent middle class with enough disposable income to purchase smaller and less formal paintings such as landscapes and genre scenes, as well as prints. Relatively inexpensive printed versions of paintings could also be sold to large numbers of people. William Hogarth (1697–1764) capitalized on this new market for art and was largely responsible for reviving the British print industry in the eighteenth century.

Trained as a portrait painter, Hogarth believed art should contribute to the improvement of society. As part of a flourishing culture of satire in Britain directed at a variety of political and social targets, he illustrated works by John Gay, a writer whose 1728 play *The Beggar's Opera* portrayed all classes as corrupt, but caricatured aristocrats in particular as feckless. In about 1730, Hogarth began illustrating moralizing tales of his own invention in sequences of four to six paintings, which he then produced in sets of mass-produced prints, enabling him to both maximize his profits and reach as many people as possible.

Between 1743 and 1745, Hogarth produced his *Marriage à la Mode* suite, inspired by Joseph Addison's 1712 essay in the *Spectator* promoting the concept of marriage based on love rather than on aristocratic machinations. In his series of paintings and later prints, Hogarth portrays the sordid story and sad end of an arranged marriage between the children of an impoverished aristocrat and a social-climbing member of the newly wealthy merchant class. In the opening scene of the series, **THE MARRIAGE CONTRACT** (FIG. 30–23), the cast of characters is assembled to legalize the union. At the right of the painting sits Lord Squanderfield, raising his gout-ridden right foot on

30–23 William Hogarth **THE MARRIAGE CONTRACT**
From *Marriage à la Mode*, 1743–1745. Oil on canvas, 27½ × 35¾" (69.9 × 90.8 cm). National Gallery, London.

a footstool as he points to his lengthy family tree (with a few wilted branches), which goes all the way back to medieval knights, as if to say that the pile of money in front of him on the table is not payment enough for the marriage contract he is being asked to sign. Young Squanderfield, a fop and a simpleton, sits on the far left, admiring himself in the mirror and ignoring his future wife as he takes a pinch of snuff. His neck is already showing signs of syphilis. The unhappy bride-to-be is extravagantly dressed but rather plain, and her wedding ring is threaded through a handkerchief to wipe away her tears. In the center, her father, the uncultured but wealthy merchant in the brash red coat, leans forward to study Lord Squanderfield's pedigree, an empty sack of money at his feet. The other

men are lawyers, including the slippery Silvertongue, who is sharpening the quill that will seal the young couple's fate. The next five scenes of the tale describe the progressively disastrous results of such a union, culminating in murder and suicide.

Hogarth hoped to create a distinctively British style of art, free of obscure mythological references and encouraging the self-improvement in viewers that would lead to social progress. His contempt for the decadent tastes of the aristocracy can be seen in the comic detail of the paintings hanging on Lord Squanderfield's walls. Hogarth wanted to entertain and amuse his audiences, but at the same time his acerbic wit lays open the tensions of class and wealth so prevalent in the Britain of his day. Hogarth's work became so popular that in 1745 he was able to give up portraiture, which he considered a deplorable form of vanity.

PORTRAITURE Sir Joshua Reynolds (1723–1792) was a generation younger than Hogarth, and represented the mainstream of British art at the end of the century. After studying Renaissance art in Italy, Reynolds settled in London in 1753, where he worked vigorously to educate artists and patrons to appreciate Classically inspired history painting. In 1768, he was appointed the first president of the Royal Academy. His *Fifteen Discourses to the Royal Academy* (1769–1790) set out his theories on art in great detail. He argued that artists should follow rules derived from studying the great masters of the past, especially those who worked in the Classical tradition; he claimed that the ideal image communicated universal truths, and that artists should avoid representations based solely on observation, as these paintings merely communicated base reality.

Reynolds was able to combine his own taste for history painting with his patrons' desire for images of themselves by developing a type of historical or mythological portraiture called the **Grand Manner**. **LADY SARAH BUNBURY SACRIFICING TO THE GRACES** (FIG. 30-24) is a good example. The large scale of the canvas suggests that it is a history painting, and its details evoke a Classical setting. Framed by a monumental Classical pier and arch and dressed in a classicizing costume, Lady Sarah plays the part of a Roman priestess making a sacrifice to the Three Graces, personifications of female beauty. Portraits such as this were intended for the public rooms, halls, and stairways of aristocratic residences. Reynolds's Grand Manner portraits were widely celebrated, and his London studio was abuzz with sitters, patrons, and assistants. But Reynolds experimented with his paints, so many of his canvases have faded badly.

A counterpoint to Reynolds's style of portraiture is found in the art of Thomas Gainsborough (1727–1788), who catered to his rich and fashionable clients' tastes for the informal poses and natural landscapes introduced to England by Van Dyck in the 1620s (SEE FIG. 23–29).

30–24 Joshua Reynolds **LADY SARAH BUNBURY SACRIFICING TO THE GRACES**

1765. Oil on canvas, 7′10″ × 5′ (2.42 × 1.53 m). The Art Institute of Chicago. Mr. and Mrs. W. W. Kimball Collection, 1922.4468.

Lady Sarah Bunbury was one of the great beauties of her era. A few years before this portrait was painted, she turned down a proposal of marriage from George III.

30–25 Thomas Gainsborough **ROBERT ANDREWS AND FRANCES CARTER (MR. AND MRS. ANDREWS)**
c. 1748–1750. Oil on canvas, 27½ × 47″ (69.7 × 119.3 cm). National Gallery, London.

Gainsborough was engaged to paint this couple's portrait shortly after the 20-year-old Robert Andrews married 16-year-old Frances Carter in November 1748. An area of painting in Frances's lap has been left unfinished, perhaps anticipating the later addition of a child for her to hold.

Gainsborough's early, unfinished **ROBERT ANDREWS AND FRANCES CARTER (FIG. 30-25)**, painted soon after their wedding in 1748, shows the wealthy young rural landowner and his wife posed on the grounds of their estate, with the Sudbury River and the hills of Suffolk in the background. The youthful Frances Carter sits stiffly on a decorative seat, the shimmering satin of her fine dress arranged around her, while her husband appears more relaxed, his hunting rifle tucked casually under his arm and his favorite dog at his side. The couple's good care of the land is revealed as well: The neat rows of grain stocks and stubble in the foreground show the use of the seed drill and plant husbandry. Sheep and horses graze in separate fields. The significance of this painting lies in the informal pose of the couple; the depictions of their land, the pride they take in it, and the wealth and power it provides; and the artist's emphasis on nature as the source of bounty and beauty.

THE ROMANCE OF SCIENCE In the English Midlands, artist Joseph Wright of Derby (1734–1797) shows an Enlightenment fascination with the drama and romance of science in his depiction of **AN EXPERIMENT ON A BIRD IN THE AIR-PUMP (FIG. 30-26)**. Wright set up his studio during the first wave of the Industrial Revolution, and many of his patrons were self-made, wealthy industrial entrepreneurs.

He belonged to the Lunar Society, a group of industrialists (including Wedgwood), merchants, traders, and progressive aristocrats who met monthly in or near Birmingham to exchange ideas about science and technology. As part of the society's attempts to popularize science, Wright painted a series of "entertaining" scenes of scientific experiments.

The second half of the eighteenth century was an age of rapid technological change, and the development of the air-pump was among the many scientific innovations of the time. Although primarily used to study the properties of gas, it was also widely used in dramatic public demonstrations of scientific principles. In the experiment shown here, air was pumped out of the large glass vessel above the scientist's head until the bird inside collapsed from lack of oxygen. Before the animal died, air was reintroduced by a simple mechanism at the top. Wright depicts the exciting moment before air is reintroduced. Dramatically lit from below by a single light source on the table, the scientist peers out of the picture and gestures like a magician about to perform a trick. By delaying the reintroduction of air, the scientist has created considerable suspense. The three men on the left watch the experiment with great interest, while the young girls on the right have a more emotional response to the proceedings. Near the window at upper right—through which a full moon shines

30–26 Joseph Wright of Derby
AN EXPERIMENT ON A BIRD IN THE AIR-PUMP
1768. Oil on canvas, 6 × 8′ (1.82 × 2.43 m). National Gallery, London.

Credit: © 2016. Copyright The National Gallery, London/Scala, Florence

(an allusion to the "Lunar" Society)—a boy stands ready to lower a cage when the bird revives. Science, the painting suggests, holds the potential for wonder, excitement, and discovery about matters of life and death.

ACADEMIES AND ACADEMY EXHIBITIONS During the seventeenth century, the French government founded a number of **academies** for the support and instruction of students in literature, painting and sculpture, music and dance, and architecture. In 1664, the French Royal Academy of Painting and Sculpture in Paris began to mount occasional exhibitions of members' recent work. This exhibition came to be known as the Salon because it was held in the Salon Carré in the Palace of the Louvre. As of 1737, the Salon was held every other year, with a jury of members selecting the works to be shown.

History paintings (based on historical, mythological, or biblical narratives and generally conveying a high moral or intellectual idea) were accorded highest place in the Academy's hierarchy of genres, followed by historical portraiture, landscape painting, various other forms of portraiture, genre painting, and still life. The Salon shows were the only public art exhibitions of importance in Paris, so they were highly influential in establishing officially approved styles and in molding public taste; they also consolidated the Academy's control over the production of art.

In recognition of Rome's importance as a training ground for aspiring history painters, the French Royal Academy of Painting and Sculpture opened a French Academy in Rome in 1666. A competitive "Prix de Rome," or Rome Prize, enabled the winners to study in Rome for three to five years. A similar prize was established by the French Royal Academy of Architecture in 1720. Many Western cultural capitals emulated the French academic model: Academies were established in Berlin in 1696, Dresden in 1705, London

in 1768 (**FIG. 30–27**), Boston in 1780, Mexico City in 1785, and New York in 1802.

Although there were several women members of the European academies of art before the eighteenth century, their inclusion amounted to little more than an honorary

30–27 Johann Zoffany **ACADEMICIANS OF THE ROYAL ACADEMY**
1771–1772. Oil on canvas, 47½ × 59½″ (120.6 × 151.2 cm). The Royal Collection, Windsor Castle, England.

Zoffany's group portrait of members of the London Royal Academy reveals how mainstream artists were taught in the 1770s. The painting shows artists, all men, setting up a life-drawing class and engaging in lively conversation. The studio is decorated with the academy's study collection of Classical statues and plaster copies. Propriety prohibited the presence of women in life-drawing studios, so Zoffany includes Royal Academicians Mary Moser and Angelica Kauffmann in portraits on the wall on the right.

Credit: Royal Collection Trust © Her Majesty Queen Elizabeth II, 2016/ Bridgeman Images.

recognition of their achievements. In France, Louis XIV proclaimed in his founding address to the French Royal Academy that its purpose was to reward all worthy artists "without regard to the difference of sex," but this resolve was not put into practice. Only seven women gained the title of "Academician" between 1648 and 1706, after which the Academy was closed to women. Despite this, four more women were admitted by 1770; however, the men, worried that women would become "too numerous," limited the total number of female members to four. Young women were neither admitted to the French Academy School nor allowed to compete for Academy prizes, both of which were required for professional success. They fared even worse at London's Royal Academy. The Swiss painters Mary Moser and Angelica Kauffmann were both founding members in 1768, but no other women were elected until 1922, and then only as associates.

HISTORY PAINTING By the time it was adapted to Neoclassicism, history painting had long been considered the highest form of art. The Swiss history painter Angelica Kauffmann (1741–1807) trained in Italy and was one of the greatest exponents of early Neoclassicism. Already accepting portrait commissions at age 15, Kauffmann painted

Winckelmann's portrait in Rome, became an ardent practitioner of Neoclassicism, and was elected to the Roman Academy of St. Luke. Most eighteenth-century women artists specialized in the "lower" painting genres of portraiture or still life, but Kauffmann boldly embarked on an independent career as a history painter. She arrived in London in 1766 to great acclaim and lived there until 1781, inspiring British artists to paint Classical history paintings and British patrons to buy them. She was welcomed immediately into Joshua Reynolds's inner circle and, as mentioned, was one of only two women named among the founding members of the Royal Academy.

After her return to Italy, Kauffmann painted **COR-NELIA POINTING TO HER CHILDREN AS HER TREASURES** (FIG. 30–28) for an English patron. The scene in the painting took place in the second century BCE during the republican era of Rome. A woman visitor shows Cornelia her jewels and then asks to see those of her hostess. In response, Cornelia shows off her daughter and two sons, saying: "These are my most precious jewels." Cornelia exemplifies the "good mother," a popular theme among some later eighteenth-century patrons who preferred Classical subjects that taught metaphorical lessons of civic and moral virtue. The value of Cornelia's maternal dedication

30–28 Angelica Kauffmann **CORNELIA POINTING TO HER CHILDREN AS HER TREASURES**
c. 1785. Oil on canvas, 40 × 50" (101.6 × 127 cm). Virginia Museum of Fine Arts, Richmond, Virginia. The Adolph D. and Wilkins C. Williams Fund.

Credit: Virginia Museum of Fine Arts, Richmond. Photo: Katherine Wetzel

30–29 Benjamin West THE DEATH OF GENERAL WOLFE
1770. Oil on canvas, 4'11½" × 7' (1.51 × 2.14 m). National Gallery of Canada, Ottawa. Transfer from the Canadian War Memorials, 1921. Gift of the 2nd Duke of Westminster, Eaton Hall, Cheshire, 1918.

The famous actor David Garrick was so moved by this painting that he enacted an impromptu interpretation of the dying Wolfe in front of the work when it was exhibited at the Royal Academy.

is emphasized by the fact that her sons, Tiberius and Gaius Gracchus, grew up to be political reformers. Kauffmann's composition is severe and Classical, but she softens the image with warm, subdued lighting and the tranquil grace of her figures.

During her early years in Rome, Kauffmann had been friends with the American-born Benjamin West (1738– 1820), who studied in Philadelphia before he left for Rome in 1759, where he met Winckelmann and became a student of Mengs. In 1763, he moved permanently to London, where he specialized in Neoclassical history painting. In 1768, along with Kauffmann and Reynolds, he became a founding member of the Royal Academy.

Two years later, West shocked Reynolds and his other academic friends with his painting **THE DEATH OF GENERAL WOLFE** (FIG. 30–29), which seemed to break completely with Neoclassicism and academic history painting. West argued that history painting was not dependent on dressing figures in Classical costume; in fact, it could represent a contemporary subject as long as the grand themes and elevated message remained intact. Thus, West's painting, and the genre it spawned, came to be known as "modern history" painting. At first, King George III and Joshua

Reynolds were appalled, but modern history pieces had a very strong attraction for both British collectors and the British public, and the king eventually commissioned one of the four replicas of the painting.

West's painting glorifies the British general James Wolfe, who died in 1759 in a British victory over the French for the control of Quebec during the Seven Years' War (1756–1763). West depicted Wolfe in his red uniform expiring in the arms of his comrades under a cloud-swept sky. Wolfe actually died at the base of a tree accompanied by two or three attendants, but the laws of history painting demanded a nobler scene. Thus, though West's painting seems naturalistic, it is not an objective document, nor was it intended to be. West employs the Grand Manner that Reynolds proposed in his *Discourses*, celebrating the valor of the fallen hero, the loyalty of the British soldiers, and the justice of their cause. To indicate the North American setting, West also included at the left a Native American warrior who contemplates the fallen Wolfe— another fiction, since the Native Americans in this battle fought on the side of the French. The dramatic lighting increases the emotional intensity of the scene, as do the poses of Wolfe's attendants, arranged to suggest a Lamentation

over the dead Christ. Extending the analogy, the British flag above Wolfe replaces the Christian cross. Just as Christ died for humanity, Wolfe sacrificed himself for the good of the nation. The brilliant color, emotional intensity, and moralizing message made this image extremely popular with the British public. It was translated into a print and received the widest circulation of any image in Britain up to that time.

ROMANTIC PAINTING The emotional drama of West's painting helped launch Romanticism in Britain. Among its early practitioners was John Henry Fuseli (1741–1825), who arrived in London from his native Switzerland in 1764. Trained in theology, philosophy, and the Neoclassical aesthetics of Winckelmann (whose writings he translated into English), Fuseli quickly became a member of

London's intellectual elite. Joshua Reynolds encouraged Fuseli to become an artist, and in 1770 he left England to study in Rome, where he spent most of the next eight years. His encounter with the sometimes tortured and expressive aspects of both Roman sculpture and Michelangelo's painting led him not to Neoclassicism, but to his own powerfully expressive style.

Back in London, Fuseli established himself as a history painter, but he specialized in dramatic subjects drawn from Homer, Dante, Shakespeare, and Milton. His interest in the dark recesses of the human mind led him to paint supernatural and irrational subjects. In **THE NIGHTMARE** (**FIG. 30–30**), he depicts a sleeping woman sprawled across a divan with her head thrown back, oppressed by a gruesome incubus (or *mara*, an evil spirit) crouching on her pelvis in an erotic dream. According to legend, the incubus

30–30 John Henry Fuseli **THE NIGHTMARE**
1781. Oil on canvas, 39¾ × 49½" (101 × 127 cm). The Detroit Institute of Arts. Founders Society purchase with
Mr. and Mrs. Bert L. Smokler and Mr. and Mrs. Lawrence A. Fleischmann funds.

Fuseli was not popular with the English critics. One writer said that his 1780 entry in the London Royal Academy exhibition "ought to be destroyed," and Horace Walpole called another painting in 1785 "shockingly mad, mad, mad, madder than ever." Even after achieving the highest official acknowledgment of his talents, Fuseli was called "the Wild Swiss" and "Painter to the Devil." But the public appreciated his work, and *The Nightmare*, exhibited at the Royal Academy in 1782, was repeated in at least three more versions and its imagery was disseminated through prints published by commercial engravers. One of these prints would later hang in the office of the Austrian psychoanalyst Sigmund Freud, who believed that dreams were manifestations of the dreamer's repressed desires.

was believed to feed by stealing women and having sex with them. In the background a horse with wild, phosphorescent eyes thrusts its head into the room through a curtain. The image communicates fear of the unknown and unknowable, and sexuality without restraint. The painting was exhibited at the Royal Academy in 1782, and although not well received by Fuseli's peers, it struck a chord with the public. He painted at least four versions of this subject, and prints of it had a wide circulation.

Fuseli's friend William Blake (1757–1827), a highly original poet, painter, and printmaker, was also inspired by the dramatic aspect of Michelangelo's art. Trained as an engraver, he enrolled briefly at the Royal Academy, where he quickly rejected the teachings of Reynolds, believing that rules limit rather than aid creativity. He became a lifelong advocate of probing the unfettered imagination. For Blake, imagination provided access to the higher realm of the spirit while reason was confined to the lower world of matter.

Blake was interested in exploring the nature of good and evil and developed an idiosyncratic form of Christian belief that drew on elements from the Bible, Greek mythology, and British legend. His "prophetic books,"

designed and printed in the mid-1790s, brought together painting and poetry to explore themes of spiritual crisis and redemption. Thematically related to the prophetic books is an independent series of 12 large color prints that he executed mostly in 1795. These include a large print of Isaac Newton (**FIG. 30–31**), the epitome of eighteenth-century rationalism, heroically naked in a cave, obsessed with reducing the universe to a mathematical drawing with his compasses—an image that recalls medieval representations of God the Creator designing the world.

John Singleton Copley, whose portrait of Sarah Morris and Thomas Mifflin opened this chapter (SEE FIG. 30–1), moved from Boston to London just before the Revolutionary War, never to return to his native land. In London, he established himself as a portraitist and painter of modern history in the vein of fellow American expatriate Benjamin West. Copley's most distinctive modern history painting was **WATSON AND THE SHARK** (**FIG. 30–32**), commissioned by Brook Watson, a wealthy London merchant and Tory politician, in 1778. Copley's painting dramatizes an episode of 1749 in which the 14-year-old Watson was attacked by a shark while swimming in Havana Harbor

30–31 William Blake NEWTON
1795–c. 1805. Color print finished in ink and watercolor, 18⅛ × 23⅝" (46 × 60 cm). Tate, London.

Credit: Photo © Peter Willi/ARTOTHEK

30–32 John Singleton Copley **WATSON AND THE SHARK**
1778. Oil on canvas, 5′10¾ × 7′6½″ (1.82 × 2.29 m). National Gallery of Art, Washington, DC. Ferdinand Lammot Belin Fund.

Credit: Image courtesy the National Gallery of Art, Washington

and lost part of his right leg before being rescued by his comrades. Copley's pyramidal composition is made up of figures in a boat and Watson in the water with a highly imaginary shark set against the backdrop of the harbor. Several of the figures were inspired by Classical sources, but the scene portrayed is anything but Classical. In the foreground, the ferocious shark lunges toward the helpless, naked Watson, while at the prow of the rescue boat a man raises his harpoon to attack the predator. At the left, two of Watson's shipmates strain to reach him while others look on in alarm. An African man standing at the apex of the painting holds a rope that curls over Watson's extended right arm, connecting him to the boat.

Some scholars have read the African figure as a servant waiting to hand the rope to his white master, but his inclusion has also been interpreted in more overtly political terms. The shark attack had occurred while Watson was working as a crew member in the transatlantic shipping trade, which included the shipment of slaves from Africa to the West Indies. At the time when Watson commissioned this painting, debate was raging in the British Parliament over the interconnected issues of the Americans' recent

Declaration of Independence and the slave trade. Several Tories, including Watson, opposed American independence, highlighting the hypocrisy of American calls for freedom from the British crown while the colonists continued to deny freedom to African slaves. Indeed, during the Revolutionary War the British offered freedom to every runaway American slave who joined the British army or navy.

Copley's painting, its subject doubtless dictated by Watson, may therefore indicate Watson's sympathy for American slaves—or the figure may be included simply to indicate that the event took place in Havana, much as the inclusion of a Native American in West's painting of the death of Wolfe (SEE FIG. 30-29) sites that picture. Copley was one of the first artists in London to exhibit his large modern history paintings in public places around the capital, making money by charging admission fees and advertising his paintings for sale. His extraordinary images and exhibitions took advantage of the spectacular displays of early nineteenth-century London's Phantasmagoria (a sensational magic lantern display with smoke, mirrors, lights, and gauze "ghosts"), panoramas, dioramas, and the Eidophusikon (a miniature theater with special effects).

Later Eighteenth-Century Art in France

How do Neoclassical architecture, history painting, and portraiture, as well as moralizing genre painting, replace Rococo in France?

In late eighteenth-century France, the Rococo was replaced by Enlightenment ideas and growing signs of revolution. French art moved increasingly toward Neoclassicism as French architects held closer to Roman proportions and sensibility, while painters and sculptors increasingly embraced didactic presentations in a sober, Classical style.

Architecture

French architects of the late eighteenth century generally considered Classicism not one of many possible artistic styles, but the single, true style. Winckelmann's argument that "imitation of the ancients" was the key to good taste was taken to heart in France. The leading French Neoclassical architect was Jacques-Germain Soufflot (1713–1780), whose church of Sainte-Geneviève, known today as the **PANTHÉON** (FIG. 30-33), is the most typical Neoclassical building in Paris. In it, Soufflot attempted to integrate three traditions: Roman architecture he had seen on two trips to Italy; French and English Baroque Classicism; and the

30–33 Jacques-Germain Soufflot **PANTHÉON (CHURCH OF SAINTE-GENEVIÈVE), PARIS**
1755–1792.

This building has an interesting history. Before it was completed, the revolutionary government in control of Paris confiscated all religious properties to raise desperately needed public funds. Instead of selling Sainte-Geneviève, however, they voted in 1791 to make it the Temple of Fame for the burial of Heroes of Liberty. Under Napoleon I (ruled 1799–1814), the building was resanctified as a Catholic church and was again used as such under King Louis-Philippe (ruled 1830–1848) and Napoleon III (ruled 1852–1870). Then it was permanently designated a nondenominational lay temple. In 1851, the building was used as a physics laboratory. Here the French physicist Jean-Bernard Foucault suspended his now-famous pendulum in the interior of the high crossing dome, and by measuring the path of the pendulum's swing proved his theory that the Earth rotated on its axis in a counterclockwise motion. In 1995, the ashes of Marie Curie, who had won the Nobel Prize for Chemistry in 1911, were moved into this "memorial to the great men of France," making her the first woman to be enshrined there.

Palladian style being revived at the time in England. The façade of the Panthéon with its huge portico is modeled on the proportions of ancient Roman temples. The dome, on the other hand, was inspired by seventeenth-century architecture, including Sir Christopher Wren's St. Paul's Cathedral in London (SEE FIGS. 23–59, 23–60), and the radical geometry of the central-plan layout (FIG. 30–34) owes as much to Burlington's Neo-Palladian Chiswick House (SEE FIG. 30–15B) as it does to Christian tradition. The Panthéon, however, is not simply the sum of its parts. Its rational, ordered plan is constructed with rectangles, squares, and circles, while its relatively plain surfaces communicate severity and powerful simplicity.

Painting

French painters such as Boucher, Fragonard, and their followers continued to work in the Rococo style in the later decades of the eighteenth century, but a strong reaction against the Rococo had set in by the 1760s. A leading detractor of the Rococo was Denis Diderot (1713–1784), whose 32-volume compendium of knowledge and skill, the *Encyclopédie* (produced in collaboration with Jean le Rond d'Alembert, 1717–1783) served as an archive of Enlightenment thought in France. In 1759, Diderot began to write reviews of the official Salon for a periodic newsletter for wealthy subscribers; he is generally considered to be the founder of modern art criticism. Diderot believed that art should be moralizing, that it should promote virtuous behavior and inspire refined manners—a function that the Rococo was not designed to fulfill.

CHARDIN Diderot greatly admired Jean-Siméon Chardin (1699–1779), an artist who as early as the 1730s began to create moralizing pictures of refined intimacy in the tradition of seventeenth-century Dutch genre painting by focusing on touching scenes of everyday middle-class life, with an emphasis on the moral goodness of everyday familial routines. **SAYING GRACE** (FIG. 30–35), for instance, shows a mother leaning to set the family table for a meal. Across from her sit two children: an older daughter partially concealed by the table and her younger brother in the foreground who has hung his toy drum on the back of his chair so he can join his hands to say grace. His mother pauses from her domestic chore to admire her son's simple piety. We might initially assume the praying child to be a girl, but young boys wore skirts in France until the twentieth century (see FIG. Intro–5 in the "Introduction"), and the toy drum would have identified this youngster as a boy for an eighteenth-century audience.

30–35 Jean-Siméon Chardin
SAYING GRACE

c. 1740. Oil on canvas, 19 × 15⅛"
(49 × 38 cm). Musée du Louvre, Paris.

Chardin was one of the first French artists
to treat the lives of women and children
with sympathy and to portray the dignity
of women's work in his images of young
mothers, governesses, and kitchen maids.
Shown at the Salon of 1740, *Saying Grace*
was purchased by King Louis XV and
remained in the royal collection until the
French Revolution.

Credit: Photo © Musée du Louvre, Dist. RMN-Grand
Palais/Angèle Dequier

GREUZE Diderot reserved his highest praise for Jean-Baptiste Greuze (1725–1805), and his own plays of the late 1750s served as a source of inspiration for Greuze's painting. Diderot expanded the traditional range of theatrical works in Paris from mostly tragedy and comedy to include the *drame bourgeois* ("middle-class drama") and "middle tragedy" (later called the "melodrama"), both of which communicated moral and civic lessons through simple stories of ordinary life. Greuze's domestic genre paintings, such as **THE VILLAGE BRIDE** (FIG. 30–36), were visual counterparts to Diderot's preferred theatrical subjects. In this painting, Greuze presents the action as a carefully constructed composition on a shallow, stagelike space under a dramatic spotlight. As an elderly father hands the dowry for his daughter to his new son-in-law, he conveys what contemporary critics saw as a moral lesson on financial management; a notary at far right records the event with cool concentration, in marked contrast to the clearly emotional reaction of the father. The mother and sister who embrace the bashful bride seem reluctant to let her go. A

strong contrast to the deception and self-serving objectives highlighted in Hogarth's *Marriage Contract* (SEE FIG. 30–23), Greuze's painting visualizes the utopian notion that moral virtue and relative prosperity can coexist in village life. This kind of highly emotional, theatrical, and moralizing genre scene was widely praised in Greuze's time, offering a counterpoint to early Neoclassical history painting in France.

VIGÉE-LEBRUN While Greuze painted scenes of the poor and middle class, Marie-Louise-Élisabeth Vigée-Lebrun (1755–1842) became famous as Queen Marie Antoinette's favorite portrait painter. Vigée-Lebrun was also notable for her election into the French Royal Academy of Painting and Sculpture, which then made only four places available to women. In 1787, she painted **MARIE ANTOINETTE WITH HER CHILDREN** (FIG. 30–37). Drawing on the "good mother" theme seen earlier in Angelica Kauffmann's Neoclassical painting of Cornelia (SEE FIG. 30–28), Vigée-Lebrun portrays the queen as a kind, stabilizing mother—a work of royal propaganda

30–36 Jean-Baptiste Greuze **THE VILLAGE BRIDE, OR THE MARRIAGE, THE MOMENT WHEN A FATHER GIVES HIS SON-IN-LAW A DOWRY**

1761. Oil on canvas, 36 × 46½″ (91.4 × 118.1 cm). Musée du Louvre, Paris.

Credit: Photo © RMN-Grand Palais (musée du Louvre)/ Franck Raux

aimed at counteracting public perceptions of Marie Antoinette as selfish, extravagant, and immoral. The queen maintains an appropriately regal pose, but her children are depicted more sympathetically. The princess leans affectionately against her mother's arm and the little dauphin—heir to a throne he would never inherit—poignantly points to the empty cradle of a recently deceased sibling. The image alludes to the allegory of Abundance and thus is also intended to signify peace and prosperity for France under the reign of Marie Antoinette's husband, Louis XVI, who came to the throne in 1774 but would be executed along with the queen in 1793.

30–37 Marie-Louise-Élisabeth Vigée-Lebrun **PORTRAIT OF MARIE ANTOINETTE WITH HER CHILDREN**

1787. Oil on canvas, 9′1½″ × 7′5⅜″ (2.75 × 2.15 m). Musée National du Château de Versailles.

As the favorite painter to the queen, Vigée-Lebrun escaped from Paris with her daughter on the eve of the Revolution of 1789 and fled to Rome. After a very successful self-exile working in Italy, Austria, Russia, and England, the artist finally resettled in Paris in 1805 and again became popular with Parisian art patrons. Over her long career, she painted about 800 portraits in a vibrant style that changed very little over the decades.

Credit: © Jean Feuillie/Centre des monuments nationaux

DAVID The most important French Neoclassical painter of the era was Jacques-Louis David (1748–1825), who dominated French art for over 20 years during the French Revolution and the subsequent reign of Napoleon. In 1774, he won the Prix de Rome and spent six years in that city, studying antique sculpture and learning the principles of Neoclassicism. After his return to Paris, he produced a series of severely plain Neoclassical paintings celebrating the antique virtues of stoicism, masculinity, and patriotism.

Perhaps the most significant of these works was the **OATH OF THE HORATII** (FIG. 30–38) of 1784–1785. A royal commission that David returned to Rome to paint, the work reflects the taste and values of Louis XVI, who, along with his minister of the arts, Count d'Angiviller, was sympathetic to the Enlightenment. Like Diderot, d'Angiviller and the king believed that art should improve public morals. Accordingly, one of d'Angiviller's first official acts was

to ban indecent nudity from the Salon of 1775 and commission a series of didactic history paintings. The commission for David's *Oath of the Horatii* in 1784 was part of that general program.

The subject of the painting was inspired by the drama *Horace*, written by the great French playwright Pierre Corneille (1606–1684), which had in turn been based on ancient Roman historical texts. The patriotic oath-taking incident David depicted, however, is not taken directly from these sources and was apparently the artist's own invention. The story is set in the seventh century BCE at a time when Rome and its rival, Alba, a neighboring city-state, agreed to settle a border dispute and avert a war by holding a battle to the death between the three sons of Horace (the Horatii), representing Rome, and the three Curatii, representing Alba. In David's painting, the Horatii stand with arms outstretched toward their father, who reaches toward them with the swords on which they pledge to fight and die for

30–38 Jacques-Louis David **OATH OF THE HORATII**
1784–1785. Oil on canvas, 10'8¼" × 14' (3.26 × 4.27 m). Musée du Louvre, Paris.

Credit: Photo © RMN-Grand Palais (musée du Louvre)/Gérard Blot/Christian Jean

30–39 Jacques-Louis David
DEATH OF MARAT
1793. Oil on canvas, 5′5″ × 4′2½″
(1.65 × 1.28 m). © Royal Museums of Fine
Arts of Belgium, Brussels.

Credit: © Royal Museums of Fine Arts of
Belgium, Brussels/Photo: J. Geleyns - Roscan

Rome. The powerful gesture of the young men's outstretched hands almost pushes their father back. In contrast to the upright, tensed, muscular angularity of the men, the group of swooning women and frightened children are limp. They weep for the lives of both the Horatii and the Curatii. Sabina (in the center) is a sister of the Curatii and also married to one of the Horatii; Camilla (at the far right) is sister to the Horatii and engaged to one of the Curatii. David's composition, which separates the men from the women and children spatially by the use of framing background arches, dramatically contrasts the young men's stoic and willing self-sacrifice with the women's emotional collapse.

The emotional intensity of this history painting pushed French academic rules on decorum to their limit. Originally a royal commission, it quickly and ironically became an emblem of the 1789 French Revolution, since its message of patriotism and sacrifice for the greater good effectively captured the mood of the leaders of the new French Republic established in 1792. As the revolutionaries abolished the monarchy and titles of nobility, took education out of the hands of the Church, and wrote a declaration of human rights, David joined the leftist Jacobin party.

In 1793, David painted the death of the Jacobin supporter, Jean-Paul Marat (**FIG. 30–39**). A radical journalist, Marat lived simply among the packing cases that he used as furniture, writing pamphlets urging the abolition of aristocratic privilege. Because he suffered from a painful skin ailment, he would often write while sitting in a medicinal bath. Charlotte Corday, a supporter of an opposition party, held Marat partly responsible for the 1792 riots in which hundreds of political prisoners judged sympathetic to the king were killed, and in retribution she stabbed Marat as he sat in his bath. David avoids the potential for sensationalism in the subject by portraying not the violent event but its tragic aftermath—the dead Marat slumped in his bathtub, his right hand still holding a quill pen, while his left hand grasps the letter that Corday used to gain access to his home. The simple wooden block beside the bath, which Marat used as a desk, bears a dedicatory inscription with the names of both Marat and the painter—"to Marat, David." It almost serves as the martyr's tombstone.

David's painting is tightly composed and powerfully stark. The background is blank, adding to the quiet mood and timeless feeling of the picture, just as the very different background of the *Oath of the Horatii* added to its drama. The color of Marat's pale body coordinates with the blood-stained sheets on which he lies, creating a compact shape that is framed by the dark background and green blanket draped over the bathtub. David transforms a brutal event into an elegiac statement of somber eloquence. Marat's pose, which echoes Michelangelo's Vatican *Pietà* (SEE FIG. 21–14), implies that, like Christ, Marat was a martyr for the people.

The French Revolution degenerated into mob rule in 1793–1794 as Jacobin leaders orchestrated the ruthless execution of thousands of their opponents in what became known as the Reign of Terror. David, as a Jacobin, was elected a deputy to the National Convention and served a two-week term as president, during which time he signed several arrest warrants. When the Jacobins lost power in 1794, he was twice imprisoned, albeit under lenient conditions that allowed him to continue to paint. He later emerged as a supporter of Napoleon and re-established his career at the height of Napoleon's ascendancy.

GIRODET-TRIOSON AND LABILLE-GUIARD David was a charismatic and influential teacher who trained most of the major French painters of the 1790s and early 1800s, including Anne-Louis Girodet-Trioson (1767–1824). Girodet-Trioson's **PORTRAIT OF JEAN-BAPTISTE BELLEY** (**FIG. 30–40**) combines the restrained color and tight composition of David with a relaxed elegance that makes the subject more lifelike and self-possessed, accessible and inaccessible at the same time. And like many of David's works, this portrait was political. The Senegalese-born Belley (1747?–1805) was a former slave who was sent to Paris as a representative to the French Convention by the colony of Saint-Domingue (now Haiti). The Haitian Revolution of 1791, in which African slaves overturned the French colonial power, resulted in the first republic to be ruled by freed African slaves. In 1794, Belley led a successful legislative campaign to abolish slavery in the colonies and grant full citizenship to people of African descent. In the portrait, Belley leans casually on the pedestal of a bust of the abbot Guillaume Raynal (1711–1796), a French philosopher whose 1770 book condemned slavery and paved the way for such legislation—making the portrait a tribute to both Belley and Raynal. Napoleon re-established slavery in the Caribbean islands in 1801, but the revolt continued until 1804, when Haiti finally achieved full independence.

Also reflecting the revolutionary spirit of the age, the painter Adélaïde Labille-Guiard (1749–1803) championed the rights of women artists. Elected to the French Royal Academy of Painting and Sculpture in the same year as Vigée-Lebrun, Labille-Guiard asserted her worthiness for this honor in a **SELF-PORTRAIT WITH TWO PUPILS** that she submitted to the Salon of 1785 (**FIG. 30–41**). The painting was a response to sexist rumors that her work and that of Vigée-Lebrun had actually been painted by men. In a witty role reversal, the only male in this monumental painting of the artist at her easel is her father, shown in a bust behind her canvas, as her muse, a role usually played by women. While the self-portrait flatters Labille-Guiard, it also portrays her as a force to be reckoned with, a woman who engages our gaze uncompromisingly and whose students are serious and intent on their study. In the year following the French Revolution, Labille-Guiard successfully petitioned the French Academy of Painting and Sculpture to end the restriction that limited its membership to four women. The reform was later reversed by the revolutionary government as it became more authoritarian.

30–40 Anne-Louis Girodet-Trioson **PORTRAIT OF JEAN-BAPTISTE BELLEY**

1797. Oil on canvas, 5'2½" × 3'8½" (1.59 × 1.13 m). Musée National du Château de Versailles.

Credit: Photo © RMN-Grand Palais (Château de Versailles)/ Gérard Blot

30–41 Adélaïde Labille-Guiard
SELF-PORTRAIT WITH TWO PUPILS

1785. Oil on canvas, 6′11″ × 4′11½″ (2.11 × 1.51 m). Metropolitan Museum of Art, New York. Gift of Julia A. Berwind, 1953 (53.225.5).

Credit: © 2016. Image copyright The Metropolitan Museum of Art/Art Resource/Scala, Florence

Sculpture

The French Neoclassical sculptor Jean-Antoine Houdon (1741–1828), who studied in Italy between 1764 and 1768 after winning the Prix de Rome, imbued the Classical style with a new sense of realism. He carved busts and full-length statues of a number of the important figures of his time, including Diderot, Voltaire, Jean-Jacques Rousseau, Catherine the Great, Thomas Jefferson, Benjamin Franklin, Lafayette (a Revolutionary hero), and Napoleon, and his studio produced a steady supply of replicas, much in demand because of the cult of great men promoted by Enlightenment thinkers to provide models of virtue and patriotism. On the basis of his bust of

Benjamin Franklin, Houdon was commissioned by the Virginia State Legislature to make a portrait of its native son **GEORGE WASHINGTON** to be installed in the Neoclassical Virginia state capitol building designed by Jefferson. In 1785, Houdon traveled to the United States to make a cast of Washington's features and create a bust in plaster, returning to Paris to execute the life-size marble figure (**FIG. 30–42**). The sculpture represents Washington in the Classical manner but dressed in contemporary clothes, much as Benjamin West had represented General Wolfe (SEE FIG. 30–29). Houdon imbued the portrait with Classical ideals of dignity, honor, and civic responsibility. Washington wears the uniform of a general, the rank he held in

the Revolutionary War, but he also rests his left hand on a Roman *fasces*, a bundle of 13 rods (representing the 13 colonies) and an axe face, that served as a Roman symbol of authority. Attached to the *fasces* are both a sword of war and a plowshare of peace. Significantly, Houdon's Washington does not touch the sword.

30–42 Jean-Antoine Houdon **GEORGE WASHINGTON**
1788–1792. Marble, height 6′2″ (1.9 m). State Capitol, Richmond, Virginia.

The plow share behind Washington alludes to Cincinnatus, a Roman soldier of the fifth century ᴸᴹⁱ who was appointed dictator and dispatched to defeat the Aequi, who had besieged a Roman army. After the victory, Cincinnatus resigned the dictatorship and returned to his farm. Washington's contemporaries compared him with Cincinnatus because, after leading the Americans to victory over the British, he resigned his commission and went back to farming rather than seeking political power. Just below Washington's waistcoat hangs the badge of the Society of the Cincinnati, founded in 1783 by the officers of the disbanding Continental Army who were returning to their peacetime occupations. Washington lived in retirement at his Mount Vernon, Virginia, plantation for five years before his 1789 election as the first president of the United States.

Spain and Spanish America

What characterizes the art and architecture of Spain and its American colonies during the late eighteenth and early nineteenth centuries?

In the first half of the eighteenth century, Philip V (ruled 1700–1746) marginalized the Spanish art world by awarding most royal commissions to foreign artists. The German painter Mengs introduced Neoclassicism into Spain with his work for Charles III (ruled 1759–1788), but Spanish artists did not embrace Neoclassicism the way they had Baroque during the previous century. At the end of the eighteenth century, however, the Spanish court appointed one of the greatest Spanish artists of the period as court painter: Francisco Goya y Lucientes (1746–1828).

Since the sixteenth century, the Spanish had commissioned art in the distant lands of their American colonies as well as in the homeland. During the eighteenth century this colonial art and architecture remained rooted in the traditions of the Spanish Baroque, intermingled with the artistic traditions of native peoples, joining the symbolism and the artistic vocabulary of two distinct cultures into a new art in Mexico and the American Southwest.

Goya

Goya was introduced to the Spanish royal workshop in 1774, when he produced tapestry cartoons under the direction of Mengs. He painted for Charles III and served as court painter to Charles IV (ruled 1788–1808), but he also belonged to an intellectual circle that embraced the ideals of the French Revolution, and his work began subtly to criticize the court in which he served.

Soon after the French Revolution, Charles IV, threatened by the possibility of similar social upheaval in Spain, reinstituted the Inquisition, halted reform, and even prohibited the entry of French books into Spain. Goya responded to this new situation by creating a series of prints aimed at the ordinary people, with whom he identified. The theme of *Los Caprichos* (*The Caprices*, a folio of 80 etchings produced between 1796 and 1798) is that reason ignored is a sleeping monster. In the print entitled **THE SLEEP OF REASON PRODUCES MONSTERS** (FIG. 30–43), the slumbering personification of Reason is haunted by a menagerie of demonic-looking owls, bats, and a cat that are let loose when Reason sleeps. Other *Caprichos* enumerate the follies of Spanish society that Goya and his circle considered equally monstrous. His goal with this series was to incite action, to alert the Spanish people to the errors of their foolish ways, and to reawaken them to reason. He tried to market his etchings as Hogarth had done in England, but it aroused controversy and was brought to the attention of his royal patrons. To deflect additional trouble, Goya presented the metal plates of the series to

30–43 Francisco Goya **THE SLEEP OF REASON PRODUCES MONSTERS**

No. 43 from *Los Caprichos* (*The Caprices*). 1796–1798; published 1799. Etching and aquatint, 8½ × 6″ (21.6 × 15.2 cm). Yale University Art Gallery. Bequest of Ralph Kirkpatrick, Hon. M.A. 1965 (1984.54.92.43)

After printing about 300 sets of this series, Goya offered them for sale in 1799. He withdrew them two days later without explanation. Historians believe that he was probably warned by the Church that if he did not do so he might have to appear before the Inquisition because of the unflattering portrayal of the Church in some of the etchings. In 1803, Goya donated the plates to the Royal Printing Office.

Credit: Image courtesy Yale University Art Gallery

the king, suggesting that the images were not intentionally critical of the monarchy. He was torn between his position as a court painter who owed allegiance to the king and his passionate desire for a more open Spain.

A large portrait of the **FAMILY OF CHARLES IV** (**FIG. 30–44**) reveals some of Goya's ambivalence. He clearly wanted his patron to connect this portrait to an earlier Spanish royal portrait, *Las Meninas* by Velázquez (SEE FIG. 23–21), thereby raising his own status as well as that of the king. Like Velázquez, Goya includes himself in the painting, to the left behind the easel. The king and queen appear at the center of this large family portrait, surrounded by their immediate family. The figures are formal and stiff. Much has been written about how Goya seems to show his patrons as faintly ridiculous here. Some seem bored; the somewhat dazed king,

30–44 Francisco Goya **FAMILY OF CHARLES IV**

1800. Oil on canvas, 9'2″ × 11' (2.79 × 3.36 m). Museo del Prado, Madrid.

Credit: © 2016. Image copyright Museo Nacional del Prado. © Photo MNP/Photo Scala, Florence

chest full of medals, stands before a relative who looks distractedly out of the painting (perhaps the face was added at the last minute); the double-chinned queen gazes obliquely toward the viewer (at that time she was having an open affair with the prime minister); their eldest daughter, to the left, stares into space; and another, older relative behind seems almost surprised to be there. One French art critic even described the painting as resembling "the corner baker and his family after they have won the lottery." Yet the royal family was apparently satisfied with Goya's depiction. At a time when the authority of the Spanish aristocracy was crumbling, this complex representation of conflicted emotions, aspirations, and responsibilities may have struck a chord with them. Some viewers who first saw it may have thought its candid representations were refreshingly modern.

In 1808, Napoleon launched a campaign to conquer Spain; he would eventually place his brother, Joseph Bonaparte (1768–1844), on the Spanish throne. At first many Spanish citizens, Goya included, welcomed the French, who brought political reform, including a new, more liberal constitution. But on May 2, 1808, a rumor spread through Madrid that the French planned to kill the royal family. The populace rose up against the French, and a day of bloody street fighting ensued, followed by mass arrests. Hundreds were herded into a convent and then executed by a French firing squad before dawn on May 3. In Goya's impassioned memorial to that slaughter (**FIG. 30-45**), the violent gestures of the defenseless rebels and the mechanical efficiency of the tight row of executioners in the firing squad create a nightmarish tableau. A spotlighted victim in a brilliant white shirt confronts his faceless killers with outstretched arms recalling the crucified Christ, an image of searing pathos. This painting is not a cool, didactic representation of civic sacrifice like David's Neoclassical *Oath of the Horatii* (SEE FIG. 30-38). It is an image of blind terror and desperate fear, the essence of Romanticism—the sensational current event, the loose brushwork, the lifelike poses, the unbalanced composition, and the dramatic lighting. There is no moral here, only hopeless rage. When asked why he painted such a brutal scene, Goya responded: "To warn men never to do it again."

30-45 Francisco Goya **THIRD OF MAY, 1808**
1814–1815. Oil on canvas, 8'9" × 13'4" (2.67 × 4.06 m). Museo del Prado, Madrid.

Soon after, the Spanish monarchy was restored. Ferdinand VII (ruled 1808, 1814–1833) once again reinstated the Inquisition and abolished the new constitution. In 1815, Goya was called before the Inquisition and charged with obscenity for an earlier painting of a female nude. He was acquitted and retired to his home outside Madrid, where he vented his anger at the world in a series of nightmarish "black paintings" rendered directly on the walls, and then spent the last four years of his life in France.

The Art of the Americas under Spain

The sixteenth-century Spanish conquest of Central and South America led to the suppression of indigenous religions. Temples were demolished and replaced with Roman Catholic churches, while Franciscan, Dominican, and Augustinian friars worked to convert the indigenous populations. Some missionaries were so appalled by the conquerors' brutal treatment of the native peoples that they petitioned the Spanish king to help improve conditions.

In the course of the Mesoamericans' forced conversion to Roman Catholicism, Christian symbolism became inextricably blended with the symbolism of indigenous religious beliefs. An example can be seen in colonial **atrial crosses**, carved early on by indigenous sculptors. Missionaries placed these crosses in church atriums, where converts gathered for education in Christianity. The sixteenth-century **ATRIAL CROSS** now in the basilica of Guadalupe near Mexico City (**FIG. 30-46**) is richly carved in the low relief of native sculptural traditions and interweaves images from Christian and native religions into a dense symbolic whole. The Christian images were probably copied from the illustrated books and Bibles of the missionaries. Visible here are the Arms of Christ (the "weapons" that Christ used to defeat the devil); the holy face, placed where his head would appear on a crucifix; the crown of thorns, draped around the cross bar; and the holy shroud, wrapped around the cross's arms. Winged angel heads and pomegranates surround the inscription at the top as symbols of regeneration. While the cross represents the redemption of humanity in Christianity, it symbolizes the tree of life in Mesoamerican religions. The blood that sprays out where the nails pierce the hands and feet of Christ are a reference to his sacrifice; such representations of sacrificial blood were also common in indigenous religious art.

Images of the Virgin Mary also took on a Mesoamerican inflection after she was believed to have appeared in Mexico. In one such case, in 1531, a Mexican peasant named Juan Diego claimed that the Virgin Mary visited him to tell him in his native Nahuatl language to build a church on a hill where an Aztec goddess had once been worshiped, subsequently causing flowers to bloom so that Juan Diego could show them to the archbishop as proof of his vision. When Juan Diego opened his bundle

30-46 ATRIAL CROSS
Before 1556. Stone, height 11'3" (3.45 m). Chapel of the Indians, basilica of Guadalupe, Mexico City.

Credit: © Jamie Lara

of flowers, the cloak he had used to wrap them is said to have borne the image of a Mexican Mary in a composition used in Europe to portray the Virgin of the Immaculate Conception, popular in Spain (SEE FIG. 23-22). The site of Juan Diego's vision was renamed Guadalupe after Our Lady of Guadalupe in Spain, and it became a venerated pilgrimage center. In 1754, Pope Benedict XIV declared the **VIRGIN OF GUADALUPE**, as depicted here in a 1779 work by Sebastian Salcedo, the patron saint of the Americas (**FIG. 30-47**).

Spanish colonial builders sought to replicate the architecture of their native country in the Americas. One of the finest examples is the **MISSION SAN XAVIER DEL BAC**, in the American Southwest near Tucson, Arizona (**FIG. 30-48**). In 1700, the Jesuit priest Eusebio Kino (1644–1711) began laying the foundations for San Xavier del Bac using stone quarried locally by people of the Pima nation. The Pima had already laid out the desert site with irrigation ditches so there would be running water in every room

30–47 Sebastian Salcedo **VIRGIN OF GUADALUPE**

1779. Oil on panel and copper, 25 × 19″ (63.5 × 48.3 cm). Denver Art Museum. Funds contributed by Mr. and Mrs. George G. Anderman and an anonymous donor (1976.56).

At the bottom right is the female personification of New Spain (Mexico) and at the left is Pope Benedict XIV (pontificate 1740–1758), who in 1754 declared the Virgin of Guadalupe to be the patroness of the Americas. Between the figures, the sanctuary of Guadalupe in Mexico can be seen in the distance. The four small scenes circling the Virgin represent the story of Juan Diego, and at the top three scenes depict Mary's miracles. The six figures above the Virgin represent Hebrew Bible prophets and patriarchs and New Testament apostles and saints.

**30–48 MISSION SAN
XAVIER DEL BAC**
Near Tucson, Arizona.
1784–1797.

Credit: Paul Moore/Fotolia

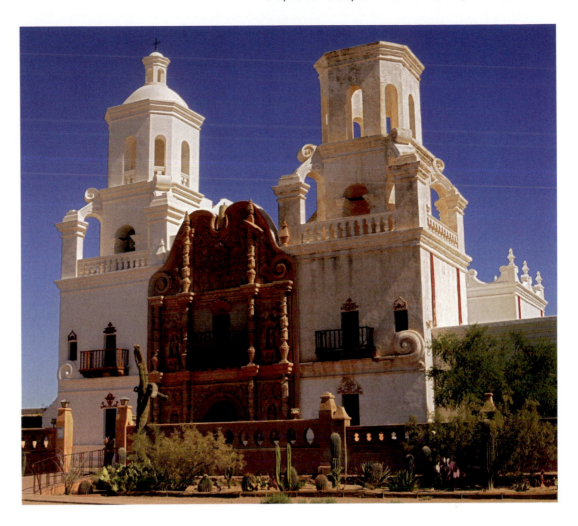

and workshop of the new mission. In 1768, before construction began, the site was turned over to the Franciscans as part of a larger change in Spanish policy toward the Jesuits. Father Kino's vision was eventually realized by the Spanish Franciscan Juan Bautista Velderrain, who arrived at the mission site in 1776.

This huge church, 99 feet long with a domed crossing and flanking bell towers, is unusual for the area because it was built of bricks and mortar rather than adobe, which is made from earth and straw. The basic structure was finished by the time of Velderrain's death in 1790, and the exterior decoration was completed by his successor in 1797. The façade of San Xavier is not a copy of Spanish architecture, although the focus of visual attention on the central entrance to the church and the style of the decoration are consistent with Spanish Baroque. Since the mission was dedicated to Francis Xavier, his statue once stood at the top of the portal decoration, and there are still four female saints, tentatively identified as Lucy, Cecilia, Barbara, and Catherine of Siena, in the niches. Hidden in the sculpted mass is one humorous element: a cat confronting a mouse, which inspired a local Pima saying: "When the cat catches the mouse, the end of the world will come" (cited in Chinn and McCarty, p. 12).

The Development of Neoclassicism and Romanticism into the Nineteenth Century

How do Neoclassicism and Romanticism develop in the early nineteenth-century art of France, England, Germany, and the United States?

Neoclassicism and Romanticism existed side by side well into the nineteenth century in European and American art. In fact, Neoclassicism survived in both architecture and sculpture beyond the middle of the century, as patrons and artists continued to use it to promote the virtues of democracy and republicanism. The longevity of Neoclassicism was also due in part to its embrace by art academies, where training was grounded in the study of antique sculpture and the work of Classical artists such as Raphael. The Neoclassical vision of art as the embodiment of universal standards of taste and beauty complemented the academy's idea of itself as a repository of venerable tradition in fast-changing times.

Romanticism, whose roots in eighteenth-century Britain we have already seen, took a variety of forms in the early nineteenth century. The common connecting thread continued to be an emphasis on emotional expressiveness and the unique experiences and tastes of the individual. Romantic paintings continued to explore dramatic subject matter taken from literature, current events, the natural world, or the artist's own imagination, with the goal of stimulating the viewer's emotions.

Developments in France

Paris increasingly established itself as a major artistic center during the nineteenth century. Between 1800 and 1830, the French academy system was the arbiter of artistic success in Paris. The École des Beaux-Arts attracted students from all over Europe and the Americas, as did the ateliers (studios) of Parisian academic artists who offered private instruction. Artists competed fiercely for a spot in the Paris Salon, the annual exhibition that gradually opened to those who were not academy members. At the beginning of the nineteenth century there was a deep division between the *poussinistes* and *rubénistes* (see "Grading the Old Masters" in Chapter 23 on page 771). The *poussinistes*

argued that line, as used in the work of Poussin (SEE FIGS. 23–54, 23–55), created fundamental artistic structure and should be the basis of all painting. The *rubénistes* argued that essential structure could be achieved more eloquently through a sophisticated use of rich, warm color, as exemplified by the paintings of Rubens (SEE FIG. 23–27). Similarly, the relative value of the **esquisse**, a preliminary sketch for a much larger work, was hotly debated. Some claimed that it was simply a tool for the larger, finished work, while others began to argue that the fast, impulsive expression of imagination captured in the *esquisse* made the finished painting seem dull and flat by comparison. This emphasis on expressiveness blossoms in Romanticism between 1815 and 1830.

THE GRAND MANNER PAINTINGS OF DAVID AND GROS With the rise of Napoleon Bonaparte, Jacques-Louis David re-established his dominant position in French painting. David saw in Napoleon the best hope for realizing France's Enlightenment-oriented political goals, and Napoleon saw in David a tested propagandist for revolutionary values. As Napoleon gained power and extended his rule across Europe, reforming law codes and abolishing aristocratic privilege, he commissioned David and his students to document his deeds.

In 1800, four years before Napoleon became emperor, David had already begun to glorify him in **NAPOLEON CROSSING THE SAINT-BERNARD** (or *Bonaparte Crossing the Alps*) (FIG. 30–49). Napoleon is represented in the Grand Manner, and David used artistic license to imagine how he might have appeared as he led his troops over the Alps into Italy. Framed by a broad shock of red drapery, he exhorts his troops to follow as he charges uphill on his powerful, rearing horse. The horse's flying mane and wild eyes, combined with the swirl of the cape, convey energy, impulsiveness, and power, backed up by the heavy guns and troops in the background. When Napoleon fell from power in 1814, David went into exile in Brussels, where he died in 1825.

30–49 Jacques-Louis David **NAPOLEON CROSSING THE SAINT-BERNARD**
1800–1801. Oil on canvas, 8'11" × 7'7" (2.7 × 2.3 m). Versailles, Châteaux de Versailles et de Trianon.

Credit: Photo © RMN-Grand Palais (Château de Versailles)/ Franck Raux

30–50 Antoine-Jean Gros **NAPOLEON IN THE PLAGUE HOUSE AT JAFFA**
1804. Oil on canvas, 17′5″ × 23′7″ (5.32 × 7.2 m). Musée du Louvre, Paris.

The huddled figures to the left were based on those around the mouth of hell in Michelangelo's *Last Judgment* (SEE FIG. 21–46).

Credit: Photo © RMN-Grand Palais (musée du Louvre)/Thierry Le Mage

Antoine-Jean Gros (1771–1835) began working in David's studio as a teenager and eventually competed with his master for commissions from Napoleon, traveling with Napoleon in Italy in 1797 and later becoming an official chronicler of his military campaigns. His painting **NAPOLEON IN THE PLAGUE HOUSE AT JAFFA** (FIG. 30–50), like David's portrait, represents an actual event in the Grand Manner. During Napoleon's campaign against the Ottoman Turks in 1799, bubonic plague broke out among his troops. To quiet fears and forestall panic among his soldiers, Napoleon decided to visit the sick and dying, who were housed in a converted mosque in the town of Jaffa (now in Israel but then part of the Ottoman Empire). The format of Gros's painting—a shallow stage with a series of pointed arches framing the main protagonists—recalls David's *Oath of the Horatii* (SEE FIG. 30–38). But Gros's painting is quite different from that of his teacher. His color is more vibrant and his brushwork more spontaneous. The overall effect is Romantic, not simply because of the dramatic lighting and the wealth of details, both exotic and

horrific, but also because the main action is meant to incite veneration of Napoleon the man more than republican sentiments in general. Near the center of the painting, surrounded by a small group of soldiers and a doctor who keep a cautious distance from the contagious patients or hold handkerchiefs to their noses to block their stench, a heroic and fearless Napoleon reaches his bare hand toward the sores of one of the victims in a pose that was meant to evoke Christ healing the sick with his touch.

GÉRICAULT The life of Théodore Géricault (1791–1824), a major proponent of French Romanticism, was cut short by his untimely death at age 32, but his brief career had a large impact on the early nineteenth-century Parisian art world. After a short stay in Rome in 1816–1817, where he discovered the art of Michelangelo, Géricault returned to Paris determined to paint a great modern history painting. He chose for his subject the scandalous and sensational shipwreck of the *Medusa* (FIG. 30–51). In 1816, this French ship bound for Senegal ran aground close to its destination.

30–51 Théodore Géricault **THE RAFT OF THE MEDUSA**
1818–1819. Oil on canvas, 16′1″ × 23′6″ (4.9 × 7.16 m). Musée du Louvre, Paris.

Credit: © akg-images/Erich Lessing

Its captain, an incompetent aristocrat commissioned by the newly restored monarchy of Louis XVIII, reserved all six lifeboats for himself, his officers, and several government representatives. The remaining 152 passengers were set adrift on a makeshift raft. When those on the raft were rescued 13 days later, just 15 had survived, some only by eating human flesh. Since the captain had been a political appointee, the press used the horrific story to indict the monarchy for this and other atrocities in French-ruled Senegal. The moment in the story that Géricault chose to depict is one fraught with emotion, as the survivors on the raft experience both the fear that the distant ship might pass them by and the hope that they will be rescued.

Géricault's monumental *The Raft of the Medusa* fits the definition of a history painting in that it is a large (16 by 23 feet), multi-figured composition that represents an event in history. It may not qualify, however, on the basis of its function—to expose incompetence and a willful disregard for human life rather than to ennoble, educate, or remind viewers of their civic responsibility. The hero of this painting is also an unusual choice for a history painting; he is not an emperor or a king, nor even an intellectual, but Jean Charles, a black man from French Senegal who showed endurance and emotional fortitude in the face of extreme danger.

Géricault's painting is arranged in a pyramid of bodies. The diagonal axis that begins in the lower left extends upward to the waving figure of Jean Charles; a complementary diagonal beginning with the dead man in the lower right extends through the mast and billowing sail, directing our attention to a huge wave. The figures are emotionally suspended between hope of salvation and fear of imminent death. Significantly, the "hopeful" diagonal in Géricault's painting terminates in the vigorous figure of Jean Charles. By placing him at the top of the pyramid of survivors and giving him the power to save his comrades by signaling to the rescue ship, Géricault suggests metaphorically that freedom is often dependent on the most oppressed members of society.

Géricault prepared his painting carefully, using each of the prescribed steps for history painting in the French academic system. The work was the culmination of extensive study and experimentation. An early pen drawing (*The Sighting of the Argus*, **FIG. 30–52**) depicts the survivors' hopeful response to the appearance of the rescue

30–52 Théodore Géricault **THE SIGHTING OF THE ARGUS**
1818. Pen and ink on paper, 13¾ × 16⅛" (34.9 × 41 cm).
Musée des Beaux-Arts, Lille.

Credit: Photo © RMN-Grand Palais/Philipp Bernard

30–53 Théodore Géricault **THE SIGHTING OF
THE ARGUS**
1818. Pen and ink, sepia wash on paper, 8⅛ × 11¼" (20.6 × 28.6 cm).
Musée des Beaux-Arts, Rouen.

Credit: Photo © RMN-Grand Palais/Philipp Bernard

ship on the horizon at the extreme left. Their excitement is in contrast to the mournful scene of a man grieving over a dead youth on the right side of the raft. The drawing is quick, spontaneous, and bursting with energy.

A later pen-and-wash drawing (FIG. 30–53) reverses the composition, creates greater unity among the figures, and establishes the modeling of their bodies. This is primarily a study of light and shade. Other studies would have focused on further analyses of the composition, arrangement of figures, and overall color scheme. The drawings look ahead to the final composition of *The Raft of the Medusa*, but both still lack the figure of Jean Charles at the apex of the painting, and the dead and dying figures at the extreme left and lower right, which fill out the composition's base.

Géricault also made separate studies of many of the figures, as well as of actual corpses, severed heads, and dissected limbs (FIG. 30–54) supplied to him by friends who worked at a nearby hospital. For several months, according to Géricault's biographer, "his studio was a kind of morgue. He kept cadavers there until they were half-decomposed, and insisted on working in this charnel-house atmosphere…." However, he did not use cadavers for any specific figures in *The Raft of the Medusa*. Rather, he traced the outline of his final composition onto its large canvas, and then painted each body directly from a living model, gradually building up his composition figure by figure. He drew from corpses and body parts in his studio to make sure that he understood the nature of death and its impact on the human form.

Indeed, Géricault did not describe the actual physical condition of the survivors on the raft: exhausted, emaciated, sunburned, and close to death. Instead, following the Grand Manner, he gave his men athletic bodies and vigorous poses, evoking the work of Michelangelo and Rubens (see Chapters 21 and 23). He did this to generalize and ennoble his subject, elevating it above the particulars of a specific shipwreck in the hope that it would speak to more fundamental human conflicts: humanity against nature, hope against despair, and life against death.

Géricault exhibited *The Raft of the Medusa* (entitled *A Shipwreck* since identifying its actual subject overtly would have been too politically inflammatory) at the 1819 Salon, where it caused considerable controversy. Most contemporary French critics and royalists interpreted the painting as a political jibe at the king, on whose favor many academicians depended, while independent liberals praised Géricault's attempt to expose corruption. The debate raised

30–54 Théodore Géricault **STUDY OF HANDS AND FEET**
1818–1819. Oil on canvas, 20½ × 25³⁄₁₈" (52 × 64 cm).
Musée Fabre, Montpellier.

Credit: Musée Fabre de Montpellier Agglomération. Photo: Frédéric Jaulmes

the question of the point at which a painting crosses the line between art and political advocacy. Although it was intended to shock rather than to edify, the painting conforms to academy rules in every other way. The king refused to buy it, so Géricault exhibited *The Raft of the Medusa* commercially on a two-year tour of Ireland and England; the London exhibition alone attracted more than 50,000 paying visitors.

DELACROIX AND RUDE The French novelist Stendhal characterized the Romantic spirit when he wrote, "Romanticism in all the arts is what represents the men of today and not the men of those remote, heroic times which probably never existed anyway." Eugène Delacroix (1798–1863), the most important Romantic painter in Paris after Géricault's death, depicted contemporary heroes and victims engaged in the violent struggles of the times. In 1830, he created what has become his masterpiece, **LIBERTY**

LEADING THE PEOPLE: JULY 28, 1830 (FIG. **30–55**), a painting that encapsulated the history of France after the fall of Napoleon. When Napoleon was defeated in 1815, the victorious neighboring nations reimposed the French monarchy under Louis XVIII (ruled 1815–1824), brother of Louis XVI. The king's power was limited by a constitution and a parliament, but the government became more conservative as years passed, undoing many revolutionary reforms. Louis's younger brother and successor, Charles X (ruled 1824–1830), reinstated press censorship, returned education to the control of the Catholic Church, and limited voting rights. These actions triggered a large-scale uprising in the streets of Paris. Over the course of three days in July 1830, the Bourbon monarchical line was overthrown and Louis-Philippe d'Orléans (ruled 1830–1848) replaced his cousin Charles X, promising to abide by a new constitution. This period in French history is now referred to as the "July Monarchy."

30–55 Eugène Delacroix **LIBERTY LEADING THE PEOPLE: JULY 28, 1830**
1830. Oil on canvas, 8′6½″ × 10′8″ (2.6 × 3.25 m). Musée du Louvre, Paris.

Credit: Photo © Musée du Louvre, Dist. RMN-Grand Palais/Philippe Fuzeau

30–56 François Rude **DEPARTURE OF THE VOLUNTEERS OF 1792 (THE MARSEILLAISE)**
Arc de Triomphe, Place de l'Étoile, Paris. 1833–1836. Limestone, height approx. 42' (12.8 m).

Credit: © Kiev.Victor/Shutterstock

In his large modern history painting Delacroix memorialized the July 1830 revolution just a few months after it took place. Although it records aspects of the actual event, it also departs from the facts in ways that further the intended message. Delacroix's revolutionaries are a motley crew of students, artisans, day laborers, and even children and top-hatted intellectuals. They stumble forward through the smoke of battle, crossing a barricade of refuse and dead bodies. The towers of Notre-Dame loom through the smoke and haze of the background. This much of the work is plausibly accurate. Their leader, however, is an energetic, allegorical figure of Liberty, personified by a gigantic, muscular, half-naked woman charging across the barricade with the revolutionary flag in one hand and a bayoneted rifle in the other. Delacroix has placed a Classical allegorical figure within the battle itself, outfitted with a contemporary weapon and Phrygian cap—the ancient symbol for a freed slave that was worn by the insurgents. He presents the event as an emotionally charged moment just before the ultimate sacrifice, as the revolutionaries charge the barricades to near-certain death. This dramatic example of Romantic painting is full of passion, turmoil, and danger—part real and part dream.

Artists working for the July Monarchy increasingly used the more dramatic subjects and styles of Romanticism to represent the 1830 revolution, just as Neoclassical principles had been used to represent the previous one. Early in the regime, the minister of the interior decided, as an act of national reconciliation, to complete the triumphal arch on the Champs-Élysées in Paris begun by Napoleon in 1806. François Rude (1784–1855) received the commission for a sculpture to decorate the main arcade with a scene that commemorated the volunteer army that had halted a Prussian invasion in 1792–1793. Beneath the urgent exhortations of the winged figure of Liberty, the volunteers surge forward, some nude, others in Classical armor (**FIG. 30–56**). Despite these Classical details, the overall impact is Romantic. The crowded, excited group stirred patriotism in Paris, and the sculpture quickly became known simply as the *Marseillaise*, the name of the French national anthem written in 1792, the same year as the action depicted.

INGRES Jean-Auguste-Dominique Ingres (1780–1867), perhaps David's most famous student, served as director of the French Academy in Rome between 1835 and 1841. As a teacher and theorist, Ingres became one of the most influential artists of his time. His paintings offer another variant on the Romantic and Neoclassical, combining the precise drawing, formal idealization, Classical composition, and graceful lyricism of Raphael (SEE FIG. 21-7) with an interest in creating sensual and erotically charged images that appeal to viewers' emotions.

Although Ingres fervently desired to be accepted as a history painter, he was made famous by his paintings of male fantasies of female slaves and his portraits of aristocratic women. He painted numerous versions of the **odalisque**, an exoticized version of a female slave or harem concubine. In his **LARGE ODALISQUE** (FIG. 30-57), the woman's calm gaze is leveled directly at her master, while she twists her reclined, naked body in a snakelike, concealing pose of calculated eroticism. The saturated, cool blues of the couch and the curtain at the right set off the effect of her cool, pale skin and blue eyes, while the tight angularity of the crumpled sheets accentuates the sensual contours of her body. The exotic details of her headdress and the brush

of the peacock fan against her thigh only intensify her sensuality. Ingres's commitment to academic line and formal structure was grounded in his Neoclassical training, but his fluid, attenuated female nudes speak more strongly of the Romantic tradition.

Although Ingres complained that making portraits was a "considerable waste of time," his skill in rendering physical likeness with scintillating clarity and in mimicking in paint the material qualities of clothing, hairstyles, and jewelry was unparalleled. He painted many life-size and highly polished portraits, but he also produced—usually in just a day—exquisite, small portrait drawings that are extraordinarily fresh and lively. The charming **PORTRAIT OF MADAME DÉSIRÉ RAOUL-ROCHETTE** (FIG. 30-58) is a flattering yet credible representation of the relaxed and elegant sitter. Her gloved right hand draws attention to her social status; fine kid gloves were worn only by members of the upper class, who did not work with their hands. And her ungloved left hand reveals her marital status with a wedding band. Ingres renders her shiny taffeta dress, with its fashionably high waist and puffed sleeves, with great economy and spontaneity, using subdued marks that suggest rather than describe the

30–57 Jean-Auguste-Dominique Ingres **LARGE ODALISQUE**
1814. Oil on canvas, approx. 35 × 64″ (88.9 × 162.5 cm). Musée du Louvre, Paris.

During Napoleon's campaigns against the British in North Africa, the French discovered the exotic Near East. Upper-middle-class European men were particularly attracted to the institution of the harem, partly as a reaction against the egalitarian demands of women of their own class that had been unleashed by the French Revolution.

30–58 Jean-Auguste-Dominique Ingres **PORTRAIT OF MADAME DÉSIRÉ RAOUL-ROCHETTE**
1830. Graphite on paper, 12⅝ × 9½" (32.2 × 24.1 cm). Cleveland Museum of Art. Purchase from the J. H. Wade Fund (1927.437).

Madame Raoul-Rochette (1790–1878), née Antoinette-Claude Houdon, was the youngest daughter of the famous Neoclassical sculptor Jean-Antoine Houdon (SEE FIG. 30–42). In 1810, at age 20, she married Désiré Raoul-Rochette, a noted archaeologist, who later became the secretary of the Académie des Beaux-Arts (Academy of Fine Arts, founded in 1816 to replace the French Royal Academy of Painting and Sculpture) and a close friend of Ingres. Ingres's drawing of Madame Raoul-Rochette is inscribed to her husband ("Ingres to his friend and colleague, Mr. Raoul-Rochette"), whose portrait Ingres also drew around the same time.

fabric. As a result, emphasis rests on the sitter's face and elaborate coiffure, which Ingres has drawn precisely and modeled with subtle evocations of light and shade.

DAUMIER Honoré Daumier (1808–1879) came to Paris from Marseille in 1816. He studied drawing at the Académie Suisse, but he learned the technique of **lithography** (see "Lithography" on page 970) as assistant to the printmaker Bélaird. Daumier published his first lithograph in 1829 at age 21 in the weekly satirical magazine *La Silhouette*.

In the wake of the 1830 revolution in Paris, Daumier began supplying pictures to *La Caricature*, an anti-monarchist, pro-republican magazine, and the equally partisan *Le Charivari*, the first daily newspaper illustrated with lithographs. His 1834 lithograph calling attention to the atrocities on **RUE TRANSNONAIN** (FIG. **30–60**) was part

of a series of large prints sold by subscription to raise money for *Le Charivari*'s legal defense fund and thus further freedom of the press. A government guard had been shot and killed on the rue Transnonain—only a few blocks from Daumier's home—during a demonstration by workers, and in response, the riot squad killed everyone in the building where they believed the marksman was hiding. Daumier shows the bloody aftermath of the event: an innocent family disturbed from their sleep and then murdered. The wife lies in the shadows to the left, her husband in the center of the room, and an elderly man to the right. It takes a few minutes for viewers to realize that under the central figure's back there are also the bloody head and arms of a murdered child. Daumier was known for his biting caricatures and social commentary, but this image is one of his most powerful.

Technique

LITHOGRAPHY

Lithography, invented in the mid-1790s, is based on the natural antagonism between oil and water. The artist draws on a flat surface—traditionally, fine-grained stone (*lithos* is Greek for "stone")—with a greasy substance. After the drawing is completed, the stone's surface is wiped first with water and then with an oil-based ink. The ink adheres to the greasy areas but not to the damp ones. After a series of such steps, a sheet of paper is laid face down on the inked stone, pressed against it with a scraper, and then rolled through a flatbed press. This transfers ink from stone to paper, thus making lithography (like relief and intaglio) a direct method of creating a printed image. Unlike earlier processes, however, grease-based lithography enables the artist to capture the subtleties of drawing with crayon and a liquid mixture called *tusche*. Francisco Goya, Théodore Géricault, Eugène Delacroix, Honoré Daumier, and Henri de Toulouse-Lautrec used the medium to great effect.

Daumier was probably the greatest exponent of lithography in the nineteenth century. The technique was widely used in France for fine-art prints and to illustrate popular magazines and even newspapers. By the 1830s, the print trade in France had exploded. Artists could use lithography to produce their own prints without the cumbersome, expensive, and time-consuming intermediary of the engraver. Daumier's picture of **THE PRINT LOVERS** (**FIG. 30–59**) shows three men who have fixed their attention on the folio of prints in front of them, despite being surrounded by works of art packed tightly on the wall behind them. By the end of the nineteenth century, inexpensive prints were in every house and owned by people at every level of society.

30–59 Honoré Daumier **THE PRINT LOVERS**
c. 1863–1865. Watercolor, black pencil, black ink, gray wash, 10⅛ × 12⅛″ (25.8 × 30.7 cm). Musée du Louvre, Paris.

Credit: Photo © RMN-Grand Palais (musée du Louvre)

diagram of the lithographic process

30–60 Honoré Daumier **RUE TRANSNONAIN, LE 15 AVRIL 1834**
1834. Lithograph, 11 × 17⅜″ (28 × 44 cm). Yale Univesity Art Gallery. Everett V. Meeks, B.A. 1901, Fund (1982.120.4)

Credit: Image courtesy Yale University Art Gallery

Romantic Landscape Painting

The Romantics saw nature as ever-changing, unpredictable, and uncontrollable, and they saw in it an analogy to equally changeable human emotions. They found nature awesome, fascinating, powerful, domestic, and delightful, and landscape painting became an important visual theme in Romantic art.

CONSTABLE John Constable (1776–1837), the son of a successful miller, claimed that the quiet domestic landscape of his youth in southern England had made him a painter before he ever picked up a paintbrush. Although he was trained at the Royal Academy, he was equally influenced by the seventeenth-century Dutch landscape-painting tradition (SEE FIG. 23–45). After moving to London in 1816, he dedicated himself to painting monumental views of the agricultural landscape (known as "six-footers"), which he considered as important as history painting. Constable's commitment to contemporary English subjects was so strong that he opposed the establishment of the English National Gallery of Art in 1832 on the grounds that it might distract painters by enticing them to paint foreign or ancient themes in unnatural styles.

THE HAY WAIN (FIG. **30–61**) of 1821 shows a quiet, slow-moving scene with the fresh color and sense of visual exactitude that persuade viewers that it must have been painted directly from observation. But although Constable made numerous drawings and small-scale color studies for his paintings, the final works were carefully constructed images produced in the studio. (His paintings are very large, even for landscape themes of historic importance, never mind views derived from the local countryside.) *The Hay Wain* represents England as Constable imagined it had been for centuries—comfortable, rural, and idyllic. Even the carefully rendered and meteorologically correct details of the sky seem natural. The painting is, however, deeply nostalgic, harking back to an agrarian past that was fast disappearing in industrializing England.

TURNER Joseph Mallord William Turner (1775–1851) is often paired with Constable. The two were English landscape painters of roughly the same period, but Turner's career followed a different path. He entered the Royal Academy in 1789, was elected a full academician at the unusually young age of 27, and later became a professor at the Royal Academy Schools. By the late 1790s, he was

30–61 John Constable THE HAY WAIN

1821. Oil on canvas, 51¼ × 73″ (130.2 × 185.4 cm). National Gallery, London. Gift of Henry Vaughan, 1886.

Credit: © 2016. Copyright The National Gallery, London/Scala, Florence

30–62 Joseph Mallord William Turner **SNOWSTORM: HANNIBAL AND HIS ARMY CROSSING THE ALPS**
1812. Oil on canvas, 4′9″ × 7′9″ (1.46 × 2.39 m). Tate, London.

Credit: © akg-images/De Agostini Picture Library

30–63 Joseph Mallord William Turner **THE BURNING OF THE HOUSES OF LORDS AND COMMONS, 16TH OCTOBER 1834**
Oil on canvas, 36¼ × 48½″ (92.1 × 123.2 cm). Philadelphia Museum of Art.
The John Howard McFadden Collection, 1928.

Credit: © 2016. Photo The Philadelphia Museum of Art/Art Resource/Scala, Florence

exhibiting large-scale oil paintings of grand natural scenes and historical subjects, in which he sought to capture the **sublime**, a concept defined by philosopher Edmund Burke (1729–1797). According to Burke, when we witness something that instills fascination mixed with fear, or when we stand in the presence of something far larger than ourselves, our feelings transcend those we encounter in normal life. Such savage grandeur strikes awe and terror into the heart of the viewer, but there is no real danger. Because the sublime is experienced vicariously, it is thrilling and exciting rather than threatening, and it often evokes the transcendent power of God. Turner translated this concept of the sublime into powerful paintings of turbulence in the natural world and the urban environment.

His **SNOWSTORM: HANNIBAL AND HIS ARMY CROSSING THE ALPS** (FIG. 30-62) of 1812 epitomizes Romanticism's view of the awesomeness of nature. An enormous vortex of wind, mist, and snow masks the sun and threatens to annihilate the soldiers marching below it. Barely discernible in the distance is the figure of Hannibal, mounted on an elephant to lead his troops through the Alps toward their encounter with the Roman army in 218 BCE. Turner probably meant his painting as an allegory of the Napoleonic Wars. Napoleon himself had crossed the Alps, an event celebrated by David in his laudatory portrait (SEE FIG. 30-49). But while David's painting, which Turner saw in Paris in 1802, presented Napoleon as a powerful figure, commanding not only his troops but nature itself, Turner reduced Hannibal to a speck on the horizon, threatened with his troops by natural disaster, as if foretelling their eventual defeat.

Closer to home, Turner based another dramatic and thrilling work on the tragic fire that severely damaged London's historic Parliament building. Blazing color and light dominate **THE BURNING OF THE HOUSES OF LORDS AND COMMONS, 16TH OCTOBER 1834** (FIG. 30-63), and the foreground of the painting shows the south bank of the Thames packed with spectators. This fire was a national tragedy; these buildings had witnessed some of the most important events in English history. Turner himself was witness to the scene and hurriedly made watercolor sketches on site; within a few months he had the large painting ready for exhibition. The painting's true theme is the brilliant light and color that spirals across the canvas in the explosive energy of loose brushwork, explaining why Turner was called "the painter of light."

COLE AND FRIEDRICH Thomas Cole (1801–1848) was one of the first great professional landscape painters in the United States. Cole emigrated from England at age 17 and by 1820 was working as an itinerant portrait painter. With the help of a patron, he traveled in Europe between 1829 and 1832, and upon his return to the United States he settled in New York and became a successful landscape painter. He frequently worked from observation when making sketches for his paintings. In fact, his self-portrait is tucked into the foreground of **THE OXBOW** (FIG. 30-64), where he turns back to look at us while pausing from his work. He is executing an oil sketch on a portable easel, but like most landscape painters of his generation, he produced his large finished works in the studio during the winter months.

30-64 Thomas Cole **THE OXBOW** 1836. Oil on canvas, 51½ × 76″ (1.31 × 1.94 m). Metropolitan Museum of Art, New York. Gift of Mrs. Russell Sage, 1908 (08.228).

Credit: © 2016. Image copyright The Metropolitan Museum of Art/Art Resource/Scala, Florence

30–65 Caspar David Friedrich **ABBEY IN AN OAK FOREST**
1809–1810. Oil on canvas, 44 × 68½" (111.8 × 174 cm). Nationalgalerie, Berlin.

Credit: © Photo Scala, Florence/bpk, Bildagentur für Kunst, Kultur und Geschichte, Berlin. Photo: Joerg P. Anders

Cole painted this work in the mid-1830s for exhibition at the National Academy of Design in New York. He considered it one of his "view" paintings because it represents a specific place and time. Although most of his other view paintings were small, this one is monumentally large, probably because it was created for exhibition at the National Academy. Its scale allows for a sweeping view of a spectacular oxbow bend in the Connecticut River from the top of Mount Holyoke in western Massachusetts. Cole wrote that the American landscape lacked the historic monuments that made European landscape interesting; there were no castles on the Hudson River of the kind found on the Rhine, and there were no ancient monuments in America of the kind found in Rome. On the other hand, he argued, America's natural wonders, such as this oxbow, should be viewed as America's natural antiquities. The painting's title tells us that Cole depicts an actual spot, but, like other landscape painters who wished to impart a larger message about the course of history in their work, he composed the scene to stress the landscape's grandeur and significance, exaggerating the steepness of the mountain and setting the scene below a dramatic sky. Along a sweeping arc produced by the dark clouds and the edge of the mountain, he contrasts the two sides of the American landscape: its dense, stormy wilderness and its congenial, pastoral valleys with settlements. The fading storm seems to suggest that the land is bountiful and ready to yield its fruits to civilization.

In Germany, the Romantic landscape painter Caspar David Friedrich (1774–1840) saw landscape as a vehicle through which to achieve spiritual revelation. As a young man, he had been influenced by the writings and teachings of Gotthard Kosegarten, a local Lutheran pastor and poet who taught that the divine was visible through a deep personal connection with nature. Kosegarten argued that just as God's book was the Bible, the landscape was God's "Book of Nature." Friedrich studied at the Copenhagen Academy before settling in Dresden, where the poet Johann Wolfgang von Goethe encouraged him to make landscape the principal subject of his art. He sketched from nature but painted in the studio, synthesizing his sketches with his memories of and feelings about nature. In **ABBEY IN AN OAK FOREST** (FIG. 30-65), a funeral procession of monks in the lower foreground is barely visible through the gloom that seems to be settling heavily on the snow-covered world of human habitation. Most prominent are the boldly silhouetted trunks and bare branches of a grove of oak trees, and nestled among them the ruin of a Gothic wall, a formal juxtaposition that creates a natural cathedral from this cold and mysterious landscape.

British and American Architecture

A mixture of Neoclassicism and Romanticism motivated architects in the early nineteenth century, many of whom worked in either mode, depending on the task at hand. Neoclassicism in architecture often imbued secular public buildings with a sense of grandeur and timelessness, while Romanticism evoked, for instance, the Gothic past with its associations of spirituality and community.

GOTHIC ARCHITECTURE The British claimed the Gothic as part of their patrimony and erected many Gothic Revival buildings during the nineteenth century, prominent among them the new **HOUSES OF PARLIAMENT** (FIG. 30-66). After Westminster Palace burned in 1834 in

30–66 Charles Barry and Augustus Welby Northmore Pugin **HOUSES OF PARLIAMENT, LONDON**
1836–1860. Royal Commission on the Historical Monuments of England, London.

Pugin published two influential books in 1836 and 1841, in which he argued that the Gothic style of Westminster Abbey was the embodiment of true English genius. In his view, the Greek and Roman Classical orders were stone replications of earlier wooden forms and therefore fell short of the true principles of stone construction.

Credit: © S.Borisov/Shutterstock

the fire so memorably painted by Turner (SEE FIG. 30–63), the British government announced a competition for a new building to be designed in the English Perpendicular Gothic style, harmonizing with the neighboring thirteenth-century church of Westminster Abbey where English monarchs are crowned.

Charles Barry (1795–1860) and Augustus Welby Northmore Pugin (1812–1852) won the commission. Barry devised the essentially Classical plan of the new building, whose symmetry suggests the balance of powers within the British parliamentary system, while Pugin designed the intricate Gothic decoration. The leading advocate of Gothic architecture at this time, Pugin published *Contrasts* in 1836, in which he compared the troubled modern era of materialism and mechanization unfavorably with the Middle Ages, which he represented as an idyllic time of deep spirituality and satisfying handcraft. For Pugin, Gothic was not a style but a principle, like Classicism. The Gothic, he insisted, embodied two "great rules" of architecture: "first, that there should be no features about a building which are not necessary for convenience, construction or propriety; second, that all ornament should consist of enrichment of the essential structure of the building."

Most Gothic Revival buildings of this period, however, were churches, usually either Roman Catholic or Anglican (Episcopalian in the United States). The British-born American architect Richard Upjohn (1802–1878) designed many of the most important American examples, including **TRINITY CHURCH** in New York (FIG. 30–67). With its tall spire, long nave, and squared-off chancel, Trinity

30–67 Richard Upjohn **TRINITY CHURCH, NEW YORK CITY**
1839–1846.

Credit: Leo Sorel Photography

30–68 Karl Friedrich Schinkel **ALTES MUSEUM, BERLIN**
1822–1830.

Credit: © 2016. Photo Scala, Florence/bpk, Bildagentur für Kunst, Kultur und Geschichte, Berlin. Photo: Volker-H Schneider

Church quotes the early fourteenth-century British Gothic style particularly admired by Anglicans and Episcopalians. Every detail is rendered with historical accuracy, but the vaults are plaster, not masonry. The stained-glass windows above the altar were among the earliest of their kind in the United States.

NEOCLASSICAL ARCHITECTURE In several European capitals in the early nineteenth century, the Neoclassical designs of national museums positioned these buildings as both temples of culture and expressions of nationalism. Perhaps the most significant was the **ALTES MUSEUM** (Old Museum) in Berlin, designed in 1822 by Karl Friedrich Schinkel (1781–1841) and built between 1824 and 1830 (**FIG. 30–68**). Commissioned to display the royal art collection, the building was built directly across from the Baroque royal palace on an island in the Spree River in the heart of the city. The museum's imposing façade consists of a screen of 18 Ionic columns raised on a platform with a central staircase. Attentive to the problem of lighting artworks on both the ground and the upper floors,

Schinkel created interior courtyards on either side of a central rotunda. Tall windows on the museum's outer walls provide natural illumination, and partition walls perpendicular to the windows eliminate glare on the varnished surfaces of the paintings on display.

Neoclassical style was also popular for large public buildings in the United States, perhaps most significantly and symbolically in the U.S. Capitol, in Washington, DC, initially designed in 1792 by William Thornton (1759–1828), an amateur architect. His monumental plan featured a large dome over a temple front flanked by two wings to accommodate the House of Representatives and the Senate. In 1803, President Thomas Jefferson (1743–1826), also an amateur architect, hired a British-trained professional, Benjamin Henry Latrobe (1764–1820), to oversee the actual construction of the Capitol. Latrobe modified Thornton's design by adding a grand staircase and Corinthian colonnade on the east front (**FIG. 30–69**). After the British gutted the building in the war of 1812, Latrobe repaired the wings and designed a higher dome. Seeking new symbolic forms for the nation within the traditional Classical vocabulary, he also created a variation on the Corinthian order for the interior by substituting indigenous crops such as corn and tobacco for the Corinthian order's acanthus leaves. In 1817, Latrobe resigned his post. The reconstruction was completed under Charles

30–69 Benjamin Henry Latrobe **U.S. CAPITOL, WASHINGTON, DC**
c. 1808. Engraving by T. Sutherland, 1825. Library of Congress, Prints and Photographs division, Washington D.C.

Credit: Courtesy the Library of Congress

Bulfinch (1763–1844), and another major renovation, resulting in a much larger dome, began in 1850.

Thomas Jefferson's graceful designs for the mountaintop home he called **MONTICELLO** (Italian for "little mountain"), near Charlottesville, Virginia, employ Neoclassical architecture in a private setting (**FIG. 30-70**). Jefferson began the first phase of construction (1769–1782) when Virginia was still a British colony, using the English Palladian style (see Chiswick House, FIG. 30-15). By 1796, however, he had become disenchanted with both the English and their architecture and had come to admire French architecture while serving as the American minister in Paris. He then embarked upon a second building campaign at Monticello (1796–1809), enlarging the house and redesigning its brick and wood exterior so that its two stories appeared from the outside as one large story in the manner then fashionable in Paris. The modern worlds of England, France, and America, as well as the ancient worlds of Greece and Rome, come together in this residence. In the second half of the nineteenth century, cultural borrowings would take on an even broader global scope.

30-70 Thomas Jefferson **MONTICELLO**
Charlottesville, Virginia.
1769–1782, 1796–1809.

Credit: © Ffooter/Shutterstock

Think About It

1 Summarize some of the key stylistic traits of French Rococo art and architecture and explain how these traits relate to the social context of salon life. Then analyze one Rococo work from this chapter and explain how it is typical of the period style.

2 Explain why artists as visually diverse as Delacroix and Friedrich can be classified under the category of Romanticism. How useful is "Romanticism" as a classifying term?

3 How did the political climate during Francisco Goya's life affect his art? Focus your answer on a discussion of *Third of May, 1808* (**FIG. 30-45**).

4 Discuss the relationship of the Enlightenment interest in archaeology with the new movement of Neoclassicism in the eighteenth century.

Crosscurrents

Double portraits of couples are common in the history of European and American art. Assess the ways in which these two examples portray the nature of the marital relationship of these men and women. How do the portrayals represent the social structures and concerns of the cultural situations in which the couples lived?

FIG. 19-1

FIG. 30-1

31-1 Gustave Eiffel **EIFFEL TOWER, PARIS**

1889 (also the date of this photograph). Height 984′ (300 m).

Chapter 31

Mid- to Late Nineteenth-Century Art in Europe and the United States

 ## Learning Objectives

31.a Identify the visual hallmarks of mid- to late nineteenth-century European and American art and architecture for formal, technical, and expressive qualities.

31.b Interpret the meaning of works of mid- to late nineteenth-century European and American art based on their themes, subjects, and symbols.

31.c Relate mid- to late nineteenth-century European and American art and artists to their cultural, economic, and political contexts.

31.d Apply the vocabulary and concepts relevant to mid- to late nineteenth-century European and American art, artists, and art history.

31.e Interpret a work of mid- to late nineteenth-century European or American art using the art historical methods of observation, comparison, and inductive reasoning.

31.f Select visual and textual evidence in various media to support an argument or an interpretation of a work of mid- to late nineteenth-century European or American art or architecture.

The world-famous **EIFFEL TOWER** (**FIG. 31–1**) is a proud reminder of the nineteenth-century French belief in the progress and ultimate perfectibility of civilization through science and technology. Structural engineer Gustave Eiffel (1832–1923) designed and constructed the tower to serve as a monumental approach to the 1889 Universal Exposition in Paris. When completed, it stood 984 feet high and was the tallest structure in the world, taller than the Egyptian pyramids or Gothic cathedrals. The Eiffel Tower was the main attraction of the Universal Exposition, one of more than 20 such international fairs staged throughout Europe and the United States in the second half of the nineteenth century. These events showcased and compared international industry, science, and the applied, decorative, and fine arts. An object of pride for the French nation, the Eiffel Tower was intended to demonstrate France's superior engineering, technological, and industrial knowledge and power. Although originally conceived as a temporary structure, it still stands today.

The initial response to the Eiffel Tower was mixed. In 1887, a group of 47 writers, musicians, and artists wrote to *Le Temps* protesting "the erection … of the useless and monstrous Eiffel Tower," which they described as "a black and gigantic factory chimney." Gustave Eiffel, however, said, "I believe the tower will have its own beauty," and that it "will show that [the French] are not simply an amusing people, but also the country of engineers." Indeed, the Eiffel Tower quickly became an international symbol of advanced thought and modernity among artists and was admired by the public as a wondrous spectacle. Today it is the symbol of Paris itself.

The tower was one of the city's most photographed structures in 1889, its immensity dwarfing the seemingly tiny buildings below. Thousands of tourists to the Exposition bought souvenir photographs taken by professional and commercial photographers. This one shows the imposing structure rising above the exhibition buildings around and behind it along the Champ de Mars.

Europe and the United States in the Mid to Late Nineteenth Century

What are the political and social backgrounds for mid-to late nineteenth-century European and American art and architecture?

The technological, economic, and social transformations initiated by the Industrial Revolution intensified during the nineteenth century. Increasing demands for coal and iron prompted improvements in mining, metallurgy, and transportation. Likewise, the development of the locomotive and steamship facilitated the shipment of raw materials and merchandise, made passenger travel easier, and encouraged the growth of cities (**MAP 31–1**). These changes also set in motion a vast population migration, as the rural poor moved to cities to find work in factories, mines, and mechanical manufacturing. Industrialists and entrepreneurs enjoyed new levels of wealth and prosperity in this system, but conditions for workers—many of them women and children—were often terrible. Although new

government regulations led to some improvements, socialist movements condemned the exploitation of workers by capitalist factory owners and argued for communal or state ownership of the means of production and distribution.

In 1848, workers' revolts broke out in several European capitals, and Karl Marx and Friedrich Engels published the *Communist Manifesto*, which predicted the violent overthrow of the bourgeoisie (middle class) by the proletariat (working class); the abolition of private property; and the creation of a classless society. At the same time, the Americans Lucretia Mott and Elizabeth Cady Stanton organized the country's first women's rights convention, in Seneca Falls, New York. They called for the legal equality of women and men, property rights for married women, acceptance of women into institutions of higher education, admission of women to all trades and professions, equal pay for equal work, and women's right to vote.

The nineteenth century also saw the rise of imperialism. In order to create new markets for their products and to secure access to cheap raw materials and cheap labor, European nations established numerous new colonies by dividing up most of Africa and nearly a third of Asia. Colonial rule often suppressed indigenous cultures while

MAP 31–1 EUROPE AND THE UNITED STATES IN THE NINETEENTH CENTURY

In the nineteenth century, Europe and the United States became increasingly industrialized, and many European nations established colonial possessions around the world. Paris was firmly established as the center of the Western art world.

exploiting the colonies for the economic development of the European colonial powers.

Scientific discoveries led to the invention of the telegraph, telephone, and radio. By the end of the nineteenth century, electricity powered lighting, motors, trams, and railroads in most European and American cities. Developments in chemistry created many new products, such as aspirin, disinfectants, photographic chemicals, and more-effective explosives. Steel, a new alloy of iron and carbon, was lighter, harder, and more malleable than iron and replaced it in heavy construction and transportation. In medicine and public health, Louis Pasteur's purification of beverages through heat (pasteurization) and the development of vaccines, sterilization, and antiseptics led to a dramatic decline in mortality rates all over the Western world.

Some scientific discoveries challenged traditional religious beliefs and changed social philosophy. Geologists concluded that the Earth was far older than the estimated 6,000 years sometimes claimed by biblical literalists. In 1859, Charles Darwin proposed that life evolved gradually through natural selection. Religious conservatives attacked Darwin's account, which seemed to deny divine creation and even the existence of God. Some of Darwin's more extreme supporters, however, suggested that the "survival of the fittest" had advanced the human race, with certain types of people—particularly the Anglo-Saxon upper classes—achieving the pinnacle of social evolution. "Social Darwinism" provided a rationalization for the poor conditions of the working class and the colonization of the "underdeveloped" parts of the world.

Industrialists, merchants, professionals, the middle classes, some governments, and national academies of art became sources of patronage in the arts. Large annual exhibitions in European and American cultural centers took on increasing importance as a means for artists to show their work, win prizes, attract buyers, and gain commissions. Cheap illustrated newspapers and magazines published art criticism that influenced the reception and production of art, both making and breaking artistic careers, and commercial art dealers emerged as important brokers of taste.

The second half of the nineteenth century saw vast changes in how art was conceptualized and created. Some artists became committed political or social activists as industrialization and social unrest continued, while others retreated into their own imagination. Some responded to the ways in which photography transformed vision and perception, either setting themselves up as photographers or emulating the new medium's clarity in their own work. Many investigated the difference between photography's detailed but superficial description of visual reality and a deeper, more human reality as a source of inspiration—as well as the artistic potential of photography's sometimes visually unbalanced compositions, its tendency to compress the illusion of depth, its sharp framing and abrupt cropping, its lack of an even focus across the picture plane (or sometimes the reverse), and the inability of early photography to "see" red and green equally, causing undifferentiated areas of white and black in a photograph. By the end of the century, while many artists were still exploring the reliability of observed reality, others were venturing ever further into the realm of abstraction.

French Academic Architecture and Art

What are the hallmarks of academic taste in French art and architecture?

The Académie des Beaux-Arts (founded in 1816 to replace the disbanded Royal Academy of Painting and Sculpture) and its official art school, the École des Beaux-Arts, continued to exert a powerful influence over the visual arts in France during the nineteenth century. Academic artists controlled the Salon juries, and major public commissions routinely went to academic architects, painters, and sculptors. It was to Paris that artists and architects from Europe and the United States came to study the conventions of academic art.

Academic art and architecture frequently used motifs drawn from historic models—a practice called **historicism**. Elaborating on earlier Neoclassical and Romantic revivals, historicist art and architecture encompassed the sweep of history. Historicists often referred to several different historical periods in a single work. Some academic artists catered to the public taste for exotic sights with Orientalist paintings (see "Orientalism" on page 982). These works also combined disparate elements, borrowing from Egyptian, Turkish, and Indian cultures to create an imaginary Middle Eastern world.

Architecture

In 1848, after rioting over living conditions erupted in French cities, Napoleon III (ruled as emperor 1852–1870) launched sweeping new reforms. The riots had devastated Paris's central neighborhoods, and Georges-Eugène Haussmann (1809–1891) was engaged to redraw the street grid and rebuild the city. Haussmann imposed a new, rational plan of broad avenues, parks, and open public places upon the medieval heart of Paris. He demolished entire neighborhoods, erasing networks of narrow, winding, medieval streets and evicting the poor from their slums rapidly and without exceptions. Then he replaced what he had destroyed with grand new buildings erected along wide, straight, tree-lined avenues that were more suitable for horse-drawn carriages and strolling pedestrians.

Art and Its Contexts

ORIENTALISM

In **THE SNAKE CHARMER** (**FIG. 31–2**), French academic painter Jean-León Gérôme (1824–1904) creates a nineteenth-century fantasy of the Middle East—a characteristic example of **Orientalism**, the European fascination with Middle Eastern cultures. A young boy, entirely naked, handles a python, while an older man behind him plays a fipple flute, and an audience huddles within the background shadows in a blue-tiled room decorated with calligraphic patterns. Gérôme paints the scene with photographic clarity and scrupulous attention to detail, leading us to think that it is an accurate representation of a specific event and locale. He traveled to the Middle East several times and was praised by critics of the 1855 Salon for his ethnographic accuracy, but his *Snake Charmer* is a complete fiction, mixing Egyptian, Turkish, and Indian cultures together in a fantasized pastiche.

Orientalism dates to Napoleon's 1798 invasion of Egypt and his rampant looting of Egyptian objects for the Louvre Museum, which he opened in 1804, and the 24-volume *Description de l'Egypte* (1809–1822), recording Egyptian people, lands, and culture, that followed. In the 1840s and 1850s, British, French, and Italian photographers established studios at major tourist sites in the Middle East in order to provide photographs for both visitors and armchair tourists, thus fueling a popular interest in the region.

Characterizing both academic and avant-garde art in the nineteenth century, the scholar Edward Said described Orientalism as the colonial gaze upon the colonized Orient (the Middle East rather than Asia), seen as something to possess by the colonizer and as a "primitive" or "exotic" playground by the "civilized" European visitor. "Native" men become savage and despotic, and "native" women—and in this painting, boys—are sensuously described and sexually available.

31–2 Jean-Léon Gérôme
THE SNAKE CHARMER
c. 1870. Oil on canvas, 33 × 48⅛″ (83.8 × 122.1 cm). Clark Art Institute, Williamstown, Massachusetts. Acquired by Sterling and Francine Clark, 1942. (1955.51).

Credit: Bridgeman Images

The **OPÉRA** (**FIG. 31–3**), a city opera house designed by Charles Garnier (1825–1898) that is still a major Parisian landmark, was built at an intersection newly created by Haussmann's grand avenues. Accessible from many directions, the Opéra was designed with transportation and vehicular traffic in mind and had a modern cast-iron internal frame; yet in other respects it is a masterpiece of historicism derived mostly from the Baroque style, revived to recall an earlier period of greatness in France. The massive façade, featuring a row of paired columns over an arcade, refers to the seventeenth-century wing of the Louvre, an association meant to assert the continuity of the French nation and to flatter Napoleon III by comparing him favorably with Louis XIV. The building's primary function—as a place of entertainment for the emperor, his entourage, and the high echelons of French society—accounts for its luxurious exterior detail. The interior, described as a "temple of pleasure," was even more opulent, with neo-Baroque sculptural groupings, heavy gilded decoration, and a lavish mix of expensive, polychromed materials. More spectacular than any performance on stage was the one on the grand, sweeping Baroque staircase (**FIG. 31–4**), where members of the Paris elite displayed themselves. As Garnier said, the purpose of the Opéra was to fulfill the human desire to hear, to see, and to be seen.

31–3 Charles Garnier **OPÉRA, PARIS**

1861–1874.

Credit: © akg-images

31–4 GRAND STAIRCASE, OPÉRA

Credit: © John Kellerman/Alamy Stock Photo

Painting and Sculpture

The taste that dominated painting and sculpture in the Académie des Beaux-Arts by the mid nineteenth century is well represented by **THE BIRTH OF VENUS** by Alexandre Cabanel (1823–1889), one of the leading academic artists of the time (FIG. 31-5). After studying with an academic master, Cabanel won the Prix de Rome in 1845 and garnered top honors at the Salon three times in the 1860s and 1870s. In his version of this popular mythological subject (compare FIG. 20–35), Venus floats above the waves as flying *putti* playfully herald her arrival with conch shells. Cabanel's technical mastery of anatomy, flesh tones, and the rippling sea derives from his academic training. But the image also carries a strong erotic charge in the languid

limbs, arched back, and diverted eyes of Venus. The combination of mythological pedigree and sexual allure proved irresistible to Napoleon III, who bought *The Birth of Venus* for his private collection.

Although academic and avant-garde art are often seen as polar opposites, the relationship was more complex. Some academic artists experimented while maintaining academic conventions, while avant-garde artists held many academic practices in high esteem and sought academic approval. The academic artist Jean-Baptiste Carpeaux (1827–1875) illustrates the kind of experimentation that took place even within the academy. Carpeaux, who had studied at the École des Beaux-Arts under the Romantic sculptor François Rude (SEE FIG. 30–56), was commissioned to carve a large sculptural group for the façade of

31-5 Alexandre Cabanel **THE BIRTH OF VENUS**

1863. Oil on canvas, 52 × 90″ (1.35 × 2.29 m). Musée d'Orsay, Paris.

Credit: Photo © RMN-Grand Palais (musée d'Orsay)/ Hervé Lewandowski

Art and Its Contexts

THE MASS DISSEMINATION OF ART

Just as contemporary artists can distribute photographic reproductions of their work, artists in the nineteenth century used engraving or etching to reproduce their work for distribution to a larger audience.

Works of art that won prizes or created controversy were often engraved for reproduction by specialists in printmaking; the prints were sold at bookstores or magazine stands. J. M. W. Turner hired a team of engravers to capture the delicate tonal shadings of his works. An engraved copper plate could be printed upward of 100 times before the repeated pressing wore down the plate and affected image quality. In the later nineteenth century, artists increasingly used steel

engraving, wood engraving, and lithography for printing. These more durable surfaces could print up to 10,000 copies of an image without much loss of quality, though only a few artists experienced such demand.

One of the canniest self-marketers of the century was Alexandre Cabanel. After Napoleon III bought *The Birth of Venus* (SEE FIG. 31-5), the artist sold the reproduction rights to the art dealer Adolphe Goupil, who in turn hired other painters to create at least two smaller-scale copies of the work. After the original artist had approved the copies and signed them, the dealer used them as models for engravers who cut steel plates so prints could be made. The dealer then sold the painted copies.

Garnier's Opéra. His work, **THE DANCE** (FIG. 31–6), shows a winged male personification of Dance leaping up joyfully in the midst of a compact group of mostly nude female dancers, an image of uninhibited Dionysian revelry. Like Cabanel's *Birth of Venus*, the work imbues a mythological subject with an erotic charge.

Unlike Cabanel's figures, Carpeaux's were not smooth and generalized in a Neoclassical manner, and this drew criticism from some academicians. The arrangement of his sculptural group also seemed too spontaneous, the facial expressions of the figures too vivid, their musculature too exact, and their bone structure and proportions too much of this world, rather than reflections of an ideal one. Carpeaux's work signaled a new direction in academic art, responding to the values of a new generation of patrons from the industrial and merchant classes. These practical new collectors were less interested in art that idealized than in art that brought the ideal down to earth.

31-6 Jean-Baptiste Carpeaux THE DANCE
1867–1868. Plaster, height approx. 15′ (4.6 m).
Musée d'Orsay, Paris.

Credit: © akg-images/Erich Lessing

Early Photography in Europe and the United States

How does photography establish itself as a new art form?

The nineteenth-century desire to record the faces of the new mercantile elite, their achievements and possessions, and even the imperial possessions of nations, found expression in photography. Since the late Renaissance, artists and others had sought a mechanical method for drawing from nature. One early device was the camera obscura (Latin, meaning "dark chamber"), which consists of a darkened room or box with a lens through which light passes, projecting an upside-down image of the scene onto the opposite wall (or box side), which an artist can then trace. By the nineteenth century, a small, portable camera obscura or even lighter *camera lucida* had become standard equipment for artists. Photography developed as a way to fix—that is, to make permanent—the images produced by a camera obscura (later called simply a "camera") on light-sensitive material.

Photography had no single inventor. Several individuals worked on the technique simultaneously, each contributing some part to a process that emerged over many years. Around 1830, a handful of experimenters had found ways to "record" the image, but the last step, "stopping" or "fixing" that image so that further exposure to light would not further darken the image, was more challenging.

In France, while experimenting with ways to duplicate his paintings, Louis-Jacques-Mandé Daguerre (1787–1851) discovered that a plate coated with light-sensitive chemicals and exposed to light for 20 to 30 minutes would reveal a "latent image" when later exposed to mercury vapors. By 1837, he had developed a method of fixing his image by bathing the plate in a solution of salt, and he vastly improved the process by using the chemical hyposulfate of soda (known as "hypo") as suggested by Sir John Frederick Herschel (1792–1871). The final image was negative, but when viewed upon a highly polished silver plate it appeared positive. The resulting picture could not be duplicated easily and was very fragile,

Technique

THE PHOTOGRAPHIC PROCESS

A camera is essentially a lightproof box with a hole, called an aperture, which is usually adjustable in size and controls how much light reaches the film. The aperture is covered with a lens, to focus the image on the film, and a shutter, a hinged flap that opens for a controlled amount of time to expose the film to light—usually a small fraction of a second. Small, modern cameras with viewfinders are usually used at eye level; looking through them, the photographer sees almost the same image that will be captured on film.

In black-and-white chemical photography, silver halide crystals (silver combined with iodine, chlorine, or other halogens) are suspended in a gelatin base to make an emulsion that coats the film; in early photography, before the invention of plastic, a glass plate was coated with a variety of emulsions. When the shutter is open, light reflected off objects enters the camera and strikes the film, exposing it. Pale objects reflect more light than dark ones. The silver in the emulsion collects most densely where it is exposed to the most light, producing a "negative" image on the film. Later, when the film is placed in a chemical bath (developed), the silver deposits turn black, as if tarnishing. The more light the film receives in the camera, the denser the black tone created by the chemicals. The final image is created in the darkroom, where the film (now called a negative) is placed over a sheet of paper that, like the film, has been treated to make it light-sensitive. Light is directed through the negative onto the paper to create a positive image. Multiple positive prints can be generated from a single negative.

Today the chemical process has been largely replaced by digital photography, which records images as digital information files that can be manipulated on computers rather than in darkrooms. Exploiting the artistic potential of this new photographic medium is a major preoccupation of contemporary artists.

but its quality was remarkably precise. In Daguerre's photograph of his studio tabletop (FIG. 31–7) the details are exquisite (though impossible to see in reproduction, even using today's technology), and the composition mimics the conventions of still-life painting. Daguerre, after he patented and announced his new technology, produced an early type of photograph called a **daguerreotype** in August 1839.

Even before Daguerre announced his photographic technique in France, the American artist Samuel Finley Breese Morse (1791–1872) traveled to Paris to exchange information about his own invention, the telegraph, for information about Daguerre's photography. Morse introduced the daguerreotype process to America within weeks of Daguerre's announcement and by 1841 had reduced exposure times enough to take portrait photographs (FIG. 31-8).

**31–7 Louis-Jacques-Mandé Daguerre
THE ARTIST'S STUDIO**
1837. Daguerreotype, 6½ × 8½″ (16.5 × 21.6 cm).
Société Française de Photographie, Paris.

Credit: © akg-images

At the same time in England, Henry Fox Talbot (1800–1877), a wealthy amateur, made negative copies of engravings, lace, and plants by placing them on paper soaked in silver chloride and exposing them to light. He also discovered that the negative image on paper could be exposed again on top of another piece of paper to create a positive image: the negative–positive process that became the basis of photographic printing. Talbot's negative could be used more than once, so he could produce a number of positive images inexpensively. But the **calotype**, as he later called it, produced a soft, fuzzy image. When he heard of Daguerre's announcement, Talbot rushed to make his own announcement and patent his process. The term for these processes—photography, derived from the Greek for "drawing with light"—was coined by Herschel.

Photography was quickly put to use in making visual records of the world. From the beginning, however, photographers also experimented with the expressive possibilities of the new medium and worked to create striking compositions. Between 1844 and 1846, Talbot published a book in six parts entitled *The Pencil of Nature*, illustrated entirely with salt-paper prints made from calotype negatives. Most of the photographs were of idyllic rural scenery or carefully arranged still lifes; they were presented as works of art rather than documents of reality. Talbot realized that the imprecision of his process could not compete with the commercial potential of the daguerreotype, and so rather than trying to do so, he chose to view photography in visual and artistic terms. In **THE OPEN DOOR** (**FIG. 31-9**), for example, shadows create a repeating pattern of diagonal lines that contrast with the rectilinear lines of the architecture. And it conveys meaning, expressing

31-8 DAGUERREOTYPE OF SAMUEL FINLEY BREESE MORSE

c. 1845. Sixth-plate daguerreotype, 2¾ × 3¼" (7 × 8.3 cm). The Daguerreotype Collection of the Library of Congress, Washington, DC.

Credit: Courtesy the Library of Congress

nostalgia for a rural way of life that was fast disappearing in industrial England.

In 1851, Frederick Scott Archer, a British sculptor and photographer, took a major step in the development of early photography. Archer found that silver nitrate would adhere to glass if it was mixed with collodion, a combination of guncotton, ether, and alcohol used in medicinal bandages. When wet, this collodion–silver nitrate mixture needed only a few seconds' exposure to light to create an image. The result was a glass negative, from which countless positive proofs with great tonal subtleties could be made.

31-9 Henry Fox Talbot
THE OPEN DOOR

1843. Salt-paper print from a calotype negative, 5⅝ × 7¹¹⁄₁₆" (14.3 × 19.5 cm). Science Museum, London. Fox Talbot Collection.

Credit: © National Media Museum/Science & Society Picture Library

31–10 Alexander Gardner **THE HOME OF THE REBEL SHARPSHOOTER: BATTLEFIELD AT GETTYSBURG**

1863. Albumen print, 7 × 9″ (18 × 23 cm). Library of Congress, Washington, DC.

Credit: Courtesy the Library of Congress

Alexander Gardner and Julia Margaret Cameron

American photographers used this newly refined process to document the momentous events of the Civil War (1861–1865) in artfully composed pictures. Alexander Gardner (1821–1882) was a "camera operator" for Mathew Brady (1822–1896) at the beginning of the conflict and working with an assistant, Timothy O'Sullivan (c. 1840–1882), made war photographs that were widely distributed. **THE HOME OF THE REBEL SHARPSHOOTER** (**FIG. 31–10**) was taken after the Battle of Gettysburg in July 1863. The technical difficulties were considerable. The glass plate used to make the negative had to be coated with a sticky substance holding the light-sensitive chemicals. If the plate dried, the photograph could not be taken, and if dust contaminated the plate, the image would be ruined. Since long exposure times made action photographs impossible, early war photographs were taken in camp or in the aftermath of battle. Gardner's image seems to show a sharpshooter who has been killed in his look-out. But this rock formation was in the middle of the battlefield and had neither the height nor the view needed for a sharpshooter. In fact, the photographers dragged the dead body to the site and posed it; the rifle propped against the wall was theirs. The staging of this photograph raises questions about visual fact and fiction. Like a painting, a photograph is composed to create a picture, but photography promises a kind of factuality that we do not expect from painting. Interestingly, the manipulation of this photograph

31–11 Julia Margaret Cameron **PORTRAIT OF THOMAS CARLYLE**

1867. Silver print, 10 × 8″ (25.4 × 20.3 cm). The Royal Photographic Society, Collection at the National Museum of Photography, Film, and Television, England.

Credit: © National Media Museum/Science & Society Picture Library

did not concern nineteenth-century viewers, who understood clearly that photography could not record the visual world without bias.

One of the most creative early photographers was Julia Margaret Cameron (1815–1879), who received her first camera as a gift from her daughters when she was 49. Her principal subjects were the great men and women of British arts, letters, and sciences, many of whom had long been family friends. Cameron's approach was experimental and radical. Like many of her portraits, that of the famous British historian **THOMAS CARLYLE** is deliberately slightly out of focus (**FIG. 31-11**): Cameron consciously rejected the sharp focus of commercial portrait photography, which she felt accentuated the merely physical attributes and neglected the inner character of the subject. By blurring the details, she sought to call attention to the light that suffused her subjects and to their thoughtful expressions. In her autobiography, Cameron said, "When I have had such men before my camera my whole soul has endeavoured to do its duty towards them in recording faithfully the greatness of the inner as well as the features of the outer man."

Realism and the Avant-Garde

How do Realism and the avant-garde in art represent the rejection of academic taste and practice, fueled by social and political concerns?

In reaction to the rigidity of academic training, some French artists began to consider themselves members of an **avant-garde**, meaning "advance guard" or "vanguard." The term was coined by the French military during the Napoleonic era to designate the forward units of an advancing army that scouted territory that the main force would soon occupy. Avant-garde artists saw themselves as working in advance of an increasingly bourgeois society. The term was first mentioned in connection with art around 1825 in the political programs of French utopian socialists. Henri de Saint-Simon (1760–1825) suggested that in order to transform modern industrialized society into an ideal state, it would be necessary to gather together an avant-garde of intellectuals, scientists, and artists to lead France into the future.

In 1831, the architect Eugène Viollet-le-Duc applied the term to the artists of Paris in the aftermath of the revolution of 1830. Viollet-le-Duc vehemently opposed the French academic system of architectural training. His concept of the avant-garde called for a small elite of independent radical thinkers, artists, and architects to break away from the Académie des Beaux-Arts and the norms of society in order to forge new thoughts, ideas, and ways

of looking at the world and art. He foresaw that this life would require the sacrifice of artists' reputations and reduce sales of their work. Most avant-garde artists were neither as radical nor as extreme as Viollet-le-Duc, and, as we have seen, the relationship between the Académie des Beaux-Arts and the avant-garde was complex. Nonetheless, the idea was embraced by a number of artists who have come to characterize the period.

Realism and Revolution

In the modern world of Paris at mid-century—a world plagued by violence, social unrest, overcrowding, and poverty—the grand, abstract themes of academic art seemed irrelevant to the thinkers who would come to represent the avant-garde. Rising food prices, high unemployment, political disenfranchisement, and government inaction ignited in a popular rebellion known as the Revolution of 1848, led by a coalition of socialists, anarchists, and workers. It brought an end to the July Monarchy and established the Second Republic (1848–1852). Conflicts among the reformers, however, led to another uprising, in which more than 10,000 of the working poor were killed or injured in their struggle against the new government's forces. Against this social and political backdrop a new intellectual movement known as Realism originated in the novels of Émile Zola, Charles Dickens, Honoré de Balzac, and others who wrote about the real lives of the urban lower classes. What art historians have labeled Realism is less of a style than a commitment to paint the modern world honestly, without turning away from the brutal truths of life for all people, poor as well as privileged.

COURBET Gustave Courbet (1819–1877) was one of the first artists to call himself avant-garde or a Realist. A big, blustery man, he was, in his own words, "not only a Socialist but a democrat and a Republican: in a word, a supporter of the whole Revolution." Born and raised near the Swiss border in the French town of Ornans, he moved to Paris in 1839. The street fighting in Paris in 1848 radicalized him and became a catalyst for two large canvases that have come to be regarded as the defining works of the Realist Movement.

Painted in 1849, the first of these, **THE STONE BREAKERS** (**FIG. 31-12**), depicts a young boy and an old man crushing rock to produce the gravel used for roadbeds. Stone breakers represent the disenfranchised peasants on whose backs modern life was being built. The younger figure strains to lift a large basket of rocks to the side of the road, dressed in tattered shirt and trousers but wearing modern work boots. His older companion, seemingly broken by the lowly work, pounds the rocks as he kneels, wearing the more traditional clothing of a peasant, including wooden clogs. The boy thus seems to represent a grim future,

31–12 Gustave Courbet
THE STONE BREAKERS
1849. Oil on canvas, 5'3" × 8'6"
(1.6 × 2.59 m). Formerly
Gemäldegalerie, Dresden;
destroyed in World War II.

Credit: © Staatliche Kunstsammlungen
Dresden/Bridgeman Images

while the man signifies an increasingly obsolete rural past. Both are conspicuously faceless.

Courbet recorded his inspiration for this painting:

> [N]ear Maisières [in the vicinity of Ornans], I stopped to consider two men breaking stones on the highway. It's rare to meet the most complete expression of poverty, so an idea for a picture came to me on the spot. I made an appointment with them at my studio for the next day…. On the one side is an old man, seventy…. On the other side is a young fellow … in his filthy tattered shirt…. Alas, in labor such as this, one's life begins that way, and it ends the same way.

Two things are clear from this description: Courbet set out to make a political statement, and he invited the men back to his studio so that he could study them more carefully, following academic practice.

By depicting labor at the size of a history painting—the canvas is over 5 by 8 feet—Courbet intended to provoke. In academic art, monumental canvases were reserved for heroic subjects, so Courbet was asserting that peasant laborers should be venerated as heroes. Bypassing the highly finished style and inspiring message of history painting, he signifies the brutality of modern life in his rough use of paint and choice of dull, dark colors, awkward poses, and a stilted composition. The scene feels realistically gloomy

31–13 Gustave Courbet **A BURIAL AT ORNANS**
1849. Oil on canvas, 10'3½" × 21'9" (3.1 × 6.6 m). Musée d'Orsay, Paris.

Credit: Photo © RMN-Grand Palais (musée d'Orsay)/Gérard Blot/Hervé Lewandowski

and degrading. In 1865 his friend the anarchist philosopher Pierre-Joseph Proudhon (1809–1865) described *The Stone Breakers* as the first socialist picture ever painted, "an irony of our industrial civilization, which continually invents wonderful machines to perform all kinds of labor … yet is unable to liberate man from the most backbreaking toil." Courbet himself described the work as a portrayal of "injustice."

Courbet began to paint **A BURIAL AT ORNANS** (FIG. **31-13**) immediately after *The Stone Breakers* and exhibited the two paintings together at the 1850–1851 Salon. *A Burial at Ornans* was inspired by the 1848 funeral of Courbet's maternal grandfather, Jean-Antoine Oudot, a veteran of the French Revolution of 1789. It is not meant as a record of that particular funeral, however, since Oudot is shown alive in profile at the extreme left of the canvas, his image adapted by Courbet from an earlier portrait. The two men to the right of the open grave, dressed not in contemporary but in late eighteenth-century clothing, are also revolutionaries of Oudot's generation. Their proximity to the grave suggests that one of their peers is being buried. Perhaps Courbet's picture links the revolutions of 1789 and 1848, both of which sought to advance the cause of democracy in France.

This is a vast painting, measuring roughly 10 by 21 feet, and depicts a rural burial life-size. A crush of people forms irregular rows across the width of the picture. The gravedigger kneels over the gaping hole in the ground, placed front and center and flanked by a bored altar boy and a distracted dog; to the left, clergy dressed in red seem indifferent while to the right, the huddle of rural mourners—Courbet's heroes of modern life—weeps. Although painted

on a scale befitting the funeral of a hero, Courbet's depiction has none of the idealization of traditional history painting; instead, it captures the awkward, blundering numbness of a real funeral and emphasizes its brutal, physical reality. When shown at the Salon, the painting was attacked by critics who objected to the elevation of a provincial funeral to this heroic scale, to Courbet's disrespect for the rules of academic composition, and even to the painting's lack of any suggestion of the afterlife. But Courbet had submitted his work to the Salon knowing that it would be denounced; he wanted to challenge the prescribed subjects, style, and finish of academic painting, to establish his position in the avant-garde, and to create controversy. After the rejection of some of his works by the International Exposition of 1855, Courbet constructed a temporary building on rented land near the fair's Pavilion of Art and installed a show of his own works that he called the "Pavilion of Realism," boldly asserting his independence from the Salon. Many artists after him would follow in his footsteps.

MILLET Similar accusations of political radicalism were leveled against Jean-François Millet (1814–1875). This artist grew up on a farm and despite living and working in Paris between 1837 and 1848, he never felt comfortable with urban life. A state commission (with stipend) awarded for his part in the 1848 revolution allowed him to move to the village of Barbizon, just south of Paris, where he painted the hardships and pleasures of the rural poor.

Among his best-known works is **THE GLEANERS** (FIG. **31-14**), which shows three women gathering stray grain

31-14 Jean-François Millet **THE GLEANERS** 1857. Oil on canvas, 33 × 44" (83.8 × 111.8 cm). Musée d'Orsay, Paris.

Credit: Photo © RMN-Grand Palais (musée d'Orsay)/Jean Schormans

from the ground after harvest. Despite its soothing, warm colors, the scene is one of extreme poverty. Gleaning was a form of relief offered to the rural poor by landowners, but it required hours of backbreaking work to collect enough wheat to make a single loaf of bread. Two women bend over to reach the tiny stalks of grain remaining on the ground, while a third straightens to ease her back. When Millet exhibited the painting in 1857, critics noted its implicit social criticism and described the work as "Realist." Millet denied the accusations, but his paintings contradict him.

COROT The landscape paintings of Jean-Baptiste-Camille Corot (1796–1875) take a more romantic and less political approach to depicting rural life. After painting historical landscapes early in his career, Corot steadily moved toward more naturalistic and intimate scenes of rural France. **FIRST LEAVES, NEAR MANTES** (FIG. 31–15) depicts a scene infused with the soft mist of early spring in the woods. Corot's feathery brushwork representing soft, new foliage contrasts with the stark, vertical tree trunks and branches and together with the fresh green of the new undergrowth evokes a lyrical mood. A man and woman pause to talk on the road winding from left to right through the painting, while a woman labors in the woods

at the lower right. These images of peaceful country life held great appeal for Parisians who had experienced the chaos of the 1848 revolution and who lived in an increasingly crowded, noisy, and fast-paced metropolis.

BONHEUR Rosa Bonheur (1822–1899) was one of the most popular French painters of farm life. Her success in a male domain owed much to the socialist convictions of her parents, who belonged to a radical utopian sect founded by the Comte de Saint-Simon that believed not only in the equality of women but also in a future female Messiah. Bonheur's father, a drawing teacher, provided most of her artistic training.

Bonheur dedicated herself to accurate depictions of modern draft animals, which were becoming increasingly obsolete as technology and industrialization transformed farming. She studied her subjects by reading zoology books and making detailed studies in stockyards and slaughterhouses; to gain access to these all-male preserves, she had to obtain police permission to dress in men's clothing. Her professional breakthrough came at the Salon of 1848, where she showed eight paintings and won a first-class medal. **THE HORSE FAIR** (FIG. 31–16), painted in 1853, was based on a horse market near Salpêtrière, but

31–15 Jean-Baptiste-Camille Corot **FIRST LEAVES, NEAR MANTES**
c. 1855. Oil on canvas, 13⅜ × 18⅛" (34 × 46 cm). Carnegie Museum of Art, Pittsburgh, Pennsylvania.

Credit: Photograph © 2016 Carnegie Museum of Art, Pittsburgh. Photo: Richard Stoner

31–16 Rosa Bonheur **THE HORSE FAIR**
1853–1855. Oil on canvas, 8′1¼″ × 16′7½″ (2.45 × 5.07 m). Metropolitan Museum of Art, New York.

Credit: © 2016. Image copyright The Metropolitan Museum of Art/Art Resource, NY/ Scala, Florence

was also partly inspired by the Parthenon marbles in London and by the art of Géricault. The scene shows grooms displaying splendid Percheron horses, some walking obediently in their circle, others rearing up. Some have interpreted the painting as a commentary on the lack of rights for women in the 1850s, but it was not read that way at the time. Although unusually monumental for a painting of farm animals, it was highly praised at the 1853 Salon. When the painting later toured throughout Britain and the United States, members of the public paid to see it, and it was widely disseminated in print form on both sides of the Atlantic. In 1887, Cornelius Vanderbilt purchased it for the new Metropolitan Museum of Art in New York. Bonheur became so famous working within the Salon system that in 1865 she received France's highest award, membership in the Legion of Honor, becoming the first woman to be awarded its Grand Cross.

Manet: "The Painter of Modern Life"

Along with the concept of the avant-garde, the idea of "modernity" also shaped art in France at this time. The experience of modern life—of constant change and renewal—was linked to the dynamic nature of the city. Themes of the modern city and of political engagement with modern life in an industrialized world are key to understanding the development of painting and literature in France in the second half of the nineteenth century.

In his 1863 essay "The Painter of Modern Life," poet Charles Baudelaire argued that in order to speak for their time and place, artists' work had to be infused with

modernity. He called for artists to be painters of contemporary manners and "of the passing moment and of all the suggestions of eternity that it contains," using both modern urban subjects and new approaches to seeing and representing the visual world. This break with the past was critical in order to comprehend and comment on the present. Especially after the invention of photography, art was expected to offer new ways of representing reality. One artist who rose to Baudelaire's challenge was the French painter Édouard Manet (1832–1883).

LUNCHEON ON THE GRASS At mid-century, the Académie des Beaux-Arts increasingly opened Salon exhibitions to non-academic artists, resulting in a surge in the number of works submitted, and inevitably rejected by, the Salon jury. In 1863, the jury turned down nearly 3,000 works. A storm of protest erupted, prompting Emperor Napoleon III to order an exhibition of the rejected work called the "Salon des Refusés" ("Salon of the Rejected Ones"). Featured in it was Manet's painting **LUNCHEON ON THE GRASS (LE DÉJEUNER SUR L'HERBE)** (**FIG. 31–17**). A well-born Parisian who had studied in the early 1850s with the independent artist Thomas Couture (1815–1879), Manet had by the early 1860s developed a strong commitment to Realism and modernity, largely as a result of his friendship with Baudelaire. *Luncheon on the Grass* scandalized contemporary viewers all the way up to Napoleon III himself, provoking a critical avalanche that mixed shock with bewilderment. Ironically, the resulting *succès de scandale* ("success from scandal") helped establish Manet's career as a radical, avant-garde, modern artist.

The most scandalous aspect of the painting was the "immorality" of Manet's theme: a suburban picnic featuring two fully dressed bourgeois gentlemen seated alongside a completely naked woman with another scantily dressed woman in the background. Manet's audience assumed that these women were prostitutes, and the men their customers. Equally shocking were the painting's references to important works of art of the past, which Académie des Beaux-Arts artists were expected to make, combined with its crude, unvarnished modernity. In contrast, one of the paintings that gathered most renown at the official Salon in that year was Alexandre Cabanel's *Birth of Venus* (SEE FIG. 31-5), which, because it presented nudity in a conventionally acceptable, Classical environment and mythological context, was favorably reviewed and quickly entered the collection of Napoleon III.

Manet apparently conceived of *Luncheon on the Grass* as a modern version of a Venetian Renaissance painting in the Louvre, *The Pastoral Concert*, then believed to be by Giorgione but now attributed to both Titian and Giorgione

or to Titian exclusively (SEE FIG. 21-27). Manet's composition also refers to a Marcantonio Raimondi engraving of Raphael's *The Judgment of Paris*, itself based on Classical reliefs of river gods and nymphs. Presenting the seamier side of city life in the guise of Classical art was intentionally provocative. And the stark lighting and sharp outlining of his nude, the cool colors, and the flat quality of his figures, who seem as if they are silhouetted cut-outs set against a painted backdrop, were unsettling to viewers accustomed to traditional, controlled gradations of shadows modeling smoothly rounded forms in perspectively mapped spaces.

OLYMPIA Shortly after completing *Luncheon on the Grass*, Manet painted **OLYMPIA** (FIG. 31-18), its title alluding to a socially ambitious prostitute of the same name in a novel and play by Alexandre Dumas the Younger. Like *Luncheon on the Grass*, Manet's *Olympia* was based on a Venetian Renaissance source, Titian's *"Venus" of Urbino* (SEE FIG. 21-30), which Manet had earlier copied in Florence.

31–17 Édouard Manet **LUNCHEON ON THE GRASS (LE DÉJEUNER SUR L'HERBE)**
1863. Oil on canvas, 7′ × 8′8″ (2.13 × 2.64 m). Musée d'Orsay, Paris.

Credit: Photo © RMN-Grand Palais (musée d'Orsay)/Hervé Lewandowski

31–18 Édouard Manet **OLYMPIA**
1863. Oil on canvas, 4'3" × 6'2¼" (1.31 × 1.91 m). Musée d'Orsay, Paris.

Credit: Photo © RMN-Grand Palais (musée d'Orsay)

At first, his painting appears to pay homage to Titian's in its subject matter (at that time believed to be a Venetian courtesan) and composition, but Manet made his reclining nude the very antithesis of Titian's. Titian's female is curvaceous and softly rounded; Manet's is angular and flattened. Titian's colors are warm and rich; Manet's are cold and harsh. Titian's "Venus" looks coyly at the male spectator; Manet's Olympia appears indifferent. And instead of looking up at us, Olympia gazes down at us, indicating that she is in the position of power and that we are subordinate, like the black servant at the foot of the bed who brings her a bouquet of flowers. Olympia's relationship with us is underscored by her cat, which—unlike the sleeping dog in the Titian—arches its back at the viewer. Manet overturns the entire tradition of the accommodating female nude. Not surprisingly, conservative critics vilified *Olympia* when it was exhibited at the Salon of 1865.

Manet generally submitted his work to every Salon, but when several were rejected in 1867, he did as Courbet had done in 1855: He asserted his independence by renting a hall nearby and staging his own show. This made Manet the unofficial leader of a group of forward-thinking artists and writers who gathered at the Café Guerbois in the Montmartre district of Paris. Among the artists who frequented the café were Edgar Degas, Claude Monet,

Camille Pissarro, and Pierre-Auguste Renoir, all of whom would soon exhibit together as the Impressionists and follow Manet's lead in challenging academic conventions.

LATER WORKS Manet worked closely with all of these artists and frequently painted themes similar to those favored by the Impressionists, but he always retained his dedication to the portrayal of modern urban life. In his last major painting, **A BAR AT THE FOLIES-BERGÈRE (FIG. 31–19)**, he maintains his focus on the complex theme of gender and class relations. A young woman serves drinks at a bar in the famous nightclub that offered circuses, musicals, and vaudeville acts (note the legs of a trapeze artist in the upper left corner of the painting). She has an unfashionably ruddy face, and her hands look raw. In the glittering light created by the electric bulbs and mirrors of the music hall she seems stiff and distant, certainly self-absorbed, and perhaps even depressed, refusing to meet the gaze of the customer in front of her. The barmaid is at once detached from the scene and part of it, one of the many items among the still life of liquor bottles, tangerines, and flowers on display for purchase. This image is about sexualized looking, and the barmaid's uneasy reflection in the mirror seems to acknowledge that both her class and gender expose her to visual and even sexual consumption.

31–19 Édouard Manet
A BAR AT THE FOLIES-BERGÈRE
1881–1882. Oil on canvas.
37¾ × 51¼″ (95.9 × 130 cm).
The Samuel Courtauld
Trust, the Courtauld Gallery,
London. (P.1934.SC.234).

Credit: © Samuel Courtauld Trust,
The Courtauld Gallery, London,
UK/Bridgeman Images

Responses to Realism beyond France

Artists of other nations embraced their own forms of realism in the period after 1850 as the social effects of urbanization and industrialization began to be felt in their countries. While these artists did not label themselves as Realists like their contemporaries in France, they did share an interest in presenting unflinching looks at reality that exposed the difficult lives of the working poor and the complexities of urban life.

REALISM IN RUSSIA: THE WANDERERS In Russia, a variant on French Realism developed in relation to a new concern for the peasantry. In 1861, the tsar abolished serfdom, emancipating Russia's peasants from the virtual slavery they had endured on the large estates of the aristocracy. Two years later, a group of painters inspired by the emancipation declared allegiance both to the peasant cause and to freedom from the St. Petersburg Academy of Art, which had controlled Russian art since 1754. Reacting against what they considered the escapist aesthetics of the academy, the members of the group dedicated themselves to a socially useful realism. Committed to bringing art to the people in traveling exhibitions, they called themselves "the Wanderers." By the late 1870s, members of the group, like their counterparts in music and literature, had also joined a nationalist movement to reassert what they considered to be an authentic Russian culture rooted in the traditions of the peasantry, rejecting the Western European customs that had long predominated among the Russian aristocracy.

Ilya Repin (1844–1930), who attended the St. Petersburg Academy and won a scholarship to study in Paris, joined the Wanderers in 1878 after his return to Russia. He painted a series of works illustrating the social injustices then prevailing in his homeland, including **BARGEHAULERS ON THE VOLGA** (**FIG. 31-20**), which features a group of peasants condemned to the brutal work of pulling ships up the Volga River. To heighten our sympathy for these workers, Repin placed in the center of the group a young man who will soon be as worn out as his companions unless something is done to rescue him. This painting was a call to action.

REALISM IN THE UNITED STATES: A CONTINUING TRADITION Although it was not a term used in the United States, realism—often with a political edge—was an unbroken tradition stretching back to colonial portrait painters (SEE FIG. 30-1) and continuing in the pioneering work of photographers during the Civil War (SEE FIG. 31-10). There were several kinds of realism in later nineteenth-century American art. Thomas Eakins (1844–1916), for instance, made a series of uncompromising paintings that were criticized for their controversial subject matter. Born in Philadelphia, Eakins trained at the Pennsylvania Academy of the Fine Arts, but since he thought the training in anatomy lacked rigor, he supplemented his studies at the Jefferson Medical College nearby. He later enrolled at the École des Beaux-Arts in Paris and then spent six months in Spain, where he encountered the profound realism of Baroque artists such as Jusepe de Ribera and Diego Velázquez (SEE FIGS. 23-17, 23-19). After he returned to

31-20 Ilya Repin **BARGEHAULERS ON THE VOLGA**
1870–1873. Oil on canvas, 4'3¾" × 9'3" (1.3 × 2.81 m). State Russian Museum, St. Petersburg.

Credit: © akg-images

Philadelphia in 1870, Eakins specialized in frank portraits and scenes of everyday life whose lack of conventional charm generated little popular interest. But he was a charismatic teacher and was soon appointed director of instruction at the Pennsylvania Academy.

THE GROSS CLINIC (FIG. 31-21) was one of Eakins's most controversial paintings. Although created specifically for the 1876 Philadelphia Centennial Exhibition, it was rejected for the fine-art exhibition—the jury did not consider surgery a fit subject for art—and relegated to the

31-21 Thomas Eakins **THE GROSS CLINIC**
1875. Oil on canvas, 8' × 6'5" (2.44 × 1.98 m). Philadelphia Museum of Art. Gift of the Alumni Association to Jefferson Medical College in 1878 and purchased by the Pennsylvania Academy of the Fine Arts and the Philadelphia Museum of Art in 2007.

Eakins, who taught anatomy and figure drawing at the Pennsylvania Academy of the Fine Arts, disapproved of the academic technique of drawing from plaster casts. In 1879, he said, "At best, they are only imitations, and an imitation of an imitation cannot have so much life as an imitation of nature itself." He added, "The Greeks did not study the antique … the draped figures in the Parthenon pediment were modeled from life, undoubtedly."

Credit: © 2016. Photo The Philadelphia Museum of Art/ Art Resource/Scala, Florence

31–22 Winslow Homer
THE LIFE LINE
1884. Oil on canvas,
28¾ × 44⅝" (73 ×
113.3 cm). Philadelphia
Museum of Art.
The George W. Elkins
Collection, 1924.

In the early sketches for
this work, the man's face
was visible. The decision
to cover it focuses
attention on the victim,
and also on the true
hero, the mechanical
apparatus known as the
"breeches buoy."

Credit: © 2016. Photo The
Philadelphia Museum of Art/
Art Resource/Scala, Florence

scientific and medical display. The monumental painting shows Dr. Samuel David Gross performing an operation that he pioneered in the surgical amphitheater of Jefferson Medical College. Dr. Gross pauses to lecture to medical students taking notes in the background, as well as to Eakins himself, whose self-portrait appears along the painting's right edge. A woman at left, presumably a relative of the patient, cringes in horror at the bloody spectacle. At this time, surgeons were regarded with fear—especially teaching surgeons, who frequently thought of the poor as objects on which to practice. But Eakins portrays Gross as a heroic figure, spotlighted by beams of light on his forehead and bloodied right hand with glinting scalpel. Principal illumination, however, is reserved for the patient, presented here not as an entire body but as a dehumanized jumble of thigh, buttock, socked feet, and bunches of cloth. In conceiving this portrait, Eakins must have had Rembrandt's famous Baroque painting of Dr. Tulp in mind (SEE FIG. 23–35), and the American painter's use of light seems to point to a similar homage to scientific achievement: Amid the darkness of ignorance and fear, modern science is the light of knowledge and the source of progress. The procedure showcased here, in fact, was a surgical innovation that allowed Dr. Gross to save a patient's leg that previously would have routinely been amputated.

Winslow Homer (1836–1910) also developed into a realist painter. Born in Boston, he began his career as a 21-year-old freelance illustrator for popular periodicals such as *Harper's Weekly*, which sent him to cover the Civil War in 1862. In 1867, after a ten-month sojourn in France, Homer returned to paint nostalgic visions of the rural scenes that had figured in his magazine illustrations. But following a sojourn during 1881–1882 in a tiny English fishing village on the rugged North Sea coast, Homer developed a commitment to depicting the working poor. Moved by the hard lives and strength of character of the people he encountered in England, he set aside idyllic subjects for themes of heroic struggle against natural adversity. In England, he had been particularly impressed by the "breeches buoy," a mechanical apparatus used for rescues at sea. During the summer of 1883, he made sketches of one imported by the lifesaving crew in Atlantic City, New Jersey. The following year he painted **THE LIFE LINE** (FIG. **31–22**), which depicts a coastguard saving a shipwrecked woman with the use of a breeches buoy—a testament not simply to valor but also to human ingenuity.

The sculptor Edmonia Lewis (1845–c. 1911) was born in New York State to a Chippewa mother and an African-American father, orphaned at the age of 4, and raised by her mother's family. As a teenager, with the help of abolitionists, she attended Oberlin College, the first college in the United States to grant degrees to women, and then moved to Boston. Her highly successful busts and medallions of abolitionist leaders and Civil War heroes financed her move to Rome in 1867, where she was welcomed into the sculptural circle of American expatriate artist Harriet Hosmer (1830–1908) and used Neoclassical style to address modern, realist concerns. Galvanized by the struggle of recently freed slaves for equality, Lewis created **FOREVER FREE** (FIG. **31–23**) in 1867 as a memorial to the Emancipation Proclamation (1862–1863). A diminutive woman kneels in gratitude beside the looming figure of her male companion, who boosts himself up on the ball that once bound his ankle and raises his broken shackles in a gesture of liberation. This sculpture not only celebrates the freeing of American slaves, but also reflects white attitudes

toward women and people of color. Lewis's female figure is less racialized and more submissive than her male counterpart to align her with the contemporary ideal of womanhood and make her more appealing to white audiences. Lewis had to borrow money to pay for the marble for this work. She shipped it from Rome back to Boston hoping that a subscription drive among abolitionists would pay back her loan. The effort was only partially successful, but the steady income from the sale of commemorative medallions eventually paid off Lewis's debt.

Other women and African Americans, groups often excluded from art schools, were among Eakins's students at the Pennsylvania Academy of the Fine Arts. One of the star pupils was Henry Ossawa Tanner (1859–1937), who became the most successful African-American painter of the late nineteenth and early twentieth centuries. The son of a bishop in the African Methodist Episcopal Church,

31–24 Henry Ossawa Tanner **THE BANJO LESSON**
1893. Oil on canvas, 49 × 35½″ (124.4 × 90 cm). Hampton University Museum, Virginia.

Credit: Hampton University's Archival and Museum Collection Hampton University

Tanner grew up in Philadelphia and after studying at the academy, he worked as a photographer and drawing teacher in Atlanta. In 1891, to further his academic training, he moved to Paris, where his painting received favorable critical attention. In the early 1890s, he painted scenes from African-American and rural French life that combined Eakins's realism with the delicate brushwork he encountered in France. With strongly felt, humanizing images like **THE BANJO LESSON** (FIG. **31–24**), he sought to counter caricatures of African-American life created by other artists. An elderly man is giving a young boy a music lesson: two figures connected by their seriousness and concentration. The use of the banjo here is especially significant since it had become identified with images of minstrels—just the sort of derogatory caricatures that Tanner sought to replace with his sympathetic genre scenes focused on the intimate interactions that brought dignity and pride to family life. After a trip to Palestine in 1897, Tanner turned to religious subjects, believing that Bible stories could illustrate the struggles and hopes of contemporary African Americans.

31–23 Edmonia Lewis **FOREVER FREE**
1867. Marble, 41¼ × 22 × 17″ (104.8 × 55 × 43.2 cm).
Howard University Gallery of Art, Washington, DC.

DEVELOPMENTS IN BRITAIN Britain also encountered social and political upheaval at the middle of the nineteenth century. The depression of the "hungry forties," the Irish Potato Famine, and the Chartist Riots threatened social stability in England. Mid-century British artists painted scenes of religious, medieval, or moral exemplars using a tight, realistic style that was quite different from both French and American realism.

In 1848, seven young London artists formed the Pre-Raphaelite Brotherhood in response to what they considered the misguided practices of contemporary British art. Instead of the "Raphaelesque" conventions taught at the Royal Academy, the Pre-Raphaelites looked back to the Middle Ages and early Renaissance (before Raphael) for a beauty and spirituality that they found lacking in their own time. They believed this earlier art was more moralistic and "real."

Dante Gabriel Rossetti (1828–1882) was a leading member of the Pre-Raphaelite Brotherhood. His painting **LA PIA DE' TOLOMEI** (FIG. **31–25**) illustrates a scene from Dante's *Purgatory* in which La Pia (the Pious One), wrongly accused of infidelity and imprisoned by her husband in a castle, is dying. The rosary and prayer book at her side refer to her piety, while the sundial and ravens suggest the passage of time and her impending death. La Pia's continuing love for her husband is represented by his letters, which lie under her prayer book. The luxuriant fig leaves that surround her are traditionally associated with shame, and they seem to suck her into themselves. They have no source in Dante, but had personal relevance for Rossetti: Jane Burden, his model for this and many other paintings, was the wife of his friend William Morris, but she had also become Rossetti's lover. By fingering her wedding ring,

31–25 Dante Gabriel Rossetti **LA PIA DE' TOLOMEI**
1868–1869. Oil on canvas, 41½ × 47½" (105.4 × 119.4 cm). Spencer Museum of Art, University of Kansas, Lawrence. (1956.0031).

The massive, gilded frame Rossetti designed for *La Pia de' Tolomei* features simple moldings on either side of broad, sloping boards, embellished with a few large roundels. The title of the painting is inscribed above the paired roundels at the lower center. On either side of them appear four lines from Dante's *Purgatory*, spoken by the spirit of La Pia, in Italian at the left and in Rossetti's English translation at the right: "Remember me who am La Pia,—me/From Siena sprung and by Maremma dead./This in his inmost heart well knoweth he/With whose fair jewel I was ringed and wed."

31–26 Philip Webb and William Morris **"SUSSEX" CHAIR AND "PEACOCK AND DRAGON" CURTAIN**

Chair (by Webb): in production from c. 1865. Ebonized wood with rush seat, 33 × 16½ × 14" (83.8 × 42 × 35.6 cm). Curtain (by Morris): 1878. Handloomed jacquard-woven woolen twill, 12'10½" × 11'5⅝" (3.96 × 3.53 m). Chair and curtain manufactured by Morris & Company. The William Morris Gallery, London Borough of Waltham Forest.

Morris and his principal furniture designer, Philip Webb (1831–1915), adapted the company's Sussex line of chairs from traditional rush-seated chairs of the Sussex region. The handwoven curtain in the background is typical of Morris's fabric designs in its use of flat patterning that affirms the two-dimensional character of the textile medium. The pattern's prolific organic motifs and soothing blue and green hues—the decorative counterpart to those of naturalistic landscape painting—were meant to provide relief from the stresses of modern urban existence.

Credit: The William Morris Gallery, London, E17, England

La Pia/Jane suggests that she is a captive not of her husband but of her marriage, evoking Rossetti's own situation.

Other British artists drew inspiration from the medieval past as a panacea for modern life in London. William Morris (1834–1896) worked briefly as a painter under the influence of the Pre-Raphaelites before turning his attention to interior design and decoration. Morris's interest in crafts developed in the context of a widespread reaction against the shoddy design of industrially produced goods. Unable to find satisfactory furnishings for his new home after his marriage in 1859, Morris designed and constructed them himself with the help of friends, later founding a decorating firm to produce a full range of medieval-inspired objects. Although many of the furnishings offered by Morris & Company were expensive,

one-of-a-kind items, others, such as the rush-seated chair illustrated here (**FIG. 31-26**), were inexpensive and simple, intended as a handcrafted alternative to machine-made furniture. Concerned with creating a "total" environment, Morris and his colleagues designed not only furniture but also stained glass, tiles, wallpaper, and fabrics, such as the "Peacock and Dragon" curtain seen in FIGURE 31-26.

Morris inspired what became known as the Arts and Crafts Movement. He rebelled against the idea that art was a highly specialized product made for a small elite, and he hoped to usher in a new era of art for the people. He said in lectures: "I do not want art for a few, any more than education for a few, or freedom for a few." A socialist, Morris opposed mass production and the deadening impact of factory life on the industrial worker. He argued that when laborers made handcrafted objects, they derived satisfaction from being involved in the entire process of creation and thus produced honest and beautiful things.

The American expatriate James Abbott McNeill Whistler (1834–1903) also focused his attention on the rooms and walls where art was hung, but he did so to satisfy elitist tastes for beauty as its own reward. He also became embroiled in several artistic controversies that laid the groundwork for abstraction in the next century. After flunking out of West Point in the early 1850s, Whistler studied art in Paris, where he was briefly influenced by Courbet's Realism; the two artists painted several seascapes together. Whistler settled in London in 1859, after which his art began to take on a more decorative quality that he called "aesthetic" and that increasingly diverged from observed reality. He believed that the arrangement of a room (or a painting) could be aesthetically pleasing in itself, without reference to the outside world. He occasionally designed exhibition rooms for his own art, with the aim of creating a total harmony of objects and space.

Whistler's ideas about art were revolutionary. He was among the first artists to conceive of his paintings as abstractions from rather than representations of observed reality, and he was among the first patrons to collect Japanese art, fascinated by what he perceived as decorative line, color, and shape, although he understood little about its meaning or intent. By the middle of the 1860s, Whistler began to call his works "symphonies" and "arrangements," suggesting that their themes resided in their compositions rather than their subject matter, and he painted several landscapes with another musically derived title, *Nocturne*. (Whistler took the term "nocturne" from the titles of piano compositions by Frédéric Chopin.) When he exhibited some of these in 1877, he drew the scorn of England's leading art critic, John Ruskin (1819–1900), a supporter of the Pre-Raphaelites and their moralistic intentions. Decrying Whistler's work as carelessly lacking in finish and purpose, Ruskin's review asked how an artist could "demand 200 guineas for flinging a pot of paint in the public's face."

31–27 James Abbott McNeill Whistler **NOCTURNE IN BLACK AND GOLD, THE FALLING ROCKET** 1875. Oil on panel, 23¾ × 18⅜" (60.2 × 46.7 cm). The Detroit Institute of Arts. Gift of Dexter M. Ferry Jr. (46.309).

Credit: Bridgeman Images

The most controversial painting in Whistler's 1877 exhibition was **NOCTURNE IN BLACK AND GOLD, THE FALLING ROCKET** (FIG. 31-27), and Ruskin's objections to it set off one of the most notorious court dramas in art history. Painted in restricted tonalities, at first glance the work appears completely abstract. In fact, the painting is a night scene depicting a fireworks show over a lake at Cremorne Gardens in London, with viewers vaguely discernible along the lake's edge in the foreground. After reading Ruskin's review, Whistler sued the critic for libel (see "Art on Trial in 1877" below). He deliberately turned the courtroom into a public forum, both to defend and to advertise his art. On the witness stand, he maintained that art has no higher purpose than creating visual delight and denied the need for paintings to have "subject matter." While Whistler never made a completely abstract painting, his theories were integral to the development of abstract art in the next century.

Art and Its Contexts

ART ON TRIAL IN 1877

This is a partial transcript of James Abbott McNeill Whistler's testimony at the libel trial that he initiated against the art critic John Ruskin. Whistler's responses often provoked laughter, and the judge at one point threatened to clear the courtroom.

Q: What is your definition of a Nocturne?

A: I have, perhaps, meant rather to indicate an artistic interest alone in the work, divesting the picture from any outside sort of interest which might have been otherwise attached to it. It is an arrangement of line, form, and color first … The *Nocturne in Black and Gold* [SEE FIG. 31–27] is a night piece, and represents the fireworks at Cremorne.

Q: Not a view of Cremorne?

A: If it were called a view of Cremorne, it would certainly bring about nothing but disappointment on the part of beholders. It is an artistic arrangement. It was marked 200 guineas …

Q: I suppose you are willing to admit that your pictures exhibit some eccentricities; you have been told that over and over again?

A: Yes, very often.

Q: You send them to the gallery to invite the admiration of the public?

A: That would be such a vast absurdity on my part that I don't think I could.

Q: Did it take you much time to paint the *Nocturne in Black and Gold*? How soon did you knock it off?

A: I knocked it off in possibly a couple of days; one day to do the work, and another to finish it.

Q: And that was the labor for which you asked 200 guineas?

A: No, it was for the knowledge gained through a lifetime.

The judge ruled in Whistler's favor; Ruskin had indeed libeled him. But he awarded Whistler damages of only one farthing. Since in those days the person who brought the suit had to pay all the court costs, the case ended up bankrupting the artist.

Impressionism

What are the origins, objectives, and subjects of Impressionist painting?

The generation of French painters maturing around 1870 continued to paint modern urban subjects, but their perspective differed from that of Manet and the Realists. Instead of challenging social commentary, these younger artists painted pretty pictures of the upper middle class at leisure in the countryside and in the city, and although several members of this group painted rural scenes, their point of view tended to be that of a city person on holiday. They also began to paint not in the studio, but **en plein air** (French for "in the open air," or outdoors), in an effort to record directly the fleeting effects of light and atmosphere by applying many small touches of pure color directly onto the canvas. *Plein air* painting was greatly facilitated by the invention in 1841 of collapsible metal tubes for oil paint, which artists could conveniently pack and take out of the studio. Setting aside the boredom of the academic program for painting, with its elaborate preparatory drawings and underpainting followed by laborious work in the studio, the Impressionists sought instead to capture the play of light quickly, before it changed.

In April 1874, a group of these artists—including Paul Cézanne, Edgar Degas, Claude Monet, Berthe Morisot, Camille Pissarro, and Pierre-Auguste Renoir—exhibited together in Paris under the title of the Société Anonyme des Artistes Peintres, Sculpteurs, Graveurs, etc. (Anonymous Corporation of Artist-Painters, Sculptors, Engravers, etc.). Pissarro organized the group along the lines advocated by anarchists such as Pierre-Joseph Proudhon, who urged citizens to band together into self-supporting grassroots organizations, rather than relying on state-sanctioned institutions. Pissarro envisioned the Société as a mutual aid group for artists who opposed the state-funded Salons. While the Impressionists are the most famous of its members today, at the time the group included artists working in several styles. All 30 participants agreed not to submit anything that year to the Salon, which had in the past often rejected their work. This was a declaration of independence from the Académie and a bid to gain the public's attention directly.

While their exhibition received some positive reviews, one critic, Louis Leroy, writing in the satirical journal *Le Charivari*, seized upon the title of Claude Monet's painting *Impression: Sunrise* (SEE FIG. 31–28) and dubbed the entire exhibition "impressionist." Leroy was ridiculing the fast, open brushstrokes and unfinished look of some of the paintings, but Monet and his colleagues embraced the term because it aptly described their aim of rendering the instantaneous impression and fleeting moment in paint. Seven more Impressionist exhibitions were held between 1876 and 1886, with the membership of the group varying slightly on each occasion; only Pissarro participated in all eight shows. The relative success of these exhibitions prompted other artists to organize their own alternatives to the Salon, and by 1900 an independent exhibition and gallery system had all but eradicated the French academic Salon system. The Academy's centuries-old stranglehold on determining and controlling artistic standards was effectively ended.

Landscape and Leisure

Claude Monet (1840–1926) was a leading exponent of Impressionism. Born in Paris but raised in the port city of Le Havre, he trained briefly with an academic teacher but soon established his own studio. His friend Charles-François Daubigny urged him to trust his personal impressions and suggested that he paint *en plein air*. Like other Impressionists, Monet's focus was the creation of a modern painting style, not the production of biting social commentary. Initially, the Impressionists celebrated the semirural pleasures of outings to the suburbs, which the Paris train system had made possible for the middle class. Few early works depict locations far from Paris; most feature Parisians at leisure—walking, boating, and visiting fashionable new parks within the city or just outside of town.

In the summer of 1870 the Franco-Prussian War broke out, and Monet fled to London, where he spent time with Pissarro and Paul Durand-Ruel, who would later be Monet's art dealer. The disastrous loss of the major industrial regions of Alsace and Lorraine to Prussia at the end of the war devastated the French economy. In Paris, for two months between March and May 1871 workers rose up and established the Commune, a working-class city government, the suppression of which led to an estimated 20,000 dead and 7,500 imprisoned. The horror rocked Paris. Courbet was imprisoned for a short time and in artists' circles, the fear of being branded as an enemy of the state sent a chill through everyone. After 1871, overt political commentary in French art diminished even more, and the challenge of the avant-garde was expressed increasingly as an insular stylistic rebellion.

In 1873, just after returning to Paris, Monet painted **IMPRESSION: SUNRISE** (FIG. 31–28), a view of the sun rising in the morning fog over the harbor in his hometown of Le Havre. The painting is rendered almost entirely of strokes of color (Leroy sneeringly called them "tongue-lickings"). The foreground is ambiguous, and the horizon line disappears among the shimmering shapes of steamships and docks in the background, clouded by a thick atmosphere of mist. Monet registers the intensity and shifting forms of a first sketch and presents it as the final work of art. He records the ephemeral play of reflected light and color and its effect on the eye, rather than describing the physical substance of forms and the spatial volumes

31–28 Claude Monet
IMPRESSION: SUNRISE

1872. Oil on canvas, 19 × 24⅜″ (48 × 63 cm). Musée Marmottan, Paris.

Credit: Bridgeman Images

they occupy. The American painter Lilla Cabot Perry, who befriended Monet in his later years, recalled him telling her:

> When you go out to paint, try to forget what objects you have before you—a tree, a house, a field, or whatever. Merely think, Here is a little square of blue, here an oblong of pink, here a streak of yellow, and paint it just as it looks to you, the exact color and shape, until it gives your own naïve impression of the scene before you.

Monet continued to explore personal impressions of light and color during a long career that extended well into the twentieth century. Beginning in the 1880s and 1890s he focused his vision even more intently, exploring a limited number of outdoor subjects through several series of paintings: haystacks, poplar trees silhouetted against the sky, and the façade of Rouen Cathedral (**FIG. 31-29**). He painted the cathedral not as an expression of personal religious conviction, but because of his fascination with the way light played across its undulating stone surface, changing its appearance constantly as the lighting changed throughout the day. He painted more than 30 canvases of the Rouen

31–29 Claude Monet **ROUEN CATHEDRAL, WEST FAÇADE, SUNLIGHT**

1894. Oil on canvas, 39⅜ × 25⅞″ (100.1 × 65.8 cm). National Gallery of Art, Washington, DC., Chester Dale Collection (1963.10.179)

Credit: Image courtesy the National Gallery of Art, Washington

façade, begun from direct observation of the cathedral from a second-story window across the street and finished later in his studio at nearby Giverny. In these paintings, Monet continued his Impressionist pursuit of capturing the fleeting effects of light and atmosphere, but his extensive reworking of the paintings in his studio produced pictures that were more carefully orchestrated and laboriously executed than his earlier, more spontaneous, *plein air* works.

Monet's friend and fellow artist Camille Pissarro (1830–1903) offered a new Impressionist image of the landscape, painting scenes where the urban meets the rural. At times he portrayed the rural landscape on its own, but he often shows urban visitors to the countryside and small towns or factories embedded in the land as the city encroaches upon them. Born in the Dutch West Indies to French parents and raised near Paris, Pissarro studied art in Paris during the 1850s and early 1860s. In 1870, while he and Monet lived in London, Pissarro had already taken up the principles that would later blossom in Impressionism. The two artists worked together in England, trying to capture what Pissarro described as "*plein air* light and fugitive effects" by lightening color intensity and hue and loosening brushstrokes.

Following his return to France, Pissarro settled in Pontoise, a small, hilly village northwest of Paris where he worked for most of the 1870s in an Impressionist style, using high-keyed color and short brushstrokes to capture fleeting qualities of light and atmosphere. In the late 1870s, his work became more visually complex, with darkened colors. In his **WOODED LANDSCAPE AT L'HERMITAGE, PONTOISE** (FIG. 31-30), for instance, a foreground composition of trees screens the view of a rural path and village behind, flattening space and partly masking the figure at the lower right. Pissarro applies his paint thickly here, with a multitude of short, multidirectional brushstrokes.

In contrast, Impressionist painter Pierre-Auguste Renoir (1841–1919) focused most of his attention not on landscapes but on figures, producing mostly images of the middle class at leisure. When he met Monet at the École des Beaux-Arts in 1862, he was already working as a figure painter. Monet encouraged him to lighten his palette and to paint outdoors, and by the mid-1870s Renoir was combining a spontaneous handling of natural light with animated figural compositions. In **MOULIN DE LA GALETTE** (FIG. 31-31), for example, Renoir depicts a convivial crowd relaxing on a Sunday afternoon at an old-fashioned dance hall—the Moulin de la Galette (the "Pancake Mill") in the Montmartre area of Paris, which opened its outdoor courtyard during good weather. Renoir glamorizes the working-class clientele by placing his attractive bourgeois artist friends and their models among them, striking poses of relaxed congeniality, smiling, dancing, and chatting. He underscores the innocence of their flirtations by including children in the painting in the lower

31-30 Camille Pissarro **WOODED LANDSCAPE AT L'HERMITAGE, PONTOISE**
1878. Oil on canvas, 18⁵⁄₁₆ × 22¹⁄₁₆" (46.5 × 56 cm). The Nelson-Atkins Museum of Art, Kansas City, Missouri.
Gift of Dr. and Mrs. Nicholas S. Pickard.

31–31 Pierre-Auguste Renoir **MOULIN DE LA GALETTE**

1876. Oil on canvas, 4′3½″ × 5′9″ (1.31 × 1.75 m). Musée d'Orsay, Paris.

Credit: Photo © RMN-Grand Palais (musée d'Orsay)/Hervé Lewandowski

31–32 Berthe Morisot **SUMMER'S DAY**

1879. Oil on canvas, 17¹³⁄₁₆ × 29⁵⁄₁₆″ (45.7 × 75.2 cm). National Gallery, London. Lane Bequest, 1917.

Credit: © 2016. Copyright The National Gallery, London/Scala, Florence

left, while emphasizing the ease of social relations through the relaxed informality of the scene. The overall mood is knit together by the dappled sunlight falling through the trees and Renoir's soft brushwork weaving blues and purples through the crowd and around the canvas. This naïve image of a carefree life of innocent leisure—a kind of bourgeois paradise removed from the real world—encapsulates Renoir's idea of the essence of art: "For me a picture should be a pleasant thing, joyful and pretty—yes pretty! There are quite enough unpleasant things in life without the need for us to manufacture more."

Impressionist artist Berthe Morisot (1841–1895) defied societal conventions to become a professional painter. Morisot and her sister, Edma, copied paintings in the Louvre and studied with several teachers, including Corot, in the late 1850s and early 1860s. The sisters exhibited their art in the five Salons between 1864 and 1868, the year they met Manet. In 1869, Edma married and gave up painting to devote herself to domestic duties, but Berthe continued painting even after her 1874 marriage to Manet's brother, Eugène, and the birth of their daughter in 1879. Morisot sent nine paintings to the first exhibition of the Impressionists in 1874 and showed her work in all but one of their subsequent shows.

As a respectable bourgeois lady, Berthe Morisot was not free to prowl the city looking for modern subjects, so she concentrated on depictions of women's lives, a subject she knew well. In the 1870s, she painted in an increasingly fluid and painterly style, flattening her picture plane and making her brushwork more prominent. In **SUMMER'S DAY** (**FIG. 31–32**), Morisot shows two elegant young ladies enjoying an outing on the lake of the fashionable Bois de Boulogne. First shown in the fifth Impressionist exhibition in 1880, the painting exemplifies the emphasis on formal features in Impressionist painting—the brushstrokes and the colors are as much its subject as the figures themselves.

Modern Life

Subjects from urban life also attracted Edgar Degas (1834–1917), although his paintings are closer to Realism in their intensely frank portrayals that often suggest social commentary. Instead of painting outdoors, Degas composed his pictures in the studio from working drawings and photographs. His rigorous academic training at the École des Beaux-Arts in the mid-1850s and his three years in Italy studying the Old Masters blossomed in paintings characterized by complex compositional structure and striking representational clarity. In many respects his themes and style were closer to Manet's than to the Impressionists.

After a period of painting psychologically probing portraits of friends and relatives, during the 1870s, Degas began painting the modern life of Paris, especially its venues of entertainment and spectacle—the racetrack, the music hall, and the opera, usually focusing on the entertainers rather than on the bourgeois audience. He was especially drawn to the ballet in the 1870s and 1880s, at a time when it was in decline. Occasionally Degas drew or painted actual dancers in rehearsal, but he also hired dancers, often very young "ballet rats" (as he called them), to come to his studio to pose for him. **THE REHEARSAL ON STAGE** (**FIG. 31–33**), for example, is a contrived scene based on such studio studies, calculated to delight the eye but also to refocus the

31–33 Edgar Degas **THE REHEARSAL ON STAGE**
c. 1874. Pastel over brush-and-ink drawing on thin, cream-colored wove paper, laid on bristol board, mounted on canvas, 21⅜ × 28¾" (54.3 × 73 cm). Metropolitan Museum of Art, New York. Bequest of Mrs. H. O. Havemeyer Collection, Gift of Horace Havemeyer, 1929 (29.160.26).

Credit: © 2016. Image copyright The Metropolitan Museum of Art/ Art Resource, NY/Scala, Florence

31–34 Edgar Degas **THE TUB**
1886. Pastel on cardboard,
23⅝ × 32⅝" (60 × 83 cm).
Musée d'Orsay, Paris.

Credit: Photo © RMN-Grand Palais (musée d'Orsay)/Hervé Lewandowski

mind on the stern realities of modern life. Several of the dancers look bored or exhausted; others stretch, perhaps to mitigate the toll this physical work took on their bodies. Because ballerinas generally came from lower-class families and showed their scantily clad bodies in public—something that "respectable" bourgeois women did not do—they were widely assumed to be sexually available, and they often attracted the attentions of wealthy men willing to support them in exchange for sexual favors. In the right background of this painting slouch two well-dressed, middle-aged men, each probably a wealthy "protector" of one of the dancers.

The composition is set in a space that seems to tilt upward, as if viewed from a box close to the stage. The abrupt foreshortening is emphasized by the dark scrolls of the double basses that jut up from the lower left. The angular viewpoint from above may derive from Japanese prints, which Degas collected, while the seemingly arbitrary cropping of figures on the left suggests photography, which he also practiced.

Whereas Degas's ballet paintings highlight informal moments associated with public performance, his later images of bathing women are furtive glimpses of intimate moments drawn from private life, usually rendered in the medium of pastel, which only heightens their sense of immediacy. **THE TUB** of 1886 (**FIG. 31–34**) represents a crouching woman perched within a small tub, washing her neck with a sponge. Initially, this may seem to be two separate pictures: at the left the compactly posed woman, balanced precariously on the steep floor of a receding interior space, and on the right a tipped-up table with a still life of objects associated with bathing. But when coordinated, they establish the viewer's elevated, domineering vantage point. The dramatic, flattened juxtaposition, as well as the

compression and cropping of the close frame, are further examples of the impact of Japanese prints and photography on Degas's art.

Another artist who exhibited with the Impressionists but whose art soon diverged from them in both style and technique—conditioned in part by her contact with Degas—was American expatriate Mary Cassatt (1844–1926). Born near Pittsburgh to a well-to-do family and raised in the cosmopolitan world of Philadelphia, she studied at the Pennsylvania Academy of the Fine Arts between 1861 and 1865, then moved to Paris for further academic training and lived there for most of the rest of her life. The realism of the figure paintings she exhibited at the Salons of the early and mid-1870s attracted the attention of Degas, who invited her to participate in the fourth Impressionist exhibition in 1879. Although she, like Degas, remained a studio painter and printmaker, her distaste for what she called the "tyranny" of the Salon jury system made her one of the group's staunchest supporters.

Like Morisot, Cassatt focused her paintings on the world she knew best: the domestic and social life of bourgeois women. She is known for extraordinarily sensitive representations of women with children, which, like the genre paintings of fellow expatriate Henry Ossawa Tanner (SEE FIG. 31–24), sought to counteract the clichéd stereotypes of her age. In **MOTHER AND CHILD** from about 1890 (**FIG. 31–35**), she contrasts the loosely painted, Impressionist treatment of clothing and setting and the solidly modeled forms of faces and hands to rivet our attention on the tender connection between mother and child at bedtime, right after a bath. The drowsy face, flushed cheeks, and weighty limbs of the child have a natural quality, even though the space occupied by the figures seems flattened. Because the composition and subject recall much earlier portrayals of the Virgin and Child, Cassatt elevates this modest scene of private life into a homage to motherhood and a dialogue with the history of art.

Gustave Caillebotte (1848–1894), another friend of Degas, was instrumental in organizing several Impressionist exhibitions and used his wealth to purchase the work

31–35 Mary Cassatt **MOTHER AND CHILD**
c. 1890. Oil on canvas, 35½ × 25⅜" (90.2 × 64.5 cm).
Wichita Art Museum, Kansas.

of his friends, amassing a large collection of paintings. He studied with an academic teacher privately and qualified for the École des Beaux-Arts, but never attended. Caillebotte was fascinated by the regularized, radiating streets of Haussmann's Paris (SEE FIG. 31–3), and his subjects and compositions often represent life along the boulevards. **PARIS STREET, RAINY DAY** (**FIG. 31–36**) has an unconventional, almost telescopic, asymmetrical composition with a tipped perspective. The broad, wet streets create the subject of this painting, with anonymous, huddled Parisians mostly pushed to the periphery, their shiny umbrellas as prominent as their silhouetted bodies. Only the connected couple strolling toward us is fully realized and personalized. Squeezed between the lamppost and the saturated red and green of a shopfront, they stand within an internally framed rectangular composition capped by the strong horizontal of the two umbrellas.

31–36 Gustave Caillebotte **PARIS STREET, RAINY DAY**
1877. Oil on canvas, 83½ × 108¾" (212.2 × 276.2 cm). The Art Institute of Chicago. Charles H. and Mary F.S. Worcester Collection (1964.336).

Credit: Photo © The Art Institute of Chicago

Japonisme

Japan was forcibly opened by the U. S. Navy to Western trade and diplomacy in 1853. Two years later, when France, England, Russia, and the United States signed trade agreements that permitted regular exchange of goods, Japanese art became available to European and American artists. One of the first works that engaged the attention of modern painters was a sketchbook called *Manga* by Katsushika Hokusai (1760–1849), which several Parisian artists eagerly passed around.

The Paris International Exposition of 1867 hosted the first exhibition of Japanese prints in Europe, and soon, Japanese lacquers, fans, bronzes, hanging scrolls, kimonos, ceramics, illustrated books, and *ukiyo-e* (prints of the "floating world," the realm of geishas and popular entertainment) began to appear for sale in specialty shops, art galleries, and even some department stores. Soon it became fashionable for those in the art world to collect Japanese objects for their homes. The French obsession with Japan and its arts reached such proportions by 1872 that the art critic Philippe Burty gave it a name: **Japonisme**.

Japanese art had a profound impact on Western painting and printmaking, and eventually also on architecture, but the influence was extraordinarily diverse. How individual artists responded depended on their own interests.

Whistler found encouragement for his purely aesthetic conception of art, liberated from Renaissance rules of representation and perspective. Degas discovered both realistic subjects and complex, diagonal compositional arrangements and elevated viewpoints. Those interested in the reform of late nineteenth-century industrial design found in Japanese objects both the fine craft and honest elegance they thought lacking in the West.

Cassatt directly emulated the compositions, designs, and colors of *ukiyo-e* after multiple visits to an influential 1890 exhibition of 725 woodblock prints mounted at the École des Beaux-Arts in Paris. This art appealed to Cassatt because its concentration on the private lives of women (**FIG. 31-37**) coordinated well with her own preferred subject matter (SEE FIG. 31-35), but she also felt a connection to the stylistic character of these prints—their cropped, diagonally structured, and often asymmetrical compositions; their use of broad, flat, unmodulated areas of color or tone; their emphasis on outline and pattern over form and space; and their oblique vantage points. This exhibition inspired Cassatt to create her own portfolio of ten prints (**FIG. 31-38**) using the contemporary medium of aquatint and drypoint. The exhibition of these prints in 1891 was her first solo show, and her work was acclaimed by her fellow artists. Cassatt's friend and mentor Degas was dumbfounded—"I do not admit that a woman can draw like that."

31-37 Suzuki Harunobu **YOUNG WOMAN LOOKING AT A POT OF PINKS**

c. 1767. Woodblock print, 10⅝ × 7½" (27 × 19.2 cm). The Cleveland Museum of Art.

Credit: Bridgeman Images

31-38 Mary Cassatt **WOMAN BATHING**

1890–1891. Color drypoint and aquatint, 16⅝ × 12" (42.3 × 30.5 cm). National Gallery of Art, Washington, DC., Dale Collection (1963.10.253)

Credit: Image courtesy the National Gallery of Art, Washington

The Late Nineteenth Century

What are the diverse stylistic innovations of the generation of artists who came after the Impressionists?

The Realists and Impressionists continued to create art until the end of the century, but by the mid-1880s they had relinquished their dominance to a younger generation of innovative artists. This period seems less unified, less directed, and less restricted geographically. Artists increasingly defined the avant-garde in terms of visual experimentation, developing new visual languages more appropriate to newly formulated messages.

These artists included French Post-Impressionists, who expressed an interior world of the imagination or imposed a new scientific rigor on representations of the world around them; late nineteenth-century French sculptors, who studied the passionate physicality of the human form; Symbolists, who retreated into fantastical and sometimes horrifying worlds of the imagination; Art Nouveau artists, who rejected the rational order of the industrial world to create images and designs ruled by the writhing, asymmetrical shapes of growing plants; and even landscape architects, who recast the urban cityscape into a rambling, natural landscape.

Post-Impressionism

The English critic Roger Fry coined the term "Post-Impressionism" in 1910 in order to describe a diverse group of painters whose work he had collected for an exhibition. He acknowledged that these artists did not share a unified approach to art, but they all used Impressionism as a springboard for developing their individual styles.

SEURAT Georges Seurat (1859–1891), who was born in Paris and trained at the École des Beaux-Arts, sought to "correct" Impressionism, which he found too intellectually shallow and improvisational. He preferred the clarity of structure he saw in Classical relief sculpture and the seemingly systematic but actually quite emotive use of color suggested by optics and color theory. He was particularly interested in the "law of the simultaneous contrast of colors" formulated by Michel-Eugène Chevreul in the 1820s. Chevreul observed that adjacent objects not only cast reflections of their own color onto their neighbors, but also create the effect of their **complementary color**. Thus, when a blue object is set next to a yellow one, the eye will detect in the blue object a trace of purple, the complement of yellow, and in the yellow object a trace of orange, the complement of blue.

Seurat's goal was to find ways to create such retinal vibrations to enliven the painted surface, using distinctively short, multidirectional strokes of almost pure color in what came to be known as "Divisionism" or "Pointillism." In theory, these juxtaposed strokes of color would merge in the viewer's eye to produce the impression of other colors. When perceived from a certain distance they would appear more luminous and intense than the same colors seen separately, while on close inspection the strokes and colors would remain distinct and separate.

Seurat's monumental painting **A SUNDAY AFTERNOON ON THE ISLAND OF LA GRANDE JATTE** (FIG. 31–39) was first exhibited at the eighth and final Impressionist exhibition in 1886. The theme of weekend leisure is typically Impressionist, but the rigorous technique, the stiff formality of the figures, and the highly calculated geometry of the composition produce a solemn effect quite at odds with the casual naturalism of Impressionism. Seurat painted the entire canvas using only 11 colors in three values. When viewed from a distance of about 9 feet, the painting reads as figures in a park rendered in many colors and tones; but when viewed from a distance of 3 feet, the individual marks of color become more apparent, while the forms dissolve into abstraction.

From its first appearance, the painting has been the subject of a number of conflicting interpretations. Contemporary accounts of the island indicate that on Sundays (the newly designated official day off for French working families) it was noisy, littered, and chaotic. Seurat may have intended to represent an ideal image of harmonious, blended working-class and middle-class life and leisure. But some art historians see Seurat satirizing the sterile habits, rigid attitudes, and domineering presence of the growing Parisian middle class—or simply engaging in an intellectual exercise on the nature of form and color.

VAN GOGH AND GAUGUIN Among the most famous Post-Impressionist artists is the Dutch painter Vincent van Gogh (1853–1890), who transformed his artistic sources into a highly expressive personal style. The oldest son of a Protestant minister, Van Gogh worked as an art dealer, a teacher, and an evangelist before deciding in 1880 to become an artist. After brief periods of study in Brussels, The Hague, and Antwerp, in 1886 he moved to Paris, where he encountered the Parisian avant-garde. Van Gogh adapted Seurat's Pointillism by applying brilliantly colored paint in multidirectional strokes of impasto (thick applications of paint) to give his pictures a turbulent emotional energy and a palpable surface texture.

Van Gogh was a socialist who believed that modern life, with its constant social change and focus on progress and success, alienated people from one other and from themselves. His paintings are efforts to communicate his emotional state by establishing a direct connection

31–39 Georges Seurat **A SUNDAY AFTERNOON ON THE ISLAND OF LA GRANDE JATTE**
1884–1886. Oil on canvas, 6′9½″ × 10′1¼″ (207 × 308 cm). The Art Institute of Chicago.
Helen Birch Bartlett Memorial Collection (1926.22).

There was a social hierarchy in Parisian parks in the late nineteenth century; the Bois de Boulogne (SEE FIG. 31–32) was an upper-middle-class park in an area of grand avenues, whereas the Grande Jatte faced a lower-class industrial area across the river and was easily accessible by train. The figures represent a range of "types" that would have been easily recognizable to the nineteenth-century viewer, such as the middle-class strolling man and his companion to the right—usually identified as a *boulevardier* (or citified dandy) and a *cocotte* (a single woman assumed to be a prostitute)—or the working-class *canotier* (oarsman) to the left.

Credit: Photo © The Art Institute of Chicago

between artist and viewer, thereby overcoming the emotional barrenness of modern society. In a prolific output over only ten years, he produced paintings that contributed significantly to the later emergence of Expressionism, in which the intensity of an artist's emotional state would override any desire for fidelity to the actual appearance of things. Van Gogh described his working method in a letter to his brother:

> I should like to paint the portrait of an artist friend who dreams great dreams, who works as the nightingale sings, because it is his nature. This man will be fair-haired. I should like to put my appreciation, the love I have for him, into the picture. So I will paint him as he is, as faithfully as I can—to begin with. But that is not the end of the picture. To finish it, I shall be an obstinate colorist. I shall exaggerate the fairness of the hair, arrive at tones of orange, chrome, pale yellow. Behind the head—instead of painting the ordinary wall of the shabby apartment, I shall paint infinity, I shall do a simple background of the richest, most intense blue that I can contrive, and by this simple combination, the shining fair head against this rich blue background, I shall obtain a mysterious effect, like a star in the deep blue sky.

One of the most famous examples of Van Gogh's approach is **THE STARRY NIGHT** (FIG. 31–40), painted near the asylum of Saint-Rémy. Above the quiet town, the sky pulsates with celestial rhythms and exploding stars. Contemplating life and death in a letter, Van Gogh wrote: "Just as we take the train to get to Tarascon or Rouen, we take death to reach a star." This idea is made visible here by the cypress tree, a traditional symbol of both death and eternal life, which rises to link the terrestrial and celestial realms. The brightest star in the sky is actually a planet, Venus, which is associated with love: It is possible that the picture's extraordinary energy also expresses Van Gogh's euphoric hope of gaining in death the love that had eluded him in life. The painting is a riot of brushstrokes of intense

color that writhe across the surface. This is clearly more a record of what Van Gogh felt than what he saw. During the last year and a half of his life, before he made this painting, he had experienced repeated psychological crises that lasted for days or weeks. While they were raging, he wanted to hurt himself, heard loud noises in his head, and could not paint. The stress of these attacks led him to the asylum where he painted *The Starry Night*, and eventually to suicide in July 1890.

In painting from imagination more than from nature in *The Starry Night*, Van Gogh may have been following the advice of his close friend Paul Gauguin (1848–1903), who once counseled another artist, "Don't paint from nature too much. Art is an abstraction. Derive this abstraction from nature while dreaming before it, and think more of the creation that will result." Born in Paris to a Peruvian mother and a radical French journalist father, Gauguin lived in Peru until age 7. During the 1870s and early 1880s, he enjoyed a comfortable bourgeois life as a stockbroker, painting in his spare time as a student of Pissarro. Between 1880 and 1886, he exhibited in the final four Impressionist

exhibitions. In 1883, he lost his job during a stock market crash, and three years later he abandoned his wife and five children to pursue a full-time painting career. Gauguin knew firsthand the business culture of his time and came to despise it. Believing that escape to a more "primitive" place would bring with it the simpler pleasures of preindustrial life, Gauguin lived for extended periods in the French province of Brittany between 1886 and 1891, traveled to Panama and Martinique in 1887, spent two months in Arles with Van Gogh in 1888, and in 1891 sailed for Tahiti, a French colony in the South Pacific. After a final sojourn in France in 1893–1895, Gauguin returned to French Polynesia, where he died in 1903.

Gauguin's art was inspired by sources as varied as medieval stained glass, folk art, and Japanese prints; he sought to paint in a "primitive" way, employing the so-called decorative qualities of folk art, such as brilliantly colored flat shapes, anti-naturalist color, and bold, black outlines. Gauguin called his style "synthetism," because he believed it synthesized observation and the artist's feelings in an abstracted application of line, shape, space, and color.

31–40 Vincent van Gogh **THE STARRY NIGHT**
1889. Oil on canvas, 28¾ × 36¼" (73 × 93 cm). Museum of Modern Art, New York. Acquired through the Lillie P. Bliss Bequest (472.1941).

Credit: © 2016. Digital Image, The Museum of Modern Art, New York/Scala, Florence

MAHANA NO ATUA (*Day of the God*) (see "Closer Look" below) is very much a product of such synthesis. Despite its Tahitian subject, it was painted in France during Gauguin's brief return after two years in the South Pacific. He had gone to Tahiti hoping to find an unspoiled, preindustrial paradise, imagining the Tahitians to be childlike and close to nature. What he discovered was a thoroughly colonized country whose native culture was rapidly disappearing under the pressures of Westernization. In paintings such as this, however, Gauguin chose to ignore this reality and depict instead the Edenic ideal of his own imagination.

A Closer Look

MAHANA NO ATUA (*DAY OF THE GOD*)

Gauguin divided the painting into three horizontal zones, increasingly abstract from top to bottom. The upper zone, painted in the most lifelike manner, centers on the statue of a god set in a beach landscape populated by Tahitians.

The central female bather dips her feet in the water and looks coyly out at viewers, while, on either side of her, two androgynous figures recline in fetuslike postures. The three poses perhaps symbolize—left to right—birth, life, and death.

As was his practice in many of his Tahitian paintings, Gauguin did not base this sculpted idol on a statue he saw in Tahiti, but rather on pictures he owned of the Buddhist temple complex at Borobudur (SEE FIG. 10–36).

Filling the bottom third of the painting is a striking pool of water, abstracted into a dazzling array of bright colors and arranged in a puzzlelike pattern of flat, curvilinear shapes. The left half of this pool seems rooted in natural description, evoking spatial recession. But on the right it becomes flatter and more stylized.

This middle zone contains three figures posed on an unnaturalistically pink beach. The green, arched form behind the central woman links her visually to the idol immediately above her.

By reflecting a strange and unexpected reality exactly where we expect to see a mirror image of the familiar world, this magic pool seems the perfect symbol of Gauguin's desire to evoke "the mysterious centers of thought." His aim was symbolic rather than descriptive works of art.

31–41 Paul Gauguin MAHANA NO ATUA (DAY OF THE GOD)
1894. Oil on canvas, 27⅜ × 35⅝" (69.5 × 90.5 cm). The Art Institute of Chicago. Helen Birch Bartlett Memorial Collection (1926.198).

Credit: Photo © The Art Institute of Chicago

MUNCH Symbolism originated in France but had a profound impact on the avant-garde in other countries, where it frequently took on Expressionist tendencies. In Norway, Edvard Munch (1863–1944) produced a body of work that shows the terrifying workings of an anguished mind. **THE SCREAM** (FIG. 31–43) is the stuff of nightmares and horror movies; its harsh, swirling colors and lines direct us wildly around the painting, but bring us right back to the human head at the center and the echoes of its haunting scream, sensed visually. Munch described how the painting began: "One evening I was walking along a path; the city was on one side, and the fjord below. I was tired and ill…. I sensed a shriek passing through nature…. I painted this picture, painted the clouds as actual blood."

31–43 Edvard Munch **THE SCREAM**

1893. Tempera and oil on unprimed canvas, 33 × 26″ (83.5 × 66 cm). Munch Museum, Oslo.

Credit: © 2016 Artists Rights Society (ARS), New York. Nasjonalgalleriet, Oslo, Norway/ Bridgeman Images.

31–44 James Ensor **THE INTRIGUE**

1890. Oil on canvas, 35½ × 59″ (90.3 × 150 cm). Koninklijk Museum voor Schone Kunsten, Antwerp.

Credit: © Lukas - Art in Flanders VZW/Photo: Hugo Maertens/Bridgeman Images

ENSOR The Belgian painter and printmaker James Ensor (1860–1949) studied for four years at the Brussels Academy, but spent the rest of his life in the nearby coastal resort town of Ostend, where like Munch he produced terrifying paintings combining Symbolist and Expressionist tendencies. **THE INTRIGUE** (**FIG. 31–44**) shows a tightly packed group of agitated people pushed toward the viewer into the foreground. Masks—modeled on the grotesque papier-mâché masks Ensor's family sold for the pre-Lenten carnival—conceal their faces, giving them a disturbing, mindless, menacing quality. Ensor's acidic colors and energetic paint handling only increase the viewer's anxiety.

French Sculpture

A defiance of conventional expectations and an interest in emotional expressiveness also characterize the work of late nineteenth-century Europe's most successful and influential sculptor, Auguste Rodin (1840–1917). Born in Paris, Rodin failed three times to gain entrance to the École des Beaux-Arts and consequently spent the first 20 years of his career as an assistant to other sculptors and decorators. After an 1875 trip to Italy, where he saw the sculpture of Donatello and Michelangelo, Rodin developed a style of vigorously modeled figures in unconventional, even awkward poses, which was simultaneously scorned by academic critics and admired by the general public.

Rodin's status as a major sculptor was confirmed in 1884 when he won a competition to create **THE BURGHERS OF CALAIS** (**FIG. 31–45**) for the city of Calais, commemorating a local event from the Hundred Years' War. In 1347, Edward III of England had offered to spare the besieged city if six leading citizens (burghers) surrendered themselves to him for execution. Edward's wife, Queen Philippa of Hainault, convinced her husband to pardon the men

31–45 Auguste Rodin **THE BURGHERS OF CALAIS**
1884–1889. Bronze, 6'10½" × 7'11" × 6'6" (2.1 × 2.4 × 2 m). Hirshhorn Museum and Sculpture Garden, Smithsonian Institution, Washington, DC. Gift of Joseph H. Hirshhorn, 1966.

Rodin's relocation of public sculpture from a high pedestal to a low base would lead to the twentieth-century elimination of the pedestal itself, thus presenting sculpture in the "real" space of the viewer.

31–46 Camille Claudel **THE WALTZ**
1892–1905. Bronze, height 9⅞″ (25 cm). Neue Pinakothek, Munich.

Credit: Photo © Blauel/Gnamm/ARTOTHEK

because she feared their execution would be a bad omen for their unborn child, but Rodin's sculpture captures a moment before this pardon was known.

The Calais commissioners were pleased neither with Rodin's conception of the event nor with his plan to display the figures on a low base, almost at street level, to suggest to viewers that ordinary people like themselves were capable of noble acts. Instead of calm, idealized heroes, Rodin presented ordinary-looking men in various attitudes of resignation and despair, dressed only in sackcloth with rope halters and carrying the keys to the city. He exaggerated their facial expressions, lengthened their arms, greatly enlarged their hands and feet, and swathed them in heavy fabric, showing not only how they may have looked but also how they must have felt as they forced themselves to take one difficult step after another. Rodin's willingness to stylize the human body for expressive purposes opened the way for subsequent sculptural abstractions.

Camille Claudel (1864–1943), who was Rodin's assistant while he worked on *The Burghers of Calais*, had already studied sculpture formally before joining Rodin's studio.

She soon became his mistress, and their relationship lasted 15 years. Claudel enjoyed independent professional success but suffered a breakdown that sent her to a mental hospital for the last 30 years of her life.

One of Claudel's most celebrated works is **THE WALTZ** (**FIG. 31–46**), produced in several versions and sizes between 1892 and 1905. The subject of the waltz alone was controversial at this time because of the close body contact demanded of dancers. The sculpture depicts a dancing couple, both nude, although the woman's lower body is covered with long, flowing drapery, a concession she made after an inspector from the Ministry of Fine Arts declared their sensuality unacceptable, recommending against a state commission for a marble version of the work. Claudel added enough drapery to regain the commission, but she never finished it. She did, however, cast the modified version in bronze as this tabletop sculpture, in which the spiral flow of the cloth creates the illusion of rapturous movement as the embracing dancers twirl through space.

Art Nouveau

The swirling mass of drapery in Claudel's *The Waltz* has a stylistic affinity with Art Nouveau (French for "new art"), a movement launched in the early 1890s that permeated all aspects of European design for more than a decade. Art Nouveau embraced the use of modern industrial materials but rejected the functional aesthetic of works such as the Eiffel Tower (**SEE FIG. 31–1**) that showcased exposed structure as architectural design. Art Nouveau artists and architects drew particular inspiration from nature, especially from vines, snakes, flowers, and winged insects, whose delicate and sinuous forms were consistent with the graceful and attenuated aesthetic principles of the movement. The goal was to harmonize all aspects of design into an integrated whole, as found in nature itself.

HORTA The artist most responsible for developing the Art Nouveau style in architecture was the Belgian Victor Horta (1861–1947). After academic training in Ghent and Brussels, Horta worked in the office of a Neoclassical architect in Brussels for six years before opening his own practice in 1890. In 1892, he received his first important commission, a private residence in Brussels for a Professor Emile Tassel. The result, especially the house's entry hall and staircase (**FIG. 31–47**), was strikingly original. The iron-work, wall decoration, and floor tiles were all designed in an intricate series of long, graceful curves. Although Horta's sources are still debated, he was apparently impressed by the stylized linear designs of the English Arts and Crafts Movement of the 1880s. His concern for integrating the various arts into a more unified whole, like his reliance on sinuous decorative line, derived in part from English reformers such as William Morris.

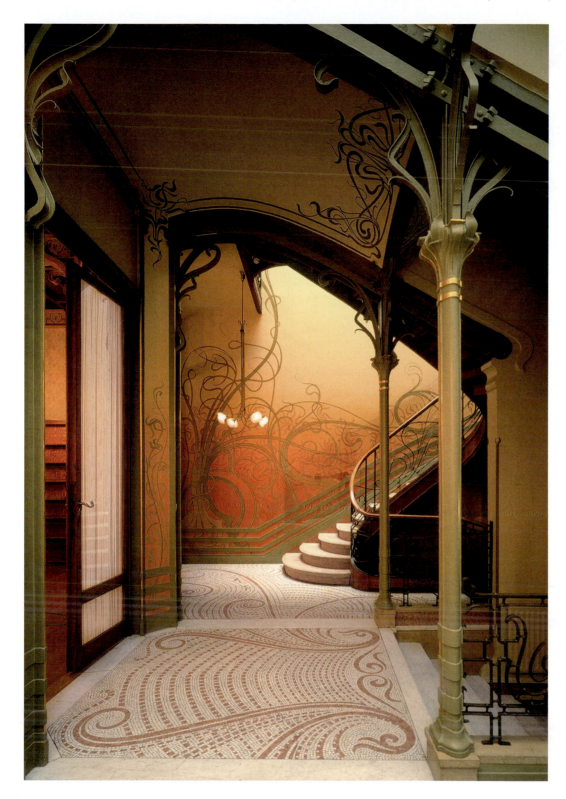

31–47 Victor Horta
STAIRWAY, TASSEL HOUSE, BRUSSELS
1892–1893.

Credit: © 2016 – Victor Horta, Bastin & Evrard/ARS NY/SOFAM, Brussels

GAUDÍ The application of graceful linearity to all aspects of design spread across Europe. In Spain, where the style was called *Modernismo*, the major practitioner was the Catalan architect Antoni Gaudí i Cornet (1852–1926). Gaudí integrated natural forms into the design of buildings and parks that are still revolutionary in their dynamic freedom of line.

In 1904, the wealthy industrialist Josep Batllò commissioned Gaudí to design a private residence to surpass the lavish houses of other prominent families in Barcelona. Gaudí convinced his patron to retain the underlying structure of an existing building, but transform its façade and interior spaces. Gaudí's façade (**FIG. 31–48**) is a dreamlike fantasy of undulating sandstone sculptures and multicolored glass and tile surfaces, imaginatively mixing the Islamic, Gothic, and Baroque visual traditions of Barcelona. The gaping lower-story windows are the source of the building's nickname, the "house of yawns,"

31–48 Antoni Gaudí **CASA BATLLÒ, BARCELONA**

43 Passeig de Gràcia. 1900–1907.

Credit: Vincent Abbey Photography

while the use of what look like giant human shinbones for upright supports led others to call it the "house of bones." The roof resembles a recumbent dragon with overlapping tiles as scales. A fanciful turret at its edge recalls the sword of St. George—patron saint of Catalunya—plunged into the back of the dragon, his legendary foe. Gaudí's highly personal alternative to academic historicism and modern industrialization reflects his affinity with Iberian traditions as well as his concern to provide imaginative surroundings to enrich the lives of city dwellers.

GUIMARD The leading French practitioner of Art Nouveau was Hector Guimard (1867–1942), who embraced the movement after meeting Horta in 1895. Guimard is most famous for his designs of entrances to the Paris Métro (subway) at the turn of the century, but he devoted much of his career to interior design and furnishings, such as this **DESK** that he made for himself (**FIG. 31–49**). Instead of a static and stable object, Guimard handcrafted an asymmetrical, organic entity that seems to undulate and grow around the person who sits at it.

31–49 Hector Guimard **DESK**
c. 1899 (remodeled after 1909).
Olive wood with ash panels,
28¾ × 47¾″ (73 × 121 cm).
Museum of Modern Art, New York.
Gift of Madame Hector Guimard.

Credit: © 2016. Digital Image, The
Museum of Modern Art/Scala, Florence/
Art Resource, NY

TOULOUSE-LAUTREC Henri de Toulouse-Lautrec (1864–1901) suffered from a genetic disorder that stunted his growth and left him physically disabled. Born into an aristocratic family in southern France, he moved to Paris in 1882, where his private academic training was transformed when he discovered the work of Degas. He also discovered Montmartre, the entertainment district of Paris that housed the most bohemian of the avant-garde artists. From the late 1880s, Toulouse-Lautrec dedicated himself to depicting the nightlife of Montmartre—the cafés, theaters, dance halls, and brothels that he himself frequented.

Between 1891 and 1901, Toulouse-Lautrec designed roughly 30 lithographic posters for Montmartre's more famous nightspots, advertising their most popular entertainers. One features the notoriously limber dancer **JANE AVRIL** performing the infamous can-can (**FIG. 31–50**). Toulouse-Lautrec places Avril on a stage that zooms into the background. The hand and face of a double-bass player, part of his instrument, and pages of music frame the poster in the extreme foreground at lower right—a bold foreshortening that recalls the compositions of Degas (SEE FIG. 31–33). But Toulouse-Lautrec's image emphasizes Avril's sexuality in order to draw in the crowds, while Degas's pictures

coax visual beauty from frank Realism. Toulouse-Lautrec outlines forms, flattens space, and suppresses modeling to accommodate the cheap colored lithographic printing technique he used, but the resulting bold silhouettes and curving lines are distinctively Art Nouveau.

31–50 Henri de Toulouse-Lautrec **JANE AVRIL**
1893. Four-color lithograph, 51⅛ × 37⅜″ (129.85 × 94.93 cm). Los Angeles County Museum of Art. Gift of Mr and Mrs Billy Wilder (59.80.15).

The Beginnings of Modernism

In what way do the innovative use of new technology in architectural design and the highly structured painting style of Paul Cézanne point toward twentieth-century Modernism?

The history of late nineteenth-century architecture reflects a dilemma faced by the industrial city, caught between the classicizing tradition of the Beaux-Arts academic style and the materials, construction methods, and new aesthetic of industry. The École des Beaux-Arts, although marginalized by the end of the century by new trends in painting, came into its own after 1880 as the training ground for European and American architects, while industrialization in places like Chicago simultaneously demanded new ways of thinking about tall and large buildings.

At the same time, Paul Cézanne, late in his life, altered the course of avant-garde painting by returning to an intense visual scrutiny of the world around him. In 1906, the year Cézanne died, a retrospective exhibition of his life's work in Paris revealed his methods to the next generation of artists, who would be the creators of Modernism.

European Architecture: Technology and Structure

The pace of life speeded up considerably over the course of the nineteenth century. Industrialization allowed people to manufacture more, consume more, travel more, and do more, in greater numbers than before. Industrialization caused urbanization, which in turn demanded more industrialization. A belief in the perfectibility of society spawned more than 20 international fairs celebrating innovations in industry and technology. One of the first of these took place in London in 1851. The Great Exhibition of the Industry of All Nations was mounted by the British to display their industrial might, assert their right to empire, and subdue lingering public unrest after the 1848 revolutions elsewhere in Europe. The centerpiece of the Great Exhibition, the Crystal Palace, introduced new building techniques and aesthetics.

THE CRYSTAL PALACE The revolutionary construction of **THE CRYSTAL PALACE** (**FIG. 31-51**), created by Joseph Paxton (1803–1865), featured a structural skeleton of cast iron that held iron-framed glass panes measuring 49 by 30 inches, the largest size that could be mass-produced at the time. Prefabricated wooden ribs and bars supported the panes. The triple-tiered edifice was the largest space that had ever been enclosed—1,851 feet long, covering more than 18 acres, and providing almost a million square feet of exhibition space. The central vaulted transept—based on the design for new cast-iron train stations—rose 108 feet to accommodate a row of the elm trees dear to Prince Albert, the husband of Queen Victoria (ruled 1837–1901). By the end of the exhibition, 6 million people had visited it, most agreeing that the Crystal Palace was a technological marvel. Even so, most architects and critics, still wedded to Neoclassicism and Romanticism, considered it a work of engineering rather than legitimate architecture because the novelty of its iron-and-glass frame overshadowed its Gothic Revival style.

31-51 Joseph Paxton
THE CRYSTAL PALACE
London. 1850–1851. Iron, glass, and wood. (Print of the Great Exhibition of 1851; printed and published by Dickinson Brothers, London, 1854. Illustration by Joseph Nash and Robert Haghe. British Library, London.)

31-52 Henri Labrouste **READING ROOM, BIBLIOTHÈQUE NATIONALE, PARIS** 1862–1868.

Credit: © Paul Almasy/Corbis

BIBLIOTHÈQUE NATIONALE Henri Labrouste (1801–1875)—trained as an architect at the École des Beaux-Arts, where he also taught—had a radical desire to combine the Academy's historicizing approach to architecture with the technical innovations of industrial engineering. Although reluctant to push his ideas at the École, he pursued them in his architecture. The **READING ROOM** of the Bibliothèque Nationale (**FIG. 31-52**) is an example of this fusion. A series of domes form the ceiling—faced with bright white ceramic tiles, crowned with glass-covered oculi that light the reading room, and supported on thin iron arches and columns that open the space visually. The mixture of historical allusions in the Classical detailing, combined with the vast open space made possible by industrial materials, is thoroughly modern.

The Chicago School

In the United States up until this time, as in Europe, major architectural projects were expected to embody Beaux-Arts historicism. But the modern city required new building types for industry, transportation, commerce, storage, and habitation—types that would accommodate more people and more activities in urban areas where land prices were skyrocketing. Chicago was a case in point.

As the transportation hub for grain, livestock, and other produce headed from the rural Midwest to the cities of the east and west coasts, Chicago had become a populous, wealthy city by the 1890s. As new department stores, commercial facilities, and office buildings were designed, primarily with practical needs in mind, Chicago also became the cradle for a novel way of thinking about urban design and construction in which function gave birth to architectural form.

WORLD'S COLUMBIAN EXPOSITION Richard Morris Hunt (1827–1895) was the first American to study architecture at the École des Beaux-Arts in Paris. Extraordinarily skilled in Beaux-Arts historicism and determined to raise the standards of American architecture, he built in every accepted style, including Gothic, French Classicist, and Italian Renaissance. After the Civil War, Hunt built many lavish mansions for a growing class of wealthy eastern industrialists and financiers, emulating aristocratic European models.

Late in his career, Hunt supervised the design of the 1893 World's Columbian Exposition in Chicago, commemorating the 400th anniversary of Christopher Columbus's arrival in the Americas. Rather than focus on engineering wonders as in previous fairs, the Chicago planning board

decided to build "permanent buildings—a dream city." To create a sense of unity among these buildings (which were, in fact temporary, constructed from a mixture of plaster and fibrous materials rather than masonry), a single style for the fair was settled upon—the Classical style, alluding to ancient Greece and republican Rome to reflect America's pride in its own democratic institutions as well as its emergence as a world power. A photograph of the **COURT OF HONOR (FIG. 31-53)** shows the Beaux-Arts style of the so-called "White City."

The World's Columbian Exposition was intended to be a model of the ideal American city—clean, spacious, carefully planned, and Classically styled—in contrast to the soot and overcrowding of most unplanned American cities. Frederick Law Olmsted, the designer of New York City's Central Park, was responsible for the exhibition's landscape design. He converted the marshy lakefront into a series of lagoons, canals, ponds, and islands, some laid out formally, as in the White City, and others informally, as in the Midway, which contained the busy conglomerate of pavilions representing "less civilized" nations. Between these two parts stood the world's first Ferris wheel, which provided a spectacular view of the fair and the city. After the fair, most of its buildings were demolished, but Olmsted's landscaping has remained.

RICHARDSON The second American architect to study at the École des Beaux-Arts was Henry Hobson Richardson (1838–1886). Born in Louisiana and educated at Harvard and Tulane, Richardson returned from Paris in 1865 to settle in New York. He designed architecture in a variety of revival styles but is most famous for a robust, rusticated style known as Richardsonian Romanesque. In 1885, he designed the **MARSHALL FIELD WHOLESALE STORE** in Chicago (**FIG. 31-54**), drawing on the design and scale of Italian Renaissance palaces such as the Palazzo Medici-Riccardi in Florence (**SEE FIG. 20-9**). Although the rough, blocklike stone facing, the arched windows, and the decorated cornice all evoke historical architecture, Richardson's mixture of diverse features resulted in a readily identifiable personal style.

Plain and sturdy, Richardson's building was a revelation to the young architects of Chicago, then engaged in rebuilding the city after the disastrous fire of 1871. About the same time, new technology for producing steel—a strong, cheap alloy of iron—created new structural opportunities for architects. The rapidly rising cost of urban land made tall buildings desirable; structural steel and the electric elevator (developed during the 1880s) made them possible. William Le Baron Jenney (1832–1907) built the first steel-skeleton building in Chicago; his lead was quickly

31-53 COURT OF HONOR, WORLD'S COLUMBIAN EXPOSITION, CHICAGO
1893. View from the east.

Surrounding the Court of Honor were, from left to right, the Agriculture Building by McKim, Mead, and White; the Administration Building by Richard Morris Hunt; and the Manufactures and Liberal Arts Building by George B. Post. The architectural ensemble was collectively called the White City, a nickname by which the exposition was also popularly known. The statue in the foreground is *The Republic* by Daniel Chester French.

Credit: © Corbis

31-54 Henry Hobson Richardson **MARSHALL FIELD WHOLESALE STORE, CHICAGO**

1885–1887. Demolished c. 1935.

Credit: Courtesy the Library of Congress

followed by younger architects in what was known as the Chicago School.

SULLIVAN The Chicago School architects produced not only a new style of architecture but a new kind of building—the skyscraper. An early example is Louis Sullivan's **WAINWRIGHT BUILDING** in St. Louis, Missouri (**FIG. 31-55**). The Boston-born Sullivan (1856–1924) studied for a year at the Massachusetts Institute of Technology (MIT), home of the United States' first formal architecture program, and for an equally brief period at the École des Beaux-Arts in Paris, where he developed a distaste for historicism. He settled in Chicago in 1875, partly because of the building boom there that had followed the fire of 1871. In 1883 he entered into a partnership with the Danish-born engineer Dankmar Adler (1844–1900).

Sullivan's first major skyscraper, the Wainwright Building has a U-shaped plan that provides an interior light-well for the illumination of inside offices. The ground floor, designed to house shops, has wide plate-glass windows for the display of merchandise. The second story, or mezzanine, also features large windows for the illumination of the shop offices. Above the mezzanine rise seven identical floors of offices lit by rectangular windows, and an attic story houses the building's mechanical plant and

utilities. A richly decorated foliate frieze in terra-cotta relief crowns the building, punctuated by bull's-eye windows and capped by a thick cornice slab.

The Wainwright Building's outward appearance clearly articulates three different levels of function: shops at the bottom, offices in the middle, and mechanical utilities at the top. It illustrates Sullivan's stated architectural philosophy: "Form ever follows function." This idea was adopted as a credo by Modernist architects, who used it to justify removal of all surface decoration from buildings. However, although Sullivan designed the Wainwright Building for function, he also created an expressive building. The thick corner piers, for example, are not structurally necessary—an internal steel-frame skeleton supports the building—but they emphasize its vertical thrust. The thinner piers between the office windows, which rise uninterrupted from the third story to the attic, echo and reinforce its spring and verticality. As Sullivan put it, a tall office building "must be every inch a proud and soaring thing, rising in sheer exultation."

In the Wainwright Building that exultation culminates in the rich vegetative ornament that swirls around the crown of the building like the foliated capital of a Corinthian column. The tripartite structure of the building itself suggests the Classical column with its base, shaft, and capital, reflecting the lingering influence of Classical design principles. Only in the twentieth century would Modernist architects reject tradition entirely to create an architectural aesthetic stripped of applied decoration.

31–55 Louis Sullivan **WAINWRIGHT BUILDING, ST. LOUIS**
Missouri. 1890–1891.

Credit: © Art on File/Corbis

The City Park

Parks originated during the second millennium BCE in China as enclosed hunting reserves for kings and the nobility. In Europe from the Middle Ages to the eighteenth century, they remained private recreation grounds for the privileged. The first urban park intended for the public was in Munich, Germany. Laid out by Friedrich Ludwig von Sckell in 1789–1795 in the picturesque style of an English landscape garden (SEE FIG. 30–16), it contained irregular lakes, gently sloping hills, broad meadows, and paths meandering through wooded areas.

The crowding and pollution of cities during the Industrial Revolution prompted the creation of large public parks whose green open spaces helped purify the air and provided city dwellers of all classes with a place for recreation. Numerous municipal parks were built in Britain during the 1830s and 1840s and in Paris during the 1850s and 1860s, when Georges-Eugène Haussmann redesigned the former royal hunting forests of the Bois de Boulogne and the Bois de Vincennes in the English style favored by Emperor Napoleon III.

In American cities before 1857, the only public outdoor spaces were small squares found between certain intersections, and larger gardens, such as the Boston Public Garden, neither of which filled the growing need for varied recreational facilities in the city. For a time, landscaped suburban cemeteries in the picturesque style were popular sites for strolling, picnicking, and even horse racing—an incongruous set of uses that strikingly demonstrated the need for more urban parks.

The rapid growth of Manhattan in the nineteenth century spurred civic leaders to set aside parkland while open space still existed. The city purchased an 843-acre tract in the center of the island and in 1857 announced a competition for its design as Central Park. The competition required that designs include a parade ground, playgrounds, a site for an exhibition or concert hall, sites for a

31–56 Frederick Law Olmsted and Calvert Vaux **PLAN OF CENTRAL PARK, NEW YORK CITY**
Revised and extended park layout as shown on a map of 1873.

Credit: Frederick Law Olmsted & Calvert Vaux/City of New York, Department of Parks

fountain and for a viewing tower, a flower garden, a pond for ice skating, and four east–west cross-streets so that the park would not interfere with the city's vehicular traffic. The latter condition was pivotal to the winning design, drawn up by architect Calvert Vaux (1824–1895) and park superintendent Frederick Law Olmsted (1822–1903), which sank the crosstown roads in trenches hidden below the surface of the park and designed separate routes for carriages, horseback riders, and pedestrians (**FIG. 31–56**).

Believing that the "park of any great city [should be] an antithesis to its bustling, paved, rectangular, walled-in streets," Olmsted and Vaux designed picturesque landscaping in the English tradition, with the irregularities of topography and planting used as positive design elements. Except for a few formal elements, such as the tree-lined mall that leads to the Classically designed Bethesda Terrace and Fountain, the park is remarkably informal and naturalistic. Where the land was low, Olmstead and Vaux further depressed it, installing drainage tiles and carving out ponds and meadows. They planted clumps of trees to contrast with open spaces, and exposed natural outcroppings of schist to provide dramatic, rocky scenery. They arranged walking trails, bridle paths, and carriage drives through the park with a series of changing vistas. Intentionally appealing were the views from the apartment houses of the wealthy on the streets surrounding the park. An existing reservoir divided the park into two sections. Olmsted and Vaux developed the southern half more completely and located most of the sporting facilities and amenities there, while leaving the northern half more like a nature reserve. Largely complete by the end of the Civil War, Central Park

was widely considered a triumph, launching a movement to build similar parks in cities across the United States.

Cézanne

No artist had a greater impact on the next generation of Modernist painters than Paul Cézanne (1839–1906). The son of a prosperous banker in the southern French city of Aix-en-Provence, Cézanne studied art first in Aix and then in Paris, where he participated in the circle of Realist artists around Manet. His early pictures, somber in color and coarsely painted, often depicted Romantic themes of drama and violence and were consistently rejected by the Salon.

In the early 1870s under the influence of Pissarro, Cézanne changed his style. He adopted a bright palette and broken brushwork and began painting landscapes. Like the Impressionists, with whom he exhibited in 1874 and 1877, Cézanne dedicated himself to the study of what he called the "sensations" of nature. Unlike the Impressionists, however, he did not seek to capture transitory effects of light and atmosphere; instead, he created highly structured paintings through a methodical application of color that merged drawing and modeling into a single process. His professed aim was to "make of Impressionism something solid and durable, like the art of the museums."

Cézanne's dedicated pursuit of this goal is evident in his repeated paintings of **MONT SAINTE-VICTOIRE**, a mountain close to his home in Aix, which he depicted in hundreds of drawings and about 30 oil paintings between the 1880s and his death in 1906. The painting in **FIGURE 31-57** presents the mountain rising above the Arc Valley, which is dotted with buildings and trees and crossed at the far right by a railroad viaduct. Framing the scene to the left is an evergreen tree, which echoes the contours of the mountains, creating visual harmony between the two principal elements of the composition. The even

31–57 Paul Cézanne **MONT SAINTE-VICTOIRE**

c. 1885–1887. Oil on canvas, 25½ × 32" (64.8 × 92.3 cm). The Samuel Courtauld Trust, the Courtauld Gallery, London. (P.1934.SC.55).

Credit: © Samuel Courtauld Trust, The Courtauld Gallery, London, UK/ Bridgeman Images

light, stable atmosphere, and absence of human activity create the sensation of timeless stillness.

Cézanne's handling of paint is deliberate and controlled. His brushstrokes, which vary from short, parallel hatchings to light lines to broader swaths of flat color, weave together the elements of the painting into a unified but flattened visual space. The surface design vies with the pictorial effect of receding space, generating tension between the illusion of three dimensions within the picture and the physical reality of its two-dimensional surface. Recession into depth is suggested by the tree in the foreground—a *repoussoir* (French for "something that pushes back") that helps draw the eye into the valley—and by the transition from the saturated hues in the foreground to the lighter values in the background, creating an effect of atmospheric perspective. But recession into depth is challenged by other more intense colors in both the foreground and background and by the tree branches in the sky, which follow the contours of the mountain, avoiding overlapping and subtly suggesting that the two are on the same plane. Photographs of this scene show that Cézanne created a composition in accordance with a harmony that he felt the scene demanded, rather than reproducing in detail the appearance of the landscape. His commitment to the painting as a work of art, which he called "something other than reality"—not a representation of nature but "a construction after nature"—was a crucial step toward the modern art of the next century.

Spatial ambiguities of a different sort appear in Cézanne's later still lifes, in which many of the objects may seem at first glance to be incorrectly drawn. In **STILL LIFE WITH BASKET OF APPLES** (FIG. 31–58), for example, the right side of the table is higher than the left, the wine bottle has two distinct silhouettes, and the pastries on the table next to it tilt upward toward the viewer, while we seem to see the apples head-on. Such shifting viewpoints are not evidence of incompetence; they come from Cézanne's rejection of the rules of traditional perspective. Although linear perspective requires that the eye of the artist (and thus the viewer) occupy a fixed point relative to the scene (see "Renaissance Perspective" in Chapter 20 on page 623), Cézanne presents the objects in his still lifes from a variety of different positions just as we might move around or turn our heads to take everything in. The composition as a whole, assembled from multiple sightings, is consequently complex and dynamic. Instead of faithfully reproducing static objects from a stable vantage point, Cézanne recreated, or reconstructed, our viewing experiences through time and space.

Cézanne enjoyed little professional success until the last years of his life, when his paintings became more complex internally and more detached from observed reality. **THE LARGE BATHERS** (FIG. 31–59), probably begun in the last year of his life and left unfinished, was the largest canvas he ever painted. It returns in several ways to the academic conventions of history painting as a monumental, multi-figured composition of nude figures in a landscape setting that suggests a mythological theme. The bodies cluster in two pyramidal groups at left and right, beneath a canopy of trees that opens in the middle onto a triangular

31–58 Paul Cézanne **STILL LIFE WITH BASKET OF APPLES**

1880–1894. Oil on canvas, 24⅜ × 31″ (62.5 × 79.5 cm). The Art Institute of Chicago. Helen Birch Bartlett Memorial Collection (1926.252).

Credit: Photo © The Art Institute of Chicago

expanse of water, landscape, and sky. The figures assume statuesque, often Classical poses and seem to exist outside recognizable time and space. Using a restricted palette of blues, greens, ochers, and roses laid down over a white ground, Cézanne suffused the picture with a cool light that emphasizes the scene's remoteness from everyday life.

Despite its unfinished state, *The Large Bathers* brings nineteenth-century painting full circle by reviving the Arcadian landscape, a much earlier category of academic painting, while opening a new window on some radical rethinking about the fundamental practice and purpose of art.

31–59 Paul Cézanne **THE LARGE BATHERS**
1906. Oil on canvas, 6'10" × 8'2" (2.08 × 2.49 m). Philadelphia Museum of Art. The W.P. Wilstach Collection.

Credit: © 2016. Philadelphia Museum of Art/Art Resource, NY/Scala, Florence

Think About It

1 Discuss the interests and goals of French academic painters and sculptors and explain how their work differed from other art of the same time and place, such as that of the Realists and Impressionists.

2 Discuss the innovative content of Impressionist paintings and explain how it differs from that of traditional European paintings by focusing on one specific work from the chapter.

3 Discuss Gustave Courbet's Realism in works such as *The Stone Breakers* (**FIG. 31–12**) and *A Burial at Ornans* (**FIG. 31–13**) in relation to the social and political issues of mid-century France.

4 Explain how the photographic process works and evaluate the roles played by Louis-Jacques-Mandé Daguerre and Henry Fox Talbot in the emergence of this medium.

Crosscurrents

European artists often include reflections of art from the past in works that address concerns of the present. This is certainly the case here, where Manet's *Olympia* recalls aspects of the composition and subject of this famous painting by Titian. The messages of the two paintings are very different, however. Analyze the meanings of these paintings. Do they express the concerns of artist, patron, or society, or some mixture of the three?

FIG. 21–30

FIG. 31–18

32–1 Pablo Picasso **MA JOLIE**

1911–1912. Oil on canvas, 39⅜ × 25¾″ (100 × 65.4 cm). Museum of Modern Art, New York.

Acquired through the Lillie P. Bliss Bequest (176.1945).

Chapter 32
Modern Art in Europe and the Americas, 1900–1950

 ## Learning Objectives

32.a Identify the visual hallmarks of modern European and American art and architecture from 1900–1950 for formal, technical, and expressive qualities.

32.b Interpret the meaning of works of modern European and American art from 1900–1950 based on their themes, subjects, and symbols.

32.c Relate modern European and American art and artists from 1900–1950 to their cultural, economic, and political contexts.

32.d Apply the vocabulary and concepts relevant to modern European and American art, architecture, artists, and art history from 1900–1950.

32.e Interpret a work of modern European or American art from 1900–1950 using the art historical methods of observation, comparison, and inductive reasoning.

32.f Select visual and textual evidence in various media to support an argument or an interpretation of a work of modern European or American art from 1900–1950.

Pablo Picasso was a towering presence at the center of the Parisian art world throughout much of the twentieth century, continually transforming the style, forms, meanings, and conceptual frameworks of his art in relation to the many factors at play in the world around him. Early in the century in his great Cubist work **MA JOLIE** (FIG. **32-1**) of 1911–1912, Picasso challenged his viewers to think about the very nature of communication through painting. Remnants of the subjects Picasso worked from are evident throughout, but any attempt to reconstruct the "subject"— a woman with a stringed instrument—poses difficulties for the viewer. *Ma Jolie* ("My Pretty One," the nickname Picasso used for his lover of the time, Marcelle Humbert) is in some sense a portrait, though Picasso makes us work to see and to understand the figure. We can discover several things about Ma Jolie from the painting; we can see parts of her head, her shoulders, the curve of her body, and a hand. But in Paris in 1911, "Ma Jolie" was also the title of a popular song, so the inclusion of writing and a musical staff and treble clef in the painting suggests other meanings. Our first impulse might be to wonder what exactly is pictured. Picasso provided the sarcastic answer, "My Pretty One."

On the other hand, it might be argued that the human subject provided only the raw material for a formal, abstract arrangement. A subtle tension between order and disorder is maintained throughout this painting. For example, the shifting effect of the surface—a delicately patterned texture of grays and browns—is unified through the use of short, horizontal brushstrokes. Similarly, with the linear elements, horizontals and verticals at first seem to dominate, but strong diagonals and occasional curves challenge the grid-like regularity. The combination of horizontal brushwork and right angles firmly establishes a grid that effectively counteracts the surface flux. Moreover, the repetition of certain diagonals and the relative lack of details in the upper left and upper right create a pyramidal shape reminiscent of Classical systems of compositional stability (SEE FIG. 21-1). Thus, what at first may seem a chaotic composition of lines and muted colors turns out to be a carefully organized design. For many, the aesthetic satisfaction of such a work depends on the way chaos seems to resolve itself into order.

In 1923, Picasso said, "Cubism is no different from any other school of painting. The same principles and the same elements are common to all. The fact that for a long time Cubism has not been understood ... means nothing. I do not read English, [but] this does not mean that the English language does not exist, and why should I blame anyone ... but myself if I cannot understand [it]?"

Europe and America in the Early Twentieth Century

What are the political and social backgrounds for early twentieth-century European and American art and architecture?

At the beginning of the twentieth century, the fragile idea that "civilization" would inexorably continue to progress began to crack and finally fell apart in an orgy of violence during World War I. Beginning in August 1914, the war initially pitted the Allies (Britain, France, and Russia) against the Central Powers (Germany and the Austro-Hungarian Empire) and the Ottoman Empire. The United States eventually entered the war on the side of Britain and France in 1917, helping to guarantee victory for the Allies the following year.

World War I transformed almost every aspect of Western society, including politics, economics, and culture (**MAP 32–1**). The war was fought with twentieth-century technology but nineteenth-century strategies. Trench warfare and the Maxim gun (an early machine gun) caused the deaths of millions of soldiers and the horrible maiming of millions more. Europe lost an entire generation of young men; whole societies were shattered. Europeans began to question the nineteenth-century imperial social and political order that had brought about this carnage and foreshadowed a change in the character of

warfare itself. Future wars would be fought over ideology as well as territory.

In the first half of the twentieth century, three very different political ideologies struggled for world supremacy: communism (as in China and the Union of Soviet Socialist Republics, or U.S.S.R.), fascism (as in Italy and Germany), and liberal–democratic capitalism (as in North America, Britain, and Western Europe). The October 1917 Russian Revolution led to the Russian Civil War and the eventual triumph of the Bolshevik ("Majority") Communist Party led by Vladimir Lenin (1870–1924), as well as to the founding of the U.S.S.R. in 1922. After Lenin's death and an internal power struggle, Joseph Stalin (1878–1953) emerged as leader of the U.S.S.R. Under Stalin, the U.S.S.R. took over several neighboring states, suffered through the Great Purge of the 1930s, and lost tens of millions during the war against Nazi Germany.

Fascism first took firm root in Italy in October 1922 when Benito Mussolini (1883–1945) came to power. In Germany, meanwhile, the postwar democratic Weimar Republic collapsed under a combination of rampant hyperinflation and the enmity between communists, socialists, centrists, Christian Democrats, and fascists. By the time of the 1932 parliamentary election, Germany's political and economic deterioration had paved the way for a Nazi Party victory and the chancellorship of its leader, Adolf Hitler (1889–1945). Fascism was not limited to Germany and Italy—it was widespread throughout Central and

MAP 32–1 EUROPE, THE AMERICAS, AND NORTH AFRICA, 1900–1950

Eastern Europe and on the Iberian peninsula, where General Francisco Franco (1892–1975) emerged victorious from the Spanish Civil War.

The economic impact of World War I was global. Although the United States emerged from it as the leading economic power in the world, hyperinflation in Germany during the 1920s, the repudiation of German war debt under the Versailles Treaty, and the United States stock market crash of 1929 plunged the Western world into a widespread economic depression that exacerbated political hostility between the major European countries, served as an incubator for fascism and communism in Europe, and tore apart the social and political fabric of Britain and America. In the United States, President Franklin D. Roosevelt (1882–1945, president 1933–1945) created the New Deal programs in 1933 to stimulate the economy with government spending, and France and Britain took their first steps toward the modern welfare state. But ultimately only the military build-up of World War II would end the United States's Great Depression. This war lasted from 1939 to 1945, and the human carnage it caused to both soldiers and civilians, particularly in German concentration camps, raised difficult questions about the very nature of our humanity.

Changes in scientific knowledge were also dramatic. Albert Einstein's publication of his Special Theory of Relativity in 1905 had shaken the foundations of Newtonian physics; they collapsed with the subsequent development of quantum theory by Niels Bohr, Werner Heisenberg, and Max Planck. These developments in physics also unlocked the Pandora's box of nuclear energy; first opened when the British split the atom in 1919, it was fully unleashed on the world when America dropped nuclear bombs on Japan in 1945.

The early twentieth century also witnessed a multitude of innovations in technology and manufacturing: the first powered flight (1903); the mass manufacture of automobiles (1909); the first public radio broadcast (1920); the electrification of most of Western Europe and North America (1920s); and the development of both television (1926) and the jet engine (1937), to mention only a few. Technology led both to better medicines for prolonging life and to more efficient warfare, which shortened it. Information about the outside world became ever more accessible with the advent of radio, television, and film. The visual popular culture of the nineteenth century had been based on paper, but that of the early twentieth century was centered in photographs and films.

Just as quantum physics fundamentally altered our understanding of the physical world, developments in psychology transformed our conception of the workings of the mind and consequently how we viewed ourselves. In 1900, Austrian psychiatrist Sigmund Freud published *The Interpretation of Dreams*, which argues that our behavior is often motivated not only by reason, but also by powerful forces that work below our level of awareness. The human unconscious, as he described it, includes strong urges for love and power that must be managed if society is to remain peaceful and whole. For Freud, we are always attempting to strike a balance between our rational and irrational sides, often erring on one side or the other. Also in 1900, Russian scientist Ivan Pavlov began feeding dogs only after ringing a bell. Soon the dogs salivated not at the sight of food, but at the sound of the bell. The later discovery that these "conditioned responses" also exist in humans showed that if we manage external stimuli we can control people's appetites. Political leaders of all stripes soon exploited this realization.

Thus the first half of the twentieth century was a time of exciting new theories and technologies, as well as increased access of ordinary people to consumer items, but it was also a time of cataclysmic social, economic, and political change when millions died in wars and concentration camps. These changes, whether for the better or for the worse, shaped the art of the early twentieth century.

Early Modern Art and Architecture in Europe

How is Modernism established and spread in Europe?

Modern artists explored many new ways of seeing their world. Few read academic physics or psychology texts, but their day-to-day life was being transformed by such fields, as well as by many technological advances. Modernist art was frequently subversive and intellectually demanding, and it was often visually, socially, and politically radical. It seems as if every movement in early twentieth-century art chose or acquired a distinctive label and wrote a manifesto or statement of intent, leading this to be described later as the age of "isms."

Most Modern art was still bound to the idea that works of art, regardless of how they challenged vision and thought, were still precious objects—primarily pictures or sculptures. But a few artistic movements—notably Dada and some elements of Surrealism, both prompted by the horrors of World War I—challenged this idea. Their preoccupations built the foundation for much art after 1950.

The Fauves: Wild Beasts of Color

In 1903, a group of discontented artists organized and founded the Salon d'Automne (Autumn Salon), so named to distinguish it from the official Salon that took place every spring. The Autumn Salon provided a showcase for progressive artists, and many major Modernist movements of the twentieth century made their debut in this Salon's

32–2 André Derain **MOUNTAINS AT COLLIOURE**

1905. Oil on canvas, 32 × 39½" (81.5 × 100 cm). National Gallery of Art, Washington, DC.

John Hay Whitney Collection.

Credit: © 2016 Artists Rights Society (ARS), New York/ADAGP, Paris. Image courtesy the National Gallery of Art, Washington

disorderly halls. The paintings exhibited in 1905 by André Derain (1880–1954), Henri Matisse (1869–1954), and Maurice de Vlaminck (1876–1958) were filled with such brilliant colors and blunt brushwork that the critic Louis Vauxcelles described the young painters as *fauves* ("wild beasts"), the French term by which they soon became known. These artists took the French tradition of color and strong brushwork to new heights of intensity and expressive power and entirely rethought the painting's surface.

Among the first major Fauve works were paintings that Derain and Matisse made in 1905 in the French Mediterranean port town of Collioure. In **MOUNTAINS AT COLLIOURE** (**FIG. 32-2**), Derain used short, broad strokes of pure color, placing next to each other the complementary colors of blue and orange (as in the mountain range) or red and green (as in the trees) to intensify the hue of each. He chose a range of semi-naturalistic colors—the grass and the trees are green, the trunks are close to brown. This is recognizable as a landscape, but it is also a self-conscious exercise in

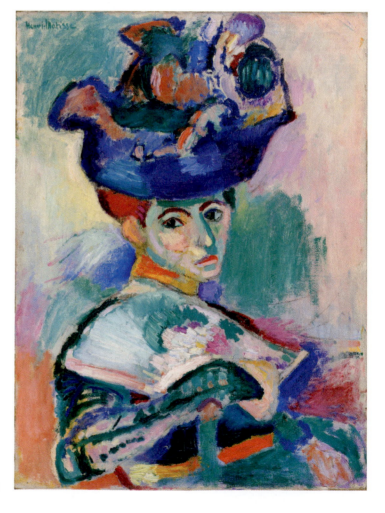

32-3 Henri Matisse **THE WOMAN WITH THE HAT**
1905. Oil on canvas, 31¾ × 23½" (80.6 × 59.7 cm). San Francisco Museum of Modern Art. Bequest of Elise S. Haas.

Credit: © 2016 Succession H. Matisse/Artists Rights Society (ARS), New York

painting. The uniform brightness of the colors undermines any effect of atmospheric perspective. As a consequence, viewers remain aware that they are looking at a flat canvas covered with paint, not an illusionistic rendering of the natural world. This tension between image and painting, along with the explosive effect of the color, generates a visual energy that positively pulses from the painting. Derain described his colors as "sticks of dynamite" and his stark juxtapositions of complementary hues as "deliberate disharmonies."

Matisse was equally interested in "deliberate disharmonies." His **WOMAN WITH THE HAT** (FIG. 32-3) was particularly controversial at the 1905 Autumn Salon because of its thick swatches of crude, seemingly arbitrary, nonnaturalistic color and its broad and blunt brushwork. For instance, the face of the subject—Matisse's wife Amélie, who was a milliner and probably sold elaborate hats like the one she wears here—includes bold green stripes across her brow and down her nose, as well as a blue rectangle between her lips and her chin. The uproar, however, did not stop siblings Gertrude and Leo Stein, among the most important American patrons of avant-garde art at this time, from purchasing the work in 1905.

The same year, Matisse also began painting **THE JOY OF LIFE (LE BONHEUR DE VIVRE)** (FIG. 32-4), a large pastoral landscape depicting a golden age—a reclining nude in the foreground plays pan pipes, another piper herds goats in the right mid-ground, lovers embrace in the foreground, and others dance in the background. Like Cézanne's *The Large Bathers* painted in the same year (SEE FIG. 31-59), *The Joy of Life* is academic in scale and theme, but avant-garde in most other respects—notably in the way the figures appear "flattened" and in the distortion of the spatial relations between them. Matisse emphasized expressive color, drawing on folk-art traditions in his use of unmodeled forms and bold outlines. In the past, artists might have expressed feeling through the figures' poses or facial expressions, but now, he wrote, "The whole arrangement of my picture is expressive. The place occupied by figures or objects, the empty spaces around them, the proportions, everything plays a part…. The chief aim of color should be to serve expression as well as possible."

32-4 Henri Matisse **THE JOY OF LIFE (LE BONHEUR DE VIVRE)**
1905–1906. Oil on canvas, 5′8½″ × 7′9¾″ (1.74 × 2.38 m). The Barnes Foundation, Merion, Pennsylvania. (BF 719).

Picasso, "Primitivism," and the Coming of Cubism

Of all Modern art "isms" created before World War I, Cubism was probably the most influential. The joint invention of Pablo Picasso (1881–1973) and Georges Braque (1882–1963)—who worked side by side in Paris, the undisputed capital of the art world before 1950—Cubism proved a fruitful launching pad for both artists, allowing them to comment on modern life and investigate the ways in which artists perceive and represent the world around them.

PICASSO'S EARLY ART Born in Málaga, Spain, Picasso was an artistic child prodigy. During his teenage years at the National Academy in Madrid, he painted highly polished works that presaged a conservative artistic career, but his restless temperament led him to Barcelona in 1899, where he involved himself in avant-garde circles. In 1900, he first traveled to Paris, and in 1904 he moved there and would live in France for the rest of his life. During this early period Picasso painted urban outcasts in weary poses using a coldly expressive blue palette that led art historians to label this his Blue Period. These paintings

seem motivated by Picasso's political sensitivity to those he considered victims of modern capitalist society, which eventually led him to join the Communist Party.

In 1904–1905, Picasso joined a larger group of Paris-based avant-garde artists and became fascinated with the subject of *saltimbanques* ("traveling acrobats"). He rarely painted these entertainers performing, however, focusing instead on the hardships of their existence on the margins of society. In **FAMILY OF SALTIMBANQUES** (FIG. 32-5), a painting from his Rose Period (so called because of the introduction of that color into his palette), five *saltimbanques* stand in weary silence to the left, while a sixth, a woman, sits in curious isolation on the right. All seem psychologically withdrawn, as uncommunicative as the empty landscape they occupy. The harlequin figure to the far left is commonly identified as a self-portrait of the artist, suggesting his identification with the circus performers as marginalized and melancholy illusionists. By 1905, Picasso had begun to sell these works to a number of important collectors.

Soon Picasso became one of the first artists in Paris to use images from African art in his paintings. In 1906, the Louvre installed a newly acquired collection of sculpture

32-5 Pablo Picasso **FAMILY OF SALTIMBANQUES** 1905. Oil on canvas, 6'11¾ × 7'6⅜" (2.1 × 2.3 m). National Gallery of Art, Washington, DC. Chester Dale Collection (1963.10.190).

Credit: © 2016 Estate of Pablo Picasso/Artists Rights Society (ARS), New York. Image courtesy the National Gallery of Art, Washington

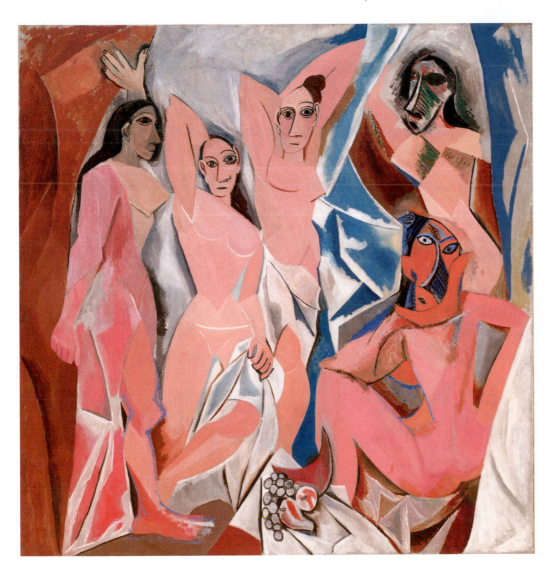

32–6 Pablo Picasso
LES DEMOISELLES D'AVIGNON (THE YOUNG LADIES OF AVIGNON)

1907. Oil on canvas, 8′ × 7′8″ (2.43 × 2.33 m). Museum of Modern Art, New York. Acquired through the Lillie P. Bliss Bequest (333.1939).

Credit: © 2016 Estate of Pablo Picasso/Artists Rights Society (ARS), New York. © 2016. Digital image, The Museum of Modern Art, New York/Scala, Florence

from the Iberian peninsula (present-day Spain and Portugal) dating from the sixth and fifth centuries BCE. Picasso certainly saw those works, but it was an exhibition of African masks that he saw around the same time that really changed the way he thought about art. The exact date of this encounter is not known, but it might have occurred at the Musée d'Éthnographie du Trocadéro, which had opened to the public in 1878. Picasso greatly admired the expressive power and formal strangeness of African masks, and since African art was relatively inexpensive, he also bought several pieces from Parisian shops and kept them in his studio.

The term **primitivism** refers to the widespread tendency among Modern artists to scour the art of other cultures beyond the Western tradition for inspiration. It is not benignly descriptive; it carries modern European perceptions that Western culture is more civilized, more developed, and more complex than other cultures, which are less civilized, less developed, and simpler. It could be argued that just as colonizing nations exploited "primitive" lands in the nineteenth century for raw materials and labor to increase their own wealth and power, so did

Western artists exploit the visual cultures of "primitive" nations to amplify ideas about themselves. Many early Modern artists thus represented other cultures and used aspects of their art without understanding—or really caring to understand—how those cultures actually functioned or how their art was used. This was the case with Picasso.

His contact with African art had a huge impact on **LES DEMOISELLES D'AVIGNON (THE YOUNG LADIES OF AVIGNON) (FIG. 32–6)**, one of the most radical and complex paintings of the twentieth century. "*Demoiselle*" was a common euphemism for prostitute at this time, and Avignon was the name of a street in the red-light district in Barcelona. The work's boldness, however, resides not only in its subject matter, but also in its size: nearly 8 feet square. Picasso may have undertaken such a large painting in 1907 to compete with both Matisse—who had exhibited *The Joy of Life* (SEE FIG. 32–4) in the Salon des Indépendants of 1906—and Cézanne—whose *Large Bathers* (SEE FIG. 31–59) was shown the same year. Like Matisse and Cézanne, Picasso revived and changed the ideas of large-scale academic history painting, using the traditional subject of nude women shown in an interior space. There are other echoes of the

Western tradition in the handling of the figures. The two women in the center display themselves to the viewer like Venus rising from the sea (SEE FIGS. 20–35, 31–5), while the one to the left takes a rigid pose with a striding stance, recalling a Greek *kouros* (SEE FIG. 5–18), and the one seated on the right might suggest the pose of Manet's *Luncheon on the Grass* (SEE FIG. 31–17). But not all visual references point to the Western tradition. Iberian sources stand behind the faces of the three leftmost figures, with their flattened features and wide, almond-shaped eyes. The masklike faces of the two figures at right imitate African art.

Picasso has created an unsettling picture from these sources. The women are shielded by masks, flattened and fractured into sharp, angular shapes. The space they inhabit is incoherent and convulsive. The central pair raise their arms in a conventional gesture of accessibility but contradict it with their hard, piercing gazes and tight mouths that create what art historian Leo Steinberg called "a tidal wave of female aggression." Even the fruit displayed in the foreground, symbols of female sexuality, seems brittle and dangerous. These women, Picasso suggests, are not the gentle and passive creatures that men would like them to be. This viewpoint contradicts an enduring tradition, prevalent at least since the Renaissance, of portraying sexual availability in the female nude, just as strongly as Picasso's treatment of space shatters the reliance on orderly perspective, also standard since the Renaissance.

Most of Picasso's friends were shocked by his new work. Matisse, for example, accused Picasso of making a joke of Modern art and threatened to break off their friendship. But one artist, Georges Braque, enthusiastically embraced Picasso's radical ideas—he saw in *Les Demoiselles d'Avignon* a potential for new visual experiments. In 1907–1908, Picasso and Braque began a close working relationship that lasted until the latter went to war in 1914. Together, they developed Picasso's formal innovations by flattening pictorial space, incorporating multiple perspectives within a single picture, and fracturing form, all features that they had admired in Cézanne's late paintings. According to Braque, "We were like two mountain climbers roped together."

ANALYTIC CUBISM Braque, a year younger than Picasso, was born near Le Havre, France, where he trained as a decorator. In 1900, he moved to Paris and began painting brightly colored Fauvist landscapes, but it was the 1906 Cézanne retrospective and Picasso's *Demoiselles* in 1907 that established his future course by sharpening his interest in altered form and compressed space. In his landscapes after 1908, he reduced nature's complexity to its essential colors and elemental geometric shapes, but the Autumn Salon rejected his work. Fellow artists dismissively referred to Braque's "little cubes," and the critic Louis Vauxcelles picked up the phrase, claiming that

Braque "reduced everything to cubes," thereby giving birth to the art historical label of Cubism.

Braque's 1909–1910 **VIOLIN AND PALETTE** (FIG. 32–7) shows the kind of relatively small still-life paintings that the two artists created during their initial collaborative

32–7 Georges Braque **VIOLIN AND PALETTE**
1909–1910. Oil on canvas, 36⅛ × 16⅞" (91.8 × 42.9 cm).
Solomon R. Guggenheim Museum, New York. (54.1412).

Credit: © 2016 Artists Rights Society (ARS), New York/ADAGP, Paris. The Solomon R. Guggenheim Foundation/Art Resource, NY.

experimentation in the gradual abstraction of recognizable subject matter and space. The still-life items here are not arranged in a measured progression from foreground to background, but push close to the picture plane, confined to a shallow space. Braque knits the various elements—a violin, an artist's palette, and some sheet music—together into a single shifting surface of forms and colors. In some areas of the painting, these formal elements have lost not only their natural spatial relations but their coherent shapes as well. Where representational motifs remain—the violin, for example—they have been fragmented by Braque to facilitate their integration into the compositional whole.

Picasso's 1910 Cubist **PORTRAIT OF DANIEL-HENRY KAHNWEILER** (**FIG. 32-8**) depicts the artist's first and most important art dealer in Paris, who saved many artists from destitution by buying their early works. Kahnweiler (1884–1979) was an early champion of Picasso's art and one of the first to recognize the significance of *Les Demoiselles d'Avignon*. His impressive stable of artists included Picasso, Braque, Derain, Fernand Léger, and Juan Gris. Since he was German, Kahnweiler fled France for Switzerland during World War I; the French government confiscated all his possessions, including his stock of paintings, which was sold by the state at auction after the war. Being Jewish, he was forced into hiding during World War II.

Braque's and Picasso's paintings of 1909 and 1910 initiated what is known as Analytic Cubism because of the way the artists broke objects into parts as if to analyze them. In works of 1911 and early 1912, such as Picasso's *Ma Jolie* (SEE FIG. 32-1), they begin to take a somewhat different approach to the breaking up of forms, in which they did not simply fracture objects visually, but also rearranged their components. Thus, Analytic Cubism begins to resemble the actual process of perception, during which we examine objects from various points of view and reassemble our glances into a whole object in our brain. Except Picasso and Braque reassembled their shattered subjects not according to the process of perception, but conforming to principles of artistic composition, to communicate meaning rather than to represent observed reality. For example, remnants of the subject are evident throughout Picasso's *Ma Jolie*, but any attempt to reconstruct them into the image of a woman with a stringed instrument would be misguided since the subject provided only the raw material for a formal composition. *Ma Jolie* is not a representation of a woman, a place, or an event; it is simply a painting.

SYNTHETIC CUBISM Works such as *Ma Jolie* brought Picasso and Braque to the brink of complete abstraction, but in the spring of 1912 they pulled back and began to create works that suggested more clearly discernible subjects. Neither artist wanted to break the link to reality; Picasso said that there was no such thing as completely abstract art, because "You have to start somewhere." This second

32-8 Pablo Picasso PORTRAIT OF DANIEL-HENRY KAHNWEILER

1910. Oil on canvas, 39½ × 28⅝" (100.6 × 72.8 cm). The Art Institute of Chicago. Gift of Mrs. Gilbert W. Chapman in memory of Charles B. Goodspeed.

Credit: © 2016 Estate of Pablo Picasso/Artists Rights Society (ARS), New York. Photo © The Art Institute of Chicago

major phase of Cubism is known as Synthetic Cubism because of the way the artists created complex compositions by combining and transforming individual elements, as in a chemical synthesis. Picasso's **BOTTLE OF SUZE (LA BOUTEILLE DE SUZE)** (**FIG. 32-9**), like many of the works he and Braque created from 1912 to 1914, is a collage (from the French *coller*, meaning "to glue"), a work composed of separate elements pasted together. At the center, assembled newsprint and construction paper suggest a tray or round table supporting a glass and a bottle of liquor with an actual label. Around this arrangement Picasso pasted larger pieces of newspaper and wallpaper.

As in earlier Cubism, Picasso offers multiple perspectives. We see the top of the blue table, tilted to face us, and simultaneously the side of the glass. The bottle stands on the table, its label facing us, while we can also see the round profile of its opening, as well as the top of the cork that plugs it. The elements together evoke not only a place—a bar—but also an activity—the viewer alone with a newspaper, enjoying a quiet drink.

The newspaper clippings glued to this picture, however, disrupt the quiet mood. They address the First Balkan War of 1912–1913, which contributed to the outbreak of World War I. Picasso may have wanted to underline the disorder in his art by comparing it with the disorder building in the world around him, or to warn viewers not to sit blindly and sip Suze while political events threatened to shatter the peaceful pleasures this work evokes—or this may simply be a collage.

Picasso employed collage three-dimensionally to produce Synthetic Cubist sculpture, such as **MANDOLIN AND CLARINET** (**FIG. 32-10**). Composed of wood scraps, the sculpture suggests the Cubist subject of two musical instruments, here shown at right angles to each other. Sculpture had traditionally been carved, modeled, or cast. Picasso's sculptural collage was a new idea and introduced **assemblage**, giving sculptors the option not only of carving or modeling masses to sit within space, but also of constructing three-dimensional works from combinations of found objects and unconventional materials, assembled in such a way that each part maintains its own identity while at the same time contributing to a new, combined form.

32-9 Pablo Picasso **BOTTLE OF SUZE
(LA BOUTEILLE DE SUZE)**
1912. Pasted paper, gouache, and charcoal, 25¾ × 19¾"
(65.4 × 50.2 cm). Mildred Lane Kemper Art Museum, Washington
University in St. Louis. University purchase, Kende Sale Fund, 1946.

Credit: © 2016 Estate of Pablo Picasso/Artists Rights Society (ARS), New York.
Photo © Hans Hinz/ARTOTHEK.

32-10 Pablo Picasso **MANDOLIN AND CLARINET**
1913. Construction of painted wood with pencil marks,
25⅝ × 14⅛ × 9" (58 × 36 × 23 cm). Musée Picasso, Paris.

Credit: © 2016 Estate of Pablo Picasso / Artists Rights Society (ARS), New York.
Photo © RMN-Grand Palais (musée Picasso de Paris)/Béatrice Hatala.

Die Brücke and Primitivism

At the same time that Picasso and Braque were transforming painting in Paris, a group of radical German artists came together in Dresden as Die Brücke (The Bridge), taking their name from a passage in Friedrich Nietzsche's *Thus Spake Zarathustra* (1883) that describes contemporary humanity's potential as a bridge to a more perfect humanity in the future. Formed in 1905, Die Brücke included architecture students Fritz Bleyl (1880–1966), Erich Heckel (1883–1970), Ernst Ludwig Kirchner (1880–1938), and Karl Schmidt-Rottluff (1884–1976). Other German and northern European artists later joined the group, which continued until 1913. These artists hoped Die Brücke would be a gathering place for "all revolutionary and surging elements" who opposed Germany's "pale, over-bred, and decadent" society.

Drawing on the work of northern visual predecessors such as Van Gogh and Munch and adopting traditional northern media such as woodcuts, these artists created intense, brutal, expressionistic images of alienation and anxiety in response to Germany's rapid and intensive

32–11 Erich Heckel STANDING CHILD
1910. Color woodcut, 14¾ × 10¾″ (37.5 × 27.5 cm).
Los Angeles County Museum of Art.

urbanization. Not surprisingly, among their favorite motifs were the natural world and the nude body—nudism was also a growing cultural trend in Germany in those years, as city dwellers forsook the city to reconnect with nature. Erich Heckel's three-color woodcut print **STANDING CHILD** (FIG. 32–11) of 1910 presents a strikingly stylized but powerfully expressive image of a naked girl—whose flesh is the reserved color of the paper itself—isolated against a spare landscape created from broad areas of pure black, green, and red. The girl stares straight out at the viewer with a confident sexuality that becomes more unsettling when we learn that this girl was the 12-year old Fränzi Fehrmann, a favorite of Die Brücke artists who, with her siblings, modeled to provide financial support for her widowed mother.

Although not part of the original Die Brücke group, Emil Nolde (1867–1956) joined in 1906 and quickly became its most committed member. Originally trained in industrial design, Nolde studied academic painting privately in Paris for a few months in 1900, but he never painted as he was taught. Nolde regularly visited Parisian ethnographic museums to study the art of Africa and Oceania, which impressed him with the radical and forceful visual presence of the human figure, especially in masks. His painting **MASKS** (FIG. 32–12) of 1911 seems to come both from what he saw in Paris and from the masquerades familiar to him from European carnivals (SEE FIG. 31–44). By merging these traditions, Nolde transforms his African and Oceanic sources into a European nightmare full of horror and implicit violence. The gaping mouths and hollow eyes of the hideously colored and roughly drawn masks taunt viewers, appearing to advance from the picture plane into their space. Nolde also uses the juxtaposition of complementaries to intensify his colors and the painting's emotionality. Nolde stopped frequenting Die Brücke's studio in 1907 but remained friendly with the group's members. On the eve of World War I, Nolde accompanied a German scientific expedition to New Guinea, explaining that what attracted him to the "native art" of Pacific cultures was their "primitivism," their "absolute originality, the intense and often grotesque expression of power and life in very simple forms."

32–12 Emil Nolde MASKS
1911. Oil on canvas, 28¾ × 30½″
(73.03 × 77.47 cm). The Nelson-Atkins
Museum of Art, Kansas City, Missouri.
Gift of the Friends of Art (54-90).

32-13 Ernst Ludwig Kirchner STREET, BERLIN
1913. Oil on canvas, 47½ × 35⅞″ (120.6 × 91 cm). Museum of Modern Art, New York. Purchase (274.39).

Credit: © 2016 Digital image The Museum of Modern Art, New York/Scala, Florence

Each summer, members of Die Brücke returned to nature, visiting remote areas of northern Germany, but in 1911 they moved to Berlin instead—perhaps preferring to imagine rather than actually live the natural life. Their images of cities, especially Berlin, are powerfully critical of urban existence. In Ernst Ludwig Kirchner's **STREET, BERLIN** (**FIG. 32-13**), two prostitutes—their profession advertised by their large, feathered hats

and fur-trimmed coats—strut past a group of well-dressed bourgeois men whom they view as potential clients. The figures are dehumanized, with masklike faces and stiff gestures. Their bodies crowd together, but they are psychologically distant, ambiguously related to one another. The biting colors, tilted perspective, and forceful brushstrokes make this a disturbing Expressionistic image of urban degeneracy and alienation.

Independent Expressionists

Beyond the members of Die Brücke, many other artists in Germany and Austria worked Expressionistically before World War I. For example, Käthe Kollwitz (1867–1945) used her art to further working-class causes and pursue social change. She preferred printmaking because its affordability gave it the potential to reach a wide audience. Between 1902 and 1908, she produced a series of seven etchings showing the sixteenth-century German Peasants' War. **THE OUTBREAK** (**FIG. 32-14**), a lesson in the power of group action, portrays the ugly fury of the peasants as they charge forward, armed only with their farm tools, bent on revenge against their oppressors. The faces of the two figures at the front of the charge are particularly grotesque, while the leader, Black Anna—whom Kollwitz modeled on herself—signals the attack with a fierce gesture, her arms silhouetted against the sky. Behind her, the crowded and chaotic mass of workers forms a passionate picture of political revolt.

Like Kollwitz, Paula Modersohn-Becker (1876–1907) studied at the Berlin School of Art for Women. In 1898, she moved to Worpswede, an artists' retreat in rural northern

32-14 Käthe Kollwitz THE OUTBREAK
From the "Peasants' War" series. 1903. Etching, 20 × 23⅓″ (50.7 × 59.2 cm). Kupferstichkabinett, Staatliche Museen zu Berlin.

Credit: © 2016 Artists Rights Society (ARS), New York/ VG Bild-Kunst, Bonn. © 2016. Photo Scala, Florence/bpk, Bildagentur für Kunst, Kultur und Geschichte, Berlin. Photo: Joerg P. Anders

32–15 Paula Modersohn-Becker **RECLINING MOTHER AND CHILD**

1906. Oil on canvas, 32 × 49" (82.5 × 124.7 cm). Paula Modersohn-Becker Museum, Bremen, Kunstsammlungen Böttcherstrasse.

Credit: © akg/P.Modersohn-Becker Museum

Germany. Dissatisfied with the Worpswede artists' naturalistic approach to rural life, she made four trips to Paris after 1900 to view recent developments in Post-Impressionist painting and was especially attracted to the "primitivizing" tendencies of Gauguin's Tahitian paintings (SEE FIG. 31–41). Many of her most powerful works were painted during 1906, her last year in Paris. **RECLINING MOTHER AND CHILD** (FIG. 32–15) highlights a monumental mother who encloses her young (perhaps nursing) child within a protective embrace. Coordinated curves and rhyming poses knit the two frankly naked figures together into a composition of interconnected flesh with no hint of glamour or allure. This iconic portrayal of motherhood becomes even more poignant with the knowledge that the artist herself was to die the year following soon after giving birth to her first child.

In contrast, the 1911 **SELF-PORTRAIT NUDE** (FIG. 32–16) of Austrian artist Egon Schiele (1890–1918) challenges viewers with his physical and psychological torment. The impact of Schiele's father's death from untreated syphilis when the artist was just 14 led him to conflate suffering with sexuality throughout his life. In many drawings and watercolors, Schiele portrays women in tormented poses that emphasize their raw sexuality and the artist's sense of its dangerous allure. In this self-portrait, Schiele turns the same harsh gaze on himself, expressing deep ambivalence toward his own sexuality and body. He stares at us with anguish, his emaciated body stretched and displayed in a halo of harsh light, lacking both hands and genitals. Some have interpreted this representational mutilation in Freudian fashion as the artist's symbolic self-punishment for indulgence in masturbation, then commonly believed to lead to insanity.

32–16 Egon Schiele **SELF-PORTRAIT NUDE**

1911. Gouache and pencil on paper, 20¼ × 13¾" (51.4 × 35 cm). Metropolitan Museum of Art, New York. Bequest of Scofield Thayer, 1982 (1984.433.298).

Credit: © 2016. Image copyright The Metropolitan Museum of Art/Art Resource/Scala, Florence

32–17 Franz Marc **THE LARGE BLUE HORSES**
1911. Oil on canvas, 3′5⅜″ × 5′11¼″ (1.05 × 1.81 m). Walker Art Center, Minneapolis. Gift of T.B. Walker Collection, Gilbert M. Walter Fund, 1942.

32–18 Vassily Kandinsky **IMPROVISATION 28 (SECOND VERSION)**
1912. Oil on canvas, 43⅞ × 63⅞″ (111.4 × 162.2 cm). Solomon R. Guggenheim Museum, New York. Solomon R. Guggenheim Founding Collection (37.239).

Spiritualism of Der Blaue Reiter

Formed in Munich by the Russian artist Vassily Kandinsky (1866–1944) and the German artist Franz Marc (1880–1916), Der Blaue Reiter ("The Blue Rider") was named for a popular image of St. George, who wears a blue cloak on the city emblem of Moscow. Just as St. George had been a spiritual leader in society, so Der Blaue Reiter aspired to offer spiritual leadership in the arts. Its first exhibition was held in December 1911 and included the work of 14 artists working in a wide range of styles from realism to radical abstraction.

By 1911, Marc was mostly painting animals rather than humans, rendering them in big, bold forms and highly saturated colors. He felt animals were more "primitive" and thus purer than humans, enjoying a more spiritual relationship with nature. In **THE LARGE BLUE HORSES** (**FIG. 32-17**), the animals—painted in blue, a color that the artist considered spiritual—merge into a homogeneous whole. Their sweeping contours reflect the harmony of their collective existence and echo the curved lines of the hills behind them, suggesting that they live in harmony with their surroundings.

Born into a wealthy Moscow family, Kandinsky initially trained as a lawyer, but after visiting exhibitions of Modernist art in Germany and taking private art lessons, he abandoned his legal career, moved to Munich, and established himself as an artist. Kandinsky was one of the first artists to investigate the theoretical possibility of purely abstract painting. Like Whistler (SEE FIG. 31-27)—an artist he both studied and admired—Kandinsky gave many of his works musical titles such as *Composition* and *Improvisation* and aspired to make paintings that responded to his own inner state and would be entirely autonomous, making no reference to the visible world.

Between 1911 and 1914, Kandinsky painted a series of works, including **IMPROVISATION 28** (**FIG. 32-18**), that, although they make clear references to landscape, architecture, and figures, initiate a progressive movement toward abstraction. In them, brilliant colors and veiled images leap and dance to express a variety of emotions and spiritualities. For Kandinsky, painting was a utopian force. He saw art's traditional focus on accurate rendering of the physical world as a misguided, materialistic quest; he hoped that his paintings would lead humanity toward a deeper awareness of spirituality and the inner world. He asks us to look at the painting as if we were hearing a symphony, responding instinctively and spontaneously to this or that passage and then to the total experience. Kandinsky further explained the musical analogy in his book *Concerning the Spiritual in Art* (1912): "Color directly influences the soul. Color is the keyboard, the eyes are the hammers, the soul is the piano with many strings. The artist is the hand that plays, touching one key or another purposively, to cause vibrations in the soul."

Extending Cubism and Questioning Art Itself

What additional transformations in European and American art and architecture emerge from Modernism?

As Cubist paintings emerged from the studios of Braque and Picasso, they altered the artistic discourse irrevocably. Cubism's way of viewing the world resonated with artists all over Europe, in Russia, and even in the United States—significantly broadening and extending its visual message beyond the ideas and objects of Picasso and Braque.

FRANCE Robert Delaunay (1885–1941) and his wife, the Ukrainian-born Sonia Delaunay (1885–1979), took the relatively monochromatic and static forms of Cubism in a new direction. Fauvist color had inflected Delaunay's early work; his deep interest in communicating spirituality through color led him to participate in Der Blaue Reiter exhibitions. In 1910, he began to fuse his interest in color with Cubism to create paintings celebrating the modern city and modern technology. In **HOMAGE TO BLÉRIOT** (**FIG. 32-19**), Delaunay pays tribute to Louis Blériot—the French pilot who in 1909 became the first person to fly across the English Channel—by portraying his airplane

32-19 Robert Delaunay **HOMAGE TO BLÉRIOT**
1914. Watercolor on paper, 31 × 26" (78 × 67 cm). Musée d'Art Moderne de la Ville de Paris. Donation of Henry-Thomas, 1976.
Credit: © 2016 White Images/Scala, Florence

flying over the Eiffel Tower, the Parisian symbol of modernity. The brightly colored circular forms that fill the rest of the painting suggest the movement of the airplane's propeller, a blazing sun in the sky, and the great rose window of the Cathedral of Notre-Dame, representing Delaunay's ideas of progressive science and spirituality. This painting's fractured colors also suggest the fast-moving parts of modern machinery.

The critic Guillaume Apollinaire labeled the art of both Robert and Sonia Delaunay "Orphism" after Orpheus, the legendary Greek poet whose lute playing charmed wild beasts, thus implying that their art had similar power. They preferred the term "simultaneity," a concept based on Michel-Eugène Chevreul's law of the simultaneous contrast of colors that proposed collapsing spatial distance and the sequence of time into a simultaneous "here and now"—creating a harmonic unity out of the disharmonious world. The Delaunays envisioned a simultaneity

32–20 Sonia Delaunay **CLOTHES AND CUSTOMIZED CITROËN B-12 (EXPO 1925 MANNEQUINS AVEC AUTO)**

From *Maison de la Mode*. 1925.

32–21 Fernand Léger **THREE WOMEN**

1921. Oil on canvas, 6′1½″ × 8′3″ (1.84 × 2.52 m). Museum of Modern Art, New York. Mrs. Simon Guggenheim Fund.

that combined the modern world of airplanes, telephones, and automobiles with spirituality.

Sonia Delaunay produced Orphist paintings with Robert, but she also designed fabric and clothing on her own. She created new fabric patterns and dress designs similar to her paintings and exhibited a line of inexpensive ready-to-wear garments that she called Simultaneous Dresses at the important 1925 International Exposition of Modern Decorative and Industrial Arts. Delaunay also decorated a Citroën sports car to match one of her ensembles for the exhibition (**FIG. 32-20**). She saw the small three-seater as an expression of a new age because, like her clothing, it was produced inexpensively for a mass market and was designed specifically to appeal to the newly independent woman of the time. Sadly, there are only black-and-white photographs of these designs.

Technology also fascinated Fernand Léger (1881–1955), who painted a more static but brilliantly colored version of Cubism based on machine forms. **THREE WOMEN** (**FIG. 32-21**) is a Purist, machine-age version of the French academic subject of the reclining nude. Purism was developed in Paris by Le Corbusier (b. Charles-Édouard Jeanneret, 1887–1965) and Amédée Ozenfant in a 1925 book, *The Foundation of Modern Art*, that argued for a return to clear, ordered forms and ideas to express the efficient clarity of the machine age—a desire commonly understood as a reaction to the chaotic horrors of World War I. In Léger's painting, the women's bodies are constructed from large, machinelike shapes arranged in an asymmetrical geometric grid that evokes both cool Classicism and an arrangement of interchangeable plumbing parts. The women are dehumanized, with identical, bland, round faces; the exuberant colors and patterns that surround them suggest an orderly industrial society in which everything has its place.

ITALY In Italy, Cubism developed into Futurism, with an emphasis on portraying technology and a sense of speed. In 1908, Italy was a state in crisis. Huge disparities of wealth separated the north from the south; four-fifths of the country was illiterate; poverty and near-starvation were rampant; and as many as 50,000 people had recently died in one of the nation's worst earthquakes. On February 20, 1909, Milanese poet and editor Filippo Tommaso Marinetti (1876–1944) published "Foundation and Manifesto of Futurism" on the front page of the Parisian newspaper *Le Figaro*. He attacked everything old, dull, and "feminine" and proposed to shake Italy free of its past by embracing an exhilarating, "masculine," "futuristic," and even dangerous world based on the thrill, speed, energy, and power of modern urban life.

In April 1911, a group of Milanese artists followed Marinetti's manifesto with the "Technical Manifesto of Futurist Painting," in which they demanded that "all subjects previously used must be swept aside in order to express our whirling life of steel, of pride, of fever, and of speed." Some of these artists traveled to Paris for a Futurist exhibition in 1912, after which they used the visual forms of Cubism to express in art their love of machines, speed, and war.

Gino Severini (1883–1966) signed the "Technical Manifesto" while living in Paris, where he served as an intermediary between the Italian-based Futurists and the French avant-garde. Perhaps more than other Futurists, Severini embraced the concept of war as a social cleansing agent. In **ARMORED TRAIN IN ACTION** (**FIG. 32-22**) of 1915—probably based on a photograph of a Belgian armored car on a train going over a bridge—Severini uses the jagged forms and splintered, overlapping surfaces of Cubism to describe a tumultuous scene of smoke, violence, and cannon blasts issuing from the speeding train seen from a disorienting viewpoint.

32-22 Gino Severini **ARMORED TRAIN IN ACTION**
1915. Oil on canvas, 45⅝ × 34⅞" (115.8 × 88.5 cm). Museum of Modern Art, New York. Gift of Richard S. Zeisler (287.86).

Credit: © 2016 Artists Rights Society (ARS), New York/ADAGP, Paris. © 2016. Digital image, The Museum of Modern Art, New York/Scala, Florence

32–23 Umberto Boccioni
UNIQUE FORMS OF CONTINUITY IN SPACE

1913. Bronze, 43⅞ × 34⅞ × 15¾"
(111 × 89 × 40 cm). Museum of
Modern Art, New York. Acquired
through the Lillie P. Bliss Bequest
(231.1948).

Credit: © 2016. Digital image, The
Museum of Modern Art, New York/Scala,
Florence

Russian Futurist artists—also known as Cubo-Futurists—claiming to have emerged independently of Italian Futurism began to move increasingly toward abstraction.

ELECTRIC LIGHT (FIG. **32-24**), painted in 1913 by Natalia Goncharova (1881–1962), shows the brightly artificial light from a new electric lamp fracturing and dissolving its surrounding forms like an analytical Cubist force. Goncharova turned to mixtures of Russian folk art and Modernist abstraction in costumes and sets she designed for Sergei Diaghilev's Ballets Russes stagings, including *Le Coq d'Or* (1914), *Night on Bald Mountain* (1923), and the revival of Igor Stravinsky's *Firebird* (1926).

After 1915, Kazimir Malevich (1878–1935) emerged as the leader of the Moscow avant-garde. He later remembered, "In the year 1913, in my desperate attempt to free art from the burden of the object, I took refuge in the square form and exhibited a picture which consisted of nothing more than a black square on a white field." *The Black Square* was one of the backdrops for Mikhail Matiushin's Russian Futurist

In 1912, Umberto Boccioni (1882–1916) argued for a Futurist "sculpture of environment" in which form should explode in a violent burst of motion from the closed and solid mass into the surrounding space. In **UNIQUE FORMS OF CONTINUITY IN SPACE** (FIG. **32-23**), Boccioni portrays a figure striding powerfully through space with muscular forms like wings flying out energetically behind it. Many of Boccioni's sculptures made use of unconventional materials; this sculpture was actually made of plaster and only cast in bronze after the artist's death. In keeping with his Futurist ideals, Boccioni celebrated Italy's entry into World War I by enlisting. He was killed in combat.

RUSSIA By 1900, Russian artists and art collectors in the cosmopolitan cities of St. Petersburg and later Moscow had begun to embrace avant-garde art, making trips to Paris to see it. Russian artists also drew on Futurist tendencies to celebrate technology and the aesthetic of speed. In 1912,

32–24 Natalia Goncharova ELECTRIC LIGHT

1913. Oil on canvas, 41½ × 32" (105.5 × 81.3 cm).
Musée National d'Art Moderne, Centre National d'Art et de Culture
Georges-Pompidou.

Credit: © 2016 Artists Rights Society (ARS), New York/ADAGP, Paris.
Photo © Centre Pompidou, MNAM-CCI, Dist. RMN-Grand Palais/Droits réservés

32–25 Kazimir Malevich
SUPREMATIST PAINTING (EIGHT RED RECTANGLES)
1915. Oil on canvas, 22½ × 18⅞″ (57 × 48 cm). Stedelijk Museum, Amsterdam.

Credit: Collection Stedelijk Museum Amsterdam

opera, *Victory Over the Sun*. At the "Last Futurist Exhibition of Paintings: 0.10" held in St. Petersburg in the winter of 1915–1916, Malevich exhibited 39 works of art consisting of flat, assembled, geometric shapes in a style he termed Suprematism, defined as "the supremacy of pure feeling in creative art." One of these works, **SUPREMATIST PAINTING (EIGHT RED RECTANGLES)** (**FIG. 32-25**), arranges eight red rectangles diagonally on a white ground—a pure abstraction.

Toward Abstraction in Sculpture

Sculpture underwent a revolution as profound as that of painting in the years prior to World War I. Perhaps Picasso's creation of three-dimensional works from diverse materials assembled and hung on a wall rather than placed on pedestals (SEE FIG. 32-10) was the most radical innovation, but not all change involved new

materials and display contexts. The Romanian artist Constantin Brancusi (1876–1957), who settled in Paris in 1904, became immediately captivated by the "primitive" art on display in the city. He admired the semiabstracted forms of much art beyond the Western tradition, believing that the artists who made such art succeeded in capturing the "essence" of their subject. Brancusi, like Picasso, rejected superficial realism. He wrote, "What is real is not the external form but the essence of things. Starting from this truth it is impossible for anyone to express anything essentially real by imitating its exterior surface."

For Brancusi, the egg symbolized the potential for birth, growth, and development—the essence of life contained in a perfect, organic, abstract ovoid. In **THE NEWBORN** (**FIG. 32-26**) of 1915, he conflates its shape with the head of a human infant to suggest the essence of humanity at the moment of birth.

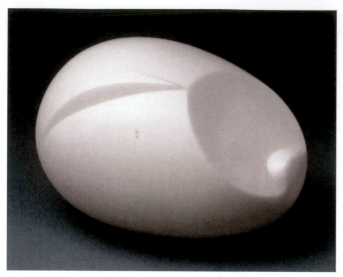

32–26 Constantin Brancusi **THE NEWBORN**
1915. Marble, 5¾ × 8¼ × 5⅞″ (14.6 × 21 × 14.8 cm).
Philadelphia Museum of Art. Louise and Walter Arensberg Collection.
(195.134.10).

Credit: © 2016 Artists Rights Society (ARS), New York/ADAGP, Paris. © 2016.
Photo The Philadelphia Museum of Art/Art Resource/Scala, Florence

In his 1924 **TORSO OF A YOUNG MAN** (**FIG. 32–27**), Brancusi distills the figure's torso and upper legs into three highly polished metal cylinders, a machinelike regularity that might relate to the works of Léger or the Futurists. This bold abstraction carries a Classical gravity and stillness, especially when perched atop the elemental earthiness of the impressive pedestal Brancusi created for it in wood and stone. On the other hand, although the sleek torso lacks a penis, the phallic nature of the displayed form itself transforms the ensemble into a sexually charged symbol of essential masculinity.

Dada: Questioning Art Itself

When World War I broke out in August 1914, most European leaders thought it would be over by Christmas. Both sides reassured their citizens that the efficiency of their armies and bravery of their soldiers would ensure a speedy resolution and that the political status quo would resume. These hopes proved illusory. World War I was the most brutal and costly in human history up to that time. On the Western Front in 1916 alone, Germany lost 850,000 soldiers, France 700,000, and Great Britain 400,000. The conflict settled into a vicious stalemate on all fronts as each side deployed new killing technologies, such as improved machine guns, flame throwers, fighter aircraft, and poison gas. On the home fronts, governments exerted control over industry and labor to manage the war effort, and ordinary people were forced to endure food rationing, propaganda attacks, and war profiteering.

Horror at the enormity of the carnage arose on many fronts. One of the first artistic movements to address the

32–27 Constantin Brancusi **TORSO OF A YOUNG MAN**
1924. Bronze on stone and wood bases; combined figure and bases 40⅜ × 20 × 18¼″ (102.4 × 50.5 × 46.1 cm). Hirshhorn Museum and Sculpture Garden, Smithsonian Institution, Washington, DC. Gift of Joseph H. Hirshhorn 1966 (HMSG 66.61)

Credit: © 2016 Artists Rights Society (ARS), New York/ADAGP, Paris

32–28 HUGO BALL RECITING THE SOUND POEM "KARAWANE"

Photographed at the Cabaret Voltaire, Zürich. 1916.

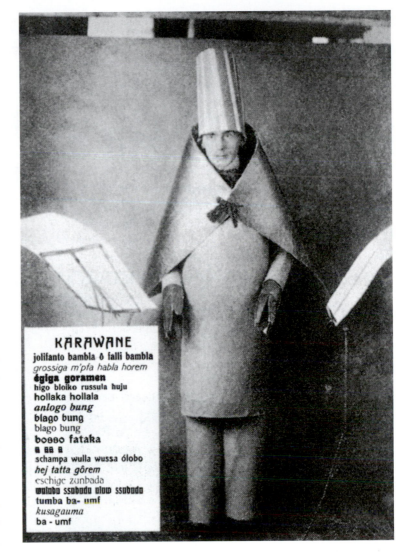

slaughter and moral questions of the war was Dada—a transnational movement with distinct local manifestations that arose during the war in Zürich and New York, then spread to Berlin, Paris, Cologne, and Hannover. If Modern art until that time questioned the traditions of art, Dada went further to question the concept of art itself. Witnessing how thoughtlessly life was discarded in the trenches, Dada mocked the senselessness of rational thought and even the foundations of modern society. It embraced a "mocking iconoclasm" even in its name, which has no real or fixed meaning. *Dada* is baby talk in German; in French it means "hobbyhorse"; in Romanian and Russian, "yes, yes"; in the Kru African dialect, "the tail of a sacred cow." Dada artists annihilated the conventional understanding of art as something precious, replacing it with a strange and irrational art focused on ideas and actions rather than objects.

HUGO BALL AND THE CABARET VOLTAIRE One of Dada's first great moments was the first performance of poet Hugo Ball's poem "Karawane" at the Cabaret Voltaire on June 23, 1916. Ball (1886–1927) and his companion, Emmy Hennings (1885–1949), a nightclub singer, moved from Germany to neutral Switzerland when World War I broke out and opened the Cabaret Voltaire in Zürich in February of 1916. Cabaret Voltaire was based loosely on the bohemian artists' cafés of prewar Berlin and Munich, and its mad, irrational world became a meeting place for exiled avant-garde writers and artists of various nationalities who shared Ball and Hennings's disgust for the war.

It was here that Ball solemnly recited one of his sound poems, **"KARAWANE" (FIG. 32–28)** with his legs and body encased in blue cardboard tubes and a white-and-blue "witch doctor's hat," as he called it, on his head. He also wore a huge, gold-painted cardboard cape that flapped when he moved his arms, and lobsterlike cardboard hands or claws. The text of Ball's poem—included in the photograph documenting the event—consists of a string of nonsensical sounds, renouncing "the language devastated and made impossible by journalism," and mocking traditional poetry. He self-consciously abandoned the rationality of adulthood and created a new and wholly incomprehensible private language of random sounds that seemed to mimic baby talk.

MARCEL DUCHAMP Although not formally a member of the Dada movement, Marcel Duchamp (1887–1968) created some of its most complex and challenging works. He also took Dada to New York when he crossed the Atlantic in 1915 to escape the war in Europe. In Paris in 1912, Duchamp had experimented with Cubism, painting *Nude Descending a Staircase No. 2*, which would be one of the most controversial works included in the notorious Armory Show in New York in 1913 (discussed later in this chapter). But by the time Duchamp himself arrived in the United States, he had discarded painting, which he claimed had become for him a mindless activity, and had devised the Dada genre that he termed the readymade, in which he transformed ordinary, often manufactured objects into works of art.

Duchamp was warmly welcomed into the American art world. The American Society of Independent Artists invited him to become a founding member, and he chaired the hanging committee for its annual exhibition in 1917. The show advertised itself as unjuried—any work of art submitted with the entry fee of $6 would be hung. His anonymous submission was a common porcelain

urinal that he purchased in a plumber's shop and turned on its side so that it was no longer functional, signing it "R. Mutt" in a play on the name of the urinal's manufacturer, J.L. Mott Iron Works. It was rejected.

FOUNTAIN (**FIG. 32–29**) remains one of the most controversial works of art of the twentieth century. It incites laughter, anger, embarrassment, and disgust by openly referring to private bathroom activities and to human carnality and vulnerability. But more significantly, in it Duchamp questions the essence of what constitutes a work of art. How much can be stripped away before an object's status as art disappears? Since Whistler's famous court case (see "Art on Trial in 1877" in Chapter 31 on page 1002), most avant-garde artists had agreed that a work of art did not have to be descriptive or well crafted, but before 1917, none would have argued, as Duchamp does in this piece, that art was primarily conceptual. For centuries, perhaps millennia, artists had regularly employed studio assistants to make parts, if not all, of the art objects that they designed. On one level, Duchamp updates that practice into modern terms by arguing that art objects can actually

32–30 Marcel Duchamp **L.H.O.O.Q.**
1919. Pencil on reproduction of Leonardo da Vinci's *Mona Lisa*, 7¾ × 4¾" (19.7 × 12.1 cm). Philadelphia Museum of Art. Louise and Walter Arensberg Collection.

Credit: © 2016. Photo The Philadelphia Museum of Art/Art Resouce/Scala, Florence. © 2016 Artists Rights Society (ARS), New York/ADAGP, Paris

32–29 Marcel Duchamp **FOUNTAIN**
1917. Porcelain plumbing fixture and enamel paint. Photograph by Alfred Stieglitz. Philadelphia Museum of Art. Louise and Walter Arensberg Collection (1998-74-1).

Stieglitz's photograph is the only known image of Duchamp's original *Fountain*, which mysteriously disappeared after it was rejected by the jury of the American Society of Independent Artists exhibition. In 1964, Duchamp supervised the production of a small edition of replicas of the original *Fountain* based on the Stieglitz photograph. One of these replicas sold at auction in 1999 for $1.76 million, setting a record for a work by Duchamp.

Credit: © 2016 Artists Rights Society (ARS), New York/ADAGP, Paris. © 2016. Photo The Philadelphia Museum of Art/Scala, Florence/Art Resource, NY

be mass-produced for the artist by industry. Duchamp creates a commentary simultaneously about consumption and about the irrationality of the modern age by claiming that the "readymade" simply bypasses the craft tradition, qualifying as a work of art because of its human conceptualization rather than its human making.

When *Fountain* was rejected, as Duchamp anticipated it would be, the artist resigned from the Society of Independent Artists in mock horror. An unsigned editorial in a Dada journal (which could have been written by the artist himself) detailed what it described as the scandal of the R. Mutt case. It claimed, "The only works of art America has given are her plumbing and bridges," and added, "Whether Mr. Mutt with his own hands made the fountain or not has no importance. He CHOSE it. He took an ordinary article of life, placed it so that its useful significance disappeared under the new title and point of view—created a new thought for that object."

After Duchamp returned to Paris, he challenged the French art world with a work that he entitled **L.H.O.O.Q.** (**FIG. 32–30**) and described as a "modified readymade." In 1911, a Louvre employee had stolen Leonardo's famous *Mona Lisa* (SEE FIG. 21-1), believing it should be returned to Italy. It took two years to recover it. While missing, however, the *Mona Lisa* became even more famous and was widely and badly reproduced in postcards, posters, and advertising. Duchamp chose to comment on the nature of fame and on the degraded image of the *Mona Lisa* by purchasing a cheap postcard reproduction and drawing a mustache and beard on its subject's famously enigmatic face. In doing so he turned a revered cultural artifact into an object of ridicule. The letters that he scrawled across the bottom of the card, "L.H.O.O.Q.," when read aloud sound phonetically similar to the French slang phrase *elle a chaud au cul*, politely translated as "she's hot for it," thus adding a crude sexual innuendo to the already cheapened image. Like *Fountain*, this work challenges traditional notions about what constitutes art and makes ridicule and bodily functions its central artistic content. As one of Dada's founders said, "Dada was born of disgust."

Duchamp made only a few readymades. In fact, he created very little art at all after about 1922, when he devoted himself almost entirely to chess. When asked about his occupation, he described himself as a "retired artist," but his radical ideas about art continued to exert influence, especially in the period after 1960.

BERLIN DADA Early in 1917, Hugo Ball and the Romanian-born poet Tristan Tzara (1896–1963) organized the Galerie Dada in Zürich. Tzara also edited the magazine *Dada*, which quickly attracted the attention of like-minded artists and writers in several European capitals and the United States. The movement spread farther when expatriate members of Ball's circle in Switzerland returned to their homelands after the war. Richard Huelsenbeck (1892–1974), for instance, took Dada to Germany, where he helped found the Club Dada in Berlin in April 1918.

Dada pursued a slightly different agenda and took on different forms in each of its major centers. One distinctive feature of Berlin Dada was its use of provocative propaganda. Compared to the more literary forms of Dada elsewhere, Berlin Dada also produced an unusually large amount of visual art—especially collage and **photomontage** (photographic collage).

One example of this is the work of Kurt Schwitters (1887–1948), who worked in Hannover and met Huelsenbeck and other Dadaists in 1919. Schwitters used discarded rail tickets, postage stamps, ration coupons, beer labels, and other street trash to create visual poetry. He called the resulting two- and three-dimensional works of art *Merzbilder* (German for "refuse pictures"). In these works Schwitters combined fragments of newspaper and other

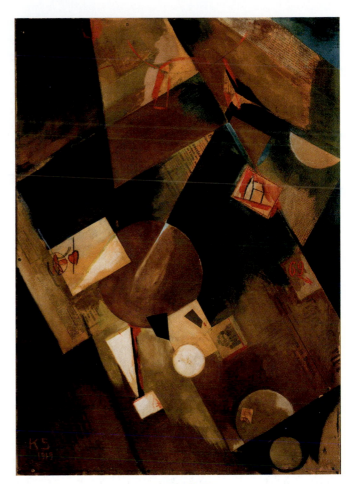

32–31 Kurt Schwitters **MERZBILD 5B (PICTURE-RED-HEART-CHURCH)**

April 26, 1919. Collage, tempera, and crayon on cardboard, 32⅞ × 23¾" (83.4 × 60.3 cm). Solomon R. Guggenheim Museum, New York. (52.1325).

printed material with drawn or painted images, incorporating them into an overall visual structure that recalled Cubism. He wrote that garbage demanded equal rights with painting. In **MERZBILD 5B** (**FIG. 32–31**), Schwitters's collage includes printed fragments from the street with newspaper scraps to comment on the postwar disorder of defeated Germany. One fragment describes the brutal overthrow of the short-lived socialist republic in Bremen.

Hannah Höch (1889–1978) produced even more pointed political photomontages. Between 1916 and 1926, she worked for Ullstein Verlag, Berlin's largest publishing house, designing decorative patterns and writing articles on crafts for a women's magazine. Höch considered herself part of the women's movement in the 1920s and disapproved of contemporary mass-media representations of women. She had to fight for her place as the sole woman in the Berlin Dada group, one of whose male members described her contribution disparagingly as merely conjuring up beer and sandwiches. In **CUT WITH THE KITCHEN KNIFE DADA THROUGH THE LAST WEIMAR BEER-BELLY**

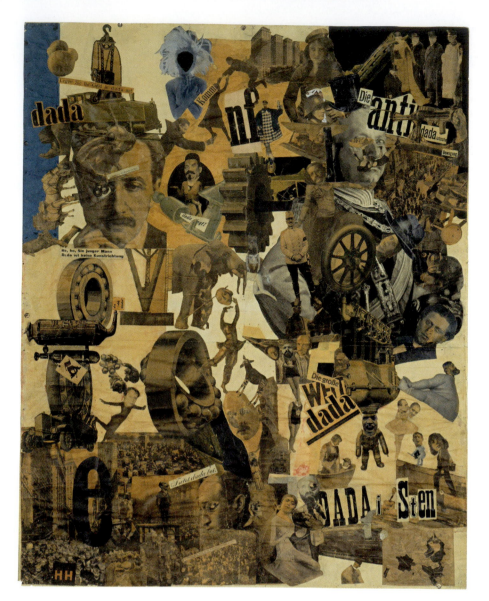

32–32 Hannah Höch CUT WITH THE KITCHEN KNIFE DADA THROUGH THE LAST WEIMAR BEER-BELLY CULTURAL EPOCH IN GERMANY
1919. Photomontage and collage with watercolor, 44⅞ × 35⅜" (114 × 90 cm). Nationalgalerie, Staatliche Museen zu Berlin.

Credit: © 2016 Photo Scala, Florence/BPK, Bildargentur für Kunst, Kultur und Geschichte, Berlin.Photo Jörg P. Anders. © 2016 Artists Rights Society (ARS), New York/VG Bild-Kunst, Bonn

the photographer Alfred Stieglitz (1864–1946). Born in New Jersey to a wealthy German immigrant family, Stieglitz studied photography in the 1880s at the Technische Hochschule in Berlin, quickly recognizing photography's artistic potential. In 1890, he began to photograph New York City street scenes. He promoted his views through an organization called the Photo-Secession, founded in 1902, and three years later opened a tiny gallery known as 291 on Fifth Avenue. Like Kahnweiler in Paris, he supported many of the early American Modernist artists in New York. By 1910, the 291 gallery had become a focal point for both photographers and painters, with Stieglitz giving shows (sometimes their first) to artists such as Arthur Dove, John Marin, and Georgia O'Keeffe, and bringing to America the art of European artists such as Matisse, Braque, Cézanne, and Rodin. As a photographer himself, Stieglitz also sought to establish the legitimacy of photography as a fine art with these exhibitions.

CULTURAL EPOCH IN GERMANY (FIG. 32-32), Höch combines images and words from the popular press, political posters, and photographs to create a complex and angry critique of the Weimar Republic in 1919. This photomontage includes portraits of androgynous Dada characters, such as herself and several other Berlin Dada artists, along with pictures of Marx and Lenin, asserting the artists' solidarity with revolutionaries in opposition to the anti-Dadaists whose images are gathered in the upper right corner.

Modernist Tendencies in America

When avant-garde Modern art was first widely exhibited in the United States, it received a cool welcome. While some American artists did work in abstract or Modernist ways, most preferred to work in a more naturalistic manner, at least until around 1915.

STIEGLITZ AND THE "291" GALLERY The chief proponent of European Modernism in the United States was

In his own photographs, Stieglitz composed poetic images of romanticized urban scenes. In THE FLATIRON BUILDING (FIG. 32-33), the tree trunk to the right is echoed by branches in the grove farther back and by the wedge-shaped Flatiron Building to the rear. The entire scene is suffused with a misty, wintery atmosphere, which the artist created by manipulating his viewpoint, exposure, and possibly both the negative and the print itself. Ironically, Stieglitz softens and romanticizes the Flatiron Building, one of New York's earliest skyscrapers and a symbol of the city's modernity. The magazine Camera Work, a high-quality photographic publication that Stieglitz edited, published a reproduction of this photograph in 1903; it

32-33 Alfred Stieglitz **THE FLATIRON BUILDING, NEW YORK**

1903. Photogravure, 6¹¹⁄₁₆ × 3⁵⁄₁₆″ (17 × 8.4 cm) mounted. Metropolitan Museum of Art, New York. Gift of J.B. Neumann, 1958 (58.577.37).

Credit: © 2016 Georgia O'Keeffe Museum/Artists Rights Society (ARS), New York. © 2016. Digital image, The Metropolitan Museum of Art, New York/Art Resource/Scala, Florence

also featured numerous images of American and European Modernist art as well as some important American Modernist art criticism.

THE ARMORY SHOW AND HOME-GROWN MODERNISM In 1913, Modernist art arrived in New York en masse with an enormous exhibition held in the drill hall of the 69th Regiment Armory on Lexington Avenue between 25th and 26th Streets. Walt Kuhn (1877–1949) and Arthur B. Davies (1862–1928) were the principal organizers of the so-called Armory Show, which featured more than 1,600 works, a quarter of them by European artists. Most of the art, even the Modernist art, was well received and sold well, but the art of a few European Modernists, including Matisse and Duchamp in particular, caused a public outcry in which the artists were described as "cousins to the anarchists." When selected works from the exhibition traveled on to Chicago, a few faculty members and some students of the School of the Art Institute hanged Matisse in effigy, while civic leaders called for a morals commission to investigate the show. Yet the exhibition consolidated American Modernist art and inspired its artists, who later found more enthusiastic collectors and exhibition venues.

One of the most significant early American Modernists was Arthur Dove (1880–1946). Dove studied the work of the Fauves in Europe in 1907–1909 and even exhibited at the Autumn Salon. After returning home, he began painting abstract nature studies at about the same time as Kandinsky, although each was unaware of the other. Dove's **NATURE SYMBOLIZED NO. 2 (FIG. 32-34)** is one of a remarkable series of small works that reveals his beliefs about the spiritual power of nature. But while Kandinsky's art focuses on a spiritual vision of nature, Dove's abstract paintings reflect his deeply felt experience of the landscape itself; he said that he had "no [artistic] background except perhaps the woods, running streams, hunting, fishing, camping, the sky." Dove supported himself by farming in rural Connecticut, but he exhibited his art in New York and was both well received by and well connected to the New York art community.

32-34 Arthur Dove **NATURE SYMBOLIZED NO. 2**

c. 1911. Pastel on paper, 18 × 21⅝″ (45.8 × 55 cm). The Art Institute of Chicago. Alfred Stieglitz Collection (1949.533).

Credit: Photo © The Art Institute of Chicago

A Closer Look

PORTRAIT OF A GERMAN OFFICER

While living in Berlin in 1914, Hartley fell in love with a young Prussian lieutenant, Karl von Freyburg, whom Hartley described as "in every way a perfect being—physically, spiritually, and mentally." Freyburg's death in World War I devastated Hartley, who memorialized this fallen warrior in a series of symbolic portraits.

Symbolic references to Freyburg include epaulettes, lance tips, and the Iron Cross he was awarded posthumously.

The black-and-white checkerboard patterns represent Freyburg's love of chess.

Freyburg's regiment number ("4") is shown at the center of the abstracted chest along with a red cursive *E*, which stands for "Edmund" (Hartley's given name). This places Hartley over Freyburg's heart.

The blue-and-white diamond pattern comes from the Bavarian flag; the red, white, and black bands constitute the flag of the German Empire, adopted in 1871, and the black-and-white stripes are those of the historic flag of Prussia.

The funereal black background heightens the intensity of the foreground colors.

Hartley identifies his subject with his initials ("Kv.F") in gold on red.

Freyburg's age ("24") is noted in gold on blue.

The red cross means injury or death and also refers to the International Red Cross, often seen in Berlin during the war.

32–35 Marsden Hartley PORTRAIT OF A GERMAN OFFICER
c. 1914. Oil on canvas, 68¼ × 41⅜″ (1.78 × 1.05 m). Metropolitan Museum of Art, New York. Alfred Stieglitz Collection, 1949 (49.70.42).

Credit: © 2016. Image copyright The Metropolitan Museum of Art/Art Resource/Scala, Florence

Another pioneer of American Modernism who exhibited at the Armory Show was Marsden Hartley (1877–1943), who was also a regular exhibitor at 291. Between 1912 and 1915, Hartley lived mostly abroad, first in Paris, where he discovered Cubism, then in Berlin, where he began to paint colorful Expressionistic art. Around 1914, however, Hartley developed a powerfully original and intense style of his own in *Portrait of a German Officer* (see "Closer Look" opposite), a tightly arranged composition of boldly colored shapes and patterns interspersed with numbers, letters, and fragments of German military imagery that memorializes Karl von Freyburg, a German soldier with whom Hartley had fallen in love.

Stieglitz "discovered" Georgia O'Keeffe (1887–1986)—born in rural Wisconsin, and already studying and teaching art between 1905 and 1915—when a New York friend showed him some of her charcoal drawings. Stieglitz's reported response was "At last, a woman on paper!"

32–37 Georgia O'Keeffe **JACK-IN-THE-PULPIT, NO. IV**
1930. Oil on canvas, 40 × 30″ (101.6 × 76.2 cm). National Gallery of Art, Washington, DC. Alfred Stieglitz Collection, Bequest of Georgia O'Keeffe 1987.58.3.

Credit: © 2016 Georgia O'Keeffe Museum/Artists Rights Society (ARS), New York. Image courtesy the National Gallery of Art, Washington

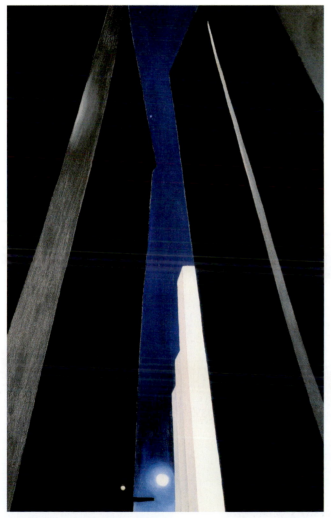

32–36 Georgia O'Keeffe **CITY NIGHT**
1926. Oil on canvas, 48 × 30″ (123 × 76.9 cm). Minneapolis Institute of Arts. Gift of funds from the Regis Corporation, Mr. and Mrs. W. John Driscoll, the Beim Foundation, the Larsen Fund (80.28).

Credit: © 2016 Georgia O'Keeffe Museum/Artists Rights Society (ARS), New York. Bridgeman Images

In 1916, he included O'Keeffe's work in a group show at 291 and mounted her first solo exhibition the following year. O'Keeffe moved to New York in 1918 and married Stieglitz in 1924. In 1925, she began to paint New York skyscrapers, which were acclaimed at the time as embodiments of American inventiveness and energy. But paintings such as **CITY NIGHT** (FIG. 32–36) are not unambiguous celebrations of lofty buildings. She portrays the skyscrapers from a low vantage point so that they appear to loom ominously over the viewer; their dark tonalities, stark forms, and exaggerated perspective produce a sense of menace that also appears in the art of other American Modernists.

In 1925, O'Keeffe also began to exhibit a series of close-up paintings of flowers, which became her best-known subjects. In **JACK-IN-THE-PULPIT, NO. IV** (FIG. 32–37) of 1930, O'Keeffe brings the heart of the flower to the front and center of the picture plane, revealing its inner forms and surfaces. By painting the flower's hidden, organic aspects rather than the way it looks to a distant viewer, she creates from it a new abstract beauty, distilling the vigor of the plant's life force. Critics described O'Keeffe's flower paintings as elementally feminine and vaginal, and

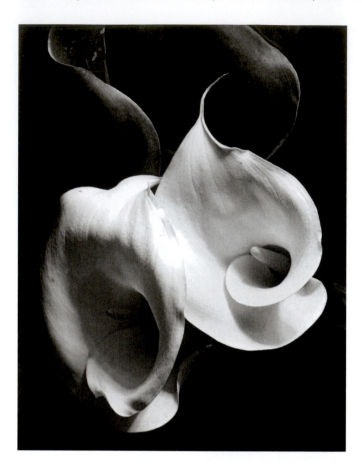

32–38 Imogen Cunningham **TWO CALLAS**
c.1925. Gelatin-silver print, 12 × 9½″ (30.4 × 24.1 cm).
Museum of Modern Art, New York.

Credit: © 2016 Imogen Cunningham Trust

Stieglitz did little to dissuade viewers from this reading. In fact, he promoted it—in spite of O'Keeffe's strong objections to this critical caricature and its implicit pigeonholing of her as a "woman artist." In 1929, O'Keeffe began spending summers in New Mexico; she moved there permanently in the 1940s, dedicating her art to evocative representations of the local landscape and culture.

Imogen Cunningham (1883–1976) followed in O'Keeffe's footsteps with a series of experimental photographs that emphasize the abstract patterns of plants by zooming in to extract them from their natural context. In her photograph of **TWO CALLAS** (**FIG. 32-38**), Cunningham uses straightforward camera work to capture the forms and textures of her subjects accurately, if drained of their color. But the artistic character of her photographic image depends not on the exacting detail recorded by the camera, but on the compositional choices and dramatic lighting controlled by the artist who used it.

32–39 Adolf Loos
STEINER HOUSE, VIENNA
1910.

Credit: Photo: Carlo Fumarola

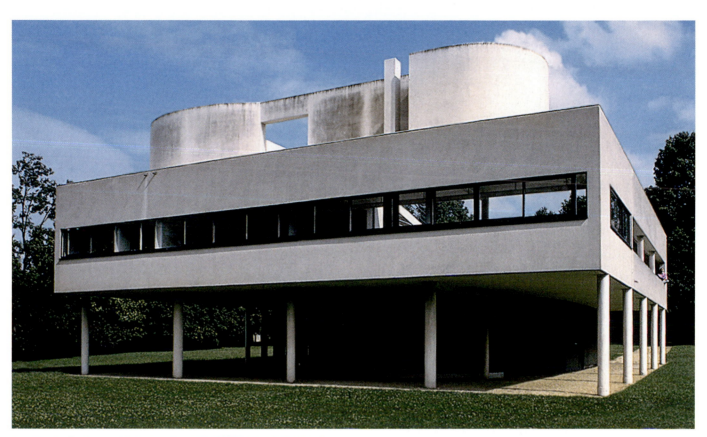

32–40 Le Corbusier **VILLA SAVOYE, POISSY-SUR-SEINE**
France. 1929–1930.

Early Modern Architecture

New industrial materials and engineering innovations enabled twentieth-century architects to create buildings of unprecedented height that vastly increased the usable space in structures built on scarce and valuable city lots. At the same time that Modernist artists in Europe rejected the decorative in painting and sculpture, American architects increasingly embraced the plain, geometric shapes and undecorated surfaces of skyscraper architecture.

EUROPEAN MODERNISM In Europe, a stripped-down and severely geometric style of Modernist architecture developed partly in reaction to the natural organic lines of Art Nouveau. In Vienna, Adolf Loos (1870–1933), one of the pioneers of European architectural Modernism, insisted in his 1913 essay "Ornament and Crime" that "the evolution of a culture is synonymous with the removal of ornament from utilitarian objects." For Loos, ornament was a sign of cultural degeneracy. Thus his **STEINER HOUSE (FIG. 32-39)** is a stucco-covered, reinforced concrete construction without decorative embellishment. The rectangular windows, for instance, are completely plain, and they were arranged only in relation to the functional demands of interior spaces. Loos argued that the only purpose of a building's interior was to provide protection from the elements.

The most important French Modernist architect was Swiss-born Le Corbusier, whose **VILLA SAVOYE (FIG. 32-40)**, a private home outside Paris, became an icon of the International Style (discussed later in this chapter) and reflects his Purist ideals in its geometric design and lack of ornamentation. It is also one of the best expressions of his **domino construction** system, introduced in 1914, in which slabs of ferroconcrete (concrete reinforced with steel bars) rest on six free-standing steel posts placed at the positions of the six dots on a domino piece. Over the next decade Le Corbusier further explored the possibilities of the domino system and in 1926 published "The Five Points of a New Architecture," in which he proposed raising houses above the ground on pilotis (free-standing posts); using flat roofs as terraces; using movable partition walls slotted between supports on the interior and **curtain walls** (non-load-bearing walls) on the exterior to allow greater design flexibility; and using ribbon windows (which run the length of a wall). These became common features of Modernist architecture. Le Corbusier believed that a modern house should be "a machine for living in," meaning that it should be designed as rationally and functionally as an automobile or a machine. After World War I—like his fellow Modernist architects—Le Corbusier developed designs for mass-produced, standardized housing to help rebuild Europe's destroyed infrastructure.

32–41 Frank Lloyd Wright **FREDERICK C. ROBIE HOUSE, CHICAGO**
1906–1909. Chicago History Museum. (HB-19312A2).

Credit: © Universal Images Group North America LLC/DeAgostini/Alamy Stock Photo

AMERICAN MODERNISM Frank Lloyd Wright (1867–1959) was not only America's most important Modernist architect, he was also one of the most influential architects in the world during the early twentieth century. After briefly studying engineering at the University of Wisconsin, Wright apprenticed to a Chicago architect, then spent five years with the firm of Dankmar Adler and Louis Sullivan (SEE FIG. 31–55), advancing to the post of chief drafter. In 1893, Wright established his own office, specializing in domestic architecture. Around 1900, he and several other architects in the Oak Park suburb of Chicago—together known as the Prairie School—began to design low, horizontal houses with flat roofs and heavy overhangs that echoed the flat plains of the prairie in the Midwest.

32–42 Frank Lloyd Wright **COLOR RECONSTRUCTION OF THE DINING ROOM, FREDERICK C. ROBIE HOUSE**

Credit: Courtesy of the Frank Lloyd Wright Trust. © 2016 Frank Lloyd Wright Foundation, Scottsdale, AZ/Artists Rights Society (ARS), NY

32–43 Frank Lloyd Wright **FALLINGWATER (EDGAR KAUFMANN HOUSE), MILL RUN**
Pennsylvania. 1937.

Credit: Thomas A Heinz, AIA, Photographer © Western Pennsylvania Conservancy 2007

The **FREDERICK C. ROBIE HOUSE** (FIG. **32–41**) is one of Wright's early **Prairie Style** masterpieces. A central chimney, above a fireplace that radiated heat throughout the house in the bitter Chicago winter, forms the center of the sprawling design. Low, flat overhanging roofs—dramatically cantilevered on both sides of the chimney—shade against the summer sun, and open porches provide places to sleep outside on cool summer nights. Low bands of windows—many with stained glass—surround the house, creating a colored screen between the interior and the outside world, while also inviting those inside to look through the windows into the garden beyond.

The main story is one long space divided into living and dining areas by a free-standing fireplace. There are no dividing walls. Wright had visited the Japanese exhibit at the 1893 Chicago World's Fair and was deeply influenced by the aesthetics of Japanese architecture, particularly its sense of space and screenlike windows (see "*Shoin* Design" in Chapter 26 on page 835). Wright's homes frequently featured built-in closets and bookcases, and he hid heating and lighting fixtures when possible. He also designed and arranged the furniture for his interiors (FIG. **32–42**). Here, machine-cut components create the chairs' modern geometric designs, while their high backs huddle around the table to form the intimate effect of a room within a room. Wright integrated lights and flower holders into posts near the table's corners so that there would be no need for lights or flowers on the table.

Wright had an uneasy relationship with European Modernist architecture; he was uninterested in the machine aesthetic of Le Corbusier. Although he routinely used new building materials such as ferroconcrete, plate glass, and steel, he tried to maintain a natural sensibility, connecting his buildings to their sites by using brick and local wood or stone. **FALLINGWATER** (FIG. **32–43**) in rural Pennsylvania is a prime example of this practice. It is also the most famous expression of Wright's conviction that buildings should not simply sit *on* the landscape but coordinate *with* it.

Fallingwater was commissioned by Edgar Kaufmann, a Pittsburgh department-store owner, to replace a family summer cottage on the site of a waterfall and a pool where his children played. To Kaufmann's surprise, Wright decided to build the new house right into the cliff and over the pool, allowing the waterfall to flow around and under the house. A large boulder where the family had sunbathed in the summers was used for the central hearthstone of the fireplace. In a dramatic move that engineers questioned (with reason, as subsequent sagging has shown), Wright used cantilevers to extend a series of broad concrete terraces out from the cliff to parallel the great slabs of natural rock below. Poured concrete forms the terraces, but Wright painted the material a soft earth tone. Long bands of windows and glass doors offer spectacular views uniting woods, water, and house. Such houses do not simply testify to the ideal of living in harmony with nature; they declare war on the modern city. When asked what could be done to improve city architecture, Wright responded: "Tear it down."

Mary Colter (1869–1958) expressed an even stronger connection to the landscape in her architecture. Born in Pittsburgh and educated at the California School of Design in San Francisco, she spent much of her career as architect and decorator for the Fred Harvey Company, a firm in the Southwest that catered to the tourist trade. Colter was an avid student of Native American arts, and her buildings quoted liberally from Puebloan traditions, notably in the use of exposed logs for structural supports. She designed several visitor facilities at Grand Canyon National Park, of which **LOOKOUT STUDIO** (**FIG. 32-44**) is the most dramatic. Built on the edge of the canyon's south rim, the building's foundation is in natural rock, its walls are built from local stone, and the roofline is deliberately irregular to echo the surrounding canyon wall. The only concession to modernity is a liberal use of glass windows and a smooth cement floor. Colter's designs for hotels and railroad stations throughout the region helped establish a distinctive Southwest style.

32-44 Mary Colter **LOOKOUT STUDIO, GRAND CANYON NATIONAL PARK**
Arizona. 1914. Grand Canyon National Park Museum Collection.

Credit: Photo ©2008 Maria Langer www.flyingmphotos.com

THE AMERICAN SKYSCRAPER After 1900, New York City assumed a lead over Chicago in the development of the skyscraper, whose soaring height was made possible by the use of the steel-frame skeleton for structural support (see "The Skyscraper" below). New York clients, however, rejected the more utilitarian Chicago style of Louis Sullivan and others, preferring the historicizing approach then still popular on the east coast. The **WOOLWORTH BUILDING** (FIG. 32–45)

of 1911–1913, designed by the Minnesota-based firm of Cass Gilbert (1859–1934), was the world's tallest building at 792 feet and 55 floors when first completed. Its Gothic-style external details, inspired by the soaring towers of late medieval churches, gave the building a strong visual personality. In 1916, a prominent New York pastor christened this building as the "Cathedral of Commerce" to characterize its status as an ethical white-collar workplace.

Elements of Architecture
THE SKYSCRAPER

The development of the skyscraper design and aesthetic depended on several things: metal beams and girders for the structural-support skeleton; separation of the building-support structure from the enclosing wall layer (the cladding); fireproof materials and measures; elevators; and overall integration of plumbing, central heating, artificial lighting, and ventilation systems. The first generation of skyscrapers, built between about 1880 and 1900, were concentrated in the Midwest, chiefly in Chicago and St. Louis (SEE FIG. 31–55). Second-generation skyscrapers, mostly with over 20 stories, date from after 1895 and are found more frequently in New York. The first tall buildings were free-standing towers, sometimes with a base, such as the Woolworth Building of 1911–1913 (SEE FIG. 32–45). New York City's Building Zone Resolution of 1916 introduced mandatory setbacks—decreases in girth as the building rose—to ensure light and ventilation to adjacent sites. Built in 1931, the 1,250-foot setback form of the Empire State Building, diagrammed here, has a streamlined design. The Art Deco exterior cladding (see diagram inset) conceals the structural elements, and mechanisms such as elevators that make its great height possible. The Empire State Building was the tallest building in the world when it was built, and its distinctive profile ensures that it remains one of the most recognizable even today.

elevator shafts (layer two)

stairwells (layer one)

setbacks

masonry wall

girder

cladding

heat source

concrete slab flooring

beam

skyscraper

32–45 Cass Gilbert **WOOLWORTH BUILDING, NEW YORK**
1911–1913.

Credit: Photo © Andrew Garn

Art Between the Wars in Europe

What are the new developments in European Modernism between World Wars I and II?

World War I had a devastating effect on Europe's artists and architects. Many responded to the destruction and loss of a generation of young men by criticizing the European tradition, while others concentrated on rebuilding. Either way, much of the art created between 1919 and 1939 addressed the needs and concerns of a society in turmoil or transition.

Utilitarian Art Forms in Russia

In the 1917 Russian Revolution, the radical socialist Bolsheviks overthrew the tsar, withdrew Russia from World War I, and turned inward to fight a civil war that lasted until 1920 and led to the establishment of the U.S.S.R. (Union of Soviet Socialist Republics). Most Russian avant-garde artists enthusiastically supported the Bolsheviks, who initially in turn supported them.

The case of Vladimir Tatlin is fairly representative. In 1919, as part of his work on a committee to implement Russian leader Vladimir Lenin's Plan for Monumental Propaganda, Tatlin conceived the Monument to the Third International (**FIG. 32–46**), a 1,300-foot-tall building to house the organization devoted to the worldwide spread of communism. Tatlin's visionary plan combined the appearance of avant-garde sculpture with a fully utilitarian building, a new hybrid form as revolutionary as the politics it represented. In Tatlin's model, the steel structural support, a pair of leaning spirals connected by grillwork, is on the outside rather than the inside of the building. He combined the skeletal structure of the Eiffel Tower (SEE FIG. 31–1)—which his tower would dwarf—with the formal vocabulary of the Cubo-Futurists to convey the dynamism of what Lenin called the "permanent revolution" of communism. Inside the steel frame would be four separate spaces: a large cube to house conferences and congress meetings, a pyramid for executive committees, a cylinder for propaganda offices, and a hemisphere at the top, apparently meant for radio equipment. Each of these units would rotate at a different speed, from yearly at the bottom to hourly at the top. Although Russia lacked the resources to build Tatlin's monument, models displayed publicly were a symbolic affirmation of faith in what the country's science and technology would eventually achieve.

CONSTRUCTIVISM In 1921, one of Tatlin's associates, Aleksandr Rodchenko (1891–1956), helped launch a group known as the Constructivists, which was committed to leaving the studio and going "into the factory, where the

32–46 Vladimir Tatlin **MODEL FOR THE MONUMENT TO THE THIRD INTERNATIONAL**
1919–1920. Wood, iron, and glass. Destroyed.

Credit: © Vladimir Tatlin

real body of life is made"—renouncing painting as a selfish activity and condemning self-expression as weak, unproductive, and socially irresponsible. Instead of pleasing themselves, politically committed artists would create useful objects and promote the aims of the collective, seeing themselves as workers who literally "constructed" art for the people. After 1921, Rodchenko himself worked as a photographer producing posters, books, textiles, and theater sets to foster the goals of the new Soviet society.

In 1925, Rodchenko designed a model **WORK-ERS' CLUB** for the Soviet Pavilion at the Paris International Exposition of Modern Decorative and Industrial Arts (**FIG. 32–47**). He emphasized ease of use and simplicity of construction; the furniture was made of wood because Soviet industry was best equipped for mass production in wood. The high, straight backs of the chairs were meant to promote a physical and moral posture of uprightness among the workers.

32–47 Aleksandr Rodchenko **WORKERS' CLUB**
Exhibited at the International Exposition of Modern Decorative and Industrial Arts, Paris. 1925.

Credit: Art © Estate of Aleksandr Rodchenko/RAO, Moscow, VAGA, New York

32–48 El Lissitzky **PROUN SPACE**
Created for the Great Berlin Art Exhibition. 1923, reconstruction 1971. Collection Van Abbemuseum, Eindhoven, the Netherlands.

Credit: Photo: Peter Cox, Eindhoven, The Netherlands

Another artist active in early Soviet Russia was El Lissitzky (1890–1941). After the Revolution, he taught architecture and graphic arts at the Vitebsk School of Fine Arts, where Malevich also taught. By 1919, Lissitzky was both teaching and using a Constructivist vocabulary for propaganda posters and for artworks he called Prouns (pronounced "pro-oon"), thought to be an acronym for the Russian *proekt utverzhdenya novogo* ("project for the affirmation of the new"). Although most Prouns were paintings or prints, a few of them were early examples of **installation art** (**FIG. 32–48**)—artworks created for a specific site, arranged to create a total environment. Lissitzky rejected painting as too personal and imprecise, preferring to "construct" Prouns for the collective using the less personal instruments of mechanical drawing. Like many other Soviet artists of the late 1920s, Lissitzky also turned to more socially engaged projects such as architectural design, typography, photography, and photomontage for publication.

SOCIALIST REALISM In the mid-1920s, Soviet artists increasingly rejected abstraction in favor of a more widely understandable, and thus more politically useful, Socialist Realism that was ultimately established as official Soviet art. Many of Russia's pioneering Modernists and Constructivists made the change willingly because they were already committed to the national cause; others who refused to change were fired from public positions and lost public support.

The move to Socialist Realism was led by the Association of Artists of Revolutionary Russia (AKhRR), founded in 1922 to depict Russian workers, peasants, revolutionary activists, and the Red Army. AKhRR documented the history of the U.S.S.R. by promoting its leaders and goals. Artists were commissioned to create public paintings and sculptures as well as posters for mass distribution; their subjects were heroic or inspirational people and themes, and their style was an easily readable realism.

Vera Mukhina (1889–1953) was a member of AKhRR and is best known for her 78-foot-tall stainless-steel **WORKER AND COLLECTIVE FARM WOMAN** (**FIG. 32–49**), a powerfully built male factory worker and an equally powerful female farm laborer with hammer and sickle held high in the air—the same two tools that appeared on the Soviet flag. The figures stand as equals, partners in their common cause, striding into the future with determined faces, their windblown clothing billowing behind them.

32–49 Vera Mukhina **WORKER AND COLLECTIVE FARM WOMAN**

Sculpture for the Soviet Pavilion, Paris Universal Exposition. 1937. Stainless steel, height approx. 78′ (23.8 m).

Credit: Art © Estate of Vera Mukhina/RAO, Moscow/VAGA, New York

De Stijl in the Netherlands

In the Netherlands after World War I, abstraction took a different turn from that in the U.S.S.R. The Dutch artist Piet Mondrian (1872–1944) encountered Cubism on a trip to Paris in 1912, where he began to abstract animals, trees, and landscapes, searching for their essential form. After his return to the Netherlands he met Theo van Doesburg (1883–1931), who in 1917 started a magazine named *De Stijl* ("The Style") that became a focal point for Dutch artists, architects, and designers after the war. Writing in the magazine, Van Doesburg argued that beauty took two distinct forms: sensual or subjective beauty and a higher, rational, universal beauty. He challenged De Stijl (note the term translates as "*The* Style" rather than "*A* Style") artists to aspire to universal beauty. Mondrian sought to accomplish this by eliminating everything sensual or subjective from his paintings, but he also followed M.H.J. Schoenmaekers's ideas about Theosophy as expressed in his 1915 book *New Image of the World*. Schoenmaekers argued that an inner visual construction of nature consisted of a balance between opposing forces, such as heat and cold, male and female, and order and disorder, and that artists might represent this inner construction in abstract paintings by using only horizontal and vertical lines and primary colors.

Mondrian's later paintings are visual embodiments of both Schoenmaekers's theory and De Stijl's artistic ideas. In **COMPOSITION WITH YELLOW, RED, AND BLUE** (FIG. 32–50), for example, Mondrian uses the three primary colors (red, yellow, and blue), two neutrals (white and black), and a grid of horizontal and vertical lines in his search for the essence of higher beauty and the balance of forces.

32–50 Piet Mondrian **COMPOSITION WITH YELLOW, RED, AND BLUE**

1927. Oil on canvas, 14⅞ × 13¾″ (37.8 × 34.9 cm). The Menil Collection, Houston.

32–51 Gerrit Rietveld **SCHRÖDER HOUSE, UTRECHT**
The Netherlands. 1925.

Credit: © Ger Bosma/Alamy Stock Photo

Mondrian's opposing lines and colors balance a harmony of opposites that he called a "dynamic equilibrium," which he achieved by carefully plotting an arrangement of colors, shapes, and visual weights grouped asymmetrically around the edges of a canvas, with the center acting as a blank white fulcrum. Mondrian hoped that De Stijl would have applications in the real world by creating an entirely new visual environment for living, designed according to the rules of a universal beauty that, when perfectly balanced, would bring equilibrium and purity to the world. Mondrian said that he hoped to be the world's last artist, because when universal beauty infused all aspects of life, there would no longer be a need for art.

32–52 Gerrit Rietveld **INTERIOR, SCHRÖDER HOUSE, WITH "RED-BLUE" CHAIR**
1925.

Credit: Photo: Jannes Linders. © 2016 Artists Rights Society (ARS), New York/c/o Pictoright Amsterdam

The architect and designer Gerrit Rietveld (1888–1964) applied Mondrian's principles of dynamic equilibrium and De Stijl's aesthetic theories to architecture and created one of the most important examples of the International Style. Interlocking gray and white planes of varying sizes, combined with horizontal and vertical accents in primary colors and black, create the radically asymmetrical exterior of the **SCHRÖDER HOUSE** in Utrecht (**FIG. 32-51**). Inside, the **"RED-BLUE" CHAIR** (**FIG. 32-52**) echoes this same arrangement. Sliding partitions allow modifications in the interior spaces used for sleeping, working, and entertaining. The patron of the house, Truus Schröder-Schräder, wanted a home that suggested an elegant austerity with basic necessities sleekly integrated into a balanced and restrained whole.

The Bauhaus in Germany

In Germany, Walter Gropius (1883–1969) considered the strict geometric shapes and lines of Purism (SEE FIG. 32-40) and De Stijl too rigid and argued that a true German architecture and design should emerge organically. To help this occur, he founded the Bauhaus ("House of Building") in Weimar in 1919. At the Bauhaus, Gropius brought together German architects, designers, and craftspeople to create an integrated system of design and production based on German traditions and styles. Gropius believed that he could revive the spirit of collaboration of the medieval building guilds (*Bauhütten*) that had once erected Germany's cathedrals.

Although Gropius's "Bauhaus Manifesto" of 1919 declared that "the ultimate goal of all artistic activity is the building," the Bauhaus offered no formal training in architecture until 1927. Gropius only allowed his students to begin architectural training after they completed a mandatory foundation course and received full training in design and crafts in the Bauhaus workshops. These included pottery, metalwork, textiles, stained glass, furniture, wood carving, and wall paintings. In 1922, Gropius added a new emphasis on industrial design and the next year hired the Hungarian-born László Moholy-Nagy (1895–1946) to reorient the workshops toward more functional design suitable for mass production.

In 1925, when the Bauhaus moved to Dessau, Gropius designed its new building. Although the structure openly acknowledges its reinforced concrete, steel, and glass materials, there is also a balanced asymmetry to its three large cubic areas that was intended to convey the dynamism of modern life (**FIG. 32-53**). A glass-panel wall wraps around two sides of the workshop wing of the building to

32-53 Walter Gropius **BAUHAUS BUILDING, DESSAU**
Anhalt, Germany. 1925–1926. View from northwest.

Credit: © stockeurope/Alamy Stock Photo.

32–54 Marianne Brandt **COFFEE AND TEA SERVICE**

1924. Silver and ebony, with glass cover for sugar bowl. Tray, 13 × 20¼" (33 × 51.5 cm). Bauhaus Archiv, Berlin.

Credit: © 2016 Artists Rights Society (ARS), New York/VG Bild-Kunst, Bonn

provide natural light for the workshops inside, while a parapet below demonstrates how modern engineering methods could create light, airy spaces. Both Moholy-Nagy and Gropius left the Bauhaus in 1928. The school eventually moved to Berlin in 1932, but lasted only one more year before the new German chancellor, Adolf Hitler, forced its closure. Hitler opposed Modernist art on two grounds: First, he believed it was cosmopolitan rather than nationalistic; second, he erroneously maintained that it was overly influenced by Jews.

Marianne Brandt's elegant **COFFEE AND TEA SERVICE** (**FIG. 32-54**)—a prototype handcrafted in silver for mass production in cheaper metals—is an example of the collaboration between design and industry at the Bauhaus. While the Bauhaus was in Dessau, Brandt (1893–1983) also designed lighting fixtures and table lamps for mass production, earning much-needed revenue for the school. After the departure of Moholy-Nagy and Gropius, Brandt took over the metal workshop for a year before she too left in 1929. As a woman in the otherwise all-male metal workshop, Brandt made an exceptional contribution to the Bauhaus.

Although the Bauhaus claimed that women were admitted on an equal basis with men, Gropius opposed their education as architects and channeled them into what he considered the more gender-appropriate workshops of pottery and textiles. Berlin-born Anni Albers (b. Annelise Fleischmann, 1899–1994) arrived at the school in 1922 and married the Bauhaus graduate and professor Josef Albers (1888–1976) in 1925. Obliged to enter the textiles workshop rather than the painting studio, Anni Albers

32–55 Anni Albers **WALL HANGING**

1926. Silk, three-ply weave, 5'11⁵⁄₁₆" × 3'11⁵⁄₈" (1.83 × 1.22 m). Harvard Art Museums/Busch-Reisinger Museum, Association Fund.

Credit: © 2016 The Josef and Anni Albers Foundation/Artists Rights Society (ARS), New York. Bridgeman Images

made "pictorial" weavings and wall hangings (FIG. 32–55) that were so innovative that they actually replaced paintings on the walls of several modern buildings. Her decentralized, rectilinear designs refer to the aesthetics of De Stijl, but differ in their open acknowledgment of the natural process of weaving. Albers's goal was "to let threads be articulate … and find a form for themselves to no other end than their own orchestration."

THE INTERNATIONAL STYLE After World War I, increased communication among Modernist architects led to the development of a common formal language transcending national boundaries, which came to be known as the International Style. The first concentrated manifestation of the movement was in 1927 at the Deutscher Werkbund's Weissenhofsiedlung exhibition in Stuttgart, Germany, directed by Ludwig Mies van der Rohe (1886–1969), an architect who, like Gropius, was associated with the Bauhaus in Germany. The purpose of this semipermanent show was to present a range of model homes that used new technologies and made no reference to historical styles. The buildings featured flat roofs, plain walls, off-center openings, and rectilinear designs by Mies, Gropius, Le Corbusier, and others.

The term "International Style" became well known as a result of a 1932 exhibition at the Museum of Modern Art in New York called "The International Style: Architecture since 1922," organized by architectural historian Henry-Russell Hitchcock and architect and curator Philip Johnson. Hitchcock and Johnson identified three fundamental principles of the style.

The first was "the conception of architecture as volume rather than mass." The use of a structural skeleton of steel and ferroconcrete made it possible to eliminate load-bearing walls on both the exterior and the interior. As a result, buildings could be wrapped in skins of glass, metal, or masonry, creating the effect of enclosed space (volume) rather than dense material (mass). Interiors featured open, free-flowing plans providing maximum flexibility in the organization of space.

The second was "regularity rather than symmetry as the chief means of ordering design." Regular distribution of structural supports and the use of standard building parts promoted rectangular regularity, not the balanced axial symmetry of Classical architecture. The avoidance of Classical balance also encouraged an asymmetrical arrangement of the building's components, including doors and windows.

The third was the rejection of "arbitrary applied decoration." The new architecture depended on the intrinsic elegance of its materials and the formal arrangement of its elements to produce harmonious aesthetic effects. The most extreme International Style buildings would be unadorned glass boxes.

According to Hitchcock and Johnson, the International Style originated in the Netherlands (De Stijl), France (Purism), and Germany (Bauhaus). After the 1932 exhibition, it spread to the United States. The conceptual clarity of the International Style allowed it to remain vital until the 1970s, especially in the United States, where many of its original European architects, such as Mies and Gropius, who had escaped Hitler and the rise of Nazism in Germany in the 1930s, practiced.

SUPPRESSION OF THE AVANT-GARDE IN NAZI GERMANY In the 1930s, the avant-garde was increasingly criticized by Hitler and the rising Nazi Party, eventually leading to direct efforts to suppress it. One of the principal targets was the Bauhaus. Through much of the 1920s, important artists such as Mies, Kandinsky, Josef Albers, and Paul Klee taught classes there, but they struggled against an increasingly hostile political climate. As early as 1924, conservatives accused the Bauhaus of being not only educationally unsound, but also politically subversive. To avoid having the school shut down, Gropius moved it to Dessau in 1925 at the invitation of Dessau's liberal mayor. But the mayor left office soon after the relocation, and his successors faced increasing political pressure to close the school. The Bauhaus moved again in 1932, this time to Berlin.

After Adolf Hitler came to power in 1933, the Nazi Party mounted an even more aggressive campaign against Modern art. In his youth Hitler had been a mediocre landscape painter, and he developed an intense hatred of the avant-garde. During the first year of his regime, the Bauhaus was forced to close permanently. A number of its faculty—including Albers, Gropius, and Mies—fled to the United States.

The Nazis also attacked German Expressionist artists, whose depictions of German politics and the economic crisis after the war criticized the state and whose frequent caricatures of German facial features and body types undermined Nazi attempts to redraw Germans as idealized Aryans. Expressionist and avant-garde art was removed from museums and confiscated, and artists were forbidden to buy materials and subjected to public intimidation.

In 1937 the Nazi leadership organized an exhibition called "Degenerate Art" of the work they had confiscated from German museums and artists. In it, they described avant-garde Modernism as sick and degraded, presenting the paintings and sculptures as specimens of pathology and scrawling slogans and derisive commentaries on the exhibition's walls (FIG. 32–56). Ironically, in Munich as many as 2 million people viewed the four-month exhibition of 650 paintings, sculptures, prints, and books, and another 1 million visitors saw it on its three-year tour of German cities.

32-56 THE DADA WALL IN ROOM 3 OF THE "DEGENERATE ART" ("ENTARTETE KUNST") EXHIBITION
Munich. 1937.

Credit: Art © Estate of George Grosz/Licensed by VAGA, New York. Akademie der Künste/Archiv Bildende Kunst/George Grosz-Archiv

Large numbers of confiscated works officially destined for destruction were actually taken by Nazi officials and sold in Switzerland in exchange for foreign currency. The ownership of much of the surviving art is still in question. Many artists fled to neighboring countries or the United States, but some, like Ernst Ludwig Kirchner, whose *Street, Berlin* (SEE FIG. 32-13) appeared in the "Degenerate Art" exhibition, were driven to suicide by their loss. Even the work of artists sympathetic to the Nazi position was not safe. The works of Emil Nolde (SEE FIG. 32-12), who had joined the Nazi Party in 1932, were also confiscated.

Surrealism and the Mind

In France during the early 1930s, a group of artists and writers took a very different approach to Modernism in a revolt against logic and reason. Embracing irrational, disorderly, aberrant, and even violent social interventions, Surrealism emerged initially as an offshoot of Dada, born from the mind of poet André Breton (1896–1966). Breton trained in medicine and psychiatry and served in a neurological hospital during World War I where he used Freudian analysis on shell-shocked soldiers. By 1924, Breton, still drawn to the vagaries of the human mind, published the "Manifesto of Surrealism," reflecting Freud's conception of the human mind as a battleground where the

forces of the unconscious wage a constant war against the rational, orderly, and oppressive forces of the conscious. Breton sought to explore humanity's most base, irrational, and forbidden sexual desires, secret fantasies, and violent instincts by freeing the conscious mind from reason. As he wrote in 1934, "we still live under the rule of logic." To escape this restraint, he and other Surrealists developed strategies to liberate the unconscious using dream analysis, free association, automatic writing, word games, and hypnotic trances. Surrealists studied acts of "criminal madness" and the "female mind" in particular, believing the latter to be weaker and more irrational than the male mind. The only way to improve the war-sick society of the 1920s, Breton thought, was to discover the more intense "surreality" that transcended rational constraint.

AUTOMATISM Surrealist artists employed a variety of techniques, including **automatism**—releasing the unconscious to create the work of art without rational intervention—in order to produce surprising new imagery and forms. Max Ernst (1891–1976), a self-taught German artist who collaborated in Cologne Dada and later joined Breton's circle in Paris, developed the automatist technique of **frottage** in 1925. First he rubbed a pencil or crayon over a piece of paper placed on a textured surface, then he allowed the resulting image to stimulate his imagination, discovering

32–57 Max Ernst **THE HORDE**
1927. Oil on canvas, 44⅞ × 57½" (114 × 146.1 cm).
Stedelijk Museum, Amsterdam.

Credit: © 2016 Artists Rights Society (ARS), New York/ADAGP,
Paris. Collection Stedelijk Museum, Amsterdam

within it fantastic creatures, plants, and land-
scapes that he articulated more clearly with
additional drawing. In painting, Ernst called
this new technique **grattage**, laying a painted
canvas on a textured surface and then scraping
the paint away, then "revealing" the imagery
he saw in the paint with additional paint-
ing. **THE HORDE** (**FIG. 32–57**) of 1927 shows
a nightmarish scene of monsters advancing
against an unseen force. Surely the horrors of
World War I that Ernst had experienced first-
hand in the German army lie behind such
frightening images.

UNEXPECTED JUXTAPOSITIONS The paintings of Sal-
vador Dalí (1904–1989) include more recognizable forms,
but they also reveal the visual wonders of an uncon-
scious mind run wild. Dalí trained at the San Fernando
Academy of Fine Arts in Madrid, where he mastered tra-
ditional methods of illusionistic representation, and trav-
eled to Paris in 1928, where he met the Surrealists. Dalí's

contribution to Surrealist theory was the "paranoid-critical
method," in which he cultivated the paranoid's ability to
misread, mangle, and misconstrue ordinary appearances,
thus liberating himself from conventional thought. Then
he painted what he had imagined.

Dalí's paintings focus on a few key themes: sexuality,
violence, and putrefaction. In the **BIRTH OF LIQUID
DESIRES** (**FIG. 32–58**), we see a large yellow **biomorphic**
form (an organic shape resembling a living organism)–

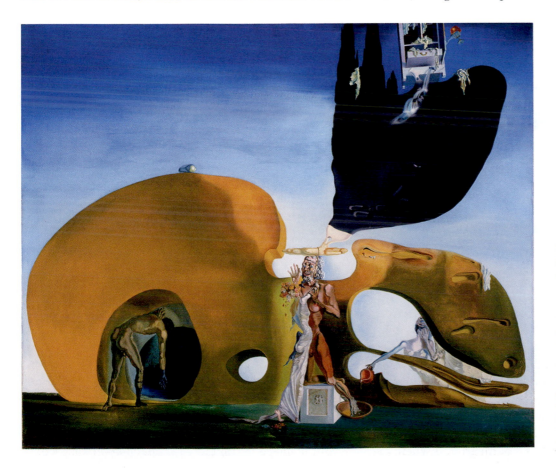

32–58 Salvador Dalí
**BIRTH OF LIQUID
DESIRES**

1931–1932. Oil and collage
on canvas, 37⅞ × 44¼"
(96.1 × 112.3 cm). The
Solomon R. Guggenheim
Foundation. Peggy
Guggenheim Collection, Venice
1976 (76.2553 PG 100).

Credit: © Salvador Dalí, Fundació
Gala-Salvador Dalí, Artists Rights
Society (ARS), New York 2016.
The Solomon R. Guggenheim
Foundation/Art Resource, NY

32–59 Meret Oppenheim **OBJECT (LUNCHEON IN FUR)**

1936. Fur-covered cup, diameter 4⅜″ (10.9 cm); fur-covered saucer, diameter 9⅜″ (23.7 cm); fur-covered spoon, length 8″ (20.2 cm); overall height, 2⅞″ (7.3 cm). Museum of Modern Art, New York.

Credit: © 2016 Artists Rights Society (ARS), New York/ProLitteris, Zurich. © 2016. Digital image, The Museum of Modern Art, New York/Scala, Florence

looking like a monster's face, a painter's palette, or a woman's body—that serves as the backdrop for four figures. A woman in white embraces a hermaphroditic figure who stands with one foot in a bowl that is being filled with liquid by a third figure, partially hidden, while a fourth figure enters a cavernous hole to the left. A thick black cloud rises above the scene. Dalí claimed that he simply painted what his paranoid-critical mind had conjured up in his nightmares. His images are thus, as Breton advocated, "the true process of thought, free from the exercise of reason and from any aesthetic or moral purpose."

They defy rational interpretation, although they trigger fear, anxiety, and even regression in our empathetic minds. But that does not mean they are without subject matter. This painting refers to the legend of William Tell, which Dali related to his own sense of rejection by his father, an anxiety intensified after 1929 because his father disapproved of his relationship with Gala Éluard, whom he would marry in 1934. The famous apple on the head of William Tell's son is replaced here by a baguette perched on the head of the central and tallest figure, evidence of the castration anxiety Dali associated with Tell's famous feat of marksmanship.

32–60 Joan Miró **COMPOSITION**

1933. Oil on canvas, 51⅜ × 64⅛″ (130.49 × 162.88 cm). Wadsworth Athenaeum, Hartford, Connecticut. The Ella Gallup Sumner and Mary Catlin Sumner Collection Fund, 1934.40.

Credit: © Successió Miró/Artists Rights Society (ARS), New York/ADAGP, Paris 2016. Photo: Allen Phillips/Wadsworth Atheneum

Dalí's strangely compelling art also draws on the Surrealist interest in unexpected juxtapositions of disparate realities. Surrealists argued that by bringing together several disparate ordinary objects in strange new contexts artists could create uncanny surrealities. One of the most disturbingly exquisite and mockingly humorous examples is **OBJECT (LUNCHEON IN FUR)** (FIG. 32-59), by the Swiss artist Meret Oppenheim (1913–1985). Oppenheim was one of the few women invited to participate in the Surrealist movement; Surrealists generally treated women as their muses or as objects of study, but not their equals. This work was inspired by a conversation between Oppenheim, Picasso, and the photographer Dora Maar at a Parisian café. After admiring the fur trim on Oppenheim's bracelet, Picasso claimed that one could cover anything with fur, to which Oppenheim is said to have replied, "Even this cup and saucer." When Breton invited her to participate in the first Surrealist exhibition devoted to objects, she bought an actual cup, saucer, and spoon and covered them with the fur of a Chinese gazelle. The result removes two objects (a tea setting and gazelle fur) from their ordinary reality and recontextualizes them in an irrational new surreality— an uncanny object that is simultaneously desirable and deeply disturbing.

BIOMORPHIC ABSTRACTION The Catalan artist Joan Miró (1893–1983) exhibited regularly with the Surrealists but never formally joined the movement. Miró's biomorphic abstraction is also intended to free the mind from rationality, but in a more benign manner. His images seem to take shape before our eyes, but their identity is always in flux. In **COMPOSITION** (FIG. 32-60) of 1933, curving biomorphic primal or mythic shapes that seem arranged by chance emerge from the artist's mind uncensored, like doodles, to dance around the canvas. The Surrealists used the free association of doodling to relax the conscious mind so that images could bubble up from the unconscious; Miró reportedly doodled on many of his canvases as a first step of creation. This particular work was based on a collage assembled from advertisements cut from catalogs, magazines, and newspapers. Miró was also fascinated by children's art, which he thought of as spontaneous and expressive. Although he was a well-trained artist himself, he said that he wished he could learn to paint with the freedom of a child.

Unit One in England

In 1933, the English artists Barbara Hepworth (1903–1975), Henry Moore (1898–1986), and Paul Nash (1889–1946), along with the poet and critic Herbert Read (1893–1968), founded Unit One. Although short-lived, this group promoted the use of handcrafted, Surrealist-influenced biomorphic forms in sculpture, brought new energy to

32–61 Barbara Hepworth **FORMS IN ECHELON**
1938. Wood, 42½ × 23⅔ × 28″ (108 × 60 × 71 cm). Tate, London. Presented by the artist 1964.

British art in the 1930s, and exerted a lasting impact on British sculpture.

Hepworth studied at the Leeds School of Art. She punctuated her exquisitely crafted sculptures with holes so that air and light could pass through them. Images seem to take shape before our eyes, but their identity is always in flux. Hepworth's **FORMS IN ECHELON** (FIG. 32-61) consists of two biomorphic shapes carved in highly polished wood. She hoped that viewers would allow their eyes to play around with these organic forms, so their imagination could generate changing associations and meanings.

Moore also carved punctured sculptural abstractions, although his works were more obviously based on the human form. He also studied at the Leeds School of Art and then at the Royal College of Art in London. The African, Oceanic, and Pre-Columbian sculpture that he saw at the British Museum, however, had a more powerful impact than his academic training on his developing aesthetic. He felt that artists beyond the Western tradition showed a greater respect for the inherent qualities of materials such as stone or wood than their Western counterparts did.

32–62 Henry Moore
RECUMBENT FIGURE

1938. Green Hornton stone, 35 × 52 × 29″ (88.9 × 132.7 × 73.7 cm). Tate, London.

Moore created this work to fulfill a commission from Russian-born British architect Serge Chermayeff, who installed it on the terrace of his modern home on the English South Downs.

The reclining female nude is the dominant theme of Moore's art. The massive, simplified body in **RECUMBENT FIGURE** (FIG. 32-62) refers to the *chacmool*, a reclining human form in Toltec and Maya art (SEE FIG. 13-15). Moore's sculptures also reveal his special sensitivity to the inherent qualities of his stone, which he sought out in remote quarries, always insisting that each of his works be labeled with the specific kind of stone he had used. While certain aspects of the human body are clearly described in this sculpture—the head, breasts, supporting elbow, and raised knee—other parts seem to flow together into an undulating mass suggestive of a hilly landscape. The cavity at the center inverts our expectations about the solid and void. In 1937, Moore wrote, "A hole can itself have as much shape-meaning as a solid mass."

Picasso's *Guernica*

In January 1937, as the Spanish Civil War between the Republicans and the Nationalists began to escalate, Picasso—a Spaniard who was then living in Paris—was commissioned to make a large painting for the Spanish

32-63 RUINS OF GUERNICA, SPAIN
April 1937.

Credit: © Bettmann/Corbis

Pavilion of the 1938 Paris Exposition, a direct descendant of the nineteenth-century World's Fairs that had resulted in the Crystal Palace and the Eiffel Tower. The 1938 Spanish Pavilion was the first Spanish national pavilion at any World's Fair.

As Picasso pondered what he might create, on April 26, 1937, Nationalist-supporting German bombers attacked the town of Guernica in the Basque region of Spain, killing and wounding 1,600 civilians. For more than three hours, 25 bombers dropped 100,000 pounds of explosives on the town, while more than 20 fighter planes strafed anyone caught in the streets trying to flee destroyed or burning buildings. Fires burned in Guernica for three days. By the end, one third of the town's population was killed or wounded and 75 percent of its buildings had been destroyed (FIG. 32-63). The cold-blooded, calculating nature of the attack shocked Europe. It seemed to serve no military purpose, other than to allow Franco's Nationalist forces to terrorize civilian populations, but the world's shock worsened with the revelation that the German commander had planned the massacre merely as a "training mission" for the German air force. Horrified, Picasso now had his subject for the Fair.

On May 1, 1 million protesters marched in Paris, and the following day Picasso made the first preliminary sketches for his visual response to this atrocity. Picasso had been trained in the traditions of academic painting, and he planned **GUERNICA** (FIG. 32-64) as a monumental history painting detailing the historic, and ignoble, events

32-64 Pablo Picasso GUERNICA
1937. Oil on canvas, 11'6" × 25'8" (3.5 × 7.8 m). Museo Nacional Centro de Arte Reina Sofía, Madrid. On permanent loan from the Museo del Prado, Madrid.

Credit: © 2016 Estate of Pablo Picasso/Artists Rights Society (ARS), New York

of the attack. During ten days of intensive planning he made several sketches (*esquisses*) to develop the composition before moving on to canvas. He worked at the painting itself—changing figures and developing themes—for another month.

Guernica is a complex painting, layered with meaning. Picasso rarely used specific or obvious symbolism in his art, preferring to let individual viewers interpret details themselves. What is beyond question, however, is that *Guernica* is a scene of brutality, chaos, and suffering. Painted in black, white, and gray, the image resonates with anguish. It freezes figures in mid-movement in stark black and white as if caught by the flashbulb of a reporter's camera. Many of the subjects are clearly identifiable: an expressionistically reconfigured head of a bull in the upper left, a screeching wounded horse in the center, broken human forms scattered across the expanse, a giant lightbulb suggesting an all-seeing eye at the top, a lamp below it, and smoke and fire visible beyond the destroyed room in which the disjointed action takes place. These images have inspired a variety of interpretations. Some have seen in the bull and horse symbols of Nationalist and Republican forces, variously identified with one or the other. The lightbulb, javelin, dagger, lamp, and bird have also been assigned specific meanings. Picasso, however, refused to acknowledge any particular significance to any of these seeming symbols. *Guernica*, he claimed, is about the massacred victims of this atrocity—beyond that, its meaning remains fluid.

Guernica appeared in the Spanish Pavilion along with other works of art supporting the Republican cause, including works by painter Joan Miró, sculptor Alexander Calder, filmmaker Luis Buñuel, and others. Because Picasso refused to allow *Guernica* to be shown in Spain under the regime of Nationalist leader General Franco,

it hung in the Museum of Modern Art in New York for years, finally traveling to Spain for installation in the Reina Sofía in Madrid only in 1981, six years after Franco's death. Since 1985, a tapestry copy of *Guernica* has hung in the headquarters of the United Nations in New York as a powerful reminder of the brutal human cost of unrestrained warfare.

Art Between the Wars in the Americas

How does art develop in the Americas between World Wars I and II?

A need for a national visual identity emerged in American art between the wars, but since the United States was a large, diverse nation with multiple "identities," attempts to preserve a fiction of a single, essentially male, Anglo-Saxon national profile only heightened the visibility of the creative and experimental works of art by African Americans, immigrants, women, and others.

The Harlem Renaissance

Between 1910 and 1930, hundreds of thousands of African Americans migrated from the rural, mostly agricultural American South to the urban, industrialized North to escape racial oppression and find greater social and economic opportunities. This First Great Migration prompted the formation of the nationwide New Negro movement and the Harlem Renaissance in New York, which called for greater social and political activism among African Americans.

32–65 James Van Der Zee **COUPLE WEARING RACCOON COATS WITH A CADILLAC, TAKEN ON WEST 127TH STREET, HARLEM, NEW YORK**

1932. Gelatin-silver print.

Credit: © Donna Mussenden VanDerZee

32–66 Aaron Douglas **ASPECTS OF NEGRO LIFE: FROM SLAVERY THROUGH RECONSTRUCTION**
1934. Oil on canvas, 5′ × 11′7″ (1.5 × 3.5 m). Schomburg Center for Research in Black Culture, New York Public Library.

Credit: Art © Heirs of Aaron Douglas/Licensed by VAGA, New York, NY. Schomburg Center, NYPL/Art Resource, NY

Harlem's wealthy middle-class African-American community produced some of the nation's most talented artists of the 1920s and 1930s, such as the jazz musician Duke Ellington, the novelist Jean Toomer, and the poet Langston Hughes. The movement's intellectual leader was Alain Locke (1886–1954), a critic and philosophy professor who argued that black artists should seek their artistic roots in the traditional arts of Africa rather than assimilate within mainstream American or European artistic traditions.

James Van Der Zee (1886–1983), a studio photographer who took carefully crafted portraits of the Harlem upper-middle classes, opened his studio in 1916, working as both a news reporter and a society photographer. **COUPLE WEARING RACCOON COATS WITH A CADILLAC (FIG. 32-65)** captures a wealthy man and woman posing with their new car in 1932, at the height of the Great Depression. The photograph reveals the glamour of Harlem, then the center of African-American cultural life.

The painter Aaron Douglas (1898–1979) moved to New York City from Topeka, Kansas, in 1925. He developed a silhouette style that owes much to African art and had a lasting impact on later African-American artists (SEE FIG. 33–69). He painted **ASPECTS OF NEGRO LIFE: FROM SLAVERY THROUGH RECONSTRUCTION (FIG. 32-66)** for the Harlem branch of the New York Public Library under the sponsorship of the Depression-era Public Works of Art Project. To the right, slaves are celebrating the Emancipation Proclamation of 1863, from which radiate concentric circles of light. At the center, an orator gestures dramatically, pointing to the United States Capitol in the background as if to urge all African Americans, some of whom are still picking cotton in the foreground, to exercise their right to vote. To the left, Union soldiers leave the South after Reconstruction, while Ku Klux Klan members, hooded and on horseback, charge in, reminding viewers that the fight for civil rights has only just begun.

The career of sculptor Augusta Savage (1892–1962) reflects the myriad difficulties faced by African Americans in the art world. Savage studied at Cooper Union in New York, but her 1923 application to study in Europe was turned down because of her race. In a letter of protest, she wrote, "Democracy is a strange thing. My brother was good enough to be accepted in one of the regiments that saw service in France during the war, but it seems his sister is not good enough to be a guest of the country for which he fought." Finally, in 1930, Savage was able to study in Paris. On her return to the United States, she sculpted portraits of several African-American leaders, including Marcus Garvey and W.E.B. DuBois. Inspired by the story of the Haitian Revolution in 1791 following the Slave Revolt (SEE FIG. 30–40), she portrayed a female figure of freedom in **LA CITADELLE: FREEDOM (FIG. 32-67)** raising her hand to the sky and balancing on the toes of one foot while she flies through the air. La Citadelle was the castle residence of one of Haiti's first leaders of African heritage. For Savage, it represented the possibility and promise of freedom and equality.

Savage established a small private art school in Harlem and received Federal funds under the Works Progress Administration to transform it into the Harlem Community Art Center. Hundreds of these centers were eventually established all over the country, but Savage's became an unofficial salon for Harlem artists, poets, composers, dancers, and historians.

One of the best-known artists to emerge from the Harlem Community Art Center was Jacob Lawrence (1917–2000). Lawrence's early works often depict

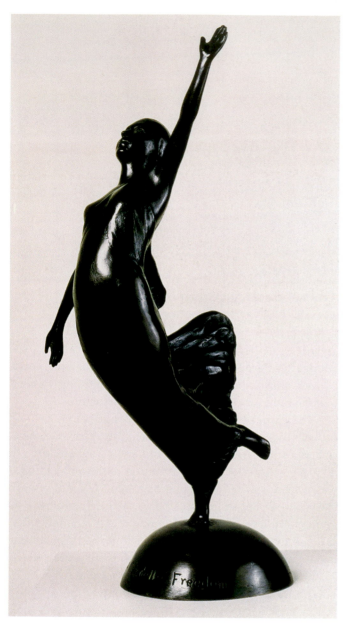

32–67 Augusta Savage **LA CITADELLE: FREEDOM**
1930. Bronze, 14½ × 7 × 6″ (35.6 × 17.8 × 15.2 cm).
Howard University Gallery of Art, Washington, DC.

Credit: © Augusta Savage

Rural America

Other artists, known collectively as the Regionalists, developed Midwestern themes during the 1930s. In 1930, at the height of the Depression, Grant Wood (1891–1942) painted **AMERICAN GOTHIC** (**FIG. 32-69**), which was purchased by the Art Institute of Chicago and established Wood's national fame. This picture embodied all that was good and bad about the heartland in the 1930s. Wood, who later taught at the University of Iowa, portrays an aging father standing with his unmarried daughter in front of their Gothic Revival framed house. Even for the time their clothes are old-fashioned. Wood's dentist and his sister Nan—wearing a homemade ricrac-edged apron and their mother's cameo—posed for the figures, and the building was modeled on a modest small-town home in Eldon, Iowa. The daughter's long, sad face echoes her father's; she is unmarried and likely to stay that way. In 1930, husbands were hard to come by in the Midwest because many young men had fled the farms for jobs in Chicago. With its tightly painted descriptive detail, this painting is a homage to the Flemish Renaissance painters that Wood admired.

FEDERAL PATRONAGE OF ART DURING THE GREAT DEPRESSION In the early 1930s during the Great Depression, President Franklin D. Roosevelt's New Deal established a series of programs to provide relief for the unemployed and to revive the nation's economy, including several initiatives to create work for American artists. The 1933 Public Works of Art Project (PWAP) lasted only five months but supplied employment to 4,000 artists, who produced more than 15,000 works. The Treasury Department established a Section of Painting and Sculpture in October 1934, which survived until 1943, commissioning murals and sculptures for public buildings. The Federal Art Project (FAP) of the Works Progress Administration (WPA), which ran from 1935 to 1943, succeeded the PWAP and was the most important work-relief agency of the Depression era. By 1943, it had employed more than 6 million workers in programs that included, in addition to the FAP, the Federal Theater Project and the Federal Writers' Project. About 10,000 artists participated in the FAP, producing a staggering 108,000 paintings, 18,000 sculptures, 2,500 murals, and thousands of prints, photographs, and posters, all of which became public property. Many of the murals and sculptures, commissioned for public buildings such as train stations, schools, hospitals, and post offices, survive today, but most easel paintings were later sold as "plumber's canvas" and destroyed.

To build public support for Federal assistance in rural America, the Resettlement Agency (RA) and Farm Security Administration (FSA) hired photographers to document the effects of the Depression across the country in photographs available to this day, copyright-free, to any newspaper, magazine, or publisher. San Francisco-based Dorothea

African-American history in series of small narrative paintings, each accompanied by a text. His themes include the history of Harlem and the lives of Haitian revolutionary leader Toussaint L'Ouverture and American abolitionist John Brown. Lawrence created his most expansive series in 1940–1941. Entitled **THE MIGRATION SERIES**, 60 panels chronicle the Great Migration, a journey that had brought Lawrence's own parents from South Carolina to Atlantic City, New Jersey. In the first panel (**FIG. 32-68**), African-American migrants stream through the doors of a Southern train station on their way to Chicago, New York, or St. Louis. Lawrence's boldly abstracted silhouette style, with its flat, bright shapes and colors, draws consciously and directly—like that of Douglas—on African visual sources.

32–68 Jacob Lawrence **THE MIGRATION SERIES, PANEL NO. 1: DURING WORLD WAR I THERE WAS A GREAT MIGRATION NORTH BY SOUTHERN AFRICAN AMERICANS**

1940–1941. Tempera on masonite, 12 × 18″ (30.5 × 45.7 cm). The Phillips Collection, Washington, DC.

Credit: © 2016 The Jacob and Gwendolyn Knight Lawrence Foundation, Seattle/Artists Rights Society (ARS), New York

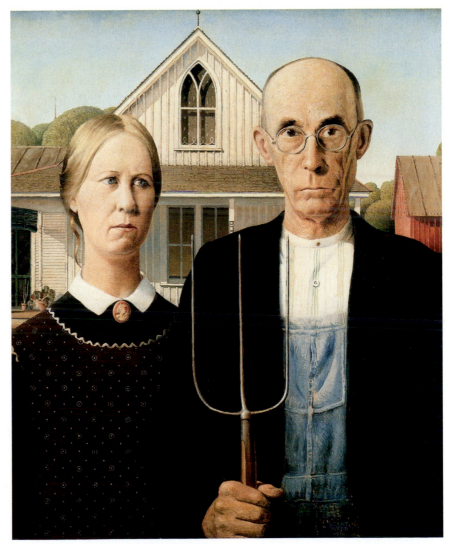

32–69 Grant Wood **AMERICAN GOTHIC**

1930. Oil on beaverboard, 29⅞ × 24⅞″ (74.3 × 62.4 cm). The Art Institute of Chicago. Friends of American Art Collection, 1930.934.

Credit: Art © Figge Art Museum, successors to the Estate of Nan Wood Graham/Licensed by VAGA, New York, NY. Photo © The Art Institute of Chicago

Lange (1895–1965), an RA/FSA photographer between 1935 and 1939, documented the plight of migrant farm laborers who fled the Dust Bowl conditions of the Great Plains and then crowded California looking for work.

MIGRANT MOTHER, NIPOMO, CALIFORNIA (FIG. **32-70**) shows Florence Owens Thompson, a 32-year-old mother of seven, representative of the poverty suffered by thousands of migrant workers in California. Lange carefully constructed her photograph for maximum emotional impact. She zoomed in very close to the subject, focusing on the mother's worn expression and apparent resolve. The composition refers to images of the Virgin Mary holding the Child Jesus (SEE FIG. 21-6) or perhaps sorrowful

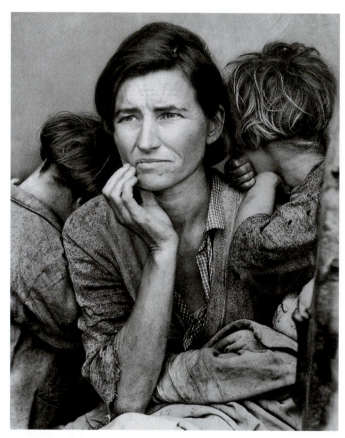

32–70 Dorothea Lange **MIGRANT MOTHER, NIPOMO, CALIFORNIA**

February 1936. Gelatin-silver print. Library of Congress, Washington, DC.

In 1960, Lange described the experience of taking this photograph, writing, "I saw and approached the hungry and desperate mother, as if drawn by a magnet. I do not remember how I explained my presence or my camera to her, but I do remember she asked me no questions. I made five exposures, working closer and closer from the same direction. I did not ask her name or her history. She told me her age, that she was thirty-two. She said that they had been living on frozen vegetables from the surrounding fields, and birds that the children killed. She had just sold the tires from her car to buy food. There she sat in that lean-to tent with her children huddled around her, and seemed to know that my pictures might help her, and so she helped me. There was a sort of equality about it." (*Popular Photography*, February 1960)

Credit: Courtesy the Library of Congress

scenes in which she contemplates his loss (SEE FIG. 21-14). Lange chose to eliminate from this photograph the makeshift tent in which the family was camped, the dirty dishes on a battered trunk, trash strewn around the campsite, and, most significant, Thompson's teenage daughter—all documented in her other photographs of the same scene. Lange decided to focus here on the purity and moral worth of her subject, for whom she sought Federal aid; she could not allude to the fact that Thompson had been a teenage mother or even that she was Cherokee. *Migrant Mother* (then unidentified by name) became the "poster child" of the Great Depression, and her powerfully sad, distant gaze still resonates with audiences today, demonstrating the propaganda power of the visual image.

During the Depression, the FAP paid a generous average salary of about $20 a week (a salesclerk at Woolworth's earned only about $11) for painters and sculptors to devote themselves full time to art. New York City's painters, in particular, developed a group identity, meeting in the bars and coffeehouses of Greenwich Village to discuss art. The FAP thus provided the financial grounds on which New York artists built a sense of community—a community that would produce the Abstract Expressionists and that allowed New York to supersede Paris as the center of the world of Modern art.

Canada

In the nineteenth century, Canadian artists, like their counterparts in the United States, began to assert independence from European art by painting Canada's great untamed wilderness. A number of Canadians, however, used the academic realism they learned in Paris to paint figurative subjects, while others painted the Canadian landscape through the lens of Impressionism.

LANDSCAPE AND IDENTITY In the early 1910s, a young group of Toronto artists, many of whom worked for the same commercial art firm, began to sketch together, adopting the rugged landscape of the Canadian north as an expression of national identity.

A key figure in this movement was Tom Thomson (1877–1917), who, as of 1912, spent the warm months of each year in Algonquin Provincial Park, a large forest reserve 180 miles north of Toronto. He made many small, swiftly painted, oil-on-board sketches as the basis for the full-size paintings that he executed in his studio during the winter. One such sketch led to **THE WEST WIND** (FIG. **32-71**). This tightly organized composition features a vibrant stylized tree rising from a rocky foreground and set against a luminous but more subdued background of lake, hills, and sky. The cropped, silhouetted form of a curvilinear tree set close to the viewer against a harmonious Canadian landscape in the distance was one of his favorite subjects.

32-71 Tom Thomson **THE WEST WIND**

1916–17. Oil on canvas, 45½ × 54" (120.7 × 137.9 cm). Art Gallery of Ontario, Toronto. Gift of Canadian Club of Toronto, 1926 #784.

Credit: © akg-images

NATIVE AMERICAN INFLUENCE

Born in Victoria, British Columbia, the West Coast artist Emily Carr (1871–1945) studied art in San Francisco, England, and Paris. On a 1907 trip to Alaska she encountered the monumental carved poles of Northwest Coast Native peoples and resolved to document these "real art treasures of a passing race." Over the next 23 years, Carr visited more than 30 sites across British Columbia making drawings and watercolors as a basis for oil paintings. After a commercially unsuccessful exhibition of her Native subjects, Carr returned to Victoria in 1913, opened a boarding house, and painted very little for the next 15 years. In 1927, however, she was invited to participate in an exhibition of West Coast art at the National Gallery of Canada. On her trip east for the show's opening, Carr met members of the Group of Seven, a group of landscape painters established in 1920 by some of Tom Thomson's former colleagues. They rekindled her interest in painting.

With the Group of Seven, Carr developed a dramatic and powerfully sculptural style full of dark, brooding energy. **BIG RAVEN** (**FIG. 32–72**), painted in 1931 from a 1912 watercolor, shows an abandoned village in the Queen Charlotte Islands where Carr found a carved raven on a pole, the surviving member of a pair that originally marked a mortuary house. In her autobiography Carr described the raven as "old and rotting," but in the painting she shows it as strong and majestic, thrusting dynamically above the swirling vegetation, a symbol of enduring spiritual power and national pride.

32-72 Emily Carr **BIG RAVEN**

1931. Oil on canvas, 34¼ × 44⅞" (87 × 114 cm). Collection of the Vancouver Art Gallery, Emily Carr Trust.

Credit: Vancouver Art Gallery, Photo: Trevor Mills

Mexico, Brazil, and Cuba

The Mexican Revolution of 1910 overthrew the 35-year dictatorship of General Porfirio Díaz and initiated ten years of political instability. In 1920, reformist president Álvaro Obregón restored political order, and the leaders of his new government—as in the U.S.S.R.—engaged artists in the service of the people and state. Several Mexican artists received government commissions to decorate public buildings with murals celebrating the history, life, and work of the Mexican people. These artists painted in a naturalistic style because the new government believed that the public at large could not understand abstract art.

Diego Rivera (1886–1957) was prominent in the Mexican mural movement that developed from these commissions. He enrolled in Mexico City's Academia de San Carlos at age 11, and from 1911 to 1919, he lived in Paris where he met Picasso and David Siqueiros (1896–1974), another Mexican muralist. Both Rivera and Siqueiros sought to create a revolutionary art in the service of the people in their public murals. In 1920–1921, Rivera traveled to Italy to study Renaissance frescoes, and he also visited ancient Mexican sites to study indigenous mural paintings. In 1945, he painted **THE GREAT CITY OF TENOCHTITLAN** (FIG. 32-73) as part of a mural cycle in the National Palace in Mexico City that used stylized forms and brilliant colors to portray the history of Mexico. Rivera also painted murals in the United States.

The art of Frida Kahlo (1907–1954) is more personal. Breton claimed Kahlo as a natural Surrealist, although she herself said, "I never painted dreams. I painted my own reality." That reality included her mixed heritage, born of a German father and Mexican mother. In a double self-portrait—**THE TWO FRIDAS** (FIG. 32-74)—Kahlo presents an identity split into two ethnic selves: the European one in a Victorian dress and the Mexican one wearing traditional Mexican clothing. The painting also reflects her stormy relationship with Diego Rivera, whom she married in 1929 but was divorcing in 1939 while painting this picture. She told an art historian at the time that the Mexican image was the Frida whom Diego loved, and the European image was one he did not. The two Fridas join hands; the artery running between them begins at a miniature portrait of Rivera as a boy held by the Mexican Frida, travels through the exposed hearts of both Fridas, and ends in the lap of the European Frida, who attempts without success to stem the flow of blood. Kahlo had suffered a broken pelvis in an accident at age 17, and she endured a lifetime of surgeries. This work alludes to her constant pain, as well as to the Aztec custom of human sacrifice by heart removal.

BRAZIL Elsewhere in Latin America, art in the nineteenth century was often dominated by the academic tradition. Several nations had thriving academies and large art communities, and artists traveled in significant numbers to study in Paris. By 1914, artists in many Latin American countries used their own versions of Impressionism to paint national themes. After World War I, artists who studied abroad also brought home ideas drawn from Modernist art and the European avant-garde, which they translated into a specifically Latin American vision. For instance, in 1922, as Brazil marked the centenary of its independence from Portugal, the avant-garde in São Paulo celebrated with Modern Art Week, an event Brazilian artists used to declare their artistic independence from Europe. Modern Art Week brought avant-garde poets, dancers, musicians, and visual artists to São Paulo and took on

32–73 Diego Rivera
THE GREAT CITY OF TENOCHTITLAN (DETAIL)
Mural in patio corridor, National Palace, Mexico City. 1945. Fresco, 16′1¾″ × 31′10¼″ (4.92 × 9.71 m).

Credit: © 2016 Banco de México Diego Rivera Frida Kahlo Museums Trust, Mexico, D.F./Artists Rights Society (ARS), New York. © 2016. Photo Art Resource/Bob Schalkwijk/Scala, Florence

32-74 Frida Kahlo **THE TWO FRIDAS**
1939. Oil on canvas, 5′8½″ × 5′8½″
(1.74 × 1.74 m). Museo de Arte Moderno,
Instituto Nacional de Bellas Artes,
Mexico City.

Credit: © 2016 Banco de México Diego Rivera Frida
Kahlo Museums Trust, Mexico, D.F./Artists Rights
Society (ARS), New York. © 2016. Photo Art Resource/
Bob Schalkwijk/Scala, Florence

a distinctly confrontational character. Poets derided their elders in poetry, dancers enacted modern versions of traditional dances, and the composer Hector Villa-Lobos (1887–1959) appeared on stage in a bathrobe and slippers to play new music based on Afro-Brazilian rhythms.

In 1928, the São Paulo poet Oswald de Andrade, one of Modern Art Week's organizers, wrote the "Anthropophagic Manifesto," proposing a tongue-in-cheek, if radical, solution to Brazil's seeming dependence on European culture. He suggested that Brazilians imitate the ancient Brazilians' response to Portuguese explorers arriving on their shore—eat them. He mockingly described this relationship as anthropophagic or cannibalistic and proposed that Brazilians gobble up European culture, digest it, let it strengthen their Brazilianness, and then get rid of it.

The painter who most closely embodies this irreverent attitude is Tarsila do Amaral (1887–1974), a daughter of the coffee-planting aristocracy, who studied in Europe with Fernand Léger (SEE FIG. 32-21), among others. Her painting **THE ONE WHO EATS (ABAPORÚ)** (FIG. 32-75) shows an appreciation of the art of Léger and Brancusi (SEE FIG. 32-27), which Tarsila collected. But she also inserted several "tropical" clichés—the abstracted forms of a cactus and a lemon-slice sun. The subject is Andrade's irreverent cannibal, sitting in a caricatured Brazilian landscape, as if to say: If Brazilians are caricatured abroad as cannibals, then let us act like cannibals. As Andrade wrote in one of his

32-75 Tarsila do Amaral **THE ONE WHO EATS (ABAPORÚ)**
1928. Oil on canvas, 34 × 29″ (86.4 × 73.7 cm). Museo de Arte
Latinoamericano, Buenos Aires. Courtesy of Guilherme Augusto do
Amaral/Malba-Coleccion Constantini, Buenos Aires.

Credit: © Tarsila do Amara. Collection of MALBA, Museo de Arte
Latinoamericano de Buenos Aires

manifestos, "Carnival in Rio is the religious outpouring of our race. Richard Wagner yields to the samba. Barbaric but ours. We have a dual heritage: The jungle and the school."

CUBA Cuba's 1920s avant-garde was one of the most interdisciplinary, consisting of anthropologists, poets, composers, and even a few scientists, who gathered in Havana and called themselves "The Minority." They issued a manifesto in 1927 repudiating government corruption, "Yankee imperialism," and dictatorship on any continent. "Minority" artists, they urged, should pursue a new, popular, Modern art rooted in Cuban soil.

Amelia Peláez (1896–1968) left Cuba for Paris shortly after this manifesto was issued. When she returned home, she joined the anthropologist Lydia Cabrera to study Cuban popular and folk arts. Her paintings focus on the woman's realm—the domestic interior—and national identity, as in **HIBISCUS (MARPACÍFICO)** (FIG. 32-76). Her visual language is Cubist, as seen in the flattened overlapping forms and compressed pictorial space, but it shows recognizable objects—a mirror, a tabletop, and local hibiscus flowers—whose heavy black outlines and pure color reflect the flat, fan-shaped stained-glass windows that decorate many Cuban homes.

32-76 Amelia Peláez **HIBISCUS (MARPACÍFICO)**
1943. Oil on canvas, 45½ × 35" (115.6 × 88.9 cm).
Art Museum of the Americas, Washington, DC. Gift of IBM.
Credit: © Amelia Pelaez Foundation

Postwar Art in Europe and the Americas

What artistic trends emerged after World War II?

The horrors of World War II surpassed even those of World War I. The human loss was almost too profound and grotesque to comprehend. Between loss of life in action, those killed in work camps and death camps (concentration camps), those lost to starvation, and those lost in the bombing of civilian targets, more than 30 million people died and an estimated 40 million people were displaced. The unimaginable horror of the concentration camps and the awful impact of the dropping of nuclear bombs shook humanity to its core. Winston Churchill described the extent of the catastrophe when he said, "What is Europe now? A rubble heap, a charnel house, a breeding ground of pestilence and hate."

Figural Responses and Art Informel in Europe

Most European artists in the immediate postwar period tried to use their art to come to terms with what they had experienced, often debating about how best to do this: figuratively or abstractly.

In England, Francis Bacon (1909–1992) captured in his canvases the horrors that haunted him. Bacon was self-taught and produced very few pictures until the 1940s. He served as an air-raid warden during World War II and saw the bloody impact of the bombing of civilians in London firsthand. In **FIGURE WITH MEAT** (FIG. 32-77), Bacon presents an anguished and insubstantial man howling in a black void as two bloody sides of beef enclose him in a claustrophobic box that contains his screams and amplifies his terror. The painting was directly inspired by Velázquez's 1650 portrait of Pope Innocent X and by Rembrandt's paintings of dripping meat. Bacon wrote, "I hope to make the best human cry in painting … to remake the violence of reality itself."

One of the most distinctive postwar European art movements was Art Informel ("Formless Art"), which was also called *Tachisme* (*tache* is French for "spot" or "stain"). Art Informel was promoted by the French critic Michel Tapié (1909–1987), who suggested that art should express an authentic concept of postwar humanity through simple, honest marks.

The informal leader of Art Informel was Wolfgang Schulze, called Wols (1913–1951), who lived through the dislocation and devastation experienced by millions in Europe in the 1930s and 1940s. Born in Germany, Wols left his homeland in protest when Hitler came to power, first settling in Paris, where he worked as a photographer for *Vogue* and *Harper's Bazaar*. When the Germans occupied

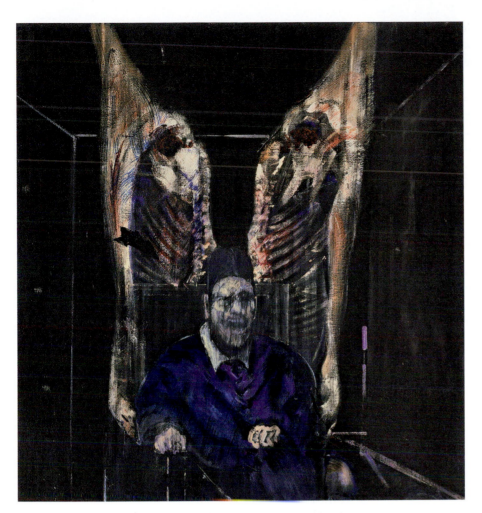

32–77 Francis Bacon **FIGURE WITH MEAT**

1954. Oil on canvas, 50¾ × 48″ (129 × 122 cm). The Art Institute of Chicago. Harriott A. Fox Fund (1956.1201).

France, he fled to Spain but was arrested, stripped of his passport, and deported to spend the rest of the war as a stateless person in a refugee camp in southern France. When the war ended, Wols returned to Paris and resumed painting, producing passionate pictures by applying paint with whatever came to hand, scraping his heavy surfaces with a knife and allowing the paint to drip and run. **PAINTING** (FIG. 32–78) represents a disease-ridden and violent world in which the semiabstracted forms resemble either infected cells or dark, muddy bacterial growths. Wols was temporarily supported by the French philosopher and novelist Jean-Paul Sartre, but died of food poisoning in 1951.

Experiments in Latin America

In Cuba, the abstract and Surrealist paintings of Wifredo Lam (1902–1980) embodied the violence and anguish of his country's struggle against colonialism. Lam was of mixed Chinese, Spanish, and African heritage and brought issues of identity and self-discovery to his art. He studied at the National Academy in Havana, moved to Paris, where he knew both Picasso and the Surrealists, and was forced to return to Cuba when the Nazis invaded France. He found himself on the same ship as the Surrealist leader Breton; Lam disembarked at Havana, while Breton traveled on to New York. Once home, Lam explored his African-Cuban heritage in the company of anthropologist Lydia Cabrera and novelist Alejo Carpentier. His work from the late 1940s reflects African-Cuban art and the polytheistic spiritual imagery of the African-Cuban religion Santería. The jagged, semiabstracted forms of **ZAMBEZIA, ZAMBEZIA** (FIG. 32–79) refer to European Modernism, but their source is in Santería religious ritual; the central figure is a composite Santería deity. "Zambezia" was the early colonial name for Zimbabwe in southeastern Africa, at this time a British colonial possession known as Rhodesia. Much earlier, Zambezia had been a source

32–78 Wols (Wolfgang Schulze) **PAINTING**

1944–1945. Oil on canvas, 31⅞ × 32″ (81 × 81.1 cm). Museum of Modern Art, New York. Gift of D. and J. de Menil Fund (29.1956).

for slaves who were brought to Cuba. Lam said, "I wanted with all my heart to paint the drama of my country…. In this way I could act as a Trojan horse spewing forth hallucinating figures with the power to surprise, to disturb the dreams of the exploiters."

In Buenos Aires, two groups of avant-garde artists formed immediately after the war—Arte Concreto-Invención and Madí, even though Argentina's fascist leader Juan Perón (1895–1974) disliked Modern art profoundly. The best-known Latin American artist of the time was the Uruguayan Joaquín Torres-García (1874–1949), who established the "School of the South" in Montevideo, Uruguay's capital. Torres-García had spent 43 years in Europe before returning home after the war, but his art was deeply rooted in the indigenous art of the Inca (for example, see FIG. 27-10); he believed ancient Uruguayan culture to be a fertile soil in which to grow a new national and cultural visual identity. In **ABSTRACT ART IN FIVE TONES AND COMPLEMENTARIES** (**FIG. 32–80**), Torres-García fused European ideas of abstraction and Modernism with Inca imagery and masonry patterns in a style that he named Constructive Universalism.

Abstract Expressionism in New York

The United States recovered from World War II more quickly than Europe did. Its territory was spared the ravages of war, and the trauma it felt was limited to those Americans who were part of military action in Europe or the Pacific, to European refugees to the United States, and to Japanese-American citizens who had been held in camps within the United States. While the European art world was disrupted by the war and Paris lost avant-garde

32–79 Wifredo Lam **ZAMBEZIA, ZAMBEZIA**
1950. Oil on canvas, 49⅜ × 43⅝" (125 × 110 cm). Solomon R. Guggenheim Museum, New York. Gift, Mr. Joseph Cantor, 1974 (74.2095).

Credit: © 2016 Artists Rights Society (ARS), New York/ADAGP, Paris. The Solomon R. Guggenheim Foundation/Art Resource, NY.

momentum, New York served as a refuge for European artists and gradually developed into a vibrant and progressive urban art center.

32–80 Joaquín Torres-García
ABSTRACT ART IN FIVE TONES AND COMPLEMENTARIES
1943. Oil on board mounted on panel, 20½ × 26⅝" (52.1 × 67 cm). Albright Knox Art Gallery, Buffalo, New York. Gift of Mr. and Mrs. Armand J. Castellani, 1979.

Credit: Art Resource, NY

THE CENTER SHIFTS TO NEW YORK Many leading European artists and writers escaped to the United States during World War II. By 1941, Breton, Dalí, Léger, Mondrian, and Ernst were all living in New York, where they altered the character and artistic concerns of the art scene. American artists were most deeply affected by the work of the European Surrealist artists in New York, but ultimately artists developed their own uniquely American artistic identities by drawing from, but radically reimagining, European and American Modernism—coming to be known as Abstract Expressionists.

The term "Abstract Expressionism" describes the art of a fairly wide range of artists in New York in the 1940s and early 1950s. It was not a formally organized movement, but rather a loosely affiliated group of artists who worked in the city and were bound by a common purpose: to express their profound social alienation after World War II and make a new kind of art.

The influential **Formalist** (valuing form over content) critic Clement Greenberg urged the Abstract Expressionists to consider their paintings "autonomous" and completely self-referential objects. The best paintings, he argued, made no reference to the outside world, but had their own internal meaning and order. Some early Abstract Expressionist artists were also deeply influenced by the theories of the Swiss psychoanalyst Carl Jung (1875–1961), who described a collective unconscious of universal archetypes shared by all humans; many early Abstract Expressionists aspired to create works that embodied such universal symbolic forms. As the 1940s progressed, however, the symbolic content of some paintings became increasingly personal and abstract.

By referring to "primitive," mythic imagery and archaic, archetypal, and primal symbolism, some artists hoped to make a connection among all people through the collective unconscious; several used biomorphic forms or developed an individual symbolic language in their paintings; all made passionate and expressive statements on large canvases. The Abstract Expressionists felt destined to transform art history.

Though their paintings project a personal vision, the Abstract Expressionists shared a commitment to two major projects: (1) an interest in the traditional history of painting, but a desire to rebel against it, including the recent ideas of European Modernism and (2) a desire to treat the act of painting on canvas as a self-contained expressive, even heroic, exercise that would communicate universal ideas.

THE FORMATIVE PHASE Arshile Gorky (1904–1948) was born in Armenia and fled to Russia in 1915 with family members during the Ottoman Turkish genocide of the Armenian people. After his mother died of starvation in exile, Gorky escaped to the United States in 1920. The trauma of Gorky's loss of his mother fills the Surrealist paintings, where he threads idyllic images of his childhood home into visual memorials to the people and places he has lost.

A series of paintings in the early 1940s called **GARDEN IN SOCHI** (FIG. 32–81) transformed Gorky's memories of his father's garden in Khorkom, Armenia, into a mythical dreamscape. According to the artist, this garden was known locally as the Garden of Wish Fulfillment because it contained both a rock upon which village women, his mother included, rubbed their bared breasts when making

32–81 Arshile Gorky **GARDEN IN SOCHI**
c. 1943. Oil on canvas, 31 × 39″ (78.7 × 99.1 cm). Museum of Modern Art, New York. Acquired through the Lillie P. Bliss Bequest (492.1969).

Credit: © 2016 The Arshile Gorky Foundation/The Artists Rights Society (ARS), New York. © 2016. Digital image, The Museum of Modern Art, New York/Scala, Florence.

32–82 Jackson Pollock **AUTUMN RHYTHM (NUMBER 30)**
1950. Oil on canvas, 8'9" × 17'3" (2.66 × 5.25 m). Metropolitan Museum of Art, New York. George A. Hearn Fund, 1957 (57.92).

Credit: © 2016 The Pollock-Krasner Foundation/Artists Rights Society (ARS), New York. © 2016. Image copyright The Metropolitan Museum of Art, New York/Art Resource/Scala, Florence

a wish, and a "Holy Tree" to which people tied strips of clothing. In this painting, the mythical garden floats on a dense white ground. Forms, shapes, and colors come together in a bare-breasted woman to the left and the Holy Tree to the center, as well as strips of clothing and "the beautiful Armenian slippers" that Gorky and his father wore in Khorkom. The painting suggests vital life forces, an ancient connection to the earth, and Gorky's vision of a lost world.

JACKSON POLLOCK AND ACTION PAINTING Jackson Pollock (1912–1956) is the most famous of the Abstract Expressionist. Born in Wyoming, Pollock moved to New York in 1930. By all accounts, he was self-destructive from an early age, developing a drinking problem by age 16, reading Jung by 22, and institutionalized for psychiatric problems and alcohol abuse at 26. Friends described two Pollocks—one shy and sober, the other obnoxious and drunk. When he entered Jungian psychotherapy in 1939, he already knew Jung's theory that visual images had the ability to tap into the primordial consciousness of viewers. Pollock remained free of alcohol from 1948–1950, supported emotionally by his lover, the artist Lee Krasner. This was when he created his most celebrated works.

Pollock's first solo exhibition was in 1943 at the heiress Peggy Guggenheim's gallery. He was propelled into stardom by the critic Clement Greenberg, who by 1947 described Pollock as "the most powerful painter

in contemporary America." Pollock pushed beyond the Surrealist strategy of automatic painting by placing raw, unstretched canvas on the floor and throwing, dripping, and dribbling paint onto it to create abstract networks of overlapping lines as the paint fell. In 1950 *Time* magazine

32–83 Rudolph Burckhardt **JACKSON POLLOCK PAINTING**
1950.

Credit: © 2016 Estate of Rudy Burckhardt and The Pollock - Krasner Foundation / Artists Rights Society (ARS), New York. © Sygma/Corbis

described Pollock as "Jack the Dripper," and two years later, Rosenberg coined the term **Action painting** in an essay, "The American Action Painters." Describing the development and purpose of Action painting, Rosenberg wrote, "At a certain moment the canvas began to appear to one American painter after another as an arena in which to act—rather than a space in which to reproduce, redesign, analyze, or 'express' an object, actual or imagined."

In 1950, while Pollock painted **AUTUMN RHYTHM (NUMBER 30)** (**FIG. 32–82**), Hans Namuth filmed him and Rudolph Burkhardt photographed him (**FIG. 32–83**). Pollock worked in a renovated barn, where he could reach into the laid canvas from all four sides. The German expatriate artist Hans Hofmann (1880–1966) had poured and dripped paint before Pollock, but Pollock's unrestrained gestures transformed the idea of painting itself by moving around and within the canvas, dripping and scoring commercial-grade enamel paint (rather than specialist artist's paint) onto it using sticks and trowels. Some have described Pollock's arcs and whorls of paint as chaotic, but he saw them as labyrinths that led viewers along complex paths and into an organic, calligraphic web of natural and biomorphic forms. Pollock's compositions lack hierarchical arrangement, contain multiple focal points, and deny perspectival space. Art historians have referred to such paintings as "all-over compositions," because of the uniform treatment of the canvas from edge to edge and how this invites viewers to explore across the surface rather than to focus on one particular area. These self-contained paintings burst with anxious energy, ready to explode at any moment.

Autumn Rhythm is heroic in scale, almost 9 feet tall by over 17 feet wide. It engulfs the viewer's entire field of vision. According to Krasner, Pollock was a "jazz addict" who spent many hours listening to the explosively improvised bebop of Charlie Parker and Dizzy Gillespie. His interests extended to Native American art, which he associated with his western roots and which

enjoyed widespread coverage in popular and art magazines in the 1930s. Pollock was particularly intrigued by the images and processes of Navajo sand painters who demonstrated their work at the Natural History Museum in New York. He also drew on Jung's theories of the collective unconscious. But Pollock was more than the sum of his influences. His paintings communicate on a grand, Modernist, primal level. In a radio interview, he said that he was creating for "the age of the airplane, the atom bomb, and the radio."

KRASNER, DE KOONING, MITCHELL, RIOPELLE, AND FRANKENTHALER Lee Krasner (1908–1984) studied in New York with Hans Hofmann. She moved in with Pollock in 1942 and virtually stopped painting in order to take care of him. But when they moved to Long Island in 1945, she set up a small studio in a guest bedroom, where she produced small, tight, gestural paintings, arriving at fully nonrepresentational work with all-over compositions in 1946, at the same time as Pollock. After Pollock's death in an automobile crash in 1956, however, Krasner took over his studio and produced a series of large, dazzling gestural paintings that marked her re-emergence into the mainstream art world. Works such as **THE SEASONS** (**FIG. 32–84**) feature bold, sweeping curves that express not only a new sense of liberation but also her powerful identification with the forces of nature in bursting, rounded forms and springlike colors. Krasner explored that "Painting, for me, when it really 'happens' is as miraculous as any natural phenomenon."

In contrast, Willem de Kooning (1904–1997) wrote that "Art never seems to make me peaceful or pure" and remarked "I'm still working out of doubt." A 1926 immigrant from the Netherlands who settled in New York, De Kooning befriended several Modernist artists. His paintings were highly structured and controlled, and although aspects of his composition appear spontaneous, they are the result of much experiment and revision. De Kooning

32–84 Lee Krasner
THE SEASONS
1957. Oil on canvas, 7'8¾" × 16'11¾" (2.36 × 5.18 m). Whitney Museum of American Art, New York. Purchased with funds from Frances and Sydney Lewis (by exchange), the Mrs. Percy Uris Purchase Fund, and the Painting and Sculpture Committee (87.7).

Credit: © 2016 Pollock-Krasner Foundation/Artists Rights Society (ARS), New York

32–85 Willem de Kooning WOMAN I
1950–1952. Oil on canvas, 75⅞ × 58″ (192.7 × 147.3 cm).
Museum of Modern Art, New York.

Credit: © 2016. Digital image, The Museum of Modern Art, New York/Scala, Florence. © 2016 The Willem de Kooning Foundation/Artists Rights Society (ARS), New York

applied paint, scraped it off, and repeated the process until he achieved the effect he wanted. In 1953, he shocked the art world by moving away from pure abstraction

with a series of figurative paintings of women. **WOMAN I** (FIG. 32–85) took him two years to complete, and his wife Elaine de Kooning estimated that he scraped and repainted it about 200 times. The portrayal of the woman appears to many as hostile, sexist, and powerfully sexual, full of implied violence and intense passion. De Kooning described his paintings of women as images of goddesses like the *Woman from Willendorf* (SEE FIG. 1–7) and early Mesopotamian statuettes (SEE FIG. 2–5), or as a composite of stereotypes taken from the media and film. He explored both figuration and abstraction throughout his career.

A second generation of Abstract Expressionist painters assembled in the Greenwich Village neighborhood of New York during the 1950s, forming a close-knit community that organized discussion groups to share their ideas and cooperative galleries to exhibit their work. Prominent among them was Joan Mitchell (1925–1992), who moved to New York after studying first at Smith College and then at the School of the Art Institute in her native Chicago. After a decade in New York, painting energetic but lyrical abstract paintings that show the impact of Gorky and De Kooning in particular, she moved permanently to France in 1959, where she continued to develop her style untouched by the Pop Art that transformed the New York scene during the 1960s. Mitchell painted in a personal adaptation of Abstract Expressionism, visualizing her memories of natural and urban landscapes and how they affected her. In **LADYBUG** (FIG. 32–86), she created energetic but controlled rhythms with gestural brushstrokes, setting the lyrical complexity of her distinctive color palette against a neutral ground in a seeming reference to the figure-and-field relationship of traditional painting. She explained, "The freedom in my work is quite controlled. I don't close my eyes and hope for the best."

Abstract Expressionism spread quickly to Canada. In his native Montreal, the French Canadian painter Jean-Paul Riopelle (1923–2002) worked with Les Automatistes, a group of artists using the Surrealist technique of automatism to create abstract paintings. In 1947, Riopelle moved to Paris and in paintings such as **KNIGHT WATCH** (FIG. 32–87) during the early 1950s, he began to squeeze paint directly

32–86 Joan Mitchell LADYBUG
1957. Oil on canvas, 6'7⅞″ × 9' (1.98 × 2.74 m). Museum of Modern Art, New York. Purchase (385.1961).

Credit: © Estate of Joan Mitchell. © 2016. Digital image, The Museum of Modern Art, New York/Scala, Florence

32–87 Jean-Paul Riopelle **KNIGHT WATCH**

1953. Oil on canvas, 38 × 76⅝″ (96.6 × 194.8 cm). National Gallery of Canada, Ottawa.

Credit: © 2016 Artists Rights Society (ARS), New York/SODRAC, Montreal. National Gallery of Canada

onto canvas before spreading it with a palette knife to create bright swatches of color traversed by networks of spidery lines.

Helen Frankenthaler (1928–2011) visited Pollock's studio in 1951 and began to create a more lyrical version of Action painting that had a significant impact on later artists. Like Pollock, she worked on the floor, but she poured paint onto unprimed canvas in thin washes so that it soaked into the fabric rather than sitting on its surface. Frankenthaler described her process as starting with an aesthetic question or image, which evolved as the self-expressive act of painting took over. She explained, "I will sometimes start a picture feeling, What will happen if I work with three blues … ? And very often midway through the picture I have to change the basis of the experience. Or I add and add to the canvas…. When I say

gesture, my gesture, I mean what my mark is. I think there is something now that I am still working out in paint; it is a struggle for me to both discard and retain what is gestural and personal." In **MOUNTAINS AND SEA** (**FIG. 32–88**), Frankenthaler outlined selected forms in charcoal and then poured several diluted colors onto the canvas. The result reminded her of the coast of Nova Scotia where she frequently went to sketch.

COLOR FIELD PAINTING AND SCULPTURE New York School artists used abstract means to express various kinds of emotional states, not all of them as urgent or improvisatory as those of the Action painters. The Color Field painters moved in a different direction, painting large, flat areas of color to produce more-contemplative moods.

Mark Rothko (1903–1970) had very little formal art training, but by 1940 he was already producing paintings deeply influenced by the European Surrealists and by Jung's archetypal imagery. By the mid-1940s, he began to paint very large canvases with rectangular shapes arranged in a vertical format in which he allowed the colors

32–88 Helen Frankenthaler **MOUNTAINS AND SEA**

1952. Oil and charcoal on canvas, 7′2¾″ × 9′8¼″ (2.2 × 2.95 m). Helen Frankenthaler Foundation, on loan to the National Gallery of Art, Washington, DC.

Credit: Image courtesy of the National Gallery of Art, Washington. © 2016 Helen Frankenthaler Foundation, Inc./Artists Rights Society (ARS), New York

32–89 Mark Rothko UNTITLED (ROTHKO NUMBER 5068.49)
1949. Oil on canvas, 6'9⅜" × 5'6⅜" (2.1 × 1.4 m). National Gallery of Art, Washington, DC.

Credit: © 1998 Kate Rothko Prizel & Christopher Rothko/Artists Rights Society (ARS), New York. Image courtesy the National Gallery of Art, Washington

together in series or rows, lit indirectly to evoke moods of transcendental meditation.

Barnett Newman (1905–1970) also addressed modern humanity's existential condition in very large canvases, some painted mostly in a single brilliant color divided by thin, jagged lines in another color that he called "zips." Newman claimed his art was about "[t]he self, terrible and constant." **VIR HEROICUS SUBLIMIS** (Latin for "Man, Heroic and Sublime") **(FIG. 32-90)** shows how Newman's total concentration on a single color focuses his meaning. The broad field of red does not describe any form; it presents an absolute state of sublime redness across a vast, heroic canvas, interrupted only by the zips of other colors that threaten, like a human flaw, to unbalance it. Newman wrote, "The present painter is concerned not with his own feelings or with the mystery of his own personality but with the penetration into the world mystery. His imagination is therefore attempting to dig into metaphysical secrets. To that extent his art is concerned with the sublime."

to bleed into one another. Paintings such as **UNTITLED (ROTHKO NUMBER 5068.49) (FIG. 32-89)** and *No. 3/No. 13 (Magenta, Black, Green on Orange)* (SEE FIG. Intro-1) are not simply arrangements of flat, geometric shapes on a canvas, nor are they atmospheric, archetypical landscapes. Rothko thought of his shapes as fundamental ideas expressed in rectangular form uninterrupted by a recognizable subject, which sit in front of a painted field (hence the name "Color Field painting"). He preferred to show his paintings

Sculpture tended to resist the kind of instantaneous gestural processes developed by painters, although some sculptors managed to communicate both abstractly and expressionistically in three dimensions. David Smith (1906–1965) learned to weld and rivet while working at an automobile plant in Indiana. He trained as a painter,

32-90 Barnett Newman VIR HEROICUS SUBLIMIS
1950–1951. Oil on canvas, 95⅜ × 213¼" (242 × 541.7 cm). Museum of Modern Art, New York. Gift of Mr. and Mrs. Ben Heller.

Credit: © 2016 The Barnett Newman Foundation, New York / Artists Rights Society (ARS), New York. © 2016. Digital image, The Museum of Modern Art, New York/ Scala, Florence

but became a sculptor after seeing reproductions of welded metal sculptures by artists such as Picasso. Smith avoided the precious materials of traditional sculpture and created works out of standard industrial materials. After World War II, he began to weld horizontally formatted sculptures that were like drawings in space. The forms of the **CUBI** series (**FIG. 32–91**) were created from precut pieces of stainless-steel sheets fabricated to the artist's specifications. The name for the series intentionally invokes the sculptures'

visual similarity to the Cubist paintings of Braque and Picasso. In photographs they sometimes look coldly industrial, but when observed outdoors as Smith intended, their highly burnished surfaces show the gestural marks made by the sculptor's tools and reflect the sun in different ways depending on the time of day, weather conditions, and the distance from which they are viewed. Vaguely humanoid, like giant totemic figures, the sculptures are surprisingly organic when seen at close range.

32-91 David Smith CUBI

"Cubi" series shown installed at Bolton Landing, New York, in 1965. *Cubi XVIII* (left), 1964. Stainless steel, 9′8″ (2.94 m). Museum of Fine Arts, Boston. *Cubi XVII* (center), 1963. Stainless steel, 9′2″ (2.79 m). Dallas Museum of Arts. *Cubi XIX* (right), 1964. Stainless steel, 9′5⅜″ (2.88 m). Tate, London.

Credit: Art © The Estate of David Smith/Licensed by VAGA, New York, NY

Think About It

1 Discuss the goals and interests of the painters associated with Abstract Expressionism. Characterize the role played by Surrealism and other early twentieth-century avant-garde art movements in the formation of this new direction in Modern art.

2 Explain the impact of the two world wars on the visual arts in Europe and North America. Use two works from this chapter—one European and one American—as the focus of your discussion.

3 Summarize the events of the Great Depression and discuss its impact on American art.

4 Explain how Dada and Surrealism changed the form, content, and concept of art. Which two works discussed in this chapter would you choose to represent these movements? Why?

Crosscurrents

Throughout the history of art, artists have created eloquent and moving expressions of the horrific violence of war and oppression. Discuss the political circumstances that led to the creation of these two examples and assess how they relate to the styles of these two artists and their time. Who were the audiences for these works?

FIG. 30–45

FIG. 32–64

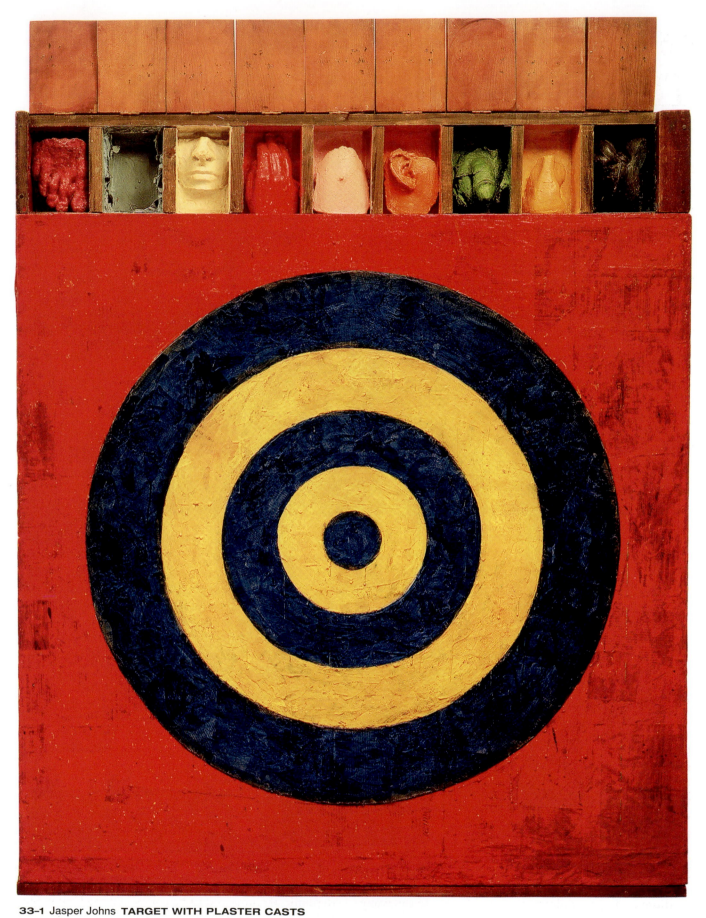

33–1 Jasper Johns **TARGET WITH PLASTER CASTS**

1955. Encaustic and collage on canvas with objects, 51 × 44″ (129.5 × 111.8 cm). Collection Mr. and Mrs. Leo Castelli.

Credit: *Courtesy Castelli Gallery, Photo: Rudolph Burckhardt. Art © Jasper Johns/Licensed by VAGA, New York, NY*

Chapter 33
The International Scene since the 1950s

 ## Learning Objectives

33.a Identify the visual hallmarks of art and architecture created since the 1950s for formal, technical, and expressive qualities.

33.b Interpret the meaning of works of art created since the 1950s based on their themes, subjects, and symbols.

33.c Relate artists and art created since the 1950s to their cultural, economic, and political contexts.

33.d Apply the vocabulary and concepts relevant to contemporary art, artists, and art history.

33.e Interpret a work of contemporary art using the art historical methods of observation, comparison, and inductive reasoning.

33.f Select visual and textual evidence in various media to support an argument or an interpretation of a work of contemporary art.

In the early 1950s, a new generation of artists emerged in New York who thought art should be firmly anchored in real life. At the time, Abstract Expressionism, championed by the powerful critic Clement Greenberg, dominated the art world. But younger artists like Robert Rauschenberg and Jasper Johns challenged Greenberg's belief that the best art was characterized by abstract imagery that conveyed transcendent meaning through an emphasis only on the formal effects of paint on a flat surface. Inspired by the expansive visual culture of postwar America, they resisted the emotional overtones of Abstract Expressionism and explored its conceptual implications through art that was ironic and intellectually demanding.

Johns pushed Greenbergian Formalism to its limit in **TARGET WITH PLASTER CASTS** (**FIG. 33–1**) by creating an object that is both sculpture and painting. Colorful casts of a foot, hand, penis, and other body parts sit in wooden boxes along the top, calling attention to the three-dimensionality of the stretched canvas and inviting the viewer to open or close the doors to the sculptures inside. The painted target below appeals to the viewer's tactile and visual senses. Johns used **encaustic**, an ancient technique in which pigment is suspended in molten beeswax that is applied in thin layers to build up an image. Unlike the Action paintings of Pollock or De Kooning, Johns's visible brushstrokes result from deliberate working of the medium and appear almost sculpted in the dense, waxy surface of the target. The concentric circles suggest an all-over abstract composition, but are also recognizable (and

functional) as an ordinary target, which raises the question: Is this a painting of a target or is it an actual target?

Unlike Abstract Expressionist paintings, Johns's art is emotionally cool and highly cerebral. Like many artists of his generation, he puts readily recognizable, real-world images and objects in purposefully unusual contexts in order to question art's form, appearance, content, and function. Thus, like much art after 1950, Johns's art demands the viewer's visual, physical, and intellectual engagement. A critical figure in art since 1950, Johns embodies themes that would become central later in the twentieth century: the ongoing desire of artists to cross boundaries separating real life from art, to investigate art's conceptual foundations, to use nontraditional materials, and to recognize art as a performative experience involving artist, viewer, and object.

The World since the 1950s

How does contemporary art challenge art history's study of period and regional styles?

As the world worked to overcome the trauma of World War II, the United States and the U.S.S.R. arose as major superpowers. The Soviet occupation and sponsorship of governments across Eastern and Central Europe and the emergence of communist dictatorships in the People's Republic of China and Cuba compelled the United States to try to contain further expansion of Soviet influence. This led to extended military actions in Korea and Vietnam and

MAP 33–1 THE WORLD SINCE 1950

International sites in the contemporary art world in the Americas, Europe, and Africa.

covert operations in Central America, intended to support regimes sympathetic to the U.S. In addition to these violent outbreaks, the United States and the U.S.S.R. each built large stockpiles of nuclear weapons, adopting a strategy of mutually assured destruction that prevented nuclear war by threatening complete destruction of both nations if either chose to strike first. This period, known as the Cold War, lasted from the 1950s until 1989, when the fall of the Berlin Wall signaled the end of the Soviet Union.

Although marked by fear of the threat of war and Soviet takeover, the postwar years were a time of extraordinary economic prosperity in the United States. A growing mass media propelled a new consumer society, selling the promise of the American dream through advertisements, glossy magazines, and television. But recognition that not everyone had the same access to this dream caused tensions around racial and social inequality and gave way to the politicized climate of the 1960s, which saw fights for African-American, gay, and women's rights and an increasing anti-establishment attitude that questioned existing political, economic, and social values.

In recent years, advancements in communication technology and the Internet continue to affect society in profound ways. Mobile devices, social networking sites, and the ability to connect with people across the globe have led to a wave of grassroots activism. The potential

for large-scale impact was realized in 2011 with the Arab Spring uprisings that spread across North Africa, giving way to revolutions in Tunisia and Egypt, and the Occupy Movement that began with a few protesters in New York's financial district and has grown into a worldwide effort to call attention to economic and social disparity.

While digital technology has bolstered humanitarian efforts around issues like worldwide poverty, social injustice, and the need for assistance in crisis, its pervasiveness has also brought new worries about religious and political extremism, violence and cultural terrorism, and tension between national security and individual privacy rights. Likewise, society's reliance on industry and technology has given rise to environmental concerns about the depletion of natural resources, global warming, and dramatic climate change.

The History of Art since the 1950s

Since the 1950s, artists have reconceptualized and reimagined art, producing radically new forms to express new ideas and content. Their art takes on complex social and political questions that lack a definitive solution and challenges us to consider own morality, behavior, and complacency. It sometimes assaults and accuses. It sometimes brings wonder, joy, and human insight. Artists today acknowledge viewers as

active participants who make meaning through their individual interpretations and contribute to a work's cultural significance. While recent art may seem challenging at first, it demands we look longer and think harder—creating a catalyst for conversations about its meaning and our world.

The study of contemporary art presents a challenge to art historians whose goal is to bring historical perspective to the art of our present time. A key issue is the fundamental need to define the period of study. A historical marker exists in the aesthetic and philosophical shifts that gave rise to Pop Art, Minimalism, and Conceptual Art. In recent decades, scholars have exploded the apparent cohesion of these art historical movements to reveal a complex network of diverse but related styles, practices, philosophical concerns, and interdisciplinary interests that emerged in the 1950s and early 1960s. The inherent messiness of this period, characterized by creative thinkers in art, literature, music, dance, theater, science, and technology working together in experimental and ephemeral formats, defies traditions of art history and museums that privilege visual analysis of the material object, and continues to present challenges today.

The artistic production of these formative years anticipates the plurality of late twentieth-century art and offers the key to making sense of more recent contemporary developments. Growth in the variety of artistic formats, creative practices, and interdisciplinary collaborations today has been made even more complicated by extraordinary growth in the art market, private and public

museums, and popular interest in art of the post–World War II period. What we find is that contemporary art is a distinct field that is currently under construction. This issue has provoked a growing crisis in art history that questions how the increasing scholarly focus on contemporary works of art may impact the discipline's established values and practices, and what its effect may be on the future of art history itself. These ongoing debates offer a unique opportunity to consider the fluid and evolving nature of academic study in art history and other humanities, as well as the cultural institutions that support them.

The Expanding Art World

What key ideas and formative artistic practices develop in the generation after Abstract Expressionism?

The generation of artists who began to make art in the 1950s increasingly addressed the ordinary experiences of life. Drawing inspiration from Cubist and Dadaist artists of the early twentieth century, they incorporated everyday objects into real space and time and expanded the idea of painting to include characteristics traditionally associated with sculpture and other creative disciplines. The result was a proliferation of new formats and techniques that aimed to blur the distinctions between art and life, investigate the role of advertising and popular imagery in visual culture, and critique the insistence on art's autonomy and formalist interpretations of meaning.

Finding New Forms

Louise Nevelson (1899–1988) collected discarded packing boxes in which she would carefully arrange chair legs, broom handles, cabinet doors, spindles, and other wooden refuse. Reflecting a Cubist approach to assemblage, Nevelson unified the fragmented forms by painting her compositions matte black, white, or gold. These monochromatic schemes obscured the identity of the individual elements and evoked some sense of mood. She heightened this poetic element in her monumental assemblage **SKY CATHEDRAL** (**FIG. 33-2**) by displaying it bathed in soft blue light, recalling moonlight. While artists like Nevelson used assemblage for formal and expressive

33-2 Louise Nevelson **SKY CATHEDRAL**
1958. Assemblage of wood construction painted black, 11'3½" × 10'¼" × 18" (3.44 × 3.05 × 0.46 m).
Museum of Modern Art, New York.

33–3 Robert Rauschenberg CANYON

1959. Oil, pencil, paper, metal, photograph, fabric, wood on canvas, plus buttons, mirror, stuffed eagle, pillow tied with cord, and paint tube; 81¾ × 70 × 24″ (2.08 × 1.78 × 0.61 m). Museum of Modern Art, New York. Gift of the family of Ileana Sonnabend.

Credit: Art © Robert Rauschenberg Foundation/Licensed by VAGA, New York, NY. @ 2016. Digital image, Museum of Modern Art/Scala, Florence

effect, others, influenced by Dada, saw that by integrating everyday objects into their art, they could challenge the artistic autonomy and high-minded intellectualism of Abstract Expressionism.

Inspired by the example of Marcel Duchamp (see Chapter 32), Jasper Johns combined assemblage with painting techniques in works like *Target with Plaster Casts* (SEE FIG. 33–1) to address formal and conceptual issues in art. Johns also raised psychological questions about perceptions of the self in the modern era. The fragmented body casts above the target lack any sense of the organic whole. Closing the lids on the boxes that contain the casts further depersonalizes the individual by obliterating all or a selective part of the human presence. The combination of fragmented and partially hidden body parts with the target takes on richer meaning when we consider that Johns was a gay artist in the restrictive climate of Cold War America.

RAUSCHENBERG, CAGE, AND BLACK MOUNTAIN COLLEGE Many of these ideas found new form at Black Mountain College in western North Carolina, founded to advance progressive education in the liberal arts within a communal living environment. For the short time it was open (1933–1956), Black Mountain College's experimental atmosphere drew creative thinkers in different fields and became a hub of avant-garde innovation. In the 1940s, the school was led by Josef Albers, who had taught at the Bauhaus, and figures such as Buckminster Fuller, Merce Cunningham, John Cage, M.C. Richards, Willem de Kooning, and Clement Greenberg served as faculty, many teaching in summer sessions when the arts were emphasized.

Raised in Texas, Robert Rauschenberg (1925–2008) studied painting in Paris after World War II before arriving at Black Mountain College in 1948. His desire "to act in the gap between [art and life]" explains his irreverent and often humorous approach to an art world dominated by Abstract Expressionism. To create *Erased De Kooning* of 1953, Rauschenberg asked Willem de Kooning for a drawing that he could erase. Knowing Rauschenberg's intent, De Kooning relinquished one that included oil paint and crayon—so it took over a month for the younger artist to rub out its imagery. This work ironically underscores Rauschenberg's impulse to make his own creative work through an active process that negated De Kooning's expressive mark. Rauschenberg's oedipal act against the generation that had come before him signaled the transition from Abstract Expressionism to the radical ideas of a new generation of artists.

In 1955, Rauschenberg began a series of assemblages that he called **combines** because they blended features of both painting and sculpture. **CANYON** (FIG. 33–3) incorporates old family photos, a picture of the Statue of Liberty, bits of newsprint, and political posters alongside ordinary objects like a flattened steel drum adhered to the work's surface. Other elements, including a stuffed eagle and a dirty pillow suspended by a piece of wood, project into the real space of the viewer. Rauschenberg added dripping splashes of paint to his composition as well, an ironic reference to Abstract Expressionist Action painting. Similar to Johns's more conceptual approach, Rauschenberg combined imagery from popular culture and avant-garde painting to undermine the idea of an autonomous art.

John Cage (1912–1992) was born in Los Angeles and studied art, music, and poetry in Europe before returning to California, where he worked with composer Arnold Schoenberg. Strongly influenced by Eastern philosophy and the ideas of Marcel Duchamp, Cage explored how chance might be used to eliminate intention and personal taste in art making. Some of his experiments included altering pianos by inserting objects between the strings, playing 12 radios at once, and assigning musical notes to the random markings found on a sheet of paper. Cage first visited Black Mountain College in 1948 and taught regularly in the summer sessions. There, his exchanges with Rauschenberg were of particular importance. In the summer of 1951, Rauschenberg exhibited a series of entirely white paintings at the college. Devoid of representation, their brightly lit surface called attention to the dust particles and shadows cast on them. Cage described these paintings as "mirrors of the air," and they inspired him to produce 4'33", a composition where the musician sits motionless for 4 minutes and 33 seconds while the audience listens. Like Rauschenberg's "blank" canvas, Cage used time to call attention to the ambient noises that take place even in what we usually consider to be silence.

In the summer of 1952, Cage organized *Theater Piece, No. 1* at Black Mountain College. Sometimes called the first "Happening" (a term discussed further later in this chapter), it took place in the dining hall and involved the simultaneous occurrence of unrelated activities including a lecture on Zen Buddhism read from atop a ladder, dancers and musicians moving around the audience, a dog interrupting the performance, and movies projected upside down on the wall. Rauschenberg, who played scratchy records from a wind-up phonograph, hung his white paintings from the ceiling as a set for the performance, which ended when coffee was served. Like Duchamp, who claimed that the artist could choose an object to be art, Cage proposed that artists might use time to bracket ordinary life events in order to heighten our awareness of the experience and thus transform it into a work of art. Other Cage–Rauschenberg collaborations in the 1950s and 1960s, often including Johns and the dancer Merce Cunningham, continued to blur the line separating art from life and to challenge disciplinary boundaries that divided the visual arts from dance, music, and theatrical performance.

New Forms Abroad

Artists in other parts of the world conducted similar experiments in the 1950s, expanding painting to include performance and interactive exhibition formats. Rejecting the spontaneity and expressionism of Art Informel, many artists in Europe worked collaboratively to explore the conceptual implications of painting and the viewer's perception of space and time. Variously associated with Nouveau Réalism in France, Arte Povera in Italy, the German Zero Group, and the New Tendencies collectives in Eastern Europe, this network of avant-garde artists pushed the limits of painting to the breaking point and crossed into realms of assemblage, kinetic sculpture, performance, and electronic media.

In a career cut short by a heart attack at age 34, Yves Klein (1928–1962) stands out as both influential and provocative. An avid interest in judo and spiritual mysticism informed Klein's diverse artistic production and his goal of freeing the creative essence in art from its material form. This ambition led him to monochromatic paintings using a distinctive color that he associated with natural forces, which he named IKB (International Klein Blue); other "paintings" made by exposing his canvases to elements like rain and fire; and his series of *Anthropométries*, made by nude women that Klein described as "living brushes." In **ANTHROPOMÉTRIES OF THE BLUE PERIOD** (**FIG. 33-4**), presented in 1960 at the Galerie Internationale d'Art Contemporain, Klein, dressed in formal

33-4 Yves Klein **ANTHROPOMÉTRIES OF THE BLUE PERIOD**
1960. Performance at the Galerie Internationale d'Art Contemporain, Paris.

Credit: © Yves Klein/Artists Rights Society (ARS), New York/ADAGP, Paris 2016. Photo: Shunk - Kender @ J Paul Getty Trust. Getty Research Institute, LA. (2014.R.20)

33–5 Shozo Shimamoto
HURLING COLORS

1956. Performance at the second Gutai Exhibition, Tokyo.

Credit: Courtesy of Shozo Shimamoto

attire, orchestrated three women's movements as they covered themselves in paint and then imprinted parts of their bodies on large sheets of white paper. Klein explained, "It would never cross my mind to soil my hands with paint. Detached and distant, the work of art must be completed under my eyes and under my command." A small string orchestra accompanied the performance with Klein's *Monotone Symphony*, a single continuous sound played for the duration. The artist's self-aggrandizing quest for the immaterial—and flare for the theatrical—have led skeptics to see Klein as a charlatan, but his work remains an important precedent for those who move art beyond the confines of material objecthood and acknowledge creative forces in nature.

In Japan, Yoshihara Jirō founded the Gutai collective of artists in 1954 "to pursue the possibilities of pure and creative activity with great energy," as he explained in a manifesto of 1956. The Gutai (meaning "concrete" or "embodiment") organized outdoor installations, theatrical events, and dramatic performances intended to reveal art's relationship to viewers and the natural surroundings. These works highlighted the physical act of creating art through sometimes violent interactions with paint, mud, paper, electric lights, and industrial materials. At the second Gutai Exhibition in 1956, Shozo Shimamoto (1928–2013) performed **HURLING COLORS** (**FIG. 33–5**) by smashing bottles of paint against a canvas on the floor. Informed by Japanese philosophy, Shimamoto recognized his act of destruction to be one of creation as well, writing that "in this age, the boundary between the two no longer exists." The Gutai moved past Pollock's gestural influence to the point where the painting's production appeared as important as the object produced, if not more so.

Happenings and Fluxus

Emphasis on the artist's creative act gave rise to a performative impulse throughout the early 1960s, most clearly seen among artists involved with Happenings and Fluxus. These loosely formed groups owe a debt to Cage's ideas about chance methods of artistic production and the synthesis of art and life. The classes Cage taught at the New School in New York from 1956 to 1961 drew a mix of artists, musicians, performers, and writers and had a lasting influence on the avant-garde community in the United States and abroad. Variously described as assemblage, environments, dance, Happenings, and events, this type of art broke all boundaries by actively invading the viewer's space and often involving the audience—sometimes unknowingly— as participants in the artwork's production.

In the late 1950s, Allan Kaprow (1927–2006), who studied with Cage in New York, began to create Environments. These built on assemblage practices to extend the work of art into space surrounding the viewer. Trained as a painter, Kaprow found inspiration in Pollock, whose drip technique and large-scale compositions suggested to him new forms of art that rejected painting entirely. In his 1958 essay "The Legacy of Jackson Pollock," Kaprow concluded that artists "must become preoccupied with and even dazzled by the space and objects of our everyday life … objects of every sort are materials for the new art." In **YARD** (**FIG. 33–6**) Kaprow filled the courtyard behind the Martha Jackson Gallery in Manhattan with used tires, tar paper, and barrels, and asked viewers to walk through it, thus positioning them as a part of the artwork itself. Different from a painting on the gallery wall, *Yard* called attention to the viewer's physical experience, stumbling amid detritus and smelling the dirty rubber and tar—features of the urban environment that might go unnoticed outside of the art gallery context.

33–6 Allan Kaprow YARD
1961. View of tires in court of Martha Jackson Gallery, New York, 1961.

Credit: Photo: Ken Heyman

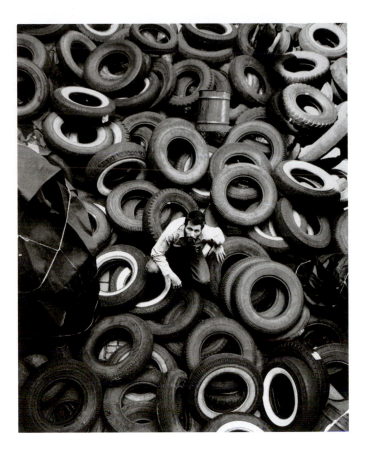

where it was filmed and photographed. Eight men and women first undressed one another, then danced, rolled on the floor ecstatically, and played with a mixture of raw fish, raw sausages, partially plucked raw and bloody chickens, wet paint, and scraps of paper. Schneemann wanted both performers and audience to experience the smell, taste, and feel of the body and its fluids. Critics described the piece variously as an erotic rite and a visceral celebration of flesh and blood. It countered the expectation that a work of art was something to be examined in the cool, detached space of an art gallery where the viewer remains passively in control and the artist remains invisible. *Meat Joy* forced the viewer to become complicit in the live event. Many feminist artists like Schneemann embraced Happenings and other forms of what was beginning to be called **performance art**, a term that distinguished such events from traditional theatrical presentation. These practices offered a powerful tool to challenge the objectification of women's bodies that had existed in art for centuries. Performance art enabled women to assert their own artistic agency by determining how their bodies were viewed and even confronting their audience who, in turn, had to acknowledge the woman's active presence.

HAPPENINGS In contrast to Environments, which invited the viewers to interact with static installations, were works that Kaprow called **Happenings**: immersive, chance-based performances like Cage's *Theatre Piece No. 1.* These overwhelmed the audience with a barrage of unrelated activities that invoked a range of sensual and emotional responses. One example was **MEAT JOY** (**FIG. 33–7**) by Carolee Schneemann (b. 1939), enacted first at the Festival de la Libre Expression in Paris and then in New York,

FLUXUS Whereas Happenings were visually stimulating and dynamic, Fluxus events were more conceptual and deliberate in their actions, which often focused on ordinary behaviors—like pouring water, cutting hair, or eating a meal—performed methodically and repeatedly, sometimes over extended periods of time. The ritualistic nature of these performances underscores the influence of Eastern religious practice, where deep contemplation of routine tasks may result in spiritual enlightenment. In spite of their aesthetic differences, Happenings and Fluxus artists often showed their work in the same galleries and other venues. One of

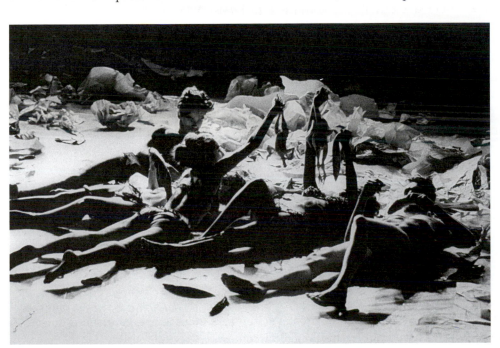

33–7 Carolee Schneemann MEAT JOY
1964. Gelatin-silver print. Photograph by Tony Ray-Jones, taken in Judson Memorial Church in November 1964.

Credit: © 2016 Carolee Schneemann/ Artists Rights Society (ARS), New York. © Tony Ray-Jones/National Media Museum/ Science & Society Picture Library

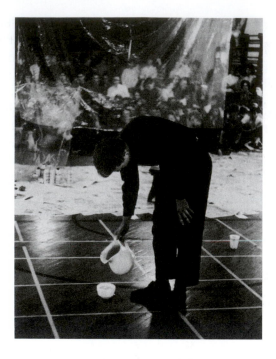

THREE AQUEOUS EVENTS

● ice

● water

● steam

Summer, 1961

33–8 George Brecht
THREE AQUEOUS EVENTS

1961. Event score from Water Yam edition, 1972. Plastic, paper. Collection Walker Art Center, Minneapolis. Walker Special Purchase Fund, 1989

Performance view, Rutgers University, New Jersey, 1963.

Credit: © 2016 Artists Rights Society (ARS), New York/ VG Bild-Kunst, Bonn. (far left) courtesy Walker Art Center; (left) photo by Peter Moore © Barbara Moore/ Licensed by VAGA, New York, NY. Courtesy Paula Cooper Gallery, New York

these, the AG Gallery, was owned by George Maciunas, who coined the name Fluxus in an attempt to codify and promote the diverse movement. As part of his efforts, Maciunas organized international festivals that helped to spread these ideas and connect the group with a broader network of avant-garde artists throughout the world.

Many Fluxus events were presented as written "scores," reflecting the importance of Cage and the broad reach of the movement to include musicians, writers, dancers, and visual artists. George Brecht's **THREE AQUEOUS EVENTS** (**FIG. 33–8**) is one of 69 cards with written instructions for activities that could be performed by the reader; the cards were collected, boxed, and published in editions. The ambiguous nature of Brecht's printed prompts reflects

the tendency of Fluxus artists to blur the boundaries between life, art, action, and object. Brecht's other scores included *Exit Event*, where the instructions were simply the word "Exit," and *Duration Event*, with only "Red" and "Green" appearing on the card. In each case, the reader is left to choose whether or not to follow the cue, how it might be realized, and even if they will acknowledge their action as a work of art.

After settling in New York, Yoko Ono (b. 1933) became involved with Fluxus in the early 1960s, and her loft at 112 Chambers Street became an important site for many avant-garde activities. In **CUT PIECE** (**FIG. 33–9**), performed first in Japan in 1964 and the following year at New York's Carnegie Hall, Ono knelt passively on stage while members of the audience were invited to use sewing shears, which were provided next to her, to cut away bits of her clothing to take with them. This powerful work demonstrated key characteristics of Fluxus: its reliance on the audience to realize the event and the ritualistic nature of the performance, which suggested both self-sacrifice and desecration. The performance was charged with implicit violence and eroticism as the body of the young Japanese woman was slowly exposed by the deliberate action of each audience member who walked

33–9 Yoko Ono **CUT PIECE**

1965. Film still of performance at the Carnegie Recital Hall, New York on March 21, 1965. Film by Albert and David Maysles.

Credit: © Yoko Ono

33–10 Nam June Paik with Charlotte Moorman **TV BRA FOR LIVING SCULPTURE**

1969. Performance view. Gelatin silver print. Collection Walker Art Center. Minneapolis, T.B.Walker Acquisition Fund, 1991. Photograph by Peter Moore.

Credit: © Barbara Moore/Licensed by VAGA, New York, NY. Courtesy Paula Cooper Gallery, New York

up and chose to make the next cut. Although *Cut Piece* was not recognized as a feminist work of art at the time, Ono has since described it as "against ageism, against racism, against sexism, and against violence."

Often described as the father of video art, Korean artist Nam June Paik (1932–2006) came from a classical music background and was deeply influenced by Cage. Paik's interest in mass-media technology led to his early experiments altering broadcast images with magnets he attached to the top of television consoles. In the 1960s, Paik produced a number of works in collaboration with musician Charlotte Moorman (1933–1991) that were included as part of Fluxus festivals. **TV BRA FOR LIVING SCULPTURE** (**FIG. 33–10**) combined Paik's interest in sculpture, technology, music, and performance and demonstrated the humor and sexual content often seen in Fluxus works. Designed to be worn by Moorman while playing the cello, the device was wired so she could manipulate images broadcast on the screens with foot pedals and her musical technique. Paik described the work as an effort to humanize technology, but it also highlighted the fetish-like status afforded both women's breasts and television in a society dominated by mass media. Moorman's role as a "living sculpture" further suggested the human body as an object akin to sculpture, thus reflecting the Fluxus idea that life itself is art that we enact every day.

Fluxus festivals and performances helped connect avant-garde artists internationally. Joseph Beuys (1921–1986) contributed conceptual and performance-based

works that, along with his roles as teacher and political activist, made him one of the most influential artists of the period. Beuys created a personal mythology for himself based on his experience as a fighter pilot in the German Luftwaffe during World War II. He claimed to have been shot down over the Crimea and saved by Tatars who wrapped him in animal fat and felt, materials that held important symbolic value for Beuys and reappeared throughout his work. Beuys saw art as a means of social redemption and healing from the horrors and guilt left after the Holocaust. As an artist, he took on a mysterious, shaman-like persona, and many of his actions assumed the seriousness of sacred rituals with goals of spiritual renewal and transformation.

In **HOW TO EXPLAIN PICTURES TO A DEAD HARE** (**FIG. 33–11**), a performance staged at the opening of an exhibition of his drawings in Dusseldorf, Beuys initially sat visible on a chair in the gallery, which was closed to visitors

33–11 Joseph Beuys **HOW TO EXPLAIN PICTURES TO A DEAD HARE**

1965. Photograph of performance at the Schmela Gallery, Dusseldorf, November 26, 1965.

Credit: © Ute Klophaus © 2016 Artists Rights Society (ARS), New York/VG Bild-Kunst, Bonn. Courtesy Ronald Feldman Fine Arts, NY

outside. His head was coated in honey and covered by a mask of gold leaf. In his lap he cradled a dead hare to which he muttered incomprehensibly. His left foot rested on felt, suggesting spiritual warmth, while his right foot rested on steel, symbolizing cold, hard reason. He carried the hare's corpse around the gallery for several hours, quietly explaining his pictures—implying a spiritual connection with the dead hare and underscoring the inadequacy of words to convey art's true meaning and potential for profound revelation. Beuys said, "Even a dead animal preserves more powers of intuition than some human beings."

Pop Art

Many artists focused their attention on the mid-century explosion in visual culture that was fueled by the growing mass media and the disposable income of the postwar generation. Pop Art originated in Britain in the years soon after World War II, but its primary development was in the United States in the early 1960s. First seen in the cool, slick aesthetic of New York artists like Andy Warhol and Roy Lichtenstein, variations of Pop Art soon emerged in Chicago and along the West Coast to reflect regional distinctions in consumer tastes and popular culture. Homes, automobiles, and luxury products reflected life as it appeared on television, in films, and in print advertising,

and the visible display of one's possessions was increasingly seen as an indication of personal identity and social standing. Pop artists seemed to both embrace and possibly critique the superficial fiction of a perfect life.

HAMILTON In the early 1950s, while the British government maintained that the country's postwar recovery depended on sustained consumption of domestic goods, an interdisciplinary collective of artists, architects, photographers, and writers came together in London as the Independent Group. One of its members, Richard Hamilton (1922–2011), argued that mass visual culture was fast replacing traditional art for the general public: Movies, television, and advertising, not high art, now defined standards of beauty. Society's idols were no longer politicians or military heroes, but international movie stars, and social status was now measured by what one bought and owned. To create a visual expression of this new world of excessive consumption, Hamilton created collages of images drawn from advertising. In **JUST WHAT IS IT THAT MAKES TODAY'S HOMES SO DIFFERENT, SO APPEALING?** (**FIG. 33–12**) from 1956, Hamilton critiques marketing strategies by imitating them. The title parodies an advertising slogan, while the collage itself shows two figures named Adam and Eve in a domestic setting. Like the biblical figures, these are almost naked, but the temptations to which they have given in are those of consumer culture. Adam is a bodybuilder and Eve a pin-up girl. In an attempt to recreate their lost Garden of Eden, the first couple has filled their home with all the best new products: a television, a tape recorder, a vacuum cleaner, and fashionable new furniture. Displayed on the wall is not high art but a poster advertising a romance novel, hung next to a traditional portrait of a stern-looking man. Adam holds a huge, suggestively placed Tootsie Pop, which the English critic Lawrence Alloway cited when he described this work as "Pop art," one possible source of the movement's name. Like assemblages in the United States, Hamilton's collage comments on the visual overload of popular

33–12 Richard Hamilton **JUST WHAT IS IT THAT MAKES TODAY'S HOMES SO DIFFERENT, SO APPEALING?**
1956. Collage, 10¼ × 9¾" (26 × 24.7 cm). Kunsthalle Tübingen, Collection Zundel.

33–13 Andy Warhol **MARILYN DIPTYCH**

1962. Oil, acrylic, and silkscreen on enamel on canvas; two panels, each 6′10″ × 4′9″ (2.05 × 1.44 m). Tate, London.

culture and on society's inability to differentiate between the advertising world and the real one.

By 1960, several American artists also began to incorporate images from popular mass culture into their art. Their reliance on everyday subject matter recalls the tendency among Rauschenberg and other artists to transgress boundaries between art and life. Pop Art, however, developed a slicker style that recalls the mass-production techniques of advertising and gives this work a flat, commercial feel that erases the presence of the hand of the individual artist. This cool, detached quality suggested both the glorification of popular culture, now raised to fine-art status, and an implicit critique of how consumer culture transformed all things—from movie stars to art itself—into commodities to be bought and sold.

WARHOL AND LICHTENSTEIN As Pop Art flourished in the United States, Andy Warhol (1928–1987) emerged as a dominant figure. Warhol created an immense body of work between 1960 and his death in 1987, including prints, paintings, sculptures, and films. He published *Interview* magazine and managed The Velvet Underground, a radical and hugely influential rock band. Since he trained as a commercial artist, Warhol knew advertising culture well,

and by 1962, he was incorporating images from American mass-media advertising in his art. He took as subjects popular consumer items such as Campbell's Soup cans and Coca-Cola bottles, reproducing them with the cheap industrial print method of **silkscreen** (in which a fine mesh fabric screen is used as a printing stencil), as well as in paintings and sculptures.

In 1962, movie star Marilyn Monroe was found dead in an apparent suicide. Warhol's **MARILYN DIPTYCH** (**FIG. 33-13**) is one of a series of silkscreens that he made immediately after the actress's death. Warhol memorializes the screen image of Monroe, using a famous publicity photograph transferred directly onto silkscreen, thus rendering it flat and bland so that Monroe's signature features—her bleach-blond hair, her ruby lips, and her sultry, blue-eye-shadowed eyes—stand out as a caricature of the actress. The face portrayed is not that of Norma Jeane (Monroe's real name) but of Marilyn, the celluloid sex symbol as made over by the movie industry. Warhol made multiple prints from this screen, aided—as he was in many of his works—by a host of assistants working with assembly-line efficiency. In 1965, Warhol ironically named his studio "The Factory," further highlighting the commercial aspect of his art.

The *Marilyn Diptych*, however, has deeper undertones. The diptych format carries religious connotations (see "Altars and Altarpieces" in Chapter 19 on page 579), perhaps implying that Monroe was a martyred saint or goddess in the pantheon of departed movie stars. In another print, Warhol surrounded her head with the gold background used in Orthodox religious icons. Additionally, the flat and undifferentiated Monroes on the colored left side of the diptych contrast with those in black and white on the right side, which fade progressively as they are printed and reprinted without re-inking the screen until all that remains of the original portrait is the ghostly image of a disappearing person.

Warhol was one of the first artists to exploit the realization that while the mass media—television in particular—seem to bring us closer to the world, they actually allow us to observe the world only as detached voyeurs, not real participants. We become desensitized to death and disaster by the constant repetition of images on television, which we are able literally to switch off at any time. While Warhol's *Marilyn Diptych* is similarly repetitive, superficial, and bland, it exploits these traits that, in the mass media, might desensitize us to the full impact of the actress's tragic life. Warhol, known for his quotable phrases, once said, "I am a deeply superficial person." But the apparent superficiality of his art seems shrewdly profound.

In 1964, in his first sculptural project, **BRILLO SOAP PADS BOXES** (FIG. 33–14), Warhol hired carpenters to create plywood boxes identical in size and shape to the

33–14 Andy Warhol **BRILLO SOAP PADS BOX**
1964. Silkscreen print on painted wood, 17 × 17 × 14" (43.2 × 43.2 × 35.6 cm). Collection of the Andy Warhol Museum, Pittsburgh.

Credit: © 2016 The Andy Warhol Foundation for the Visual Arts, Inc./Artists Rights Society (ARS), New York

33–15 Roy Lichtenstein **OH, JEFF... I LOVE YOU, TOO... BUT...**
1964. Oil and Magna on canvas, 48 × 48" (122 × 122 cm). Private collection.

Credit: © Estate of Roy Lichtenstein/DACS 2016

cardboard cartons used to ship boxes of Brillo soap pads to supermarkets. By silkscreening onto these boxes the logos and texts that appeared on the actual cartons, the artist created what were essentially useless replicas of commercial packaging. Stacking the fabricated boxes in piles, Warhol transformed the interior space of the Stable Gallery in New York into what looked like a grocery stockroom, simultaneously pointing to the commercial foundation of the art gallery system and critiquing the nature of art.

Roy Lichtenstein (1923–1997) also investigated the ways that popular imagery resonated with high art, imitating the format of comic books in his critique of mass-produced visual culture. In 1961, while teaching at Rutgers University with Allan Kaprow, Lichtenstein began to make paintings based on panels from war and romance comic books. He cropped and simplified the source images to focus on dramatic emotions or actions, simultaneously representing and parodying the flat, superficial ways in which comic books of the time graphically communicated with their readers. His use of heavy black outlines, flat primary colors, and hand-painted **Benday dots** like those used in commercial printing ironically replicate the mechanical character of cartoons. **OH, JEFF... I LOVE YOU TOO... BUT...** (FIG. 33–15) compresses into a single frame a romantic storyline involving a crisis threatening a love relationship. Lichtenstein plays a witty game: We know that comic books are often unrealistically melodramatic, yet he presents this overblown episode vividly, almost reverently, enshrined in a work of high art.

Minimalism

Around the same time Pop artists like Warhol and Lichtenstein were gaining notoriety, another group of New York artists began to produce spare, geometric objects in a style that soon became known as Minimalism. Although Minimalism shuns representational subject matter, it is similar to Pop Art in its lack of obvious content, reference to techniques of mass production, and literal presentation style. Dan Flavin's unaltered fluorescent lightbulbs, Carl Andre's rows of firebricks, and Sol LeWitt's gridlike cubes seemed simplified to the extreme and initially gave rise to names like "ABC Art" and "No-Art Nihilism." Frank Stella, a painter linked to the movement, wrote famously, "What you see is what you see." Stella's work of this period relied on the shape of the canvas to dictate his abstract imagery, echoing Warhol's imitation of advertising images—both used as strategies to reduce artistic subjectivity and expressionism, hallmarks of Abstract Expressionism, in art.

The group's most visible advocates were Donald Judd (1928–1994) and Robert Morris (b.1931), who produced sophisticated essays explaining their ideas. In 1965, Judd, who worked as an art critic as well as an artist, published "Specific Objects" in *Arts Yearbook*. Although he included such artists as Klein, Claes Oldenburg, and Kenneth Noland, the essay clearly articulates his own position and significantly influenced the critical response to Minimalism. Morris's series of essays entitled "Notes on Sculpture" appeared in *Artforum* from 1966 to 1969, staking out his artistic stance to provide an intellectual framework for the new sculptural aesthetic. The two artists' highly theoretical discourse signals an important shift in the history of art. In contrast to the Abstract Expressionists, many postwar artists were able to attend college on the GI Bill, a government program that paid veterans' educational expenses. Similar to early Modernists' publishing manifestos, this generation recognized language as an essential complement to their art, and they relied on it to communicate about and shape the public's understanding of their work.

The Minimalist creation of three-dimensional objects was a logical extension of the desire to eliminate illusionism in art, effectively moving it into the real space of the gallery. In "Specific Objects" Judd wrote, "The new work obviously resembles sculpture more than it does painting, but it is nearer to painting." He further rejected the gesture and emotion invested in the handcrafted object by hiring industrial fabricators to create his sculpture in materials such as Plexiglas and steel. Judd explained that this approach synthesized art's various component parts into a unified whole that could be valued for its formal and material qualities. This idea is evident in **UNTITLED** (**FIG. 33–16**) of 1969, consisting of ten rectangular units made of galvanized iron and tinted Plexiglas that are hung in a vertical row on the gallery wall. Although each unit remains

33–16 Donald Judd **UNTITLED**

1969. Galvanized iron and Plexiglas; 10 units, each 6 × 27⅛ × 24" (15.24 × 68.8 × 60.96 cm), overall 120 × 27⅛ × 24" (3.05 × 0.69 × 0.61 m). Albright-Knox Art Gallery, Buffalo, New York.

discrete, the regular repetition of identical forms creates the impression of a single, large-scale structure. Judd's industrial production technique eliminates the expressionistic implications of brushwork to leave a smooth, even surface infused with subtle color. The arrangement avoids references to any imagined subject, allowing the objects to be seen only as themselves.

While characteristic of Minimalism's repeated geometric forms, industrial materials, and machine-made surfaces that lack the artist's touch, Morris's **UNTITLED (MIRRORED CUBES)** (FIG. 33–17) is different because the mirrors deflect the viewer's attention away from the boxes. Morris argued that Minimalist sculpture heightens psychological perceptions of an object in its spatial surroundings, forcing viewers to consider the art's relationship to their own bodily experience moving around the gallery and observing the work from many sides. This idea derived in part from Morris's involvement in dance and experimental performance with artists involved in Happenings and Fluxus, and contributed to critic Michael Fried's characterization of Minimalism as "theatrical" because it relied on space, time, and physical interaction with the viewer.

The Dematerialization of Art

What interests and ideas gave rise to alternative formats and art's "dematerialization" in the 1960s?

The experiments of the early 1960s marked a crucial turning point for new artistic formats that developed throughout the decade. Writing in 1968, art critics John R. Chandler and Lucy Lippard characterized the period by "the dematerialization of art" that resulted from a shift away from traditional painting and sculpture. Ephemeral, anti-aesthetic, and unskilled forms of art proliferated, emphasizing artistic concept over the material object of display. At the heart of this change was Duchamp's assertion that the idea motivating an artist to create a work of art could be separated from production of the artwork's final form, whose primary function was to communicate meaning to the viewer. Artists explored a range of media they felt could best represent their underlying concept and called attention to how they developed an idea to its final outcome. For this reason, conceptual works of art usually include a visual trace, such as a written text, photograph, or film, that serves as an artifact documenting the artist's process. Within the politicized context of the 1970s, artists' reliance on impermanent forms for their work resisted **commodification** (the treatment of art as merely something to be bought and sold) and carried an implicit—sometimes explicit—critique of the commercial galleries, museums, critics, and art historians who assign cultural and economic value to works of art.

Conceptual Art and Language

Conceptual Art found inspiration in both Fluxus and Minimalism, especially in art's relationship to systems of communication. Artists like Joseph Kosuth rejected traditional aesthetics and employed language itself as a medium for art. Drawing on the linguistic philosophy of Ludwig Wittgenstein and the study of semiotics, Kosuth explored the role of visual signs to communicate meaning in **ONE AND THREE CHAIRS** (FIG. 33–18). He illustrated this idea by juxtaposing a wooden chair, a photograph of a chair, and a printed definition of the word "chair" in the dictionary. The installation showed the visual equivalence of three distinct forms to represent a singular abstract concept.

33–18 Joseph Kosuth **ONE AND THREE CHAIRS**

1965. Wooden folding chair, photograph of chair, and photographic enlargement of dictionary definition of chair; chair 32⅜ × 14⅞ × 20⅞" (82.2 × 37.8 × 53 cm), photo panel 36 × 24⅛" (91.4 × 61.3 cm), text panel 24⅛ × 24½" (61.3 × 62.2 cm). Museum of Modern Art, New York. Larry Aldrich Foundation Fund (383.1970 a–c).

Credit: © 2016 Joseph Kosuth/Artists Rights Society (ARS), New York. © 2016. Digital image, The Museum of Modern Art/Scala, Florence

The title highlights the inherent ambiguity in systems of communication: We can read this work as one chair represented three different ways or as three different chairs. Kosuth's work may seem a philosophical exercise, but his questions about words and what they represent encourage more critical inquiry into the systems that endow art with value and meaning.

New Media

Bruce Nauman (b. 1941) uses performance, video, and other nontraditional media to explore the effects of physical, psychological, and intellectual experiences. Like Kosuth, Nauman considers the role of language and visual representation in demonstrating our individual identities. From 1966 to 1967, Nauman made a series of 11 color photographs based on his reenactment of common words and phrases. **SELF-PORTRAIT AS A FOUNTAIN** (FIG. 33–19) shows the bare-chested artist tipping his head back and spurting water into the air. Cleverly pulling together artistic identity, bodily experience, and visual communication, Nauman's photograph serves many functions. It documents his physical transformation into "a fountain," resembling the nude statues that often work to fill a traditional public fountain's basin. It acts as a self-portrait that represents the artist as his own work of art. And Nauman's title also recalls Duchamp's *Fountain* (SEE FIG. 32–29), suggesting the young artist's authority to recreate the famous readymade using his own body. Characteristically, Nauman uses humor and wit to engage the viewer and investigate challenging conceptual issues.

Known for her pioneering use of technology in art, Laurie Anderson (b. 1947) crosses boundaries between experimental music, performance art, traditional storytelling, and popular entertainment. One of her earliest performances, **DUETS ON ICE** (FIG. 33–20), was presented in 1974 at five different locations throughout New York. For each, Anderson alternated telling personal stories and playing the violin while wearing ice skates frozen in blocks of ice until the ice melted to release the blades. Anderson's piece dealt with issues of identity, physical experience, and artistic expression, similar to Nauman's work, but it did so through the mediating factors of technology and public performance. Describing her violin as a ventriloquist dummy or alter ego, Anderson modified her instrument with technology in ways that allowed her to pre-record audio, distort sounds, or accompany her own live playing. By manipulating her "voice," she challenges the expressive authenticity of the artist's performance, an effect further highlighted by any changes in her playing brought about by the physical discomfort of standing in ice for an extended time.

33–19 Bruce Nauman **SELF-PORTRAIT AS A FOUNTAIN**

1966–1967. Color photograph, 19¾ × 23¾" (50.1 × 60.3 cm). Courtesy Leo Castelli Gallery, New York.

Credit: Photo: Eric Pollitzer. © 2016 Bruce Nauman/Artists Rights Society (ARS), New York

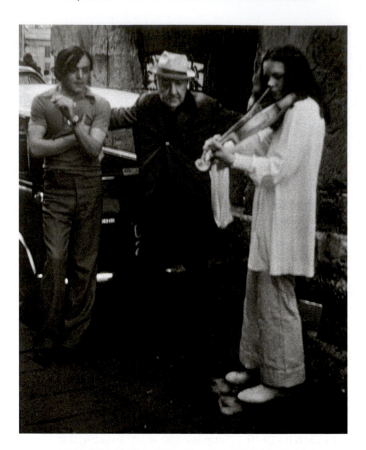

33–20 Laurie Anderson **DUETS ON ICE**
1974. Photograph of a performance in New York, 1975.

Credit: Courtesy the artist. Photo: Bob Bielecki

VIOLA AND PAIK In 1996, the California video artist Bill Viola (b. 1951) created **THE CROSSING** (**FIG. 33–21**), which consists of two brilliantly colored videos projected simultaneously on opposite sides of a 16-foot screen. One side shows a man who slowly walks forward to fill the entire screen. A few drops of water start to fall, gradually becoming a downpour that obliterates the man's image and seems to wash him away. On the other side, a similar scenario unfolds. A man appears surrounded by small flames that escalate until a giant conflagration engulfs him entirely. Interested in how perception affects meaning, Viola supplies a soundtrack that fills the room with soft percussive noise that grows to a deafening roar. Synchronized to the natural elements as they intensify in each video, the sound remains ambiguous, but we perceive it as either fire or water depending on which scene we watch. Presented in a darkened room, the large scale of the projection and the surrounding sound overwhelm the viewer in an appeal to all the senses. Viola's use of fire and water evokes the elemental

33–21 Bill Viola THE CROSSING
1996. Two channels of color video projections from opposite sides of a large dark gallery onto two back-to-back screens suspended from the ceiling and mounted on the floor; four channels of amplified stereo sound, four speakers. Height 16′ (4.88 m).

Credit: Courtesy Bill Viola Studio LLC. Performer: Phil Esposito. Photo: Kira Perov

33–22 Nam June Paik **ELECTRONIC SUPERHIGHWAY: CONTINENTAL U.S.**
1995. Forty-seven-channel closed-circuit video installation with 313 monitors; neon, steel structure, color, and sound, approx. 15 × 32 × 4′ (4.57 × 9.75 × 1.2 m). Smithsonian American Art Museum, Washington, DC. Gift of the artist.

Credit: © Estate of Nam June Paik. Gift of the artist. Photograph © 2016 Photo Smithsonian American Art Museum/Art Resource/ Scala

symbolism of ritual, adding to the work's open-ended meaning and encouraging viewers to find personal significance in their experience.

In **ELECTRONIC SUPERHIGHWAY: CONTINENTAL U.S.** (**FIG. 33-22**), Nam June Paik (1931–1996) built on his early experiments with video and new media to comment on communication technology in the United States. A tribute to Paik's adopted country, the monumental sculpture refers to the intricate system of interstate highways across the United States, which were still new in 1964 when the Korean artist first arrived. Outlined in colorful neon lights, each of the 50 states is filled with television monitors—336 in the entire work—that flicker out moving images from popular entertainment, news broadcasts, and Paik's own video footage.

The artist chose imagery based on his associations with each state. Some, like scenes from the film *The Wizard of Oz* in Kansas, pictures of potatoes in Idaho, and Martin Luther King giving a speech in Alabama, reflect shared cultural knowledge; others are more personal, like Charlotte Moorman seen on screens in her home state of Arkansas in *TV Bra for Living Sculpture* (SEE FIG. 33-10), her collaborative performance with Paik. Paik also chose to involve the viewer in a witty way by placing a closed-circuit live feed of visitors looking at the work on the monitor in the District of Columbia, where the sculpture resides in the collection of the Smithsonian American Art Museum. The title *Electronic Superhighway* seems to predict the growth of the Internet, only beginning when Paik produced this sculpture in 1995, into a digital superhighway that increases the ability of mass media and social networking to connect people globally and create cultural identity through the proliferation of visual imagery.

Process and Materials

Some artists in the 1960s looked to art making itself as a source of conceptual investigation. Since the 1950s, artists inspired by Pollock's Action painting had sought new ways to bring together process and form. In their efforts to eliminate the expressionistic associations of the artist's hand, Pop and Minimalist artists emphasized the mass-produced "objecthood" of their work. In 1968, Robert Morris published "Anti-Form," expanding his earlier "Notes on Sculpture" to address the importance of materials to artistic process and sculptural form. Whereas the "well-built" cubes of Minimalism were the logical outcome of using rigid plywood, steel, and glass, Morris and other artists began to explore the variability of forms made with materials like molten lead, industrial fiber, and a variety of organic matter.

American artist Eva Hesse (1936–1970) adapted the formal vocabulary of abstraction in sculptures that highlight both process and tactility. Born in Hamburg and narrowly escaping the Holocaust as a child, she made evocative works full of personal history and meaning. For feminist critics such as Lucy Lippard, this type of "eccentric" abstraction suggested an alternative to the confrontational style of male-dominated Minimalism. **NO TITLE** (**FIG. 33-23**) exemplifies the organic quality of Hesse's sculpture. Like her Minimalist colleagues, Hesse often used industrial materials, but instead of steel and Plexiglas, she used latex, polyester resin, and fiberglass, giving her work a translucency and texture very different than the slick, machinelike surfaces of Minimalism. In *No Title* Hesse put knots in a long piece of rope before dipping it in liquid

33–23 Eva Hesse
NO TITLE

1969–1970. Latex over rope, string, and wire; two strands, dimensions variable. Whitney Museum of American Art, New York. Purchase, with funds from Eli and Edythe L. Broad, the Mrs. Percy Uris Purchase Fund, and the Painting and Sculpture Committee (88.17 a–b).

Credit: © The Estate of Eva Hesse. Hauser & Wirth. Whitney Museum of American Art, New York. Photo: Geoffrey Clement

latex and hanging it from the ceiling to dry. The resulting sculpture is a chaotic mass of looping, open webs and dense tangles, showing the pull of gravity on the heavy rope suspended from above. Hesse intended the sculpture to morph, shrink, expand, and look different each time it was exhibited, and this openness contributes to the work's impression of being alive: The unusual forms suggest internal organs or other bodily tissue; we can also imagine them as a literal representation of the expressive drips and lines of a Pollock painting. Hesse embraced the instability, irrationality, and emotive power of art, reflecting her own life and feelings in the work.

ARTE POVERA Italian critic and curator Germano Celant coined the term Arte Povera in 1967 to describe a range of international art practices incorporating everyday,

"poor," materials, but it is applied more narrowly today to describe the Italian artists involved in this activity. The group's emphasis on organic materials and physical interactions between natural and manmade objects links Arte Povera to other types of Process Art. Gilberto Zorio (b. 1944) created sculpture and performances using salt, acids, and other reactive compounds that altered the work's aesthetic and structural form. Inspired by the medieval practice of alchemy, Zorio saw the scientific process of metamorphosis as a visual metaphor for the power of art to effect social change. In **PINK-BLUE-PINK (FIG. 33-24)**, he sliced an industrial pipe in half and filled it with a thick paste made from cobalt chloride. Highly sensitive to humidity, the chemical alternates between blue and pink depending on its surrounding environmental conditions. Measuring over 9 feet, the sculpture was long enough that

33–24 Gilberto Zorio
PINK-BLUE-PINK

1967. Semicylinder filled with cobalt chloride, $11\frac{7}{8} \times 112\frac{1}{4} \times 6''$ (30 × 285 × 15 cm). Galleria Civic D'Arte Moderna e Contemporanea, Torino, Italy. Purchased by the Fondazione Guido ed Ettore De Fornaris from Pier Luigi Pero, Turin, 1985.

Credit: © 2016 Artists Rights Society (ARS), New York/SIAE, Rome. Photo: Fotografico Studio Gonella, 2006

33-25 Robert Smithson
SPIRAL JETTY

1969–1970. Mud, precipitated salt crystals, rocks, and water; length 1,500′ (457 m), width 15′ (4.5 m). Great Salt Lake, Utah.

Smithson incorporated one of the few living organisms found in the otherwise dead lake into his work: an alga that turns a reddish color under certain conditions. *Spiral Jetty* is one vehicle wide: To create the work, earth was hauled out into the lake in a huge land-moving truck.

Credit: Photo Gianfranco Gorgoni. Courtesy James Cohan Gallery, New York. Art © Holt-Smithson Foundation/Licensed by VAGA, New York, NY

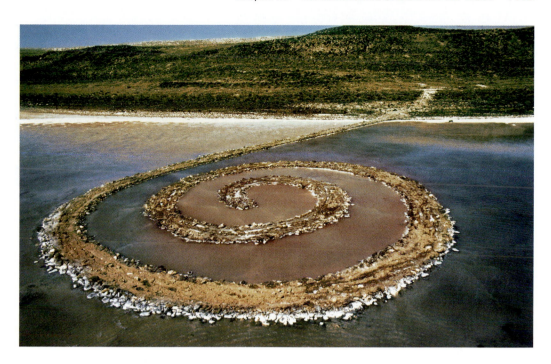

the humidity (and thus the color) might vary along different segments of the pipe. Like other conceptual artists of the period, Arte Povera artists intended the impermanence of their sculpture and performances as a way to prevent institutions from reducing art to symbols of wealth and status. Their work was evidence of a politically charged desire among many artists to see nature as an arcane source of power and beauty, well suited to countering the social ills brought on by industrial expansion.

Earthworks

Some artists, sharing this interest in nature and desire to operate outside the art market, chose to move entirely away from the confines of the gallery. They turned to the earth itself as a medium to manipulate, craft, and change. Some earthworks are vast sculptures that altered the landscape permanently, and others are ambitious temporary works that called attention to their environmental surroundings and the social conditions of their production. Like other ephemeral art practices, earthworks are often documented through photographs and film, which provide collectable objects other than the work itself. Many of these projects are in remote, difficult to access locations, making it a real effort for most viewers to visit. Part of these works, then, is the idea of pilgrimage, which likens the viewer's physical encounter with a unique work of art in its natural surroundings to a spiritual experience.

Robert Smithson (1938–1973) sought to illustrate what he called the "ongoing dialectic" in nature between the constructive forces that build and shape form and the destructive forces that destroy it. **SPIRAL JETTY** (FIG. **33-25**) of 1970, a 1,500-foot stone-and-earth platform spiraling into the Great Salt Lake in Utah, reflects these

ideas. To Smithson, the salty water and algae of the lake suggested both the primordial ocean where life began and a dead sea that killed it; the abandoned oil rigs dotting the lake's shore reminded him of dinosaur skeletons and the remains of vanished civilizations. Smithson used the spiral because it is an archetypal shape—found throughout nature in galaxies, DNA molecules, seashells, as well as used for millennia in the art of different cultures. Although it recalls the geometry favored by Modernist artists, the spiral is a "dialectical" shape that endlessly curls and uncurls, suggesting growth and decay, creation and destruction, or, in Smithson's words, the perpetual "coming and going of things." He ordered that no maintenance be done on *Spiral Jetty* so that the work would be governed by the natural elements over time. Since its completion, the work has been changed by the varying environmental conditions of the lake, including years when it was completely submerged. Now covered with crystallized salt, it is visible to visitors at the site and as well as on Google Earth.

Christo Javacheff (b. 1935) and Jeanne-Claude de Guillebon (1935–2009), who use only their first names in their work as artists, are best known for monumental site-specific projects that temporarily alter their surroundings. In 1958, Christo emigrated from Bulgaria to Paris, where he met Jeanne-Claude; they moved to New York together in 1964. By using swathes of fabric to cover entire buildings and land masses, they transform familiar urban and rural settings into dramatic art installations that demand our attention. For example, they erected *Running Fence* across 24½ miles of farmland into Bodega Bay in Northern California in 1976, and "wrapped" the Reichstag (the building where the German Parliament meets) in Berlin 1995. Their work is political and interventionist in its references to capitalism and the packaging of consumer products.

33-26 Christo and Jeanne-Claude **THE GATES, CENTRAL PARK, NEW YORK, 1979–2005**
1979–2005. Shown here during its installation in 2005.

Credit: © 2016 Christo and Jeanne-Claude. Photo: Wolfgang Volz

The process of planning and overcoming government regulations is part of every piece, taking years to complete compared to the final project, which stays in place for a very short time.

THE GATES, CENTRAL PARK, NEW YORK, 1979–2005 (**FIG. 33-26**) took Christo and Jeanne-Claude 26 years to realize. The artists battled their way through various New York bureaucracies, meeting many obstacles and making changes to the work along the way. Working with an army of paid workers, they finally installed 7,503 saffron-colored nylon panels on "gates" along 23 miles of pathway in Central Park in February 2005. Lasting for only 16 days, the brightly colored flapping panels enlivened the frigid winter landscape and drew many visitors, becoming an enormous public success.

Feminist Art

What characterizes the work of feminist artists in the 1970s?

Rooted in the fight for civil rights and social activism of the 1960s, the women's liberation movement of the early 1970s paralleled a call in the art world for greater recognition of women artists both past and present. Art historical research revealed that although women had regularly contributed to the development of Western art, they were rarely mentioned in its written history. Feminist art historians began the process of recovering the legacies of these artists and expanding the canon to include their stories. Linda Nochlin pushed deeper in her groundbreaking essay of 1971, "Why Have There Been No Great Women Artists?," to show the lack of women in art's history as systemic within patriarchal society. Nochlin argued that women could not be described as "great" if the standard for greatness relied on a canon, or set of accepted "great works," that always favored men. She showed that throughout history, art institutions had denied women access to art education and opportunities readily available to men, effectively making competition on equal terms impossible. Thus, for women to be acknowledged as great artists, the conditions of the canon and the art system had to be changed.

Feminist artists drew on the experimental and politicized art forms that had emerged throughout 1960s. Performance and Conceptual Art offered alternatives to established traditions like painting and sculpture that had historically been dominated by men and in which women commonly appeared as passive objects of sexual desire, created by and for men. Some artists were influenced by essentialist ideas of feminism that defined female experience in terms of the biological differences between women and men. They created imagery based on female anatomy, explored taboo topics around menstruation

and reproduction, and used their own bodies in performance. Looking to women's domestic roles as a source of empowerment, they took up traditions of craft and decorative arts that had historically employed women, but had previously been considered marginal to the fine arts. Others looked to constructivist theories that considered gender to be shaped by social demands and established codes of behavior; these artists adapted Conceptual Art practices to critique social, political, and art historical frameworks that maintained the systematic oppression of women.

Chicago and Schapiro

Born Judy Cohen and married as Judy Gerowitz, Judy Chicago (b. 1939) adopted the name of the city of her birth in order to free herself from "all names imposed upon her through male social dominance." Chicago used a Minimalist aesthetic in her early work, but in the late 1960s she began making abstracted images of female genitalia to challenge the male-dominated art world and to assert the value of the female experience. In 1970, she established a feminist studio art course at Fresno State College (now California State University, Fresno) and the next year moved to Los Angeles to join the painter Miriam Schapiro

(1923–2015) in establishing the Feminist Art Program at the California Institute of the Arts (CalArts).

In 1971–1972 Chicago, Schapiro, and 21 of their female students created *Womanhouse*, a collaborative art environment in a run-down Hollywood mansion that the artists renovated and filled with feminist installations. In collaboration with Sherry Brody, Schapiro's contribution to the project was *Dollhouse*, a mixed-media construction of several miniature rooms adorned with richly patterned fabrics. Schapiro subsequently began to incorporate pieces of fabric into her acrylic paintings, developing a type of work she called femmage (from "female" and "collage"). Characteristic of femmage, **PERSONAL APPEARANCE #3** (**FIG. 33-27**) celebrates traditional women's crafts with a formal and emotional richness that was meant to counter the male-dominated Minimalist aesthetic of the 1960s. Schapiro later returned to New York to lead the Pattern and Decoration movement, a group of female and male artists who merged the aesthetics of abstraction with ornamental motifs derived from women's craft, folk art, and art beyond the Western tradition in a nonhierarchical manner.

Chicago's **THE DINNER PARTY** (**FIG. 33-28**) is a large, complex, mixed-media installation dedicated to hundreds of women and women artists rescued from anonymity by early feminist artists and historians. It took six years of collaborative effort to make and drew on the assistance of hundreds of female and several male volunteers. At the center is a large, triangular table, each side stretching 48 feet; Chicago conceived of the equilateral triangle as a symbol of both the feminine and the equalized world sought by feminism. The table rests on a triangular platform of 2,304 triangular porcelain tiles comprising the "Heritage Floor" that bears the names of 999 notable women from myth, legend, and history. Along each side of the table are 13 place settings representing famous women—13 being the number of men at the Last Supper as well as the number of witches in a coven. Among the 39 women honored with individual place settings are the Egyptian ruler Hatshepsut (SEE FIG. 3-22), the Italian noblewoman Isabella d'Este (SEE FIG. 21-29), the Baroque painter Artemisia Gentileschi (SEE FIG. 23-13), the American abolitionist Sojourner Truth, and the American painter Georgia O'Keeffe (SEE FIGS. 32-36, 32-37).

33-27 Miriam Schapiro **PERSONAL APPEARANCE #3**
1973. Acrylic and fabric on canvas, 60 × 50" (152.4 × 127 cm). Collection of Marilyn Stokstad.
Credit: Photo: Robert Hickerson

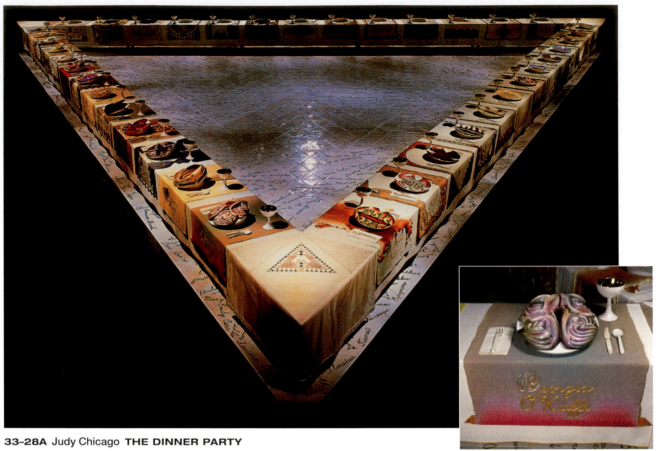

33–28A Judy Chicago THE DINNER PARTY
1974–1979. Overall installation view. White tile floor inscribed in gold with 999 women's names; triangular table with painted porcelain, sculpted porcelain plates, and needlework, each side 48 × 42 × 3' (14.6 × 12.8 × 1 m). Brooklyn Museum, New York. Gift of the Elizabeth A. Sackler Foundation (2002.10).

Credit: Photo ©Donald Woodman/Through the Flower. © 2016 Judy Chicago/Artists Rights Society (ARS), New York

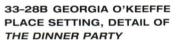

33–28B GEORGIA O'KEEFFE PLACE SETTING, DETAIL OF *THE DINNER PARTY*

Credit: Photo ©Donald Woodman/Through the Flower. © 2016 Judy Chicago/Artists Rights Society (ARS), New York

Each larger-than-life place setting includes a 14-inch-wide painted porcelain plate, ceramic flatware, a ceramic chalice with a gold interior, and an embroidered napkin, sitting upon an elaborately ornamented woven and stitched runner. Most of the plates feature abstract designs based on female genitalia because, as Chicago said, "that is all [these women] had in common…. They were from different periods, classes, ethnicities, geographies, experiences, but [that is] what kept them within the same confined historical space." The prominent place given to china painting and needlework in *The Dinner Party* celebrates traditional women's crafts and argues for their place in the pantheon of "high art," while at the same time informing the viewer about some of the unrecognized contributions that women have made to history.

ANA MENDIETA Ana Mendieta (1948–1985) was born in Cuba but sent to Iowa in 1961 as part of "Operation Peter Pan," which relocated 14,000 unaccompanied Cuban children after the 1959 revolution that brought Fidel Castro and communism to power in Cuba. Mendieta never fully recovered from the trauma of her removal. A sense of

33-29 Ana Mendieta UNTITLED, FROM THE "TREE OF LIFE" SERIES
1977. Color photograph, 20 × 13¼" (50.8 × 33.7 cm).

Credit: © Estate of Ana Mendieta Collection, LLC. Courtesy Galerie Lelong, New York

personal dislocation haunted her, and much of her work reveals a need to find deeper connection with her physical surroundings. Influenced by the work of Beuys and the African-Cuban religion of Santería, Mendieta produced ritualistic actions that invoked both spiritual redemption through communion with nature and the power of the feminine rooted in the earth. For the creation of her "Silhouettes," Mendieta enacted 200 private performances on location in Mexico and Iowa, which she documented in photographs and on film. Each involved the artist using materials such as mud, flowers, gunpowder, and fire to act upon the landscape, leaving a trace form or impression of her body. An image from her **TREE OF LIFE** series (**FIG. 33–29**) shows Mendieta with arms upraised, pressed against a tree and covered in mud, as if to invite the tree to absorb her and connect her to the earth as a maternal source of life.

MARY KELLY Produced over a six-year period by Mary Kelly (b. 1941), **POST-PARTUM DOCUMENT** (**FIG. 33–30**)

is a monumental artwork that tracks the artist's changing relationship with her son after his birth. Kelly's pseudo-scientific approach draws on Marxism, feminist philosophy, and psychoanalytic theory to explore her experience as a woman, a professional, and a mother in a male-dominated society. Although she based *Post-Partum Document* on her own life, she describes it as "an interplay of voices—the mother's experience, feminist analysis, academic discussion, political debate." The work, which includes 135 objects, photographs, diagrams, charts, printed transcripts, handwritten notes, scribbles, and drawings, acts as both a personal record of her child's development and evidence of Kelly's rigorous art-making process. Each of its six parts focuses on key moments related to the child's acquisition of language and Kelly's feelings of loss and change as her son grows up. Although *Post-Partum Document* has only been exhibited once in its entirety, Kelly has also published the project as a book, underscoring how conceptual artists often rely on multiple formats to communicate their ideas.

33–30 Mary Kelly POST-PARTUM DOCUMENT
1975. Documentation III, Analysed Markings and Diary-perspective Schema. Perspex unit, white card, sugar paper, crayon. 1 of 13 units, 14 × 11" (35.3 × 28 cm).

Credit: *Courtesy Susanne Vielmetter Los Angeles Projects*

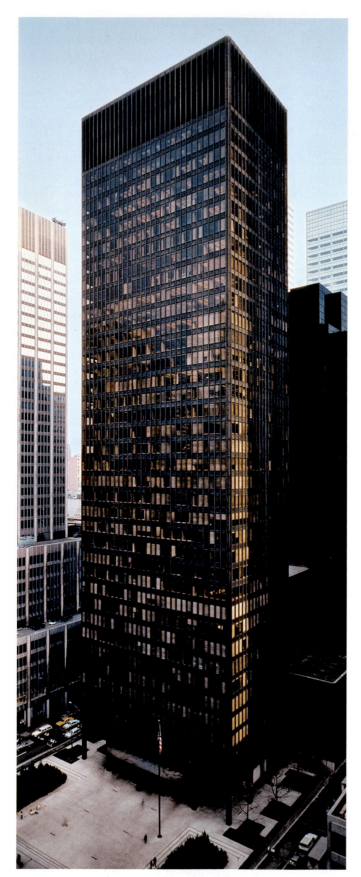

33–31 Ludwig Mies van der Rohe and Philip Johnson **SEAGRAM BUILDING, NEW YORK**
1954–1958.

Credit: Photo: Andrew Garn.

Architecture: Mid-Century Modernism to Postmodernism

What formal and technological changes occur in architecture in the mid-twentieth century?

The International Style, with its plainly visible structure and rejection of historicism, dominated new urban construction in much of the world after World War II, which meant that the utopian and revolutionary aspects of Modernist architecture settled into a form that largely came to stand for corporate power and wealth. Several major European International Style architects, such as Walter Gropius (SEE FIG. 32–53), migrated to the United States and assumed important positions in architecture schools, where they trained several generations of like-minded architects.

Mid-Century Modernist Architecture

Ludwig Mies van der Rohe (1886–1969) created the most extreme examples of postwar International Style buildings (see Chapter 32). A former Bauhaus teacher and a refugee from Nazi Germany, Mies designed the rectilinear glass towers that came to personify postwar capitalism. The crisp, clean lines of the **SEAGRAM BUILDING** in New York City (**FIG. 33–31**), designed with Philip Johnson, epitomize the standardization and impersonality that became synonymous with corporations in the postwar period. Such buildings, with their efficient construction methods and use of materials, allowed architects to pack an immense amount of office space into a building on a very small lot; they were also economical to construct. Although criticized for building relatively unadorned glass boxes, Mies advocated "Less is more." He did, however, use nonfunctional, decorative bronze beams on the outside of the Seagram Building to echo the functional beams inside and give the façade a sleek, rich, and dignified appearance.

Although the pared-down, rectilinear forms of the International Style dominated the urban skyline, other architects departed from its impersonal principles so that even in commercial architecture, expressive designs using new structural techniques and more materials also appeared. For instance, the **TRANS WORLD AIRLINES (TWA) TERMINAL** (**FIG. 33–32**) at John F. Kennedy Airport in New York City, by the Finnish-born American architect Eero Saarinen (1910–1961), dramatically breaks out of the box. Saarinen sought to evoke the thrill and glamour of air travel by giving the TWA Terminal's roof two broad, wing-like canopies of reinforced concrete that suggest a huge bird about to take flight. The interior consists of large, open, dramatically flowing spaces. Saarinen designed each

33-32 Eero Saarinen **TRANS WORLD AIRLINES (TWA) TERMINAL, JOHN F. KENNEDY AIRPORT, NEW YORK**
1956–1962.

Credit: Photo © Karen Johnson

detail of the interior—from ticket counters to telephone booths—to complement his gull-winged shell.

Frank Lloyd Wright (SEE FIGS. 32–41, 32–42, 32–43) transformed museum architecture with the **GUGGENHEIM MUSEUM** (FIG. 33–33) in New York, designed as a sculptural work of art in its own right. The Guggenheim was created to house Solomon Guggenheim's personal collection of Modern art and, like the TWA Terminal, took

on an organic shape, in this case a spiral. The museum's galleries spiral downward from a glass ceiling, wrapping themselves around a spectacular five-story atrium. Wright intended visitors to begin by taking the elevator to the top floor and then walk down the sloping and increasingly widening ramp, enjoying paintings along the way. Today, the interior maintains the intended intimacy of a "living room," despite alterations by the museum's first directors.

33-33 Frank Lloyd Wright **SOLOMON R. GUGGENHEIM MUSEUM, NEW YORK**
1943–1959.

The large building behind the museum is a later addition designed in 1992 by Gwathmey Siegel and Associates.

Credit: Photo © Andrew Garn.

Wright wanted the building to contrast with skyscrapers like the Seagram Building and become a Manhattan landmark—and it remains one of the twentieth century's most distinctive museum spaces.

Postmodern Architecture

In the 1970s, architects began to move away from the sleek, glass-and-steel boxes of the International Style and add elements of past styles into their designs. Architectural historians trace the origins of this new Postmodern style to the work of Jane Jacobs (1916–2006), who wrote *The Death and Life of Great American Cities* (1961), as well as to Philadelphia architect Robert Venturi (b. 1925), who rejected the abstract purity of the International Style by incorporating elements drawn from vernacular (meaning popular, common, or ordinary) sources into his designs.

Venturi parodied Mies's aphorism "Less is more" with his own: "Less is a bore." He accused Mies and other Modernist architects of ignoring human needs in their quest for uniformity, purity, and abstraction and challenged Postmodernism to address the complex, contradictory, and heterogeneous mixture of "high" and "low" architecture that comprised the modern city. Venturi encouraged new architecture to embrace eclecticism; he reintroduced references to past architectural styles into his own designs and began to apply decoration to his buildings.

While writing his treatise on Postmodernism—*Complexity and Contradiction in Architecture* (1966)—Venturi designed a house for his mother (**FIG. 33-34**) that put many of his new ideas into practice. The shape of the façade returns to the traditional Western "house" shape that Modernists (SEE FIGS. 32-39, 32-40, 32-51) had rejected because of its clichéd historical associations. Venturi's vocabulary of triangles and squares is arranged in a playful asymmetry that skews the staid harmonies of Modernist design, while the curved moldings are a purely decorative flourish—forbidden in the strict International Style. But the most disruptive element of the façade is the deep cleavage over the door, which opens to reveal a mysterious upper wall and chimney top. The interior is also complex and contradictory. The irregular floor plan, including

33-34A Robert Venturi **FAÇADE, VANNA VENTURI HOUSE, CHESTNUT HILL**
Philadelphia, Pennsylvania. 1961–1964.

Credit: Venturi, Scott Brown Collection. © The Architectual Archives, University of Pennsylvania. Photo: Matt Wargo

33-34B Robert Venturi **PLAN, VANNA VENTURI HOUSE, CHESTNUT HILL**
Philadelphia, Pennsylvania. 1961–1964.

Credit: Venturi, Scott Brown Collection. © The Architectual Archives, University of Pennsylvania.

an odd stairway leading up to the second floor, is further complicated by irregular ceiling levels that are partially covered by a barrel vault.

In the 1970s, Postmodern ideas were also applied to commercial architecture. One of the first examples was the **AT&T CORPORATE HEADQUARTERS** (now the Sony Building) in New York City (**FIG. 33-35**) by Philip Johnson (1906–2005) and John Burgee (b. 1933). This elegant, granite-clad skyscraper has 36 oversized stories, making it as tall as the average 60-story building. It mimics its International Style neighbors with its smooth, uncluttered skin, while its Classical window groupings set between vertical piers also echo nearby skyscrapers from much earlier in the century. But the overall profile of the building bears a whimsical resemblance to the shape of a Chippendale highboy, an eighteenth-century chest of drawers with a long-legged base and angled top—this seems to be an intended pun on the terms "highboy" and "high-rise." The round notch at the top of the building as well as the rounded entryway at its base suggest the coin slot and coin return of an old pay telephone in a clever reference to the building's client, the AT&T telephone company.

33-35 Philip Johnson and John Burgee **AT&T CORPORATE HEADQUARTERS, NEW YORK** 1978–1983.

Credit: © Mathias Beinling/Alamy Stock Photo

Postmodernism

How do Postmodernism and changing attitudes around identity affect art after the 1970s?

Throughout the 1970s, Postmodernist ideas percolated throughout the Western art world, and by 1980 much of the art produced served as a clear illustration of theories set out by philosophers like Roland Barthes, Michel Foucault, and Jean Baudrillard. Rather than a distinctive style, Postmodernist art is best recognized by its attempt to undermine key principles of Modernism, especially its insistence on an art that was pure, autonomous, and universal. Just as Modernist art had heralded an industrial, technological society, the advent of Postmodernism signaled a shift toward a post-industrial, capitalist society living in an age of mass communication that required tolerance for difference and rapid change. The 1980s gave rise to the personal computer, music videos, and cable TV. Immersed in a vast visual culture that had now become commonplace, artists chose imagery from high-art and lowbrow sources, combining it in complex, contrary, and humorous ways that resisted formal unity and singular meaning. The effect was to crack the authoritative façade of Modernism and reveal that its truths were fiction, open to revision and interpretation.

Neo-Expressionism

Neo-Expressionism, one of the first international manifestations of Postmodernism, reintroduced large-scale representational paintings that brought back the luxury of the painted surface, but also employed Postmodernist strategies to layer meaning through eclectic imagery and expressive technique. The German artist Anselm Kiefer (b. 1945), born in the final weeks of World War II, builds on the style and political undertones of German Expressionism from the early twentieth century (see Chapter 32). Heavily worked with thick layers of paint and shellac, **HEATH OF THE BRANDENBURG MARCH** (FIG. 33-36) evokes the historical tradition of German landscape painting to confront his country's Nazi past. The linear perspective of the central road pulls the viewer into a scorched and barren countryside, alluding to centuries of past warfare in this region around Berlin. Scrawled on top of the desolate scene, the words of the Nazi marching song "Märkische Heide, märkische Sand" appear in the foreground. Kiefer's work resists being interpreted in only one way, but instead has layers of meaning when looked at through the varied lenses of artistic style, cultural heritage, and political association. Combining the influences of Postmodernism and Kiefer's teacher Beuys, Kiefer's art confronts Germany's rich—and at times horrific—historical past, perhaps suggesting an opportunity for national healing.

Brooklyn-born Jean-Michel Basquiat (1960–1988) grew up in middle-class comfort before leaving home as a teenager for New York's Lower East Side. As a street artist, he covered walls with short and witty philosophical texts signed with the tag "SAMO©." He gained critical attention in 1980 in the highly publicized "Times Square Show," which showcased many of the city's subway and graffiti artists. Basquiat's active brushwork,

33–36 Anselm Kiefer **HEATH OF THE BRANDENBURG MARCH**
1974. Oil, acrylic, and shellac on burlap, 3'10½" × 8'4" (1.18 × 2.54 m). Collection Van Abbemuseum, Eindhoven, the Netherlands.

33–37 Jean-Michel Basquiat **HORN PLAYERS**

1983. Acrylic and oil paintstick on canvas; three panels, overall 8′ × 6′5″ (2.44 × 1.91 m). Broad Art Foundation, Santa Monica, California.

Credit: © The Estate of Jean-Michel Basquiat/ADAGP, Paris/ARS, New York 2016

autobiographical elements, and personal iconography link him to Neo-Expressionism. **HORN PLAYERS** (**FIG. 33–37**) of 1983 references the triptych format to pay homage to musicians Charlie Parker (upper left) and Dizzy Gillespie (center right). A fan of jazz, Basquiat echoes the improvisational bebop style Parker made popular in the 1950s in his painting technique, and his expressive images and text offer a range of interpretative meanings. The painting underscores Basquiat's passionate determination to focus on African-American subjects in an unsentimental way. As he said, "Black people are never portrayed realistically, not even portrayed, in Modern art, and I'm glad to do that."

Appropriation, Identity, and Critique

Many Postmodern artists found appropriation a useful strategy with which to counter Modernist values. They borrowed imagery directly from the onslaught of mass visual culture, repositioning and recontextualizing it to twist and complicate its meaning. For artists known as the "Pictures" generation, photography was a conceptual tool to deconstruct Modernist beliefs about originality, patriarchal authority, and artistic identity. Their work exposes how consumer culture and the mass media bombard us with pictures of a life that is impossible to attain but made to seem real by the very images that present it to us.

Jeff Koons (b. 1955) capitalizes on the ambiguity of Pop Art to elevate and critique everyday subjects at the same time. He has made a career glorifying the banal and superficial in contemporary life with a knack for self-promotion that some critics believe surpasses his art. In the 1980s, Koons appropriated consumer goods such as basketballs and vacuum cleaners, exhibiting them in Plexiglas showcases similar to those in department stores—and in

museums. The effect is to place the objects' artistic status directly alongside their value as products for sale, thus underscoring their dual role as commodities with economic and cultural worth. **PINK PANTHER** (FIG. 33–38) recalls Warhol's *Marilyn Diptych* (SEE FIG. 33–13) in its attention to celebrity culture, but Koons's work is closer to celebrity's kitschy imitation. The pin-up girl, based on B-movie star Jayne Mansfield, is caught striking a pose as she embraces the cuddly cartoon character in one hand while the other covers her exposed breast. The garish pastels and slickly textured finish heighten her artificial prettiness. Although the nearly life-size sculpture appears to elevate a tawdry subject, Koons hired European fabricators to produce the object in porcelain, a material better known for cheap knick-knacks than fine art in museums. Koons's work suggests

33–39 Sherrie Levine AFTER WALKER EVANS: 4
1981. Gelatin-silver print, 5¹⁄₁₆ × 3⁷⁄₈" (12.8 × 9.8 cm). Metropolitan Museum of Art, New York. Gift of the artist, 1995.

33–38 Jeff Koons PINK PANTHER
1988. Porcelain, ed. 1/3. 41 × 20½ × 19" (104.1 × 52.1 × 48.3 cm). Collection Museum of Contemporary Art, Chicago.

the influence of both Duchamp and Minimalist sculpture while also addressing key Postmodern themes. Yet his bland presentation style seems openly materialistic and shallow—inviting, and even welcoming, critical dissent.

Like Neo-Expressionist painting, the work of Sherrie Levine (b. 1947) and others of the Pictures generation signaled the return of image making after a decade dominated by dematerialized art forms. **AFTER WALKER EVANS: 4** (FIG. 33–39) is from a provocative series of photographs—actually reproductions of Depression-era photographs by Walker Evans—in which Levine questions the nature of artistic originality and authority. While working with the Farm Securities Administration in the 1930s, Evans produced images that were widely shown as evidence of poverty in the South. Levine's direct appropriation of Evans's work claims the legacy of a well-known male artist for herself, while seeming to indict his own appropriation of his destitute subjects for personal artistic and commercial gain. Furthermore, as exact copies of Evan's images, Levine's work highlights photography's resistance to how Modernism tends to value most highly the original work of art and forces us to consider the influence of mass media on cultural knowledge.

FEMINISM AND APPROPRIATION Barbara Kruger (b. 1945) appropriates advertising and marketing techniques to subvert the messages in mainstream mass media. Her early career, working as a designer and art director at *Mademoiselle, House and Garden*, and other popular magazines, informs the signature look of her work. She relies on her provocative juxtapositions of words and image to challenge expected meanings that come from our experience of popular advertising. **UNTITLED (YOUR GAZE HITS THE SIDE OF MY FACE)** (FIG. 33–40) is typical in the slightly nostalgic quality of the female mannequin's appearance and the graphic contrast that recalls the three-color printing once common in newspapers. By addressing the viewer directly, Kruger forces us to acknowledge the relationship usually kept hidden between the viewer and the viewed. Framed within an advertising context, the viewer is likened to the consumer who looks at an object of desire for purchase. Although Kruger's pronouns are ambiguous in terms of gender, they seem an implicit reference to the "male gaze" in art described by critics like Laura Mulvey and John Berger and much discussed in the 1970s and 1980s. Kruger's work, however, raises broad Postmodernist issues of power and the need to expose underlying social structures that oppress and subjugate others.

While women contributed significantly to artistic developments in the 1960s and 1970s, major museums and galleries continued to privilege work by male artists. In 1984 the Museum of Modern Art included only 13 women among 169 (mostly white) artists in "An International Survey of Painting and Sculpture," an exhibition claiming to highlight the period's most important art. In response, a group of feminist artists, curators, critics, and art historians in New York formed the Guerrilla Girls, an activist group that would function, in their words, as "the conscience of the art world." The group's mandate is to expose gender and racial inequities in the art world, demonstrate against discrimination, and fight for the rights of women and artists of color.

The Guerrilla Girls use the tactics of guerrilla warfare: acting covertly to strike at the enemy. Their first campaign was to paste posters on walls throughout New York's art districts, citing damning statistics of discrimination in the city's galleries and art museums. Members remain anonymous, but adopt the names of dead women artists as pseudonyms. This strategy protects them from reprisal and circumvents the art world's tendency to focus on individual instead of collective accomplishment. To protect their identities at protests and public events, they don gorilla masks, a play on the word "guerrilla" that reflects their use of humor to disarm critics and promote their message. The group produces sharp, witty posters that draw on the best advertising strategies. The posters are now collected by many of the institutions that they were made to critique.

33–40 Barbara Kruger **UNTITLED (YOUR GAZE HITS THE SIDE OF MY FACE)**
1981. Photograph, red painted frame, 55 × 41" (140 × 104 cm). Mary Boone Gallery, New York.
Credit: © Barbara Kruger. Courtesy Mary Boone Gallery, New York

One of the most famous features Ingres's *Large Odalisque* wearing a gorilla mask with the headline "Do women have to be naked to get into the Met. Museum?" The poster, made in 1989, notes that while women represented less than 5 percent of the artists in the famous museum, they were 85 percent of the nudes on display. (The Guerrilla Girls repeated the survey in 2005 and found the number of women artists had decreased to only 3 percent—but pointed out with characteristic humor that at least there were more naked men.) **THE ADVANTAGES OF BEING A WOMAN ARTIST** (FIG. 33–41) delivers a clever, ironic, and sadly still accurate list of the treatment afforded women artists.

Cindy Sherman (b. 1954) also turned to photography as a way to engage in Postmodern critique. In her series "Untitled Film Stills," Sherman creates fictional narratives with herself in the starring role. Each of the black-and-white photographs resembles a publicity still from popular cinema of the early 1960s, in which Sherman appears, costumed and made-up, in settings that seem to quote from the plots of old movies. Although each untitled image stands alone, we recognize these women's stories. In **UNTITLED FILM STILL #21** (FIG. 33–42), for instance, Sherman assumes the part of "small-town girl" recently

33–41 Guerrilla Girls **THE ADVANTAGES OF BEING A WOMAN ARTIST**
1988. Offset print, 17 × 22" (43.2 × 55.9 cm). Collection of the artists.

Credit: © Guerrilla Girls www. guerrillagirls.com

THE ADVANTAGES OF BEING A WOMAN ARTIST:

Working without the pressure of success
Not having to be in shows with men
Having an escape from the art world in your 4 free-lance jobs
Knowing your career might pick up after you're eighty
Being reassured that whatever kind of art you make it will be labeled feminine
Not being stuck in a tenured teaching position
Seeing your ideas live on in the work of others
Having the opportunity to choose between career and motherhood
Not having to choke on those big cigars or paint in Italian suits
Having more time to work when your mate dumps you for someone younger
Being included in revised versions of art history
Not having to undergo the embarrassment of being called a genius
Getting your picture in the art magazines wearing a gorilla suit

A PUBLIC SERVICE MESSAGE FROM **GUERRILLA GIRLS** CONSCIENCE OF THE ART WORLD

arrived in the big city. Others show her as "the hardworking housewife," "the femme-fatale," "the teenage runaway," and other stereotypical personae. Part performance and part Conceptual Art, these works play on the documentary status we give the photograph and our familiarity with the cinematic narratives Sherman recreates. By forcing us to acknowledge the illusion of her own image, Sherman underscores the power of visual representation to construct female identity and alludes to the performances we enact every day in roles like "the best friend" or "the good student."

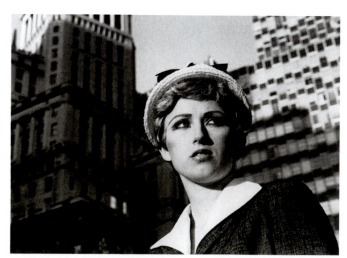

33–42 Cindy Sherman **UNTITLED FILM STILL #21**
1978. Black-and-white photograph, 8 × 10" (20.3 × 25.4 cm).

Credit: Courtesy the artist and Metro Pictures

Identity Politics and the Culture Wars

For some, Postmodernism's challenge to the status quo seemed a strike at Western culture's most fundamental values. Throughout the 1980s, tensions grew between factions with opposing beliefs about religion and politics, finally giving way around 1990 to what is sometimes called the "Culture Wars." This battle was pronounced in the art world, where conflicts raged over freedom of speech and public funding for the arts, particularly with regard to the right to make art that might be considered offensive or obscene by others. Building on the model of feminist artists asserting their identity, others made art addressing racial and ethnic difference and began to explore the topic of gender broadly to consider its relationship to sexual identity and orientation. Fueled by the emotion and urgency brought about by the AIDS crisis, individuals who had once stayed at the edges of society and the art establishment began to claim center stage by making work confronting issues of identity and unequal treatment based on gender, sexual orientation, race, or class.

James Luna (b. 1950) asks us to confront Native American stereotypes in **THE ARTIFACT PIECE** (**FIG. 33–43**), first staged in 1987 in a hall dedicated to a traditional ethnographic exhibition at the Museum of Man in San Diego. Luna lay almost naked in a glass display case filled with sand embedded with artifacts from his life, including his favorite music and books and personal legal papers. Museum-style labels pointed to marks and scars on his

33–43 James Luna
THE ARTIFACT PIECE
First staged in 1987 at the Museum of Man, San Diego. Luna also performed the piece for "The Decade Show," 1990, in New York.

Credit: Courtesy James Luna

body that he had acquired while drinking or fighting or in accidents. In this way, Luna turned his living body and his life into an ethnographic object for people to ogle and judge. By objectifying himself, he challenges our prejudices and assumptions about Native Americans and highlights the cultural role of institutions to perpetuate or counter such myths.

Using Postmodern strategies similar to Barbara Kruger and Cindy Sherman, Lorna Simpson (b. 1960) also addresses female stereotyping, but she expands the issue to include the question of race. In **STEREO STYLES** (FIG. **33-44**), Simpson arranges ten Polaroid photographs in two rows. Each depicts an African-American woman wearing a plain white shift and photographed from behind to reveal her head and shoulders. The only key to her identity is the distinctive hairstyle in each image, described by words such as "Daring," "Boyish," "Magnetic," "Country Fresh," and "Sweet" written in cursive on a plaque between the rows. Simpson's gridlike display of black-and-white images uses Conceptual Art's straightforward presentation of information, encouraging us to look more closely at the relationship of visual appearance to our perceptions of individual identity.

African-American artist Faith Ringgold (b. 1930) uses narrative structure and non-Western traditions to consider race and gender in society. Trained as an abstract painter in the 1950s, Ringgold—engaged by the civil rights and feminist movements—shifted to other formats like performance and craft-based practices in the 1960s. In the 1980s, she began making "story-quilts," which combine representational subject matter, African-American quilt making, and written text to create visual narratives richly layered with meaning. In **TAR BEACH** (FIG. **33-45**) the narrator is 8-year-old Cassie Louise Lightfoot—although Ringgold draws on her own memories growing up in Harlem. "Tar Beach" refers to the roof of the apartment building where

33–44 Lorna Simpson STEREO STYLES
1988. Ten black-and-white Polaroid prints and ten engraved plastic plaques, 5′4″ × 9′8″ (1.63 × 2.95 m) overall. Private collection.

Credit: Courtesy of the artist

33–45 Faith Ringgold
TAR BEACH
Part I from the "Women on a Bridge" series. 1988. Acrylic on canvas, bordered with printed, painted, quilted, and pieced cloth, 74⅝ × 68½" (190.5 × 174 cm). Solomon R. Guggenheim Museum, New York. Gift of Mr. and Mrs. Gus and Judith Lieber.

Credit: © Faith Ringgold

Ringgold slept on hot summer nights and describes as a magical place. Surrounded by a colorful patchwork border, the central panel of the quilt shows Cassie on the roof with her brother, lying on a blanket while their parents and neighbors play cards. Hand-written on white horizontal panels stitched into the border are details of the story. Cassie tells of her dream that she can possess all the things she flies over: She claims the George Washington Bridge for herself; a new union-constructed building for her father, who as an African-American construction worker was not allowed to join the union; and an ice-cream factory for her mother. Cassie's fantasy is charming, but reminds viewers of the real social and economic prejudices facing African Americans. The popularity of *Tar Beach* inspired Ringgold to recreate the story-quilt as a children's picture book, which received a prestigious Caldecott Medal in 1992.

Controversies Over Funding in the Arts

Some of the most notorious battles in the Culture Wars revolved around public funding of the arts. At the center

was the National Endowment for the Arts (NEA), a federal agency established by Congress in 1965 to provide funding giving "Americans the opportunity to participate in the arts, exercise their imaginations, and develop their creative capacities." The controversy gained national attention in 1989 when Andres Serrano's photograph *Piss Christ* drew criticism from religious groups and conservative politicians. Although Serrano did not receive public money to produce the photograph, the Southeastern Center for Contemporary Art had paid Serrano a stipend to include the work in an exhibition organized with NEA support.

Created in 1987, two years before the NEA controversy, **PISS CHRIST** (**FIG. 33–46**) is one of many photographs Serrano (b. 1950) made that involve bodily fluids like blood, semen, and human milk. These function to highlight the tension between his images' aesthetic appeal and the abject undertones Serrano makes clear in the title. *Piss Christ* is an almost 2-foot-high, brilliantly colored Cibachrome photograph that shows a Christian crucifix bathed in a hazy, ethereal light. Serrano made the haunting image by submerging a small plastic crucifix in a Plexiglas container filled with his own urine. Serrano, who was raised a strict Catholic, has argued that the work addresses the physical death of Christ's body and critiques the commercialization of Christ's image.

Around the same time that the exhibition of *Piss Christ* was being challenged, another traveling exhibition funded by the NEA—this one a retrospective of photographer

Robert Mapplethorpe organized by Philadelphia's Institute of Contemporary Art—came under similar attack for the inclusion of several homoerotic and sadomasochistic images, including self-portraits of the artist, who had recently died of AIDS. A flurry of debate developed in Congress questioning the authority of the NEA to distribute taxpayers' money to support art that some members of the public found distasteful or obscene.

Succumbing to political pressure, the Corcoran Gallery of Art in Washington, DC cancelled the Mapplethorpe exhibition. When it was shown in Cincinnati in 1990, the show was shut down and the museum director arrested on charges of obscenity. That same year, the NEA rescinded grants awarded to four artists—who became known as the "NEA Four" (Karen Finley, John Fleck, Holly Hughes, and Tim Miller)—because their art included lesbian, gay, or radical feminist content. Although the artists sued and won back their grants in 1993, a so-called "obscenity clause" was added to NEA regulations requiring jurors to consider the "general standards of decency and respect

33-47 Chris Ofili **THE HOLY VIRGIN MARY**
1996. Acrylic, oil paint, polyester resin, paper collage, glitter, map pins, and elephant dung on linen, 7'11" × 5'11⁵⁄₁₆" (2.44 × 1.83 m). MONA, Museum of Old and New Art, Hobart, Tasmania, Australia.

Credit: © Chris Ofilli. Courtesy the Artist and Victoria Miro Gallery, London

for the diverse beliefs and values of the American public" when making awards. Over the next few years, the Republican-controlled House of Representatives, some of whose members wanted to eliminate the agency altogether, dramatically restructured the NEA, including cutting its budget by 40 percent.

Another controversy erupted in 1999 when the Brooklyn Museum exhibited "Sensation: Young British Artists from the Saatchi Collection." New York Mayor Rudolph Giuliani and Catholic leaders took particular offense to **THE HOLY VIRGIN MARY** (FIG. **33-47**) by Nigerian-British artist Chris Ofili (b. 1968). The large, glittering canvas features a stylized African Madonna augmented with mixed-media elements of elephant dung and found pornographic photographs of women's buttocks. Ofili, who spent a year studying in Zimbabwe, explained that many African nations have a tradition of using found objects and materials in both popular and high art. He intended the painting as a contemporary, bicultural reinvention of the Western Madonna tradition, using elephant dung to reinforce this black Madonna's connection to the art and religion of Zimbabwe and to represent her fertility.

33-46 Andres Serrano **PISS CHRIST**
1987. Cibachrome print mounted on Plexiglas, 23½ × 16" (59.7 × 40.6 cm).

Credit: © Andres Serrano/Courtesy of the artist and Yvon Lambert Paris, New York

When the Brooklyn Museum refused Mayor Giuliani's demands to cancel the show, the mayor withheld the city's monthly maintenance payment to the museum of $497,554 and filed a suit in the state court to revoke its lease. In response, the museum filed for an injunction against Giuliani's actions on the grounds that they violated the First Amendment. A federal district court eventually barred Giuliani from punishing or retaliating against the museum in any way for mounting the exhibition. Guiliani had argued that Ofili's art fostered religious intolerance, but the court ruled that the government has "no legitimate interest in protecting any or all religions from views distasteful to them," adding that taxpayers "subsidize all manner of views with which they do not agree" and even those "they abhor."

Public Art

Debates over public funding of art do not always stem from moral outcry over artists' use of sexual or religious content. Many revolve around the art produced for public spaces. Throughout history, art has functioned as propaganda to reinforce cultural values, commemorate historical events, and celebrate individual accomplishments. Most controversies around public art today involve community response to a work's appearance and questions about its artistic and cultural value. Such concerns grow when tax dollars are used to finance projects that some find objectionable for reasons ranging from the costs involved to misperceptions or disagreement about the art's meaning. In the early 1980s, two such public projects gained a great deal of attention for the reaction and challenge brought by the public. A comparison reveals the contentiousness of contemporary art in the public realm and asks us to consider its place in the world today.

In 1981, Richard Serra (b. 1939) won a commission from the United States General Services Administration, which approved plans for **TILTED ARC** (**FIG. 33–48**), a curved and slightly angled Cor-Ten steel wall, 120 feet long, 12 feet tall, and 2½ inches thick, that would bisect the plaza in front of the Javits Federal Building in New York. After its installation, the sculpture began to draw criticism for its impact on the public space, because it forced people to detour as they crossed the plaza and made it impossible to hold concerts or performances. Over time, the steel weathered to a rusty brown and became covered with pigeon droppings and graffiti. Public outrage grew so intense that in 1986 Serra's sculpture was removed to a Brooklyn parking lot, an action that incited further furor, this time among artists and critics. Serra argued that moving *Tilted Arc* effectively

33–48 Richard Serra **TILTED ARC**
1981–1989. Jacob K. Javits Federal Plaza, New York. Steel. Destroyed.

Credit: © 2016 Richard Serra/Artists Rights Society (ARS), New York. Photo: David Aschkenas

33–49 Maya Lin **VIETNAM VETERANS MEMORIAL, WASHINGTON, DC**
1981–1983.

Credit: © Frank Fournier

destroyed the site-specific sculpture; he filed a lawsuit claiming censorship, but the federal district court found no legal merit in his case and denied his plea.

Around the same time of Serra's commission, a jury of architects, landscape architects, and sculptors awarded Maya Lin (b. 1959) the commission for the **VIETNAM VETERANS MEMORIAL** (**FIG. 33–49**), to be built near the National Mall in Washington, DC. A student at Yale University, Lin proposed a simple and dramatic memorial cut into the ground in a V shape like a scar, as a symbol of national healing over the divisive war. The sculpture is made of two highly polished black granite slabs that reach out from deep in the earth at the center. Each slab is 247 feet long, and they meet at a 130-degree angle where they are 10 feet tall. The names of 58,272 American soldiers killed or declared missing in action during the Vietnam War are listed chronologically in the order they died or were lost, beginning in 1956 at the shallowest point to the left and climaxing in 1968 at the tallest part of the sculpture, representing the year of highest casualties. The memorial serves both to commemorate the dead and missing and to provide a place where survivors can confront their own loss.

It is one of the best-known works of public art in the United States and has transformed the way the nation mourns its war dead.

Visitors often describe the *Vietnam Veterans Memorial* as a powerful and profound experience, but Lin's design was contested at the time of her commission. Opponents described it as a "black gash in the Mall," its color contrasting with the pervasive white marble of the surrounding memorials. Others saw Lin's use of abstraction as a departure from the representational monuments often used to honor war heroes. In response to the criticism, the Vietnam Veterans Memorial Fund commissioned Frederick Hart (1943–1999) in 1983 to create another, more naturalistic memorial depicting three soldiers, which was placed 120 feet from the wall; in 1993, a comparable sculpture of three nurses by Glenda Goodacre (b. 1939) was added 300 feet to the south to memorialize the contribution of women during the war.

While Serra and Lin's monuments appear similar, their distinctive qualities may explain the differing public responses to each. In addition to the spare geometric forms of the sculptures, both rely on their physical scale

to heighten the viewer's perceptual awareness and suggest additional meaning. In *Tilted Arc*, this translates to a vaguely threatening feeling as the imposing structure looms ominously over viewers and forces them to alter their path walking across the plaza. By contrast, Lin's sculpture seems to grow in height, impressing visitors physically with the sheer magnitude of inscribed names as they walk the lengthy path. Instead of Serra's industrial steel, Lin employs polished granite, commonly used for tombstones, that reflects the faces of visitors as they read names of the dead and missing. The effect is both to humanize the written words and to implicate the viewer who now bears witness to the national tragedy of the war.

The examples of *Tilted Arc* and the *Vietnam Veterans Memorial* raise important questions about the rights and responsibilities of artists, as well as the obligations of those who commission public works of art. The case of *Tilted Arc* prompted changes in the commissioning of public sculpture. (In court, the artist had not attempted to defend his work on aesthetic grounds, but claimed the right to create the piece as planned and approved.) Today neighborhood groups and local officials meet with artists well in advance of public commissions, but rarely are all parties completely satisfied.

High Tech and Deconstructivist Architecture

What are some of the formal and technological changes affecting architecture since the 1980s?

Computer-aided design (CAD) programs with 3-D graphics transformed architecture and architectural practice in the 1980s and 1990s. These new tools enabled architects to design structures virtually, to calculate engineering stresses faster and more precisely, to experiment with advanced building technologies and materials, and to imagine new ways of composing a building's mass.

High Tech Architecture

The new technology let architects break out of the restrictive shape of the Modernist "glass box" (SEE FIG. 33–31) and experiment with dramatically designed engineering marvels. These buildings are characterized by a spectacular use of materials, equipment, and architectural components and frequently by a visible display of service systems such as heating and power.

The **HONG KONG & SHANGHAI BANK** (FIG. 33–50) by British architect Norman Foster (b. 1935) is among the most spectacular examples of High Tech architecture. Foster was invited to spare no expense in designing this

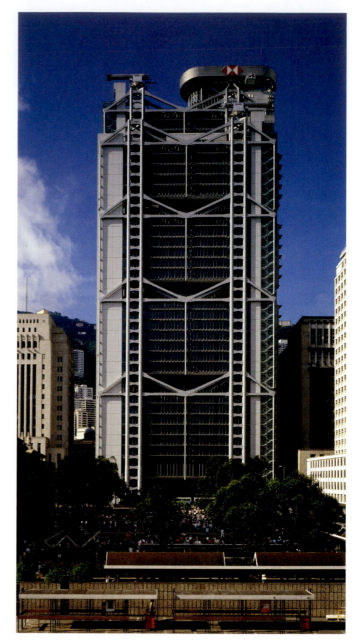

33–50 Norman Foster **HONG KONG & SHANGHAI BANK, HONG KONG**
1986.

Credit: © Arcaid Images/Alamy Stock Photo

futuristic 47-story skyscraper. The load-bearing steel skeleton, composed of giant masts and girders, is on the exterior. The individual stories hang from it, making possible the uninterrupted rows of windows that fill the building with natural light. Motorized "sunscoops" at the top of the structure track the sun's rays and channel them into the building, pouring additional daylight into a ten-story atrium space in the banking hall in the lower part of the building. The sole concession Foster makes to tradition in this design is his placement of two bronze lions taken from the bank's previous headquarters flanking the public entrance. Touching the lions before entering the bank is believed to bring good luck.

Deconstructivist Architecture

Deconstructivist architecture, more theory-based than High Tech, emerged in the early 1990s. Deconstructivist architects deliberately disturb traditional architectural assumptions about harmony, unity, and stability to create "decentered," skewed, and distorted designs. The aesthetic of Russian Suprematists and Constructivists (SEE FIG. 32–48) is an influence, as are the principles of Deconstruction as developed by French philosopher Jacques Derrida (1930–2004). Derridean Deconstruction claims that written texts possess no single, intrinsic meaning, that meaning is always "intertextual," a product of one text's relationship to other texts. As a result, meaning is always "decentered," "dispersed," or "diffused" through an infinite web of "signs," which themselves have unstable meanings. Deconstructivist architecture is likewise intertextual, in that it plays with meaning by mixing diverse architectural features, forms, and contexts; it is decentered by this diffusion as well as by its perceived instability of both meaning and form.

A good example of Deconstructivist architecture is the **VITRA FIRE STATION** in Weil-am-Rhein, Germany (**FIG. 33–51**), designed by Baghdad-born architect Zaha Hadid (b. 1950), who studied in London and established her practice there in 1979. Formally influenced by the paintings of Kazimir Malevich (SEE FIG. 32–25), the Vitra Fire Station features reinforced concrete walls that lean into one another, meet at unexpected angles, and jut out dramatically into space, denying a sense of visual unity or structural coherence but creating a feeling of immediacy, speed, and dynamism appropriate to the building's function.

The Toronto-born, California-based Frank O. Gehry (b. 1929) also creates dynamic Deconstructivist forms with curved, winglike shapes that extend far beyond the solid masses of his buildings. One of his most spectacular designs is the **GUGGENHEIM MUSEUM** in Bilbao, Spain (**FIG. 33–52**). In the 1990s, the designing of art museums became more and more spectacular as they increasingly came to define the visual landscape of cities. Gehry developed his asymmetrical design using a CATIA CAD program that enabled him to create a powerfully organic, sculptural structure. The complex steel skeleton is covered by a thin skin of silvery titanium that shimmers gold or silver depending on the time of day and the weather conditions. From the north the building resembles a living organism, while from other angles it looks like a giant ship, a reference to the industry on which Bilbao has traditionally depended, thereby identifying the museum with the city. Despite the sculptural beauty of the museum, however, the interior is a notoriously difficult space in which to display art, a characteristic this building shares with Wright's spiraling design of the New York Guggenheim (SEE FIG. 33–33), a notable forebear of Gehry's explorations of the sculptural potential of architecture.

33–51 Zaha Hadid
VITRA FIRE STATION, WEIL-AM-RHEIN
Germany. 1989–1993.

Credit: © F1 ONLINE/ SuperStock

33–52 Frank O. Gehry **GUGGENHEIM MUSEUM, BILBAO**
Spain. 1993–1997. Sculpture of spider in foreground: Louise Bourgeois (1911–2010), *Maman*, 1999.

Credit: © AAD Worldwide Travel Images/Alamy Stock Photo

Contemporary Art in an Expanding World

What are some ways that artists since the 1990s have synthesized aesthetic interests, social content, and political activism in their work?

Since the 1990s, the art world has mirrored the multiplicity and connectivity of today's global culture. Artists look to the alternative practices, ideas, and formats that emerged in the latter half of the twentieth century, as well as to traditional media like painting and photography, adapting them in many ways to produce new works that respond to a rapidly changing culture. The popularity of postwar art has exploded in recent years. New museums devoted to its display are on the rise; many, like the Broad in Los Angeles, have been opened by private collectors. In addition to long-held international exhibitions like the Venice Biennale and Documenta, in Kassel, West Germany, international exhibitions now occur regularly in places such as Sharjah in United Arab Emirates, Gwanju in China, and Havana, Cuba. These offer curators a global stage on which to explore broad themes and changing ideologies, and generate extensive—often contentious—critical response. A similar proliferation of art fairs like Art Basel in Switzerland allows artists, dealers, and collectors to gather throughout the year. All this has led to unprecedented growth in the international art market, which reached $53.9 billion in 2014, with Modern and contemporary art accounting for 48 percent of total sales. That this boom has occurred at a time when many people are experiencing financial and political hardship raises issues of art's continued elitism, with critics pointing to the relatively small number of artists and collectors who participate in these major events.

Globalization and the Art World

Globalization refers to the expanding economic, social, and cultural network that has developed through transnational trade agreements, economic unions, and advancements in digital communication since the 1990s. Postcolonial discourse has long warned of the excessive influence of industrialized nations on developing countries—and as the world becomes smaller, anxieties arise about the effects of globalization on national identity and cultural heritage. There are also increasing conflicts over religious differences and political control. Artists like Shirin Neshat and Yinka Shonibare (SEE FIG. 29–25) highlight the complexity of these issues, forcing us to acknowledge our cultural biases and to recognize our shared histories, entwined by the legacy of imperialism.

Born in Iran in 1957, Neshat moved to the United States in 1974. She returned to Iran for the first time in 1993 to see the country transformed by the fundamentalist regime that came to power with the 1979 Islamic Revolution. Soon afterward, Neshat began to create beautifully poetic photographs and films that explore complicated realities of gender, religion, and cultural difference. In her 1994 "Women of Allah" series, she exposes Western stereotypes of Muslim women, claiming their identities are more

varied and complex than usually assumed. Typical of the series, **REBELLIOUS SILENCE** (FIG. 33–53) is a black-and-white photograph of a woman clad in a traditional chador. The woman's face is exposed, and Neshat has inscribed on the photograph, in Farsi, text from a twentieth-century Iranian female writer. A rifle barrel runs vertically through the composition, bisecting the woman's figure. Like the veil covering her body, the calligraphy and gun seem to protect the woman and show how little we understand her. She looks out to meet our gaze, challenging beliefs about submissive Muslim women and reinforcing fears of fundamentalist Islamic militarism. Produced for Western audiences, the image's meaning remains unclear as Neshat confronts our national prejudices and raises questions about the role of women in post-revolutionary Iran.

Wenda Gu (b. 1955) studied traditional ink painting at China's National Academy of Fine Arts before emigrating to the United States in 1987. In 1992, he began the ongoing project "United Nations Series" that now includes more than 20 "monuments," which highlight the histories and traditions of particular countries. These large-scale installations are constructed with transparent walls and screens of human hair collected from the floors of hairdressers around the world and woven to create lacelike patterns and pseudo-characters based on Chinese, English, Arabic, and Hindi languages. Although the text appears readable, closer scrutiny shows it to be Gu's own invented script. His point is that in a global society our understanding of one another may be fragmented, misunderstood, or incorrect.

Gu references an imperial altar from the Ming dynasty in **CHINA MONUMENT: TEMPLE OF HEAVEN** (FIG. 33–54),

33–53 Shirin Neshat **REBELLIOUS SILENCE**
1994. Black-and-white RC print and ink (photograph by C. Preston), 11 × 14″ (27.9 × 35.6 cm). Barbara Gladstone Gallery, New York.

Credit: © Shirin Neshat. Courtesy Gladstone Gallery

33–54 Wenda Gu **CHINA MONUMENT: TEMPLE OF HEAVEN**

1998. Installation with screens of human hair, wooden chairs and tables, and video. Commissioned by the Asia Society. Permanent collection of the Hong Kong Museum of Art.

Credit: © Wenda Gu. Photo by Jiang Min

33–55 Felix Gonzalez-Torres **"UNTITLED" (LOVERBOY)**

1990. Blue paper, endless supply, at ideal height 7½ × 29 × 23″ (19.1 × 73.7 × 58.4 cm). Installation view at Andrea Rosen Gallery, New York, 1990.

Credit: © The Felix Gonzalez-Torres Foundation. Courtesy of Andrea Rosen Gallery, New York. Photo: Peter Muscato

commissioned in 1998 by the Asia Society in New York. Draped curtains, made from hair collected in China, New York's Chinatown, and other American cities, enclose the space around a meditation area. Video monitors in chairs project images of clouds and sky while music of ancient Chinese bells plays in the background. Gu's goal to bring all people together may seem utopian, but he feels his dream can be "fully realized in the art world."

The Body in Contemporary Art

An important theme throughout art history, the body was central to postwar artists who sought to demonstrate art's relationship to human life, experience, and identity. While such concerns remained prominent, they took on new dimensions in the wake of the AIDS epidemic. For many artists, the body offered a universal metaphor to explore the material, psychological, and philosophical questions inherent to the human condition. AIDS activists highlighted the physical effects of the disease, linking it to emotional pain and suffering felt by others, even those not personally afflicted. The Culture Wars had railed against artists who incorporated graphic imagery or used the body to explore gender and sexuality—but these strategies brought new attention to the body's material reality and physiological functions and led artists throughout the 1990s to address topics, traditionally suppressed by societal taboo, that delve deep into the psychological effects of our most basic instincts.

THE IMPACT OF AIDS ON ART In 1981, reports emerged about a mysterious disease that seemed to be affecting gay men. Over the next decade, society came to learn that the disease—named Acquired Immune Deficiency Syndrome in 1983—was caused by the human immunodeficiency virus (HIV), a blood-borne, sexually transmitted virus that could live for years in the carrier's

body and be unknowingly passed to others, regardless of gender or sexual orientation. By the mid-1980s AIDS was declared a global epidemic, and by 1994 it was the leading cause of death among all Americans between 25 and 44. Throughout the 1980s, uncertainty about how it was spread led to paranoia among the general public, and the disproportionate impact of AIDS on the gay community, bolstered by preexisting stigmas about homosexuality, led some to disregard the seriousness of the epidemic. During this time, the rapid spread of AIDS, its physical effects on the body, and the loss of thousands of people—most in the prime of life—had a profound effect on the arts community. Many artists adapted activist strategies to educate the public about the disease and to call for government action. Others, inspired by their own suffering and loss, created artworks confronting human emotions such as anger, love, grief, and hope.

Felix Gonzales-Torres (1957–1996) infused Minimalism's preference for spare geometries, repetition, and mass-produced materials with deeply personal meaning in works that offer profound statements on human mortality. He created **"UNTITLED" (LOVERBOY)** (FIG. 33-55) in 1990 when his longtime partner, Ross Laycock, was dying from AIDS. The piece was deceptively simple: A stack of pale blue paper sat on the gallery floor with instructions for visitors to take a sheet with them. As the sheets were removed, the vertical stack gradually diminished in height, an allegory of the slowly disappearing body of Gonzalez-Torres's partner. Similarly, in *"Untitled"* of 1991 the artist created a mound of individually wrapped candies totalling 175 pounds—his partner's ideal weight—which viewers were invited to take away with them, thus realizing the meaning in the work and carrying with them a small reminder of its purpose. By involving the viewer as a participant, Gonzalez-Torres transformed a story of individual loss into a political act that called attention to the social impact of the AIDS epidemic, as well as a lasting memorial to those who had died. Gonzalez-Torres himself died of AIDS in 1996.

David Wojnarowicz (1955–1992), another artist lost to AIDS, found inspiration for his photographs, films, and books in the stories of people he met while living on the

33–56 David Wojnarowicz **UNTITLED (HANDS)**
1992. Silver print with silkscreened text, 38 × 26″ (96.5 × 66 cm). Courtesy of the estate of David Wojnarowicz and PPOW Gallery, New York.

Credit: Courtesy of the estate of David Wojnarowicz and PPOW Gallery, New York

streets after leaving an abusive home. His frequent combination of imagery with lengthy passages of texts suggests a need to give voice to those marginalized by society. Around 1987, when faced with the death of his lover, photographer Peter Hujar, and his own diagnosis as HIV-positive, Wojnarowicz began to focus his art on the feelings involved in watching a loved one die while facing one's own mortality. **UNTITLED (HANDS)** (FIG. 33–56) shows a black-and-white photograph of two outstretched hands, bound by white bandages that suggest human pain, suffering, and the need for compassion. Superimposed is an angry text in red type taken from Wojnarowicz's book *Memories That Smell Like Gasoline*, in which he describes himself hollowing out from the inside and becoming invisible as he dies. Wojnarowicz's work can often be disturbing in its graphic imagery and allusion to religious symbolism. A frequent target of critics during the Culture Wars of the 1990s, it remains controversial even today.

The **AIDS MEMORIAL QUILT** (FIG. 33–57) is an ongoing effort to address personal loss and political issues brought about by the AIDS epidemic. Quilts have historically served a

33–57 THE AIDS MEMORIAL QUILT
1987–present. Photograph taken at the Mall, Washington DC on October 12, 1996.

Credit: © Evan Agostini/ Getty Images

community purpose, often made collectively to mark life events like marriages and births and to preserve cultural history and beliefs. Growing out of the gay community in San Francisco, the *AIDS Memorial Quilt* builds on this tradition to educate the public and create a lasting tribute to thousands of individuals who have lost their lives to AIDS. Gay-rights activist Clive Jones began the *Quilt* in the mid-1980s. Each 3 by 6 foot panel is sewn by friends, families, and lovers to commemorate an individual lost to AIDS. The panels are then organized in 8-panel, 12-foot-square blocks that can be exhibited separately. An assembly of 1,920 panels was displayed on the National Mall in Washington, DC in 1987 as a visual demonstration of the scale of the epidemic and to incite a call for government action toward research and education preventing its spread. In 1989, the project was nominated for a Nobel Peace Prize. Today, the quilt includes 48,000 panels in remembrance of over 94,000 individuals, and it is still growing. The NAMES Project Foundation, an international nonprofit organization, continues this work by inviting participants to create new memorial panels, organizing exhibitions of the *Quilt* around the world, and maintaining an archive of each person's name in a searchable online database.

THE MATERIAL BODY Kiki Smith (b. 1954), whose sister died of AIDS, focuses on the body's materiality and loss of physical control in **UNTITLED** (**FIG. 33–58**), in which two life-size, naked figures, female and male, hang limply side by side about a foot above the ground. Milk appears to drip from the woman's breasts and semen down the man's leg, as if both figures have lost control of bodily functions that were once a source of vitality and pleasure. Reflecting the influence of process-based artists like Hesse, the flesh-colored beeswax contributes a tactility that underscores Smith's visceral content. She points out that the societal demand that we conceal and control bodily functions makes our inability to maintain them when sick and dying humiliating and frightening. Acceptance of our body's reality generates a profound sense of loss, but also of release and liberation. Like essentialist feminists who gave voice to female experience by representing taboo subjects like menstruation, Smith calls attention to the body that cannot be controlled and asks us to consider the impact of this repression.

Along with Ofili, Damien Hirst (b. 1965) is one of the so-called "YBAs," or Young British Artists. Hirst first gained notoriety in the 1990s for his outrageous behavior

33–58 Kiki Smith **UNTITLED** 1990. Beeswax with microcrystalline wax figures on metal stands; female figure installed height 6'1½" (1.87 m), male figure 6'4¹⁵⁄₁₆" (1.95 m). Whitney Museum of American Art, New York.

Credit: © Kiki Smith, courtesy Pace Gallery. Photo: Jerry L. Thompson

33–59 Damien Hirst **MOTHER AND CHILD (DIVIDED), EXHIBITION COPY 2007 (ORIGINAL 1993)**
2007. Glass, painted stainless steel, silicone, acrylic, monofilament, stainless steel, cow, calf, and formaldehyde solution; two tanks at 82⅓ × 126⅞ × 43″ (209 × 322 × 109 cm), two tanks at 45 × 66½ × 24⅝″ (114 × 169 × 62.5 cm). Photo: Prudence Cuming Associates.

Credit:

and shocking artwork that he continues to produce. An example is *For the Love of God* (2007), a diamond-encrusted human skull with an asking price of $100 million. Despite its sensationalism, the object speaks to Hirst's persistent interest in death and philosophical questions involving mortality and spiritual existence. Many of his works feature dead and preserved animals. In **MOTHER AND CHILD (DIVIDED)** (**FIG. 33-59**), Hirst bisected vertically and longitudinally the bodies of a cow and her calf and displayed them in glass cases filled with formaldehyde solution. This sculpture resembles a display in a natural history museum, but here viewers can walk around and between the cases. From the outside, the animals look amazingly lifelike (even their eyelashes and individual hairs are visible), preserved inside the brilliant blue formaldehyde solution, but once we see the cleavages in their bones, muscles, organs, and flesh on the "inside" sides of the cases, the reality of the dead carcasses is overwhelming. Hirst also plays on the art historical theme of the mother and child, iconic in Christian tradition, to symbolize the union of earthly and spiritual realms. *Mother and Child (Divided)* suggests that we are caught between the separation of life and death, between mother and child, and between scientific reality and our own fears and emotions.

Between 1994 and 2002, Matthew Barney (b. 1967) created a series of films entitled "The Cremaster Cycle" in which he developed an arcane sexual mythology drawing on Celtic legend, Masonic ritual, Mormonism, and the life of Harry Houdini. The concept of biological mutability dominates the narrative, which questions gender assignation and roles throughout. The cremaster muscle, for which the series is named, controls the ascent and descent of the testes, usually in response to changes in temperature but also in response to fear or sexual arousal. It also determines sexual differentiation in the human embryo. Barney uses a diagrammatic representation of the cremaster muscle as his visual emblem throughout the series.

Each film has its own complex narrative and catalog of multilayered symbols. *Cremaster 3* from 2002 describes the construction of the Chrysler Building in New York and features the artist Richard Serra as the architect. In one segment, the Solomon R. Guggenheim Museum in New York is the setting where Barney, playing Serra's apprentice, dressed in a peach-colored kilt and gagged, must accomplish a series of tasks to assert his supremacy over the master. Barney scales the walls of the rotunda to complete a task on each level before gaining enlightenment. Along the way he encounters a series of challenges—a line of Rockettes dressed as Masonic lambs; warring punk-rock bands; a leopard woman played by the double-amputee athlete; model, and speaker Aimee Mullins; and finally Serra, throwing molten wax down the museum's spiraling ramp in a nod to the sculptor's famous casting of process-based works out of lead in the 1960s. The settings and costumes are lavish, and the epic plot is complex and enigmatic.

33–60 Matthew Barney **CREMASTER 3: MAHABYN**
2002. 46½ × 54 × 1½" (118 × 137 × 3.8 cm).

Credit: © Matthew Barney, courtesy Barbara Gladstone Gallery (Part of the Cremaster Cycle 1994–2002). Photo: Chris Winget

In **MAHABYN** (**FIG. 33–60**), from *Cremaster 3*, Barney and the leopard woman transform by donning modified Masonic costumes. While the meaning remains ambiguous, the extravagant work seems to refer to a crisis among white, middle-class, heterosexual male artists in an era exploring difference and identity.

New Approaches to Painting and Photography

Gerhard Richter (b. 1932) studied art in Soviet-controlled Dresden before moving in 1961 to West Germany where he first learned about Pop Art and Fluxus. Although Richter consistently identifies as a painter, his work's underlying conceptualism characterizes much painting of the contemporary period. Rejecting the expectation that artists demonstrate only one "signature" style, Richter has worked throughout his career simultaneously in abstract and representational styles, often using photographic sources as the basis for his work. **MAN SHOT DOWN (1) ERSCHOSSENER (1) FROM OCTOBER 18, 1977** (**FIG. 33–61**) is from Richter's 1988 series based on newspaper reports in 1977 about three members of the Red Army Faction, an anticapitalist terrorist group known as the Baader-Meinhof Gang, who were found dead in their prison cells. Although the deaths were ruled as suicides, suspicions arose about whether the German government had been responsible. In life-size paintings, Richter reproduces in blurry detail the grainy black-and-white photographs that appeared in the press. His direct reproduction questions the powerful role of the mass media to shape historical events, the ability of photography to create cultural and personal memories of the past, and the value of the hand of the artist, even when, as in this case, it is almost invisible.

33–61 Gerhard Richter **MAN SHOT DOWN (1) ERSCHOSSENER (1) FROM OCTOBER 18, 1977**
1988. Oil on canvas, 39½ × 55¼" (100 × 140 cm). Museum of Modern Art, New York. The Sidney and Harriet Janis Collection, gift of Philip Johnson, and acquired through the Lillie P. Bliss Bequest (all by exchange); Enid A. Haupt Fund; Nina and Gordon Bunshaft Bequest Fund; and gift of Emily Rauh Pulitzer (169.1995.g.).

Credit: © Gerhard Richter

33–62 Jeff Wall **AFTER "INVISIBLE MAN" BY RALPH ELLISON, THE PREFACE**
1999–2001. Transparency in lightbox, 68½ × 98⅝" (174 × 250.5 cm).

Credit: Courtesy Marian Goodman Gallery

One of the Pictures generation of artists, Jeff Wall (b. 1946) uses multiple photographs and elaborate stage sets to create large-scale visual narratives that he compares to nineteenth-century history paintings. Wall exhibits these as brilliantly colored transparencies mounted in lightboxes—a format used in advertising that also recalls the cinema. He works like a movie director, carefully designing sets and posing actors to photograph, then digitally combining multiple images to create the final transparency. **AFTER "INVISIBLE MAN" BY RALPH ELLISON, THE PREFACE** (**FIG. 33–62**), is an elaborate composition; it took 18 months to design and construct the sets and 3 weeks to take the photographs. Basing the work on Ralph Ellison's 1951 novel about a young African-American man struggling to find recognition in a racially divided society, Wall depicts a scene from the book's prologue where the narrator explains that he's retreated to an underground cellar, lit by 1,369 lightbulbs, to write his story.

African-American painter Kerry James Marshall (b. 1955) also looks to narrative history painting to address contemporary issues of race, class, and poverty in the United States. **MANY MANSIONS** (**FIG. 33–63**) is one of Marshall's series of five paintings based on public housing projects. The work refers to Chicago's Stateway Gardens,

which was one of the largest and worst-maintained housing projects in America before its demolition in 2007. Playing on the irony of the development's name, Marshall depicts three well-dressed African-American men tending a garden of manicured topiary, flowerbeds, and cellophane-wrapped Easter baskets before the high-rise buildings in the background. The painting includes other biting elements, including the red ribbon at the top with the inscription "In my mother's house there are many mansions," twisting the gender of a biblical reference to God (John 14:2) and offering derisive commentary on the housing conditions. Adding to the fantasy are two bluebirds, like those in a Disney cartoon, which carry a light blue ribbon that reads "Bless our happy home" to place above the seal of the Chicago Housing Authority. Based on Géricault's *The Raft of the Medusa* (SEE FIG. 30–51), Marshall's triangular composition lends his subject the dramatic heroism of history painting. Similarly, the visible drips and patches of loosely applied paint refer to Abstract Expressionism, but here they look more like graffiti and whitewashing done to mask urban blight.

Born in Ethiopia, Julie Mehretu (b. 1970) builds on the abstraction pioneered by Kandinsky and other early Modern artists to give visual form to complex systems and

33–63 Kerry James Marshall **MANY MANSIONS**

1994. Acrylic on paper mounted on canvas, 114¼ × 135⅛" (290 × 343 cm). The Art Institute of Chicago. Max V. Kohnstamm Fund (1995.147).

Credit: Image courtesy of the artist and Jack Shainman Gallery, NY. Photo © The Art Institute of Chicago

global networks. Her highly finished paintings, made from thinly applied layers of translucent paint built up and polished, have a smooth, waxy-looking surface. Working on a monumental scale, Mehretu employs a rich vocabulary from sources that include architectural drawings, maps, graffiti, and aerial photographs. One of a triptych of paintings created for the 2004–2005 Carnegie International, **STADIA II** (FIG. **33-64**) captures the excitement and energy of major athletic events by layering fragmented architectural drawings of sports arenas from around the world. Mehretu uses the subject to address themes of national identity, commerce, entertainment, and conflict. Colorful geometric shapes suggest flags and banners denoting cultural and team alliances, and superimposed graphic elements unify the composition while also contributing dynamism and a sense of chaos.

33–64 Julie Mehretu **STADIA II**

2004. Ink and acrylic on canvas, 107⅜ × 140⅛ × 2¼" (272.73 × 355.92 × 5.71 cm). Gift of Jeanne Greenberg Rohatyn and Nicolas Rohatyn and A.W. Mellon Acquisition Endowment Fund.

Credit: © Julie Mehretu. Courtesy of the artist, Marian Goodman Gallery and White Cube. Photo by Richard Stoner

The New Formalism

During the 1990s, a new aesthetic emerged that is seen clearly in sculpture and large-scale installations. Different from Greenberg's reductive ideas, this contemporary tendency shows a renewed interest in the potential meanings associated with artists' materials and technical processes. Drawing on Process art and feminist appropriation of craft practices in the 1970s, artists today choose from a range of formal strategies to produce visual, tactile, and spatial sensations for the viewer—all of which work together to form the artwork's content. This desire to engage the viewer aesthetically makes these recent works different from their mid-twentieth-century predecessors, which adopted an anti-aesthetic stance to emphasize their conceptual underpinnings and prevent expressive readings.

Today, sculptors produce frankly beautiful works of art, like Anish Kapoor's *Cloud Gate* in Chicago's Millennium Park and Serra's breathtaking series of mammoth torqued ellipses and spirals. Others like Ann Hamilton and Olafur Eliasson offer joyous site-specific installations, commissioned to fill the large spaces museums have built to accommodate such ambitious projects. Likewise, artists like Martin Puryear, Cat Mazza, and El Anatsui (SEE FIG. 29-21) have redefined contemporary craft arts by exploring materials, production methods, conceptual practices, and modes of display that reject craft's once marginalized place in the world of fine art.

CRAFT AND CRAFTSMANSHIP Although the clarity and scale of Martin Puryear's abstract sculptures suggest a Minimalist influence, his emphasis on technique reflects ideas of Process art. But unlike these earlier movements, Puryear's art draws on vernacular craft traditions that value the handmade object and highly skilled workmanship. Puryear (b. 1941) learned woodworking from African carvers while in Sierra Leone with the Peace Corps. He later studied traditional furniture-making techniques used in Scandinavia and the United States before pursuing an MFA in sculpture at Yale University.

In **PLENTY'S BOAST** (FIG. 33-65), Puryear highlights the sculpture's visible joints and natural materials. He exploits the grain of the wood in the radiating lines inside the horn and spirals around the tail. His attention to detail is further revealed in the precision of his joining method, the irregular hand-finished surfaces on the mouth of the sculpture, and the binding of its tail. But Puryear's work diverges from traditional craft by lacking the practical function of furniture or a well-built cabinet. And while he wants viewers to appreciate the aesthetic qualities of his work, his forms create many allusions. The bell shape of *Plenty's Boast* may be seen as a musical horn, an old-fashioned gramophone horn, a flower's bell, or most likely, a cornucopia (horn of plenty) filled with the fruits of harvest and symbolizing abundance. Ironically, however, this cone is empty, implying an "empty boast"—a phrase suggested by the title.

A socially minded artist committed to working in the public realm, David Hammons (b. 1943) is an outspoken critic of the gallery system, arguing that art must intervene in society in order to resist commercialization and encourage action. In **UNTITLED** (FIG. 33-66), he makes a provocative statement asserting the place of African Americans within American culture. Traditionally sewn by hand, flags are deeply meaningful objects that publically proclaim national identity, political alliance, and ideological values through abstract forms and colors. Originally created in 1990 for the Studio Museum in Harlem, Hammon's flag responded to a controversy about the flying of the Confederate flag

33-65 Martin Puryear
PLENTY'S BOAST
1994–1995. Red cedar and pine. 68 × 83 × 118" (172.7 × 210.8 × 299.7 cm) The Nelson-Atkins Museum of Art, Kansas City, Missouri. Purchase of the Renee C. Crowell Trust (95-16 A-C).

Credit: © Martin Puryear. Courtesy Matthew Marks Gallery, New York

33–66 David Hammons **UNTITLED (AFRICAN-AMERICAN FLAG)**

2004. Custom appliqued, single-reverse nylon flag, 72" x 120" (1.83 x 3.05m). Studio Museum, Harlem. Gift of the artist.

Credit: The Studio Museum in Harlem. Photo: Marc Bernier

under apartheid. In the film, the medical examination of Soho Eckstein—a greedy white businessman character in several of Kentridge's films—symbolizes white South Africans recognizing their responsibility for the suffering under apartheid. Kentridge describes drawing as an act of compassion and redemption. He explains that he finds sympathy for others through the extended contemplation and time spent studying his subjects, and that this process redeems his appropriation of their pain as the raw material for his art.

IMMERSIVE INSTALLATION The site-specific installations of Ann Hamilton (b. 1956) demonstrate the intersection of craft tradition, conceptual practice, and immersive experience in contemporary art. Hamilton uses sensual materials like horsehair, fabric, and audiovisual elements, as well as live animals and performers, to evoke a range of emotional and physical responses in viewers. Trained in textile design, she often uses sewing and weaving as metaphors for social interactions that she feels are rooted in the body. For example, her 2012 installation at New York's Park Avenue Armory, *In the Event of a Thread,* relied on visitors to raise and lower a billowing white curtain, set in motion by giant swings that controlled a web of strings and pulleys on the ceiling.

Hamilton's installations respond to the architectural conditions and social histories of their particular sites. **MYEIN** (**FIG. 33–68**), created for the 1999 Venice Biennale, was inspired by the Neoclassical building that housed the

on public buildings in some states. By replacing the colors of the flag of the United States with those of the Pan-African Flag, adopted by the Universal Negro Improvement Association and African Communities League in 1920 as a symbol of liberation for all people of African descent, Hammons counters the racist implications of the Confederate emblem and suggests that African Americans are integrated into the very fabric of American society.

South African artist William Kentridge (b. 1955) explores difficult themes like violence, pain, and social justice in animated films made more affecting by his expressive drawing style and narrative structure. Kentridge creates each scene by filming a large charcoal drawing, which he erases and redraws to advance the narrative. This physical process is visible in the final film as trace markings appear and disappear throughout each scene. Created from 20 individual drawings, **HISTORY OF THE MAIN COMPLAINT** (**FIG. 33–67**) was made in 1996, soon after South Africa established the Truth and Reconciliation Commission to conduct public hearings of civil rights abuses that had taken place

33–67 William Kentridge **HISTORY OF THE MAIN COMPLAINT**

1996. Stills. Film, 35 mm, shown as video, projection, black and white, and sound (mono), 5 min. 50 sec. Courtesy Marion Goodman Gallery, New York.

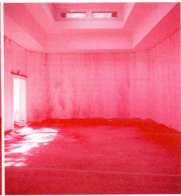

33–68 Ann Hamilton **MYEIN**

1999. Installation at the United States Pavilion, 48th Venice Biennale, 1999.

Four skylights, glass and gridded steel wall [18 × 90′ (5.4 × 27.4 m)], wood table, white cloths, mirrored glass, vinyl powder, auger system, electronic controllers, plaster, recorded voice, digital audio, computer, 16 speakers.

Credit: © Ann Hamilton

United States Pavilion and by Hamilton's interest in the darker parts of American history that are invisible or unspoken, although we know they exist. This is reflected in her title, an ancient Greek word meaning "to close the eyes or mouth," which also refers to the practice of medieval cults keeping their initiation rites secret. For the installation, Hamilton surrounded the pavilion with a 90 by 16-foot glass wall that blurred the building's façade, suggesting movement and alluding to the perceptual distortions caused by the passage of time. Inside, words by the poet Charles Reznikoff describing human suffering and injustice in the United States were written in Braille on the white walls. Fine fuchsia powder fell from the perimeter of the ceiling, collecting on the raised Braille surfaces and pooling in bright areas on the floor. The installation also included a soundtrack in which Abraham Lincoln's second Inaugural Address was whispered in phonetic code to make the words indecipherable. The effect was haunting yet beautiful and reflected Hamilton's goal to call attention to unspoken histories that remain mysterious and cryptic.

Kara Walker (b. 1969) uses installation as a strategy to involve, and perhaps implicate, her viewers. She has said, "It's interesting that as soon as you start telling the story of racism you start reliving it." In **DARKYTOWN REBELLION** (**FIG. 33–69**) she depicts a story about slave revolt and massacre. Based on eighteenth-century craft tradition, Walker's large-scale silhouettes are cut out of black construction paper, then applied to gallery walls to tell an unfolding tale of horror. Like the nightlight in a child's room, beautiful yellow, pink, and blue lights swirl through the gallery, but they reveal nightmarish shadows dancing across the walls. As we walk around the space, we step in front of the light source, casting our own shadows that insert us into the narrative. Set in the antebellum American South, Walker's stories draw variously from slave narratives, minstrel shows, advertising

33–69 Kara Walker **DARKYTOWN REBELLION**

2001. Cut paper and projection on wall, 14 × 37′ (4.3 × 11.3 m) overall. Installation view of "Kara Walker: My Complement, My Enemy, My Oppressor, My Love", Walker Art Center, Minneapolis, 2007. Collection Musée d'Art Moderne Grand-Duc Jean (MUDAM), Luxembourg.

Credit: © Kara Walker/Courtesy of Sikkema Jenkins & Co., New York. Photo: Dave Sweeney

33–70 Olafur Eliasson **THE WEATHER PROJECT**
2004 installation, Turbine Hall, Tate Modern, London.

Credit: © Olafur Eliasson. Photo: Jens Ziehe. Courtesy of the artist; neugerriemschneider, Berlin; Tanya Bonaker Gallery, New York

memorabilia, and even Harlequin romance novels, blending fiction and fact to evoke a history of oppression and terrible violence. Her grotesque rendering of plantation life can be an uncomfortable experience, forcing us to confront racial stereotypes and fears, as well as our culpability in maintaining them.

The growing popularity—and scale—of contemporary art propelled a wave of expansive projects in museums around the world. When London's Tate Gallery decided to relocate its Modern and contemporary art collections into a refurbished power plant, they transformed the Turbine Hall, an enormous area where the building's electric generators once stood, into an impressive entry for the new museum. Measuring 115 by 375 feet, it provides an ideal site for monumental installations, and the Tate launched the Unilever Series, which commissions artists to create temporary works specifically for this vast open space. Projects have included a large crack that ran the length of the concrete floor (Doris Salcedo, *Shibboleth*, 2007) and choreographed encounters that encouraged conversations among strangers who crowd the hall (Tito Seghal, *These Associations*, 2012). In **THE WEATHER PROJECT** (**FIG. 33–70**), Danish artist Olafur Eliasson (b. 1967) covered the entire ceiling with foil mirrors to visually double the massive hall, which he filled with an artificially generated foglike mist. At one end of the hall, he placed a semicircular screen backlit by 200 mono-frequency lights that, when reflected in the mirrors, created the illusion of a giant yellow sun shining brilliantly in a darkened sky.

Eliasson based the project on his notion that weather is one of the few authentic ways that city dwellers interact with nature. His goal was to bring the city into the museum and to encourage visitors to take the memory of their experience back outside. Visitors were overwhelmed by the immense scale and simple beauty of the installation. People gathered, wandered around, and even lay down on the floor to enjoy the soft, golden light that permeated the space. While such reactions may recall the Romantic landscape painters' pursuit of the sublime, Eliasson instead hoped to highlight the artifice of the encounter imposed by the museum context. By exposing the wires and mechanical devices used to create the illusion, he asked viewers to question their experience, perhaps contrasting it to real moments they spent in nature.

Activist Strategies and Participatory Art

Like the AIDS activists discussed earlier, many contemporary artists assume an intentionally political stance, turning their attention to the shifting social causes and current issues that garner public concern. Activist art today relies on practices used by conceptual artists in the 1960s and 1970s for institutional critique and by collectives like the Art Workers' Coalition, formed in New York in 1969, and Situationist International, active throughout the 1960s. Their influence is especially apparent in projects that enlist viewers directly as agents of social protest and change. Sometimes called Social Practice, this art encompasses a range of participatory strategies that work outside traditional contexts to engage directly with the public, government, or other institutions to realize the artists' activist goals. One example is Conflict Kitchen, a take-out restaurant in Pittsburgh that serves food that is traditional in countries currently in conflict with the United States. Started in 2010 by Jon Rubin and Dawn Weleski, art professors at Carnegie Mellon University, the project builds on the dynamics of sharing a meal to encourage diners to converse and learn about these other cultures. The Internet and social media have also provided artists with a tool to

spread their message, as in the case of Chinese artist Ai Weiwei who, despite Chinese government restrictions on his travel from 2011 to 2015, was able to maintain contact with an international audience.

In the late 1980s, Polish-born Canadian artist Krzysztof Wodiczko (b. 1943) designed the **HOMELESS VEHICLE** (**FIG. 33-71**) in collaboration with homeless people in New York. The vehicle, shown in art exhibitions and prototyped on the streets, was intended to draw attention to the problem of homelessness in New York. Recalling Constructivist product design, the *Homeless Vehicle* includes an extendable metal pod for sleeping, washing, or toilet needs, baskets underneath to store belongings and cans that could be sold, and a brightly colored flag to signal approach. Wodiczko explains its use as "both communication and the transport; a vehicle that could articulate the real conditions of work and life and the resistance of this group" instead of the stolen grocery carts often linked to the homeless. Critics of his work say that the project undermines efforts to help homelessness because it does not address the systemic roots of the problem.

Another of the YBAs, sculptor Rachel Whiteread (b. 1963) made her reputation by casting the inside of ordinary objects like mattresses or book shelves, thus transforming overlooked negative spaces into poignant memorials alluding to absence and loss. Made with materials like rubber, resin, and plaster, Whiteread's work has the spare appearance of Minimalist sculpture, but visible details offer hints to its functional origins. Whiteread addressed the invisibility of the British working classes in **HOUSE** (**FIG. 33-72**). She sprayed liquid concrete on the inner walls of a three-story Victorian row house before it was carefully dismantled, leaving a ghostlike replica in its place. The project took place in the Grove Road area of London's East End, where the last row of the Victorian houses that had originally filled the area was slated to be demolished by developers. Over the years, similar projects had effectively erased all vestiges of the community by replacing the row houses with high-rise apartments and other structures. Like much of Whiteread's work, *House* is about the memories

contained in places and times and how easily they can be lost. Whiteread intended *House* as a political statement about development practices in England and "the ludicrous policy of knocking down homes like this and building badly designed tower blocks which themselves have to be knocked down after 20 years." The publicity surrounding Whiteread's project, which occurred at the same time as she won the prestigious Turrner Prize, succeeded in bringing these critical issues to the public's attention.

American artist Patricia Cronin (b. 1963) employs many artistic formats for her politically charged subjects. Addressing themes of homosexuality, feminism, and art history, Cronin's work supports her goal of raising public awareness of these issues. **SHRINE FOR GIRLS** (FIG. 33–73) presented in conjunction with the 2015 Venice Biennale, appeared at the sixteenth-century church of San Gallo. On the chapel's three marble altars, Cronin placed photographs of young girls next to mounds of clothing to suggest relics of religious martyrs. The monuments referred to incidents of violence against women around the world. Brilliantly colored saris on the central altar related to two Indian teenagers who were gang-raped, murdered, and found strung from trees in 2014. Muslim hijabs (head coverings) were on the altar to the left, representing 276 Nigerian schoolgirls kidnapped in 2014 by Boko Haram militants in Nigeria; the altar on the right displayed uniforms like those worn by women imprisoned and forced to work in Magdalene asylums across Europe and the United States throughout the nineteenth and into the twentieth century.

Cronin's installation exploited the aesthetic contrast of the rich, colorful fabrics and the stone architecture to contribute visual impact and iconographical meaning, and the photographs gave a human face to a problem that might seem far removed from our own experience. Cronin notes that the church context brought about a behavioral change in many visitors, who become quiet and respectful as they viewed *Shrine for Girls.* Cronin's installation was temporary, but she used the opportunity to enlist visitors to do something by creating a website suggesting ways to help end global violence toward women and listing organizations dedicated to this cause.

The Future of New Media

Since the mid twentieth century, artists have continued to explore intersections of scientific and technological innovations and artistic production. Since the 1990s, art has been made using biological and genetic components, robotics, augmented and virtual reality, data visualization, and other web-based platforms that encourage viewer interaction and widespread distribution. Today architects, designers, engineers, computer programmers, scientists, and artists are among the people exploring the creative use of new media, and its potential for growth is enormous. The ongoing expansion of new media presents a new challenge to the old question "What is art?"

Video games are an example of interactive technology that is gaining acceptance as art in museums. Since gaming's emergence in the 1970s, its technology, graphic effects, and popularity have increased exponentially. Advocates argue that, rooted in visual experience, video games are a new development in the way artists and viewers interact that is distinct from video, performance, and other time-based media. Paola Antonelli, senior curator in the Department of Architecture and Design at the Museum of Modern Art in New York, explains that in addition to a game's historical and cultural relevance, its "visual quality and aesthetic experience … and the elegance of the coding to design viewer's behavior" are criteria for inclusion in that museum's collection.

While games like Tetris and Minecraft encourage geometrical problem-solving, **FLOWER** (FIG. 33–74), created by Jenova Chen (b. 1981) and Kellee Santiago (b. 1979) of Thatgamecompany, allows the viewer to assume the

33–73 Patricia Cronin
SHRINE FOR GIRLS
2015. Installation at Chiesa di San Gallo, Campo San Gallo, solo Collateral Event at the 56th Venice Biennale.

33-74 Jenova Chen and Kellee Santiago **FLOWER**

2007. Video game for SONY PS3, color, sound. Smithsonian American Art Museum, Washington, DC. Gift of Thatgamecompany.

Credit: © 2016. Photo Smithsonian American Art Museum/Art Resource/Scala, Florence

role of the wind and navigate through a lush and lyrical landscape, creating their own visual narrative as they are propelled along their path. Having grown up in the dense urban environment of Shanghai, Chen says his inspiration for the game was driving through rolling green hills and pastures on his first visit to California. The goal for *Flower* was to recreate that sensation by allowing the player to fly up and see the scale of the surrounding landscape. He explains, "[Games have] the sense of endlessness, the sense of freedom. You can go anywhere you want." While still images capture the saturated color and pleasing contours that make *Flower* so visually appealing, the game requires the player's interaction to demonstrate its full effects.

In *Flower*, we recognize ideas and themes that have emerged in art since 1950. The reliance on the viewer, the desire to blur the distinction between art and real life, and the synthesis of conceptual origins and aesthetic experience find new form in the intersection of computer animation and interactive design. As the world continues to evolve and develop in ways we cannot yet imagine, artists will certainly advance new theories and explore innovative formats that aim to communicate their interests and offer us alternative perspectives from which to consider the world and our place in it. Although art in the future will no doubt be different from contemporary art today, it will continue its historical tradition to reflect, critique, and document humanity's struggles and accomplishments and to inspire those who encounter it.

Think About It

1 How did the emergence of Pop Art and Minimalism in the early 1960s reflect cultural changes in the postwar United States? Compare and contrast works associated with each movement.

2 In what ways have artists built on the experimental art formats and practices that emerged in the 1950s and 1960s? Choose an example made after 1980 and discuss its relationship to an artistic development in the mid twentieth century.

3 Discuss the changing role of the viewer in art since the 1950s. Choose two examples from this chapter and compare how they engage the viewer.

4 Explain the effect of globalism on art today. What are some of the themes, styles, and characteristics that reflect this influence?

Crosscurrents

Distinguished twentieth-century architects designed private homes as well as large, commercial, religious, or public buildings. Discuss the circumstances that led to the creation of these two famous houses. How do these works fit into the careers of their architects and also engage with the larger concerns of architectural design at the moment when they were built? How is the physical context of each related to its design?

FIG. 32–43

FIG. 33–34A

Glossary

abacus (p. 110) The flat slab at the top of a **capital**, directly under the **entablature**.

abbey church (p. 226) An abbey is a monastic religious community headed by an abbot or abbess. An abbey church often has an especially large **choir** to provide space for the monks or nuns.

absolute dating (p. 12) A method, especially in archaeology, of assigning a precise historical date at which, or span of years during which, an object was made. Based on known and recorded events in the region, as well as technically extracted physical evidence (such as carbon-14 disintegration). See also **radiometric dating**, **relative dating**.

abstract (p. 8) Of art that does not attempt to describe the appearance of visible forms but rather to transform them into stylized patterns or to alter them in conformity to ideals.

academy (p. 942) An institution established for the training of artists. Academies date from the Renaissance and after; they were particularly powerful, state-run institutions in the seventeenth and eighteenth centuries.In general, academies replaced **guilds** as the venues where students learned the craft of art and were educated in art theory. Academies helped the recognition of artists as trained specialists, rather than craftspeople, and promoted their social status. An academician is an academy-trained artist.

acanthus (p. 111) A Mediterranean plant whose leaves are reproduced in Classical architectural ornament used on **moldings**, **friezes**, and **capitals**.

acroterion (pl. **acroteria**) (p. 111) An ornament at the corner or peak of a roof.

Action painting (p. 1091) Using broad gestures to drip or pour paint onto a pictorial surface. Associated withmid-twentieth-century American Abstract Expressionists, such as Jackson Pollock.

adobe (p. 404) Sun-baked blocks made of clay mixed with straw. Also: buildings made with this material.

aedicula (p. 622) A decorative architectural frame, usually found around a niche, door, or window. An aedicula is made up of a **pediment** and **entablature** supported by **columns** or **pilasters**.

aerial perspective (p. 633) See under **perspective**.

agora (p. 140) An open space in a Greek town used as a central gathering place or market. Compare **forum**.

aisle (p. 226) Passage or open corridor of a church, hall, or other building that parallels the main space, usually on both sides, and is delineated by a row, or **arcade**, of **columns** or **piers**. Called side aisles when they flank the **nave** of a church.

akropolis (p. 131) The citadel of an ancient Greek city, located at its highest point and housing temples, a treasury, and sometimes a royal palace. The most famous is the Akropolis in Athens.

album (p. 810) A book consisting of a series of paintings or prints (album leaves) mounted into book form.

allegory (p. 635) In a work of art, an image (or images) that symbolizes an idea, concept, or principle, often moral or religious.

alloy (p. 24) A mixture of metals; different metals melted together.

altarpiece (p. xxxvi) A painted or carved panel or ensemble of panels placed at the back of or behind and above an altar. Contains religious imagery (often specific to the place of worship for which it was made) that viewers can look at during liturgical ceremonies (especially the **Eucharist**) or personal devotions.

amalaka (p. 306) In Hindu architecture, the circular or square-shaped element on top of a spire (*shikhara*), often crowned with a **finial**, symbolizing the cosmos.

ambulatory (p. 228) The passage (walkway) around the **apse** in a church, especially a **basilica**, or around the central space in a **central-plan building**.

amphora (*pl.* **amphorae**) (p. 103) An ancient Greek or Roman jar for storing oil or wine, with an egg-shaped body and two curved handles.

animal style (p. 445) Decoration made of interwoven animals or serpents, often found in early medieval Northern European art.

ankh (p. 51) A looped cross signifying life, used byancient Egyptians.

apartheid (p. 435) A political system in South Africa that used race as grounds for the segregation, discrimination, and political disenfranchisement of nonwhite South Africans. It officially ended in 1994.

appropriation (p. xxiv) The practice of some Postmodern artists of adopting images in their entirety from other works of art or from visual culture for use in their own art. The act of recontextualizing the appropriated image allows the artist to critique both it and the time and place in which it was created.

apse (p. 192) A large semicircular or polygonal (and usually **vaulted**) recess on an end wall of a building. In a Christian church, it often contains the altar. "Apsidal" is the adjective describing the condition of having such a space.

arabesque (p. 270) European term for a type of linear surface decoration based on foliage and calligraphic forms, thought by Europeans to be typical of Islamic art and usually characterized by flowing lines and swirling shapes.

arcade (p. 171) A series of **arches**, carried by **columns** or **piers** and supporting a common wall or lintel. In a **blind arcade**, the arches and supports are **engaged** and have a purely decorative function.

arch (p. 96) In architecture, a curved structural element that spans an open space. Built from wedge-shaped stone blocks called **voussoirs** placed together and held at the top by a trapezoidal **keystone**. It forms an effective space-spanning and weight-bearing unit, but requires **buttresses** at each side to contain the outward **thrust** caused by the weight of the structure. *Corbeled arch*: an arch or **vault** formed by **courses** of stones, each of which projects beyond the lower course until the space is enclosed; usually finished with a **capstone**. *Horseshoe arch*: an arch of more than a half-circle; typical of western Islamic architecture. *Round arch*: an arch that displaces most of its weight, or downward thrust, along its curving sides, transmitting that weight to adjacent supporting uprights (door or window **jambs**, **columns**, or **piers**). *Ogival arch*: a sharply pointed arch created by S curves. *Relieving arch*: an arch built into a heavy wall just above a **post-and-lintel** structure (such as a gate, door, or window) to help support the wall above by transferring the load to the side walls. *Transverse arch*: an arch that connects the wall **piers** on both sides of an interior space, up and over a stone **vault**.

Archaic smile (p. 117) The curved lips of ancient Greek statues in the period c. 600–480 BCE, usually interpreted as a way of animating facial features.

architrave (p. 110) The bottom element in an **entablature**, beneath the **frieze** and the **cornice**.

archivolt (p. 491) A band of **molding** framing an **arch**, or a series of stone blocks that form an arch resting directly on flanking **columns** or **piers**.

ashlar (p. 101) A highly finished, precisely cut block of stone. When laid in even **courses**, ashlar masonry creates a uniform face with fine joints. Often used as a facing on the visible exterior of a building, especially as a veneer for the **façade**. Also called **dressed stone**.

assemblage (p. 1040) Artwork created by gathering and manipulating two- and/or three-dimensional found objects.

astragal (p. 111) A thin convex decorative **molding**, often found on a Classical **entablature**, and usually decorated with a continuous row of beadlike circles.

atelier (p. 790) The studio or workshop of a master artist or craftsperson, often including junior associatesand apprentices.

atmospheric perspective (p. 185) See under **perspective**.

atrial cross (p. 959) A cross placed in the **atrium** of a church. In Colonial America, used to mark a gathering and teaching place.

atrium (p. 160) An unroofed interior courtyard or room in a Roman house, sometimes having a pool or

garden, sometimes surrounded by **columns**. Also: the open courtyard in front of a Christian church; or an entrance area in modern architecture.

automatism (p. 1072) A technique in which artists abandon the usual intellectual control over their brushes or pencils to allow the subconscious to create the artwork without rational interference.

avant-garde (p. 989) Term derived from the French military word meaning "before the group," or "vanguard." Avant-garde denotes those artists or concepts of a strikingly new, experimental, or radical nature for their time.

axis (p. xxviii) In pictures, an implied line around which elements are composed or arranged. In buildings, a dominant line around which parts of the structure are organized and along which human movement or attention is concentrated.

axis mundi (p. 305) A concept of an "axis of the world," which marks sacred sites and denotes a link between the human and celestial realms. For example, in SouthAsian art, the axis mundi can be marked by monumental free-standing decorative pillars.

baldacchino (p. 484) A canopy (whether suspended from the ceiling, projecting from a wall, or supported by columns) placed over an honorific or sacred space such as a throne or church altar.

bar tracery (p. 522) See under **tracery**.

barbarian (p. 152) A term used by the ancient Greeks and Romans to label all foreigners outside their cultural orbit (for example, Celts, Goths, Vikings). The word derives from an imitation of what the "barblings" of their language sounded like to those who could not understand it.

barrel vault (p. 190) See under **vault**.

bas-relief (p. 328) Another term for low relief ("bas" is the French word for "low"). See under **relief sculpture**.

basilica (p. 192) A large rectangular building. Often built with a **clerestory**, side **aisles** separated from the center **nave** by **colonnades**, and an **apse** at one or both ends. Originally Roman centers for administration, later adapted to Christian church use.

bay (p. 171) A unit of space defined by architectural elements such as **columns**, **piers**, and walls.

beehive tomb (p. 100) A corbel-vaulted tomb, conical in shape like a beehive, and covered by an earthen mound.

Benday dots (p. 1108) In modern printing and typesetting, the individual dots that, together with many others, make up lettering and images. Often machine- or computer-generated, the dots are very small and closely spaced to give the effect of density and richness of tone.

bilum (p. 880) Netted bags made mainly by women throughout the central highlands of New Guinea. The bags can be used for everyday purposes or even to carry the bones of the recently deceased as a sign of mourning.

biomorphic (p. 1073) Denoting the biologically or organically inspired shapes and forms that were routinely included in abstracted Modern art in the early twentieth century.

black-figure (p. 108) A technique of ancient Greek **ceramic** decoration in which black figures are painted on a red clay ground. Compare **red-figure**.

blackware (p. 869) A **ceramic** technique that produces pottery with a primarily black surface with **matte** and glossy patterns on the surface.

blind arcade (p. 794) See under **arcade**.

bodhisattva (p. 304) In Buddhism, a being who has attained enlightenment but chooses to remain in this world in order to help others advance spiritually. Also defined as a potential buddha.

Book of Hours (p. 562) A prayer book for private use, containing a calendar, services for the canonical hours, and sometimes special prayers.

boss (p. 450) A decorative knoblike element that can be found in many places, e.g. at the intersection of a Gothic **rib vault** or as a buttonlike projection on metalwork.

bracket, bracketing (p. 346) An architectural element that projects from a wall to support a horizontal part of a building, such as beams or the eaves of a roof.

buon fresco (p. 89) See under **fresco**.

burin (p. 602) A metal instrument used in **engraving** to cut lines into the metal plate. The sharp end of the burin is trimmed to give a diamond-shaped cutting point, while the other end is finished with a wooden handle that fits into the engraver's palm.

buttress, buttressing (p. 171) A projecting support built against an external wall, usually to counteract the lateral **thrust** of a **vault** or **arch** within. In Gothic church architecture, a **flying buttress** is an arched bridge above the **aisle** roof that extends from the upper **nave** wall, where the lateral thrust of the main vault is greatest, down to a solid **pier**.

cairn (p. 18) A pile of stones or earth and stones that served both as a prehistoric burial site and as a marker for underground tombs.

calligraphy (p. 279) Handwriting as an art form.

calotype (p. 987) The first photographic process utilizing negatives and paper positives; invented by William Henry Fox Talbot in the late 1830s.

calyx krater (p. 121) See under **krater**.

came (pl. **cames**) (p. 512) A lead strip used in the making of leaded or **stained-glass** windows. Cames have an indented groove on the sides into which individual pieces of glass are fitted to make the overall design.

cameo (p. 177) Gemstone, clay, glass, or shell having layers of color, carved in low relief (see under **relief sculpture**) to create an image and ground of different colors.

camera obscura (p. 762) An early cameralike device used in the Renaissance and later for recording images from the real world. It consists of a dark box (or room) with a hole in one side (sometimes fitted with a lens). The camera obscura operates when bright light shines through the hole, casting an upside-down image of an object outside onto the inside wall of the box.

canon of proportions (p. 52) A set of ideal mathematical ratios in art based on measurements, as in the proportional relationships between the basic elements of the human body.

canopic jar (p. 54) In ancient Egyptian culture, a special jar used to store the major organs of a body before embalming.

capital (p. 68) The sculpted block that tops a **column**. According to the **conventions** of the orders, capitals include different decorative elements (see **order**). A *historiated capital* is one displaying a figural composition and/or narrative scenes.

capriccio (pl. **capricci**) (p. 931) A painting or print of a fantastic, imaginary landscape, usually with architecture.

capstone (p. 18) The final, topmost stone in a **corbeled arch** or **vault**, which joins the sides and completes the structure.

cartoon (p. 512) A full-scale drawing of a design that will be executed in another **medium**, such as wall painting, **tapestry**, or **stained glass**.

cartouche (p. 189) A frame for a **hieroglyphic** inscription formed by a rope design surrounding an oval space. Used to signify a sacred or honored name. Also: in architecture, a decorative device or plaque, usually with a plain center used for inscriptions or epitaphs.

caryatid (p. 110) A sculpture of a draped female figure acting as a **column** supporting an **entablature**.

cassone (pl. **cassoni**) (p. 630) An Italian dowry chest, often highly decorated with carvings, paintings, inlaid designs, and gilt embellishments.

catacomb (p. 217) An underground cemetery consisting of tunnels on different levels, having niches for urns and **sarcophagi** and often incorporating rooms (*cubicula*).

cathedral (p. 222) The principal Christian church in a diocese, the bishop's administrative center and housing his throne (*cathedra*).

celadon (p. 362) A high-fired, transparent **glaze** of pale bluish-green hue whose principal coloring agent is an oxide of iron. In China and Korea, such glazes were typically applied over a pale gray **stoneware** body, though Chinese potters sometimes applied them over **porcelain** bodies during the Ming (1368–1644) and Qing (1644–1911) dynasties. Chinese potters invented celadon glazes and initiated the continuous production of celadon-glazed wares as early as the third century CE.

cella (p. 110) The principal interior room at the center of a Greek or Roman temple within which the cult statue was usually housed. Also called the **naos**.

celt (p. 387) A smooth, oblong stone or metal object, shaped like an axe-head.

cenotaph (p. 783) A funerary monument commemorating an individual or group buried elsewhere.

centering (p. 171) A temporary structure that supports a masonry **arch**, **vault**, or **dome** during construction until the mortar is fully dried and the masonry is self-sustaining.

central-plan building (p. 225) Any structure designed with a primary central space surrounded by symmetrical areas on each side, e.g., a **rotunda**.

ceramics (p. 20) A general term covering all types of wares made from fired clay.

chacmool (p. 400) In Maya sculpture, a half-

reclining figure probably representing an offering bearer.

chaitya (p. 309) A type of Buddhist temple found in India. Often built in the form of a hall or **basilica**, a *chaitya* hall is highly decorated with sculpture and usually is carved from a cave or natural rock location. It houses a sacred shrine or **stupa** for worship.

chamfer (p. 793) The slanted surface produced when an angle is trimmed or beveled, common in building and metalwork.

chasing (p. 445) Ornamentation made on metal by incising or hammering the surface.

château (*pl.* **châteaux**) (p. 704) A French country house or residential castle. A *château fort* is a military castle incorporating defensive works such as towers and battlements.

chattri (p. 793) In Indian architecture, a decorative pavilion with an umbrella-shaped **dome**.

chevron (p. 360) A decorative or heraldic motif of repeated *V*s; a zigzag pattern.

chiaroscuro (p. 650) An Italian word designating the contrast of dark and light in a painting, drawing, or print. *Chiaroscuro* creates spatial depth and volumetric forms through gradations in the intensity of light and shadow.

choir (p. 454) The part of a church reserved for the clergy, monks, or nuns, either between the **transept** crossing and the **apse** or extending farther into the **nave**; separated from the rest of the church by screens or walls and fitted with stalls (seats).

cista (*pl.* *cistae*) (p. 159) Cylindrical containers used in antiquity by wealthy women as a case for toiletry articles such as a mirror.

clerestory (p. 59) In a **basilica**, the topmost zone of a wall with windows, extending above the **aisle** roofs. Provides direct light into the **nave**.

cloisonné (p. 262) An **enameling** technique in which artists affix wires or strips to a metal surface to delineate designs and create compartments (*cloisons*) that they subsequently fill with enamel.

cloister (p. 458) An enclosed space, open to the sky, especially within a monastery, surrounded by an **arcaded** walkway, often having a fountain and garden. Since the most important monastic buildings (e.g., dormitory, refectory, church) open off the cloister, it represents the center of the monastic world.

codex (*pl.* **codices**) (p. 249) A book, or a group of **manuscript** pages (folios), held together by stitching or other binding along one edge.

coffer (p. 198) A recessed decorative panel used to decorate ceilings or **vaults**. The use of coffers is called coffering.

coiling (p. 863) A technique in basketry. In coiled baskets a spiraling coil, braid, or rope of material is held in place by stitching or interweaving to create a permanent shape.

collage (p. 917) A composition made of cut and pasted scraps of materials, sometimes with lines or forms added by the artist.

colonnade (p. 69) A row of **columns**, supporting a straight **lintel** (as in a **porch** or **portico**) or a series of **arches** (an **arcade**).

colophon (p. 447) The data placed at the end of a book listing the book's author, publisher, illuminator, and other information related to its production. In East Asian **handscrolls**, the inscriptions which follow the painting are also called colophons.

column (p. 111) An architectural element used for support and/or decoration. Consists of a rounded or polygonal vertical **shaft** placed on a base and topped by a decorative **capital**. In Classical architecture, columns are built in accordance with the rules of one of the architectural **orders**. They can be free-standing or attached to a background wall (**engaged**).

combine (p. 1100) Term used by Robert Rauschenberg to describe his works that combined painting and nontraditional sculptural elements.

commodification (p. 1100) Treating goods, services, ideas, or art merely as things to be bought or sold.

complementary color (p. 1011) The primary and secondary colors across from each other on the color wheel (red and green, blue and orange, yellow and purple). When juxtaposed, the intensity of both colors increases. When mixed together, they negate each other to make a neutral gray–brown.

Composite order (p. 162) See under **order**.

composite pose or **image** (p. 11) Combining different viewpoints within a single representation.

composition (p. xxv) The overall arrangement, organizing design, or structure of a work of art.

conch (p. 239) A halfdome.

connoisseur (p. 294) A French word meaning "an expert," and signifying one who studies and evaluates art based primarily on formal, visual, and stylistic analysis. A connoisseur studies the style and technique of an object to assess its relative quality and identify its maker through visual comparison with other works of secure authorship. See also **Formalism**.

continuous narrative (p. 249) See under **narrative image**.

contrapposto (p. 124) Italian term meaning "set against," used to describe the Classical convention of representing human figures with opposing alternations of tension and relaxation on either side of a central **axis** to give figures a sense of the potential for movement.

convention (p. 31) A traditional way of representing forms.

corbel, corbeling (p. 18) An early roofing and arching technique in which each **course** of stone projects slightly beyond the previous layer (a corbel) until the uppermost corbels meet; see also under **arch**. Also: **brackets** that project from a wall.

corbeled vault (p. 101) See under **vault**.

Corinthian order (p. 110) See under **order**.

cornice (p. 111) The uppermost section of a Classical **entablature**. More generally, a horizontally projecting element found at the top of a building wall or **pedestal**. A *raking cornice* is formed by the junction of two slanted cornices, most often found in **pediments**.

course (p. 101) A horizontal layer of stone used in building.

crenellation, crenellated (p. 44) Alternating high and low sections of a wall, giving a notched appearance and creating permanent defensive shields on top of fortified buildings.

crocket (p. 598) A stylized leaf used as decoration along the outer angle of spires, pinnacles, gables, and around **capitals** in Gothic architecture.

cruciform (p. 233) Of anything that is cross-shaped, as in the cruciform plan of a church.

cubiculum (*pl.* *cubicula*) (p. 224) A small private room for burials in a **catacomb**.

cuneiform (p. 29) An early form of writing with wedge-shaped marks impressed into wet clay with a **stylus**, primarily used by ancient Mesopotamians.

curtain wall (p. 1059) A wall in a building that does not support any of the weight of the structure.

cyclopean (p. 96) A method of construction using huge blocks of rough-hewn stone. Any large-scale, monumental building project that impresses by sheer size. Named after the Cyclopes (sing. Cyclops), one-eyed giants of legendary strength in Greek myths.

cylinder seal (p. 34) A small cylindrical stone decorated with **incised** patterns. When rolled across soft clay or wax, the resulting raised pattern or design served in Mesopotamian and Indus Valley cultures as an identifying signature.

dado (*pl.* **dadoes**) (p. 162) The lower part of a wall, differentiated in some way (by a **molding** or different coloring or paneling) from the upper section.

daguerreotype (p. 986) An early photographic process that makes a positive print on a light-sensitized copperplate; invented and marketed in 1839 by Louis-Jacques-Mandé Daguerre.

dendrochronology (p. xxxiii) The dating of wood based on the patterns of the tree's growth rings.

desert varnish (p. 411) A naturally occurring coating that turns rock faces into dark surfaces. Artists would draw images by scraping through the dark surface and revealing the color of the underlying rock. Extensively used in southwest North America.

diptych (p. xxxiii) Two panels of equal size (usually decorated with paintings or reliefs) hinged together.

dogu (p. 366) Small human figurines made in Japan during the Jomon period. Shaped from clay, the figures have exaggerated expressions and are in contorted poses. They were probably used in religious rituals.

dolmen (p. 17) A prehistoric structure made up of two or more large upright stones supporting a large, flat, horizontal slab or slabs.

dome (p. 190) A rounded **vault**, usually over a circular space. Consists of curved masonry and can vary in shape from hemispherical to bulbous to ovoidal. May use a supporting vertical wall (**drum**), from which the vault springs, and may be crowned by an open space (**oculus**) and/or an exterior **lantern**. When a dome is built over a square space, an intermediate element is required to make the transition to a circular drum. There are two systems. A dome on **pendentives** incorporates

arched, sloping intermediate sections of wall that carry the weight and **thrust** of the dome to heavily **buttressed** supporting **piers**. A dome on **squinches** uses an arch built into the wall (squinch) in the upper corners of the space to carry the weight of the dome across the corners of the square space below. A halfdome or **conch** may cover a semicircular space.

domino construction (p. 1059) System of building construction introduced by the architect Le Corbusier in which reinforced concrete floor slabs are floated on six free-standing posts placed as if at the positions of the six dots on a domino playing piece.

Doric order (p. 110) See **order**.

dressed stone (p. 87) Another term for **ashlar**.

drillwork (p. 190) The technique of using a drill for the creation of certain effects in sculpture.

drum (p. 111) The circular wall that supports a **dome**. Also: a segment of the circular **shaft** of a **column**.

drypoint (p. 759) An **intaglio** printmaking process by which a metal (usually copper) plate is directly inscribed with a pointed instrument (**stylus**). The resulting design of scratched lines is inked, wiped, and printed. Also: the print made by this process.

earthenware (p. 21) A low-fired, opaque **ceramic** ware, employing humble clays that are naturally heat-resistant and remain porous after firing unless **glazed**. Earthenware occurs in a range of earth-toned colors, from white and tan to gray and black, with tan predominating.

earthwork (p. 402) Usually very large-scale, outdoor artwork that is produced by altering the natural environment.

echinus (p. 111) A cushionlike circular element found below the **abacus** of a Doric **capital**. Also: a similarly shaped **molding** (usually with egg-and-dart motifs) underneath the **volutes** of an Ionic capital.

electronic spin resonance (p. 13) Method that uses magnetic field and microwave irradiation to date material such as tooth enamel and its surrounding soil.

elevation (p. 110) The arrangement, proportions, and details of any vertical side or face of a building. Also: an architectural drawing showing an exterior or interior wall of a building.

embroidery (p. 403) Stitches applied in a decorative pattern on top of an already-woven fabric ground.

en plein air (p. 1003) French term (meaning "in the open air") describing the Impressionist practice of painting outdoors so artists could have direct access to the fleeting effects of light and atmosphere while working.

enamel (p. 259) Powdered, then molten, glass applied to a metal surface, and used by artists to create designs. After firing, the glass forms an opaque or transparent substance that fuses to the metal background. Also: an object created by the enameling technique. See also **cloisonné**.

encaustic (p. 1097) A painting **medium** using pigments mixed with hot wax.

engaged (p. 172) Of an architectural feature, usually a **column**, attached to a wall.

engraving (p. 602) An **intaglio** printmaking process of inscribing an image, design, or letters onto a metal or wood surface from which a print is made. An engraving is usually drawn with a sharp implement (**burin**) directly onto the surface of the plate. Also: the print made from this process.

entablature (p. 110) In the Classical **orders**, the horizontal elements above the **columns** and **capitals**. The entablature consists of, from bottom to top, an **architrave**, a **frieze**, and a **cornice**.

entasis (p. 110) A slight swelling of the **shaft** of a Greek **column**. The optical illusion of entasis makes the column appear from a distance to be straight.

esquisse (p. 962) French for "sketch." A quickly executed drawing or painting conveying the overall idea for a finished painting.

etching (p. 759) An **intaglio** printmaking process in which a metal plate is coated with acid-resistant resin and then inscribed with a **stylus** in a design, revealing the plate below. The plate is then immersed in acid, and the exposed metal of the design is eaten away by the acid. The resin is removed, leaving the design etched permanently into the metal and the plate ready to be inked, wiped, and printed.

Eucharist (p. 222) The central rite of the Christian Church, from the Greek word for "thanksgiving." Also known as the Mass or Holy Communion, it reenacts Christ's sacrifice on the cross and commemorates the Last Supper. According to traditional Catholic Christian belief, consecrated bread and wine become the body and blood of Christ; in Protestant belief, bread and wine symbolize the body and blood.

exedra (*pl.* **exedrae**) (p. 198) In architecture, a semicircular niche. On a small scale, often used as decoration, whereas larger exedrae can form interior spaces (such as an **apse**).

expressionism (p. 153) Artistic styles in which aspects of works of art are exaggerated to evoke subjective emotions rather than to portray objective reality or elicit a rational response.

façade (p. 53) The face or front wall of a building.

faience (p. 89) Type of **ceramic** covered with colorful, opaque glazes that form a smooth, impermeable surface. First developed in ancient Egypt.

fang ding (p. 339) A square or rectangular bronze vessel with four legs. The *fang ding* was used for ritual offerings in ancient China during the Shang dynasty.

fête galante (p. 926) A subject in painting depicting well-dressed people at leisure in a park or country setting. It is most often associated with eighteenth-century French Rococo painting.

filigree (p. 93) Delicate, lacelike ornamental work.

fillet (p. 111) The flat ridge between the carved-out **flutes** of a **column shaft**.

finial (p. 306) A knoblike architectural decoration usually found at the top point of a spire, pinnacle, canopy, or gable. Also found on furniture. Also the ornamental top of a staff.

flutes (p. 111) In architecture, evenly spaced, rounded parallel vertical grooves incised on **shafts**

of **columns** or on columnar elements such as **pilasters**.

flying buttress (p. 516) See under **buttress**.

flying gallop (p. 89) A non-naturalistic pose in which animals are depicted hovering above the ground with legs fully extended backward and forward to signify that they are running.

foreshortening (p. xxvii) The illusion created on a flat surface by which figures and objects appear to recede or project sharply into space. Accomplished according to the rules of **perspective**.

formal analysis (p. xxv) An exploration of the visual character that artists bring to their works through the expressive use of elements such as line, form, color, and light, and through its overall structure or composition.

Formalism (p. 1089) An approach to the understanding, appreciation, and valuation of art based almost solely on considerations of form. The Formalist's approach tends to regard an artwork as independent of its time and place of making.

forum (p. 178) A Roman town center; site of temples and administrative buildings and used as a market or gathering area for the citizens.

fresco (p. 83) A painting technique in which water-based pigments are applied to a plaster surface. If the plaster is painted when wet, the color is absorbed by the plaster, becoming a permanent part of the wall (*buon fresco*). *Fresco secco* is created by painting on dried plaster, and the color may eventually flake off. Murals made by both these techniques are called frescos.

frieze (p. 110) The middle element of an **entablature**, between the **architrave** and the **cornice**. Usually decorated with sculpture, painting, or **moldings**. Also: any continuous flat band with **relief sculpture** or painted decoration.

frottage (p. 1072) A design produced by laying a piece of paper over a textured surface and rubbing with charcoal or other soft **medium**.

fusuma (p. 834) Sliding doors covered with paper, used in traditional Japanese construction. *Fusuma* are often highly decorated with paintings and colored backgrounds.

gallery (p. 241) A roofed passageway with one or both of its long sides open to the air. In church architecture, the story found above the side **aisles** of a church or across the width at the end of the **nave** or **transepts**, usually open to and overlooking the area below. Also: a building or hall in which art is displayed or sold.

garbhagriha (p. 306) From the Sanskrit word meaning "womb chamber," a small room or shrine in a Hindu temple containing its principal holy image.

genre painting (p. 727) A term used to loosely categorize paintings depicting scenes of everyday life, including (among others) domestic interiors, parties, inn scenes, and street scenes.

geoglyph (p. 402) Earthen design on a colossal scale, often created in a landscape as if to be seen from an aerial viewpoint.

gesso (p. 556) A primer made from glue, gypsum, and/or chalk, used as the ground of a wood panel or the priming layer of a canvas. Provides a smooth surface for painting.

gilding (p. 91) The application of paper-thin gold leaf or gold pigment to an object made from another **medium** (for example, a sculpture or painting). Usually used as a decorative finishing detail.

giornata (*pl. giornate*) (p. 551) Adopted from the Italian term meaning "a day's work," a *giornata* is the section of a **fresco** plastered and painted in a single day.

glazing (p. 613) In **ceramics**, an outermost layer of vitreous liquid (**glaze**) that, upon firing, renders the ware waterproof and forms a decorative surface. In painting, a technique used with oil **media** in which a transparent layer of paint (glaze) is laid over another, usually lighter, painted or glazed area. In architecture, the process of filling openings in a building with windows of clear or **stained glass**.

gold leaf (p. 47) Paper-thin sheets of hammered gold that are used in **gilding**. In some cases (such as Byzantine **icons**), also used as a ground for paintings.

gopura (p. 787) The towering gateway to an Indian Hindu temple complex.

Grand Manner (p. 940) An elevated style of painting popular in the eighteenth century in which the artist looked to the ancients and to the Renaissance for inspiration; for portraits as well as history painting, the artist would adopt the poses, compositions, and attitudes of Renaissance and antique models.

Grand Tour (p. 929) Popular during the eighteenth and nineteenth centuries, an extended tour of cultural sites in France and Italy intended to finish the education of a young upper-class person primarily from Britain or North America.

granulation (p. 93) A technique of decoration in which metal granules, or tiny metal balls, are fused onto a metal surface.

graphic arts (p. 711) A term referring to those arts that are drawn or printed and that utilize paper as the primary support.

grattage (p. 1073) A pattern created by scraping off layers of paint from a canvas laid over a textured surface. Compare **frottage**.

grid (p. 65) A system of regularly spaced horizontally and vertically crossed lines that gives regularity to an architectural plan or in the composition of a work of art. Also: in painting, a grid is used to allow designs to be enlarged or transferred easily.

grisaille (p. 552) A style of monochromatic painting in shades of gray. Also: a painting made in this style.

groin vault (p. 190) See under **vault**.

grozing (p. 512) Chipping away at the edges of a piece of glass to achieve the precise shape needed for inclusion in the composition of a **stained-glass** window.

guild (p. 425) An association of artists or craftspeople. Medieval and Renaissance guilds had great economic power, as they controlled the marketing of their members' products and provided economic protection, political solidarity, and training in the craft to its members. The painters' guild was usually dedicated to St. Luke, their patron saint.

hall church (p. 532) A church with **nave** and **aisles** of the same height, giving the impression of a large, open hall.

halo (p. 217) A circle of light that surrounds and frames the heads of emperors and holy figures to signify their power and/or sanctity. Also known as a nimbus.

handscroll (p. 347) A long, narrow, horizontal painting or text (or combination thereof) common in Chinese and Japanese art and of a size intended for individual use. A handscroll is stored wrapped tightly around a wooden pin and is unrolled for viewing or reading.

hanging scroll (p. 810) In Chinese and Japanese art, a vertical painting or text mounted within sections of silk. At the top is a semicircular rod; at the bottom is a round dowel. Hanging scrolls are kept rolled and tied except for special occasions, when they are hung for display, contemplation, or commemoration.

haniwa (p. 366) Pottery forms, including cylinders, buildings, and human figures, that were placed on top of Japanese tombs or burial mounds during the Kofun period (300–552 C.E.).

Happening (p. 1103) Term coined by Allan Kaprow in the 1960s to describe artworks incorporating elements of performance, theater, and visual images. Organized without a specific narrative or intent and with audience participation, the event proceeded according to chance and individual improvisation.

hemicycle (p. 525) A semicircular interior space or structure.

henge (p. 18) A circular area enclosed by stones or wood posts set up by Neolithic peoples. It is usually bounded by a ditch and raised embankment.

hierarchic scale (p. 27) The use of differences in size to indicate relative importance. For example, with human figures, the larger the figure, the greater her or his importance.

hieratic (p. 495) Highly stylized, severe, and detached, often in relation to a strict religious tradition.

hieroglyph (p. 53) Picture writing; words and ideas rendered in the form of pictorial symbols.

high relief (p. 312) See under **relief sculpture**.

historiated capital (p. 497) See under **capital**.

historicism (p. 981) The strong consciousness of and attention to the institutions, themes, styles, and forms of the past, made accessible by historical research, textual study, and archaeology.

history paintings (p. 942) Paintings based on historical, mythological, or biblical narratives. Once considered the noblest form of art, history paintings generally convey a high moral or intellectual idea and are often painted in a grand pictorial style.

horizon line (p. 581) A horizontal "line" formed by the implied meeting point of earth and sky. In linear perspective (under **perspective**), the **vanishing point** or points are located on this "line."

horseshoe arch (p. 277) See under **arch**.

hue (p. 79) Pure color. The saturation or intensity of the hue depends on the purity of the color. Its value depends on its lightness or darkness.

hydria (p. 142) A large ancient Greek or Roman jar with three handles (horizontal ones at both sides and one vertical at the back), used for storing water.

hypostyle hall (p. 66) A large interior room characterized by many closely spaced **columns** that support its roof.

icon (p. 250) An image representing a sacred figure or event in the Byzantine (later the Orthodox) Church. Icons are venerated by the faithful, who believe their prayers are transmitted through them to God.

iconic image (p. 217) A picture that expresses or embodies an intangible concept or idea.

iconoclasm (p. 251) The banning and/or destruction of images, especially **icons** and religious art. Iconoclasm in eighth- and ninth-century Byzantium and sixteenth- and seventeenth-century Protestant territories arose from differing beliefs about the power, meaning, function, and purpose of imagery in religion.

iconography (p. xxix) Identifying and studying the subject matter and **conventional** symbols in works of art.

iconology (p. xxx) Interpreting works of art as embodiments of cultural situation by placing them within broad social, political, religious, and intellectual contexts.

iconophile (p. 251) From the Greek for "lover of images." In periods of **iconoclasm**, iconophiles advocate the continued use of sacred images.

idealization (p. 136) A process in art through which artists strive to make their forms and figures attain perfection, based on pervading cultural values and/or their own personal ideals.

illumination (p. 249) A painting on paper or parchment used as an illustration and/or decoration in a **manuscript** or **album**. Usually richly colored, often supplemented by gold and other precious materials. The artists are referred to as illuminators. Also: the technique of decorating manuscripts with such paintings.

impasto (p. 761) Thick applications of paint that give a painting a palpable surface texture.

impluvium (p. 180) A pool under a roof opening that collected rainwater in the **atrium** of a Roman house.

impost block (p. 171) A block of masonry imposed between the top of a **pier** or above the **capital** of a **column** in order to provide extra support at the springing of an **arch**.

incising (p. 120) A technique in which a design or inscription is cut into a hard surface with a sharp instrument. Such a surface is said to be incised.

ink painting (p. 826) A monochromatic style of painting developed in China, using black ink with gray washes.

inlay (p. 29) To set pieces of a material or materials into a surface to form a design. Also: material used in or decoration formed by this technique.

installation, installation art (p. 1066) Contemporary art created for a specific site, especially a gallery or outdoor area, that creates a complete and controlled environment.

intaglio (p. 602) A technique in which the design

is carved out of the surface of an object, such as an engraved seal stone. In the **graphic arts**, intaglio includes **engraving**, **etching**, and **drypoint**—all processes in which ink transfers to paper from incised, ink-filled lines cut into a metal plate.

intarsia (p. 636) Technique of **inlay** decoration using variously colored woods.

intuitive perspective (p. 182) See under **perspective**.

Ionic order (p. 110) See under **order**.

iwan (p. 283) In Islamic architecture, a large, vaulted chamber with a monumental arched opening on one side.

jamb (p. 491) In architecture, the vertical element found on both sides of an opening in a wall, and supporting an **arch** or **lintel**.

Japonisme (p. 1010) A style in French and American nineteenth-century art that was highly influenced by Japanese art, especially prints.

jasperware (p. 935) A fine-grained, unglazed, white **ceramic** developed in the eighteenth century by Josiah Wedgwood, often with raised designs remaining white above a background surface colored by metallic oxides.

Jataka tales (p. 308) In Buddhism, stories associated with the previous lives of Shakyamuni, the historical Buddha.

joggled voussoirs (p. 279) Interlocking **voussoirs** in an **arch** or **lintel**, often of contrasting materials for colorful effect.

joined-block sculpture (p. 376) Large-scale wooden sculpture constructed by a method developed in Japan. The entire work is made from smaller hollow blocks, each individually carved, and assembled when complete. The joined-block technique allowed production of larger sculpture, as the multiple joints alleviate the problems of drying and cracking found with sculpture carved from a single block.

kantharos (p. 121) A type of ancient Greek goblet with two large handles and a wide mouth.

keep (p. 490) The innermost and strongest structure or central tower of a medieval castle, sometimes used as living quarters, as well as for defense. Also called a donjon.

kente (p. 898) A cloth made by the Asante peoples of Ghana. It is woven in long, narrow strips featuring complex, irregular, geometric patterns. The strips are then sewn together to make a large rectangular fabric, which is worn by wrapping it around the body under the arms with one end draped up over one shoulder.

key block (p. 843) The master block in the production of a colored **woodblock print**, which requires different blocks for each color. The key block is a flat piece of wood upon which the outlines for the entire design of the print were first drawn on its surface and then all but these outlines were carved away with a knife. These outlines serve as a guide for the accurate **registration** or alignment of the other blocks needed to add colors to specific parts of a print.

keystone (p. 171) The topmost **voussoir** at the center of an **arch**, and the last block to be placed. The pressure of this block holds the arch together. Often of a larger size and/or decorated.

kiln (p. 21) An oven designed to produce enough heat for the baking, or firing, of clay, for the melting of the glass used in **enamel** work, and for the fixing of vitreous paint on **stained glass**.

kiva (p. 409) A subterranean, circular room used as a ceremonial center in some Native American cultures.

kondo (p. 370) The main hall inside a Japanese Buddhist temple where the images of Buddha are housed.

korambo (p. 879) A ceremonial or spirit house in Pacific cultures, reserved for the men of a village and used as a meeting place as well as to hide religious artifacts from the uninitiated.

kore (*pl. kourai*) (p. 116) An Archaic Greek statue of a young woman.

koru (p. 886) A design depicting a curling stalk with a bulb at the end that resembles a young tree fern; often found in Maori art.

kouros (*pl. kouroi*) (p. 116) An Archaic Greek statue of a young man or boy.

kowhaiwhai (p. 886) Painted curvilinear patterns often found in Maori art.

krater (p. 101) An ancient Greek vessel for mixing wine and water, with many subtypes that each have a distinctive shape. *Calyx krater:* a bell-shaped vessel with handles near the base that resembles a flower calyx. *Volute krater:* a krater with handles shaped like scrolls.

Kufic (p. 280) An ornamental, angular Arabic script.

kylix (p. 124) A shallow ancient Greek cup, used for drinking, with a wide mouth and small handles near the rim.

lacquer (p. 840) A type of hard, glossy surface varnish, originally developed for use on objects in East Asian cultures, made from the sap of the Asian sumac or from shellac, a resinous secretion from the lac insect. Lacquer can be layered and manipulated or combined with pigments and other materials for various decorative effects.

lakshana (p. 311) The 32 marks of the historical Buddha. The *lakshana* include, among others, the Buddha's golden body, his long arms, the wheel impressed on his palms and the soles of his feet, the *urna* between his eyes, and the *ushnisha* on his head.

lamassu (p. 41) Supernatural guardian-protector of ancient Near Eastern palaces and throne rooms, often represented sculpturally as a combination of the bearded head of a man, powerful body of a lion or bull, wings of an eagle, and the horned headdress of a god, usually possessing five legs.

lancet (p. 516) A tall, narrow window crowned by a sharply pointed arch, typically found in Gothic architecture.

lantern (p. 476) A turretlike structure situated on a roof, vault, or dome, with windows that allow light into the space below.

lekythos (*pl. lekythoi*) (p. 144) A slim ancient Greek oil vase with one handle and a narrow mouth.

linear perspective (p. 607) See under **perspective**.

linga shrine (p. 319) A place of worship centered on an object or representation in the form of a phallus or column (the *linga*), which symbolizes the power of the Hindu god Shiva.

lintel (p. 18) A horizontal element of any material carried by two or more vertical supports to form an opening.

literati painting (p. 807) A style of painting that reflects the taste of the educated class of East Asian intellectuals and scholars. Characteristics include an appreciation for the antique, small scale, and an intimate connection between maker and audience.

lithography (p. 969) Process of making a print (lithograph) from a design drawn on a flat stone block with greasy crayon. Ink is applied to the wet stone and adheres only to the greasy areas of the design.

loggia (p. 546) Italian term for a **gallery**. Often used as a corridor between buildings or around a courtyard, a loggia usually features an **arcade** or **colonnade**.

longitudinal-plan building (p. 225) Any structure designed with a rectangular shape and a longitudinal axis. In a cross-shaped building, the main arm of the building would be longer than any arms that cross it. For example, a **basilica**.

lost-wax casting (p. 36) A method of casting metal, such as bronze. A wax model is covered with clay and plaster, then fired, thus melting the model and leaving a hollow form. Molten metal is then poured into the hollow space and slowly cooled. When the hardened clay and plaster exterior shell is removed, a solid metal form remains to be smoothed and polished.

low relief (p. 40) See under **relief sculpture**.

lunette (p. 223) A semicircular wall area, framed by an **arch** over a door or window. Can be either plain or decorated.

lusterware (p. 281) Pottery decorated with metallic glazes.

madrasa (p. 283) An Islamic institution of higher learning, where teaching is focused on theology and law.

maenad (p. 105) In ancient Greece, a female devotee of the wine god Dionysos who participated in orgiastic rituals. Often depicted with swirling drapery to indicate wild movement or dance. Also called a Bacchante, after Bacchus, the Roman equivalent of Dionysos.

majolica (p. 585) Pottery painted with a tin **glaze** that, when fired, gives a lustrous and colorful surface.

mandala (p. 307) An image of the cosmos represented by an arrangement of circles or concentric geometric shapes containing diagrams or images. Used for meditation and contemplation by Buddhists.

mandapa (p. 306) In a Hindu temple, an open hall dedicated to ritual worship.

mandorla (p. 248) Light encircling, or emanating from, the entire figure of a sacred person.

manuscript (p. 248) A hand-written book or document.

maqsura (p. 277) An enclosure in a Muslim **mosque**,

near the *mihrab*, designated for dignitaries.

martyrium (*pl.* **martyria**) (p. 242) A church, chapel,or shrine built over the grave of a Christian martyr.

mastaba (p. 54) A flat-topped, one-story structure with slanted walls built over an ancient Egyptian underground tomb.

matte (p. 585) Of a smooth surface that is without shine or luster.

mausoleum (p. 177) A monumental building used as a tomb. Named after the tomb of King Mausolos erected at Halikarnassos around 350 B.C.E.

medallion (p. 224) Any round ornament or decoration. Also: a large medal.

medium (*pl.* **media**) (p. xxv) The material from which a work of art is made.

megalith (*adj.* **megalithic**) (p. 17) A large stone used in some prehistoric architecture.

megaron (p. 95) The main hall of a Mycenaean palace or grand house.

memento mori (p. 925) From Latin for "remember that you must die." An object, such as a skull or extinguished candle, typically found in a *vanitas* image, symbolizing the transience of life.

menorah (p. 188) A Jewish lampstand with seven ornine branches; the nine-branched menorah is used during the celebration of Hanukkah. Representations of the seven-branched menorah, once used in the Temple of Jerusalem, became a symbol of Judaism.

metope (p. 111) The carved or painted rectangular panel between the **triglyphs** of a Doric **frieze**.

mihrab (p. 269) A recess or niche that distinguishes the wall oriented toward Mecca (*qibla*) in a **mosque**.

millefiori (p. 447) A glassmaking technique in which rods of differently colored glass are fused in a long bundle that is subsequently sliced to produce disks or beads with small-scale, multicolor patterns. The term derives from the Italian for "a thousand flowers."

minaret (p. 274) A tower on or near a **mosque** from which Muslims are called to prayer five times a day.

minbar (p. 269) A high platform or pulpit in a **mosque**.

miniature (p. 249) Anything small. In painting, miniatures may be illustrations within **albums** or **manuscripts** or intimate portraits.

mirador (p. 286) In Spanish and Islamic palace architecture, a very large window or room with windows, and sometimes balconies, providing views to interior courtyards or the exterior landscape.

mithuna (p. 310) The amorous male and female couples in Buddhist sculpture, usually found at the entrance to a sacred building. The *mithuna* symbolizes the harmony and fertility of life.

moai (p. 889) Statues found in Polynesia, carved from tufa, a yellowish brown volcanic stone, and depicting the human form. Nearly 1,000 of these statues have been found on the island of Rapa Nui but their significance has been a matter of speculation.

modeling (p. xxv) In painting, the process of creating the illusion of three-dimensionality on a two-dimensional surface by use of light and shade. In sculpture, theprocess of molding a three-dimensional form out of a malleable substance.

module (p. 351) A segment or portion of a repeated design. Also: a basic building block.

molding (p. 323) A shaped or sculpted strip with varying contours and patterns. Used as decoration on architecture, furniture, frames, and other objects.

mortise-and-tenon (p. 19) A method of joining two elements. A projecting pin (tenon) on one element fits snugly into a hole designed for it (mortise) on the other.

mosaic (p. 148) Image formed by arranging small colored stone or glass pieces (**tesserae**) and affixing them to a hard, stable surface.

mosque (p. 269) A building used for communal Islamic worship.

Mozarabic (p. 455) Of an eclectic style practiced in Christian medieval Spain when much of the Iberian peninsula was ruled by Islamic dynasties.

mudra (p. 312) A symbolic hand gesture in Buddhist art that denotes certain behaviors, actions, or feelings.

mullion (p. 522) A slender straight or curving bar that divides a window into subsidiary sections to create **tracery**.

muqarna (p. 286) In Islamic architecture, one of the nichelike components, often stacked in tiers to mark the transition between flat and rounded surfaces and often found on the **vault** of a **dome**.

naos (p. 241) The principal room in a temple or church. In ancient architecture, the **cella**. In a Byzantine church, the **nave** and **sanctuary**.

narrative image (p. 217) A picture that recounts anevent drawn from a story, either factual (e.g. biographical) or fictional. In **continuous narrative**, multiple scenesfrom the same story appear within a single compositional frame.

narthex (p. 222) The vestibule or entrance porch of a church.

nave (p. 192) The central space of a church, two or three stories high and usually flanked by **aisles**.

ndop (p. 900) A Kikuba (Kuba) term meaning "statue." It is sculpted of wood to commemorate a Kuba king (*nyim*) and the role he serves in Kuba society.

necropolis (p. 54) A large cemetery or burial area; literally a "city of the dead."

nemes headdress (p. 51) The royal headdress of ancient Egypt.

niello (p. 93) A metal technique in which a black sulfur **alloy** is rubbed into fine lines engraved into metal (usually gold or silver). When heated, the alloy becomes fused with the surrounding metal and provides contrasting detail.

oculus (*pl.* **oculi**) (p. 190) In architecture, a circular opening. Usually found either as windows or at the apex of a **dome**. When at the top of a dome, an oculus is either open to the sky or covered by a decorative exterior **lantern**.

odalisque (p. 968) Turkish word for "harem slave girl" or "concubine."

oil paint (p. 585) Pigments suspended in a medium of oil and used for painting. Oil paint has particular properties that allow for greater ease of working: among others, a slow drying time (which allows for corrections), and a great range of relative opaqueness of paint layers (which permits a high degree of detail and luminescence).

oinochoe (p. 128) An ancient Greek jug used for wine.

olpe (p. 107) Any ancient Greek vessel without a spout.

one-point perspective (p. 264) See under **perspective**.

orant (p. 222) Of a standing figure represented praying with outstretched and upraised arms.

oratory (p. 233) A small chapel.

order (p. 111) A system of proportions in Classical architecture that includes every aspect of the building's plan, elevation, and decorative system. *Composite*: a combination of the Ionic and the Corinthian orders. The **capital** combines **acanthus** leaves with **volute** scrolls. *Corinthian*: the most ornate of the orders, the Corinthian includes a **base** and a **fluted column shaft** with a capital elaborately decorated with acanthus leaf carvings. Its **entablature** consists of an **architrave** decorated with **moldings**, a **frieze** often containing **relief sculpture**, and a **cornice** with **dentils**. *Doric*: the column shaft of the Doric order can be fluted or smooth-surfaced and has no base. The Doric capital consists of an undecorated **echinus** and **abacus**. The Doric entablature has a plain architrave, a frieze with **metopes** and **triglyphs**, and a simple cornice. *Ionic*: the column of the Ionic order has a base, a fluted shaft, and a capital decorated with volutes. The Ionic entablature consists of an architrave of three panels and moldings, a frieze usually containing sculpted relief ornament, and a cornice with dentils. *Tuscan*: a variation of Doric characterized by a smooth-surfaced column shaft with a base, a plain architrave, and an undecorated frieze. *Colossal* or *giant*: any of the above built on a large scale, rising through two or more stories in height and often raised from the ground on a **pedestal**.

Orientalism (p. 982) A fascination with Middle Eastern cultures that inspired eclectic nineteenth-century European fantasies of exotic life that often formed the subject of paintings.

orthogonal (p. 141) Any line running back into the represented space of a picture perpendicular to the imagined **picture plane**. In **linear perspective**, all orthogonals converge at a single **vanishing point** in the picture and are the basis for a **grid** that maps out the internal space of the image. An orthogonal plan is any plan for a building or city that is based exclusively on right angles, such as the grid plan of many major cities.

pagoda (p. 352) An East Asian **reliquary** tower built with successively smaller, repeated stories. Each story is usually marked by an elaborate projecting roof.

painterly (p. 257) A style of painting which emphasizes the techniques and surface effects of brushwork (also color, light, and shade).

palace complex (p. 41) A group of buildings used for living and governing by a ruler and his or her supporters, usually fortified.

palazzo (p. 614) Italian term for palace, used for

any large urban dwelling.

palette (p. 184) A hand-held support used by artists for arranging colors and mixing paint during the process of painting. Also: the choice of a range of colors used by an artist in a particular work, as typical of his or her style. In ancient Egypt, a flat stone used to grind and prepare makeup.

panel painting (p. xxxvii) Any painting executed on awood support, usually planed to provide a smooth surface. A panel can consist of several boards joined together.

parchment (p. 249) A writing surface made from treated skins of animals. Very fine parchment is known as **vellum**.

parterre (p. 772) An ornamental, highly regimented flowerbed; especially as an element of the ornate gardens of a seventeenth-century palace or **château**.

passage grave (p. 18) A prehistoric tomb under a **cairn**, reached by a long, narrow, slab-lined access passageway or passageways.

pastel (p. 930) Dry pigment, chalk, and gum in stick or crayon form. Also: a work of art made with pastels.

pedestal (p. 110) A platform or base supporting a sculpture or other monument. Also: the block found below the base of a Classical **column** (or **colonnade**), serving to raise the entire element off the ground.

pediment (p. 110) A triangular gable found over major architectural elements such as Classical Greek **porticos**, windows, or doors. Formed by an **entablature** and the ends of a sloping roof or a raking **cornice**. A similar architectural element is often used decoratively above a door or window, sometimes with a curved upper **molding**. A *broken pediment* is a variation on the traditional pediment, with an open space at the center of the topmost angle and/or the horizontal cornice.

pendant (also **pendent**) (p. 652) One of a pair of artworks meant to be seen in relation to each other as a set.

pendentive (p. 241) The concave triangular section of a **vault** that forms the transition between a square or polygonal space and the circular base of a **dome**.

performance art (p. 1103) Works of art that are performed live by the artist and sometimes involve audience participation.

peristyle (p. 66) In Greek architecture, a surrounding **colonnade**. A peristyle building is surrounded on the exterior by a colonnade. Also: a peristyle court is an open colonnaded courtyard, often having a pool and garden.

perspective (p. xxiii) A system for representing three-dimensional space on a two-dimensional surface. *Atmospheric* or *aerial perspective*: a method of rendering the effect of spatial distance by subtle variations in color and clarity of representation. *Intuitive perspective*: a method of giving the impression of recession by visual instinct, not by the use of an overall system or program. *Oblique perspective*: an intuitive spatial system in which a building or room is placed with one corner in the **picture plane**, and the other parts of the structure recede to an imaginary **vanishing point** on its other side. Oblique perspective is not a comprehensive, mathematical system. *One-point* and multiple-point perspective (also called linear, scientific, or mathematical perspective): a methodof creating the illusion of three-dimensional space on a two-dimensional surface by delineating a **horizon line** and multiple **orthogonal** lines. These recede to meet at one or more points on the horizon (vanishing point), giving the appearance of spatial depth. Called scientific or mathematical because its use requires some knowledge of geometry and mathematics, as well as optics.*Reverse perspective*: a Byzantine perspective theory in which the orthogonals or rays of sight do not converge on a vanishing point in the picture, but are thought to originate in the viewer's eye in front of the picture. Thus, in reverse perspective the image is constructed with orthogonals that diverge, giving a slightly tipped aspect to objects.

photomontage (p. 1053) A photographic workcreated from many smaller photographs arranged (and often overlapping) in a composition that is then rephotographed.

pictograph (p. 340) A highly stylized depiction serving as a symbol for a person or object. Also: a type of writing utilizing such symbols.

picture plane (p. 587) The theoretical plane corresponding with the actual surface of a painting, separating the spatial world evoked in the painting from the spatial world occupied by the viewer.

picturesque (p. 935) Of the taste for the familiar, the pleasant, and the agreeable, popular in the eighteenthand nineteenth centuries in Europe. Originally used to describe the "picturelike" qualities of some landscape scenes. When contrasted with the **sublime**, thepicturesque stood for the interesting but ordinarydomestic landscape.

piece-mold casting (p. 338) A casting technique in which the mold consists of several sections that are connected during the pouring of molten metal, usually bronze. After the cast form has hardened, the pieces of the mold are disassembled, leaving the completed object.

pier (p. 273) A masonry support made up of many stones, or rubble and concrete (in contrast to a column **shaft** which is formed from a single stone or a series of **drums**), often square or rectangular in plan, and capable of carrying very heavy architectural loads.

pietà (p. 231) A devotional subject in Christianreligious art. After the Crucifixion the body of Jesus was laid across the lap of his grieving mother, Mary. When other mourners are present, the subject is called the Lamentation.

pietra serena (p. 613) A gray Tuscan sandstone used in Florentine architecture.

pilaster (p. 161) An **engaged** columnlike element that is rectangular in format and used for decoration in architecture.

pilgrimage church (p. 226) A church that attracts visitors wishing to venerate **relics** as well as attend religious services.

pinnacle (p. 517) In Gothic architecture, a steep pyramid decorating the top of another element such as a **buttress**. Also: the highest point.

plate tracery (p. 516) See under **tracery**.

plein air (p. 1003) See under *en plein air*.

plinth (p. 162) The slablike base or **pedestal** of a **column**, statue, wall, building, or piece of furniture.

podium (p. 141) A raised platform that acts as the foundation for a building, or as a platform for a speaker.

poesia (*pl.* **poesie**) (p. 668) Italian Renaissance paintings based on Classical themes, often with erotic overtones, notably in the mid-sixteenth-century works of the Venetian painter Titian.

polychromy (p. 537) Multicolored decoration applied to any part of a building, sculpture, or piece of furniture. This can be accomplished with paint or by the use of multicolored materials.

polyptych (p. xxxiii) An **altarpiece** constructed from multiple panels, sometimes with hinges to allow for movable wings.

porcelain (p. 20) A type of extremely hard and fine white **ceramic** first made by Chinese potters in the eighth century CE. Made from a mixture of kaolin and petuntse, porcelain is fired at a very high temperature, and the final product has a translucent surface.

porch (p. 110) The covered entrance on the exterior of a building. With a row of **columns** or **colonnade**, also called a **portico**.

portal (p. 40) A grand entrance, door, or gate, usually to an important public building, often decorated with sculpture.

portico (p. 63) In architecture, a projecting roof or porch supported by **columns**, often marking an entrance. See also **porch**.

post-and-lintel (p. 17) An architectural system of construction with two or more vertical elements (posts) supporting a horizontal element (**lintel**).

potassium-argon dating (p. 12) Archaeological method of **radiometric dating** that measures the decay of a radioactive potassium isotope into a stable isotope of argon, and inert gas.

potsherd (p. 21) A broken piece of **ceramic** ware.

poupou (p. 886) In Pacific cultures, a house panel, often carved with designs.

Prairie Style (p. 1061) Style developed by a group of Midwestern architects who worked together using the aesthetic of the prairie and indigenous prairie plants for landscape design to create mostly domestic homes and small public buildings.

predella (p. 557) The base of an **altarpiece**, often decorated with small scenes that are related in subject to that of the main panel or panels.

primitivism (p. 1037) The borrowing of subjects or forms, usually from non-European or prehistoric sources, by Western artists in an attempt to infuse work with expressive qualities attributed to other cultures, especially colonized cultures.

pronaos (p. 110) The enclosed vestibule of a Greek or Roman temple, found in front of the **cella** and marked bya row of **columns** at the entrance.

proscenium (p. 151) The stage of an ancient Greek or Roman theater. In a modern theater, the area of the stage in front of the curtain. Also: the framing

arch that separates a stage from the audience.

psalter (p. 260) In Jewish and Christian scripture, a book of the Psalms (songs) attributed to King David.

psykter (p. 127) An ancient Greek vessel with anextended base to allow it to float in a larger **krater**; used to chill wine.

putto (*pl. putti*) (p. 228) A plump, naked little boy, often winged. In Classical art, called a cupid; in Christian art, a cherub.

pylon (p. 66) A massive gateway formed by a pair of tapering walls of oblong shape. Erected by ancient Egyptians to mark the entrance to a temple complex.

qibla (p. 274) The **mosque** wall oriented toward Mecca; indicated by the *mihrab*.

quatrefoil (p. 520) A four-lobed decorative pattern common in Gothic art and architecture.

quillwork (p. 861) A Native American technique in which the quills of porcupines and bird feathers are dyed and attached to materials in patterns.

radiometric dating (p. 12) Archaeological method of **absolute dating** by measuring the degree to which radioactive materials have degenerated over time. For dating organic (plant or animal) materials, one radiometric method measures a carbon isotope called radiocarbon,or carbon-14.

raigo (p. 382) A painted image that depicts the Amida Buddha and other Buddhist deities welcoming the soul of a dying believer to paradise.

raku (p. 838) A type of **ceramic** made by hand, coated with a thick, dark **glaze**, and fired at a low heat. The resulting vessels are irregularly shaped and glazed and are highly prized for use in the Japanese tea ceremony.

readymade (p. 913) An object from popular or material culture presented without further manipulation as an artwork by the artist.

récupération (p. 913) A French term for the West African method of using found objects to make fine-art sculptures and installations.

red-figure (p. 120) A technique of ancient Greek **ceramic** decoration characterized by red clay-colored figures on a black background. The figures are reserved against a painted ground and details are drawn, not engraved; compare **black-figure**.

register (p. 30) A device used in systems of spatial definition. In painting, a register indicates the use of differing ground-lines
to differentiate layers of spacewithin an image. In **relief sculpture**, the placement ofself-contained bands of reliefs in a vertical arrangement.

registration marks (p. 843) In Japanese **woodblock prints**, two marks carved on the blocks to indicate proper alignment of the paper during the printing process. In multicolor printing, which used a separate block for each color, these marks were essential for achieving the proper position or registration of the colors.

relative dating (p. 12) Archaeological process of determining relative chronological relationships among excavated objects. Compare **absolute dating**.

relic (p. 226) Venerated object or body part associated with a holy figure, such as a saint, and usually housed in a **reliquary**.

relief sculpture (p. 5) A three-dimensional image

or design whose flat background surface is carved away to a certain depth, setting off the figure. Called *high* or *low (bas-) relief* depending upon the extent of projection of the image from the background. Called *sunken relief* when the image is carved below the original surface of the background, which is not cut away.

reliquary (p. 371) A container, often elaborate and made of precious materials, used as a repository for sacred relics.

repoussé (p. 93) A technique of pushing or hammering metal from the back to create a protruding image. Elaborate reliefs are created by pressing or hammering metal sheets against carved wooden forms.

rhyton (p. 90) A vessel in the shape of a figure or an animal, used for drinking or pouring liquids on special occasions.

rib vault (p. 511) See under **vault**.

ridgepole (p. 17) A longitudinal timber at the apex of a roof that supports the upper ends of the rafters.

roof comb (p. 396) In a Maya building, a masonry wall along the apex of a roof that is built above the level of the roof proper. Roof combs support the highly decorated false **façades** that rise above the height of the building at the front.

rose window (p. 516) A round window, often filled with stained glass set into tracery patterns in the form of wheel spokes, found in the **façades** of the **naves** and **transepts** of large Gothic churches.

rosette (p. 108) A round or oval ornament resembling a rose.

rotunda (p. 197) Any building (or part thereof) constructed in a circular (or sometimes polygonal) shape, usually producing a large open space crowned by a **dome**.

round arch (p. 171) See under **arch**.

roundel (p. 161) Any ornamental element with a circular format, often placed as a decoration on the exterior of a building.

rune stone (p. 452) In early medieval northern Europe, a stone used as a commemorative monument and carved or inscribed with runes, a writing system used by early Germanic peoples.

rustication (p. 614) In architecture, the rough, irregular, and unfinished effect deliberately given to the exterior facing of a stone edifice. Rusticated stones are often large and used for decorative emphasis around doors or windows, or across the entire lower floors of a building.

sacra conversazione (p. 642) Italian for "holy conversation." Refers to a type of religious painting developed in fifteenth-century Florence in which a central image of the Virgin and Child is flanked by standing saints of comparable size who stand within the same spatial setting and often acknowledge each other's presence.

salon (p. 923) A large room for entertaining guests or a periodic social or intellectual gathering, often of prominent people, held in such a room. Also: a hall or **gallery** for exhibiting works of art.

sanctuary (p. 105) A sacred or holy enclosure used for worship. In ancient Greece and Rome, consisted of one or more temples and an altar. In Christian architecture, the space around the altar in a church

called the chancel or presbytery.

sarcophagus (*pl. sarcophagi*) (p. 49) A stone coffin. Often rectangular and decorated with **relief sculpture**.

scarab (p. 51) In ancient Egypt, a stylized dung beetle associated with the sun and the god Amun.

scarification (p. 413) Ornamental decoration applied to the surface of the body by cutting the skin for cultural and/or aesthetic reasons.

school of artists or **painting** (p. 288) An art historical term describing a group of artists, usually working at the same time and sharing similar styles, influences, and ideals. The artists in a particular school may not necessarily be directly associated with one another, unlike those in a workshop or **atelier**.

scriptorium (*pl. scriptoria*) (p. 248) A room in a monastery for writing or copying **manuscripts**.

scroll painting (p. 352) A painting executed on a flexible support with rollers at each end. The rollers permit the horizontal scroll to be unrolled as it is studied or the vertical scroll to be hung for contemplation or decoration.

sculpture in the round (p. 5) Three-dimensional sculpture that is carved free of any background or block. Compare **relief sculpture**.

serdab (p. 54) In ancient Egyptian tombs, the small room in which the *ka* statue was placed.

sfumato (p. 650) Italian term meaning "smoky," soft, and mellow. In painting, the effect of haze in an image. Resembling the color of the atmosphere at dusk, *sfumato* gives a smoky effect.

sgraffito (p. 615) Decoration made by incising or cutting away a surface layer of material to reveal a different color beneath.

shaft (p. 111) The main vertical section of a **column** between the **capital** and the base, usually circular in cross section.

shaft grave (p. 98) A deep pit used for burial.

shikhara (p. 306) In the architecture of northern India, a conical (or pyramidal) spire found atop a Hindu temple and often crowned with an *amalaka*.

shoin (p. 835) A term used to describe the various features found in the most formal room of upper-class Japanese residential architecture.

shoji (p. 835) A standing Japanese screen covered in translucent rice paper and used in interiors.

siapo (p. 889) A type of *tapa* cloth found in Samoa and still used as an important gift for ceremonial occasions.

silkscreen printing (p. 1107) A technique of printing in which paint or ink is pressed through a stencil and specially prepared cloth to reproduce a design in multiple copies.

silverpoint (p. 591) A drawing technique using a stylus with a sharp silver tip to produce very fine, precise lines.

sinopia (*pl. sinopie*) (p. 551) Italian word taken from Sinope, the ancient city in Asia Minor that was famous for its red-brick pigment. In **fresco** paintings, a full-sized, preliminary sketch done in this color on the first rough coat of plaster or *arriccio*.

site-specific (p. 895) Commissioned and/or

designed for a particular location.

skeuomorph (p. 427) A decorative object or design that mimics elements from a predecessor object that were integral to the function or structure of the predecessor.

slip (p. 120) A mixture of clay and water applied to a **ceramic** object as a final decorative coat. Also: a solution that binds different parts of a vessel together, such as the handle and the main body.

spandrel (p. 171) The area of wall adjoining the exterior curve of an **arch** between its **springing** and the **keystone**, or the area between two arches, as in an **arcade**.

spolia (p. 227) Fragments of older architecture or sculpture reused in a secondary context. Latin for "hide stripped from an animal."

springing (p. 171) The point at which the curve of an **arch** or **vault** meets with and rises from its support.

squinch (p. 241) An **arch** or **lintel** built across the upper corners of a square space, allowing a circular or polygonal **dome** to be securely set above the walls.

stained glass (p. 293) Glass stained with color while molten, using metallic oxides. Stained glass is most often used in windows, for which small pieces of different colors are precisely cut and assembled into a design, held together by lead **cames**. Additional details may be added with vitreous paint.

stave church (p. 453) A Scandinavian wooden structure with four huge timbers (staves) at its core.

stele (*pl.* **stelai**), also **stela** (*pl.* **stelae**) (p. 27) A stone slab placed vertically and decorated with inscriptions or reliefs. Used as a grave marker or commemorative monument.

stereobate (p. 111) In Classical architecture, the foundation upon which a temple stands.

still life (*pl.* **still lifes**) (p. xxx) A type of painting that has as its subject inanimate objects (such as food and dishes) or fruit and flowers taken out of their natural contexts.

stoa (p. 109) In Greek architecture, a long roofed walkway, usually having **columns** on one long side and a wall on the other.

stoneware (p. 21) A high-fired, vitrified, but opaque **ceramic** ware that is fired in the range of 1,200 to 1,400 degrees Centigrade. At that temperature, particles of silica in the clay bodies fuse together so that the finished vessels are impervious to liquids, even without glaze. Stoneware pieces are glazed to enhance their aesthetic appeal and to aid in keeping them clean. Stoneware occurs in a range of earth-toned colors, from white and tan to gray and black, with light gray predominating. Chinese potters were the first in the world to produce stoneware, which they were able to make as early as the Shang dynasty.

stringcourse (p. 517) A continuous horizontal band, such as a **molding**, decorating the face of a wall.

stucco (p. 74) A mixture of lime, sand, and other ingredients made into a material that can easily be molded or modeled. When dry, it produces a durable surface used for covering walls or for architectural sculpture and decoration.

stupa (p. 306) In Buddhist architecture, a bell-shaped or dome-like religious monument, made of piled earth, brick, or stone, and containing sacred **relics**.

style (p. xxxiii) A particular manner, form, or character of representation, construction, or expression that is typical of an individual artist or of a certain place or period.

stylobate (p. 111) In Classical architecture, the stone foundation on which a temple **colonnade** stands.

stylus (p. 29) An instrument with a pointed end (used for writing and printmaking), which makes a delicate line or scratch. Also: a special writing tool for **cuneiform** writing with one pointed end and one triangular.

sublime (p. 973) Of a concept, thing, or state of greatness or vastness with high spiritual, moral, intellectual, or emotional value; or something awe-inspiring. The sublime was a goal to which many nineteenth-century artists aspired in their artworks.

sunken relief (p. 73) See under **relief sculpture**.

symposium (p. 121) An elite gathering of wealthy and powerful men in ancient Greece that focused principally on wine, music, poetry, conversation, games, and love-making.

syncretism (p. 222) A process whereby artists assimilate and combine images and ideas from different cultural traditions, beliefs, and practices, giving them new meanings.

taotie (p. 338) A mask with a dragon- or animal-like face common as a decorative motif in Chinese art.

tapa (p. 889) A type of cloth used for various purposes in Pacific cultures, made from tree bark stripped and beaten, and often bearing subtle designs from the mallets used to work the bark.

tapestry (p. 295) Multicolored decorative weaving to be hung on a wall or placed on furniture. Pictorial or decorative motifs are woven directly into the supporting fabric, completely concealing it.

tatami (p. 835) Mats of woven straw used in Japanese houses as a floor covering.

temenos (p. 110) An enclosed sacred area reserved for worship in ancient Greece.

tempera (p. 144) A painting **medium** made by blending egg yolks with water, pigments, and occasionally other materials, such as glue.

tenebrism (p. 738) The use of strong *chiaroscuro* and artificially illuminated areas to create a dramatic contrast of light and dark in a painting.

terra cotta (p. 116) A **medium** made from clay fired over a low heat and sometimes left unglazed. Also: the orange–brown color typical of this medium.

tessera (*pl.* **tesserae**) (p. 148) A small piece of stone, glass, or other object that is pieced together with many others to create a **mosaic**.

thatch (p. 17) Plant material such as reeds or straw tied over a framework of poles to make a roof, shelter, or small building.

thermo-luminescence dating (p. 13) A method of **radiometric dating** that measures the irradiation of the crystal structure of material such as flint or pottery and the soil in which it is found, determined by how much a sample glows when it is heated.

tholos (p. 100) A small, round building. Sometimes built underground, as, for example, with a Mycenaean tomb.

thrust (p. 171) The outward pressure caused by the weight of a **vault** and supported by **buttressing**. See also under **arch**.

tondo (*pl.* **tondi**) (p. 128) A painting or **relief sculpture** of circular shape.

torana (p. 306) In Indian architecture, an ornamented gateway arch in a temple, usually leading to the **stupa**.

torc (p. 152) A circular neck ring worn by Celtic warriors.

toron (p. 425) In West African **mosque** architecture, one of the wooden beams that project from the walls. Torons are used as support for the scaffolding erected annually for the replastering of the building.

tracery (p. 517) Stonework or woodwork forming a pattern in the open space of windows or applied to wall surfaces. In *plate tracery*, a series of openings are cut through the wall. In *bar tracery*, **mullions** divide the space into segments to form decorative patterns.

transept (p. 226) The arm of a **cruciform** church perpendicular to the **nave**. The point where the nave and transept intersect is called the crossing. Beyond the crossing lies the **sanctuary**, whether **apse**, **choir**, or chevet.

transverse arch (p. 475) See under **arch**.

trefoil (p. 302) An ornamental design made up of three rounded lobes placed adjacent to one another.

triforium (p. 516) The element of the interior elevation of a church found directly below the **clerestory** and consisting of a series of arched openings in front of a passageway within the thickness of the wall.

triglyph (p. 111) Rectangular block between the **metope**s of a Doric **frieze**. Identified by the three carved vertical grooves, which approximate the appearance of the end of wooden beams.

triptych (p. 579) An artwork made up of three panels. The panels may be hinged together in such a way that the side segments (wings) fold over the central area.

trompe l'oeil (p. 587) A manner of representation in which artists faithfully describe the appearance of natural space and forms with the express intention of fooling the eye of the viewer, who may be convinced momentarily that the subject actually exists as three-dimensional reality.

trumeau (p. 491) A **column**, **pier**, or post found at the center of a large **portal** or doorway, supporting the **lintel**.

tugra (p. 293) A calligraphic imperial monogram used in Ottoman courts.

tukutuku (p. 886) Lattice panels created by women from the Maori culture and used in architecture.

Tuscan order (p. 161) See under **order**.

twining (p. 863) A basketry technique in which short rods are sewn together vertically. The panels are then joined together to form a container or other object.

tympanum (p. 491) In medieval and later architecture, the area over a door enclosed by an **arch** and a **lintel**, often decorated with sculpture or mosaic.

ukiyo-e (p. 842) A Japanese term for a type of popular art that was favored from the sixteenth century, particularly in the form of color **woodblock prints**. *Ukiyo-e* prints often depicted the world of the common people in Japan, such as courtesans and actors, as well as landscapes and myths.

undercutting (p. 214) A technique in sculpture by which the material is cut back under the edges so that the remaining form projects strongly forward, casting deep shadows.

underglaze (p. 813) Color or decoration applied to a **ceramic** piece before glazing.

upeti (p. 890) In Pacific cultures, a carved wooden design tablet, used to create patterns in cloth by dragging the fabric across it.

uranium-thorium dating (p. 12) Technique used to date prehistoric cave paintings by measuring the decay of uranium into thorium in the deposits of calcium carbonate that cover the surfaces of cave walls, to determine the minimum age of the paintings under the crust.

urna (p. 311) In Buddhist art, the curl of hair on the forehead that is a characteristic mark of a buddha. The *urna* is a symbol of divine wisdom.

ushnisha (p. 311) In Asian art, a round cranial bump or bun of hair symbolizing royalty and, when worn by a buddha, enlightenment.

vanishing point (p. 623) In a **perspective** system, the point on the **horizon line** at which **orthogonals** meet. A complex system can have multiple vanishing points.

vanitas (p. xxxii) An image, especially popular in Europe during the seventeenth century, in which all the objects symbolize the transience of life. *Vanitas* paintings are usually of **still lifes** or genre subjects.

vault (p. 18) An arched masonry structure that spans an interior space. *Barrel* or *tunnel vault*: an elongated or continuous semicircular vault, shaped like a half-cylinder. *Corbeled vault*: a vault made by projecting **courses** of stone; see also under **corbel**. *Groin* or *cross vault*: a vault created by the intersection of two barrel vaults of equal size which creates four side compartments of identical size and shape. *Quadrant vault*: a half-barrel vault. *Rib vault*: a groin vault with ribs (extra masonry) demarcating the junctions. Ribs may function to reinforce the groins or may be purely decorative.

veduta (*pl.* **vedute**) (p. 931) Italian for "vista" or "view." Paintings, drawings, or prints, often of expansive city scenes or of harbors.

vellum (p. 249) A fine animal skin prepared for writing and painting. See also **parchment**.

verism (p. 169) Style in which artists concern themselves with describing the exterior likeness of an object or person, usually by rendering its visible details in a finely executed, meticulous manner.

vihara (p. 309) From the Sanskrit term meaning "for wanderers." A *vihara* is, in general, a Buddhist monastery in India. It also signifies monks' cells and gathering places in such a monastery.

volute (p. 111) A spiral scroll, as seen on an Ionic **capital**.

votive figure (p. 31) An image created as a devotional offering to a deity.

voussoir (p. 171) Wedge-shaped stone block used to build an **arch**. The topmost voussoir is called a **keystone**. See also **joggled voussoirs**.

warp (p. 295) The vertical threads in a weaver's loom. Warp threads make up a fixed framework that provides the structure for the entire piece of cloth, and are thus often thicker than **weft** threads.

wattle and daub (p. 17) A wall construction method combining upright branches, woven with twigs (wattles) and plastered or filled with clay or mud (daub).

wax print fabric (p. 918) Cotton fabric printed to look like Indonesian batik cloth. Originally made in the Netherlands and exported to African coastal nations during the fifteenth through twenty-first centuries, it is now manufactured around the world, including in many African countries.

weft (p. 295) The horizontal threads in a woven piece of cloth. Weft threads are woven at right angles to and through the **warp** threads to make up the bulk of the decorative pattern. In carpets, the weft is often completely covered or formed by the rows of trimmed knots that form the carpet's soft surface.

westwork (p. 457) The monumental, west-facing entrance section of a Carolingian, Ottonian, or Romanesque church. The exterior consists of multiple stories between two towers; the interior includes an entrance vestibule, a chapel, and a series of **galleries** overlooking the **nave**.

white-ground (p. 143) A type of ancient Greek pottery in which the background color of the object was painted with a **slip** that turns white in the firing process. Figures and details were added by painting on or incising into this slip. White-ground wares were popular in the Classical period as funerary objects.

woodblock print (p. 602) A print made from one or more carved wooden blocks. In Japan, woodblock prints were made using multiple blocks carved in relief, usually with a block for each color in the finished print. See also **woodcut**.

woodcut (p. 602) A type of print made by carving a design into a wooden block. The ink is applied to the block with a roller. As the ink touches only on the surface areas and lines remaining between the carved-away parts of the block, it is these areas that make the print when paper is pressed against the inked block, leaving the carved-away parts of the design to appear blank. Also: the process by which the woodcut is made.

yaksha, yakshi (p. 305) The male (*yaksha*) and female (*yakshi*) nature spirits associated with fertility and abundance. Their sculpted images are often found on Buddhist and Hindu temples and other sacred places, particularly at the entrances.

yamato-e (p. 377) A native style of Japanese painting developed during the twelfth and thirteenth centuries, distinguished from Japanese painting styles that emulated Chinese traditions.

ziggurat (p. 29) In ancient Mesopotamia, a tall stepped tower of earthen materials, often supporting a shrine.

Bibliography

This bibliography is composed of books in English that are suggested "further reading" titles. Most are available in good libraries, whether college, university, or public. Recently published works have been emphasized so that the research information would be current. There are three classifications of listings: general surveys and art history reference tools, including journals and Internet directories; surveys of large periods that encompass multiple chapters (ancient art in the Western tradition, European medieval art, European Renaissance through eighteenth-century art, Modern art in the West, Asian art, African and Oceanic art, and art of the Americas); and books for individual Chapters 1 through 33.

General Art History Surveys and Reference Tools

Adams, Laurie Schneider. *Art Across Time.* 4th ed. New York: McGraw-Hill, 2011.

Barnet, Sylvan. *A Short Guide to Writing about Art.* 11th ed. Upper Saddle River, NJ: Pearson/Prentice Hall, 2010.

Bony, Anne. *Design: History, Main Trends, Main Figures.* Edinburgh: Chambers, 2005.

Boström, Antonia. *Encyclopedia of Sculpture.* 3 vols. New York: Fitzroy Dearborn, 2004.

Broude, Norma, and Mary D. Garrard, eds. *Feminism and Art History: Questioning the Litany.* Icon Editions. New York: Harper & Row, 1982.

Chadwick, Whitney. *Women, Art, and Society.* 4th ed. New York: Thames & Hudson, 2007.

Chilvers, Ian, ed. *The Oxford Dictionary of Art.* 4th ed. New York: Oxford Univ. Press, 2009.

Curl, James Stevens. *A Dictionary of Architecture and Landscape Architecture.* 2nd ed. Oxford: Oxford Univ. Press, 2006.

Davies, Penelope J.E., et al. *Janson's History of Art: The Western Tradition.* 8th ed. Upper Saddle River, NJ: Prentice Hall, 2010.

The Dictionary of Art. Ed. Jane Turner. 34 vols. New York: Grove's Dictionaries, 1996.

Frank, Patrick, Duane Preble, and Sarah Preble. *Prebles' Artforms.* 10th ed. Upper Saddle River, NJ: Pearson/Prentice Hall, 2011.

Gaze, Delia, ed. *Dictionary of Women Artists.* 2 vols. London: Fitzroy Dearborn, 1997.

Griffiths, Antony. *Prints and Printmaking: An Introduction to the History and Techniques.* 2nd ed. London: British Museum Press, 1996.

Hadden, Peggy. *The Quotable Artist.* New York: Allworth Press, 2002.

Hall, James. *Dictionary of Subjects and Symbols in Art.* 2nd ed. Boulder, CO: Westview Press, 2008.

Holt, Elizabeth Gilmore, ed. *A Documentary History of Art.* 3 vols. New Haven: Yale Univ. Press, 1986.

Honour, Hugh, and John Fleming. *The Visual Arts: A History.* 7th ed. rev. Upper Saddle River, NJ: Pearson/Prentice Hall, 2010.

Johnson, Paul. *Art: A New History.* New York: HarperCollins, 2003.

Kemp, Martin, ed. *The Oxford History of Western Art.* Oxford: Oxford Univ. Press, 2000.

Kleiner, Fred S. *Gardner's Art through the Ages.* Enhanced 15th ed. Belmont, CA: Thomson/Wadsworth, 2011.

Kostof, Spiro. *A History of Architecture: Settings and Rituals.* 2nd ed. Revised Greg Castillo. New York: Oxford Univ. Press, 1995.

Levenson, Jay A., ed. *Circa 1492: Art in the Age of Exploration.* New Haven: Yale Univ. Press and the National Gallery of Art, Washington, DC, 1991.

MacGregor, Neil. *A History of the World in 100 Objects.* New York: Penguin Books, 2013.

Mackenzie, Lynn. *Non-Western Art: A Brief Guide.* 2nd ed. Upper Saddle River, NJ: Pearson/Prentice Hall, 2001.

Marmor, Max, and Alex Ross, eds. *Guide to the Literature of Art History 2.* Chicago: American Library Association, 2005.

Onians, John, ed. *Atlas of World Art.* New York: Oxford Univ. Press, 2004.

Sayre, Henry M. *Writing about Art.* 6th ed. Upper Saddle River, NJ: Pearson/Prentice Hall, 2009.

Sed-Rajna, Gabrielle. *Jewish Art.* Trans. Sara Friedman and Mira Reich. New York: Abrams, 1997.

Slatkin, Wendy. *Women Artists in History: From Antiquity to the Present.* 4th ed. Upper Saddle River, NJ: Pearson/Prentice Hall, 2001.

Sutton, Ian. *Western Architecture: From Ancient Greece to the Present.* World of Art. New York: Thames & Hudson, 1999.

Trachtenberg, Marvin, and Isabelle Hyman. *Architecture, from Prehistory to Postmodernity.* 2nd ed. Upper Saddle River, NJ: Pearson/Prentice Hall, 2002.

Tucker, Amy. *Visual Literacy: Writing about Art.* Boston: McGraw-Hill, 2002.

Watkin, David. *A History of Western Architecture.* 4th ed. New York: Watson-Guptill, 2005.

Art History Journals: A Selected List of Current Titles

African Arts. Quarterly. Los Angeles: Univ. of California at Los Angeles, James S. Coleman African Studies Center, 1967–.

American Art: The Journal of the Smithsonian American Art Museum. 3/year. Chicago: Univ. of Chicago Press, 1987–.

American Journal of Archaeology. Quarterly. Boston: Archaeological Institute of America, 1885–.

Antiquity: A Periodical of Archaeology. Quarterly. Cambridge: Antiquity Publications Ltd., 1927–.

Apollo: The International Magazine of the Arts. Monthly. London: Apollo Magazine Ltd., 1925–.

Archaeology Magazine. Bimonthly. New York: Archaeological Institute of America, 1948–.

Architectural History. Annually. Farnham, UK: Society of Architectural Historians of Great Britain, 1958–.

Archives of American Art Journal. Quarterly. Washington, DC: Archives of American Art, Smithsonian Institution, 1960–.

Archives of Asian Art. Annually. New York: Asia Society, 1945–.

Ars Orientalis: The Arts of Asia, Southeast Asia, and Islam. Annually. Ann Arbor: Univ. of Michigan Dept. of Art History, 1954–.

Art Bulletin. Quarterly. New York: College Art Association, 1913–.

Art History: Journal of the Association of Art Historians. 5/year. Oxford: Blackwell Publishing Ltd., 1978–.

Art in America. Monthly. New York: Brant Publications Inc., 1913–.

Art Journal. Quarterly. New York: College Art Association, 1960–.

The Art Newspaper. Monthly. London and New York: The Art Newspaper, 1990–.

Art Nexus. Quarterly. Bogota, Colombia: Arte en Colombia Ltda, 1976–.

Art Papers Magazine. Bimonthly. Atlanta: Atlanta Art Papers Inc., 1976–.

Artforum International. 10/year. New York: Artforum International Magazine Inc., 1962–.

Artibus Asiae. Biannually. Zürich: Museum Rietberg, 1925–.

Artnews. 11/year. New York: Artnews LLC, 1902–.

Bulletin of the Metropolitan Museum of Art. Quarterly. New York: Metropolitan Museum of Art, 1905–.

The Burlington Magazine. Monthly. London: Burlington Magazine Publications Ltd., 1903–.

Dumbarton Oaks Papers. Annually. Locust Valley, NY: J.J. Augustin Inc., 1940–.

Flash Art International. Bimonthly. Trevi, Italy: Giancarlo Politi Editore, 1980–.

Gesta. Semiannually. New York: International Center of Medieval Art, 1963–.

History of Photography. Quarterly. Abingdon, UK: Taylor & Francis Ltd., 1976–.

International Review of African American Art. Quarterly. Hampton, VA: International Review of African American Art, 1976–.

Journal of the American Research Center in Egypt. Annually. San Antonio: The American Research Center in Egypt, 1962–.

Journal of Design History. Quarterly. Oxford: Oxford Univ. Press, 1988–.

Journal of Egyptian Archaeology. Annually. London: Egypt Exploration Society, 1914–.

Journal of Hellenic Studies. Annually. London: Society for the Promotion of Hellenic Studies, 1880–.

Journal of Roman Archaeology. Annually. Portsmouth, RI: Journal of Roman Archaeology LLC, 1988–.

Journal of the Society of Architectural Historians. Quarterly. Chicago: Society of Architectural Historians, 1940–.

Journal of the Warburg and Courtauld Institutes. Annually. London: Warburg Institute, 1937–.

Leonardo: Art, Science, and Technology. 6/year. Cambridge, MA: MIT Press, 1968–.

Marg. Quarterly. Mumbai, India: Scientific Publishers, 1946–.

Master Drawings. Quarterly. New York: Master Drawings Association, 1963–.

Muqarnas. Annually. Cambridge, MA: E.J. Brill, 1983–.

October. Cambridge, MA: MIT Press, 1976–.

Oxford Art Journal. 3/year. Oxford: Oxford Univ. Press, 1978–.

Parkett. 3/year. Zürich, Switzerland: Parkett Verlag AG, 1984–.

Print Quarterly. Quarterly. London: Print Quarterly Publications, 1984–.

Simiolus: Netherlands Quarterly for the History of Art. Quarterly. Apeldoorn, Netherlands: Stichting voor Nederlandse Kunsthistorische Publicaties, 1966–.

Source: Notes in the History of Art. Quarterly. Chicago: Univ. of Chicago Press, 1981–.

Studies in Iconography. Annually. Kalamazoo: Medieval Institute Publications, Western Michigan Univ., 1993–.

Woman's Art Journal. Semiannually. Philadelphia: Old City Publishing Inc., 1980–.

Internet Directories for Art History Information: A Selected List

ALBERTI'S WINDOW: AN ART HISTORY BLOG,
http://albertis-window.com
Maintained by art historian Monica Bowen, this blog provides interesting and accessible posts for those curious about the history of art of various cultures and periods.

ARCHITECTURE AND BUILDING,
http://www.library.unlv.edu/arch/rsrce/webresources/
A directory of architecture websites collected by Jeanne Brown at the Univ. of Nevada at Las Vegas. Topical lists include architecture, building and construction, design, history, housing, planning, preservation, and landscape architecture. Most entries include a brief annotation and the last date the link was accessed by the compiler.

ART HISTORY RESOURCES ON THE WEB,
http://witcombe.sbc.edu/ARTHLinks.html
Authored by Professor Christopher L.C.E. Witcombe of Sweet Briar College in Virginia since 1995, the site includes an impressive number of links for various art historical eras as well as links to research resources, museums, and galleries. The content is frequently updated.

THE ART STORY,
http://www.theartstory.org
Dedicated to demonstrating the significance of modern and contemporary art, this site includes topic pages on the important artists, movements, and ideas from the mid nineteenth to the twenty-first century, as well as timelines and a blog with frequent posts examining a variety of related topics.

ART THROUGH TIME: A GLOBAL VIEW,
http://www.learner.org/courses/globalart/
Developed by Annenberg Learner, this 13-part series is a thematic and global overview of the history of art. The website makes use of videos, images, and text for each of the themes, which include the body, conflict, portraits, death, belief, cultures, dreams, history, ceremony, writing, domestic life, the natural world, and urban experience.

ART21,
http://www.art21.org/
Devoted to chronicling contemporary art and artists, this site provides access to films, articles, interviews, and other interpretive resources in order to introduce the public to contemporary art and the creative process.

ARTBABBLE,
http://www.artbabble.org/
An online community created by staff at the Indianapolis Museum of Art to showcase art-based video content, including interviews with artists and curators, original documentaries, and art installation videos. Partners and contributors to the project include ART21, Los Angeles County Museum of Art, the Museum of Modern Art, the New York Public Library, San Francisco Museum of Modern Art, and Smithsonian American Art Museum.

ARTCYCLOPEDIA: THE GUIDE TO GREAT ART ON THE INTERNET,
http://www.artcyclopedia.com
With more than 2,100 art sites and 75,000 links, this is one of the most comprehensive Web directories for artists and art topics. The primary search is by artist's name but access is also available by title of artwork, artistic movement, museum and gallery, nationality, period, and medium.

ARTSTOR,
http://www.artstor.org
Created by the Andrew W. Mellon Foundation, Artstor is a digital library of more than 1.9 million images for educational and research purposes gathered from institutions and databases around the world. The site also provides instructor resources, including curriculum and subject guides as well as tools for sharing and downloading images.

ARTSY,
https://www.artsy.net
With the goal of making the world's art accessible online, Artsy provides a rapidly expanding image database for works of art, design, and architecture from galleries, museums, estates, auctions, art fairs, and foundations. Especially strong in contemporary art and collecting, this site also continues to develop its pool of historical images and educational resources, including lesson plans.

EUROPEANA COLLECTIONS,
http://www.europeana.eu/portal/
Excellent for accessing more than 48 million European artworks, artifacts, videos, and books, this site offers compilations of collections by theme, period, location, or artist as well as online curated exhibitions, blog posts, and eBooks.

THE GETTY,
http://www.getty.edu/museum/index.html
The J. Paul Getty Museum's website is a great resource with access to the archived collection with thousands of downloadable images, art-historical research databases, and videos exploring works and themes related to the collection, conservation, and exhibitions.

GOOGLE ART PROJECT,
https://www.google.com/culturalinstitute/u/0/project/art-project
In 2011, Google launched this site in order to make the world's cultural heritage and objects more widely accessible for a global audience. Since then, they have compiled more than 700 digitized collections worldwide and have partnered with more than 850 institutions to provide access to high-resolution images and curated digital exhibitions.

HEILBRUNN TIMELINE OF ART HISTORY,
http://www.metmuseum.org/toah/
Illustrating the Metropolitan Museum of Art's collection, this resource compiles essays and images alongside chronologies to narrate the global history of art and culture. Includes the option to search for content by time period, region, or theme.

THE MODERN ART NOTES PODCAST,
https://manpodcast.com/
Hosted and produced by the historian and award-winning art critic Tyler Green, the MAN Podcast features hour-long interviews with artists, art historians, authors, curators, and conservators each week to discuss their work and topics current in the art world.

MoMA LEARNING,
http://www.moma.org/learn/moma_learning
The Museum of Modern Art's online resources for approaching modern and contemporary art. Organized by theme or artist, this site compiles lesson plans, PowerPoints, worksheets, and videos to engage students with the art in MoMA's collection.

MOTHER OF ALL ART AND ART HISTORY LINKS PAGES,
http://umich.edu/~motherha
Maintained by the Dept. of the History of Art at the Univ. of Michigan, this directory covers art history departments, art museums, and fine-arts schools and departments, as well as links to research resources. Each entry includes annotations.

VOICE OF THE SHUTTLE,
http://vos.ucsb.edu
Sponsored by Univ. of California, Santa Barbara, this directory includes more than 70 pages of links to humanities and humanities-related resources on the Internet. The structured guide includes specific subsections on architecture, on art (modern and contemporary), and on art history. Links usually include a one-sentence explanation, and the resource is frequently updated with new information.

Ancient Art in the Western Tradition, General

Amiet, Pierre. *Art in the Ancient World: A Handbook of Styles and Forms*. New York: Rizzoli, 1981.

Beard, Mary, and John Henderson. *Classical Art: From Greece to Rome*. Oxford History of Art. Oxford: Oxford Univ. Press, 2001.

Boardman, John. *Oxford History of Classical Art*. New York: Oxford Univ. Press, 2001.

Chitham, Robert. *The Classical Orders of Architecture*. 2nd ed. Boston: Elsevier/Architectural Press, 2005.

Ehrich, Robert W., ed. *Chronologies in Old World Archaeology*. 3rd ed. 2 vols. Chicago: Univ. of Chicago Press, 1992.

Gerster, Georg. *The Past from Above: Aerial Photographs of Archaeological Sites*. Ed. Charlotte Trümpler. Trans. Stewart Spencer. Los Angeles: J. Paul Getty Museum, 2005.

Groenewegen-Frankfort, H.A., and Bernard Ashmole. *Art of the Ancient World: Painting, Pottery, Sculpture, Architecture from Egypt, Mesopotamia, Crete, Greece, and Rome*. Library of Art History. Upper Saddle River, NJ: Prentice Hall, 1972.

Haywood, John. *The Penguin Historical Atlas of*

Ancient Civilizations. New York: Penguin, 2005.

Milleker, Elizabeth J., ed. *The Year One: Art of the Ancient World East and West*. New York: Metropolitan Museum of Art, 2000.

Nagle, D. Brendan. *The Ancient World: A Social and Cultural History*. 7th ed. Upper Saddle River, NJ: Pearson/ Prentice Hall, 2010.

Saggs, H.W.F. *Civilization before Greece and Rome*. New Haven: Yale Univ. Press, 1989.

Smith, William Stevenson. *Interconnections in the Ancient Near East: A Study of the Relationships between the Arts of Egypt, the Aegean, and Western Asia*. New Haven: Yale Univ. Press, 1965.

Tadgell, Christopher. *Imperial Form: From Achaemenid Iran to Augustan Rome*. New York: Whitney Library of Design, 1998.

———. *Origins: Egypt, West Asia, and the Aegean*. New York: Whitney Library of Design, 1998.

Trigger, Bruce G. *Understanding Early Civilizations: A Comparative Study*. New York: Cambridge Univ. Press, 2003.

Woodford, Susan. *The Art of Greece and Rome*. 2nd ed. New York: Cambridge Univ. Press, 2004.

European Medieval Art, General

Backman, Clifford R. *The Worlds of Medieval Europe*. 2nd ed. New York: Oxford Univ. Press, 2009.

Bennett, Adelaide Louise, et al. *Medieval Mastery: Book Illumination from Charlemagne to Charles the Bold: 800– 1475*. Trans. Lee Preedy and Greta Arblaster-Holmer. Turnhout: Brepols, 2002.

Benton, Janetta R. *Art of the Middle Ages*. World of Art. New York: Thames & Hudson, 2002.

Binski, Paul. *Painters*. Medieval Craftsmen. London: British Museum Press, 1991.

Brown, Sarah, and David O'Connor. *Glass-painters*. Medieval Craftsmen. London: British Museum Press, 1991.

Calkins, Robert G. *Medieval Architecture in Western Europe: From A.D. 300 to 1500*. New York: Oxford Univ. Press, 1998.

Cherry, John F. *Goldsmiths*. Medieval Craftsmen. London: British Museum Press, 1992.

Clark, William W. *The Medieval Cathedrals*. Westport, CT: Greenwood Press, 2006.

Coldstream, Nicola. *Masons and Sculptors*. Medieval Craftsmen. London: British Museum Press, 1991.

———. *Medieval Architecture*. Oxford History of Art. Oxford: Oxford Univ. Press, 2002.

De Hamel, Christopher. *Scribes and Illuminators*. Medieval Craftsmen. London: British Museum Press, 1992.

Duby, Georges. *Art and Society in the Middle Ages*. Trans. Jean Birrell. Malden, MA: Blackwell, 2000.

Fossier, Robert, ed. *The Cambridge Illustrated History of the Middle Ages*. Trans. Janet Sondheimer and Sarah Hanbury Tenison. 3 vols. Cambridge: Cambridge Univ. Press, 1986–97.

Hoffman, Eva R., ed. *Late Antique and Medieval Art of the Mediterranean World*. Malden, MA: Blackwell Publishing Ltd., 2007.

Hürlimann, Martin, and Jean Bony. *French Cathedrals*. Rev. & enlarged ed. London: Thames & Hudson, 1967.

Jotischky, Andrew, and Caroline Susan Hull. *The Penguin Historical Atlas of the Medieval World*. New York: Penguin, 2005.

Kenyon, John. *Medieval Fortifications*. Leicester: Leicester Univ. Press, 1990.

Pfaffenbichler, Matthias. *Armourers*. Medieval Craftsmen. London: British Museum Press, 1992.

Rebold Benton, Janetta. *Art of the Middle Ages*. World of Art. New York: Thames & Hudson, 2002.

Rudolph, Conrad, ed. *A Companion to Medieval Art*. Blackwell Companions to Art History. Oxford: Blackwell, 2006.

Sekules, Veronica. *Medieval Art*. Oxford History of Art. New York: Oxford Univ. Press, 2001.

Snyder, James, Henry Luttikhuizen, and Dorothy Verkerk. *Art of the Middle Ages*. 2nd ed. Upper Saddle River, NJ: Pearson/Prentice Hall, 2006.

Staniland, Kay. *Embroiderers*. Medieval Craftsmen. London: British Museum Press, 1991.

Stokstad, Marilyn. *Medieval Art*. 2nd ed. Boulder, CO: Westview Press, 2004.

———. *Medieval Castles*. Greenwood Guides to Historic Events of the Medieval World. Westport, CT: Greenwood Press, 2005.

European Renaissance through Eighteenth-Century Art, General

Black, C.F., et al. *Cultural Atlas of the Renaissance*. New York: Prentice Hall, 1993.

Blunt, Anthony. *Art and Architecture in France, 1500–1700*. 5th ed. Revised Richard Beresford. Pelican History of Art. New Haven: Yale Univ. Press, 1999.

Brown, Jonathan. *Painting in Spain: 1500–1700*. Pelican History of Art. New Haven: Yale Univ. Press, 1998.

Campbell, Stephen J., and Michael W. Cole. *Italian Renaissance Art*. New York: Thames & Hudson, 2014.

Cole, Bruce. *Studies in the History of Italian Art, 1250–1550*. London: Pindar Press, 1996.

Graham-Dixon, Andrew. *Renaissance*. Berkeley: Univ. of California Press, 1999.

Harbison, Craig. *The Mirror of the Artist: Northern Renaissance Art in Its Historical Context*. Perspectives. New York: Abrams, 1995.

Harris, Ann Sutherland. *Seventeenth-Century Art & Architecture*. 2nd ed. Upper Saddle River, NJ: Pearson/ Prentice Hall, 2008.

Harrison, Charles, Paul Wood, and Jason Gaiger. *Art in Theory 1648–1815: An Anthology of Changing Ideas*. Oxford: Blackwell, 2000.

Hartt, Frederick, and David G. Wilkins. *History of Italian Renaissance Art: Painting, Sculpture, Architecture*. 7th ed. Upper Saddle River, NJ: Pearson/Prentice Hall, 2011.

Jestaz, Bertrand. *The Art of the Renaissance*. Trans. I. Mark Paris. New York: Abrams, 1994.

Minor, Vernon Hyde. *Baroque & Rococo: Art & Culture*. New York: Abrams, 1999.

Paoletti, John T., and Gary M. Radke. *Art in Renaissance Italy*. 3rd ed. Upper Saddle River, NJ: Pearson/Prentice Hall, 2005.

Smith, Jeffrey Chipps. *The Northern Renaissance*. Art & Ideas. London and New York: Phaidon Press, 2004.

Stechow, Wolfgang. *Northern Renaissance, 1400–1600: Sources and Documents*. Upper Saddle River, NJ: Pearson/ Prentice Hall, 1966.

Summerson, John. *Architecture in Britain, 1530–1830*. 9th ed. Pelican History of Art. New Haven: Yale Univ. Press, 1993.

Waterhouse, Ellis K. *Painting in Britain, 1530–1790*. 5th ed. Pelican History of Art. New Haven: Yale Univ. Press, 1994.

Whinney, Margaret Dickens. *Sculpture in Britain: 1530– 1830*. 2nd ed. Revised John Physick. Pelican History of Art. London: Penguin, 1988.

Modern Art in the West, General

Arnason, H.H., and Elizabeth C. Mansfield. *History of Modern Art: Painting, Sculpture, Architecture, Photography*. 6th ed. Upper Saddle River, NJ: Pearson/Prentice Hall, 2009.

Ballantyne, Andrew, ed. *Architectures: Modernism and After*. New Interventions in Art History, 3. Malden, MA: Blackwell, 2004.

Barnitz, Jacqueline. *Twentieth-Century Art of Latin America*. Austin: Univ. of Texas Press, 2001.

Bjelajac, David. *American Art: A Cultural History*. Rev. and expanded ed. Upper Saddle River, NJ: Pearson/Prentice Hall, 2005.

Bowness, Alan. *Modern European Art*. World of Art. New York: Thames & Hudson, 1995.

Brettell, Richard R. *Modern Art, 1851–1929: Capitalism and Representation*. Oxford History of Art. Oxford: Oxford Univ. Press, 1999.

Chipp, Herschel B. *Theories of Modern Art: A Source Book by Artists and Critics*. California Studies in the History of Art, 11. Berkeley: Univ. of California Press, 1984.

Clarke, Graham. *The Photograph*. Oxford History of Art. Oxford: Oxford Univ. Press, 1997.

Craven, David. *Art and Revolution in Latin America, 1910–1990*. New Haven: Yale Univ. Press, 2002.

Craven, Wayne. *American Art: History and Culture*. 2nd ed. Boston: McGraw-Hill, 2003.

Doordan, Dennis P. *Twentieth-Century Architecture*. New York: Abrams, 2002.

Doss, Erika. *Twentieth-Century American Art*. Oxford History of Art. Oxford: Oxford Univ. Press, 2002.

Edwards, Steve, and Paul Wood, eds. *Art of the Avant-Gardes*. Art of the 20th Century. New Haven: Yale Univ. Press, 2004.

Foster, Hal, et al. *Art Since 1900: Modernism, Antimodernism, Postmodernism*. New York: Thames & Hudson, 2004.

Gaiger, Jason, ed. *Frameworks for Modern Art*. Art of the 20th Century. New Haven: Yale Univ. Press, 2003.

———, and Paul Wood, eds. *Art of the Twentieth Century: A Reader*. New Haven: Yale Univ. Press, 2003.

Hamilton, George Heard. *Painting and Sculpture in Europe, 1880–1940*. 6th ed. Pelican History of Art. New Haven: Yale Univ. Press, 1993.

Hammacher, A.M. *Modern Sculpture: Tradition and Innovation*. Enl. ed. New York: Abrams, 1988.

Harris, Ann Sutherland, and Linda Nochlin. *Women Artists: 1550–1950*. Los Angeles: Los Angeles County Museum of Art, 1976.

Harrison, Charles, and Paul Wood, eds. *Art in Theory: 1900–2000: An Anthology of Changing Ideas*. 2nd ed. Malden, MA: Blackwell, 2003.

Hunter, Sam, John Jacobus, and Daniel Wheeler. *Modern Art: Painting, Sculpture, Architecture, Photography*. 3rd rev. & exp. ed. Upper Saddle River, NJ: Pearson/Prentice Hall, 2004.

Krauss, Rosalind E. *Passages in Modern Sculpture*. Cambridge, MA: MIT Press, 1977.

Mancini, JoAnne Marie. *Pre-Modernism: Art-World Change and American Culture from the Civil War to the Armory Show*. Princeton, NJ: Princeton Univ. Press, 2005.

Marien, Mary Warner. *Photography: A Cultural History*. 3rd ed. Upper Saddle River, NJ: Pearson/ Prentice Hall, 2011.

Meecham, Pam, and Julie Sheldon. *Modern Art: A Critical Introduction*. 2nd ed. New York: Routledge, 2005.

Newlands, Anne. *Canadian Art: From Its Beginnings to 2000*. Willowdale, Ont.: Firefly Books, 2000.

Phaidon Atlas of Contemporary World Architecture. London: Phaidon Press, 2004.

Powell, Richard J. *Black Art: A Cultural History.* World of Art. 2nd ed. New York: Thames & Hudson, 2003.

Rosenblum, Naomi. *A World History of Photography.* 4th ed. New York: Abbeville Press, 2007.

Ruhrberg, Karl. *Art of the 20th Century.* Ed. Ingo F. Walther. 2 vols. New York: Taschen, 1998.

Scully, Vincent Joseph. *Modern Architecture and Other Essays.* Princeton, NJ: Princeton Univ. Press, 2003.

Stiles, Kristine, and Peter Selz. *Theories and Documents of Contemporary Art: A Sourcebook of Artists' Writings.* California Studies in the History of Art, 35. Berkeley: Univ. of California Press, 1996.

Tafuri, Manfredo. *Modern Architecture.* History of World Architecture. 2 vols. New York: Electa/Rizzoli, 1986.

Upton, Dell. *Architecture in the United States.* Oxford History of Art. Oxford: Oxford Univ. Press, 1998.

Wood, Paul, ed. *Varieties of Modernism.* Art of the 20th Century. New Haven: Yale Univ. Press, 2004.

Woodham, Jonathan M. *Twentieth-Century Design.* Oxford History of Art. Oxford: Oxford Univ. Press, 1997.

Asian Art, General

Addiss, Stephen, Gerald Groemer, and J. Thomas Rimer, eds. *Traditional Japanese Arts and Culture: An Illustrated Sourcebook.* Honolulu: Univ. of Hawai'i Press, 2006.

Barnhart, Richard M. *Three Thousand Years of Chinese Painting.* New Haven: Yale Univ. Press, 1997.

Blunden, Caroline, and Mark Elvin. *Cultural Atlas of China.* 2nd ed. New York: Checkmark Books, 1998.

Brown, Kerry, ed. *Sikh Art and Literature.* New York: Routledge in collaboration with the Sikh Foundation, 1999.

Chang, Léon Long-Yien, and Peter Miller. *Four Thousand Years of Chinese Calligraphy.* Chicago: Univ. of Chicago Press, 1990.

Chang, Yang-mo. *Arts of Korea.* Ed. Judith G. Smith. New York: Metropolitan Museum of Art, 1998.

Clark, John. *Modern Asian Art.* Honolulu: Univ. of Hawai'i Press, 1998.

Clunas, Craig. *Art in China.* 2nd ed. Oxford History of Art. Oxford: Oxford Univ. Press, 2009.

Coaldrake, William H. *Architecture and Authority in Japan.* London: Routledge, 1996.

Collcutt, Martin, Marius Jansen, and Isao Kumakura. *Cultural Atlas of Japan.* New York: Facts on File, 1988.

Craven, Roy C. *Indian Art: A Concise History.* Rev. ed. World of Art. New York: Thames & Hudson, 1997.

Dehejia, Vidya. *Indian Art.* Art & Ideas. London: Phaidon Press, 1997.

Fisher, Robert E. *Buddhist Art and Architecture.* World of Art. New York: Thames & Hudson, 1993.

Fu, Xinian. *Chinese Architecture.* Ed. & exp. ed., Nancy S. Steinhardt. New Haven: Yale Univ. Press, 2002.

Hearn, Maxwell K., and Judith G. Smith, eds. *Arts of the Sung and Yüan: Papers Prepared for an International Symposium.* New York: Dept. of Asian Art, Metropolitan Museum of Art, 1996.

Heibonsha Survey of Japanese Art. 31 vols. New York: Weatherhill, 1972–80.

Hertz, Betti-Sue. *Past in Reverse: Contemporary Art of East Asia.* San Diego: San Diego Museum of Art, 2004.

Japanese Arts Library. 15 vols. New York: Kodansha International, 1977–87.

Kerlogue, Fiona. *Arts of Southeast Asia.* World of Art. New York: Thames & Hudson, 2004.

Khanna, Balraj, and George Michell. *Human and Divine: 2000 Years of Indian Sculpture.* London: Hayward Gallery, 2000.

Lee, Sherman E. *A History of Far Eastern Art.* 5th ed. Ed. Naomi Noble Richards. New York: Abrams, 1994.

———. *China, 5000 Years: Innovation and Transformation in the Arts.* New York: Solomon R. Guggenheim Museum, 1998.

Leidy, Denise Patry. *The Art of Buddhism: An Introduction to Its History and Meaning.* Boston: Shambhala Publications, 2008.

Liu, Cary Y., and Dora C.Y. Ching, eds. *Arts of the Sung and Yüan: Ritual, Ethnicity, and Style in Painting.* Princeton, NJ: Art Museum, Princeton Univ., 1999.

McArthur, Meher. *The Arts of Asia: Materials, Techniques, Styles.* New York: Thames & Hudson, 2005.

———. *Reading Buddhist Art: An Illustrated Guide to Buddhist Signs and Symbols.* New York: Thames & Hudson, 2002.

Mason, Penelope. *History of Japanese Art.* 2nd ed. Upper Saddle River, NJ: Pearson/Prentice Hall, 2005.

Michell, George. *Hindu Art and Architecture.* World of Art. London: Thames & Hudson, 2000.

———. *The Penguin Guide to the Monuments of India.* 2 vols. New York: Viking, 1989.

Mitter, Partha. *Indian Art.* Oxford History of Art. Oxford: Oxford Univ. Press, 2001.

Murase, Miyeko. *Bridge of Dreams: The Mary Griggs Burke Collection of Japanese Art.* New York: Metropolitan Museum of Art, 2000.

Nickel, Lukas, ed. *Return of the Buddha: The Qingzhou Discoveries.* London: Royal Academy of Arts, 2002.

Pak, Youngsook, and Roderick Whitfield. *Buddhist Sculpture: Handbook of Korean Art.* London: Laurence King Publishing, 2003.

Rawson, Philip. *The Art of Southeast Asia.* World of Art. London: Thames & Hudson, 1967.

Sullivan, Michael. *The Arts of China.* 5th ed., rev. & exp. Berkeley: Univ. of California Press, 2008.

Thorp, Robert L., and Richard Ellis Vinograd. *Chinese Art & Culture.* New York: Abrams, 2001.

Topsfield, Andrew, ed. *In the Realm of Gods and Kings: Arts of India.* London: Philip Wilson, 2004.

Tucker, Jonathan. *The Silk Road: Art and History.* Chicago: Art Media Resources, 2003.

Tregear, Mary. *Chinese Art.* Rev. ed. World of Art. New York: Thames & Hudson, 1997.

Vainker, S.J. *Chinese Pottery and Porcelain: From Prehistory to the Present.* New York: Braziller, 1991.

African and Oceanic Art and Art of the Americas, General

Anderson, Richard L., and Karen L. Field, eds. *Art in Small-Scale Societies: Contemporary Readings.* Upper Saddle River, NJ: Pearson/Prentice Hall, 1993.

Bassani, Ezio, ed. *Arts of Africa: 7000 Years of African Art.* Milan: Skira, 2005.

Benson, Elizabeth P. *Retratos: 2,000 Years of Latin American Portraits.* San Antonio, TX: San Antonio Museum of Art, 2004.

Berlo, Janet Catherine, and Lee Anne Wilson. *Arts of Africa, Oceania, and the Americas: Selected Readings.* Upper Saddle River, NJ: Prentice Hall, 1993.

Calloway, Colin G. *First Peoples: A Documentary Survey of American Indian History.* 3rd ed. Boston: Bedford/St. Martin's, 2008.

Coote, Jeremy, and Anthony Shelton, eds. *Anthropology, Art, and Aesthetics.* New York: Oxford Univ. Press, 1992.

Drewal, Henry, and John Pemberton III. *Yoruba: Nine Centuries of African Art and Thought.* New York: Center for African Art, 1989.

Evans, Susan Toby. *Ancient Mexico & Central America: Archaeology and Culture History.* 2nd ed. New York: Thames & Hudson, 2008.

———, and David L. Webster, eds. *Archaeology of Ancient Mexico and Central America: An Encyclopedia.* New York: Garland, 2001.

———, and Joanne Pillsbury, eds. *Palaces of the Ancient New World: A Symposium at Dumbarton Oaks, 10th and 11th October, 1998.* Washington, DC: Dumbarton Oaks Research Library and Collection, 2004.

Mack, John, ed. *Africa, Arts and Cultures.* London: British Museum Press, 2000.

Mexico: Splendors of Thirty Centuries. New York: Metropolitan Museum of Art, 1990.

Nunley, John W., and Cara McCarty. *Masks: Faces of Culture.* New York: Abrams in assoc. with the Saint Louis Art Museum, 1999.

Perani, Judith, and Fred T. Smith. *The Visual Arts of Africa: Gender, Power, and Life Cycle Rituals.* Upper Saddle River, NJ: Pearson/Prentice Hall, 1998.

Phillips, Tom, ed. *Africa: The Art of a Continent.* New York: Prestel, 1995.

Rabineau, Phyllis. *Feather Arts: Beauty, Wealth, and Spirit from Five Continents.* Chicago: Field Museum of Natural History, 1979.

Scott, John F. *Latin American Art: Ancient to Modern.* Gainesville: Univ. Press of Florida, 1999.

Stepan, Peter. *Africa.* Trans. John Gabriel and Elizabeth Schwaiger. London: Prestel, 2001.

Visonà, Monica Blackmun, et al. *A History of Art in Africa.* 2nd ed. Upper Saddle River, NJ: Pearson/Prentice Hall, 2008.

Introduction

Acton, Mary. *Learning to Look at Paintings.* 2nd ed. New York: Routledge, 2009.

Arnold, Dana. *Art History: A Very Short Introduction.* Oxford and New York: Oxford Univ. Press, 2004.

Baxandall, Michael. *Patterns of Intention: On the Historical Explanation of Pictures.* New Haven: Yale Univ. Press, 1985.

Clearwater, Bonnie. *The Rothko Book.* London: Tate Publishing, 2006.

Decoteau, Pamela Hibbs. *Clara Peeters, 1594–ca.1640 and the Development of Still-Life Painting in Northern Europe.* Lingen: Luca Verlag, 1992.

Geertz, Clifford. "Art as a Cultural System." *Modern Language Notes* 91 (1976): 1473–1499.

Hochstrasser, Julie Berger. *Still Life and Trade in the Dutch Golden Age.* New Haven: Yale Univ. Press, 2007.

Holstein, Jonathan. *The Pieced Quilt: An American Design Tradition.* New York: Galahad Books, 1973.

Jolly, Penny Howell. "Rogier van der Weyden's Escorial and Philadelphia Crucifixions and Their Relation to Fra Angelico at San Marco." *Oud Holland* 95 (1981): 113–126.

Mainardi, Patricia. "Quilts: The Great American Art." *The Feminist Art Journal* 2/1 (1973): 1, 18–23.

Miller, Angela L., et al. *American Encounters: Art, History, and Cultural Identity.* Upper Saddle River, NJ: Pearson/Prentice Hall, 2008.

Minor, Vernon Hyde. *Art History's History.* Upper Saddle River, NJ: Pearson/Prentice Hall, 2001.

Nelson, Robert S., and Richard Shiff, eds. *Critical Terms for Art History.* 2nd ed. Chicago: Univ. of Chicago Press, 2003.

Panofsky, Erwin. *Studies in Iconology: Humanistic*

Themes in the Art of the Renaissance. New York: Oxford Univ. Press, 1939.

———. *Meaning in the Visual Arts.* Phoenix ed. Chicago: Univ. of Chicago Press, 1982.

Preziosi, Donald, ed. *The Art of Art History: A Critical Anthology.* 2nd ed. Oxford and New York: Oxford Univ. Press, 2009.

Rothko, Mark. *Writings on Art.* Ed. Miguel López-Remiro. New Haven: Yale Univ. Press, 2006.

———. *The Artist's Reality: Philosophies of Art.* Ed. Christopher Rothko. New Haven: Yale Univ. Press, 2004.

Schapiro, Meyer. "The Apples of Cézanne: An Essay on the Meaning of Still Life." *Art News Annual* 34 (1968): 34–53. Reprinted in *Modern Art 19th & 20th Centuries: Selected Papers* 2. London: Chatto & Windus, 1978.

Sowers, Robert. *Rethinking the Forms of Visual Expression.* Berkeley: Univ. of California Press, 1990.

Taylor, Joshua. *Learning to Look: A Handbook for the Visual Arts.* 2nd ed. Chicago: Chicago Univ. Press, 1981.

Tucker, Mark. "Rogier van der Weyden's 'Philadelphia Crucifixion.'" *Burlington Magazine* 139 (1997): 676–683.

Wang, Fangyu, et al., eds. *Master of the Lotus Garden: The Life and Art of Bada Shanren (1626–1705).* New Haven: Yale Univ. Press, 1990.

Chapter 18 Fourteenth-Century Art in Europe

Alexander, Jonathan, and Paul Binski, eds. *Age of Chivalry: Art in Plantagenet England, 1200–1400.* London: Royal Academy of Arts, 1987.

Backhouse, Janet. *Illumination from Books of Hours.* London: British Library, 2004.

Boehm, Barbara Drake, and Jiří Fajt, eds. *Prague: The Crown of Bohemia, 1347–1437.* New York: Metropolitan Museum of Art, 2005.

Bony, Jean. *The English Decorated Style: Gothic Architecture Transformed, 1250–1350.* The Wrightsman Lecture, 10. Oxford: Phaidon Press, 1979.

Cennini, Cennino. *The Craftsman's Handbook "Il libro dell'arte."* Trans. D.V. Thompson, Jr. New York: Dover, 1960.

Derbes, Anne, and Mark Sandona, eds. *The Cambridge Companion to Giotto.* Cambridge and New York: Cambridge Univ. Press, 2003.

Fajt, Jiří, ed. *Magister Theodoricus, Court Painter to Emperor Charles IV: The Pictorial Decoration of the Shrines at Karlstejn Castle.* Prague: National Gallery, 1998.

Holt, Elizabeth Gilmore, ed. *A Documentary History of Art.* 2 vols. Princeton, NJ, Princeton Univ. Press, 1982–86.

Ladis, Andrew. ed, *The Arena Chapel and the Genius of Giotto: Padua.* Giotto and the World of Early Italian Art, 2. New York: Garland, 1998.

Meiss, Millard. *Painting in Florence and Siena after the Black Death: The Arts, Religion, and Society in the Mid-Fourteenth Century.* 2nd ed. Princeton, NJ: Princeton Univ. Press, 1978.

Moskowitz, Anita Fiderer. *Italian Gothic Sculpture: c. 1250–c. 1400.* New York: Cambridge Univ. Press, 2001.

Norman, Diana, ed. *Siena, Florence, and Padua: Art, Society, and Religion 1280–1400.* 2 vols. New Haven: Yale Univ. Press, 1995.

Poeschke, Joachim. *Italian Frescoes, the Age of Giotto, 1280–1400.* New York: Abbeville Press, 2005.

Schleif, Corine. "St. Hedwig's Personal Ivory Madonna: Women's Agency and the Powers of Possessing Portable Figures." *The Four Modes of Seeing: Approaches to Medieval Imagery in Honor of Madeline Harrison Caviness.* Ed. Evelyn Staudinger Lane, Elizabeth Carson Paston, and Ellen M. Shortell. Farnham, Surrey: Ashgate, 2009: 282–403.

Vasari, Giorgio. *The Lives of the Artists.* Trans. Julia Conaway Bondanella and Peter Bondanella. Oxford World's Classics. New York: Oxford Univ. Press, 2008.

Welch, Evelyn S. *Art in Renaissance Italy, 1350–1500.* New ed. Oxford History of Art. Oxford: Oxford Univ. Press, 2000.

White, John. *Art and Architecture in Italy, 1250 to 1400.* 3rd ed. Pelican History of Art. Harmondsworth, UK: Penguin, 1993.

Wieck, Roger S. *Time Sanctified: The Book of Hours in Medieval Art and Life.* 2nd ed. New York: Braziller, 2001.

Chapter 19 Fifteenth-Century Art in Northern Europe

Art from the Court of Burgundy: The Patronage of Philip the Bold and John the Fearless 1364–1419. Dijon: Musée des Beaux-Arts and Cleveland: Cleveland Museum of Art, 2004.

Baxandall, Michael. *The Limewood Sculptors of Renaissance Germany.* New Haven: Yale Univ. Press, 1980.

Blum, Shirley. *Early Netherlandish Triptychs: A Study in Patronage.* California Studies in the History of Art, 13. Berkeley: Univ. of California Press, 1969.

Borchert, Till-Holger. *Age of Van Eyck: The Mediterranean World and Early Netherlandish Painting, 1430–1530.* New York: Thames & Hudson, 2002.

Campbell, Lorne. *The Fifteenth-Century Netherlandish Schools.* National Gallery Catalogues. London: National Gallery, 1998.

Cavallo, Adolph S. *The Unicorn Tapestries at the Metropolitan Museum of Art.* New York: Metropolitan Museum of Art, 1998.

Chastel, Andrè. *French Art: The Renaissance, 1430–1620.* Paris: Flammarion, 1995.

Dhanens, Elisabeth. *Van Eyck: The Ghent Altarpiece.* New York: Viking Press, 1973.

Füssel, Stephan. *Gutenberg and the Impact of Printing.* Trans. Douglas Martin. Burlington, VT: Ashgate, 2005.

Koster, Margaret L. "The *Arnolfini Double Portrait*: A Simple Solution." *Apollo* 157 (September 2003): 3–14.

Lane, Barbara G. *The Altar and the Altarpiece: Sacramental Themes in Early Netherlandish Painting.* New York: Harper & Row, 1984.

Marks, Richard, and Paul Williamson, eds. *Gothic: Art for England 1400–1547.* London: V&A Publications, 2003.

Meiss, Millard. *French Painting in the Time of Jean de Berry: The Limbourgs and their Contemporaries.* 2 vols. New York: Braziller, 1974.

Müller, Theodor. *Sculpture in the Netherlands, Germany, France, and Spain: 1400–1500.* Trans. Elaine and William Robson Scott. Pelican History of Art. Harmondsworth, UK: Penguin, 1966.

Pächt, Otto. *Early Netherlandish Painting: From Rogier van der Weyden to Gerard David.* Ed. Monika Rosenauer. Trans. David Britt. London: Harvey Miller, 1997.

———. *Van Eyck and the Founders of Early Netherlandish Painting.* London: Miller, 1994.

Panofsky, Erwin. *Early Netherlandish Painting, Its Origins and Character.* 2 vols. Cambridge, MA:

Harvard Univ. Press, 1966.

Parshall, Peter W., and Rainer Schoch. *Origins of European Printmaking: Fifteenth-Century Woodcuts and their Public.* Washington, DC: National Gallery of Art, 2005.

Plummer, John. *The Last Flowering: French Painting in Manuscripts, 1420–1530, from American Collections.* New York: Pierpont Morgan Library, 1982.

Seidel, Linda. *Jan van Eyck's Arnolfini Portrait: Stories of an Icon.* New York: Cambridge Univ. Press, 1993.

Smith, Jeffrey Chipps. *The Northern Renaissance.* London and New York: Phaidon Press, 2004.

Snyder, James. *Northern Renaissance Art: Painting, Sculpture, the Graphic Arts from 1350 to 1575.* 2nd ed. rev. Larry Silver and Henry Luttikhuizen. Upper Saddle River, NJ: Prentice Hall, 2005.

Vos, Dirk de. *The Flemish Primitives: The Masterpieces.* Princeton, NJ: Princeton Univ. Press, 2002.

Zuffi, Stefano. *European Art of the Fifteenth Century.* Trans. Brian D. Phillips. Art through the Centuries. Los Angeles: J. Paul Getty Museum, 2005.

Chapter 20 Renaissance Art in Fifteenth-Century Italy

Adams, Laurie Schneider. *Italian Renaissance Art.* Boulder, CO: Westview Press, 2001.

Ahl, Diane Cole, ed. *The Cambridge Companion to Masaccio.* New York: Cambridge Univ. Press, 2002.

Alberti, Leon Battista. *On Painting.* Trans. John R. Spencer. New Haven: Yale Univ. Press, 1966.

Ames-Lewis, Francis. *Drawing in Early Renaissance Italy.* 2nd ed. New Haven: Yale Univ. Press, 2000.

———. *The Intellectual Life of the Early Renaissance Artist.* New Haven: Yale Univ. Press, 2000.

Baxandall, Michael. *Painting and Experience in Fifteenth- Century Italy: A Primer in the Social History of Pictorial Style.* 2nd ed. Oxford: Oxford Univ. Press, 1988.

Boskovits, Miklós. *Italian Paintings of the Fifteenth Century.* The Collections of the National Gallery of Art. Washington, DC: National Gallery of Art, 2003.

Botticelli and Filippino: Passion and Grace in Fifteenth-Century Florentine Painting. Milan: Skira, 2004.

Brown, Patricia Fortini. *Art and Life in Renaissance Venice.* Perspectives. New York: Abrams, 1997. Reissue ed. Upper Saddle River, NJ: Pearson/Prentice Hall, 2006.

Brucker, Gene. *Florence: The Golden Age, 1138–1737.* Berkeley: Univ. of California Press, 1998.

Christiansen, Keith, Laurence B. Kanter, and Carl Brandon Strehlke. *Painting in Renaissance Siena, 1420–1500.* New York: Metropolitan Museum of Art, 1988.

Gilbert, Creighton, ed. *Italian Art, 1400–1500: Sources and Documents.* Evanston, IL: Northwestern Univ. Press, 1992.

Heydenreich, Ludwig Heinrich. *Architecture in Italy, 1400–1500.* Revised Paul Davies. Pelican History of Art. New Haven: Yale Univ. Press, 1996.

Hind, Arthur M. *An Introduction to a History of Woodcut.* New York: Dover, 1963.

Hyman, Timothy. *Sienese Painting: The Art of a City-Republic (1278–1477).* World of Art. New York: Thames & Hudson, 2003.

King, Ross. *Brunelleschi's Dome: How a Renaissance Genius Reinvented Architecture.* New York: Walker, 2000.

Pächt, Otto. *Venetian Painting in the 15th Century: Jacopo, Gentile and Giovanni Bellini and Andrea Mantegna*. Ed. Margareta Vyoral-Tschapka and Michael Pächt. Trans. Fiona Elliott. London: Harvey Miller, 2003.

Partridge, Loren W. *The Art of Renaissance Rome, 1400–1600*. 2nd ed. Upper Saddle River, NJ: Pearson/Prentice Hall, 2006.

———. *Art of Renaissance Florence, 1400–1600*. Berkeley: Univ. of California Press, 2009.

de Pisan, Christine. *The Book of the City of Ladies*. Trans. Rosalind Brown-Grant. London: Penguin Books, 1999.

Poeschke, Joachim. *Donatello and His World: Sculpture of the Italian Renaissance*. Trans. Russell Stockman. New York: Abrams, 1993.

Pope-Hennessy, John. *Italian Renaissance Sculpture*. 4th ed. London: Phaidon Press, 1996.

Radke, Gary M., ed. *The Gates of Paradise: Lorenzo Ghiberti's Masterpiece*. New Haven: Yale Univ. Press, 2007.

Randolph, Adrian W.B., *Engaging Symbols: Gender, Politics, and Public Art in Fifteenth-Century Florence*. New Haven: Yale Univ. Press, 2002.

Troncelliti, Latifah. *The Two Parallel Realities of Alberti and Cennini: The Power of Writing and the Visual Arts in the Italian Quattrocento*. Studies in Italian Literature, vol. 14. Lewiston, NY: Mellen Press, 2004.

Turner, Richard. *Renaissance Florence: The Invention of a New Art*. Perspectives. New York: Abrams, 1997. Reissue ed. Upper Saddle River, NJ: Pearson/Prentice Hall, 2006.

Vasari, Giorgio. *The Lives of the Artists*. Trans. Julia Conaway Bondanella and Peter Bondanella. Oxford World's Classics. New York: Oxford Univ. Press, 2008.

Verdon, Timothy, and John Henderson, eds. *Christianity and the Renaissance: Image and Religious Imagination in the Quattrocento*. Syracuse, NY: Syracuse Univ. Press, 1990.

Walker, Paul Robert. *The Feud that Sparked the Renaissance: How Brunelleschi and Ghiberti Changed the Art World*. New York: William Morrow, 2002.

Welch, Evelyn S. *Art and Society in Italy, 1350–1500*. Oxford History of Art. Oxford: Oxford Univ. Press, 1997.

Chapter 21 Sixteenth-Century Art in Italy

Acidini Luchinat, Cristina, et al. *The Medici, Michelangelo,& the Art of Late Renaissance Florence*. New Haven:Yale Univ. Press, 2002.

Bambach, Carmen. *Drawing and Painting in the Italian Renaissance Workshop: Theory and Practice, 1330–1600*. Cambridge: Cambridge Univ. Press, 1999.

Barriault, Anne B., ed. *Reading Vasari*. London: Philip Wilson in assoc. with the Georgia Museum of Art, 2005.

Brambilla Barcilon, Pinin. *Leonardo: The Last Supper*. Chicago: Univ. of Chicago Press, 2001.

Brown, Patricia Fortini. *Art and Life in Renaissance Venice*. Perspectives. New York: Abrams, 1997.

Cellini, Benvenuto. *Autobiography*. Rev. ed. Trans. George Bull. Penguin Classics. New York: Penguin, 1998.

Chelazzi Dini, Giulietta, Alessandro Angelini, and Bernardina Sani. *Sienese Painting: From Duccio to the Birth of the Baroque*. New York: Abrams, 1998.

Clark, Kenneth. *Leonardo da Vinci*. Ed. Martin Kemp. London: Penguin, 2015.

Cole, Alison. *Virtue and Magnificence: Art of the Italian Renaissance Courts*. Perspectives. New York:

Abrams, 1995. Reissue ed. as *Art of the Italian Courts*. Upper Saddle River, NJ: Pearson/Prentice Hall, 2006.

Franklin, David, ed. *Leonardo da Vinci, Michelangelo, and the Renaissance in Florence*. Ottawa: National Gallery of Canada in assoc. with Yale Univ. Press, 2005.

Freedberg, S.J. *Painting in Italy, 1500 to 1600*. 3rd ed.Pelican History of Art. New Haven: Yale Univ. Press, 1993.

Goffen, Rona. *Renaissance Rivals: Michelangelo, Leonardo, Raphael, Titian*. New Haven: Yale Univ. Press, 2002.

———. *Titian's Venus of Urbino*. Masterpieces of Western Painting. Cambridge: Cambridge Univ. Press, 1997.

———. *Titian's Women*. New Haven: Yale Univ. Press, 1997.

Hall, Marcia B. *After Raphael: Painting in Central Italy in the Sixteenth Century*. New York: Cambridge Univ. Press, 1999.

———, ed. *The Cambridge Companion to Raphael*. New York: Cambridge Univ. Press, 2005.

Hollingsworth, Mary. *Patronage in Sixteenth Century Italy*. London: John Murray, 1996.

Hopkins, Andrew. *Italian Architecture: From Michelangelo to Borromini*. World of Art. New York: Thames & Hudson, 2002.

Hughes, Anthony. *Michelangelo*. Art & Ideas. London: Phaidon Press, 1997.

Huse, Norbert, and Wolfgang Wolters. *Art of Renaissance Venice: Architecture, Sculpture, and Painting, 1460–1590*. Trans. Edmund Jephcott. Chicago: Univ. of Chicago Press, 1990.

Joannides, Paul. *Titian to 1518: The Assumption of Genius*. New Haven: Yale Univ. Press, 2001.

Klein, Robert, and Henri Zerner. *Italian Art, 1500–1600: Sources and Documents*. Upper Saddle River, NJ: Pearson/ Prentice Hall, 1966.

Kliemann, Julian-Matthias, and Michael Rohlmann. *Italian Frescoes: High Renaissance and Mannerism, 1510–1600*. Trans. Steven Lindberg. New York: Abbeville Press, 2004.

Landau, David, and Peter Parshall. *The Renaissance Print: 1470–1550*. New Haven: Yale Univ. Press, 1994.

Lieberman, Ralph. *Renaissance Architecture in Venice, 1450–1540*. New York: Abbeville Press, 1982.

Lotz, Wolfgang. *Architecture in Italy, 1500–1600*. Revised Deborah Howard. Pelican History of Art. New Haven: Yale Univ. Press, 1995.

Meilman, Patricia, ed. *The Cambridge Companion to Titian*. New York: Cambridge Univ. Press, 2004.

Mitrovic, Branko. *Learning from Palladio*. New York:Norton, 2004.

Murray, Linda. *The High Renaissance and Mannerism: Italy,the North and Spain, 1500–1600*. World of Art. London: Thames & Hudson, 1995.

Palladio, Andrea. *The Four Books on Architecture*. Trans. Robert Tavernor and Richard Schofield. Cambridge, MA: MIT Press, 1997.

Partridge, Loren W. *The Art of Renaissance Rome, 1400–1600*. 2nd ed. Upper Saddle River, NJ: Pearson/Prentice Hall, 2006.

———. *Art of Renaissance Florence, 1400–1600*. Berkeley: Univ. of California Press, 2009.

———. *Michelangelo, the Last Judgment: A GloriousRestoration*. New York: Abrams, 1997.

Pilliod, Elizabeth. *Pontormo, Bronzino, Allori: A Genealogy of Florentine Art*. New Haven: Yale Univ. Press, 2001.

Pope-Hennessy, John. *Italian High Renaissance and

Baroque Sculpture*. 4th ed. London: Phaidon Press, 1996.

Rosand, David. *Painting in Cinquecento Venice: Titian, Veronese, Tintoretto*. Rev. ed. Cambridge: Cambridge Univ. Press, 1997.

Rowe, Colin, and Leon Satkowski. *Italian Architectureof the 16th Century*. New York: Princeton Architectural Press, 2002.

Rowland, Ingrid D. *The Culture of the High Renaissance: Ancients and Moderns in Sixteenth Century Rome*. Cambridge: Cambridge Univ. Press, 1998.

Shearman, John. *Mannerism*. Harmondsworth, UK: Penguin, 1967. Reissue ed. New York: Penguin, 1990.

Syson, Luke. *Leonardo da Vinci: Painter at the Court of Milan*. London and New Haven: Yale Univ. Press, 2011.

Vasari, Giorgio. *The Lives of the Artists*. Trans. Julia Conaway Bondanella and Peter Bondanella. Oxford World's Classics. New York: Oxford Univ. Press, 2008.

Verheyen, Egon. *The Paintings in the Studiolo of Isabella d'Este at Mantua*. Monographs on Archaeology andFine Arts, 23. New York: New York Univ. Press, 1971.

Williams, Robert. *Art, Theory, and Culture inSixteenth-Century Italy: From Techne to Metateche*. Cambridge: Cambridge Univ. Press, 1997.

Zöllner, Frank et al. *Michelangelo: Complete Works*. Cologne: Taschen, 2014.

Chapter 22 Sixteenth-Century Art in Northern Europe and the Iberian Peninsula

Bartrum, Giulia. *Albrecht Dürer and his Legacy: The Graphic Work of a Renaissance Artist*. London: British Museum Press, 2002.

———. *German Renaissance Prints 1490–1550*. London: British Museum Press, 1995.

Brown, Jonathan. *Painting in Spain, 1500–1700*. Pelican History of Art. New Haven: Yale Univ. Press, 1998.

Buck, Stephanie, and Jochen Sander. *Hans Holbein the Younger: Painter at the Court of Henry VIII*. Trans. Rachel Esner and Beverley Jackson. New York: Thames & Hudson, 2004.

Chapuis, Julien. *Tilman Riemenschneider: Master Sculptor of the Late Middle Ages*. Washington, DC: National Gallery of Art, 1999.

Davies, David, and John H. Elliott. *El Greco*. London: National Gallery, 2003.

Dixon, Laurinda. *Bosch*. Art & Ideas. New York: Phaidon Press, 2003.

Foister, Susan. *Holbein and England*. New Haven: Published for Paul Mellon Centre for Studies in British Art by Yale Univ. Press, 2004.

Harbison, Craig. *The Art of the Northern Renaissance*. London: Laurence King Publishing, 2012.

Hayum, Andrée. *The Isenheim Altarpiece: God's Medicine and the Painter's Vision*. Princeton Essays on the Arts, 18. Princeton, NJ: Princeton Univ. Press, 1989.

Hearn, Karen, ed. *Dynasties: Painting in Tudor and Jacobean England, 1530–1630*. New York: Rizzoli, 1996.

Koerner, Joseph Leo. *The Reformation of the Image*. Chicago: Univ. of Chicago Press, 2004.

———. *The Moment of Self-Portraiture in German Renaissance Art*. Chicago: Univ. of Chicago Press, 1996.

Kubler, George. *Building the Escorial*. Princeton, NJ: Princeton Univ. Press, 1982.

Nash, Susie. *Northern Renaissance Art*. Oxford

History of Art. New York: Oxford Univ. Press, 2008.

Price, David Hotchkiss. *Albrecht Dürer's Renaissance: Humanism, Reformation, and the Art of Faith.* Studies in Medieval and Early Modern Civilization. Ann Arbor: Univ. of Michigan Press, 2003.

Roberts-Jones, Philippe, and Françoise Roberts-Jones.*Pieter Bruegel.* New York: Abrams, 2002.

Smith, Jeffrey Chipps. *Nuremberg, a Renaissance City, 1500–1618.* Austin: Huntington Art Gallery, Univ. of Texas, 1983.

———. *The Northern Renaissance.* London and New York: Phaidon Press, 2004.

———. *Durer.* London and New York: Phaidon, 2012.

Snyder, James. *Northern Renaissance Art: Painting, Sculpture, the Graphic Arts from 1350 to 1575.* 2nd ed. rev. Larry Silver and Henry Luttikhuizen. Upper Saddle River, NJ: Pearson/Prentice Hall, 2005.

Strong, Roy C. *Artists of the Tudor Court: The Portrait Miniature Rediscovered, 1520–1620.* London: V&A Publications, 1983.

Zerner, Henri. *Renaissance Art in France: The Invention of Classicism.* Paris: Flammarion, 2003.

Zorach, Rebecca. *Blood, Milk, Ink, Gold: Abundance and Excess in the French Renaissance.* Chicago: Univ. of Chicago Press, 2005.

Chapter 23 Seventeenth-Century Art in Europe

Adams, Laurie Schneider. *Key Monuments of the Baroque.* Boulder, CO: Westview Press, 2000.

Allen, Christopher. *French Painting in the Golden Age.* World of Art. New York: Thames & Hudson, 2003.

Alpers, Svetlana. *The Art of Describing: Dutch Art in the Seventeenth Century.* Chicago. Chicago Univ. Press, 1983.

———. *The Making of Rubens.* New Haven: Yale Univ. Press, 1995.

Blankert, Albert. *Rembrandt: A Genius and His Impact.* Melbourne: National Gallery of Victoria, 1997.

Belkin, Kristin Lohse. *Rubens. Art & Ideas.* London: Phaidon, 1998.

Boucher, Bruce. *Italian Baroque Sculpture.* World of Art.New York: Thames & Hudson, 1998.

Brown, Beverly Louise, ed. *The Genius of Rome, 1592–1623.* London: Royal Academy of Arts, 2001.

Brown, Jonathan. *Painting in Spain, 1500–1700.* Pelican History of Art. New Haven: Yale Univ. Press, 1998.

———, and Carmen Garrido. *Velásquez: The Technique of Genius.* New Haven: Yale Univ. Press, 2003.

Careri, Giovanni. *Baroques.* Tran. Alexandra Bonfante-Warren. Princeton: Princeton Univ. Press, 2003.

Chapman, H. Perry. *Rembrandt's Self-Portraits: A Study in 17th-Century Identity.* Princeton: Princeton Univ. Press, 1990.

Chong, Alan, and Wouter Kloek. *Still-Life Paintings from the Netherlands, 1550–1720.* Zwolle: Waanders, 1999.

Enggass, Robert, and Jonathan Brown. *Italian and Spanish Art, 1600–1750: Sources and Documents.* 2nd ed. Evanston, IL: Northwestern Univ. Press, 1992.

Franklin, David, and Sebastian Schütze. *Caravaggio and his Followers in Rome.* New Haven: Yale Univ. Press, 2011.

Frantis, Wayne E., ed. *The Cambridge Companion to Vermeer.* Cambridge: Cambridge Univ. Press, 2001.

———. *Dutch Seventeenth-Century Genre Painting:Its Stylistic and Thematic Evolution.* New Haven: Yale Univ. Press, 2004.

Harbison, Robert. *Reflections on Baroque.* Chicago: Univ. of Chicago Press, 2000.

Keazor, Henry. *Nicolas Poussin, 1594–1665.* Cologne & London: Taschen, 2007.

Kiers, Judikje, and Fieke Tissink. *Golden Age of Dutch Art: Painting, Sculpture, Decorative Art.* London: Thames & Hudson, 2000.

Lagerlöf, Margaretha Rossholm. *Ideal Landscape: Annibale Carracci, Nicolas Poussin, and Claude Lorrain.* New Haven: Yale Univ. Press, 1990.

Martin, John Rupert. *Baroque.* Boulder, CO: Westview Press, 1977.

McPhee, Sarah. *Bernini and the Bell Towers: Architecture and Politics at the Vatican.* New Haven: Yale Univ. Press, 2002.

Millon, Henry A., ed. *The Triumph of the Baroque: Architecture in Europe, 1600–1750.* 2nd ed. rev. New York: Rizzoli, 1999.

Morrissey, Jake. *The Genius in the Design: Bernini, Borromini, and the Rivalry that Transformed Rome.* New York: William Morrow, 2005.

Puttfarken (translation of Roger de Piles), referenced p727

Rand, Richard. *Claude Lorrain, the Painter as Draftsman: Drawings from the British Museum.* New Haven: Yale Univ. Press; Williamstown, MA: Clark Art Institute, 2006.

Slive, Seymour. *Dutch Painting 1600–1800.* Pelican History of Art. New Haven: Yale Univ. Press, 1995.

Summerson, John. *Inigo Jones.* New Haven: Publishedfor the Paul Mellon Centre for Studies in British Art by Yale Univ. Press, 2000.

Tomlinson, Janis. *From El Greco to Goya: Painting in Spain, 1561–1828.* Perspectives. New York: Abrams, 1997.

Vlieghe, Hans. *Flemish Art and Architecture, 1585–1700.* Pelican History of Art. Reissue ed. 2004. New Haven: Yale Univ. Press, 1998.

Walker, Stefanie, and Frederick Hammond, eds. *Life and the Arts in the Baroque Palaces of Rome: Ambiente Barocco.* New Haven: Yale Univ. Press; for the Bard Graduate Center for Studies in the Decorative Arts, New York, 1999.

Westermann, Mariët. *Rembrandt. Art & Ideas.* London: Phaidon, 2000.

———. *A Worldly Art: The Dutch Republic, 1585–1718.* New Haven and London: Yale Univ. Press, 2004.

Wheelock Jr., Arthur K. *Flemish Paintings of the Seventeenth Century.* Washington, DC: National Gallery of Art, 2005.

Wittkower, Rudolf. *Art and Architecture in Italy, 1600–1750.* 6th ed. Revised Joseph Connors and Jennifer Montague. Pelican History of Art. New Haven: Yale Univ. Press, 1999.

Zega, Andrew, and Bernd H. Dams. *Palaces of the Sun King: Versailles, Trianon, Marly: The Châteaux of Louis XIV.*New York: Rizzoli, 2002.

Chapter 24 Art of South and Southeast Asiaafter 1200

Asher, Catherine B. *Architecture of Mughal India.* New York: Cambridge Univ. Press, 1992.

Beach, Milo Cleveland. *Mughal and Rajput Painting.* New York: Cambridge Univ. Press, 1992.

Brown, Rebecca M. *Art for a Modern India, 1947–1980.* Durham and London: Duke Univ. Press, 2009.

Guy, John, and Deborah Swallow, eds. *Arts of India, 1550–1900.* London: V&A Publications, 1990.

Khanna, Balraj, and Aziz Kurtha. *Art of Modern India.* London: Thames & Hudson, 1998.

Koch, Ebba. *Mughal Art and Imperial Ideology: Collected Essays.* New Delhi: Oxford Univ. Press, 2001.

Love Song of the Dark Lord: Jayadeva's Gitagovinda. Trans. Barbara Stoler Miller. New York: Columbia Univ. Press, 1977.

Michell, George. *Hindu Art and Architecture.* World of Art. London: Thames & Hudson, 2000.

Mitter, Partha. *Art and Nationalism in Colonial India, 1850–1922: Occidental Orientations.* Cambridge andNew York: Cambridge Univ. Press, 1997.

Moynihan, Elizabeth B., ed. *The Moonlight Garden:New Discoveries at the Taj Mahal.* Asian Art & Culture. Washington, DC: Arthur M. Sackler Gallery, 2000.

Nou, Jean-Louis. *Taj Mahal.* Text by Amina Okada and M.C. Joshi. New York: Abbeville Press, 1993.

Pal, Pratapaditya. *Court Paintings of India, 16th–19th Centuries.* New York: Navin Kumar, 1983.

———. *The Peaceful Liberators: Jain Art from India.* New York: Thames & Hudson, 1994.

Rossi, Barbara. *From the Ocean of Painting: India's Popular Paintings, 1589 to the Present.* New York: Oxford Univ. Press, 1998.

Schimmel, Annemarie. *The Empire of the Great Mughals: History, Art and Culture.* Ed. Burzine K. Waghmar. Trans. Corinne Attwood. London: Reaktion Books, 2004.

Stronge, Susan. *Painting for the Mughal Emperor: The Art of the Book, 1560–1660.* London: V&A Publications, 2002.

Tillotson, G.H.R. *Mughal India.* Architectural Guides for Travelers. San Francisco: Chronicle Books, 1990.

———. *The Tradition of Indian Architecture: Continuity, Controversy, and Change since 1850.* New Haven:Yale Univ. Press, 1989.

Verma, Som Prakash. *Painting the Mughal Experience.* New York: Oxford Univ. Press, 2005.

Welch, Stuart Cary. *The Emperors' Album: Images of Mughal India.* New York: Metropolitan Museum of Art, 1987.

———. *India: Art and Culture 1300–1900.* New York: Metropolitan Museum of Art, 1985.

Chapter 25 Chinese and Korean Art after 1279

Andrews, Julia Frances, and Kuiyi Shen. *A Century in Crisis: Modernity and Tradition in the Art of Twentieth-Century China.* New York: Solomon R. Guggenheim Museum, 1998.

Barnhart, Richard M. *Painters of the Great Ming:The Imperial Court and the Zhe School.* Dallas: Dallas Museum of Art, 1993.

Barrass, Gordon S. *The Art of Calligraphy in Modern China.* London: British Museum Press, 2002.

Berger, Patricia Ann. *Empire of Emptiness: Buddhist Art and Political Authority in Qing China.* Honolulu: Univ. of Hawai'i Press, 2003.

Bickford, Maggie. *Ink Plum: The Making of a Chinese Scholar-Painting.* New York: Cambridge Univ. Press, 1996.

Billeter, Jean François. *The Chinese Art of Writing.* New York: Skira/Rizzoli, 1990.

Bush, Susan, and Hsio-yen Shih, eds. *Early Chinese Texton Painting.* Cambridge, MA: Harvard Univ. Press, 1985.

Cahill, James. *The Distant Mountains: Chinese Paintingin the Late Ming Dynasty, 1580–1644.* New York: Weatherhill, 1982.

———. *Hills Beyond a River: Chinese Painting of the Y'uan Dynasty, 1279–1368.* New York: Weatherhill, 1976.

———. *Parting at the Shore: Chinese Painting of the Early and Middle Ming Dynasty 1368–1580*. New York: Weatherhill, 1978.

Chaves, Jonathan (trans.). *The Chinese Painter as Poet*. New York: Art Media Resources, 2000.

Chung, Anita. *Drawing Boundaries: Architectural Images in Qing China*. Honolulu: Univ. of Hawai'i Press, 2004.

Clunas, Craig. *Pictures and Visuality in Early Modern China*. Princeton, NJ: Princeton Univ. Press, 1997.

Fang, Jing Pei. *Treasures of the Chinese Scholar: Form, Function, and Symbolism*. Ed. J. May Lee Barrett. New York: Weatherhill, 1997.

Fong, Wen C. *Between Two Cultures: Late-Nineteenth- and Twentieth-Century Chinese Paintings from the RobertH. Ellsworth Collection in the Metropolitan Museum of Art*. New York: Metropolitan Museum of Art, 2001.

Hearn, Maxwell K., and Judith G. Smith, eds. *Chinese Art: Modern Expressions*. New York: Dept. of Asian Art, Metropolitan Museum of Art, 2001.

Ho, Chuimei, and Bennet Bronson. *Splendors of China's Forbidden City: The Glorious Reign of Emperor Qianlong*. Chicago: Field Museum, 2004.

Ho, Wai-kam, ed. *The Century of Tung Ch'i-Ch'ang, 1555–1636*. 2 vols. Kansas City, MO: Nelson-Atkins Museum of Art, 1992.

Kim, Hongnam. *The Life of a Patron: Zhou Lianggong(1612– 1672) and the Painters of Seventeenth-Century China*. New York: China Institute in America, 1996.

Knapp, Ronald G. *China's Vernacular Architecture: House Form and Culture*. Honolulu: Univ. of Hawai'i Press, 1989.

Lee, Sherman, and Wai-Kam Ho. *Chinese Art Under the Mongols: The Y'uan Dynasty, 1279–1368*. Cleveland: Cleveland Museum of Art, 1968.

Lim, Lucy, ed. *Wu Guanzhong: A Contemporary Chinese Artist*. San Francisco: Chinese Culture Foundation, 1989.

Moss, Paul. *Escape from the Dusty World: Chinese Paintings and Literati Works of Art*. London: Sydney L. Moss, 1999.

Ng, So Kam. *Brushstrokes: Styles and Techniques of Chinese Painting*. San Francisco: Asian Art Museum of San Francisco, 1993.

The Poetry [of] Ink: The Korean Literati Tradition, 1392–1910. Paris: Réunion des Musées Nationaux: Musée National des Arts Asiatiques Guimet, 2005.

Smith, Karen. *Nine Lives: The Birth of Avant-Garde Art in New China*. Zürich: Scalo, 2006.

Till, Barry. *The Manchu Era (1644–1912), Arts of China's Last Imperial Dynasty*. Victoria, BC: Art Gallery of Greater Victoria, 2004.

Vainker, S.J. *Chinese Pottery and Porcelain: From Prehistoryto the Present*. London: British Museum Press, 1991.

Watson, William. *The Arts of China 900–1620*. Pelican History of Art. New Haven: Yale Univ. Press, 2000.

Weidner, Marsha Smith. *Views from Jade Terrace: Chinese Women Artists, 1300–1912*. Indianapolis, IN: Indianapolis Museum of Art, 1988.

Xinian, Fu, et al. *Chinese Architecture*. Ed. NancyS. Steinhardt. New Haven: Yale Univ. Press, 2002.

Chapter 26 Japanese Art after 1333

Addiss, Stephen. *The Art of Zen: Painting and Calligraphyby Japanese Monks, 1600–1925*. New York: Abrams, 1989.

Berthier, François. *Reading Zen in the Rocks: The Japanese Dry Landscape Garden*. Trans. & essay Graham Parkes. Chicago: Univ. of Chicago Press, 2000.

Calza, Gian Carlo. *Ukiyo-e*. New York: Phaidon Press, 2005.

Graham, Patricia J. *Faith and Power in Japanese Buddhist Art, 1600–2005*. Honolulu: Univ. of Hawai'i Press, 2007.

———. *Tea of the Sages: The Art of Sencha*. Honolulu: Univ. of Hawai'i Press, 1998.

Guth, Christine. *Art of Edo Japan: The Artist and the City 1615–1868*. Perspectives. New York: Abrams, 1996.

Hickman, Money L. *Japan's Golden Age: Momoyama*. New Haven: Yale Univ. Press, 1996.

Kobayashi, Tadashi, and Lisa Rotondo-McCord. *An Enduring Vision: 17th to 20th Century Japanese Painting from the Gitter-Yelen Collection*. New Orleans: New Orleans Museum of Art, 2003.

Lillehoji, Elizabeth, ed. *Critical Perspectives on Classicism in Japanese Painting, 1600–1700*. Honolulu: Univ. of Hawai'i Press, 2004.

McKelway, Matthew P. *Traditions Unbound: Groundbreaking Painters of Eighteenth-Century Kyoto*. San Francisco: Asian Art Museum–Chong-Moon Lee Center, 2005.

Meech, Julia, and Jane Oliver. *Designed for Pleasure: The World of Edo Japan in Prints and Paintings, 1680–1860*. Seattle: Univ. of Washington Press in association with the Asia Society and Japanese Art Society of America, New York, 2008.

Miyajima, Shin'ichi and Sato Yasuhiro. *Japanese Ink Painting*. Ed. George Kuwayama. Los Angeles: Los Angeles County Museum of Art, 1985.

Munroe, Alexandra. *Japanese Art after 1945: Scream Against the Sky*. New York: Abrams, 1994.

Murase, Miyeko, ed. *Turning Point: Oribe and the Arts of Sixteenth-Century Japan*. New York: Metropolitan Museum of Art, 2003.

Newland, Amy Reigle, ed. *The Hotei Encyclopedia ofJapanese Woodblock Prints*. 2 vols. Amsterdam: Hotei Publishing, 2005.

Ohki, Sadako. *Tea Culture of Japan*. New Haven: Yale Univ. Press, 2009.

Rousmaniere, Nicole, ed. *Crafting Beauty in Modern Japan: Celebrating Fifty Years of the Japan Traditional Art Crafts Exhibition*. Seattle: Univ. of Washington Press, 2007.

Screech, Timon. *The Lens Within the Heart: The Western Scientific Gaze and Popular Imagery in Later Edo Japan*.2nd ed. Honolulu: Univ. of Hawai'i Press, 2002.

Singer, Robert T., and John T. Carpenter. *Edo, Art in Japan 1615–1868*. Washington, DC: National Gallery of Art, 1998.

Chapter 27 Art of the Americas after 1300

Bauer, Brian S. *Ancient Cuzco: Heartland of the Inca*. Joe R. and Teresa Lozano Long Series in Latin American and Latino Art and Culture. Austin: Univ. of Texas Press, 2004.

Berlo, Janet Catherine, and Ruth B. Phillips. *Native North American Art*. Oxford History of Art. 2nd ed. Oxford: Oxford Univ. Press, 2014.

Bringhurst, Robert. *The Black Canoe: Bill Reid and the Spiritof Haida Gwaii*. Seattle: Univ. of Washington Press, l991.

Burger, Richard L., and Lucy C. Salazar, eds. *Machu Picchu: Unveiling the Mystery of the Incas*. New Haven: Yale Univ. Press, 2004.

Coe, Michael D. and Rex Koontz. *Mexico: From the Olmecsto the Aztecs*. 5th ed. New York: Thames & Hudson, 2005.

Fields, Virginia M., and Victor Zamudio-Taylor. *The Roadto Aztlan: Art from a Mythic Homeland*. Los Angeles: Los Angeles County Museum of Art, 2001.

Griffin-Pierce, Trudy. *Earth is my Mother, Sky is my Father: Space, Time, and Astronomy in Navajo Sandpainting*. Albuquerque: Univ. of New Mexico Press, 1992.

Jonaitis, Aldona. *Art of the Northwest Coast*. Seattle: Univ. of Washington Press, 2006.

Kaufman, Alice, and Christopher Selser. *The Navajo Weaving Tradition: 1650 to the Present*. New York: Dutton, 1985.

Macnair, Peter L., Robert Joseph, and Bruce Grenville.*Down from the Shimmering Sky: Masks of the Northwest Coast*. Vancouver: Douglas & McIntyre, 1998.

Matos Moctezuma, Eduardo, and Felipe R. Solís Olguín. *Aztecs*. London: Royal Academy of Arts, 2002.

Matthews, Washington. "The Night Chant: A Navaho Ceremony." *Memoirs of the American Museum of Natural History*, vol. 6. New York, 1902.

Moseley, Michael E. *The Incas and Their Ancestors:The Archaeology of Peru*. Rev. ed. London: Thames & Hudson, 2001.

Nabokov, Peter, and Robert Easton. *Native American Architecture*. New York: Oxford Univ. Press, 1989.

Pasztory, Esther. *Aztec Art*. Norman: Univ. of Oklahoma Press, 2000.

Rushing III, W. Jackson, ed. *Native American Art in the Twentieth Century: Makers, Meanings, Histories*. New York: Routledge, 1999.

Shaw, George Everett. *Art of the Ancestors: Antique North American Indian Art*. Aspen, CO: Aspen Art Museum, 2004.

Taylor, Colin F. *Buckskin & Buffalo: The Artistry of the Plains Indians*. New York: Rizzoli, 1998.

Townsend, Richard F., ed. *The Aztecs*. 2nd rev. ed. Ancient Peoples and Places. London: Thames & Hudson, 2000.

Trimble, Stephen. *Talking with the Clay: The Art of Pueblo Pottery in the 21st Century*. 20th anniversary rev. ed. Santa Fe, NM: School for Advanced Research Press, 2007.

Wood, Nancy C. *Taos Pueblo*. New York: Knopf, 1989.

Chapter 28 Art of Pacific Cultures

Caruana, Wally. *Aboriginal Art*. 2nd ed. World of Art. New York: Thames & Hudson, 2003.

Craig, Barry, Bernie Kernot, and Christopher Anderson, eds. *Art and Performance in Oceania*. Honolulu: Univ. of Hawai'i Press, 1999.

D'Alleva, Anne. *Arts of the Pacific Islands*. Perspectives.New York: Abrams, 1998.

Herle, Anita, et al. *Pacific Art: Persistence, Change, and Meaning*. Honolulu: Univ. of Hawai'i Press, 2002.

Kaeppler, Adrienne Lois, Christian Kaufmann, andDouglas Newton. *Oceanic Art*. Trans. Nora Scott and Sabine Bouladon. New York: Abrams, 1997.

Kirch, Patrick Vinton. *The Lapita Peoples: Ancestors of the Oceanic World*. The Peoples of South-East Asia and the Pacific. Cambridge, MA: Blackwell, 1997.

Kjellgren, Eric. *Splendid Isolation: Art of Easter Island*. New York: Metropolitan Museum of Art, 2001.

———, and Carol Ivory. *Adorning the World: Art of the Marquesas Islands*. New Haven: Yale Univ. Press in assoc. with the Metropolitan Museum of Art, 2005.

Küchler, Susanne, and Graeme Were. *Pacific Pattern*. London: Thames & Hudson, 2005.

Lilley, Ian, ed. *Archaeology of Oceania: Australia and*

thePacific Islands. Malden, MA: Blackwell, 2006.

McCulloch, Susan. Contemporary Aboriginal Art: A Guide to the Rebirth of an Ancient Culture. Rev. ed. Crows Nest, NSW, Australia: Allen & Unwin, 2001.

Moore, Albert C. Arts in the Religions of the Pacific: Symbols of Life. Religion and the Arts Series. New York: Pinter, 1995.

Morphy, Howard. Aboriginal Art. London: Phaidon Press, 1998.

Morwood, M.J. Visions from the Past: The Archaeology of Australian Aboriginal Art. Washington, DC: Smithsonian Institution Press, 2002.

Neich, Roger, and Mick Pendergrast. Traditional Tapa Textiles of the Pacific. London: Thames & Hudson, 1997.

Newton, Douglas, ed. Arts of the South Seas: Island Southeast Asia, Melanesia, Polynesia, Micronesia; The Collections of the Musée Barbier-Mueller. Trans. David Radzinowicz Howell. New York: Prestel, 1999.

Rainbird, Paul. The Archaeology of Micronesia. Cambridge World Archaeology. New York: Cambridge Univ. Press, 2004.

Smidt, Dirk, ed. Asmat Art: Woodcarvings of Southwest New Guinea. New York: George Braziller in assoc. with Rijksmuseum voor Volkenkunde, Leiden, 1993.

Starzecka, D.C., ed. Maori Art and Culture. London: British Museum Press, 1996.

Taylor, Luke. Seeing the Inside: Bark Painting in Western Arnhem Land. Oxford Studies in Social and Cultural Anthropology. New York: Oxford Univ. Press, 1996.

Thomas, Nicholas. Oceanic Art. World of Art. New York: Thames & Hudson, 1995.

———, Anna Cole, and Bronwen Douglas, eds. Tattoo: Bodies, Art, and Exchange in the Pacific and the West. Durham, NC: Duke Univ. Press, 2005.

Chapter 29 Arts of Africa from the Sixteenth Century to the Present

Adewunmi, Bim. "Zanele Muholi: 'I Cannot Give Up Myself and My Soul Simply Because I Need Some Exposure.' The Photographer and Visual Activist Talks to Bim Adewunmi." The New Statesman (March 30, 2013). Accessed September 4, 2015. http://www.newstatesman.com/bim-adewunmi/2013/03/zanele-muholi-i-cannot-give-myself-and-my-soul-simply-because-i-need-some-expos.

Aronson, Lisa, and John S. Weber. Environment and Object: Recent African Art. Saratoga Springs, NY: Frances Young Tang Teaching Museum and Art Gallery at Skidmore College, 2012.

Dina, Jeanne. "The Hazomanga among the Masikoro of Southwest Madagascar: Identity and History." Ethnohistory, 48, no. 1/2 (Winter–Spring 2001): 13–30. http://www.jstor.org/stable/40280039.

Enwezor, Okwui, and Chika Okeke-Agulu. Contemporary African Art Since 1980. Bologna: Damiani, 2009.

Farrell, Laurie Ann, ed. Looking Both Ways: Art of the Contemporary African Diaspora. Gent: Snoeck Publishers and the Museum for African Art, New York, 2003.

Geary, Christraud. "Bamum Two-Figure Thrones: Additional Evidence." African Arts 16, no. 4 (August 1983): 46–53, 86–87. http://www.jstor.org/stable/3336034.

Jewsiewicki, Bogumil, D. Dibwe dia Mwembu, and Museum for African Art (New York). A Congo Chronicle: Patrice Lumumba in Urban Art. New York: Museum for African Art, 1999.

Martinez, Jessica Levin. "Ephemeral Fang Reliquaries:A Post-History." African Arts 43, no. 1 (Spring 2010): 28–43. http://www.jstor.org/stable/29546084.

Mutu, Wangechi, et al. Wangechi Mutu: A FantasticJourney. Durham, NC: Nasher Museum of Art, Duke Univ. Press, 2013.

Chapter 30 European and America Art, 1715–1840

Bailey, Colin B., Philip Conisbee, and Thomas W. Gaehtgens. The Age of Watteau, Chardin, and Fragonard: Masterpieces of French Genre Painting. New Haven: Yale Univ. Press in assoc. with the National Gallery of Canada, Ottawa, 2003.

Boime, Albert. Art in an Age of Bonapartism, 1800–1815. Chicago: Univ. of Chicago Press, 1990.

———. Art in an Age of Counterrevolution, 1815–1848. Chicago: Univ. of Chicago Press, 2004.

———. Art in an Age of Revolution, 1750–1800. Chicago: Univ. of Chicago Press, 1987.

Bowron, Edgar Peters, and Joseph J. Rishel, eds. Art in Rome in the Eighteenth Century. London: Merrell in association with Philadelphia Museum of Art, 2000.

Brown, David Blayney. Romanticism. London: Phaidon Press, 2001.

Chinn, Celestine, and Kieran McCarty. Bac: Where the Waters Gather. Univ. of Arizona: Mission San XavierDel Bac, 1977.

Craske, Matthew. Art in Europe, 1700–1830: A History of the Visual Arts in an Era of Unprecedented Urban Economic Growth. Oxford History of Art. Oxford: Oxford Univ. Press, 1997.

Denis, Rafael Cardoso, and Colin Trodd, eds. Art and the Academy in the Nineteenth Century. New Brunswick, NJ: Rutgers Univ. Press, 2000.

Goodman, Elise, ed. Art and Culture in the Eighteenth Century: New Dimensions and Multiple Perspectives. Studies in Eighteenth-Century Art and Culture. Newark: Univ. of Delaware Press, 2001.

Hofmann, Werner. Goya: To Every Story There Belongs Another. New York: Thames & Hudson, 2003.

Irwin, David G. Neoclassicism. Art & Ideas. London: Phaidon Press, 1997.

Jarrassé, Dominique. 18th-Century French Painting. Trans. Murray Wyllie. Paris: Terrail, 1999.

Kalnein, Wend von. Architecture in France in the Eighteenth Century. Trans. David Britt. Pelican History of Art.New Haven: Yale Univ. Press, 1995.

Levey, Michael. Painting in Eighteenth-Century Venice.3rd ed. New Haven: Yale Univ. Press, 1994.

Lewis, Michael J. The Gothic Revival. World of Art. New York: Thames & Hudson, 2002.

Lovell, Margaretta M. Art in a Season of Revolution: Painters, Artisans, and Patrons in Early America. Early American Studies. Philadelphia: Univ. of Pennsylvania Press, 2005.

Monneret, Sophie. David and Neo-Classicism. Trans. Chris Miller and Peter Snowdon. Paris: Terrail, 1999.

Natter, Tobias, ed. Angelica Kauffman: A Woman of Immense Talent. Ostfildern: Hatje Cantz, 2007.

Porterfield, Todd, and Susan L. Siegfried. Staging Empire: Napoleon, Ingres, and David. University Park: Pennsylvania State Univ. Press, 2006.

Poulet, Anne L. Jean-Antoine Houdon: Sculptor of the Enlightenment. Washington, DC: National Gallery of Art, 2003.

Summerson, John. Architecture of the Eighteenth Century. World of Art. New York: Thames & Hudson, 1986.

Wilton, Andrew, and Ilaria Bignamini, eds. Grand Tour:The Lure of Italy in the Eighteenth Century. London:Tate Gallery, 1996.

Chapter 31 Mid- to Late Nineteenth-Century Artin Europe and the United States

Adams, Steven. The Barbizon School and the Origins of Impressionism. London: Phaidon Press, 1994.

Bajac, Quentin. The Invention of Photography. Discoveries. New York: Abrams, 2002.

Barger, M. Susan, and William B. White. The Daguerreotype: Nineteenth-Century Technology and Modern Science. Washington, DC: Smithsonian Institution Press, 1991.

Benjamin, Roger. Orientalist Aesthetics: Art, Colonialism, and French North Africa, 1880–1930. Berkeley: Univ. of California Press, 2003.

Bergdoll, Barry. European Architecture, 1750–1890. Oxford History of Art. New York: Oxford Univ. Press, 2000.

Blühm, Andreas, and Louise Lippincott. Light!: The Industrial Age 1750–1900: Art & Science, Technology & Society. New York: Thames & Hudson, 2001.

Boime, Albert, The Academy and French Painting in the Nineteenth Century. 2nd ed. New Haven: Yale Univ. Press, 1986.

Butler, Ruth, and Suzanne G. Lindsay. European Sculpture of the Nineteenth Century. Washington, DC: National Gallery of Art, 2000.

Callen, Anthea. The Art of Impressionism: Painting Technique & the Making of Modernity. New Haven: Yale Univ. Press, 2000.

Chu, Petra ten-Doesschate. Nineteenth Century European Art. 3rd. ed. Upper Saddle River, NJ: Pearson/Prentice Hall, 2012.

Clark, T. J. The Painting of Modern Life: Paris in the Art of Manet and His Followers. Rev. ed. London: Thames & Hudson, 1999.

Conrads, Margaret C. Winslow Homer and the Critics: Forging a National Art in the 1870s. Princeton, NJ: Princeton Univ. Press in assoc. with the Nelson-Atkins Museum of Art, 2001.

Denis, Rafael Cardoso, and Colin Trodd. Art and the Academy in the Nineteenth Century. New Brunswick, NJ: Rutgers Univ. Press, 2000.

Eisenman, Stephen F. Nineteenth Century Art: A Critical History. 3rd ed. New York: Thames & Hudson, 2007.

Eitner, Lorenz. Nineteenth Century European Painting: David to Cezanne. Rev. ed. Boulder, CO: Westview Press, 2002.

Frazier, Nancy. Louis Sullivan and the Chicago School. New York: Knickerbocker Press, 1998.

Fried, Michael. Manet's Modernism, or, The Face of Paintingin the 1860s. Chicago: Univ. of Chicago Press, 1996.

Gerdts, William H. American Impressionism. 2nd ed.New York: Abbeville Press, 2001.

Greenhalgh, Paul, ed. Art Nouveau, 1890–1914. London: V&A Publications, 2000.

Grigsby, Darcy Grimaldo. Extremities: Painting Empire in Post-Revolutionary France. New Haven: Yale Univ. Press, 2002.

Groseclose, Barbara. Nineteenth-Century American Art. Oxford History of Art. Oxford: Oxford Univ. Press, 2000.

Harrison, Charles, Paul Wood, and Jason Gaiger. Art

in Theory 1815–1900: An Anthology of Changing Ideas. Oxford: Blackwell, 1998.

Herrmann, Luke. Nineteenth Century British Painting. London: Giles de la Mare, 2000.

Hirsh, Sharon L. Symbolism and Modern Urban Society.New York: Cambridge Univ. Press, 2004.

Kaplan, Wendy. The Arts & Crafts Movement in Europe & America: Design for the Modern World. New York: Thames & Hudson in assoc. with the Los Angeles County Museum of Art, 2004.

Kendall, Richard. Degas: Beyond Impressionism. London: National Gallery, 1996.

Lambourne, Lionel. Japonisme: Cultural Crossings between Japan and the West. New York: Phaidon Press, 2005.

Lemoine, Bertrand. Architecture in France, 1800– 1900.Trans. Alexandra Bonfante-Warren. New York:Abrams, 1998.

Lewis, Mary Tompkins, ed. Critical Readings in Impressionism and Post-Impressionism: An Anthology. Berkeley: Univ. of California Press, 2007.

Lochnan, Katharine Jordan. Turner Whistler Monet. London: Tate Publishing in assoc. with the Art Galleryof Ontario, 2004.

Miller, Angela L., et al. American Encounters: Art, History, and Cultural Identity. Upper Saddle River, NJ: Pearson/ Prentice Hall, 2008.

Moffett, Charles S., et al. The New Painting: Impressionism 1874–1886. San Francisco: The Fine Arts Museums, 1986.

Nochlin, Linda. Realism. New York: Penguin Books, 1990.

———. The Politics of Vision: Essays on Nineteenth-Century Art and Society. New York: Harper and Row, 1989.

Noon, Patrick J. Crossing the Channel: British and French Painting in the Age of Romanticism. London: Tate Publishing, 2003.

Pissarro, Joachim. Pioneering Modern Painting: Cézanne & Pissarro 1865–1885. New York: Museum of Modern Art, 2005.

Rodner, William S. J.M.W. Turner: Romantic Painter of the Industrial Revolution. Berkeley: Univ. of California Press, 1997.

Rosenblum, Robert, and H.W. Janson. 19th Century Art. Rev. & updated ed. Upper Saddle River, NJ: Pearson/ Prentice Hall, 2005.

Rubin, James H. Impressionism. Art & Ideas. London: Phaidon Press, 1999.

Rybczynski, Witold. A Clearing in the Distance: Frederick Law Olmsted and America in the Nineteenth Century. New York: Scribner, 1999.

Smith, Paul. Seurat and the Avant-Garde. New Haven: Yale Univ. Press, 1997.

Thomson, Belinda. Impressionism: Origins, Practice, Reception. World of Art. New York: Thames & Hudson, 2000.

Twyman, Michael. Breaking the Mould: The First Hundred Years of Lithography. The Panizzi Lectures, 2000. London: British Library, 2001.

Vaughan, William, and Francoise Cachin. Arts of the19th Century. 2 vols. New York: Abrams, 1998.

Werner, Marcia. Pre-Raphaelite Painting and Nineteenth- Century Realism. New York: Cambridge Univ. Press, 2005.

Zemel, Carol M. Van Gogh's Progress: Utopia, Modernity,and Late-Nineteenth-Century Art. California Studiesin the History of Art, 36. Berkeley: Univ. of California Press, 1997.

Chapter 32 Modern Art in Europe and the Americas, 1900–1950

Ades, Dawn, comp. Art and Power: Europe under the Dictators, 1930–45. Stuttgart, Germany: Oktagon in assoc. with Hayward Gallery, 1995.

Antliff, Mark, and Patricia Leighten. Cubism and Culture. World of Art. London: Thames & Hudson, 2001.

Bailey, David A. Rhapsodies in Black: Art of the Harlem Renaissance. London: Hayward Gallery, 1997.

Balken, Debra Bricker. Debating American Modernism: Stieglitz, Duchamp, and the New York Avant-Garde. New York: American Federation of Arts, 2003.

Barron, Stephanie, ed. Degenerate Art: The Fate of theAvant-Garde in Nazi Germany. Los Angeles: Los Angeles County Museum of Art, 1991.

———, and Wolf-Dieter Dube, eds. German Expressionism: Art and Society. New York: Rizzoli, 1997.

Bochner, Jay. An American Lens: Scenes from Alfred Stieglitz's New York Secession. Cambridge, MA: MIT Press, 2005.

Bohn, Willard. The Rise of Surrealism: Cubism, Dada, and the Pursuit of the Marvelous. Albany: State Univ. of New York Press, 2002.

Bowlt, John E., and Evgeniia Petrova, eds. Painting Revolution: Kandinsky, Malevich and the RussianAvant-Garde. Bethesda, MD: Foundation for International Arts and Education, 2000.

Bown, Matthew Cullerne. Socialist Realist Painting. New Haven: Yale Univ. Press, 1998.

Brown, Milton W. Story of the Armory Show. 2nd ed.New York: Abbeville Press, 1988.

Caws, Mary Ann. Surrealism. Themes and Movements. London: Phaidon, 2004.

Chassey, Eric de, ed. American Art: 1908–1947, from Winslow Homer to Jackson Pollock. Trans. Jane McDonald. Paris: Réunion des Musées Nationaux, 2001.

Corn, Wanda M. The Great American Thing: Modern Art and National Identity, 1915–1935. Berkeley: Univ. of California Press, 1999.

Curtis, Penelope. Sculpture 1900–1945: After Rodin. Oxford History of Art. Oxford: Oxford Univ. Press, 1999.

Dachy, Marc. Dada: The Revolt of Art. Trans. Liz Nash. New York: Abrams, 2006.

Dickerman, Leah, ed. Dada: Zurich, Berlin, Hannover, Cologne, New York, Paris. Washington, DC: National Gallery of Art, 2005.

Elger, Dietmar. Expressionism: A Revolution in German Art. Ed. Ingo F. Walther. Trans. Hugh Beyer. New York: Taschen, 1998.

Fer, Briony. On Abstract Art. New Haven: Yale Univ. Press, 1997.

Fletcher, Valerie J. Crosscurrents of Modernism: Four Latin American Pioneers: Diego Rivera, Joaquín Torres-García, Wifredo Lam, Matta. Washington, DC: Hirshhorn Museum and Sculpture Garden in assoc. with the Smithsonian Institution Press, 1992.

Folgarait, Leonard. Mural Painting and Social Revolution in Mexico, 1920–1940: Art of the New Order. New York: Cambridge Univ. Press, 1998.

Forgács, Eva. The Bauhaus Idea and Bauhaus Politics. Trans. John Bátki. New York: Central European Univ. Press, 1995.

Frampton, Kenneth. Modern Architecture: A Critical History. 4th ed. World of Art. London: Thames & Hudson, 2007.

Gooding, Mel. Abstract Art. Movements in Modern Art. Cambridge: Cambridge Univ. Press, 2001.

Grant, Kim. Surrealism and the Visual Arts: Theory and Reception. New York: Cambridge Univ. Press, 2005.

Gray, Camilla, and Marian Burleigh-Motley. The Russian Experiment in Art, 1863–1922. World of Art. New York: Thames and Hudson, 1986.

Green, Christopher. Art in France: 1900–1940. Pelican History of Art. New Haven: Yale Univ. Press, 2000.

Harris, Jonathan. Federal Art and National Culture: The Politics of Identity in New Deal America. Cambridge Studies in American Visual Culture. New York: Cambridge Univ. Press, 1995.

Harrison, Charles, Francis Frascina, and Gill Perry. Primitivism, Cubism, Abstraction: The Early Twentieth Century. New Haven: Yale Univ. Press, 1993.

Haskell, Barbara. The American Century: Art & Culture, 1900–1950. New York: Whitney Museum of American Art, 1999.

Herskovic, Marika, ed. American Abstract Expressionism of the 1950s: An Illustrated Survey: With Artists' Statements, Artwork and Biographies. New York: New York School Press, 2003.

Hill, Charles C. The Group of Seven: Art for a Nation. Ottawa: National Gallery of Canada, 1995.

James-Chakraborty, Kathleen, ed. Bauhaus Culture: From Weimar to the Cold War. Minneapolis: Univ. of Minnesota Press, 2006.

Karmel, Pepe. Picasso and the Invention of Cubism. New Haven: Yale Univ. Press, 2003.

Krauss, Rosalind. The Originality of the Avant-Garde and Other Modernist Myths. Cambridge, MA and London: MIT Press, 1986.

Kuenzli, Rudolf. Dada. Themes and Movements. London: Phaidon, 2006.

Lista, Giovanni. Futurism. Trans. Susan Wise. Paris: Terrail, 2001.

Lucie-Smith, Edward. Latin American Art of the 20th Century. 2nd ed. World of Art. London: Thames & Hudson, 2005.

McCarter, Robert, ed. On and by Frank Lloyd Wright:A Primer of Architectural Principles. New York: Phaidon Press, 2005.

Moudry, Roberta, ed. The American Skyscraper: Cultural Histories. New York: Cambridge Univ. Press, 2005.

Rickey, George. Constructivism: Origins and Evolution. Rev. ed. New York: Braziller, 1995.

Taylor, Brandon. Collage: The Making of Modern Art. London: Thames & Hudson, 2004.

Weston, Richard. Modernism. London: Phaidon Press, 1996.

White, Michael. De Stijl and Dutch Modernism. Critical Perspectives in Art History. New York: Manchester Univ. Press, 2003.

Whitfield, Sarah. Fauvism. World of Art. New York: Thames & Hudson, 1996.

Whitford, Frank. The Bauhaus: Masters and Students by Themselves. Woodstock, NY: Overlook Press, 1993.

Zurier, Rebecca, Robert W. Snyder, and Virginia M. Mecklenburg. Metropolitan Lives: The Ashcan Artists and Their New York. Washington, DC: National Museum of American Art, 1995.

Chapter 33 The International Scene since the 1950s

Alberro, Alexander, and Blake Stimson, eds. Conceptual Art: A Critical Anthology. Cambridge, MA: MIT Press, 1999.

Archer, Michael. Art Since 1960. 2nd ed. World of Art.New York: Thames & Hudson, 2002.

Atkins. Robert. Artspeak: A Guide to Contemporary Ideas, Movements, and Buzzwords. 2nd ed. New

York: Abbeville Press, 1997.

Ault, Julie. *Art Matters: How the Culture Wars Changed America.* Ed. Brian Wallis, Marianne Weems, and Philip Yenawine. New York: New York Univ. Press, 1999.

Battcock, Gregory. *Minimal Art: A Critical Anthology.* Berkeley: Univ. of California Press, 1995.

Beardsley, John. *Earthworks and Beyond: Contemporary Art in the Landscape.* 4th ed. eBook. New York: Abbeville Press, 2006.

Bird, Jon, and Michael Newman, eds. *Rewriting Conceptual Art.* Critical Views. London: Reaktion Books, 1999.

Bishop, Claire. *Installation Art: A Critical History.* New York: Routledge, 2005.

Bishop, Claire. *Participation.* London: Whitechapel, 2006.

Blais, Joline, and Jon Ippolito. *At the Edge of Art.* London: Thames & Hudson, 2006.

Buchloh, Benjamin H.D. *Neo-Avantgarde and Culture Industry: Essays on European and American Art from 1955 to 1975.* Cambridge, MA: MIT Press, 2000.

Buszek, Maria Elena. *Extra/ordinary: Craft and Contemporary Art.* Durham, NC: Duke Univ. Press, 2011.

Causey, Andrew. *Sculpture Since 1945.* Oxford History of Art. Oxford: Oxford Univ. Press, 1998.

Corris, Michael, ed. *Conceptual Art: Theory, Myth, and Practice.* New York: Cambridge Univ. Press, 2004.

De Oliveira, Nicolas, Nicola Oxley, and Michael Petry. *Installation Art in the New Millennium: The Empire of the Senses.* New York: Thames & Hudson, 2003.

De Salvo, Donna, ed. *Open Systems: Rethinking Art c. 1970.* London: Tate Gallery, 2005.

Dumbadze, Alexander Blair, and Suzanne Perling Hudson. *Contemporary Art: 1989 to the Present.* Chichester, West Sussex: Wiley-Blackwell, 2013.

Fabozzi, Paul F. *Artists, Critics, Context: Readings In and Around American Art Since 1945.* Upper Saddle River, NJ: Pearson/Prentice Hall, 2002.

Fineberg, Jonathan. *Art Since 1940: Strategies of Being.* 3rd ed. Upper Saddle River, NJ: Pearson/Prentice Hall, 2011.

Flood, Richard, and Frances Morris. *Zero to Infinity: Arte Povera, 1962–1972.* Minneapolis, MN: Walker Art Center, 2001.

Fried, Michael. "Art and Objecthood." *Artforum* 5(June 1967): 12–23.

Goldberg, RoseLee. *Performance Art: From Futurism to the Present.* Rev. and exp. ed. World of Art. London: Thames & Hudson, 2001.

Goldstein, Ann. *A Minimal Future? Art as Object 1958–1968.* Los Angeles: Museum of Contemporary Art, 2004.

Grande, John K. *Art Nature Dialogues: Interviews with Environmental Artists.* Albany: State Univ. of New York Press, 2004.

Grosenick, Uta, ed. *Women Artists in the 20th and 21st Century.* New York: Taschen, 2001.

Grunenberg, Christoph, ed. *Summer of Love: Art of the Psychedelic Era.* London: Tate Gallery, 2005.

Haskell Barbara, and John G. Hanhardt. *Blam! the Explosion of Pop, Minimalism, and Performance, 1958–1964.* New York: Whitney Museum of American Art in association with W.W. Norton & Co, 1984.

Heineman, David S. *Thinking about Video Games: Interviews with the Experts.* Bloomington: Indiana Univ. Press, 2015.

Higgins, Hannah. *Fluxus Experience.* Berkeley: Univ. of California Press, 2002.

Hitchcock, Henry Russell, and Philip Johnson. *The International Style.* New York: Norton, 1995.

Hopkins, David. *After Modern Art: 1945–2000.* Oxford History of Art. Oxford: Oxford Univ. Press, 2000.

Jencks, Charles. *The New Paradigm in Architecture: The Language of Post-Modernism.* New Haven: Yale Univ. Press, 2002.

Jodidio, Philip. *New Forms: Architecture in the 1990s.* Taschen's World Architecture. New York: Taschen, 2001.

Johnson, Deborah, and Wendy Oliver, eds. *WomenMaking Art: Women in the Visual, Literary, and Performing Arts Since 1960.* Eruptions, vol. 7. New York: Peter Lang, 2001.

Jones, Caroline A. *Machine in the Studio: Constructing the Postwar American Artist.* Chicago: Univ. of Chicago Press, 1996.

Joselit, David. *American Art Since 1945.* World of Art. London: Thames & Hudson, 2003.

Judd, Donald. "Specific Objects." *Arts Yearbook* 8 (1965): 74–82.

Kaprow, Allan. "The Legacy of Jackson Pollock." *Art News* 57, no. 6 (October 1958): 24–26, 55–57.

Legault, Réjean, and Sarah Williams Goldhagen, eds. *Anxious Modernisms: Experimentation in Postwar Architectural Culture.* Montréal: Canadian Centre for Architecture, 2000.

Lucie-Smith, Edward. *Movements in Art Since 1945.* New ed. World of Art. London: Thames & Hudson, 2001.

Madoff, Steven Henry, ed. *Pop Art: A Critical History.* The Documents of Twentieth-Century Art. Berkeley: Univ. of California Press, 1997.

Molesworth, Helen Anne, and Ruth Erickson. *Leap Before You Look: Black Mountain College, 1933–1957.* New Haven: Yale Univ. Press, 2015.

Meyer, James Sampson. *Minimalism: Art and Polemics in the Sixties.* New Haven: Yale Univ. Press, 2001.

Nochlin, Linda. "Why Have There Been No Great Women Artists?" *Art News* 69 (January 1972): 22–39.

Owens, Craig. "The Discourse of Others: Feminists and Postmodernism." *The Anti-Aesthetic: Essays onPostmodern Culture*, ed. Hal Foster. Seattle: Bay Press, 1983: 57–82.

Phillips, Lisa. *The American Century: Art and Culture, 1950–2000.* New York: Whitney Museum of American Art, 1999.

Pop Art: Contemporary Perspectives. Princeton, NJ: Princeton Univ. Art Museum, 2007.

Ratcliff, Carter. *The Fate of a Gesture: Jackson Pollock and Postwar American Art.* New York: Farrar, Straus, Giroux, 1996.

Reckitt, Helena, ed. *Art and Feminism.* Themes and Movements. London: Phaidon Press, 2001.

Robertson, Jean, and Craig McDaniel. *Themes of Contemporary Art: Visual Art after 1980.* 3rd ed. New York: Oxford Univ. Press, 2013.

Robinson, Hilary, ed. *Feminism-Art-Theory: An Anthology, 1968–2000.* Malden, MA: Blackwell, 2001.

Rorimer, Anne. *New Art in the 60s and 70s: Redefining Reality.* New York: Thames & Hudson, 2001.

Rush, Michael. *New Media in Late 20th-Century Art.* 2nd ed. World of Art. London: Thames & Hudson, 2005.

———. *Video Art.* 2nd ed. London: Thames & Hudson, 2007.

Sandler, Irving. *Art of the Postmodern Era: From the Late 1960s to the Early 1990s.* New York: Icon Editions, 1996.

Schimmel, Paul, and Kristine Stiles. *Out of Actions:Between Performance and the Object, 1949–1979.* Los Angeles: The Museum of Contemporary Art, 1998.

Shohat, Ella. *Talking Visions: Multicultural Feminism in a Transnational Age.* Documentary Sources in Contemporary Art, vol. 5. New York: New Museum of Contemporary Art, 1998.

Smith, Terry. *Contemporary Art: World Currents.* Upper Saddle River, NJ: Pearson/Prentice Hall, 2011.

Stiles, Kristine, and Peter Selz. *Theories and Documents of Contemporary Art: A Sourcebook of Artists' Writings.* California Studies in the History of Art, 35. 2nd ed. Berkeley: Univ. of California, 2012.

Sylvester, David. *About Modern Art.* 2nd ed. New Haven: Yale Univ. Press, 2001.

Varnedoe, Kirk, Paola Antonelli, and Joshua Siegel, eds. *Modern Contemporary: Art since 1980 at MoMA.* Rev. ed. New York: Museum of Modern Art, 2004.

Waldman, Diane. *Collage, Assemblage, and the Found Object.* New York: Abrams, 1992.

Weintraub, Linda, Arthur Danto, and Thomas McEvilley. *Art on the Edge and Over: Searching for Art's Meaningin Contemporary Society, 1970s–1990s.* Litchfield, CT:Art Insights, 1996.

Yoshihara, Jirō. "The Gutai Manifesto." *Genijutsu Shincho.* December, 1956. 821. Reprinted in Kristine Stiles and Peter Selz. *Theories and Documents of Contemporary Art.* 2nd ed. Berkeley: Univ. of California Press, 2012.

Text Credits

Index

Figures in *italics* refer to illustrations; (c) refers to captions.

A

À Rebours (Huysmans) 1015
Abbas, Shah 792, *792*
Abbey in an Oak Forest (Friedrich) 974, *974*
Abelam society, Papua New Guinea 879
Abstract Art in Five Tones and Complementaries (Torres-García) 1088, *1088*
Abstract Expressionism 822, 1082, 1088–95, 1097, 1100
academies 942–3
 see also French Royal Academies; Royal Academy
Action Painting 1090–91
Adam and Eve (Dürer) 699, *699*–700, 701
Addison, Joseph 939
Adler, Dankmar 1025, 1060
adobe houses, Nankani 911–12, *912*
Advantages of Being a Woman, The (Guerrilla Girls) 1127, *1128*
aediculae 622
Aelst, Pieter van (shop of): Sistine tapestries 656, *657*
Afghanistan 784, 790, 792
Africa 895
 art 896–7, 911, 916 (20th century)
 colonial conquest 903–5, 980–81
 maps *896*, *903*
 modern objects 905
 see also specific countries
African-Americans 1098
 painting 999, *999*
 photography 1129, *1129*
 Harlem Renaissance 1078–80
 quilting 1129–30, *1130*
 sculpture 998–9, *999*
After "Invisible Man"... (Wall) 1143, *1143*
After Walker Evans: 4 (Levine) 1126, *1126*
Agra, India: Taj Mahal *782*, 783, 793–4, *794*
Ai Weiwei 1149
AIDS 1131, 1138–40
Aids Memorial Quilt 1139, *1139*–40
Akan Empire 897
Akbar, Mughal emperor 787, 790, 791, 792, 796
 Akbar Inspecting the Construction of Fetehpur Sikri 791, *791*
Akbarnama 791, *791*
Alba, Ambrosio Spinola, Duke of 745
Albani, Cardinal Alessandro 931–2
Albers, Anni 1070
 wall hangings *1070*, 1071
Albers, Josef 1070, 1071, 1100
Albert, Archdue 750
Albert, Prince Consort 1022
Alberti, Leon Battista 623, 627, 637, 665, 675
Alembert, Jean le Rond d' 949
allegories 635
Allegory with Venus and Cupid (Bronzino) *681*, 681–2
Alloway, Lawrence 1106
altarpieces 579, *579*

Altarpiece of the Holy Blood (Riemenschneider) 694, *694*–5
Chartreuse de Champmol (Broederlam) 578, *578*
Deposition (Pontormo) 678, *679*, 679–80
Ghent Altarpiece (Jan and Hubert(?) van Eyck) 588–9, *588–9*
Isenheim Altarpiece (Grünewald and Hagenauer) 695–6, *696*, 697
Maestà (Duccio) 554, *555*–7, 557–8, 561
Mérode Altarpiece (Master of Flémalle) 585–7, *586*
Pesaro Madonna (Titian) 671, *671*
Portinari Altarpiece (van der Goes) 593–5, *594*–5, 598
St. Wolfgang Altarpiece, Austria (Pacher) 600, *601*, 602
Sassetti Chapel, Santa Trinità, Florence (Ghirlandaio) 632–3, *633*
Altdorfer, Albrecht 701
 Danube Landscape 701–2, *703*
Altes Museum, Berlin (Schinkel) 976, *976*
Amanat Khan 783
Amaral, Tarsila do 1085
 The One Who Eats (Abaporú) 1085, *1085*
Amaranth (Yun Shouping) 820–21, *821*
American Civil War 988, *988*, 996, 998
American Gothic (Wood) 1080, *1081*
American Society of Independent Artists 1051, 1052
American War of Independence 922
Americas 851
 see Native Americans
 map *852*
Amsterdam, Netherlands 754, 757, 765, 767
 Portuguese Synagogue 765, *765*
An Gyeon 814
 Dream Journey to the Peach Blossom Land 824–5, *825*
Anatomy Lesson of Dr. Nicolaes Tulp, The (Rembrandt) 758, *758*, 998
Anatsui, El 911, 914
 Flag for a New World Power 914–15, *915*
Andachtsbilder 568–9, *569*
Anderson, Laurie 1111
 Duets on Ice 1111, *1112*
Andrade, Oswald de 1085
Andre, Carl 1109
Andrews, Mr. and Mrs.: portrait (Gainsborough) 941, *941*
Angelico, Fra 626
 Annunciation xxxiv, *xxxiv*, 626, *626*
Angiviller, Count d' 952
Angkor Thom, Cambodia 798
Angola 911
Anguissola, Sofonisba 682
 Self-Portrait 682, *682*
Anne of Austria 770
Annunciation (Angelico) xxxiv, *xxxiv*, 626, *626*
Annunciation (Martini and Memmi) 558, *558*, 560–61, 589
Annunciation (Pontormo) 678
Antonio di Tuccio Manetti 610
Antwerp 694, 711, 714–15, 749, 750, 751

Rubens's house 750, *751*
Aphrodite of Knidos (Praxiteles) 635
Apollinaire, Guillaume 1046
Apotheosis of Homer jar (Wedgwood) 935–6, *937*
Appiano, Semiramide d' 635
Apple Cup (Krug family) 683, *693*
Appreciation of Painting (Kano School) 835–6, *836*
appropriation xxii, 1125–8, 1145
Archer, Frederic Scott 987
architecture xviii–xix, xxii–xxiii
 American 868, *869* (Puebloan), 974, 974–5 (Gothic Revival), *976*, 976–7, *977* (Neoclassical), 1022, 1023–5, *1024*–6 (late 19th century), 1060–62, *1060–62* (Modernist), 1063, *1063*, *1064* (skyscrapers), 1120, 1120–22, *1121* (20th century), *1122*, 1122–3, *1123* (Postmodern)
 Art Nouveau 1018–20, *1019*, *1020*
 Aztec 854, *855*
 Baroque 727, *728*, 731, 731–2, *732*
 Bauhaus 1069, *1069*–70
 Belgian (Art Nouveau) 1018, *1019*
 Chinese (Mongol) 816, *816*
 Deconstructivist 1135, *1135*
 Dutch (De Stijl) 1068, *1069*
 English 567, *567*–8 (Decorated style), 568 (Perpendicular style), 721–2, *722*, *723* (Elizabethan), 778–80, *779*–81 (17th century), 934, *934*–5 (Neo-Palladian), 937, 937–8, *938*, 974–5, *975* (Gothic Revival)
 Flamboyant 598, *598*, *599*
 French 598, *598*, *599* (Flamboyant), 704, *705*, *705*, 706–7, *707* (16th century), 771, *773*, *774* (17th century), 928, *928* (Rococo), 948, *948*–9, *949* (18th century), 981, *982*, *983*, 989, 1023, *1023* (19th century), 1020 (Art Nouveau)
 German 928, *929* (Rococo), 976, *976* (Neoclassical), *1069*, 1069–70 (Bauhaus), 1071 (International Style), 1135, *1135* (Deconstructivist)
 Gothic Revival 802, *802*, 937, 937–8, *938*
 High Tech 1134, *1134*
 historicist 981, 982, *983*, 1023, *1023*
 Inca 857–8, *858*, *859*
 Indian 786, *786* (Jain), 784, 786–7, *787* (Islamic), 787–9, *788*, *789* (Hindu), *782*, 783, 787, 790–91, 791, 793–4, *794* (Mughal), 796, 796–7, *797* (Rajput), 802, 802–3, *803* (British)
 International Style 1071, 1120, 1122
 Islamic *782*, 783, 787, *787*, 793–4, *794* (India), *801*, 801–2 (Indonesia)
 Italian 546, *546*, 610–15, *611*, *612*, *614*, *615*, 636, 636–7, *637*, 641, *641* (15th century), 663–4, *664*, 665, *665*, 666, *666*, 675–7, *675*–7, 686, 686–9, *688* (16th century), 727, *728*, 731, 731–2, *732* (17th century)
 Japanese 834, *834* (castles), 834–5, *835*, 1061 (*shoin* design), 847–8, *848* (postwar)
 Malaysian 804, *805*
 Maori 885, *885*–6
 Micronesian 883–4, *884*
 Modernist *1058*–62, *1059–62*, 1071
 Mughal *782*, 783, 790–91, *791*, 793–4, *794*
 Myanmar 798–9, *799*

Nankani (Ghana) 911–12, *912*
Neoclassical 976, *976* (German), *976*, 976–7, *977*
 (American)
Neo-Palladian *934*, 934–5
Perpendicular 568, 721
Puebloan 868, *869*
Rajput *796*, 796–7
Rococo 928, *929*
Spanish 707–8, *708*, 709, 748 (16th century),
 748, *748* (17th century), 1019–20, *1020* (Art
 Nouveau)
Thai 300–1, *801*
Arita, Japan: porcelain 845, *847*
armor (Halder) 722, *722*
Armored Train in Action (Severini) *1047*, 1047
Armory Show, New York (1913) 1055
Arnolfini Double Portrait (van Eyck) *574*, 575, 577,
 589–90, 593, 747
Arowogun (sculptor) 901
Arras 582
Arruda, Diogo de: Tomar church window, Portugal
 708–9, *709*
Arruda, Francisco 708
art: definition xx
art history xxiii–xxxv
Art Informel 1086
Art Nouveau 1011, 1018
 architecture 1018–20, *1019*, *1020*
 desk 1020, *1021*
Art Workers' Coalition 1148
Arte Concreto-Invención 1088
Arte Povera 1101, 1114–15
Artifact Piece, The (Luna) 1128–9, *1129*

Arts and Crafts movement 1018
 furniture 1001, *1001*
Aryans 784
Asante Empire 897, 911
 kente cloth *897*, 897–8, 914
 okyeame poma (speaker's staff) 898, *898*
Ashikaga era, Japan 831–3
Ashoka, Maurya king 784
Asmat, the 881
 memorial poles (*bisj*) 881, *881*
*Aspects of Negro Life: From Slavery through
 Reconstruction* (Douglas) *1079*, 1079
assemblages 1040
Assisi, Italy: St. Martin Chapel frescos (Martini) 558
Association of Artists of Revolutionary Russia 1066
Assumption of the Virgin (Correggio) *667*, 667–8
Asuka era, Japan 830
AT&T Building, New York (Johnson and Burgee)
 1123, 1123
Athropométries of the Blue Period (Klein) *1101*, 1101–2
atolls, Micronesian 883
Augustinians 959
Australians, indigenous 875, 876, 877–8
 bark paintings 878, *878*
 Barunga Statement *874*, 875
 Central Desert painting 890–91, *892*
 The Dreaming/Dreamtime 877, *878*
 Spirit Beings 877–8
Austria 693, 742, 1032
 painting 1043, *1043*
 St. Wolfgang Altarpiece, Austria (Pacher) 600,
 601, 602
 see also Vienna
automatism *1072*, 1092
Automatistes, Les 1092
Autumn Rhythm (Numer 30) (Pollock) *1090*, 1091
avant-garde, the 989, 1052, 1071
Avalokiteshvara, Bodhisattva *785*, 785–6
Avignon: papal court 577

Aztec Empire 852–3, 860, 959
 Calendar Stone *853*
 Codex Mendoza 853–4, *854*
 featherwork 856, *856*
 manuscripts 853–4, *854*, 856, *857*
 sculpture 855, *855*
 Tenochtitlan 853–4, *854*, *855*

B

Babur, Mughal emperor 790
Bacchus (Caravaggio) *734*, 735
Bacon, Francis 769, 1086
 Figure with Meat 1086, *1087*
Bada Shanren xxx
Baerze, Jacques de 578
Baldacchino (Bernini) 728–9, *729*, 731
Baldung Grien, Hans 701
 Death and the Matron 701, *702*
Ball, Hugo 1051
 "Karawane" 1051, *1051*
Ballets Russes 1048
Balzac, Honoré de 989
Bamum kingdom, Cameroon 898–9
Bandi 791(c)
Bangkok, Thailand 800
 Temple of the Emerald Buddha 800–1, *801*
Banjo Lesson, The (Tanner) *999*, 999
bankers/banking 599, 609, 632
Bantu speakers 899
Baptism of Christ (Piero della Francesca) *637*, 637–8
Bar at the Folies-Bergère, A (Manet) *995*, 996
Barcelona, Spain
 Casa Batlló (Gaudí) 1019–20, *1020*
Bargehaulers on the Volga (Repin) *996*, 997
bark cloth, Samoan 889–90, *890*
bark paintings, indigenous Australian *878*, 878
Barney, Matthew: "The Cremaster Cycle" 1141–2,
 1142
Baroque style 726
 architecture 727–8, *728*, 731, 731–2, *732*
 (Italian)
 painting and frescos 726–7, 732–41, *733–41*
 (Italian)
 sculpture *724*, 725, 728–9, *729*, 730, 730–31
 (Italian)
Barry, Charles, and Pugin, Augustus W. N. 974–5,
 975
Barthes, Roland 1124
Barunga Statement, the *874*, 875
basketry, Eastern Woodlands 863–4, *854*
Basquiat, Jean-Michel 1124–5
 Horn Players 1125, *1125*
Bateman, Ann and Peter: goblet *936*
Bateman, Hester: double beaker *936*
Battle of San Romano, The (Uccello) 606, 607, 609, *627*
Battle of the Nudes, The (Pollaiuolo) 629–30, *630*
Baudelaire, Charles 993
Baudrillard, Jean 1124
Bauhaus 1069–71, 1120
Bauhaus Building, Dessau, Germany (Gropius)
 1069, 1069–70, 1071
Baule peoples: *blolo bla* 907, 907–8
Baxandall, Michael 635
beadwork, Eastern Woodlands 862–3, *863*
Beauvais tapestry manufactory 926
Beijing, China 808, 809, 812, 814, 8320
 The Forbidden City 816, *816*
Bélaird (printmaker) 969
Belgium 577, 582, 915, 917
 Art Nouveau architecture 1018, *1019*
 painting *1016*, 1017 (19th century)
 tapestries 722, *723*
Belley, Jean-Baptiste: portrait (Girodet-Trioson) *954*,

954
Bellini, Gentile 641, 668, 671
 *Procession of the Relic of the True Cross before the
 Church of St. Mark* 641, *642*
Bellini, Giovanni 641, 668, 669, 671
 St. Francis in Ecstasy 642–3, *643*
 *Virgin and Child Enthroned with SS. Francis, John
 the Baptist, Job, Dominic, Sebastian, and Louis of
 Toulouse* 641–2, *642*
Bellini, Jacopo 641, 668
Bellori, Giovanni: *Lives of the Painters* 736–7
Benci di Cione 546
Benday dots 1108
Benedict XI, Pope 551
Benedict XIV, Pope 959, *960*
Benin City
 British Punitive Expedition (1897) *904*, 904–5
 Palace ancestral altar to Ovonramwen 905, *905*
Berger, John 1127
Berlin
 Academy 942
 Altes Museum (Schinkel) *976*, 976
 Club Dada 1053
Berlin Conference (1884–5) 903–4, 917
Bernini, Gianlorenzo 727–8, *629*, 740, 781
 Baldacchino, St. Peter's 728–9, *729*, 731
 Cornaro Chapel, Santa Maria della Vittoria, Rome
 730, *730–31*
 David 730, *730*
 St. Peter's Basilica and piazza 687,
 727, *728*
 St. Teresa of Ávila in Ecstasy 724, *725*
Betrayal of Jesus (Duccio) *557*, 557–8
Beuys, Joseph 1105, 1119, 1124
 How to Explain Pictures to a Dead Hare
 1105, 1105–6
Bharat Mata (A. Tagore) 803, *803*
Biagio d'Antonio *see* Sellaio, Jacopo del
Bibles
 Gutenberg's 604
 Vulgate xxxiii
bieri, Fang 908, 908–9
Big Raven (Carr) 1083, *1083*
bilum (net bags), New Guinea 880, *880*
biomorphic forms 1073–4, 1075
Birth of Liquid Desires (Dalí) 1073, 1073–4
Birth of Venus (Botticelli) *635*, 635–6
Birth of Venus, The (Cabanel) *984*, 984,
 985, 984
Bismarck, Otto von 903
Black Death 543, 544, 559, 562, 566
Black Mountain College, North Carolina 1100, 1101
Black Square, The (Malevich) 1048
Blackfoot, the: tipis 864, 865
Blake, William 946
 Newton 946, *946*
Blaue Reiter, Der 1045
Bleyl, Fritz 1040
blind arcades 794
Boccaccio, Giovanni 544
 The Decameron 544
 De Claris Mulieribus 580, *580*
Boccioni, Umberto 1048
 Unique Forms of Continuity in Space
 1048, *1048*
bodhisattvas 785
Boffrand, Germain: Salon de la Princesse
 923, 924
Bohier, Thomas 704, *705*
Bohr, Niels 1033
Bolivia 742
Bologna 646, 665, 668, 733
 Cathedral sculpture (Properzia de' Rossi) *668*, 668

Bonaparte, Joseph, King of Spain 958
Bonheur, Rosa 992
 The Horse Fair 992–3, *993*
Book of Hours of Jeanne d'Évreux (Pucelle)
 562, *563*
books, printed *604*, 604–5 (15th century)
Borch, Gerard ter 763, 925
 The Suitor's Visit 763–4, *764*
Borromini, Francesco 731
 San Carlo alle Quattro Fontane, Rome 731, 731–2,
 732
Bosch, Hieronymus 709, 711, 716
 Garden of Earthly Delights 711–13, *712–13*
bosses 568
Boston, Massachusetts 921
 Academy 942
 Public Garden 1026
Böttger, Johann Friedrich 813
Botticelli, Sandro 635, 636, 640
 Birth of Venus 635, *635–6*
 Primavera (Spring) *634*, 635
Bottle of Suze (Picasso) 1039–40
Boucher, François 926, 927, 949
 Girl Reclining: Louise O'Murphy 926, *926*
Bouman, Elias 765
Bourges, France: Jacques Coeur's house
 598, *599*
Bouts, Dieric 593
 Virgin and Child 593, *593*
Boyne, Gustavus Hamilton, 2nd Viscount: portrait
 (Carriera) *930*, 931
Brady, Mathew 988
Brahman 784
Bramante, Donato 652(c), 665, 707
 St. Peter's, Rome 686, 68*7*, 687, 781
 Tempietto, Rome 665, *665*
Brancacci Chapel (Santa Maria del Carmine),
 Florence: Masaccio frescos *624*, 624–6, *625*, 648
Brancusi, Constantin 1049
 The Newborn 1049, *1050*
 Torso of a Young Man 1050, *1050*
Brandt, Isabella *749*, 750–51
Brandt, Marianne: coffee and tea service 1070, *1070*
Braque, Georges 1036, 1038, 1039,
 1045, 1054
 Violin and Palette 1038, 1038–9
Brazil 1084–5
 painting *1085*, 1085–6
Brecht, George
 Duration Event 1104
 Exit Event 1104
 Three Aqueous Events 1104, *1104*
Breton, André 1072, 1074, 1075, 1084,
 1087, 1089
Briconnet, Catherine 705
Bridget of Sweden, St. 695
Brillo Soap Pads Box (Warhol) 1108, *1108*
Brindavan, India: Govind Deva Temple 787
Britain 778, 911, 933, 1032
 Arts and Crafts furniture 1001, *1001*
 colonialism in Africa 903, 911
 painting *719*, 720, *721* (16th century),
 752–3, *753* (17th century), 939–42, *939–42* (18th
 century), *945*, 945–6 (Romantic), *1000*, 1000–1
 (Pre-Raphaelite) 971, *972*, 973 (19th century),
 1086, *1087* (postwar)
 prints *946*, 946
 World War I casualties 1050
 see also England
British Museum, London 904(c), 905,
 910, *911*
Brody, Sherry 1117
Broederlam, Melchior: altarpiece of Chartreuse de

Champmol 578, *578*
bronzes /bronzework
 French *1017*, 1017–18, *1018* (19th century)
 Italian 546, *547*, 548, *548*, 609–10, *610*, 618–19,
 618–21, 621, *629*, 629–30, *630* (15th century)
 Pala dynasty 785, *785*
Bronzino (Agnolo di Cosimo di Mariano Tori)
 680–81
 Allegory with Venus and Cupid 681,
 681–2
 *Portrait of Eleonora of Toledo and her Son Giovanni
 de' Medici 680*, 681
Brown, Lancelot ("Capability") 935
Brücke, Die (The Bridge) 1040–42
Bruegel, Pieter, the Elder 711, 716–17, 752
 The Harvesters 718, 718
 Return of the Hunters 717, 717
Brueghel, Jan, the Elder 752
Bruges, Belgium 576(c), 577, 593, 595
Brugghen, Hendrick ter 755
 St. Sebastian Tended by St. Irene 755, *755*
Brunelleschi, Filippo 610, 623, 627
 Capponi Chapel, Santa Felicità, Florence 612, 678,
 678, 680
 Florence Cathedral 610–12, *611*
 Ospedale degli Innocenti 612, *612–13*
 Sacrifice of Isaac 609, 610, *610*
 San Lorenzo, Florence 613–14, *614*
Brussels, Belgium 577, 582
 tapestries 722, *723*
 Tassel House (Horta) 1018, *1019*
Buddhas
 Emerald Buddha 800
 Seated Buddha (Khmer) 798, *798*
 Sukothai Buddhas 799, *800*
Buddhism 784, 798
 architecture 798–9, *799*
 in China 818
 Esoteric 830
 in Japan 830, 831
 Pure Land Buddhism 830, 831
 sculpture 798, *798*
 see also Zen Buddhism
Bukka 787
Bulfinch, Charles: U.S. Capitol 976–7
Bull and Puppy (Rosetsu) 841, *841*
Bunbury, Lady Sarah 940(c)
 Lady Sarah Bunbury Sacrificing to the Graces
 (Reynolds) 940, *940*
buncheong ceramics 823–4, *824*
Bunsei 831
 Landscape 831, 831–2
Buñuel, Luis 1078
Burgee, John: AT&T Building, New York (with
 Johnson) 1123, *1123*
Burghers of Calai, The (Rodin) *1017*, 1017–18
Burgundy 707
Burgundy, dukes of 576(c), 577, 584
Burial at Ornans, A (Courbet) *990*, 991
Burial of Count Orgaz (Greco) 709–10, *710*
burins 602
Burke, Edmund 973
Burkina Faso: Bwa people 912–13, *913*
Burlington, Richard Boyle, 3rd Earl of 935
 Chiswick House *934*, 934–5, 949
Burma *see* Myanmar
*Burning of the Houses of Lords and Commons, 16th
 October 1834, The* (Turner) *972*, 973
Burrows, Alice and George: snuffbox *936*
Burty, Philippe 1010
Buseau, Marie-Jeanne 926
Buxheim St. Christopher, the (woodcut)
 603, 603

Bwa people 912
 masks 912–13, *913*
Byzantine painting 548, 549, 550, 554

C

Ca d'Oro (Contarini Palace), Venice 641, *641*
Cabanel, Alexandre: *The Birth of Venus* 984, *984*,
 985, 984
Cabrera, Lydia 1086, 1087
Cage, John 1100, 1101, 1102, 1105
 4'33" 1101
 Theater Piece, No. 1 1101, *1103*
Caillebotte, Gustave 1008–9
 Paris Street, Rainy Day 1009, *1009*
Calcutta, India 802, 847
Calder, Alexander 1078
Calendar Stone, Aztec *853*
calligraphy, Chinese 808, 809, 818–19
Calling of St. Matthew, The (Caravaggio)
 735, 737
Calvin, John 693, 703
Cambodia 798, 805
camera lucida 985
camera obscura 762, 931, 985
Camera Work (magazine) 1054
cameras 986, *986*
Cameron, Julia Margaret 989
 Thomas Carlyle 988, 989
Cameroon 898–9
Campbell, Colen 934
Campin, Robert *see* Flémalle, Master of
Canadian art 1082–3, *1083*, 1092–3, *1093*, 1149, *1149*
Canaletto (Giovanni Antonio Canal) 931
 The Doge's Palace and the Riva degli Schiavoni 930,
 931
Canova, Antonio 932
 Cupid and Psyche 933, *933*
Canterbury Tales, The (Chaucer) 544, 566
Canyon (Rauschenberg) *1100*, 1100
capricci 931
Caprichos, Los (Goya) 956–7, *957*
Capture of a Sabine Woman, The (Giambologna) 684,
 684
Caravaggio (Michelangelo Merisi) 725,
 734–5, 736–8, 742, 743, 751, 755, 757,
 771, 774
 Bacchus 734, 735
 The Calling of St. Matthew 735, 737
 Contarelli Chapel paintings 735, *736*, 737
 Conversion of St. Paul 736, *738*
 Death of the Virgin 749–50
 The Martyrdom of St. Matthew 735
Carducho, Vincente: *Dialogue on Painting* 736
Caricature, La (magazine) 969
Carlyle, Thomas: portrait (Cameron)
 988, 989
Carpeaux, Jean-Baptiste 984
 The Dance 984–5, *985*
Carr, Emily 1083
 Big Raven 1083, *1083*
Carracci, Agostino 733
Carracci, Annibale 733, 749, 751, 776
 Palazzo Farnese ceiling *733*, 733–4, 774
Carracci family 732
Carriera, Rosalba 930–31
 *Gustavus Hamilton, 2nd Viscount Boyne
 930*, 931
Carthusians xxxv
cartography 646
cartoons, Raphael's 656, *657*
Casas y Nóvoas, Fernando: Cathedral of St. James,
 Santiago de Compostela 748, *748*

Cassatt, Mary 1008, 1010
 Mother and Child 1008, *1009*
 Woman Bathing 1010, *1010*
cassoni 630–31, *631*, 673
Castagno, Andrea del: *The Last Supper*
 627, *627*–8
 Japanese 834, *834*
Catherine de' Medici, Queen of France 703, 705,
 706, 735
Catherine the Great 955
Catholicism/Catholic Church 646, 647, 684, 692, 693,
 703, 704, 720, 726, 729, 742; *see also* Counter-
 Reformation
Celant, Germano 1114
Cellini, Benvenuto 683
 Saltcellar of Francis I 683, *683*
Cennini, Cennino 548, 556
cenotaphs 783
ceramics
 American 1126, *1126*
 Chinese 797, 812–13, *813* (Ming)
 English 935–6, *937*
 French 926
 Japanese 830, 837–8, *838*, 845, *847*
 Korean 823–4, *824*
 Lapita 877, *877*
 Neoclassical 935–6, *937*
 Puebloan 869, *869*
 Vietnamese 797, *797*
Cerico, Deejay *see* Pelli, César
Cesare, Giuseppe 735
Cézanne, Paul 1003, 1022, 1027, 1028, 1038, 1054
 The Large Bathers 1028–9, *1029*, 1035, 1037
 Mont Sainte-Victoire 1027, *1027*–8
 Still Life with Basket of Apples 1028, *1028*
chacmool 1077
Chandler, John R. 1110
Chang'an (Xi'an), China 808, 816
Chardin, Jean-Siméon 949
 Saying Grace 949, *950*
Charivari, Le (newspaper) 969, 1003
Charles I, of England 656, 751, 753, 778, 780
 Charles I at the Hunt (van Dyck) 753, *753*
Charles II, of Spain 742
Charles III, of Spain 956
Charles IV, of Bohemia 570, 571, 573
Charles IV, of France 562, 570
Charles IV, of Spain 956, *957*, 957–8
Charles IX, of France 703
Charles V, of France 562, 577
Charles V, Holy Roman Emperor 646, 667, 671, 684,
 693, 706,
 707, 711, 716, 742, 853, 856
Charles VII, of France 596, 597
Charles VIII, of France 598
Charles X, of France 966
Charles, Jean 964
Chartreuse de Champmol, Dijon 577
 Altarpiece (Broederlam) 578, *578*
 Well of Moses (Sluter) *579*, 579–80, 589
châteaux 689, 704, 705, *705*, 706, *706*, 926
chattris 793, *794*
Chaucer, Georffrey: *Canterbury Tales*
 544, 566
Chen, Jenova, and Santiago, Kellee: *Flower* 1150–51,
 1151
Chenonceau, Châtea of 704, 705, *705*, 706
Chevalier, Étienne 597
 Étienne Chevalier and St. Stephen (Fouquet) *596*,
 597
Chevreul, Michel-Eugène 1011, 1046
chiaroscuro 650, 761
Chicago 1022, 1023

Marshall Field Wholesale Store (Richardson)
 1024, *1025*
 Robie House (Wright) *1060*, 1061
 World's Columbian Exposition (1893) 1023–4,
 1024, 1061
 World's Fair (1933) 869
Chicago, Judy 1117
 The Dinner Party 1117–18, *1118*
Chichester-Constable Chasuble *566*, 566–7
Chilkat Tlingit blankets 867, *867*
China 807–8, 822, 829, 830, 1097
 album paintings *xxix*, 810, 811, 817, *817*, 820–21,
 821, 822
 Buddhism 818
 calligraphy 808, 809, 818–19
 ceramics 802, 812–13, *813* (Ming)
 handscrolls/hanging scrolls 811, *811*; *806*, 807
 (Qing), *810*, 810–12, *812* (Yuan), *814*, 814–15,
 815, 816, *817*, 818, *820* (Ming)
 ink painting *806*, 807
 literati 807, 808, 809–10, 812, 812(c), 814, 816, 818,
 841
 map *809*
 Mongols 808–9, 816, *186*
 paintings *see* album paintings; handscrolls (*above*)
 town planning (Mongol) 816, *186*
 see also Confucius/Confucianism
China Monument: Temple of Heaven (Gu)
 1137, 1137–8
Chishti, Salim 790
Chiswick House, London (Burlington) *934*, 934–5,
 949
Chojiro: tea bowl *838*, 838, 845
Christ Giving the Keys to St. Peter (Perugino) 623
Christine de Pizan 544
 The Book of the City of Ladies 544
Christo (Javacheff) and Jeanne-Claude
 (de Guillebon) 1115–16
 The Gates, Central Park, New York 1116, *1116*
Christ's Charge to Peter (Raphael) 656, *656*, 657
Christus, Petrus 593, 596
 A Goldsmith in His Shop 592, *592*, 593, 715
Cimabue 548, 551, 646
 Virgin and Child Enthroned 548–9, *549*
Citadelle, La: Freedom (Savage) 1079, *1080*
City Night (O'Keeffe) 1057, *1057*
Claesz, Peter 767
 Still Life with Tazza 767, *767*
Claudel, Camille 1018
 The Waltz 1018, *1018*
Claude Lorrain (Claude Gellée) 776, 777
 A Pastoral Landscape 777, 778
Clement V, Pope 708
Clement VI, Pope 571
Clement VII, Pope 646, 663, 684
Clodion (Claude Michel) 928
 The Invention of the Balloon 928, *928*
Clothes and Customized Citroën B-12
 (S. Delaunay) *1046*, 1047
Clouet, Jean 704
 Francis I 704, *704*
Coalbrookdale, England: Severn River Bridge
 (Darby) 938, *938*
Coatlicue (goddess) 855, *855*
Codex Fejervary-Mayer 856, *857*
Coeur, Jacques: house, Bourges 598, *599*
Colbert, Jean-Baptiste 770, 771
Cole, Thomas 973
 The Oxbow 973–4, *974*
collages *917*, 917–18, 1039–40, *1040*, *1053*, 1053–4,
 1054, 1106, *1106*–7
Cologne, Germany 1051, 1072
color(s) xv–xvi, xvii, xxv

Color Field painting 1093–4, *1094*
Colter, Mary 1062
 Lookout Studio, Grand Canyon 1062, *1062*
combines 1100
commodification of art 1110
Company of Captain Frans Banning Cocq, The
 (Rembrandt) 759, *759*
complementary colors 1011
composition xvii, xxiii
Composition (Miró) 1075, *1075*
Composition with Yellow, Red, and Blue (Mondrian)
 1067, 1067–8
Conceptual art/Conceptualism 895, 1099, 1110–11,
 116
condottieri 608, 619, 639
Conflict Kitchen, Pittsburgh 1148
Confucius/Confucianism/Neo-Confucianism 807,
 808, 823, 836, 838, 844
Congo, Democratic Republic of 899, 917
 see also Kongo peoples; Kuba kingdom
Congo: Shadow of a Shadow (Mpane) *916*, 916–17
Congregation of the Oratory 737
Constable, John 971
 The Hay Wain 971, *971*
Constantine, Emperor 687
Constantinople 640
Constructivism, Russian 826, 1064–5, 1135
content xvii
Conversion of St. Paul (Caravaggio) 736, *738*
Cook, Captain James 875, 886
Cooke, Elizabeth: salver *936*
co-passio xxxv
Copernicus, Nicolaus: *On the Revolutions of the
 Heavenly Spheres* 769
Copley, John Singleton 921–2, 946, 947
 *Thomas Mifflin and Sarah Morris (Mr. and Mrs.
 Mifflin)* *920*, 921
 Watson and the Shark 946–7, *947*
corbels 567
Corbusier, Le (Charles-Édouard Jeanneret) 1059,
 1071
 Nôtre-Dame-de-Haut, Ronchamp, France *xxii*,
 xxiii
 Villa Savoye, France 1059, *1059*
Corday, Charlotte 953
Corneille, Pierre: *Horace* 952
Cornelia Pointing to Her Children as Her Treasures
 (Kauffmann) *943*, 943–4
Corot, Jean-Baptiste-Camille 992, 1007
 First Leaves, Near Mantes 992, *992*
Correggio 667, 672, 680, 734
 Assumption of the Virgin 667, *667*–8
Cortés, Hernán 852, 856
Cortona, Pietro da 739
 The Glorification of the Papacy of Urban VIII 739–40,
 740
Cosmati work 719(c)
Cotán, Jan Sánchez 742, 744
 *Still Life with Quince, Cabbage, Melon, and
 Cucumber* *742*, 742
Counter-Reformation, Catholic 684, 687, 689, 725,
 727, 729, 735
Courbet, Gustave 989, 1001, 1003
 A Burial at Ornans *990*, 991
 The Stone Breakers 989–91, *990*
craft or art? 863
Cranach, Lucas, the Elder 701, 702
 Nymph of the Spring 701, *702*
Creation of Adam (Michelangelo) 662, *662*
"Cremaster Cycle, The" (Barney) 1141–2, *1142*
crockets 598
Cronin, Patricia 1150

Shrine for Girls 1150, *1150*
Cropper, Elizabeth 680(c)
Crossing, The (Viola) *1112*, 1112–13
Crucifixion Triptych with Donors and Saints (van der Weyden) *xxxiii*, xxxiii–xxxiv
Crucifixion with the Virgin and St. John the Evangelist (van der Weyden) *xxx*, xxi–xxxiii, xxxiv, xxxv, *xxxv*
Crusades 708
Cuba 1086, 1097
 art 1086, *1086*, 1087–8, *1088*, *1118*, 1118–19
Cubi (D. Smith) 1095, *1095*
Cubism 1031, 1036, 1045, 1047, 1051, 1099
 analytic 1038–9
 synthetic 1039–40
 cultural context xxviii, xxxiv–xxxv
Cumberland, George Clifford, 3rd Earl of
 armor (Halder) 722, */22*
 portrait (Hilliard) 720, *721*
Cunningham, Imogen 1058
 Two Callas 1058, *1058*
Cunningham, Merce 1100, 1101
Cupid and Psyche (Canova) 933, *933*
Cusco, Peru 856, 857–8, 860
Cut Piece (Ono) *1104*, 1104–5
Cut with the Kitchen Knife Dada... (Höch) 1053–4, *1054*
Czech Republic *see* Prague

D

Dada 1033, 1050–54, 1072, 1099, 1100
Daguerre, Louis-Jacques-Mandé/daguerreotypes 986, *986*, *986*, 987, *987*
Dai Jin: *Returning Home Late from a Spring Outing* 814, *814*
daimyo 833
Dalí, Salvador 1073, 1075, 1089
 Birth of Liquid Desires 1073, 1073–4
Dance, The (Carpeaux) 984–5, *985*
Danger Cave, Utah 863
Daniele da Volterra 686
Dante Alighieri 544
 The Divine Comedy 544, 551
Danube Landscape (Altdorfer) 701–2, *703*
Daoism 807, 808
Darby III, Abraham: Severn River Bridge 938, *938*
Darkytown Rebellion (Walker) *1147*, 1147–8
Darwin, Charles 981
Daubigny, Charles-François 1003
Daumier, Honoré 969
 The Print Lovers 970, *970*
 Rue Transnonain, Le 15 Avril 1834 969, *970*
David (Bernini) 730, *730*
David (Donatello) 618, *618*, 659, 730
David (Michelangelo) 659, *659*, 730
David (Verrocchio) 629, *629*, 730
David, Jacques-Louis 952, 954, 962, 963
 Death of Marat 953, *953*
 Napoleon Crossing the Saint-Bernard 962, *962*, 973
 Oath of the Horatii 952, 952–3, 958, 963
Davies, Arthur B. 1055
Death and the Matron (Baldung) 701, *702*
Death of General Wolfe, The (West) 944, 944–5, 947
Death of Marat (David) 953, *953*
Death of the Virgin (Caravaggio) 749–50
Decameron, The (Boccaccio) 544
Declaration of Independence, American 947
Deconstructivist architecture 1135, *1135*
Decorated style (architecture) 567, 567–8
Degas, Edgar 995, 1003, 1007, 1008, 1010, 1021
 The Rehearsal on Stage 1007, 1007–8

The Tub 1008, *1008*
"Degenerate Art" exhibition (Munich, 1937) 1071–2, *1072*
Déjeuner sur l'herbe, Le see Luncheon on the Grass
De Kooning, Willem 1091–2, 1100
 Woman I 1092, *1092*
Delacroix, Eugène 966, 970
 Liberty Leading the People: July 28, 1830 966, 966–7
Delaunay, Robert 1045
 Homage to Blériot 1045, 1045–6
Delaunay, Sonia 1045, 1046, 1047
 Clothes and Customized Citroën B-12 1046, 1047
Delaware people 861
 bandolier bag 862–3, *863*
 Wampum Belt 861, *862*
Delft, Netherlands 754, 762, *762*
Delhi, India 786–7, 790, 802, 803
 Qutb Minar 787, *787*
Demoiselles d'Avignon, Les 1037, 1037–8, 1039
dendrochronology xxxi
Departure of the Volunteers of 1792, The (Rude) 967, *967*
Deposition (Pontormo) 678, *679*, 679–80
Deposition (van der Weyden) 590, 590–91
Derain, André 1034, 1039
 Mountains at Collioure 1034, 1034–5
Derrida, Jacques 1135
Descartes, René 769
desk (Guimard) 1020, *1021*
De Stijl movement 1067–9
Deutscher Werkbund 1071
di sotto in sù 639, 739
Diaghilev, Sergei 1048
Diane de Poitiers 705
Dickens, Charles 989
Diderot, Denis 949, 950. 955
 Encyclopédie 949
Diego, Juan 959
digital technology 1098
Dijon, France 576(c)
 see also Chartreuse de Champmol
Dilwara Temples, Mount Abu, India 786, *786*
Dinis, King of Portugal 708
Dinner Party, The (Chicago) 1117–18, *1118*
Dinteville, Jean de *719*, 720
Diptych of Maarten van Nieuwenhove (Memling) *595*, 595–6
diptychs 579, *579*, 595, 595–6, *596*, 597
Ditchley Portrait of Elizabeth I (Gheeraerts the Younger) 720, *721*
Divine Comedy, The (Dante) 544, 551
Divisionism 1011
Djibouti 911
Doesburg, Theo van 1067
Doge's Palace and the Riva degli Schiavoni, The (Canaletto) *930*, 931
Dollhouse (Schapiro and Brody) 1117
Dominicans 636, 674, 703, 959
Donatello 616–17, 618, 619, 639
 David 618, *618*, 659, 730
 equestrian statue of Gattamelata 619, *619*
 St. George 617, 617–18
Dong Qichang 818–19, 820, 821
 The Qingbian Mountains 819, *820*
Dong Yuan 807, 819
Double Portrait of Giovanni Arnolfini and His Wife (van Eyck) 574, 575, 577, 589–90, 593, 747
Douglas, Aaron 1079
 Aspects of Negro Life: From Slavery through Reconstruction 1079, *1079*

Dove, Arthur 1054, 1055
 Nature Symbolized No. 2 1055, *1055*
Dream Journey to the Peach Blossom Land (An Gyeon) 824–5, *825*
Dresden 974
 Academy 942
drypoint 759–60
DuBois, W. E. B. 1079
Duccio di Buoninsegna 544, 554, 558
 Maestà altarpiece 554, *555–7*, 557–8, 561
Duchamp, Marcel 1051–2, 1055, 1100, 1101, 1110, 1126
 Fountain 1051–2, *1052*, 1111
 L.H.O.O.Q. 1052, *1053*
 Nude Descending a Staircase No. 2 1051
du Châtelet, Madame 923
Duets on Ice (Anderson) 1111, *1112*
Dumas, Alexandre, the Younger: *Olympe de Clevès* 994
Dunn, Dorothy 869
Dupin, Louise 705
Durand-Ruel, Paul 1003
Dürer, Albrecht 589, 691, 693, 698, 699, 700, 701, 702, 714
 Adam and Eve 699, 699–700, 701
 Four Apostles 700, 700–1
 The Four Horsemen of the Apocalypse 691, 698, 698–9
 Self-Portrait 690, 691, 698
Dutch art *see* Netherlands, the
Dvaravati culture 799
Dyck, Antony van 682, 749, 752–3, 771
 Charles I at the Hunt 753, *753*

E

Eakins, Thomas 996–7, 999
 The Gross Clinic 997, 997–8
earthworks 1115–16
East India Company 802, 921
Easter Island *see* Rapa Nui
Eastern Woodlands peoples 860, 861
 basketry 863–4, *864*
 beadwork 862–3. *863*
 quillwork 861–2, *862*
 wampum beadwork 861, *862*
Eck, Benedict, abbot of Mondsee 600
Edict of Nantes (1598) 704
Edo *see* Tokyo
 Edo period, Japan 838–45
Education of the Virgin, The (La Tour) xxiv
Edward I, of England 566
Edward III, of England 567
Edward VI, of England 720
Effects of Good Government in the City and in the Country, The (Lorenzetti) 542, 543, 560–61, 561–2
Eiffel, Gustave: Eiffel Tower, Paris 938, 978, *979*, 1018
Einstein, Albert 1033
Electric Light (Goncharova) 1048, *1048*
Electronic Superhighway: Continental U.S. (Paik) 1113, *1113*
Eleonora of Toledo and Her Son Giovanni de' Medici (Bronzino) 680, *681*
Eliasson, Olafur 1145
 The Weather Project 1148, *1148*
Elizabeth I, of England 720, 722
 Ditchley Portrait (Gheeraerts the Younger) 720, *721*
Ellington, Duke 1079
encaustic paint 1097
Engels, Friedrich *see* Marx, Karl
England 577, 566, 646, 707, 720, 778–9
 architecture *567*, 567–8 (Decorated style), 568 (Perpendicular style), 721–2, *722*, *723*

(Elizabethan), *778–80*, *779–81* (17th century), *934*, *934–5* (Neo-Palladian), *937*, *937–8*, *938*, *974–5*, *975* (Gothic Revival), *1022*, *1022* (19th century)
ceramics (Neoclassical) 935–6, *937*
iron bridge 938, *938*
opus anglicanum 566, *566–7*
photography 987, *987*, *988*, 989 (19th century)
picturesque garden 935, *935*
sculpture 1075, *1076*, *1077*
see also Britain
English Civil War 778
engraving(s) 602, *603*, 603–4, 629–30, *630*, 699, 699–700, 760
Enlightenment, the 922, 936
Ensor, James 1017
The Intrigue 1016, 1017
ephemeral arts xviii
Erased De Kooning (Rauschenberg) 1100, *1100*
Erasmus, Desiderius 692
Ernst, Max 1072–3, 1089
The Horde 1073, *1073*
Escorial, near Madrid (Juan Bautista de Toledo and Juan de Herrera) 707–8, *708*, 709, 748
esquisse 962
Este, Isabella d' 672
portrait (Titian) 671–3, *672*
Étampes, Anne, duchess of 706
etching(s) 759–60, 931, *931*, 956–7, *957*, 1042, *1042*
Evans, Walker 1126
Exeter Cathedral, England 567, *567–8*
Experiment on a Bird in the Air-pump, An (Wright of Derby) 941–2, *942*
Expressionism xviii, 1012
German 1042–3, 1071
Expulsion of Adam and Eve from Paradise, The (Masaccio) 624, *624*, 625
Eyck, Jan van 585, 587, 593, 596, 720
Double Portrait of Giovanni Arnolfini and His Wife 574, *575*, 577, 589–90, 593, 747
Ghent Altarpiece 588–9, *588–9*
Man in a Red Turban 587, *587–8*

F

Fall of the Giants (Giulio Romano) 666, *667*
Fallingwater, Pennsylvania (Wright) 1061, *1061–2*
Family of Charles IV (Goya) 957, *957–8*
Family of Saltimbanques (Picasso) 1036, *1036*
Fang people 908
reliquary figures *908*, 908–9
FAP *see* Federal Art Project
Farm Security Administration 1080, 1082, 1126
Farnese, Cardinal Alessandro 689
Farnese, Cardinal Odoardo 733
Fascism 1032–3, *see also* Nazi Party
Fatehpur Sikri, India 790
Diwan-i-Khas 790–91, *791*
Fauves/Fauvism 1034, 1038, 1045, 1055
Fazl, Abu 791
Feast in the House of Levi (Veronese) 673, *673–4*
Feast of St. Nicholas, The (Steen) 764, *764–5*
featherwork
cloak from Hawaii 888, *888*
Headress of Moctezuma 856, *856*
Pomo basket 864, *864*
Federal Art Project 1080, 1082
feminists 1103, 1116–19, 1127–8, 1145
Fenollosa, Ernest 846
Ferdinand I, Holy Roman Emperor 693, 742

Ferdinand II, of Aragon 665, 707
Ferdinand VIII, of Spain 959
Ferrara, Italy 608
ferroconcrete 1060
Festival of Pacific Arts 890, *891*
fêtes galantes 926
Figure with Meat (Bacon) 1086, *1087*
Fiji 876, 890
Finley, Karen 1131
First Leaves, Near Mantes (Corot) 992, *992*
Flag for a New World Power (Anatsui) 914–15, *915*
Flamboyant architecture 598
Flanders 577, 711, 742, 749
see Flemish painting, sculpture, *and* tapestries
Flatiron Building, New York (Stieglitz) 1054–5, *1055*
Flavin, Dan 1109
Flaxman, John, Jr.: *The Apotheosis of Homer* 936, *937*
Fleck, John 1131
Flémalle, Master of: Mérode Altarpiece 585–7, *586*
Flemish painting 574, 575, 584–96, *586–96* (15th century), 704, *704* (16th century), 749–53, *749–54* (17th century)
Flemish sculpture 579, *579–80*
Flemish tapestries 582–4, *583*, 711
Flitcroft, Henry *see* Hoare, Henry
Floating Lights (Taikan) 847, *847*
Florence, Italy 545–6, 548, 562, 607, 608, 609, 614, 615, 618–19, 629, 636, 647–8, 659, 929
Academy of Design 738
Baptistery doors 546, *547*, 548, *548*, 609–10, *610*, 620, 621, *621*
Brancacci Chapel fresco, Santa Maria Novella (Masaccio) 622, *622*, 624, 624–6, *625*, 628, 648
Capponi Chapel, Santa Felicità (Brunelleschi) 612, *678*, *678*, 680
The Capture of a Sabine Woman (Giambologna) 684, *684*
Cathedral 545, 610–12, *611*
Loggia 546, *546*
Orsanmichele 616–18, *616*, *617*
Ospedale degli Innocenti (Brunelleschi) 612, 612–13, *613*
Palazzo della Signoria 546, *546*
Palazzo Medici-Riccardi 614–15, *615*
San Lorenzo (Brunelleschi) 613–14, *614*: Laurentian Library (Michelangelo) 663–4, *664*; Medici tombs (Michelangelo) 663, *663*
San Marco frescos (Angelico) xxxiv, *xxxiv*, 626, *626*
Sant' Apollonia fresco (Castagno) 627, *627–8*
Sassetti Chapel frescos, Santa Trinità (Ghirlandaio) 632, *632*, *633*
Strozzi Altarpiece, Santa Maria Novella (Orcagna) 559, *559*
Flower (Chen and Santiago) 1150–51, *1151*
Flower Still Life (Ruysch) 768, *768*
Flowers of Beauty in the Floating World..., *The* (Suzuki Harunobu) 828, *829*
Fluxus 1102, 1103–5
Fontainebleau, Château of 689, 706, *706*, 926
Fontana, Lavinia 682
Noli Me Tangere 682–3, *683*
Fontenelle, Bernard de 922
For the Love of God (Hirst) 1141
foreshortening xxviii, 625, 636, 642, 667
Forever Free (Lewis) 998–9, *999*
form xv, xxv
formal analysis xxiii, xxv, xxvi
Formalism/Formalists 1089, 1145

Forms in Echelon (Hepworth) 1075, *1075*
Foster, Norman: Hong Kong & Shanghai Bank 1134, *1134*
Foucault, Jean-Bernard 948(c)
Foucault, Michel 1124
Fountain (Duchamp) 1051–2, *1052*, 1111
Fouquet, Jean 597
Étienne Chevalier and St. Stephen 596, *597*
Virgin and Child 596, *597*
Four Apostles (Dürer) 700, *700–1*
Four Crowned Martyrs (Nanni) 616, *617*
Four Horsemen of the Apocalypse, The (Dürer) 691, *698*, 698–9
Fragonard, Jean-Honoré 927, 949
The Swing 927, *927–8*
France 562, 646, 665, 703–4, 769–70, 903, 911, 922, 989, 1003, 1032
academies 942, 962, *see* French Royal Academy...
architecture 598, *598*, *599* (Flamboyant), 704, 705, *705*, 706–7, *707* (16th century), 771, 773, 774 (17th century), 928, *928* (Rococo), 948, 948–9, *949* (18th century), 981, *982*, *983*, 989, 1023, *1023* (19th century), 1020 (Art Nouveau)
Art Informel 1086
ceramics 926
colonialism 912, 913
drawing 968–9, *969*
interior decoration 923, 924 (Rococo)
"July Monarchy" 966, 967, 989
lithography 969, 970, *970*
manuscript illumination 562, 563, *563* (14th century)
Neoclassical painting 952, *952–3*
painting 596, *596–8*, *597* (15th century), 774–8, *774–7* (17th century), 924–8, *924–7*, 949 (Rococo), 949–54, *950–55* (18th century), 963–6, *963–6*, 968, 968–9 (Romantic), 989–95, *990–95* (Realist), 982, *982* (Orientalist), 984, *984* (19th century), 1003–5, *1004–8*, 1007–8 (Impressionist), 1008–9, *1009* (late 19th century), 1011–12, *1012*, 1027–9, *1027–9* (Post-Impressionist), 1015, *1015* (Symbolist), *1045*, 1045–6, *1046*, 1047 (Cubist), 1046–7 (Orphist)
photography 985–6, *986*
sculpture *564*, 564–6, *565* (14th century), 928, *928* (Rococo), 955–6, *956* (Neoclassical), 984–5, *985*, 1017, 1017–18, *1018* (19th century)
Surrealism 1072–4
tapestries 926
World War I casualties 1050
Francis I, of France 645, 652, 656, 682, 703, 704, 705, 706, 720
portrait (Clouet) 704, *704*
Franciscans 614, 632, 959, 961
Franco, General Francisco 1033, 1077, 1078
Franco-Prussian War (1970) 1003
Frankenthaler, Helen 1093
Mountains and Sea 1093, *1093*
Franklin, Benjamin 936
bust (Houdon) 955
Frederick the Wise, Elector of Saxony 701
Frederick Henry, Prince of Orange 754
Freedberg, Sydney 647
French, Daniel Chester: *The Republic* 1024
French Ambassadors, The (Holbein the Younger) 718, 720
French Revolution 705, 952, 953, 954, 956, 991
French Royal Academy of Architecture 771
French Royal Academy of Painting and Sculpture 771, 774, 775, 926, 927, 931, 942, 950, 954, 969(c)
frescos 551, *551*, 625
Baroque 733, *733–4*, 739–41, *740*, *741* (Italian)
German 932, *932* (18th century)

Italian 622, *622, 623,* 624–6, *624–7,* 627–8, 632, *632, 633,* 639, *639,* 648 (15th century) 652–3, *654, 655,* 660, *660, 661,* 662, 666, *666–8, 667,* 684–6, *685* (16th century), 733, *733–4,* 739–41, *740, 741* (17th century)
Freud, Sigmund 1072
 The Interpretation of Dreams 1015, 1033
Freyburg, Karl von 1056, 1057
Fried, Michael 1110
Friedrich, Caspar David 974
 Abbey in an Oak Forest 974, *974*
frottage 1073–4
Fry, Roger 1011
Fugger bankers 599
Fuller, Richard Buckminster 1100
furniture
 Art Nouveau 1020, *1021*
 Arts and Crafts 1001, *1001*
 Chinese (Ming) 818, *818*
 Dutch (De Stijl) *1068,* 1069
Fuseli, John Henry 945
 The Nightmare 945, *945–6*
fusuma 834, 835–6, *836–7*
Futurism, Italian 1047–9

G

Gabon: Fang reliquary figures *908,* 908–9
Gainsborough, Thomas 940
 Mr. and Mrs. Andrews 941, *941*
Galileo Galilei 769
Gandhi, Mohandas ("Mahatma") 804, 805
Garden in Sochi (Gorky) 1089, 1089–90
Garden of Earthly Delights (Bosch) 711–13, *712–13*
gardens
 Chinese (Ming) 181, *819*
 English picturesque 935, *935*
 Zen (Japan) 832–3, *833*
Gardner, Alexander 988
 The Home of the Rebel Sharpshooter 988, *988–9*
Garnier, Charles: Paris Opéra 982, *983,* 984–5, *985*
Garvey, Marcu 1079
Gates, Central Park, New York (Christo and Jeanne-Claude) 1116, *1116*
Gates of Paradise (Florence Baptistery doors) (Ghiberti) *620,* 621, *621*
Gattamelata, equestrian statue of (Donatello) 619, *619*
Gaudí i Cornet, Antoni 1019
 Casa Batlló, Barcelona 1019–20, *1020*
Gauguin, Paul 1013, 1043
 Mahana no Atua (Day of the God) 1014, *1014*
Gaulli, Giovanni Battista 740–41
 The Triumph of the Name of Jesus and Fall of the Damned 740–41, *741*
Gay, John: *The Beggar's Opera* 939
Gehry, Frank O. 1135
 Guggenheim Museum, Bilbao, Spain 1135, *1136*
Geneva, Switzerland 703
Genghiz Khan, Mongol ruler 808
genre paintings 727, 735
 Dutch 763–5, *764, 765*
 French 949, 950, *950, 951*
 Korean 826, *826*
Gentileschi, Artemisia 738
 Judith Beheading Holofernes 738, *739*
Gentileschi, Orazio 738
George III, of Britain 931
George V, of Britain 803
Géricault, Théodore 963, 970, 993
 The Raft of the Medusa 963–6, *964,* 1143

The Sighting of the Argus 964–5, *965*
Study of Hands and Feet 965, *965*
Germany 742, 903, 1032
 architecture 928, *929* (Rococo), 976, *976* (Neoclassical), 1069, 1069–70 (Bauhaus), 1071 (International Style), 1135, *1135* (Deconstructivist)
 Bauhaus *1069,* 1069–71
 ceramics 813
 literature 933
 manuscript 569–70, *570*
 metalwork 693, *693*
 painting 599–600, *600, 601* (15th century), 695–6, *696, 697,* 700, 700–2, *702, 703* (16th century), 932, *933* (18th century), 702, 974, *974* (Romantic), 1040–42, *1041–2* (Die Brücke) 1042–3, *1043,* 1071 (Expressionist), *1044,* 1045 (Der Blaue Reiter)
 printed books 604–5 (15th century)
 prints *603,* 603–4, 698, *698–700, 699*
 sculpture 568–9, *569,* 694, *694–5, 696, 696*
 World War I casualties 1050
 see also Nazi Party
Gérôme, Jean-Léon: *The Snake Charmer* 982, *982*
Gersaint, Edmé-François 924(c), 925, 926
gesso 556
Gesù, Il (Vignola) *688,* 689, 727
Ghana 897, 911
 Nankani adobe houses 911–12, *912*
 see also Asante Empire
Gheeraerts, Marcus, the Younger: *Queen Elizabeth I* (The Ditchley Portrait) 720, *721*
Ghent 577, 589, 593
Ghent Altarpiece (Jan and Hubert(?) van Eyck) 588–9, *588–9*
Ghiberti, Lorenzo 616
 Gates of Paradise (Florence Baptistery doors) *620, 621, 621*
 Sacrifice of Isaac 610, *610*
Ghirlandaio (Domenico di Tommaso Bigordi) 632, 640, 658
 Life of St. Francis fresco cycle 632, *632, 633*
 Nativity and Adoration of the Shepherds 632–3, *633*
Giambologna 683–4
 The Capture of a Sabine Woman 684, *684*
Giant Daruma (Hakuin) 844, *845*
Gilbert, Cass 1063
Giorgione (Giorgio da Castelfranco) 668–9, *670, 671,* 673, 675
 The Pastoral Concert 670, *670,* 994
 The Tempest 669, *669–70*
Giotto di Bondone 544, 550, 559, 646
 Scrovegni Chapel frescos 551–4, *552–4*
 Virgin and Child Enthroned 550, *550–51*
Girl Reclining: Louise O'Murphy (Boucher) 926, *926*
Girodet-Trioson, Anne-Louise: *Portrait of Jean-Baptiste Belley* 954, *954*
Gita Govinda (Jayadeva) 794, *795*
Giuliani, Rudolph 1131, 1132
Giuliano da Maiano (?): Studiolo of Federico da Montefeltro 636–7, *637*
Giulio Romano 666, 680, 706
 Fall of the Giants 666, *667*
 Palazzo del Te, Mantua 666, *666*
Giustiniani, Vincenzo 735
Gleaners, The (Millet) 991, *991–2*
globalization 1138
Glorification of the Papacy of Urban VIII, The (Cortona) 739–40, *740*
Glorious Revolution (1689) 778

Go-Daigo, Emperor 831
Gobelins tapestry manufactory 926
Goes, Hugo van der 593, 597
 Portinari Altarpiece 593–5, *594–5,* 598, 632, 633
Goethe, Johann von 974
 The Sorrows of Young Werther 933
Goffen, Rona 673
Gogh, Vincent van 1011–12, 1040
 The Starry Night 1012–13, *1013*
Goldsmith in His Shop, A (Christus) 592, *592,* 593, 715
Goncharova, Natalia 1048
 Electric Light 1048, *1048*
Gonzaga, Federigo II, of Mantua 666, 667
Gonzaga, Francesco II, of Mantua 672
Gonzaga, Ludovico, marquis of Mantua 639
Gonzaga, Vincenzo, Duke of Mantua 749
Gonzaga family 608, 665
Gonzalcz Torres, Felix 1138
 "*Untitled*" (Loverboy) 1138, *1183*
Goodacre, Glenda 1133
gopuras 787, 789, *789*
Gorky, Arshile 1089, 1092
 Garden in Sochi 1089, 1089–90
Goryeo dynasty (Korea) 823, 824
Gossaert, Jan 711, 713–14
 St. Luke Drawing the Virgin Mary 713–14, *714*
Gothic Revival style 802, *802*
 architecture 937, *937–8, 938*
Goujon, Jean *see* lescot, Pierre
Goya y Lucientes, Francisco 956, 958, 959, 970
 Los Caprichos 956
 Family of Charles IV 957, *957–8*
 The Sleep of Reason Produces Monsters 956–7, *957*
 Third of May, 1808 958, *958*
Grand Tour 929, 930
graphic arts xviii, 711
grattage 1073
Grazing at Shendi (Nour) 894, *895*
Great City of Tenochtitlan, The (Rivera) 1084, *1084*
Great Depression 1033, 1080, 1082
Great Exhibition (1851) 1022, *1022*
Great Plains peoples 864
 hide painting 865, *865–6*
 tipis 864, *864–5*
Great Wave, The (Hokusai) 843, *844*
Greco, El (Domenikos Theotokopoulos) 709
 Burial of Count Orgaz 709–10, *710*
Greenberg, Clement 1089, 1090, 1097, 1100, 1145
Gregory XIII, Pope 735
Greuze, Jean-Baptiste 950
 The Village Bride 950, *951*
Gris, Juan 1039
grisaille paintings 552, 562
Gropius, Walter 1069, 1070, 1071, 1120
 Bauhaus Building, Dessau *1069,* 1069–70
Gros, Antoine Jean 963
 Napoleon in the Plague House at Jaffa 963, *963*
Gross Clinic, The (Eakins) 997, *997–8*
Group of Seven 1083
Grünewald, Matthias 695, 698
 Isenheim Altarpice 695–6, *696, 697*
Gu, Wenda 823, 1137
 China Monument: Temple of Heaven 1137, *1137–8*
Guercino 777
Guernica (Picasso) *1076–7, 1077–8*
Guerrilla Girls 1127
 The Advantages of Being a Woman 1127, *1128*
Guersi, Guido 696
Guggenheim, Peggy: gallery 1090

Guggenheim Museum, Bilbao, Spain (Gehry) 1135, *1136*
Guggenheim Museum, New York (Wright) *1121*, 1121–2, 1135, 1141
guilds 544, 584–5, 593, 599, 609, 616, 617
Guimard, Hector 1020
 desk 1020, *1021*
Gupta dynasty, India 784
Gutai, the 1102
Gutenberg, Johann 604
Gyokuran 849

H

Haarlem, Netherlands 754, 755, 756, 757, 766
Habsburgs 646, 682, 693, 711, 742
Hackwood, William: "Am I Not a Man and a Brother" 936, *937*
Hadid, Zaha: Vitra Fire Station, Germany 1135, *1135*
Hagenauer, Nikolaus: Isenheim Altarpiece 695, 696, *696*
Haida, the 866, 871
 dugout canoes 871
 The Spirit of Haida Gwaii 872, *872*
 totem poles 871
Haitian Revolution (1791) 954
Hakuin Ekaku 844
 Giant Daruma 844, *845*
Halder, Jacob: armor 722, *722*
Hals, Franz 755, 756, 757, 758, 764
 Officers of the Haarlem Militia Company of St. Adrian 756, *756*
 Malle Babbe 756, *757*
Hamatsa society 867, 868
Hamilton, Ann 1145, 1146
 Myein 1146–7, *1147*
Hamilton, Gavin 931, 932
Hamilton, Richard 1106
 Just What Is It That Makes Today's Homes So Different, So Appealing? 1106, 1106–7
Hamilton, William 936
Hammons, David 1145
 Untitled 1146, 1145–6
Han dynasty (China) 808
handscrolls/hanging scrolls
 Chinese 811, *811*; *806*, *807* (Qing), 809, *810*, 810–12, *812* (Yuan), *814*, 814–15, *815*, 816, *817*, 818, *820* (Ming)
 Japanese *831*, 831–2, *832*
 Korean 824–6, *825*
Han'geul 823
Hanseatic League 599
Happenings 1101, 1102–3
Hardouin-Mansart, Jules: Versailles 771, *773*
Hardwick Hall, England (Smythson) 721–2, *722*
Harihara 787
Harlem Renaissance 1078–80
Harschner, Erhart 694
Hart, Frederick 1133
Hartley, Marsden 1057
 Portrait of a German Officer 1056, 1057
Harunobu, Suzuki 842
 The Flowers of Beauty in the Floating World... 828, 829
 Young Woman Looking at a Pot of Pinks 1010
Harvesters, The (Bruegel the Elder) 718, *718*
Haussmann, Georges-Eugène: reconstruction of Paris 981, 982, 1009, 1026
Hawaii 877
 feather cloak 888, *888*
 tattoos 887
Hawke, Bob 875
Hay Wain, The (Constable) 971, *971*

hazomanga, Madagascar *909*, 909–10
Heath of the Brandenburg March (Kiefer) 1124, *1124*
Heckel, Erich 1040
 Standing Child 1041, *1041*
Hedwig Codex 569–70, *570*
Heian period, Japan 830, 831
Heisenberg, Werner 1033
Hemessen, Caterina van 716
 Self-Portrait 716, *716*
Hemessen, Jan Sanders van 716
Hendrick III, Count of Nassau 711, 713
Henry II, of France 705, *706*
Henry III, of England 567
Henry III, of France 703, 705
Henry IV, of France 704, 769
 Henry IV Receiving the Portrait of Marie de' Medici (Rubens) *751*, 751–2
Henry VIII, of England 656, 693, 720
Henry the Navigator, Prince 708
Hepworth, Barbara 1075
 Forms in Echelon 1075, *1075*
Hercules and Antaeus (Pollaiuolo) 629, 630, *630*
Herrera, Juan de *see* Juan Bautista de Toledo
Hérrines Charthouse, Belgium xxxv
Herschel, Sir John Frederick 985, 987
Hesse, Eva 1113
 No Title 1113–14, *1114*
Hey, Jean, the Master of Moulins 597
 Portrait of Margaret of Austria 597, 597–8
Hibiscus (Peláez) 1086, *1086*
Hideyoshi, Toyotomi 834, 838
High Tech architecture 1134, *1134*
Hilliard, Nicholas 720
 George Clifford 720, *721*
Himeji Castle, Hyogo, Japan 834, *834*
Hinduism/Hindus 784, 787
 architecture 787–9, *788*, *789*
Hiroshige, Utagawa 843
Hirst, Damien 1140–41
 For the Love of God 1141
 Mother and Child (Divided) 1141, *1141*
historicism 981, 982
History of the Main Complaint (Kentridge) 1146, *1146*
history paintings 942, *943*, 943–5, *944*
Hitler, Adolf 1032, 1071, 1086
Hoare, Henry 935
 The Park at Stourhead (with Flitcroft) 935, *935*
Höch, Hannah 1053
 Cut with the Kitchen Knife Dada... 1053–4, *1054*
Hofmann, Hans 1091
Hogarth, William 939, 956
 The Marriage Contract (Marriage à la Mode) 939, 939–40
Hoi An hoard *797*, 797
Hokusai, Katsushika 842–3
 The Great Wave 843, *844*
 Manga 1010
Holbein, Hans, the Younger 720
 The French Ambassadors 719, 720
Holstein, Jonathan xxii
Holy Family, The (Michaelangelo) xxv
Holy Roman Empire 568, 599, 646, 665, 726, 742, 749
Holy Virgin Mary, The (Ofili) *1131*, 1131–2
Homage to Blériot (R. Delaunay) *1045*, 1045–6
Homeless Vehicle (Wodiczko) 1149, *1149*
Homer, Winslow 998
 The Life Line 998, *998*
homosexuals 1098, 1131
Hong Kong & Shanghai Bank (Foster) 1134, *1134*
Honorius III, Pope 632, *633*

Horde, The (Ernst) 1073, *1073*
Horn Players (Basquiat) *1125*, 1125
Horse-Fair, The (Bonheur) 992–3, *993*
Horta, Victor 1018, 1020
 Tassel House, Brussels 1018, *1019*
Hosmer, Harriet 998
Hosokawa Sansai 836
Hosokawa Yusai 836
Houdon, Jean-Antoine 955, 969(c)
 George Washington 955–6, *956*
Hour of Cowdust (Kangra School) 794–5, *795*
House (Whiteread) 1149, 1149–50
How to Explain Pictures to a Dead Hare (Beuys) *1105*, 1105–6
Huelsenbeck, Richard 1053
Hughes, Holly 1131
Hughes, Langston 1079
Huguenots 703
Huineng (monk) 818
Huitzilopochtli (god) 852, 854, 855
Hujar, Peter 1139
humanism/humanists, Italian 609, 613, 632, 646, 676, 682, 691, 709
Humay and Humayun (Junayd) xxv
Humayun, Mughal emperor 792
Hundred Years' War 544, 566, 577
Hundreds of Birds Admiring the Peacocks (Yin Hong) 814, *814*
Hunt, Richard Morris 1023
 Administration Building, World's Columbian Exposition *1024*
Hurling Colors (Shimamoto) 1102, *1102*
Huron, the 861
Hus, Jan/Hussites 573
Husain, Maqbool Fida 804–5
 Vedic 804, *805*
Huysmans, Joris-Karl: À Rebours 1015

I

iconoclasm, 16th-century 711
iconography xvii, xxviii, xxix
iconology xxviii
idealism 668, 688
idealization xviii
Ignatius of Loyola, St. 684, 709, 725
ignudi 662, 734
Ikere, Nigeria 901, 902
Illinois, the 861
illusionism xviii, 636, 637, 639, 668, 734, 739
Immaculate Conception, The (Murillo) 747, *747*
impasto 761, 1011
Impression: Sunrise (Monet) 1003–4, *1004*
Impressionist Exhibition (1874) 1003, 1007
Impressionists/Impressionism 995, 1003–5, *1004–6*, 1007, 1011, 1015
Improvisation 28 (Kandinsky) *1044*, 1045
Inca Empire 856–7, 860
 architecture 857–8, *858*, *859*
 silver figurines 860, *860*
 textiles 859
 tunic *859*, 859–60, 863
Independent Group 1106
India 784, 802
 architecture *786*, 786 (Jain), 784, 786–7, *787* (Islamic), 787–9, *788*, *789* (Hindu), *782*, *783*, 787, 790–91, *791*, 793–4, *794* (Mughal), *796*, 796–7 (Rajput), *802*, 802–3, *803* (British)
 British Raj 802, 803, 804
 Buddhism 784, 785–6
 Gupta dynasty 784
 Hinduism 784
 Jainism 784, 786

Kushans 784
Maurya dynasty 784
painting 780, 791–3, *791–3* (Mughal), 794–5, *795*
(Rajput), 803, *803* (20th century)
see also Mughal dynasty
Indo-Saracenic architecture 803
Indonesia 801, 879
Islamic architecture *801*, 801–2
Industrial Revolution 922, 980
Infant in Swaddling Clothes (A. della Robbia) 613, *613*
Ingres, Jean-Auguste-Dominique 968
Large Odalisque 968, *968*, 1127
Portrait of Madame Désiré Raoul-Rochette 968–9, *969*
ink painting
Chinese *806*, 807
Korean 824–6, *825*, *826*
Zen (Japanese) *831*, 831–2, *832*
Innocent X, Pope: portrait (Velázquez) 1086
Inquisition, the 674, 684, 956, 957(c)
installation art 1066, *1137*, 1137–8, *1146–7, 1147*,
1150, *1150*
Institute of American Indian Arts,
Santa Fe 871
intaglio techniques 602, *602*, 760
intarsia 636
International Expositions, Paris 991 (1855), 1010
(1867), 1046 (1925)
International Gothic style 577, 578, 599
International Style (architecture) 1071, 1120, 1122
intonaco 651(c)
Intrigue, The (Ensor) 1016, *1017*
iron, use of 938, *938*
Iroquois, the 861
Isabella, Queen of Spain 665, 707
Isabella Clara Eugenia, Princess 750
Ise, palace of, Nigeria 901, 902, *902*
Isenheim Altarpiece (Grünewald and Hagenauer)
695–6, 696, 697
isometric drawings xix
Islam 784, 786–7, 798
architecture *782, 783, 787, 787,* 793–4, *794* (India),
801, 801–2 (Indonesia)
Italy 545, 607–9, 903
architecture 546, *546,* 610–15, *611, 612, 614, 615,
636, 636–7, 637, 641, 641* (15th century), 663–4,
664, 665, *665, 666, 666,* 675–7, *675–7, 686, 686–9,
688* (16th century), 727, *728,* 731, *731–2, 732*
(17th century)
bronzework 546, *547, 548, 548,* 609–10, *610,*
618–19, *618–21,* 621, *629,* 629–30, *630* (15th
century)
frescos 622, *622, 623,* 624–6, *624–7,* 627–8, 632, *632,
633, 639, 639,* 648 (15th century), 652–3, *654,
655, 660, 660, 661, 662, 666, 666–8, 667,* 684–6,
685 (16th century), 733, *733–4,* 739–41, *740, 741*
(17th century)
Futurism 1047–9
Grand Tour 929, 930
map *608*
paintings 606, 607, *627, 627,* 628, *628,* 632–3,
633–5, 635–6, 637, 637–9, 638, 641–3, *642, 643*
(15th century), *644,* 645, *648, 648,* 650, *651–3,
652–3,* 668–75, *669–74* (16th century), 732–3,
734, 734–8, 736–9 (17th century), 1047, *1047*
(Futurist), *see also* frescos
sculpture 615–19, *617–19, 629,* 629–30 (15th
century), 658, *658–9, 659, 663, 663, 668, 668*
(16th century), 724, *725, 728–9, 729, 730, 730–31*
(17th century), 932–3, *933* (Neoclassical), 1048,
1048 (Futurist)
ivory chests, French 564–6, *565*
Ivory Coast: Baule *blolo bla* 907, 907–8
iwans 794

J

Jack-in-the-Pulpit, No. IV (O'Keeffe) 1057, *1057*
Jacobs, Jane 1122
Jahangir, Mughal emperor 790, 791–2
Jahangir and Prince Khurram Feasted by Nur Jahan
(Mughal painting) 793, *793*
Jahangir and Shah Abbas (Nadir al-Zaman) 792, *792*
Jainism 784, 786
James I, of England (James VI, of Scotland) 753,
778, 780
James II, of England 778
Jane Avril (Toulouse-Lautrec) 1021, *1021*
Japan 808, 822, 824, 826, 829–30, 847
architecture 834, *834* (castles), 834–5, *835,* 848,
1061 (*shoin* design), 847–8, *848* (postwar)
Buddhism 830, 831
ceramics 830, 837–8, *838,* 845, *847*
kabuki theater 842
kosode 844–5, *846*
lacquerwork 839, 839–40
literature 830
map *830*
Meiji Restoration 845, 846
painting 803, 846 (Nihonga) 835–6, *836–7* (Kano),
838–9, *839* (Rinpa), 841–2, *842* (literati), 844, *845*
(Zen)
samurai 830, 831
Shinto 830
tea ceremony 835, 836–8, 841, 845
woodblock prints *828, 829,* 842–3, *843,* 1008, 1010,
1010, 1013
Japonisme 1010
jasperware 935–6, *937*
Java, Indonesia: Kudus Mosque *801,* 801–2
Jayadeva: *Gita Govinda* 794, *795*
Jayavarman VII, Khmer king 798
Jean, Duke of Berry 577
Jean II, Duke of Bourbon 597
Jeanne d'Évreux, Queen 564
Book of Hours (Pucelle) 562, *563*
Jefferson, Thomas 955, 976
Monticello, Charlottesville, Virginia
877, *877*
Jenney, William Le Baron 1024
Jeong Seon 825
Panoramic View of the Diamond Mountains 825,
825–6
Jerusalem 708
Jesuit Order/Society of Jesus 684, 689,
725, 726
Jingdezhen kilns, China 812
Jirō, Yoshihara 1102
Joan of Arc 596
John of the Cross, St. 709
Johns, Jasper 1097, 1100
Target with Plaster Casts 1096, 1097, 1100
Johnson, John G. xxxii
Johnson, Philip
AT&T Building (with Burgee) 1123, *1123*
Seagram Building (with Mies van der Rohe) 1120,
1120
Jolly, Penny Howell xxxiv, xxxv
Jomon period, Japan 830
Jones, Clive 1140
Jones, Inigo 779, 781
Banqueting House, London *778,* 779, *779*
Joseon Dynasty (Korea) 807, 823, 826
ceramics 823–4, *824*
painting 824–6, *825–7*
Joseph and Potiphar's Wife (Properzia de' Rossi) 668,
668
Joy of Life, The (Matisse) 1035, *1035,* 1037

Juan Bautista de Toledo and Juan de Herrera: The
Escorial, Spain 707–8, *708*
Judd, Donald 1109
Untitled 1109, 1109–10
Judith Beheading Holofernes (Gentileschi)
738, *739*
Julius II, Pope 646, 652, 653, 656, 660, 662, 665, 687
Jumbo, Julia 851
Two Grey Hills tapestry weaving *850,* 851
Jung, Carl 1089, 1090, 1091, 1093
Junayd xxv
Humay and Humayun xxv
Juran (painter) 807
*Just What Is It That Makes Today's Homes So Different,
So Appealing?* (R. Hamilton) 1106, 1106–7
Justin of Nassau 745

K

kabuki theater 842
Kahlo, Frida 1084
The Two Fridas 1084, *1085*
Kahnweiler, Daniel-Henry 1039
portrait (Picasso) 1039, *1039*
Kamakura period, Japan 830, 831
Kamehameha III, King of Hawaii 888
Kammermaister, Sebastian 604
Kandinsky, Vassily 1045, 1055, 1071
Concerning the Spiritual in Art 1045
Improvisation 28 1044, 1045
Kangra School painting, India 794–5, *795*
Kanishka, Kushan king 784
Kano School of painting, Japan 835–6, *836–7*
Kapoor, Anish: Cloud Gate 1145
Kaprow, Allan 1102, 1108
Yard 1102, *1103*
"*Karawane*" (Ball) 1051, *1051*
katsinas 870
Kauffmann, Angela 931, 942(c), 943, 944
Cornelia Pointing to Her Children as Her Treasures
943, 943–4
Kaufmann House *see* Fallingwater
Kearny, Commodore Lawrence 888
Keïta, Seydou 913–14
Untitled (Family Portrait) 914, *914*
Kelly, Mary: Post-partum Document 1119, *1119*
Kent, William 935
Chiswick House and garden, London 935
kente cloth 897, 897–8, 914
Kentridge, William 1146
History of the Main Complaint 1146, *1146*
Kenzo, Tange: Hiroshima Peace Memorial Museum
847–8, *848*
Kepler, Johannes 769
Khmer, the 798
Khmer Rouge, Cambodia 805
Kiefer, Anselm 1124
Heath of the Brandenburg March 1124, *1124*
Kihara, Shigeyuki 892, 893
Ulugali'i Samoa: Samoan Couple 892–3, *893*
Kim Hongdo 826
Roof Tiling 826, *826*
Kim, Whanki 826
Universe 5-IV-71 #200 826–7, *827*
Kino, Eusebio 959, 961
Kirchner, Ernst Ludwig 1040
Street, Berlin 1042, *1042,* 1072
Kiss of Judas (Giotto) 554, *554*
Klah, Hosteen 871
Whirling Log Ceremony sand painting
871, *871*
Klee, Paul 1071
Klein, Yves 1101, 1109

Anthropométries of the Blue Period 1101, 1101–2
Knight Watch (Riopelle) 1092–3, *1093*
Knights of Christ 708
Knights of Malta 738
Knowles, Martha, and Thomas, Henrietta:
 My Sweet Sister Emma xx, *xxi*, xxi–xxii, xxiii
Koburger, Anton: *Nuremberg Chronicle*
 603, 603–4
Kofun period, Japan 830
Kollwitz, Käthe 1042
 The Outbreak 1042, *1042*
Konarak, India: Sun Temple 787
Kongo peoples 899, 906
 nkisi knondo 906, 906–7
Koons, Jeff 1125–6
 Pink Panther 1126, *1126*
Korea 808, 823, 826
 ceramics 823–4, *824*
 inventions 823
 Joseon dynasty 807, 823–6
 map *809*
 painting 824–6, *825–7*
Korean War (1950–53) 826, 1097
Korin, Ogata: lacquer box *839*, 839–40
Kosegarten, Gotthard 974
Koshares of Taos (Velarde) 869, 870, *870*
kosode 844–5. *846*
Kosuth, Joseph
 One and Three Chairs 1110–11, *1111*
Kpelle people 910
Krasner, Lee 1090, 1091
 The Seasons 1091,*1091*
Krishna and the Gopis (Rajput) 794, *795*
Krishnadevaraya, king of Vijayanagara
 787–8
Krug, Hans, Hans the Younger, and Ludwig: Apple
 Cup 693, *693*
Kruger, Barbara 1127, 1129
 Untitled (*Your Gaze Hits the Side of My Face*) 1127,
 1127
Kuala Lumpur, Malaysia: Petronas Towers (Pelli
 and Cerico) *804*, 805
Kuba kingdom 899–900
 ndop portrait of King Mishe miShyaang maMbul
 900, 900–1
 sleeping house 900, *900*
Kublai Khan, Mongol ruler 808, 810
Kudus Mosque, Indonesia *801*, 801–2
Kuhn, Walt 1055
Kumasi, Ghana 897, 898, 911, 914
Kushans 784
Kwakwaka'wakw, the 866
 masks 863, 867, 868, *868*
 Winter Ceremony 867–8
Kyanzittha, king of Bagan 784
Kyoto, Japan 830, 831, 833, 840, 841
 Rock Garden, Ryoanji 832–3, *833*

L

Labille-Guiard, Adélaïde 954
 Self-Portrait with Two Pupils 954, *955*
Labrouste, Jenri 1023
 Reading Room, Bibliothèque Nationale, Paris
 1023, *1023*
lacquerwork, Japanese *839*, 839–40
Ladybug (Mitchell) 1092, *1092*
La Fayette, Madame de 923
Lafayette, Marquis de 955
Lam, Wifredo 1087
 Zambezia, Zambezia 1087–8, *1088*
Lamentation (Giotto) 553, *553*
Lances, The see Surrender at Breda, The

Landscape (Bunsei) *831*, 831–2
landscape painting 669
 Chinese *806*, 807, 808, 811–12, *812*, 814, *814*, 816,
 817, *817*, 819, *820*
 Dutch 765–6, *766*
 English Romantic 971, *971*, *972*, 973
 French 776, 776–8, *777* (17th century), 1005, *1005*,
 1007 (Impressionist)
 German 701–2, *703*
 Japanese *831*, 831–2, *832*
 Northern European 577
Landscape with St. John on Patmos (Poussin) 776, *777*
Landscape with St. Matthew and the Angel (Poussin)
 776, *776*
Lange, Dorothea 1080, 1082
 Migrant Mother, Nipomo, California 1082, *1082*
Laocoön and His Sons 706, *727*
Laozi 808
Lapita culture 876–7, 887
 jar 877, *877*
Large Bathers, The (Cézanne 1028–9, *1029*, 1035, 1037
Large Blue Horses, The (Marc) 1044, *1045*
Large Odalisque (Ingres) 968, *968*, 1127
Last Judgment (Giotto) 552
Last Judgment (Michelangelo) 684–6, *685*
Last Supper, The (Castagno) 627, 627–8
Last Supper, The (Leonardo) 650, *651*,
 675, 694
Last Supper, The (Riemenschneider) *694*,
 694–5
Last Supper, The (Tintoretto) 674, 674–5
Lastman, Pieter 757
La Tour, Georges de 774
 The Education of the Virgin xxiv
 Mary Magdalen with the Smoking Flame
 774, *775*
Latrobe, Benjamin Henry: U.S. Capitol
 976, *976*
Laurana, Luciano: Palace, Urbino
 636, *636*
Lawrence, Jacob 1079–90
 The Migration Series 1080, *1081*
Le Brun, Charles: Versailles 771, *773*, 774
Lee, Sir Henry 720
Leeuwenhoek, Anton van 769
Léger, Fernand 1039, 1089
 Three Women 1046, *1047*
Le Nain, Antoine, Louis, and Mathieu 775
 A Peasant Family in an Interior 775, *775*
Lenin, Vladimir 1032, 1054, 1064
Le Nôtre, André: Versailles gardens 771,
 772, *772*
Leo X, Pope 652, 656, 663, 703
Leonardo da Vinci 629, 645, 648, 650, 652, 665, 668,
 669, 672, 704, 738, 771
 The Last Supper 650, *651*, 675, 694
 Mona Lisa 644, 645, 647, 650, 652, *1052*, 1053
 The Virgin of the Rocks 648, *648*, 650, 652
 Vitruvian Man 649, *649*, 650, 871
Leopold II, King of the Belgians 915, 917
Leroy, Louis 1003
Lescot, Pierre, and Goujon, Jean: Cour Carrée,
 Louvre 706–7, *707*
Lesyngham, Robert: Exeter Cathedral window *567*,
 568
Le Vau, Louis 771
 Versailles and gardens 771, 772, *772*, 773
Levine, Sherrie 1126
 After Walker Evans: 4 1126, *1126*
Lewis, Edmonia 998
 Forever Free 998–9, *999*
LeWitt, Sol 1109
Leyster, Judith 756–7

Self-Portrait 757, *757*
L.H.O.O.Q. (Duchamp) *1052*, 1053
Li Bo 838
Liberty Leading the People: July 28, 1830 (Delacroix)
 966, 966–7
Lichtenstein, Roy 1108, 1109
 Oh, Jeff... I Love You, Too... But... 1108, *1108*
Life Line, The (Homer) 998, *998*
Life of St. Francis fresco cycle (Ghirlandaio) 632, *632*,
 633
light xv, xvi, xxiv, *see also* chiaroscuro
Limbourg Brothers (Paul, Herman, and Jean) 580
 Très Riches Heures 580–82, *581*, 718
Lin, Maya: Vietnam Veterans Memorial
 1133, 1133–4
Lindisfarne Gospels xxiv
line xv, xxiv
Lippard, Lucy 1110, 1113
Lippi, Fra Filippo 628
 Portrait of a Woman and Man 628, *628*
Lissitzky, El 1066
 Proun Space 1066, *1066*
literati
 Chinese 807, 808, 809–10, 812, 812(c), 814, 816,
 818, 841
literature
 English 544, 937
 14th century 544
 Japanese 830
 Realist 989
 Symbolist 1015
lithography 969, 970, *970*, 1021, *1021*
Littemont, Jacob de 597
Locke, Alain 1079
Locke, John 922
London
 Banqueting House (Jones) 778, 779, *779*
 Chiswick House (Burlington) *934*,
 934–5, 949
 Crystal Palace (Paxton) 1022, *1022*
 Great Fire (1666) 781
 Houses of Parliament 972, 973, 974–5, *975*
 Royal Academy 940, 942, *942*, 943, 944
 St. Paul's Cathedral (Wren) *780*,
 781, 949
 Strawberry Hill (Walpole) 937, 937–8, *938*
Lookout Studio, Grand Canyon (Colter)
 1062, *1062*
Loos, Adolf 1059
 Steiner House, Vienna *1058*, 1059
Lorenzetti, Ambrogio 543, 559
 *The Effects of Good Government in the City and in the
 Country* 542, 543, 560–61,
 561–2
l'Orme, Philibert de 706
Louis IX, of France 562, 567
Louis XI, of France 596–7
Louis XIII, of France 751, 769, 771, 774, 776
Louis XIV, of France 645, 769–70, 771, 774, 925, 943
 portrait (Rigaud) 770, 770–71, *774*
Louis XV, of France 772, 922, 926, 930
Louis XVI, of France 951, 952, 966
Louis XVIII, of France 966
Louis of Anjou 577
Louis-Philippe, King of France 948(c), 966
Louise of Lorraine 705
Louvre, Paris 645, 706–7, *707*, 781, 1036–7
Lucca, Italy 607
Luke, St. 544
 Gospel 578, 594
 St. Luke (Master Theodoric) *572*, 573
Lumumba, Patrice 915–16
Luna, James: *The Artifact Piece* 1128–9, *1129*

Luna Vasahi, Mount Abu, India 786, *786*
Lunar Society 941, 942
Luncheon on the Grass (*Le Déjeuner sur l'herbe*)
(Manet) 993–4, *994*, 1038
Luther, Martin 692, 693, 698, 700, 701, 703, 719(c),
720
Lutheranism 700(c), 742

M

Ma Jolie (Picasso) *1030*, 1031, 1039
Maar, Dora 1075
Mabel of Bury St. Edmunds 566
Mabuse *see* Gossaert, Jan
Machu Picchu, Peru 858, *858*, *859*
Maciunas, George 1104
McKim, Mead, and White: Agriculture Building
1024
Madagascar: *hazomanga* pole *909*, 909–10
Mme. Charpentier and Her Children (Renoir) xxvi,
xxvii, xxvii–xxviii
Maderno, Carlo 731
Cornaro Chapel, Santa Maria della Vittoria, Rome
730
St. Peter's, Rome 687, *687*, 727, *728*
Madhu Kalan 791(c)
Madhu Khurd 791(c)
Madí (group) 1088
Madonna of the Goldfinch (*Madonna del Cardellino*)
(Raphael) xxvi, *xxvi*,
xxvii–xxviii, 652, *653*
Madonna of the Long Neck (Parmigianino)
680, *680*
Madras, India 802
Madrid, Spain 747, *see also* Escorial, El
Madurai, India: Minakshi-Sundareshvara Temple
789, *789*
Maestà altarpiece (Duccio) 554, *555–7*,
557–8, 561
Magenta, Black, Green on Orange (Rothko) xxi, xxi,
xxiii, *1094*, 1094
Mahana no Atua (*Day of the God*) (Gauguin) 1014,
1014
Mahavira 784, 786
Maids of Honor, The see Meninas, Las
Mainardi, Patricia xxii
malagan ceremonies, New Ireland 881–2, *882*
Malaysia: Islam 801
Petronas Towers, Kuala Lumpur (Pelli and
Cerico) 804, 806
Malevich, Kazimir 1048, 1065, 1135
The Black Square 1048–9
Suprematist Painting (*Eight Red Rectangles*) 1049,
1049
Mali 897
Malle Babbe (Hals) 756, *757*
Man in a Red Turban (van Eyck) 587, 587–8
Man Shot Down... (Richter) *1142*, 1142
mana 884–5
Manchu, the 808, 820
Mandan: hide painting *865*, 865–6
Mander, Carel van: *The Painter's Book* 711, 715
Mandolin and Clarinet 1040, *1040*
Manet, Édouard 747, 993, 1027
A Bar at the Folies-Bergère 995, *996*
Luncheon on the Grass (*Le Déjeuner sur l'herbe*)
993–4, *994*, 1038
Olympia 994–5, *995*
Manet, Eugène 1007
Manga (Hokusai) 1010
maniera greca 548
Mannerism/Mannerists 666, 675, 678, 727
painting *678*, 678–83, *679–83*, 706, 713, 716

sculpture *683*, 683–4, *684*
Man's Love Story (Tjapaltjarri) 891, *892*
Mansart, François 771
Mantegna, Andrea 639, 641, 642, 672, 734
Camera Picta, Ducal Palace, Mantua 639, *639*, 667,
668
Mantua, Italy 608, 636, 639, 665
Camera Picta, Ducal Palace (Mantegna) 639, *639*,
667, 668
Palazzo del Te (Giulio Romano) 666, *666–7*
Manuel I, of Portugal 708, 709
manuscripts
Aztec 853–4, *854*, 856, 857
German 569–70, *570*
Hours of Jeanne d'Évreux (Pucelle)
562, *563*
Hours of Mary of Burgundy 582, *582*
Netherlandish 580, *580–82*, *581*
Many Mansions (Marshall) 1143, *1144*
Maori, the 875, 885
meeting houses *885*, 885–6
tattoos 887
Mapplethorpe, Robert 1130–31
maps
Africa 896, *903*
The Americas after 1300 *852*
China *809*
Europe *545*, *675*, *692*, *726*, *923*, *980*, *1032*
Japan *830*
Korea *809*
North America *861*, *923*
South and Southeast Asia *785*
United States *980*, *1032*
World since 1950 *1098*
Marat, Jean-Paul *953*, 953–4
Marc, Franz 1045
The Large Blue Horses *1044*, 1045
Margaret of Austria 598
portrait (Hey) *597*, 597–8
Marie Antoinette 950
Marie Antoinette with Her Children
(Vigée-Lebrun) 950–51, *951*
Marie de' Medici, Queen of France 751, 767, 769, 925
Marilyn Diptych (Warhol) *1107*, 1107–8, 1126
Marin, John 1054
Marinetti, Filippo Tommaso: Futurist Manifesto
1047
Marquesas Islands 885, 887, 890
tattoos 887, *887*
Marriage at Cana (Giotto) 552, *553*
Marriage Contract, The (*Marriage à la Mode*) (Hogarth)
939, 939–40
Marseillaise, The (Rude) *967*, 967
Marshall, Kerry James 1143
Many Mansions 1143, *1144*
Marshall Islands 883
Martinez, Maria Montoya, and Martinez, Julian 869
Black-on-black storage jar 869, *869*
Martini, Simone 558, 561
Annunciation (with Memmi) 558, *558*, 560–61, 589
St. Martin Chapel, Assisi, frescos 558
Martyrdom of St. Bartholomew (Ribera) 743, *743*
Marx, Karl 1054
Communist Manifesto (with Engels) 980
Mary, depictions of 578, 579
Mary Magdalen with the Smoking Flame
(La Tour) 774, *775*
Mary of Burgundy Painter: *Book of Hours*
582, *582*
Mary of Hungary 716
Masaccio 622, 628, 636, 637, 648
The Expulsion of Adam and Eve from Paradise 624,
624, 625

The Tribute Money 624–6, *625*
*Trinity with the Virgin, St. John the Evangelist, and
Donors* 622, *622*, 624, 642
masks
Bwa 912–13, *913*
Kwakwaka'wkaw 863, 867, 868, *868*
sowei masks 910, *910*
Tubuan 882, 882–3
Masks (Nolde) 1041, *1041*
masonry, Inca 857, 858, *858*
Massys, Quentin 715
Money Changer and His Wife 715, 715–16
Matisse, Henri 1038, 1054, 1055
The Joy of Life (*Le Bonheur de Vivre*) 1035, *1035*,
1037
Woman with the Hat 1034, 1035
Matulu, Tshibumba Kanda 915, 916
Tombeau sans Cercueil (*Tomb without a Coffin* 915,
915–16
Maui (god) 885
Maurya dynasty (India) 784
Mazarin, Cardinal Jules 770
Meat Joy (Schneemann) 1103, *1103*
Medici, Cosimo the Elder 609, 614, 615(c), 626
Medici, Duke Cosimo I de' 681, 682, 683
Medici, Grand Duke Cosimo II de' 738
Medici, Francesco I de', GRand Duke 681, 684
Medici, Cardinal Giovanni de' 680, 681
Medici, Lorenzo de' ("the Magnificent") 607, 609,
629, 632, 633, 658, 663
Medici, Lorenzo di Pierfrancesco de' 635
Medici family 608, 609, 613, 635
medium/media xxiii
meeting houses, Maori *885*, 885–6
Meeting of Antony and Cleopatra, The (Mengs) 935
Mehretu, Julie 1143–4
Stadia II 1144, *1144*
Meiji Restoration (Japan) 845, 846
Meiss, Millard 559
Melanesia 876, *877*, 878–9, 883
memento mori 925
Memling, Hans 595
Diptych of Maarten van Nieuwenhove 595, 595–6,
598
Memmi, Lippo *see* Martini, Simone
Mende, the: *sowei* mask 910, *910*, 911
Mendieta, Ana 1118–19
Untitled (from *Tree of Life* series) *1118*, 1119
Mengs, Anton Raphael 932, 944, 956
The Meeting of Antony and Cleopatra 935
Parnassus 932, *932*
Meninas, Las (*The Maids of Honor*) (Veláquez) 746,
747, 957
Merian, Maria Sibylla 769
The Metamorphosis of the Insects of Surinam 769, *769*
Merzbilder (Schwitters) 1053, *1053*
Metamorphosis of the Insects of Surinam, The (Merian)
769, *769*
Mewar Kingdom 796
Mexica people 852–3
painting 959, *960*, 1084, *1084*, *1085*
Mexico 742, *see* Mexica people; Mexico City
Mexico City 854
Academy 942
Atrial cross 959, *959*
sculpture 959, *959*
Michelangelo Buonarroti 614, 626, 648, 653(c), 658,
664, 665, 680, 688, 698, 771
David 659, *659*, 730
The Holy Family xxv
Laurentian Library 663–4, *664*
Medici tombs 663, *663*
Pietà 658, 658–9

St. Peter's, Rome 686, *686*, 687, *687*, 707
Sistine Chapel frescos 656, 660, *660–62*, 662, 684–6, *685*, 734
Michelozzo di Bartolomeo 612, 614
Micronesia 876, 877, 883–4
Midjaw, Jimmy Midjaw: *Three Dancers and Two Musicians...* 878, *878*
Mies van der Rohe, Ludwig 1071, 1120, 1122
Seagram Building, New York 1120, *1120*
Mifflin, Thomas: portrait (Copley) 920, 921–2
Migrant Mother, Nipomo, California (Lange) 1082, *1082*
Migration Series, The (Lawrence) 1080, *1081*
Milan, Italy 607, 608, 615, 618, 648, 659, 707
Santa Maria delle Grazie: *The Last Supper* (Leonardo) 650, *651*
Miller, Tim 1131
Millet, Jean-François 991
The Gleaners 991, *991–2*
Minakshi-Sundareshvara Temple, Madurai, India 789, *789*
Minamoto Yoritomo 830
Ming dynasty (China) 812, 816, 821, 823
ceramics 797, 812–13, *813*
furniture 818, *818*
gardens 818, *819*
painting 807, 816, 817, *817*, 825
Minimalism 895, 1099, 1109–10, 1113, 1117
in sculpture *1109*, 1109–10, *1110*, 1126
Miraculous Draft of Fishes (Witz) 600, *600*
Miró, Joan 1075, 1078
Composition 1074, *1075*
Mission San Xavier del Bac, Arizona 959, 961, *961*
Mitchell, Joan 1092
Ladybug 1092, *1092*
Moai ancestor figures, Rapa Nui 888–9, *889*
modeling xviii, xxiii
Modernism 1033, 1124, 1125
Modersohn-Becker, Paula 1042–3
Reclining Mother and Child 1043, *1043*
Moholy-Nagy, László 1069, *1070*
Momoyama period, Japan 833–8
Mon, the 799
Mona Lisa (Leonardo) 644, 645, 647, 650, 652, *1052*, 1053
Mondrian, Piet 1067, 1068, 1089
Composition with Yellow, Red, and Blue 1067, *1067–8*
Monet, Claude 995, 1003, 1004
Impression: Sunrise 1003–4, *1004*
Rouen Cathedral, West Façade, Sunlight 1004, 1004–5
Money Changer and His Wife (Massys) 715, 715–16
Mongols 808–9, 810, 812, 816
Monroe, Marilyn *1107*, 1107–8
Mont Sainte-Victoire (Cézanne) *1027*, 1027–8
Monte, Cardinal Francesco Maria del 735
Montefeltro, Federico da 608, 636, 637, 652(c)
portrait (Piero della Francesco) *638*, 638–9
Montefeltro, Guidobaldo da 652(c)
Montefeltro family 608, 665
Monticello, Virginia (Jefferson) 977, *977*
Moore, Henry 1075
Recumbent Figure 1076, *1077*
Moorman, Charlotte 1105, 1113
More, Thomas 720
Moreau, Gustave 1015
The Apparition 1015, *1015*
Morelli-Nerli wedding chests (del Sellaio, Biagio, and Zanobi) 630–31, *631*
Morisot, Berthe 1003, 1007

Summer's Day *1006*, 1007
Morisot, Edma 1007
Morley, Elizabeth: toddy ladle *936*
Morris, Jane (*née* Burden) 1000–1
Morris, Robert 1109, 1113
Untitled (*Mirrored Cubes*) 1110, *1110*
Morris, William 1000, 1001, 1018
see also Webb, Philip
Morse, Samuel Finley 986, *987*
mosaics, Venetian 641, 642
Moser, Mary 942(c), 943
Moses 580, 643
Mother and Child (Cassatt) 1008, *1009*
Mother and God (Divided) (Hirst) 1141, *1141*
Mother and God (A. Tagore) 803, *803*
Mott, Lucretia 980
Moulin de la Galette (Renoir) 1005, *1006*, 1007
Moulins, the Master of *see* Hey, Jean
Mountains and Sea (Frankenthaler) 1093, *1093*
Mountains at Collioure (Derain) 1034, 1034–5
Mpane, Aimé 916
Congo: Shadow of a Shadow 916, 916–17
Mughal dynasty 783, 790, 796, 802
architecture *782*, 783, 790–91, *791*, 793–4, *794*
painting 790, 791–3, *791–32*
Mugua (Zhu Da) 821, *822*
Muholi, Zanele 918–19
Thobe and Phila I 919, *919*
Mukhina, Vera 1066
Worker and Collective Farm Woman 1066, *1067*
Mullins, Aimee 1141
Mulvey, Laura 1127
Mumbai, India
Gateway of India 803, *803*
Victoria Terminus 802, *802*
Mumtaz Mahal 793
Munch, Edvard 1016, 1040
The Scream 1016, *1016*
Munich
"Degenerate Art" exhibition (Munich, 1937) 1071–2, *1072*
park (von Sckell) 1026
Muqi xxx
Murasaki, Lady: *The Tale of Genji* 830
Murillo, Bartolomé Estebán: *The Immaculate Conception* 747, *747*
Muromachi period, Japan 831–3
Museum of Modern Art xxi, 1127
"The International Style..." (1932) 1071
Mussolini, Benito 729, 1032
Mutu, Wangechi 917
Le Noble Sauvage 917, 917–18
My Sweet Sister Emma (Knowles and Thomas) xx, xxi, xxi–xxii, xxiii
Myanmar (Burma) 784, 790
ceramics 797
Shwedagon Stupa 798–00, *799*
Myein (A. Hamilton) 1146–7, *1147*
mystics/mysticism 568, 709, 725
Sufi 790

N

Nabeshima ware 845, *847*
Nagasaki, Japan 827
NAMES Project Foundation 1140
Namuth, Hans: *Jackson Pollock Painting* 1090, 1091
Nan Madol, Pohnpei 877, 883–4, *884*
Nankani people (Ghana) 911, 912
adobe houses 911–12, *912*

Nanni di Banco 616
The Four Crowned Martyrs 616, *617*
Naples 615, 707, 727, 742, 929
Napoleon Bonaparte 645, 948(c), 952, 954, 955, 958, 962, 963, 966, 973, 982
Napoleon Crossing the Saint-Bernard (David) 962, *962*, 973
Napoleon in the Plague House at Jaffa (Gros) 963, *963*
Napoleon III, Emperor 981, 982, 984, 993, 1026
Nara period (Japan) 830
Nash, Paul 1075
National Endowment for the Arts (NEA) 1130–31
National Museum of the American Indian, Washington, DC 873, *873*
Native Americans 851, 860
Eastern Woodlands 861–4
Great Plains 864–6
Northwest Coast 866–8
performance art 1128–9, *1129*
Southwest 868–71
Nativity and Adoration of the Shepherds (Ghirlandaio) 632–3, *633*
naturalism xvii
Nature Symbolized No. 2 (Dove) 1055, *1055*
Nauman, Bruce 1111
Self-Portrait as a Fountain 1111, *1111*
Navajo, the 851, 868
blankets 851, 870
sand painting 870–71
tapestry 871, *871*
Nayaks 787, 789
Nazi Party xxvii, 589, 1032, 1071–2, 1086, 1087, 1124
Nchare, King of Bamum 898
ndop 900–1
NEA *see* National Endowment for the Arts
"NEA Four" 1131
Neoclassicism 929, 933, 961
in ceramics 935–6, *937*
in painting 929, 943, 943–5, *944*, 952, 952–3, *929*, 931–2, *932*
in sculpture 932–3, *933*, 955–6, *956*, 998–9, *999*
Neo-Expressionism 1124–5
Neoplatonism 609, 635, 658
Nepal 786
Neri, Fra Filippo 737
Neshat, Shirin 1136
Rebellious Silence 1137, *1137*
Netherlands/the Dutch 577, 646, 707, 711, 718, 726, 742, 749, 754–5, 829
architecture (De Stijl) *1068*, 1069
De Stijl movement 1067–9
furniture *1068*, 1069
painting 711–18, *712–18*, 719 (16th century), xxix, xxx, 755–68, *755–68* (17th century), 1011–13, *1013* (Post-Impressionist), 1067, *1067–8* (De Stijl)
Neumann, Johann Balthasar: Church of the Vierzehnheiligen, Germany 928, *929*
Nevelson, Louise 1099
Sky Cathedral 1099, *1099*
New Britain: Tubuan masks 882, 882–3
New Caledonia 876
New Guinea 876, 879, *see* Papua New Guinea
New Ireland 881
malagan ceremonies 881–2. *882*
New Tendencies collectives 1101
Newborn, The (Brancusi) 1049, *1050*
Newman, Barnett 1094
Vir Heroicus Sublimis 1094, *1094*
newspapers 969, 981

Newton (Blake) 946, *946*
Newton, Isaac 922
New York 1082, 1089, 1097
 Academy 942
 AG Gallery, New York 1104
 Armory Show (1913) 1055
 AT&T Building (Johnson and Burgee)
 1123, *1123*
 Brooklyn Museum 1131, 1132
 Central Park (Olmsted and Vaux) 1024, *1026*,
 1026–7
 Chrysler Building 1141
 Flatiron Building 1054–5, *1055*
 Guggenheim Museum (Wright) *1121*, 1121–2,
 1135, 1141
 Harlem Renaissance 1078–80
 Metropolitan Museum of Art 993
 National Academy of Design 974
 Seagram Building (Mies van der Rohe and
 Johnson) 1120, *1120*
 Trinity Church (Upjohn) *975*, 975–6
 TWA Terminal, Kennedy Airport (Saarinen)
 1120–21, *1121*
 291 Gallery 1054
 United Nations headquarters 1078
 Whitney Museum *xxiv*
 Woolworth Building (Gilbert) 1063, *1064*
New Zealand 876, 877, 885
 see also Maoris
Ngāti Pāoa tribe: storehouse doorway
 886, *886*
Ni Zan 811, 812
 The Rongxi Studio 811–12, *812*
Niccolò da Tolentino *606*, 607
Nicolas, Master 568
Nietzsche, Friedrich: *Thus Spake Zarathustra* 1040
Nigeria 901, 905
 see also Yoruba sculpture
Night Watch, The (Rembrandt) *759*, *759*
Nightmare, The (Fuseli) *945*, 945–6
Nihonga artists, Japan 803, 846
Njoya, Ibrahim, King of Bamum 898–9, *899*
nkisi nkondo 906, 906–7
Nkrumah, Kwame 911
No Title (Hesse) 1113–14, *1114*
Noble Sauvage, Le (Mutu) *917*, 917–18
Nobunaga, Oda 833–4, 838
Nochlin, Linda 1116
Nocturne in Black and Gold, The Falling Rocket
 (Whistler) 1002, *1002*
Noland, Kenneth 1109
Nolde, Emil 1041, 1072
 Masks 1041, *1041*
Noli Me Tangere (Fontana) 682–3, *683*
Noli Me Tangere (Giotto) 553
nonrepresentational art *xviii*
North America 860, 922
 painting *920*, 921–2
Northwest Coast 866
 animal imagery 866, *866*
 textiles 867, *867*
Nôtre-Dame-de-Haut, Ronchamp, France
 (Corbusier) *xxii*, *xxiii*
Nour, Amir 895
 Grazing at Shendi *894*, 895
Nouveau Réalism 1101
Nsangu, King of Bamum 899
Nude Descending a Staircase No. 2 (Duchamp) 1051
Nuñez, Andrés 709
Nur Jahan, Mughal empress 792–3, *793*
Nuremberg, Germany 691, 693, 698, 700(c), 701
Nuremberg Chronicle 604, 604–5
Nymph of the Spring (Cranach the Elder) 701, *702*

O

Oath of the Horatii (David) *952*, 952–3,
 958, 963
Object (*Luncheon in Fur*) (Oppenheim) *1074*, 1075
oculi 612
Officers of the Haarlem Militia Company of St. Adrian
 (Hals) 756, *756*
Ofili, Chris: *The Holy Virgin Mary* 1131, 1131–2
Oh, Jeff... I Love You, Too... But... (Lichtenstein) 1108,
 1108
oil paint/oil painting 585, 587, 647, 675
Okakura, Kakuzo 846
 Ideals of the East 846
O'Keeffe, Georgia 1054, 1057, 1058
 City Night 1057, *1057*
 Jack-in-the-Pulpit, No. IV 1057, *1057*
Okeke, Uche 911
Okyo, Maruyama 841
Oldenburg, Claes 1109
Olmsted, Frederick Law 1024
 Central Park, New York (with Vaux) 1024, *1026*,
 1026–7
Olowe of Ise 901
 palace doors 902, *902*
 veranda posts *901*, 901–2
Olympia (Manet) 994–5, *995*
One and Three Chairs (Kosuth) 1110–11, *1111*
One Who Eats, The (do Amaral) *1085*, 1085
Ono, Yoko 1104
 Cut Piece 1104, 1104–5
Open Door, The (Talbot) 987, *987*
Oppenheim, Meret 1075
 Object (*Luncheon in Fur*) *1074*, 1075
opus anglicanum 566, 566–7
Orcagna (Andrea di Cione): Strozzi Altarpiece 559,
 559
Order of the Gold Fleece: cope 584, *584*
Orientalism 981, 982
Orléans, Philippe II, duc d' 922
Orphism 1046–7
orthogonal lines 621, 623, *623*, 625
O'Sullivan, Timothy 988
Otani Oniji in the Role of Yakko Edobe (Sharaku) 842,
 843
Outbreak, The (Kollwitz) 1042, *1042*
Ovonramwen, *oba* 905
 altar dedicated to 905, *905*
Oxbow, The (Cole) 973, 973–4

P

Pachacuti, Inca ruler 857, 858
Pacher, Michael 600
 St. Wolfgang Altarpiece, Austria 600,
 601, 602
Pacific Ocean 875–6
Padua, Italy
 equestrian statue of Gattamelata (Donatello) 619,
 619
 Scrovegni Chapel frescos (Giotto) 551–4, *552–4*
Paik, Nam June 827, 1105
 Electronic Superhighway: Continental U.S. 1113,
 1113
 TV Bra for Living Sculpture 1105, *1105*, 1113
painterly *xviii*
painting *xviii*
 Abstract Expressionist 1089–93,
 1089–93
 African 913, *915*, 915–16
 African-American 1079, *1079*, 1080, *1081*
 American *920*, 921, 931, *944*, 944–5,
 946–7, *947* (18th century), *973*, 973–4, 996–8,
 997, 999, *999*, 1008–9, *1009* (19th century),
 1055, *1055–7*, 1057–8 (Modernist), 1080,
 1081 (Regionalist), 1088–90, *1089* (Abstract
 Expressionist), *1090*, 1090–91 (Action painting),
 1093–4, *1094* (Color Field)
 Australian, indigenous 890–91, *892*
 Brazilian 1085, 1085–6
 British 719, 720, 721 (16th century), 939–42, *939–
 42* (18th century), *945*, 945–6 (Romantic) 1000,
 1000–1 (Pre-Raphaelite), 1086, *1087* (postwar)
 Byzantine 548, 549, 550
 Chinese *xxviii*, *xxix*, xxx, 808, 810, 811, 817, *817*,
 820–21, *821*, *822*; *see also* handscrolls *under*
 China
 Cuban 1086, *1086*, 1087–8, *1088*
 Dutch 574, 575 (15th century), 711–18, *712–18*, 719
 (16th century), 755–68,
 755–68 (17th century), 1011–13, *1013* (Post-
 Impressionist), *1067*, 1067–8
 (*De Stijl*)
 Flemish 574, 575, 584–96, *586–96* (15th century),
 704, *704* (16th century), 749–53, *749–54* (17th
 century)
 French 596, *596–8*, 597 (15th century), 774–8,
 774–7 (17th century), 924–8, *924–7*, 949
 (Rococo), 949–54, *950–55* (18th century), 963–6,
 963–6, 968, 968–9 (Romantic),
 989–95, *990–95* (Realist), 982, *982* (Orientalist),
 984, *984* (19th century), 1003–5, *1004–8*,
 1007–8 (Impressionist), 1008–9, *1009* (late 19th
 century), 1011–12, *1012*, 1027–9, *1027–9* (Post-
 Impressionist), 1015, *1015* (Symbolist), *1045*,
 1045–6, *1046*, 1047 (Cubist) 1046–7 (Orphist)
 German 599–600, *600*, *601* (15th century), 695–6,
 696, 697, 700, 700–2, *702*, *703*
 (16th century), 932, *933* (18th century), 702,
 974, *974* (Romantic), 1040–42,
 1041–2 (Die Brücke) 1042–3, *1043*,
 1071 (Expressionist), *1044*, 1045
 (Der Blaue Reiter)
 Great Plains Indians 865, 865–6
 Impressionist 1003–5, *1004–8*, 1007–8
 Indian 780, 791–3, *791–3* (Mughal), 794–5, *795*
 (Rajput), 803, *803* (20th century)
 International Gothic style 577
 Italian *606*, 607, 627, *627*, 628, *628*, 632–3, *633–5*,
 635–6, *637*, 637–9, *638*, 641–3, *642*, *643* (15th
 century), *644*, 645, 648, *648*, 650, *651–3*, 652–3,
 668–75, *669–74* (16th century), 732–3, *734*,
 734–8,
 736–9 (17th century), 1047, *1047* (Futurist); *see
 also* frescos
 Japanese 835–6, *836–7* (Kano School), 838–9, *839*
 (Rinpa School), 841–2, *842* (literati), 844, *845*
 (Zen)
 Korean 824–6, *825–7*
 Mannerist 678–83, *678–83*, 706, 713, 716
 Mexican 959, *960*, 1084, *1084*, 1085
 Mughal 790, 791–3, *791–3*
 Neoclassical 929, 931–2, *932*, 943, 943–4, *944*, 952,
 952–3, 958, 968
 Orientalist 982, *982*
 Rajput 794–5, *795*
 Realist 989–95, *990–96* (France), 996, *997* (Russia),
 996–8, *997*, 998 (United States)
 Romantic 702, 945–7, *945–7*, 963–6, *963–6*, 968, *968*
 Russian 996, *997* (Realist), *1044*, 1045 (Modernist),
 1048, 1048–9 (Futurist)
 Spanish 709–10, *710* (16th century), 742–5, *742–7*,
 747 (17th century), 957, 957–8, *958* (18th–19th
 century), *1073*, 1073–4, *1074*, 1075 (20th
 century); *see also* Picasso, Pablo
 Surrealist *1073*, 1073–5, *1074*, 1075

Uruguayan 1088, *1088*
Painting (Wols) 1087, *1087*
Pala dynasty 784, 786
 bronze sculpture *785*, 785–6
Palladio, Andrea/Palladianism 675–6, 708, 771, 779, 934, 977
 San Giorgio Maggiore, Venice 674, *675*, 676, 676–7
 Villa Rotonda, Vicenza 677, *677*, 934
Panofsky, Erwin xxvii, xxviii, xxxii
Panoramic View of the Diamond Mountains (Jeong Seon) *825*, 825–6
papacy, the 646
Papua New Guinea 879
 Asmat *bisj* poles 881, *881*
 bilum (net bags) 880, *880*
 korambo 879, 879–80
 musicians 890, *891*
 see also New Britain; New Ireland
Papunya Tula, Australia 890–91
Paris 544, 577, 706, 922, 923, 929, 962, 981, 966, 1009, 1021
 Académie des Beaux-Arts 981, 984, 989, 994, 1003
 Bibliothèque Nationale (Labrouste) 1023, *1023*
 Café Guerbois 995
 École des Beaux-Arts 962, 1007, 1010, 1017, 1022, 1023, 1024
 Eiffel Tower 938, *978*, 979, 1018
 Exposition (1938) 1077
 Louvre 645, 706–7, 707, 942, 982
 Opéra (Garnier) 982, *983*
 Salon d'Automne, Paris 1033–4, 1038
 Salon de la Princess (Boffrand) 923, 924
 Salon des Indépendants, Paris 1037
 Salon des Refusés, Paris 993
 salons 923–4
 Salons 942, 949, 952, 962, 981, 984, 991, 993, 995, 1003
Paris Street, Rainy Day (Caillebotte) 1009, *1009*
parks, city 1026, *1026* (American)
Parler, Peter 544, 571
 Church of the Holy Cross, Schwäbisch Gmünd (with Heinrich Parler) 571, *571*, 573
Parma 665
 Cathedral frescoes (Correggio) *667*, 667–8
Parmigianino (Francesco Mazzola) 680, 683
 Madonna of the Long Neck 680, *680*
Parnassus (Mengs) 932, *932*
parterres 772
pastels 930, *930*, *1055*
Pasteur, Louis 981
Pastoral Concert, The (Giorgione/Titian) 670, *670*, 994
Pastoral Landscape, A (Claude Lorrain) *777*, 778
patrons/patronage 608, 609, 647, 678, 693–4, 725, 735, 736, 747
Paul III, Pope 684, 686, 689
Paul V, Pope 687, 727, 730
Pavlov, Ivan 1033
Paxton, Joseph: Crystal Palace 1022, *1022*
Peasant Family in an Interior, A (Le Nain brothers) 775, *775*
Peasants' War (1524–6) 695, 698
Peeters, Clara 753
 Still Life with Flowers, Goblet, Dried Fruit, and Pretzels 753, *754*
Peláez, Amelia 1086
 Hibiscus (Marpacífico) 1086, *1086*
Pelli, César, and Cerico, Deejay: Petronas Towers, Kuala Lumpur *804*, 805
Pelouze, Marguerite 705
Pencil of Nature, The (Talbot) 987

Pennsylvania Academy of the Fine Arts 996, 997(c), 999, 1008
performance art 1103, 1116
Perón, Juan 1088
Perry, Lilla Cabot 1004
Perry, Commodore Matthew 829, 845
Personal Appearance #3 (Schapiro) 1117, *1117*
perspective xxi, xvii
 aerial 633
 atmospheric xvi, 577, 594, 618, 623, 625
 divergent xvi
 intuitive xvi
 linear xvi, 607, 621, 623, *623*, 625, 636, 637, 639
 vertical xvi
Perugino (Pietro Vannucci) 629, 635, 640, 652, 672
 Christ Giving the Keys to St. Peter 623, 640, *640*
Pesaro, Jacopo 671
Pesaro Madonna (Titian) 671, *671*
Peter, St. 687, 728, 729
Petrarch 544, 608
 The Triumphs 544
Petronas Towers, Kuala Lumpur (Pelli and Cerico) *804*, 805
Philadelphia, Pennsylvania
 Centennial Exhibition (1876) 997
 Vanna Venturi House (Venturi) 1122, 1122–3
Philip II, of Spain 693, 707, 708, 709, 712(c), 750
Philip III, of Spain 742
Philip IV, of Spain 742, 744, *745*, 747, 751
Philip V, of Spain 770(c)
Philip, Archbishop of Utrecht 713
Philip the Bold 577
Philip the Fair 711
Philip the Good 584, 587, 589, 711
Phillips, James 904
Photo-Secession 1054
photography xviii, 981
 African-American 1078, 1079, 1129, *1129*
 American 986, *988*, 988–9 (19th century), 1054–5, *1055*, 1058, *1058*, 1078, 1079, 1080, 1082, *1082*, 1126–8, *1126–8*, 1138–9, *1139* (20th century)
 English 987, *987*, *988*, 989
 French 985–6, *986*
 Iranian 1136–7, *1137*
 Malian 913–14, *914*
photomontage 1053–4, *1054*
Picasso, Pablo 747, 1031, 1036, 1038, 1039, 1045, 1049, 1075, 1084, 1087
 Bottle of Suze 1039–40, *1040*
 Les Demoiselles d'Avignon 1037, 1037–8, 1039
 Family of Salimbanques 1036, *1036*
 Guernica 1076–7, 1077–8
 Ma Jolie 1030, 1031, 1039
 Mandolin and Clarinet 1040, *1040*
 Portrait of Daniel-Henry Kahnweiler 1039, *1039*
Pictures generation 1126, 1143
Piero della Francesca 637, 638
 Baptism of Christ 637, 637–8
 Battista Sforza and Federico da Montefeltro 638, 638–9
pietra dura 794
pietra serena 613, 614
Pietà (Michelangelo *658*, 658–9
Piles, Roger de 727, 771
Pilgrimage to the Island of Cythera (Watteau) *925*, 925–6
pilgrimages 748

Pima nation 959, 961
Pine Spirit (Wu Guanzhong) 822, *823*
Pink-Blue-Pink (Zorio) *1114*, 1114–15
Pink Panther (Koons) 1126, *1126*
Piranesi, Giovanni Battista 931
 View of the Pantheon, Rome 931, *931*
Pisa 659
Pisano, Andrea 559
 Florence baptistery doors 546, *547*, 548, *548*, 609, 621
Piss Christ (Serrano) 1130, *1131*
Pissarro, Camille 995, 1003, 1005, 1013, 1027
 Wooded Landscape at L'Hermitage, Pontoise 1005, *1005*
plague *see* Black Death
Plains Indians *see* Great Plains
Planck, Max 1033
Plato 609
plein air painting 1003, 1005
Plenty's Boast (Puryear) 1145, *1145*
Pleydenwurff, Wilhelm *see* Wolgemut, Michael
Pliny 711
Poe, Edgar Allan 1015
poesie 668
Poet on a Mountaintop (Shen Zhou) 816, 817, *817*
Pointillism 1011
Poliziano, Angelo 632, *633*
Pollaiuolo, Antonio del 629
 Hercules and Antaeus 629, 630, *630*
 The Battle of the Nudes 629–30, *630*
Pollock, Jackson 1090, 1090–91, 1093, 1102, 1113, 1114
 Autumn Rhythm (Number 30) *1090*, 1091
Polo, Marco 810, 813
Polynesia 876, 877, 884–5
polyptychs 579, *579*
Pomo baskets 863, 864, *864*
Pompadour, Madame de 926
Pontormo, Jacopo Carucci da 678, 680
 Annunciation 678
 Deposition 678, *679*, 679–80
Pop Art 1092, 1099, 1106–8, 1109, 1113
porcelain
 Chinese 812, 813
 Japanese 845, *847*
 Korean 824, *824*
Porta, Giacomo della
 Il Gesù, Rome 689
 St. Peter's, Rome 686, 687
Portinari Altarpiece (van der Goes) 593–5, *594–5*, 598, 632, *633*
Portrait of a German Officer (Hartley) *1056*, 1057
Portrait of a Woman and Man (Filippo Lippi) 628, *628*
portraits 577
 British 940, 940–41, *941*
 Dutch (17th century) 755–8
 Indian 792, *792*, *793*
Portugal/Portuguese 646, 707, 709, 742, 765, 829, 834, 897, 903, 911
 sculpture 708–9, *709*
Portuguese Synagogue, Amsterdam (de Witte) 765, *765*
Post, George B.: Manufactures and Liberal Arts Building *1024*
posters, Art Nouveau (Toulouse-Lautrec) 1021, *2021*
Post-Impressionism/Post-Impressionists 1011–14, *1012–14*, 1027–9, *1027–9*, 1043
Postmodernism 896, 1124, 1128
 in architecture 1122–3

Post-partum Document (Kelly) 1119, *1119*
Poussin, Nicolas 771, 774, 776, 962
 Landscape with St. John on Patmos
 776, *777*
 Landscape with St. Matthew and the Angel 776, *77*
poussinistes 771, 962
Prague, Czech Republic 570–71, 573
 Holy Cross Chapel, Karlstejn Castle 573
Prairie School 1060, *1061*
Praxiteles: *Aphrodite of Knidos* 635
Pre-Raphaelite Brotherhood 1000–1
Primaticcio, Francesco 689, 706
 Château of Fontainebleau decoration
 706, *706*
Primavera (Botticelli) *634*, 635
primitivism 1037
Print Lovers, The (Daumier) 970, *970*
printing press 693
printmaking/prints *602*, 602–3
 British 946, *946*
 Dutch 769–61, *760*
 German 603–4, *604*, 698, 698–700, *699*
 Italian 931, *931*
 Japanese *828*, 829, 842–3, *843*, 1008, 1010, *1010*,
 1013
 Spanish 956–7, *957*
 see also engraving(s); etching(s); lithography
"Prix de Rome" 942, 952, 955, 984
Process Art 1114, 1145
Procession of the Relic of the True Cross before the
 Church of St. Mark (Gentile Bellini) 641, *642*
Prometheus Bound (Rubens and Snyders)
 752, *752*
Protestantism/Protestants 646, 695, 703, 720
 see also Reformation, Protestant
Proudhon, Pierre-Joseph 1003
Proun Space (Lissitzky) 1066, *1066*
public art 1132–4
Pucci, Antonio 632
Pucelle, Jean 544
 Book of Hours of Jeanne d'Évreux 562, *563*
Puebloans 868
 architecture 868–9, *869*
 ceramics 868, *869*
 painting 869–70, *870*
Pugin, Augustus W. N. 975
 Houses of Parliament, London (with Barry)
 974–5, *975*
Puryear, Martin 1145
 Plenty's Boast 1145, *1145*

Q

Qin dynasty (China) 808
Qing dynasty (China) 808, 816, 820, 821, 822
 album painting 820–21, *821*, *822*
 hanging scroll *806*, 807
Qingbian Mountains, The (Dong Qichang)
 819, *820*
Qiu Ying 814, *815*
 Spring Dawn in the Han Palace 814–15, *815*
quadratura 739, 740
quadri riportati 734, 740
quillwork, Eastern Woodlands 861–2, *862*
quilting xx, *xxi*, xxi–xxii, 1129–30, *1130*
 Aids Memorial Quilt 1139, 1139–40
Quince (Zhu Da) 821, *822*
Qutb-ud-din Aibak 786–7

R

Raft of the Medusa, The (Géricault) 963–6,
 964, 1143

Raimondi, Marcantonio 994
Raising of Lazarus (Duccio) 556, 557
Raising of Lazarus (Giotto) 553, *553*, 554
Raising of the Cross, The (Rubens) 750, 751
Rajputs 794
 architecture 796, 796–7
 painting 794–5, *795*
raku ware 838, *838*
Ram Khamhaeng, Sukothia king 799
Rama I, Chakri king 800
Ramsey, Captain Hans 899
Raoul-Rochette, Madame Désiré: portrait (Ingres)
 968–9, *969*
Rapa Nui (Easter Island) 876, 877, 888,
 889, 890
 Moai ancestor figures 888–9, *889*
Raphael (Raffaello Santi/Sanzio) 648, 652, 665, 668,
 678, 680, 709, 771, 961, 968
 Agnelo Doni 652, *653*
 Christ's Charge to Peter (study for) 656, *656*
 The Judgment of Paris 994
 Maddalena Strozzi 652, *653*
 Madonna of the Goldfinch (*Madonna del Cardellino*)
 xxvi, *xxvi*, xxvii–xxviii,
 652, *653*
 St. Peter's, Rome 686, 687
 The School of Athens 652–3, *654*, 655
 Sistine Chapel tapestry cartoons 656, *657*
 The Small Cowper Madonna 652, *652*
 Stanza della Segnatura, Vatican 652–3,
 654, 655
Rauschenberg, Robert 1097, 1100, 1101, 1107
 Canyon 1100, *1100*
 Erased De Kooning 1100
 Theater Piece, No. 1 1101
Read, Herbert 1075
readymades 913, 1052
realism xvii, 736, 738
Realism/Realists, 19th-century 989, 1011
 in literature 989
 in painting 989–95, *990–96* (France), 996, *997*
 (Russia),
 996–8, *997*, *998*, 999, *999* (United States)
Rebellious Silence (Neshat) 1137, *1137*
Reclining Mother and Child (Modersohn-Becker)
 1043, *1043*
Recumbent Figure (H. Moore) *1076*, 1077
récupération 913, *914*
"Red-Blue" Chair (Rietveld) *1068*, 1069
Red Mean, The (J. Smith) 871, *872*
Reeve-Tucker, Major W. R. 902
Reformation, Protestant 646, 684, 692–4, 711, 725,
 726
Regionalists, American 1080
Rehearsal on Stage, The (Degas) 1007, 1007–8
Reid, Bill 871
 The Spirit of Haida Gwaii 872, *872*
relief printing 602, *602*
relief sculpture xviii
Rembrandt van Rijn 755, 757, 758,
 771, 1086
 The Anatomy Lesson of Dr. Nicolaes Tulp 758, *758*,
 998
 The Company of Captain Frans Banning Cocq (*The*
 Night Watch) 759, *759*
 Self-Portrait (1658) 761, *761*
 Three Crosses 760, 760–61
Reminiscences of Qinhuai River (Shitao)
 821, *822*
Renaissance, Italian 608–9, 647, 688, 726
Renaissance, Northern 576–77
Renoir, Pierre-Auguste 995, 1005
 Mme. Charpentier and Her Children xxvi, *xxvii*,

xxvii–xxviii
 Moulin de la Galette 1005, *1006*, 1007
Repin, Ilya 996
 Bargehaulers on the Volga 996, *997*
repoussoir 1028
Republic, The (D. French) *1024*
Resurrection, the: symbols 584
Resurrection (Giotto) 553
Return of the Hunters (Bruegel the Elder)
 717, *717*
Returning Home Late from a Spring Outing
 (Dai Jin) 814, *814*
Reynolds, Sir Joshua 940, 943, 944, 945, 946
 Discourses 940, 944
 Lady Sarah Bunbury Sacrificing to the Graces 940,
 940
Ribera, Jusepe 742–3, 744, 996
 Martyrdom of St. Bartholomew 743, *743*
Richards, M. C. 1100
Richardson, Henry Hobson 1024
 Marshall Field Wholesale Store 1024, *1025*
Richelieu, Armand du Plessis, Cardinal
 769, 771
Richter, Gerhard 1142
 Man Shot Down... 1142, *1142*
Riemenschneider, Tilman 694, 695
 Altarpiece of the Holy Blood *694*, 694–5
Rietveld, Gerrit 1069
 "Red-Blue" Chair *1068*, 1069
 Schröder House, Utrecht *1068*, 1069
Rigaud, Hyacinthe: *Louis XIV* 770,
 770–71, *774*
Ringgold, Faith 1129
 Tar Beach 1129–30, *1130*
Rinpa School painting, Japan 838–40, *839*
Riopelle, Jean-Paul 1092
 Knight Watch 1092–3, *1093*
Rivera, Diego 1084
 The Great City of Tenochtitlan 1084, *1084*
Robbia, Andrea della 613
 Infant in Swaddling Clothes 613, *613*
Robbia, Luca della 613
Robin, Pierre (?): Saint-Maclou, Rouen
 598, *598*
Robusti, Marietta 675
Rococo style 922, 932
 interior decoration *923*, 924
 painting 924–8, *924–7*, 949
 sculpture 928, *928*
Rodchenko, Aleksandr 1064–5
 Workers' Club (model) 1065, *1065*
Rodin, Auguste 1017, 1054
 The Burghers of Calais 1017, 1017–18
Roggeveen, Captain Jacob 888
Roman Catholic Church *see* Catholicism
Romanian sculpture 1049–50, *1050*
Romanticism 922, 933, 961–2
 in painting 945–7, *945–7* (in Britain),
 957–8, *958* (Spanish), 963–6, *963–6*, 938, 968–9
 (French), 971, *971*, *972*, 973 (English), 702, 974,
 974 (German)
Rome 609, 636, 640, 665, 727, 729, 731, 929, 931, 942
 Academy of St. Luke 930, 943
 Cornaro Chapel, Santa Maria della Vittoria
 (Bernini) 730, 730–31
 Il Gesù (Vignola) *688*, 689, 727, 740; ceiling
 (Gaulli) 740–41, *741*
 map 647
 Palazzo Barberini ceiling (Cortona)
 739–40, *740*
 Palazzo Farnese ceiling (Annibale Carracci) *733*,
 733–4, 774
 Pantheon 931, *931*

Sack of (1527) 646, 680, 684

St. Peter's 646, 665, 684, 686, *686*, 687, *687*, 707, 727, 728

San Carlo alle Quattro Fontane (Borromini) *731*, 731–2, *732*

San Luigi dei Francesi 735; Caravaggio paintings (Contarelli Chapel) 735, *736*, 737

Santa Maria della Vittoria (Maderno) 730

Sistine Chapel 635; frescos *623*, 656, 660, *660*, *661*, 662, *662*

Tempietto (Bramante) 665, *665*

Trajan's Column 706

Villa Albani 931, 932, *932*

Rongxi Studio, The (Ni Zan) 811–12, *812*

Roof Tiling (Kim Hongdo) 826, *826*

Roosevelt, Franklin D., President 1033, 1080

Roscioli, Giovanni Maria 776

Rosenberg, Harold 1091

Rosetsu, Nagasawa 841

Bull and Puppy 841, *841*

Rossetti, Dante Gabriel 1000

Le Pia de' Tolomei 1000, *1000*–1

Rossi, Properzia de' 668

Joseph and Potiphar's Wife 668, *668*

Rosso Fiorentino 706

Rothko, Mark xx, xxi, xxii, 1093–4

Magenta, Black, Green on Orange xxiii, 1094

Untitled (Rothko Number 5068.49) 1094, *1094*

Rouen, France: Saint-Maclou (Robin) 598, *598*

Rouen Cathedral... (Monet) 1004, *1004*–5

Rousseau, Jean-Jacques 955

Rovere, Guidobaldo della, duke of Urbino 673

Royal Academy, London 940, 942, *942*, 943, 944, 946

rubénistes 771, 962

Rubens, Peter Paul 725, 744, 749–50, 751, 753, 755, 771, 962

Banqueting House ceiling paintings 779, 780

Henry IV Receiving the Portrait of Marie de' Medici 751, 751–2, 925

The Raising of the Cross 750, 751

Rubens's House 750, 751

Self-Portrait with Isabella Brandt 749, 750–51

Rubens's House (Rubens) 750, 751

Rubin, Jon 1148

Rucellai, Giovanni 608

Rude, François 984, 967

Departure of the Volunteers of 1792 (The Marseillaise) 967, *967*

Rue Transnonain, Le... (Daumier) 969, *970*

Ruisdael, Jacob van: *View of Haarlem from the Dunes at Overveen* 766, *766*

Rukupo, Raharuhi: Te-Hau-Ki-Turinga (Maori meeting house) 885, 885–6, *886*

Ruskin, John 1001, *1002*

Russia/Soviet Union 1032, 1064, 1097, 1098

Constructivists 826, 1064–5, *1065*, 1135

painting 996, *997* (Realist), *1044*, 1045 (Modernist), *1048*, 1048–9 (Futurist)

Russian Revolution (1917) 1032, 1064

rustication 614–15

Ruysch, Rachel 767, 768

Flower Still Life 768, *768*

Ryoanji rock garden, Kyoto 832–3, *833*, 836

S

Saarinen, Eero: TWA Terminal, Kennedy Airport, New York 1120–21, *1121*

sacra conversazione 642(c)

Sacrifice of Isaac (Brunelleschi) 609–10, *610*

Sacrifice of Isaac (Ghiberti) 610, *610*

Said, Edward 982

St. Francis in Ecstasy (Giovanni Bellini) 642–3, *643*

St. George (Donatello *617*, 617–18

St. Louis, Missouri: Wainwright Building (Sullivan) 1025, *1026*

St. Luke Drawing the Virgin and Child (van der Weyden) *591*, 591–2

St. Luke Drawing the Virgin Mary (Gossaert) 713–14, *714*

St. Paul's Cathedral, London (Wren) 780, 781

St. Peter's *see under* Rome

St. Sebastian Tended by St. Irene (ter Brugghen) 755, *755*

St. Serapion (Zurbarán) 743, *743*, 744

St. Teresa of Ávila in Ecstasy (Bernini) 724, 725, 730–31

St. Wolfgang Altarpiece, Austria (Pacher) 600, *601*, 602

Sajjan Singh, Maharana 797

Salcedo, Doris: *Shibboleth* 1148

Salcedo, Sebastian: *Virgin of Guadalupe* 959, *960*

Salimbeni, Lionardo Bartolini 607, 609

Saltcellar of Francis I (Cellini) 683, *683*

Samoa 876, 877

siapo/tapa (bark cloth) 889–90, *890*

Festival of Pacific Arts 890, *891*

samurai 830, 831, 838

sand painting, Navajo 870–71

Sande women: *sowei* mask 910, *910*, 911

Sangallo, Antonio da, the Younger: St. Peter's, Rome 686, 687

San Romano, Battle of (1432) 606, 607

Santa Fe Indian School 869–70

Santiago, Kellee *see* Chen, Jenova

Santiago de Compostela, Spain: Cathedral of St. James (Casas y Nóvoas) 748, *748*

Sassetti, Francesco 632

Savage, Augusta 1079

La Citadelle: Freedom 1079, *1080*

Savonarola, Fra Girolamo 636

Sawankhalok kilns, Thailand 797

Saying Grace (Chardin) 949, *950*

Sayoko, Eri 848–9

Ornamental Box 848, *849*

Schapiro, Meyer xxxii

Schapiro, Miriam 1117

Dollhouse (with Brody) 1117

Personal Appearance #3 1117, *1117*

Schedel, Hartmann: *Nuremberg Chronicle* 603, 603–4

Schiele, Egon: *Self-Portrait Nude* 1043, *1043*

Schinkel, Karl Friedrich: Altes Museum, Berlin 976, *976*

Schmidt-Rottluff, Karl 1040

Schneemann, Carolee: *Meat Joy* 1103, *1103*

Schoenberg, Arnold 1101

Schoenmaekers, M. H. J. 1067

Schongauer, Martin 603, 698

The Temptations of St. Anthony 603, 603–4, 699

School of Athens, The (Raphael) 652–3, *654*, 655

Schregel, Sebald 604

Schröder House, Utrecht (Rietveld) *1068*, 1069

Schwäbisch Gmünd, Germany (H. and P. Parler) *571*, 571–2

Schwitters, Kurt 1053, *1053*

science and technology 769, 1033

Sckell, Friedrich Ludwig von: park, Munich 1026

Scotland 778, 780

Scramble for Africa (Shonibare) 918, *918*

Scream, The (Munch) 1016, *1016*

scrolls *see* handscrolls/hanging scrolls

sculpture xviii

African-American 1079, *1080*

American 998–9, *999*, 1094, *1095*

Asante 898, *898*

Aztec 855, *855*

Baroque 724, 725, 728–9, 729, 730, 730–31

Baule 907, 907–8

English 1075, *1076*, 1077

Fant 908, 908–9

Flemish 579, 579–80

French 928, *928*, 955–6, *956*, 984–5, *985*, 1017, 1017–18, *1018*

German 568–9, *569* 694, 694–5, 696, *696*

Italian 615–19, *617–19*, 629, 629–30 (15th century), 658, 658–9, *659*, 663, *663*, 668, *668* (16th century), *724*, 725, 728–9, *729*, 730, 730–31 (17th century), 932–3, *933* (Neoclassical), 1048, *1048* (Futurist)

Kuba *ndops* 900, 900–1

Madagascar 909, 909–10

Mannerist 683, 683–4, *684*

Maori 886, *886*

Mexican 959, *959*

Minimalist *1109*, 1109–10, *1110*, 1126

Neoclassical 932–3, *933*, 955–6, *956*, 998–9, *999*

Portuguese 708–9, *709*

Rococo 928, *928*

Romanian 1049–50, *1050*

Sudanese 894, 895

Yoruba 901, 901–2, *902*

Seasons, The (Lee) 1091, *1091*

Seaweed, Willie: Kwakwaka'wakw bird mask 868, *868*

Self-Portrait (Anguissola) 682, *682*

Self-Portrait (Dürer) 690, 691, 698

Self-Portrait (van Hemessen) 716, *716*

Self-Portrait (Leyster) 757, *757*

Self-Portrait (Rembrandt) 761, *761*

Self-Portrait as a Fountain (Nauman) 1111, *1111*

Self-Portrait Nude (Schiele) 1043, *1043*

Self-Portrait with Isabella Brandt (Rubens) 749, 750–51

Self-Portrait with Two Pupils (Labille-Guiard) 954, *955*

Sellaio, Jacopo del, Biagio d'Antonio, and Zanobi di Domenico: Morelli-Nerli wedding chests 630–31, *631*

Selve, Bishop Georges de *719*, 720

Sen no Rikyu 836

Taian tearoom 836–7, *837*

Sen no Sotan 838

Serlio, Sebastiano 721

Serra, Richard 1141

Tilted Arc *1132*, 1132–4

Serrano, Andres: *Piss Christ* 1130, *1131*

Sesshu 814, 832

Winter Landscape 832, *832*

Seurat, Georges 1011

A Sunday Afternoon on the Island of La Grande Jatte 1011, *1012*

Severini, Gino 1047

Armored Train in Action 1047, *1047*

Severn River Bridge (Darby) 938, *938*

Sévigné, Madame de 923

Seville, Spain 747

Sèvres porcelain 926

Seychelles, the 911

Sforza, Battista: portrait (Piero della Francesca) 638, *638*

Sforza, Ludovico, Duke of Milan 650, 651(c)

Sforza family 608, 648, 665
sfumato 650, 668
shading xxiii
Shah Jahan, Mughal emperor 783, 790, 793
Shakes of Wrangell, Chief 866
Shakespeare, William: *Macbeth* 778
Shang dynasty (China) 808
Sharaku, Toshusai 842
 Otani Oniji in the Role of Yakko Edobe
 842, *843*
Sheep and Goat (Zhao Mengfu) 810, *810*
Shen Zhou 816
 Poet on a Mountaintop 816, *817*, 817
Sherman, Cindy 1127, 1129
 Untitled Film Still #21 1127–8, *1128*
Shimamoto, Shozo: *Hurling Colors* 1102, *1102*
Shinto 830
Shitao 821
 Reminiscences of Qinhua River 821, *822*
Shiva (god) 788, 789
shoin architecture 834–5, *835*, 848, 1061
shoji screens 835, *835*
Shonibare, Yinka 918, 1136
 Scramble for Africa 918, *918*
Shrewsbury, Elizabeth, Countess of 721
Shrine for Girls (Cronin) 1150, *1150*
Shubun (monk-artist) 831, 832
Shute, John 721
Shwedagon Stupa, Myanmar 798–9, *799*
siapo (bark cloth) 889–90, *890*
Sicily 727, 742
Siena, Italy 543, 554, 561, 607, 659
 Palazzo Pubblico *560*, 561; frescos (Lorenzetti)
 542, 543, *560–61*, 561–2
Sierra Leone: *sowei* masks 910, *910*, 911
Sighting of the Argus, The (Géricault)
 964–5, *965*
Signboard of Gersaint, The (Watteau) 924, *925*
Silkhak movement (Korea) 825
silkscreen printing 1107, *1107*
silverpoint 591–2
silverwork
 British *936*
 French 564, *564*
 German 693, *693*, 1070, *1070*
 Inca 860, *860*
Simpson, Lorna 1129
 Stereo Styles 1129, *1129*
sinopia 551, *551*
Sioux 862, 865
 baby carrier 862, *862*, 863
Siqueiros, David 1084
Sistine Chapel, Rome 635, *640*
 frescos 623 (Perugino), 656, 660, *660*, 661, 662, *662*,
 684–6, *685*, 734 (Michelangelo)
 tapestries (Raphael) 656, *657*
Sixtus IV, Pope 635, 640
Sixtus V, Pope 727, 729, 731
Sky II (Sueharu) 848, *848*
Sky Cathedral (Nevelson) 1099, *1099*
skyscrapers 1063, *1063*, *1064*, 1123, *1123*
slavery 936, 937, 947, 954
Sleep of Reason Produces Monsters, The (Goya) 956–7,
 957
Sluter, Claus 579
 Well of Moses *579*, 579–80, 589
Small Cowper Madonna, The (Raphael)
 652, *652*
Smith, David 1094–5
 Cubi 1095, *1095*
Smith, Jaune Quick-to-See : *The Red Mean: Self-
 Portrait* 871, *872*
Smith, Kiki: *Untitled* 1140, *1140*

Smithson, Robert 1115
 Spiral Jetty 1115, *1115*
Smythson, Robert: Hardwick Hall 721–2, *722*
Snake Charmer, The (Gérôme) 982, *982*
Snowstorm: Hannibal and His Army Crossing the Alps
 (Turner) 972, *973*
Snyders, Frans 752
 Prometheus Bound (with Rubens) 752, *752*
Socialist Realism 1066
Société Anonyme des Artistes Peintres, Sculpteurs,
 Graveurs, etc. 1003
Society of Jesus *see* Jesuit Order
Song dynasty (China) 807, 808, 809,
 813(c), 838
 painting 814, 825
 porcelain 813
Sorel, Agnès 597
Sotatsu, Tawaraya 838
 Waves at Matsushima 838–9, *839*
Soufflot, Jacques-Germain: *Panthéon*, Paris 948,
 948–9, *949*
South Africa
 lidded vessel 905, *906* (19th century)
 photography 918–19, *919*
 20th century art 1146, *1146*
South America 959
Southwestern Native Americans 868
 ceramics 869, *869*
 Pueblos 868–9, *869*
 Santa Fe Indian School 869–70
 see also Navajos
Spain 646, 665, 682, 693, 707, 718, 726, 742, 749, 765,
 903, 932, 956, 969
 architecture 707–8, *708*, 709, 748 (16th century),
 748, *748* (17th century), 1019–20, *1020* (Art
 Nouveau)
 painting 709–10, *710* (16th century),
 742–5, *742–7*, 747(17th century), 957, 957–8, *958*
 (18th–19th century), 1073, 1073–4, *1074*, 1075
 (20th century); *see also* Picasso, Pablo
 prints 956–7, *957*
Spanish Civil War 1033, 1077, 1078
Spiral Jetty (Smithson) 1115, *1115*
Spirit of Haida Gwaii, The (Reid) 872, *872*
Spring (Botticelli) 634, 635
Spring Dawn in the Han Palace (Qiu Ying) 814–15, *815*
Stadia II (Mehretu) 1144, *1144*
Staël, Madame de 923
Stalin, Joseph 1032
Stalpaert, Daniel 765
Standing Child (Heckel) 1041, *1041*
Stanton, Elizabeth Cady 980
Starry Night, The (van Gogh) 1012–13, *1013*
Steen, Jan 764
 The Feast of St. Nicholas 764, *764*–5
Stein, Gertrude and Leo 1035
Steinberg, Leo 1038
Steiner House, Vienna (Loos) *1058*, 1059
Stella, Frank 1109
Stereo Styles (simpson) 1129, *1129*
Stevens, Frederick: Victoria Terminus, Mumbai,
 India 802, *802*
Stieglitz, Alfred 1054, 1057, 1058
 Duchamp's *Fountain* 1052
 The Flatiron Building, New York 1054–5, *1055*
still life painting xxviii; *xxviii*, *xxix*, *xxx* (Chinese),
 735 (Italian), 753 (Flemish), 757–8 (Dutch)
 Still Life with Basket of Apples (Cézanne) 1028, *1028*
 *Still Life with Flowers, Goblet, Dried Fruit, and
 Pretzels* (Peeters) *xxix*, xxx, 753, *754*
 *Still Life with Quince, Cabbage, Melon, and
 Cucumber* (Cotán) 742, *742*
 Still Life with Tazza (Claesz) 767, *767*

Stone Breakers, The (Courbet) 989–91, *990*
Stourhead, England: The Park (Flitcroft and Hoare)
 935, *935*
Stravinsky, Igor: *Firebird* 1048
Strawberry Hill, Twickenham (Walpole) 937, 937–8,
 938
Street, Berlin (Kirchner) 1042, *1042*, 1072
stuccowork 706, *706*, 924
Study of Hands and Feet (Géricault) 965, *965*
Stuttgart, Germany: Weissenhofsiedlung exhibition
 (1927) 1071
subject matter xxvii–xxviii
sublime, the 973
Sudan: sculpture *894*, 895
Sueharu, Fukami 848
 Sky II 848, *848*
Sufi mystic 790
Sui dynasty (China) 808
Suitor's Visit, The (ter Borch) 763–4, *764*
Sukhothai, kingdom of 799–800
 Buddhas 799, *800*
 potters 797
Sullivan, Louis 1025, 1060, 1063
 Wainwright Building, St. Louis, Missouri 1025,
 1026
Summer's Day (Morisot) 1006, *1007*
Sunday Afternoon on the Island of La Grande Jatte, A
 (Seurat) 1011, *1012*
Suprematist Painting (Eight Red Rectangles) (Malevich)
 1049, *1049*
Suprematists 1135
Surrealism/Surrealists 1033, 1072–3, 1092, 1087, 1093
 painting *1073*, 1073–5, *1074*
Surrender at Breda, The (The Lances) (Velázquez) 745,
 745, 747
Suzhou, China: Garden of the Cessation of Official
 Life 818, *819*
Swing, The (Fragonard) 927, 927–8
Swiss artists *see* Fuseli, John Henry; Kauffmann,
 Angelica
Symbolism/Symbolists 1011, *1015*, 1015–17, *1016*

T

Tachisme 1086
Tagore, Abanindranath 803
 Bharat Mata (Mother India) 803, *803*
Tagore, Rabindranath 803
Taian tearoom (Sen no Rikyi) 836–7, *837*
Taibei, Taiwan 808
Taiga, Ike 841, 849
 View of Kojima Bay 841–2, *842*
Taikan, Yokoyama 846
 Floating Lights 847, *847*
Taj Mahal, Agra, India 782, 783, 793–4, *794*
Talbot, Henry Fox 987
 The Open Door 987, *987*
 The Pencil of Nature 987
Tale of Genji, The (Lady Murasaki) 830
Talenti, Simone 546
Tang dynasty (China) 807, 808, 813(c), 815
Tanner, Henry Ossawa 999
 The Banjo Lesson 999, *999*
Tantric Buddhism 784, 785, 786
Tao Qian 825
Taos Pueblo, New Mexico 868–9, *869*
tapestries
 Brussels 722, *723*
 Flemish 582–4, *583*, 711
 French 926
 Raphael cartoons 656, *657*
 Two Grey Hills, New Mexico 850, 851
Tapié, MIchel 1087

Tar Beach (Ringgold) 1129–30, *1130*
Target with Plaster Casts (Johns) *1096*, 1097, 1100
Tasmania 876
Tassi, Agostino 777
tatami mats 835, *835*
Tatlin, Vladimir 1064
 Model for the Monument to the Third
 International 1064, *1065*
tattoos, Polynesian 887, *887*
Te-Hau-Ki-Turanga (Maori meeting house) *885*,
 885–6, *886*
technique xviii
Temne people 910
tempera 647
Tempest, The (Giorgione) 669, *669*–70
Tempietto, Rome (Bramante) 665, *665*
Templars 708
Temptations of St. Anthony, The (Schongauer) *603*,
 603–4, 699
tenebrism *738*, 744, 755, 757, 774
Tenochtitlan 853–4, *854*, *855*
Teresa of Ávila, St. 709, 730
 St. Teresa of Ávila (Bernini) *724*, 725, 730–31
textiles
 Bauhaus *1070*, 1070–71 (A. Albers)
 Chilkat Tlingit blankets 867, *867*
 English *566*, 566–7 (14th century)
 Inca *859*, 859–60
 kente cloth 897, *897*–8
 Navajo blankets 851
 see also tapestries
texture xvi
Thailand 805; *see also* Sukothai
Theater Piece, No. 1 (Cage) 1101, *1103*
Theodoric, Master 544, 573
 St. Luke 572, *573*
Theophilus Presbyter: *De Diversis Artibus* 585
Third of May, 1808 (Goya) *958*, 958
Thirty-Six Views of Mount Funi (Hokusai)
 843, *844*
Thobe and Phila I (Muholi) 919, *919*
Thomas of Witney: bishop's throne, Exeter
 Cathedral *567*, 568
Thomson, Tom 1082
 The West Wind 1082, *1083*
Thornton, William: U.S. Capitol, Washington, DC
 976
Thousand Peaks and Myriad Ravines, A (Wang Hui)
 806, 807
Three Aqueous Events (Brecht) *1104*, 1104
Three Crosses (Rembrandt) *760*, 760–61
Three Dancers and Two Musicians... (Midjaw) *878*, 878
Three Women (Léger) *1046*, 1047
Tibet 786, 808
tiercerons 568
Tilted Arc (Serra) *1132*, 1132–4
Time magazine 1090–91
Tintoretto (Jacopo Robusti) 674, *675*, 709
 The Last Supper 674, *674*–5
tipis, Native American *864*, 864–5
tirthankaras (pathfinders) 786
Titian (Tiziano Vecellio) 670, 671, 672, 673, 675, 682,
 709, 771
 Isabella d'Este 671–3, *672*
 The Pastoral Concert *670*, 670, 994
 Pesaro Madonna 671, *671*
 "Venus" of Urbino 672, *673*, 994–5
Tjapaltjarri, Clifford Possum 891
 Man's Love Story 891, *892*
Tlingit, the 866
 blankets 867, *867*
 Grizzly bear screen *866*, 866
Tokugawa Ieyasu 834, 838

Tokugawa shogunate 829, 841, 845
Tokyo 829, 838, 845
Toledo, Spain 709
Tomar, Portugal: church window (Arruda) 708–9,
 709
Tombeau sans Cercueil (*Tomb without a Coffin*)
 (Matulu) 915, *915*–16
Tonga 876, 877, 890
Torres-García, Joaquín 1088
 Abstract Art in Five Tones and Complementaries
 1088, *1088*
Torso of a Young Man (brancusi) 1050, *1050*
Toulouse-Lautrec, Henri de 970, 1021
 Jane Avril 1021, *1021*
Tournai, France 577, 582
town planning, Chinese (Mongol) 816, *816*
Trajan's Column, Rome 706
Tree of Life series (Mendieta) *1118*, 1119
Trent, Council of (1545–63) 684, 727, 735
Très Riches Heures de Duc de Berry (Limbourg
 Brothers) 580–82, *581*, 718
Tribute Money, The (Masaccio) 624–6, *625*
*Trinity with the Virgin, St. John the Evangelist, and
 Donors*
 (Masaccio) 622, *622*, 624, 642
triptychs 579, *579*, 585–7, *586*
Trissino, Giangiorgio 676
*Triumph of the Name of Jesus and Fall of the Damned,
 The* (Gaulli) 740–41, *741*
trompe l'oeil 587–8, 636, 662, 667. 695
Tub, The (Degas) 1008, *1008*
Tubuan masks *882*, 882–3
Tucker, Mark xxxi, xxxii, xxxv
Tucson, Arizona: Mission San Xavier del Bac 959,
 961, *961*
Tulsi Kalan 791(c)
Turks 668, 671
Turner, Joseph Mallord William 971, 973
 *The Burning of the Houses of Lords and Commons,
 16th October 1834* 972, *973*
 *Snowstorm: Hannibal and His Army Crossing the
 Alps* 972, *973*
TV Bra for Living Sculpture (Paik) 1105, *1105*, 1113
Two Callas (Cunningham) *1058*, 1058
Two Fridas, The (Kahlo) 1084, *1085*
Two Grey Hills, New Mexico: tapestry weaving
 850, 851
Tzara, Tristan 1053

U

Uccello, Paolo 627
 The Battle of San Romano 606, *607*, 609, 627
Udai Singh II, Maharana 796
udaipur, India: City Palace (Rajput) *796*, 796–7
ukiyo-e prints 842–43, 844, 1010
Ulugali'i Samoa: Samoan Couple (Kihara) 892–3, *893*
underglaze painting 813
Unicorn Tapestry *583*, 583–4
Unique Forms of Continuity in Space (Boccioni) 1048,
 1048
Unit One (group) 1075
United States 860, 1032, 1033, 1088, 1097–8
 architecture 868, *869* (Puebloan), 974, 974–5
 (Gothic Revival), 976, 976–7, *977* (Neoclassical),
 1022, 1023–5, *1024–6* (late 19th century),
 1060–62, *1060–62*, (Modernist), 1063, *1063*,
 1064 (skyscrapers), 1120, *1120*–22, *1121* (20th
 century), *1122*, 1122–3, *1123* (Postmodern)
 Harlem Renaissance 1078–80, *1081*
 painting *920*, 921, 931, *944*, 944–5, 946–7, *947* (18th
 century), *973*, 973–4, 996–8,
 997, 999, *999*, 1008–9, *1009* (19th century), 1055,

 1055–7, *1057–8* (Modernist),
 1080, *1081* (Regionalist), 1088–90,
 1089 (Abstract Expressionist), *1090*, 1090–91
 (Action painting), 1093–4, *1094* (Color Field)
 photography 986, *988*, 988–9 (19th century),
 1054–5, *1055*, 1058, *1058*, *1078*, 1079, 1080,
 1082, *1082*, 1126–8, *1126–8*, 1138–9, *1139* (20th
 century)
 sculpture 998–9, *999*, 1094–5, *1095*
Universe 5-IV-71 #200 (Whanki KIm)
 826–7, *827*
Untitled (Hammons) *1146*, 1145–6
Untitled (Judd) *1109*, 1109–10
Untitled (K. Smith) 1140, *1140*
Untitled Film Still #21 (Sherman)
 1127–8, *1128*
"Untitled" (Loverboy) (Gonzalez-Torres)
 1138, 1138
Untitled (Mirrored Cubes) (R. Morris) 1110, *1110*
Untitled (Rothko Number 5068.49) (Rothko) 1094,
 1094
Untitled (Your Gaze Hits the Side of My Face) (Kruger)
 1127, *1127*
Upanishads, the 784
Upjohn, Richard: Trinity Church, New York *975*,
 975–6
Urban VIII, Pope 728, 739, 776
Urbino, Italy 608, 636, 638, 665, 673
 Ducal Palace (Laurana) 636, *636*
 San Bernardino 652(c)
 Studiolo of Federico da Montefeltro
 636–7, *637*
Uruguayan painting 1088, *1088*
Utrecht, Netherlands 754, 755, 756
 Schröder House (Rietveld) *1068*, 1069

V

Vai people 910
Vajrayana Buddhism *see* Tantric Buddhism
van der Hoof, Gail xxii
Van Der Zee, James 1079
 Couple Wearing Raccoon Coats...
 1078, 1079
Vanderbilt, Cornelius 993
vanishing point 622, *623*, 623, 625, 642
vanitas paintings xxx, 925
Vasari, Giorgio 550, 585, 614, 627, 645, 646, 653(c),
 668, 711
Vatican, the 727; *see also* Sistine Chapel
Vaux, Calvert *see* Olmsted, Frederick Law
Vauxcelles, Louis 1034, 1038
Vedas/Vedic tradition 784
Vedic (Husain) *804*, 805
vedute 931
Velarde, Pablita 869–70
 Koshares of Taos 869, *870*, 870
Velázquez, Diego de 744, 755, 996
 Las Meninas (The Maids of Honor) 746,
 747, 957
 Pope Innocent X 1086
 The Surrender at Breda (The Lances) 745,
 745, 747
 Water Carrier of Seville 744, *744*
Velderrain, Juan Bautista 961
Venice, Italy 607, 636, 640, 665, 668, 673, 929,931
 Biennale 1136, 1146, 1150
 Ca d'Oro (Contarini Palace) 641, *641*
 Doge's Palace 739, *930*
 St. Mark's Cathedral 640, *641*
 San Giorgio Maggiore (Palladio) 674, *675*, 676,
 676–7
Venturi, Robert 1122

Vanna Venturi House, Philadelphia *1122,* 1122–3
"Venus" of Urbino (Titian) *672, 673,* 994–5
Vermeer, Johannes (Jan) 755, 762
 View of Delft 762, *762*
 Woman Holding a Balance 762–3, *763*
Veronese (Paolo Caliari) 673, 674, 709, 771
 Feast in the House of Levi 673, 673–4
Verrocchio, Andrea del 612. 629, 648
 David 629, *629,* 730
Versailles, Palace of (Le Brun, Le Vau, and
 Hardouin-Mansart) 771, *773, 774,* 922, 923, 926
 gardens (Le Vau and Le Nôtre) 771,
 772, *772*
 Trianon *772, 772*
Vesalius, Andreas 758
Vesperbild 568–9, *569*
Vicenza, Italy: Villa Rotonda (Palladio) 677, *677,* 934
Victoria, Queen 802, 1022
video art 1105, 1112–13
video games 1150–51
Vienna: Steiner House (Loos) *1058,* 1059
Vierzehnheiligen, Church of the, Germany
 (Neumann) 928, *929*
Vietnam: ceramics 797, *797*
Vietnam Veterans Memorial (Lin) *1133,* 1133–4
Vietnam War 1097
View of Delft (Vermeer) 762, *762*
View of Haarlem from the Dunes at Overveen (van
 Ruisdael) 766, *766*
View of Kojima Bay (Taiga) 841–2, *842*
View of the Pantheon, Rome (Piranesi) 931, *931*
Vigée-Lebrun, Marie-Louise-Élisabeth 950, 951(c)
 Portrait of Marie Antoinette with Her Children
 950–51, *951*
Vignola (Giacomo Barozzi) 688–9, 708
 Il Gesù, Rome 688, 689, 727, 740
Vijayanagara, India 787
 Elephant Stables *788,* 788–9
 Virupaksha Temple 787–8, *788*
Villa Savoye, Poissy, France (Le Corbusier) 1059,
 1059
Village Bride, The (Greuze) 950, *951*
Villa-Lobos, Hector 1085
Viola, Bill: *The Crossing 1112,* 1112–13
Violin and Palette (Braque) *1038,* 1038–9
Viollet-le-Duc, Eugène 989
Vir Heroicus Sublimis (Newman) *1094, 1094*
Virgin and Child (Bouts) 593, *593*
Virgin and Child (Fouquet) *596,* 597
Virgin and Child Enthroned (Cimabue)
 548–9, *549*
Virgin and Child Enthroned (Giotto) 550, 550–51
*Virgin and Child Enthroned with SS. Francis, John the
 Baptist, Job, Dominic, Sebastian, and Louis of
 Toulouse* (Giovanni Bellini) 641–2, *642*
Virgin of Guadalupe (Salcedo) 959, *960*
Virgin of the Rocks, The (Leonardo) 648, *648,* 650, 652
Virupaksha Temple, Vijayanagara, India 787–8, *788*
Visconti family 608
Vitra Fire Station, Germany 1135, *1135*
Vitruvian Man (Leonardo) 649, *649,* 650, 871
Vitruvius: *On Architecture* 649, 665, 676, 688, 711, 771
Vlaminck, Maurice de 1034
Voltaire 955

W

Wainwright Building, St. Louis, Missouri (Sullivan)
 1025, *1026*
Waitangi, Treaty of (1840) 875
Walker, Kara 1147
 Darkytown Rebellion 1147, 1147–8
Wall, Jeff 1143
 After "Invisible Man"... 1143, *1143*
Walpole, Horace
 The Castle of Otranto 937
 Strawberry Hill, Twickenham *937,*
 937–8, *938*
Waltz, The (Claudel) 1018, *1018*
wampum, Eastern Woodlands 861, *862*
"Wanderers, the" 996
Wang Hui: *A Thousand Peaks and Myriad Ravines*
 806, *807*
Wapepe Navigation Chart 883, *883*
Warhol, Andy 1106, 1107, 1108, 1109
 Brillo Soap Pads Box 1108, *1108*
 Marilyn Diptych 1107, 1107–8, 1126
Washington, DC
 Corcoran Gallery 1131
 National Museum of the American Indian 873,
 873
 U.S. Capitol (Latrobe) 976, 976–7
 Vietnam Veterans Memorial (Lin) *1133,* 1133–4
Washington, George 956(c)
 statue (Houdon) 955–6, *956*
Water Carrier of Seville (Velázquez) 744, *744*
Watson and the Shark (Copley) 946–7, *947*
Watteau, Jean-Antoine 924–5
 Pilgrimage to the Island of Cythera 925, 925–6
 The Signboard of Gersaint 924, *925*
Waves at Matsushima (Sotatsu) 838–9, *839*
wax-print fabric 918, *918*
Weather Project, The (Eliasson) *1148,* 1148
Webb, Philip, and Morris, William
 "Peacock and Dragon" curtain 1001
 "Sussex" chair 1001, *1001*
Wedgwood, Josiah 935, 936, 941
 jasperware 935–6, *937*
Weleski, Dawn 1148
Well of Moses (Sluter) *579,* 579–80, 589
West, Benjamin 931, 944, 946
 The Death of General Wolfe 944, 944–5, *947*
West Wind, The (Thomson) 1082, *1083*
Weyden, Rogier van der xxxv, 590, 593
 Crucifixion Triptych with Donors and Saints xxxiii,
 xxxiii–xxxiv
 *Crucifixion with the Virgin and St. John the
 Evangelist xxx,* xxi–xxxiii, xxxiv, xxxv, *xxxv*
 Deposition 590, 590–91
 St. Luke Drawing the Virgin and Child 591, 591–2,
 714
Whirling Log Ceremony, Navajo 871, *871*
Whistler, James Abbott McNeill 1001, 1052
 Nocturne in Black and Gold, The Falling Rocket 1002,
 1002
Whiteread, Rachel 1149
 House 1149, 1149–50
William and Mary 778–9
Winckelmann, Johann Joachim 932, 944, 945
 portrait (Kauffmann) *943*
Witte, Emanuel de 765
 Portuguese Synagogue, Amsterdam 765, *765*
Wittet, George: Gateway of India, Mumbai 803, *803*
Witz, Konrad 600
 Miraculous Draft of Fishes 600, 600
Wodiczko, Krzysztof: *Homeless Vehicle*
 1149, *1149*
Wojnarowicz, David 1138–9
 Untitled (Hands) 1139, *1139*
Wolfe, General James *944,* 944–5
Wolgemut, Michael 698
 Nuremberg Chronicle (with Pleydenwurff) *604,*
 604–5
Wols (Wolfgang Schulze) 1086–7
 Painting 1087, *1087*
Woman Bathing (Cassatt) 1010, *1010*
Woman I (De Kooning) 1092, *1092*
Woman Holding a Balance (Vermeer) 762–3, *763*
Woman with the Hat (Matisse) *1034,* 1035
Womanhouse (Chicago and Schapiro) 117
women xxii; 646, 668, 675, 682–3, 705, 716 (16th
 century), 738, 753, 756–7 (17th century),
 930–31, 942–3, 954 (18th century), 923, 942–3,
 1007, 1008–9 (19th century); and Bauhaus 1070;
 United States (19th century) 980
Wood, Grant: *American Gothic* 1080, *1081*
woodcuts/woodblock prints 602, *602,* 603, *603,* 698,
 698–9
 Japanese 828, *829,* 842–3, *843,* 1008, 1010, *1010,*
 1013
Wooded Landscape at L'Hermitage, Pontoise (Pissarro)
 1005, *1005*
Woolworth Building, New York (Gilbert) 1063, *1064*
Worker and Collective Farm Woman (Mukhina) 1066,
 1067
Workers' Club (Model) (Rodchenko)
 1065, *1065*
Works Progress Administration 1079, 1080
World War I 705(c), 899, 1032, 1033, 1038, 1040,
 1050–51, 1064, 1072, 1073
World War II xxiii, 589, 651(c), 705(c), 735, 825, 847,
 1039, 1086–7, 1088, 1097, 1105
Worpswede artists 1042–3
Worth, Charles Frederick xxviii
Wren, Christopher 781
 St. Paul's Cathedral, London *780,* 781, 949
Wright, Frank Lloyd 1060
 Fallingwater, Pennsylvania *1061,* 1061–62
 Guggenheim Museum, New York *1121,* 1121–2,
 1135
 Robie House, Chicago *1060,* 1061
Wright, Joseph, of Derby: *An Experiment on a Bird in
 the Air-pump* 941–2. *942*
Wu Guanzhong 822
 Pine Spirit 822, 823

X

Xavier, Francis 961
Xia dynasty (China) 808
Xuande emperors 812

Y

Yard (Kaprow) 1102, *1103*
Yayoi period, Japan 830
Yi Seonggye, General 823
Yin Hong 814
 Hundreds of Birds Admiring the Peacocks
 814, *814*
Yongle emperors 812, 816
Yoruba sculpture *901,* 901–2, *902*
Young British Artists 1131, 1140, 1149
Young Woman Looking at a Pot of Pinks (Harunobu)
 1010
Yuan dynasty (China) 807, 808,
 809, 810
 hand- and hanging scrolls *810,* 810–12,
 812, 816
Yun Shouping 820–21
 Amaranth 821

Z

al-Zaman, Nadir: *Jahangir and Shah Abbas*
 792, *792*
Zambezia, Zambezia (Lam) 1087–8,
 1088
Zanobi di Domenico *see* Sellaio, Jacopo del

Zappi, Gian Paolo 682
Zen Buddhism 818, 831, 832, 836, 838
 dry gardens 832–3, *833*
 painting 844, *845*
Zero Group 1101
Zhao Mengfu 810
 Sheep and Goat 810, *810*
Zhe-style painting 814
Zhou dynasty (China) 808
Zhu Da xxviii, xxx, 821
 Quince (Mugua) xxix, 821, *822*
Zhu Yuanzhang, Ming ruler 812
Zhuangzi 808
Zoffany, Johann: *Academicians of the Royal Academy*
 942
Zola, Émile 989
Zorio, Gilberto 1114
 Pink-Blue-Pink 1114, 1114–15
Zurbarán, Francisco de 743–4, 747
 St. Serapion 743, *743*, 744
Zürich 1053
 Cabaret Voltaire 1051